ISBN 978-1-332-00567-3
PIBN 10267161

This book is a reproduction of an important historical work. Forgotten Books uses
state-of-the-art technology to digitally reconstruct the work, preserving the original format
whilst repairing imperfections present in the aged copy. In rare cases, an imperfection in
the original, such as a blemish or missing page, may be replicated in our edition. We do,
however, repair the vast majority of imperfections successfully; any imperfections that
remain are intentionally left to preserve the state of such historical works.

1 MONTH OF
FREE
READING

at

www.ForgottenBooks.com

English
Français
Deutsche
Italiano
Español
Português

www.forgottenbooks.com

Mythology Photography **Fiction**
Fishing Christianity **Art** Cooking
Essays Buddhism Freemasonry
Medicine **Biology** Music **Ancient**
Egypt Evolution Carpentry Physics
Dance Geology **Mathematics** Fitness
Shakespeare **Folklore** Yoga Marketing
Confidence Immortality Biographies
Poetry **Psychology** Witchcraft
Electronics Chemistry History **Law**
Accounting **Philosophy** Anthropology
Alchemy Drama Quantum Mechanics
Atheism Sexual Health **Ancient History**
Entrepreneurship Languages Sport
Paleontology Needlework Islam
Metaphysics Investment Archaeology
Parenting Statistics Criminology
Motivational

LIBRARY OF CONGRESS

COPYRIGHT OFFICE

CATALOGUE

OF

COPYRIGHT ENTRIES

PART 1:

BOOKS, GROUP 1

NEW SERIES, VOLUME 8

FOR THE YEAR 1911

Nos. 1–134

Published by authority of the Acts of Congress of March 3, 1891, of June 30, 1906, and of March 4, 1909

WASHINGTON

GOVERNMENT PRINTING OFFICE

1911

28636—12——14

The act of March 4, 1909, provides that the Catalogue of Copyright Entries shall be "admitted in any court as prima facie evidence of the facts stated therein as regards any copyright registration."

Number of entries of books included in the Catalogue for 1911:

 (a) United States publications... 6,033
 (b) Foreign books in foreign languages................................. 1,410
 (c) Foreign books in English language under *ad interim* provisions of law
 of Mar. 4, 1909... 238

 Total.. 7,681

1–130

LIBRARY OF CONGRESS

COPYRIGHT OFFICE

CATALOGUE

OF

COPYRIGHT ENTRIES

PUBLISHED BY AUTHORITY OF THE ACTS OF CONGRESS
OF MARCH 3, 1891, OF JUNE 30, 1906, AND
OF MARCH 4, 1909

PART 1, GROUP 1

BOOKS

New Series, Volume 8, Group 1

No. 1

Published February 2, 1911

..

WASHINGTON
GOVERNMENT PRINTING OFFICE
LIBRARY DIVISION
1911

The Act of March 4, 1909, provides that the Catalogue of Copyright Entries shall be "admitted in any court as prima facie evidence of the facts stated therein as regards any copyright registration."

NOTICE.

Sections 59 and 60 of the "Act to amend and consolidate the Acts respecting copyright" provide as follows:

SEC. 59. That of the articles deposited in the copyright office under the provisions of the copyright laws of the United States or of this Act, the Librarian of Congress shall determine what books and other articles shall be transferred to the permanent collections of the Library of Congress, including the law library, and what other books or articles shall be placed in the reserve collections of the Library of Congress for sale or exchange, or be transferred to other governmental libraries in the District of Columbia for use therein.

SEC. 60. That of any articles undisposed of as above provided, together with all titles and correspondence relating thereto, the Librarian of Congress and the register of copyrights jointly shall, at suitable intervals, determine what of these received during any period of years it is desirable or useful to preserve in the permanent files of the copyright office, and, after due notice as hereinafter provided, may within their discretion cause the remaining articles and other things to be destroyed: *Provided,* That there shall be printed in the Catalogue of Copyright Entries from February to November, inclusive, a statement of the years of receipt of such articles and a notice to permit any author, copyright proprietor, or other lawful claimant to claim and remove before the expiration of the month of December of that year anything found which relates to any of his productions deposited or registered for copyright within the period of years stated, not reserved or disposed of as provided for in this Act: *And provided further,* That no manuscript of an unpublished work shall be destroyed during its term of copyright without specific notice to the copyright proprietor of record, permitting him to claim and remove it.

In compliance with the above-cited provisions of law, **Notice is hereby given** to the author, copyright proprietor, or other lawful claimant of any printed book, pamphlet, circular, leaflet, etc., deposited for copyright registration in the Office of the Librarian of Congress during the years 1870 to 1879, inclusive, that any such author, copyright proprietor, or other lawful claimant

may send to the Register of Copyrights his full name, the full title of the book, pamphlet, circular or leaflet, the year in which copyright registration was made, and, if possible, the number under which such book, pamphlet, circular, or leaflet was entered for copyright, with a request for its return. On receipt of such information and request, such book, pamphlet, circular, or leaflet will be returned to the author, copyright proprietor, or other lawful claimant, unless it has been otherwise disposed of according to law.

Application for the return of such book or pamphlet, etc., should be made as early as possible during the year 1911. If no such application has been received during said year, such book or pamphlet, etc. may be disposed of in accordance with the provisions of section 60 of said Act.

<div align="right">THORVALD SOLBERG,

Register of Copyrights.</div>

FEBRUARY 1, 1911.

COPYRIGHT BOOKS FORWARDED FOR PRINTED TITLE CARDS

The catalogue titles for books deposited for copyright registration for which printed cards are furnished to other libraries are prepared by the Catalogue Division of the Library of Congress. These books are indicated in the Catalogue of Copyright Entries by the printer's number attached to each title, which can be used in ordering printed title cards.

The books deposited in the Copyright Office divide themselves into two classes:

Class a Books received with informal applications or informal affidavits, or without the registration fee, or without the data required in order to make the copyright registration.

In the case of these books, before any action can take place in the Copyright Office to indicate the registration number, correspondence must be had with the depositors. The necessary letters of inquiry are promptly dispatched, but it depends entirely upon the promptness with which replies to these letters of inquiry are received when these books can be numbered and forwarded for cataloguing. They are, however, commonly the less important works and are not received from the leading or regular publishers, but from occasional depositors.

Class b Books received with the necessary fee, application, and affidavit, and these documents in such order that the registration can be promptly proceeded with.

In the case of the books of class "b" the manner of handling them in the Copyright Office enables each to be given promptly a registration number, and such books, with a printer's copy card for each containing the full copyright notice, are sent forward from the Copyright Office for cataloguing, for the most part, on the day of receipt. These are mostly books deposited by the regular publishers, and include, therefore, not only the greater part of the books deposited, but also nearly all the important books. Of a total of 8254 books received and drawn up into the Library of Congress from the Copyright Office from November 8, 1909, to June 30, 1910, inclusive, 1338 were of class "a" and 6916 of class "b." Of the 6916 books of class "b" each book was sent up on the day it was received in the Copyright Office.

———

For the present fiscal year, out of a total of 7380 books received and drawn up into the Library of Congress from the Copyright Office July 1, 1910, to February 1, 1911, inclusive, 760 were of class "a" and 6620 of class "b." · Of the 6620 books of class "b" each book was sent up on the day it was received in the Copyright Office.

2198—pt. 1, no. 1—11—1*

THE Catalogue of Copyright Entries, Part 1, Group 1, containing the titles for books, is printed weekly with entries arranged alphabetically by author, or, if anonymous, by title. This group contains mainly the titles of books for which printed catalogue cards are issued by the Library of Congress, etc., also including the titles of foreign books and books registered under the act of March 4, 1909, for ad interim protection.

The Catalogue of Copyright Entries, Part 1, Group 2 (monthly), contains mainly the titles of pamphlets, leaflets, and literary contributions to periodicals, and all other productions registered under the legal designation "book" not found in Group 1, including also, however, preliminary reports of court decisions, local directories, herd-books and other annuals, etc. Group 2 also contains in three separate alphabets the titles for the entries made for Lectures, sermons and addresses prepared for oral delivery, Dramatic compositions, and Maps.

Under the Act of March 4, 1909, in effect from July 1, 1909, copyright initiates upon publication with notice. The preliminary entry of title ceases, and registration follows deposit of copies with an application for entry in the Copyright Office.

To save space in the Catalogue the copyright notice after each title is abbreviated. The abbreviations used in this Part are as follows: "A," Class A, Books; "A—Foreign," Foreign books in foreign languages; "C," Class C, Lectures, sermons and addresses prepared for oral delivery; "D," Class D, Dramatic compositions; "F," Class F, Maps; "©" stands for copyright registration, followed by date of publication, and "2c." for 2 copies, followed by date of their receipt. "A ad int." implies ad interim copyright registration under the law of March 4, 1909, of a book published abroad in the English language, for which the deposit of only one copy is required.

The number at the end of each title, after the notice of copyright, is a citation number by means of which reference is made in the index to this title.

The printed catalogue cards published by the Library of Congress may be ordered by the number in parentheses, printed with a hyphen, immediately following the copyright notice of the books for which such cards are supplied.

A list of the copyright renewals and extensions made for books under sec. 24 of the Act of March 4, 1909, will be found at the end of the last issue of Part 1, Group 1, for each month, just prior to the index. A similar list for dramatic compositions will be found in Part 1, Group 2.

———— — ···

The annual subscription price for the Catalogue of Copyright Entries (received only for the calendar year), for Part 1, Groups 1 and 2, is $1.00 for 1911, payable in advance to the Superintendent of Documents, Washington, D. C., by postal money order, express order, or New York draft.

Ainsworth, Percy C.

The threshold grace; meditations in the Psalms, by
Percy C. Ainsworth ... London, C. H. Kelly [°1911]
116 p. 16ᵐ. 1/6
Reprinted from the "Methodist times."
© 1c. Jan. 1, 1911; A ad int. 434; published Dec. 1, 1910; Fleming H. Re-
vell co., New York, N. Y. (11–922) **1**

Albertus *Magnus, bp. of Ratisbon,* 1193?–1280, *supposed
author.*

Albertus Magnus; being the approved, verified, sympa-
thetic and natural Egyptian secrets, white and black art
for man and beast ... by that celebrated occult student ...
New rev., enl. ed. prepared for publication under the
editorship of Dr. L. W. de Laurence. Three books which
were faithfully tr. from the German original and now
pub. in one new rev. large volume ... Chicago, Ill., De
Laurence, Scott & co., 1910.
2 p. l., [iii]–iv, [5]–208 p. 19¼ᵐ. $1.00
© Dec. 29, 1910; 2c. Jan. 3, 1911; A 278785; De Laurence, Scott & co.,
Chicago, Ill. (11–766) **2**

Applin, Arthur.

The pantomime girl, by Arthur Applin ... London,
Everett & co. [°1911]
318 p. 19ᵐ. 2/
© 1c. Jan. 12, 1911; A ad int. 441; published Dec. 14, 1910; A. Applin,
England. (11–943) **3**

Ashton, William Easterly, 1859–

... Essentials of obstetrics arranged in the form of ques-
tions and answers, prepared especially for students of
medicine, by William Easterly Ashton ... 7th ed., rev., by
John A. McGlinn ... Philadelphia and London, W. B.
Saunders company, 1911.
2 p. l., 11–287 p. illus., pl. 18½ᵐ. (Saunders' question-compends. no. 5)
$1.00
© Jan. 3, 1911; 2c. Jan. 5, 1911; A 278899; W. B. Saunders co., Philadel-
phia, Pa. (11–936) **4**

Ayscough, John.

Mezzogiorno, by John Ayscough. St. Louis, Mo., B.
Herder, 1911.
1 p. l., 410 p. 20ᵐ. $1.50
© Jan. 12, 1911; 2c. Jan. 14, 1911; A 280091; Joseph Gummersbach, St.
Louis, Mo. (11–945) **5**

Bandler, Samuel Wyllis, 1869–
Vaginal celiotomy, by S. Wyllis Bandler ... with 148 original illustrations. Philadelphia and London, W. B. Saunders company, 1911.
2 p. l., 13–450 p. incl. plates. 26ᶜᵐ. $5.00
© Jan. 5, 1911; 2c. Jan. 7, 1911; A 278961; W. B. Saunders co., Philadelphia, Pa. (11–935) 6

Barnhill, John F 1865–
Principles and practice of modern otology, by John F. Barnhill ... and Ernest deWolfe Wales ... with 314 original illustrations, many in colors. 2d ed., thoroughly rev. Philadelphia and London, W. B. Saunders company, 1911.
598 p. illus. (partly col.) col. plates. 25ᶜᵐ. $5.50
"The first three chapters, chapter xviii, and some of the pathology have been prepared by Dr. Wales; the balance of the work by Dr. Barnhill."— Pref. to 1st ed.
© Jan. 3, 1911; 2c. Jan. 5, 1911; A 278900; W. B. Saunders co., Philadelphia, Pa. (11–934) 7

Baskerville, Charles, 1870– *ed.*
Municipal chemistry; a series of thirty lectures by experts on the application of the principles of chemistry to the city, delivered at the College of the city of New York, 1910; ed. by Charles Baskerville ... New York [etc.] McGraw-Hill book company, 1911.
ix, 526 p. illus. 24ᶜᵐ. $5.00
© Dec. 30, 1910; 2c. Jan. 3, 1911; A 278839; McGraw-Hill book co., New York, N. Y. (11–502) 8

Baxter, *Mrs.* **Marion (Babcock)**
Bits of verse and prose, by Marion B. Baxter. Seattle, Printed by Lowman & Hanford co. [ᶜ1910]
54 l. front. 18¼ᶜᵐ. $1.00
© Dec. 8, 1910; 2c. Jan. 3, 1911; A 278819; Beatrice Baxter McClure, Seattle, Wash. (11–583) 9

Bender's lawyers' diary and directory for the state of New York, 1911 ... 20th year ... Albany, N. Y., M. Bender & co., 1910.
7 p. l., [11]–791 p. 23¼ᶜᵐ. $3.00
© Dec. 31, 1910; 2c. Dec. 30, 1910; A 280015; Matthew Bender & co., Albany, N. Y. 10

Benson, Robert Hugh, 1871–
None other gods, by Robert Hugh Benson ... St. Louis, Mo., B. Herder, 1911.
viii, 477 p. 19ᶜᵐ. $1.50
© Jan. 7, 1911; 2c. Jan. 9, 1911; A 278988; Joseph Gummersbach, St. Louis, Mo. (11–773) 11

Bible. *Selections. English.*
... Five minute Bible readings from Genesis to Revelation, for private use and family worship; arranged by a layman, with introduction by Henry Van Dyke, d. d. New York, Chicago [etc.] Fleming H. Revell company [ᶜ1910]
x, 378 p. 22¼ᶜᵐ. $1.50
© Dec. 21, 1910; 2c. Jan. 5, 1911; A 278896; Fleming H. Revell co., New York, N. Y. (11–831) 12

2

Biese, Alfred.

Deutsche literaturgeschichte, von Alfred Biese. 3. bd.
Von Hebbel bis zur gegenwart. 1. bis 3. aufl. ... Mün-
chen, C. H. Beck'sche verlagsbuchhandlung Oskar Beck,
1911.

vii, 675 p. front., ports. 22cm.
© Dec. 20, 1910; 2c. Jan. 10, 1911; A — Foreign 2294; C. H. Beck'sche
verlagsbuchhandlung Oskar Beck, Munich, Germany. 13

Bole, John Archibald, *ed.*

Deutsche wirtschaft; selections from Loening's Grund-
züge der verfassung des Deutschen Reiches and from
Arndt's Deutschlands stellung in der weltwirtschaft, ed.
with notes and vocabulary, by John A. Bole ... New York,
H. Holt and company, 1910.

iii p., 1 l., 162 p. 17$\frac{1}{2}$cm. $0.35
© Dec. 30, 1910; 2c. Jan. 3, 1911; A 278789; Henry Holt & co., New York,
N. Y. (11–709) 14

Brannan, Joseph Doddridge, 1848– *ed.*

The negotiable instruments law annotated, with refer-
ences to the English Bills of exchange act and with the
cases under the negotiable instruments law and the Bills
of exchange act and comments thereon, by Joseph Dod-
dridge Brannan ... together with comments and criticisms
on the negotiable instruments law (reprinted from the
Harvard law review, the Yale law journal and the Amer-
ican law register) by James Barr Ames ... Judge Lyman
D. Brewster ... and Charles L. McKeehan ... 2d ed., rev.,
re-arranged, enl. Cincinnati, The W. H. Anderson com-
pany, 1911.

xxxiv, 330 p. 24cm. $3.00
© Jan. 3, 1911; 2c. Jan. 5, 1911; A 278894; J. D. Brannan, Cambridge, Mass.
(11–663) 15

Braun, Frederick Augustus.

Margaret Fuller and Goethe; the development of a
remarkable personality, her religion and philosophy, and
her relation to Emerson, J. F. Clarke and transcendental-
ism, by Frederick Augustus Braun ... New York, H. Holt
and company, 1910.

1 p. l., v–vii, [2], 271 p. 19$\frac{1}{2}$cm. $1.35
Bibliography: p. 259–261.
© Dec. 30, 1910; 2c. Jan. 3, 1911; A 278791; Henry Holt & co., New York,
N. Y. (11–770) 16

Brown, Frank Clyde.

Elkanah Settle. his life and works, by F. C. Brown.
Chicago. Ill., The University of Chicago press [°1910]

x. 170 p. plates, facsims. 25cm.
Bibliography: p. [135]–160.
© Dec. 23, 1910; 2c. Jan. 3, 1911; A 278821; University of Chicago, Chi-
cago, Ill. (11–584) 17

3

Campbell, William Francis, 1865–

A text-book of surgical anatomy, by William Francis Campbell ... 2d ed., rev., with 319 original illustrations. Philadelphia and London, W. B. Saunders company, 1911.
675 p. illus. 23½ᶜᵐ. $5.00
Bibliography: p. 641–642.
© Jan. 3, 1911; 2c. Jan. 5, 1911; A 278901; W. B. Saunders co., Philadelphia, Pa. (11-888) 18

Carrigan, Franklin Pierce.

Easter blessings, by Franklin Pierce Carrigan; lettered by Oswald Cooper. Boston and Chicago, W. A. Wilde company [ᶜ1911]
16 l. 19ᶜᵐ. $0.50
© Jan. 4, 1911; 2c. Jan. 7, 1911; A 278977; W. A. Wilde co., Chicago, Ill. (11-751) . 19

Carter, Emma Smuller.

Lays of the lake, and other lyrics, by Emma Smuller Carter. New York, Chicago [etc.] Fleming H. Revell company [ᶜ1910]
232 p. front., plates. 20ᶜᵐ. $1.00
Partly reprinted from various periodicals.
© Dec. 13, 1910; 2c. Jan. 4, 1911; A 278879; Fleming H. Revell co., New York, N. Y. (11-687) 20

Cattell, Henry Ware, 1862–

"606"; Ehrlich's new preparation, arsenobenzol ("606"), in the treatment of syphilis, by Henry W. Cattell ... True syphilitic iritis (iritis papulosa) treated with an injection of Ehrlich's "606," by G. E. De Schweinitz ... and E. A. Shumway ... [Philadelphia, J. B. Lippincott company, ᶜ1910]
cover-title, 9 p. plates (1 col.) 23½ᶜᵐ.
"Reprinted from International clinics, vol. IV, twentieth series."
© Dec. 31, 1910; 2c. Jan. 3, 1911; A 278851; J. B. Lippincott co., Philadelphia, Pa. (11-898) 21

Chesley, Albert Meader, 1875–

Social activities for men and boys [by] Albert M. Chesley ... New York, Young men's Christian association press, 1910.
xii, [4], 304 p. incl. front., illus. 20ᶜᵐ. $1.00
"Acknowledgment and bibliography": p. [xiv]
© Dec. 30, 1910; 2c. Jan. 3, 1911; A 278825; Internatl. committee of Y. M. C. A., New York, N. Y. (11-893) 22

Cole, Carter Stanard, 1862–

Lays and lyrics, by Carter S. Cole, M. D.; illustrations by Thomas Fogarty, Dan Smith, Henry Raleigh; decorations by R. S. Ament. [New York? ᶜ1910]
4 p. l., 72 p. illus. 19ᶜᵐ. $2.50
© Dec. 21, 1910; 2c. Jan. 6, 1911; A 278947; C. S. Cole, New York, N. Y. (11-744) 23

De Laurence, Lauron William, 1868–

Hypnotism, magnetism, mesmerism, suggestive thera-
peutics and magnetic healing ... Prepared for the self-
instruction of beginners as well as for the use of advanced
students and practitioners. By Dr. L. W. de Laurence ...
Chicago, Ill., De Laurence, Scott & co., 1910.

188 p. incl. front. (port.) plates. 19½ᶜᵐ. $1.00
© Dec. 29, 1910; 2c. Jan. 3, 1911; A 278782; De Laurence, Scott & co., Chi-
cago, Ill. (11–768) 24

"Magnetic hypnotism," "medical hypnosis" and "sug-
gestive therapeutics." Enl. rev. ed. De Laurence's
standard and official work on hypnotism and control by
his famous silent methods and secret systems, by Dr. L. W.
de Laurence ... Chicago, Ill., De Laurence, Scott, & co.,
1910.

3 p. l., 5–256 p. front. (port.) plates. 19½ᶜᵐ. $1.75
© Dec. 29, 1910; 2c. Jan. 3, 1911; A 278783; De Laurence, Scott & co., Chi-
cago, Ill. (11–764) 25

The sixth and seventh books of Moses ... the wonderful
magical and spirit arts of Moses and Aaron, and the old
wise Hebrews, taken from the Mosaic books of the Cabala
and the Talmud, for the good of mankind. Prepared for
publication under the editorship of Dr. L. W. de Laurence
... Chicago, Ill., De Laurence, Scott & co., 1910.

190 p. front., illus. 20ᶜᵐ. $1.00
© Dec. 29, 1910; 2c. Jan. 3, 1911; A 278784; De Laurence, Scott & co., Chi-
cago, Ill. (11–761) 26

Dickens, Charles.

... Ausgewählte romane und geschichten, übersetzt u.
hrsg. von Gustav Meyrink. 9. u. 10. bd. Die Pickwickier.
München, A. Langen [1910]

2 v. 21½ᶜᵐ.
© Dec. 2, 1910; 2c. Jan. 10, 1911; A—Foreign 2274; Albert Langen, Mu-
nich, Germany. 27

Dimnet, Ernest.

... Les sœurs Brontë. Paris, Bloud & cⁱᵉ, 1910.

xii, 276 p. front. (port.) 19½ᶜᵐ. (Les grands écrivains étrangers)
fr. 3.50
© Dec. 16, 1910; 2c. Jan. 7, 1911; A—Foreign 2266; Bloud & co., Paris,
France. (11–1021) 28

Engel, Georg Jul. Leopold, 1866–

Die leute von Moorluke; novellen von Georg Engel.
Berlin, Concordia deutsche verlags-anstalt, g. m. b. h.
[ᶜ1910]

244 p., 2 l. 20ᶜᵐ.
CONTENTS.—Die zänkische Durtig.—Der vogel Phönix.—Der fliegende
Holländer.—Bismarck.—Lütt Fiken.
© Dec. 2, 1910; 2c. Jan. 7, 1911; A—Foreign 2258: Concordia deutsche
verlags-anstalt, g. m. b. h., Berlin, Germany. (11–916) 29

5

Essays in American history dedicated to Frederick Jackson Turner. New York, H. Holt and company, 1910.
vii, 293 p. 22ᶜᵐ.
Edited by Guy Stanton Ford.
CONTENTS.—Mathews, L. K. Some activities of the Congregational church west of the Mississippi.—Schafer, J. Oregon pioneers and American diplomacy.—James, J. A. Some problems of the Northwest in 1779.—Becker, C. L. Kansas.—Hockett, H. C. Federalism and the West.—Buck, S. J. Independent parties in the western states, 1873-1876.—Ambler, C. H. Virginia and the presidential succession, 1840-1844.—Phillips, U. B. The southern Whigs, 1834-1854.—Robertson, W. S. The beginnings of Spanish-American diplomacy.—Reinsch, P. S. Some notes on the study of South American history.
© Dec. 30, 1910; 2c. Jan. 3, 1911; A 278792; Henry Holt & co., New York, N. Y. (11-620) 30

Farnol, Jeffery.
The broad highway, by Jeffery Farnol. Boston, Little, Brown, and company, 1911.
xi, 518 p. 19½ᶜᵐ. $1.35
© Jan. 2, 1911; 2c. Jan. 4, 1911; A 278881; Little, Brown & co., Boston, Mass. (11-472) 31

Fenwick, George.
An Athabascan princess, by George Fenwick; illustrated by Max W. Kollm. New York & Seattle, The Alice Harriman company, 1910.
156 p. front., plates. 19ᶜᵐ. $1.35
© Dec. 28, 1910; 2c. Jan. 4, 1911; A 280014; G. Fenwick, New York, N. Y. (11-842) 32

Fisher, Mary A 1839-
The ghost in the garret, and other stories, by Mary A. Fisher ... New York, Aberdeen publishing company [°1910]
147 p. incl. front. 19½ᶜᵐ. $1.00
CONTENTS.—The ghost in the garret.—The sealed jar.—The work or the woman.—The man with an idea.—Minerva Knowlton.—How it came back.—Helen Hamilton's hero.
© Aug. 23, 1910; 2c. Jan. 3, 1911; A 278817; M. A. Fisher, Mt. Vernon, N. Y. (11-471) 33

Fones, Warren.
The man with the scar [by] Warren & Alice Fones. Boston, R. G. Badger, 1911.
244 p. front. 19½ᶜᵐ. $1.50
© Dec. 30, 1910; 2c. Jan. 3, 1911; A 278808; Richard G. Badger, Boston, Mass. (11-470) 34

Fyfe, John William, 1839-
Pocket essentials of modern materia medica and therapeutics, by John William Fyfe ... with a formulary, by George W. Boskowitz ... Cincinnati, The Scudder brothers company, 1911.
344 p. 18ᶜᵐ. $2.00
Pub. 1903 under title: The essentials of modern materia medica and therapeutics.
© Jan. 2, 1911; 2c. Jan. 5, 1911; A 278903; J. W. Fyfe, Saugatuck, Conn. (11-933) 35

Gildersleeve, Basil Lanneau.

Syntax of classical Greek from Homer to Demosthenes. 2d pt. ... By Basil Lanneau Gildersleeve ... New York, Cincinnati [etc.] American book company [1911]

vii, 191–332 p. 24½ᶜᵐ. $1.50

ⓒ Jan. 3, 1911; 2c. Jan. 7, 1911; A 278965; B. L. Gildersleeve, Baltimore, Md. 36

Glasenapp, Carl Friedrich, 1847–

Siegfried Wagner und seine kunst. Gesammelte aufsätze über das dramatische schaffen Siegfried Wagners vom 'Bärenhäuter' bis zum 'Banadietrich,' von C. Fr. Glasenapp. Mit buchschmuck und federzeichnungen von Franz Stassen und fünf photographischen porträts. Leipzig, Breitkopf & Härtel, 1911.

xvi, 423 p. illus., 5 port. (incl. front.) 29½ᶜᵐ. M. 15

ⓒ Jan. 3, 1911; 2c. Jan. 10, 1911; A—Foreign 2288; Breitkopf & Härtel, Leipzig, Germany. (11–970) 37

Goethe, Johann Wolfgang von, 1749–1832.

Gott, gemüt und welt. Goethes selbstzeugnisse über seine stellung zur religion und zu religiös-kirchlichen fragen. In zeitlicher folge zusammengestellt von d. dr. Theodor Vogel ... 4. aufl. Leipzig und Berlin, B. G. Teubner, 1911.

v, [1], 256 p. illus. 20ᶜᵐ. M. 4

ⓒ Jan. 5, 1911; 2c. Jan. 11, 1911; A—Foreign 2298; B. G. Teubner, Leipzig, Germany. (11–1019) 38

Guerber, Hélène Adeline.

... The story of modern France, by H. A. Guerber. New York, Cincinnati [etc.] American book company [ᶜ1910]

350 p. illus. (incl. maps) 19ᶜᵐ. (Eclectic school readings) $0.65

ⓒ Dec. 30. 1910; 2c. Jan. 3, 1911; A 278823; H. A. Guerber, Nyack, N. Y. (11–821) 39

Gurley, *firm, math. instr. makers, Troy.*

(1910. *W. & L. E. Gurley*)

A manual of the principal instruments used in American engineering and surveying, manufactured by W. & L. E. Gurley, Troy, N. Y. ... 45th ed. ... Troy, N. Y., W. & L. E. Gurley, 1910.

516 p. illus., plates (partly col.) 2 port. 17ᶜᵐ. $0.50

ⓒ Dec. 16, 1910; 2c. Jan. 3, 1911; A 278860; W. & L. E. Gurley, Troy, N. Y. (11–676) 40

Hall, Arthur Graham, 1865–

Plane and spherical trigonometry, by Arthur Graham Hall ... and Fred Goodrich Frink ... New York, H. Holt and company [ᶜ1910]

x, 176 p. diagrs. 24ᶜᵐ. [Mathematical series, v] $1.00

ⓒ Dec. 28, 1910; 2c. Jan. 3, 1911; A 278794; Henry Holt & co., New York, N. Y. (11–939) 41

7

Hall, Arthur Graham, 1865–

Trigonometric and logarithmic tables, by Arthur Graham Hall ... and Fred Goodrich Frink ... New York, H. Holt and company [°1910]
3 p. l., 3–97 p. 24ᶜᵐ. $0.75
© Dec. 28, 1910; 2c. Jan. 3, 1911; A 278793; Henry Holt & co., New York, N. Y. (11–669) **42**

Harbitz, Alf.

... Kamp for kjærlighet, skuespil i fire akter. Kristiania, H. Aschehoug & co. (W. Nygaard) 1910.
2 p. l., 134 p. 20ᶜᵐ.
© Nov. 23, 1910; 2c. Dec. 13, 1910; D 23078; H. Aschehoug & co., Christiania, Norway. (11–1027) **42***

Henson, Llewellyn Lafayette.

Researches in Palestine, by Llewellyn Lafayette Henson ... with a foreword by Lewis Bayles Paton ... Boston, Mass., S. D. Towne [°1910]
6 p. l., [11]–85 p. front., plates, map, plans. 23ᶜᵐ. $1.00
Bibliography: p. 83–85.
© Dec. 31, 1910; 2c. Jan. 3, 1911; A 278864; Salem D. Towne, Boston, Mass. (11–948) **43**

Herbertson, Jessie Leckie.

Young life, by Jessie Leckie Herbertson. New York, Duffield & company, 1911.
2 p l, [7]–304 p. 19ᶜᵐ. $1.20
© Jan. 5, 1911; 2c. Jan. 7, 1911; A 278960; Duffield & co., New York, N. Y. (11–637) **44**

Hoffmann, August, 1862–

Funktionelle diagnostik und therapie der erkrankungen des herzens und der gefässe. Von professor dr. Aug. Hoffmann ... Mit 109 abbildungen und einer farbigen tafel. Wiesbaden, J. F. Bergmann, 1911.
xiii p., 1 l., 483 p. illus., col. pl. 26ᶜᵐ. M. 12
Contains "Literatur."
© Nov. 30, 1910; 2c. Jan. 7, 1911; A—Foreign 2238; J. F. Bergmann, Wiesbaden, Germany. (11–791) **45**

Hopkins, Herbert Müller, 1870–

Poems, by Herbert Müller Hopkins. Boston, R. G. Badger, 1911.
88 p. front. (port.) 19½ᶜᵐ. $1.00
© Dec. 31, 1910; 2c. Jan. 14, 1911; A 280090; Pauline Mackie Hopkins, New York, N. Y. (11–959) **46**

Howe, *Mrs.* **Julia Ward,** 1819–1910.

At sunset, by Julia Ward Howe. Boston and New York, Houghton Mifflin company, 1910.
xii, 150 p., 1 l. front. (port.) 19½ᶜᵐ. $1.25
© Dec. 10, 1910; 2c. Jan. 13, 1911; A 280068; Houghton Mifflin co., Boston, Mass. (11–917) **47**

Hyan, Hans, 1868–

... Die spitzenkönigin, roman. Berlin, C. Duncker [ᶜ1910]

2 p. l., 223 p. 18¼ᶜᵐ. M. 3

© Dec. 28, 1910; 2c. Jan. 7, 1911; A—Foreign 2252; Carl Duncker, Berlin, Germany. (11–1025) **48**

... The **Indiana** digest. A digest of the decisions of the courts of Indiana reported in vols. 1–8, Blackford's reports, Smith's reports, Wilson's Superior court reports, vols. 1–*172, Indiana reports, vols. 1–*43, Indiana Appellate court reports, vols. 1–91, Northeastern reporter; vol. 92, pp. 1–480 ... comp. under the American digest classification. v. 1. St. Paul, West publishing co., 1910.

vii, 1012 p. 26¼ᶜᵐ. (American digest system. State series) $6.00

"*And parts of volumes not yet published, but reported in the Northeastern reporter."

v. 1 © Dec. 27, 1910; 2c. Jan. 3, 1911; A 278811; West pub. co., St. Paul, Minn. (11–661) **49**

International correspondence schools, *Scranton, Pa.*

Tratado de alumbrado y tranvías eléctricos, preparado especialemente para los estudiantes de los Escuelas internacionales de enseñanza por correspondencia. t. 2, 3 ... Scranton, Pa., International textbook company [1910]

2 v. illus., plates, tables, diagrs. 23ᶜᵐ.

© Dec. 15, 1910, Dec. 21, 1910; 2c. each Jan. 3, 1911; A 278866, 278867; International textbook co., Scranton, Pa. **50, 51**

Jack, *Mrs.* Ellen E 1842–

The fate of a fairy, by Ellen E. Jack. Chicago, W. B. Conkey company [ᶜ1910]

213 p. plates. 20ᶜᵐ. $1.50

© Dec. 23, 1910; 2c. Jan. 3, 1911; A 278836; E. E. Jack, Colorado Springs, Colo. (11–469) **52**

Jepson, Willis Linn.

... The silva of California, by Willis Linn Jepson. Berkeley, The University press, 1910.

480 p. illus., 85 pl. (partly fold.) 3 fold. maps. 32¼ᶜᵐ. (Memoirs of the University of California, v. 2)

© Dec. 29, 1910; 2c. Jan. 6, 1911; A 278949; W. L. Jepson, Berkeley, Cal. (11–817) **53**

Johnson, Alexander Bryan, 1860–

Surgical diagnosis, by Alexander Bryan Johnson ... 2d ed. ... New York and London, D. Appleton and company, 1911.

3 v. illus., col. plates. 25¼ᶜᵐ. $18.00

© Jan. 3, 1911; 2c. Jan. 7, 1911; A 278975; D. Appleton & co., New York, N. Y. (11–896) **54**

Johnson, George Sands.

Ballads of the seasons, by George Sands Johnson; illustrations by Isabella Morton. New York, Aberdeen publishing company [°1910]

 4 p. l., 100 p. illus. 24 x 19½ᶜᵐ. $1.50

© Aug. 16, 1910; 2c. Jan. 3, 1911; A 278814; G. S. Johnson, Richmond, Va. (11–587) **55**

Karapetoff, V.

Experimental electrical engineering and manual for electrical testing for engineers and for students in engineering laboratories, by V. Karapetoff. v. 2. 2d ed. corrected ... New York, J. Wiley & sons; London, Chapman & Hall, ltd., 1911.

 xiv, 333 p. illus. (incl. diagrs.) fold. diagr. 23½ᶜᵐ. $2.50

© Jan. 3, 1911; 2c. Jan. 5, 1911; A 278921; V. Karapetoff, Ithaca, N. Y. **56**

Keyserling, Hermann, *graf* **von,** 1880–

... Unsterblichkeit; eine kritik der beziehungen zwischen naturgeschehen und menschlicher vorstellungswelt ... 2. aufl. München, J. F. Lehmann, 1911.

 4 p. l., 285 p. 22½ᶜᵐ. M. 5

© Dec. 20, 1910; 2c. Jan. 10, 1911; A—Foreign 2273; J. F. Lehmann, Munich, Germany. (11–925) **57**

Kingsley, *Mrs.* **Florence (Morse)** 1859–

To the highest bidder, by Florence Morse Kingsley ... illustrated by John Rae. New York, Dodd, Mead and company, 1911.

 3 p. l., 302 p. front. 19½ᶜᵐ. $1.30

© Jan. 11, 1911; 2c. Jan. 12, 1911; A 280057; Dodd, Mead & co., New York, N. Y. (11–848) **58**

Kline, John Jacob, 1856–

A history of the Lutheran church in New Hanover, Montgomery County, Penna., comp. and arranged by the pastor, Rev. J. J. Kline ... New Hanover, Penna., Pub. by the congregation, 1910.

 x, 5–710 p. front. (port.) illus., plates, fold. facsims. 23½ᶜᵐ. $1.50

© Dec. 31, 1910; 2c. Jan. 3, 1911; A 278856; J. J. Kline, Pottstown, Pa. (11–442) **59**

Kobbé, Gustav, 1857–

The Hudson-Fulton celebration, MCMIX, by Gustav Kobbé, with a foreword by William Loring Andrews. New York, Society of iconophiles, 1910.

 63, [5] p. front., illus. 25½ᶜᵐ. $30.00

© Dec. 31, 1910; 2c. Jan. 3, 1911; A 278820; Soc. of iconophiles, New York, N. Y. (11–699) **60**

Köstlin, Heinrich Adolf, 1846–1907.

Geschichte der musik im umriss, von H. A. Köstlin ...
6., vollständig neu bearb. und wesentlich ergänzte ausg.,
hrsg. von prof. dr. Wilibald Nagel. Leipzig, Breitkopf &
Härtel, 1910.

xv, [1], 746 p. 23½ᶜᵐ. M. 10
© Dec. 4, 1910; 2c. Jan. 7, 1911; A—Foreign 2242; Breitkopf & Härtel,
Leipzig, Germany. (11-969) 61

Kraus, Karl, 1874–

Heine und die folgen, von Karl Kraus. München, A.
Langen [ᶜ1910]

45 p. 19ᶜᵐ.
© Dec. 2, 1910; 2c. Jan. 10, 1911; A—Foreign 2280; Albert Langen, Mu-
nich, Germany. (11-996) 62

Kruse, Walther, 1864–

Allgemeine mikrobiologie, die lehre vom stoff- und
kraftwechsel der kleinwesen, für ärzte und naturforscher
dargestellt von dr. med. Walther Kruse ... Leipzig,
F. C. W. Vogel, 1910.

xv, 1184 p. 23½ᶜᵐ. M. 30
© Nov. 23, 1910; 2c. Jan. 7, 1911; A—Foreign 2241; F. C. W. Vogel, Leip-
zig, Germany. (11-815) 63

Labauche, L.

Leçons de théologie dogmatique, par L. Labauche ...
Dogmatique spéciale. t. 1. Paris, Bloud et cᶦᵉ, 1911.

viii, 388 p. 23ᶜᵐ. fr. 7.50
© Dec. 16, 1910; 2c. Jan. 7, 1911; A—Foreign 2263; Bloud & cie., Paris,
France. (11-924) 64

Lambert, Adrian Van Sinderen, 1872– comp.

A terminology of disease, to facilitate the classifica-
tion of histories in hospitals, adopted by the managers of
the Vanderbilt clinic of the College of physicians and
surgeons of Columbia university, New York. Comp. by
Adrian V. S. Lambert, M. D. and Walton Martin, M. D. ...
New York, 1910.

x p., 1 l., 122 p. 18½ᶜᵐ.
© Dec. 27. 1910; 2c. Jan. 3, 1911; A 278861; A. V. S. Lambert and W.
Martin, New York, N. Y. (11-861) 65

Le Gallienne, Richard, 1866–

October vagabonds, by Richard Le Gallienne; the illus-
trations by Thomas Fogarty. New York, London, M.
Kennerley, 1910.

201 p. col. front., illus., plates. 20½ᶜᵐ. $1.50
© Nov. 19, 1910; 2c. Jan. 11, 1911; A 280031; Mitchell Kennerley, New
York, N. Y. (11-958) 66

Legouis, Émile Hyacinthe, 1861–

... Geoffroy Chaucer. Paris, Bloud & cᶦᵉ, 1910.

vii, 261 p., 1 l. front. (port.) 19ᶜᵐ. (Les grands écrivains étrangers)
fr. 3.50
© Dec. 16, 1910; 2c. Jan. 7, 1911; A—Foreign 2262; Bloud & cie., Paris,
France. (11-963) 67

Lehmann-Haupt, *Frau* Therese, 1864-

Komm, es will lenzen; gedichte von Therese Lehmann-Haupt. Berlin, Concordia deutsche verlagsanstalt, g. m. b. h. [c1910]

148, [4] p. 22cm.

© Dec. 2, 1910; 2c. Jan. 7, 1911; A—Foreign 2257; Concordia deutsche verlags-anstalt, g. m. b. h., Berlin, Germany. (11-1020) 68

Levine, Samuel Walter, 1877-

A treatise on the law of pawnbroking as governed by the principles of the common law, and as modified by the statutes of the different states of the United States, and the ordinances of the municipalities, regulating pawnbroking, and a review of pawnbroking. By Samuel W. Levine ... New York [Press of Fremont Payne] 1911.

4 p. l., [7]-125 p. 23cm. $3.50

© Jan. 6, 1911; 2c. Jan. 9, 1911; A 278987; S. W. Levine, New York, N. Y. (11-931) 69

Lindsay, Arthur Adolphus.

Mind the transformer; the new psychology complete, by A. A. Lindsay ... Seattle, Wash., Lindsay publishing company [c1911]

2 p. l., 9-154 p. front. (port.) plates. 17½cm. $0.75

© Dec. 28, 1910; 2c. Jan. 9, 1911; A 278981; A. A. Lindsay, Seattle, Wash. (11-910) 70

Louisiana. *Supreme court.*

Reports of cases argued and determined in the Supreme court of Louisiana and in the Superior court of the Territory of Louisiana. Annotated ed. ... Book 20, containing a verbatim reprint of vols. 11 & 12 of Robinson's reports. St. Paul, West publishing co., 1911.

viii, 334, vii, 423 p. 23cm. $7.50

© Dec. 21, 1910; 2c. Jan. 3, 1911; A 278810; West pub. co., St. Paul, Minn. 71

Loux, Du Bois H.

Maitland Varne; or, The bells of De Thaumaturge, by Du Bois H. Loux. New York, De Thaumaturge company, 1911.

2 p. l., 396 p 19½cm. $1.50

© Jan. 3, 1911; 2c. Jan. 7, 1911; A 278971; Du B. H. Loux, Meriden, Conn. (11-636) 72

Lyndon, Lamar.

Storage battery engineering; a practical treatise for engineers, by Lamar Lyndon. 3d ed., rewritten and enl. New York [etc.] McGraw-Hill book company, 1911.

viii p., 1 l., 601 p. illus., diagrs. (partly fold.) 24cm. $4.00
Bibliography: p. 587-588.

© Dec. 31, 1910; 2c. Jan. 3, 1911; A 278795; McGraw-Hill book co., New York, N. Y. (11-492) 73

McCulloch, James Edward, 1873–

The mastery of love; a narrative of settlement life, by James E. McCulloch ... New York, Chicago [etc.] Fleming H. Revell company [ᶜ1910]

272 p. 20½ᶜᵐ. $1.25
© Dec. 22, 1910; 2c. Jan. 5, 1911; A 278895; Fleming H. Revell co., New York, N. Y. (11–550) **74**

Mast, Samuel Ottmar.

Light and the behavior of organisms, by S. O. Mast ... 1st ed. 1st thousand. New York, J. Wiley & sons; [etc., etc.] 1911.

xi, 410 p. illus., diagrs. 21ᶜᵐ. $2.50
Bibliography: p. 379–392.
© Dec. 29, 1910; 2c. Jan. 3, 1911; A 278838; S. O. Mast, Baltimore, Md. (11–668) **75**

Matull, Kurt.

... Fata Morgana, roman. Berlin, C. Duncker [ᶜ1910]

2 p. l., 202 p. 18½ᶜᵐ. M. 3
© Dec. 28, 1910; 2c. Jan. 7, 1911; A—Foreign 2249; Carl Duncker, Berlin, Germany. (11–920) **76**

Mearns, Lillian Hathaway.

A Philippine romance, by Lillian Hathaway Mearns. New York, Aberdeen publishing company [ᶜ1910]

124 p. incl. front. plates. 19½ᶜᵐ. $1.00
© Nov. 20, 1910; 2c. Jan. 3, 1911; A 278815; L. H. Mearns, Washington, D. C. (11–468) **77**

Michaëlis, Karin i. e. Katharine Marie Bech (Brøndum) 1872–

Rachel, ein Ghetto-roman, von Karin Michaëlis; deutsch von Mathilde Mann. Berlin, Concordia deutsche verlagsanstalt, g. m. b. h. [ᶜ1910]

2 p. l., 246 p. 20ᶜᵐ.
© Dec. 2, 1910; 2c. Jan. 7, 1911; A—Foreign 2253; Concordia deutsche verlags-anstalt, g. m. b. h., Berlin, Germany. (11–1023) **78**

Michie, Thomas Johnson, ed.

Railroad reports (vol. 59 American and English railroad cases, new series); a collection of all cases affecting railroads of every kind, decided by the courts of last resort in the United States. Ed. by Thomas J. Michie. v. 36. Charlottesville, Va., The Michie company, 1910.

vii, 838 p. 23½ᶜᵐ.
© Jan. 9, 1911; 2c. Jan. 10, 1911; A 280010; Michie co., Charlottesville, Va. **79**

Mida's trade-mark bureau, *Chicago, comp.*

Confectionery trade-marks, comp. by Mida's trade-mark bureau, Chicago ... Chicago, Ill., The Criterion publishing co., ᶜ1910·

96 p. 26ᶜᵐ. $5.00
© Dec. 31, 1910; 2c. Jan. 4, 1911; A 278885; Criterion pub. co., Chicago, Ill. (11–858) **80**

13

Mills, Wilbur Thoburn, 1868–

American school building standards [by] Wilbur T. Mills
... Columbus, O., Franklin educational publishing company, 1910.

2 p. l., 7–324 p. illus. (incl. plans) 17½ᶜᵐ. $3.00
© Dec. 29, 1910; 2c. Jan. 3, 1911; A 278828; W. T. Mills, Columbus, O. (11–1012) **81**

Minton, Orlena Marian.

Rag weed rhymes of rural folks, by Orlena Marian Minton. New York, Aberdeen publishing company [°1910]

vi, 7–92 p. front., plates. 19½ᶜᵐ. $1.00
© Nov. 1, 1910; 2c. Jan. 3, 1911; A 278816; O. M. Minton, Manchester, Ia. (11–514) **82**

Missouri. *St. Louis, Kansas City and Springfield courts of appeals.*

Cases determined ... reported for the St. Louis court of appeals, Nov. 30, 1909, to Feb. 1, 1910, by Thomas E. Francis ... for the Kansas City court of appeals, by John M. Cleary ... and for the Springfield court of appeals, June 6, 1910, to July 7, 1910, by Lewis Luster ... official reporters. v. 146. Columbia, Mo., E. W. Stephens, 1910.

xviii, 792, xviii p. 23½ᶜᵐ. $3.00
© Jan. 4, 1911; 2c. Jan. 5, 1911; A 280107; E. W. Stephens, Columbia, Mo. **83**

Moore, John Trotwood, 1858–

The gift of the grass; being the autobiography of a famous racing horse, by John Trotwood Moore ... illustrated by G. Patrick Nelson. Boston, Little, Brown, and company, 1911.

viii p., 1 l., 347, [1] p. col. front., col. plates. 19½ᶜᵐ. $1.50
© Jan. 14, 1911; 2c. Jan. 17, 1911; A 280147; Little, Brown & co., Boston, Mass. (11–1008) **84**

Moritz, Robert Édouard, 1868–

Elements of plane trigonometry; a text-book for high schools, technical schools and colleges, by Robert E. Moritz ... 1st ed. 1st thousand. New York, J. Wiley & sons; [etc., etc.] 1911.

xiv, 361, 91 p. diagrs. 23½ᶜᵐ. $2.00
© Dec. 30, 1910; 2c. Jan. 3, 1911; A 278797; R. E. Moritz, Seattle, Wash. (11–608) **85**

The **national** law finder for all states of the United States, showing where the cases in the reports of the several states have been exhaustively annotated in the selected case, sets that cover the general field of law, also, where any case decided in any state court has been affirmed, reversed or distinguished by the United States Supreme court. Detroit, Mich., The Law stamps co., 1911.

421 p. 21½ᶜᵐ.
© Jan. 3, 1911; 2c. Jan. 7, 1911; A 278968; Law stamps co., Detroit, Mich. (11–885) **86**

Neihardt, John Gneisenau, 1881–

The dawn-builder, by John G. Neihardt. New York and London, M. Kennerley, 1911.

335 p. 19^{cm}. $1.50

© Nov. 23, 1910; 2c. Jan. 14, 1911; A 280086; Mitchell Kennerley, New York, N. Y. (11-946) 87

New York (*State*) *Supreme court.*

... Reports of cases heard and determined in the appellate division of the Supreme court of the state of New York. Jerome B. Fisher, reporter. v. 138, 1910. ₁Official ed.₁ Albany, N. Y., J. B. Lyon company ₁1910₁

lxii, 1005 p. 24^{cm}. $1.00

© Dec. 19, 1910; 2c. Jan. 3, 1911; A 278855; Samuel S. Koenig, sec. of state of New York, in trust for the benefit of people of said state, Albany, N. Y. 88

Nordau, Max Simon, 1849–

The interpretation of history, by Max Nordau; tr. from the German by M. A. Hamilton. New York, Moffat, Yard and company, 1911.

3 p. l., 414 p. 21½^{cm}. $2.00

CONTENTS.—History and the writing of history.—The customary philosophy of history.—The anthropomorphic view of history.—Man and nature.—Society and the individual.—The psychological roots of religion.—The psychological premises of history.—The question of progress.—Eschatology.—The meaning of history.

© Dec. 31, 1910; 2c. Jan. 5, 1911; A 278912; Moffat, Yard & co., New York, N. Y. (11-601) 89

North Dakota. *Supreme court.*

Report of cases decided ... February, 1908, to November, 1909. F. W. Ames, reporter. v. 18. Bismarck, N. D., Tribune, state printers and binders, 1910.

xi, 746 p. 23½^{cm}.

© Dec. 1, 1910; 2c. Jan. 7, 1911; A 278976; F. W. Ames, Mayville, N. D.
 90

... The **Northwestern** reporter, with key-number annotations. v. 127. Permanent ed. Containing all the decisions of the supreme courts of Minnesota, Michigan, Nebraska, Wisconsin, Iowa, North Dakota, South Dakota ... August 5–November 18, 1910. St. Paul, West publishing co., 1910.

xiv, 1283 p. 26½^{cm}. (National reporter system—State series) $4.00

© Dec. 27, 1910; 2c. Jan. 3, 1910; A 278812; West pub. co., St. Paul, Minn.
 91

Oppenheim, Edward Phillips, 1866–

Berenice, by E. Phillips Oppenheim ... with illustrations by Howard Chandler Christy and Howard Somerville. Boston, Little, Brown, and company, 1911.

264 p., 1 l. incl. plates col. front. 20^{cm}. $1.25

© Jan. 14, 1911; 2c. Jan. 17, 1911; A 280148; Little, Brown, & co., Boston, Mass. (11-1010) 92

15

Orcutt, William Dana, 1870–
The lever; a novel, by William Dana Orcutt ... New York and London, Harper & brothers, 1911.
3 p. l., 3–318 p., 1 l. front. 19½ᶜᵐ. $1.50
© Jan. 12, 1911; 2c. Jan. 14, 1911; A 280087; Harper & bros., New York, N. Y. (11–1007) 93

Paracelsus, 1493–1541.
The Hermetic and alchemical writings of Aureolus Phillippus Theophrastus Bombast, of Hohenheim, called Paracelsus, the Great, now for the first time faithfully and accurately translated into English. The present American, Oriental, Egyptian and Asiatic ed. prepared for publication under the editorship of Dr. L. W. de Laurence ... Faithfully reproduced from the London ed. of 1894, which was edited, with a biographical preface, elucidatory notes, and a copious Hermetic vocabulary and accurate index, by Arthur Edward Waite ... Limited ed. ... Chicago, Ill., De Laurence, Scott & co., 1910.
2 v. fronts. (ports.) 29ᶜᵐ. $12.00
CONTENTS.—v. 1. Hermetic chemistry.—v. 2. Hermetic medicine and hermetic philosophy.
© Dec. 29, 1910; 2c. Jan. 3, 1911; A 278786; De Laurence, Scott & co., Chicago, Ill. (11–522) 94

Paris, Estelle Wallace.
A song o' the West ... [Portland? Or.] °1910.
17 l. 24½ x 14ᶜᵐ.
© Dec. 5, 1910; 2c. Jan. 9, 1911; A 278996; E. W. Paris, Portland, Or. (11–961) 95

Partridge, Anthony.
The golden web, by Anthony Partridge ... with illustrations by William Kirkpatrick. Boston, Little, Brown, and company, 1911.
vi p., 1 l., 339 p. front., plates. 20ᶜᵐ. $1.50
© Jan. 7, 1911; 2c. Jan. 10, 1911; A 280003; Little, Brown & co., Boston. Mass. (11–774) 96

Pell, Edward Leigh, 1861–
Prayers, by Edward Leigh Pell. Richmond, Va., The Harding press [°1910]
3 p. l., 9–63 p. 16ᶜᵐ. $0.25
© Dec. 20, 1910; 2c. Jan. 5, 1911; A 278926; E. L. Pell, Richmond, Va. (11–763) 97

Pinski, David.
... Der schatz. Komödie in vier akten. Berlin, E. Bloch [°1910]
131 p. 19ᶜᵐ.
© Feb. 15, 1910; 2c. Dec. 8, 1910; D 23019; Theaterverlag Eduard Bloch, Berlin, Germany. (11–919) 97*

Pusey, William Allen, 1865–
The principles and practice of dermatology, designed for students and practitioners, by William Allen Pusey ...

Pusey, William Allen—Continued
with five plates, one in color, and three hundred and
eighty-four text illustrations. 2d ed. New York and
London, D. Appleton and company, 1911.
xxix, 1079 p. illus., plates (1 col.) 24½ᶜᵐ.
Bibliography: p. ₍1029₎–1047.
© Jan. 3, 1911; 2c. Jan. 7, 1911; A 278970; D. Appleton & co., New York,
N. Y. (11–899) 98

Rice, Louise.
Practical graphology; or, The science of reading char-
acter through handwriting; a text book, by Louise Rice.
Chicago, The Library shelf ₍ᶜ1910₎
4 p. l., 11–255 p. facsims. 23½ᶜᵐ. $1.50
© Dec. 30, 1910; 2c. Jan. 3, 1911; A 278870; Library shelf, Chicago, Ill.
(11–1001) 99

Roberts, Charles George Douglas, 1860–
Neighbors unknown, by Charles G. D. Roberts ... New
York, The Macmillan company, 1911.
vii, 266 p. 19½ᶜᵐ. $1.50
© Jan. 11, 1911; 2c. Jan. 12, 1911; A 280049; Macmillan co., New York,
N. Y. (11–846) 100

Russell, Thomas Herbert, 1862–
... Canadian commercial law and legal forms, by Thom-
as Herbert Russell ... and William J. Jackman ... ₍Min-
neapolis₎ International law and business institute ₍ᶜ1910₎
459 p. 24ᶜᵐ. (International business library ... vol. x)
© Dec. 29, 1910; 2c. Jan. 3, 1911; A 278834; International law & business
institute, Minneapolis, Minn. (11–756) 101

Sahli, Hermann, 1856–
A treatise on diagnostic methods of examination, by
Prof. Dr. Hermann Sahli ... ed., with additions, by Na-
thaniel Bowditch Potter ... 2d ed., rev., authorized trans-
lation from the 5th rev. and enl. German ed. Philadel-
phia and London, W. B. Saunders company, 1911.
2 p. l., 7–1229 p. illus. (partly col.) plates (partly col.) fold. tab. 25ᶜᵐ.
$6.50
© Jan. 3, 1911; 2c. Jan. 5, 1911; A 278902; W. B. Saunders co., Philadel-
phia, Pa. (11–900) 102

Sampter, Jessie Ethel, 1883–
The seekers, by Jessie E. Sampter; with an introduc-
tion by Professor Josiah Royce. New York, M. Kenner-
ley, 1910.
3 p. l., v–xii, 302 p. 19ᶜᵐ. $1.25
© Dec. 29, 1910; 2c. Jan. 16, 1911; A 280110; Mitchell Kennerley, New
York, N. Y. (11–923) 103

Sanders, Thomas E 1868–
Opening exercises for schools, by Thomas E. Sanders
... Chicago, A. Flanagan company ₍ᶜ1910₎
136 p. 18ᶜᵐ.
© Dec. 16, 1910; 2c. Jan. 9, 1911; A 278992; T. E. Sanders, Racine, Wis.
(11–1015) 104

Schnackenberg, Elmer Jacob, 1889– *comp.*

Notes on probate law and procedure, comp. by E. J. Schnackenberg. Chicago, E. J. Schnackenberg and P. M. Knight, 1911.

ix p., 1 l., 71 p. 23ᶜᵐ. $1.75
© Jan. 4, 1911; 2c. Jan. 7, 1911; A 278963; Schnackenberg & Knight, Chicago, Ill. (11–886) 105

Schweriner, Oscar T.

... Mit versiegelten orders, roman. Berlin, C. Duncker [ᶜ1910]

2 p. l., 291, [1] p. front. (port.) 19ᶜᵐ. M. 3.50
© Dec. 28, 1910; 2c. Jan. 7, 1911; A—Foreign 2250; Carl Duncker, Berlin, Germany. (11–1028) 106

Service, Robert William, 1876–

The trail of '98; a Northland romance, by Robert W. Service ... with illustrations by Maynard Dixon. New York, Dodd, Mead and company, 1911.

vii p., 1 l., [4], 3–514 p. front., plates. 19½ᶜᵐ. $1.20
© Jan. 11, 1911; 2c. Jan. 12, 1911; A 280056; Dodd, Mead & co., New York, N. Y. (11–847) 107

Shaw, Alonzo B.

Trails in Shadow land; stories of a detective, by Alonzo B. Shaw. [Columbus, O., The Hann & Adair printing co., ᶜ1910]

298 p. front., illus., plates, ports. 20ᶜᵐ. $1.00
Preface signed: Thos. E. Foster.
© Dec. 15, 1910; 2c. Jan. 5, 1911; A 278908; Thos. E. Foster, Columbus, O. (11–972) 108

Sheffield, Herman Bernard, 1871–

Modern diagnosis and treatment of diseases of children; a treatise on the medical and surgical diseases of infancy and childhood, with especial emphasis upon clinical diagnosis and modern therapeutics. For practitioners and students of medicine, by Herman B. Sheffield ... with one hundred and fifty original half-tone photoengravings and numerous smaller illustrations, some in colors. Philadelphia, F. A. Davis company, 1911.

xii, 619 p. illus. (partly col.) 24½ᶜᵐ. $4.50
© Jan. 2, 1911; 2c. Jan. 5, 1911; A 278907; F. A. Davis co., Philadelphia, Pa. (11–863) 109

Soares, Theodore Gerald, 1869–

Heroes of Israel; a teacher's manual to be used in connection with the student's textbook, by Theodore Gerald Soares ... Chicago, Ill., The University of Chicago press [1910]

xxix, 240 p. 20ᶜᵐ. (*Half-title:* Constructive Bible studies [Elementary series])
© Dec. 27, 1910; 2c. Jan. 3, 1911: A 278822; University of Chicago, Chicago, Ill. (11–726) 110

18

Steinmetz, Charles Proteus, 1865–

Engineering mathematics; a series of lectures delivered at Union college, by Charles Proteus Steinmetz ... New York [etc.] McGraw-Hill book company, 1911.

xvii, 292 p. diagrs. 24½ᶜᵐ. $3.00

ⓒ Jan. 4, 1911; 2c. Jan. 5, 1911; A 278893; McGraw-Hill book co., New York, N. Y. (11–816) 111

Sunderland, Jabez Thomas, 1842–

Oh, to be rich and young! by Jabez T. Sunderland ... Boston, American Unitarian association, 1910.

6 p. l., 102 p. 20ᶜᵐ. $1.00

CONTENTS.—Wealth which all may win.—Beauty which all may attain.—Perpetual youth for all.

ⓒ Dec. 9, 1910; 2c. Dec. 20, 1910; A 278407; Amer. Unitarian assn., Boston, Mass. (11–2) 112

Swan, Caroline Davenport.

The unfading light, by Caroline Davenport Swan. Boston, Sherman, French & company, 1911.

5 p. l., 171 p. 19½ᶜᵐ. $1.00

ⓒ Dec. 29, 1910; 2c. Jan. 6, 1911; A 278948; Sherman, French & co., Boston, Mass. (11–743) 113

Tettau, Eberhard, *freiherr* **von.**

Der russisch-japanische krieg, amtliche darstellung des russischen Generalstabes; deutsche vom russischen Kriegsministerium mit allerhöchster genehmigung autorisierte ausgabe von freiherr von Tettau ... bd. 2: Vorkämpfe und schlacht bei Liaoyan. 2. t., Die schlacht bei Liaoyan. Berlin, E. S. Mittler und sohn, 1911.

x, 340 p. fold. maps in pocket. 24½ᶜᵐ. M. 7

ⓒ Dec. 21, 1910; 2c. Jan. 10, 1911; A—Foreign 2284; E. S. Mittler & sohn, Berlin, Germany. 114

Thayer, Alexander Wheelock.

Ludwig van Beethovens leben, von Alexander Wheelock Thayer. Nach dem original-manuskript deutsch bearb. von Hermann Deiters. 3. bd. 2. aufl. ... neu bearb. und ergänzt von Hugo Riemann. Leipzig, Breitkopf & Härtel, 1911.

x, 656 p. 23½ᶜᵐ. M. 12

ⓒ Dec. 22, 1910; 2c. Jan. 10, 1911; A—Foreign 2271; Breitkopf & Härtel, Leipzig, Germany. 115

Turner, Jessie C.

How to use Hawaiian fruits, by Jessie C. Turner [and] Agnes B. Alexander. Honolulu, T. H., Hawaiian gazette co., ltd., 1910.

58 p. 23½ᶜᵐ. $0.50

ⓒ Dec. 14, 1910; 2c. Jan. 3, 1911; A 278863; A. B. Alexander, Honululu, T. H. (11–855) 116

Underhill, Mrs. Lora Altine (Woodbury) 1844–

Descendants of Edward Small of New England, and the allied families, with tracings of English ancestry, by Lora Altine Woodbury Underhill. Cambridge, Priv. print. at the Riverside press, 1910.

3 v. fronts. (v. 3, col. coat of arms) plates, ports., maps, facsims. 23½ᶜᵐ.
Allied families: Heard.—Hatch.—Sawyer.—McKenney.—Mitchells from Plymouth.—Cooke.—Jenney.—Cushman.—Allerton.—Andrews.—Stetson.—Pratt.—Chandler.—Roberts.—Mariner.— Dyer.— Mitchells from Kittery.—Talbot.

ⓒ Dec. 19 and 31, 1910; 2c. Jan. 14, 1911; A 280081; Ada Small Moore, New York, N. Y. (11–977) 117

U. S. Circuit courts of appeals.

... Reports, with annotations. v. 102. St. Paul, West publishing co., 1910.

xli, 765 p. 23½ᶜᵐ. $2.85
ⓒ Dec. 21, 1910; 2c. Jan. 3, 1911; A 278813; West pub. co., St. Paul, Minn.
118

Vedel, Valdemar, 1865–

Ritterromantik, mittelalterliche kulturideale II. von dr. Vald. Vedel ... Leipzig, B. G. Teubner, 1911.

iv, 170 p. 18½ᶜᵐ. (Aus natur und geisteswelt ... 293. bdchen.)
ⓒ Nov. 26, 1910; 2c. Jan. 7, 1911; A—Foreign 2245; B. G. Teubner, Leipzig, Germany. 119

Vorländer, Karl, 1860–

... Geschichte der philosophie, von Karl Vorländer. 3. aufl. (7.–9. tausend) ... Leipzig, Dürr'sche buchhandlung, 1911.

2 v. 20ᶜᵐ. (Philosophische bibliothek. bd. 105–106) M. 10
CONTENTS.—1. bd. Altertum, mittelalter und übergang zur neuzeit.—2. bd. Philosophie der neuzeit.
ⓒ Dec. 28, 1910; 2c. Jan. 7, 1911; A—Foreign 2259; Dürr'sche buchhandlung, Leipzig, Germany. (11–1004) 120

Waite, Alice Vinton, ed.

Modern masterpieces of short prose fiction, ed., with introduction and notes by Alice Vinton Waite ... and Edith Mendall Taylor ... New York, Chicago, D. Appleton and company, 1911.

xxi, 408 p. 19½ᶜᵐ. ' $1.50
CONTENTS.—A living relic, by I. Turgenev.—The death of the dauphin, by A. Daudet.—Leeby and Jamie, by J. Barrie.—The hunter, by Olive Schreiner.—Uncle Remus. His songs and his sayings, by J. C. Harris.—An episode under the terror, by H. de Balzac.—The Venus of Ille, by P. Mérimée.—The purloined letter, by E. A. Poe.—Rappaccini's daughter, by N. Hawthorne.—The man without a country, by E. E. Hale.—Master and man, by L. Tolstoi.—The piece of string, by G de Maupassant.—The merry men, by R. L. Stevenson. — Brooksmith, by H. James. — The man who would be king, by R. Kipling.—The doll's house, by H. Ibsen.
ⓒ Jan. 3, 1911; 2c. Jan. 7, 1911; A 278969; D. Appleton & co., New York, N. Y. (11–1017) 121

Warner, Horace Emory.

The psychology of the Christian life; a contribution to the scientific study of Christian experience and character, by Horace Emory Warner ... with introduction by John R. Mott, LL. D. New York, Chicago [etc.] Fleming H. Revell company [°1910]

401 p. incl. fold. chart. charts (partly fold.) 21ᶜᵐ. $1.50

© Dec. 3, 1910; 2c. Jan. 4, 1911; A 278880; Fleming H. Revell co., New York, N. Y. (11–717) **122**

Wechselmann, Wilhelm.

Die behandlung der syphilis, mit dioxydiamidoarseno-benzol "Ehrlich-Hata 606," von sanitätsrat dr. Wilhelm Wechselmann ... mit einem vorwort von professor dr. Paul Ehrlich ... mit 15 textfiguren und 16 tafeln in vier-farbendruck. Berlin, O. Coblentz, 1911.

4 p. l., 144 p. illus., xvi col. pl. (partly fold.) 28½ᶜᵐ.

© Dec. 15, 1910; 2c. Jan. 10, 1911; A—Foreign 2287; Oscar Coblentz, Berlin, Germany. (11–937) **123**

Wells, Herbert George, 1866–

The new Machiavelli, by H. G. Wells ... New York, Duffield & company, 1910.

4 p. l., [3]–490 p. 19½ᶜᵐ. $1.35

© Dec. 30, 1910; 2c. Jan. 3, 1911; A 278806; Duffield & co., New York, N. Y. (11–553) **124**

White, Edward Joseph, 1869–

Commentaries on the law in Shakespeare, with explanations of the legal terms used in the plays, poems and sonnets, and discussions of the criminal types presented. By Edw. J. White ... St. Louis, Mo., The F. H. Thomas law book co., 1911.

2 p. l., iii–xviii, 524 p. 23½ᶜᵐ. $3.50

© Jan. 5, 1911; 2c. Jan. 7, 1911; A 278983; E. J. White, Aurora, Mo. (11–834) **125**

White, William Allen, 1868–

A theory of spiritual progress; an address delivered before the Phi beta kappa society of Columbia university in the city of New York, by William Allen White. Emporia, Kan., The Gazette press [°1910]

3 p. l., 53 p. 19½ᶜᵐ. $1.00

© Dec. 16, 1910; 2c. Jan. 16, 1911; A 280126; W. A. White, Emporia, Kan. (11–960) **126**

Wilbrandt, Adolf von, 1837–

Hiddensee, roman von Adolf Wilbrandt. Stuttgart [etc.] Union deutsche verlagsgesellschaft [°1910]

262 p. 20ᶜᵐ. M. 4

© Dec. 1, 1910; 2c. Jan. 7, 1911; A—Foreign 2254; Union deutsche verlagsgesellschaft, Stuttgart, German. (11–1024) **127**

Wilkinson, Elizabeth Hays.

The lane to Sleepy Town, and other verses, by Elizabeth Hays Wilkinson. Pittsburgh, Reed and Witting, 1910.

vii, 66 p. plates. 15½ᶜᵐ. $1.25
© Dec. 20, 1910; 2c. Jan. 3, 1911; A 278853; E. H. Wilkinson, Pittsburg, Pa. (11–748) **128**

Will, Arthur Percival, 1868– *ed.*

Standard encyclopædia of procedure; editor: Arthur P. Will ... supervising editors: James De Witt Andrews ... Edgar W. Camp ... v. 1. Los Angeles, Chicago, L. D. Powell company [ᶜ1911]

3 p. l., 1040 p. 24ᶜᵐ. $6.00
© Jan. 6, 1911; 2c. Jan. 9, 1911; A 278993; L. D. Powell co., Los Angeles, Cal. (11–884) **129**

Wolfrum, Philipp, 1855–

Johann Sebastian Bach, von Philipp Wolfrum ... Leipzig, Breitkopf & Härtel, 1910.

2 v. front., plates, ports., facsims. (partly fold.) 20ᶜᵐ. (*On cover:* Breitkopf & Härtels musikbücher)
1. bd.: 2., neu durchgesehene aufl.
CONTENTS.—1. bd. Bachs leben, die instrumentalwerke.—2. bd. J. S. Bach als vokaler tondichter.
bd. 1: © Dec. 17, 1910; 2c. Jan. 10, 1911; A—Foreign 2281; bd. 2: Nov. 7, 1910; 2c. Dec. 9, 1910; A—Foreign 2089; Brietkopf & Härtel, Leipzig, Germany. (11–736) **130, 130ᵃ**

Number of entries of books included in the Catalogue since Jan. 1, 1911:

a) United States publications_____ 103
b) Foreign books in foreign languages_____ 25
c) Foreign books in English language under *ad interim* provisions of law of Mar. 4, 1909_____ 2
 ———
 Total _____ 130

This index contains the names of copyright proprietors of books the titles of which are printed in this number of the CATALOGUE. The index in the last number of the CATALOGUE of Part 1, Group 1, of each month will contain in one alphabet, in addition to the names of the copyright proprietors, the names also of the authors of the books the title of which have appeared during the month, and the titles of anonymous books.

LIBRARY OF CONGRESS
COPYRIGHT OFFICE

———

CATALOGUE

OF

COPYRIGHT ENTRIES

PUBLISHED WEEKLY BY AUTHORITY OF THE ACTS OF CONGRESS
OF MARCH 3, 1891, OF JUNE 30, 1906, AND
OF MARCH 4, 1909

———

Part 1, Group 1

BOOKS

———

1911

New Series, Volume 8, No. 2

———

WASHINGTON
GOVERNMENT PRINTING OFFICE
LIBRARY DIVISION
1911

The Act of March 4, 1909, provides that the Catalogue of Copyright Entries shall be "admitted in any court as prima facie evidence of the facts stated therein as regards any copyright registration."

Published February 9, 1911

BOOKS

Group 1

Adami, John George.

The principles of pathology, by J. George Adami ... and Albert G. Nicholls ... v. 2, Systematic pathology. 2d ed. ... Philadelphia and New York, Lea & Febiger, 1911.

xv, [17]-1160 p. illus., plates. 25ᶜᵐ. $6.00

© Jan. 13, 1911; 2c. Jan. 16, 1911; A 280123; Lea & Febiger, Philadelphia, Pa. 131

Ahrens, Wilhelm Ernst Martin Georg, 1872–

... Mathematische spiele, von dr. W. Ahrens. 2., verm. und verb. aufl., mit einem titelbild und 77 figuren im text. Leipzig, B. G. Teubner, 1911.

vi, 121, [1] p. front., illus., diagrs. 18½ᶜᵐ. (Aus natur und geisteswelt; sammlung wissenschaftlich - gemeinverständlicher darstellungen. 170. bdchen.) M. 1.25

© Dec. 8, 1910; 2c. Jan. 7, 1911; A—Foreign 2246; B. G. Teubner, Leipzig, Germany. (11-1082) 132

Allen, Alfred Henry.

Allen's commercial organic analysis; a treatise on the properties, modes of assaying, and proximate examination of the various organic chemicals and products employed in the arts, manufactures, medicine, etc. ... v. 4 ... 4th ed. ... Ed. by W. A. Davis ... and Samuel S. Sadtler ... Philadelphia, P. Blakiston's son & co., 1911.

viii, 466 p. illus. 24ᶜᵐ. $5.00

© Jan. 17, 1911; 2c. Jan. 18, 1911; A 280180; P. Blakiston's son & co., Philadelphia, Pa. 133

American bankruptcy reports annotated (cited Am. B. R.) reporting the bankruptcy decisions and opinions in the United States, of the federal courts, state courts and referees in bankruptcy. Ed. by Melvin Bender and Harold J. Hinman ... v. 24. Albany, N. Y., M. Bender & co., 1910.

xxxi, 1047 p. 24ᶜᵐ. $5.00

© Jan. 11, 1911; 2c. Jan. 12, 1911; A 280062; Matthew Bender & co., Albany, N. Y. 134

2229—ot. 1. no. 2—11—1**

Artaud de Montor, Alexis François.

The lives and times of the popes ... Being a series of volumes giving the history of the world during the Christian era, retranslated, revised and written up to date from Les vies des papes, by the Chevalier Artaud de Montor ... [v. 8 and 9. Lateran ed.] New York, The Catholic publication society of America [1910–1911]

2 v. ports. 26ᶜᵐ. $10.00 per vol.

v. 8 © Dec. 31, 1910; v. 9 © Jan. 12, 1911; 2c. each Jan. 21, 1911; A 280255, 280256; Catholic publication soc. of America, New York, N. Y.

 135, 136

... The **Atlantic** reporter, with key-number annotations. v. 77. Permanent ed. ... August 25–December 8, 1910. St. Paul, West publishing co., 1911.

xv, 1278 p. 26¼ᶜᵐ. (National reporter system—State series) $4.00

© Jan. 16, 1911; 2c. Jan. 21, 1911; A 280274; West pub. co., St. Paul, Minn.

 137

Barr, John Henry, 1861–

Kinematics of machinery. A brief treatise on constrained motions of machine elements. By John H. Barr ... rev. by Edgar H. Wood ... with over two hundred figures. 2d ed., rev. Total issue, seven thousand. New York, J. Wiley & sons; [etc., etc.] 1911.

vii, 264 p. illus., diagrs. 23¼ᶜᵐ. $2.50

© Jan. 4, 1911; 2c. Jan. 6, 1911; A 278946; J. H. Barr, Syracuse, N. Y.

(11–1150) **138**

Bau, A.

... Bierbrauerei, von dr. A. Bau ... mit 47 abbildungen im text. Leipzig, B. G. Teubner, 1911.

2 p. l., 117, [1] p. illus. 18¼ᶜᵐ. (Aus natur und geisteswelt; sammlung wissenschaftlich-gemeinverständlicher darstellungen. 333. bdchen.) M. 1.25

© Jan. 3, 1911; 2c. Jan. 10, 1911; A—Foreign 2290; B. G. Teubner, Leipzig, Germany. (11–1077) **139**

Bernoulli, Eduard, 1867–

Aus liederbüchern der humanistenzeit, eine bibliographische und notentypographische studie, vorgelegt von dr. Eduard Bernoulli; mit 33 notenbeilagen. Leipzig, Breitkopf & Härtel, 1910.

116 p. 24¼ᶜᵐ. M. 3

© Dec. 10, 1910; 2c. Jan. 7, 1911; A—Foreign 2237; Breitkopf & Härtel, Leipzig, Germany. (11–1119) **140**

Bianchi, *Mrs.* Martha Gilbert (Dickinson)

A Cossack lover, by Martha Gilbert Dickinson Bianchi ... New York, Duffield & company, 1911.

363 p. 19¼ᶜᵐ. $1.30

© Jan. 14, 1911; 2c. Jan. 17, 1911; A 280154; Duffield & co., New York, N. Y. (11–1132) **141**

Brugsch, Theodor.

Diätetik innerer erkrankungen, zum praktischen ge-
brauche für ärzte und studierende, von professor dr.
Theodor Brugsch. Berlin, J. Springer, 1911.

vi p., 1 l., 245, [1] p. 22ᶜᵐ.

© Jan. 3, 1911; 2c. Jan. 7, 1911; A—Foreign 2256; Julius Springer, Berlin,
Germany. (11–1145) 142

Bunyan, John, 1628–1688.

Путь Паломника (богомолця) із сього сьвіта в
будучий сьвіт. Написав Джан Боніян. (З англій-
ского переклав Ів. Бодруг) ... New York, American
tract society [ᶜ1910]

249 p. incl. front., illus. 19½ᶜᵐ.

© Dec. 31, 1910; 2c. Jan. 3, 1911; A 278818; Amer. tract soc., New York,
N. Y. (11–1128) 143

Burton, Harry Edwin, 1868–

A Latin grammar, by Harry Edwin Burton ... New
York, Boston [etc.] Silver, Burdett & company [ᶜ1911]

xiii, 337 p. 19½ᶜᵐ. $0.90

© Jan. 10, 1911; 2c. Jan. 16, 1911; A 280129; Silver, Burdett & co., Boston,
Mass. (11–1100) 144

California. *Supreme court.*

Reports of cases determined ... C. P. Pomeroy, re-
porter. v. 157. San Francisco, Bancroft-Whitney com-
pany, 1910 [1911]

xxxix, 941 p. 23ᶜᵐ. $3.00

© Jan. 12, 1911; 2c. Jan. 19, 1911; A 280210; Bancroft-Whitney co., San
Francisco, Cal. 145

Campbell, Gilbert Lewis.

Industrial accidents and their compensation, by Gilbert
Lewis Campbell ... Boston and New York, Houghton
Mifflin company, 1911.

xii p., 1 l., 105, [1] p. tables. 21ᶜᵐ. (*Half-title:* Hart, Schaffner &
Marx prize essays, VII)

© Jan. 9, 1911; 2c. Jan. 17, 1911; A 280150; Hart, Schaffner & Marx, Chi-
cago, Ill. (11–1172) 146

Cathcart, William Ledyard, 1855–

The elements of graphic statics and of general graphic
methods, by William Ledyard Cathcart ... and J. Irvin
Chaffee ... with 159 illustrations. New York, D. Van
Nostrand company, 1910.

viii, 312 p. illus., diagrs. 23ᶜᵐ. $3.00

© Dec. 13, 1910; 2c. Jan. 6, 1911; A 278951; D. Van Nostrand co., New
York, N. Y. (11–1151) 147

Chadwick, Lester.

A quarter-back's pluck; a story of college football, by Lester Chadwick ... New York, Cupples & Leon company [°1910]

2 p. l., 305 p. front., plates. 19½ᶜᵐ. (*His* The college sports series) $1.00

© Aug. 1, 1910; 2c. Jan. 19, 1911; A 280197; Cupples & Leon co., New York, N. Y. (11-1131) **148**

Chase, Harry.

Powers, duties and work of game wardens; a handbook of practical information for officers and others interested in the enforcement of fish and game laws, written and comp. by Harry Chase ... Rutland, Vt., The Tuttle company, printers [°1910]

145 p. 15ᶜᵐ. $0.50

© Jan. 11, 1911; 2c. Jan. 13, 1911; A 280270; H. Chase, Bennington, Vt. (11-1163) **149**

Clayton, William Brasher, 1888–

A general treatise on electricity and electrical apparatus, by W. B. Clayton and Jas. W. Craig ... 1st ed., 2d thousand. Lynn, Mass., Association technical institute, Young men's Christian association [°1910]

357 p. illus., diagrs. 17½ᶜᵐ.

© Jan. 2, 1911; 2c. Jan. 4, 1911; A 278884; Young men's Christian assn., Lynn, Mass. (11-1153) **150**

Crockett, Daniel W.

A digest of all the decisions of the Supreme court and the Criminal court of appeals, reported in the Oklahoma reports and the Pacific reporter from December, 1907, to August, 1910, comp. under American digest classification, key number system, being volume one of the Oklahoma cumulative digest ... prepared and ed. by Daniel W. Crockett ... Indianapolis, The Bobbs-Merrill company, 1910.

3 p. l., 1212 numb. col. 26½ᶜᵐ.

© Nov. 21, 1910; 2c. Jan. 9, 1911; A 278979; Bobbs-Merrill co., Indianapolis, Ind. (11-1049) **151**

Dalwigk, Friedrich von, 1864–

Vorlesungen über darstellende geometrie, von dr. F. v. Dalwigk ... 1. bd. Leipzig und Berlin, B. G. Teubner, 1911.

xvi, 363, [1] p. diagrs. (partly fold.) 23ᶜᵐ. M. 13

bd. 1 © Jan. 3, 1911; 2c. Jan. 10, 1911; A—Foreign 2286; B. G. Teubner, Leipzig, Germany. (11-1081) **152**

Dauthendey, Max, 1867–

Die spielereien einer kaiserin; drama in vier akten, einem vorspiel und einem epilog, von Max Dauthendey. München, A. Langen [°1910]

235 p., 1 l. 19ᶜᵐ.

© Nov. 17, 1910; 2c. Dec. 24, 1910; D 22968; Albert Langen, Munich, Germany. (11-1112) **152ᵃ**

Dernehl, Carl.

El comerciante; spanisches lehrbuch für kaufleute ...
von Carl Dernehl ... unter mitwirkung Hamburger kauf-
leute und der spanischen lehrer D. Ezequiel Solana ...
D. Claudio Herreros ... 2. aufl. Leipzig und Berlin, B. G.
Teubner, 1911.
xii, 276 p. illus., 3 pl., map. 22½ᶜᵐ. M. 3.60
© Jan. 5, 1911; 2c. Jan. 19, 1911; A—Foreign 2366; B. G. Teubner, Leipzig,
Germany. 153

Dietrich, Bernhard.

Kleinasiatische stickereien, von dr. Bernhard Dietrich
... Plauen i. V., Dr. Dietrichs selbstverlag, 1911.
vii, 152 p. illus., xvi col. pl. (incl. front.) 22½ᶜᵐ. M. 16.50
© Jan. 3, 1911; 2c. Jan. 10, 1911; A—Foreign 2292; Dr. Dietrichs selbstver-
lag, Plauen i. V., Germany. (11–1155) 154

Doyen, Eugène.

... Atlas d'anatomie topographique ... fasc. no. 5 quin-
ter; coupes de tronçonnage chez un Nègre ... Paris,
A. Maloine, 1911.
1 p. l., 24 pl. 32½ᶜᵐ. fr. 7.50
At head of title: Dr. E. Doyen, J.-P. Bouchon, R. Doyen.
© Jan. 6, 1911; 2c. Jan. 21, 1911; A—Foreign 2387; E. Doyen, Paris,
France. 155

Emerton, Ephraim, 1851–

Unitarian thought, by Ephraim Emerton ... New York,
The Macmillan company, 1911.
ix, 309 p. 19¼ᶜᵐ. $1.50
© Jan. 18, 1911; 2c. Jan. 19, 1911; A 280193; Macmillan co., New York,
N. Y. (11–1127) 156

... The **Federal** reporter, with key-number annotations.
v. 181. Permanent ed. ... October–December, 1910.
St. Paul, West publishing co., 1911.
xi, 1133 p. 22½ᶜᵐ. (National reporter system—United States series)
$3.50
© Jan. 12, 1911; 2c. Jan. 21, 1911; A 280273; West pub. co., St. Paul, Minn.
 157

Franklin, Charles Kendall.

What nature is; an outline of scientific naturalism, by
Charles Kendall Franklin ... Boston, Sherman, French
& company, 1911.
3 p. l., 74 p. 19¼ᶜᵐ. $0.75
© Jan. 12, 1911; 2c. Jan. 16, 1911; A 280138; Sherman, French & co., Bos-
ton, Mass. (11–1080) 158

Frech, Fritz Daniel.

Aus der vorzeit der erde. [bd.] 5. Steinkohle, wüsten
und klima der vorzeit, von dr. Fritz Frech ... 2. wesent-
lich verm. aufl. ... Leipzig, B. G. Teubner, 1911.
2 p. l., 32 p. fold. front., illus, fold. pl., maps, diagrs. 18½ᶜᵐ. (Aus
natur und geisteswelt) M. 1.25
© Jan. 5, 1911; 2c. Jan. 11, 1911; A—Foreign 2300; B. G. Teubner, Leipzig,
Germany. 159

Funk, Jacob.

War versus peace; a short treatise on war: its causes, horrors, and cost; and peace: its history and means of advancement, by Jacob Funk. Elgin, Ill., Brethren publishing house, 1910.

175 p. 20ᶜᵐ. $0.75

© Jan. 18, 1911; 2c. Jan. 20, 1911; A 280234; Brethren pub. house, Elgin, Ill. (11–1169) **160**

Galbraith, Anna Mary, 1859–

Personal hygiene and physical training for women, by Anna M. Galbraith ... Philadelphia and London, W. B. Saunders company, 1911.

371 p. illus., plates. 21ᶜᵐ. $2.00

© Jan. 14, 1911; 2c. Jan. 16, 1911; A 280130; W. B. Saunders co., Philadelphia, Pa. (11–1148) **161**

Gesammelte gemeinnützige volksbibliothek. 1. t., 1ᵇⁱˢ, 10. heft. M. Gladbach, Volksvereins-verlag g. m. b. h., 1910.

Various paging. illus. 21ᶜᵐ. 50 pfg.

t. 1 © Dec. 12, 1910; 2c. Dec. 29, 1910; A—Foreign 2232; Volksvereins-verlag g. m. b. h., M. Gladbach, Germany. (11–1139) **162**

Gibbons, Emma.

Books for children. A 2d ed. of Literature for children, by Emma Gibbons. Buffalo, N. Y., Priv. print., 1910.

2 p. l., 34 p. 20ᶜᵐ. $0.50

© Dec. 12, 1910; 2c. Jan. 9, 1911; A 280001; Miss E. Gibbons, Buffalo, N.Y. (11–1141) **163**

Gött, Emil, 1864–1908.

Emil Götts gesammelte werke, hrsg. von Roman Woerner ... München, C. H. Beck, 1911.

3 v. front. (port.) 17ᶜᵐ.

CONTENTS.—1. bd. Gedichte, sprüche, aphorismen.—2. bd. Der schwarz-künstler. Edelwild.—3. bd. Mauserung. Fortunatas biss.

bd. 1, 2 and 3 © Nov. 24, 1910; 2c. each Jan. 10, 1911; A—Foreign 2291; C. H. Beck'sche verlagsbuchhandlung, Oskar Beck, Munich, Germany. (11–1036) **164**

Goslee, Hart John, 1871–

Principles and practice of crown and bridgework; a practical, systematic and modern treatise upon the requirements and technique of artificial crown and bridgework. With 1141 illustrations. 3d ed. By Hart J. Goslee ... New York, The Consolidated dental mfg. co.; [etc., etc.] 1910.

4 p. l., 600, vii p. illus. 24ᶜᵐ. $5.00

© Dec. 30, 1910; 2c. Dec. 31, 1910; A 278887; H. J. Goslee, Chicago, Ill. (11–1147) **165**

Grand army of the republic.

Observance of the centennial anniversary of the birth of Abraham Lincoln, February twelfth, 1909, under the inspiration of the Grand army of the republic. ₍New York₎ Priv. print. by the National committee, G. A. R. ₍°1910₎

164 p. incl. front., plates (1 col.) ports., facsims. 25½ᶜᵐ.

"Matter arranged by Wilbur F. Brown, secretary of the Committee."

© Dec. 31, 1910; 2c. Jan. 20, 1911; A 280232; John E. Gilman, commander in chief G. A. R., and his successors, New York, N. Y. (11–1144)

166

Gregg, William Henry, 1831–

Controversial issues in Scottish history; a contrast of the early chronicles with the works of modern historians, by William H. Gregg, with over three hundred facsimile reproductions from old chronicles and authentic works, and with maps and illustrations. New York and London, G. P. Putnam's sons, 1910.

x p., 1 l., 601 p. illus., plates, fold. maps, facsims., fold. geneal. tab. 27ᶜᵐ. $6.00

© Dec. 22, 1910; 2c. Jan. 6, 1911; A 278930; W. H. Gregg, St. Louis, Mo. (11–1044) 167

Haendcke, Berthold, 1862–

Kunstanalysen aus neunzehn jahrhunderten; ein handbuch für die betrachtung von kunstwerken, von Berthold Haendcke. 2., verb. und verm. aufl. Braunschweig, G. Westermann ₍°1910₎

4 p. l., 288 p. illus. (partly col.) plates (partly fold., 1 col.) 28ᶜᵐ. M. 10

© Dec. 23, 1910; 2c. Jan. 19, 1911; A—Foreign 2317; George Westermann, Braunschweig, Germany. (11–1158) 168

Hausmann, Walter L.

Der goldwahn ... von Walter L. Hausmann ... Berlin, Puttkammer & Mühlbrecht, 1911.

5 p. l., ₍5₎–536 p. 22ᶜᵐ.

Half-title: Der goldwahn; die bedeutung der goldzentralisation für das wirtschaftsleben.

© Jan. 3, 1911; 2c. Jan. 19, 1911; A—Foreign 2364; W. L. Hausmann, Berlin, Germany. (11–1167) 169

Heigel, Karl Theodor, 1842–

... Politische hauptströmungen in Europa im 19. jahrhundert, von Karl Theodor Heigel. 2., verb. und verm. aufl. Leipzig, B. G. Teubner, 1911.

2 p. l., 125, ₍1₎ p. 18½ᶜᵐ. (Aus natur und geisteswelt; sammlung wissenschaftlich-gemeinverständlicher darstellungen. 129. bdchen.) M. 1.25

"Literatur" at beginning of each chapter.

© Jan. 3, 1911; 2c. Jan. 7, 1911; A—Foreign 2244; B. G. Teubner, Leipzig, Germany. (11–1047) 170

Hemmy, Martin.

Shorthand, by Martin Hemmy ... Chicago, Ill., The Auxiliary text-book co., ℮1911·

144 p. 19¼ᵐ. $1.50
© Jan. 12, 1911; 2c. Jan. 3, 1911; A 280160; M. Hemmy, Kenosha, Wis.
(11–1140) 171

Hey, Julius, 1832–1909.

Richard Wagner als vortragsmeister, 1864–1876, erinnerungen von Julius Hey; hrsg. von Hans Hey; mit drei bildnissen und zwei faksimiles. Leipzig, Breitkopf & Härtel, 1911.

x p., 1 l., 253 p. 3 port. (incl. front.) 2 fold. facsim. 20ᵐ. (On cover: Breitkopf & Härtels musikbücher) M. 6
© Dec. 16, 1910; 2c. Jan. 10, 1911; A—Foreign 2289; Breitkopf & Härtel, Leipzig, Germany. (11–1096) 172

Hirsch, Charles Henry, 1870–

... Le crime de Potru, soldat; illustrations d'après les dessins de Renefer. Paris, A. Fayard, ℮1910·

188 p. incl. illus., plates. 24ᵐ. fr. 1.50
© Dec. 16, 1910; 2c. Jan. 7, 1911; A—Foreign 2267; Arthème Fayard, Paris, France. (11–1035) 173

Huntington, Dwight Williams, 1851–

Our wild fowl and waders, by Dwight W. Huntington ... with twenty-four full page illustrations and a map of the wild ducks' breeding grounds. New York, The Amateur sportsman co. [1910]

v, 207 p. front. (port.) plates, map. 21½ᵐ. $2.00
© Dec. 24, 1910; 2c. Jan. 18, 1911; A 280163; Amateur sportsman co., New York, N. Y. (11–1161) 174

Huret, Jules.

... En Allemagne: La Bavière et la Saxe ... Paris, E. Fasquelle, 1911.

2 p. l., 458 p., 1 l. 19ᵐ. fr. 3.50
© Dec. 16, 1910; 2c. Jan. 7, 1911; A—Foreign 2261; J. Huret & Eugène Fasquelle, Paris, France. (11–1046) 175

Illinois. *Supreme court.*

Reports of cases at law and in chancery ... v. 246 ... Samuel Pashley Irwin, reporter of decisions. Bloomington, Ill., 1911.

vii, [9]–718 p. 22½ᵐ. $1.50
© Jan. 26, 1911; 2c. Jan. 30, 1911; A 280443; Samuel P. Irwin, Bloomington, Ill. 176

[International correspondence schools, *Scranton, Pa.*]

Curso de italiano; sistema para aprender el italiano con ayuda del fonógrafo ... t. 1. Scranton, Pa., International textbook company [℮1910]

Various paging. 23ᵐ.
t. 1 © Dec. 21, 1910; 2c. Jan. 3, 1911; A 278865; International textbook co., Scranton, Pa. (11–1107) 177

Jones, Walter Clyde, *ed.*

Notes on the Illinois reports; a cyclopedia of Illinois law ... by W. Clyde Jones and Keene H. Addington ... editors in chief, and Donald J. Kiser ... v. 5. Chicago, Callaghan & company, 1911.

1 p. l., 1023 p. 26ᶜᵐ.

© Jan. 17, 1911; 2c. Jan. 23, 1911; A 280303; Callaghan & co., Chicago, Ill.

 178

Kallmeyer, Charles.

How to become a citizen of the United States of America. New York, C. Kallmeyer [ᶜ1911]

88 p. 20½ᶜᵐ. $1.00

© Jan. 10, 1911; 2c. Jan. 11, 1911; A 280034; Chas. Kallmeyer, New York, N. Y. (11-1170) 179

Kentucky. *Laws, statutes, etc.*

Annotations to the Kentucky constitution, statutes and codes, supplementing all other annotated publications and bringing the annotations down to June, 1910; prepared and ed. by Charles B. Seymour, editor-in-chief, Bradford Webster, associate editor, Samuel L. Trusty, associate editor ... [Cumulative ed.] Indianapolis, The Bobbs-Merrill company [ᶜ1910]

Various paging. 24½ᶜᵐ.

© Dec. 16, 1910; 2c. Jan. 12, 1911; A 280054; Bradford Webster, Louisville, Ky. (11-1050) 180

Keyes, Edward Loughborough, 1873–

Diseases of the genito-urinary organs considered from a medical and surgical standpoint, including a description of gonorrhea in the female and conditions peculiar to the female urinary organs, by Edward L. Keyes, jr. ... with one hundred and ninety-five illustrations in the text and seven plates, four of which are colored. New York and London, D. Appleton and company, 1911.

xvii, 975 p. col. front., illus., plates (partly col.) 24½ᶜᵐ. $6.00

© Jan. 3, 1911; 2c. Jan. 7, 1911; A 278973; D. Appleton & co., New York, N. Y. (11-1039) 181

Kolle, Frederick Strange, 1871–

Plastic and cosmetic surgery, by Frederick Strange Kolle ... with one colored plate and five hundred and twenty-two illustrations in text. New York and London, D. Appleton and company, 1911.

xxi, 511 p. front., illus., plates (1 col.) 24½ᶜᵐ. $5.00

© Jan. 3, 1911; 2c. Jan. 7, 1911; A 278974; D. Appleton & co., New York, N. Y. (11-1041) 182

Lansden, John McMurray, 1836–

A history of the city of Cairo, Illinois, by John M. Lansden; with maps and illustrations. Chicago, R. R. Donnelley & sons company, 1910.

303 p. front., plates, ports., maps (partly fold.) facsims. 24½ᶜᵐ.

© Dec. 17, 1910; 2c. Jan. 9, 1911; A 278990; J. M. Lansden, Cairo, Ill. (11-1055)' 183

Lewisohn, Ludwig, 1882– *ed.*
German style, an introduction to the study of German prose, by Ludwig Lewisohn ... New York, H. Holt and company, 1910.
xxix, 215 p. 17ᶜᵐ. $0.75
© Dec. 30, 1910; 2c. Jan. 3, 1911; A 278787; Henry Holt & co., New York, N. Y. (11-1032) **184**

Liliencron, Detlev *i. e.* **Friedrich Adolph Axel Detlev,** *freiherr* **von,** 1844–1909.
Detlev von Liliencrons briefe an Hermann Friedrichs aus den jahren 1885–1889. Mit anmerkungen von H. Friedrichs. Vollständige ausg. Berlin, Concordia deutsche verlags-anstalt, g. m. b. h., 1910.
viii, 367, [1] p. 22ᶜᵐ.
© Dec. 2, 1910; 2c. Jan. 7, 1911; A—Foreign 2243; Concordia deutsche verlags-anstalt, g. m. b. h., Berlin, Germany. (11-1108) **185**

Liszt, Franz.
Gesammelte schriften von Franz Liszt. [bd.] 3, 4. Leipzig, Breitkopf & Härtel, 1910.
2 v. in 1. 20ᶜᵐ. M. 6
CONTENTS.—3. Die zigeuner und ihre musik in Ungarn.—4. Ausgewählte schriften.
© Dec. 23, 1910; 2c. Jan. 19, 1911; A—Foreign 2314; Breitkopf & Härtel, Leipzig, Germany. **186**

Loyd, William Henry, *comp.*
Cases on civil procedure. pt. 2. By William H. Loyd ... Philadelphia, Town printing company, 1911.
cover-title, 2 p. l., 249–426 p. 23ᶜᵐ. $1.75
© Jan. 20, 1911; 2c. Jan. 23, 1911; A 280302; W. H. Loyd, Philadelphia, Pa.
 187

Meissner, Marie, 1851–
Das märchen von heute, von M. Meissner ... with notes and vocabulary by Morton C. Stewart ... New York, H. Holt and company, 1910.
2 p. l., 122 p. 17½ᶜᵐ. $0.35
© Dec. 15, 1910; 2c. Dec. 17, 1910; A 278928; Henry Holt & co., New York, N. Y. (11-1033) **188**

Meredith, George.
The works of George Meredith. Memorial ed. v. 23. [Miscellaneous prose. New York, C. Scribner's sons, 1910]
vi p., 1 l., 213 p. facsim. 21½ᶜᵐ. $2.00
© Dec. 20, 1910; 2c. Jan. 10, 1911; A 280006; Chas. Scribner's sons, New York, N. Y. **189**

Michel, André.
Histoire de l'art, depuis les premiers temps chrétiens jusqu'à nos jours; publiée sous la direction de André Michel ... t. 4, La renaissance, 1. ptie. Paris, Librairie A. Colin, 1909.
1 p. l., iii, 486, [1] p. illus., plates. 29ᶜᵐ. fr. 15
© Dec. 30, 1910; 2c. Jan. 21, 1911; A—Foreign 2383; Max Leclerc & H. Bourrelier, Paris, France. **190**

Michie, Thomas Johnson, *ed.*

The encyclopedic digest of Georgia reports, being a complete encyclopedia and digest of all the Georgia case law up to and including vol. 132 Georgia reports, and vol. 6 Georgia appeals. Under the editorial supervision of Thomas Johnson Michie. Table of cases. vols. 1-16. Charlottesville, Va., The Michie company, 1910.

xii, 1090 p. 24½ᶜᵐ. $7.50

© Jan. 23, 1911; 2c. Jan. 25, 1911; A 280353; Michie co., Charlottesville, Va.

191

The encyclopedic digest of Texas reports ... under the editorial supervision of Thomas Johnson Michie. v. 2. Charlottesville, Va., The Michie company, 1911.

iv p., 1 l., 1087 p. 26ᶜᵐ.

© Jan. 13, 1911; 2c. Jan. 14, 1911; A 280082; Michie co., Charlottesville, Va.

192

Minnesota. *Supreme court.*

Minnesota reports, v. 111; cases argued and determined ... May 6–July 22, 1910. Henry Burleigh Wenzell, reporter. St. Paul, Lawyers' co-operative publishing co., 1911.

xviii, 618 p. 22½ᶜᵐ. $2.00

© Jan. 14, 1911; 2c. Jan. 19, 1911; A 280209; Julius A. Schmahl, sec. of the state of Minnesota, in trust for the benefit of the people of said state, St. Paul, Minn.

193

Molière, Jean Baptiste Poquelin, 1622–1673.

The Kiltartan Molière: The miser. The doctor in spite of himself. The rogueries of Scapin. Tr. by Lady Gregory. Dublin, Maunsel & company, ltd., 1910.

4 p. l., [3]–231 p. 19ᶜᵐ.

© Oct. 29, 1910; 2c. Jan. 6, 1911; D 23048; Lady Gregory, Gort, Ireland. (11-1113)

193*

Morrison, Henry Clay, 1842–

World tour of evangelism, by Rev. H. C. Morrison ... Louisville, Ky., Pentecostal publishing company [1911]

280 p. front., plates, ports. 19½ᶜᵐ. $1.00

© Jan. 7, 1911; 2c. Jan. 19, 1911; A 280217; Pentecostal pub. co., Louisville, Ky. (11-1126)

194

Nash, Eugene Beauharnais, 1838–

The testimony of the clinic, by E. B. Nash ... Philadelphia, Boericke & Tafel, 1911.

2 p. l., [9]–209 p., 1 l. front. (port.) 19ᶜᵐ. $1.50

© Dec. 24, 1910; 2c. Jan. 10, 1911; A 280002; Boericke & Tafel, Philadelphia, Pa. (11-1043)

195

Nearing, Scott.

Social adjustment, by Scott Nearing ... New York, The Macmillan company, 1911.

xvi p., 1 l., 377 p. 19½ᶜᵐ. $1.50

© Jan. 18, 1911; 2c. Jan. 19, 1911; A 280192; Macmillan co., New York, N. Y. (11-1164)

196

Neuendorff, Edmund, 1875–

Hinaus in die ferne! Zwei wanderfahrten deutscher jungen durch deutsche lande, erzählt von Edmund Neuendorff; mit buchschmuck von Karl Mühlmeister. Leipzig und Berlin, B. G. Teubner, 1911.

4 p. l., 235, [1] p. illus. 20½cm · M. 3
© Jan. 5, 1911; 2c. Jan. 11, 1911; A—Foreign 2299; B. G. Teubner, Leipzig, Germany. (11-1090) **197**

Nexø, Martin Andersen.

Pelle Erobreren; gryet, roman. [4. bd.] Folkeudgave. [Kristiania, Kjøbenhavn] Gyldendalske boghandel, Nordisk forlag, 1910.

248 p. 22cm. kr. 13
© Nov. 18, 1910; 2c. Dec. 27, 1910; A—Foreign 2422; M. A. Nexø, Espergarde, Denmark. **198**

... The **Northeastern** reporter, with key-number annotations. v. 92. Permanent ed. Containing all the decisions of the supreme courts of Ohio, Illinois, Indiana, Massachusetts, Appellate court of Indiana, and the Court of appeals of New York ... July 5–December 13, 1910. St. Paul, West publishing co., 1911.

xxi, 1300 p. 26½cm. (National reporter system—State series) $4.00
© Jan. 20, 1911; 2c. Jan. 28, 1911; A 280431; West pub. co., St. Paul, Minn.
 199

Oklahoma. *Supreme court.*

Oklahoma reports. v. 26. Cases determined ... March 8, 1910–July 12, 1910. Howard Parker, state reporter. Guthrie, Okl., The State capital company, 1910.

xvi, 911 p. 22½cm. $1.50
© Jan. 17, 1911; 2c. Jan. 20, 1911; A 280231; Howard Parker, state reporter, for benefit of the state of Oklahoma, Guthrie, Okl. **200**

The **pastor** his own evangelist; methods, texts, seed thoughts and illustrations, with an introduction by J. Wilbur Chapman, D. D., and a preliminary chapter on preparing for a revival, by Charles L. Goodell, D. D. Cleveland, O., F. M. Barton company, 1910.

6 p. l., [ix]–xxii, 477 p. 23½cm. $2.50
© Jan. 6, 1911: 2c. Jan. 12, 1911; A 280046; F. M. Barton co., Cleveland, O.
(11-1070) **201**

Pennsylvania. *Superior court.*

Pennsylvania Superior court reports, v. 43, containing cases decided by the Superior court of Pennsylvania, April term, 1910. Reported by William I. Schaffer, state reporter, and Albert B. Weimer, assistant state reporter. New York, The Banks law publishing co., 1911.

xxxix, 721 p. 23½cm. $1.08
© Jan. 17, 1911; 2c. Jan. 18, 1911; A 280171; Robert McAfee, sec. of the commonwealth for the state of Pennsylvania, Harrisburg, Pa. **202**

Pennsylvania. *Supreme court.*

Pennsylvania state reports, v. 228, containing cases de-
cided by the Supreme court of Pennsylvania at January
and May terms, 1910. Reported by William I. Schaffer,
state reporter. New York, The Banks law publishing co.,
1911.

xxx, 732 p. 24ᶜᵐ. $0.89

© Jan. 14, 1911; 2c. Jan. 16, 1911; A 280139; Robert McAfee, sec. of the
commonwealth for the state of Pennsylvania, Harrisburg, Pa. 203

Petit, G E.

... La télégraphie sans fil, la téléphonie sans fil, appli-
cations diverses par MM. G. E. Petit ... Léon Bouthillon
... 175 gravures. Paris, C. Delagrave [ᶜ1910]

2 p. l., 148 p. illus., diagrs. 25½ᶜᵐ. fr. 7.50

At head of title: T. s. f.

© Dec. 16, 1910; 2c. Jan. 17, 1911; A—Foreign 2264; Ch. Delagrave, Paris,
France. (11–1076) 204

Presber, Rudolf, 1868–

... Späne. 4. aufl. Berlin, Concordia deutsche verlags-
anstalt, g. m. b. h. [ᶜ1910]

175 p. 19½ᶜᵐ.

© Dec. 2, 1910; 2c. Jan. 7, 1911; A—Foreign 2251; Concordia deutsche ver-
lags-anstalt, g. m. b. h., Berlin, Germany. (11–1109) 205

Protestant Episcopal church in the U. S.

Constitution and canons for the government of the
Protestant Episcopal church in the United States of
America, adopted in general conventions, 1789–1910.
[New York] Printed for the Convention, 1910.

163 p. 23½ᶜᵐ. $0.75

© Jan. 9, 1911; 2c. Jan. 12, 1911; A 280044; Henry Anstice, sec., New York,
N. Y. (11–1073) 206

Rothes, Walter.

Christus; des Heilands leben, leiden, sterben und ver-
herrlichung in der bildenden kunst aller jahrhunderte,
von dr. phil. Walter Rothes ... mit 196 abbildungen im
text und 5 farbendruckbildern. 1. bis 6. tausend. Köln
a. Rh., J. P. Bachem [ᶜ1911]

xiv, 324 p. illus., pl., 5 col. pl. (incl. front.) 26ᶜᵐ. M. 8

© Jan. 3, 1911; 2c. Jan. 10, 1911; A—Foreign 2272; J. P. Bachem, Cologne,
Germany. (11–1087) 207

Rustum, Michal.

... Al-gareeb fi-el-garb. The "stranger in the West"
(poem) New York city, Commercial printing house,
ᶜ1909.

359 p. illus. (incl. ports.) 26½ᶜᵐ. $2.00

© Dec. 15, 1910; 2c. Dec. 23, 1910; A 280095; M. Rustum, New York, N. Y.
(11–1034) 208

Scott, Wilfred Welday, 1876–

Qualitative chemical analysis; a laboratory guide, by Wilfred Welday Scott ... New York, D. Van Nostrand company, 1910.

xi, 165 p. col. front., illus., plates. 22½ᶜᵐ. $1.50

© Dec. 20, 1910; 2c. Jan. 6, 1911; A 278950; D. Van Nostrand co., New York, N. Y. (11–1079) 209

Sheets, *Mrs.* Emily Churchill (Thompson) 1875–

In Kali's country; tales from sunny India, by Emily T. Sheets; illustrations from drawings by Elma McNeal Childs. New York, Chicago [etc.] Fleming H. Revell company [°1910]

208 p. front., illus., 7 pl. 19½ᶜᵐ. $1.00

CONTENTS.—Kalighat.—Shama Sahai.—Old Sarah.—A son of the law.—Mundra.—Of the tribe of Haunamon.—In ways mysterious.—The way to happiness.—Bachelor dreams.—The cost.—Among the clouds.—The infidel.

© Dec. 19, 1910; 2c. Jan. 5, 1911; A 278904; Fleming H. Revell co., New York, N. Y. (11–1129) 210

Shipp, *Mrs.* Ellis Reynolds.

Life lines; poems by Ellis Reynolds Shipp ... Salt Lake City, Utah, Skelton publishing company, 1910.

316 p. front. (port.) 21ᶜᵐ. $1.50

© Dec. 17, 1910; 2c. Jan. 17, 1911; A 280157; Mrs. E. R. Shipp, Salt Lake City, Utah. (11–1031) 211

Sills, Finous Hall, 1882–

Roman Catholicism investigated and exposed [by] F. H. Sills ... Savannah, Ga., Savannah morning news, 1911.

123 p. 18½ᶜᵐ. $0.50

© Jan. 2, 1911; 2c. Jan. 4, 1911; A 278888; F. H. Sills, Savannah, Ga. (11–1069)' 212

Soulavie, Jean Louis Giraud, 1752–1813, *ed.*

Madame de Pompadour, from the note-book of Maréchale D., by Jean Louis Soulavie; tr. from the French by E. Jules Méras. New York, Sturgis & Walton company, 1910.

ix, 281 p. front., pl., ports. 19½ᶜᵐ. (*Half-title:* The court series of French memoirs) $1.50

© Jan. 16, 1911; 2c. Jan. 17, 1911; A 280156; Sturgis & Walton co., New York, N. Y. (11–1089) ' 213

South Carolina. *Supreme court.*

Reports of cases heard and determined ... v. 85, containing cases of November term. 1909, by C. M. Efird, state reporter. Columbia, S. C., The R. L. Bryan company, 1910.

xi, 635 p. 24ᶜᵐ. $2.00

© Jan. 2, 1911; 2c. Jan. 14, 1911; A 280084; R. L. Bryan co., Columbia, S. C. 214

Southwestern reporter.

Missouri decisions reported in the Southwestern reporter, vols. 25, 26, 27, and 28, March, 1894, to January, 1895 ... St. Paul, West publishing co., 1911.

Various paging. 26¼ᶜᵐ. $5.50

© Jan. 6, 1911; 2c. Jan. 19, 1911; A 280212; West pub. co., St. Paul, Minn.
215

Springer, Anton Heinrich, 1825–1891.

Handbuch der kunstgeschichte, von Anton Springer ... 1. bd. 9., erweiterte aufl., bearb. von Adolf Michaelis ... Leipzig, E. A. Seemann, 1911.

xii, 564 p. front., illus., col. plates. 28ᶜᵐ.

·bd. 1 © Jan. 6, 1911; 2c. Jan. 19, 1911; A—Foreign 2369; E. A. Seemann, Leipzig, Germany. (11–1159) 216

Stealey, Orlando Oscar, 1842–

130 pen pictures of live men, by O. O. Stealey. Washington, D. C. ₁Publishers printing company, New York₁ 1910.

2 p. l., 3–473 p. 24¼ᶜᵐ. $5.00

© Dec. 7, 1910; 2c. Dec. 7, 1910; A 280037; O. O. Stealey, Washington, D. C.
(11–1057) 217

Stokar, Kurt von.

Die syphilis-behandlung mit salvarsan (Ehrlich Hata 606) nebst einer systematischen zusammenfassung der bisher veröffentlichten literatur, von dr. Kurt von Stokar ... München, J. F. Lehmann, 1911.

40 p. 23ᶜᵐ. M. 1.20
"Literatur": p. 28–40.

© Dec. 5, 1910; 2c. Jan. 7, 1911; A—Foreign 2255; J. F. Lehmann, Munich, Germany. (11–1040) 218

Tappan, Eva March, 1854–

The story of the Roman people; an elementary history of Rome, by Eva March Tappan ... Boston, New York ₁etc.₁ Houghton Mifflin company ₁ᶜ1910₁

4 p. l., 251, ₁1₁ p. front., illus., maps. 19¼ᶜᵐ. $0.65

© Dec. 23, 1910; 2c. Jan. 13, 1911; A 280069; E. M. Tappan, Worcester, Mass. (11–1045) 219

Tauler, Johannes, ca. 1300–1361.

The sermons and conferences of John Tauler, of the Order of preachers, surnamed "the illuminated doctor"; being his spiritual doctrine. First complete English translation, with introduction and index, by Very Rev. Walter Elliott ... Brookland Station, Washington, D. C., Apostolic mission house, 1910.

13 p. l., ₁3₁–780, ₁6₁ p. 23¼ᶜᵐ. $3.00

© May 1, 1910; 2c. Jan. 9, 1911; A 278998; Walter Elliott, New York, N. Y.
(11–1071) 220

Texas. *Courts of civil appeals.*

The Texas civil appeals reports. Cases argued and adjudged ... during May, June and October, 1908. A. E. Wilkinson, reporter Texas Supreme court, J. A. Martin, assistant reporter. v. 51. Chicago, T. H. Flood & co., 1910.

xxvi, 725 p. 24ᶜᵐ. $3.00
© Jan. 17, 1911; 2c. Jan. 19, 1911; A 280215; Alfred E. Wilkinson, Austin, Tex. **221**

Thackeray, William Makepeace.

The works of William Makepeace Thackeray; with biographical introductions by his daughter Lady Ritchie. In 26 vols. v. 5, 6 ... [The centenary biographical ed.] New York and London, Harper & brothers [1910]

2 v. fronts., illus., plates. 21½ᶜᵐ. $2.00 per vol.
CONTENTS. — 5. The memoirs of Mr. Charles J. Yellowplush; Men's wives; Character sketches; and Flore et Zephyr.—6. The history of Samuel Titmarsh and the great Hoggarty diamond; Adventures of Major Gahagan; and Notes of a journey from Cornhill to Grand Cairo.
© Dec. 16, 1910; 2c. each Jan. 23, 1911; A 280280, 280281; Harper & bros., New York, N. Y. **222, 223**

Thompson, John Edmund, 1878–

Human energy, by J. Edmund Thompson, A. B. [7th ed.] Worcester, Mass., ᶜ1911·

2 p. l., [3]–68 p. illus. (port.) 17ᶜᵐ.
© Jan. 13, 1911; 2c. Jan. 14, 1911; A 280089; J. E. Thompson, Worcester, Mass. (11–1042) **224**

Trezise, Frederick James, 1875–

Letters & letter construction, with chapters on design & decoration, by F. J. Trezise; fully illustrated by W. E. Stevens and others. Chicago, The Inland printer company [ᶜ1911]

158 p. illus. 22ᶜᵐ. $2.00
© Jan. 2, 1911; 2c. Jan. 12, 1911; A 280041; Inland printer co., Chicago, Ill. (11–1084) **225**

Vaillat, Léandre.

... La Savoie. 2. ptie: Genève, Le Rhône, Hautecombe, Annecy, Les Bauges, Chambéry, Aix-les-Bains. Illustrations de Fréd. Boissonnas. [Genève, F. Boissonnas & cⁱᵉ] 1910.

1 p. l., 119 p. front., illus. 33 x 25ᶜᵐ. $4.00
© Dec. 22, 1910; 2c. Jan. 26, 1911; A—Foreign 2417; Fréd. Boissonnas & cie., Geneva, Switzerland. **226**

Vale, Ruby R.

A digest of the decisions of the courts of the commonwealth of Pennsylvania from 1754 to 1907, including all cases contained in the Pennsylvania state and superior court reports and all Pennsylvania legal periodicals with manuscript cases ... by Ruby R. Vale ... and Thomas E.

Vale, Ruby R.—Continued
Vale ... v. 6. Philadelphia, The George T. Bisel company, 1911.
2 p. l., 7758–9475 p. 27½ᶜᵐ $8.00
© Jan. 21, 1911; 2c. Jan. 25, 1911; A 280344; George T. Bisel co., Philadelphia, Pa. 227

Vermont. *Supreme court.*
Reports of cases argued and determined ... by John W. Redmond. v. 83, new series v. 8. Burlington, Free press printing company, 1910.
xxi, 617 p. 23ᶜᵐ.
© Jan. 2, 1911; 2c. Jan. 16, 1911; A 280108; Guy W. Bailey, sec. of state for the state of Vermont, Essex Junction, Vt. 228

Volkmann, Hans.
Emanuel d'Astorga, von Hans Volkmann. 1. bd. Leipzig, Breitkopf & Härtel, 1911.
2 p. l., 216 p. 20ᶜᵐ. (*On cover:* Breitkopf & Härtels musikbücher) M. 4
bd. 1 © Dec. 20, 1910; 2c. Jan. 10, 1911; A—Foreign 2277; Breitkopf & Härtel, Leipzig, Germany. (11–1120) 229

Wagner, Peter Josef, 1865–
Einführung in die gregorianischen melodien; ein handbuch der choralwissenschaft, von Peter Wagner ... 1. t. 3. aufl. Leipzig, Breitkopf & Härtel, 1911.
xi, 360 p. 23½ᶜᵐ. M. 7
t. 1 © Dec. 10, 1910; 2c. Jan. 7, 1911; A—Foreign 2240; Breitkopf & Härtel, Leipzig, Germany. (11–1095) 230

Ward, Mary Augusta (Arnold) *"Mrs. Humphry Ward."*
The writings of Mrs. Humphry Ward. ₍Autograph ed. v. 11–14₎ Boston and New York, Houghton Mifflin company, 1910.
4 v. fronts., plates. 23ᶜᵐ. $5.00 per vol.
CONTENTS.—v. 11. Lady Rose's daughter.—v. 12. The marriage of William Ashe.—v. 13. Fenwick's career and The story of Bessie Costrell.—v. 14. The testing of Diana Mallory.
© Nov. 28, 1910; 2c. each Jan. 13, 1911; A 280063–280066; Houghton Mifflin co., Boston, Mass. 231-234

Wasielewski, Wilhelm Joseph von, 1822–1896.
... Die violine und ihre meister. 5., wesentlich veränderte und verm. aufl., von Waldemar von Wasielewski. Leipzig, Breitkopf & Hårtel, 1910.
xvi, 664 p. illus. 23½ᶜᵐ. M. 10
© Dec. 20, 1910; 2c. Jan. 10, 1911; A—Foreign 2282; Breitkopf & Härtel, Leipzig, Germany. (11–1094) 235

Wegener, Hans, 1869–
We young men, by Hans Wegener; the sexual problem of an educated young man before marriage: purity, strength and love. Introduction by Sylvanus Stall. Phil-

Wegener, Hans—Continued

adelphia, Pa., The Vir publishing company; ₁etc., etc.,
°1911₁
4 p. l., 11–204 p. 19½ x 14½ᶜᵐ. $0.70
© Jan. 3, 1911; 2c. Jan. 9, 1911; A 278991; Sylvanus Stall, Philadelphia,
Pa. (11–1173) 236

Wells, William Hughes, 1859–

... Compend of gynecology, by William Hughes Wells
... 4th ed., rev. and enl., with 153 illustrations. Philadel-
phia, P. Blakiston's son & co., 1911.
xix, 290 p. illus. 18ᶜᵐ. (Blakiston's ?quiz-compends?) $1.00
© Jan. 16, 1911; 2c. Jan. 17, 1911; A 280153; P. Blakiston's son & co., Phil-
adelphia, Pa. (11–1149) 237

Wiborg, Julli.

... Frøken Kiss. 2. oplag. Kristiania, J. W. Cappelen
₁etc.₁ 1910.
144 p. 20ᶜᵐ. kr. 2
© Nov. 26, 1910; 2c. Jan. 6, 1911; A—Foreign 2235; J. W. Cappelen, Chris-
tiania, Norway. (11–1110) 238

Wilson, Wood Levette.

The end of dreams, by Wood Levette Wilson; illustra-
tions by A. G. Learned. New York, M. Kennerley ₁1910₁
348 p. front., plates. 19½ᶜᵐ. $1.50
© Oct. 22, 1910; 2c. Jan. 12, 1911; A 280058; Mitchell Kennerley, New
York, N. Y. 239

Young men's Christian associations. *International com-*
mittee. Railroad department.

The railroad Young men's Christian association hand-
book, prepared under the direction of the Railroad de-
partment of the International committee. New York,
Young men's Christian association press, 1911.
v p., 1 l., 9–137 p. 20ᶜᵐ. $1.00
Bibliography: p. 135–137.
© Jan. 10, 1911; 2c. Jan. 12, 1911; A 280045; Internat. committee of Y. M.
C. A., New York, N. Y. (11–1072) 240

Zahniser, Charles Reed.

Social Christianity; the gospel for an age of social
strain, by Charles Reed Zahniser, PH. D. Nashville, Tenn.,
The Advance publishing co., 1911.
173 p. 19½ᶜᵐ. $0.75
© Jan. 2, 1911; 2c. Jan. 6, 1911; A 278931; Advance pub. co., Nashville,
Tenn. (11–1168) 241

Number of entries of books included in the Catalogue for 1911:
 a) United States publications---------------------------------- 182
 b) Foreign books in foreign languages------------------------- 57
 c) Foreign books in English language under *ad interim* provi-
 sions of law of March 4, 1909---------------------------- 2

 Total -- ·241

LIBRARY OF CONGRESS

COPYRIGHT OFFICE

CATALOGUE

OF

COPYRIGHT ENTRIES

PUBLISHED WEEKLY BY AUTHORITY OF THE ACTS OF CONGRESS
OF MARCH 3, 1891, OF JUNE 30, 1906, AND
OF MARCH 4, 1909

PART 1, GROUP 1

BOOKS

1911

New Series, Volume, 8, No. 3

WASHINGTON
GOVERNMENT PRINTING OFFICE
LIBRARY DIVISION
1911

The Act of March 4, 1909, provides that the Catalogue of Copyright Entries shall be "admitted in any court as prima facie evidence of the facts stated therein as regards any copyright registration."

Published February 16, 1911

[Adams, William Frederick] 1848–
James Hayward, born April 4, 1750, killed in the battle
of Lexington April 19, 1775, with genealogical notes relating to the Haywards ... Springfield, Mass., Priv. print.,
1911.
58 p. incl. front., illus., port. plates, port., facsim. 23½ᶜᵐ. $2.50
© Jan. 6, 1911; 2c. Jan. 21, 1911; A 280272; Wm. Frederick Adams, Springfield, Mass. (11–1382) 242

Ainsworth, Percy C.
Threshold grace; meditations in the Psalms, by Percy
C. Ainsworth ... New York, Chicago [etc.] Fleming H.
Revell company [°1911]
127 p. 19½ᶜᵐ. $0.50
© Jan. 21, 1911; 2c. Jan. 26, 1911; A 280378; Fleming H. Revell co., New
York, N. Y. (11–1272) 243

Alabama. *Supreme court.*
Reports of cases argued and determined ... 2d ed. ...
Book 3, containing a verbatim reprint of vols. 1 & 2, Stewart & Porter's reports. St. Paul, West publishing co.,
1911.
vii, 161, v, 162 p. 26½ᶜᵐ. $6.00
© Jan. 25, 1911; 2c. Feb. 4, 1911; A 280595; West pub. co., St. Paul, Minn.
 244

American academy of political and social science, *Philadelphia.*
Electric railway transportation ... Philadelphia, American academy of political and social science, 1911.
v, [1], 244 p. illus., plates, fold. chart. 26ᶜᵐ. (The annals of the American academy of political and social science. vol. XXXVII, no. 1)
"Book department": p. 223–244.
CONTENTS.—pt. I. Traffic and financial problems: The urban transportation problem: a general discussion, by B. J. Arnold; The decreasing financial returns upon urban street railway properties, by T. Conway, jr.; The depreciation problem, by W. B. Jackson; Methods of increasing the efficiency of surface lines in large cities, by W. Fish; The investigation of traffic possibilities of proposed subway lines, by W. S. Twining; Possibilities of freight traffic on interurban lines, by F. S. Cummins; Express business on interurban lines, by A. Eastman; Economic factors in the selection of cars for urban service, by S. M. Curwen; The relations of the electric railway company with its employees, by C. D. Emmons; The strike problem upon electric railways, by D. T. Pierce; Educating the public to a proper appreciation of urban street railway problems, by A. W. Warnock; The presentation of interurban problems to the public, by A. D. B. Van Zandt.—pt. II. Public regulation of electric railways: Valuation of intangible street railway property, by F. R. Ford; The indeterminate permit as

American academy of political and social science, *Philadelphia*—Continued

a'satisfactory franchise, by W. O. Morgan; State supervision of electric railways in Wisconsin, by B. H. Meyer; The fruits of public regulation in New York, by M. R. Maltbie; Supervising engineers and street railway service, by G. Weston.—Communication: Industrial arbitration in Australia, by P. S. Eldershaw, and P. P. Olden.

© Jan. 11, 1911; 2c. Jan. 16, 1911; B 224523; Amer. acad. of political & social science, Philadelphia, Pa. (11-1270) **244***

... The need for currency reform; introductory remarks, Dr. L. S. Rowe ... addresses by Hon. Nelson W. Aldrich ... Hon. Theodore E. Burton ... Hon. A. Piatt Andrew ... Hon. George E. Roberts ... Session of the American academy of political and social science, Thursday evening, December 8, 1910. Philadelphia, The American academy of political and social science, 1911.

32 p. 26^{cm}. (Supplement to the Annals of the American academy of political and social science. January, 1911)

© Jan. 11, 1911; 2c. Jan. 16, 1911; B 224524; Amer. acad. of political & social science, Philadelphia, Pa. (11-1269) **244****

Asbjørnsen, Peter Christen, 1812-1885.

Werenskiold, samtlige tegninger og studier til Norske folkeeventyr ved P. Chr. Asbjørnsen, Jørgen Moe og Moltke Moe. Facsimileudgave. Kristiania og Kjøbenhavn, Gyldendalske boghandel, Nordisk forlag, 1910.

6 p. l., 178 p., 1 l. incl. illus., plates, port. 34 x 24^{cm}.

© Nov. 28, 1910; 2c. Jan. 21, 1911; A—Foreign 2381; Erik Werenskiold, Christiania, Norway. (11-1372) **245**

Barnes, Charles Merritt.

Combats and conquests of immortal heroes, sung in song and told in story, by Charles Merritt Barnes ... San Antonio, Tex., Guessaz & Ferlet company, 1910.

268 p. col. front., illus. (incl. ports.) 25½^{cm}.

© Jan. 5, 1911; 2c. Jan. 10, 1911; A 280004; C. M. Barnes, San Antonio, Tex. (11-1261) **246**

Barth, Ernst Alfred Max, 1863-

... Therapeutisches taschenbuch der ohrenheilkunde, von oberstabsarzt a. d. dr. Ernst Barth ... mit 15 abbildungen im text. Berlin, Fischer's medicin. buchhandlung H. Kornfeld, 1911.

vii, [1], 138 p. illus. 18^{cm}. (Fischer's therapeutische taschenbücher, x) M. 4

© Jan. 2, 1911; 2c. Jan. 19, 1911; A—Foreign 2348; Fischer's medicin. buchhandlung H. Kornfeld, Berlin, Germany. (1-1298) **247**

Baud-Bovy, Daniel, 1870-

... En Grèce par monts et par vaux; avec une préface par Th. Homolle ... et des notices archéologiques par Georges Nicole. Genève, F. Boissonnas & co.; [etc., etc.] 1910.

3 p. l., 5-167 p. illus., xL pl. (incl. front.) map. 52 x 42½^{cm}. $120.00

"Bibliographie générale": p. 157.

© Dec. 1, 1910; 2c. Jan. 26, 1911; A—Foreign 2418; Fred Boissonnas et cie., Geneva, Switzerland. (11-1320) **248**

Bauer, Ludwig, 1876–

Der königstrust; operette ohne musik in drei akten, von Ludwig Bauer. Berlin, E. Fleischel & co., 1911.

2 p. l., 147, ₁1₁ p. 19ᶜᵐ.

© Jan. 25, 1911; 2c. Jan. 9, 1911; D 230064; Egon Fleischel & co., Berlin, Germany. (11–1371) **248***

Bell, Ralcy Husted, 1869–

The religion of beauty and the impersonal estate, by Ralcy Husted Bell ... New York city, Hinds, Noble & Eldredge ₍ᶜ1911₎

5 p. l., 3–262 p. 19½ᶜᵐ. $1.25

CONTENTS.—Dedication.—Dedicatory note.—Preface.—Credo.—The impersonal estate.—Sky and stars.—Memories under the moon.—Sun-worship.—The city.—The old priest.—Life in death.—Books.—The open.—Children.—The last will and testament of Charles Lounsbury.—Dogs.—The sea. — Pictures. — Friendship and beauty.—"The simple life."—Real wealth.

© Jan. 18, 1911; 2c. Jan. 21, 1911; A 280266; Hinds, Noble & Eldredge, New York, N. Y. (11–1350) **249**

Bell telephone company of Pennsylvania.

... Specifications no. 3300. General specifications for aerial cable construction. The Bell telephone company of Pennsylvania and controlled companies. Engineering department. ₍2d ed.₎ ₍Philadelphia?₎ 1910.

2 p. l., 3–107 p. illus. 16ᶜᵐ.

© Jan. 13, 1911; 2c. Jan. 17, 1911; A 280158; Bell telephone co. of Pennsylvania, Philadelphia, Pa. (11–1329) · **250**

Bellermann, Ludwig, 1836–

Schiller, von Ludwig Bellermann. 2. verb. aufl., mit 16 bildnissen. Leipzig, E. A. Seemann, 1911.

viii, 363, ₁1₁ p. ports. 23ᶜᵐ.

© Jan. 3, 1911; 2c. Jan. 10, 1911; A—Forign 2275; E. A. Seemann, Leipzig, Germany. (11–1224) **251**

Bernaldo de Quirós, Constantino, 1873–

... Modern theories of criminality, by C. Bernaldo de Quirós; tr. from the Spanish by Alfonso de Salvio ... with an introduction by Wm. W. Smithers, esq. Boston, Little, Brown, and company, 1911.

xxvii, 249 p. 23½ᶜᵐ. (The modern criminal science series; pub. under the auspices of the American institute of criminal law and criminology ₍1₁)

© Jan. 14, 1911; 2c. Jan. 18, 1911; A 280178; Little, Brown & co., Boston, Mass. (11–1200) **252**

Bible. O. T. Selections. English.

The Old Testament narrative, separated out, set in connected order, and ed. by Alfred Dwight Sheffield ... Boston and New York, Houghton Mifflin company, 1910.

xxi, 510 p., 1 l. illus. 19ᶜᵐ. $1.50

© Dec. 10, 1910; 2c. Jan. 13, 1911; A 280067; A. D. Sheffield, Cambridge, Mass. (11–1250) **253**

43

Bigelow, Anson Hardin, 1867–

... Elements of business arithmetic, by Anson H. Bigelow ... and W. A. Arnold ... New York, The Macmillan company, 1911.

xi, 258 p. illus., tab. 19½ᶜᵐ. (Macmillan's commercial series) $0.70
© Jan. 11, 1911; 2c. Jan. 12, 1911; A 280051; Macmillan co., New York, N. Y. (11–1277) **254**

Bishop, William George, 1863–

A short course in business training for normal schools, high schools, common schools, teachers and independent students, by Wm. G. Bishop ... Chicago and Lincoln, The University publishing company, 1911.

v p., 1 l., 9–124 p. incl. forms. 22½ᶜᵐ. $0.90
© Jan. 11, 1911; 2c. Jan. 23, 1911; A 280288; University pub. co., Lincoln, Neb. (11–1361) **255**

Bitterauf, Theodor, 1877–

... Napoleon I., von dr. Theodor Bitterauf. 2. aufl., mit einem bildnis Napoleons. Leipzig, B. G. Teubner, 1911.

viii, 112 p. front. (port.) 18½ᶜᵐ. (Aus natur und geisteswelt; sammlung wissenschaftlich-gemeinverständlicher darstellungen. 195. bdchen.) M. 1.25
"Literatur": p. vii–viii.
© Jan. 3, 1911; 2c. Jan. 19, 1911; A—Foreign 2347; B. G. Teubner, Leipzig, Germany. (11–1319) **256**

Bleibtreu, Karl, 1859–

Das heer, von Karl Bleibtreu. Frankfurt am Main, Literarische anstalt Rütten & Loening [ᶜ1910]

187, [1] p. 19½ᶜᵐ. (Added t.-p.: Die gesellschaft; sammlung sozialpsychologischer monographien, hrsg. von M. Buber. 37.–38. bd.)
© Dec. 31, 1910; 2c. Jan. 13, 1911; A—Foreign 2307; Literarische anstalt Rütten & Loening, Frankfort a. M., Germany. (11–1190) **257**

Brennan, Ignatius.

Mountain state gleanings [by] Ignatius Brennan. Boston, R. G. Badger, 1911.

155 p. front. (port.) 19½ᶜᵐ. $1.25
© Dec. 31, 1910; 2c. Jan. 27, 1911; A 280403; I. Brennan, Wheeling, W. Va. (11–1373) **258**

Brinchmann, Christopher, 1864–

National-forskeren P. A. Munch hans liv og virke, av Chr. Brinchmann. Kristiania, J. W. Cappelen [1910]

1 p. l., 102 p. illus., pl., 3 port. (incl. front.) 19½ᶜᵐ. $1.50
© Dec. 5, 1910; 2c. Jan. 6, 1911; A—Foreign 2236; J. W. Cappelen, Christiania, Norway. (11–1375) **259**

Bull, Charles Livingston.

Under the roof of the jungle; a book of animal life in the Guiana wilds, by Charles Livingston Bull; with sixty full-page plates and many minor decorations from drawings from life, by the author. Boston, L. C. Page & company, 1911.

xiv, 271 p. col. front., illus., plates (partly col.) 21ᶜᵐ. $2.00
© Jan. 20, 1911; 2c. Jan. 23, 1911; A 280290; L. C. Page & co., inc., Boston, Mass. (11–1314) **260**

Burdick, Harvey Lee, 1864–

History of the Eastern star and the Mystic shrine, by
Harvey L. Burdick, John U. Wagner. [Philadelphia, Mc-
Clure publishing co., 1910]

3 p. l., p. 539–570. 26½ᶜᵐ. $1.00
Reprinted from "Lexicon and history of freemasonry ... by Albert G.
Mackey ... Philadelphia, 1910."

© Jan. 7, 1911; 2c. Jan. 11, 1911; A 280011; T. A. McClure, Philadelphia,
Pa. (11–1359) 261

Callaghan & company's cumulative quarterly to the Mich-
igan digest, comp. by the publishers' editorial staff,
Donald J. Kiser, managing editor. [v. 1, no. 2, January,
1911] Chicago, Callaghan & company, 1911.

1 p. l., 506 p. 25½ᶜᵐ. $4.00

© Jan. 17, 1911; 2c. Feb. 2, 1911; A 280529; Callaghan & co., Chicago, Ill.
262

[Cobb, Edward L] 1835–

Optic views and impressions of the National soldiers'
home, South branch N. H. D. V. S., near Hampton, Vir-
ginia, as seen and described by one of its members ...
South branch N. H. D. V. S., Va., E. L. Cobb, 1910.

156 p. incl. port. front., plates, ports. 22½ᶜᵐ. $2.00

· © Aug. 28, 1910; 2c. Jan. 3, 1911; A 278859; E. L. Cobb, National soldiers'
home, Va. (11–1189) 263

Colorado. *Laws, statutes, etc.*

Laws passed at the extraordinary session of the seven-
teenth General assembly of the state of Colorado. Con-
vened at Denver the 9th day of August, A. D. 1910. Pub.
by authority. Denver, Col., The Smith-Brooks printing
company, state printers, 1910.

83 p. 23ᶜᵐ. $0.50

© Jan. 2, 1911; 2c. Jan. 23, 1911; A 280486; James B. Pearce, sec. of state,
for the use of the state of Colorado, Denver, Col. 264

Cooke, Mary Huntington.

A few memories of William Reed Huntington, by his
sister Mary Huntington Cooke. Cambridge, Priv. print.
at the Riverside press, 1910.

37, [1] p. 18ᶜᵐ.

© Dec. 20, 1910; 2c. Dec. 31, 1910; A 280013; M. H. Cooke, Cambridge,
Mass. (11–1284) 265

Crossen, Harry Sturgeon.

Diagnosis and treatment of diseases of women, by
Harry Sturgeon Crossen ... 2d ed., rev. and enl., with
seven hundred and forty-four engravings. St. Louis,
C. V. Mosby company, 1910.

xxix, [1], 1025 p. illus. 25ᶜᵐ. $6.00

© Dec. 15, 1910; 2c. Jan. 13, 1911; A 280345; C. V. Mosby co., St. Louis,
Mo. (11–1299) 266

Earle, Samuel Thomas, 1849–

Diseases of the anus, rectum, and sigmoid, for the use of students and general practitioners, by Samuel T. Earle ... with 152 illustrations in the text. Philadelphia & London, J. B. Lippincott company [°1911]

xiv, 476 p. illus., plates (1 fold.) 24½ᶜᵐ.

© Jan. 3, 1911; 2c. Jan. 23, 1911; A 280295; J. B. Lippincott co., Philadelphia, Pa. (11-1296) **267**

Emerson, Henry Pendexter.

Modern English, book 1; lessons in language, literature and composition. New York state ed., rev. By Henry P. Emerson ... and Ida C. Bender ... New York, The Macmillan company, 1911.

xv, 383 p. illus. 19ᶜᵐ. $0.50

© Feb. 1, 1911; 2c. Feb. 2, 1911; A 280519; Macmillan co., New York, N. Y. **268**

Färber, Carl.

Arithmetik, bearb. von dr. Carl Färber ... mit 9 figuren im text. Leipzig und Berlin, B. G. Teubner, 1911.

xv, 410 p. 23½ᶜᵐ. (Added t.-p.: Grundlehren der mathematik, für studierende und lehrer. 1. bd. [1. t.]) M. 9

© Jan. 5, 1911; 2c. Jan. 19, 1911; A—Foreign 2367; B. G. Teubner, Leipzig, Germany. (11-1315) **269**

Farseth, Olaus C 1852–

Haandsrækning for nybegyndere i religionsundervisning af O. C. Farseth; en gjennemgaaelse af Sverdrups forkortede udgave af Forklaringen ... Minneapolis, Minn., Augsburg publishing house [°1910]

208 p. 20ᶜᵐ. $0.60

© Jan. 12, 1911; 2c. Jan. 16, 1911; A 280134; Augsburg pub. house, Minneapolis, Minn. (11-1377) **270**

Fischer, Gustav.

... Landwirtschaftliche maschinenkunde, von dr. Gustav Fischer ... mit 62 abbildungen im text. Leipzig, B. G. Teubner, 1911.

v, 125, [1] p. illus. 18½ᶜᵐ. (Aus natur und geisteswelt; sammlung wissenschaftlich-gemeinverständlicher darstellungen. 316. bdchen.) M. 1.25

© Jan. 3, 1911; 2c. Jan. 19, 1911; A—Foreign 2361; B. G. Teubner, Leipzig, Germany. (11-1289) **271**

Fite, Warner.

Individualism; four lectures on the significance of consciousness for social relations, by Warner Fite ... New York [etc.] Longmans, Green, and co., 1911.

xix, 301 p. 20½ᶜᵐ. $1.60

CONTENTS.—The conception of the individual.—The individual as a conscious agent.—Individuality and social unity.—Individual rights and the social problem.

© Jan. 9, 1911; 2c. Jan. 21, 1911; A 280258; Longmans, Green & co., New York, N. Y. (11-1271) **272**

Föppl, August, 1854–

Vorlesungen über technische mechanik, von dr. Aug.
Föppl ... 1. bd. 4. aufl. Leipzig und Berlin, B. G. Teubner, 1911.

xv, 424 p. diagrs. 22½ᶜᵐ. M. 10
bd. 1 © Jan. 5, 1911; 2c. Jan. 19, 1911; A—Foreign 2365; B. G. Teubner,
Leipzig, Germany. (11–1332) 273

Freudenberg, Ika.

Die frau und die kultur des öffentlichen lebens, von Ika
Freudenberg. Leipzig, C. F. Amelang, 1911.

viii, 332 p. 19½ᶜᵐ. (*Added t.-p.:* Die kulturaufgaben der frau, hrsg. von
J Wychgram. (2. bd.)) M. 5
© Jan. 3. 1911; 2c. Jan. 7, 1911; A—Foreign 2247; C. F. Amelangs verlag,
Leipzig, Germany. (11–1201) 274

Freund, Ernst, 1864–

Cases on administrative law, selected from decisions of
English and American courts, by Ernst Freund ... St.
Paul, West publishing company, 1911.

xxi, 681 p. 26½ᶜᵐ. (American casebook series) $4.00
© Jan. 6. 1911; 2c. Jan. 19, 1911; A 280211; West pub. co., St. Paul, Minn.
(11–1358) 275

Gayley, Charles Mills, 1858– ed.

The classic myths in English literature and in art,
based originally on Bulfinch's "Age of fable" (1855) accompanied by an interpretative and illustrative commentary,. by Charles Mills Gayley ... New ed., rev. and enl.
Boston, New York [etc.] Ginn and company [°1911]

xli, 597 p. front., illus., maps, fold. geneal. tab. 20ᶜᵐ. $1.60
© Jan. 11, 1911; 2c. Jan. 14, 1911; A 280092; C. M. Gayley, Berkeley, Cal.
(11–1253)· 276

The Geiger-Jones co., *Canton, O.*

Non-taxable incomes; a book of important information
for investors. [3d ed.] Canton, O., The Geiger-Jones co.
[°1911]

58 p. 20ᶜᵐ.
© Jan. 12, 1911; 2c. Jan. 16, 1911; A 280117; Geiger-Jones co., Canton, O.
(11–1203)· 277

Geilenkirchen, Th.

Grundzüge des eisenhüttenwesens. Von dr.-ing. Th.
Geilenkirchen ... 1. bd. Allgemeine eisenhüttenkunde.
Berlin, J. Springer, 1911.

vii, [1], 249 p. illus., plates, fold. map. 24ᶜᵐ.
© Jan. 2, 1911; 2c. Jan. 19, 1911; A—Foreign 2324; Julius Springer, Berlin, Germany. (11–1336) 278

Gordon, Eleanor Lytle Kinzie.

John Kinzie, the "father of Chicago"; a sketch, by
Eleanor Lytle Kinzie Gordon. [Savannah? Ga., °1910]

2 p. l., 3–31 p. plates, fold. facsim. 21ᶜᵐ.
© May 14. 1910; 2c. Jan. 11, 1911; A 280036; E. K. Gordon, Savannah, Ga.
(11–1257) 279

Graves, Etta Merrick.
A year of primary occupation work, by Etta Merrick
Graves ... 2d term ... Boston, New York [etc.] Educational publishing company [1911]
xvii, 87–172 p. illus., plates, diagrs. 24^{cm}. $0.50
© Jan. 14, 1911; 2c. Jan. 19, 1911; A 280650; Educational pub. co., Boston.
Mass. **280**

Same. 3d term ... Boston, New York [etc.] Educational
publishing company [1911]
xvii, [1], 173–241 p. illus., plates, diagrs. 24^{cm}. $0.50
© Jan. 28, 1911; 2c. Feb. 4, 1911; A 280579; Educational pub. co., Boston,
Mass. **281**

Greenwood, Alice Davis Odekirk, 1851–
Cawn dodgahs, by Alice D. O. Greenwood. Chicago,
The Library shelf, 1910.
2 p. l., 7–65 p. illus. 20^{cm}. $0.75
© Dec. 20, 1910; 2c. Jan. 3, 1911; A 278872; Library shelf, Chicago, Ill.
(11–1240) **282**

Groth, Klaus, 1819–1899.
Klaus Groths briefe an seine braut, Doris Finke, hrsg.
von professor Hermann Krumm; mit einem bildnis und
dem faksimile eines gedichtes. Braunschweig, G. Westermann, 1910.
xi, 264 p. front. (port. group) facsim. 21^{cm}. M. 4
© Dec. 23, 1910; 2c. Jan. 19, 1911; A—Foreign 2330; George Westermann,
Braunschweig, Germany. (11–1374) **283**

Gustafson, Axel Carl Johan, 1849–
The hero of the Cameron dam; or, Sketch of John F.
Deitz and his struggle with the lumber companies, by
Axel Gustafson ... [Milwaukee, The Co-operative printery, ©1910]
38 p. illus. (incl. ports.) 22½^{cm}. $0.25
© Dec. 24, 1910; 2c. Jan. 9, 1911; A 280159; A. Gustafson, Chicago, Ill.
(11–1259) **284**

Hare, Hobart Amory, *ed.*
Modern treatment; the management of disease with
medicinal and non-medicinal remedies, in contributions
by American and foreign authorities, ed. by Hobart
Amory Hare ... assisted by H. R. M. Landis ... In two
volumes. v. 2. Philadelphia and New York, Lea & Febiger [1911]
vii, 17–900 p. illus. (incl. charts) plates (partly col.) 25^{cm}. $6.00
© Jan. 24, 1911; 2c. Jan. 27, 1911; A 280399; Lea & Febiger, Philadelphia,
Pa. **285**

Harris, Ada Van Stone.
Guide books to English, book 1. By Ada Van Stone
Harris ... and Charles B. Gilbert ... [New ed.] New
York, Boston [etc.] Silver, Burdett and company [1910]
xvii, 307 p. illus. 19^{cm}. $0.45
© Dec. 31, 1910; 2c. Jan. 31, 1911; A 280469; Silver, Burdett & co., Boston,
Mass. **286**

Henneberg, Lebrecht *i. e.* **Ernst Lebrecht,** 1850–

... Die graphische statik der starren systeme, von dr. Lebrecht Henneberg ... mit 394 figuren im text. Leipzig und Berlin, B. G. Teubner, 1911.

xv, 732 p. diagrs. 23ᶜᵐ. (B. G. Teubners sammlung von lehrbüchern auf dem gebiete der mathematischen wissenschaften ... bd. xxxi) M. 24

© Jan. 3, 1911; 2c. Jan. 20, 1911; A—Foreign 2370; B. G. Teubner, Leipzig, Germany. (11–1178) **287**

Hogan, Louise E (Shimer) *"Mrs. J. L. Hogan,"* 1855–

Children's diet in home and school with classified recipes and menus; a reference book for parents, nurses, teachers, women's clubs and physicians, by Louise E. Hogan (Mrs. John L. Hogan) ... Rev. ed. New York, Doubleday, Page & co., 1910.

viii, 194, [14] p. illus. 15½ᶜᵐ. $0.75

© Sept. 8, 1910; 2c. Jan. 19, 1911; A 280219; L. E. Hogan, New York, N. Y. (11–1192) **288**

Holmes, Gordon.

The house of silence, by Gordon Holmes ... New York, E. J. Clode [ᶜ1911]

3 p. l., 297 p. 19½ᶜᵐ. $1.50

© Jan. 25, 1911; 2c. Jan. 26, 1911; A 280379; Edw. J. Clode, New York, N. Y. (11–1312) **289**

Hoopes, Wilford Lawrence, 1863–

The code of the spirit; an interpretation of the decalogue, by Wilford L. Hoopes ... Boston, Sherman, French & company, 1911.

4 p. l., 154 p. 19½ᶜᵐ. $1.20

© Jan. 9, 1911; 2c. Jan. 16, 1911; A 280137; Sherman, French & co., Boston, Mass. (11–1219) **290**

Hubbard, William Lines, *ed.*

The American history and encyclopedia of music. Essentials of music ... Emil Liebling, editor. New York, I. Squire [1910]

2 v. col. fronts., illus., ports. 24ᶜᵐ.

© Dec. 28, 1910; 2c. Jan. 7, 1911; A 280216; Irving Squire, Toledo, O. **291**

Hübner, Heinrich.

D. Rudolf Rocholl; ein lebens- und charakterbild auf grund seines schriftlichen nachlasses und anderer erster quellen, dargestellt von Heinrich Hübner ... illustriert von Theodor Rocholl, mit benutzung von originalen seines vaters. Elberfeld, Lutherischer bücherverein, 1910.

viii, 390 p. col. front. (port.) illus. 23ᶜᵐ. M. 5.50

© Dec. 20, 1910; 2c. Jan. 10, 1911; A—Foreign 2283; Luth. bücherverein, Elberfeld, Germany. (11–1225) **292**

Hughston, Caroline Mary.
The shrine in the desert, Our lady of Lourdes of San
Xavier del Bac, by Caroline Mary Hughston. Tucson,
Ariz. ₍Press of the Arizona daily star, ·1910₎
 22, ₍2₎ p. incl. illus., pl. 18¼ᶜᵐ. $0.25
 © Dec. 21, 1910; 2c. Jan. 3, 1911; A 280161; C. M. Hughston, Tucson, Ariz.
 (11-1273) 293

Iddings, Roscoe Charles, 1889-
Universal manual of fire insurance cancellations, pre-
senting earned and unearned premiums, both pro rata and
short rate, on premiums of $1.00 to $10.00, from 1 day to
365 days; also tables for term policies, calculations min-
imized and easily made, also a digest of the law of can-
cellation of fire insurance policies as interpreted by the
higher courts, by Roscoe C. Iddings ... New York, Chi-
cago, The Spectator company ₍·1910₎
 67 p. incl. tables. 21¼ᶜᵐ. $3.00
 "The law of cancellation of fire insurance policies, by Daniel W. Idd-
ings," p. 16-20.
 © Dec. 31, 1910; 2c. Jan. 10, 1911; A 280005; Spectator co., New York, N. Y.
 (11-1355) 294

Illinois. *Appellate courts.*
Reports of cases determined ... with a directory of the
judiciary of the state corrected to December 8, 1910.
v. 151, A. D. 1910 ... Ed. by W. Clyde Jones and Keene H.
Addington ... Chicago, Callaghan & company, 1910.
 xxxv, 656 p. 23ᶜᵐ. $3.50
 © Nov. 1, 1910; 2c. Feb. 2, 1911; A 280514; Callaghan & co., Chicago, Ill.
 295

Same. Corrected to July 22, 1910 ... v. 152, A. D. 1910
... Ed. by W. Clyde Jones and Keene H. Addington ...
Chicago, Callaghan & company, 1910.
 xviii, 688 p. 23ᶜᵐ. $3.50
 © Dec. 27, 1910; 2c. Feb. 2, 1911; A 280515; Callaghan & co., Chicago, Ill.
 296

... **Indiana** digest; a digest of the decisions of the courts
of Indiana ... Comp. under the American digest classi-
fication. v. 2, Bailment-Contra formam statuti. St.
Paul, West publishing co., 1911.
 iii, 961 p. 26¼ᶜᵐ. (American digest system—State series) $6.00
 © Jan. 23, 1911; 2c. Feb. 4, 1911; A 280599; West pub. co., St. Paul, Minn.
 297

International conference on state and local taxation. *4th,*
Milwaukee, 1910.
State and local taxation; Fourth international confer-
ence under the auspices of the International tax associa-
tion, held at Milwaukee, Wisconsin, August 30 to Septem-
ber 2, 1910. Addresses and proceedings. Columbus, O.,
International tax association, 1911.
 432 p. front. (port.) 22¼ᶜᵐ. $2.00
 © Jan. 14, 1911; 2c. Jan. 19, 1911; A 280185; Internatl. tax assn., Colum-
bus, O. (11-1356) 298

Iowa. *Supreme court.*

Reports of cases at law and in equity ... September term, 1909, by W. W. Cornwall. v. 27, being volume 144 of the series. Chicago, Ill., T. H. Flood & co., 1910.

viii, 854 p. 23½ᶜᵐ. $3.00

© Jan. 30, 1911; 2c. Feb. 2, 1911; A 280517; W. C. Hayward, sec. of state. Des Moines, Ia. 299

Jacobs, Victor, 1858–

Thirty years of ups and downs of a commercial traveler, his unaided rise to a prominent Chicago cloak manufacturer and the story of his financial ruin by unprincipled Chicago lawyers, related by Victor Jacobs. ₍Chicago? Ill., '1911₎

82 p. 17½ᶜᵐ. $0.50

© Jan. 10, 1911; 2c. Jan. 13, 1911; A 280075; V. Jacobs, Chicago, Ill. (11–1360) 300

Jahrbuch über die fortschritte auf allen gebieten der luftschiffahrt 1911; hrsg. von Ansbert Vorreiter ... München, J. F. Lehmann ₍ᶜ1910₎

xiii, ₍3₎, 507 p. illus., plates (partly fold., partly col.) fold. tables, fold. diagrs. 23ᶜᵐ. M. 10

© Dec. 23, 1910; 2c. Jan. 19, 1911; A—Foreign 2325; J. F. Lehmann, Munich, Germany. (11–1328) 301

Jarrel, Evarts Fenelon, 1875–

Veterinary medicine and surgery, together with simplified diagnosis, practical treatment and prescriptions, by E. F. Jarrel ... Cincinnati, O., Monfort & company, print., 1911.

244 p. front. (port.) 19½ᶜᵐ. $2.00

© Jan. 1, 1911; 2c. Jan. 18, 1911; A 280174; E. F. Jarrel, Ft. Worth, Tex. (11–1286) 302

Jones, Forrest Robert, 1861–

Automobile catechism, for the use of owners and drivers of cars fitted with internal combustion motors, by Forrest R. Jones ... 3d ed. New York, The Class journal company, 1910.

3 p. l., 264 p. front., diagrs. 18½ᶜᵐ. $2.50

© Jan. 5, 1911; 2c. Jan. 20, 1911; A 280225; Class journal co., New York, N. Y. (11–1177) 303

Jordan, David Starr, 1851–

The stability of truth; a discussion of reality as related to thought and action; being the third series of John Calvin McNair lectures before the University of North Carolina at Chapel Hill, January 7, 1910, by David Starr Jordan ... New York, H. Holt and company, 1911.

4 p. l., 3–180 p. 20ᶜᵐ. $1.25

© Jan. 3, 1911; 2c. Jan. 18, 1911; A 280169; Henry Holt & co., New York, N. Y. (11–1217) 304

Judson, Harry Pratt, 1849–
The higher education as a training for business, by
Harry Pratt Judson ... [2d ed.] Chicago, Ill., The Uni-
versity of Chicago press [1911]
2 p. l., 3–54 p. 18⅓ᶜᵐ.
© Jan. 6, 1911; 2c. Jan. 9, 1911; A 278995; University of Chicago, Chicago,
Ill. (11–1396) 305

Kalb, Wilhelm.
Spezialgrammatik zur selbständigen erlernung der rö-
mischen sprache für lateinlose jünger des rechts. Mit
übersetzungsbeispielen aus dem gebiete des römischen
rechts. Von Wilhelm Kalb ... Leipzig, O. Nemnich, 1910.
xii, 310 p. 23ᶜᵐ.
© Oct. 27, 1910; 2c. Jan. 19, 1911; A—Foreign 2354; W. Kalb, Nürnberg,
Germany. (11–1210) 306

Kingsley, Sherman Culver, 1866– *ed.*
Open air crusaders; a report of the Elizabeth McCor-
mick open air school, together with a general account of
open air school work in Chicago and a chapter on school
ventilation, ed. by Sherman C. Kingsley ... Chicago, Ill.,
United charities of Chicago [ᶜ1910]
107 p. incl. front., illus. 22½ᶜᵐ.
"Bibliography of open air schools": p. 103–105.
© Jan. 6, 1911; 2c. Jan. 18, 1911; A 280162; United charities of Chicago,
Chicago, Ill. (11–1397) 307

Kirkman, Marshall Monroe, 1842–
Cars, their construction, handling and supervision, in
two books ... Forming one of the series of volumes com-
prised in the rev. and enl. ed. of The science of railways,
by Marshall M. Kirkman. Ed. 1911. Chicago, Cropley
Phillips company, 1911.
viii, 435, 279 p. incl. illus., forms. diagrs. (partly fold.) 20ᶜᵐ. $7.50
© Jan. 12, 1911; 2c. Jan. 14, 1911; A 280100; Cropley Phillips co., Chicago,
Ill. (11–1176) 308

Koch, Felix John.
A little journey to our western wonderland (Califor-
nia); for home and school, intermediate and upper
grades, by Felix J. Koch ... New ed., rev. and cor. by
George Wharton James ... Chicago, A. Flanagan com-
pany [1911]
222 p. front., illus. 19½ᶜᵐ. (*On cover:* Library of travel) $0.50
© Jan. 23, 1911; 2c. Feb. 2, 1911; A 280538; A. Flanagan co., Chicago, Ill.
 309

Kraepelin, Karl Matthias Friedrich, 1848–
Naturstudien in fernen zonen, plaudereien in der däm-
merstunde, ein buch für die jugend, von dr. Karl Kraepe-
lin; mit zeichnungen von O. Schwindrazheim. Leipzig
und Berlin, B. G. Teubner, 1911.
vi, 188 p. front., illus. 22½ᶜᵐ. M. 3.60
© Jan. 5, 1911; 2c. Jan. 19, 1911; A—Foreign 2332; B. G. Teubner, Leip-
zig, Germany. (11–1281) 310

Kraus, Edward Henry, 1875–

Descriptive mineralogy, with especial reference to the occurrences and uses of minerals, by Edward Henry Kraus ... Ann Arbor, Mich., G. Wahr, 1911.

viii, 334 p. illus. 26½cm. $2.75
Bibliography: p. [vii]–viii.
© Jan. 4, 1911; 2c. Jan. 9, 1911; A 278982; E. H. Kraus, Ann Arbor, Mich.
(11–1279) 311

Ladd, Charles Frederic, 1868–

Gospel fishing, a manual for personal workers, by C. F. Ladd ... Cincinnati, O., Standard publishing co., °1910·

91 p. 16cm. $0.50
© Dec. 28, 1910; 2c. Jan. 3, 1911; A 278801; Standard pub. co., Cincinnati, O.
(11–1378). 312

Laflin, *Mrs.* **Florence Priscilla (Meyer)** 1870–

Is your smile worth a fortune? by Florence M. Laflin. New York, Aberdeen publishing company [°1911]

2 p. l., [7]–58 p. 18cm. $0.35
© Jan. 6, 1911; 2c. Jan. 10, 1911; A 280009; F. M. Laflin, St. Louis, Mo.
(11–1362) 313

Locke, Charles Edward.

Eddyism. Is it Christian? Is it scientific? How long will it last? By Charles Edward Locke ... Los Angeles, Grafton publishing company [°1911]

64 p. 18cm. $0.10
© Jan. 6, 1911; 2c. Jan. 16, 1911; A 280125; Grafton pub. co., Los Angeles,
Cal. (11–1322) 314

Lommel, Eugen Cornelius Joseph von, 1837–1899.

Lehrbuch der experimentalphysik, von dr. E. von Lommel ... 17.–19. neubearb. aufl. hrsg. von dr. Walter König ... Mit 441 figuren im text und einer spektraltafel. Leipzig, J. A. Barth, 1911.

x, 644 p. col. front., illus. 22½cm. M. 7.50
© Dec. 23, 1910; 2c. Jan. 19, 1911; A—Foreign 2315; Johann Ambrosius
Barth, Leipzig, Germany. (11–1280) 315

London, Jack, 1876–

When God laughs, and other stories, by Jack London ... New York, The Macmillan company, 1911.

ix, 319 p. front., plates. 19cm. $1.50
CONTENTS. — When God laughs. — The apostate. — A wicked woman.—
Just meat.—Created He them.—The Chinago. — Make westing. — Semper
idem.—A nose for the king.—The "Francis Spaight."—A curious frag-
ment.—A piece of steak.
© Jan. 25, 1911; 2c. Jan. 26, 1911; A 280368; Macmillan co., New York, N. Y.
(11–1311) 316

Lougheed, Victor.

Vehicles of the air; a popular exposition of modern aeronautics with working drawings, by Victor Lougheed ... [2d ed.—rev. and enl.] Chicago, The Reilly and Britton co. [°1910]

514 p. incl. front., illus., diagrs. plates (partly double) 23½cm. $2.50
© Aug. 2, 1910; 2c. Jan. 24, 1911; A 280324; Reilly & Britton co., Chicago,
Ill. (11–1335) 317

Lowell, James Russell, 1819-1891.

... Lowell's The vision of Sir Launfal, and selected poems; ed., with notes and introduction by Allan Abbott ... New York [etc.] Longmans, Green, and co., 1910.

xxxi p., 1 l., 78 p. 18½ᶜᵐ. (*Half-title:* Longmans' English classics ...) $0.25

© Jan. 11, 1911; 2c. Jan. 21, 1911; A 280259; Longmans, Green & co., New York, N. Y. (11-1208)　　　**318**

Lynch, Jeremiah, 1849-

A senator of the fifties: David C. Broderick, of California, by Jeremiah Lynch ... San Francisco, A. M. Robertson, 1911.

6 p. l., 246 p. front., plates, ports., facsim. 20ᶜᵐ. $1.50

© Dec. 24, 1910; 2c. Dec. 31, 1910; A 278927; J. Lynch, San Francisco, Cal. (11-1304)　　　**319**

Mabie, Henry Clay, 1847-

The divine reason of the cross; a study of the atonement as the rationale of our universe, by Henry C. Mabie, D. D. New York, Chicago [etc.] Fleming H. Revell company [°1911]

186 p. 19½ᶜᵐ. $1.00

CONTENTS.—The cross and highest reason.—The universe redemptocentric.—The reconciled antinomy in God.—The Father sharing Calvary.—The divine mediation unique. —"The cross" as watchword. — Superabundance of grace.—The moral and forensic one.—The evangelical principle.—Faith and philosophy congruous.

© Jan. 16, 1911; 2c. Jan. 26, 1911; A 280377; Fleming H. Revell co., New York, N. Y. (11-1323)　　　**320**

McMurtrie, Douglas Crawford.

Some considerations affecting the primary education of crippled children, together with a survey of the historical development and present status of care for cripples. By Douglas C. McMurtrie. New York city, Association for the aid of crippled children, 1910.

22 p., 1 l. 17ᶜᵐ. $0.50

© Nov. 22, 1910; 2c. Jan. 3, 1911; A 278832; D. C. McMurtrie, New York, N. Y. (11-1395)　　　**321**

McWillie, Thomas A.

Digest of the officially reported decisions of the Supreme court of Mississippi, embracing v. 74 to 93 inclusive, Mississippi reports ... By Thomas A. McWillie and Robert H. Thompson. Nashville, Tenn., Marshall & Bruce company, 1911.

1094 p. 26½ᶜᵐ. $10.00

© Jan. 28, 1911; 2c. Feb. 1, 1911; A 280512; Marshall & Bruce co., Nashville, Tenn.　　　**322**

Maistre, Xavier *i. e.* **François Xavier,** *comte* de, 1763-1852.

... La jeune Sibérienne, par Xavier de Maistre, ed. with exercises, notes. and vocabulary, by C. Fontaine ... Boston, D. C. Heath & co., 1911.

iv, 121 p. illus. (map) 17ᶜᵐ. (Heath's modern language series) $0.30

© Jan. 7, 1911; 2c. Jan. 12, 1911; A 280055; D. C. Heath & co., Boston, Mass. (11-1347)　　　**323**

Marshall, Carl Coran, 1852–

Inductive commercial arithmetic; a practical treatise on business computation, by Carl Coren Marshall ... and Samuel Horatio Goodyear ... Cedar Rapids, Ia., Goodyear-Marshall publishing company, 1910.

2 p. l., 351, (3) p. illus. (forms.) 21½ᶜᵐ. $0.90
© Dec. 1, 1910; 2c. Dec. 16, 1910; A 278932; Goodyear-Marshall pub. co., Cedar Rapids, Ia. (11–1199) 324

Marvin, Helen.

The embroidery guide, by Helen Marvin. (New York city, Woman's home companion, ᶜ1910)

cover-title, 24 p. illus. (partly col.) 26½ᶜᵐ. $1.00
© Jan. 14, 1911; 2c. Jan. 18, 1911; A 280172; Crowell pub. co., Springfield, O. (11–1330) 325

Men and religion (by) Fayette L. Thompson, John R. Mott, Hubert Carleton, Marion Lawrance, Charles W. Gilkey, Francis W. Parker, Ira Landrith, James G. Cannon, Elmore Harris, Will R. Moody, Henry B. F. Macfarland, John Timothy Stone, George L. Robinson, Graham Taylor, Fred B. Smith. Pub. for the Men and religion forward movement. New York, Young men's Christian association press, 1911.

x, 168 p. 19½ᶜᵐ. $0.50
© Jan. 17, 1911; 2c. Jan. 18, 1911; A 280182; Internatl. committee of Y. M. C. A., New York, N. Y. (11–1251) 326

Merriman, Mansfield, 1848– *ed.*

American civil engineers' pocket book, editor-in-chief, Mansfield Merriman, associate editors, Ira O. Baker, Charles B. Breed, Walter J. Douglas (and others) ... 1st ed., 5th thousand. New York, J. Wiley & sons; (etc., etc.) 1911.

viii, 1380 p. incl. tables, diagrs. 18½ᶜᵐ. $5.00
© Jan. 14, 1911; 2c. Jan. 17, 1911; A 280145; John Wiley & sons, New York, N. Y. (11–1327) 327

Meyer, Martin H.

Modern butter making and dairy arithmetic, by Martin H. Meyer ... Madison, Wis., The author, 1910.

7 p. l., 306 p. illus. 19½ᶜᵐ. $1.50
© Jan. 1, 1911; 2c. Jan. 3, 1911; A 280204; M. H. Meyer, Madison, Wis. (11–1288) 328

Michie, Thomas Johnson, *ed.*

The encyclopedia of United States Supreme court reports; being a complete encyclopedia of all the case law of the federal Supreme court up to and including vol. 206 U. S. Supreme court reports (book 51 Lawyers' ed.) under the editorial supervision of Thomas Johnson Michie. v. 11 (Special assessments–Zinc) Charlottesville, Va., The Michie company, 1911.

vi p., 1 l., 1142 p. 26ᶜᵐ. $6.00
© Feb. 3, 1911; 2c. Feb. 4, 1911; A 280582; Michie co., Charlottesville, Va. 329

Minerva. Handbuch der gelehrten welt ... 1. bd. ...
Strassburg, K. J. Trübner, 1911.
viii, 627 p. front. (port.) 16½ᶜᵐ.
Editors: G. Lüdtke, J. Beugel.
1. bd. © Jan. 5, 1911; 2c. Jan. 19, 1911; A—Foreign 2349; Karl J. Trübner,
Strassburg, Germany. (11-1195) 330

Missouri. *St. Louis, Kansas City and Springfield courts
of appeals.*
Cases determined ... reported for the St. Louis court
of appeals, Feb. 1, 1910, to April 5, 1910, by Thomas E.
Francis ... for the Kansas City court of appeals, by John
M. Cleary ... and for the Springfield court of appeals, by
Lewis Luster ... official reporters. v. 147. Columbia,
Mo., E. W. Stephens, 1910.
xvi, 783, xviii p. 23½ᶜᵐ. $3.00
© Jan. 19, 1911; 2c. Jan. 18, 1911; A 280590; E. W. Stephens, Columbia,
Mo. 331

—— *Supreme court.*
Reports of cases determined ... between March 30, and
April 26, 1910. Perry S. Rader, reporter. v. 227. Co-
lumbia, Mo., E. W. Stephens [1910]
xviii, 805, vi p. 23½ᶜᵐ. $3.00
© Nov. 15, 1910; 2c. Nov. 16, 1910; A 280591; F. W. Stephens, Columbia,
Mo. 332

Montana. *Supreme court.*
Reports of cases argued and determined ... from March
26, 1910, to October 13, 1910. Official report. v. 41. San
Francisco, Bancroft-Whitney company, 1911.
xxv, 685 p. 23ᶜᵐ. $4.00
© Jan. 27, 1911; 2c. Feb. 6, 1911; A 280607; Bancroft-Whitney co., San
Francisco, Cal. 333

Moorehead, Warren King, 1866–
The stone age in North America; an archæological en-
cyclopedia of the implements, ornaments, weapons, uten-
sils, etc., of the prehistoric tribes of North America, with
more than three hundred full-page plates and four hun-
dred figures illustrating over four thousand different ob-
jects, by Warren K. Moorehead ... Boston and New
York, Houghton Mifflin company, 1910.
2 v. col. fronts., illus., plates (partly col., 1 fold.) 25½ᶜᵐ. $5.00
Bibliography: v. 2, p. [369]–410.
© Dec. 30, 1910; 2c. Jan. 13, 1911; A 280070; W. K. Moorehead, Andover,
Mass. (11-1291) 334

Müller, Hubert, 1840–
Lehr- und übungsbuch der arithmetik und algebra für
knaben-mittelschulen. Im anschluss an das unterrichts-
werk von prof. H. Müller hrsg. von dr. Albert Bieler ...
2., nach den lehrplänen von 1910 umgearb. aufl. Mit 6
figuren im text. Leipzig und Berlin, B. G. Teubner, 1911.
2 p. l., 136 p. diagrs. 22½ᶜᵐ. M. 1.50
© Jan. 3, 1911; 2c. Jan. 10, 1911; A—Foreign 2293; B. G. Teubner, Leipzig,
Germany. (11-1183) 335

Muret, Eduard, 1833–1904.

... Muret-Sanders enzyklopädisches englisch-deutsches und deutsch-englisches wörterbuch, mit angabe der aussprache nach dem phonetischen system der methode Toussaint-Langenscheidt. Hand- und schulausg. (auszug aus der groszen ausg.) ... Berlin-Schöneberg, Langenscheidtsche verlagsbuchhandlung (Prof. G. Langenscheidt) [ᶜ1910]

2 v. 27½ᶜᵐ.
Added t.-p. in English with imprint: London, H. Grevel & co.; New York, The International news company.
At head of title: Methode Toussa;nt-Langenscheidt.
"Quellen": v. 1, p. xviii–xix.
CONTENTS.—t. 1. Englisch-deutsch, von B. Klatt, neubearb. von E. Klatt. 108.–137. tausend.—t. 2. Deutsch-englisch, neue, verb. und stark verm. aufl. von H. Baumann. 99.–129. tausend.
© Dec. 23, 1910; 2c. each Jan. 19, 1911; A—Foreign 2326–2327; Langenscheidtsche verlagsbuchhandlung (G. Langenscheidt) Berlin-Schöneberg, Germany. (11–1209) 336, 337

Nevada. *Supreme court.*

Reports of cases ... during the year 1865, 1866. v. 1, 2, with notes on Nevada reports. A facsimile reprint of the original volume. San Francisco, Cal., Bancroft-Whitney co., 1911.

2 v. 23½ᶜᵐ. $6.00
© Jan. 17, 1911; 2c. each Jan. 30, 1911; A 280536; Bancroft-Whitney co., San Francisco, Cal. 338

Newton, William Wilberforce, 1843–

Yesterday with the fathers, by Wm. Wilberforce Newton. D. D. New York, Cochrane publishing company, 1910.

210 p. 20ᶜᵐ. $1.50
© Dec. 20, 1910; 2c. Jan. 28, 1911; A 280419; Cochrane pub. co., New York, N. Y. (11–1376) 339

Noodt, Gustav, *ed.*

Leitfaden der naturlehre für lyzeen (höhere lehrerinnenseminare) nach den ausführungsbestimmungen zu dem erlasse vom 18. august 1908 über die neuordnung des höheren mädchenschulwesens in Preussen, unter mitwirkung von dr. Marie Gernet, prof. dr. Paul Schweden, dr. Eduard Wrampelmeyer, oberlehrer Julius Ziegler, hrsg. von prof. dr. Gustav Noodt. 1. bd. Leipzig und Berlin, B. G. Teubner, 1911.

v. [1], 230 p. illus., pl., diagrs. 25ᶜᵐ. M. 3.80
bd. 1 © Jan. 3, 1911; 2c. Jan. 19, 1911; A—Foreign 2312; B. G. Teubner, Leipzig, Germany. (11–1278) 340

Ogden, Henry Neely, 1868–

Rural hygiene, by Henry N. Ogden ... New York, The Macmillan company, 1911.

xvii, 434 p. incl. illus., plans, tables, diagrs. 19½ᶜᵐ. (*Half-title:* The rural science series. ed. by L. H. Bailey) $1.50
© Jan. 18, 1911; 2c. Jan. 19, 1911; A 280195; Macmillan co., New York, N. Y. (11–1193) 341

Ohio. *Laws, statutes, etc.*

Wilson's Ohio criminal code, annotated with decisions, forms and precedents for indictments, informations, and affidavits, forms for writs, docket and journal entries, being both the criminal practice and procedure in the Ohio courts. 9th ed. By Frank N. Patterson ... Cincinnati, The W. H. Anderson company, 1911.

xlii, 1204 p. 26¼ᶜᵐ. $6.50
© Jan. 17, 1911; 2c. Jan. 19, 1911; A 280191; W. H. Anderson co., Cincinnati, O. (11-1222) 342

Omar Khayyām.

The Rubáiyát of Omar Khayyám, tr. from the original Persian by Isaac Dooman. Boston, R. G. Badger, 1911.

79 p. 18ᶜᵐ. $1.00
© Dec. 20, 1910; 2c. Jan. 23, 1911; A 280284; Richard G. Badger, Boston, Mass. (11-1241) 343

Ostrom, Homer Irvin, 1852–

Leucorrhœa and other varieties of gynæcological catarrh; a treatise on the catarrhal affections of the genital canal of women; their medical and surgical treatment. By Homer Irvin Ostrom ... Philadelphia, Pa., Boericke & Tafel, 1910.

vi, 179 p. 19¼ᶜᵐ. $1.00
© Dec. 17, 1910; 2c. Jan. 7, 1911; A 278955; Boericke & Tafel, Philadelphia, Pa. (11-1297) 344

Perrin, Daniel A 1839–

Ave Maria; or, The Mother of Jesus in verse, with some selected poems and songs for Sunday school, church and home, by the Rev. D. A. Perrin ... Normal, Ill., D. A. Perrin & co. [ᶜ1910]

2 p. l., [3]-57 p. illus., pl., port. 20¼ᶜᵐ. $0.35
Bound with this: New songs; sacred, patriotic, sentimental, comp. ... by the Rev. D. A. Perrin ... Normal, Ill. [ᶜ1910]
© Dec. 30, 1910; 2c. Jan. 12, 1911; A 280053; D. A. Perrin, Norman, Ill. (11-1348) 345

Peterson, Oscar William, *tr.*

Songs and lyrics from the Swedish. Oscar William Peterson, translator. Brownfield, Me., The translator, 1910.

1 p. l., [5]-39 p. 18¼ᶜᵐ. $0.50
© Dec. 20, 1910; 2c. Jan. 21, 1910; 280269; O. W. Peterson, Brownfield, Me. (11-1244) 346

Phelps, William Lyon, 1865–

Essays on Russian novelists, by William Lyon Phelps ... New York, The Macmillan company, 1911.

ix, 322 p. front. (port.) 19¼ᶜᵐ. $1.50
CONTENTS.—Russian national character.—Gogol.—Turgenev.—Dostoevski.—Tolstoi.—Gorki.—Chekhov.—Artsybashev.—Andreev. — Kuprin's picture of garrison life.—List of publications.
© Jan. 25, 1911; 2c. Jan. 26, 1911; A 280365; Macmillan co., New York, N. Y. (11-1349) 347

Pichon, J E.

Deutsches lese- und redebuch, von professor J. E. Pichon ... und dr. phil. F. Sättler ... Freiburg (Baden) J. Bielefelds verlag, 1910.

159 p. front., illus. 20ᶜᵐ. M. 2

© Dec. 28, 1910; 2c. Feb. 2, 1911; A—Foreign 2429; J. Bielefelds verlag, Freiburg, Baden, Germany. 348

Pirquet von Cesenatico, Klemens Peter, *freiherr*, 1874–

Allergie, von dr. Clemens frh. von Pirquet ... mit 30 in den text gedruckten abbildungen. Berlin, J. Springer, 1910.

96 p. diagrs. 26ᶜᵐ.
"Literatur": p. [87]–96.

© Dec. 6, 1910; 2c. Jan. 7, 1911; A—Foreign 2239; Julius Springer, Berlin, Germany. (11–1184) 349

Rathom, John Revelstoke, 1868–

Two Chicago sketches: when the city wakes to life; Lake Michigan in calm and storm, by John R. Rathom. [Providence, R. I., Livermore & Knight co., °1910]

[44] p. illus. 24½ᶜᵐ.

© Dec. 25, 1910; 2c. Dec. 30, 1910; A 278886; J. R. Rathom, United States. (11–1258) 350

Reeder, Albert, 1839–

Sketches of South Charleston, Ohio; reminiscences of early scenes, anecdotes and facts about early residents, by Albert Reeder. [Columbus, O., The New Franklin printing co., °1910]

39 p. front. (port.) illus. 23ᶜᵐ.

© Dec. 21, 1910; 2c. Dec. 24, 1910; A 278953; A. Reeder, South Charleston, O. (11–1283) 351

Richards, Ellen Henrietta (Swallow) *"Mrs. R. H. Richards,"* 1842–

Conservation by sanitation; air and water supply; disposal of waste ⟨including a laboratory guide for sanitary engineers⟩ by Ellen H. Richards. New York, J. Wiley & sons; [etc., etc.] 1911.

xii, 305 p. front., illus., fold. map, tables. 23½ᶜᵐ. $2.50

© Jan. 18, 1911: 2c. Jan. 20, 1911; A 280233; E. H. Richards, Boston, Mass. (11–1295) 352

Rollins, Montgomery, *comp.*

... Montgomery code ⟨17th printing⟩ [5th ed.] rev. and enl., especially adapted for use in the banking and investment business ... by Montgomery Rollins ... Boston, M. Rollins; [etc., etc., °1910]

iv, 616 p. 18ᶜᵐ. $5.00
Originally published by E. H. Rollins & sons.

© Jan. 14, 1911; 2c. Jan. 17, 1911; A 280152; M. Rollins, Boston, Mass. (11–1204) 353

Rowland, Henry Cottrell, 1874–

The magnet (published serially as "The pilot-fish") a romance, by Henry C. Rowland; illustrations by Clarence F. Underwood. New York, Dodd, Mead and company, 1911.

4 p. l., 328 p. front., plates. 19½ᶜᵐ. $1.25

© Jan. 20, 1911; 2c. Jan. 23, 1911; A 280287; Dodd, Mead & co., New York, N. Y. (11–1309) 354

Sames, Charles MacCaughey, 1866–

A pocket-book of mechanical engineering; tables, data, formulas, theory and examples for engineers and students, by Charles M. Sames ... 4th ed., rev. and enl. Jersey City, N. J., C. M. Sames, 1911.

viii, 218 p. incl. tables, diagrs. 16½ᶜᵐ. $2.00

© Jan. 19, 1911; 2c. Jan. 21, 1911; A 280260; C. M. Sames, Jersey City, N. J. (11–1174) 355

Schachner, Robert.

... Australien in politik, wirtschaft und kultur, von dr. Robert Schachner ... 2. bd. Jena, G. Fischer, 1911.

vi, 394 p. map. 24½ᶜᵐ. M. 9

CONTENTS.—Die soziale frage in Australien und Neuseeland.

© Jan. 5, 1911; 2c. Feb. 2, 1911; A—Foreign 2426; Gustav Fischer, Jena, Germany. 356

Schaff-Herzog encyclopedia.

The new Schaff-Herzog encyclopedia of religious knowledge, ed. by Samuel Macauley Jackson ... with the assistance of Charles Colebrook Sherman ... and George William Gilmore ... v. 9, Petri–Reuchlin. New York and London, Funk and Wagnalls company [1911]

xvii, [1], 500 p. 27½ᶜᵐ. $5.00

© Feb. 3, 1911; 2c. Feb. 4, 1911; A 280593; Funk & Wagnalls co., New York, N. Y. 357

Scheuerman, Kate Bunting.

The Holy Land as seen through Bible eyes; being the record of a journey through Syria, Palestine and Europe in the years 1908–1909. By Kate Bunting Scheuerman ... Seattle, The Metropolitan press printing company, 1910.

3 p. l., [xiii]–xv, 289, [1] p. front., illus., ports. 27½ᶜᵐ.

© Dec. 29, 1910; 2c. Jan. 3, 1911; A 280254; K. B. Scheuerman, Seattle, Wash. (11–1318) 358

Schlundt, Herman, 1868–

Laboratory experiments in general chemistry, by Herman Schlundt ... Columbia, Mo., Press of E. W. Stephens publishing company, 1910.

85 p. illus. 20ᶜᵐ. $0.50

© Oct. 1, 1910; 2c. Sept. 26, 1910; A 280103; H. Schlundt, Columbia, Mo. (11–1186) 359

Schmid, Ulrich, *ed.*

Das katholische kirchenjahr in bildern, hrsg. unter mit-wirkung der katechetenvereine in München und Wien von dr. Ulrich Schmid. Nebst einer einleitung von prälat dr. theol. et phil. Heinrich Swoboda ... Leipzig, E. A. Seemann [°1910]

6 p. l., 60 pl. (partly fold.) 39 x 29ᶜᵐ. M. 15
© Dec. 21, 1910; 2c. Jan. 19, 1911; A—Foreign 2319; E. A. Seemann, Leipzig, Germany. (11–1265) 360

Schmidt, Nathaniel, 1862–

... The messages of the poets; the books of Job and Canticles and some minor poems in the Old Testament, with introductions, metrical translations, and paraphrases, by Nathaniel Schmidt ... New York, C. Scribner's sons, 1911.

xxiv, 415 p. 17ᶜᵐ. (*Half-title:* The messages of the Bible, ed. by F. K. Sanders and C. F. Kent, vol. vii) $1.25
© Jan. 14, 1911; 2c. Jan. 19, 1911; A 280196; Chas. Scribner's sons, New York, N. Y. (11–1252) 361

Schultz, Alfred Paul Karl Eduard, 1878–

The end of Darwinism; not change but persistence is characteristic of life, every change is essentially a persistence; only what persists can change. An essay, by Alfred P. Schultz ... Monticello, N. Y., A. P. Schultz [°1911]

1 p. l., 20 p. 21ᶜᵐ. $0.50
Bibliography: p. 18–19.
© Jan. 9, 1911; 2c. Jan. 11, 1911; A 280033; A. P. Schultz, Monticello, N. Y. (11–1185) 362

Scott, Winfield Gemain, 1854–

White paints and painting materials: source and manufacture; composition and properties; uses and formulas; physical tests and chemical analysis, by W. G. Scott ... Chicago, The Modern painter, 1910.

xxvii, 500 p. illus., plates, tables (partly fold.) 24ᶜᵐ. $3.50
© Jan. 5, 1911; 2c. Jan. 9, 1911; A 278984; W. G. Scott, Clinton, Wis. (11–1367) 363

Shakespeare, William, 1564–1616.

... Shakespeare's King Henry the Fifth, ed., with an introduction and notes, by Brainerd Kellogg ... New York, Charles E. Merrill company [°1911]

181 p. front. (port.) plates. 17ᶜᵐ. (Merrill's English texts) $0.25
© Jan. 14, 1911; 2c. Jan. 24, 1911; A 280309; Chas. E. Merrill co., New York, N. Y. (11–1242) 364

... Shakespeare's Macbeth, ed., with an introduction and notes by Brainerd Kellogg ... New York, Charles E. Merrill company [°1911]

177 p. front. (port.) illus. (map) plates. 17ᶜᵐ. (Merrill's English texts) $0.25
© Jan. 18, 1911; 2c. Jan. 24, 1911; A 280310; Chas. E. Merrill co., New York, N. Y. (11–1243) 365

Siebel, John Ewald, 1845–

Compend of mechanical refrigeration and engineering; a comprehensive digest of general engineering and thermodynamics for the practical use of ice manufacturers, cold storage men, contractors ... and all other users of refrigeration in the various industries, also, students of refrigeration in connection with engineering. 8th ed., by J. E. Siebel ... Chicago, Nickerson & Collins co., 1911.

596 p. incl. illus., tables, diagrs. front. (port.) 20ᶜᵐ.
© Jan. 9, 1911; 2c. Jan. 10, 1911; A 280074; Nickerson & Collins co., Chicago, Ill. (11-1333) **366**

Singleton, Esther.

The children's city, by Esther Singleton ... New York, Sturgis & Walton company, 1910.

8 p. l., 277 p. front., plates, plans, fold. map. 18½ᶜᵐ. $1.25
© Jan. 16, 1911; 2c. Jan. 17, 1911; A 280155; Sturgis & Walton co., New York, N. Y. (11-1260) . **367**

Snowden, James Henry, 1852–

The basal beliefs of Christianity, by James H. Snowden ... New York, The Macmillan company, 1911.

ix p., 2 l., 252 p. 19½ᶜᵐ. $1.50
© Jan. 25, 1911; 2c. Jan. 26, 1911; A 280367; Macmillan co., New York, N. Y. (1-1324) **368**

... The **Southwestern** reporter, with key-number annotations. v. 131. Permanent ed. ... November 9–December 21, 1910. St. Paul, West publishing co., 1911.

xvi, 1378 p. 26½ᶜᵐ. (National reporter system—State series) $4.00
© Jan. 25, 1911; 2c. Feb. 4, 1911; A 280596; West pub. co., St. Paul, Minn. **369**

—— Missouri decisions reported in the Southwestern reporter, vols. 21, 22, 23, and 24, February, 1893, to February, 1894 ... St. Paul, West publishing co., 1911.

Various paging. 26½ᶜᵐ. $5.50
© Jan. 26, 1911; 2c. Feb. 4, 1911; A 280598; West pub. co., St. Paul, Minn. **370**

[**Staunton, Howard**] 1810–1874.

The American chess player's handbook. Teaching the rudiments of the game, and giving an analysis of all the recognized openings ... Rev. ed. Based on the work of Staunton and modern authorities. Philadelphia, The John C. Winston co. [ᶜ1910]

256 p. front., illus. 17½ᶜᵐ. $1.00
© June 5, 1910; 2c. Jan. 13, 1911; A 280071; John C. Winston co., Philadelphia, Pa. (11-1290) ' **371**

Steinhauff, A.

Lehrbuch der erdkunde für höhere schulen, hrsg. von A. Steinhauff ... und prof. dr. M. G. Schmidt ... Ausg. M (für höhere mädchenschulen) 1.–3. t. Leipzig und Berlin, B. G. Teubner, 1911.

3 pts. illus., plates (partly col.) 24ᶜᵐ.
© t. 1, 3, Jan. 5, 1911; t. 2, Jan. 3, 1911; 2c. each Jan. 19, 1911; A—Foreign 2334–2336; B. G. Teubner, Leipzig, Germany. (11-1293) **372-374**

Storr, Francis, 1839– *ed.*
Half a hundred hero tales of Ulysses and the men of
old, ed. by Francis Storr ... with illustrations by Frank
C. Papé. New York, H. Holt and company, 1911.
vii p., 1 l., 384 p. front., 7 pl. 21ᶜᵐ. $1.35
© Jan. 16, 1911; 2c. Jan. 18, 1911; A 280170; Henry Holt & co., New
York, N. Y. (11–1346) 375

Taylor, Thomas Ulvan, 1858–
Backbone of perspective, by T. U. Taylor ... Chicago,
The Myron C. Clark publishing company, 1910.
2 p. l., 56 p. diagrs. 18½ᶜᵐ. $1.00
© Jan. 10, 1911; 2c. Jan. 18, 1911; A 280177; Myron C. Clark pub. co.,
Chicago, Ill. (11–1175) 376

[**Terhune,** *Mrs.* **Mary Virginia (Hawes)**]
The story of canning and recipes [by] Marion Harland
[*pseud.*] [Bel Air, Md.] National canners association,
ᶜ1910.
39, [1] p. illus. 20½ᶜᵐ.
© Jan. 1, 1911; 2c. Jan. 12, 1911; A 277979; National canners assn., Bel Air,
Md. (11–1334) 377

U. S. *Circuit court of appeals.*
Reports, with annotations. v. 103. St. Paul, West pub-
lishing co., 1911.
xliii, 728 p. 23½ᶜᵐ. $2.85
© Jan. 27, 1911; 2c. Feb. 4, 1911; A 280597; West pub. co., St. Paul, Minn.
 378

Vogelsang, Willem.
Le meuble hollandais au Musée national d'Amsterdam,
par Willem Vogelsang. Amsterdam, Van Rijkom frères;
[etc., etc., ᶜ1910]
[13] p. LXIV pl. 36 x 27½ᶜᵐ.
© Dec. 31, 1910; 2c. Jan. 14, 1911; A—Foreign 2371; Martinus Nijhoff,
The Hague, Holland. (11–1264) 379

Waddell, Alexander Henry, 1858–
Herds and flocks and horses, by Captain A. H. Wad-
dell. Chicago, Ill., Pedigree publishing company, ᶜ1911.
82 p. front., illus. 20ᶜᵐ. $0.50
© Jan. 11, 1911; 2c. Jan. 14, 1911; A 280093; A. H. Waddell, Chicago, Ill.
(11–1287) 380

Waller, Elbert, 1870–
Waller's brief history of Illinois, by Elbert Waller ...
3d ed. ... Galesburg, Ill., Wagoner printing company,
1910.
102 p., 1 l. incl. front., illus. port. 17ᶜᵐ. $0.40
© Jan. 10, 1911; 2c. Jan. 20, 1911; A 280276; E. Waller, Tamaroa, Ill.
(11–1256) 381

Wattles, Wallace Delois, 1860–
The science of being great, by Wallace D. Wattles ...
Holyoke, Mass., E. Towne, 1911.
158 p. front. (port.) 19½ᶜᵐ. $1.00
© Jan. 13, 1911; 2c. Jan. 20, 1911; A 280236; W. D. Wattles, Elwood, Ind.
(11–1218) 382

Weiss, Johannes, 1863–

... Der erste Korintherbrief, völlig neu bearb. von d. Johannes Weiss ... Göttingen, Vandenhoeck & Ruprecht, 1910.

xlviii, 388 p. 24½ᶜᵐ. (Kritisch-exegetischer kommentar über das Neue Testament, begründet von H. A. W. Meyer. 5. abt., 9. aufl.) M. 9
© Dec. 12, 1910; 2c. Jan. 19, 1911; A—Foreign 2368; Vandenhoeck & Ruprecht, Göttingen, Germany. (11–1254) **383**

Weyl, Theodor, 1851– *ed.*

Einzelschriften zur chemischen technologie, hrsg. von dr. Th. Weyl ... 1. lfg. Leipzig, J. A. Barth, 1911.

3 p. l., 11, 145 p. illus. 22ᶜᵐ. M. 14.20
© Jan. 3, 1911; 2c. Jan. 19 1911; A—Foreign 2313; Johan Ambrosius Barth, Leipzig, Germany. (11–1331) **384**

Willis, Henry Parker, 1874–

... Stephen A. Douglas, by Henry Parker Willis, PH. D. Philadelphia, G. W. Jacobs & company [1910]

3 p. l., [5]–371 p. front. (port.) 19½ᶜᵐ. (*Half-title:* American crisis biographies, ed. by E. P. Oberholtzer) $1.25
Bibliography: p. [354]–355.
"Bibliographical notes": p. [356]–359.
© Dec. 31, 1910; 2c. Jan. 6, 1911; A 278939; Geo. W. Jacobs & co., Philadelphia, Pa. (11–1285) **385**

Wirminghaus, *Frau* Else, 1867–

Die frau und die kultur des körpers, von Else Wirminghaus. Leipzig, C. F. Amelang, 1911.

viii, 325 p. 19½ᶜᵐ. (Die kulturaufgaben der frau, hrsg. von J. Wychgram. [3. bd.]) M. 5
"Literatur": p. 324–325.
© Jan. 3, 1911; 2c. Jan. 7, 1911; A—Foreign 2248; C. F. Amelang's verlag, Leipzig, Germany. (11–1202) **386**

Wohlauer, Franz.

... Atlas und grundriss der rachitis, von dr. Franz Wohlauer ... Mit 2 farbigen und 108 schwarzen abbildungen auf 34 autotypischen und 12 photographischen tafeln und mit 10 textabbildungen. München, J. F. Lehmann, 1911.

vii, 154 p. illus., 34 pl. (2 col.) xii phot. 25ᶜᵐ. (Lehmann's medizinische atlanten, bd. x) M. 20
bd. 10 © Dec. 23, 1910; 2c. Jan. 19, 1911; A—Foreign 2322; J. F. Lehmann, Munich, Germany. (11–1191) **387**

Number of entries of books included in the Catalogue for 1911:
a) United States publications------------------------------------ 292
b) Foreign books in foreign languages--------------------------- 93
c) Foreign books in English language under *ad interim* provisions of law of Mar. 4, 1909------------------------------------ 2

Total --- 387

LIBRARY OF CONGRESS

COPYRIGHT OFFICE

CATALOGUE

OF

COPYRIGHT ENTRIES

PUBLISHED WEEKLY BY AUTHORITY OF THE ACTS OF CONGRESS
OF MARCH 3, 1891, OF JUNE 30, 1906, AND
OF MARCH 4, 1909

PART 1, GROUP 1

BOOKS

1911

New Series, Volume 8, No. 4

List of Copyright Renewals

WASHINGTON
GOVERNMENT PRINTING OFFICE
LIBRARY DIVISION
1911

Published February 23, 1911

[Addison, Joseph] 1672–1719.

... The Sir Roger de Coverley papers, from the Spectator, with questions and suggestions for study by Homer K. Underwood ... New York, Cincinnati [etc.] American book company [°1911]

167 p. 17ᶜᵐ. (Eclectic English classics)

© Jan. 28, 1911; 2c. Jan. 31, 1911; A 280473; Amer. book co., New York, N. Y. (11–1472) **388**

Alabama. *Supreme court.*

Report of cases argued and determined ... during the November term, 1909–1910. By Lawrence H. Lee, supreme court reporter. v. 165. Montgomery, Ala., The Brown printing company, 1910.

xix, 743 p. 23½ᶜᵐ. $2.00

© Jan. 30, 1911; 2c. Feb. 2, 1911; A 280542; Emmet O'Neal, governor of Alabama, for use of said state, Montgomery, Ala. **389**

Armstrong, Joseph.

The mother church. By Joseph Armstrong. 10th ed. Boston, The Christian science publishing society, 1911.

ix, 107 p., 1 l. front., plates, facsims. 19½ᶜᵐ.

© Jan. 25, 1911; 2c. Jan. 27, 1911; A 280389; Mary E. Armstrong, Boston, Mass. (11–1427) **390**

Armstrong, Ramsey Clarke, 1842–

Christian science exposed, by Rev. R. C. Armstrong, B. D. Nashville, Tenn., and Dallas, Tex., Printed for the author, Smith & Lamar, agents, Publishing house M. E. church, South [°1910]

356 p. front. (port.) 19½ᶜᵐ. $1.50

© Nov. 18, 1910; 2c. Jan. 3, 1911; A 280052; R. C. Armstrong, Fort Worth, Tex. (11–1481) **391**

Baldwin, James Mark, 1861–

The individual and society; or, Psychology and sociology, by James Mark Baldwin ... Boston, R. G. Badger, 1911.

10 p., 2 l., 13–210 p. 19½ᶜᵐ. $1.50

Baldwin, James Mark—Continued

"The French edition bears the title, 'Psychologie et sociologie (l'Individu et la société)'"
One chapter (VI) has been added to the book in the English form.
"The material of the book has also served as a basis for a course of twenty-five lectures on 'Psycho-sociology,' delivered in the National university of Mexico, October to December, 1910."

© Jan. 19, 1911; 2c. Jan. 26, 1911; A 280381; J. M. Baldwin, Baltimore, Md.
(11-1439) **392**

Bardeen, Charles William, 1847-

A little fifer's war diary, with 17 maps, 60 portraits, and 246 other illustrations; by C. W. Bardeen ... with an introduction by Nicholas Murray Butler ... Syracuse, N. Y., C. W. Bardeen, 1910.
16 p., 1 l., 17–329 p. illus. (incl. ports., maps, facsims.) 24ᶜᵐ. $2.00
© Jan. 3, 1911; 2c. Jan. 20, 1911; A 280360; C. W. Bardeen, Syracuse, N. Y. (11-1505) **393**

Bennett, Enoch Arnold, 1867-

The ghost; a modern phantasy, by Arnold Bennett ... Boston, Small, Maynard & company, 1911.
3 p. l., 312 p. 19½ᶜᵐ. $1.20
© Jan. 28, 1911; 2c. Jan. 31, 1911; A 280484; Small, Maynard & co., inc., Boston, Mass. (11-1448) **394**

Bessière, Émile.

... Théatre ... Marseille, Édition nouvelle, ᶜ1910.
cover-title, 171 p., 1 l. 23ᶜᵐ. fr. 3
CONTENTS.—Mendiant d'amour.—Le déserteur.—Rédemption.—L'amour et l'honneur.—Samedi de paie.—Les vieux.—La revanche.—Eveil d'âme.—Jean Degrève.
© Dec. 24, 1910; 2c. Dec. 20, 1910; A—Foreign 2415; Bessière, Marseille, France. (11-1543) **395**

Bible. *O. T. German.*

Die schriften des Alten Testaments in auswahl; neu übersetzt und für die gegenwart erklärt von Hugo Gressmann, Hermann Gunkel, M. Haller, Hans Schmidt, W. Stärk und Paul Volz. 2. abt. ... 1. bd. Die älteste geschichtsschreibung und prophetie Israels (von Samuel bis Amos und Hosea) ... Göttingen, Vandenhoeck & Ruprecht, 1910.
xviii, 388 p. 25½ᶜᵐ. M. 6
© Dec. 12, 1910; 2c. Feb. 11, 1911; A—Foreign 2474; Vandenhoeck & Ruprecht, Göttingen, Germany. **396**

Bible. *Selections. English.*

The Bible universal, including the books of the creation, the laws of Moses and the teachings of Christ. Cambridge, Mass., 1905.
226 p. 19ᶜᵐ.
Ed. by H. B. Kipper.
© Dec. 30, 1910; 2c. Jan. 20, 1911; A 280249; H. B. Kipper, Syracuse, N. Y.
(11-1479) **397**

Blanton, Annie Webb.
Supplementary exercises in punctuation and composition, by Annie Webb Blanton ... Rev. ed., 1910. New York, Charles E. Merrill co. [c1910]
75 p. 19cm. $0.25
© Nov. 7, 1910; 2c. Dec. 1, 1910; A 280296; A. W. Blanton, Denton, Tex.
(11–1537) **398**

Boccaccio, Giovanni.
... The Decameron "La comedia umana," now for the first time completely translated by John Payne; with introduction by Hugo Albert Rennert ... illustrations by Jacques Wagrez. 7th and 8th day. Philadelphia, Printed for subscribers only by G. Barrie & sons [1911]
2 v. fronts., illus., plates. 31cm. $30.00 per vol.
Illustrations and plates in two states.
© Feb. 8, 1911; 2c. each Feb. 10, 1911; A 280683; George Barrie & sons,
Philadelphia, Pa. **399**

Boulenger, Marcel.
... Le pavé du roi. Paris, P. Lafitte & cie. [1910]
298 p., 1 l. 19cm. fr. 3.50
© May 20, 1910; 2c. Feb. 2, 1911; A—Foreign 2443; Pierre Lafitte & cie.,
Paris, France. **400**

Boyd, Louie Croft.
State registration for nurses, by Louie Croft Boyd ... Philadelphia and London, W. B. Saunders company, 1911.
v, 42 p. 24cm. $0.50
Bibliography: p. 33–40.
© Jan. 17, 1911; 2c. Jan. 19, 1911; A 280187; W. B. Saunders co., Philadelphia, Pa. (11–1494) **401**

Bricker, Garland Armor.
The teaching of agriculture in the high school, by Garland Armor Bricker ... with an introduction by Dr. W. C. Bagley ... New York, The Macmillan company, 1911.
xxv p., 1 l., 202 p. illus., plates. 20cm. $1.00
© Jan. 25, 1911; 2c. Jan. 26, 1911; A 280371; Macmillan co., New York, N. Y.
(11–1528) **402**

Brooks, Stratton Duluth, 1869–
English composition, bk. 1, by Stratton D. Brooks ... New York. Cincinnati [etc.] American book company [1911]
294 p. 19cm. $0.75
bk. 1 © Jan. 31, 1911; 2c. Feb. 2, 1911; A 280520; S. D. Brooks, Boston,
Mass. (11–1609) **403**

Brown, John Franklin, 1865–
The training of teachers for secondary schools in Germany and the United States, by John Franklin Brown ... New York, The Macmillan company, 1911.
x, 335 p. 19½cm. $1.25
Bibliography: p. 327–330.
© Jan. 25, 1911; 2c. Jan. 26, 1911; A 280370; Macmillan co., New York, N. Y.
(11–1456) **404**

Bugge, Alexander, 1870–

Fortællingen om Sigurd Favnesbane, norrøne heltesagn og eventyr, gjenfortalt for ungdommen av Alexander Bugge. Kristiania og Kjøbenhavn, Gyldendalske boghandel, Nordisk forlag, 1910.

3 p. l., 169 p. 20ᶜᵐ. kr. 2.50

CONTENTS.—Valund smed.—Sverdet Tyrfing.—Ragnar Lodbrok og hans sønner.—Fortællingen om Jomsvikingerne.—Olav Tryggvason.

© Nov. 23, 1910; 2c. Jan. 21, 1911; A—Foreign 2375; Gyldendalske boghandel, Nordisk forlag, Christiania, Norway. (11–1542) **405**

Bull, Jacob Breda, 1853–

Knut Veum, et folkelivsbillede. 2. oplag. Kristiania og København, Gyldendalske boghandel, Nordisk forlag, 1910.

148 p. 20ᶜᵐ. kr. 3.80

© Nov. 28, 1910; 2c. Jan. 21, 1911; A—Foreign 2373; Gyldendalske boghandel, Nordisk forlag, Christiania, Norway. (11–1540) **406**

Caesar, C. Julius.

Caesar's Gallic war, books I–IV, and selections from books V–VII, with notes, grammatical appendix, and prose composition, by Walter B. Gunnison ... and Walter S. Harley ... with additional selections for sight reading, from Caesar's Civil war and from Cornelius Nepos. [New York ed.] New York, Boston [etc.] Silver, Burdett and company [ᶜ1911]

xxxv, 144, ia–xliviia, [145]–464 p. incl. front. (port.) illus. 5 pl. (4 col.) maps, plans. 19½ᶜᵐ. $1.25

"Works of reference": p. xxxv.

© Jan. 7, 1911; 2c. Jan. 13, 1911; A 280076; Silver, Burdett & co., New York, N. Y. (11–1423) **407**

Carnegie, Andrew, 1837– *ed.*

... Business, ed. by Andrew Carnegie ... Boston, Hall and Locke company [ᶜ1911]

xiv, 401, [1] p. incl. col. front. col. plates. 21ᶜᵐ. (*Added t.-p.:* Young folks library ... Vocations. W. D. Hyde ... editor-in-chief ... [vol. IV])

At head of title: Vocations.

"Supplementary readings": 1 p. at end.

© Jan. 14, 1911; 2c. Jan. 20, 1911; A 280240; Hall & Locke co., Boston, Mass. (11–1517) **408**

Chalmers, Stephen, 1880–

A prince of romance, by Stephen Chalmers ... illustrated by Charles B. Falls. Boston, Small, Maynard and company [ᶜ1911]

5 p. l., 340 p., 1 l. front. 19½ᶜᵐ. $1.20

© Jan. 28, 1911; 2c. Jan. 31, 1911; A 280842; S. Chalmers, Eastport, Me. (11–1450) **409**

Chamberlin, Georgia Louise.

The Hebrew prophets; or, Patriots and leaders of Israel. pt. 2 ... By Georgia Louise Chamberlin ... Chicago, Ill., The University of Chicago press [1911]

v, 101–168 p. front. (maps) 22ᶜᵐ. (Constructive Bible studies. Secondary series)

© Jan. 31, 1911; 2c. Feb. 6, 1911; A 280605; University of Chicago, Chicago, Ill. 410

Clouston, *Mrs.* Adella Octavia, 1864–

The lady of the robins; a romance of some of New York's 400, by Adella Octavia Clouston ... Boston, The American humane education society [°1910]

3 p. l., 194 p. 18½ᶜᵐ. $0.20

© Jan. 25, 1911; 2c. Jan. 27, 1911; A 280402; Amer. humane education soc., Boston, Mass. (11–1433) 411

Cook, Joel, 1842–1910.

The Mediterranean and its borderlands, by Joel Cook ... Philadelphia, The John C. Winston co. [°1910]

2 v. fronts., plates. 20½ᶜᵐ. $5.00

CONTENTS.—v. 1. Western countries.—v. 2. Eastern countries.

© Nov. 7, 1910; 2c. Jan. 23, 1911; A 280286; John C. Winston co., Philadelphia, Pa. (11–1548) 412

Cope, Henry Frederick, 1870–

The efficient layman; or, The religious training of men; thesis for PH. D. degree, Ripon college, 1908, by Henry Frederick Cope ... Philadelphia, Boston [etc.] The Griffith & Rowland press [1911]

xii, 244 p. 20½ᶜᵐ. $1.00

© Jan. 3, 1911; 2c. Feb. 1, 1911; A 280500; A. J. Rowland, sec., Philadelphia, Pa. (11–1595) 413

[Cory, Vivian]

Self and the other, by Victoria Cross [*pseud.*] ... London, T. W. Laurie [°1911]

3 p. l., 303, [1] p. 19½ᶜᵐ. 6/

© 1c. Jan. 28, 1911; A ad int. 465; published Dec. 30, 1910; V. C. Griffin, London, England. (11–1451) 414

Cox, Kenyon, 1856– *ed.*

... The fine arts, ed. by Kenyon Cox ... Boston, Hall and Locke company [°1911]

xvi, 399, [1] p. incl. front. plates. 21ᶜᵐ. (*Added t.-p.:* Young folks library ... Vocations. W. D. Hyde ... editor-in-chief ... [vol. XI])

At head of title: Vocations.

"Supplementary readings": 1 p. at end.

© Jan. 14, 1911; 2c. Jan. 20, 1911; A 280246; Hall & Locke co., Boston, Mass. (11–1564) 415

Curtis, Olin Alfred, 1850–

Personal submission to Jesus Christ, its supreme importance in the Christian life and theology. Matriculation day address delivered by Olin Alfred Curtis, professor in Drew theological seminary, September 28, 1910. New York, Eaton & Mains; Cincinnati, Jennings & Graham [°1910]

35 p. 17½ᶜᵐ. $0.25

© Jan. 4, 1911; 2c. Jan. 23, 1911; A 280291; Eaton & Mains, New York, N. Y. (11–1430) **416**

Dandridge, *Mrs.* Danske (Bedinger) 1864–

American prisoners of the revolution, by Danske Dandridge ... Charlottesville, Va., The Michie company, printers, 1911.

ix, 504 p. front. 20½ᶜᵐ. $3.00
Bibliography: p. [503]–504.

© Jan. 27, 1911; 2c. Jan. 28, 1911; A 280424; D. Dandridge, Shepherdstown, W. Va. (11–1506) **417**

Descaves, Lucien, 1861–

... La vie douloureuse de Marceline Desbordes-Valmore, par Lucien Descaves ... Paris, Éditions d'Art et de littérature [°1910]

2 p. l., vii–xiv, 279 p., 2 l. 2 port. (incl. front.) 19ᶜᵐ. (Les femmes illustres) fr. 3
"Bibliographie": p. [271]–279.

© Jan. 4, 1911; 2c. Jan. 21, 1911; A—Foreign 2395; J. Ed. Richardin, Paris, France. (11–1476) **418**

Dixon, Thomas, *jr.*, 1864–

The root of evil; a novel, by Thomas Dixon ... illustrated by George Wright. Garden City, N. Y., Doubleday, Page & company, 1911.

5 p. l., 3–407 p. col. front., col. plates. 19½ᶜᵐ. $1.20

© Jan. 25, 1911; 2c. Jan. 27, 1911; A 280407; T. Dixon, New York, N. Y. (11–1432) **419**

Dugdale, Richard L 1841–1883.

The Jukes; a study in crime, pauperism, disease, and heredity, by Robert [!] L. Dugdale. 4th ed. with a foreword by Elisha Harris ... and an introduction by Franklin H. Giddings ... New York and London, G. P. Putnam's sons, 1910.

v, 120 p., 1 l. incl. tables. fold. tables. 20ᶜᵐ. $1.50

© Dec. 15, 1910; 2c. Jan. 7, 1911; A 278954; G. P. Putnam's sons, New York, N. Y. (11–1441) **420**

Eberle, Eugene Gustave, 1863–

The student in pharmacy; embracing theoretical and practical pharmacy, a guide for studying the preparations of the pharmacopoeia and national formulary, which

Eberle, Eugene Gustave—Continued
are here included only by reference ... v. 1. By E. G.
Eberle ... Dallas, Tex., The Southern pharmaceutical
journal ₍ᶜ1910₎
> 224 p. illus. 25ᶜᵐ. $2.00
> "Largely a reprint of the articles appearing in the 'Students' columns' of
> the Southern pharmaceutical journal."—Pref.
> v. 1 © Dec. 30, 1910; 2c. Jan. 5, 1911; A 278913; E. G. Eberle, Dallas, Tex.
> (11–1496) 421

Egge, Peter, 1869–
... Idyllen. Kristiania og Kjøbenhavn, Gyldendalske
boghandel, Nordisk forlag, 1910.
> 2 p. l., ₍7₎–260 p. 20ᶜᵐ.
> © Nov. 23, 1910; 2c. Jan. 21, 1911; D 23158; Gyldendalske boghandel,
> Nordisk forlag, Christiania, Norway. (11–1465) 421*

Falke, Gustav, 1853–
Geelgösch; novellen von Gustav Falke. Leipzig ₍etc.₎
Grethlein & co. ₍ᶜ1910₎
> 4 p. l., 11–241 p. 18½ᶜᵐ. M. 3
> CONTENTS.—Geelgösch.—Persönlichkeit.—Sein letztes abenteuer.
> © Dec. 15, 1910; 2c. Jan. 19, 1911; A—Foreign 2338; Grethlein & co., Leip-
> zig, Germany. (11–1560) 422

Fraser, Robert.
The fire opal, by Robert Fraser ... New York, E. J.
Clode ₍ᶜ1911₎
> vi, 311 p. 19½ᶜᵐ. $1.25
> © Feb. 1, 1911; 2c. Feb. 2, 1911; A 280526; Edw. J. Clode, New York, N. Y.
> (11–1518) 423

Fuller, Melville Weston, 1833–1910, *ed.*
... The professions, ed. by Melville Weston Fuller ...
Boston, Hall and Locke company ₍ᶜ1911₎
> xv, 399, ₍1₎ p. incl. col. front. col. plates. 21ᶜᵐ. (*Added t.-p.:* Young
> folks library ... Vocations. W. D. Hyde ... editor-in-chief ... ₍vol. VI₎)
> At head of title: Vocations.
> "Supplementary readings": 1 p. at end.
> © Jan. 14, 1911; 2c. Jan. 20, 1911; A 280241; Hall & Locke co., Boston,
> Mass. (11–1515) 424

Garfield, James Rudolph, 1865– *ed.*
... Public service, ed. by James Rudolph Garfield ...
Boston, Hall and Locke company ₍ᶜ1911₎
> xix, 395, ₍1₎ p. incl. col. front. col. plates. 21ᶜᵐ. (*Added t.-p.:* Young
> folks library ... Vocations. W. D. Hyde ... editor-in-chief ... ₍vol. VII₎)
> At head of title: Vocations.
> "Supplementary readings": 1 p. at end.
> © Jan. 14, 1911; 2c. Jan. 20, 1911; A 280242; Hall & Locke co., Boston,
> Mass. (11–1516) 425

Garrison, *Mrs.* Theodosia (Pickering)
The earth cry, and other poems, by Theodosia Garrison.
New York, M. Kennerley, 1910.
> 159 p. 16½ᶜᵐ. $1.00
> © Oct. 31, 1910; 2c. Feb. 3, 1911; A 280549; Mitchell Kennerley, New
> York, N. Y. (11–1536) 426

Gibbs, George Fort, 1870–

The bolted door, by George Gibbs ... New York and London, D. Appleton and company, 1911.

ix, 346 p., 1 l. col. front., plates. 19¼ᶜᵐ. $1.25

© Jan. 27, 1911; 2c. Feb. 1, 1911; A 280495; D. Appleton & co., New York, N. Y. (11–1452) **427**

Guelph, John R. Wettin, 1861–

The memoirs of Prince John De Guelph, rex et imperator de jure of Great Britain and Ireland; with introduction and many photographs. New York, B. W. Dodge & company, 1910.

xxxi, 461 p. front., ports., facsims. 21ᶜᵐ. $2.00

© Dec. 31, 1910; 2c. Jan. 12, 1911; A 280059; Wm. Rickey, New York, N. Y. (11–1550) **428**

Hale, Louise Closser.

The married Miss Worth; a novel, by Louise Closser Hale ... New York and London, Harper & brothers, 1911.

2 p. l., 298 p., 1 l. front. 19¼ᶜᵐ. $1.20

© Feb. 2, 1911; 2c. Feb. 4, 1911; A 280589; Harper & bros., New York, N. Y. (11–1520) **429**

Hardung, Victor, 1861–

Die gedichte von Victor Hardung ... Zürich, H. Bachmann-Gruner [ᶜ1910]

116 p. front. 21¼ᶜᵐ.

© Nov. 23, 1910; 2c. Jan. 23, 1911; A—Foreign 2414; H. Bachmann-Gruner, Zürich, Switzerland. (11–1559) **430**

Haring, Fred Benson.

A manual of procedure. The law of conditional sales, containing the essential features of the laws governing conditional sales in every state and territory of the United States; also approved forms for conditional contracts of sale, acknowledgments, etc., etc. (Supplementary to October 1, 1910) By Fred Benson Haring ... Buffalo, N. Y., 1910.

[73] p. 23ᶜᵐ. $2.00

© Dec. 30, 1910; 2c. Jan. 21, 1911; A 280262; F. B. Haring, Buffalo, N. Y.
 431

Heyse, Paul Johann Ludwig, 1830–

L'arrabbiata; novelle von Paul Heyse; ed., with introduction, notes, exercises, and a vocabulary, by Steven T. Byington. Boston, New York [etc., Ginn and company, ᶜ1911]

xii, 82 p. incl. front., illus. (map) 17¼ᶜᵐ. $0.30

© Jan. 20, 1911; 2c. Jan. 23, 1911; A 280490; Ginn & co., Boston, Mass. (11–1468) **432**

Hills, Elijah Clarence, 1867– *comp.*

Las mejores poesías líricas de la lengua castellana, escogidas por Don Elías C. Hills y Don Silvano G. Morley. Nueva York, H. Holt y compañia, 1910.

ix, 224 p. 19ᶜᵐ. $1.25

© Dec. 30, 1910; 2c. Jan. 3, 1911; A 278790; Henry Holt & co., New York, N. Y. (11–1422) 433

Hodgdon, Jeannette Rector.

A first course in American history, by Jeannette Rector Hodgdon. Boston, D. C. Heath & co., 1911.

vi, 372 p. front. (port.) illus. 19ᶜᵐ. $0.60

© Jan. 25, 1911; 2c. Jan. 28, 1911; A 280433; D. C. Heath & co., Boston, Mass. (11–1502) 434

Hoffman, Otto Sichel, 1862– *ed.*

Optimistic voices; little messages of cheer and hope, ed. by O. S. Hoffman; introduction by Horace Fletcher ... 3d ed., rev. and enl. Battle Creek, Mich., The editor [ᶜ1911]

80 p. 18ᶜᵐ. $0.35

© Jan. 30, 1911; 2c. Feb. 1, 1911; A 280502; O. S. Hoffman, Battle Creek, Mich. (11–1533) 435

Hoffmann, Hans, 1848–1909.

... Iwan der Schreckliche und sein hund, roman von Hans Hoffmann; ed., with introduction, notes, and vocabulary, by Charles Marshall Poor ... New York, Oxford university press, American branch; [etc., etc.] 1911.

ix, 344 p. front. (port.) 18½ᶜᵐ. (Oxford German series) $0.60

© Jan. 28, 1911; 2c. Jan. 31, 1911; A 280475; Oxford university press, Amer. branch, New York, N. Y. (11–1544) 436

[Holstein, *Mrs*. Ottilie Victoria (Wolff)] 1867–

1001 household hints, arranged by Ottilie V. Ames [*pseud.*] [Chicago, ᶜ1910]

2 p. l., 3–210 p. 20½ᶜᵐ. $1.00

© Nov. 26, 1910; 2c. Nov. 29, 1910; A 275805; Mrs. C. V. Holstein, Chicago, Ill. (11–1489) 437

Hooper, William F 1866–

A practical treatise on typhoid and all other slow fevers broken in fourteen days, by W. F. Hooper, M. D. Booneville, Ark., The Booneville incorporated book company [ᶜ1910]

vii, 186 p. 22½ᶜᵐ. $2.00

© Oct. 29, 1910; 2c. Jan. 27, 1911; A 280397; Booneville book co., inc., Booneville, Ark. (11–1492) 438

Howe, George, 1881–

Mathematics for the practical man, explaining simply and quickly all the elements of algebra, geometry, trigonometry, logarithms, coördinate geometry, calculus, by George Howe, M. E. New York, D. Van Nostrand company, 1911.

2 p. l., iii–v, 143 p. diagrs. 19½ᶜᵐ. $1.25

© Jan. 21, 1911; 2c. Jan. 30, 1911; A 280463; D. Van Nostrand co., New York, N. Y. (11–1604) **439**

Idaho. *Supreme court.*

Reports of cases argued and determined ... by I. W. Hart (ex-officio reporter) v. 18. San Francisco, Bancroft-Whitney company, 1911.

xli, 861 p. 23ᶜᵐ. $3.25

© Feb. 6, 1911; 2c. Feb. 13, 1911; A 280767; I. W. Hart, for the benefit of the state of Idaho, Boise, Id. **440**

Illinois. *Appellate courts.*

Reports of cases determined ... with a directory of the judiciary of the state corrected to December 8, 1910. v. 153, A. D. 1911 ... Ed. by W. Clyde Jones and Keene H. Addington ... Chicago, Callaghan & company, 1911.

xvii, 683 p. 23ᶜᵐ. $3.50

© Jan. 27, 1911; 2c. Feb. 1, 1911; A 280511; Callaghan & co., Chicago, Ill.
441

Kemp, Edward, 1817–1891.

Landscape gardening; how to lay out a garden, by Edward Kemp ... ed., rev. and adapted to North America by F. A. Waugh ... 4th ed., 1st thousand. New York, J. Wiley & sons; [etc., etc.] 1911.

xxii, 292 p. incl. front., illus., plans. plates. 19½ᶜᵐ. $1.50
First issued in 1850 under title: How to lay out a small garden.

© Jan. 25, 1911; 2c. Jan. 27, 1911; A 280395; F. A. Waugh, Amherst, Mass. (11–1532) **442**

Kent, Charles Foster, 1867–

... The great teachers of Judaism and Christianity, by Charles Foster Kent. New York, Eaton & Mains; Cincinnati, Jennings & Graham [°1911]

166 p. 19ᶜᵐ. (Modern Sunday school manuals, ed. by C. F. Kent in collaboration with J. T. McFarland)

© Jan. 19, 1911; 2c. Jan. 23, 1911; A 280292; C. F. Kent, New Haven, Conn. (11–1431) **443**

Klauwell, Otto, 1851–

Geschichte der programmusik von ihren anfängen bis zur gegenwart, von dr. Otto Klauwell. Leipzig, Breitkopf & Härtel, 1910.

viii, 426 p. 19½ᶜᵐ. (*On cover:* Breitkopf & Härtels musikbücher) M.6

© Dec. 29, 1910; 2c. Jan. 19, 1911; A—Foreign 2339; Breitkopf & Härtel, Leipzig, Germany. (11–1459) **444**

Knapp, Ella Adelaide, 1861– *ed.*

The speech for special occasions, ed. by Ella A. Knapp ... and John C. French ... New York, The Macmillan company, 1911.

xliii p., 1 l., 397 p. 19½ᶜᵐ. $1.10

© Jan. 11. 1911; 2c. Jan. 12, 1911; A 280050; Macmillan co., New York, N. Y. (11–1425) 445

Knowles, Archibald Campbell, 1865–

The practice of religion, a short manual of instructions and devotions ... by the Reverend Archibald Campbell Knowles ... 3d ed. With a preface by the Right Reverend the Bishop of Fond du Lac. New York, E. S. Gorham, 1911.

xiv, 181 p. front., plates. 14ᶜᵐ.

© Jan. 17, 1911; 2c. Jan. 23, 1911; A 280294; A. C. Knowles, Germantown, Pa. (11–1429) 446

Krag, Thomas Peter, 1868–

... Vej og vidde. 2. oplag. Kristiania og Kjøbenhavn, Gyldendalske boghandel, Nordisk forlag, 1910.

252 p. 20ᶜᵐ. kr. 4

CONTENTS.—Sagn og syner.—Skarven.—Da sjøormen gik til sagfører.— Vissnet liv.—Fra Mønnegaarden.—Over afgrunden.—Fremmed.—Vinter.— Skogstien.—Egil Orre.—Rokkangutten.—William Glyn.—Hævnen.—Kirnden med opaløinene.

© Nov. 2, 1910; 2c. Jan. 21, 1911; A—Foreign 2374; Gyldendalske boghandel, Nordisk forlag, Christiania, Norway. (11–1558) 447

Küster, Emil, 1877–

Kompendium der praktischen bakterienkunde, für studierende der medizin und praktische ärzte, von dr. med. et med. vet. E. Küster ... und dr. med. A. Geisse ... mit 26 abbildungen und 18 farbigen tafeln. Strassburg i. E. und Leipzig, J. Singer, 1911.

vi, ₍2₎, 184 p. illus., 17 (i. e. 18) pl. 16¼ᶜᵐ.

© Dec. 28. 1910; 2c. Jan. 23, 1911; A—Foreign 2406; Josef Singer, Strassburg, Germany. (11–1606) 448

Lanslots, Don Ildephonse, 1859–

Catholic theology; or, The catechism explained, by Rev. D. I. Lanslots, o. s. b.; with a preface by the Right Rev. F. A. Gasquet ... St. Louis, Mo. ₍etc.₎ B. Herder, 1911.

2 p. l., iii–v, 622 p. 20¼ᶜᵐ. $1.75

© Jan. 25, 1911; 2c. Jan. 27, 1911; A 280391; Jos. Gummersbach, St. Louis, Mo. (11–1428) 449

Leroux, Gaston.

The phantom of the opera, by Gaston Leroux ... illustrated by André Castaigne. New York, Indianapolis, The Bobbs-Merrill company ₍©1911₎

4 p. l., 357 p. col. front., double col. plates. 19ᶜᵐ. $1.25

© Jan. 28, 1911; 2c. Feb. 1, 1911; A 280510; Bobbs-Merrill co., Indianapolis, Ind. (11–1449) 450

75

Lie, Johanne Vogt.

Kunstnerliv i Nord og Syd. Kristiania og Kjøbenhavn, Gyldendalske boghandel, Nordisk forlag, 1910.

160 p. 20ᶜᵐ. kr. 2.50

© Nov. 16, 1910; 2c. Jan. 21, 1911; A—Foreign 2379; Glydendalske bog-
handel, Nordisk forlag, Christiania, Norway. (11–1541) **451**

Lipps, Gottlob Friedrich, 1865–

Weltanschauung und bildungsideal; untersuchungen zur begründung der unterrichtslehre, von G. F. Lipps. Leipzig und Berlin, B. G. Teubner, 1911.

viii, ₍2₎, 230 p. 23ᶜᵐ. M. 5

© Dec. 30, 1910; 2c. Jan. 19, 1911; A—Foreign 2311; B. G. Teubner, Leip-
zig, Germany. (11–14555) **452**

Lowther, Minnie Kendall.

History of Ritchie County, with biographical sketches of its pioneers and their ancestors, and with interesting reminiscences of revolutionary and Indian times, by Minnie Kendall Lowther; with portraits and other illustrations. Wheeling, W. Va., Wheeling news litho. co. ₍ᶜ1911₎

xiv, 681 p. incl. front. (port.) illus. 2 groups of ports. 24ᶜᵐ.

© Jan. 27, 1911; 2c. Jan. 30, 1911; A 280453; M. K. Lowther, Fonzo, W. Va.
(11–1585) **453**

Maclaurin, Richard Cockburn, ed.

... The mechanic arts, ed. by Richard C. Maclaurin ... Boston, Hall and Locke company ₍ᶜ1911₎

xxvii, 387, ₍1₎ p. incl. col. front. col. plates, port. 21ᶜᵐ. (*Added t.-p.:*
Young folks library ... Vocations. W. D. Hyde ... editor-in-chief ...
₍vol. 11₎)

At head of title: Vocations ...
"Supplementary readings": 1 p. at end.

© Jan. 14, 1911; 2c. Jan. 20, 1911; A 280237; Hall & Locke co., Boston,
Mass. (11–1573) **454**

Madeleine, Marie.

Auf Kypros, von Marie Madeleine. ₍Berlin-Charlot-
tenburg₎ Est-est-verlag ₍1910₎

132 p. illus, mounted plates. (partly col.) 37½ᶜᵐ. M. 45

© Dec. 13, 1910; 2c. Jan. 7, 1911; A—Foreign 2265; Rudolf Möhring, Est-
est-verlag. g. m. b. h., Berlin-Charlottenburg, Germany. **455**

Marchand, Charles M *ed.*

... Five thousand French idioms, Gallicisms, proverbs, idiomatic adverbs ... With explanatory notes, one hundred and fifty-six exercises in prose composition and thirteen versions récapitulatives. Ed. by Charles M. Marchand ... New ed. entirely remodelled, carefully rev. and much enl. Paris, New York, E. Terquem, 1910.

1 p. l., v, ₍1₎, 335 p. 19ᶜᵐ. fr. 6.25

© Jan. 6, 1911; 2c. Jan. 21, 1911; A—Foreign 2394; Chas. M. Marchand,
Denver, Col. (11–1475) **456**

[Misuraca, Frank] 1884–

... Metodi moderni di difesa personale (con 40 illustrazioni) New York, N. Y., Pub. a cura del Alpha-delta institute [°1910]

87, [1] p. illus. 17½ᶜᵐ. $2.00
Author's pseudonym, F. Karasumi, at head of title.
© Dec. 21, 1910; 2c. Dec. 27, 1910; A 279557; Alpha delta institute, New York, N. Y. (11–1483) **457**

Monroe, Lewis Baxter, 1825?–1879.

Physical and vocal training, for school use and private instruction, by Lewis Baxter Monroe ... with biographical sketch and personal reminiscences, illustrations by Hammat Billings. New York, E. S. Werner & company, °1911·

viii, 112 p. front. (port.) illus. 20ᶜᵐ. $1.00
© Jan. 14, 1911; 2c. Jan. 18, 1911; A 280326; Edgar S. Werner, New York, N. Y. (11–1485) **458**

Monroe, Paul, 1869– *ed.*

A cyclopedia of education, ed. by Paul Monroe ... with the assistance of departmental editors and more than one thousand individual contributors. v. 1. New York, The Macmillan company, 1911.

xiii, 654 p. illus., plates (partly col.) ports. 28ᶜᵐ. $5.00
v. 1 © Jan. 25, 1911; 2c. Jan. 26, 1911; A 280372; Macmillan co., New York, N. Y. (11–1511) **459**

Moore, Edward Alexander, 1842–

The story of a cannoneer under Stonewall Jackson, in which is told the part taken by the Rockbridge artillery in the Army of northern Virginia, by Edward A. Moore ... with introductions by Capt. Robert E. Lee, jr., and Hon. Henry St. George Tucker. Fully illustrated by portraits. Lynchburg, Va., J. P. Bell company, inc., 1910.

331 p. incl. front. plates, ports., facsim. 22ᶜᵐ. $2.00
© Dec. 15, 1910; 2c. Jan. 23, 1911; A 280478; E. A. Moore, Lexington, Va. (11–1504) **460**

Müller, Gustav Adolf, 1866–

Das sterbende Pompeji, ein roman aus Pompejis letzten tagen, von Gustav Adolf Müller. Leipzig, O. Weber [°1910]

xvi, 425 p. 19ᶜᵐ. M. 5
© Nov. 26, 1910; 2c. Jan. 19, 1911; A—Foreign 2356; Otto Weber, Leipzig, Germany. (11–1611) **461**

Münch, Paul Georg, 1877–

Arnd und Silene; novellen, von Paul Georg Münch. Leipzig [etc.] Grethlein & co. [°1910]

217 p. 18½ᶜᵐ. M. 2
CONTENTS.—Schön-Hildrun.—Arnd und Silene.
© Dec. 15, 1910; 2c. Jan. 19, 1911; A—Foreign 2331; Grethlein & co., Leipzig, Germany. (11–1545) **462**

Musser, John Herr, 1856– *ed.*

A handbook of practical treatment, by many writers, ed. by John H. Musser ... and A. O. J. Kelly ... v. 1. Philadelphia and London, W. B. Saunders company, 1911.

2 p. l., 11–909 p. illus., plates (partly col.) 25½ᶜᵐ. $6.00
Contains bibliographies.

v. 1 © Jan. 26, 1911; 2c. Jan. 27, 1911; A 280393; W. B. Saunders co., Philadelphia, Pa. (11–1495) 463

The **new** international encyclopædia; editors: Daniel Coit Gilman ... Harry Thurston Peck ... Frank Moore Colby ... New York, Dodd, Mead and company, 1911.

20 v. fold. front., illus., plates (partly col.) ports., maps (partly double) plans (partly fold. and double) facsims., diagrs. 26ᶜᵐ. $85.00
First published 1902–1904.

© Jan. 5, 1911; 2c. Jan. 25, 1911; A 280350; Dodd, Mead & co., New York, N. Y. (11–1590) 464

New York (*State*) *Court of appeals.*

The New York court of appeals reports, rev. ed. with notes, ed by John T. Cook ... Book 39, comprising vols. 191–195, New York, original series; Bedell's reports, 29; Newcomb, 1, 2; Fiero, 1, 2. Albany, N. Y., M. Bender & co., 1911.

xxx, 1296 p. 26½ᶜᵐ. $5.00

© Feb. 3, 1911; 2c. Feb. 10, 1911; A 280682; Matthew Bender & co., Albany, N. Y. 465

A **note** on the art of mezzotint and mezzotint printing in colours ... London, H. C. Dickins [¹1911]

cover-title, [16] p. mounted illus. (partly col.) 19½ᶜᵐ.

© 1c. Jan. 19, 1911; A ad int. 458; published Jan. 12, 1911; H. C. Dickins, London, England. (11–1563) 466

Ogden, James Gordon, 1865–

Heat, by J. Gordon Ogden ... Chicago, Popular mechanics co. [¹1911]

3 p. l., 9–119 p. illus., diagrs. 17½ᶜᵐ. (Popular mechanics twenty-five-cent handbook series) $0.25

© Jan. 19, 1911; 2c. Jan. 23, 1911; A 280301; Henry H. Windsor, Chicago, Ill (11–1497) 467

Ostrup, John Christian, 1864–

Standard specifications for structural steel—timber—concrete, and reinforced concrete, by John C. Ostrup ... 2d ed. New York [etc.] McGraw-Hill book company, 1911.

vii, 99 p. illus. 24ᶜᵐ. $1.00

© Jan. 12, 1911; 2c. Jan. 25, 1911; A 280349; McGraw-Hill book co., New York, N. Y. (11–1413) 468

Painter, Franklin Verzelius Newton, 1852–

Introduction to American literature, including illustrative selections with notes, by F. V. N. Painter ... Rev. ed. Boston, Chicago, Sibley & company [c1911]

vii, 584 p. ports. 19½ᶜᵐ. $1.25

© Jan. 23, 1911; 2c. Jan. 25, 1911; A 280341; Sibley & co., Boston, Mass. (11–1473) **469**

Palmer, Daniel David, 1842–

Text-book of the science, art and philosophy of chiropractic for students and practitioners, by D. D. Palmer ... founded on tone. Portland, Or., Portland printing house company, 1910.

1007 p. illus. (incl. ports.) 24ᶜᵐ. $10.00

© Dec. 29, 1910; 2c. Jan. 18, 1911; A 280175; D. D. Palmer, Portland, Or. (11–1493) **470**

Parker, Horatio William, 1863– *ed.*

... Music and drama, ed. by Horatio Parker ... Boston, Hall and Locke company [c1911]

xxii, 393, [1] p. incl. col. front. col. plates. 21ᶜᵐ. (*Added t.-p.*: Young folks library ... Vocations. W. D. Hyde ... editor-in-chief ... [vol. IX])

At head of title: Vocations ...

"Supplementary readings": 1 p. at end.

© Jan. 14, 1911; 2c. Jan. 20, 1911; A 280245; Hall & Locke co., Boston, Mass. (11–1547) **471**

Patton, Jacob Harris, 1812–1903.

The history of the American people; introductory article on "True Americanism" by Theodore Roosevelt ... other material by Jacob H. Patton, John Lord ... and others ... Chicago, The L. W. Walter company [c1911]

4 v. 19½ᶜᵐ.

Previously issued under various titles: History of the United States of America (1860), Patton's concise history of the American people (1876), etc., etc.

© Jan. 26, 1911; 2c. Jan. 30, 1911; A 280454; L. W. Walter co., Chicago, Ill. (11–1503) **472**

Pepper, George Wharton.

Pepper and Lewis's digest; a digest of the laws of Pennsylvania 1700 to 1907, the Constitution of the United States and the constitution of Pennsylvania, with notes and references to the decisions bearing thereon ... 2d ed. By George Wharton Pepper ... and William Draper Lewis ... v. 4 ... Philadelphia, T. & J. W. Johnson co., 1910.

1 p. l., 9676 numb. col. 27½ᶜᵐ. $24.00 for four vols.

© Dec. 21, 1910; 2c. Feb. 10, 1911; A 280679; T. & J. W. Johnson co., Philadelphia, Pa. **473**

Petronius Arbiter.

The Bellum civile of Petronius; ed. with introduction, commentary, and translation by Florence Theodora Baldwin, PH. D. New York, The Columbia university press, 1911.

viii, 264 p. 18ᶜᵐ. (*Half-title:* Columbia university studies in classical philology) $1.25

© Jan. 17, 1911; 2c. Jan. 19, 1911; A 280184; Columbia university press, New York, N. Y. (11–1471) **474**

Photiadès, Constantin.

... George Meredith, sa vie — son imagination — son art — sa doctrine; avec deux phototypies hors texte. Paris, A. Colin, 1910.

viii, 294 p., 1 l. front. (port.) pl. 19ᶜᵐ. fr. 3.50

© Dec. 30, 1910; 2c. Jan. 21, 1911; A—Foreign 2397; Max Leclerc & H. Bourrelier, Paris, France. (11–1470) **475**

Popper, Josef, 1838–

Der maschinen- und vogelflug. Eine historisch-kritische flugtechnische untersuchung. Mit besonderer hervorhebung der arbeiten von Alphonse Pénaud, von Josef Popper-Lynkeus. Mit figuren im text. Erweiterter sonderabdruck aus der automobil- und flugtechnischen zeitschrift "Der Motorwagen." Berlin, M. Krayn, 1911.

103, [1] p. diagrs. 25½ᶜᵐ.

© Jan. 5, 1911; 2c. Jan. 20, 1911; A—Foreign 2412; M. Krayn, Berlin, Germany. (11–1575) **476**

Quervain, Alfred de.

Durch Grönlands eiswüste; reise der Deutsch-schweizerischen Grönlandexpedition 1909 auf das inlandeis, von dr. A. de Quervain und dr. A. Stolberg; mit 8 vollbildern in lichtdruck, 26 textbildern und einer karte. Strassburg i. E. und Leipzig, J. Singer, 1911.

xii, 180 p. front., illus., plates, fold. map. 21ᶜᵐ.

© Dec. 28, 1910; 2c. Jan. 23, 1911; A—Foreign 2407; Josef Singer, Strassburg, Germany. (11–1486) **477**

Rabelais, François, *ca.* 1490–1553?

Rabelais pour la jeunesse. Pantagruel; texte adapté par Marie Butts ... Paris, Librairie Larousse [°1910]

2 v. col. fronts., illus., col. plates. 20ᶜᵐ. fr. 2.50

© Jan. 6, 1911; 2c. Jan. 21, 1911; A—Foreign 2391; Librairie Larousse, Paris, France. (11–1464) **478**

Raymond, George Lansing, 1839–

Fundamentals in education, art and civics; essays and addresses by George Lansing Raymond ... New York and London, Funk & Wagnalls company, 1911.

350 p. 20ᶜᵐ. $1.40

© Jan. 12, 1911; 2c. Jan. 24, 1911; A 280321; Funk & Wagnalls co., New York, N. Y. (11–1509) **479**

Richardin, Edmond *i. e.* Marie Ernst Edmond, 1850–

La cuisine française du xiv° au xx° siècle; l'art du bien manger ... Préface d'André Theuriet ... Édition accompagnée d'une série de reproductions d'estampes d'après les maîtres de la peinture ... expliqués par Gustave Geffroy ... Ouvrage adopté par le Ministère de l'instruction publique et par la ville de Paris ... Le tout recueilli et annoté par Edmond Richardin. Paris, Éditions d'Art et de littérature [°1910]

2 p. l., [iii]–xvi p., 1 l., 926 p. incl. illus., plates. front. 20°°. fr. 7.50
"Bibliographie": p. [iii]–iv.

© Jan. 4, 1911; 2c. Jan. 21, 1911: A—Foreign 2398; J. Ed. Richardin, Paris, France. (11–1488) 480

Rose, *Mrs.* Héloïse (Durant)

Dante; a dramatic poem, by Héloise Durant Rose ... New York, M. Kennerley, 1910.

6 p. l., [11]–244 p. front. 19°°. $2.00

© Oct. 1, 1910; 2c. Feb. 4, 1911; A 280584; Mitchell Kennerley, New York, N. Y. (11–1534) 481

Salisbury, Albert, 1843–

School management; a text-book for county training schools and normal schools, by Albert Salisbury ... Chicago, Row, Peterson & company [°1911]

196 p. 19½°°. $1.00

© Jan. 8, 1911; 2c. Jan. 20, 1911; A 280248; A. Salisbury, Whitewater, Wis. (11–1510) 482

Schaefer, Joseph] 1848–

The life of the blessed John B. Marie Vianney, curé of Ars. With a novena and litany to this zealous worker in the vineyard of the Lord. Comp. from approved sources. New York, J. Schaefer [°1911]

1 p. l., iii, [2], 6–110 p. front. (port.) 15°°. $0.15

© Jan. 17, 1911; 2c. Jan. 19, 1911; A 280198; J. Schaefer, New York, N. Y. (11–1549) 483

Shakespeare, William, 1564–1616.

... Shakespeare's Midsummer-nights' dream, ed. by John Louis Haney ... New York, Cincinnati [etc.] American book company [°1911]

102 p. 17°°. (Eclectic English classics)

© Jan. 28, 1911; 2c. Jan. 31, 1911; A 280474; Amer. book co., New York, N. Y. (11–1463) 484

Sharpe, Richard Worthy, 1869–

A laboratory manual for the solution of problems in biology, by Richard W. Sharpe ... New York, Cincinnati [etc.] American book company [°1911]

352 p. illus., diagrs. 19°°. $0.75

© Jan. 31, 1911; 2c. Feb. 2, 1911; A 280521; R. W. Sharpe, New York, N. Y. (11–1605) 485

Sheldon, Henry Clay, 1845–

New Testament theology, by Henry C. Sheldon ... New York, The Macmillan company, 1911.

3 p. l., v–vii, 364 p. 19½ᶜᵐ. $1.50

© Jan. 25, 1911; 2c. Jan. 26, 1911; A 280366; Macmillan co., New York, N. Y. (11-1594) **486**

Shook, Charles Augustus, 1876–

Cumorah revisited; or, "The book of Mormon" and the claims of the Mormons re-examined from the viewpoint, of American archaeology and ethnology, by Charles A. Shook ... Cincinnati, The Standard publishing company, 1910.

589 p. incl. front., illus. plates. 20ᶜᵐ. $1.50

"Authors": p. 578–581.

© Jan. 17, 1911; 2c. Jan. 30, 1911; A 280444; Standard pub. co., Cincinnati, O. (11-1567) **487**

Stevens, Ethel Stefana.

The mountain of God, by E. S. Stevens ... London, Mills & Boon, limited [1911]

xii, 380 p. front., plates. 19½ᶜᵐ. 6/

© 1c. Jan. 31, 1911; A ad int. 468; published Jan. 2, 1911; E. S. Stevens, London, England. (11-1435) **488**

Strauss, Richard.

... Der rosenkavalier. Ein führer durch das werk von Alfred Schattmann. Berlin, Paris, A. Fürstner, 1911.

1 p. l., [vi]–ix, [2], 88 p. facsim. 19ᶜᵐ. M. 1

1 fold. sheet of music.

© Jan. 21, 1911; 2c. Feb. 11, 1911; A—Foreign 2476; Adolph Fürstner, Berlin, Germany. **489**

Sudermann, Hermann, 1857–

... Frau Sorge von Hermann Sudermann; abridged and ed., with notes and vocabulary, by Eugene Leser ... and Carl Osthaus ... Boston, D. C. Heath & co., 1911.

vi, 353 p. front. (port.) 18½ᶜᵐ. (Heath's modern language series) $0.90

© Jan. 21, 1911; 2c. Jan. 28, 1911; A 280434; D. C. Heath & co., Boston, Mass. (11-1469) **490**

Swenson, Bernard Victor.

Testing of electro-magnetic machinery and other apparatus, by Bernard Victor Swenson ... and Budd Frankenfield ... assisted by John Myron Bryant ... v. 2, Alternating currents. New York, The Macmillan company, 1911.

xxvi, 323, [1] p. plates, diagrs. 22½ᶜᵐ. $2.60

© Feb. 8, 1911; 2c. Feb. 9, 1911; A 280664; Macmillan co., New York, N. Y. **491**

[Terhune, *Mrs.* Mary Virginia (Hawes)] *ed.*

... Home making, ed. by Marion Harland [*pseud.*] ...
Boston, Hall and Locke company [°1911]

xxi, 393, [1] p. incl. col. front. col. plates. 21⁻. (*Added t.-p.*: Young
folks library ... Vocations. W. D. Hyde ... editor-in-chief ... [vol. III])
At head of title: Vocations ...
"Supplementary readings": 1 p. at end.
© Jan. 14, 1911; 2c. Jan. 20, 1911; A 280238; Hall & Locke co., Boston,
Mass. (11-1572) **492**

Terwilliger, Roy Lawrence, 1875–

The Way of the Little King; stories told at the Carmen
de Beas: by the Way of the Little King in Granada: 1908.
Composed and illustrated by R. L. Terwilliger. [Chicago,
Printed by J. C. Veeder company, °1910]

7 p. l., 6–60 numb. l. 7 pl. 19½⁻.
CONTENTS.—The Way of the Little King.—The story of the three
trees.—The story of Kaseem.—The story of the builder.—The wisdom of
the sword.—The tower of the luminary.—Mohammed and Nadia.
© Jan. 18, 1911; 2c. Jan. 25, 1911; A 280359; R. L. Terwilliger, Chicago, Ill.
(11-1434) **493**

Tews, Johannes, 1860–

... Grossstadtpädagogik; vorträge, gehalten in der
Humboldt-akademie zu Berlin, von J. Tews. Leipzig,
B. G. Teubner, 1911.

iv, 142, [2] p. 18½⁻. (Aus natur und geisteswelt; sammlung wissen-
schaftlich-gemeinverständlicher darstellungen. 327. bdchen.) M.. 1.25
"Literatur": 1 page following p. 142.
© Jan. 3, 1911; 2c. Jan. 19, 1911; A—Foreign 2362; B. G. Teubner, Leip-
zig, Germany. (11-1513) **494**

... Schulkämpfe der gegenwart; vorträge, gehalten in
der Humboldt-akademie in Berlin, von J. Tews. 2. aufl.
Leipzig, B. G. Teubner, 1911.

iv, 162 p. 18½⁻. (Aus natur und geisteswelt: sammlung wissenschaft-
lich-gemeinverständlicher darstellungen. 111. bdchen.) M. 1.25
© Jan. 3, 1911: 2c. Jan. 19, 1911; A—Foreign 2329; B. G. Teubner, Leip-
zig, Germany. (11-1453) **495**

Thomazeau, Maria.

... Petit Jacques ... Paris, Librairie Vuibert [°1910]

2 p. l., 140 p., 1 l. illus. 23⁻. fr. 5
At head of title: Mlle. M. Thomazeau.
© Dec. 23, 1910; 2c. Jan. 21, 1911; A—Foreign 2382; Vuibert, Paris, France.
(11-1546) **496**

[Thompson, Alys H R]

The year's rosary, by "Tipherith" [*pseud.*] a cycle of
sonnets for every week in the year. Chicago, The Libra-
ry shelf [°1910]

2 p. l., 9–60 p., 1 l. 22½⁻. $0.75
© Dec. 21, 1910; 2c. Jan. 3, 1911; A 278871; Library shelf, Chicago, Ill.
(11-1426) **497**

Van Dyke, Henry, 1852– ed.

... Literature, ed. by Henry Van Dyke ... Boston, Hall
and Locke company ₁ᶜ1911₁

xix, 394 p., 1 l. incl. col. front. col. plates. 21ᶜᵐ. (*Added t.-p.:* Young
folks library ... Vocations. W. D. Hyde ... editor-in-chief ... ₁vol. vIII₁)
At head of title: Vocations ...
"Supplementary readings": 1 l. at end.

© Jan. 14, 1911; 2c. Jan. 20, 1911; A 280244; Hall & Locke co., Boston,
Mass. (11–1539) **498**

Vinsnes, Johan Frederik, 1866–

... Regnbuen. Kristiania og Kjøbenhavn, Gyldendalske
boghandel, Nordisk forlag, 1910.

224 p. 20ᶜᵐ. kr. 3.50

© Nov. 19, 1910; 2c. Jan. 21, 1911; A—Foreign 2378; Gyldendalske boghan-
del, Nordisk forlag, Christiania, Norway. (11–1610) **499**

Von Broecklin, Joseph.

... Psychic facts, by Joseph Von Broecklin ... Chicago,
Ill., The Imperial book shop ₁ᶜ1910₁

290 p., 2 l. illus. 23½ᶜᵐ. $2.00

© Jan. 14, 1911; 2c. Jan. 26, 1911; A 280376; J. S. Von Broecklin, Chicago,
Ill. (11–1523) **500**

Wallin, Clarence Monroe.

Gena of the Appalachians, by Clarence Monroe Wallin.
New York, Cochrane publishing company, 1910.

109 p. 19½ᶜᵐ. $1.00

© Dec. 21, 1910; 2c. Jan. 28, 1911; A 280418; C. M. Wallin, New Tazewell,
Tenn. (11–1519) **501**

Warnecke, Georg, 1854–

Vorschule der kunstgeschichte; textbuch zu dem kunst-
geschichtlichen bilderbuch von Georg Warnecke. 7.,
verm. aufl. Leipzig, E. A. Seemann, 1911.

2 p. l., ₁iii₁–vi, 144 p. 20½ᶜᵐ.

© Jan. 6, 1911; 2c. Jan. 19, 1911; A—Foreign 2337; E. A. Seemann, Leip-
zig, Germany. (11–1599) **502**

Webster, Noah, 1758–1843.

Webster's new century dictionary of the English lan-
guage based upon the unabridged dictionary of Noah
Webster, ll. d. Rev. and brought up to date in accord-
ance with the most recent eminent English and American
authorities, by Edward T. Roe, ll. b.; with appendix con-
taining synonyms and antonyms, foreign phrases, lan-
guage of flowers, coins, weights and measures, differences
in time, etc., etc. ₁Popular ed.₁ New York, Cupples &
Leon company ₁ᶜ1911₁

1 p. l., 1000 p. plates. 19½ᶜᵐ.

© Jan. 28, 1911; 2c. Jan. 30, 1911; A 280471; Cupples & Leon co., New
York, N. Y. (11–1538) **503**

Werner, Arno, 1865–

Städtische und fürstliche musikpflege in Weissenfels bis zum ende des 18. jahrhunderts. Von Arno Werner. Leipzig, Breitkopf & Härtel, 1911.

viii, 160 p. plates, ports. 25ᶜᵐ. M. 3

© Jan. 3, 1911; 2c. Jan. 19, 1911; A—Foreign 2323; Breitkopf & Härtel, Leipzig, Germany. (11–1458) **504**

White, Fred Merrick, 1859–

Dropped from the fast express; or, A daughter's sacrifice, by Fred M. White; a romance in high life, intensely thrilling and dramatic. Chicago, Laird & Lee [ᶜ1911]

265 p. incl. front. plates. 20ᶜᵐ.

© Jan. 20, 1911; 2c. Feb. 4, 1911; A 280298; Wm. H. Lee, Chicago, Ill. (11–1521) **505**

Widtsoe, John Andreas, 1872–

Dry-farming; a system of agriculture for countries under a low rainfall, by John A. Widtsoe ... New York, The Macmillan company, 1911.

xxii p., 1 L, 445 p. incl. illus., maps. front. (port.) 19½ᶜᵐ. (*Half-title:* The rural science series, ed. by L. H. Bailey) $1.50

"A partial bibliography of the literature of dry-farming": p. 417–424.

© Jan. 25, 1911; 2c. Jan. 26, 1911; A 280363; Macmillan co., New York, N. Y. (11–1531) **506**

Wildenvey, Herman.

.... Ringsgang. Kristiania og Kjøbenhavn, Gyldendalske boghandel, Nordisk forlag, 1910.

2 p. L, [7]–149 p. 20ᶜᵐ. kr. 2.75

© Nov. 19, 1910; 2c. Jan. 21, 1911; D 23159; Gyldendalske boghandel, Nordisk forlag, Christiania, Norway. (11–1466) **506ᵃ**

Woman's club of Palo Alto, *Palo Alto, Cal.*

Santa Clara Valley; a promotion magazine ... Palo Alto, Cal., Woman's club of Palo Alto, 1911.

81 p. illus., fold. plan. 28½ᶜᵐ.

© Jan. 18, 1911; 2c. Jan. 24, 1911; A 280314; Woman's club of Palo Alto, Palo Alto, Cal. (11–1588) **507**

Woodman, Mary.

A touch of Portugal; or, The little count of Villa Moncão, by Mary Woodman. Boston, Atlantic printing company, 1910.

132 p. front., plates. 19ᶜᵐ. $1.50

© Dec. 28, 1910; 2c. Jan. 23, 1911; A 280304; M. Woodman, Boston, Mass. (11–1310) **508**

Woodruff, George, 1881–

South American impressions; being a series of newspaper articles written by George and Frederick W. Woodruff, special correspondents of the Joliet Sunday herald. [Joliet? Ill., ᶜ1910]

1 p. l., 52 p. illus. 22½ᶜᵐ.

© Dec. 13, 1910; 2c. Dec. 15, 1910; A 278933; Archibald S. Leckie, Joliet, Ill. (11–1255) **509**

Woolley, Mary Emma, 1863– *ed.*

... Education, ed. by Mary Emma Woolley ... Boston,
Hall and Locke company [°1911]

xviii, 397, [1] p. incl. col. front. col. plates. 21^{cm}. (*Added t.-p.:* Young
folks library ... Vocations. W. D. Hyde ... editor-in-chief ... [vol. VII])
At head of title: Vocations.
"Supplementary readings": 1 p. at end.
© Jan. 14, 1911; 2c. Jan. 20' 1911; A 280243; Hall & Locke co., Boston,
Mass. (11–1512) **510**

Number of entries of books included in the Catalogue for 1911:
 a) United States publications------------------------------------- 383
 b) Foreign books in foreign languages------------------------- 122
 c) Foreign books in English language under *ad interim* provi-
 sions of law of Mar. 4, 1909------------------------------- 5

 Total -- 510

Adams, William P.

The musical writing book, ed. by Wm. P. Adams. Being a continuation of the first series, etc., by H. G. Tiepke.
© by Louis P. Adams, New York, N. Y., as the widow of the author, in renewal for 28 years. Renewal no. 1519. Jan. 18, 1911. Original entry, Jan. 27, 1883, no. 11902. **1**

Adams, William Taylor.

Down the Rhine; or, Young America in Germany, by Oliver Optic [pseud.]
© by Alice Adams Russell, New York, N. Y., as the child of the deceased author, in renewal for 28 years. Renewal no. 1394. Jan. 4, 1911. Renewal entry, May 13, 1897, no. 29207. **2**

Lightning express; or, The rival academies, by Oliver Optic [pseud.] (The lake shore series)
© by Alice Adams Russell, New York, N. Y., as the child of the deceased author, in extension for 14 years. Renewal no. 1397. Jan. 4, 1911. Renewal entry, May 13, 1897, no. 29204. **3**

On time; or, The young captain of the Ucayga steamer, by Oliver Optic [pseud.] (The lake shore series)
© by Alice Adams Russell, New York, N. Y., as the child of the deceased author, in extension for 14 years. Renewal no. 1396. Jan. 4, 1911. Renewal entry, May 13, 1897, no. 29205. **4**

Switch off; or, The war of the students, by Oliver Optic [pseud.] (The lake shore series)
© by Alice Adams Russell, New York, N. Y., as the child of the deceased author, in extension for 14 years. Renewal no. 1395. Jan. 4, 1911. Renewal entry, May 13, 1897, no. 29206. **5**

Through by daylight; or, The young engineer of the Lake shore railroad, by Oliver Optic [pseud.] (The lake shore series)
© by Alice Adams Russell, New York, N. Y., as the child of the deceased author, in extension for 14 years. Renewal no. 1398. Jan. 4, 1911. Renewal entry, May 13, 1897, no. 29203. **6**

[Ahn, Franz]

Ahn's American interpreter. Ahn's amerikanischer dolmetscher für Deutsche, zum erlernen der englischen sprache ohne lehrer ... New York, E. Steiger & co.
© by E. Steiger, New York, N. Y., as author, in renewal for 28 years. Renewal no. 1482. Jan. 14, 1911. Original entry, Oct. 29, 1883, no. 19941. **7**

Alden, William L.

The cruise of the canoe club. Illustrated.

© by Agnes M. Alden, °/° Harper & bros., New York, N. Y., as the widow of the author, in renewal for 28 years. Renewal no. 1498. Jan. 10, 1911. Original entry, Apr. 19, 1883, no. 7328. 8

Baldwin, James.

The story of Roland.

© by J. Baldwin, East Orange, N. J., as author, in renewal for 28 years. Renewal no. 1489. Jan. 14, 1911. Original entry, June 1, 1883, no. 9960.
 9

Baldwin, John D.

Pre-historic nations; or, Inquiries concerning some of the great peoples and civilizations of antiquity, and their probable relation to a still older civilization of the Ethiopians or Cushites of Arabia.

© by Charles C. Baldwin, Worcester, Mass., as the child of the deceased author, in extension for 14 years. Renewal no. 1496. Jan. 10, 1911. Renewal entry, Dec. 9, 1896, no. 67092. 10

Beówulf, an Anglo-Saxon poem; The fight at Finnsburgh, a fragment: with text and glossary on the basis of M. Heyne, ed., corrected and enlarged by James A. Harrison and Robert Sharp.

© by James A. Harrison, Charlottesville, Va., and Robert Sharp, New Orleans, La., as authors, in renewal for 28 years. Renewal no. 1414. Jan. 7, 1911. Original entry, May 3, 1883, no. 8121. 11

Bishop, William Henry.

Old Mexico and her lost provinces.

© by W. H. Bishop, °/° Harper & bros., New York, N. Y., as author, in renewal for 28 years. Renewal no. 1501. Jan. 10, 1911. Original entry, Sept. 15, 1883, no. 16951. 12

Briggs, Charles A.

Biblical study; the principles, methods and history of its several·departments together with a catalogue of books of reference.

© by C. A. Briggs, New York, N. Y., as author, in renewal for 28 years. Renewal no. 1491. Jan. 14, 1911. Original entry, Sept. 28, 1883, no. 17774. 13

Brooks, Phillips.

·Sermons preached in English churches.

© by William G. Brooks, Boston, Mass., as executor, in renewal for 28 years. Renewal no. 1410. Jan. 7, 1911. Original entry, Sept. 26, 1883, no. 17654. 14

Browning, Robert.

Lyrical and dramatic poems, selected from the works of Robert Browning. With an extract from Stedman's Victorian poets. Ed. by Edward T. Mason.

© by Edward T. Mason, Ossining, N. Y., as the author, in renewal for 28 years. Renewal no. 1440. Jan. 6, 1911. Original entry, Jan. 18, 1883, no. 1242. 15

Carlyle, Thomas.

The correspondence of Thomas Carlyle and Ralph Waldo Emerson, 1834-1872. [Ed. by Charles Eliot Norton] 2. v.

© by Eliot, Sara, Elizabeth Gaskell, Rupert, Margaret, and Richard Norton, New York, N. Y., as the children of the deceased author, in renewal for 28 years. Renewal nos. 1532, 1533. Jan. 25, 1911. Original entries, Jan. 26, 1883, nos. 1816, 1817. **16, 17**

Clemens, Samuel L.

The innocents abroad; or, The new pilgrim's progress, being some account of the steamship "Quaker City's" pleasure excursion to Europe and the Holy Land. By Mark Twain [pseud.] Illustrated.

© by Clara Gabrilowitsch, °/° Harper & bros., New York, N. Y., as the child of the deceased author, in extension for 14 years. Renewal no. 1495. Jan. 10, 1911. Renewal entry, July 14, 1897, no. 40845. **18**

Life on the Mississippi, by Mark Twain [pseud.] With more than 300 illustrations.

© by Clara Gabrilowitsch, °/° Harper & bros., New York, N. Y., as the child of the deceased author, in renewal for 28 years. Renewal no. 1494. Jan. 10, 1911. Original entry, Jan. 18, 1883, no. 1259. **19**

Dodge, Mary Mapes.

Donald and Dorothy. With original illustrations.

© by James Mapes Dodge, Germantown, Pa., as the child of the deceased author, in renewal for 28 years. Renewal no. 1408. Jan. 6, 1911. Original entry, Nov. 16, 1883, no. 21249. **20**

Du Bois, A. Jay.

Strains in framed structures, with numerous practical applications to cranes, bridge, roof, etc. (Mechanics of engineering. v. 2)

© by A. J. Du Bois, New Haven, Conn., as author, in renewal for 28 years. Renewal no. 1444. Jan. 4, 1911. Original entry, June 27, 1883, no. 11843. **21**

Ely, Richard T.

French and German socialism in modern times.

© by R. T. Ely, °/° Harper & bros., New York, N. Y., in renewal for 28 years. Renewal no. 1500. Jan. 10, 1911. Original entry, Sept. 7, 1883, no. 16337. **22**

Fisher, George P.

The grounds of theistic and Christian belief.

© by Charlotte R. Pepper, Philadelphia, Pa., as the child of the deceased author, in renewal for 28 years. Renewal no. 1492. Jan. 14, 1911. Original entry, Sept. 21, 1883, no. 17375. **23**

Fletcher, John.

The two noble kinsmen, written by the memorable worthies of their time, Mr. John Fletcher and Mr. William Shakespeare, gent. Ed., with notes, by William J. Rolfe.

© by John C. Rolfe, Philadelphia, Pa., as the child of the deceased author, in renewal for 28 years. Renewal no. 1446. Jan. 11, 1911. Original entry, Jan. 30, 1883, no. 1994. **24**

Gilman, Daniel C.
James Monroe in his relations to the public service during a half century, 1776 to 1826. (American statesmen)

© by Elizabeth D. W. Gilman, Baltimore, Md., as the widow of the author, in renewal for 28 years. Renewal no. 1551. Jan. 25, 1911. Original entry, Feb. 19, 1883, no. 3351. **25**

Hanshew, Thomas W.
A living lie; or, The grave between them.

© by T. W. Hanshew, London, England, as author, in renewal for 28 years. Renewal no. 1452. Jan. 13, 1911. Original entry in Family story paper, Feb. 19, 1883; Feb. 6, 1883, no. 2498. **26**

The ocean of life; or, Broken hearts and broken vows.

© by T. W. Hanshew, London, England, as author, in renewal for 28 years. Renewal no. 1451. Jan. 13, 1911. Original entry in Family story paper, Aug. 27, 1883; Sept. 1, 1883, no. 16069. **27**

A wedded widow; or, The love that lives.

© by T. W. Hanshew, London, England, as author, in renewal for 28 years. Renewal no. 1434. Jan. 6, 1911. Original entry in Street and Smith's New York weekly, Apr. 9–July 16, 1883; Mar. 27, 1883, no. 5642, to July 5, 1883, no. 12324. **28**

Young Mrs. Charnleigh; or, The dark prophecy.

© by T. W. Hanshew, London, England, as author, in renewal for 28 years. Renewal no. 1435. Jan. 6, 1911. Original entry in Street and Smith's New York weekly, Jan. 22–Apr. 9, 1883; Jan. 15, 1883, no. 910, to Mar. 27, 1883, no. 5642. **29**

Hay, John.
The bread winners; a social study.

© by Clara S. Hay, Washington, D. C., as the widow of the author, in renewal for 28 years. Renewal no. 1505. Jan. 14, 1911. Original entry, Dec. 3, 1883, no. 22258. **30**

Kidd, Robert.
New elocution and vocal culture.

© by Robert J. Kidd, Flagstaff, Ariz., as the child of the deceased author, in renewal for 28 years. Renewal no. 1507. Jan. 18, 1911. Original entry, Jan. 25, 1883, no. 1691. **31**

Klemm, L. R.
Elementary German reader. Ed. by W. D. Whitney. (Whitney-Klemm German series)

© by L. R. Klemm, Washington, D. C., as author, in renewal for 28 years Renewal no. 1438. Jan. 6, 1911. Original entry, Jan. 11, 1883, no. 668. **32**

Knapp, William I.
Modern French readings, ed. by William I. Knapp.

© by Adeline R. Knapp, New York, N. Y., as the widow of the author, in renewal for 28 years. Renewal no. 1413. Jan. 7, 1911. Original entry, Sept. 6, 1883, no. 16261. **33**

Modern Spanish readings, embracing text, notes and an etymological vocabulary.

© by Adeline R. Knapp, New York, N. Y., as the widow of the author, in renewal for 28 years. Renewal no. 1412. Jan. 7, 1911. Original entry, May 26, 1883, no. 9707. **34**

Knox, Thomas W.

Adventures of two youths in a journey through Africa.
Illustrated. (Boy travellers in the Far East. pt. 5)

© by Emily J. G. Chapman, Philadelphia, Pa., as the next of kin of the
author who is not living, in renewal for 28 years. Renewal no. 1504.
Jan. 14, 1911. Original entry, Aug. 11, 1883, no. 14874. 35

Lacombe, Paul.

The growth of a people; a short study in French his-
tory, by Paul Lacombe. A translation of the Petite his-
toire du peuple française by Lewis A. Stimson.

© by Lewis A. Stimson, New York, N. Y., as author, in renewal for 28
years. Renewal no. 1442 Jan. 6, 1911. Original entry, May 10, 1883,
no. 8588. 36

Lanier, Sidney.

The English novel and the principle of its development.

© by Mary D. Lanier, Greenwich, Conn., as the widow of the author, in
renewal for 28 years. Renewal no. 1487. Jan. 14, 1911. Original entry,
Apr. 24, 1883, no. 7657. 37

Lowry, Robert.

The gates of day; a service of Scripture and song for
Easter-tide.

© by Mary Runyon Lowry, Plainfield, N. J., as the widow of the author,
in renewal for 28 years. Renewal no. 1562. Feb. 1, 1911. Original
entry, Feb. 3, 1883, no. 2271. 38

Luther, Martin.

Dr. Martin Luther's Small catechism with explana-
tions; to which is appended the Confession of faith ... tr.
from the German. New York, J. E. Stohlmann. (Edi-
tion with explanations and Bible verses, no. 3)

© by Theodore Stohlmann, New York, N. Y., as the child of the deceased
author, in renewal for 28 years. Renewal no. 1537. Jan. 23, 1911.
Original entry, Aug. 22, 1883, no. 15450. 39

Same. German and English editions combined. New
York, J. E. Stohlmann. (Edition with explanations and
Bible verses, no. 3)

© by Theodore Stohlmann, New York, N. Y., as the child of the deceased
author, in renewal for 28 years. Renewal no. 1538. Jan. 23, 1911. Orig-
inal entry, Aug. 22, 1883, no. 15451. 40

Miller, *Mrs.* Alexander McVeigh.

Sworn to silence; or, Aline Rodney's secret. chap.
1-56, 60–62.

© by Mrs. Alex. McVeigh Miller, Forest Hills, Mass., as author, in re-
newal for 28 years. Renewal no. 1433. Jan. 6, 1911. Original entry in
New York fireside companion, Oct. 1, 1883, to Jan. 7, 1884, and Jan. 21,
1884; Sept. 12, 1883, no. 16681, to Dec. 19, 1883, no. 23580, and Dec. 28,
1883, no. 24481. 41

91

Müller, C. C.

Tables for the writing of elementary exercises in the study of harmony; arr. in conformity with S. Siehter's Fundamental harmonies. (Second series, Harmonization of melodies)

© by C. C. Müller, New York, N. Y., as author, in renewal for 28 years. Renewal no. 1506. Jan. 16, 1911. Original entry, Nov. 30, 1883, no. 22031. **42**

Newcomb, Simon.

Astronomy, by Simon Newcomb and Edward S. Holden. (American science series, Briefer course)

© by Anita Newcomb McGee, Washington, D. C., as the child of the deceased author, and Edward S. Holden, West Point, N. Y., as author, in renewal for 28 years. Renewal no. 1443. Jan. 6, 1911. Original entry, Sept. 20, 1883, no. 17296. **43**

Newell, William Wells.

Games and songs of American children, coll. and compared by William Wells Newell.

© by Robert B. Stone, Boston, Mass., as executor, in renewal for 28 years. Renewal no. 1497. Jan. 10, 1911. Original entry, Mar. 15, 1883, no. 4812. **44**

Perry, Thomas Sergeant.

English literature in the eighteenth century.

© by T. S. Perry, Boston, Mass., as author, in renewal for 28 years. Renewal no. 1502. Jan. 14, 1911. Original entry, Jan. 30, 1883, no. 1995. **45**

Phelps, Austin.

English style in public discourses with special reference to the usages of the pulpit.

© by Lawrence Phelps, Atlanta, Ga., as the child of the deceased author, in renewal for 28 years. Renewal no. 1486. Jan. 14, 1911. Original entry, Apr. 24, 1883, no. 7656. **46**

Pinkerton, Allan.

The spy of the rebellion.

© by Joan Chalmers, Chicago, Ill., as the child of the deceased author, in renewal for 28 years. Renewal no. 1411. Jan. 6, 1911. Original entry, Jan. 8, 1883, no. 450. **47**

Pyle, Howard.

Merry adventures of Robin Hood, written and illustrated by Howard Pyle.

© by H. Pyle, Wilmington, Del., as author, in renewal for 28 years. Renewal no. 1488. Jan. 14, 1911. Original entry, May 17, 1883, no. 9137. **48**

Quincy, Josiah.

Figures of the past from the leaves of old journals, by Josiah Quincy and Josiah P. Quincy.

© by Josiah Quincy and M. A. De Wolfe Howe, Boston, Mass., as executors, in renewal for 28 years. Renewal no. 1453. Jan. 12, 1911. Original entry, Jan. 29, 1883, no. 1883. **49**

Schaff, Philip.

History of the Christian church. A new ed. thoroughly rev. and enl. v. 2.

© by David S. Schaff, Pittsburg, Pa., as the child of the deceased author, in renewal for 28 years. Renewal no. 1485. Jan. 14, 1911. Original entry, Oct. 31, 1883, no. 20115. 50

Schouler, James.

A treatise on the law of executors and administrators.

© by J. Schouler, Boston, Mass., as author, in renewal for 28 years. Renewal no. 1566. Feb. 2, 1911. Original entry, Apr. 16, 1883, no. 7155. 51

Sewall, Frank.

Moody Mike; or, The power of love.

© by F. Sewall, Washington, D. C., as author, in extension for 14 years. Renewal no. 1468. Jan. 11, 1911. Renewal entry, June 4, 1897, no. 33786. 52

Shakespeare, William.

Shakespeare's comedy of the merchant of Venice. Ed., with notes, by William J. Rolfe.

© by John C. Rolfe, Philadelphia, Pa., as the child of the deceased author, in renewal for 28 years. Renewal no. 1450. Jan. 11, 1911. Original entry, Oct. 16, 1883, no. 19075. 53

Shakespeare's history of Pericles, prince of Tyre. Ed., with notes, by William J. Rolfe.

© by John C. Rolfe, Philadelphia, Pa., as the child of the deceased author, in renewal for 28 years. Renewal no. 1447. Jan. 11, 1911. Original entry, Jan. 31, 1883, no. 2020. 54

Shakespeare's sonnets. Ed., with notes, by William J. Rolfe.

© by John C. Rolfe, Philadelphia, Pa., as the child of the deceased author, in renewal for 28 years. Renewal no. 1449. Jan. 11, 1911. Original entry, June 22, 1883, no. 11425. 55

Shakespeare's tragedy of Titus Andronicus. Ed., with notes, by William J. Rolfe.

© by John C. Rolfe, Philadelphia, Pa., as the child of the deceased author, in renewal for 28 years. Renewal for 28 years. Renewal no. 1445. Jan. 11, 1911. Original entry, Nov. 20, 1883, no. 21532. 56

Shakespeare's Venus and Adonis, Lucrece, and other poems. Ed. with notes, by William J. Rolfe.

© by John C. Rolfe, Philadelphia, Pa., as the child of the deceased author, in renewal for 28 years. Renewal no. 1448. Jan. 11, 1911. Original entry, Mar. 15, 1883, no. 4811. 57

Sharkey, *Mrs.* Emma Augusta (Brown)

A beautiful fiend; or, Bound to destroy, by Mrs. E. Burke Collins.

© by Wm. J. Benners, Philadelphia, Pa., as executor, in renewal for 28 years. Renewal no. 1436. Jan. 13, 1911. Original entry in New York family story paper, June 18–Aug. 20, 1883; June 4, 1883, no. 10155, to Aug. 6, 1883, no. 14626. 58

Stoddard, John T.

An outline of qualitative analysis for beginners.

© by J. T. Stoddard, Northampton, Mass., as author, in renewal for 28 years. Renewal no. 1565. Feb. 2, 1911. Original entry, Feb. 6, 1883, no. 2497. 59

Stoddard, William O.

Among the lakes.

© by W. O. Stoddard, Madison, N. J., as author, in renewal for 28 years. Renewal no. 1490. Jan. 14, 1911. Original entry, Aug. 14, 1883, no. 14978. 60

Sumner, William Graham.

What social classes owe to each other.

© by Jeannie W. Sumner, ℅ Harper & bros., New York, N. Y., as the widow of the author, in renewal for 28 years. Renewal no. 1503. Jan. 14, 1911. Original entry, July 14, 1883, no. 12984. 61

Swinton, William.

Swinton's primer and first reader.

© by Jean Swinton Kelley, Brooklyn, N. Y., as the child of the deceased author, in renewal for 28 years. Renewal no. 1392. Jan. 3, 1911. Original entry, Jan. 5, 1883, no. 268. 62

Terhune, Mary V.

The cottage kitchen, by Marion Harland [pseud.] (Common sense in the household series)

© by M. V. Terhune, New York, N. Y., as author, in renewal for 28 years. Renewal no. 1493. Jan. 14, 1911. Original entry, Oct. 4, 1883, no. 18152. 63

U. S. *Supreme court.*

Reports of cases argued and decided ... Complete ed. with notes and references. Book 8, containing Peters, vols. 5, 6, 7 and 8.

© by Lawyers cooperative pub. co., Rochester, N. Y., as proprietors, in renewal for 28 years. Renewal no. 1415. Jan. 6, 1911. Original entry, Jan. 22, 1883, no. 1446. 64

Same. Complete ed. with notes and references by Stephen K. Williams. Book 9, containing Peters, vols. 9, 10, 11 and 12.

© by Lawyers cooperative pub. co., Rochester, N. Y., as proprietors, in renewal for 28 years. Renewal no. 1416. Jan. 6, 1911. Original entry, Mar. 10, 1883, no. 4482. 65

Same. Complete ed. with notes and references by Stephen K. Williams. Book 10, containing Peters, vols. 13, 14, 15 and 16.

© by Lawyers cooperative pub. co., Rochester, N. Y., as proprietors, in renewal for 28 years. Renewal no. 1417. Jan. 6, 1911. Original entry, Apr. 28, 1883, no. 7908. 66

Same. Complete ed. with notes and references by Stephen K. Williams. Book 11, containing Howard, vols. 1, 2, 3 and 4, and general index to notes to books 1 to 11.

© by Lawyers cooperative pub. co., Rochester, N. Y., as proprietors, in renewal for 28 years. Renewal no. 1418. Jan. 6, 1911. Original entry, June 18, 1883, no. 11046. 67

511–646

LIBRARY OF CONGRESS

COPYRIGHT OFFICE

CATALOGUE

OF

COPYRIGHT ENTRIES

PUBLISHED WEEKLY BY AUTHORITY OF THE ACTS OF CONGRESS
OF MARCH 3, 1891, OF JUNE 30, 1906, AND
OF MARCH 4, 1909

PART 1, GROUP 1

BOOKS

1911

New Series, Volume 8, No. 5

WASHINGTON
GOVERNMENT PRINTING OFFICE
LIBRARY DIVISION
1911

Published March 2, 1911

BOOKS

GROUP 1

Adams, John Duncan, 1879–

Arts-crafts lamps, by John D. Adams ... Chicago, Popular mechanics co. [c1911]

87 p. illus. 18cm. (Popular mechanics twenty-five cent handbook series) $0.25

© Jan. 23, 1911; 2c. Jan. 25, 1911; A 280358; Henry H. Windsor, Chicago, Ill. (11–1741). **511**

The **American** digest annotated, key-number series. v. 9 ... April 1, 1910, to August 31, 1910 ... Prepared and ed. by the editorial staff of the American digest system. St. Paul, West publishing co., 1911.

xii, 3283 p. 26½cm. (American digest system. Key-number series) $6.00

© Feb. 7, 1911; 2c. Feb. 21, 1911; A 280919; West pub. co., St. Paul, Minn. **512**

American society for testing materials.

... Proceedings of the 13th annual meeting held at Atlantic City, N. J., June 28–July 2, 1910. v. 10. Ed. by the secretary under the direction of the Committee on publications. Philadelphia, Pa., The Society, 1910.

671 p. illus., plates, port., fold. tab., diagrs. 24cm. $5.00

© Feb. 8, 1911; 2c. Feb. 11, 1911; A 280730; American society for testing materials, Philadelphia, Pa. **513**

The **American** state reports, containing the cases of general value and authority ... decided in the courts of last resort of the several states. Selected, reported, and annotated by A. C. Freeman. v. 135. San Francisco, Bancroft-Whitney company, 1911.

15 p., 1 l., 17–1214 p. 23cm. $4.00

© Feb. 10, 1911; 2c. Feb. 16, 1911; A 280826; Bancroft-Whitney co., San Francisco, Cal. **514**

The **American** year book; a record of events and progress 1910. [v. 1] ... New York and London, D. Appleton and company, 1911.

xx, 867 p. 20½cm.

Editor: S. N. D. North ... under direction of a supervisory board representing national learned societies.

© Jan. 23, 1911; 2c. Jan. 28, 1911; A 280425; D. Appleton & co., New York, N. Y. (11–1626) **515**

Architectural league of New York.

... Catalogue of the 26th annual exhibition. Galleries of the American fine arts society ... from January 29 to February 18, inclusive, 1911. ₍New York, Press of Redfield brothers, inc., 1911₎

308 p. col. front., illus., diagrs. 33½ᶜᵐ. $1.00
© Jan. 27, 1911; 2c. Feb. 4, 1911; A 280632; Stowe Phelps, sec. of the Architectural league of New York, New York, N. Y. 516

Axenfeld, Theodor i. e. Karl Theodor Paul Polykarpos, 1867– ed.

Lehrbuch der augenheilkunde, bearb. von prof. Axenfeld ... prof. Bach ... ₍u. a.₎ hrsg. von dr. Theodor Axenfeld ... 2. aufl., mit 11 farbentafeln und 455 zum grossen teil mehrfarbigen abbildungen im text. Jena, G. Fischer, 1910.

xvi, 708 p. illus. (partly col.) xi col. pl. 26ᶜᵐ. M.14
© Dec. 30, 1910; 2c. Feb. 2, 1911; A—Foreign 2432; Gustav Fischer, Jena, Germany. (11–1804) 517

Bailey, Liberty Hyde, 1858– ed.

... Farm and forest, ed. by Liberty Hyde Bailey ... Boston, Hall and Locke company ₍ᶜ1911₎

xxviii, 387, ₍1₎ p. incl. col. front. col. plates. 21ᶜᵐ. (*Added t.-p.:* Young folks library ... Vocations. W. D. Hyde ... editor-in-chief ... ₍vol. III₎)
At head of title: Vocations.
"Supplementary readings": 1 p. at end.
© Jan. 14, 1911; 2c. Jan. 20, 1911; A 280239; Hall & Locke co., Boston, Mass. (11–1670) 518

Baker, William Washington, 1844–

Memoirs of service with John Yates Beall, c. s. n., by W. W. Baker ... ed., with an introduction by Douglas Southall Freeman, ph. d. Richmond, Va., The Richmond press, 1910.

69 p. 2 port. (incl. front.) 25ᶜᵐ.
© Jan. 18, 1911; 2c. Jan. 18, 1911; A 280543; Dogulas S. Freeman, Richmond, Va. (11–1624) 519

Baumann, Heinrich.

... Englisch zur schnellsten aneignung der umgangssprache durch selbstunterricht, reisesprachführer, konversationsbuch, grammatik und wörterbuch, gespräche, auch zur anwendung für sprechmaschinen, verfasst von H. Baumann ... 16. bis 20. tausend. Berlin-Schöneberg, Langenscheidt ₍ᶜ1910₎

lxxx, 352 p. 16ᶜᵐ. M. 3
At head of title: Methode Toussaint-Langenscheidt. Der kleine Toussaint-Langenscheidt, mit angabe der aussprache nach dem phonetischen system der Methode Toussaint-Langenscheidt.
Inserted: "Leserost zum Kleinen Toussaint-Langenscheidt," a contrivance of black pasteboard intended to make the single lines more distinct.
© Dec. 23, 1910; 2c. Jan. 19, 1911; A—Foreign 2340; Langenscheidtsche verlagsbuchhandlung (Prof. G. Langenscheidt) Berlin-Schöneberg, Germany. (11–1747) 520

Bergner, Heinrich.

Grundriss der kunstgeschichte, von Heinrich Bergner; mit 443 abbildungen und 5 farbentafeln. Leipzig, E. A. Seemann, 1911.

viii, 333 p. incl. illus., pl. v col. pl. (incl. front.) 24½ᶜᵐ. M. 2.80
© Jan. 16, 1911; 2c. Feb. 2, 1911; A—Foreign 2430; E. A. Seemann, Leipzig, Germany. (11–1805) 521

Bible. *N. T. Matthew. English.*

... Commentary on the Gospel according to Matthew, by A. T. Robertson ... New York, The Macmillan company, 1911.

xiii, 294 p. front. (map) 17ᶜᵐ. (*Half-title:* The Bible for home and school, S. Mathews, general editor) $0.60
© Jan. 25, 1911; 2c. Jan. 26, 1911; A 280364; Macmillan co., New York, N. Y. (11–1838) 522

Black, James.

The pilgrim ship, by the Rev. James Black ... London, Hodder & Stoughton, 1910.

viii, 359 p. 20½ᶜᵐ. $1.50
On cover: Advance copy.
© 1c. Dec. 27, 1910; A ad int. 437; published Nov. 24, 1910; George H. Doran co., New York, N. Y. (11–1765) 523

Blackwelder, Eliot, 1880–

Elements of geology, by Eliot Blackwelder ... and Harlan H. Barrows ... New York, Cincinnati [etc.] American book company [°1911]

475 p. illus. (incl. maps) 20ᶜᵐ. $1.40
Contains "References."
© Jan. 31, 1911; 2c. Feb. 2, 1911; A 280523; E. Blackwelder, Madison, Wis., and H. H. Barrows, Chicago, Ill. (11–1735) 524

Boll, Robert H.

... Lessons on Hebrews, by R. H. Boll. Nashville, Tenn., McQuiddy printing company, 1910.

3 p. l., [5]–225 p. 19½ᶜᵐ. $1.00
© Jan. 6, 1911; 2c. Jan. 19, 1911; A 280275; R. H. Boll, Nashville, Tenn. (11–1834) 525

Boulton, William]

The family strawberry patch and the way to make it a success. [Alpena? Mich.] °1911·

1 p. l., 62 p. 14½ᶜᵐ. $0.50
Running title: Strawberry culture. By William Boulton.
© Jan. 3, 1911; 2c. Jan. 7, 1911; A 278959; W. Boulton, Alpena, Mich. (11–1671) 526

Breckenridge, Bertha Anna (Kelsey) *"Mrs.* J. Breckenridge," 1852–

Mahanomah, by Mrs. John Breckenridge. New York, Cochrane publishing company, 1910.

128 p. 19ᶜᵐ. $1.25
© Jan. 3, 1911; 2c. Jan. 28, 1911; A 280417; Cochrane pub. co., New York, N. Y. (11–1798) 527

97

Brunot, Ferdinand.

... Histoire de la langue française, des origines à 1900. t. 3. La formation de la langue classique (1600–1660) 2me ptie. Paris, Librairie A. Colin, 1911.

2 p. l., [421]–738 p. 25½cm. fr. 7.50

© Feb. 3, 1911; 2c. Feb. 18, 1911; A—Foreign 2515; Max Leclerc & H. Bourrelier, Paris, France. **528**

Buchner, Georg.

Das ätzen und färben der metalle; kleines lehrbuch der oberflächenbehandlung der metalle und legierungen durch ätzen und färben, von Georg Buchner ... Berlin, M. Krayn, 1911.

6 p. l., 99, [8] p. 23½cm. M. 2.50

© Jan. 5, 1911; 2c. Jan. 20, 1911; A—Foreign 2413; M. Krayn, Berlin, Germany. (11-1775) **529**

Caldwell, Frederick Perry, 1875– comp.

The complete Kentucky form book of both legal and business forms, including all forms of procedure authorized under the statutes and the civil and criminal codes of the state of Kentucky, and all business forms, such as forms of affidavits, bonds, contracts ... etc., annotated with notes containing references to decisions in point, and to the sections of the statutes and codes on which the forms are based, by Fred P. Caldwell ... Cincinnati, The W. H. Anderson company, 1911.

2 v. 26½cm. $15.00

© Feb. 1, 1911; 2c. each Feb. 2, 1911; A 280547, 280548; W. H. Anderson co., Cincinnati, O. (11-1656) **530, 531**

Callaghan & company's cumulative quarterly to Simmons' new Wisconsin digest, ed. by Gilson G. Glasier ... [v. 1, no. 3, November, 1910] Chicago, Callaghan & company, 1911.

2 p. l., 246 p. 25½cm. $4.00

© Feb. 2, 1911; 2c. Feb. 11, 1911; A 280731; Callaghan & co., Chicago, Ill. **532**

Campbell, Benjamin J.

Essentials of business English, by Benjamin J. Campbell ... and Bruce L. Vass. [Battle Creek, Mich., Ellis publishing co.] c1910.

2 p. l., 131, vii p. 20½cm. $0.65

"List of books consulted": p. vii.

© Dec. 27, 1910; 2c. Jan. 4, 1911; A 280073; B. J. Campbell and B. L. Vass, Jackson, Mich. (11-1757) **533**

Capus, Alfred.

... Théâtre complet. 5. Notre jeunesse, Le beau jeune homme, Les passagères. Paris, A. Fayard [1911]

430, [2] p. 19cm. fr. 3.50

© Jan. 20, 1911; 2c. Feb. 18, 1911; A—Foreign 2506; Arthème Fayard, Paris, France. **534**

Carter, Ada.

Priest and layman, by Ada Carter ... London, T. W. Laurie [°1911]

3 p. l., xi-xii, 275, [1] p. 19½ᶜᵐ. 6/

© 1c. Feb. 9, 1911; A ad int. 475; published Jan. 10, 1911; Wessels & Bissell co., New York, N. Y. (11-1760) 535

Chalmers, Stephen, 1880–

The trail of a tenderfoot, by Stephen Chalmers; illustrations by H. T. Dunn, C. F. Peters and J. M. Gleeson. New York, Outing publishing company, 1911.

234 p. incl. front., illus. 19½ᶜᵐ. $1.25

© Feb. 1, 1911; 2c. Feb. 6, 1911; A 280612; Outing pub. co., New York, N. Y. (11-1645) 536

Clough, Edwin H.

"Ramona's marriage place," the house of Estudillo, by Edwin H. Clough, with illustrations and decorations by Virginia Goodrich. Chula Vista, Cal., Denrich press [°1910]

[35] p. front., illus., plates. 18 x 25½ᶜᵐ. $1.00

© Dec. 27, 1910; 2c. Jan. 3, 1911; A 278875; Denrich press, Chula Vista, Cal. (11-1627) 537

Comstock, William Phillips, *comp.*

Garages and motor boat houses, comprising a large number of designs for both private and commercial buildings ... contributed by architects from different sections of the United States, comp. by Wm. Phillips Comstock ... New York, The William T. Comstock company [°1911]

121 p. illus., plans. 26½ᶜᵐ. $2.00

© Jan. 28, 1911; 2c. Feb. 1, 1911; A 280504; Wm. T. Comstock co., New York, N. Y. (11-1809) 538

Corkey, Alexander.

The victory of Allan Rutledge; a tale of the middle West, by Alexander Corkey; photogravure illustrations by Florence Rutledge Wilde. New York, The H. K. Fly company [°1910]

319 p. front., plates. 19ᶜᵐ. $1.50

© Nov. 15, 1910; 2c. Feb. 7, 1911; A 280635; H. K. Fly co., New York, N. Y. (11-1646) 539

Cotton, Howard Preble.

We three; a tale of the Erie canal, by Howard Preble Cotton; with illustrations by R. I. Conklin. Boston, Mass., The C. M. Clark publishing company [°1910]

2 p. l., 297, [1] p. front., plates. 19½ᶜᵐ. $1.50

© Nov. 16, 1910; 2c. Feb. 11, 1911; A 280734; C. M. Clark pub. co., Boston, Mass. (11-1797) 540

Coursier, Édouard.

Handbuch der französischen umgangssprache für Franzosen und Deutsche, von Éduard Coursier. 32. aufl. unter berücksichtigung des erlasses des französischen Unterrichtsministeriums vom 31. juli 1901 neubearb. und verm. von professor Paul Banderet. Berlin-Schöneberg, Langenscheidt [c1910]

vi p., 1 l., 624 p. 16½ᶜᵐ. M. 3

Added t.-p. in French.

© Dec. 23, 1910; 2c. Jan. 19, 1911; A—Foreign 2352; Langenscheidtsche verlagsbuchhandlung (G. Langenscheidt) Berlin-Schöneberg, Germany. (11-1746) 541

Crockett, Cary Ingram, 1878–

A working knowledge of Spanish, by Lieutenant Cary I. Crockett ... Menasha, Wis., George Banta publishing company [c1910]

100 p. 19½ᶜᵐ.

© Jan. 21, 1910; 2c. Jan. 23, 1911; A 280351; C. I. Crockett, Ft. Thomas, Ky. (11-1630) 542

Davenport, Charles Benedict, 1866–

Elements of zoology, to accompany the field and laboratory study of animals, by Charles Benedict Davenport ... and Gertrude Crotty Davenport ... with four hundred and twenty-one illustrations. Rev. ed. New York, The Macmillan company, 1911.

x p., 1 l., 508 p. col. front., illus. 19ᶜᵐ. $1.25

"A list of books dealing chiefly with ecological and systematic zoology of American animals": p. 473–485.

© Feb. 1, 1911; 2c. Feb. 2, 1911; A 280518; Macmillan co., New York, N. Y. (11-1702) 543

Day, Charles.

... Industrial plants; their arrangement and construction, by Charles Day. New York, The Engineering magazine, 1911.

1 p. l., 294 p. illus., fold. plates. 19½ᶜᵐ. (Works management library) $3.00

© Jan. 31, 1911; 2c. Feb. 2, 1911; A 280525; John R. Dunlap, New York, N. Y. (11-1639) 544

Day, Holman Francis, 1865–

The skipper and the skipped; being the shore log of Cap'n Aaron Sproul, by Holman Day ... New York and London, Harper & brothers, 1911.

2 p l., 416 p., 1 l. front. 19½ᶜᵐ. $1.50

© Feb. 9, 1911; 2c. Feb. 11, 1911; A 280726; Harper & bros., New York, N. Y. (11-1800) 545

De Waters, *Mrs.* Lillian (Stephenson) 1883–

Auf der reise, von Lillian De Waters, aus dem englischen übersetzt von Meta Vogel Virtue. Stamford, Conn., L. De Waters [c1910]

2 p. l., 9–53 p. 18ᶜᵐ. $0.50

© Jan. 27, 1911; 2c. Feb. 1, 1911; A 280503; Mrs. L. De Waters, Stamford, Conn. (11–1665) 546

Dippe, Gustav von.

Auf grosswild. Jagd- und reiseabenteuer in den tro pen. Von Gustav von Dippe. Mit 24 vollbildern in lichtdruck u. 125 textillustrationen. Strassburg i. E. und Leipzig, J. Singer, 1911.

4 p. l., 360 p. front., illus., plates. ports. 24ᶜᵐ.

© Dec. 28, 1910; 2c. Jan. 23, 1911; A—Foreign 2409; Josef Singer, Strassburg, Germany. (11–1669) 547

The Druggists circular.

The modern materia medica; the source, chemical and physical properties, therapeutic action, dosage, antidotes and incompatibles of all additions to the newer materia medica that are likely to be called for on prescriptions, together with the name and address of the manufacturer or proprietor, and in the case of foreign articles, of the American agent. 2d ed., rev. and enl. New York, The Druggists circular, 1911.

iv p., 1 l., 432 p. 19ᶜᵐ. $1.25

© Jan. 28, 1911; 2c. Jan. 31, 1911; A 280470; Druggists circular, New York, N. Y. (11–1693) 548

Durley, Richard John.

Kinematics of machines; an elementary text-book, by R. J. Durley ... 2d ed., 1st thousand. New York, J. Wiley & sons; [etc., etc.] 1911.

viii, 397 p. illus., diagrs. 23½ᶜᵐ. $2.50

© Feb. 4, 1911; 2c. Feb. 8, 1911; A 280646; R. J. Durley, Montreal, Canada. (11–1774) 549

Ebbell, Bendix Joachim, 1869–

... Paa liv og død mot nord, fire aarhundreders eventyr fortalt for ungdom, med 21 illusrationer [!] og et kart. Kristiania og Kjøbenhavn, Gyldendalske boghandel, Nordisk forlag, 1910.

210 p. illus., fold. map. 20ᶜᵐ. kr. 3

"Benyttet literatur": p. [208]–210.

© Nov. 23, 1910; 2c. Jan. 21, 1911; A—Foreign 2376; Gyldendalske boghandel, Nordisk forlag, Christiania, Norway. (11–1706) 550

Eddy, Walter Hollis, 1877–

Experimental physiology and anatomy, by Walter Hollis Eddy ... Rev. ed. New York, Cincinnati [etc.] American book company [c1911]

119 p. illus. 18½ᶜᵐ. $0.60

© Feb. 6, 1911; 2c. Feb. 8, 1911; A 280657; W. H. Eddy, New York, N. Y. (11–1821) 551

101

{The Editor}
1001 places to sell manuscripts. 8th ed., rev. and enl.
Ridgewood, N. J., The Editor company, 1911.
2 p. l., 3–158 p. 19½ᶜᵐ. $1.00
© Jan. 28, 1911; 2c. Feb. 2, 1911; A 280532; Editor co., Ridgewood, N. J.
(11-1658) 552

The Electric journal. v. 7, January–December, 1910.
Pittsburg, Pa. {The Electric journal, 1911}
2 p. l., {3}–998, 46 p. illus., ports., diagrs. 23ᶜᵐ. $4.00
© Feb. 9, 1911; 2c. Feb. 10, 1911; A 280706; Electric journal, Pittsburg, Pa.
553

Elson, Henry William, 1857–
A guide to English history for young readers, by Henry
William Elson ... New York, The Baker & Taylor com-
pany, 1911.
viii, 298 p. front., plates, ports., maps (1 fold.) 19ᶜᵐ. $1.25
© Feb. 8, 1911; 2c. Feb. 10, 1911; A 280681; Baker & Taylor co., New
York, N. Y. (11-1814) 554

Escherich, Karl, 1871–
Termitenleben auf Ceylon; neue studien zur soziologie
der tiere zugleich ein kapitel kolonialer forstentomologie,
von K. Escherich ... mit einem systematischen anhang,
mit beiträgen von A. Forel, Nils Holmgren, W. Michael-
sen, F. Schimmer, F. Silvestri und E. Wasmann; mit 3
tafeln und 68 abbildungen im text. Jena, G. Fischer, 1911.
xxxii, 262 p., 1 l. illus. 3 pl. 24½ᶜᵐ. M. 6.50
"Literaturverzeichnis": p. {253}–255.
© Dec. 30, 1910; 2c. Feb. 2, 1911; A—Foreign 2427; Gustav Fischer, Jena,
Germany. (11-1824) 555

Fernández Gordiano, Samuel, 1883–
Discursos biblicos por el Rev. Samuel F. Gordiano ...
New York, Mayans & Carrion, 1910.
3 p. l., {vi}–viii p., 3 l., 112 p. front. (port.) 19ᶜᵐ. $1.00
© Jan. 15, 1911; 2c. Jan. 27, 1911; A 280392; S. Fernández Gordiano, New
York, N. Y. (11-1763) 556

Fiori, Annibale.
Handbuch der italienischen und deutschen konversa-
tionssprache; oder, Vollständige anleitung für Deutsche,
die sich im italienischen richtig und geläufig ausdrücken
wollen, auch ein vademecum für reisende, von Annibale
Fiori. 10. aufl., neu bearb. und mit einer kurzen italieni-
schen grammatik versehen, von G. Cattaneo ... Berlin-
Schöneberg, Langenscheidt {°1910}
xiv p., 1 l., 484 p. 16½ᶜᵐ. M. 3
Added t.-p. in Italian.
© Dec. 23, 1910; 2c. Jan. 19, 1911; A—Foreign 2355; Langenscheidtsche
verlagsbuchhandlung (G. Langenscheidt) Berlin-Schöneberg, Germany.
(11-1752) 557

Fitch, John Andrews.

... The steel workers, by John A. Fitch ... New York, Charities publication committee, 1910.

xiii, 380 p. incl. tables. front., plates, ports., map. 24ᶜᵐ. (The Pittsburgh survey; findings in six volumes, ed. by P. U. Kellogg) $1.50
At head of title: Russell Sage foundation.
© Feb. 1, 1911; 2c. Feb. 4, 1911; A 280580; Russell Sage foundation, New York, N. Y. (11–1781) 558

Gariner, F E.

Christhood and adeptship; a work giving the laws which lead to success and soul illumination, and will give the people the religion they have been looking for. The illumination of the soul. By F. E. Gariner and Dr. R. Swinburne Clymer. Allentown, Pa., The Philosophical publishing co. [ᶜ1910]

1 p. l., [5]–101 p. 23½ᶜᵐ. $0.75
© Dec. 26, 1910; 2c. Dec. 28, 1910; A 278999; R. Swinburne Clymer, Allentown, Pa. (11–1835) 559

Gautier, Émile Félix, 1864–

... La conquête du Sahara; essai de psychologie politique. Paris, A. Colin, 1910.

2 p. l., 259 p., 1 l. 19ᶜᵐ. fr. 3.50
© Dec. 30, 1910; 2c. Jan. 21, 1911; A—Foreign 2396; Max Leclerc and H. Bourrelier, Paris, France. (11–1719) 560

[Giesecke, Alfred] ed.

Schaffen und schauen, ein führer ins leben ... 2. aufl. ... Leipzig und Berlin, B. G. Teubner, 1911.

2 v. plates. 21½ᶜᵐ. M. 10
Vol. 1: 7.–13. tausend; v. 2: 7.–12. tausend.
CONTENTS.—1. Von deutscher art und arbeit.—2. Des menschen sein und werden.
© Jan. 2, 1911; 2c. Jan. 19, 1911; A—Foreign 2358; B. G. Teubner, Leipzig, Germany. (11–1810) 561

Gilbreth, Frank Bunker, 1868–

Motion study, a method for increasing the efficiency of the workman, by Frank B. Gilbreth ... with an introduction by Robert Thurston Kent ... New York, D. Van Nostrand company, 1911.

xxiii, 116 p. illus. 20ᶜᵐ. $2.00
© Jan. 19, 1911; 2c. Jan. 30, 1911; A 280462; D. Van Nostrand co., New York, N. Y. (11–1772) 562

Gout, Paul Émile, 1852–

... Le Mont-Saint-Michel, histoire de l'abbaye et de la ville, étude archéologique et architecturale des monuments ... Paris, A. Colin, 1910.

2 v. fronts. (v. 1 col.) illus., plates (partly col., partly double) maps, plans. 29ᶜᵐ. fr. 50
"Bibliographie": v. 2, p. [713]–730.
© Dec. 30, 1910; 2c. Jan. 21, 1911; A—Foreign 2384; Max Leclerc and H. Bourrelier, Paris, France. (11–1720) 563

Habershon, Ada R.
"Things concerning Himself"; sacred songs and Bible studies, by Ada R. Habershon ... New York, Fleming H. Revell company [c1910]
80 p. 19ᶜᵐ. $0.15
© Dec. 20, 1910; 2c. Jan. 18, 1911; A 280166; Chas. M. Alexander, Philadelphia, Pa. (11-1785) **564**

Hamersley, William, 1838–
The parting of the ways; suggestions on the constitution of the American union, by William Hamersley. Hartford, Conn., Priv. print. [The Case, Lockwood & Brainard company] 1911.
138 p. 24ᶜᵐ. $0.75
© Feb. 1, 1911; 2c. Feb. 4, 1911; A 280581; W. Hamersley, Hartford, Conn. (11-1682) **565**

Haring, Alexander.
Engineering law ... by Alexander Haring ... 1st ed., 1st thousand. v. 1. Chicago, The Myron C. Clark publishing co., 1910.
x p., 1 l., 518 p. 23½ᶜᵐ. $4.00
v. 1 © Feb. 1, 1911; 2c. Feb. 3, 1911; A 280566; Myron C. Clark pub. co., Chicago, Ill. (11-1640) **566**

Harmand, Jules i. e. **François Jules.**
... Domination et colonisation ... Paris, E. Flammarion, 1910.
2 p. 1., 370 p., 1 l. 19ᶜᵐ. (Bibliothèque de philosophie scientifique) fr. 3.50
© Dec. 28, 1910; 2c. Jan. 30, 1911; A—Foreign 2421; Ernest Flammarion, Paris, France. (11-1651) **567**

Havermyer, Alfred, 1840–
The conversion of John Stoneman, by Alfred Havermyer. [Berea, O., Berea printing company, c1910]
2 p. 1., 162 p. 24ᶜᵐ. $1.00
© Jan. 19, 1911; 2c. Jan. 23, 1911; A 280289; Berea printing co., Berea, O. (11-1644) **568**

Hermann, Isaac, 1838–
Memoirs of a veteran who served as a private in the 60's in the war between the states; personal incidents, experiences and observations, written by Capt. I. Hermann ... Atlanta, Ga., Byrd printing company, 1911.
285 p. incl. front. (port.) plates. 21ᶜᵐ.
© Jan. 31, 1911; 2c. Feb. 4, 1911; A 280578; I. Hermann, Sandersville, Ga. (11-1721) **569**

Heussi, Karl.
Kompendium der kirchengeschichte, von Karl Heussi ... 2. verb. aufl. Tübingen, J. C. B. Mohr (P. Siebeck) 1910.
xxxii, 612 p. 24½ᶜᵐ. M. 4
"Literatur-auswahl": p. xvi–xxxii.
© Dec. 28, 1910; 2c. Feb. 2, 1911; A—Foreign 2431; J. C. B. Mohr (Paul Siebeck) Tübingen, Germany. (11-1837) **570**

Hill, Edward Curtis, 1863–

A text-book of chemistry, for students and practition-
ers of medicine, pharmacy and dentistry, by Edward Cur-
tis Hill ... 2d thoroughly rev., rewritten and considerably
enl. ed. With 100 illustrations in the text and 14 full-page
half-tone and colored plates. Philadelphia, F. A. Davis
company, 1911.

xii, 659 p. illus., xiv pl. (partly col.) 24ᶜᵐ. $3.25
© Jan. 26, 1911; 2c. Jan. 30, 1911; A 280445; F. A. Davis co., Philadelphia,
Pa. (11–1700) 571

Hill, Sarah Chapman, 1875–

A cook book for nurses, by Sarah C. Hill ... 4th ed.,
rev. Boston, Whitcomb & Barrows, 1911.

4 p. l., 76 p. illus. 21½ᶜᵐ. $0.75
© Jan. 26, 1911; 2c. Feb. 1, 1911; A 280508; S. C. Hill, New Brunswick,
N. J. (11–1694) 572

Hiorth-Schøyen, Rolf.

... Maskerade. Kristiania og Kjøbenhavn, Gylden-
dalske boghandel, Nordisk forlag, 1910.

150 p. 20ᶜᵐ.
CONTENTS.—Kontoristens fortælling.—Den anonyme hviledag.—Maske-
rade.
© Nov. 16, 1910; 2c. Jan. 21, 1911; A—Foreign 2377; Gyldendalske bog-
handel, Nordisk forlag, Christiania, Norway. (11–1749) 573

Holcombe, Arthur Norman.

Public ownership of telephones on the continent of Eu-
rope, by A. N. Holcombe ... Awarded the David A. Wells
prize for the year 1909–10, and published from the income
of the David A. Wells fund. Boston and New York,
Houghton Mifflin company, 1911.

xx, 482 p., 1 l. 23ᶜᵐ. (Half-title: Harvard economic studies ... vol.
VI) $2.00
"Bibliographical appendix": p. [465]–470.
© Jan. 26, 1911; 2c. Feb. 7, 1911; A 280620; President and fellows of Har-
vard college, Cambridge, Mass. (11–1782) 574

Houghton, Stanley.

"Independent means"; a comedy in four acts, by Stan-
ley Houghton. New York [etc.] S. French, °1911.

87 p. plan. 18ᶜᵐ.
On cover: French's acting edition. no. 2378.
Author's port. on cover.
© Feb. 6, 1911; 2c. Feb. 7, 1911; D 23286; Samuel French, ltd., London,
England. (11–1745) 574*

Hughes, William Taylor.

Equity, its principles in procedure, codes and practice
acts, the prescriptive constitution, herefrom codes re-
affirm organic principles. These enumerated and dis-
cussed. An explication from fundamental maxims, illus-
trated by leading cases from the English, federal and

Hughes, William Taylor—Continued

best state decisions. The code a system reaffirming principles of the prescriptive constitution, regulated for simplification, unification and expedition. Limitations of legislative power, by William T. Hughes ... St. Louis, Mo., Central law journal co., 1911.
xxxv, 383, 427–610 p. 24½ᶜᵐ. $6.00
© Feb. 2, 1911; 2c. Feb. 7, 1911; A 280651; Edw. D'Arcy, St. Louis, Mo. (11–1841) 575

Hunter, George William, 1873–

Essentials of biology presented in problems, by George William Hunter ... New York, Cincinnati [etc.] American book company [ᶜ1911]
448 p. incl. front., illus., diagrs. 21ᶜᵐ. $1.25
Contains bibliographies.
© Jan. 31, 1911; 2c. Feb. 2, 1911; A 280522; G. W. Hunter, New York. N. Y. (11–1701) 576

Hutyra, Ferencz, 1860–

Spezielle pathologie und therapie der haustiere, von dr. Franz Hutyra ... und dr. Josef Marek ... 3. umgearb. und verm. aufl. ... Jena, G. Fischer, 1910.
2 v. illus. (partly col.) 15 fold. pl. (12 col.) 26ᶜᵐ. M. 50
Contains "Literatur."
CONTENTS.—1. bd. Infektionskrankheiten. Krankheiten des blutes und der blutbildung, der milz, des stoffwechsels, der harnorgane und der zirkulationsorgane.—2. bd. Krankheiten der atmungsorgane, der verdauungsorgane, des nervensystems, der bewegungsorgane und der haut.
© Dec. 30, 1910; 2c. each Feb. 2, 1911; A—Foreign 2457; Gustav Fischer, Jena, Germany. (11–1832) 577

Iglehart, *Mrs.* **Fanny (Chambers) Gooch**, 1851–

The boy captive of the Texas Mier expedition, by Fanny Chambers Gooch-Iglehart ... Rev., reprinted and republished by the author; illustrations by Bock. [San Antonio, Tex., Press of J. R. Wood printing co., ᶜ1909]
331 p. incl. col. front., illus., plates, ports. pl., map. 20ᶜᵐ. $1.25
© Dec. 24, 1910; 2c. Jan. 17, 1911; A 280457; Mrs. F. C. G. Iglehart, San Antonio, Tex. (11–1761) 578

The **Inglenook** cook book. New and rev. ed. Choice recipes contributed by sisters of the Church of the Brethren, subscribers and friends of the Inglenook magazine. Elgin, Ill., Brethren publishing house, 1911.
416 p. 21ᶜᵐ. $1.00
© Jan. 20, 1911; 2c. Feb. 1, 1911; A 280530; Brethren pub. house, Elgin, Ill. (11–1698) 579

James, Edmund Janes, 1855–

... The origin of the Land grant act of 1862 (the so-called Morrill act) and some account of its author, Jonathan B. Turner, by Edmund J. James ... Urbana-Champaign, University press [ᶜ1910]
139 p. 25ᶜᵐ. (University of Illinois. The University studies, vol. IV, no. 1) $0.75

James, Edmund Janes—Continued

"Books and articles published by the corps of instruction of the University of Illinois between May 1, 1909, and May 1, 1910" : p. ₍113₎–139.

Appendix A, Letter from Senator Morrill.—Appendix B, Extract from Forquer's letter.—Appendix C, The Turner pamphlet.

© Jan. 30, 1911; 2c. Feb 3, 1911; A 280396; University of Illinois, Urbana, Ill. (11–1828) 580

Jepson, Willis Linn.

A flora of western middle California, by Willis Linn Jepson ... 2d ed. San Francisco, Cunningham, Curtiss & Welch ₍1911₎

515 p. 20½ᶜᵐ. $2.50

© Jan. 25, 1911; 2c. Feb. 8, 1911; A 280652; W. L. Jepson, Berkeley, Cal. (11–1822) 581

Johnson, Emory Richard, 1864–

Railroad traffic and rates, by Emory R. Johnson ... and Grover G. Huebner ... New York and London, D. Appleton and company, 1911.

2 v. maps (partly fold.) forms (partly fold.) 21½ᶜᵐ. (Half-title: Appleton's railway series, ed. by E. R. Johnson) $5.00

Contains references.

CONTENTS.—v. 1. The freight service.—v. 2. Passenger, express, and mail services.

© Feb. 3, 1911; 2c. Feb. 9, 1911; A 280665; D. Appleton & co., New York, N. Y. (11–1844) 582

Jones, Philip Lovering, 1838–

Script and print; a practical primer for use in the preparation of manuscript and print, by Philip L. Jones ... Philadelphia, Boston ₍etc.₎ The Griffith & Rowland press ₍1911₎

54 p. 17½ᶜᵐ. $0.25

© Jan. 28, 1911; 2c. Feb. 1, 1911; A 280501; A. J. Rowland, sec., Philadelphia, Pa. (11–1756) 583

Krehbiel, Henry Edward, 1854–

... The pianoforte and its music, by Henry Edward Krehbiel ... with portraits and illustrations. New York, C. Scribner's sons, 1911.

ix, 314 p. front., illus., plates, ports. 19ᶜᵐ. (Half-title: The music lover's library) $1.25

© Jan. 14, 1911; 2c. Jan. 19, 1911; A 280322; Chas. Scribner's sons, New York, N. Y. (11–1634) 584

Leche, Wilhelm i. e. Jakob Wilhelm Ebbe Gustaf, 1850–

Der mensch, sein ursprung und seine entwicklung, in gemeinverständlicher darstellung von Wilhelm Leche ... mit 369 abbildungen. (Nach der 2. schwedischen aufl.) Jena, G. Fischer, 1911.

vii, ₍1₎, 375 p. illus., plates (partly fold.) 26ᶜᵐ. M. 7.50

© Jan. 5, 1911; 2c. Feb. 2, 1911; A—Foreign 2424; Gustav Fischer, Jena, Germany. (11–1820) 585

Lee, Higginson & co.

Inheritance taxes of all the states. Boston, New York
[etc.] Lee, Higginson & co. [ᶜ1911]

1 p. l., 19 p. 23ᶜᵐ

© Jan. 28, 1911; 2c. Jan. 31, 1911; A 280491; Lee, Higginson & co., Boston,
Mass. (11-1683) **586**

Lie, Erik Røring Møinichen, 1868–

... Finn, Jan og Ola Smørbuk, guttefortælling; med
omslagstegning av Jacob Sømme. Kristiania og Kjøben-
havn, Gyldendalske boghandel, Nordisk forlag, 1910.

91 p. 20ᶜᵐ.

© Nov. 30, 1910; 2c. Jan. 21, 1911; A—Foreign 2380; Gyldendalske bog-
handel, Nordisk forlag, Christiania, Norway. (11-1659) **587**

Lindau, Paul.

... Illustrierte romane und novellen. 4. bd. Die gehil-
fin. 2. t. Elise, Henri. Mit illustrationen von Paul
Kraemer. Berlin, S. Schottlaenders schlesische verlags-
anstalt [1911]

240 p. illus. 20½ᶜᵐ. M. 3

© Feb. 18, 1911; 2c. Feb. 18, 1911; A—Foreign 2523; S. Schottlaenders
schlesische verlagsanstalt, g. m. b. h., Berlin, Germany. **588**

London, E S.

Das radium in der biologie und medizin, von E. S. Lon-
don ... mit 20 abbildungen im text. Leipzig, Akademische
verlagsgesellschaft m. b. h., 1911.

v p., 1 l., 199 p. illus. 23½ᶜᵐ.

"Literaturverzeichnis": p. [179]–199.

© Jan. 5, 1911; 2c. Jan. 23, 1911; A—Foreign 2408; Akademische ver-
lagsgesellschaft m. b. h., Leipzig, Germany. (11-1768) **589**

Lyons, Albert Edwin, 1866–

Speed talks; a series of advertisements and speed-up
letters to salesmen expressive of the modern business
building spirit, by Albert E. Lyons ... Libertyville, Ill.,
Sheldon university press, 1910.

127 p. 20½ᶜᵐ. $1.00

© Jan. 10, 1911; 2c. Feb. 3, 1911; A 280565; A. E. Lyons, Worcester, Mass.
(11-1649) **590**

McCombs, Robert Shelmerdine, 1880–

Diseases of children for nurses, including infant feed-
ing, therapeutic measures employed in childhood, treat-
ment for emergencies, prophylaxis, hygiene, and nursing,
by Robert S. McCombs ... 2d ed., thoroughly rev. Phila-
delphia and London, W. B. Saunders company, 1911.

· 470 p. illus., 7 pl. (6 col.) 21ᶜᵐ. $2.00

© Jan. 25, 1911; 2c. Jan. 27, 1911; A 280394; W. B. Saunders co., Phila-
delphia, Pa. (11-1691) **591**

McDougal, Henry Clay.

Recollections 1844–1909, by Henry Clay McDougal. Kansas City, Mo., F. Hudson publishing co., 1910.

1 p. l., 7–466 p. front. (port.) 24ᶜᵐ. $2.50

p. 230–232, Roll of Company A, Sixth regiment Va. inf. (Union)

CONTENTS.—I. Lawyers pictured by ₁Gilbert J.₁ Clark.—II. Lawyers— Two observations. — III. Lawyers — West Virginia. Lawyers of other states.—IV. Presidents I have known.—V. A few other statesmen I have met.—VII ₁i. e. VI₁ Soldier friends.—VII. Journalists.—VIII. Poets.—IX. A few others worth while.—Appendix ₁containing reprints of author's addresses₁

© Jan. 18, 1911; 2c. Jan. 30, 1911; A 280448; H. C. McDougal, Kansas City. Mo. (11–1625) 592

McPherson, C E.

Life of Levi R. Lupton, twentieth century apostle of the gift of tongues, divine healer, etc. ... by C. E. McPherson. ₁Alliance, O., ᶜ1911₁

6 p. l., 17–247 p., 2 l. incl. illus., port. front. (port.) 18½ᶜᵐ. $1.00

© Jan. 11, 1911; 2c. Jan. 14, 1911; A 280122; C. E. McPherson, Alliance, O. (11–1628) 593

Maeterlinck, Maurice, 1862–

The blue bird; a fairy play in six acts by Maurice Maeterlinck, tr. by Alexander Teixeira de Mattos. New York, Dodd, Mead and company, 1911.

287 p. 20ᶜᵐ. $1.20

"A new act appears for the first time in this edition and is inserted as act IV—The palace of happiness."

© Feb. 4, 1911; 2c. Feb. 6, 1911; A 280649; Dodd, Mead & co., New York, N. Y. (11–1744) 594

Marburg, Edgar.

Framed structures and girders, theory and practice, by Edgar Marburg ... ₁Brooklyn, N. Y., Scientific press, 1911₁

120 p. diagrs. 23ᶜᵐ.

© Jan. 31, 1911; 2c. Feb. 3, 1911; A 280673; McGraw Hill book co., New York, N. Y. 595

Markham, Edwin i. e. Charles Edwin, ed.

The real America in romance ... v. 12, 13. Art ed. New York, Chicago, W. H. Wise & company, 1910.

2 v. fronts., plates, ports. 24½ᶜᵐ. $4.00 per vol.

CONTENTS.—12. Brothers for ever, the age of union, 1854–1868.—13. The eagle's wings, the age of expansion, 1868–1910.

© v. 12, Jan. 27, 1911; v. 13, Feb. 8, 1911; 2c. each Feb. 16, 1911; A 280897, 280898; Funk & Wagnalls co., New York, N. Y. 596, 597

Massachusetts. Supreme judicial court.

Massachusetts reports, 206. Cases argued and determined ... May, 1910–October, 1910. Henry Walton Swift, reporter. Boston, Little, Brown, and company, 1911.

xxi, 757 p. 24ᶜᵐ.

© Feb. 16, 1911; 2c. Feb. 18, 1911; A 280862; Little, Brown, & co., Boston, Mass. 598

Menge, Hermann *i. e.* **August Hermann, 1841–**

... Taschenwörterbuch der griechischen und deutschen sprache ... t. 1. Zusammengestellt von professor dr. Hermann Menge ... Berlin-Schöneberg, Langenscheidt [°1910]

3 p. l., 540 p. 16ᶜᵐ. (Methode Toussaint-Langenscheidt) M. 2
t. 1 © Dec. 23, 1910; 2c. Jan. 19, 1911; A—Foreign 2328; Langenscheidt-sche verlagsbuchhandlung (G. Langenscheidt) Berlin-Schöneberg, Germany. (11–1753) **599**

... Taschenwörterbuch der lateinischen und deutschen sprache ... zusammengestellt von professor dr. Hermann Menge ... Berlin-Schöneberg, Langenscheidt [°1910]

2 v. 16ᶜᵐ. (Methode Toussaint-Langenscheidt) M. 2
t. 1: 36. bis 45. tausend; t. 2: 31. bis 37. tausend.
CONTENTS.—t. 1. Lateinisch-deutsch.—t. 2. Deutsch-lateinisch.
© Dec. 23, 1910; 2c. each Jan. 19, 1911; A—Foreign 2345–2346; Langenscheidtsche verlagsbuchhandlung (Prof. G. Langenscheidt) Berlin-Schöneberg, Germany. (11–1748) **600, 601**

Meredith, George.

The works of George Meredith. Memorial ed. v. 21. [Farina. General Ople. Tale of Chloe. New York, C. Scribner's sons, 1910]

4 p. l., 266 p. front., pl. 22ᶜᵐ. $2.00
© Dec. 15, 1910; 2c. Feb. 21, 1911; A 280921; Charles Scribner's sons, New York, N. Y. **602**

Miles, Herbert De la Haye, 1866–

The science of currency and centralized banking; a study of publications recently issued by the National monetary commission, by Herbert D. Miles. Chicago, New York, Rand-McNally press, 1911.

47 p. 20ᶜᵐ. $0.50
© Jan. 28, 1911; 2c. Jan. 31, 1911; A 280492; Rand, McNally & co., Chicago, Ill. (11–1784) **603**

Morel, Eugène, 1869–

La librairie publique, par Eugène Morel ... Paris, A. Colin, 1910.

2 p. l., 322 p. 19ᶜᵐ. fr. 3.50
© Dec. 30, 1910; 2c. Jan. 21, 1911; A—Foreign 2388; Max Leclerc and H. Bourrelier, Paris, France. (11–1677) **604**

National society for the study of education.

The 10th yearbook ... pt. 1, 2 ... Chicago, Ill., The University of Chicago press [1911]

2 v. 23ᶜᵐ. $0.75 per vol.
CONTENTS.—1. The city school as a community center, by H. C. Leipziger, Mrs. S. E. Hyre, R. D. Warden, C. W. Crampton, E. W. Stitt, E. J. Ward, Mrs. E. C. Grice, C. A. Perry.—2. The rural school as a community center, by B. H. Crocheron, Miss Jessie Field, F. W. Howe, E. C. Bishop, A. B. Graham, O. J. Kern, M. T. Scudder.
© Feb. 10, 1911; 2c. each Feb. 17, 1911; A 280832, 280833; S. Chester Parker, sec. of soc., Chicago, Ill. **605, 606**

[Page, William Kenneth] 1884–

Short cuts and money-making methods; how to handle lists of names in the advertising, accounting, payroll, shipping and general office departments of any business ... Chicago, The Addressograph company [c1910]

128 p. illus. 20ᶜᵐ. $1.50

© Sept. 1, 1910; 2c. Jan. 20, 1911; A 280386; Addressograph co., Chicago, Ill. (11–1681) 607

Patrick, Hugh Talbot, 1860– ed.

... Nervous and mental diseases, ed. by Hugh T. Patrick ... Peter Bassoe ... Chicago, The Year book publishers [c1911]

1 p. l., 5–248 p. illus.; plates. 19½ᶜᵐ. (The practical medicine series ... vol. x ... Series 1910)

© Jan. 15. 1911; 2c. Jan. 21, 1911; A 280278; Year book publishers, Chicago, Ill. (11–1692) 608

Paz y Mélia, Antonio.

... Taschenwörterbuch der spanischen und deutschen sprache, mit angabe der aussprache nach dem phonetischen system der Methode Toussaint-Langenscheidt ... zusammengestellt von A. Paz y Mélia ... 26.–33. tausend. Berlin-Schöneberg, Langenscheidt [c1910]

2 v. 16ᶜᵐ. (Methode Toussaint-Langenscheidt)

Added t.-p. in Spanish.

CONTENTS.—t. 1. Spanisch-deutsch.—t. 2. Deutsch-spanisch.

© Dec. 23, 1910; 2c. each Jan. 19, 1911; A—Foreign 2341, 2342; Langenscheidtsche verlagsbuchhandlung (Prof. G. Langenscheidt) Berlin-Schöneberg, Germany. (11–1750) 609, 610

Péladan, Joséphin, *called* Le Sar, 1859–

Ernest Hébert, son œuvre et son temps, d'après sa correspondance intime et des documents inédits, par Peladan; avec une préface de Jules Claretie ... Paris, C. Delagrave [c1910]

2 p. l., 282 p., 1 l. illus., plates, ports. 32ᶜᵐ. fr. 30

"Liste chronologique des tableaux": p. [269]–272.

© Jan. 6, 1911; 2c. Jan. 21, 1911; A—Foreign 2386; Chas. Delagrave, Paris, France. (11–1710) 611

Perot, Elliston Joseph, 1868–

Notes on the American liturgy, for use in parish instruction, and in the preparation of candidates for confirmation, by the Rev. Elliston J. Perot ... Philadelphia, Jacobs' book store [c1911]

84 p. 20ᶜᵐ.

© Jan. 21, 1911; 2c. Jan. 24, 1911; A 280316; E. J. Perot, Salem, N. J. (11–1663) 612

Quirk, Leslie W 1882–

How to write a short story; an exposition of the technique of short fiction, by Leslie W. Quirk. Ridgewood, N. J., The Editor company, 1911.

2 p. l., ₁3₁–77 p. 17 x 10ᶜᵐ. $0.50

© Feb. 1, 1911; 2c. Feb. 6, 1911; A 280615; Editor co., Ridgewood, N. J.
(11–1629) 613

Reifferscheid, Karl.

... Die Röntgentherapie in der gynäkologie, von prof. dr. Karl Reifferscheid ... Mit 4 tafeln und einem anhang über die Röntgentechnik in der gynäkologie von prof. dr. Paul Krause ... Leipzig, J. A. Barth, 1911.

92 p. illus., ɪv pl. (2 col.) 25½ᶜᵐ. (Zwanglose abhandlungen aus dem gebiete der medizinischen elektrologie und Röntgenkunde. hft. 9) M. 4

"Literaturverzeichnis": p 70–77.

© Dec. 29, 1910; 2c. Jan. 19, 1911; A—Foreign 2333; Johann Ambrosius Barth, Leipzig, Germany. (11–1777) 614

Rice, Edw Le Roy, 1871–

Monarchs of minstrelsy, from "Daddy" Rice to date, by Edw. Le Roy Rice ... New York city, N. Y., Kenny publishing company ₁ᶜ1911₁

9 p. l., 366 p. front., illus., ports. 26ᶜᵐ. $4.00

© Jan. 13, 1911; 2c. Jan. 21, 1911; A 280257; Emma L. Rice, Brooklyn, N. Y.
(11–1635) 615

Rochester, Minn. St. Mary's hospital.

Collected papers by the staff of St. Mary's hospital, Mayo clinic, Rochester, Minnesota, 1905–1909. Philadelphia and London, W. B. Saunders company, 1911.

x, 668 p. illus. 25ᶜᵐ. $5.50

Originally published in current medical literature. cf. Pref.

© Feb. 2, 1911; 2c. Feb. 3, 1911; A 280561; W. B. Saunders co., Philadelphia, Pa. (11–1802) 616

Roger-Milès, L.

... Les créateurs de la mode; dessins et documents de Jungbluth, texte de L. Roger-Milès. Paris, C. Eggimann ₁ᶜ1910₁

156, ₁7₁ p. incl. illus., plates (partly col.) 33ᶜᵐ. fr. 25

At head of title: Édition du Figaro.

© Dec. 30, 1910; 2c. Jan. 21, 1911; A—Foreign 2385; Ch. Eggimann, Paris, France. (11–1705) 617

Rother, Aloysius Joseph, 1859–

Certitude; a study in philosophy, by Rev. Aloysius Rother ... St. Louis, Mo. ₁etc.₁ B. Herder, 1911.

3 p. l., 94 p. 19½ᶜᵐ. $0.50

© Feb. 1, 1911; 2c. Feb. 3, 1911; A 280557; Jos. Gummersbach, St. Louis, Mo. (11–1664) 618

Rutz, Ottmar, 1881–

Sprache, gesang und körperhaltung; handbuch zur typenlehre Rutz, von dr. Ottmar Rutz. München, C. H. Beck, 1911.

vi, 151, ₁l₁ p. pl., fold. tables. 19½ᶜᵐ.

© Dec. 24, 1910; 2c. Jan. 10, 1911; A—Foreign 2276; C. H. Beck'sche verlagsbuchhandlung, Oscar Beck, Munich, Germany. (11–1636) 619

Sacerdote, Gustavo.

... Taschenwörterbuch der italienischen und deutschen sprache, mit angabe der aussprache nach dem phonetischen system der Methode Toussaint-Langenscheidt, zusammengestellt von Gustavo Sacerdote ... Rev. ausg. ... Berlin-Schöneberg, Langenscheidt [ᶜ1910]

2 v. 16ᶜᵐ. (Methode Toussaint-Langenscheidt) M. 2
t. 1: 36.–50. tausend; t. 2: 31.–45. tausend.
Added t.-p. in Italian.
CONTENTS.—t. 1. Italienisch-deutsch.—t. 2. Deutsch-italienisch.

© Dec. 23, 1910; 2c. each Jan. 19, 1911; A—Foreign 2343-2344; Langenscheidtsche verlagsbuchhandlung (G. Langenscheidt) Berlin-Schöneberg, Germany. (11–1751) 620, 621

Saunders, Ripley Dunlap, 1856–

Colonel Todhunter of Missouri, by Ripley D. Saunders; with illustrations by W. B. King. Indianapolis, The Bobbs-Merrill company [ᶜ1911]

4 p. l., 327, ₁l₁ p. front., plates. 19½ᶜᵐ. $1.50

© Feb. 4, 1911; 2c. Feb. 9, 1911; A 280658; Bobbs-Merrill co., Indianapolis, Ind. (11–1759) 622

Schaumann, H.

Die ätiologie der beriberi unter berücksichtigung des gesamten phosphorstoffwechsels. Von dr. H. Schaumann ... mit 41 abbildungen im text und auf 12 tafeln. Leipzig, J. A. Barth, 1910.

397 p. 12 pl. on 6 l. 25ᶜᵐ. (Added t.-p.: Beihefte zum Archiv für schiffs- und tropenhygiene unter besonderer berücksichtigung der pathologie und therapie. bd. xiv ... beihft. 8) M. 15
"Literaturverzeichnis": p. 375–385.

bd. 14 © Dec. 29, 1910; 2c. Jan. 19, 1911; A—Foreign 2316; Johann Ambrosius Barth, Leipzig, Germany. (11–1776) 623

Smirnow, Louis.

The last days of St. Pierre, by Louis Smirnow; with illustrations by R. I. Conklin. Boston, Mass., The C. M. Clark publishing company [ᶜ1910]

4 p. l., 604 p. front., plates. 19½ᶜᵐ. $1.50

© Dec. 2, 1910; 2c. Feb. 11, 1911; A 280735; C. M. Clark pub. co., Boston, Mass. (11–1796) 624

Sobotta, Johannes, 1867–

... Atlas und lehrbuch der histologie und mikroskopischen anatomie des menschen, von J. Sobotta ... 2., verm. und verb. aufl. Mit 400 zum grössten teil mehrfarbigen abbildungen nach originalen von universitäts-zeichner W. Freytag. München, J. F. Lehmann, 1911.

xiv, ¡2¡, 307 p. illus., 56 pl. (partly col.) 24½ᶜᵐ. (Lehmann's medizinische atlanten. bd. ɪx) M. 24

© Dec. 30, 1910; 2c. Feb. 2, 1911; A—Foreign 2433; J. F. Lehmann, Munich, Germany. (11–1818) 625

Stilwell, Arthur Edward, 1859–

Universal peace—war is mesmerism, by Arthur Edward Stilwell ... 1st ed. New York, The Bankers publishing company; ¡etc., etc.¡ 1911.

181 p. incl. front. (port.) 21ᶜᵐ. $2.00

p. 161–179, chapters reproduced from the author's "Confidence, or national suicide."

© Feb. 6, 1911; 2c. Feb. 9, 1911; A 280661; A. E. Stilwell, New York, N. Y. (11–1842) 626

Stockton, Charles Herbert, 1845–

A manual of international law for the use of naval officers, by C. H. Stockton ... Annapolis, Md., Naval institute, 1911.

313 p. 19½ᶜᵐ.

"Authorities consulted": p. ¡9¡

© Jan. 20, 1911; 2c. Feb. 1, 1911; A 280499; U. S. Naval institute, Annapolis, Md. (11–1650) 627

Stone, Alfred Holt, 1870–

The truth about the boll weevil; being some observations on cotton growing under boll weevil conditions in certain areas of Louisiana, Texas and Mississippi. By Alfred H. Stone and Julian H. Fort ... ¡Greenville? Miss.¡ 1910.

¡36¡ p. 23ᶜᵐ.

© Jan. 25, 1911; 2c. Jan. 27, 1911; A 280401; First national bank, Greenville, Miss. (11–1831) 628

Tennyson, Alfred Tennyson, *1st baron*, 1809–1892.

... Tennyson's Idylls of the king: The coming of Arthur, Gareth and Lynette, Lancelot and Elaine, Guinevere, The passing of Arthur; ed., with an introduction and notes, by W. D. Lewis ... New York, Charles E. Merrill company ¡ᶜ1911¡

215 p. front. (port.) 17ᶜᵐ. (Merrill's English texts) $0.30

© Feb. 1, 1911; 2c. Feb. 4, 1911; A 280585; Chas. E. Merrill co., New York, N. Y. (11–1535) 629

Terra, Paul de.

Vergleichende anatomie des menschlichen gebisses und der zähne der vertebraten, von dr. Paul de Terra ... mit 200 textabbildungen. Jena, G. Fischer, 1911.

xiii, [1], 451, [1] p. illus. 26ᶜᵐ. M. 12

"Literaturverzeichnis": p. [388]–441.

ⓒ Jan. 5, 1911; 2c. Feb. 2, 1911; A—Foreign 2425; Gustav Fischer, Jena, Germany. (11–1823) 630

Texas. *Court of criminal appeals.*

The Texas criminal reports. Cases argued and adjudged ... during January, February, March and April, 1910. Reported by Rudolph Kleberg. v. 58. Chicago, Ill., T. H. Flood & company, 1910.

xxiii, 715 p. 24ᶜᵐ. $3.00

ⓒ Feb. 14, 1911; 2c. Feb. 18, 1911; A 280844; Rudolph Kleberg, Austin, Tex. 631

Texas. *Laws, statutes, etc.*

... White's Penal code [Rev. ed.] embracing all penal legislation down to and including the acts of the fourth called session of the thirty-first Legislature of 1910, annotated in cyclopedic style to include the 56th volume of Texas criminal reports and 121st volume of Southwestern reporter, together with forms for indictment following each offense named in the code, with an introductory chapter treating of indictments, complaints and informations generally, by Walter Willie ... Austin, Tex., Gammel's book store, 1911.

2 v. 26ᶜᵐ. $12.00

ⓒ Jan. 31, 1911; 2c. each Feb. 3, 1911; A 280558; H. P. N. Gammel, Austin, Tex. (11–1839) 632

Thomas, Isaac Lemuel, 1860– *ed.*

Methodism and the negro, ed. by I. L. Thomas, D. D. New York, Eaton & Mains; Cincinnati, Jennings & Graham [ᶜ1910]

328 p. front., plates. ports. 19½ᶜᵐ. $1.00

ⓒ Jan. 13, 1911; 2c. Jan. 23, 1911; A 280293; Eaton & Mains, New York, N. Y. (11–1477) 633

Tilton, John Littlefield.

... The Pleistocene deposits in Warren County, Iowa ... Chicago, Ill., The University of Chicago press [1911]

iv, 42 p. illus. 24½ᶜᵐ. $0.50

Thesis (PH. D.)—University of Chicago.

Bibliographical foot-notes.

ⓒ Jan. 17, 1911; 2c. Jan. 21, 1911; A 280277; University of Chicago, Chicago, Ill. (11–1771) 634

U. S. *Naval academy, Annapolis. Dept. of marine engineering and naval construction.*

Engineering mechanics; a revision of "Notes on machine design," prepared by officers of the Department of marine engineering and naval construction, U. S. Naval academy, combined with the mathematics and general principles necessary for the solution of the problems, by C. N. Offley, u. s. n. Department of marine engineering and naval construction, U. S. Naval academy. Annapolis, Md., The United States Naval institute, 1911.

322, vi p. incl. illus., tables, diagrs. fold. plates. 23½ᶜᵐ.

© Jan. 27, 1911; 2c. Feb. 1, 1911; A 280498; U. S. Naval institute, Annapolis, Md. (11-1743) **635**

U. S. *Supreme court.*

Cases argued and decided ... October terms, 1909, 1910, in 215, 216, 217, 218 U. S. Book 54. Lawyers' ed. ... Rochester, N. Y., The Lawyers co-operative publishing company, 1911.

1317, ₍30₎ p. 25ᶜᵐ. $5.00

© Feb. 17, 1911; 2c. Feb. 20, 1911; A 280875; Lawyers co-operative pub. co., Rochester, N. Y. **636**

Wallace, Alfred Russel, 1823–

The world of life; a manifestation of creative power, directive mind and ultimate purpose, by Alfred Russel Wallace ... New York, Moffat, Yard & company, 1911.

xvi, 441 p. illus., plates. 22½ᶜᵐ. $3.00

© Jan. 31, 1911; 2c. Feb. 8, 1911; A 280647; Moffat, Yard & co., New York, N. Y. (11-1767) **637**

Wellman, Walter, 1858–

The aerial age; a thousand miles by airship over the Atlantic Ocean; airship voyages over the Polar Sea; the past, the present and the future of aerial navigation. By Walter Wellman ... New York, A. R. Keller & company, 1911.

448 p. front., plates, ports. 20½ᶜᵐ. $1.75

© Feb. 4, 1911; 2c. Feb. 7, 1911; A 280624; A. R. Keller, New York, N. Y. (11-1742) **638**

White, William Alanson, 1870–

... Outlines of psychiatry, by William A. White ... 3d ed., rev. and enl. New York, The Journal of nervous and mental disease publishing company, 1911.

viii, 272 p. illus., diagrs. 23½ᶜᵐ. (Nervous and mental disease monograph series, no. 1) $2.50

© Jan. 28, 1911; 2c. Jan. 30, 1911; A 280464; W. A. White, Washington, D. C. (11-1779) **639**

Whitlock, Brand, 1869-

On the enforcement of law in cities; a reply to a letter from representatives of the Federation of churches, by Brand Whitlock ... ₁Toledo, O., Golden rule publishing co., ʻ1911₁

cover-title, 27 p. 23ᶜᵐ. $0.25

© May 2, 1910; 2c. Jan. 28, 1911; A 280458; Golden rule pub. co., Toledo, O. (11-1780) **640**

Wigmore, John Henry.

Select cases on the law of torts with notes, and a summary of principles, by John Henry Wigmore ... In 2 vols. v. 1, book 2. Boston, Little, Brown, and company, 1911.

3 p. l., xiii–xix, ₁1₁, 764–1076, xxx p. 24ᶜᵐ.

© Feb. 15, 1911; 2c. Feb. 17, 1911; A 280846; J. H. Wigmore, Evanston, Ill. **641**

Williams, Henry Francis, 1848-

In four continents; a sketch of the foreign missions of the Presbyterian church, U. S., by Rev. Henry F. Williams ... Richmond, Va., Presbyterian committee of publication, 1910.

243 p. incl. front. plates, maps. 19½ᶜᵐ. $0.50

"Books suggested for missionary libraries": p. 241-243.

© July 20, 1910; 2c. Feb. 7, 1911; A 280630; R. E. Magill, sec. of pub., Richmond, Va. (11-1766) **642**

Wilson & Toomer fertilizer co.

Citrus culture for profit; practical directions by Wilson & Toomer fertilizer co. St. Augustine, Fla., The Record co. ₁ʻ1911₁

vii, 83 p. illus., plates. 16½ᶜᵐ

© Jan. 14, 1911; 2c. Jan. 20, 1911; A 280247; Wilson & Toomer fertilizer co., Jacksonville, Fla. (11-1668) **643**

Wordsworth, William, 1770-1850.

The complete poetical works of William Wordsworth ... ₁Large paper ed.₁ Boston and New York, Houghton Mifflin company, 1910.

5 v. fronts., plates, ports. 23ᶜᵐ.

© Dec. 22, 1910; 2c. Feb. 7, 1911; A 280621; Houghton Mifflin co., Cambridge, Mass. (11-1631) **644**

Wullstein, Ludwig, 1864- *ed.*

Lehrbuch der chirurgie, bearb. von prof. Klapp ... prof. Küttner ... ₁u. a.₁ hrsg. von prof. Wullstein ... und prof. Wilms ... 2. umgearb. aufl. ... Jena, G. Fischer, 1910.

3 v. illus. (partly col.) col. plates. 25½ᶜᵐ. M. 28.50

CONTENTS.—1. bd. Allgemeiner teil. Chirurgie des kopfes, des halses, der brust und der wirbelsäule.—2. bd. Bauchdecken, leber, milz, pankreas, magen, darm, hernien, harn- und geschlechtsorgane und becken.—3. bd. Extremitäten: Erkrankungen und verletzungen der weichteile, deformitäten, missbildungen, verletzungen und erkrankungen der knochen und gelenke, amputationen und exartikulationen.

© Dec. 30, 1910; 2c. each Feb. 2, 1911; A—Foreign 2423; Gustav Fischer, Jena, Germany. (11-1801) **645**

117

Wynne, Joseph F.

1. Izamal, by Joseph F. Wynne ... Detroit, Mich., The Angelus publishing company [°1911]
.2 p. l., 7–280 p. 18^{cm}. $1.00
© Jan. 19, 1911; 2c. Feb. 2, 1911; A 280531; Angelus pub. co., Detroit, Mich. (11–1647) 646

Number of entries of books included in the Catalogue for 1911:
 a) United States publications_____ 479
 b) Foreign books in foreign languages_____ 160
 c) Foreign books in English language under *ad interim* provi-
 sions of law of Mar. 4, 1909_____ 7

 Total _____ 646

LIBRARY OF CONGRESS

COPYRIGHT OFFICE

CATALOGUE

OF

COPYRIGHT ENTRIES

PUBLISHED WEEKLY BY AUTHORITY OF THE ACTS OF CONGRESS
OF MARCH 3, 1891, OF JUNE 30, 1906, AND
OF MARCH 4, 1909

PART 1, GROUP 1

BOOKS

1911

New Series, Volume 8, No. 6

WASHINGTON
GOVERNMENT PRINTING OFFICE
LIBRARY DIVISION
1911

The Act of March 4, 1909, provides that the Catalogue of Copyright Entries shall be "admitted in any court as prima facie evidence of the facts stated therein as regards any copyright registration."

Published March 9, 1911

Abbott, Wilbur Cortez, 1868–

Colonel Thomas Blood, crownstealer 1618–1680, by Wilbur Cortez Abbott ... Rochester, N. Y. ₍Genesee press₎ 1910.

98 p. front. (port.) 21½ᶜᵐ. (*Half-title:* Rochester reprints XIII)
© Nov. 29, 1910; 2c. Feb. 15, 1911; A 280790; Edw. Wheelock, Portobello, Md. (11–2022) **647**

Abraham Lincoln, by some ·men who knew him; being personal recollections of Judge Owen T. Reeves, Hon. James S. Ewing, Col. Richard P. Morgan, Judge Franklin Blades, John W. Bunn, with introduction by Hon. Isaac N. Phillips. Bloomington, Ill., Pantagraph printing & stationery co. ₍ᶜ1910₎

167 p. ports. 18½ᶜᵐ. $1.50
© Feb. 1, 1911; 2c. Feb. 13, 1911; A 280756; Pantagraph printing & stationery co., Bloomington, Ill. (11–2062) **648**

Atkinson, William Walker, 1862–

The crucible of modern thought; what is going into it; what is happening there; what is to come out of it? A study of the prevailing mental unrest, by William Walker Atkinson ... Chicago, The Progress company; ₍etc., etc.₎ 1910.

3 p. l., 5–218 p. 20ᶜᵐ. $1.00
"This book is an outgrowth of a series of articles originally published in the Progress magazine under a pseudonym."—Pref.
© Jan. 7, 1911; 2c. Jan. 26. 1911; A 280690; Progress co., Chicago, Ill. (11–2040) **649**

Audoux, Marguerite.

Marie-Claire, by Marguerite Audoux, tr. by John N. Raphael; with an introduction by Arnold Bennett. New York, Hodder & Stoughton ₍etc., ᶜ1911₎

xiii p., 1 l., 210 p. 19½ᶜᵐ. $1.20
© Feb. 14, 1911; 2c. Feb. 16, 1911; A 280824; Geo. H. Doran co., New York, N. Y. (11–1929) **650**

Baer, John Richard, 1869–

Bank organization ₍by₎ John R. Baer. Kutztown, Pa., Press of J. B. Esser, 1910.

vi, 7–16 (i. e. 141) p. forms. 23½ᶜᵐ. $1.50
"This chapter on 'Organization of banks' has been added to the author's book, 'My first year in banking,' of which this is merely a reprint."—Pref.
© Jan. 26, 1911; 2c. Feb. 6, 1911; A 280618; J. R. Baer, Philadelphia, Pa. (11–1909) **651**

Balck, William.

Tactics, by Balck ... v. 1. Tr. by Walter Krueger ...
4th completely rev. ed. With numerous plates in the text.
Fort Leavenworth, Kan., U. S. Cavalry association, 1911.
xix p., 2 l., 539 p. illus., plates. 23cm. $3.00
v. 1 © Feb. 6, 1911; 2c. Feb. 8, 1911; A 280653; Walter Krueger, Fort
Leavenworth, Kan. (11-1980) **652**

Beede, Lillian Barker.

Through the mists, by Lillian Barker Beede. [Mar-
shalltown, Ia., Marshalltown printing co.] 1910.
52 p. front. (port.) 20$\frac{1}{2}$cm. $0.75
Poems.
Pub. by the Newport publishing company.
© Dec. 20, 1910; 2c. Jan. 4, 1911; A 278877; L. B. Beede, Los Angeles, Cal.
(11-1916) **653**

Begbie, Harold, 1871–

Souls in action, in the crucible of the new life; expand-
ing the narrative of Twice-born men, by Harold Begbie
... New York, Hodder & Stoughton, George H. Doran
company [°1911]
310 p. 20cm.
CONTENTS.—Preface.—Introduction.—Seekers and savers.—The flowing
tide.—Two roads.—The vision of a lost soul.—Betrayed.—Out of the
depths. — The carriage lady. — A girl and her lover. — Tale of a treaty
port.—The cleanest thing in the house.—Sister Agatha's way.—Notes.
© Feb. 11, 1911; 2c. Feb. 13, 1911; A 280774; Geo. H. Doran co., New
York, N. Y. (11-1902) **654**

Bell telephone company of Pennsylvania.

... Specifications no. 3290. General specifications for
distribution plant and service wire construction, replacing
specifications 2200 and 2750. The Bell telephone com-
pany of Pennsylvania and controlled companies. Engi-
neering department. [2d ed.] [Philadelphia?] 1911.
160 p. illus., diagrs. 16$\frac{1}{2}$cm.
© Jan. 21, 1911; 2c. Jan. 30, 1911; A 280461; Bell telephone co. of Pennsyl-
vania, Philadelphia, Pa. (11-1893) **655**

Bennett, Enoch Arnold, 1867–

The book of Carlotta, being a revised edition (with new
preface) of Sacred and profane love, by Arnold Bennett
... New York, George H. Doran company [°1911]
xi, [2] p., 2 l., 3-294 p. 19$\frac{1}{2}$cm. $1.20
© Feb. 10, 1911; 2c. Feb. 11, 1911; A 280745; Geo. H. Doran co., New
York, N. Y. (11-1854) **656**

Bennewitz, Hilmar.

... Die weisse dame. Roman von Hilmar Bennewitz.
Dresden, R. H. Dietrich. °1909–°10.
[584] p. illus. 29cm. M. 8
Pages taken from the periodical "Heimat und fremde."
© Dec. 16, 1910; 2c. Feb. 13, 1911; A—Foreign 2484; Rich. Herm. Dietrich,
Dresden, Germany. **657**

Bergling, John Mauritz, 1866–

Art monograms and lettering, by J. M. Bergling; for
the use of engravers, artists, designers, and art workmen.
[Chicago, J. M. Bergling, ᶜ1911]

44 l. 30ᶜᵐ. $3.00

© Feb. 6, 1911; 2c. Feb. 8, 1911; A 280638; J. M. Bergling, Chicago, Ill.
(11–2013) **658**

[Beyle, **Marie Henri**] 1783–1842.

... Journal d'Italie, publié par Paul Arbelet. Paris,
Calmann-Lévy [ᶜ1911]

2 p. l., xxi, 388 p. 19ᶜᵐ. (*On cover:* Bibliothèque contemporaine)
fr. 3.50

Author's pseudonym, Stendhal, at head of title.

© Jan. 25, 1911; 2c. Feb. 7, 1911; A—Foreign 2459; Calmann-Lévy, Paris,
France. (11–1920) **659**

The **bibelot,** a reprint of poetry and prose for book lov-
ers, chosen in part from scarce editions and sources not
generally known. v. 16. Portland, Me., T. B. Mosher,
1910.

4 p. l., 5–467, [2] p. 16ᶜᵐ. $2.00

© Nov. 23, 1910; 2c. Feb. 27, 1911; A 283051; Thomas B. Mosher, Port-
land, Me. **660**

Bigourdan, Guillaume, 1851–

... L'astronomie; évolution des idées et des méthodes;
50 illustrations. Paris, E. Flammarion, 1911.

vii, 399 p. diagrs. 18½ᶜᵐ. (Bibliothèque de philosophie scientifique)
fr. 3.50

© Feb. 1, 1911; 2c. Feb. 11, 1911; A—Foreign 2471; Ernest Flammarion,
Paris. France. (11–1970) **661**

Blaess, Viktor.

Die strömung in röhren und die berechnung weitver-
zweigter leitungen und kanäle, mit rücksicht auf be- und
entlüftungsanlagen, grubenbewetterung, gastransport,
pneumatische materialförderung, etc., von dr.-ing. Viktor
Blaess ... München und Berlin, R. Oldenbourg, 1911.

v p., 1 l., 146 p. illus., fold. pl., diagrs. 22ᶜᵐ. *and* atlas of 85 pl. 32½ᶜᵐ.

© Jan. 14, 1911; 2c. Feb. 15, 1911; A—Foreign 2497; R. Oldenbourg, Mu-
nich, Germany. (11–1977) **662**

Boissière, Albert.

Z..., le tueur à la corde. Paris, P. Lafitte & cⁱᵉ [ᶜ1910]

3 p. l., [9]–368 p. 19ᶜᵐ. fr. 3.50

© Aug. 5, 1910; 2c. Feb. 2, 1911; A—Foreign 2441; A. Boissière, Paris,
France. (11–1922) **663**

Bonifaccio, G.

... Deutsch-italienischer briefsteller, muster zu briefen
jeder art, mit der gegenübergedruckten italienischen über-
setzung; mit einer vollständigen handelskorrespondenz

Bonifaccio, G.—Continued

und mit formularen zu geschäftsaufsätzen, zeitungsanzeigen usw. 4. verb. aufl. Berlin-Schöneberg, Langenscheidt [°1910]

 x, 342 p. 16¼ᶜᵐ. M. 3
 Added t.-p. in Italian.
 © Dec. 23, 1910; 2c. Jan. 19, 1911; A—Foreign 2353; Langenscheidtsche verlagsbuchhandlung (G. Langenscheidt) Berlin-Schöneberg, Germany. (11–1877) **664**

Boothby, Charles Henry.

Visendum; poetical description of a visit to the father land, by Charles Henry Boothby. Lawrence, Mass., The Boothby press [°1910]

 2 p. l., 7–143 p. 17ᶜᵐ. $2.00
 © Dec. 31, 1910; 2c. Dec. 30, 1910; A 280781; C. H. Boothby, Beverly, Mass. (11–2003) **665**

Brown, Eli F.

... The new tocology; the science of sex and life ... by Eli F. Brown ... and Joseph H. Greer ... [Popular ed.] illustrated by Ruth Blake, M. D. Chicago, Laird & Lee [°1911]

 398 p. front., illus. 20ᶜᵐ. $1.00
 © Feb. 4, 1911; 2c. Feb. 11, 1911; A 280743; Wm. H. Lee, Chicago, Ill. (11–1985) **666**

Burleigh, B W comp.

A book of Dakota rhymes, collected and arranged by B. W. Burleigh and G. G. Wenzlaff. 4th ed. Mitchell, S. D., Educator school supply company, 1910.

 7 p. l., 175 p. 17½ᶜᵐ. $0.80
 © Dec. 1, 1910; 2c. Feb. 10, 1911; A 280705; B. W. Burleigh, Perry, Iowa. and G. G. Wenzlaff, Springfield, S. D. (11–1883) **667**

Burnett, *Mrs.* Frances (Hodgson) 1849–

The little princess; a play for children and grown-up children in three acts, by Mrs. Frances Hodgson Burnett ... New York [etc.] S. French, °1911·

 68 p. 19ᶜᵐ.
 © Feb. 11, 1911; 2c. Feb. 13, 1911; D 23335; Mrs. F. H. Burnett, Manhasset, N. Y. (11–2045) **667***

Butterfield, Kenyon Leech, 1868–

The country church and the rural problem; the Carew lectures at Hartford theological seminary, 1909, by Kenyon L. Butterfield ... Chicago, Ill., The University of Chicago press [1911]

 ix, 153 p. 20ᶜᵐ. $1.00
 © Feb. 14, 1911; 2c. Feb. 18, 1911; A 280855; University of Chicago, Chicago, Ill. (11–2041) **668**

Cabot, Richard Clarke, 1868–

Differential diagnosis presented through an analysis of 383 cases, by Richard C. Cabot ... Philadelphia and London, W. B. Saunders company, 1911.

1 p. l., 13–753 p. incl. illus. (charts) plates, tables. plates. 25¼ᶜᵐ. $5.50

© Feb. 3, 1911; 2c. Feb. 7, 1911; A 280626; W. B. Saunders co., Philadelphia, Pa. (11–1940) 669

Carter, Russell Kelso, 1849–

Caleb Koons, a 'postle of common sense, by Russell Kelso Carter, M. D. (Orr Kenyon) ... Boston, Mass., The C. M. Clark publishing company [ᶜ1910]

xiii, 440 p. col. front., plates. 19¼ᶜᵐ. $1.50

© Oct. 11, 1910; 2c. Feb. 11, 1911; A 280739; C. M. Clark pub. co., Boston, Mass. (11–1967) 670

Carus, Paul, 1852–

Truth on trial; an exposition of the nature of truth, preceded by a critique of pragmatism and an appreciation of its leader, by Paul Carus ... Chicago, The Open court publishing company; [etc., etc.] 1911.

v, [1], 138 p. 23½ᶜᵐ. $1.00

© Feb. 10, 1911; 2c. Feb. 11, 1911; A 280738; Open court pub. co., Chicago, Ill. (11–2039) 671

Chamisso, Adelbert von, 1781–1838.

Frauenliebe und leben, von A. von Chamisso; illustriert von prof. Friedrich Klein-Chevalier. Berlin, Neufeld & Henius, ᶜ1910·

3 p. l., 5–75 p. 9 col. pl. 30ᶜᵐ. M. 6.50

© Dec. 2, 1910; 2c. Feb. 15, 1911; A—Foreign 2489; Neufeld & Henius, Berlin, Germany. (11–1998) 672

Chatley, Herbert.

Principles and design of aëroplanes. By Herbert Chatley ... New York, D. Van Nostrand company, 1911.

109 p. front., illus. 15½ᶜᵐ. (On cover: Van Nostrand's science series, no. 126) $0.50

© Jan. 21, 1911; 2c. Feb. 13, 1911; A 280773; D. Van Nostrand co., New York, N. Y. (11–1935) 673

Chester, Alden, 1848– *ed.*

Legal and judicial history of New York ... Alden Chester, editor. New York, National Americana society, 1911.

3 v. fronts., plates, ports. 25½ᶜᵐ. $21.00

"The text of the first volume was almost wholly written by Mr. Lyman Horace Weeks ... Mr. Weeks has also contributed all the local monographs in the third volume except such as have been signed by others."—Pref.

On t.-p. of v. 2: Constitutional history of New York state from the colonial period to the present time, by J. Hampden Dougherty.

© Jan. 27, 1911; 2c. Feb. 10, 1911; A 280678; Natl. Americana soc., New York, N. Y. (11–1905) 674

Cook, George Cram.

The chasm; a novel by George Cram Cook ... New York, Frederick A. Stokes company [1911]

2 p. l., 379 p. 19½ᶜᵐ. $1.25

© Feb. 10, 1911; 2c. Feb. 13, 1911; A 280766; Frederick A. Stokes co., New York, N. Y. (11-1855) **675**

Cooley, Stoughton.

The captain of the Amaryllis, by Stoughton Cooley. Boston, Mass., The C. M. Clark publishing company [°1910]

3 p. l., 416 p. front., plates. 19½ᶜᵐ. $1.50

© Oct. 20, 1910; 2c. Feb. 10, 1911; A 280723; C. M. Clark pub. co., Boston, Mass. (11-1926) **676**

Cox, Henry Clay, 1845–

Abraham Lincoln; an appreciation, by Henry C. Cox. Chicago, The Abbey company [°1911]

39 p. 16¼ᶜᵐ. $0.25

© Feb. 9, 1911; 2c. Feb. 11, 1911; A 280747; Abbey co., Chicago, Ill. (11-2063) **677**

Craigen, George John, 1851–

Practical methods for appraising lands, buildings and improvements, by George J. Craigen ... [New York?] °1911]

2 p. l., 126, [2] p. illus. 19ᶜᵐ.

© Feb. 1, 1911; 2c. Feb. 4, 1911; A 280600; G. J. Craigen, Brooklyn, N. Y. (11-1908) **678**

Cramp, Walter Samuel, 1867–

Across the arid zone, by Walter S. Cramp ... Boston, Mass., The C. M. Clark publishing company [°1910]

2 p. l., 315 p. 19½ᶜᵐ. $1.50

© Nov. 10, 1910; 2c. Feb. 10, 1911; A 280718; C. M. Clark pub. co., Boston, Mass. (11-1857) **679**

Creelman, James, 1859–

Diaz, master of Mexico, by James Creelman ... New York and London, D. Appleton and company, 1911.

vii, [1] p., 1 l., 441, [1] p. front., plates, ports. 21¼ᶜᵐ. $2.50

© Feb. 17, 1911; 2c. Feb. 20, 1911; A 280881; D. Appleton & co., New York, N. Y. (11-2066) **680**

Crosby, Edward Harold.

The evolution of Fredda, by Edward Harold Crosby ... with illustrations by H. Boylston Dummer. Boston, Mass., The C. M. Clark publishing co. [°1911]

3 p. l., 382 p., 1 l. front., plates. 19½ᶜᵐ. $1.50

© Jan. 9, 1911; 2c. Feb. 10, 1911; A 280700; C. M. Clark pub. co., Boston, Mass. (11-1853) **681**

Dana, William Buck, 1829–

A day for rest and worship; its origin, development and present day meaning, by William B. Dana. New York, Chicago [etc.] Fleming H. Revell company [c1911]

3 p. l., 5–265 p. front. (port.) 19½ᶜᵐ. $1.25
© Jan. 31, 1911; 2c. Feb. 2, 1911; A 280524; Fleming H. Revell co., New York, N. Y. (11–2007) **682**

Dickson, Henry.

Dickson's How to speak in public ... Appendix: "How to be popular," by Orison Swett Marden ... Chicago, Dickson school of memory [c1911]

192, 32 p. front. (port.) 19½ᶜᵐ.
"Memory; a lecture ... by Henry Dickson": 32 p. at end.
© Feb. 7. 1911; 2c. Feb. 6, 1911; A 280750; H. Dickson, Chicago, Ill. (11–2000) **683**

Donnerberg, Edit.

... Paradoxa, verse eines dekadenten. Berlin, A. Schott-laender [c1911]

95, [1] p. 21½ᶜᵐ.
© Feb. 18, 1911; 2c. Feb. 18, 1911; A—Foreign 2525; S. Schottlaenders schlesische verlagsanstalt, Berlin, Germany. (11–2001) **684**

Drummond, Hamilton.

The justice of the king, by Hamilton Drummond ... frontispiece by J. A. Williams. New York, The Macmillan company, 1911.

vi p., 1 l., 335 p. col. front. 20ᶜᵐ. $1.20
© Feb. 15, 1911; 2c. Feb. 17, 1911; A 280837; Macmillan co., New York, N. Y. (11–1963) **685**

[Earle, Mrs. Teda Morgan] 1854–

Jack Frost jingles; an extravaganza in verse for children of all ages, by Earlaine Morgan [pseud.] illustrations by Ann Waters. Boston, The C. M. Clark publishing company, 1910.

2 p. l., 90 p. col. front., col. illus. 21ᶜᵐ. $0.75
© Nov. 25, 1910; 2c. Feb. 10. 1911; A 280704; C. M. Clark pub. co., Boston, Mass. (11–1997) **686**

Edel, Edmund.

Der gefährliche alte; bekenntnisse eines mannes um die fünfzig, von Edmund Edel. 1.–10. tausend. Berlin-Charlottenburg, Est-est verlag g. m. b. h. [c1911]

116 p. 20ᶜᵐ. M. 1
© Jan. 20, 1911; 2c. Feb. 4, 1911; A—Froeign 2452; Est-est verlag g. m. b. h., Berlin-Ch., Germany. (11–1886) **687**

Eppens, Edward Henry, 1873–

The dilemma of the modern Christian; how much can he accept of traditional Christianity? by Edward H. Eppens. Boston, Sherman, French & company, 1911.

3 p. l., 181 p. 19½ᶜᵐ $1.20
© Jan. 24, 1911; 2c. Feb. 4, 1911; A 280586; Sherman, French & co., Boston, Mass. (11–1899) **688**

125

Footner, Hulbert.

Two on the trail; a story of the far Northwest, by Hulbert Footner; illustrated by W. Sherman Potts. Garden City, N. Y., Doubleday, Page & company, 1911.

viii p., 2 l., 3–349 p. front., plates. 19½ᶜᵐ. $1.20

© Feb. 16, 1911; 2c. Feb. 20. 1911; A 280883; Doubleday, Page & co., Garden City, N. Y. (11–1969) **689**

Forman, Justus Miles, 1875–

The unknown lady; a novel, by Justus Miles Forman ... New York and London, Harper & brothers, 1911.

3 p. l., 350 p., 1 l. front. 19ᶜᵐ. $1.50

© Feb. 16, 1911; 2c. Feb. 18, 1911: A 280847; Harper & bros., New York, N. Y. (11–1961) **690**

Fränkel, Sigmund, 1868–

Dynamische biochemie. Chemie der lebensvorgänge. Von dr. Sigmund Fränkel ... Wiesbaden, J. F. Bergmann, 1911.

xi, [1], 600 p., 1 l. 26ᶜᵐ. M. 18.60

© Jan. 17, 1911; 2c. Feb. 11, 1911; A—Foreign 2475; J. F. Bergmann, Wiesbaden, Germany. (11–1971) **691**

French, Allen, 1870–

The siege of Boston, by Allen French. New York, The Macmillan company, 1911.

xi, 450 p. front., illus., plates, port. 20ᶜᵐ. $1.50

© Feb. 8, 1911; 2c. Feb. 9, 1911; A 280663; Macmillan co., New York, N. Y. (11–1871) **692**

Gilbert, *Mrs.* Helen Josephine White, *ed.*

Rushford and Rushford people, planned, ed. and pub. by Helen Josephine White Gilbert ... [Rushford, N. Y.] H. J. W. Gilbert, 1910.

6 p. l., 572 p. illus. (incl. ports.) double map. 20½ᶜᵐ. $2.00

Books consulted: 2d prelim. leaf.

© Jan. 2, 1911; 2c. Feb. 9, 1911; A 280670; Mrs. H. W. Gilbert, Rushford, N. Y. (11–1873) **693**

Griffiths, Arthur Llewellyn.

Wild Scottish clans and bonnie Prince Charlie, by Arthur Llewellyn Griffiths ... Boston, Mass., The C. M. Clark publishing co. [°1910]

6 p. l., 110 p. 2 pl., 2 port. (incl. front.) 19ᶜᵐ. $1.00

© Dec. 30, 1910; 2c. Feb. 10, 1911; A 280701; C. M. Clark pub. co., Boston, Mass. (11–2021) **694**

Gross, Hans Gustav Adolf, 1847–

... Criminal psychology; a manual for judges, practitioners, and students, by Hans Gross ... tr. from the 4th German ed. by Horace M. Kallen ... with an intro-

Gross, Hans Gustav Adolf—Continued

duction by Joseph Jastrow ... Boston, Little, Brown, and company, 1911.

xx, 514 p. diagrs. 23½ᶜᵐ. (The modern criminal science series, pub. under the auspices of the American institute of criminal law and criminology) $5.00

"Bibliography, including texts more easily within the reach of English readers": p. ₁493₁-499.

"Works on psychology of general interest": p. ₁500₁-501.

© Jan. 14, 1911; 2c. Jan. 19, 1911; A 280755; Little, Brown & co., Boston, Mass. (11-1860) **695**

Hall, Arthur Crawshay Alliston, *bp.*, 1847-

The sevenfold unity of the Christian church, by the Rt. Rev. A. C. A. Hall ... New York ₁etc.₁ Longmans, Green, and co., 1911.

vii, 63 p. 19½ᶜᵐ. $0.75

"This book contains the substance of addresses given at retreats in the autumn of 1910."—Pref.

© Feb. 2, 1911; 2c. Feb. 10, 1911; A 280686; Longmans, Green & co., New York, N. Y. (11-2009) **696**

Hammer, Bonaventure.

God, Christ, and the church; Catholic doctrine and practice explained, with answers to objections and examples, by Rev. Bonaventure Hammer ... New York, Cincinnati ₁etc.₁ Benziger brothers, 1911.

500 p. front., plates. 21ᶜᵐ. $2.00

"List of authors": p. 7.

© Feb. 11, 1911; 2c. Feb. 13, 1911; A 280763; Benziger bros., New York, N. Y. (11-2037) **697**

Hanna, Charles Augustus.

The wilderness trail; or, The ventures and adventures of the Pennsylvania traders on the Allegheny path, with some new annals of the old West, and the records of some strong men and some bad ones, by Charles A. Hanna ... with eighty maps and illustrations ... New York and London, G. P. Putnam's sons, 1911.

2 v. fronts., plates, maps (partly fold.) facsim. 24½ᶜᵐ. $10.00

© Jan. 28, 1911; 2c. Feb. 17, 1911; A 280839; C. A. Hanna, Montclair, N. J. (11-2065) **698**

Harbitz, Alf.

... Novelletter. Kristiania, H. Aschehoug & co. (W. Nygaard) 1909.

3 p. l., ₁3₁-146 p. 18½ᶜᵐ.

CONTENTS.— Havsus.— Svalerne.— Duel.—Dumme unge hjerter.—Vaarfrost.

© Nov. 5, 1909; 2c. Feb. 4, 1911; A—Foreign 2467; H. Aschehoug & co., Christiania, Norway. (11-1885) **699**

Harper, Kenton Neal, 1857– *comp.*

History of the Grand lodge and of freemasonry in the District of Columbia, with biographical appendix. Comp. by W. Bro. Kenton N. Harper, Naval lodge, no. 4. Pub. by order of the Grand lodge. Washington, D. C., R. Beresford, printer, 1911.

xiv p., 1 l., 452 p. front., plates, ports., facsims. 24ᶜᵐ. $2.25
© Feb. 7, 1911; 2c. Feb. 11, 1911; A 280748; K. N. Harper, Washington, D. C. (11–1911) 700

Hebbel, Friedrich *i. e.* **Christian Friedrich,** 1813–1863.

... Agnes Bernauer; ein deutsches trauerspiel in fünf akten von Friedrich Hebbel; ed., with introduction and notes by Camillo Von Klenze ... New York, Oxford university press, American branch; [etc., etc.] 1911.

1 p. l., xl, 178 p. 18½ᶜᵐ. (Oxford German series. General editor, J. Goebel) $0.60
Bibliography: p. 175–178.
© Feb. 6, 1911; 2c. Feb. 7, 1911; A 280634; Oxford university press, Amer. branch, New York, N. Y. (11–1882) 701

Hickox, William Eugene, 1858–

Similar outlines; a thesaurus of classified phonographic outlines that resemble each other, designed to aid shorthand writers in translating reporting notes, by William Hickox ... [Boston? ᶜ1911]

iv p., 1 l., 7–106 p. 18½ᶜᵐ. $1.00
© Jan. 24, 1911; 2c. Feb. 2, 1911; A 280537; W. Hickox, Boston, Mass. (11–1948) 702

Hinkson, Katharine (Tynan) *"Mrs.* **H. A. Hinkson,"** 1861–

Princess Katharine, by Katharine Tynan ... New York, Duffield & company, 1911.

vi, 331, [1] p. 19½ᶜᵐ. $1.20
© Feb. 11, 1911; 2c. Feb. 18, 1911; A 280849; Duffield & co., New York, N. Y. (11–1964) 703

Hollebecque,

Il y avait une fois, histoires pour les enfants, racontées par M. Hollebecque et ornées des belles images de MM. Alix, Benjamin Rabier, A. Blanchet, C. Cellier, Dick Dumas, G.-P. Fauconnet, P. Girieud, M. May. Paris, A. Quillet [ᶜ1910]

3 p. l., viii, 169, [1] p., 1 l. incl. illus. (partly col.) plates. 27 x 24½ᶜᵐ.
fr. 10
© Jan. 19, 1911; 2c. Feb. 18, 1911; A — Foreign 2516; Aristide Quillet. Paris, France. (11–2043) 704

Hund, John, 1853–

The physician and the social evil; a study of the development of the medical science under religious influence, with special reference to the social evil. By Dr. John Hund. Milwaukee, Wis., Enterprise ptg. co., 1911.

1 p. l., 44 p. 22ᶜᵐ. $0.25
© Feb. ... 1911; 2c. Feb. 4, 1911; A 280587; J. Hund, Milwaukee, Wis. (11–1953) 705

Interstate medical journal.

... Recent literature on syphilis, with special reference to serodiagnosis and treatment; a reprint from the Interstate medical journal, vol. xvii, no. 10, and vol. xviii, no. 1. St. Louis, Interstate medical journal co., 1911.

175 p. illus. (incl. charts) 26ᶜᵐ. (Medical symposium series, no. 1) $1.60

Contains bibliographies.

© Jan. 24, 1911; 2c. Feb. 10, 1911; A 280688; Interstate medical journal co., St. Louis, Mo. (11–1983) 706

Jackson, Chevalier

Poultry for profit ... Haysville, Pa., L. Jackson [1911]

79 p. illus. 15ᶜᵐ. $0.25

© Dec. 31, 1910; 2c. Feb. 20, 1911; A 280896; Lawrence Jackson farm, Haysville, Pa. 707

Japan. *Admiral staff.*

Der japanisch-russische seekrieg, 1904/1905 ... übersetzt von ... v. Knorr. 1. bd. Die bekämpfung der russischen seestreitkräfte in Ryojun ... Berlin, E. S. Mittler und sohn, 1911.

vi, 275 p. fold. maps. 24½ᶜᵐ.

© Dec. 13, 1910; 2c. Jan. 10, 1911; A—Foreign 2285; E. S. Mittler & sohn, Berlin, Germany. 708

Johns Hopkins hospital, *Baltimore.*

The Johns Hopkins hospital reports. v. 16. Baltimore, The Johns Hopkins press, 1911.

xiii, 670, [1] p. illus. 27ᶜᵐ.

© Feb. 21, 1911; 2c. Feb. 24, 1911; A 280976; Johns Hopkins press, Baltimore, Md. 709

Jolly, Rudolf.

Atlas of microscopic diagnosis in gynecology, with preface and explanatory text by Dr. Rudolf Jolly ... Only authorized English translation by P. W. Shedd ... with 52 lithographs in color and 2 textual figures. New York, Rebman company [ᶜ1911]

ix, 192 p. illus., xxvi col. pl. 28ᶜᵐ. $5.50

© Feb. 2, 1911; 2c. Feb. 4, 1911; A 280671; Rebman co., New York, N. Y. (11–1982) 710

Jones, Walter Clyde.

Notes on the Illinois reports; a cyclopedia of Illinois law, comprising a digest of the Supreme and appellate court decisions, references to all Illinois citations both in Illinois courts and courts of other jurisdictions, and a complete index and table of cases, by W. Clyde Jones and Keene H. Addington ... and Donald J. Kiser ... v. 6. Chicago, Callaghan & company, 1911.

1 p. l., 1087 p. 26¼ᶜᵐ. $7.50

© Feb. 23, 1911; 2c. Feb. 25, 1911; A 283019; Callaghan & co., Chicago, Ill. 711

Kelly, Howard Atwood.

Stereo-clinic ... [v. 15. Troy, N. Y., The Southworth company, 1911]

79 p. illus. 23 x 18ᶜᵐ. $11.75

CONTENTS.—Bismuth paste injections, by Emil G. Beck, M. D., pt. 1st & 2d.

© Feb. 11, 1911; 2c. Feb. 13, 1911; A 280769; Southworth co., Troy, N. Y.
 712

Kittredge, Herman Eugene, 1871–

Ingersoll; a biographical appreciation, by Herman E. Kittredge ... New York, The Dresden publishing co., 1911.

xviii, 581 p. incl. front. pl., ports., fold. facsim. 23ᶜᵐ. $2.50

© Feb. 15, 1911; 2c. Feb. 17, 1911; A 280843; Dresden pub. co., New York, N. Y. (11-2064) **713**

Klug, Ignaz, 1877–

Gottes reich. Apologetische abhandlungen für studierende und für gebildete laien. Von dr. I. Klug. 2. aufl. Paderborn, F. Schöningh, 1910.

xi, 314 p. 15½ᶜᵐ. M. 2

"Literaturangabe": p. ix–xi.

© Dec. 23, 1910; 2c. Feb. 15, 1911; A—Foreign 2493; Ferdinand Schöningh, Paderborn, Germany. (11-2038) **714**

Laing, Herbert Greyson.

Bob Carlton, American, by Herbert Greyson Laing; with illustrations by R. I. Conklin. Boston, Mass., The C. M. Clark publishing company [°1910]

3 p. l., 399, [1] p. col. front., plates. 19½ᶜᵐ. $1.50

© Nov. 17, 1910; 2c. Feb. 10, 1911; A 280717; C. M. Clark pub. co., Boston, Mass. (11-1851) **715**

[Lake, *Mrs.* Carlotta (Mixer)] 1869–

The Progress meatless cook book and valuable recipes and suggestions for cleaning clothing, hats, gloves, house furnishings, walls and woodwork and all kinds of helps for the household. Chicago, The Progress company [°1911]

272 p. 20ᶜᵐ. $1.00

© Jan. 23, 1911; 2c. Jan. 26, 1911; A 280387; Progress co., Chicago, Ill. (11-1975) **716**

Latzarus, Louis.

... La demoiselle de la Rue des Notaires. Paris, Calmann-Lévy [°1911]

2 p. l., 304 p. 19ᶜᵐ.

On cover: 3. éd.

© Jan. 18, 1911; 2c. Feb. 7, 1911; A—Foreign 2458; Calmann-Lévy, Paris, France. (11-1923) **717**

Lawrence, David Herbert, 1885–

The white peacock; a novel, by D. H. Lawrence. New York, Duffield & company, 1911.

4 p. l., 3–496 p. 19½ᶜᵐ. $1.30
© Jan. 19, 1911; 2c. Jan. 31, 1911; A 280477; Duffield & co., New York, N. Y. (11–1960) **718**

Lewis, Edwin Herbert, 1866–

Business English, by Edwin Herbert Lewis ... Chicago, La Salle extension university [ᶜ1911]

1 p. l., ii p., 2 l., 287 p. 24½ᶜᵐ. $1.40
© Feb. 4, 1911; 2c. Feb. 10, 1911; A 280675; La Salle extension university, Chicago, Ill. (11–1861) **719**

Lewis, Myron Henry, 1877–

Popular hand book for cement and concrete users; a comprehensive and popular treatise on the principles involved and methods employed in the design and construction of modern concrete work ... By Myron H. Lewis ... and Albert H. Chandler ... fully illustrated. New York, The Norman W. Henley publishing company, 1911.

ix, 430 p. incl. illus., tables. 23½ᶜᵐ. $2.50
Authorities consulted: p. iii–iv.
© Jan. 31, 1911; 2c. Feb. 6, 1911; A 280611; Norman W. Henley pub. co., New York, N. Y. (11–1894) **720**

Louthan, *Mrs.* Hattie (Horner) 1865–

A Rocky Mountain feud, by Hattie Horner Louthan ... Boston, Mass., The C. M. Clark publishing company [1910]

6 p. l., 210 p. front., plates. 19½ᶜᵐ. $1.25
© Dec. 17, 1910; 2c. Feb. 10, 1911; A 280720; C. M. Clark pub. co., Boston, Mass. (11–1928) **721**

Lowry, Edith Belle, 1878–

Truths; talks with a boy concerning himself, by E. B. Lowry, M. D. Chicago, Forbes & company, 1911.

95 p. 17½ᶜᵐ. $0.50
© Feb. 14, 1911; 2c. Feb. 16, 1911; A 280827; Forbes & co., Chicago, Ill. (11–1987) **722**

Lutz, R.

Das fahrgestell von gaskraftwagen. 1. t. Von dr.-ing. R. Lutz ... Berlin, M. Krayn, 1911.

4 p. l., 5–202 p. illus., diagrs. 25½ᶜᵐ. (*Added t.-p.:* Automobiltechnische bibliothek [bd. vi]) M. 7.50
t. 1 © Jan. 15, 1911; 2c. Feb. 6, 1911; A—Foreign 2455; M. Krayn, Berlin, Germany. (11–1890) **723**

Macfadden, Bernarr Adolphus, 1868–

Macfadden's encyclopedia of physical culture; a work of reference, providing complete instructions for the cure of all diseases through physcultopathy, with general information on natural methods of health-building and a

Macfadden, Bernarr Adolphus—Continued
description of the anatomy and physiology of the human
body, by Bernarr Macfadden ... assisted by specialists in
the application of natural methods of healing. v. 1. New
York city, Physical culture publishing company, 1911.

[v]–xxxii, 500 p. col. front. (port.) illus., col. plates (1 superimposed)
26½ᶜᵐ. $25.00 per set (5 v.)
v. 1 © Jan. 13, 1911; 2c. Feb. 2, 1911; A 280528; B. Macfadden, Chicago,
Ill. (11–2017) **724**

Mains, George Preston, 1844–
Modern thought and traditional faith, by George Pres-
ton Mains. New York, Eaton & Mains; Cincinnati, Jen-
nings & Graham [°1911]

xxi, 279 p. 22½ᶜᵐ. $1.50
Bibliography: p. 269–271.
© Feb. 1. 1911; 2c. Feb. 17, 1911; A 280831; Eaton & Mains, New York. N. Y
(11–2008) **725**

Manville, H E.
Eden; or, Three days, a poem, by H. E. Manville.
Cleveland, J. F. Gepfert, 1910.

128 p. 17ᶜᵐ. $0.50
© Jan. 15, 1911; 2c. Jan. 20, 1911; A 280252; H. E. Manville, Marysville, O.
(11–1943) **726**

Mathiesen, Sigurd.
... Satan som seirer, drama i fem akter. Kristiania og
Kjøbenhavn, Gyldendalske boghandel, Nordisk forlag,
1910.

2 p. l., [7]–129 p. 20ᶜᵐ.
© Nov. 16, 1910; 2c. Jan. 21. 1911; D 23157: Gyldendalske boghandel, Nor-
disk forlag, Christiania, Norway. (11–1878) **726*ᵃ**

Michel, Karl.
Die sprache des körpers. in 721 bildern dargestellt von
Karl Michel ... Leipzig, J. J. Weber, 1910.

xli, 167, [1] p. illus. 27½ᶜᵐ. M. 10
© Oct. 5, 1910; 2c. Jan. 13, 1911; A—Foreign 2308; K. Michel, Berlin-
Steglitz, Germany. (11–1944) **727**

Miller, Marion Mills, 1864–
Manual of ready reference to classic fiction; containing
brief analyses of the world's great stories and analytical
indexes of the chief elements found therein [by] Marion
Mills Miller ... New York, Authors press [°1909]

1 p. l., xv, 141 p. 23ᶜᵐ. $1.50
© Oct. 26, 1909; 2c. Feb. 8, 1911; A 280637; Authors press, New York,
N. Y. (11–1919) **728**

Moody, Christina.
A tiny spark, by Christina Moody. Washington, D. C.,
Murray brothers press, 1910.

43 p. 15½ᶜᵐ. $0.50
© Dec. 24, 1910; 2c. Jan. 3, 1911; A 280668; C. Moody, Washington, D. C.
(11–1879) **729**

Moren, Sven.

... Aust or markom; skildringar fraa skogane. Kristiania, H. Aschehoug & co. (W. Nygaard) 1909.

3 p. l., i3–145 p. 18¼ᶜᵐ.

© Nov. 11, 1909; 2c. Feb. 4, 1911; A—Foreign 2466; H. Aschehoug & co., Christiania, Norway. (11–1884) 730

Morse, John Lovett, 1865–

Case histories in pediatrics. A collection of histories of actual patients selected to illustrate the diagnosis, prognosis and treatment of the most important diseases of infancy and childhood. By John Lovett Morse ... Boston, W. M. Leonard, 1911.

314 p. illus. 24ᶜᵐ. $3.00

© Feb. 8, 1911; 2c. Feb. 13, 1911; A 280759; Wallace M. Leonard, Boston, Mass. (11–1984) 731

Mraček, Franz, 1848–1908.

... Franz Mraček's atlas und grundriss der haut-krankheiten. 3., teilweise umgearb. und erweiterte aufl. hrsg. von dr. Albert Jesionek ... Mit 109 farbigen tafeln und 96 schwarzen abbildungen. München, J. F. Lehmann, 1911.

xx, 418 p. plates (109 col.) 19ᶜᵐ. (Lehmann's medizinische handatlanten, bd. v) M. 18

© Jan. 10, 1911; 2c. Feb. 11, 1911; A—Foreign 2477; J. F. Lehmann, Munich, Germany. (11–1986) 732

Münzer, Kurt, 1879–

Ruhm; tragikomödie in drei akten, von Kurt Münzer. Berlin-Charlottenburg, Vita, deutsches verlagshaus [ᶜ1910]

144 p. 20ᶜᵐ. M. 3

p. [138]–144, advertising matter.

© Dec. 30, 1910; 2c. Feb. 8, 1911; D 23308; Vita, deutsches verlagshaus, g. m. b. h., Berlin-Ch., Germany. (11–1880) 732*

New York (*State*) *Laws, statutes, etc.*

Decedent estate law of the state of New York, chapter thirteen of the Consolidated laws (became a law February 17, 1909; chapter 18, laws of 1909) together with all amendments, the notes of the Board of statutory consolidation, notes of the original revisers of the revised statutes, the report of the commissioners of statutory revision on the originals, and the full text of all the statutes codified in the decedent estate law, also, an introduction, notes of judicial decisions and a commentary, historical and expository, on the text of the statutes, by Robert Ludlow Fowler ... New York, Baker, Voorhis & company, 1911.

xxix, 592 p. 24ᶜᵐ. $5.50

© Jan. 4, 1911; 2c. Feb. 10, 1911; A 280687; R. L. Fowler, New York, N. Y. (11–1904) 733

New York. Metropolitan museum of art.

... Catalogue of a loan exhibition of arms and armor, by Bashford Dean ... New York, February the sixth to April the sixteenth, MCMXI. [New York, The Gilliss press, •1911]

xxv, 85, [1] p. front., illus., plates. 22ᶜᵐ. $0.25

© Feb. 6, 1911; 2c. Feb. 11, 1911; A 280732; Metropolitan museum of art, New York, N. Y. (11-2014) **734**

Novicow, Jacques, 1849-

War and its alleged benefits, by J. Novicow ... tr. by Thomas Seltzer. New York, H. Holt and company, 1911.

3 p. l., 130 p. 18ᶜᵐ. $1.00

© Feb. 10, 1911; 2c. Feb. 15, 1911; A 280805; Henry Holt & co., New York, N. Y. (11-2052) **735**

Ohio cases annotated, stating the points on which these cases are annotated by L. R. A. notes, including (1) the Ohio cases fully reported and annotated in L. R. A. and (2) the Ohio cases considered and cited in the annotation of other cases on the same subjects. Rochester, N. Y., The Lawyers co-operative publishing company, 1911.

2 p. l., 356 p. 24ᶜᵐ. $1.00

© Feb. 14, 1911; 2c. Feb. 16, 1911; A 280828; Lawyers cooperative pub. co., Rochester, N. Y. (11-2049) **736**

... The **Pacific** reporter, with key-number annotations. v. 111. Permanent ed. ... October 31, 1910–January 2, 1911. St. Paul, West publishing co., 1911.

xiv, 1250 p. 26½ᶜᵐ. (National reporter system—State series) $4.00

© Feb. 16, 1911; 2c. Feb. 27, 1911; A 283041; West pub. co., St. Paul, Minn. **737**

Patterson, Marjorie.

Fortunata; a novel, by Marjorie Patterson. New York and London, Harper & brothers, 1911.

2 p. l., 334 p., 1 l. front. 19½ᶜᵐ. $1.30

© Feb. 16, 1911; 2c. Feb. 18, 1911; A 280848; Harper & bros., New York, N. Y. (11-1962) **738**

Pease, Abraham Per Lee, 1847-

Winter wanderings; being an account of travels in Abyssinia, Samoa, Java, Japan, the Philippines, Australia, South America and other interesting countries, by A. Per Lee Pease, M. D. New York, Cochrane publishing company, 1910.

387 p. front. (port.) plates. 19½ᶜᵐ. $1.50

© Dec. 19, 1910; 2c. Jan. 28, 1911; A 280420; Cochrane pub. co., New York, N. Y. (11-2016) **739**

Pennell, William Wesley, 1853–

Jonas Hawley, by William W. Pennell. Boston, Mass.,
The C. M. Clark publishing company [°1910]

x, 443, [1] p. col. front., plates. 19½ᶜᵐ. $1.50

© Oct. 22, 1910; 2c. Feb. 10, 1911; A 280707; C. M. Clark pub. co., Boston,
Mass. (11–1927) **740**

Pennsylvania. *Courts.*

The district reports of cases decided in all the judicial
districts of the state of Pennsylvania during the year
1910. v. 19 ... Philadelphia, H. W. Page, 1910.

xxvi, 1248 p. 23½ᶜᵐ. $5.00

© Feb. 24, 1911; 2c. Feb. 20, 1911; A 280876; Howard W. Page, Philadel-
phia, Pa. **741**

Perrault, Charles, 1628–1703.

Contes de Perrault; images de Georges Delaw, préface
de Madame Edmond Rostand. Paris, A. Sporck, °1910.

68 p. col. illus. 23½ᶜᵐ. fr. 6

© Dec. 23, 1910; 2c. Feb. 18, 1911; A—Foreign 2513; Adrien Sporck, Paris,
France. (11–2044) **742**

Pinero, *Sir* Arthur Wing, 1855–

... Preserving Mr. Panmure. A comic play, in four acts.
By Arthur Pinero. London, Printed at the Chiswick
press, 1910.

2 p. l., 134 p., 1 l. 21½ᶜᵐ.

© 1c. Dec. 29, 1910; D 22946; A. Pinero, London, England. (11–1888)
 742ᵃ

[Pratt, William Knight] 1875–

The American artisan window display manual; a choice
collection of window displays of hardware and kindred
lines ... together with complete descriptions thereof.
Practical window dressing suggestions for the retailer.
Chicago, D. Stern, 1911.

1 p. l., 271 p. illus. 20ᶜᵐ. (*On cover:* The American artisan manuals)
$3.50

© Jan. 31, 1911; 2c. Feb. 9, 1911; A 280660; Daniel Stern, Chicago, Ill.
(11–1955) **743**

Ray, Anna Chapin, 1865–

A woman with a purpose, by Anna Chapin Ray ...
Boston, Little, Brown, and company, 1911.

3 p. l., 338 p. col. front. 20ᶜᵐ. $1.25

© Feb. 11, 1911; 2c. Feb. 14, 1911; A 280785; Little, Brown & co., Boston,
Mass. (11–1856) **744**

Recollections of a society clairvoyant. London, E. Nash, 1911.

2 p. l., 7–206, [2] p. 23ᶜᵐ. 7/6

© 1c. Feb. 3, 1911; A ad int. 469; published Jan. 5, 1911; Eveleigh Nash,
London, England. (11–1901) **745**

135

Reed, John Oren.

College physics, by John Oren Reed ... and Karl Eugen Guthe ... pt. 2. Electricity and magnetism. New York, The Macmillan company, 1911.

2 p. l., 271–572 p. incl. illus., diagrs. 22½ᶜᵐ. $1.90

© Feb. 15, 1911; 2c. Feb. 18, 1911; A 280845; Macmillan co., New York, N. Y. **746**

Rice, Charles Elmer.

By the name of Rice; an historical sketch of Deacon Edmund Rice, the pilgrim (1594–1663) founder of the English family of Rice in the United States; and of his descendants to the fourth generation. Done briefly by omitting some 15000 names that can be had upon application to the author. By Charles Elmer Rice ... Alliance, O., Press of The Williams printing co., 1911.

96, ⟨2⟩ p., 1 l. 19½ᶜᵐ. $1.00

© Feb. 9, 1911; 2c. Feb. 13, 1911; A 280768; C. E. Rice, Alliance, O. (11–1896) **747**

Roberts, John Stuart.

Cases on bailments and carriers, selected by John Stuart Roberts ... Chicago, Thompson & company [ᶜ1911]

3 p. l., 233 p. 23½ᶜᵐ. $1.50

© Feb. 7, 1911; 2c. Feb. 11, 1911; A 280744; Thompson & co., Chicago, Ill. (11–2048) **748**

Rothwell, J S S.

Deutsch-englischer briefsteller, muster zu briefen jeder art, mit der gegenübergedruckten englischen übersetzung von J. S. S. Rothwell ... 6. aufl. ... Berlin-Schöneberg, Langenscheidt [ᶜ1910]

vii, ⟨1⟩, 192 p. 16½ᶜᵐ. M. 3

Added t.-p. in English.

CONTENTS.—I. Familienbriefsteller. Neubearb. und verm. von P. Wagner.—II. Handelsbriefsteller. Von J. Montgomery.

© Dec. 23, 1910; 2c. Jan. 19, 1911; A—Foreign 2351; Langenscheidtsche verlagsbuchhandlung (G. Langenscheidt) Berlin-Schöneberg, Germany. (11–1887) **749**

Rubinstein, Joseph Samuel.

... Legal proceedings in England. A short guide to practice and procedure in the English courts, together with a special cypher code. By J. S. Rubinstein ... Issued by Messrs. Rubinstein, Nash & co. ... London. Boston, Mass., L. H. Lane, 1911.

cover-title, 48 p. 22ᶜᵐ. $0.50

© Feb. 4, 1911; 2c. Feb. 9, 1911; A 280667; Rubinstein, Nash & co., London, England. (11–2050) **750**

Sabatini, Rafael.

The lion's skin; a romance, by Rafael Sabatini ... illustrated by Edmund Frederick ... New York, D. Appleton and company, 1911.

4 p. l., 339, (1) p. front., plates. 19½ᶜᵐ. $1.25

© Feb. 17, 1911; 2c. Feb. 20, 1911; A 280879; D. Appleton & co., New York, N. Y. (11-1965) 751

The lion's skin; a romance, by Rafael Sabatini ... London, S. Paul & co. [°1911]

311 p. 20ᶜᵐ. 6/

© 1c. Feb. 15, 1911; A ad int. 480; published Feb. 14, 1911; D. Appleton & co., New York, N. Y. (11-1930) 752

Scheube, Botho *i. e.* Heinrich Botho, 1853–

Die krankheiten der warmen länder. Ein handbuch für ärzte, von dr. B. Scheube ... 4. umgearb. und erweiterte aufl. Mit 5 geographischen karten, 1 tafel und 142 abbildungen im texte. Jena, G. Fischer, 1910.

viii, 1072 p. illus. (partly col.) col. pl., 5 fold. maps. 25ᶜᵐ. M. 22.50
Contains "Literatur."

© Dec. 30, 1910; 2c. Feb. 2, 1911; A—Foreign 2428; Gustav Fischer, Jena, Germany. (11-1938) 753

Schumann, Alanson Tucker.

The man and the rose [by] Alanson Tucker Schumann. Boston, R. G. Badger, 1911.

128 p. 19½ᶜᵐ. $1.50
Poems.

© Feb. 8, 1911; 2c. Feb. 13, 1911; A 280758; A. T. Schumann, Gardiner, Me. (11-1889) 754

Seegmiller, Wilhelmina.

A hand clasp, by Wilhelmina Seegmiller. Chicago, P. F. Volland & company [°1911]

11 l. 18 x 10½ᶜᵐ. $0.50

© Feb. 3, 1911; 2c. Feb. 11, 1911; A 280753; P. F. Volland & co., Chicago, Ill. (11-1917) 755

Sherman, Henry Clapp, 1875–

Chemistry of food and nutrition, by Henry C. Sherman ... New York, The Macmillan company, 1911.

viii p., 1 l., 355 p. incl. illus., tables. 19½ᶜᵐ. $1.50
"References" at end of each chapter.

© Feb. 15, 1911; 2c. Feb. 17, 1911; A 280838; Macmillan co., New York, N. Y. (11-1979) 756

Short, Robert Louis.

Secondary-school mathematics, by Robert L. Short ... and William H. Elson ... Book 2. Boston, D. C. Heath & co., 1911.

viii, 171–363 p. diagrs. 18½ᶜᵐ. $1.00

© Feb. 20, 1911; 2c. Feb. 23, 1911; A 280949; D. C. Heath & co., Boston, Mass. 757

Sisters of Notre Dame, *Namur, comp.*

Compendium of church history, comp. for use in Catholic schools, by the Sisters of Notre Dame, Namur. New York, Schwartz, Kirwin & Fauss [1911]

143 p. 2 maps. 19ᶜᵐ. $0.60

Bound with this: A brief history of the Catholic church in the United States, comp. ... by the Sisters of Notre Dame, Namur. New York [1910]

© Feb. 2, 1911; 2c. Feb. 3, 1911; A 280575; Schwartz, Kirwin & Fauss, New York, N. Y. (11-1900) **758**

Smart, Janie Sawyer.

The vintage of Spain, by Janie Sawyer Smart. Boston, Mass., The C. M. Clark publishing company [ᶜ1910]

3 p. l., 358 p. col. front., plates. 19¼ᶜᵐ. $1.50

© Nov. 8, 1910; 2c. Feb. 10, 1911; A 280721; C. M. Clark pub. co., Boston, Mass. (11-1852) **759**

Smith, Albert, 1873–

Stresses in simple framed structures; a text book to accompany exercises in the computation of the axial stresses in the members of load-bearing frames. By Albert Smith ... Lafayette, Ind., Printed by the Burt-Haywood company, 1911.

190 p. diagrs. 23½ᶜᵐ. $2.50

"List of treatises on stresses": p. 190.

© Feb. 2, 1911; 2c. Feb. 6, 1911; A 280606; A. Smith, West Lafayette, Ind. (11-1936) **760**

Sophocles.

Oedipus, king of Thebes, by Sophocles; tr. into English rhyming verse, with explanatory notes, by Gilbert Murray ... London, G. Allen & sons, 1911.

x p., 1 l., 91, [1] p., 1 l. 20ᶜᵐ.

© 1c. Feb. 15, 1911; A ad int. 479; published Feb. 16, 1911; Oxford univ. press, Amer. branch, New York, N. Y. (11-2002) **761**

South Dakota historical society.

South Dakota historical collections ... comp. by the State historical society. v. 5. 1910. Pierre, S. D., State publishing company [1911]

444 p. incl. illus., ports. front. (port.) 24ᶜᵐ. $1.50

© Feb. 15, 1911; 2c. Feb. 23, 1911; A 280967; Doane Robinson, sec., for the benefit of the State historical society, Pierre, S. D. **762**

Stille, Carl.

Telegraphen- und fernsprechkabelanlagen, von C. Stille ... mit 163 abbildungen im text und auf einer tafel. Braunschweig, F. Vieweg & sohn, 1911.

xvi, 350 p. illus., fold. pl. 24½ᶜᵐ. M. 12

"Literatur": p. [ix]

© Jan. 25, 1911; 2c. Feb. 15, 1911; A—Foreign 2486; Friedr. Vieweg & sohn, Braunschweig, Germany. (11-1937) **763**

Stratz, Rudolf, 1864–

Liebestrank; roman, von Rudolph Stratz. 2.–5. aufl. Stuttgart und Berlin, J. G. Cotta, 1910.

404 p. 20^{cm}. M. 4

© Dec. 1, 1910; 2c. Feb. 3, 1911; A—Foreign 2451; J. G. Cotta'sche buchhandlung nachfolger, Stuttgart, Germany. (11–1881) 764

Sue, Eugène *i. e.* Marie Joseph Eugène.

The sword of honor; or, The foundation of the French Republic; a tale of the French revolution, by Eugène Sue. In 2 vols. v. 2. Tr. from the original French by Solon De Leon. [New York] New York labor news company, 1910.

4 p. l., 327, [1] p. 19½^{cm}. $1.00

© Feb. 16, 1911; 2c. Feb. 18, 1911; A 280860; New York labor news co., New York, N. Y. 765

Tanner, Thomas Hawkes, 1824–1871.

Memoranda on poisons, by Thomas Hawkes Tanner ... 11th rev. ed. By Henry Leffmann ... Philadelphia, P. Blakiston's son & co., 1911.

viii, 9–167 p. 18½^{cm}. $0.75

© Feb. 4, 1911; 2c. Feb. 6, 1911; A 280616; P. Blakiston's son & co., Philadelphia, Pa. (11–1941) 766

Textile world record.

... Kinks on dyeing, from the questions and answers department of the Textile world record, comp. and ed. by Clarence Hutton. Boston, Mass., Lord & Nagle company [°1911]

1 p. l., [7]–106 p. incl. forms. 15½^{cm}. (The Textile world record kink books. no. 7) $0.75

no. 7 © Feb. 8, 1911; 2c. Feb. 10, 1911; A 280674; Lord & Nagle co., Boston, Mass. (11–1934) 767

Tower, Francis Emory, 1836–

The reason of suffering, and kindred themes, by Francis E. Tower ... Boston, Mass., The C. M. Clark publishing co., 1910.

3 p. l., iii–iv, 337 p. front. (port.) 19½^{cm}. $1.50

© Nov. 30, 1910; 2c. Feb. 10, 1911; A 280719; C. M. Clark pub. co., Boston, Mass. (11–2006) 768

Vaucaire, Maurice, 1863–

... Jaune et blanche. Paris, P. Lafitte & c^{ie} [°1910]

2 p. l., 354 p., 1 l. 19^{cm}. fr. 3.50

At head of title: Maurice Vaucaire et Marcel Luguet.

© May 4, 1910; 2c. Feb. 2, 1911; A—Foreign 2442; Pierre Lafitte & cie., Paris, France. (11–1945) 769

Vincent, Edgar La Verne, 1851–

Hot coals; a story of to-day, by Edgar L. Vincent ...
Boston, Mass., The C. M. Clark publishing company
[ᶜ1910]
4 p. l., 465 p. front. 19½ᶜᵐ. $1.50
© Nov. 10, 1910; 2c. Feb. 11, 1911; A 280740; C. M. Clark pub. co., Boston,
Mass. (11–1850) 770

Wettstein, Hermann, 1840–

The teleo-mechanics of nature; or, The source, nature
and functions of the subconscious (biologic) minds from
scientific, religious, political and medical viewpoints. An
answer to Prof. Ernst Haeckel's Riddle of the universe,
Henry Drummond's The ascent of man, and M. Alfred
Binet's The psychic life of the micro-organisms, by Her-
mann Wettstein ... Fitzgerald, Ga., Fitzgerald publish-
ing company, ᶜ1911·
3 p. l., iii–x, [11]–293 p. front. (port.) 23ᶜᵐ. $2.00
Three pages on "The horrors of vaccination" inserted between p. 288
and 289.
© Jan. 31, 1911; 2c. Feb. 4, 1911; A 280583; H. Wettstein, Fitzgerald, Ga.
(11–2034) 771

White, James Terry, 1845–

For lovers and others; a book of roses commemorating
anniversary days from dawn to evening time of life, by
James Terry White ... [Author's ed.] New York, Fred-
erick A. Stokes company [ᶜ1911]
9 p. l., [3]–126, [6] p. front., illus. 19ᶜᵐ. $1.25
© Feb. 10, 1911; 2c. Feb. 13, 1911; A 280754; J. T. White, New York, N. Y.
(11–1918) 772

Widener, Harry Elkins, 1885–

A catalogue of some of the more important books, man-
uscripts and drawings in the library of Harry Elkins
Widener. Philadelphia, Priv. print., 1910.
4 p. l., 233 p. plates, facsims. 32½ᶜᵐ.
© Feb. 3, 1911; 2c. Feb. 8, 1911; A 280656; H. E. Widener, Philadelphia, Pa.
(11–1949) 773

Wieland, Konstantin.

Eine deutsche abrechnung mit Rom; protest gegen den
päpstlichen modernisteneid, von Konstantin Wieland.
München, M. Riegersche universitätsbuchhandlung, 1911.
xv, 128 p. 23ᶜᵐ.
© Feb. 2, 1911; 2c. Feb. 15, 1911; A—Foreign 2495; K. Wieland, Lauingen,
Germany. (11–2036) 774

Die heilstat Christi als neuschöpfung und wiedergeburt,
von Konstantin Wieland, hrsg. von Bruno Wieland ...
Leipzig, Eigenverlag des herausgebers, auslieferung
durch F. Wagner, 1910.
vi, 133, [1] p. 23ᶜᵐ.
© Feb. 2, 1911; 2c. Feb. 15, 1911; A—Foreign 2491; B. Wieland, Ravens-
burg, Germany. (11–2035) 775

Winston's self-pronouncing school and office dictionary
of the English language ... based upon the solid founda-
tion laid by Noah Webster and other lexicographers,
thoroughly modernized by Charles Morris ... With an
appendix containing foreign words and phrases, myth-
ological and classical names, forms of address, abbre-
viations. Philadelphia, Chicago, The John C. Winston
company [°1908]

3 p. l., v–xiii, 943 p. 18½ᶜᵐ. $0.50
© Dec. 16, 1909; 2c. Feb. 8, 1911; A 280641; John C. Winston co., Phila-
delphia, Pa. (11–1946) 776

Woodburn, James Albert, 1856–

Elementary American history and government, by
James Albert Woodburn ... and Thomas Francis Moran
... New York, Chicago [etc.] Longmans, Green, and co.
[°1911]

xii, 467, xiii–xliv p. incl. front. (port.) illus. maps. 21ᶜᵐ. $1.00
"References for additional reading" at end of each chapter.
© Jan. 24, 1911; 2c. Feb. 10, 1911; A 280685; Longmans, Green & co., New
York, N. Y. (11–1870) 777

Woodworth, Joseph Vincent, 1877–

Drop forging, die sinking and machine forming of steel;
modern shop practice, processes, methods, machines, tools
and details ... by Joseph V. Woodworth ... containing 300
illustrations. New York, The Norman W. Henley pub-
lishing co., 1911.

1 p. l., 341 p. illus. 24ᶜᵐ. $2.50
© Feb. 14, 1911; 2c. Feb. 15, 1911; A 280795; Norman W. Henley pub. co.,
New York, N. Y. (11–1978) 778

Number of entries of books included in the Catalogue for 1911:
a) United States publications_____ 581
b) Foreign books in foreign languages_____ 187
c) Foreign books in English language under *ad interim* provi-
 sions of law of Mar. 4, 1909_____ 10

 Total _____ 778

LIBRARY OF CONGRESS

COPYRIGHT OFFICE

CATALOGUE

OF

COPYRIGHT ENTRIES

PUBLISHED WEEKLY BY AUTHORITY OF THE ACTS OF CONGRESS
OF MARCH 3, 1891, OF JUNE 30, 1906, AND
OF MARCH 4, 1909

PART 1, GROUP 1

BOOKS

1911

New Series, Volume 8, no. 7

WASHINGTON
GOVERNMENT PRINTING OFFICE
LIBRARY DIVISION
1911

The Act of March 4, 1909, provides that the Catalogue of Copyright Entries shall be "admitted in any court as prima facie evidence of the facts stated therein as regards any copyright registration."

Published March 16, 1911

Adam, Paul.

... La force; édition revue par l'auteur pour "l'Idéal-
bibliothèque"; illustrations de M. Mahut. Paris, P. La-
fitte & cie [c1910]

124 p. incl. front., illus. 24½cm. (Idéal-bibliothèque [15]) fr. 0.95
© June 25, 1910; 2c. Feb. 2, 1911; A—Foreign 2444; Pierre Lafitte & cie.,
Paris, France. (11–2109) 779

Alabama. *Supreme court.*

Reports of cases argued and determined ... 2d ed. ...
Book 2, containing a verbatim reprint of vols. 2 & 3, Stew-
art's reports. St. Paul, West publishing co., 1911.

viii, 255, vi, 237 p. 26½cm. $6.00
© Feb. 24, 1911; 2c. Mar. 4, 1911; A 283169; West pub. co., St. Paul, Minn.
780

Albright, Jacob Dissinger, 1870–

The general practitioner as a specialist; a treatise de-
voted to the consideration of medical specialties; a guide
to the development of office practice, by Jacob Dissinger
Albright, M. D. 4th ed., rev., enl., and illustrated. Phila-
delphia, Pa., The author, 1911.

xii, [17]–467 p. illus. 24cm. $3.00
© Feb. 21, 1911; 2c. Feb. 24, 1911; A 280995; J. D. Albright, Philadelphia,
Pa. (11–2697) 781

Aldrich, Nelson Wilmarth, 1841–

The Aldrich plan for banking legislation, submitted to
the National monetary commission by Hon. Nelson W.
Aldrich, chairman, with complete index. New York, The
Bankers publishing co., 1911.

48 p. 14½ x 12cm. (*Half-title:* Bankers handy series, VI) $0.50
© Feb. 9, 1911; 2c. Feb. 17, 1911; A 280835; Bankers pub. co., New York,
N. Y. (11–2168) 782

Allen, John Kermott, 1858–

Hot water for domestic use; a complete guide to the
methods of supplying and heating water for domestic
purposes, giving each step to be taken and explaining why
it is done. Ed. by Jno. K. Allen ... Chicago, Domestic
engineering co., 1910.

122 p. incl. illus., tables. 17cm. $0.50
© May 31, 1910; 2c. Feb. 18, 1911; A 280867; Domestic engineering co.,
Chicago, Ill. (11–2499) 783

143

American surgical association.

Transactions ... v. 28. Ed. by Archibald MacLaren ... Philadelphia, Printed for the association, 1910.

xxxvi, 664 p. illus., fold. charts, tables. 24cm. $5.00

© Mar. 1, 1911; 2c. Mar. 3, 1911; A 283127; Archibald MacLaren, recorder of the assn., St. Paul, Minn. 784

Ames, Edgar Willey, 1870–

New York state government, by Edgar W. Ames ... New York, The Macmillan company, 1911.

56 p. plates. 19cm.

On cover: Supplement to Ashley's American government.

© Feb. 8, 1911; 2c. Feb. 10, 1911; A 280684; Macmillan co., New York, N. Y. (11–2226) 785

Anthony, Gardner Chace, 1856–

... The essentials of gearing; a text book for technical students and for self-instruction, containing numerous problems and practical formulas, by Gardner C. Anthony ... Revised. Boston, D. C. Heath & co., 1911.

xxiii, 86 p. 15 fold. pl., diagrs. 15 x 20cm. (Technical drawing series) $1.50

© Feb. 8, 1911; 2c. Feb. 23, 1911; A 280948; G. C. Anthony, Tufts College, Mass. (11–2500) 786

Atwell, William Hawley, 1869–

A treatise on federal criminal law procedure, with forms of indictment. By William H. Atwell ... Chicago, T. H. Flood & co., 1911.

452 p. 24cm. $5.00

© Feb. 21, 1911; 2c. Feb. 24, 1911; A 283006; W. H. Atwell, Dallas, Tex. (11–2244). 787

Babcock, Maltbie Davenport, 1858–1901.

The joy of work, reprinted chapters from "Fragments that remain" from the ministry of Maltbie Davenport Babcock; reported and arranged by Jessie B. Goetschius. New York, Chicago [etc.] Fleming H. Revell company [°1910]

45 p. 18½cm. $0.35

CONTENTS.—Work: a spiritual necessity.—Work: a social grace.—The one talent man.

© July 2, 1910; 2c. Feb. 23, 1911; A 280950; Fleming H. Revell co., New York, N. Y. (11–2154) 788

Balzac, Honoré de, 1799–1850.

... Eugénie Grandet; illustrations de G. Dupuis. Paris, P. Lafitte & cie [°1910]

123 p. incl. front., illus. 24cm. (Idéal-bibliothèque [14]) fr. 0.95

© May 25, 1910; 2c. Feb. 2, 1911; A—Foreign 2445; Pierre Lafitte & cie., Paris, France. (11–2107) 789

Barry, Joseph Gayle Hurd, 1858–

The Christian's day; a book of meditations, by the Reverend J. G. H. Barry ... New York, E. S. Gorham, 1910.
5 p. l., 3–257 p. 19ᶜᵐ. $1.50
ⓒ Jan. 10, 1911; 2c. Feb. 6, 1911; A 280910; Edwin S. Gorham, New York, N. Y. (11–2725) **790**

Baumbach, Rudolf, 1840–1905.

Truggold, von Rudolf Baumbach; illustriert von P. Grot Johann, in farbe gesetzt von Curt Agthe. Berlin, Neufeld & Henius, ᶜ1910·
1 p. l., 217, (1) p. 10 col. pl. 30ᶜᵐ. M. 8.50
ⓒ Dec. 2, 1910; 2c. Feb. 15, 1911; A—Foreign 2487; Neufeld & Henius, Berlin, Germany. (11–2103) **791**

Beck, Emil G 1866–

Bismuth paste in chronic suppurations, its diagnostic importance and therapeutic value, by Emil G. Beck ... with an introduction by Carl Beck, M. D., and a chapter on the application of bismuth paste in the treatment of chronic suppuration of the nasal accessory sinuses and the ear, by Joseph C. Beck, M. D. With eighty-one engravings, nine diagrammatic illustrations, and a colored plate. St. Louis, C. V. Mosby company, 1910.
237 p. incl. col. front., illus. 24ᶜᵐ. $2.50
ⓒ Dec. 15, 1910; 2c. Jan. 13, 1911; A 280346; C. V. Mosby co., St. Louis, Mo. (11–2701) **792**

Bennett, Enoch Arnold, 1867–

Denry the audacious, by Arnold Bennett ... New York, E. P. Dutton & company (ᶜ1911)
v p., 1 l., 350 p. 19½ᶜᵐ. $1.35
ⓒ Feb. 15, 1911; 2c. Feb. 16, 1911; A 280920; E. P. Dutton & co., New York, N. Y. (11–2076) **793**

Bible. N. T. Gospels. Latin.

The golden Latin Gospels P in the library of J. Pierpont Morgan (formerly known as the "Hamilton Gospels" and sometimes as King Henry the VIIIᵗʰ'ˢ Gospels) now edited for the first time, with critical introduction and notes, and accompanied by four full-page fac-similes, by H. C. Hoskier. New York, Priv. print., 1910.
cxvi, (2), 363 p., 1 l. 4 facsim. (incl. front.) 37½ x 28ᶜᵐ.
"Two hundred copies of this book have been privately printed by Frederic Fairchild Sherman for J. Pierpont Morgan, MCMXI."
ⓒ Feb. 16, 1911; 2c. Feb. 18, 1911; A 280936; H. C. Hoskier, South Orange, N. J. (11–2098) **794**

Boissière, Albert.

... La tragique aventure du Mime Properce; illustrations de Maurice de Lambert. Paris, P. Lafitte & cⁱᵉ (ᶜ1910)
124 p. incl. front., illus., plates. 24½ᶜᵐ. (Idéal-bibliothèque (11)) fr. 0.9
ⓒ Mar. 1, 1910; 2c. Feb. 2, 1911; A—Foreign 2449; Pierre Lafitte & cie., Paris, France. (11–2108) **795**

Bookwalter, John Wesley, 1837–

Rural versus urban, their conflict and its causes; a study of the conditions affecting their natural and artificial relations, by John W. Bookwalter ... New York, The Knickerbocker press, 1910.

viii, 292 p. 22½ᶜᵐ. $2.50

"The subject-matter of this volume was originally contained in a series of letters ... published in a local paper in Springfield, Ohio ..."

© Feb. 9, 1911; 2c. Feb. 18, 1911; A 280852; J. W. Bookwalter, Springfield, O. (11–2100) 796

Camp, Samuel Granger, 1877–

The fine art of fishing, by Samuel G. Camp ... illustrated from photographs by the author ... New York, Outing publishing company, 1911.

ix, 177 p. front., plates. 18½ᶜᵐ. $1.00

"The greater part of the ... text and photographs have appeared in Outing, Recreation, and Country life in America."

© Feb. 11, 1911; 2c. Feb. 16, 1911; A 280814; Outing pub. co., New York, N. Y. (11–2090) 797

Chesterton, Gilbert Keith, 1873–

Alarms and discursions, by G. K. Chesterton. New York, Dodd, Mead and company, 1911.

viii, 301 p. 19½ᶜᵐ. $1.50

© Feb. 24, 1911; 2c. Feb. 25, 1911; A 283008; Dodd, Mead & co., New York, N. Y. (11–2712) 798

Chittenden, Hiram Martin, 1858–

War or peace, a present duty and a future hope, by Hiram M. Chittenden ... Chicago, A. C. McClurg & co., 1911.

273 p. 21½ᶜᵐ. $1.00

© Feb. 18, 1911; 2c. Feb. 23, 1911; A 280941; A. C. McClurg & co., Chicago, Ill. (11–2235) 799

Covey, Alfred Dale, 1869–

The secrets of specialists, by A. Dale Covey ... 3d ed. Newark, N. J., Physicians drug news co. [°1911]

383 p. illus. 20½ᶜᵐ. $3.00

© Feb. 18, 1911; 2c. Feb. 20, 1911; A 280906; Physicians drug news co., Newark, N. J. (11–2119) 800

Craik, *Mrs.* Dinah Maria (Mulock) 1826–1887.

The adventures of a brownie as told to my child, by Dinah Maria Mulock Craik; ed. by Marion Foster Washburne; illustrated by Will Vawter ... Chicago, New York [etc.] Rand, McNally & company [°1911]

153 p. front. (port.) illus., pl. 18ᶜᵐ. (*Half-title:* The Canterbury classics ...) $0.35

"A reading list": p. 140–142.

© Feb. 18, 1911; 2c. Feb. 23, 1911; A 280951; Rand, McNally & co., Chicago, Ill. (11–2689) 801

Daudet, Léon A 1868–

... La mésentente, roman de mœurs conjugales. Paris, E. Fasquelle, 1911.

3 p. l., 353 p., 1 l. 19ᶜᵐ. fr. 3.50

ⓒ Jan. 20, 1911; 2c. Feb. 18, 1911; A—Foreign 2504; Eugène Fasquelle, Paris, France. (11–2707) **802**

Drummond, Hamilton.

The justice of the king, by Hamilton Drummond ... London, S. Paul & co. [°1911] .

328 p. 20ᶜᵐ. 6/–

ⓒ 1c. Feb. 2, 1911; A ad int. 481; published Jan. 17, 1911; Macmillan co., New York, N. Y. (11–2688) **803**

Durand, _Mme._ Alice Marie Céleste (Fleury)] 1842–1902.

... Mon chien Bop et ses amis. Paris, Plon-Nourrit et cⁱᵉ [°1910]

2 p. l., 300 p. 19ᶜᵐ. fr. 3.50

Author's pseudonym, Henry Gréville, at head of title.

ⓒ Jan. 20, 1911; 2c. Feb. 18, 1911; A—Foreign 2519; Plon-Nourrit & cie., Paris, France. (11–2708) ·**804**

Egelhaaf, Gottlob.

Politische jahresübersicht für 1910, von Gottlob Egelhaaf. 3. jahrgang der politischen jahresübersicht. Stuttgart, Carl Krabbe verlag, E. Gussmann, 1911.

124 p. 20½ᶜᵐ. . M. 2.75

ⓒ Feb. 1, 1911; 2c. Mar. 4, 1911; A—Foreign 2556; Carl Krabbe verlag, Erich Gussmann, Stuttgart, Germany. **805**

Ehrlich, Paul, 1854– _ed._

Abhandlungen über salvarsan (Ehrlich-Hata-präparat 606 gegen syphilis) gesammelt und mit einem vorwort und schlussbemerkungen hrsg. von dr. Paul Ehrlich ... München, J. F. Lehmann, 1911.

viii, 402 p. 23½ᶜᵐ. M. 7.50

ⓒ Jan. 3, 1911; 2c. Feb. 11, 1911; A—Foreign 2472; J. F. Lehmann, Munich, Germany. (11–2700) **806**

Ellbrecht, G.

Ost og osteproduktion, af G. Ellbrecht ... med 146 illustrationer. København og Kristiania, Gyldendalske boghandel, Nordisk forlag, 1911.

264 p. illus. 25ᶜᵐ.

"Literatur": p. [253]–258.

ⓒ Jan. 25, 1911; 2c. Feb. 6, 1911; A—Foreign 2456; G. Ellbrecht, Copenhagen, Denmark. (11–2087) **807**

Emerson, Charles Phillips, 1872–

Essentials of medicine; a text-book of medicine for students beginning a medical course, for nurses, and for all others interested in the care of the sick, by Charles Phillips Emerson ... illustrated by the author. 2d ed.; rev. Philadelphia & London, J. B. Lippincott company [°1911]

xi, 7–401 p. illus. 22ᶜᵐ. $2.00

© Feb. 14, 1911; 2c. Feb. 23, 1911; A 280943; J. B. Lippincott co., Philadelphia, Pa. (11–2118) 808

Emmet, Thomas Addis, 1848–

Incidents of my life; professional — literary — social, with services in the cause of Ireland, by Thomas Addis Emmet ... with twenty-seven illustrations. New York and London, G. P. Putnam's sons, 1911.

3 p. l., v–xxx p., 1 l., 480 p. front., plates, ports. 26½ᶜᵐ. $6.00

© Feb. 11, 1911; 2c. Feb. 28, 1911; A 283070; T. A. Emmet, New York, N. Y. (11–2692) 809

[Fahmy-Bey, *Mme.* J]

... Au cœur du harem. Paris, F. Juven [°1911]

291, [1] p. 19ᶜᵐ. fr. 3.50

Author's pseudonym, Jehan d'Ivray, at head of title.

© Jan. 27, 1911; 2c. Feb. 18, 1911; A—Foreign 2518; Société d'édition et de publications, Paris, France. (11–2721) 810

Faust, Charles Ayers, 1860–

Faust's complete card-writer; lessons and alphabets for use of brushes — marking — Soennecken — Payzant and common pens. Air-brushes and relief-pencils. [Chicago? 1911]

112 p. illus. 16 x 25½ᶜᵐ.

© Feb. 8, 1911; 2c. Feb. 11, 1911; A 280725; C. A. Faust, Chicago, Ill. (11–2092) 811

French, *Mrs.* Anne (Warner) 1869–

How Leslie loved, by Anne Warner ... with illustrations by A. B. Wenzell. Boston, Little, Brown, and company, 1911.

vi p., 1 l., 292 p., 1 l. col. front., col. plates. 19½ᶜᵐ. $1.50

© Feb. 18, 1911; 2c. Feb. 21, 1911; 280928; Little, Brown & co., Boston, Mass. (11–2077) 812

Gammon, Samuel R.

The evangelical invasion of Brazil: or, A half century of evangelical missions in the land of the southern cross. By Samuel R. Gammon ... Richmond, Va., Presbyterian committee of publication [°1910]

179 p. front., plates, ports., map. 20½ᶜᵐ. $0.75

© May 1, 1910; 2c. Feb. 7, 1911; A 280629; R. E. Magill, sec. of pub., Richmond, Va. (11–2726) 813

Ganter-Schwing, Joseph, 1867–

The American method of tone production ... by Jos. Ganter-Schwing ... ₍Chicago ?₎ °1911·

40 p. 19ᶜᵐ. $1.25

© Jan. 28, 1911; 2c. Jan. 30, 1911; A 280460; J. Ganter-Schwing, Chicago, Ill. (11–2231) 814

General federation of women's clubs.

... Handbook of art in our own country. 2d ed., rev. and enl., comp. and ed. by Mrs. Everett W. Pattison ... ₍Troy, N. Y., Printed by the General federation bulletin, °1911₎

104 p. 23 x 11½ᶜᵐ.

© Feb. 9, 1911; 2c. Feb. 15, 1911; A 280798; Alice M. G. Pattison, St. Louis, Mo. (11–2127) 815

Goodyear, Lloyd E.

Farm accounting for the practical farmer, by Lloyd E. Goodyear. Cedar Rapids, Ia., Goodyear-Marshall publishing co., 1911.

36 p. incl. forms. 27½ᶜᵐ. $0.50

© Jan. 1, 1911; 2c. Jan. 5, 1911; A 278952; Goodyear-Marshall pub. co., Cedar Rapids, Ia. (11–2091) 816

Gran, Gerhard von der Lippe, 1856–

... Bjørnstjerne Bjørnson, høvdingen, 8. december 1910. In memoriam. Kristiania, H. Aschehoug & co. (W. Nygaard) 1910.

2 p. l., 49 p. 20ᶜᵐ. kr. 0.60

© Dec. 1, 1910; 2c. Feb. 4, 1911; A—Foreign 2453; H. Aschehoug & co., Christiania, Norway. (11–2084) 817

Grandin, Marie.

Compliments et chansons, par Mademoiselle Marie Grandin ... Paris, C. Delagrave ₍°1910₎

68 p., 1 l. 18½ᶜᵐ. fr. 1

© Jan. 27, 1911; 2c. Feb. 18, 1911; A—Foreign 2510; Ch. Delagrave, Paris, France. (11–2239) 818

Petites fleurs de France; poésies pour les enfants, par Mademoiselle Marie Grandin ... Paris, C. Delagrave ₍°1910₎

276 p. 19ᶜᵐ. fr. 3.50

© Jan. 27, 1911; 2c. Feb. 18, 1911; A—Foreign 2502; Ch. Delagrave, Paris, France. (11–2240) 819

Hale, William Jay, 1876–

The calculations of general chemistry, with definitions, explanations, and problems, by William J. Hale ... 2d ed., rev. New York, D. Van Nostrand company, 1910.

2 p. l., vii–xi, 174 p. 19ᶜᵐ. $1.00

© Apr. 6, 1910; 2c. Feb. 13, 1911; A 280772; D. Van Nostrand co.. New York, N. Y. (11–2147) 820

Harris, Corra May (White) *"Mrs. L. H. Harris."*
Eve's second husband, by Corra Harris ... Philadelphia, Henry Altemus company [°1911]
352 p. front., plates. 19ᶜᵐ. $1.50
© Feb. 21, 1911; 2c. Feb. 23, 1911; A 280955; Howard E. Altemus, Philadelphia, Pa. (11-2078) **821**

Hasslauer, Wilhelm.
Die ohrenheilkunde des praktischen arztes, von dr. Wilhelm Hasslauer ... Mit 124 abbildungen im text. München, J. F. Lehmann, 1911.
viii, 419 p. illus. 23½ᶜᵐ.
© Jan. 21, 1911; 2c. Feb. 11, 1911; A—Foreign 2473; J. F. Lehmann, Munich, Germany. (11-2699) **822**

Healy, Maude *i. e.* **Catharine Maude, 1884–**
The brown dusk [by] Maude Healy. [Chicago, Clinic publishing co.] 1910.
97 p. 20½ᶜᵐ. $1.00
© Feb. 10, 1911; 2c. Feb. 15, 1911; A 280799; M. C. Healy, Chicago, Ill. (11-2495) **823**

Hening, Crawford Dawes, 1866– *comp.*
Cases on the law of suretyship, selected from decisions of English and American courts, by Crawford D. Hening ... St. Paul, West publishing company, 1911.
xx, 620 p. 26½ᶜᵐ. (American casebook series, J. B. Scott, general ed.) $4.00
© Feb. 16, 1911; 2c. Feb. 27, 1911; A 283042; West pub. co., St. Paul, Minn. (11-2511) **824**

Hillyer, Virgil Mores, 1875–
Kindergarten at home; a kindergarten course for the individual child at home, by V. M. Hillyer ... New York, The Baker & Taylor company [1911]
152 p. illus. 23½ᶜᵐ. $1.25
© Feb. 8, 1911; 2c. Feb. 10, 1911; A 280630; Baker & Taylor co., New York, N. Y. (11-2516) **825**

Hirsch, Charles Henry, 1870–
... Amaury d'Ornières, roman. Paris, E. Fasquelle, 1911.
2 p. l., 398 p., 1 l. 19ᶜᵐ. fr. 3.50
© Jan. 15, 1911; 2c. Feb. 18, 1911; A—Foreign 2509; C. H. Hirsch, Paris, France. (11-2716) **826**

Hughes, Daniel E.
Hughes' practice of medicine, including a section on mental diseases and one on diseases of the skin. 10th ed., rev. and enl. by R. J. E. Scott ... with 63 illustrations. Philadelphia, P. Blakiston's son & co., 1911.
xviii, 878 p. illus. (partly col.) col. pl. 19½ᶜᵐ. $2.50
© Feb. 20, 1911; 2c. Feb. 21, 1911; A 280922; P. Blakiston's son & co., Philadelphia, Pa. (11-2120) **827**

... The **Indiana** digest; a digest of the decisions of the
courts of Indiana ... Comp. under the American digest
classification. v. 3. Contribution – Distribution. St.
Paul, West publishing co., 1911.

iii, 951 p. 26½^{cm}. (American digest system. State series) $6.00

© Feb. 20, 1911; 2c. Mar. 3, 1911; A 283137; West pub. co., St. Paul, Minn.
828

Jewett, Sarah Orne, 1849–1909.

... The night before Thanksgiving, A white heron and
selected stories by Sarah Orne Jewett, with introductory
notes, and questions and suggestions, by Katharine H.
Shute ... Boston, New York [etc.] Houghton Mifflin com-
pany [°1911]

2 p. l., [iii]–xiii, 119, [1] p. front. (port.) 17½^{cm}. (The Riverside lit-
erature series. [no. 202]) $0.15

CONTENTS.—To the teacher.—To the pupil.—A white heron.—The gar-
den tea. — A little traveler. — The circus at Denby. — The night before
Thanksgiving.—A war debt.—Miss Esther's guest.—Martha's lady.

© Jan. 18, 1911; 2c. Feb. 14, 1911; A 280784; Houghton Mifflin co., Boston,
Mass. (11–2074)
829

Keller, Gottfried, 1819–1890.

... Die drei gerechten kammacher, Frau Regel Amrain
und ihr jüngster; zwei novellen von Gottfried Keller, ed.
with introduction, notes and vocabulary, by Herbert Z.
Kip ... New York, Oxford university press, American
branch; [etc., etc.] 1911.

xi, 268 p. front. (port.) 18½^{cm}. (Oxford German series, general
editor: J. Goebel) $0.60

© Feb. 14, 1911; 2c. Feb. 16, 1911; A 280815; Oxford university press,
Amer. branch, New York, N. Y. (11–2494)
830

King, Georgiana Goddard.

The Bryn Mawr spelling book, by Georgiana Goddard
King, M. A. 2d ed. Bryn Mawr, Pa., Bryn Mawr college,
1911.

3 p. l., [5]–114 p. 19^{cm}. $0.25

© Jan. 27, 1911; 2c. Feb. 13, 1911; A 280762; G. G. King, Bryn Mawr, Pa.
(11–2713)
831

Kingsley, Maud Elma.

Outline of ancient history, by Maud Elma Kingsley ...
Boston, The Palmer company, °1911·

2 p. l., 40 p. 19½^{cm}. $0.35

© Feb. 16, 1911; 2c. Feb. 21, 1911; A 280938; Palmeer co., Boston, Mass.
(11–2122)
832

Kinsley, William Wirt, 1837–

Man's tomorrow, by William W. Kinsley ... Boston,
Sherman, French & company, 1911.

4 p. l., 190 p. 21½^{cm}. $1.20

© Feb. 17, 1911; 2c. Feb. 23, 1911; A 280957; Sherman, French & co., Bos-
ton, Mass. (11–2097)
833

Kraus, Rudolf, ed.

Handbuch der technik und methodik der immunitäts-
forschung, unter mitwirkung von dr. St. Baecher ... prof.
A. Besredka ... [u. a.] hrsg. von prof. dr. R. Kraus ...
und dr. C. Levaditi ... 1. ergänzungsband ... Jena, G.
Fischer, 1911.

3 p. l., 664 p. illus. (partly col.) plates (partly col., partly fold.) 26ᶜᵐ.
M. 24
Contains "Literatur."

© Dec. 28, 1910; 2c. Feb. 15, 1911; A—Foreign 2485; Gustav Fischer, Jena,
Germany. (11-2145) 834

Leonard, William Samuel, 1856–

Machine-shop tools and methods, by W. S. Leonard ...
with over 700 illustrations. 6th ed., rev. and enl. 1st
thousand. New York, J. Wiley & sons; [etc., etc.] 1911.

ix, 573 p. illus., diagrs. 23½ᶜᵐ. $4.00

© Feb. 24, 1911; 2c. Feb. 27, 1911; A 283037; W. S. Leonard, Atlanta, Ga.
(11-2503) 835

Lockhart, Caroline.

"Me—Smith," by Caroline Lockhart; with illustra-
tions by Gayle Hoskins. Philadelphia & London, J. B.
Lippincott company, 1911.

315 p. incl. col. front. plates. 19½ᶜᵐ. $1.20

© Feb. 16, 1911; 2c. Feb. 23, 1911; A 280944; J. B. Lippincott co., Phila-
delphia, Pa. (11-2073) 836

Løchen, Antonie.

... Smaahistorier om dyr. Kristiania, H. Aschehoug
& co. (W. Nygaard) 1909.

2 p. l., 108 p. 18½ᶜᵐ.

© Nov. 8, 1909; 2c. Feb. 4, 1911; A—Foreign 2468; H. Aschehoug & co.,
Christiania, Norway. (11-2113) 837

Louisiana. *Supreme court.*

Louisiana reports, v. 126; cases argued and determined
in the Supreme court of Louisiana sitting at New Orleans
at term beginning first Monday of October, 1909 ... Ed.
under the direction of the court by Charles G. Gill. St.
Paul, West publishing co., 1911.

xxv p., 1202 numb. col. 23ᶜᵐ. $4.50

© Feb. 28, 1911; 2c. Mar. 4, 1911; A 283172; West pub. co., St. Paul, Minn.
 838

Reports of cases argued and determined in the Su-
preme court of Louisiana and in the Superior court of
the territory of Louisiana. Annotated ed. ... Book 19,
containing a verbatim reprint of vols. 9 & 10 of Robin-
son's reports. St. Paul, West publishing co., 1911.

x, 340, vii, 328 p. 23ᶜᵐ. $7.50

© Feb. 24, 1911; 2c. Mar. 4, 1911; A 283173; West pub. co., St. Paul, Minn.
 839

MacBrayne, Lewis Edward, 1872–

The men we marry, by Lewis MacBrayne; with illustrations by R. I. Conklin. Boston, Mass., The C. M. Clark publishing co. [ᶜ1910]

4 p. l., 424 p. col. front., plates. 19½ᶜᵐ. $1.50

© Dec. 2, 1910; 2c. Feb. 11, 1911; A 280733; C. M. Clark pub. co., Boston, Mass. (11–2687) **840**

McFarland, Raymond.

A history of the New England fisheries, with maps, by Raymond McFarland ... [Philadelphia] University of Pennsylvania; New York, D. Appleton and company, agents, 1911.

5 p. l., 457 p. 3 maps. 20ᶜᵐ. $2.00

Bibliography: p. 338–363.

© Feb. 10, 1911; 2c. Feb. 13, 1911; A 280789; University of Pennsylvania, Philadelphia, Pa. (11–2088) **841**

McLean, Ridley.

The bluejacket's manual, United States navy, 1911. Rev. and enl. Prepared by Lieutenant Ridley McLean, u. s. n.; rev. (1907) by Lieutenant R. Z. Johnston, u. s. n.; rev. (1908) by Lieutenant Commander H. J. Ziegemeier, u. s. n.; rev. (1910) by Lieutenant Commander R. Z. Johnston, u. s. n. ... Annapolis, Md., The Naval institute [ᶜ1911]

188, 188a–188b, 189–407 p. illus. (partly col.) diagrs. (2 fold.) fold. tab. 15½ᶜᵐ.

© Jan. 21, 1911; 2c. Feb. 16, 1911; A 280813; P. R. Alger, u. s. n., secy. and treas. U. S. Naval institute, Annapolis, Md. (11–2236) **842**

Margueritte, Paul, 1860–

... L'eau souterraine; illustrations de A. de Parys. Paris, P. Lafitte & cᶦᵉ [ᶜ1910]

124 p. incl. front., illus., plates. 24ᶜᵐ. (Idéal-bibliothèque [12]) fr. 0.95

At head of title: Paul et Victor Margueritte.

© Mar. 1, 1910; 2c. Feb. 2, 1911; A—Foreign 2447; Pierre Lafitte & cie., Paris, France. (11–2106) **843**

Mathews, Ferdinand Schuyler, 1854–

... Familiar trees and their leaves, described and illustrated by F. Schuyler Mathews ... with illustrations in colors and over two hundred drawings by the author, and an introduction by Prof. L. H. Bailey ... [Edition in colors] New York and London, D. Appleton and company, 1911.

xvii, 334 p. incl. illus., 2 pl. col. front., plates (partly col.)· 21ᶜᵐ. $1.75

© Feb. 17, 1911; 2c. Feb. 20, 1911; A 280880; D. Appleton & co., New York, N. Y. (11–2142) **844**

Metal worker, plumber and steam fitter.

Practical sheet metal work and demonstrated patterns; a comprehensive treatise in several volumes on shop and outside practice and pattern drafting ... v. 1, 3. Comp. from the Metal worker, plumber and steam fitter, ed. by J. Henry Teschmacher, jr. New York, David Williams company, 1910.

2 v. illus., diagrs. 28ᶜᵐ.

v. 1 © Jan. 28, 1911; 2c. Feb. 11, 1911; A 280737; David Williams co., New York, N. Y.

v. 3 © Feb. 8, 1911; 2c. Feb. 11, 1911; A 283130; David Williams co., New York, N. Y. (11-2093) 845, 846

Michigan. *Supreme court.*

Michigan reports. Cases decided ... from June 8 to September 27, 1910. James M. Reasoner, state reporter. v. 162, 1st ed. Chicago, Callaghan & co., 1911.

xxx, 786 p. 22½ᶜᵐ. $1.30

© Feb. 24, 1911; 2c. Mar. 2, 1911; A 283105; Frederick C. Martindale, sec. of state for the state of Mich., Lansing, Mich. 847

[Moersberger, *Frau* Rose (Schliewen)]

Bilder aus den vier wänden; novellen von Felicitas Rose [pseud.] Berlin [etc.] Deutsches verlagshaus Bong & co. [ᶜ1911]

2 p. l., 374 p., 1 l. 20ᶜᵐ. M. 4

CONTENTS.—Bilder aus den vier wänden.—Tagebuch einer närrin.—Unsere Male auf urlaub.—Tagebuch einer dienstmagd.—Mein vetter Balduin.

© Jan. 25, 1911; 2c. Feb. 15, 1911; A—Foreign 2496; Deutsches verlaghaus Bong & co., Berlin, Germany. (11-2110) 848

Moody, Walter Dwight, 1874– *ed.*

Business administration; theory, practice and application; editor-in-chief, Walter D. Moody ... managing editor, Samuel MacClintock ... Chicago, La Salle extension university [ᶜ1910]

6 v. illus. (incl. tables, charts) forms (partly fold.) 24½ᶜᵐ. $3.00 each.

© Feb. 6, 1911; 2c. each Feb. 6, 1911; A 280819–280823, 280985; La Salle extension university, Chicago, Ill. (11-2227) 849-854

Mowbray, Jay Henry.

Thrilling achievements of "bird men" with flying machines, being a comprehensive history of aerial navigation ... by Jay Henry Mowbray ... embellished with a great number of pictures ... Philadelphia, Pa., National publishing co. [ᶜ1911]

vi, 17–256 p. • col. front., illus., plates. 25ᶜᵐ. $1.00

© Feb. 15, 1911; 2c. Feb. 18, 1911; A 280853; Geo. W. Bertron, Philadelphia, Pa. (11-2501) 855

Navarre, Albert, 1874–

... Traité pratique de sténographie et de dactylographie, par Albert Navarre ... Paris, C. Delagrave [°1910]

3 p. l., 252 p. illus. 18½ᶜᵐ. (Bibliothèque des écoles primaires supérieures et des écoles professionnelles, publiée sous la direction de F. Martel) fr. 2.50

© Jan. 27, 1911; 2c. Feb. 18, 1911; A—Foreign 2512; Ch. Delagrave, Paris, France. (11–2218) 856

New York (*State*) *Education dept.*

... Selections for study and memorizing, poetry and prose, prescribed by the New York state education department in the course of study and syllabus for elementary schools, 1910. Boston, New York [etc.] Houghton Mifflin company [°1910]

vi, 121, [1] p. 17½ᶜᵐ. (The Riverside literature series) $0.15

© Dec. 20, 1910; 2c. Feb. 14, 1911; A 280783; Houghton Mifflin co., Boston, Mass. (11–2082) 857

New York (*State*) *Surrogate's courts.*

Reports of cases argued and determined in the Surrogate's courts of the state of New York, with annotations, ed. by Chas. H. Mills ... v. 1. Albany, N. Y., W. C. Little & co., 1911.

1 p. l., v–xxx, 655 p. 24ᶜᵐ. $5.50

© Feb. 18, 1911; 2c. Feb. 20, 1911; A 280907; W. C. Little & co., Albany, N. Y. (11–2243) 858

... The **New York** supplement, with key-number annotations. v. 125. Permanent ed. (New York state reporter, vol. 159) ... November 7, 1910–January 2, 1911. St. Paul, West publishing co., 1911.

xxxiv, 1272 p. 23½ᶜᵐ. (National reporter system. N. Y. supp. and state reporter) $3.00

© Feb. 18, 1911; 2c. Mar. 3, 1911; A 283140; West pub. co., St. Paul, Minn.
859

... The **Northwestern** reporter, with key-number annotations. v. 128. Permanent ed. Containing all the decisions of the supreme courts of Minnesota, Michigan, Nebraska, Wisconsin, Iowa, North Dakota, South Dakota ... November 25, 1910–January 13, 1911. St. Paul, West publishing co., 1911.

xxvi, 1279 p. 26½ᶜᵐ. (National reporter system—State series) $4.00

© Feb. 20, 1911; 2c. Mar. 3, 1911; A 283138; West pub. co., St. Paul, Minn.
860

Noyes, William Albert, 1857–

The elements of qualitative analysis, by Wm. A. Noyes ... 6th ed., rev., in collaboration with the author, by G. McP. Smith ... New York, H. Holt and company, 1911.

v, 131 p. tables. 22ᶜᵐ. $0.75

© Feb. 9, 1911; 2c. Feb. 16, 1911; A 280829; Henry Holt & co., New York, N. Y. (11–2144) 861

Odhner, Carl Theophilus, 1863–

Michael Servetus, his life and teachings, by Carl Theophilus Odhner ... Philadelphia, Press of J. B. Lippincott company, 1910.

v, 94, ₍2₎ p. 2 port. (incl. front.) 20ᶜᵐ.

© July 6, 1910; 2c. Feb. 10, 1911; A 280677; C. T. Odhner, Bryn Athyn, Pa. (11–2096) **862**

Ohnet, Georges, 1848–

La légende et l'histoire. Pour tuer Bonaparte, par Georges Ohnet; dessins de A. de Parys. 15. éd. Paris, P. Ollendorff, ᶜ1911.

2 p. l., 363, ₍1₎ p. incl. illus., plates. 18½ᶜᵐ. fr. 3.50

© Jan. 20, 1911; 2c. Feb. 18, 1911; A—Foreign 2503; G. Ohnet, Paris, France. (11–2496) **863**

O'Reilly, Brefney Rolph.

A manual of physical diagnosis, by Brefney Rolph O'Reilly ... with 6 plates and 49 other illustrations. Philadelphia, P. Blakiston's son & co., 1911.

xxi, 369 p. incl. illus. (partly col.) 3 pl., diagrs. 3 pl. 20ᶜᵐ. $2.00

© Feb. 17, 1911; 2c. Feb. 18, 1911; A 280861; P. Blakiston's son & co., Philadelphia, Pa. (11–2117) **864**

Overlock, Melvin George, 1865–

The working people; their health and how to protect it, by M. G. Overlock ... ₍2d ed.₎ Boston, Massachusetts health book publishing company ₍ᶜ1911₎

293 p. incl. front. (port.) port. 20½ᶜᵐ. $2.00

© Feb. 23, 1911; 2c. Feb. 23, 1911; A 280992; M. G. Overlock, Worcester, Mass. (11–2698) **865**

Pennsylvania infantry. *155th regt.,* 1862–1865.

Under the Maltese cross, Antietam to Appomattox, the loyal uprising in western Pennsylvania, 1861–1865; campaigns 155th Pennsylvania regiment, narrated by the rank and file. Pittsburg, Pa., The 155th regimental association, 1910.

1 p. l., xiii, ₍3₎, 817 p. col. front., illus. (incl. ports.) plates (partly col., 1 fold.) fold. map. 26½ᶜᵐ.

© Feb. 14, 1911; 2c. Feb. 20, 1911; A 280894; John T. Porter, financial secy., Pittsburg, Pa. (11–2152) **866**

Phillips, Claude A.

A history of education in Missouri; the essential facts concerning the history and organization of Missouri's schools, by Claude A. Phillips ... Jefferson City, Mo., The Hugh Stephens printing company ₍ᶜ1911₎

x, 292, v p. 19½ᶜᵐ. $1.25
Bibliography: p. 292.

© Jan. 31, 1911; 2c. Feb. 2, 1911; A 280546; C. A. Phillips, Warrensburg, Mo. (11–2517) **867**

Poe, Edgar Allan, 1809-1849.

... Contes étranges; traduction de Armand Masson, illustrations de J. Wély. Paris, P. Lafitte & c¹ᵉ [°1910]

125 p. incl. front., illus. 24½ᶜᵐ. (Idéal-bibliothèque [13₁]) fr. 0.95

© Apr. 30, 1910; 2c. Feb. 2, 1911; A—Foreign 2446; Pierre Lafitte & cie., Paris, France. (11-2105) 863

Ramm, Minda.

... Valgaar, novelle. Kristiania, H. Aschehoug & co. (W. Nygaard) 1909.

2 p. l., 154 p. 20ᶜᵐ.

© Nov. 11, 1909; 2c. Feb. 4, 1911; A—Foreign 2469; H. Aschehoug & co., Christiania, Norway. (11-2112) 869

Read, Clifford Kingsley.

New ideals of social justice and social service, by Clifford Kingsley Read, delivered before the Wesley brotherhood, August 19, 1910. Ridgefield Park, N. J., The Wesley brotherhood, 1911.

31 p. 19½ᶜᵐ. $0.25

© Feb. 11, 1911; 2c. Feb. 15, 1911; A 280803; Wesley brotherhood, Ridgefield Park, N. J. (11-2101) 870

Reboux, Paul, 1877–

... La petite Papacoda, roman napolitain. Paris, E. Fasquelle, 1911.

3 p. l., 365 p. 19ᶜᵐ. fr. 3.50

© Jan. 27, 1911; 2c. Feb. 18, 1911; A—Foreign 2507; Eugène Fasquelle, Paris, France. (11-2715) 871

Reynolds, James Bronson, 1861– ed.

... Civic bibliography for Greater New York, ed. by James Bronson Reynolds for the New York research council. New York. Charities publication committee, 1911.

xvi, 296 p. 24ᶜᵐ. (Russell Sage foundation [publications])

"The original work was done by Messrs. Howard B. Woolston, PH. D., and Roger Howson ... Their work was subsequently added to and completed by Miss Catharine S. Tracey."—Pref.

© Feb. 14, 1911; 2c. Feb. 18, 1911; A 280850; Russell Sage foundation, New York, N. Y. (11-2217) 872

Rowe, Jesse Perry, 1871–

Practical mineralogy simplified, for mining students, miners and prospectors, by Jesse Perry Rowe ... 1st ed. 1st thousand. New York, J. Wiley & sons; [etc., etc.] 1911.

162 p. fold. tables. 19½ᶜᵐ. $1.25

© Feb. 18, 1911; 2c. Feb. 21, 1911; A 280923; J. P. Rowe, Missoula, Mont. (11-2143) 873

Schäfer, Wilhelm, 1868–

Der schriftsteller, von Wilhelm Schäfer. Frankfurt am Main, Literarische anstalt Rütten & Loening [*1910]

90 p., 1 l. 19½ᶜᵐ. (*Added t.-p.:* Die gesellschaft; sammlung sozialpsychologischer monographien, hrsg. von M. Buber. 39. bd.)

© Dec. 31, 1910; 2c. Jan. 13, 1911; A—Foreign 2306; Literarische anstalt Rütten & Loening, Frankfurt a. M., Germany. (11–2710) **874**

Seligman, Edwin Robert Anderson, 1861–

The income tax; a study of the history, theory and practice of income taxation at home and abroad, by Edwin R. A. Seligman ... New York, The Macmillan company, 1911.

xi, 711 p. fold. tables. 22½ᶜᵐ. $3.00

Bibliography: p. [675]–700.

© Feb. 23, 1911; 2c. Feb. 24, 1911; A 280978; Macmillan co., New York, N. Y. (11–2522) **875**

Shamel, Clarence Albert.

Profitable stock raising; a careful discussion of the problems involved in the development of profitable live stock and the maintenance of soil fertility, by Clarence Albert Shamel ... New York, Orange Judd company, 1911.

ix p., 1 l., 274 p. front., illus., plates. 19ᶜᵐ. $1.50

© Jan. 26, 1911; 2c. Feb. 18, 1911; A 280854; Orange Judd co., New York, N. Y. (11–2089) **876**

Sophocles.

The Antigone of Sophocles, tr. into English verse by Joseph Edward Harry ... Cincinnati, The Robert Clarke company, 1911.

69 p. 21ᶜᵐ. $1.00

© Feb. 21, 1911; 2c. Feb. 23, 1911; A 280994; Robt. Clarke co., Cincinnati, O. (11–2711) **877**

... The **Southwestern** reporter, with key-number annotations. v. 132. Permanent ed. ... December 28, 1910– January 25, 1911. St. Paul, West publishing co., 1911.

xvi, 1356 p. 26½ᶜᵐ. (National reporter system—State series) $4.00

© Feb. 25, 1911; 2c. Mar. 4, 1911; A 283170; West pub. co., St. Paul, Minn. **878**

——— Kentucky decisions reported in the Southwestern reporter annotated vols. 126, 127, 128, 129, 130, and 131, April, 1910, to December, 1910 ... St. Paul, West publishing co., 1911.

Various paging. diagrs. 26½ᶜᵐ. $6.00

© Feb. 23, 1911; 2c. Mar. 3, 1911; A 283135; West pub. co., St. Paul, Minn. **879**

... The **Southwestern** reporter—Continued

———— Texas decisions reported in the Southwestern reporter annotated, vols. 130 and 131, August to December, 1910 ... St. Paul, West publishing co., 1911.

Various paging. 26¼ᶜᵐ. $5.50

© Feb. 25, 1911; 2c. Mar. 4, 1911; A 283171; West pub. co., St. Paul, Minn.
 880

Spencer, Edward Whiton.

A treatise on the law of domestic relations and the status and capacity of natural persons as generally administered in the United States, by Edward W. Spencer ... New York, The Banks law publishing co., 1911.

xcv, 777 p. 24ᶜᵐ. $6.00

© Feb. 21, 1911; 2c. Feb. 23, 1911; A 280952; Banks law pub. co., New York, N. Y. (11–2245) 881

Storrer, Jacob, 1861–

Compendium of Biblical texts and topics for every Sunday of the year, by Rev. J. Storrer. Cleveland, O., Central publishing house, 1910.

169 p. 23ᶜᵐ.

© Dec. 20, 1910; 2c. Feb. 13, 1911; A 280760; J. Storrer, Buffalo, N. Y. (11–2095) 882

Tower, Olin Freeman, 1872–

A course of qualitative chemical analysis of inorganic substances, with explanatory notes, by Olin Freeman Tower ... 2d ed., rev. Philadelphia, P. Blakiston's son & co., 1911.

xiii, 84 p. 24ᶜᵐ. $1.00

© Feb. 11, 1911; 2c. Feb. 13, 1911; A 280777; P. Blakiston's son & co., Philadelphia, Pa. (11–2146) 883

Watson, Henry Brereton Marriott, 1863–

Alise of Astra, by H. B. Marriott Watson ... with frontispiece by F. Graham Cootes. Boston, Little, Brown, and company, 1911.

vi p., 1 l., 312 p. front. 20ᶜᵐ.

© Feb. 18, 1911; 2c. Feb. 21, 1911; A 280929; Little, Brown & co., Boston, Mass. (11–2072) 884

Wells, Carolyn.

The gold bag, by Carolyn Wells ... with a frontispiece by George W. Barratt. Philadelphia and London, J. B. Lippincott company, 1911.

333 p. incl. col. front. 19¼ᶜᵐ. $1.20

© Feb. 16, 1911; 2c. Feb. 23, 1911; A 280942; J. B. Lippincott co., Philadelphia, Pa. (11–2075) 885

Wells, Herbert George, 1866–

... L'étrange aventure de M. Hoopdriver; traduction Savine et Georges Michel; illustrations de J. Wély. Paris, P. Lafitte & c^{ie} [*1910]

126 p. incl. front., illus. 24½^{cm}. ("Idéal-bibliothèque." [16]) fr. 0.95

© July 25, 1910; 2c. Feb. 2, 1911; A—Foreign 2450; Pierre Lafitte & cie., Paris, France. (11–2085) 886

Wetmore, Monroe Nichols, 1863–

Index verborum Vergilianus, by Monroe Nichols Wetmore ... New Haven, Yale university press; [etc., etc.] 1911.

x, 554 p., 1 l. 25^{cm}. $4.00

© Feb. 15, 1911; 2c. Feb. 15, 1911; A 280934; Yale university press, New Haven, Conn. (11–2238) 887

Wiley, Harvey Washington, 1844–

Foods and their adulteration; origin, manufacture, and composition of food products; infants' and invalids' foods; detection of common adulterations, and food standards, by Harvey W. Wiley ... With eleven colored plates and eighty-seven other illustrations. 2d ed., rev. and enl. Philadelphia, P. Blakiston's son & co., 1911.

xii, 641 p. illus., 11 col. pl. 24^{cm}. $4.00

© Feb. 21, 1911; 2c. Feb. 23, 1911; A 280964; P. Blakiston's son & co., Philadelphia, Pa. (11–2502) 888

Wisconsin. *Supreme court.*

Wisconsin reports, 142. Cases determined ... February 22–May 24, 1910. Frederic K. Conover, official reporter. Chicago, Callaghan and company, 1910.

xxix, 737 p. 23½^{cm}. $1.30

© Sept. 16, 1910; 2c. Mar. 2, 1911; A 283103; James A. Frear, sec. of state of the state of Wisconsin, for the benefit of the people of said state, Madison, Wis. 889

Wisconsin reports, 143. Cases determined ... May 24–November 15, 1910. Frederic K. Conover, official reporter. Chicago, Callaghan and company, 1911.

xxxvi, 721 p. 23½^{cm}. $1.45

© Feb. 24, 1911; 2c. Mar. 2, 1911; A 283104; James A. Frear, sec. of state of the state of Wisconsin, for the benefit of the people of said state, Madison, Wis. 890

Wroth, Lawrence Counselman, 1884–

Parson Weems; a biographical and critical study, by Lawrence C. Wroth. Baltimore, Md., The Eichelberger book company, 1911.

104 p. front. (port.) plates, facsim. 20^{cm}. $1.00

© Feb. 17, 1911; 2c. Feb. 20, 1911; A 280888; L. C. Wroth, Baltimore, Md. (11–2151) 891

Zola, Émile, 1840–1902.

... Le rêve; illustrations de René Lelong. Paris, P. Lafitte & c⁰ᵉ ₁°1910₎
121 p. incl. front., illus. 24½ᶜᵐ. (Idéal-bibliothèque. ₁18₎) fr. 0.95
© Oct. 4, 1910; 2c. Feb. 2, 1911; A—Foreign 2448; Pierre Lafitte & cie.,
Paris, France. (11–2086) 892

Number of entries of books included in the Catalogue for 1911:
a) United States publications_____ 667
b) Foreign books in foreign languages_____ 214
c) Foreign books in English language under *ad interim* provisions of law of Mar. 4, 1909_____ 11

 Total _____ 892

LIBRARY OF CONGRESS

COPYRIGHT OFFICE

CATALOGUE

OF

COPYRIGHT ENTRIES

PUBLISHED WEEKLY BY AUTHORITY OF THE ACTS OF CONGRESS
OF MARCH 3, 1891, OF JUNE 30, 1906, AND
OF MARCH 4, 1909

PART 1, GROUP 1

BOOKS

1911

New Series, Volume 8, no. 8

WASHINGTON
GOVERNMENT PRINTING OFFICE
LIBRARY DIVISION
1911

The Act of March 4, 1909, provides that the Catalogue of Copyright Entries shall be "admitted in any court as prima facie evidence of the facts stated therein as regards any copyright registration."

Published March 23, 1911

Acton, Amy Florence, 1869–

... Local option in Massachusetts, by Amy F. Acton ... New York, Charities publication committee, 1911.

ix, 152 p. 20½ᶜᵐ. (Russell Sage foundation (publication)) $0.75
© Feb. 23, 1911; 2c. Feb. 27, 1911; A 283048; Russell Sage foundation, New York, N. Y. (11–3261) 893

American school of correspondence, *Chicago.*

Cyclopedia of drawing; a general reference work ... Editor-in-chief: Harris C. Trow ... Prepared ... by a staff of architects, designers, and experts ... two thousand illustrations, tables and formulae. Chicago, American school of correspondence, 1911.

4 v. fronts., illus., plates, diagrs. 25ᶜᵐ.
CONTENTS.—pt. I. Mechanical; architectural; pen and ink rendering; lettering.— pt. II. Freehand; perspective; shades and shadows; Roman orders.—pt. III. Working shop drawings; machine design.—pt. IV. Sheet metal pattern drafting; index.
© Feb. 9, 1911; 2c. Feb. 21, 1911; A 280935; Amer. school of correspondence, Chicago, Ill. (11–2990) 894

Armfield, Anne Constance (Smedley) *"Mrs. Maxwell Armfield."*

Mothers and fathers; a novel, by Mrs. Maxwell Armfield (Constance Smedley) London, Chatto & Windus, 1911.

3 p. l., [vi]–vi, 402 p. 19½ᶜᵐ.
© 1c. Feb. 27, 1911; A ad int. 495; published Feb. 21, 1911; Constance Armfield, Minchin Hampton, England. (11–2967) 895

Art, Georges.

La mémoire verbale et pratique, son développement naturel et logique par l'audition, la vision, l'idée; méthode Georges Art. Nantes, 1911.

3 p. l., 309 p. 19ᶜᵐ. fr. 3.50
© Jan. 18, 1911; 2c. Feb. 18, 1911; A—Foreign 2508; G. Art, Nantes, France. (11–3245) 896

Babbitt, Charles Jacob, 1856–

The law applied to motor vehicles, with a collection of all the reported cases decided during the first ten years of the use of motor vehicles upon the public thoroughfares, by Charles J. Babbitt ... with an introduction by Francis Hurtubis, jr. ... Washington, D. C., J. Byrne & co., 1911.

1217 p. 23¼ᶜᵐ. $6.50
"Text writers consulted": p. 73–75.
© Mar. 6, 1911; 2c. Mar. 7, 1911; A 283222; John Byrne & co., Washington, D. C. (11–3502) **897**

Bacheller, Irving Addison, 1859–

Keeping up with Lizzie, by Irving Bacheller; illustrated by W. H. D. Koerner. New York and London, Harper & brothers, 1911.

5 p. l., 157, [1] p. front., plates. 18½ᶜᵐ. $1.00
© Mar. 2, 1911; 2c. Mar. 4, 1911; A 283155; Harper & bros., New York, N. Y (11–3473) **898**

Bacon, *Mrs.* Josephine Dodge (Daskam) 1876–

While Caroline was growing, by Josephine Daskam Bacon ... New York, The Macmillan company, 1911.

5 p. l., 330 p. plates. 19¼ᶜᵐ. $1.50
© Mar. 1, 1911; 2c. Mar. 2, 1911; A 283108; Macmillan co., New York, N. Y. (11–2970) **899**

Bailey, Liberty Hyde, 1858–

The outlook to nature, by L. H. Bailey. New and rev. ed. New York, The Macmillan company, 1911.

xii p., 1 l., 195 p. 20ᶜᵐ. $1.25
"This book contains four lectures given in the Colonial theatre, Boston, as a part of the university course, under the auspices of the Education committee of the Twentieth century club ... Parts of the fourth lecture once appeared in the Independent."
CONTENTS.—The realm of the commonplace.—Country and city.—The school of the future.—Evolution: the quest of truth.
© Feb. 23, 1911; 2c. Feb. 24, 1911; A 280979; Macmillan co., New York, N. Y. (11–2987) **900**

Beal, James Hartley.

Elementary principles of the theory and practice of pharmacy, by J. H. Beal ... pt. 2. Manufacturing pharmacy (Galenical) Scio, O., J. H. Beal [1911]

262 p. illus. 23ᶜᵐ. $2.00
© Feb. 24, 1911; 2c. Mar. 8, 1911; A 283240; J. H. Beal, Scio, O. **901**

Bennett, Enoch Arnold, 1867–

The old wives' tale. A new ed., with preface, by Arnold Bennett ... New York, Hodder & Stoughton, G. H. Doran company [c1911]

3 p. l., v–ix, [2], 612 p. 20½ᶜᵐ. $1.50
First published in 1908.
© Mar. 4, 1911; 2c. Mar. 6, 1911; A 283196; Geo. H. Doran co., New York, N. Y. (11–3628) [Copyright is claimed on preface] **902**

Berry, Charles William, 1872–

The temperature-entropy diagram, by Charles W.
Berry ... 3d ed., rev. and enl. 1st thousand. New York,
J. Wiley & sons; [etc., etc.] 1911.

xv, [2], 393 p. diagrs. 19½ᶜᵐ. $2.50
© Feb. 24. 1911; 2c. Feb. 27, 1911; A 283034; C. W. Berry, Boston, Mass.
(11–3249) 903

Bigelow, Melville Madison, 1846–

A false equation; the problem of the great trust, by
Melville M. Bigelow ... Boston, Little, Brown, and com-
pany, 1911.

vii p., 1 l., 251 p. 20ᶜᵐ. $1.50
© Feb. 25, 1911; 2c. Feb. 28, 1911; A 283073; Little, Brown, and company,
Boston, Mass. (11–3263) 904

Binns, Henry Bryan, 1873–

The adventure; a romantic variation on a Homeric
theme [by] Henry Bryan Binns ... New York, B. W.
Huebsch; [etc., etc.] 1911.

5 p. l., 96 p. 18½ᶜᵐ.
© Feb. 15, 1911; 2c. Feb. 20, 1911; D 23442; H. B. Binns, London, England.
(11–3479) 904*

Blodgett, May Adel, 1861–

New exercises and problems in elementary algebra, for
use as supplementary material in addition to regular text
book work, by May A. Blodgett ... Minneapolis, Minn.,
North-western school supply co. [°1911]

3 p. l., 89 p. 19ᶜᵐ. $0.25
© Feb. 7, 1911; 2c. Feb. 11, 1911; A 280746; North-western school supply
co., Minneapolis, Minn. (11–3376) 905

Blythe, Marion.

An American bride in Porto Rico, by Marion Blythe.
New York, Chicago [etc.] Fleming H. Revell company
[°1911]

205 p. incl. front. plates. 19½ᶜᵐ. $1.00
© Feb. 25, 1911; 2c. Mar. 1, 1911; A 283084; Fleming H. Revell co., New
York, N. Y. (11–3272) 906

Booth, Edna Perry.

Nursery rhymes for the grown-ups, and some of another
kind, by Edna Perry Booth ... New York, The Grafton
press, 1910.

viii, 60 p. 19½ᶜᵐ. $1.00
© Dec. 30. 1910; 2c. Feb. 28, 1911; A 283077; E. P. Booth, Brooklyn, N. Y.
(11–3650) 907

Bottomley, Gordon, 1874–

The riding to Lithend; a play in one act by Gordon
Bottomley. Portland, Me., T. B. Mosher, 1910.

vi p., 1 l., 61, [1] p., 1 l. 18ᶜᵐ.
© Oct. 1, 1910; 2c. Feb. 27, 1911; D 23470; Thos. B. Mosher, Portland, Me.
(11–3649) 907*

Boyer, Michael K 1858–

The Curtiss poultry book. $100,000 a year from poultry; being a complete and accurate account of the great plant and present successful methods of W. R. and W. J. Curtiss, operating the Niagara poultry farm of Ransomville, N. Y., largest general poultry enterprise in the world. By Michael K. Boyer ... Philadelphia, Wilmer Atkinson co., 1911.

55 p. incl. front., illus. 22½ᶜᵐ. $0.25

Published in 1910 under title: $100,000 per year from poultry. The Curtiss poultry book ...

© Feb. 18, 1911; 2c. Feb. 20, 1911; A 280904; Wilmer Atkinson co., Philadelphia, Pa. (11–3653) **908**

Buchanan, Thompson.

The second wife, by Thompson Buchanan; frontispiece by Harrison Fisher; illustrations by W. W. Fawcett. New York, W. J. Watt & company [°1911]

2 p. l., 3–318 p., 1 l. col. front., illus. 19ᶜᵐ. $1.50

© Feb. 25, 1911; 2c. Feb. 27, 1911; A 283039; W. J. Watt & co., New York, N. Y. (11–2978) **909**

Buchanan, Uriel.

The heart of being; or, Truth and destiny, by Uriel Buchanan ... Chicago, The Library shelf, 1909.

3 p. l., 9–89 p. 18ᶜᵐ. $0.75

© Dec. 14, 1909; 2c. Feb. 27, 1911; A 283057; Library shelf, Chicago, Ill. (11–3651) **910**

Byrne, Austin Thomas, 1859–

Inspection of the materials and workmanship employed in construction. A reference book for the use of inspectors, superintendents, and others engaged in the construction of public and private works ... By Austin T. Byrne ... 3d ed., thoroughly rev. Total issue, 7,000. New York, J. Wiley & sons; [etc., etc.] 1911. •

xvi, 609 p. 18½ᶜᵐ. $3.00

© Feb. 28, 1911; 2c. Mar. 2, 1911; A 283117; A. T. Byrne, Baldwins, N. Y. (11–3374) **911**

Carleton, William, *pseud.*

One way out; a middle-class New-Englander emigrates to America, by William Carleton. Boston, Small, Maynard & company [1911]

5 p. l., 303 p. 19½ᶜᵐ.

© Jan. 28, 1911; 2c. Feb. 4, 1911; A 280602; Small, Maynard & co., inc., Boston, Mass. (11–35154) **912**

Chambers, Robert William, 1865–

The adventures of a modest man, by Robert W. Chambers; illustrated by Edmund Frederick. New York and London, D. Appleton and company, 1911.

xv, [1], 325, [1] p. front., illus., plates. 19½ᶜᵐ. $1.30

© Feb. 24, 1911; 2c. Feb. 27, 1911; A 283046; R. W. Chambers, Broadalbin, N. Y. (11–2973) 913

Chesterton, Gilbert Keith, 1873–

Appreciations and criticisms of the works of Charles Dickens, by G. K. Chesterton. London, J. M. Dent & sons, ltd.; New York, E. P. Dutton & co. [ᶜ1911]

xxx, 243 p. 8 port. (incl. front.) 22½ᶜᵐ. $2.00

© Feb. 21, 1911; 2c. Feb. 24, 1911; A 280986; E. P. Dutton & co., New York, N. Y. (11–2983) 914

Cooke, Louis Joseph, 1868–

Manual of personal hygiene, by Louis J. Cooke ... For use in freshman course in personal hygiene, University of Minnesota. Minneapolis, The H. W. Wilson company, 1910.

4 p. l., 3–93 p. illus. 22½ᶜᵐ. $0.90

© Sept. 15, 1910; 2c. Mar. 2, 1911; A 281912; L. J. Cooke, Minneapolis, Minn. (11–3656) 915

[Cory, Vivian]

Self and the other, by Victoria Cross [pseud.] ... New York [Press of W. G. Hewitt, Brooklyn, N. Y.] 1911.

2 p. l., 268 p. 19½ᶜᵐ. $1.50

© Feb. 21, 1911; 2c. Feb. 28, 1911; A 283142; V. C. Griffin, London, England. (11–3472) 916

District of Columbia. *Court of appeals.*

Reports of cases adjudged from April 5, 1910, to November 1, 1910. Charles Cowles Tucker, reporter ... v. 35 (To be cited as "35 App. D. C.") ... New York, Rochester, N. Y. [etc.] The Lawyers co-operative publishing company, 1911.

xxiii, 671 p. 23½ᶜᵐ. $5.00

© Mar. 8, 1911; 2c. Mar. 13, 1911; A 283348; Charles Cowles Tucker, Washington, D. C. 917

Duncan, John Christie.

The economic side of works management ... [New York? ᶜ1911]

2 p. l., p. 183–316. illus. (incl. forms) 19½ᶜᵐ.

"Appeared in 1907 in the Business world" and forms the third part of the author's Principles of industrial management. *cf.* Pref.

© Feb. 27, 1911; 2c. Mar. 1, 1911; A 283089; D. Appleton & co., New York. N. Y. (11–3493) 918

Essays in modern theology and related subjects, gathered and published as a testimonial to Charles Augustus Briggs, D. D., D. LITT., graduate professor of theological encyclopædia and symbolics in the Union theological seminary in the city of New York, on the completion of his seventieth year, January 15, 1911, by a few of his pupils, colleagues and friends. New York, C. Scribner's sons, 1911.

xvi p., 1 l., 347 p. 2 pl. 23½ᶜᵐ. $2.50

CONTENTS.—Polytheism in Genesis as a mark of date, by C. H. Toy.—The meaning of Hebrew Bithrôn, 2 Sam. 2²⁹, by W. R. Arnold.—Exegetical notes on Jeremiah, by J. A. Bewer.—The return of the Jews under Cyrus, by E. L. Curtis.—The sons of Korah, by J. P. Peters.—The anti-sacrificial psalms, by K. Fullerton.—The decline of prophecy, by F. Brown.—Man and the Messianic hope, by T. F. Day.—Notes on two passages in the Old Testament Apocrypha, by A. V. W. Jackson.—The definition of the Jewish canon and the repudiation of Christian Scriptures, by G. F. Moore.—The Greek and the Hittite gods, by W. H. Ward.—Babylonian eschatology, by S. H. Langdon.—Some characteristics of the common Arabic speech of Syria and Palestine, by F. J. Bliss.—The person of Jesus in the double tradition of Matthew and Luke, by G. H. Gilbert.—The integrity of Second Corinthians, by M. R. Vincent.—Οἱ ἄτακτοι, 1 Thess. 5¹⁴, by J. E. Frame.—Calvin's theory of the church, by A. C. McGiffert.—The repression of scientific inquiry in the ancient church, by J. W. Platner.—The Christian demand for unity: its nature and implications, by W. A. Brown.—A definition of mysticism, by T. C. Hall.—One law of the interpretation of religion, by E. C. Moore.—The theory of pleasure, by H. N. Gardiner.—Natural teleology, by F. J. E. Woodbridge.—Bibliography containing a list of the principal writings of Professor Briggs, by C. R. Gillett (p. 327–347)

© Feb. 11, 1911; 2c. Mar. 3, 1911; A 283129; Chas. Scribner's sons. New York, N. Y. (11–3361) 919

Fillebrown, Thomas, 1836–1908.

Resonance in singing and speaking, by Thomas Fillebrown ... Boston, Oliver Ditson company; New York, C. H. Ditson & co.; [etc., etc., ᶜ1911]

viii p., 1 l., 93 p. illus. 20½ᶜᵐ.

"Books consulted": p. 86–88.

© Feb. 14, 1911; 2c. Feb. 23, 1911; A 280958; Oliver Ditson co., Boston, Mass. (11–3486) 920

Frenssen, Gustav, 1863–

Klaus Hinrich Baas; the story of a self-made man, by Gustav Frenssen ... Authorized translation from the German by Esther Everett Lape and Elizabeth Fisher Read. New York, The Macmillan company, 1911.

3 p. l., 440 p. 20ᶜᵐ.

© Mar. 1, 1911; 2c. Mar. 2, 1911; A 283107; Macmillan co., New York, N. Y. (11–2977) 921

Gachot, Édouard, 1862–

Histoire militaire de Massena. La troisième campagne d'Italie (1805–1806) guerre de l'an xiv—expédition de

Gachot, Édouard—Continued

Naples—le vrai Fra Diavolo—lettres inédites des princes Eugène et Joseph Napoléon, par Édouard Gachot. Ouvrage accompagné de trois gravures, d'un plan et de trois cartes. Paris, Plon-Nourrit et c¹ᵉ, 1911.

3 p. l., 404 p. front. (port.) pl., fold. maps, plans. 23ᶜᵐ. fr. 7.50

© Feb. 10, 1911; 2c. Mar. 4, 1911; A—Foreign 2550; Plon-Nourrit & cie., Paris, France. (11–3642) 922

Goodman, Jules Eckert.

Mother, by Jules Eckert Goodman; with illustrations by John Rae. New York, Dodd, Mead and company, 1911.

5 p. l., 322 p. front., plates. 19½ᶜᵐ. $1.20

© Feb. 24, 1911; 2c. Feb. 25, 1911; A 283007; Dodd, Mead & co., New York, N. Y. (11–2975) 923

Greilsamer, Lucien.

... L'hygiène du violon, de l'alto et du violoncelle; conseils pratiques sur l'acquisition, l'entretien, le réglage, et la conservation des instruments à archet. Avec 50 figures explicatives et 4 planches hors texte. Paris, C. Delagrave [°1910]

2 p. l., 124 p. illus., 4 pl. 20½ᶜᵐ.

"Ouvrages sur la lutherie utiles à consulter": p. [117]–121.

© Jan. 27, 1911; 2c. Feb. 18, 1911; A—Foreign 2505; Ch. Delagrave, Paris, France. (11–3487) 924

Grey, Zane, 1872–

The young pitcher, by Zane Grey ... New York and London, Harper & brothers, 1911.

4 p. l., 248 p., 1 l. front., plates. 19½ᶜᵐ. $1.25

© Mar. 2, 1911; 2c. Mar. 4, 1911; A 283154; Harper & bros., New York, N. Y. (11–3475) 925

Grinnell, George Bird, 1849–

American game-bird shooting, by George Bird Grinnell ... with colored plates of ruffed grouse and bobwhite, forty-eight full-page portraits of game birds and shooting scenes, and many cuts in text. New York, Forest and stream publishing company [°1910]

1 p. l., vii–xviii, 558 p. col. front., illus., plates (1 col.) 23ᶜᵐ. $3.50

© Dec. 14, 1910; 2c. Dec. 21, 1910; A 278462; Forest and stream pub. co., New York, N. Y. (10–31154) 926

Griset, J.

... Prononciation & expression musicales. Paris, H. Lemoine et c¹ᵉ, °1911.

120 p. 19ᶜᵐ. fr. 1.50

© Feb. 25, 1911; 2c. Feb. 20, 1911; A — Foreign 2528; J. Griset, Paris, France (11–3488) 927

Grisewood, Robert Norman, 1876–

The venture; a story of the shadow world, by R. Norman Grisewood ... New York, R. F. Fenno & company [°1911]

228 p. incl. front. 20ᶜᵐ. $1.00

© Feb. 25, 1911; 2c. Mar. 3, 1911; A 283147; R. F. Fenno & co., New York, N. Y. (11–3476) **928**

Hall, Henry, 1845–

How money is made in security investments; or, A fortune at fifty-five, by Henry Hall. 5th ed. New York [The DeVinne press] 1911.

2 p. l., vii–x, 239 p. incl. tables. 21ᶜᵐ. $1.50

"Financial terms and phrases": p. 182–192.

"Range of leading stocks for nineteen years": p. 193–209.

© Feb. 27, 1911; 2c. Mar. 4, 1911; A 283175; H. Hall, New York, N. Y. (11–3501) **929**

Harbison-Walker refractories co., *Pittsburg*.

A study of the open hearth; an elementary treatise on the open hearth furnace and the manufacture of open hearth steel, by Harbison-Walker refractories co., Pittsburgh. [2d ed.] [New York, Chasmar-Winchell press] 1911.

3 p. l., 9–91, [1] p. diagrs. 17½ᶜᵐ.

© Feb. 18, 1911; 2c. Feb. 21, 1911; A 280926; Harbison-Walker refractories co., Pittsburg, Pa. (11–3373) **930**

The Herald co., *Toronto*.

A method for aborting gonorrhea. [Toronto] °1911·

[4] p. 19 x 16½ᶜᵐ.

© Jan. 25, 1911; 2c. Feb. 17, 1911; A 280840; Herald co., Toronto, Canada. (11–3659) **931**

Hillman, Harry W 1870–

"The call of the farm," by H. W. Hillman. New Haven, Valley view publishing company, 1911.

4 p. l., 7–309 p. 19½ᶜᵐ. $1.50

© Feb. 19, 1911; 2c. Feb. 27, 1911; A 283030; Valley view pub. co., New Haven, Conn. (11–2980) **932**

Hispanic society of America.

Catalogue of Mexican maiolica belonging to Mrs. Robert W. De Forest, exhibited by the Hispanic society of America, February 18 to March 19, 1911, by Edwin Atlee Barber ... New York, The Hispanic society of America, 1911.

2 p. l., 3–151, [1] p. incl. LII pl. col. front. 20½ᶜᵐ.

© Feb. 18, 1911; 2c. Feb. 20, 1911; A 280892; Hispanic soc. of Amer., New York, N. Y. (11–3254) **933**

Hittell, Theodore Henry, 1830–

The adventures of James Capen Adams, mountaineer and grizzly bear hunter of California, by Theodore H. Hittell ... New ed. New York, C. Scribner's sons, 1911.

xiii, 373 p. front. (port.) plates. 19½ᶜᵐ. $1.50

© Feb. 11, 1911; 2c. Feb. 21, 1911; A 280913; Chas. Scribner's sons, New York, N. Y. (11–3274) 934

Hoe, Robert, 1839–1909.

Illustrated catalogue de luxe of the very valuable art property collected by the late Robert Hoe ... to be sold at unrestricted public sale by order of ... executors, beginning ... February 15th, 1911 ... The sale will be conducted by Mr. Thomas E. Kirby, of the American art association, managers. New York, American art association, 1911.

[1165] p. incl. illus., plates. front. 36 x 29ᶜᵐ. $25.00

© Jan. 31, 1911; 2c. Mar. 4, 1911; A 283176; Amer. art assn., New York, N. Y. (11–3663) 935

Hollander, Jacob Harry, 1871–

... David Ricardo, a centenary estimate, by Jacob H. Hollander ... Baltimore, The Johns Hopkins press, 1910.

ix, 11–137 p. 25ᶜᵐ. (Johns Hopkins university studies in historical and political science ... Series xxviii, no. 4)

© Feb. 26, 1911; 2c. Mar. 1, 1911; A 283087; Johns Hopkins press, Baltimore, Md. (11–3499) 936

Hollenbeck, Leroy Adelbert, 1856–

Meditations, by Leroy A. Hollenbeck. 1st ed. ... [Denver? Col.] °1911.

100, [2] p. 16ᶜᵐ. $1.00

© Jan. 18, 1911; 2c. Feb. 3, 1911; A 280573; L. A. Hollenbeck, Denver, Col. (11–3647) 937

Hotchkiss, Chauncey Crafts, 1852–

Mavde Baxter, by C. C. Hotchkiss ... illustrations by Will Grefé. New York, W. J. Watt & company [°1911]

2 p. l., 3–319 p. front., plates. 19½ᶜᵐ. $1.50

© Feb. 25, 1911; 2c. Feb. 27, 1911; A 283040; W. J. Watt & co., New York, N. Y. (11–2966) 938

Houghton, Albert Allison, 1879–

Practical silo construction; a treatise illustrating and explaining the most simple and easiest practical methods of constructing concrete silos of all types; with unpatented forms and molds ... By A. A. Houghton ... Twenty illustrations. New York, The Norman W. Henley publishing co., 1911.

2 p. l., 9–69 p. illus. 18½ᶜᵐ. (On cover: Concrete worker's reference books ... no. 3) $0.50

© Mar. 1, 1911; 2c. Mar. 2, 1911; A 283114; Norman W. Henley pub. co., New York, N. Y. (11–3652) 939

Howard, William Lee, 1860–

Confidential chats with boys, by William Lee Howard ... New York, E. J. Clode [ᶜ1911]

x, 3–162 p. 19½ᶜᵐ. $1.00

© Mar. 3, 1911; 2c. Mar. 4, 1911; A 283149; Edw. J. Clode, New York, N. Y. (11–3500) **940**

Howes, Clifton Armstrong, 1872–

Canada; its postage stamps and postal stationery, by Clifton A. Howes ... Boston, The New England stamp co., 1911.

287 p. front., illus., xiv pl. (in pocket) 28ᶜᵐ. $4.00

© Feb. 18, 1911; 2c. Feb. 21, 1911; A 280930; New England stamp co., Boston, Mass. (11–3631) **941**

Illinois. *Appellate courts.*

Reports of cases determined ... with a directory of the judiciary of the state corrected to December 8, 1910. v. 154, A. D. 1911 ... Ed. by W. Clyde Jones and Keene H. Addington ... Chicago, Callaghan & company, 1911.

xvi, 689 p. 23ᶜᵐ. $3.50

© Mar. 4, 1911; 2c. Mar. 11, 1911; A 283327; Callaghan & co., Chicago, Ill. **942**

Kahlenberg, Louis, 1870–

Qualitative chemical analysis; a manual for college students, by Louis Kahlenberg ... and James H. Walton, jr. ... Madison, Wis. [Cantwell printing company] 1911.

ix p., 1 l., 173 p. illus. 22½ᶜᵐ. $1.25

© Feb. 20, 1911; 2c. Feb. 25, 1911; A 283017; L. Kahlenberg and J. H. Walton, jr., Madison, Wis. (11–3377) **943**

Kaiser-Wilhelm-dank, verein der soldatenfreunde.

Deutschland als weltmacht; vierzig jahre Deutsches Reich, unter mitarbeit einer grossen anzahl berufener deutscher gelehrter, offiziere und fachmänner hrsg. vom Kaiser-Wilhelm-dank, verein der soldatenfreunde; mit 500 abbildungen ... Berlin, Kameradschaft, wohlfahrtsgesellschaft m. b. h. [ᶜ1910]

vii, 848 p. plates, maps. 25½ᶜᵐ.

© Dec. 8, 1910; 2c. Mar. 4, 1911; A—Foreign 2558; Kameradschaft, wohlfahrtsgesellschaft m. b. h., Berlin, Germany. (11–3643) **944**

Kales, Albert Martin.

Cases on persons and domestic relations, selected from decisions of English and American courts, by Albert M. Kales ... St. Paul, West publishing company, 1911.

xxix, 654 p. 26½ᶜᵐ. (American casebook series, J. B. Scott, general ed.) $4.00

© Feb. 20, 1911; 2c. Mar. 3, 1911; A 283136; West pub. co., St. Paul, Minn. (11–3370) **945**

Kealing, Ethel Black.

Desra of the Egyptians; a romance of the earlier centuries, by Ethel Black Kealing. Indianapolis, Printed by Wheeler & Kalb ₍°1910₎

4 p. l., 212 p., 1 l. front. (port.) 22½ᶜᵐ. $1.50

© Feb. 25, 1911; 2c. Mar. 1, 1911; A 283085; E. B. Kealing, Indianapolis, Ind. (11-2979) 946

Kellogg, Minnie D.

Flowers from mediæval history, by Minnie D. Kellogg ... San Francisco, P. Elder and company ₍°1910₎

2 p. l., iii–xvii, 145 p., 1 l. mounted front., 31 mounted pl. 18ᶜᵐ. $1.50

"To me the Gothic cathedrals are the flowers of thirteenth century history."—p. 3.

"A word regarding bibliography": p. 139–141.

© Feb. 20, 1911; 2c. Feb. 25, 1911; A 283015; Paul Elder & co., San Francisco, Cal. (11-3253) 947

Kelly, Albanis Ashmun, 1849–

The expert sign painter; a book of reference designed for the use of practical sign painters & letterers, by A. Ashmun Kelly ... Malvern, Pa., °1911·

1 p. l., x, 302 p. 20ᶜᵐ. $3.00

© Feb. 24, 1911; 2c. Mar. 7, 1911; A 283099; A. A. Kelly, Malvern, Pa. (11-3371) 948

Key, Ellen Karolina Sofia, 1849–

Love and marriage, by Ellen Key ... tr. from the Swedish by Arthur G. Chater; with a critical and biographical introduction by Havelock Ellis. New York and London, G. P. Putnam's sons, 1911.

xvi p., 1 l., 399 p. 20ᶜᵐ. $1.50

© Feb. 18, 1911; 2c. Feb. 28, 1911; A 283068; G. P. Putnam's sons, New York, N. Y. (11-2996) 949

Kirkpatrick, John Ervin.

Timothy Flint, pioneer, missionary, author, editor, 1780–1840; the story of his life among the pioneers and frontiersmen in the Ohio and Mississippi Valley and in New England and the South, by John Ervin Kirkpatrick ... Cleveland, O., The Arthur H. Clark company, 1911.

331 p. incl. front., plates. 24½ᶜᵐ. $3.50

Bibliography: p. ₍305₎–318.

© Feb. 16, 1911; 2c. Feb. 18, 1911; A 280918; J. E. Kirkpatrick, Topeka, Kan. (11-3273) 950

Külpe, *Frau* **Frances** (James) 1862–

Rote tage, baltische novellen aus der revolutionszeit, von Frances Külpe. Berlin, S. Schottlaenders schlesische verlagsanstalt ₍°1910₎

280 p. 21½ᶜᵐ.

© Feb. 18, 1911; 2c. Feb. 18, 1911; A—Foreign 2524; S. Schottlaenders schlesische verlagsanstalt, g. m. b. h., Berlin, Germany. (11-2981) 951

Lake states forest fire conference, *St. Paul, Minn.*, 1910.

Proceedings of the Lake states forest fire conference held at St. Paul, Minn., Dec. 6–7, 1910. Chicago, The American lumberman [c1911]

1 p. l., 5–181 p. 21½ᶜᵐ.

© Feb. 24, 1911; 2c. Feb. 27, 1911; A 283060; Amer. lumberman, Chicago, Ill. (11–2988) **952**

Lawyers co-operative publishing co., *Rochester, N. Y.*
Editorial dept.

Notes on the American decisions; showing how each case in these reports has been applied, developed, strengthened, limited, or in any way affected by later decisions that have cited it as a precedent ... v. 9 ... San Francisco, Bancroft-Whitney co.; Rochester, N. Y., The Lawyers co-op. pub. co., 1911.

1 p. l., 1313 p. 24ᶜᵐ. $6.50

© Mar. 4, 1911; 2c. Mar. 7, 1911; A 283226; Bancroft-Whitney co., San Francisco, Cal., and Lawyers co-operative pub. co., Rochester, N. Y.
 953

Lehnert, W M.

... La technique du froid; tr. de l'allemand par Gaston Dermine ... préface de J. de Loverdo; 140 figures—12 planches hors texte. Paris, C. Delagrave [c1910]

viii, 201 p., 1 l. illus., xii fold. pl. 18½ᶜᵐ. fr. 6

At head of title: G. Lehnert; Introduction signed: W. M. Lehnert.

© Jan. 13, 1911; 2c. Feb. 18, 1911; A—Foreign 2514; Ch. Delagrave, Paris, France. (11–3248) **954**

L'Houet, A.

Zur psychologie der kultur. Briefe an die grossstadt von A. l'Houet. Bremen, C. Schünemann, 1910.

viii, 370 p. 23½ᶜᵐ. M. 5

© Sept. 22, 1910; 2c. Dec. 29, 1910; A—Foreign 2531; Carl Schünemann, Bremen, Germany. (11–3632) **955**

Libbey & Struthers, *New York.*

Digest of inheritance tax laws and list of principal stocks affected by their provisions. New York city, Libbey & Struthers, 1911.

1 p. l., 76 p. 20½ x 12ᶜᵐ.

© Feb. 27, 1911; 2c. Mar. 1, 1911; A 283094; Libbey & Struthers, New York, N. Y. (11–3633) **956**

Lord, Clara Sophia, 1872– *comp.*

Recipes, comp. by Clara S. Lord. Washington, D. C., Press of the Hayworth publishing house, 1911.

100 p. 23ᶜᵐ. $0.50

© Feb. 27, 1911; 2c. Feb. 13, 1911; A 282935; C. S. Lord, Washington, D. C. (11–3657) **957**

McEwan, Oliver.

McEwan's stenography; the manual of stenography in a week, with supplements, arranged for self-instruction by Oliver McEwan ... New York, The United States school of secretaries; [etc., etc.] ⁰1911·

80 p. illus. (ports.) 18ᶜᵐ.

© Feb. 27, 1911; 2c. Mar. 1, 1911; A 283091; O. McEwan, New York, N. Y.

© Feb. 14, 1911; 2c. Feb. 16, 1911; A 280982; O. McEwan, New York, N. Y.
(11–3636) 958, 959

McGovern, John, 1850–

The fireside university for home circle, study and entertainment, with complete indexes, by John McGovern ... [Rev. ed.] Chicago, Philadelphia, Union publishing house [⁰1911]

x, 11–561, [14] p. front., illus., plates, ports. 21ᶜᵐ.

© Feb. 2, 1911; 2c. Feb. 7, 1911; A 280899; M. B. Downer & co., Chicago,
Ill. (11–3250) 960

Maire, Frederick.

Carriage painting; a series of practical treatises on the painting of carriages and wagons ... Each treatise is followed with test questions for the student, by F. Maire ... Chicago, F. J. Drake & company [⁰1911]

1 p. l., 17–162, iii–ix p. illus. 17½ᶜᵐ. (*On cover:* The red book series of trade school manuals [v. 5]） $0.60

© Feb. 6, 1911; 2c. Feb. 11, 1911; A 280984; Frederick J. Drake, Chicago,
Ill. (11–3252) 961

Wood finisher; a series of practical treatises on hardwood finishing and all its branches ... Each treatise is followed with test questions for the student, by F. Maire ... Chicago, F. J. Drake & company [⁰1911]

1 p. l., 17–156, iii–vii p. illus. 17ᶜᵐ. (*On cover:* The red book series of trade school manuals [v. 6]） $0.60

© Feb. 18, 1911; 2c. Feb. 23. 1911; A 280945; Frederick J. Drake, Chicago,
Ill. (11–3251) 962

Marshall, Logan, *ed.*

A compendium of every-day knowledge. The uplift manual of necessary information for home, school and office, practically arranged for ready reference, ed. by Logan Marshall assisted by a corps of experts. 1910 ed. Philadelphia, The Uplift publishing co. [⁰1910]

1 p. l., xv, 1280 p. col. front., plates, maps. 19½ᶜᵐ. $1.50

p. 1–930 published also under title "Winston's self-pronouncing school and office dictionary of the English language."

© June 23, 1910; 2c. Feb. 8, 1911; A 280642; John C. Winston co., Philadelphia, Pa. (11–3648) 963

Martin, *Mrs.* **Helen (Riemensnyder)** 1868–

When half-gods go; being the story of a brief wedded life as told in intimate and confidential letters written by a bride to a former college mate, by Helen Reimensnyder Martin ... New York, The Century co., 1911.

3 p. l., 3–154 p. 19½ᶜᵐ $1 00

© Feb. 18, 1911; 2c. Feb. 25, 1911: A 283024; Century co., New York, N. Y. (11–2971) **964**

Mendell, Clarence Whittlesey.

Sentence connection in Tacitus ... New Haven, Yale university press; [etc., etc.] 1911.

vi, viii, 158 p. 23ᶜᵐ. $1.25

© Feb. 21, 1911; 2c. Feb. 23, 1911; A 280991; Yale university press, New Haven, Conn. (11–3357) **965**

Mississippi. *Supreme court.*

Cases argued and decided ... at the March term, 1909, and October term, 1909. v. 95. Reported by T. A. Mc-Willie. Chicago, T. H. Flood & company, 1910.

xxi 1021 p. 23½ᶜᵐ. $4.25

© Mar. 2, 1911; 2c. Mar. 6, 1911; A 283211; T. H. Flood & co., Chicago, Ill. **966**

Missouri. *St. Louis, Kansas City and Springfield courts of appeals.*

Cases determined ... reported for the St. Louis court of appeals, Feb. 1, 1910, to April 5, 1910, by Thomas E. Francis ... for the Kansas City court of appeals, by John M. Cleary ... and for the Springfield court of appeals, by Lewis Luster ... official reporters. v. 148. Columbia. Mo., E. W. Stephens, 1910.

xv, 796, xviii p. 23½ᶜᵐ. $3.00

© Feb. 22, 1911; 2c. Feb. 24, 1911; A 283308; E. W. Stephens, Columbia, Mo. **967**

Moler, Arthur B 1866–

The barbers' manual, by A. B. Moler. [Chicago, Ill., ᶜ1911]

168 p. illus. 15ᶜᵐ. $1.00

© Feb. 15, 1911; 2c. Feb. 20, 1911; A 280903; A. B. Moler, Chicago, Ill. (11–3372) **968**

Moninger, Herbert H 1876–

The adult Bible class in training for service, by Herbert Moninger ... Cincinnati, O., The Standard publishing co., ᶜ1910·

83 p. illus. (incl. maps) 21ᶜᵐ. $0.40

© Feb. 8, 1911; 2c. Feb. 20, 1911; A 280874; H. Moninger, Cincinnati, O. (11–3243) **969**

Montgomery, Harry Earl.

Christ's social remedies, by Harry Earl Montgomery ... New York and London, G. P. Putnam's sons, 1911.

iii p., 1 l., 433 p. 20ᶜᵐ. $1.50

CONTENTS.—Responsibility of citizenship.—Was Christ an anarchist?—Was Christ a socialist?—The kingdom of God.—Non-resistance.—Marriage and divorce.—Crime and the criminal.—Wealth.—Labour.—Sunday observance.—International controversies.—Social reconstruction.

© Feb. 18, 1911; 2c. Feb. 28, 1911; A 283067; H. E. Montgomery, Buffalo, N. Y. (11–3382) 970

Morrow, Albert Sidney, 1878–

Diagnostic and therapeutic technic; a manual of practical procedures employed in diagnosis and treatment, by Albert S. Morrow ... with 815 illustrations, mostly original. Philadelphia and London, W. B. Saunders company, 1911.

2 p. l., 7–775 p. illus. 25ᶜᵐ. $5.00

© Mar. 1, 1911; 2c. Mar. 2. 1911; A 283116; W. B. Saunders co., Philadelphia, Pa. (11–3658) 971

Mountford, *Mrs.* Lydia Mary Olive (Mamreoff von Finkelstein) 1855–

Jesus Christ in his homeland; lectures by Mme. Lydia M. von Finkelstein Mountford, stenographically reported. Cincinnati, Press of Jennings and Graham [ᶜ1911]

138 p. front. (port.) plates. 19ᶜᵐ. $1.00

© Feb. 8, 1911; 2c. Feb. 20, 1911; A 280877; L. M. von Finkelstein Mountford. Cincinnati, O. (11–3244) 972

New York. *Metropolitan museum of art.*

... Catalogue of a loan exhibition of paintings by Winslow Homer, New York, February the sixth to March the nineteenth, MCMXI. [New York, ᶜ1911]

xxiv p., 2 l., 3–53, [1] p. incl. front. 22½ᶜᵐ. $0.25

Bibliography: p. xxiii–[xxv]

© Feb. 6, 1911; 2c. Mar. 1, 1911; A 283090; Metropolitan museum of art, New York, N. Y. (11–3661) 973

North, Laurence.

Impatient Griselda; a comedy in resolved discords, by Laurence North. London, M. Secker, 1911.

viii, 9–304 p. 19¼ᶜᵐ. 6/

© 1c. Mar. 2, 1911; A ad int. 501; published Feb. 2, 1911; L. North, London, England. (11–3630) 974

Noyes, William Albert, 1857–

Organic chemistry for the laboratory, by W. A. Noyes ... 2d ed., rev. and enl. Easton, Pa., The Chemical publishing co.; [etc., etc.] 1911.

xi, 291 p. illus. 23½ᶜᵐ. $2.00

© Feb. 15. 1911; 2c. Feb. 28, 1911; A 283076; Edw. Hart, Easton, Pa. (11–3378) 975

Oklahoma. *Criminal court of appeals.*
Oklahoma criminal reports, v. 4. Cases determined ...
May 23, 1910-January 9, 1911. Howard Parker, state
reporter. Guthrie, Okl., The State capital company, 1911.
xiv, 739 p. 22½ᶜᵐ. $1.50
© Mar. 4, 1911; 2c. Mar. 7, 1911; A 283221; Howard Parker, state reporter,
for the benefit of state of Oklahoma, Guthrie, Okl. 976

Owen, Wilber Allen, 1873–
Questions and answers on common law and equity
pleading. Prepared with the aid of Stephen, Chitty,
Gould, and McKelvie of common law pleading, and Story,
Mitford and Tyler, Langdell, and Cooper on equity plead-
ing, the text of Stephen being followed in the arrange-
ment of the common law questions. 2d ed. By Wilber A.
Owen, LL. M. Washington, D. C. [J. Byrne & co.] 1911.
127 p. 17ᶜᵐ. (*On cover:* John Byrne & co's quiz books)
© Feb. 17, 1911; 2c. Feb. 23, 1911; A 280968; John Byrne & co., Washing-
ton, D. C. (11–3367) 977

Patterson, J E.
Tillers of the soil, by J. E. Patterson ... New York,
Duffield & company, 1911.
3 p. l., v-xi, 364 p. 19½ᶜᵐ. $1.30
© Jan. 12, 1911; 2c. Jan. 31, 1911; A 280476; Duffield & co., New York, N.Y.
(11–3241) 978

Pearson, Henry Clemens, 1858–
The rubber country of the Amazon; a detailed descrip-
tion of the great rubber industry of the Amazon Valley,
which comprises the Brazilian states of Pará, Amazonas
and Matto Grosso, the territory of the Acre, the Montaña
of Peru and Bolivia, and the southern portions of Colom-
bia and Venezuela, by Henry C. Pearson ... New York,
The India rubber world, 1911.
x, 228 p. incl. front., illus., maps. 23ᶜᵐ. $3.50
© Feb. 10, 1911; 2c. Feb. 24, 1911; A 280974; H. C. Pearson, New York,
N. Y. (11–2995) 979

Penrose, Mary Elizabeth (Lewis) *"Mrs. H. H. Penrose,"*
1860–
Denis Trench; a plotless history of how he followed the
gleam and worked out his own salvation, by Mrs. H. H.
Penrose ... London, A. Rivers, ltd., 1911.
viii, 432 p. 19ᶜᵐ. 6/
© 1c. Feb. 6, 1911; A ad int. 472; published Jan. 9, 1911; Mrs. H. H. Pen-
rose, London, England. (11–3238) 980

Phillpotts, Eden, 1862–
Demeter's daughter, by Eden Phillpotts ... London,
Methuen & co. ltd. [1911]
3 p. l., 344 p. 20ᶜᵐ. $1.50
© 1c. Feb. 28, 1911; A ad int. 496; published Feb. 2, 1911; E. Phillpotts,
Torquay, England. (11–3629) 981

Plumb, Charles Sumner, 1860– *ed.* .

A partial index to animal husbandry literature, by Charles S. Plumb ... Columbus, O., The author, 1911.

1 p. l., 94 p. 23ᶜᵐ. $1.00
© Feb. 27, 1911; 2c. Feb. 28, 1911; A 283081; C. S. Plumb, Columbus, O.
(11–3258) 982

Powell, Arthur Gray.

A practical treatise on the law and procedure involved in the preparation and trial of cases of ejectment and other actions at law respecting titles to land, treating particularly of the pleading, practice and evidence, and in a general way, also of the principles of substantive law involved in such actions, by Arthur Gray Powell ... Atlanta, The Harrison company, 1911.

753 p. 23½ᶜᵐ. $7.50
© Mar. 1, 1911; 2c. Mar. 3, 1911; A 283132; A. G. Powell, Atlanta, Ga.
(11–3368) . 983

Powell, Edward Payson, 1833–

How to live in the country, by E. P. Powell; with a foreword by N. O. Nelson ... New York, Outing publishing company, 1911.

7 p. l., 11–300 p. front., plates. 21½ᶜᵐ. $1.75
© Mar. 1, 1911; 2c. Mar. 4, 1911; A 283179; Outing pub. co., New York, N. Y. (11–3654) 984

A **pulpit** commentary on Catholic teaching; a complete exposition of Catholic doctrine, discipline and cult in original discourses, by pulpit preachers of our own day. v. 4. The liturgy of the church ... New York, J. F. Wagner [1911]

2 p. l., 400 p. 23½ᶜᵐ. $2.00
© Nov. 17, 1910; 2c. Mar. 7, 1911; A 283219; Joseph F. Wagner, New York, N. Y. 985

Raymond, George Lansing, 1839–

The writer; a concise, complete, and practical text-book of rhetoric, designed to aid in the appreciation as well as production of all forms of literature, explaining, for the first time, the principles of written discourse by correlating them to those of oral discourse [by] George L. Raymond ... and Post Wheeler ... New ed., fully rev. New York and London, G. P. Putnam's sons, 1911.

xi, 203 p. 19ᶜᵐ. $1.00
© Feb. 14, 1911; 2c. Feb. 28, 1911; A 283069; G. P. Putnam's sons, New York, N. Y. (11–3356) 986

Rhode Island. *Supreme court.*

... Reports of cases argued and determined ... Edward C. Stiness, reporter. [v. 31] Providence, E. L. Freeman company, 1911.

xxv, 593 p. 24ᶜᵐ. $3.00
© Feb. 28, 1911; 2c. Mar. 8, 1911; A 283237; Edward C. Stiness, Providence, R. I. • 987

Ricci, Corrado,. 1858–

... Art in northern Italy, by Corrado Ricci ... New York, C. Scribner's sons, 1911.

vii, 372 p., 1 l. col. front., illus., col. plates. 19ᶜᵐ. (Ars una: species mille. General history of art). $1.50

Bibliography at end of each chapter.

© Jan. 12, 1911; 2c. Mar. 2. 1911: A 283102; Chas. Scribner's sons. New York, N. Y. (11-3662) **988**

Rice, Cale Young, 1872–

The immortal lure, by Cale Young Rice ... Garden City, N. Y., Doubleday, Page & company, 1911.

5 p. l., 3–92 p. 20ᶜᵐ. $1.25

CONTENTS.—Giorgione.—Arduin.—O-ume's gods —The immortal lure.

© Feb. 23, 1911; 2c. Feb. 25, 1911; A 283011; C. Y. Rice. Louisville. Ky. (11-3478) **989**

Rich, Joseph W 1838–

The battle of Shiloh, by Joseph W. Rich. Iowa City, Ia., State historical society of Iowa, 1911.

134 p. front. (port.) viii maps on 4 l. 23½ᶜᵐ. $1.25

"Notes and references": p. ₍117₎-123.

© Feb. 21, 1911; 2c. Feb. 24. 1911; A 280977; State historical soc. of Iowa, Iowa City, Ia. (11-3266) **990**

Robertson, Archibald Thomas, 1863–

John, the loyal; studies in the ministry of the Baptist. by A. T. Robertson ... New York, C. Scribner's sons, 1911.

ix p., 1 l., 315 p. 19½ᶜᵐ. $1.25

Bibliography: p. 307–308.

© Feb. 25, 1911; 2c. Mar. 2. 1911; A 283100: Chas. Scribner's sons. New York, N. Y. (11-3358) **991**

Rocine, Victor G.

Heads, faces, types, races, by V. G. Rocine ... Chicago, Ill., Vaught-Rocine pub. co. ₍ᶜ1910₎

2 p. l., 7–327 p. incl. front. (port.) illus. (incl. ports.) 20ᶜᵐ. (Half-title: Text-book of phrenology, vol 1 ...) $2 00

© Dec 23, 1910; 2c. Dec. 27, 1910; A 278873; V. G. Rocine. Chicago, Ill. (11-3247) **992**

Savile, Frank Mackenzie.

The road; a modern romance, by Frank Savile ... Boston, Little, Brown, and company, 1911.

vi, 313 p. 19½ᶜᵐ. $1.50

© Feb. 2, 1911; 2c. Mar. 1, 1911; A 283095; Little, Brown, and company, Boston, Mass. (11-2969) **993**

Scott, Morgan.

Ben Stone at Oakdale, by Morgan Scott ... with four original illustrations by Theo. Bechtolf. New York, Hurst & company ₍ᶜ1911₎

4 p., 1 l., 5–316 p. front., plates. 20½ᶜᵐ. $0.60

© Mar. 1, 1911; 2c. Mar. 6, 1911; A 283194; Hurst & co., New York, N. Y. (11-3627) **994**

Séailles-Ransan, Gabriel, 1852–

... Eugène Carrière, essai de biographie psychologique, avec 8 phototypies hors texte. Paris, A. Colin, 1911.

viii, 270 p., 3 l. viii pl. 19ᶜᵐ. fr. 3.50
At head of title: Gabriel Séailles.
"Bibliographie": p. ₍259₎–260.
"Catalogue": p. ₍261₎–270.
"Lithographies": 1 l. following p. 270.

© Feb. 3, 1911; 2c. Feb. 18, 1911; A—Foreign 2511; Max Leclerc & H. Bourrelier, Paris, France. (11–3255) 995

Shaw, George Bernard, 1856–

The doctor's dilemma, Getting married, and The shewing-up of Blanco Posnet, by Bernard Shaw. New York, Brentano's, 1911.

5 p. l., v–xcii, 443 p. 19¼ᶜᵐ. $1.50

© Feb. 16, 1911; 2c. Feb. 23, 1911; A 283098; G. B. Shaw, London, England. (11–3353) 996

₍Sheffeld, Charles Arthur₎ 1873–

Silk; its origin, culture, and manufacture; illustrated from photographs taken at the Corticelli silk mills, and by colored plates reproduced from original Japanese photographs ... Florence, Mass., The Corticelli silk mills, ᶜ1911.

47, ₍1₎ p. incl. col. front., plates (partly col.) 21ᶜᵐ. $0.50

© Feb. 8, 1911; 2c. Feb. 18, 1911; A 280864; Corticelli silk mills, Florence, Mass. (11–3491) 997

Simonton, Thomas Moore.

Tax sales in New Jersey under the act of 1903 (chapter 208, laws 1903) the amendments, and supplements thereto, entitled "An act for the assessment and collection of taxes," approved April 8th, 1903, and containing a general exposition of the law relating to tax sales under other acts having similar provisions, by Thomas Moore Simonton ... Paterson, N. J., News printing co., ᶜ1911·

3 p. l., ₍3₎–99 p. 24ᶜᵐ. $3.00

© Feb. 17, 1911; 2c. Feb. 25, 1911; A 283022; T. M. Simonton, New York, N. Y. (11–3366) 998

Sloane, Thomas O'Conor, 1851–

Electricity simplified; a treatise covering the practice and theory of electricity ... by T. O'Conor Sloane ... 13th ed., rev. and enl. New York, The Norman W. Henley publishing co., 1911.

1 p. l., ₍v₎–viii, ₍9₎–174 p. illus., diagrs. 18½ᶜᵐ. $1.00

© Feb. 16, 1911; 2c. Feb. 20, 1911; A 280871; Norman W. Henley pub. co., New York, N. Y. (11–3379) 999

Smart, Isabelle Thompson.

What a father should tell his little boy, by Isabelle
Thompson Smart ... Book three in a series which tells
the story of the mysteries of life in simple, plain words.
New York, The Bodmer company [°1911]

1 p. l., 5–116 p. 16ᶜᵐ. $0.75
© Feb. 8, 1911; 2c. Feb. 15, 1911; A 283001; Bodmer co., New York, N. Y.
(11–3384) 1000

What a father should tell his son, by Isabelle Thompson
Smart ... Book four in a series which tells the story of
the mysteries of life in simple, plain words. New York,
The Bodmer company [°1911]

1 p. l., 5–103 p. 16ᶜᵐ. $0.75
© Feb. 8, 1911; 2c. Feb. 15, 1911; A 283000; Bodmer co., New York, N. Y.
(11–3385) 1001

Smart, Isabelle Thompson.

What a mother should tell her daughter, by Isabelle
Thompson Smart ... Book two in a series which tells the
story of the mysteries of life in simple, plain words. New
York, The Bodmer company [°1911]

1 p. l., 5–113 p. 16ᶜᵐ. $0.75
© Feb. 8, 1911; 2c. Feb. 15, 1911; A 283002; Bodmer co., New York, N. Y.
(11–3383) 1002

What a mother should tell her little girl, by Isabelle
Thompson Smart ... Book one in a series which tells the
story of the mysteries of life in simple, plain words. New
York, The Bodmer company [°1911]

1 p. l., 5–105 p. 16ᶜᵐ. $0.75
© Feb. 8, 1911; 2c. Feb. 15, 1911; A 283003; Bodmer co., New York, N. Y.
(11–3386) 1003

Smith, Albert William, 1856–

The giant, and other nonsense verse, by Albert W.
Smith. Ithaca, N. Y., Andrus & Church, 1910.

2 p. l., 65 [1] p. 21ᶜᵐ. $0.75
© Feb. 15, 1911; 2c. Feb. 20, 1911; A 280893; A. W. Smith, Ithaca, N. Y.
(11–3480) 1004

Smith, Arthur Douglas Howden, 1887–

The Wastrel, by Arthur D. Howden Smith ... New
York, Duffield and company, 1911.

4 p. l., 333 p. col. front. 19½ᶜᵐ. $1.30
© Feb 25, 1911; 2c. Mar. 1, 1911; A 283083; Duffield & co., New York,
N. Y. (11–3626) 1005

Solotaroff, William.

Shade-trees in towns and cities; their selection, plant-
ing, and care as applied to the art of street decoration;
their diseases and remedies; their municipal control and
supervision, by William Solotaroff ... 1st ed. 1st thou-
sand. New York, J. Wiley & sons; [etc., etc.] 1911.

xviii, 287 p. incl. front., illus. 23½ᶜᵐ. $3.00
© Feb. 18, 1911; 2c. Feb. 21, 1911; A 280924; W. Solotaroff, East Orange,
N. J. (11–2986) 1006

Spearman, Frank Hamilton, 1859–

Robert Kimberly, by Frank H. Spearman; illustrated by James Montgomery Flagg. New York, C. Scribner's sons, 1911.

4 p. l., 437, ₁1₁ p. col. front., col. plates. 19½ᵐ. $1.30
© Feb. 25, 1911; 2c. Mar. 2, 1911; A 283101; Chas. Scribner's sons, New York, N. Y. (11–2974) 1007

Spingarn, Joel Elias, 1875–

The new criticism; a lecture delivered at Columbia university, March 9, 1910, by J. E. Spingarn ... New York, The Columbia university press, 1911.

v, 35 p. 19ᵐ. $0.75
"The present paper ... was first published (under the general title of 'Literary criticism') in the Columbia university lectures on literature, from which it is now reprinted."
© Feb. 16, 1911; 2c. Feb. 18, 1911; A 280895; Columbia university press, New York, N. Y. (11–3354) 1008

Stevens, Ethel Stefana.

The mountain of God, by E. S. Stevens ... New York ₁Press of W. G. Hewitt, Brooklyn, N. Y.₁ 1911.

5 p. l., 385 p. 19½ᵐ. $1.50
© Feb. 27, 1911; 2c. Mar. 1, 1911; A 283144; E. S. Stevens, London, Eng. (11–3242) 1009

Street, Robert Gould, 1843–

The law of civil liability for personal injuries by negligence in Texas. By Robert G. Street ... Chicago, T. H. Flood and company, 1911.

lxxi, 710 p. 24ᵐ. $6.00
© Feb. 19, 1911; 2c. Feb. 24, 1911; A 283004; R. G. Street, Galveston, Tex. (11–3482) 1010

Tennessee. *Laws, statutes, etc.*

Corporation laws of Tennessee, including counties and municipalities, also federal corporation income tax law. Rev. and annotated by James L. Watts ... Nashville, Tenn., Marshall & Bruce co., 1910.

710 p. 23ᵐ. $4.00
© Dec. 28, 1910; 2c. Dec. 31, 1910; A 278730; Marshall & Bruce co., Nashville, Tenn. (11–328) 1011

Trent, Paul.

The vow; a novel, by Paul Trent ... with frontispiece in color by John Rae. New York, Frederick A. Stokes company ₁1911₁

4 p. l., 341 p. col. front. 19½ᵐ. $1.25
© Feb. 24, 1911; 2c. Feb. 27, 1911; A 283047; Frederick A. Stokes co., New York, N. Y. (11–2972) 1012

Warwick, Anne, *pseud.*

Compensation, by Anne Warwick. New York, John Lane company, 1911.

3 p. l., 332 p. 1 ₁. 19ᵐ. $1.50
© Feb. 24, 1911; 2c. Feb. 28, 1911; A 283074; John Lane co., New York, N. Y. (11–2976) 1013

Webb, Henry Law.

The silences of the moon, by Henry Law Webb. New
York, John Lane company; [etc., etc.] 1911.
3 p. l., 139 p. 19½ᶜᵐ. $1.50
© Feb. 24, 1911; 2c. Feb. 28, 1911; A 283075; John Lane co., New York, N. Y.
(11–3477) 1014

White, James Edson.

The coming King ... by James Edson White. Wash-
ington, D. C., New York [etc.] Review and herald publish-
ing assoc.; Nashville, Tenn., Atlanta, Ga. [etc.] Southern
publishing association [°1911]
viii, 9–320 p. incl. col. front., illus. (partly col.) 20ᶜᵐ.
© Jan. 27, 1911; 2c. Feb. 15, 1911; A 283020; J. E. White, Nashville, Tenn.
(11–3246) 1015

Wright, Harold Bell.

That printer of Udell's, by Harold Bell Wright ... with
illustrations by John Clitheroe Gilbert. Chicago, The
Book supply company [1911]
346 p. front., plates. 19½ᶜᵐ. $1.50
© Mar. 2, 1911; 2c. Mar. 4, 1911; A 283174; Elsbery W. Reynolds, Morgan
Park, Ill. (11–3474) 1016

Zamacoïs, Miguel, 1866–

... L'arche de Noé. Paris, Librairie théâtrale, 1911.
2 p. l., 160 p. illus. 19½ᶜᵐ. fr. 4
© Feb. 25, 1911; 2c. Feb. 20, 1911; A—Foreign 2529; M. Zamacoïs, Paris,
France. (11–2982) 1017

Number of entries of books included in the Catalogue for 1911:
a) United States publications ------------------------------------- 778
b) Foreign books in foreign languages---------------------------- 224
c) Foreign books in English languge under *ad interim* provi-
 sions of law of Mar. 4, 1909-------------------------------- 15

 Total -- 1,017

Balzac, Honoré de, 1799–1850.

Le cousin Pons, par Honoré de Balzac; ed., with introduction, notes, and questionnaire by Hugo Paul Thieme ... Ann Arbor, G. Wahr, 1911.

xliv p., 1 l., 275 p. 18ᶜᵐ. $0.90
Bibliography: p. ₍xl₎–xliv.

© Feb. 20, 1911; 2c. Feb. 23, 1911; A 283021; George Wahr, Ann Arbor, Mich. (11–3961) 1018

Bergson, Henri Louis, 1859–

Creative evolution, by Henri Bergson ... authorized translation by Arthur Mitchell, PH. D. New York, H. Holt and company, 1911.

xv, 370 p. 22¼ᶜᵐ. $2.50

© Mar. 2, 1911; 2c. Mar. 4, 1911; A 283151; Henry Holt & co., New York, N. Y. (11–3948) 1019

Beyerlein, Franz Adam, 1871–

... La retraite, adaptation de Maurice Rémon; illustrations de Guillonnet et Deygas. Paris, P. Lafitte & cⁱᵉ ₍1910₎

124 p. incl. front., illus., plates. 24ᶜᵐ. (Idéal-bibliothèque. ₍21₎)
fr. 0.95

© Feb. 17, 1911; 2c. Mar. 4, 1911; A—Foreign 2541; Pierre Lafitte & co., Paris, France. (11–4136) 1020

Bödecker, Henry William Charles, 1875–

Das metalleinlage-verfahren; die goldguss-einlage, von H. W. C. Bödecker ... 2. aufl., mit 157 abbildungen im text und 14 tafeln. Berlin, H. Meusser, 1911.

4 p. l., 140 p. illus., xIV pl. 23½ᶜᵐ. M. 7

© Jan. 25, 1911; 2c. Mar. 6, 1911; A—Foreign 2565; Hermann Meusser, Berlin, Germany. (11–4113) 1021

... La boxe anglaise & française, par les champions du ring, Jimmy Britt, Charlemont ... avec la collaboration de J. Mortane; préface de J. Joseph-Renaud. Ouvrage orné de 48 pages d'illustrations photographiques et cinématographiques hors texte. Paris, P. Lafitte & cⁱᵉ ₍1911₎

2 p. l., 376 p., 1 l. plates. 20¼ᶜᵐ. (Sports-bibliothèque) fr. 3.50

© Feb. 17, 1911; 2c. Mar. 4, 1911; A—Foreign 2539; Pierre Lafitte & co., Paris, France. (11–4120) 1022

Brandeis, Louis Dembitz, 1856–

Scientific management and railroads; being part of a brief submitted to the Interstate commerce commission, by Louis D. Brandeis. New York, The Engineering magazine, 1911.

5 p. l., 92 p. 24ᶜᵐ. $1.50

© Mar. 3, 1911; 2c. Mar. 6, 1911; A 283187; John R. Dunlap, New York, N. Y. (11–4163) 1023

Brown, *Mrs.* **Grace (Mann)** 1859–

To-day; the present moment is God's own time; written ... by Grace M. Brown ... ₍Denver, Col.₎ Grace M. Brown ₍ᶜ1911₎

200 p. 18ᶜᵐ. $1.00

© Dec. 1, 1910; 2c. Jan. 28, 1911; A 280430; G. M. Brown, Denver, Col. (11–1524) 1024

Carpenter, Edmund Janes, 1845–

The Pilgrims and their monument, by Edmund J. Carpenter ... New York, D. Appleton & co., 1911.

x p., 1 l., 309, ₍1₎ p. front., plates, ports. 23ᶜᵐ. $2.00

© Mar. 4, 1911; 2c. Mar. 9, 1911; A 283269; D. Appleton & co., New York, N. Y. (11–3981) 1025

The **Catholic** encyclopedia ... Ed. by Charles G. Herbermann ₍and others₎ ... v. 10 ₍Mass–Newman₎ New York, R. Appleton company ₍1911₎

xv, 800 p. illus., plates (partly col.) ports., col. maps, facsims. 28ᶜᵐ. $6.00

© Mar. 14, 1911; 2c. Mar. 17, 1911; A 283474; Robert Appleton co., New York, N. Y. 1026

Crowell, Frank.

How to forecast business and investment conditions, ₍ Frank Crowell. New York city, Ticker publishing cor pany ₍ᶜ1911₎

189 p. 18ᶜᵐ. $2.00

© Jan. 25, 1911; 2c. Jan. 31, 1911; A 280617; Ticker pub. co., New Yoₗ N. Y. (11–3967) 1027

Curwood, James Oliver, 1878–

The honor of the big snows, by James Oliver Curwood ... with illustrations by Charles Livingston Bull. Indianapolis, The Bobbs-Merrill company ₍ᶜ1911₎

4 p. l., 317, ₍1₎ p. col. front., col. plates. 19¾ᶜᵐ. $1.50

© Mar. 4, 1911; 2c. Mar. 8, 1911; A 283250; Bobbs-Merrill co., Indianapolis, Ind. (11–3944) 1028

Cushman, Herbert Ernest.

A beginner's history of philosophy, by Herbert Ernest Cushman ... v. 2. Modern philosophy. Boston, New York ₍etc.₎ Houghton Mifflin company ₍1911₎

xvii p., 1 l., 377 p. front., ports., maps. 20ᶜᵐ. $1.60

© Feb. 6, 1911; 2c. Mar. 17, 1911; A 283470; H. E. Cushman, Medford, Mass. 1029

Dejerine, Joseph Jules, 1849–

Les manifestations fonctionnelles des psychonévroses, leur traitement par la psychothérapie, par J. Dejerine ... E. Gauckler ... Paris, Masson et cⁱᵉ, 1911.

ix, 561 p. front. 23½ᶜᵐ. fr. 8

© Feb. 10, 1911; 2c. Mar. 4, 1911; A—Foreign 2553; Masson & co., Paris, France. (11–3973) 1030

Doty, Alvah H.

Prevention of infectious diseases, by Alvah H. Doty ...
New York and London, D. Appleton and company, 1911.

5 p. l., 280 p., 1 l. 20ᶜᵐ. $2.50
© Mar. 3, 1911; 2c. Mar. 6, 1911; A 283193; D. Appleton & co., New York,
N. Y. (11–3974) 1031

[Duval, Paul Alexandre Martin] 1856–1906.

... Ellen; illustrations de Mahut. Paris, P. Lafitte &
cⁱᵉ [ᵉ1911]

126 p. incl. front., illus. 24½ᶜᵐ. (Idéal-bibliothèque. [22]) fr. 0.95
Author's pseudonym, Jean Lorrain, at head of title.
© Feb. 17, 1911; 2c. Mar. 4, 1911; A—Foreign 2543; Pierre Lafitte & co.,
Paris, France. (11–4135) 1032

Eckardt, Homer Mark Philip, 1869–

A rational banking system; a comprehensive study of
the advantages of the branch bank system, by H. M. P.
Eckardt ... New York and London, Harper & brothers,
1911.

3 p. l., 328 p., 1 l. 21½ᶜᵐ. $1.50
© Mar. 2, 1911; 2c. Mar. 4, 1911; A 283153; Harper & bros., New York, N. Y.
(11–4161) 1033

'ischer, Guido *i. e.* **Johann August Guido,** 1877–

Die lokale anästhesie in der zahnheilkunde, mit spezi-
er berücksichtigung der schleimhaut- umd leitungs-
ästhesie. Kompendium für zahnärzte, ärzte und stu-
,erende, von privatdozent dr. Guido Fischer ... Mit 81
meist farbigen figuren im text und vii tafeln. Berlin,
H. Meusser, 1911.

4 p. l., 171 p. incl. illus. (partly col.) vii pl. 25ᶜᵐ. M. 8.50
© Jan. 25, 1911; 2c. Mar. 6, 1911; A—Foreign 2572; Hermann Meusser,
Berlin, Germany. (11–4115) 1034

Forman, Samuel Eagle.

Supplement: Government in Ohio. [New York, Cin-
cinnati [etc.] American book company, 1911]

32 p. 19ᶜᵐ. [*With* Forman, S. E. Essentials in civil government]
© Mar. 11, 1911; 2c. Mar. 14, 1911; A 283532; American book co., New
York, N. Y. 1035

Frühling, Robert.

Anleitung zur untersuchung der für die zuckerindustrie,
in betracht kommenden rohmaterialien, produkte, neben-
produkte und hilfssubstanzen; für die laboratorien der
zuckerfabriken für chemiker fabrikanten, landwirte und
steuerbeamte, sowie für technische und landwirtschaft-
liche lehranstalten, von prof. dr. R. Frühling ... 7. um-
gearb. und verm. aufl., mit 140 eingedruckten abbildungen.
Braunschweig, F. Vieweg und sohn, 1911.

xviii p., 1 l., 535 p. illus. 23½ᶜᵐ. M. 15
© Feb. 11, 1911; 2c. Mar. 4, 1911; A—Foreign 2557; Friedr. Vieweg &
sohn, Braunschweig, Germany. (11–3971) 1036

Harris, James Coffee, 1858–
The personal and family history of Charles Hooks and Margaret Monk Harris, by James Coffee Harris ... [Rome? Ga.] ᶜ1911·

3 p. l., [5]–116 p. ports., geneal. tab. 23½ᶜᵐ. $1.00
© Feb. 15, 1911; 2c. Feb. 21, 1911; A 283206; J. C. Harris, Rome, Ga. (11–3978) 1037

Hartmann, Henri, 1860–
... Gynécologie opératoire, par Henri Hartmann ... avec 422 figures dans le texte dont 80 en couleur. Paris, G. Steinheil, 1911.

vi, 498 p. illus. (partly col.) 28½ᶜᵐ. (Traité de médicine opératoire et de thérapeutique chirurgicale, pub. sous la direction de H. Hartmann. P. Berger, P. Lecène) fr. 18
© Feb. 10, 1911; 2c. Mar. 4, 1911; A—Foreign 2554; Georges Steinheil, Paris, France. (11–3976) 1038

Higinbotham, John U . 1867–
Three weeks in the British Isles, by John U. Higinbotham. Chicago, The Reilly & Britton co. [ᶜ1911]

5 p. l., 9–328 p. front., plates. 20ᶜᵐ. $1.50
© Feb. 16, 1911; 2c. Mar. 1, 1911; A 283082; Reilly & Britton co., Chicago, Ill. (11–4125) 1039

Hinckley, Mercy Adeline, 1871–
The home spirit; a collection of poems, by M. Adeline Hinckley. New York, Cochrane publishing company, 1910.

80 p. 19½ᶜᵐ. $0.60
© Feb. 3, 1911; 2c. Mar. 4, 1911; A 283166; M. A. Hinckley, Woburn, Mass. (11–4133) 1040

Hoek, Henry.
Der schi und seine sportliche benutzung, von Henry Hoek. 5. aufl., mit 12 kunstblättern und 171 textbildern. München, Verlag der Deutschen alpenzeitung g. m. b. h., 1911.

vii, 246 p. illus., plates. 19ᶜᵐ.
"Schiliteratur": p. 214–217.
© Jan. 24, 1911; 2c. Feb. 15, 1911; A—Foreign 2492; Verlag der Deutschen alpenzeitung, g. m. b. h., Munich, Germany. (11–4118) 1041

Le Roux, Robert Charles Henri *called* **Hugues,** 1860–
... O mon passé; illustrations de J. Janet. Paris, P. Lafitte & cⁱᵉ [ᶜ1910]

113 p. incl. front., illus. 24½ᶜᵐ. (Idéal-bibliothèque. [20]) fr. 0.95
CONTENTS.—O mon passé.—Médéric et Lisée.
© Feb. 17, 1911; 2c. Mar 4, 1911; A—Foreign 2542; Pierre Lafitte & co., Paris, France. (11–4134) 1042

London, Jack, 1876–
Adventure, by Jack London ... New York, The Macmillan company, 1911.

viii p., 1 l., 405 p. 19½ᶜᵐ. $1.50
© Mar. 8, 1911; 2c. Mar. 9, 1911; A 283265; Macmillan co., New York, N. Y. (11–3945) 1043

Mansfield, Blanche (McManus) *"Mrs. M. F. Mansfield."*

Gerard, our little Belgian cousin, by Blanche McManus; illustrated by the author. Boston, L. C. Page & company, 1911.

vi p., 1 l., ₁2₁, 106 p. front., illus. (map) 5 pl. 19½ᶜᵐ. (*On verso of half-title:* The little cousin series) $0.60

© Mar. 3, 1911; 2c. Mar. 8, 1911; A 283236; L. C. Page & co., inc., Boston, Mass. (11–4099) **1044**

Melendy, Mary Ries, 1842–

The ideal woman, for maidens—wives—mothers; a book giving full information on all the mysterious and complex matters pertaining to women ... A complete medical guide for women, by Mary R. Melendy ... ₁Chicago?ᶜ1911₁

1 p. l., 7–448 p. col. front., illus., plates (partly col.) 24ᶜᵐ.
Published in 1903 under title: Perfect womanhood.

© Feb. 23, 1911; 2c. Mar. 2, 1911; A 283246; J. R. Peper, Chicago, Ill.
(11–4114) **1045**

Metropolitan business college, *Chicago.*

Metropolitan business letter writing; a manual for commercial students. Chicago, Metropolitan business college, 1911.

102 p. 25ᶜᵐ. $0.50

© Feb. 17, 1911; 2c. Feb. 23, 1911; A 283143; Metropolitan business college, Chicago, Ill. (11–4162) **1046**

Mundy, Floyd Woodruff, *ed.*

The earning power of railroads, 1911 ... Comp. and ed. by Floyd W. Mundy of Jas. H. Oliphant & co. New York city, Chicago, Ill., J. H. Oliphant & co., 1911.

492 p. 19ᶜᵐ.

© Mar. 6, 1911; 2c. Mar. 17, 1911; A 283450; F. W. Mundy, New York, N. Y. **1047**

Nyce, A William.

Grace before meals; brief prayers arranged for each day in the year, comp. by· A. William Nyce and Hubert Bunyea. Philadelphia, The John C. Winston co. ₁ᶜ1911₁

167 p. 14ᶜᵐ. $0.50

© Feb. 13, 1911; 2c. Feb. 17, 1911; A 280834; John C. Winston co., Philadelphia, Pa. (11–3951) **1048**

The **Ohio** nisi prius reports. New series, v. 10, being reports of cases decided by the superior, common pleas, probate and insolvency courts of the state of Ohio. Vinton R. Shepard, editor. Cincinnati, The Ohio law reporter company, 1911.

v, 709 p. 23½ᶜᵐ. $2.50

© Mar. 14, 1911; 2c. Mar. 17, 1911; A 283467; Ohio law reporter co., Cincinnati, O. **1049**

Peker, Charles Godfrey, 1878–

How to read plans; a simple, practical explanation of the meaning of various lines, marks, symbols and devices used on architectural working drawings, so that they can be correctly followed by the workman, by Charles G. Peker ... 2d ed., rev. and enl. New York, Industrial book company, 1911.

104 p. illus. 19^{cm}. $0.50

© Mar. 2. 1911; 2c. Mar. 4, 1911; A 283180; C. G. Peker, New York, N. Y. (11–3969) 1050

Price, George McCready.

God's two books; or, Plain facts about evolution, geology, and the Bible, by George McCready Price ... Washington, D. C., New York city [etc.] Review and herald publishing association, 1911.

2 p. l., 9–183 p. front., illus. (incl. ports.) 18¼^{cm}. $1.00

© Feb. 13, 1911; 2c. Feb. 14, 1911; A 280787; Review & herald pub. assn., Takoma Park, D. C. (11–3949) 1051

The **priest;** a tale of modernism in New England, by the author of "Letters to His Holiness, Pope Pius x." Boston, Sherman, French & company, 1911.

3 p. l., 269 p. 20¼^{cm}. $1.25

© Feb. 27, 1911; 2c. Mar. 8, 1911; A 283234; Sherman, French & co., Boston, Mass. (11–4100) 1052

Rice, Louise.

Dainty dishes from foreign lands, by Louise Rice ... Chicago, The Library shelf, 1909.

58 p. 18¼^{cm}. $0.75

© Dec. 16, 1909; 2c. Feb. 27, 1911; A 283058; Library shelf, Chicago, Ill. (11–3968) 1053

Roberts, Theodore i. e. **George Edward Theodore,** 1877–

A captain of Raleigh's; a romance, by G. E. Theodore Roberts ... with a frontispiece in full color from a painting by John Goss. Boston, L. C. Page & company, 1911.

4 p. l., 351 p. col. front. 20^{cm}. $1.25

© Mar. 2, 1911; 2c. Mar. 8, 1911; A 283235; L. C. Page & co., inc., Boston, Mass. (11–3943) 1054

Rubinstein, Joseph Samuel.

... Legal proceedings in England. A short guide to practice and procedure in the English courts, together with a special cypher code. By J. S. Rubinstein ... Issued by Messrs. Rubinstein, Nash & co. ... London, Sweet & Maxwell, ltd., 1910.

cover-title, 48 p. 22^{cm}. 1/

© 1c. Jan. 20, 1911; A ad int. 461; published Jan. 7, 1911; Rubinstein, Nash & co., London, England. (11–3956) 1055

Rückert, Friedrich, 1788–1866.

... Liebesfrühling, illustriert von Hans Koberstein. Berlin, Nevfeld & Henivs verlag ₍ᶜ1911₎

1 p. l., 159, ₍1₎ p. 12 col. pl. 29¼ᶜᵐ. M. 7.50

© Jan. 2, 1911; 2c. Feb. 24, 1911; A—Foreign 2532; Neufeld & Henius-verlag, Berlin, Germany. (11–3958) 1056

Simons, Emogene Sanford.

First year English for high schools, by Emogene Sanford Simons ... New York, Boston ₍etc.₎ Silver, Burdett and company ₍ᶜ1911₎

210 p. illus. 18½ᶜᵐ. $0.60

© Feb. 18, 1911; 2c. Feb. 25, 1911; A 283027; Silver, Burdett & co., Boston, Mass. (11–3960) 1057

Smith, Joseph, 1805–1844.

A brief history of Joseph Smith, the prophet, by himself. Salt Lake City, Utah, Deseret Sunday school union, 1910.

1 p. l., ₍5₎–63 p. 17ᶜᵐ. $0.25

"Closing years of Joseph Smith, the prophet, by Edward H. Anderson": p. 51–63.

© Apr. 18, 1910; 2c. Feb. 3, 1911; A 283079; Wm. Albert Morton, Salt Lake City, Utah. (11–3979) 1058

˙art, John Sylvester, 1864–

ᴌaw of taxation in Texas, by John S. Stewart ... Chiᴄago, T. H. Flood & co., 1911.

2 p. l., ₍7₎–746 p. 24ᶜᵐ. $6.00

© Feb. 19, 1911; 2c. Feb. 24, 1911; A 283005; J. S. Stewart, Houston, Tex. (11–3953) 1059

Sumerwell, Florida Pope.

Four in family; the story of how we look from where the dog sits, by Florida Pope Sumerwell; with illustrations and decorations by George Kerr. Indianapolis, The Bobbs-Merrill company ₍ᶜ1911₎

5 p. l., 181, ₍1₎ p. col. front., col. plates. 18ᶜᵐ. $1.00

© Mar. 4, 1911; 2c. Mar. 8, 1911; A 283251; Bobbs-Merrill co., Indianapolis, Ind. (11–3946) 1060

Thackeray, William Makepeace.

The works of William Makepeace Thackeray; with biographical introductions by his daughter Lady Ritchie ... ₍The centenary biographical ed.₎ v. 7–9. New York and London, Harper & brothers ₍1910₎

3 v. fronts., illus., plates, port. 21½ᶜᵐ.

CONTENTS.—v. 7. Memoirs of Barry Lyndon, esq. and the fatal boots.—v. 8. Contributions to "Punch," v. 1. Novels by eminent hands, etc.—v. 9. Contributions to "Punch," v. 2, The book of snobs, etc.

© Dec. 16, 1910; 2c. each Mar. 16, 1911; A 283427, 283425, 283426; Harper & bros., New York, N. Y. ₍Copyright claimed on Introductions₎

 1061–1063

U. S. *Supreme court.*
United States reports, v. 218. Cases adjudged ... at
October term, 1909, and October term, 1910. Charles
Henry Butler, reporter. New York, The Banks law pub-
lishing co., 1911.
lii, 764 p. 23½ᶜᵐ. $2.00
© Mar. 15, 1911; 2c. Mar. 16, 1911; A 283440; Banks law pub. co., New
York, N. Y. **1064**

Veech, James, 1808–1879.
The Monongahela of old; or, Historical sketches of
south-western Pennsylvania to the year 1800, by James
Veech ... Pittsburgh, 1858–92 [°1910]
2 p. l., [17]–259 p. front., illus., ports., plan. 23½ᶜᵐ. $5.00
"This unfinished work of the author, which has been 'in sheets' since
1858, is now issued for private distribution only. By the addition of pages
241–259. which were included in a pamphlet issued in 1857, entitled 'Mason
and Dixon's line,' the chapter relating to the boundary controversy between
Pennsylvania and Virginia is completed."
© Dec. 23, 1910; 2c. Dec. 28, 1910; A 280480; James Hadden, Uniontown,
Pa. (11–1586) **1065**

Webb, Hugh Goold.
A history of the Knights of Pythias and its branches
and auxiliary; together with an account of the origin of
secret societies, the rise and fall of chivalry and historical
chapters on the Pythian ritual, by Capt. Hugh Goold
Webb ... Anaheim, Cal., The Uniform rank co-operative
association, 1910.
470 p. incl. front., illus., plates, ports., map, facsim., fold. tables. ports.
18ᶜᵐ. $1.50
© Feb. 1, 1911; 2c. Feb. 23, 1911; A 280969; H. G. Webb, Los Angeles, Cal.
(11–3964) **1066**

Wilson, William Bender.
History of the Pennsylvania railroad department of
the Young men's Christian association of Philadelphia,
by William Bender Wilson ... Philadelphia, Stephen
Greene company, printers, 1911.
296 p. front., plates, ports. 25ᶜᵐ. $2.00
© Mar. 6, 1911; 2c. Mar. 8, 1911; A 283232; W. B. Wilson, Holmesburg,
Pa. (11–4143) **1067**

Winter, William, 1836–
Gray days and gold, by William Winter ... New York,
Moffat, Yard and company, 1911.
371 p. incl. front. plates, ports. 23ᶜᵐ. $3.00
A companion to "Shakespeare's England" and "Over the border."
CONTENTS. — Southampton. — Salisbury and Stonehenge. — Haunts of
Moore.—Bath and Bristol.—The Faithful city.—Lichfield and Dr. John-
son.—Bosworth and King Richard.—Old York.—Stratford gleaning.—The
Childs fountain.—The Shakespeare church.—Rambles in Arden.—On the
Avon.—Hereford and Tintern Abbey.—Tennyson.—Stratford to Notting-
ham.—Nottingham and Newstead.—Byron.—Hucknall-Torkard church.—
Haunts of Wordsworth.—Gray and Arnold.—Through Surrey and Kent.—
A French vignette.—From London to Edinburgh.
© Mar. 4, 1911; 2c. Mar. 9, 1911; A 283274; W. Winter, New Brighton,
N. Y. (11–4124) **1068**

Alden, Isabella Macdonald, "*Mrs. G. R. Alden*", 1841–

Lost on the trail, by Pansy [*pseud.*] ... illustrated by Elizabeth Withington. Boston, Lothrop, Lee & Shepard co. [1911]

iv p., 1 l., 466 p. front., plates. 19½ᶜᵐ. $1.50

© Mar. 10, 1911; 2c. Mar. 13, 1911; A 283359; Lothrop, Lee & Shepard co., Boston, Mass. (11–4603)　　　　　　　　　　　　　1069

Arnold, Adelaide Victoria (England) "*Mrs. J. O. Arnold.*"

The fiddler, by Mrs. J. O. Arnold ... London, A. Rivers, ltd., 1911.

4 p. l., 3–379, [1] p. 19ᶜᵐ.　6/

© 1c. Feb. 16, 1911; A ad int. 483; published Jan. 18, 1911; Mrs. J. O. Arnold, London, England. (11–4212)　　　　　　　　1070

Autry, Allen Hill.

Grapeshot and canister from the arsenal of truth on mission methods, by Allen Hill Autry ... with an introduction by Reverend Benjamin Cox ... Little Rock, Ark., The Doctrinal interpreter, 1911.

178 p. 19½ᶜᵐ. $0.75

© Mar. 4, 1911; 2c. Mar. 10, 1911; A 283300; A. H. Autry, Nashville, Ark. (11–4458)　　　　　　　　　　　　　　　　1071

Blair, Thomas Stewart, 1867–

Public hygiene, by Thos. S. Blair ... assisted by numerous contributors ... Boston, R. G. Badger [°1911]

2 v. fronts., illus., plates. 24ᶜᵐ. $10.00

© Mar. 4, 1911; 2c. Mar. 10, 1911; A 283290, 283291; Richard C. Badger, Boston, Mass. (11–4612)　　　　　　　　　1072, 1073

Bordeaux, Henry, 1870–

The parting of the ways, by Henry Bordeaux; tr. by Louise Seymour Houghton. New York, Duffield & company, 1911.

5 p. l., [5]–266 p. 19½ᶜᵐ. $1.20

© Mar. 8, 1911; 2c. Mar. 11, 1911; A 283322; Duffield & co., New York, N. Y. (11–4604)　　　　　　　　　　　　1074

Brown, Basil.

... Supposed caricature of the Droeshout portrait of Shakespeare, with fac-simile of the rare print taken from a very scarce tract of an Elizabethan poet, by Basil Brown. Printed for private circulation. New York, 1911.

1 p. l., 34 p. front., illus. 24ᶜᵐ. (*His* Notes on Elizabethan poets.— no. 1)

© Feb. 15, 1911; 2c. Feb. 16, 1911; A 280983; B. Brown, New York, N. Y. (11–4622)　　　　　　　　　　　　　　1075

Busoni, Ferruccio Benvenuto, 1866–

Sketch of a new esthetic of music, by Ferruccio Busoni; tr. from the German by Dr. Th. Baker. New York, G. Schirmer, 1911.

2 p. l., 45 p. 19ᶜᵐ. $0.75
© Feb. 11, 1911; 2c. Feb. 13, 1911; A 280901; G. Schirmer, New York, N. Y. (11-4452) **1076**

Church, Albert Ensign, 1807–1878.

Elements of descriptive geometry, with applications to spherical and isometric projections, shades and shadows, and perspective, by Albert E. Church ... and George M. Bartlett ... New York, Cincinnati [etc.] American book company [ᶜ1911]

286 p. diagrs. 21½ᶜᵐ. $2.25
© Mar. 3, 1911; 2c. Mar. 7, 1911; A 283217; G. M. Bartlett, Ann Arbor, Mich. (11-4223) **1077**

Clobes, Heinz Wilhelm, 1876–

Rudolf Presber, ein rheinisches dichterleben. Biographisch-literarische studie von Wilhelm Clobes. Berlin, Concordia deutsche verlags-anstalt, g. m. b. h. [ᶜ1910]

4 p. l., 138 p., 1 l. illus., plates. 2 port. (incl. front.) 19½ᶜᵐ. M.2
© Dec. 16, 1910; 2c. Mar. 6, 1911; A—Foreign 2567; Concordia deutsche verlags-anstalt, g. m. b. h., Berlin, Germany. (11-4232) **1078**

Coffin, Rhoda M (Johnson) 1826–1909.

Rhoda M. Coffin; her reminiscences, addresses, papers and ancestry, ed. by Mary Coffin Johnson. New York, The Grafton press, 1910.

5 p. l., 3–291 p. front. (port.) pl. 22ᶜᵐ.
© Dec. 30, 1910; 2c. Mar. 8, 1911; A 283244; M. C. Johnson, Brooklyn, N. Y. (11-4216) **1079**

Conway, Thomas, jr.

Investment and speculation; a description of the modern money market and analysis of the factors determining the value of securities, by Thomas Conway, jr. ... in collaboration with Albert W. Atwood ... New York city, Alexander Hamilton institute [ᶜ1911]

xxix, 443 p. 24ᶜᵐ. (*Half-title:* Modern business; the principles and practice of commerce, accounts and finance, prepared and edited under the direct supervision of J. F. Johnson. [vol. VII]) $3.50
© Mar. 6, 1911; 2c. Mar. 9, 1911; A 283277; Alexander Hamilton institute, New York, N. Y. (11-4463) **1080**

Coppée, François i. e. Francis Édouard Joachim, 1842–1908.

The guilty man (Le coupable) by François Coppée; authorized English version by Ruth Helen Davis; illustrations by Clarence Rowe. New York, G. W. Dillingham company [ᶜ1911]

2 p. l., [3]–310 p. front., plates. 19ᶜᵐ. $1.50
© Feb. 25, 1911; 2c. Mar. 10, 1911; A 283297; G. W. Dillingham co., New York, N. Y. (11-4601) **1081**

Coyle, Robert Francis, 1850–

Rocks and flowers; seven discourses on the Apostles' creed, by Robert Francis Coyle ... Denver, Colo., The Fisher book & stationery co., °1910·

76 p. 18½ᶜᵐ. $0.75
© Dec. 20, 1910; 2c. Mar. 6, 1911; A 283202; Fisher book and stationery co., Denver, Col. (11–4456) 1082

Culler, Joseph Albertus, 1858–

... The first book of anatomy, physiology and hygiene of the human body for pupils in the lower grades, by J. A. Culler ... Philadelphia and London, J. B. Lippincott company [°1911]

x, 7–180 p. illus. 19ᶜᵐ. (Lippincott's physiologies)
First published 1904.
© Jan. 23, 1911; 2c. Feb. 23, 1911; A 280965; J. B. Lippincott co., Philadelphia, Pa. (11–4222) 1083

... The third book of anatomy, physiology and hygiene of the human body, by J. A. Culler ... Philadelphia and London, J. B. Lippincott company [°1911]

xiii, 5–404 p. illus. 19ᶜᵐ. (Lippincott's physiologies)
First published 1904.
© Jan. 26, 1911; 2c. Feb. 23, 1911; A 280966; J. B. Lippincott co., Philadelphia, Pa. (11–4221) 1084

Dunham, Curtis.

Wurra-Wurra; a legend of Saint Patrick at Tara, here first transcribed and compared with the testimony of ancient records and modern historical research by Curtis Dunham ... with illustrations, including a reconstruction of the very ancient Celtic idol called Wurra-Wurra, by John Innes. New York, D. Fitzgerald, inc. [°1911]

93 p. col. front., illus. (partly col.) plates (partly col.) 16ᶜᵐ. $1.00
© Mar. 11, 1911; 2c. Mar. 13, 1911; A 283370; Desmond Fitzgerald, inc., New York, N. Y. (11–4621) 1085

Fiske, Amos Kidder, 1842–

The great epic of Israel; the web of myth, legend, history, law, oracle, wisdom and poetry of the ancient Hebrews, by Amos Kidder Fiske ... New York, Sturgis & Walton company, 1911.

x, [2], 376 p. 19½ᶜᵐ. $1.50
© Mar. 9, 1911; 2c. Mar. 11, 1911; A 283329; Sturgis & Walton co., New York, N. Y. (11–4640) 1086

Foote, Edward Milton, 1866–

A text-book of minor surgery, by Edward Milton Foote ... 3d ed., illustrated by four hundred and seven engravings from original drawings and photographs. New York and London, D. Appleton and company, 1911.

4 p. l., vii–xxviii, 810 p. illus. 24½ᶜᵐ. $5.00
© Mar. 8, 1911; 2c. Mar. 11, 1911; A 283314; D. Appleton & co., New York, N. Y. (11–4613) 1087

Gareis, Karl, 1844–

Introduction to the science of law; systematic survey of
the law and principles of legal study, by Karl Gareis ... tr.
from the 3d, rev. ed. of the German by Albert Kocourek ...
with an introduction by Roscoe Pound ... Boston, The
Boston book company, 1911.

2 p. l., [iii]–xxix, 375 p. 22ᶜᵐ. [Jurisprudence and philosophy of law
series, II] $3.50

© Mar. 6, 1911; 2c. Mar. 9, 1911; A 283284; Boston book co., Boston, Mass
(11–4641) 1088

Goldman, Harrie, 1879– comp.

The handy cyclopedia of business, for busy business men
... Giving practical tables, laws, advice and valuable
points of information. Covering in a simple and concise
manner — business, finance, law, insurance, advertising,
and other important subjects of interest. Comp. by Har-
rie Goldman ... Cincinnati, O., H. Goldman publishing
co., 1911.

3 p. l., 249 p. incl. tables. 23½ᶜᵐ.

© Mar. 6, 1911; 2c. Mar. 13, 1911; A 283365; Harrie Goldman, Cincinnati,
O. (11–4619) 1089

Graham, Harry J C 1874–

Lord Bellinger; an autobiography; with an introduc-
tion by Harry Graham. London, E. Arnold, 1911.

vii, 264 p. 19½ᶜᵐ. 6/

© 1c. Mar. 11, 1911; A ad int. 518; published Feb. 16, 1911; Duffield & co.,
New York, N. Y. (11–4599) 1090

Gruender, Hubert, 1870–

Free will, the greatest of the seven world-riddles; three
lectures by Hubert Gruender ... St. Louis, Mo. [etc.] B.
Herder, 1911.

2 p. l., 96 p. 19½ᶜᵐ. $0.50

© Dec. 31, 1910; 2c. Jan. 3, 1911; A 278824; Joseph Gummersbach, St.
Louis, Mo. (11–1480) 1091

Grull, Werner.

Die inventur. Aufnahmetechnik, bewertung und kon-
trolle. Für fabrik- und warenhandelsbetriebe dargestellt
von Werner Grull ... Berlin, J. Springer, 1911.

xii, 235, [1] p. 24½ᶜᵐ. M. 6

© Jan. 24, 1911; 2c. Mar. 6, 1911; A—Foreign 2569; Julius Springer, Ber-
lin, Germany. (11–4618) 1092

Harris, *Mrs.* Mary Moore (Vantrece) 1857–

Lincoln memoirs; from the log cabin to the White
House, by Mary M. Harris. Springfield, Ill., Phillips
bros., printers [1910]

89 p. illus. (incl. ports.) 23½ᶜᵐ. $0.75

© Sept. 20, 1910; 2c. Nov. 18, 1910; A 283080; M. M. Harris, Riverton, Ill.
(11–4217) 1093

Harrison, William Welsh, 1850–

Harrison, Waples and allied families; being the ancestry of George Leib Harrison of Philadelphia and of his wife Sarah Ann Waples, by their son William Welsh Harrison ... Philadelphia, Printed for private circulation only, 1910.

6 p. l., 176 p. front., illus., plates, ports., plan, facsim., fold. geneal. tab., coats of arms. 29ᶜᵐ.
© Feb. 25, 1911; 2c. Mar. 4, 1911; A 283333; W. W. Harrison, Philadelphia, Pa. (11–4607) 1094

Hermant, Abel, 1862–

... Histoire d'un fils de roi; illustrations d'après les dessins de Pierre Brissaud. Paris, A. Fayard, ᶜ1911·

158 p. incl. front., illus. 24½ᶜᵐ. fr. 1.50
© Feb. 17, 1911; 2c. Mar. 4, 1911; A—Foreign 2552; ₍A.₎ Fayard, Paris, France. (11–4244) 1095

Hichens, Robert Smythe, 1864–

The dweller on the threshold, by Robert Hichens ... New York, The Century co., 1911.

3 p. l., 3–273 p. 20ᶜᵐ. $1.10
© Mar. 10, 1911; 2c. Mar. 13, 1911; A 283358; Century co., New York, N. Y. (11–4602) 1096

Insurance and real estate; part ɪ: Fire insurance, by Edward R. Hardy ... part ɪɪ: Real estate, by Walter Lindner ... New York city, Alexander Hamilton institute ₍ᶜ1911₎

xxv, 505 p. 24ᶜᵐ. (Half-title: Modern business; the principles and practice of commerce, accounts and finance, prepared and edited under the direct supervision of J. F. Johnson. ₍vol. vɪɪɪ₎) $3.50
© Mar. 6, 1911; 2c. Mar. 9, 1911; A 283276; Alexander Hamilton institute, New York, N. Y. (11–4464) 1097

Jochum, Paul.

Der drehrohrofen als modernster brennapparat, von dr. Paul Jochum ... Braunschweig, F. Vieweg & sohn, 1911.

2 p. l., 3–70 p., 1 l. plates, tables, diagrs. 27½ᶜᵐ. M. 6
© Feb. 8, 1911; 2c. Mar. 6, 1911; A—Foreign 2571; Friedr. Vieweg & sohn, Braunschweig, Germany. (11–4227) 1098

Le Queux, William, 1864–

The money-spider; a mystery of the Arctic, by William Le Queux ... with a frontispiece by Cyrus Cuneo. London, New York ₍etc.₎ Cassell and company, limited, 1911.

viii, 343, ₍1₎ p. col. front. 19½ᶜᵐ. 6/
© 1c. Mar. 9, 1911; A ad int. 513; published Feb. 10, 1911; W. Le Queux, London, England. (11–4213) 1099

Leroux, Gaston.

... Le fauteuil hanté. Paris, P. Lafitte & cⁱᵉ ₍ᶜ1911₎

3 p. l., ₍9₎–359, ₍1₎ p., 2 l. 19ᶜᵐ. fr. 3.50
CONTENTS.—Le fauteuil hanté.—L'homme qui a vu le diable.
© Feb. 17, 1911; 2c. Mar. 4, 1911; A—Foreign 2546; Pierre Lafitte & co., Paris, France. (11–4235) 1100

Mackay, *Mrs*. Helen Gansevoort (Edwards) 1876–

Half loaves; a story, by Helen Mackay ... New York, Duffield and company, 1911.

3 p. l., [3]–377 p. 19½ᶜᵐ. $1.30
© Mar. 8, 1911; 2c. Mar. 11, 1911; A 283323; Duffield & co., New York, N. Y. (11–4597) **1101**

[Magarity, Eleanor Hildegarde] 1875– *comp.*

Entertainer and entertained; compilation of Eleanor H. Caldwell [*pseud.*] Boston, Mayhew publishing co., 1911.

4 p. l., 143 p. 19½ᶜᵐ. $1.00
© Feb. 1, 1911; 2c. Feb. 3, 1911; A 280572; E. H. Caldwell, Wilmington, Del. (11–4626) **1102**

Malloch, Douglas.

Resawed fables, by Douglas Malloch. Chicago, American lumberman, 1911.

128 p. incl. front. (port.) 20ᶜᵐ. $1.00
© Feb. 20, 1911; 2c. Mar. 6, 1911; A 283182; Amer. lumberman, Chicago, Ill. (11–4236) **1103**

May, Florence Land.

Lyrics from lotus lands [by] Florence Land May. Boston, The Poet lore company, 1911.

5 p. l., 13–178 p. 18½ᶜᵐ. $1.50
© Mar. 4, 1911; 2c. Mar. 10, 1911; A 283288; F. L. May, New York, N. Y. (11–4623) **1104**

Plutarchus.

Plutarch on education; embracing the three treatises: The education of boys, How a young man should hear lectures on poetry, The right way to hear. By Charles William Super ... Syracuse, N. Y., C. W. Bardeen [ᶜ1910]

192 p. 19ᶜᵐ.
© Jan. 13, 1911; 2c. Feb. 15, 1911; A 280801; C. W. Bardeen, Syracuse, N. Y. (11–4448) **1105**

Porter, Charles Sanford, 1862–

Milk diet as a remedy for chronic disease, by Charles Sanford Porter, M. D. 3d ed. Burnett P. O., (city of Long Beach) Cal., 1911.

184 p. 18½ᶜᵐ.
© Feb. 15, 1911; 2c. Mar. 6, 1911; A 283205; C. S. Porter, Burnett, Cal. (11–4614) **1106**

Randall, Mallinson, *comp.*

... The choirmaster's guide to the selection of hymns and anthems for the services of the church, comp. by Mallinson Randall; with an introduction by the Rev. George R. Van De Water ... [Rev. ed.] New York, The H. W. Gray co., sole agents for Novello & co., limited [ᶜ1911]

120 p. 23ᶜᵐ.
© Feb. 18, 1911; 2c. Feb. 20, 1911; A 280887; H. W. Gray co., New York, N. Y. (11–4451) **1107**

Roberts, Morley, 1857–

Thorpe's way; a joyous book, by Morley Roberts. London, E. Nash, 1911.

vii, [1], 343 p. 19½ᶜᵐ. 6/

© 1c. Mar. 9, 1911; A ad int. 512; published Feb. 9, 1911; M. Roberts, London, England. (11–4211) 1108

Sheehan, Patrick Augustine, 1852–

The intellectuals; an experiment in Irish club-life, by Canon Sheehan ... New York [etc.] Longmans, Green, and co., 1911.

viii, 386 p. 22ᶜᵐ. $1.50

© Feb. 23, 1911; 2c. Mar. 9, 1911; A 283268; Longmans, Green, & co., New York, N. Y. (11–4598) 1109

Sherman, George Henry, 1858–

Vaccine therapy in general practice, by George H. Sherman, M. D. Detroit, Mich., The author, 1911.

142 p. 18ᶜᵐ. $1.00

© Mar. 2, 1911; 2c. Mar. 8, 1911; A 283229; G. H. Sherman, Detroit, Mich. (11–4611) 1110

Smith, *Mrs.* Jeanie Oliver (Davidson)

Sonnets of life, by Jeanie Oliver Smith (Temple Oliver) ... Boston, R. G. Badger, 1911.

71 p. 19½ᶜᵐ. $1.00

© Mar. 4, 1911; 2c. Mar. 10, 1911; A 283287; J. O. Smith, Johnstown, N. Y. (11–4624) 1111

The **Vermont** digest, annotated; a digest of all the reported decisions of the Supreme court of the state of Vermont down to October 25, 1910, including volume 83 Vermont reports, American digest classification, key-number system, comp. and pub. under authority of the state of Vermont ... v. 1, 2. St. Paul, West publishing co., 1911.

2 v. 26½ᶜᵐ. $21.50 per set of 3 vols.

v. 1 © Feb. 24, 1911; 2c. Mar. 4, 1911; A 283167; v. 2 © Feb. 25, 1911; 2c. Mar. 4, 1911; A 283168; West pub. co., St. Paul, Minn. (11–3955)
1112, 1113

Walter, Eugene.

The easiest way; a story of metropolitan life, by Eugene Walter and Arthur Hornblow; illustrations by Archie Gunn and Joseph Byron. New York, G. W. Dillingham company [°1911]

347 p. front., plates. 20ᶜᵐ. $1.50

© Feb. 25, 1911; 2c. Mar. 10, 1911; A 283296; G. W. Dillingham co., New York, N. Y. (11–4600) 1114

Webster, Noah, 1758–1843.

Webster's home, school and office dictionary, illustrated, based upon the unabridged dictionary of the English language of Noah Webster, LL. D. Rev. and brought up to date in accordance with the most recent eminent English and American authorities ... New York, Barse & Hopkins [°1911]

[1033] p. plates (partly col.) diagrs. 19½ᶜᵐ. $2.50
© Feb. 20, 1911; 2c. Feb. 25, 1911; A 283028; Barse & Hopkins, New York, N. Y. (11–4238) **1115**

Webster's new standard dictionary, illustrated, based upon the unabridged dictionary of the English language of Noah Webster, LL. D., rev. and brought up to date in accordance with the most recent eminent English and American authorities. Containing the 1910 census, with maps. New York, National press association, 1911.

[1048] p. plates (partly col.) maps, diagrs. 19½ᶜᵐ. $2.50
© Mar. 6, 1911; 2c. Mar. 9, 1911; A 283273; Nat'l press assn., New York, N. Y. (11–4800) **1116**

Weigle, Luther Allan, 1880–

... The pupil and the teacher, by Luther A. Weigle ... Philadelphia, Pa., The Lutheran publication society [°1911]

iv, [2] p., 1 l., 9–217 p. 19½ᶜᵐ. (Lutheran teacher-training series for the Sunday school ... book 2) $0.50
© Feb. 21, 1911; 2c. Feb. 23, 1911; A 280956; Lutheran publication soc., Philadelphia, Pa. (11–4631) **1117**

Wood, Casey Albert, 1856–

A system of ophthalmic operations; being a complete treatise on the operative conduct of ocular diseases and some extraocular conditions causing eye symptoms. Ed. and partly written by Casey A. Wood ... Completely indexed and illustrated with eighteen color plates and over one thousand drawings in black and white, many of them original ... Chicago, Cleveland press, 1911.

2 v. illus., xviii pl. (partly col., 1 fold.) 25ᶜᵐ. $15.00
© Feb. 23, 1911; 2c. Mar. 4, 1911; A 283148; Cleveland press, Chicago, Ill. (11–3975) **1118**

Woodworth, Joseph Vincent, 1877–

American tool making and interchangeable manufacturing; a treatise upon the designing, constructing, use, and installation of tools, jigs, fixtures ... and labor-saving contrivances ... by Joseph V. Woodworth ... 2d ed., illustrated by six hundred engravings from original drawings by the author. New York, The Norman W. Henley publishing co., 1911.

2 p. l., [7]–535 p. illus. 23½ᶜᵐ. $4.00
© Mar. 3, 1911; 2c. Mar. 4, 1911; A 283150; Norman W. Henley pub. co., New York, N. Y. (11–3970) **1119**

B2035.4

Alexander, Friedrich Wilhelm, 1855–

Johann Georg Meyer von Bremen; das lebensbild eines deutschen genremalers von Fr. W. Alexander, mit 142 abbildungen. Leipzig, E. A. Seemann, 1910.

3 p. 1., 9–90 p. illus., 100 pl., 2 port. (incl. front.) 25½ᶜᵐ.

© D. 15, 1910; 2c. Ja. 19, 1911: A—For. 2318; E. A. Seemann.
(11–4790) 1120

The **American** and English annotated cases; containing the important cases selected from the current American, Canadian, and English reports, thoroughly annotated. Ed. by William M. McKinney and H. Noyes Greene. v. 18. Northport, N. Y., E. Thompson company, 1911.

1 p. 1., viii, 1298 p. 26ᶜᵐ. $5.00

© Mr. 16, 1911; 2c. Mr. 18, 1911; A 283512; Edward Thompson co.
 1121

American gynecological society.

Transactions of the American gynecological society. v. 35, for the year 1910 ... Philadelphia, W. J. Dornan, 1910.

lxii, 566 p. illus., plates. 22½ᶜᵐ. $5.00

© Ja. 5, 1911; 2c. Ja. 7, 1911; A 278958; Amer. gynecological soc., N. Y.
 1122

American numismatic society, *New York*.

Catalogue of sculpture by Prince Paul Trobetzkoy, exhibited by the American numismatic society, at the Hispanic society of America, February 12 to March 12, 1911, with introduction by Christian Brinton. New York, The American numismatic society, 1911.

3 p. 1., 3–128 p. incl. plates. front., plates. 20ᶜᵐ.

© F. 8, 1911; 2c. F. 20, 1911; A 280891; Hispanic soc. of Amer., N. Y.
(11–4980) 1123

Barclay, Edith Noël (Daniell) *"Mrs.* Hubert Barclay," 1872–

Trevor Lordship, by Mrs. Hubert Barclay. New York, The Macmillan company, 1911.

viii p., 1 1., 389 p. 20ᶜᵐ. $1.20

© F. 23, 1911; 2c. F. 24, 1911; A 280980; Macmillan co.
(11–4931) 1124

Brown, Sanford Miller, 1855–

Church organization and work, by S. M. Brown, with introduction by R. K. Maiden. Kansas City, Mo., Western Baptist publishing company [c1910]

104 p. 18ᶜᵐ. $0.50

© Ja. 16, 1911; 2c. Ja. 16, 1911; A 280997; S. M. Brown, Kansas City.
(11–4784) 1125

201

Buat, Edmond, 1868–
L'artillerie de campagne; son histoire, son évolution, son état actuel, par E. Buat ... Avec 75 figures dans le texte. Paris, F. Alcan, 1911.
2 p. l., iii, 347, [1] p. illus., diagrs. 19ᶜᵐ. (Nouvelle collection scientifique. Directeur: E. Borel) fr. 3.50
© F. 10, 1911; 2c. Mr. 4, 1911; A—For. 2548; Félix Alcan & R. Lisbonne, Paris. (11–4974) **1126**

Buchanan, James, *pres. U. S.*
The works of James Buchanan, comprising his speeches, state papers, and private correspondence; collected and ed. by John Bassett Moore. v. 12. Biographical. Philadelphia & London, J. B. Lippincott company, 1911.
xviii, 479 p. front. (port.) 25ᶜᵐ. $5.00
© Mr. 2, 1911; 2c. Mr. 21, 1911; A 283565; J. B. Lippincott, Phil.
 1127

California. *District courts of appeal.*
Reports of cases determined ... C. P. Pomeroy, reporter, H. L. Gear, assistant reporter. v. 13. San Francisco, Bancroft-Whitney company, 1911.
xxx, 962 p. 23ᶜᵐ. $3.00
© Mr. 14, 1911; 2c. Mr. 22, 1911; A 283598; Bancroft-Whitney co.
 1128

Cook, P.
Successful incubation; a working manual for large hatching plants, by P. Cook ... Los Angeles, Cal., Weimar press [°1911]
36 p. diagrs. 21½ᶜᵐ. $1.00
© F. 3, 1911; 2c. F. 14, 1911; A 280782; Peter Cook, Los Angeles. (11–4971) **1129**

Coyle, Robert Francis, 1850–
The passion play at Oberammergau, by Rev. Robt. F. Coyle ... Denver, Colo., The Fisher book and stationery co., °1910.
30 p. front. (port.) 16ᶜᵐ. $0.25
© D. 15, 1910; 2c. Mr. 6, 1911; A 283203; Fisher book & stationery co. (11–4960)| **1130**

... The **Federal** reporter, with key-number annotations. v. 182. Permanent ed. ... December, 1910–January, 1911. St. Paul, West publishing co., 1911.
xii, 1124 p. 22½ᶜᵐ. (National reporter system—United States series) $3.50
© Mr. 11, 1911; 2c. Mr. 24, 1911; A 283652; West pub. co. **1131**

[**Fornel**, *Mme.* **Sophie Victorine (Perrault)**] 1842–
Les lunettes de grand'maman, par Pierre Perrault [*pseud.*] dessins de J. Geoffroy, ed. with notes and vocabulary, by Mary Sinclair Crawford. New York, H. Holt and company, 1911.
v, 121 p. incl. front., illus. 17½ᶜᵐ. $0.35
© F. 11, 1911; 2c. F. 15, 1911; A 280806; Henry Holt & co. (11–4799)| **1132**

₁Gilmore, Charles L ₎

Government lands and how to obtain them; a digest of the rules and regulations governing entries. ₁This treatise applies to the following states and territories: Arizona, California, Colorado, Washington, Idaho, Montana, Nevada, New Mexico, Wyoming, Oregon, Utah, written by Chas. L. Gilmore ... San Francisco, Printed by the Hicks-Judd company, ᶜ1911₁
cover-title, 21 p., 1 l. 23ᶜᵐ. $0.25
© F. 2, 1911; 2c. Mr. 8, 1911; A 283249; C. L. Gilmore, San Fran.
 (11–4803)₎ 1133

Gondouin, Ch.

... Le football; Rugby, américain, association, par Ch. Gondouin ... et Jordan ... Préface de Louis Dedet ... Ouvrage orné de 48 pages d'illustrations photographiques et cinématographiques hors texte. Paris, P. Lafitte & cᶦᵉ ₁ᶜ1910₁
2 p. l., ₁7₁–352 p., 1 l. illus., plates. 20¼ᶜᵐ. (Sports bibliothèque)
fr. 3.50
© F. 17, 1911; 2c. Mr. 4, 1911; A—For. 2551; Pierre Lafitte & co.
 (11–4794)₎ 1134

Griffin, Martin Ignatius Joseph.

Catholics and the American revolution, by Martin I. J. Griffin. ₁v.₁ 3 ... Philadelphia, The author, 1911.
7 p. l., 400 p. front., illus., plates, ports., facsims. 24½ᶜᵐ. $3.00
© Mr. 25, 1911; 2c. Mr. 22, 1911; A 283750; M. I. J. Griffin. 1135

₁Hanners, Horace₁

Hanners quick calculator. ₁New York?₁ ᶜ1911·
102 p. 17¼ᶜᵐ. $1.00
© F. 21, 1911; 2c. F. 24, 1911; A 280998; H. Hanners, N. Y.
 (11–4805)₎ 1136

Heyse, Paul Johann Ludwig, 1830–

... Hochzeit auf Capri, von Paul Heyse, ed. with introduction, notes, exercises, and vocabulary, by Charles Wesley Robson, A. B. New York, Charles E. Merrill company ₁ᶜ1911₁
135 p. front. (port.) illus., pl. 17¼ᶜᵐ. (Merrill's German texts)
$0.40
© F. 25, 1911; 2c. F. 28, 1911; A 283071; Chas. E. Merrill co.
 (11–4798) 1137

Indiana. *Supreme court.*

Reports of cases decided ... Geo. W. Self, official reporter, Sol. H. Esarey, assistant reporter. v. 173 ... Indianapolis, W. B. Burford, 1910.
xl, 818 p. 23ᶜᵐ. $1.50
© F. 2, 1911; 2c. F. 9, 1911; A 283728; Secretary of state of Indiana. Indianapolis. 1138

Jaffe, Moses Simon, 1843–
... Light and truth in the art of healing, by M. S. Jaffe
... A treatise regarding the advantage of vegetable remedies over mineral and chemical compounds ... Columbus,
O., American publishing company, 1911.
 78 p., 1 l. front. (port.) 22½ᶜᵐ. $1.00
 © F. 16, 1911; 2c. F. 28, 1911; A 283252; M. S. Jaffe, Sacramento.
 (11–4990) **1139**

ₗJames, Edmund Janesⱼ 1855–
... Newspapers and periodicals of Illinois, 1814–1879.
Rev. and enl. ed., by Franklin William Scott ... Springfield, Ill., The Trustees of the Illinois state historical
library, 1910.
 5 p. l., v–civ, ₗ2ⱼ, 610 (*i. e.* 612) p. 4 facsim. (incl. front.) 23ᶜᵐ. (*Half
 title:* Collections of the Illinois state historical library, vol. vi. ₗBibliographical series, vol. i₎)
 Series title also at head of t.-p.
 Issued in 1899 under title: A bibliography of newspapers published in
 Illinois prior to 1860. Publications of the Illinois state historical library.
 vol. i, no. i.
 "A list of Illinois newspapers and periodicals in Illinois libraries":
 p. ₗ363ⱼ–398; "In libraries outside of Illinois": p. 398–413.
 © F. 18, 1911; 2c. Mr. 6, 1911; A 283195; Illinois state historical library.
 (11–3980) **1140**

Johnson, William Francis.
Practice; actions at law in Pennsylvania embracing
trials, motion in arrest of judgment and rule for new
trial, appeals ... with forms ... by William F. Johnson ...
v. 2. Philadelphia, R. Welsh & co., 1911.
 xl, 1120 p. 24ᶜᵐ. $6.00
 © Mr. 24, 1911; 2c. Mr. 27, 1911; A 283726; Rees Welsh & co. **1141**

Kester, Vaughan, 1869–
The prodigal judge, by Vaughan Kester ... with illustrations by M. Leone Bracker. Indianapolis, The Bobbs-
Merrill company ₗᶜ1911ⱼ
 5 p. l., 448 p. front., plates. 20ᶜᵐ. $1.50
 © Mr. 11, 1911; 2c. Mr. 14, 1911; A 283401; Bobbs-Merrill co.
 (11–4774) **1142**

Kraemer, Hans, *ed.*
Der mensch und die erde; die entstehung, gewinnung
und verwertung der schätze der erde als grundlagen der
kultur, hrsg. von Hans Kraemer in verbindung mit regierungsrat dr. Otto Appel ... u. a. m. 7. bd. ... Berlin.
Leipzig ₗetc.ⱼ Deutsches verlagshaus Bong & co. ₗ1911ⱼ
 xii, 468 p. illus., plates (partly col., partly fold.) 30ᶜᵐ. M. 12
 © F. 1, 1911; 2c. Mr. 22, 1911; A—For. 2640; Deutsches verlaghaus Bong
 & co. **1143**

Lambling, Eugène.
Précis de biochimie, par E. Lambling ... Paris, Masson et cⁱᵉ, 1911.
 xxiii, 600 p. 20ᶜᵐ. fr. 8
 © F. 10, 1911; 2c. Mr. 4, 1911; A—For. 2544; Masson & co.
 (11–4978) **1144**

Larned, Josephus Nelson, 1836–

A study of greatness in men, by J. N. Larned ... Boston and New York, Houghton Mifflin company, 1911.

5 p. l., ₁3₁–303, ₁1₁ p. 19¼ᶜᵐ. $1.25

"The lectures now somewhat expanded in print were prepared and given, in 1906, first as a public course and then repeated in the high schools of Buffalo, N. Y.₁"

CONTENTS.—What goes into the making of a great man?—Napoleon: a prodigy, without greatness.—Cromwell: imperfect in greatness.—Washington: impressive in greatness.—Lincoln: simplest in greatness.

© Mr. 11, 1911; 2c. Mr. 15, 1911; A 283419; J. N. Larned, Buffalo.
(11–4953) 1145

The **lawyers** reports annotated. New series. Book 29. Burdett A. Rich, Henry P. Farnham, editors. 1911. Rochester, N. Y., The Lawyers co-operative publishing company, 1911.

viii, 1290 p. 25ᶜᵐ. $4.00

© Mr. 10, 1911; 2c. Mr. 14, 1911; A 283389; Lawyers co-op. pub. co.
 1146

——— Index to the Lawyers reports annotated. New series, vols. 25–29 ... Rochester, N. Y., The Lawyers co-operative publishing company, 1911.

218 p. 24ᶜᵐ.

© Mr. 10, 1911; 2c. Mr. 14, 1911; A 283390; Lawyers co-op. pub. co.
 1147

Missouri. *Supreme court.*

Reports of cases determined ... between June 14 and July 2, 1910. Perry S. Rader, reporter. v. 229. Columbia, Mo., E. W. Stephens ₁1911₁

xv, 833, vi p. 23½ᶜᵐ.

© F. 8, 1911; 2c. F. 10, 1911; A 283606; E. W. Stephens. 1148

₁Moreton, David Penn₁

How to make a wireless set, by Arthur Moore ₁*pseud.*₁ ... Chicago, Popular mechanics co. ₁ᶜ1911₁

3 p. l., 9–84 p. illus. 17½ᶜᵐ. (Popular mechanics twenty-five cent handbook series) $0.25

© F. 20, 1911; 2c. F. 25, 1911; A 283016; Henry H. Windsor, Chic.
(11–4944) 1149

Murat, Joachim Napoléon, *prince.*

Lettres et documents pour servir à l'histoire de Joachim Murat, 1767–1815; publiées par S. A. le prince Murat ... 5. Campagne de Pologne, 1806–1807 ... Paris, Plon-Nourrit et cie., 1911.

2 p. l., 504 p. front. (port.) fold. facsims. 23ᶜᵐ. fr. 7.50

© Mr. 10, 1911; 2c. Mr. 25, 1911; A—For. 2672; Plon-Nourrit & co.
 1150

Musser, John Herr, *ed.*

A handbook of practical treatment, by many writers, ed. by John H. Musser ... and A. O. J. Kelly ... v. 2. Philadelphia and London, W. B. Saunders company, 1911.

2 p. l., 9–865 p. illus., plates, diagrs. 25½ᶜᵐ. $6.00

© Mr. 22, 1911; 2c. Mr. 24, 1911; A 283644; W. B. Saunders co. 1151

New York (*State*) *Court of appeals.*

Reports of cases decided ... from and including decisions of June 7, to and including decisions of November 15, 1910, with notes, references and index. J. Newton Fiero, state reporter. v. 199. Albany, J. B. Lyon company, 1911.

xxxv, 659 p. 23½ᶜᵐ. $0.65

© F. 4, 1911; 2c. Mr. 20, 1911; A 283552; Edward Lazansky, sec. of the state of New York, in trust for the benefit of the people of the said state, Albany, N. Y. · **1152**

—— *Supreme court.*

... Reports of cases heard and determined in the appellate division of the Supreme court of the state of New York. Jerome B. Fisher, reporter. v. 139, 1910. [Official ed.] Albany, N. Y., J. B. Lyon company [1911]

lvi, 1014 p. 24ᶜᵐ. $1.00

© Ja. 19, 1911; 2c. Mr. 20, 1911; A 283551; Edward Lazansky, sec. of the state of New York, in trust for the benefit of the people of the said state, Albany, N. Y. **1153**

New York neurological society. *Collective investigation committee.*

... Epidemic poliomyelitis; report on the New York epidemic of 1907 by the Collective investigation committee, Dr. B. Sachs, chairman ... New York, The Journal of nervous and mental disease publishing company, 1910.

iii, 119 p. illus., plates, fold. maps. 25ᶜᵐ. (Nervous and mental disease monograph series, no. 6) $2.00

© Ap. 1, 1910; 2c. Mr. 7, 1911; A 283224; Journal of nervous and mental disease pub. co.

(11–4992) **1154**

Oxenham, John.

The coil of Carne, by John Oxenham ... London, Methuen & co. ltd. [1911]

x, 395, [1] p. 20ᶜᵐ. 6/

© 1c. Mr. 15, 1911; A ad int. 525; pubd. F. 16, 1911; J. Oxenham, Lond.

(11–4776) **1155**

Prince, Leon Cushing, 1875–

The sense and nonsense of Christian science, by Leon C. Prince. Boston, R. G. Badger, 1911.

143 p. 19½ᶜᵐ. $1.00

© Mr. 4, 1911; 2c. Mr. 10, 1911; A 283289; Richard G. Badger, Boston.

(11–4785) **1156**

Die **Rampe;** theater-jahrbuch des Verbandes deutscher bühnenschriftsteller, 1911. Berlin, Concordia deutsche verlags-anstalt, g. m. b. h. [ᶜ1910]

201 p. 23½ᶜᵐ.

© D. 16, 1910; 2c. Mr. 6, 1911; A—For. 2570; Concordia deutsche verlags-anstalt, g. m. b. h.

(11–4239) **1157**

Rice, Wallace de Groot Cecil, 1859– *comp.*
The humbler poets (second series) a collection of news-
paper and periodical verse 1885 to 1910, by Wallace and
Frances Rice. Chicago, A. C. McClurg & co., 1911.
xxv, 428 p. 20½ᶜᵐ. $1.50
© Mr. 11, 1911; 2c. Mr. 13. 1911; A 283349; A. C. McClurg & co.
(11–4959) 1158

Schulenburg, Werner von der, 1881–
Stechinelli, der roman eines kavaliers, von Werner v.
der Schulenburg ... Dresden, C. Reissner, 1911.
2 v. pl. 19½ᶜᵐ. M.6
© F. 28, 1911; 2c. Mr. 13, 1911; A—For. 2608; Carl Reissner.
(11–4963) 1159

Singleton, Esther.
How to visit the great picture galleries, by Esther Sin-
gleton; with numerous illustrations. New York, Dodd,
Mead and company, 1911.
viii, ⟨2⟩ p., 1 l., ⟨vii⟩–x, 492 p. front., plates. 17ᶜᵐ. $2.00
© F. 24, 1911; 2c. F. 25, 1911; A 283009; Dodd, Mead & co.
 1160

Smith, James MacGregor.
A digest of New York statutes and reports from Janu-
ary 1, 1910, to January 1, 1911 ... being a continuation of
Abbott's New York digest; by James MacGregor Smith.
New York, Baker, Voorhis & company, 1911.
xxviii, 490 p. 26½ᶜᵐ. $4.25
© Mr. 17, 1911; 2c. Mr. 24, 1911; A 283649; J. M. Smith, N. Y. 1161

Steinhauff, A.
Lehrbuch der erdkunde für höhere schulen, hrsg. von
A. Steinhauff ... und prof. dr. M. G. Schmidt ... Ausg.
M (für höhere mädchenschulen) ... 4. t.: für klasse 4.
Die fremden erdteile. 7. t.: für klasse 1. Allgemeine
physische erdkunde. Leipzig und Berlin, B. G. Teubner,
1911.
2 v. illus., plates (partly col.) 24ᶜᵐ. 4. t., M. 1; 7. t., M. 1.60
© Ja. 13, 1911; 2c. each Mr. 22,.1911; A—For. 2631, 2632; B. G. Teubner.
 1162, 1163

Taylor, William Brooks, 1865–
Studies in the Epistles and Revelation, by Prof. W. B.
Taylor ... for advanced training-classes, adult Bible
classes, college classes, Bible classes, Y. M. and Y. W. C.
A. Bible classes, etc. Scholar's ed. ... Cincinnati, O.,
The Standard publishing company, 1910.
208 p. 16½ᶜᵐ. $0.50
© F. 3, 1911; 2c. F. 20, 1911; A 280873; Standard pub. co.
(11–4951) 1164

Téramond, Edmond Gautier, *called* **Guy de,** 1869–

... Maisons de science ... Paris, P. Lafitte & c^ie ¡^c1911¡

326 p., 1 l. 19^cm. fr. 3.50

© F. 17, 1911; 2c. Mr. 4, 1911; A—For. 2547; Pierre Lafitte & co.
(11–4958) 1165

Tucker, Mary Lathrop, *"Mrs.* **F. H. Tucker,"** 1849–

Handbook of conservation, by Mrs. Fred H. Tucker ...
Boston, Geo. H. Ellis co., printers, 1911.

viii, 91 p. 20½^cm.

Bibliography: p. 88–91.

© F. 10, 1911; 2c. F. 11, 1911; A 280830; Mrs. F. H. Tucker, Bost.
(11–4804) 1166

¡**Valentine, Caro Syron**¡ 1855–

The Indian runner duck book ... Ridgewood, N. J.,
F. H. Valentine, 1911.

2 p. l., 3–87, ¡2¡ p. illus. 22½^cm.

© F. 17, 1911; 2c. F. 20, 1911; A 280886; F. H. & C. S. Valentine, Ridge-
wood, N. J.
(11–4972) 1167

Wechselmann, Wilhelm.

The treatment of syphilis with salvarsan, by Sanitäts-
rat Dr. Wilhelm Wechselmann ... with an introduction by
Professor Dr. Paul Ehrlich ... Only authorized transla-
tion, by Abr. L. Wolbarst ... with 15 textual figures and
16 coloured illustrations. New York, Rebman company;
¡etc., etc., ^c1911¡

2 p. l., 175 p. xvi col. pl., diagrs. 27½^cm. $5.00

"References to the American and British literature, prepared by the
translator for the English edition": p. 167–169.

© Mr. 8, 1911; 2c. Mr. 9, 1911; A 283285; Rebman co.
(11–5201) 1168

Wentworth, Patricia.

A little more than kin, by Patricia Wentworth ... Lon-
don, A. Melrose, 1911.

2 p. l., 311, ¡1¡ p. 19½^cm.

© 1c. Mr. 14, 1911; A ad int. 523; puhd. F. 15, 1911; G. P. Putnam's sons,
N. Y.
(11–4777) 1169

Wiggin, Kate Douglas (Smith) *"Mrs.* **G. C. Riggs,"** 1857–

Robinetta, by Kate Douglas Wiggin, Mary Findlater,
Jane Findlater, Allan McAulay. Boston and New York,
Houghton Mifflin company ¡1911¡

vi p., 1 l., 330 p., 1 l. col. front. 19^cm. $1.10

© F. 25, 1911; 2c. Mr. 17, 1911; A 283469; K. D. Riggs, N. Y.
(11–4934) 1170

B2035.4

U. S. Government

Abbott, Wilbur Cortez, 1868–
Colonel Thomas Blood, crown-stealer, 1618–1680, by
Wilbur Cortez Abbott ... New Haven, Yale university
press; [etc., etc.] 1911.
98 p. incl. front. (port.) 21ᶜᵐ. $0.90
"Bibliographical note": p. 95–98.
© Mr. 3, 1911; 2c. Mr. 4, 1911; A 283444; Yale univ. press.
(11–5219) 1171

Adams, Andy, 1859–
Wells brothers, the young cattle kings, by Andy Adams;
with illustrations by Erwin E. Smith. Boston and New
York, Houghton Mifflin company, 1911.
vi p., 1 l., 356 p., 1 l. front., plates. 19½ᶜᵐ. $1.20
© Mr. 11, 1911; 2c. Mr. 15, 1911; A 283417; A. Adams, Colorado Springs.
(11–4936) 1172

Alabama. *Supreme court.*
Report of cases argued and determined ... during the
November term, 1909–1910. By Lawrence H. Lee ...
v. 166. Montgomery, Ala., The Brown printing compa-
ny, 1911.
xvi, 736 p. 23½ᶜᵐ. $2.00
© Mr. 18, 1911; 2c. Mr. 30, 1911; A 283830; Emmet O'Neal, gov. of Ala.,
for use of said state, Montgomery. 1173

Anthologie des écrivains français ... pub. sous la direc-
tion de Gauthier-Ferrières ... Paris, Bibliothèque La-
rousse, ᶜ1911·
2 v. illus., ports. 20½ᶜᵐ.
CONTENTS.—Prose (XVIIIᵉ siècle)—Poésie (XVIIIᵉ siècle)
© Ja. 6, 1911; 2c. Ja. 21, 1911; A—For. 2389–2390; Librairie Larousse.
(11–5210) 1174, 1175

Barr, *Mrs.* **Amelia Edith (Huddleston)** 1831–
Sheila Vedder, by Amelia E. Barr; frontispiece by Har-
rison Fisher. New York, Dodd, Mead and company, 1911.
5 p. l., 341 p. col. front. 19½ᶜᵐ. $1.25
© Mr. 17, 1911; 2c. Mr. 18, 1911; A 283493; Dodd, Mead & co.
(11–5189) 1176

Chase, Joseph Smeaton, 1864–
Cone-bearing trees of the California mountains, by J.
Smeaton Chase ... fully illustrated from photographs and
drawings. Chicago, A. C. McClurg & co., 1911.
ix, [3], 13–99 p. incl. illus., plates. 18½ᶜᵐ. $0.75
© F. 25, 1911; 2c. F. 27, 1911; A 283031; A. C. McClurg & co.
(11–4975) 1177

Culler, Joseph Albertus.
... The second book of anatomy, physiology and hy-
giene of the human body, by J. A. Culler ... Philadelphia
and London, J. B. Lippincott company [1911]
xiv, 5–339 p. illus. 19ᶜᵐ. (Lippincott's physiologies)
© F. 27, 1911; 2c. Mr. 21, 1911; A 283563; J. B. Lippincott co. 1178

209

Duncan, John Christie, 1881–

The principles of industrial management, by John C. Duncan ... New York and London, D. Appleton and company, 1911.

xviii, 323 p. incl. illus., maps, plans, forms. plates, fold. map. 20⁻.
$2.00

© Mr. 3, 1911; 2c. Mr. 6, 1911; A 283192; D. Appleton & co.
(11–4941) 1179

Gade, John Allyne.

Cathedrals of Spain, by John Allyne Gade, fully illustrated. Boston and New York, Houghton Mifflin company, 1911.

xiv, 279, ₁1₎ p. front., 29 pl., 8 plans. 24½⁻. $5.00
"Books consulted": p. ₍267₎–268.

© F. 25, 1911; 2c. Mr. 15, 1911; A 283418; J. A. Gade, N. Y.
(11–5195) 1180

Galsworthy, John, 1867–

The patrician, by John Galsworthy ... New York, Charles Scribner's sons, 1911.

4 p. l., 3–393 p. 19½⁻. $1.35

© Mr. 6, 1911; 2c. Mr. 18, 1911; A 283499; Chas. Scribner's sons.
(11–5187) 1181

Gouraud, F Xavier.

What shall I eat? A manual of rational feeding, by Dr. F. X. Gouraud ... with a preface by Prof. Armand Gautier ... only authorized translation into the English language by Francis J. Rebman. With a glossary containing definitions of the principal technical terms, and an index of diseases referred to in the text. New York, Rebman company ₍c1911₎

xvi, 379 p. 20½⁻. $1.50

© Mr. 10, 1911; 2c. Mr. 11, 1911; A 283343; Rebman co.
(11–5200) 1182

Graves, Henry Solon, 1871–

The principles of handling woodlands, by Henry Solon Graves ... 1st ed., 1st thousand. New York, J. Wiley & sons; ₍etc., etc.₎ 1911.

xxi, 325 p. front., illus. 21⁻. $1.50

© Mr. 4, 1911; 2c. Mr. 7, 1911; A 283218; H. S. Graves, Wash.
(11–4969) 1183

Hackett, Frank Warren, 1841–

Reminiscences of the Geneva tribunal of arbitration, 1872, the Alabama claims, by Frank Warren Hackett. Boston and New York, Houghton Mifflin company, 1911.

xvi p., 1 l., 450 p., 1 l. 21⁻. $2.00
"List of books": p. ₍xiii₎–xvi.

© F. 25, 1911; 2c. Mr. 15, 1911; A 283423; F. W. Hackett, Wash.
(11–5217) 1184

Haynes, Wilson Albinus, 1873–
The beautiful word pictures of the Epistle to the Ephe-
sians; or, The busy man's commentary upon the Bible;
interpretations made according to the conceptions of the
writer in the time of writing, and not as these concep-
tions have been modified by more modern theories, by
W. A. Haynes. Caney, Kan., Busy man's Bible company,
1911.
213 p. 20ᶜᵐ. $1.00
© Mr. 4, 1911; 2c. Mr. 9, 1911; A 283278; W. A. Haynes, Caney, Kan.
(11-4952) 1185

Hornung, Ernest William, 1866–
The camera fiend, by E. W. Hornung ... New York,
C. Scribner's sons, 1911.
vi p., 2 l., 3–346 p. · front., plates. 19½ᶜᵐ. $1.25
© Mr. 6, 1911; 2c. Mr. 18, 1911; A 283498; Chas. Scribner's sons.
(11-5186) 1186

Houghton, Albert Allison, 1879–
Molding concrete chimneys, slate and roof tiles; a prac-
tical treatise explanatory of the construction of block and
monolithic types of concrete chimneys with easily con-
structed molds for same ... By A. A. Houghton ... Fully
illustrated by original drawings. New York, The Nor-
man W. Henley publishing co., 1911.
2 p. l., 9–61 p. illus. 18½ᶜᵐ. (*On cover:* Concrete worker's reference
books, no. 4) $0.50
© Mr. 4, 1911; 2c. Mr. 6, 1911; A 283191; Norman W. Henley pub. co.
(11-4947) 1187

Howe, Edgar Watson, 1854–
Country town sayings; a collection of paragraphs from
the Atchison globe, by E. W. Howe ... Topeka, Kan.,
Crane & company, 1911.
298 p. 18ᶜᵐ. $1.00
© Mr. 7, 1911; 2c. Mr. 9, 1911; A 283283; E. W. Howe, Atchison, Kan.
(11-5213) 1188

Illinois. *Supreme court.*
Reports of cases at law and in chancery ... v. 247 ...
Samuel Pashley Irwin, reporter of decisions. Blooming-
ton, Ill., 1911.
vii, (9)–702 p. 22½ᶜᵐ. $1.50
© Mr. 29, 1911; 2c. Mr. 31, 1911; A 283844; Samuel Pashley Irwin, Bloom-
ington, Ill. 1189

Innes, Mary.
Schools of painting, by Mary Innes; ed., with a chapter
on schools of painting in America, and certain further
additional material, by Charles De Kay; with 106 illus-
trations. New York and London, G. P. Putnam's sons,
1911.
xxvii, 408 p. front., 62 pl. 22½ᶜᵐ. $2.50
"Books recommended for further reading": p. 391–392.
© Mr. 11, 1911; 2c. Mr. 16, 1911; A 283443; G. P. Putnam's sons.
(11-5196) 1190

Janney, Oliver Edward, 1856–

The white slave traffic in America, by O. Edward Janney ... New York city, National vigilance committee [°1911]

203 p. 17½ᶜᵐ.

© Mr. 13, 1911; 2c. Mr. 15, 1911; A 283402; O. E. Janney, Balt.
(11–5214) 1191

Japan. *Laws, statutes, etc.*

The commercial code of Japan, by Yang Yin Hang ... Boston, The Boston book company, 1911.

xxiii, 319 p. 21ᶜᵐ. [University of Pennsylvania law school series, no. 1]
$3.50

© Mr. 10, 1911; 2c. Mr. 13, 1911; A 283357; Univ. of Pa., Phil.
(11–5007) 1192

Johnson, William Samuel.

Glamourie; a romance of Paris, by William Samuel Johnson. New York and London, Harper & brothers, 1911.

x p., 1 l., 294 p., 1 l. 19½ᶜᵐ. $1.20

© Mr. 16, 1911; 2c. Mr. 18, 1911; A 283492; Harper & bros.
(11–5188) 1193

La Fayette, Marie Magdeleine (Pioche de La Vergne) *comtesse* de, 1634–1693.

... La princesse de Clèves; La princesse de Montpensier; La comtesse de Tende; notice par Louis Coquelin; neuf gravures dont deux hors texte. Paris, Bibliothèque Larousse, °1911·

179, [1] p. incl. ports., facsim. 2 port. (incl. front.) 20½ᶜᵐ. fr. 1

© Ja. 6, 1911; 2c. Ja. 21, 1911; A—For. 2393; Librairie Larousse.
(11–5209) 1194

Lamb, Charles, 1775–1834.

... Elia, by Charles Lamb; ed. for school use by George W. Benedict ... Chicago, New York, Scott, Foresman and company [°1911]

339 p. 17ᶜᵐ. (*On verso of half-title:* The Lake English classics, ed. by L. T. Damon) $0.35
"Bibliographical note": p. 41–42.

© Mr. 4, 1911; 2c. Mr. 8, 1911; A 283230; Scott, Foresman & co.
(11–4797) 1195

Louisiana. *Supreme court.*

Reports of cases argued and determined in the Supreme court of Louisiana and in the Superior court of the Territory of Louisiana. Annotated ed. ... Book 18, containing a verbatim reprint of vols. 7 & 8 of Robinson's reports. St. Paul, West publishing co., 1911.

ix, 335, vi, 379 p. 23ᶜᵐ. $7.50

© Mr. 15, 1911; 2c. Mr. 24, 1911; A 283653; West pub. co.
 1196

Low, Albert Howard, 1855–
Technical methods of ore analysis, by Albert H. Low ...
5th ed., rev. and enl. Total issue, six thousand. New
York, J. Wiley & sons; [etc., etc.] 1911.
xiv, 362 p. illus. 23½ᶜᵐ. $3.00
© Mr. 9, 1911; 2c. Mr. 13, 1911; A 283351; A. H. Low, Denver, Col.
(11–4943) 1197

McGinty, William Henry, 1861–
Ancient Irish art and architecture [by] William H. Mc-
Ginty. Boston, Mass., 1911.
97 p. incl. illus., pl. 23ᶜᵐ.
Authorities consulted: p. [3]
© F. 13, 1911; 2c. F. 24, 1911; A 283245; W. H. McGinty, Bost.
(11–4789) 1198

Mach, Ernst, 1838–
History and root of the principle of the conservation of
energy, by Ernst Mach, tr. from the German and anno-
tated by Philip E. B. Jourdain ... Chicago, The Open
court publishing co.; [etc., etc.] 1911.
116 p. diagrs. 20ᶜᵐ. $1.25
© Mr. 1, 1911; 2c. Mr. 6, 1911; A 283201; Open court pub. co.
(11–4977) 1199

Malech, George David, 1837–1909.
History of the Syrian nation and the old evangelical-
apostolic church of the East, from remote antiquity to
the present time, by Prof. George David Malech ... after
his death edited, with numerous pictures and illustra-
tions, by his son, the Reverend Nestorius George Malech,
archdeacon. Minneapolis, Minn. [°1910]
xxii, 449 p. incl. front. (port.) illus., maps. 23ᶜᵐ. $2.50
© F. 15, 1911; 2c. Mr. 4, 1911; A 283210; N. G. Malech, Minneapolis.
(11–4786) 1200

Marks, Jeannette Augustus, 1875–
The end of a song, by Jeannette Marks ... Boston and
New York, Houghton Mifflin company, 1911.
4 p. l., 259, [1] p., 1 l. col. front. 19½ᶜᵐ. $1.15
© Mr. 11, 1911; 2c. Mr. 15, 1911; A 283420; J. Marks, South Hadley, Mass.
(11–4935) 1201

Misch, *Mrs.* **Marion L Simons,** 1869– *comp.*
Selections for homes and schools, comp. by Marion L.
Misch. Philadelphia, The Jewish publication society of
America, 1911.
444 p. 19½ᶜᵐ. $1.25
© Mr. 8, 1911; 2c. Mr. 10, 1911; A 283293; Jewish publ. soc. of Amer.
(11–4957) 1202

New York. Metropolitan museum of art.
... Catalogue of the collection of pottery, porcelain and
faïence, by Garrett Chatfield Pier ... New York, 1911.
xxii, 425, [1] p. front., 42 pl. 22ᶜᵐ. $0.75
Bibliography: p. xix–xxii.
© Mr. 6, 1911; 2c. Mr. 17, 1911; A 283461; Metropolitan museum of art.
(11–5197) 1203

Olmsted, Frederick Law, 1870–

... Pittsburgh main thoroughfares and the down town district; improvements necessary to meet the city's present and future needs; a report by Frederick Law Olmsted. Prepared under the direction of the Committee on city planning. Adopted by the commission December 1910. [Pittsburg, ᶜ1911]
xvi, 169 p. incl. front., illus. maps (1 fold.) plan. 26ᶜᵐ.
At head of title: Pittsburgh civic commission.
"Publication no. 8."
© Mr. 14, 1911; 2c. Mr. 16, 1911; A 283446; Pittsburg civic commission.
(11–5198) 1204

Osborn, Norris Galpin, ed.

Men of mark in Connecticut; ideals of American life told in biographies and autobiographies of eminent living Americans, ed. by Colonel N. G. Osborn ... v. 5. Hartford, Conn., W. R. Goodspeed, 1910.
568 p. incl. ports. 24ᶜᵐ. $7.00
© Ja. 15, 1911; 2c. Ja. 16, 1911; A 280388; W. R. Goodspeed. 1205

Osborne, William Hamilton, 1873–

The catspaw, by William Hamilton Osborne ... with illustrations by F. Graham Cootes. New York, Dodd, Mead and company, 1911.
5 p. l., 333 p. front., plates. 19½ᶜᵐ. $1.25
© Mr. 17, 1911; 2c. Mr. 18, 1911; A 283494; W. H. Osborne, Newark.
(11–5185) 1206

Peacock, Thomas Love, 1785–1866.

Thomas Love Peacock letters to Edward Hookham and Percy B. Shelley, with fragments of unpublished mss., ed. by Richard Garnett for the members of the Bibliophile society. Boston, The Bibliophile society, 1910.
3 p. l., 3–250 p. front. (port.) 24½ᶜᵐ. $8.75
© Ja. 2, 1911; 2c. Ja. 12, 1911; A 280347; Bibliophile soc.
(11–1030) 1207

Pennsylvania. *Superior court.*

Pennsylvania Superior court reports, v. 44, containing cases decided ... April and November terms, 1910. Reported by William I. Schaffer, state reporter, and Albert B. Weimer, assistant state reporter. New York, The Banks law publishing co., 1911.
xliii, 722 p. 24ᶜᵐ. $1.08
© Mr. 29, 1911; 2c. Mr. 30, 1911; A 283810; Robert McAfee, sec. of the commonwealth for the state of Pa., Harrisburg. 1208

Ralston health club.

Personal book of the Ralston health club, introducing its "personal system" ... Washington, D. C., Ralston university company; Hopewell, N. J., Ralston company, 1911.
198 p., 1 l. illus. 24ᶜᵐ. $2.00
© Mr. 7, 1911; 2c. Mr. 9, 1911; A 283272; Ralston univ. co. [Copyright is claimed on all added matter and changes]
(11–4991) 1209

Rose, Walter Malins.

Notes on Texas reports. A chronological series of annotations of the decisions of the Supreme court and the various civil and criminal appellate courts of Texas, showing their present value as authority as disclosed by all subsequent citations ... By Walter Malins Rose ... rev. and brought down to date by Charles L. Thompson ... book 5. San Francisco, Bancroft-Whitney company, 1911.

3 p. l., 1250 p. 23½ᶜᵐ. $7.50

© Mr. 20, 1911; 2c. Mr. 30, 1911; A 283809; Bancroft-Whitney co.

1210

Seidell, Atherton, 1878–

Solubilities of inorganic and organic substances; a handbook of the most reliable quantitative solubility determinations, recalculated and comp. by Atherton Seidell ... 2d printing, with corrections. New York, D. Van Nostrand company; [etc., etc.] 1911.

x, 367 p. 24ᶜᵐ. $3.00

© Mr. 8, 1911; 2c. Mr. 14, 1911; A 283376; D. Van Nostrand co.
(11-5206) 1211

Seymour, Edward Loomis Davenport, 1888–

Garden profits, big money in small plots, by E. L. D. Seymour ... Garden City, N. Y., Doubleday, Page & company, 1911.

6 p. l., 3–245, [11] p. front., illus. (incl. plans, tables) 19½ᶜᵐ. $1.10

© Mr. 8, 1911; 2c. Mr. 11, 1911; A 283324; Doubleday, Page & co.
(11-4968) 1212

Sharp, Dallas Lore, 1870–

The face of the fields, by Dallas Lore Sharp ... Boston and New York, Houghton Mifflin company, 1911.

5 p. l., [3]–250 p., 1 l. 19½ᶜᵐ. $1.25

"All but two of these papers made their first appearance in 'The Atlantic monthly.' 'The nature-writer' was first printed in 'The Outlook' and 'Hunting the snow' in 'The Youth's companion.'"

CONTENTS.—The face of the fields.—Turtle eggs for Agassiz.—The edge of night.—The scarcity of skunks.—The nature-writer.—John Burroughs.—Hunting the snow.—The clam farm.—The commuter's Thanksgiving.

© Mr. 11, 1911; 2c. Mr. 15, 1911; A 283414; D. L. Sharp, Hingham, Mass.
(11-5205) 1213

Skelton, Oscar Douglas, 1878–

Socialism; a critical analysis, by O. D. Skelton ... Boston and New York, Houghton Mifflin company, 1911.

ix, 329, [1] p. 21ᶜᵐ. (Half-title: Hart, Schaffner & Marx prize essays, VI) $1.50

Bibliography: p. [313]–322.

© F. 25, 1911; 2c. Mr. 15, 1911; A 283421; Hart, Schaffner & Marx, Chic.
(11-5216) 1214

215

Sophocles.

Oedipus, king of Thebes, by Sophocles; tr. into English rhyming verse, with explanatory notes, by Gilbert Murray ... New York, Oxford university press, American branch, 1911.

xi, 92 p. 19½ᶜᵐ. $0.75
© Mr. 7, 1911; 2c. Mr. 7, 1911; A 283385; Oxford univ. press, Am. branch.
(11-51212) 1215

... The **Southern** reporter, with key-number annotations, v. 53. Permanent ed. ... August 20, 1910–February 11, 1911. St. Paul, West publishing co., 1911.

xiii, 1181 p. 26½ᶜᵐ. (National reporter system—State series) $4.00
© Mr. 16, 1911; 2c. Mr. 24, 1911; A 283655; West pub. co. 1216

Spofford, *Mrs.* Harriet Elizabeth Prescott, 1835–

The making of a fortune; a romance, by Harriet Prescott Spofford; with illustrations by Alice Barber Stephens. New York and London, Harper & brothers, 1911.

3 p. l., 113, [1] p. front., plates. 18½ᶜᵐ. $1.00
© Mr. 16, 1911; 2c. Mr. 18, 1911; A 283491; Harper & bros.
(11-5192) 1217

Thackeray, William Makepeace.

The works of William Makepeace Thackeray; with biographical introductions by his daughter Lady Richie ... v. 10. The history of Henry Esmond, esq. [The centenary biographical ed.] New York and London, Harper & brothers, 1910.

3 p. l., [xv]-xlix, [10]-346 p. illus., plates. 21½ᶜᵐ.
© D. 16, 1910; 2c. Mr. 25, 1911; A 283674; Harper & bros. 1218

Troly-Curtin, Marthe.

Phrynette and London, by Marthe Troly-Curtin. London, G. Richards ltd. [1911]

334 p. 20ᶜᵐ. 6/
© 1c. Mr. 16, 1911; A ad int. 527; pubd. F. 15, 1911; Grant Richards, ltd.
(11-5194) 1219

The **Vermont** digest annotated; a digest of all the reported decisions of the Supreme court of the state of Vermont down to October 25, 1910, including vol. 83 Vermont reports. American digest classification key-number system. Comp. and pub. under authority of the state of Vermont ... v. 3. Prisons–Younger ... St. Paul, West publishing co., 1911.

vii p., 1 l., 5997-8776 numb. col. 26½ᶜᵐ. $21.50 per set.
© Mr. 11, 1911; 2c. Mr. 24, 1911; A 283656; West pub. co. 1220

Vrooman, Hiram.

Religion rationalized, by Rev. Hiram Vrooman. v. 2. Minneapolis, Minn., The Nunc licet press, 1911.

2 p. l., 157 p. 19ᶜᵐ. $0.75
© Mr. 21, 1911; 2c. Mr. 27, 1911; A 283850; H. Vrooman, Providence, R. I.
1221

Abbott, Frank Frost, 1860- *U. S. Government*

A history and description of Roman political institutions, by Frank Frost Abbott ... 3d ed. Boston, New York [etc.] Ginn & company [°1911]

viii, 451 p. 19ᶜᵐ. $1.50
Bibliography at end of each chapter.

© F. 11, 1911; 2c. Mr. 11; A 233342; F. F. Abbott, Princeton, N. J.
(11-5366) **1222**

American school of correspondence, *Chicago.*

Cyclopedia of telephony and telegraphy; a general reference work ... Prepared by a corps of telephone and telegraph experts, and electrical engineers of the highest professional standing; illustrated with over two thousand engravings ... Chicago, American school of correspondence, 1911.

4 v. fronts. (ports.) illus., plates. 25ᶜᵐ. $12.80
"Authorities consulted" at beginning of each volume.

CONTENTS.—v. 1. Principles; sub-stations; party-line; systems; protection.—v. 2. Manual switchboards; automatic systems; power plants.—v. 3. Construction; engineering; maintenance; measurements; batteries.—v. 4. Telegraphy, wireless; transmission; electricity; index.

© Mr. 9, 1911; 2c. Mr. 13; A 283355; Amer. school of correspondence.
(11-4948) **1223**

Baker, Arthur Latham, 1853-

Quaternions as the result of algebraic operations, by Arthur Latham Baker ... New York, D. Van Nostrand company, 1911.

ix, 92 p. diagrs. 21ᶜᵐ. $1 25

© F. 28, 1911; 2c. Mr. 14; A 283375; D. Van Nostrand co.
(11-5386) **1224**

Barton, William Eleazer, *ed.*

Young folks' library ... v. 1-8. Chicago, The Howard-Severance company [1911]

8 v. col. fronts., illus., col. plates. 21ᶜᵐ. $28.00

CONTENTS.—v. 1. Wilder, C. F. The child's own book.—v. 2. Strong, A. L. Boys and girls of the Bible.—v. 3. Beard, F. Journeys and adventures of the mighty men of old.—v. 4. Mann, M. R. & Hoss, M. E. Building of a nation.—v. 5. Soares, T. G. & L. M. Lessons from great teachers.—v. 6. Wilder, C. F. The wonderful story of Jesus.—v. 7. Arnold, S. K. Into all the world.—v. 8. Barton, W. E. Bible classics.

© Mr. 10, 1911; 2c. Mr. 13; A 283369; Howard-Severance co. **1225**

Bolton, Reginald Pelham, 1856-

Building for profit; principles governing the economic improvement of real estate, by Reginald Pelham Bolton ... New York, The De Vinne press, 1911.

4 p. l., 3-124 p. front., plates, diagrs. 28ᶜᵐ. $2.00

© Mr. 8, 1911; 2c. Mr. 9; A 283392; R. P. Bolton, N. Y.
(11-5229) **1226**

Cazamian, Louis.

... L'Angleterre moderne, son évolution. Paris, E. Flammarion, 1911.

2 p. l., 329 p., 1 l. 19ᶜᵐ. (Bibliothèque de philosophie scientifique) fr. 3.50

© Mr. 1, 1911; 2c. Mr. 13; A—For. 2606; Ernest Flammarion.
(11-5383) 1227

Clayton, Gertrude L.

Crayon, chalk, and pencil drawing, by Gertrude L. Clayton. Over sixty studies with six full pages in color. Chicago, A. Flanagan company [ᶜ1911]

88 p. col. front., illus., col. plates. 19ᶜᵐ. $0.50

© F. 15, 1911; 2c. F. 20; A 280870; A. Flanagan co.
(11-5356) 1228

Cossum, William Henry, 1863–

Mountain peaks of prophecy and sacred history, by W. H. Cossum, M. A. Chicago, The Evangel publishing house [ᶜ1911]

2 p. l., 7–195 p. maps. 20ᶜᵐ. $0.65

© F. 27, 1911; 2c. Mr. 6; A 283186; Wm. Hamner Piper, Chic.
(11-5345) 1229

Crawford, Francis Marion, 1854–1909.

Uncanny tales, by F. Marion Crawford ... London, T. F. Unwin, 1911.

4 p. l., 3–307, [1] p. 19½ᶜᵐ. 6/–

American ed. has title: Wandering ghosts.

CONTENTS.—The dead smile.—The screaming skull.—Man overboard!— For the blood is the life.—The upper berth.—By the waters of paradise.— The doll's ghost.

© 1c. Mr. 21, 1911; A ad int. 537; pubd. Mr. 13, 1911; Macmillan co., N. Y.
(11-5376) 1230

Dawe, William Carlton Lanyon, 1865–

The black spider, by Carlton Dawe. London, E. Nash, 1911.

vi, [7]–311 p. 19½ᶜᵐ. 6/–

© 1c. Mr. 20, 1911; A ad int. 533; pubd. F. 21, 1911; C. Dawe, Lond.
(11-5225) 1231

Eastman, Charles Alexander, 1858–

The soul of the Indian; an interpretation, by Charles Alexander Eastman (Ohiyesa) ... Boston and New York, Houghton Mifflin company, 1911.

xiii, [1] p., 2 l., 3–170 p., 1 l. front. 19ᶜᵐ. $1.00

© F. 25, 1911; 2c. Mr. 15; A 283416; C. A. Eastman, Amherst, Mass.
(11-5343) 1232

Erb, J Lawrence.

Hymns and church music, by J. Lawrence Erb ... Wooster, O., Conservatory press, ᶜ1911·

134 p., 1 l. 19½ᶜᵐ. $0.75

© Mr. 2, 1911; 2c. Mr. 7; A 283228; J. L. Erb, Wooster, O.
(11-5360) 1233

Finney, Lewis Erwin.

Dan's ministry, by Lewis Erwin Finney ... New York,
Chicago ,etc., Broadway publishing co. ,^c1911,

279 p. front., plates. 20½^{cm}. $1.50

© F. 24, 1911; 2c. Mr. 18; A 283485; L. E. Finney, Greenville, Tex.
(11–5190) 1234

Fisher, Irving, 1867–

The purchasing power of money; its determination and
relation to credit, interest and crises, by Irving Fisher ...
assisted by Harry G. Brown ... New York, The Macmil-
lan company, 1911.

xxii p., 1 l., 505 p. tables (2 fold.) diagrs. 22^{cm}. $3.00

© Mr. 15, 1911; 2c. Mr. 16; A 283429; Macmillan co.
(11–5246) 1235

Garrett, Albert Osbun, 1870–

Spring flora of the Wasatch region, by A. O. Garrett ...
Salt Lake City, Utah, Skelton publishing company, 1911.

xii, 106 p. 20^{cm}. $1.00

© F. 28, 1911: 2c. Mr. 6; A 283204; A. O. Garrett, Salt Lake City.
(11–5385) 1236

Gorst, Nina (Kennedy) "Mrs. H. E. Gorst."

The leech, by Mrs. Harold E. Gorst ... London, Mills
& Boon, limited ,1911,

3 p. l., 376 p. 19½^{cm}. 6/

© 1c. Mr. 20, 1911; A ad int. 535; pubd. F. 23, 1911; Mrs. H. E. Gorst,
Lond. (11–5379) 1237

Henderson, Archibald, 1877–

Interpreters of life and the modern spirit, by Archibald
Henderson. New York and London, M. Kennerley, 1911.

5 p. l., 3–330 p., 1 l. front. (port.) 20½^{cm}. $1.50
Partly reprinted from various periodicals.

CONTENTS.—George Meredith.—Oscar Wilde.—Maurice Maeterlinck.—
Henrik Ibsen: I. The evolution of his mind and art; II. The genesis of his
dramas.—George Bernard Shaw.

© D. 24, 1910; 2c. Mr. 16, 1911; A 283428; Mitchell Kennerley.
(11–5211) 1238

Huret, Jules, 1864–

... L'Amérique moderne ... t. 1. Paris, P. Lafitte &
c^{ie}, 1911.

2 p. l., 240 p., vi p. plates (partly col.) 33^{cm}. fr. 15
First issued in semimonthly parts, May 1910.

© F. 17, 1911; 2c. Mr. 4; A—For. 2540; Pierre Lafitte.
(11–5344) 1239

If I were King George, by Happy, the king's dog ...
,London, Hodder & Stoughton ,^c1911,

2 p. l., 9–54 p., 1 l. col. front. 19^{cm}. $0.50

© 1c. Mr. 14, 1911; A ad int. 522; pubd. Mr. 13, 1911; Geo. H. Doran co.
(11–5388) 1240

... The **Indiana** digest; a digest of the decisions of the
courts of Indiana ... Comp. under the American di-
gest classification. v. 4. District and prosecuting at-
torneys–Exemplifications. St. Paul, West publishing
co., 1911.
iii; 1000 p. 26½ᶜᵐ. (American digest system—State series) $6.00
© Mr. 20, 1911; 2c. Ap. 1; A 283878; West pub. co. **1241**

Jackman, William James, 1850–
The world's workshop; science, invention, discovery,
progress; a pictorial library for home reading, covering
all the very latest events in the workshops of the indus-
trial, scientific and natural world ... By W. J. Jackman
... Trumbull White ... Ferdinand Ellsworth Cary ... Em-
bellished and illuminated with five hundred photographic
illustrations. ₍Chicago? °1911₎
9, ₍8₎, 24–518 p. incl. front., illus. 24½ᶜᵐ. $2.00
© Mr. 10, 1911; 2c. Mr. 13; A 283360; L. H. Walter, Chic.
(11–5384) · **1242**

Lemperly, Paul.
Book-plates and other engravings by Edwin Davis
French, with a foreword by Charles Dexter Allen, lent
by Paul Lemperly. Cleveland, The Rowfant club, 1911.
45, ₍1₎ p. front. (port.) 26ᶜᵐ. $1.50
© Mr. 4, 1911; 2c. Mr. 14; A 283387; Rowfant club co.
(11–5012) **1243**

Lessard, L.
... Manuel simple et pratique de l'automobile; la voi-
ture de tourisme, par L. Lessard ... ouvrage illustré de
135 figures. Paris, C. Delagrave ₍°1910₎
2 p. l., 318 p., 1 l. illus. 18½ᶜᵐ. (Collection de la science au xxᵉ siècle)
fr. 5
© F. 10, 1911; 2c. Mr. 4; A—For. 2549; Ch. Delagrave.
(11–5382) **1244**

Loria, Gino.
... Spezielle algebraische und transzendente ebene kur-
ven, theorie und geschichte ... deutsche ausg. von prof.
Fritz Schütte ... 2. aufl. 2. bd. Die transzendenten und
die abgeleiteten kurven ... Leipzig und Berlin, B. G.
Teubner, 1911.
viii, 384 p. fold. diagrs. (B. G. Teubners sammlung von lehrbüchern
auf dem gebiete der mathematischen wissenschaften. bd. 5, 2) M. 14
© Ja. 19, 1911; 2c. Mr. 22; A—For. 2634; B. G. Teubner. **1245**

McCaleb, John Moody, 1861–
Christ, the light of the world; ten lectures delivered at
Foster Street Church of Christ, Nashville, Tenn., Sep-
tember 5–14, 1910, by J. M. McCaleb ... Nashville, Tenn.,
McQuiddy printing company, 1911.
vi, 271 p. front., plates. 20ᶜᵐ. $1.00
© F. 22, 1911; 2c. Mr. 3; A 283212; McQuiddy printing co.
(11–5347) **1246**

McDowell, John Anderson.

Supplement to Reinsch's Civil government for the
state of Ohio, by John Anderson McDowell ... Boston,
New York [etc.] B. H. Sanborn & co. [1911]
1 p. l., 99 p. front. (ports.) illus. 18½ᶜᵐ. [With Reinsch, Paul S. Civil
government. Boston, New York [etc., 1909]]
© F. 4. 1911; 2c. Mr. 27; A 283731; Benj. H. Sanborn & co. 1247

Macfarlane, Peter Clark, 1871–

Höfvitsmannens berättelse af P. C. Macfarlane, be-
myndigad öfversättning af Adolph [pseud.] Crompton,
R. I., A. Liljengren [ᶜ1911]
45 p. 19ᶜᵐ. $0.35
© F. 11. 1911; 2c. F. 27; A 283052; Fleming H. Revell co.
(11–5234) 1248

Merz, William.

Merz's practical cutting system for ladies' jackets and
cloaks ... [New York?] W. Merz [ᶜ1911]
70 p. illus., diagrs. 26ᶜᵐ. $10.00
© F. 18. 1911; 2c. Mr. 13; A 283374; W. Merz, Colorado Springs.
(11–5360) 1249

[Mohun, Sister Stephanie] 1869–

Driftwood, by "Lee" [pseud.] New York, F. H. Hitch-
cock, 1911.
48 p. 16 x 12ᶜᵐ. $0.75
 11–5233
© F. 20. 1911; 2c. F. 28; A 283078; Ladies literary institute, N. Y.
(11–5233) 1250

Nebraska. *Supreme court.*

Reports of cases ... January and September terms,
1910. v. 87. Harry C. Lindsay, official reporter; pre-
pared and ed. by Henry P. Stoddart, deputy reporter.
Lincoln, Neb., State journal company, 1911.
xiv, 894 p. 22ᶜᵐ. $2.00
© Mr. 31, 1911; 2c. Ap. 3; A 283920; Harry C. Lindsay, reporter of the
Supreme court, for the benefit of the state of Nebraska, Lincoln, Neb.
 1251

... The **New York** supplement, with key-number annota-
tions. v. 126. Permanent ed. (New York state re-
porter, vol. 160) ... January 9–February 20, 1911. St.
Paul, West publishing co., 1911.
xx, 1296 p. 23½ᶜᵐ. (National reporter system. N. Y. supp. and state
reporter) $3.00
© Mr. 29, 1911; 2c. Ap. 1; A 283876; West pub. co. 1252

Patten, Simon Nelson, 1852–

... The social basis of religion, by Simon N. Patten ...
New York, The Macmillan company, 1911.
xviii, 247 p. 19½ᶜᵐ. (American social progress series) $1.25
© Mr. 15, 1911; 2c. Mr. 16; A 283432; Macmillan co.
(11–5215) 1253

Rice, Muriel.
Poems, by Muriel Rice. New York, M. Kennerley, 1910.
70 p. 19½ᶜᵐ. $1.00
© D. 14, 1910; 2c. Mr. 18, 1911; A 283508; Mitchell Kennerley.
(11-5235) 1254

Second, Henry, *pseud.*
Captivating Mary Carstairs, by Henry Second. Boston, Small, Maynard and company [ᶜ1910]
viii, 346 p. front. 19½ᶜᵐ. $1.30
© Ja. 28, 1911; 2c. Ja. 31; A 280483; Small, Maynard & co., inc.
(11-5228) 1255

Selborne, John.
The thousand secrets, by John Selborne. London, Everett & co., ltd., 1911.
3 p. l., 312 p. 20½ᶜᵐ. $1.00
© 1c. Mr. 16, 1911; A ad int. 528; publd. F. 14, 1911; Mitchell Kennerley.
(11-5227) 1256

Snead, Littleton Upshur.
Suggestions or hints and helps on the simple life; home influence, Bible instructions, God's plan for saving the boy to the church, with valuable recipes and articles on various miscellaneous subjects, by L. U. Snead ... Upland, Ind., The L. U. Snead co. [ᶜ1911]
159, [3] p., 1 l. front. (port.) plates. 23ᶜᵐ. $1.00
© F. 28, 1911; 2c. Mr. 6; A 283198; L. U. Snead.
(11-5341) 1257

... The **Southeastern** reporter, with key-number annotations. v. 69. Permanent ed. ... October 29, 1910–February 18, 1911. St. Paul, West publishing co., 1911.
xiv, 1289 p. 26½ᶜᵐ. (National reporter system—State series) $4.00
© Mr. 27, 1911; 2c. Ap. 1; A 283875; West pub. co. 1258

Southwestern reporter.
Missouri decisions reported in the Southwestern reporter, vols. 130, 131, and 132, August, 1910, to January, 1911 ... St. Paul, West publishing co., 1911.
Various paging. 26½ᶜᵐ. $5.50
© Mr. 27, 1911; 2c. Ap. 1; 283877; West pub. co. 1259

Spencer, A L.
Spencerian light line shorthand, by A. L. Spencer. Jersey City, N. J., 1910.
31, [9] p. 17½ᶜᵐ. $0.50
© Ja. 22, 1911; 2c. F. 20; A 280905; A. L. Spencer.
(11-5401) 1260

Squier, J Bentley.
Manual of cystoscopy, by J. Bentley Squier ... and Henry G. Bugbee ... New York city, P. B. Hoeber, 1911.
2 p. l., 9–117 p. incl. 25 pl. (partly col.) col. front. 20ᶜᵐ. $3.00
© F. 23, 1911; 2c. F. 27; A 283038; Paul B. Hoeber.
(11-5353) 1261

Stilgebauer, Edward, 1868–

... Purpur, roman von Edward Stilgebauer. Dresden, C. Reissner [°1911]

2 p. l., 425 p. 19½ᶜᵐ. (Die lügner des lebens) M. 4

© F. 28, 1911; 2c. Mr. 13; A For.—2607; Carl Reissner.
(11–5338) 1262

Sturdy, William Allen, 1840–

Human equity, by W. A. Sturdy ... Boston, J. D. Bonnell & son, 1911.

4 p. l., 364 p. 20ᶜᵐ. $1.00

© F. 27, 1911; 2c. Mr. 8; A 283257; W. A. Sturdy, Chartley, Mass.
(11–5391) 1263

Stutzer, Otto.

Die wichtigsten lagerstätten der "nicht-erze," von dr. O. Stutzer ... 1. t. Berlin, Gebrüder Borntraeger, 1911.

xv, 474 p. illus. 26ᶜᵐ. M. 16.

© F. 27, 1911: 2c. Mr. 8; A—For. 2575; Gebrüder Borntraeger verlagsbuchhandlung. (11–5381) 1264

Stuyvesant, Alice.

The vanity box, by Alice Stuyvesant; illustrated by Charlotte Weber-Ditzler. Garden City, New York, Doubleday, Page & company, 1911.

4 p. l., 3–319 p. col. front., col. plates. 19½ᶜᵐ. $1.20

© F. 23, 1911; 2c. Mr. 22; A 283585; Doubleday, Page & co.
(11–5372) 1265

Thomass-Correï, Ella] 1877–

... Vom blühenden da – sein; zehn geschichten. Berlin, Concordia deutsche verlags-anstalt g. m. b. h. [°1910]

172 p. 19ᶜᵐ. M. 2

Author's pseudonym, El-Correï, at head of title.

CONTENTS.—Von der schönen Zaïra.--Von den zwei freunden.--Vom seidenen kleid aus Amerika.—Von der offenbarung der suppenschussel.—Von diamanten und perlen.—Vom guten Marras.—Vom glas im staube.—Von Peter und Petersilie.—Von Giulio und Romea.—Von Signor Massimos liebe.

© N. 29, 1910; 2c. Mr. 6, 1911; A—For. 2566; Concordia deutsche verlagsanstalt, g. m. b. h. (11–5236) 1266

Thuland, C M.

... Leif Erikson; historisk drama i tre handlinger. 1. oplag. Seattle, Wash., Washington ptg. co. [°1910]

58 p. 19ᶜᵐ.

© D. 8, 1910; 2c. D. 27; D 23190; C. M. Thuland, San Diego.
(11–4956) 1266*

Victor, Ralph.

The boy scouts patrol, by Ralph Victor; illustrated by Rudolf Mencl. New York, A. L. Chatterton co. [°1911]

2 p. l., 9–194 p. incl. plates. front. 20ᶜᵐ $0.50

© Mr. 13, 1911; 2c. Mr. 17; A 283458; A. L. Chatterton co.
(11–5191) 1267

Ward, Leslie Dodd, *b.* 1845.

De luxe illustrated catalogue of the valuable paintings by "the men of 1830," their contemporaries and modern Dutch masters forming the private collection of the late Dr. Leslie D. Ward ... to be sold at unrestricted public sale by order of ... executors, at Mendelssohn hall ... on ... [January 13th, 1911] The sale will be conducted by Mr. Thomas E. Kirby of the American art association, managers. New York, The American art association, 1911.

[96] p. illus., 31 pl. 30ᶜᵐ. $15.00
"Arranged by Mr. Thomas E. Kirby. Descriptions by Mr. Charles H. Caffin."

© D. 27, 1910; 2c. F. 25, 1911; A 283014; Amer. art assn.
(11-5355) 1268

Watson, Arthur Eugene, 1866–

Storage batteries, their theory, construction and use, by A. E. Watson ... 2d ed., completely rev. and enl. Lynn, Mass., Bubier publishing company, 1911.

vii, 166 p. illus. 18ᶜᵐ. $1.50

© Mr. 1, 1911; 2c. Mr. 23; A 283615; Bubier pub. co.
(11-5659) 1269

Whitby, Beatrice.

Rosamund, by Beatrice Whitby ... London, Methuen & co., ltd. [1911]

2 p. l., 296 p. 19½ᶜᵐ. 6/

© 1c. Mr. 22, 1911; A ad int. 539; publd. F. 23, 1911; B. Whitby, Lond.
(11-5375) 1270

Wilcox, Delos Franklin.

Municipal franchises; a description of the terms and conditions upon which private corporations enjoy special privileges in the streets of American cities, by Delos F. Wilcox ... v. 2. Transportation franchises, taxation and control of public utilities. New York, The Engineering news publishing company, 1911.

xxi, 885 p. 20½ᶜᵐ. $5.00

© Mr. 23, 1911; 2c. Mr. 25; A 283673; D. F. Wilcox, Elmhurst, N. Y.
 1271

Wise, Jennings Cropper.

Ye kingdome of Accawmacke; or, The eastern shore of Virginia in the seventeenth century, by Jennings Cropper Wise ... Richmond, Va., The Bell book and stationery co., 1911.

x, 406 p. 23ᶜᵐ. $2.00

© Mr. 13, 1911; 2c. Mr. 16; A 283439; J. C. Wise, Richmond.
(11-5252) 1272

Albee, *Mrs.* **Helen (Rickey)** 1864–

The gleam, by Helen R. Albee ... New York, H. Holt and company, 1911.

5 p. l., 3–312 p. 19½ᶜᵐ. $1.35
© Mar. 17, 1911; 2c. Mar. 20, 1911*; A 283544; Henry Holt & co.
(11-5346) 1273

American academy of political and social science, *Philadelphia.*

The public health movement ... Philadelphia, American academy of political and social science, 1911.

v, [1], 334 p. illus. 25½ᶜᵐ. (The annals of the American academy of political and social science. vol. xxxvii, no. 2)
"Book department": p. [299]–331.
"Report of the Board of directors of the American academy of political and social science for the fiscal year ended December 31, 1910": p. [332]–334.
CONTENTS.—pt. I. The general problem: Health needs and civic action, by W. H. Allen; Housing and health, by L. Veiller; Scientific research by the public health service, by J. W. Kerr; The census and the public health movement, by C. L. Wilbur; Sources of information upon the public health movement, by R. E. Chaddock; Work of the Committee of one hundred on national health, by W. J. Schieffelin; Public health movement on the Pacific coast, by Sarah I. Shuey; Protecting public health in Pennsylvania, by S. G. Dixon; Health problems of the Indians, by J. A. Murphy; Health problems of the negroes, by J. A. Kenney.—pt. II. Disease carriers—the control of causes: The rural health movement, by C. W. Stiles; Sanitation in rural communities, by C. E. North; Tropical diseases and health in the United States, by J. M. Swan; The house fly as a carrier of disease, by E. Hatch, jr.; The mosquito campaign as a sanitary measure, by J. B. Smith; Clean milk and public health, by J. D. Burks; Ventilation and public health, by D. D. Kimball.—pt. III. Elimination of diseases—physical care of individuals: Social service work in hospitals, by R. C. Cabot; Mouth hygiene and its relation to health, by A. H. Merritt; The physical care of children, by W. S. Cornell; What American cities are doing for the health of school children, by L. P. Ayres; The elimination of feeble-mindedness, by H. H. Goddard; Prevention of infantile blindness, by C. F. F. Campbell; The warfare against infant mortality, by S. W. Newmayer.
© Mar. 8, 1911; 1c. Mar. 11, 1911; B 242310; Amer. academy of political & social science. (11-5432) 1273*

Ballenger, William Lincoln, 1861–

Diseases of the nose, throat and ear, medical and surgical, by William Lincoln Ballenger ... 3d ed., rev. and enl., illustrated with 506 engravings and 22 plates. Philadelphia and New York, Lea & Febiger, 1911.

xi, 17–983 p. illus., xxii pl. (partly col.) 25ᶜᵐ. $5.00
© Mar. 16, 1911; 2c. Mar. 18, 1911*; A 283497; Lea & Febiger.
(11-5350) 1274

Barnes, Parker Thayer.

The suburban garden guide, comp. by Parker Thayer Barnes. New York, Harrisburg, Pa. [etc.] The Suburban press [ᶜ1911]

64 p. 19½ᶜᵐ. $0.25
© Mar. 15, 1911; 2c. Mar. 17, 1911*; A 283457; Suburban press, Harrisburg. (11-5435) 1275

225

Beard, Charles Austin, 1874– ed.

Loose leaf digest of short ballot charters; a documentary history of the commission form of municipal government, ed. by Charles A. Beard ... 1st ed.—500 copies, no. 45. New York, The Short ballot organization [°1911]
[301] p. 30ᶜᵐ. $5.00
Bibliography: p. [281]–[291]
© Mar. 7, 1911; 2c. Mar. 10, 1911; A 283480; Short ballot organization.
(11–5390) **1276**

Beaurepaire-Froment, Paul de, 1872–

... Bibliographie des chants populaires français. 3. éd., rev. et augm., avec une introduction sur La chanson populaire. Paris, Rouart, Lerolle & cᶦᵉ, °1911·
xciii, 183, [2] p. 19ᶜᵐ. fr 5
© Mar. 11, 1911; 2c. Mar. 6. 1911*; A—Foreign 2564; Rouart, Lerolle & cie. (11–5416) **1277**

Benson, Edward Frederic, 1867–

Account rendered, by E. F. Benson. Garden City, New York, Doubleday, Page & company, 1911.
3 p. l., 3–367 p. 19½ᶜᵐ. $1.20
© Mar. 18, 1911; 2c. Mar. 22, 1911*; A 283594; Doubleday, Page & co. (11–5373) **1278**

Bloomfield, Meyer.

... The vocational guidance of youth, by Meyer Bloomfield ... with an introduction by Paul H. Hanus. Boston, New York [etc.] Houghton Mifflin company [°1911]
xii p., 2 l., 123, [1] p., 1 l. 18ᶜᵐ. (Riverside educational monographs, ed. by H. Suzzallo) $0.60
"References": p. 117–[120]
© Feb. 23, 1911; 2c. Mar. 17, 1911*; A 283472; M. Bloomfield, Boston. (11–5431) **1279**

Booth, Henry Spencer.

The insurgent of St. Mark's, by Henry Spencer Booth. Bristol, Tenn., The King printing co., 1911.
419 p. 20ᶜᵐ $1.50
© Mar. 17, 1911; 2c. Mar. 24, 1911*; A 283645; H. S. Booth, Morristown, Tenn. (11–5407) **1280**

Brown, Frederick Walworth.

Dan McLean's adventures, by Frederick Walworth Brown ... New York, The Baker & Taylor company [°1911]
5 p. l., 9–311 p. 2 pl. (incl. front.) 19ᶜᵐ. $1.50
© Mar. 18, 1911; 2c. Mar. 20, 1911*; A 283525; Baker & Taylor co. (11–5224) **1281**

[Case, Frances Powell]

An old maid's vengeance, by Frances Powell [pseud.] New York, C. Scribner's sons, 1911.
3 p. l., 330 p. 19½ᶜᵐ. $1.25
© Mar. 18, 1911; 2c. Mar. 23, 1911*; A 283627; Chas. Scribner's sons. (11–5408) **1282**

Chadwick, Lester.

Batting to win; a story of college baseball, by Lester
Chadwick ... New York, Cupples & Leon company [°1911]
2 p. l., 308 p. front., plates. 19½ᶜᵐ. $1.00
© Mar. 15, 1911; 2c. Mar. 21, 1911*; A 283554; Cupples & Leon co.
(11-5377) 1283

Chase, Joseph Smeaton, 1864–

Yosemite trails; camp and pack-train in the Yosemite
region of the Sierra Nevada, by J. Smeaton Chase; with
illustrations from photographs and a map. Boston and
New York, Houghton Mifflin company, 1911.
x p., 1 l., 354 p., 1 l. front., plates, map. 21½ᶜᵐ. $2.00
© Mar. 11, 1911; 2c. Mar. 15,.1911*; A 283415; J· S. Chase, Los Anglees.
(11-5255) 1284

Comstock, Mrs. Harriet Theresa, 1860–

Joyce of the north woods, by Harriet T. Comstock ...
illustrated by John Cassel. Garden City, New York,
Doubleday, Page & company, 1911.
3 p. l., v–viii p., 2 l., 3–390 p. front., plates. 19½ᶜᵐ. $1.20
© Mar. 18, 1911; 2c. Mar. 22, 1911*; A 283584; Doubleday, Page & co.
(11-5371) 1285

Cooley, Anna M.

Domestic art in woman's education, for the use of those
studying the method of teaching domestic art and its place
in the school curriculum, by Anna M. Cooley ... New
York, C. Scribner's sons, 1911.
xi, 274 p. tables (1 fold.) 19ᶜᵐ. $1.25
"References for study" at end of most of the chapters.
"A selected bibliography of books helpful in the study of the various
phases of domestic art": p. 269–274.
© Feb. 11, 1911; 2c. Feb. 21, 1911*; A 280912; Chas. Scribner's sons.
(11-5423) 1286

Coughlan, Arthur Thomas, 1868–

The prophecy; a play of the days of persecution under
Henry VIII of England. (For male characters.) By Rev.
Arthur T. Coughlan ... Northeast, Penna., St. Mary's
college [°1911]
68 p. 15½ᶜᵐ.
© Feb. 16, 1911; 2c. Feb. 18, 1911; D 23441; A. T. Coughlan, St. Mary's
college. (11-4955) 1286*

Crawford, Francis Marion, 1854–1909.

Wandering ghosts, by F. Marion Crawford ... with
frontispiece. New York, The Macmillan company, 1911.
v, 302 p. front. 20ᶜᵐ. $1.25
Pub. in England under title: Uncanny tales.
CONTENTS.—The dead smile.—The screaming skull.—Man overboard!—
For the blood is the life.—The upper berth.—By the waters of paradise.—
The doll's ghost.
© Mar. 22, 1911; 2c. Mar. 23, 1911*; A 283609; Macmillan co.
(11-5409) 1287

Fenchel, Adolf Siegmund Leopold.

Metallkunde; ein lehr- und handbuch für fabrikanten,
werkmeister und gewerbetreibende der gesamten metall-
industrie, von dr. Ad. Fenchel ... mit 111 abbildungen.
Hamburg, Boysen & Maasch, 1911.

viii, 236 p. illus., diagrs. 23½ᶜᵐ.
Issued also, with slight differences, under the title "Metallkunde; ein
lehr- und handbuch für zahnärzte."
"Literatur": p. [221]-231.
© Feb. 13, 1911; 2c. Mar. 11, 1911*; A—Foreign 2601; Boysen & Maasch.
(11-5421) **1288**

Fisher, Sophie.

The imprudence of Prue, by Sophie Fisher; with illus-
trations by Herman Pfeifer. Indianapolis, The Bobbs-
Merrill company [°1911]

4 p. l., 357 p. front., plates. 19½ᶜᵐ. $1.25
© Mar. 18, 1911; 2c. Mar. 22, 1911*; A 283583; Bobbs-Merrill co.
(11-5374) **1289**

Fullerton, Anna Martha.

A handbook of obstetric nursing, for nurses, students
and mothers; comprising the course of instruction in ob-
stetric nursing given to the pupils of the training school
for nurses connected with the Woman's hospital of Phil-
adelphia, by Anna M. Fullerton ... 7th rev. ed. Illus-
trated. Philadelphia, P. Blakiston's son & co., 1911.

2 p. l., vii-xv, 272 p. illus. · 18ᶜᵐ. $1.00
© Mar. 15, 1911; 2c. Mar. 16, 1911*; A 283442; A. M. Fullerton, Phila.
(11-5351) · **1290**

Green, Thomas Hill, 1836-1882.

... An estimate of the value and influence of works of
fiction in modern times, ed., with introduction and notes,
by Fred Newton Scott ... Ann Arbor, Mich., G. Wahr,
1911.

79 p. 19ᶜᵐ. $0.65
© Mar. 13, 1911; 2c. Mar. 16, 1911*; A 283435; F. N. Scott, Ann Arbor.
(11-5339) **1291**

Griffith, John Price Crozer, 1856-

The care of the baby; a manual for mothers and nurses,
containing practical directions for the management of in-
fancy and childhood in health and in disease, by J. P. Cro-
zer Griffith ... 5th ed., thoroughly rev. Philadelphia and
London, W. B. Saunders company, 1911.

1 p. l., 7-455 p. illus., plates, fold. chart. 21ᶜᵐ. $1.50
© Mar. 14, 1911; 2c. Mar. 15, 1911*; A 283410; W. B. Saunders co.
(11-5352) **1292**

Hamsun, Knut, 1859-

... Livet ivold; skuespil i fire akter. Kristiania og Kjø-
benhavn, Gyldendalske boghandel, Nordisk forlag, 1910.

3 p. l., [5]-295 p. 20ᶜᵐ
© Jan. 28, 1911; 2c. Feb. 13, 1911; D 23514; Gyldendalske boghandel, Nor-
disk forlag. (11-4801) **1292***

Hastings, Wells.

The professor's mystery, by Wells Hastings and Brian Hooker; with illustrations by Hanson Booth. Indianapolis, The Bobbs-Merrill company [°1911]

4 p. l., 341 p. front., plates. 19½ᶜᵐ. $1.25
© Mar. 18, 1911; 2c. Mar. 22, 1911*; A 283582; Bobbs-Merrill co.
(11-5370) 1293

Holley, Myle Joseph, 1888–

Holley's review for the bar examination (New York) and rules governing the practice on admission after a successful examination, by Myle J. Holley ... Rochester, N. Y., New York [etc.] The Lawyers co-operative publishing company [°1911]

4 p. l., 188 p. 24ᶜᵐ. $2.00
© Mar. 13, 1911; 2c. Mar. 15, 1911*; A 283412; Lawyers co-op. pub. co.
(11-5240) 1294

Hunt, Rockwell Dennis, 1868–

... California the golden, by Rockwell D. Hunt ... with illustrations and maps. New York, Boston [etc.] Silver, Burdett and company [°1911]

xi, [1], 362 p. front. (map) illus. 19ᶜᵐ. (Stories of the states) $0.65
© Mar. 11, 1911; 2c. Mar. 13, 1911*; A 283352; Silver, Burdett & co., Bost.
(11-5251) 1295

Hutchinson, Rollin William, jr., 1880–

High-efficiency electrical illuminants and illumination, by Rollin W. Hutchinson, jr. 1st ed. 1st thousand. New York, J. Wiley & sons; [etc., etc.] 1911.

vii, 278 p. illus., diagrs. 21ᶜᵐ. $2.50
© Mar. 17, 1911; 2c. Mar. 20, 1911*; A 283537; R. W. Hutchinson, jr., Eatonton, Ga. (11-5424) 1296

Kirkham, Stanton Davis, 1868–

East and West; comparative studies of nature in eastern and western states, by Stanton Davis Kirkham ... New York and London, G. P. Putnam's sons, 1911.

x p., 1 l., 280 p. front., 12 pl. 21ᶜᵐ. $1.75
© Mar. 11, 1911; 2c. Mar. 14, 1911*; A 283395; S. D. Kirkham, Canandaigua, N. Y. (11-5387) 1297

Lathbury, Clarence.

The great morning, by Clarence Lathbury. Minneapolis, The Nunc licet press, 1911.

4 p. l., 71 p. pl. 17½ᶜᵐ. $0.75
CONTENTS.—Sunset.—The great morning.—And beyond.
© Mar. 15, 1911; 2c. Mar. 20, 1911*; A 283528; Nunc licet press.
(11-5393) 1298

Laurance, Jeanette.

Marriage and divorce and the downfall of the sacred union, by Jeanette Laurance ... New York, Chicago [etc.] Broadway publishing co. [°1911]

45 p. 19½ᶜᵐ. $1.00
© Feb. 11, 1911; 2c. Mar. 18, 1911*; A 283488; Broadway pub. co.
(11-5365) 1299

Loyd, William Henry.

Cases on civil procedure. pt. 3. By William H. Loyd ... Philadelphia, International printing co., 1911.

cover-title, 427-652, ₁2₁ p. 23ᶜᵐ. $2.00

© Apr. 1, 1911; 2c. Apr. 5, 1911*; A 283959; W. H. Loyd, Philadelphia.

1300

Macy, John Albert, 1877–

A guide to reading, for young and old, by John Macy ... New York, The Baker & Taylor company, 1910.

273 p. incl. front. (port.) 11 port. 19ᶜᵐ. (*On cover:* The guide series) $1.25

Published in 1909 under title: A child's guide to reading.

© Dec. 11, 1909; 2c. Mar. 20, 1911; A 283576; Baker & Taylor co. (11–5415) 1301

Madden, Richard Robert.

The United Irishmen; their lives and times, by Richard Robert Madden ... newly ed., with notes, bibliography and index, by Vincent Fleming O'Reilly. ₁The Shamrock ed. v. 5-8₁ New York, Tandy publishing company ₁1911₁

4 v. fronts. (partly col.) plates, ports., facsims. 23½ᶜᵐ. $3.50 per vol.

© Mar. 13, 1911; 2c. each Apr. 6, 1911*; A 283963; Tandy pub. co.

1302

Marriott, Crittenden.

Out of Russia, by Crittenden Marriott ... with illustrations by Frank McKernan. Philadelphia & London, J. B. Lippincott company, 1911.

258 p. col. front., plates. 19½ᶜᵐ. $1.25

© Mar. 13, 1911; 2c. Mar. 21, 1911*; A 283561; J. B. Lippincott co. (11–5378) 1303

Nearing, Scott.

The solution of the child labor problem, by Scott Nearing ... New York, Moffat, Yard and company, 1911.

viii, 145 p. 18½ᶜᵐ. $1.00

© Mar. 11, 1911; 2c. Mar. 18, 1911*; A 283501; S. Nearing, Philadelphia. (11–5428) 1304

Neilson, William Allan, 1869– *ed.*

The chief Elizabethan dramatists, excluding Shakespeare; selected plays by Lyly, Peele, Greene, Marlowe, Kyd, Chapman, Jonson, Dekker, Marston, Heywood, Beaumont, Fletcher, Webster, Middleton, Massinger, Ford, Shirley; ed. from the original quartos and folios, with notes, biographies and bibliographies, by William Allan Neilson ... Boston and New York, Houghton Mifflin company, 1911.

*vi p., 1 l., 878, ₁2₁ p., 1 l. front. (group of ports.) 21½ᶜᵐ. $2.75

"Bibliographies": p. ₁861₁–867.

© Feb. 10, 1911; 2c. Mar. 17, 1911*; A 283468; W. A. Neilson, Cambridge, Mass. (11–5340) 1305

Poughkeepsie, N. Y. Christ church.
The records of Christ church, Poughkeepsie, New York, ed. by Helen Wilkinson Reynolds. Published by the wardens and vestrymen upon the tenth anniversary of the institution of the rector, the Reverend Alexander Griswold Cummins, A. M., LITT. D. Poughkeepsie, F. B. Howard, 1911.
x p., 1 l., 440 p., 1 l. incl. front. (port.) illus. plates, ports., map. 25ᶜᵐ. $5.00
Ⓒ Mar. 11, 1911; 2c. Mar. 17, 1911*; A 283463; Wardens and vestrymen of Christ church. (11–5392) 1306

Pryor, Sara Agnes (Rice) *"Mrs. R. A. Pryor,"* 1830-
The colonel's story ⸤by⸥ Mrs. Roger A. Pryor ... New York, The Macmillan company, 1911.
4 p. l., 3–387 p. 19½ᶜᵐ. $1.20
Ⓒ Mar. 22, 1911; 2c. Mar. 23, 1911*; A 283610; Macmillan co.
(11–5406) 1307

⸤Reed, Myrtle⸥ 1874-
Everyday desserts, by Olive Green ⸤pseud.⸥ New York & London, G. P. Putnam's sons, 1911.
iv p., 1 l., 525 p. 16½ᶜᵐ. ⸤Putnam's homemaker series. ıxı $1.00
Ⓒ Mar. 11, 1911; 2c. Mar. 14, 1911*; A 283394; G. P. Putnam's sons.
(11–5230) 1308

Everyday dinners, by Olive Green ⸤pseud.⸥ New York and London, G. P. Putnam's sons, 1911.
iv p., 1 l., 410 p. 16½ᶜᵐ. ⸤Putnam's homemaker series. xı $1.00
Ⓒ Mar. 11, 1911; 2c. Mar. 14, 1911*; A 283393; G. P. Putnam's sons.
(11–5231) 1309

Ringrose, Hyacinthe *i. e.* **William Hyacinthe Archibald,** 1872- *ed.*
Marriage and divorce laws of the world, ed. by Hyacinthe Ringrose ... London, New York ⸤etc.⸥ The Musson-Draper company, 1911.
270, ⸤2⸥ p. 24ᶜᵐ. $2.50
Ⓒ Mar. 18, 1911; 2c. Mar. 20, 1911*; A 283550; H. Ringrose, N. Y.
(11–5426) 1310

Rostand, Edmond, 1868-
Œuvres complètes illustrées de Edmond Rostand ... Paris, P. Lafitte et cⁱᵉ ⸤ᶜ1910⸥
4 v. col. fronts., illus., col. plates. 30ᶜᵐ.
Ⓒ Feb. 17, 1911; 2c. Mar. 4, 1911; D 23541–23544; Pierre Lafitte & co.
(11–3962) 1310*

Rouillion, Louis.
The economics of manual training; a complete treatise giving just the information needed by all interested in manual training, covering the cost of equipping and maintaining hand work in the elementary and secondary schools, by Louis Rouillion ... 2d ed., fully illustrated. New York, The Norman W. Henley publishing co., 1911.
1 p. l., 7–174 p. illus. 20ᶜᵐ. $1.50
Ⓒ Mar. 7, 1911; 2c. Mar. 10, 1911*; A 283292; Norman W. Henley pub. co.
(11–5422) 1311

Sample, Thomas Mitchell, 1859–
The dragon's teeth; a mythological prophesy, by T. M. Sample ... New York, Chicago [etc.] Broadway publishing co. [°1911]
339 p. front. (port.) 20ᶜᵐ. $1.50
© Feb. 24, 1911; 2c. Mar. 18, 1911*; A 283483; T. M. Sample, Chattanooga, Tenn. (11-5245) 1312

Schomburgk, Hans.
Wild und wilde im herzen Afrikas; zwölf jahre jagd- und forschungsreisen, von Hans Schomburgk; mit einer kartenbeilage, 8 voll- und 103 textbildern nach original- aufnahmen von Hans Schomburgk und J. Mc. Neil und einem vorwort von Carl Hagenbeck. Berlin, E. Fleischel & co., 1910.
xiv p., 1 l., 373, [1] p. incl. front. (port.) illus. map. 24½ᶜᵐ. M.8
© Dec. 15, 1910; 2c. Mar. 10, 1911*; A—Foreign 2577; Egon Fleischel & co. (11-5436) 1313

Schreiner, Olive, "*Mrs.* **S. C. Cronwright Schreiner."**
Woman and labour, by Olive Schreiner ... London [etc.] T. F. Unwin, 1911.
282 p., 1 l. 23½ᶜᵐ. $1.25
© 1c. Mar. 20, 1911; A ad int. 534; pubd. Feb. 20, 1911; Frederick A. Stokes co., N. Y. (11-5429) 1314

Sinclair, Upton Beall, *jr.,* 1878–
Love's pilgrimage; a novel [by] Upton Sinclair. New York and London, M. Kennerley [°1911]
5 p. l., 3–663 p. 19ᶜᵐ.
"An advance copy ... for private circulation only."
© Mar. 10, 1911; 1c. Mar. 13, 1911; 1c. Mar. 18, 1911; A 283619; Mitchell Kennerley. (11-5410) 1315

[Snodgrass, Charles Albert] 1876–
Short methods; a treatise on cutting, designing & manu- facturing men's clothing ... Charlotte, N. C., The Charles publishing co., °1911·
[3]–119, [3] p. illus. 26ᶜᵐ. $10.00
© Mar. 8, 1911; 2c. Mar. 13, 1911*; A 283366; Charles pub. co. (11-5420) 1316

Stewart, Albert Struthers, 1847–
St. Luke's garden, by Albert S. Stewart. Boston, Sher- man, French & company, 1911.
5 p. l., 124 p. 19½ᶜᵐ. $1.00
CONTENTS.—St. Luke's garden.—An afternoon in the fields.—A mission field in West Virginia.—Huckleberries.—A roundabout ramble [in W. Va.]—A study in green.—The poplars of Horse Creek [W. Va.]—Scenes unsung. — The top of the world. — Branching waters. — From forest to lake.—Notes of passage [eastern Pa. to N. Y.]—The Hudson.—A rural road.—Down East.—A ride to Denmark [Me]—The land of snow.—Orange and Sussex.—A hill country.—Out the Erie.—Going to presbytery.—The Hudson highlands.—From Passaic to Paterson.—Memories of the mead- ows.—Prohibition park.—Lest we forget.—The church of St. Nicholas the conquerer.—A morning ride.—A pauper funeral.—The Irish shoemaker.— An appreciation.
© Mar. 10, 1911; 2c. Mar. 14, 1911*; A 283384; Sherman, French & co. (11-5250) 1317

Aix, *pseud.*

Thieves; a novel, by Aix ... New York, Duffield & company, 1911.

4 p. l., 3–338 p. front., plates. 19½ᶜᵐ. $1.30
© Mar. 22, 1911; 2c. Mar. 25. 1911*; A 283678; Duffield & co.
(11-5476) **1318**

Baltzell, Winton James, 1864-

Baltzell's dictionary of musicians; containing concise biographical sketches of musicians of the past and present, with the pronunciation of foreign names, by W. J. Baltzell. Boston, Oliver Ditson company; New York, C. H. Ditson & co.; [etc., etc.] °1911·

[263] p. 22ᶜᵐ.
© Mar. 1, 1911; 2c. Mar. 21, 1911*; A 283574; Oliver Ditson co.
(11-5639) **1319**

Bauer, Wilhelm.

Lehrbuch der mathematik, zum gebrauche an lyzeen, bearb. von prof. Wilhelm Bauer und prof. Erich v. Hanxleden ... Braunschweig, F. Vieweg & sohn, 1911.

3 v. diagrs. 23½ᶜᵐ.
CONTENTS.—1. bd. Planimetrie und arithmetik; pensum der klasse III.—
2. bd. Planimetrie, trigonometrie und arithmetik; pensum der klasse II.—
3. bd. Stereometrie, arithmetik, analytische geometrie, der ebene; pensum der klasse I.
© Feb. 21, 1911; 2c. each Mar. 11, 1911*; A—Foreign 2598-2600; Friedr. Vieweg & sohn. (11-5658) **1320-1322**

Benson, Edward Frederic, 1867–

Account rendered, by E. F. Benson ... London, W. Heinemann, 1911.

2 p. l., 321, [1] p. 19½ᶜᵐ.
© 1c. Mar. 17, 1911; A ad int. 538; pubd. Feb. 17, 1911; Doubleday, Page & co., Garden City, N. Y. (11-5478) **1323**

Bingham, Eugene Cook, 1878–

A laboratory manual of inorganic chemistry, by Eugene C. Bingham ... and George F. White ... 1st ed. 1st thousand. New York, J. Wiley & sons; [etc., etc.] 1911.

viii. 147 p. illus. 19½ᶜᵐ. $1 00
"Chemical reference literature": p. 140
© Mar. 16, 1911; 2c. Mar. 18, 1911*; A 283510; E. C. Bingham, Richmond, Va. (11-5486) **1324**

Boynton, Frank David, 1863-

Actual government of New York; a manual of the local. municipal, state and federal government for use in public and private schools of New York state ... Boston, New York [etc.] Ginn and company [1911]

ix, [1], 169, lxxvi p. illus. 18½ᶜᵐ.
© Feb. 18, 1911; 2c. Mar. 11, 1911*; A 283337; F. D. Boynton, Ithaca, N. Y. **1325**

233

Brooks, Fred Emerson.

Buttered toasts, by Fred Emerson Brooks. Chicago, Forbes & company, 1911.

96 p. 15½ᶜᵐ. $0.50

© Mar. 24, 1911; 2c. Mar. 27, 1911*; A 283715; Forbes & co.
(11-5541) **1326**

Chase, William Arthur.

Higher accountancy, principles and practice, under supervision of William Arthur Chase ... managing editor, Samuel MacClintock ... Chicago, La Salle extension university [ᶜ1911]

2 v. 24½ᶜᵐ. $6.00

Issued also as a part of the work "Business administration," edited by Walter Dwight Moody.

CONTENTS.—[v. 1] Accounting, by H. P. Willis and others.—[v. 2] Auditing and cost accounting, by W. A. Chase and others.

© Mar. 15, 1911; 2c. each Mar. 20, 1911*; A 283526, 283527; La Salle extension university. (11-5504) **1327, 1328**

Corsi, Cosimo, *cardinal*.

Little sermons on the catechism, from the Italian of Cosimo Corsi ... New York, J. F. Wagner [ᶜ1910]

2 p. l., [iii]–iv, 216 p. 21ᶜᵐ $1.00

© Nov. 17, 1910; 2c. Mar. 11, 1911*; A 283330; Jos. F. Wagner.
(11-5518) **1329**

Dean, Janet Williams.

Proems, by Janet Williams Dean. East Aurora, N. Y., The Roycrofters, 1911.

14 p., 1 l. 20ᶜᵐ. $1.00

© Mar. 13, 1911; 2c. Mar. 20, 1911*; A 283535; J. W. Dean, Corona, Cal.
(11-5708) **1330**

Driver, John Merritte, 1858–

Americans all; a romance of the great war, by John Merritte Driver. Chicago, Forbes & company, 1911.

6 p. l., 15–537 p. 20ᶜᵐ. $1.20

© Mar. 24, 1911; 2c. Mar. 27, 1911*; A 283716; Forbes & co.
(11-5644) **1331**

Duffey, *Mrs.* Eliza Bisbee, *d.* 1898.

The blue book of etiquette for ladies and gentlemen; a complete manual of the manners and dress of American society, containing forms of letters, invitations, acceptances and regrets ... by Mrs. E. B. Duffy ... New and rev. ed. Philadelphia, The John C. Winston company [ᶜ1911]

352 p. 19½ᶜᵐ. $0.75

© Jan. 26, 1911; 2c. Mar. 22, 1911*; A 283595; Alexander Hamilton, Philadelphia. (11-5516) **1332**

Dwelley, Jedediah, 1834–
History of the town of Hanover, Massachusetts, with
family genealogies, by Jedediah Dwelley and John F.
Simmons. [Hanover, Mass.] Pub. by the town of Hano-
ver, 1910.
291, [1], 474 p. illus., plates, 2 port. (incl. front.) 25½ cm. $2.50
"Genealogical work": 474 p.
© Mar. 6, 1911; 2c. Mar. 20, 1911*; A 283533; Town of Hanover.
(11-5628) 1333

Fenchel, Adolf Siegmund Leopold.
Metallkunde; ein lehr- und handbuch für zahnärzte,
von dr. Ad. Fenchel ... mit 111 abbildungen. Hamburg,
Boysen & Maasch, 1911.
viii, 236 p. illus., diagrs. 23½ cm.
"Literatur": p. [221]–231.
Issued also, with slight differences, under title "Metallkunde; ein lehr-
und handbuch für fabrikanten, werkmeister und gewerbetreibende der ge-
samten metallindustrie."
© Feb. 13, 1911; 2c. Mar. 11, 1911*; A—Foreign 2602; Boysen & Maasch.
(11-5491) 1334

Garrold, R. P.
Freddy Carr's adventures; a sequel to "Freddy Carr
and his friends," by Rev. R. P. Garrold ... New York,
Cincinnati [etc.] Benziger brothers, 1911.
262 p. 19 cm. $0.85
© Mar. 27, 1911; 2c. Mar. 30, 1911; A 283807; Benziger bros. 1335

Gifford, John Clayton, 1870–
The Everglades and other essays relating to southern
Florida, by John Gifford ... Kansas City, Mo., Ever-
glade land sales co. [c1911]
4 p. l., 134 p. illus. 21 cm. $1.00
Reprints of articles which originally appeared in various periodicals.
© Mar. 22, 1911; 2c. Mar. 25, 1911*; A 283671; Everglade land sales co
(11-5626) 1336

Graham, Harry J C 1874–
Lord Bellinger; an autobiography, ed. by Harry Gra-
ham. New York, Duffield & company, 1911.
v, 9–346 p. 19½ cm. $1.20
© Mar. 22, 1911; 2c. Mar. 25, 1911*; A 283676; Duffield & co.
(11-5477) 1337

Greene, James Hoffman, 1880–
Analyzed New York decisions and citations, 1908–1911,
covering duplicate reports. A table of cases decided, af-
firmed, cited, criticised, disapproved, distinguished, ex-
plained, followed or overruled, with analysis of each cita-
tion. By James H. Greene. Rochester, N. Y., William-
son law book company, 1911.
4 p. l., 793 p. 26½ cm.
Lettered: Haviland & Greene's table of New York cases. (Analyzed)
... 1908–1911. Third volume.
© Feb. 20, 1911; 2c. Mar. 17, 1911*; A 283473; Williamson law book co.
(11-5530) 1338

Groner, Augusta.

The man with the black cord, by Augusta Groner ...
tr. by Grace Isabel Colbron. New York, Duffield & company, 1911.

4 p. l., 3–287 p. front., pl. 19½ᶜᵐ. $1.20

© Mar. 22, 1911; 2c. Mar. 25, 1911*; A 283677; Duffield & co.
(11-5475) 1339

Hermuth, Paul.

... Der junge aviatiker; eine anleitung zum bau von flugmodellen; hrsg. von der redaktion des Guten kameraden, bearb. von Paul Hermuth; mit 136 abbildungen. Stuttgart ₍etc.₎ Union deutsche verlagsgesellschaft ₍°1911₎

128 p. illus. 15½ᶜᵐ. (Illustrierte taschenbücher für die jugend ₍bd. 32₎)
M. 1

© Jan. 31, 1911; 2c. Mar. 4, 1911*; A—Foreign 2555; Union deutsche verlagsgesellschaft. (11-5495) 1340

Hofmeister, Franz, 1850–

Leitfaden für den praktisch-chemischen unterricht der mediziner, zusammengestellt von Franz Hofmeister ... 4., neu durchgesehene und vervollständigte aufl. Braunschweig, F. Vieweg & sohn, 1911.

vii, ₍1₎, 152 p. 20ᶜᵐ. M. 4

© Feb. 20. 1911; 2c. Mar. 11, 1911*; A—Foreign 2603; Friedr. Vieweg & sohn. (11-5656) 1341

Howe, Edgar Watson, 1854–

The trip to the West Indies, by E. W. Howe. Topeka, Crane & company, 1910.

349 p. illus. (map) plates. 22ᶜᵐ. $1.35

© Dec. 21, 1910; 2c. Dec. 24, 1910; A 283536; Crane & co.
(11-5627) 1342

International school of engineering, *Chicago*.

Complete practical railroading; a series of text books prepared especially and exclusively for instruction on locomotive engineering, by motive power superintendents, master mechanics, traveling engineers and mechanical experts associated with the International school of engineering ... ₍Standard brotherhood ed.₎ Chicago, International school of engineering ₍°1911₎

6 v. illus. (partly col.) plates (partly fold.) 17½ᶜᵐ. $26.50

CONTENTS.—First, second and third year progressive examinations, with answers.—Air brake practice self-taught.—Boilers and engines; their operation, care and management.—Practical electricity for enginemen.—Practical repairing of everyday breakdowns.—Standard rules, car heating and lighting.

© Mar. 10, 1911; 2c. Mar. 13, 1911; A 283546; Internatl. school of engineering. (11-5496) 1343

Kellogg, Vernon Lyman, 1867–

The animals and man; an elementary textbook of zoology and human physiology, by Vernon Lyman Kellogg ... New York, H. Holt and company, 1911.

x p., 1 l., 495 p. incl. front., illus., pl. 19½ᶜᵐ. $1.25

"Chapters xxi to xxviii, on human structure and physiology, were written by Assistant Professor Isabel McCracken."—Prefatory note.

"Reference books": p. 466–468.

© Mar. 11, 1911; 2c. Mar. 20, 1911*; A 283545; Henry Holt & co.
(11-5485) 1344

Lang, *Mrs.* Louisa Lockhart (Steuart)

Knight checks queen, by Mrs. L. Lockhart Lang. London, A. Rivers, ltd., 1911.

3 p. l., 325. ₍₁₎ p. 19ᶜᵐ. 6/
© 1c. Mar. 23. 1911*; A ad int. 540; publ. Feb. 24, 1911; L. L. Lang, London. (11-5479) 1345

Lynch, Charles, 1868–

Compendio del libro di testo della Croce rossa americana sul primo aiuto. Ed. industriale; un manuale di istruzione del maggiore Carlo Lynch ... e del primo luogotenente M. J. Shields ... Preparato per ed indorsato dalla Croce rossa americana. Con 49 illustrazioni. Philadelphia, P. Blakiston's son & co., 1911.

xii, 195 p. illus. 15ᶜᵐ. $0.30
© Feb. 28. 1911; 2c. Mar. 1, 1911*; A 283093; P. Blakiston's son & co.
(11-5492) 1346

Macaulay, Thomas Babington Macaulay, *1st baron*, 1800–1859.

... Macaulay's essay on Milton, ed. by William Edward Mead ... New York, Cincinnati [etc.] American book company [ᶜ1911]

95 p. incl. front. (port.) 17ᶜᵐ. (Eclectic English classics) $0.20
© Mar. 20, 1911; 2c. Mar. 23, 1911*; A 283608; Amer. book co. [Copyright claimed on Macaulay's style and method, etc.] (11-5634) 1347

McGlothlin, William J 1867–

Baptist confessions of faith, by W. J. McGlothlin ... Philadelphia, Boston [etc.] American Baptist publication society [1911]

xii, 368 p. 20¼ᶜᵐ. $2.50
© Mar. 20, 1911; 2c. Mar. 23, 1911*; A 283617; A. J. Rowland, sec., Philadelphia. (11-5517) 1348

Malory, *Sir* Thomas, *15th cent.*

Malory's King Arthur and his knights; an abridgment of Le morte Darthur, ed. by Henry Burrowes Lathrop; illustrated by Reginald Birch. New York, The Baker & Taylor company [1911]

xv p., 3 l., 3–421 p. col. front., col. plates. 21¼ᶜᵐ. $1.25
© Mar. 18, 1911; 2c. Mar. 20, 1911*; A 283524; Baker & Taylor co.
(1 -5520) 1349

Martialis, Marcus Valerius.

A Roman wit; epigrams of Martial rendered into English by Paul Nixon. Boston and New York, Houghton Mifflin company, 1911.

xx, 119, [1] p. 19½ᶜᵐ. $1.00
© Mar. 11, 1911; 2c. Mar. 15, 1911*; A 283422; P. Nixon, Brunswick. Me.
(11-5532) 1350

Mason, Daniel Gregory, 1873–

A guide to music, for beginners and others, by Daniel Gregory Mason ... New York, The Baker & Taylor company, 1910.

6 p. l., 11–243 p. 12 port. (incl. front.) 19ᶜᵐ. (*On cover:* The guide series) $1.25
© Oct. 18, 1909; 2c. Mar. 20, 1911; A 283578; Baker & Taylor co.
(11-5638) 1351

Mierow, Charles Christopher.

The essentials of Latin syntax; an outline of the ordinary prose constructions, together with exercises in composition based on Caesar and Livy, by Charles Christopher Mierow ... Boston, New York [etc.] Ginn and company [°1911]

vi, 98 p. 19ᶜᵐ. $0.90
© Feb. 10, 1911; 2c. Mar. 11, 1911; A 283341; C. C. Mierow, Princeton, N. J. (11-5533) 1352

Mott, John Raleigh, 1865–

Die entscheidungsstunde der weltmission und wir, von dr. John R. Mott; autorisierte übersetzung aus dem englischen, mit 8 bildern. Basel, Basler missionsbuchhandlung, 1911.

2 p. l., 195, [1] p. plates. 19½ᶜᵐ. (*Added t.-p.:* Handbücher zur missionskunde, 4. bd.)
4. bd. © Feb. 13, 1911; 2c. Mar. 6, 1911*; A—Foreign 2568; Basler missionsbuchhandlung. (11-5514) 1353

Müllenhoff, Emma, 1871–

Von solchen, die zur seite stehen. Von E. Müllenhoff. 3. bis 5. tausend. Stuttgart, Ev. gesellschaft, 1910.

160 p. 19½ᶜᵐ. (*Half-title:* Aus klaren quellen)
© Dec. 28, 1910; 2c. Mar. 22, 1911; A—Foreign 2647; Verlag der Ev. gesellschaft. 1354

Perrin, Anna Falconer, 1842–

Allied families of Purdy, Fauconnier, Archer, Perrin, by Anna Falconer Perrin and Mary Falconer Perrin Meeker. New York, Frank Allaben genealogical company [°1911]

9 p. l., 15–114 p. front., plates, ports., maps, fold. geneal. tables, coats of arms. 24½ᶜᵐ. $12.00
"Public research references": p. 95–98.
© Jan. 13, 1911; 2c. Mar. 20, 1911*; A 283520; Frank Allaben genealogical co. (11-5625) 1355

238

Poe, Edgar Allan, 1809–1849.

The raven, Annabel Lee & The bells, by Edgar Allan Poe; with drawings by John Rea Neill. Chicago, The Reilly & Britton co. [c1910]

5 p. l., 13–110 p. incl. front., plates. 20ᶜᵐ. $1.25
© Oct. 29, 1910; 2c. Mar. 23, 1911*; A 283614; Reilly & Britton co.
(11-5537) 1356

Schmauk, Theodore Emanuel, 1860–

In mother's arms, for mothers of babes from birth to two years of age ... mother's first text-book in Lutheran General council graded system of child-training and instruction for Sunday and parish schools, by Theodore E. Schmauk. Philadelphia, General council publication board. 1910.

7 p. l., 11–135 p. front., illus., plates, forms. 20ᶜᵐ. $1.25
© Mar. 1, 1911; 2c. Mar. 11, 1911*; A 283313; Board of publication of the General council of the Evangelical Lutheran church in North America.
(11-5519) 1357

Schweriner, Oskar T.

... Ums blaue band des ozeans, roman ... Berlin, C. Duncker [c1910]

cover-title, 258 p. 18½ᶜᵐ
"Feuilleton-manuskript."
© Dec. 15, 1910; 2c. Jan. 10, 1911*; A—Foreign 2278; Carl Duncker.
(11-1022) 1358

Scott, Loa Ermina.

The life of Jesus; a manual for use in Sunday schools, teacher training classes and in the home, by Loa Ermina Scott, ᴘʜ. ᴍ. Chicago, The New Christian century co. [c1910]

3 p. l., 3–120 p. front. (map) 20ᶜᵐ. $0.50
© Dec. 8, 1910; 2c. Dec. 19, 1910; A 278874; L. E. Scott, Chagrin Falls, O.
(11-1002) 1359

Scott, Sir Walter, bart., 1771–1832.

... Scott's Marmion; a tale of Flodden field, ed. by H. E. Coblentz ... New York, Cincinnati [etc.] American book company [c1911]

262 p. incl. front. (port.) map. 17ᶜᵐ. (Eclectic English classics) $0.20
© Mar. 20, 1911; 2c. Mar. 23, 1911*; A 283607; Amer. book co. [Copyright claimed on Introduction, etc.] (11-5539) 1360

Shakespeare, William, 1564–1616.

Shakespeare's Macbeth, ed. by Felix E. Schelling ... New York, H. Holt and company, 1911.

xxxiii, [1], 173 p. front. (port.) illus., map. 17ᶜᵐ. (Half-title: English readings for schools. General editor: W. L. Cross) $0.35
"Descriptive bibliography": p. xxix–xxxiii.
© Jan. 18, 1911; 2c. Mar. 20, 1911*; A 283541; Henry Holt & co.
(11-5536) 1361

Shakespeare, William, 1564–1616.

Shakespeare's Merchant of Venice, ed. by Frederick Erastus Pierce ... New York, H. Holt and company, 1911.

xxxv, [1], 158 p. front. (port.) illus. 17ᶜᵐ. (Half-title: English readings for schools. General editor: W. I. Cross) $0.35

"Descriptive bibliography": p. xxxi–xxxv.

© Jan. 18, 1911; 2c. Mar. 20, 1911*; A 283542; Henry Holt & co.
(11–5535) 1362

Sinclair, Upton Beall, jr., 1878–

The fasting cure, by Upton Sinclair. New York and London, M. Kennerley, 1911.

4 p. l., [5]–153 p. front. (ports.) 19ᶜᵐ. $1.00

Enlarged from two articles first published in the Cosmopolitan magazine.

© Mar. 15, 1911; 2c. Mar. 18, 1911*; A 283509; Mitchell Kennerley, N. Y.
(11–5490) 1363

Staus, Anton.

Der indikator und seine hilfseinrichtungen. Von dr.-ing. Anton Staus. Mit 219 textfiguren. Berlin, J. Springer, 1911.

vi p., 1 l., 188 p. illus., diagrs 24ᶜᵐ. M. 5

© Jan. 24, 1911; 2c. Mar. 6, 1911*; A—Foreign 2573; Julius Springer.
(11–5497) 1364

Strunsky, Simeon.

The patient observer and his friends, by Simeon Strunsky. New York, Dodd, Mead and company, 1911.

viii p., 1 l., 348 p. 19½ᶜᵐ. $1.20

Partly reprinted from various periodicals.

CONTENTS.—Cowards.—The church universal.—The doctors.—Interrogation.—The mind triumphant.—On calling white black.—The solid flesh.—Some newspaper traits.—A fledgling.—The complete collector—i.—The everlasting feminine.—The fantastic toe.—On living in Brooklyn.—Palladino outdone.—The cadence of the crowd.—What we forget.—The children that lead us.—The Martians.—The complete collector—ii.—When a friend marries.—The perfect union of the arts.—An eminent American.—Behind the times.—Public liars.—The complete collector—iii.—The commuter.—Headlines.—Usage.—60 h. p.—The sample life.—The complete collector—iv.—Chopin's successors.—The irrepressible conflict.—The germs of culture

© Mar. 17, 1911; 2c. Mar. 18, 1911*; A 283495; Dodd, Mead & co.
(11–5538) 1365

Sunne, Dagny Gunhilda.

Some phases in the development of the subjective point of view during the post-Aristotelian period, by Dagny Gunhilda Sunne. Chicago, Ill., The University of Chicago press [1911]

96 p. 25ᶜᵐ. (On cover: Philosophic studies, issued under the direction of the Department of philosophy of the University of Chicago, no. 3) $0.50

© Mar. 14, 1911; 2c. Mar. 17, 1911*; A 283462; University of Chicago.
(11–5394) 1366

Bao 35.x

PART I, BOOKS, GROUP I

no. 16, April, 1911

272

APR 1911

From the

U. S. Government.

Babson, Roger Ward, 1875–

Business barometers used in the accumulation of money; a text book on applied economics for merchants, bankers and investors, by Roger W. Babson ... 4th ed. Wellesley Hills, Mass., Babson's compiling offices [°1911]
391 p. fold. tables, fold. diagrs. 19½ᶜᵐ. $2.00
© Mar. 13, 1911; 2c. Mar. 14, 1911; A 283602; R. W. Babson.
(11–5971) 1367

Bancroft, Hugh, 1879–

Inheritance taxes for investors; some practical notes on the inheritance tax laws of each of the states of the United States, with particular reference to their application to non-resident investors. A reproduction of a series of articles published in the Boston news bureau in February and March, 1911. Rev. and annotated by Hugh Bancroft ... Boston, Boston news bureau company, 1911.
139 p. 24ᶜᵐ. $1.00
© Mar. 21, 1911; 2c. Mar. 22, 1911; A 283624; Boston news bureau co.
(11–5972) 1368

Benson, Robert Hugh, 1871–

Christ in the church; a volume of religious essays, by Robert Hugh Benson ... St. Louis, Mo., B. Herder. 1911.
3 p. l., v–vi, 231 p. 20ᶜᵐ. $1.00
© Mar. 10, 1911; 2c. Mar. 13, 1911*; A 283346; Jos. Gummersbach, St. Louis. (11–5721) 1369

Billings, Frank, 1854– *ed.*

... General medicine, ed. by Frank Billings ... and J. H. Salisbury ... Chicago, The Year book publishers, 1911.
4, 7–405 p. illus., plates. 19½ᶜᵐ. (The practical medicine series ... vol. 1 ... Series 1911)
© Mar. 16, 1911; 2c. Mar. 23, 1911*; A 283621; Year book publishers.
(11–6031) 1370

Bingham, Theodore Alfred, 1858–

The girl that disappears; the real facts about the white slave traffic, by Gen. Theodore A. Bingham ... Boston, R. G. Badger, 1911.
4 p. l., 7–87 p. front. 19½ᶜᵐ. $1.00
© Mar. 22, 1911; 2c. Mar. 27, 1911*; A 283702; Richard G. Badger.
(11–5725) 1371

Booth, William Stone, 1864–

The Droeshout portrait of William Shakespeare; an experiment in identification with thirty-one illustrations, by William Stone Booth ... Boston, W. A. Butterfield, 1911.
2 p. l., 7, [3] p. ports. 29ᶜᵐ. $1.50
© Mar. 15, 1911; 2c. Mar. 25, 1911*; A 283693; W. S. Booth, Cambridge, Mass. (11–5980) 1372

241

Buckler, Henry Reginald, 1840–
Spiritual considerations, by Fr. H. Reginald Buckler ... New York, Cincinnati [etc.] Benziger brothers, 1911.
238 p. 19ᶜᵐ.
ⓒ Mar. 7, 1911; 2c. Mar. 10, 1911*; A 283298; Benziger bros.
(11–5720) **1373**

Bürkner, Richard, 1856–
... Kunstpflege in haus und heimat, von Richard Bürkner. 2. aufl., mit 29 abbildungen im text. Leipzig, B. G. Teubner, 1910.
vi, 133, [1] p. illus. 18¼ᶜᵐ. (Aus natur und geisteswelt; sammlung wissenschaftlich-gemeinverständlicher darstellungen. 77. bdchen.) M. 1.25
"Literarischer anhang": p. [131]–133.
ⓒ Dec. 28, 1910; 2c. Mar. 22, 1911*; A—Foreign 2646; B. G. Teubner.
(11–6006) **1374**

Cole, Anne Frances (Springsteed) "Mrs. Thomas Cole."
The expert waitress; a manual for the pantry, kitchen, and dining-room, by Anne Frances Springsteed (Mrs. Thomas Cole) Rev. ed. New York and London, Harper & brothers, 1911.
xi, 134 p. 17¼ᶜᵐ. $1.00
ⓒ Jan. 12, 1911; 2c. Jan. 14, 1911*; A 280088; Harper & bros.
(11–5955) **1375**

Daudet, Alphonse, 1840–1897.
... Tartarin de Tarascon, par Alphonse Daudet ... ed., with notes and vocabulary, by Richmond Laurin Hawkins ... Boston, D. C. Heath & co., 1911.
vii, 167 p. front. (port.) 17ᶜᵐ. (Heath's modern language series) $0.45
ⓒ Mar. 10, 1911; 2c. Mar. 22, 1911*; A 283588; D. C. Heath & co.
(11–5982) **1376**

Dawson, Coningsby William.
The road to Avalon, by Coningsby Dawson. New York. Hodder & Stoughton, George H. Doran company [ᶜ1911]
5 p. l., [3]–284 p. 19½ᶜᵐ. $1.20
ⓒ Mar. 27, 1911; 2c. Mar. 28, 1911*; A 283753; Geo. H. Doran co.
(11–5994) **1377**

Eggleston, George Cary, 1839–
What happened at Quasi; the story of a Carolina cruise, by George Cary Eggleston; illustrated by H. C. Edwards. Boston, Lothrop, Lee & Shepard co. [1911]
6 p. l., 3–368 p. front., plates. 19½ᶜᵐ. $1.50
ⓒ Mar. 27, 1911; 2. Mar. 29, 1911*; A 283791; Lothrop, Lee & Shepard co.
(11–5991) **1378**

Eldred, Warren L.
... Camp St. Dunstan, by Warren L. Eldred; illustrated by Arthur O. Scott. Boston, Lothrop, Lee & Shepard co. [1911]
5 p. l., 325 p. incl. plan. front., plates. 20½ᶜᵐ. (His St. Dunstan series) $1.50
ⓒ Mar. 27, 1911; 2c. Mar. 29, 1911*; A 283795; Lothrop, Lee & Shepard co.
(11–5993) **1379**

Ellis, *Mrs*. Jean Morris.

Character building and reading; a correlation of the facts of psychology and physiology in their relation to soul discipline and physiognomy, by Jean Morris Ellis ... Eugene, Ore., Church & school publishing co., 1911.

338 p., 1 l. incl. front. (port.) illus. ports. 19½ᶜᵐ. $1.50

© Mar. 7, 1911; 2c. Mar. 14, 1911*; A 283388; J. M. Ellis, Eugene, Or.
(11–6022) 1380

Greene, Harry Irving, 1868–

Barbara of the snows, by Harry Irving Greene ... illustrated by Harvey T. Dunn. New York, Moffat, Yard and company, 1911.

3 p. l., 358 p. col. front., plates. 19½ᶜᵐ. $1.35

© Mar. 25, 1911; 2c. Mar. 29, 1911*; A 283773; Moffat, Yard & co.
(11–5990) 1381

Gregory, Isabella Augusta (Persse) *lady*.

The full moon. A comedy in one act. By Lady Gregory. Dublin, The author [ᶜ1911]

49, [2] p. 21ᶜᵐ.

© Jan. 26, 1911; 2c. Mar. 24, 1911; D 23748; Lady Gregory, Gort, Ireland.
(11–5984) 1381*

Guitteau, William Backus, 1877–

Government and politics in the United States; a textbook for secondary schools, by William Backus Guitteau ... with illustrations. Boston, New York [etc.] Houghton Mifflin company [ᶜ1911]

xix, 473, xxxvi p., 1 l. front., plates, maps, facsims., diagrs. 20ᶜᵐ.
$1.00

"General references" at end of each chapter.

© Mar. 16, 1911; 2c. Mar. 24, 1911*; A 283665; W. B. Guitteau, Toledo, O. (11–5726) 1382

Houghton, Albert Allison, 1879–

Concrete monuments, mausoleums and burial vaults; a practical treatise explanatory of the molding of various types of concrete monuments ... by A. A. Houghton ... New York, The Norman W. Henley publishing co., 1911.

1 p. l., 7–65 p. illus. 18½ᶜᵐ. (*On cover:* Concrete worker's reference books ... no. 6) $0.50

© Mar. 15, 1911; 2c. Mar. 16, 1911*; A 283438; Norman W. Henley pub. co. (11–6039) 1383

Molding and curing ornamental concrete; a practical treatise covering the various methods of preparing the molds and filling with the concrete mixture ... by A. A. Houghton ... New York, The Norman W. Henley publishing co., 1911.

2 p. l., 9–58 p. illus. 18½ᶜᵐ. (*On cover:* Concrete worker's reference books ... no. 5)

© Mar. 10, 1911; 2c. Mar. 13, 1911*; A 283361; Norman W. Henley pub. co. (11–6038) 1384

Ironside, John.

Forged in strong fires, by John Ironside ... frontispiece illustration by F. Stanley Wood. Boston, Little, Brown, and company, 1911.

4 p. l., 318 p., 1 l. front. 20ᶜᵐ. $1.25
© Mar. 25, 1911; 2c. Mar. 28, 1911*; A 283742; Little, Brown, and company. (11-5997) 1385

Keller, Hans.

... Werdegang der modernen physik, von dr. Hans Keller; mit 13 figuren. Leipzig, B. G. Teubner, 1911.

2 p. l., 113, [1] p. illus. 18½ᶜᵐ. (Aus natur und geisteswelt; sammlung wissenschaftlich-gemeinverständlicher darstellungen. 343. bdchen.) M. 1.25
© Feb. 8, 1911; 2c. Mar. 22, 1911*; A—Foreign 2659; B. G. Teubner.
(11-5951) 1386

McDowell, James R comp.

Mississippi laws made plain; laws and legal forms prepared for the use of business men, farmers and mechanics. Comp. by Hon. Jas. R. McDowell ... and Hon. Carl Fox ... [Sedalia, Mo.] Bankers law publishing co., ᶜ1911.

cover-title, 100 p. 22ᶜᵐ.
© Mar. 14, 1911; 2c. Mar. 20, 1911*; A 283531; Bankers law pub. co.
(11-5713) 1387

Meyer, *Mrs.* Annie (Nathan) 1867–

The dominant sex; a play in three acts, by Annie Nathan Meyer. New York, Brandu's, 1911.

4 p. l., 11–112 p. 19ᶜᵐ.
© Mar. 22, 1911; 2c. Mar. 23, 1911; D 23761; A. N. Meyer, N. Y.
(11-5709) 1387*

Minkowski, Hermann, 1864–1909.

Gesammelte abhandlungen von Hermann Minkowski, unter mitwirkung von Andreas Speiser und Hermann Weyl hrsg. von David Hilbert ... Leipzig und Berlin, B. G. Teubner, 1911.

2 v. fronts. (ports.) diagrs. (1 fold.) 26½ᶜᵐ. M. 14
"Hermann Minkowski. Gedächtnisrede, gehalten in der öffentlichen sitzung der K. Gesellschaft der wissenschaften zu Göttingen am 1. mai, 1909, von David Hilbert": v. 1, p. [V]-xxxi.
© Jan. 19, 1911; 2c. Mar. 22, 1911*; A—Foreign 2621; B. G. Teubner.
(11-5950) 1388

Mulford, Clarence Edward.

Bar-20 days, by Clarence E. Mulford ... with illustrations in color by Maynard Dixon. Chicago, A. C. McClurg & co., 1911.

5 p. l., 9–412 p. col. front., col. plates. 21ᶜᵐ. $1.35
© Mar. 25, 1911; 2c. Mar. 29, 1911*; A 283763; A. C. McClurg & co.
(11-5995) 1389

New York (*City*) *Ordinances, etc.*

Code of ordinances of the city of New York, as approved November 8, 1906, with all amendments, containing all ordinances in force January 1, 1911, and the sanitary code, the building code, the park regulations, and

New York (*City*) *Ordinances, etc.*—Continued
municipal explosive committee regulations, comp. and
annotated by Arthur F. Cosby ... New York, The Banks
law publishing company, 1911.
 xviii, 467 p. 18½ᶜᵐ. $3.00
© Mar. 23, 1911; 2c. Mar. 24, 1911*; A 283646; Banks law pub. co.
 (11-5961) 1390

Osada, Stanisław.
Literatura polska i polsko-amerykańska dla ludu pol-
skiego w Ameryce, opracował Stanisław Osada. Część.
pierwsza. Chicago, Ill., W. Dyniewicz pub. co., 1910.
 312 p. illus. (incl. ports.) 20ᶜᵐ. $1.00
© Feb. 18, 1911; 2c. Feb. 24, 1911; A 283065; W. Dyniewicz pub. co.
 (11-6173) 1391

Parrish, Randall, 1858–
Love under fire, by Randall Parrish ...·with five illus-
trations in full color by Alonzo Kimball. Chicago, A. C.
McClurg & co., 1911.
 400 p. col. front., col. plates. 21½ᶜᵐ. $1.35
© Mar. 25, 1911; 2c. Mar. 29, 1911*; A 283766; A. C. McClurg & co.
 (11-5992) 1392

Rhoades, Nina, 1863–
Maisie's merry Christmas, by Nina Rhoades ... illus-
trated by Elizabeth Withington. Boston, Lothrop, Lee &
Shepard co. [1911]
 311 p. front., plates. 19ᶜᵐ. $1.00
CONTENTS.— Maisie's merry Christmas. — Jill and Lill. — How Reggie
saw the sphinx.
© Mar. 27, 1911; 2c. Mar. 29, 1911*; A 283792; Lothrop, Lee & Shepard
co. (11-5996) 1393

Schiller, Johann Christoph Friedrich von, 1759–1805.
Schillers Wilhelm Tell; ed., with introduction, notes,
and repetitional exercises, by Bert John Vos ... Ed. with
vocabulary ... Boston, New York [etc.] Ginn and com-
pany [ᶜ1911]
 lvii, 387 p. front. (port.) plates, maps. 17½ᶜᵐ. (International modern
language series) $0.70
 Bibliography: p. lii–lvi.
© Mar. 21, 1911; 2c. Mar. 23, 1911*; A 283629; B. J. Vos, Bloomington,
Ind. (11-5983) 1394

Same. Ed. without vocabulary ... Boston, New York
[etc.] Ginn and company [ᶜ1911]
 lvii, 300 p. front. (port.) plates, maps. 17½ᶜᵐ. (International modern
language series) $0.60
 Bibliography: p. lii–lvi.
© Mar. 21, 1911; 2c. Mar. 23, 1911*; A 283630; B. J. Vos, Bloomington,
Ind. (11-5985) 1395

Schmidt, Ernst Willy.
... Das aquarium, von Ernst Willy Schmidt; mit 15
figuren im text. Leipzig, B. G. Teubner, 1911.
 iv, 126 p. illus. 18½ᶜᵐ. (Aus natur und geisteswelt; sammlung wissen-
schaftlich-gemeinverständlicher darstellungen. 335. bdchen.) M. 1.25
© Jan. 20, 1911; 2c. Mar. 22, 1911*; A—Foreign 2658; B. G. Teubner.
 (11-5952) 1396

Schulze, Arthur i. e. Franz Arthur, 1872–

... Die grossen physiker und ihre leistungen, von prof. dr. F. A. Schulze ... mit 5 bildnissen. Leipzig, B. G. Teubner, 1910.

2 p. l., 108 p. front., ports. 18½ᶜᵐ. (Aus natur und geisteswelt; sammlung wissenschaftlich-gemeinverständlicher darstellungen. 324. bdchen.) M. 1.25

CONTENTS.—Galileo Galilei.—Isaac Newton.—Christian Huygens.—Michael Faraday.—Hermann von Helmholtz.—Literatur (p. 108)

© Dec. 28, 1911; 2c. Mar. 22, 1911*; A—Foreign 2645; B. G. Teubner. (11–5953) **1397**

Shaw, Charles Gray, 1871–

The value & dignity of human life as shown in the striving and suffering of the individual, by Charles Gray Shaw. Boston, R. G. Badger [ᶜ1911]

3 p. l., [5]–403 p. 19½ᶜᵐ. $2.50

© Mar. 22, 1911; 2c. Mar. 27, 1911*; A 283701; Richard G. Badger. (11–5723) **1398**

Spiess, Karl.

... Die deutschen volkstrachten, von Karl Spiess ... mit 11 abbildungen im text. Leipzig, B. G. Teubner, 1911.

v, [1], 138 p. illus. 18½ᶜᵐ. (Aus natur und geisteswelt; sammlung wissenschaftlich-gemeinverständlicher darstellungen. 342. bdchen.) M. 1.25

"Bibliographie": p. 124–131.

© Feb. 7, 1911; 2c. Mar. 22, 1911*; A—Foreign 2656; B. G. Teubner. (11–5933) **1399**

Stevenson, Burton Egbert, 1872–

A guide to biography, for young readers. American—men of action. By Burton E. Stevenson ... New York, The Baker & Taylor company, 1910.

388 p. 12 port. (incl. front.) 19ᶜᵐ. (On cover: The guide series) $1.25

© Dec. 11, 1909; 2c. Mar. 20, 1911; A 283577; Baker & Taylor co. (11–5701) **1400**

Tennant, Eleanor A.

The A B C of bridge; rules and laws of the game, how to score, what to lead, and how to play, by Eleanor A. Tennant. 5th ed., rev. and enl., with new chapters. Philadelphia, D. McKay [ᶜ1911]

119 p. 14ᶜᵐ. $0.50

© Mar. 11, 1911; 2c. Mar. 15, 1911*; A 283404; David McKay. (11–5653) **1401**

Thackeray, William Makepeace.

The works of William Makepeace Thackeray; with biographical introductions by his daughter Lady Ritchie ... v. 11. The lectures on the English humourists; The four Georges; and Charity and humour. [The centenary biographical ed.] New York and London, Harper & brothers [1910]

3 p. l., [xi]–lx, v–vii, [347]–725 p. front., illus., plates 21½ᶜᵐ.

© Dec. 16, 1910; 2c. Mar. 25, 1911*; A 283675; Harper & bros. **1402**

Thompson, Joseph Frank, 1850–

The palace of mirrors, and other essays, by Rev. J. Frank Thompson ... Boston and Chicago, The Murray press [1911]

3 p. l., 142 p. 18½ᶜᵐ. $0.50

CONTENTS. — The palace of mirrors. — Scaffolding and building. — The knock at the door.—The essentials of happiness.—The duty of happiness.—The value of life.—The bright side.—Appreciation.—The Child in the temple.

© Mar. 13, 1911; 2c. Mar. 15, 1911*; A 283407; Universalist pub. house, Boston. (11–5232) 1403

Tolstoï, Lev Nikolaevich, *graf,* 1828–1910.

Resurrection, by Lyof N. Tolstoï, tr. by Aline P. Delano. New York, T. Y. Crowell & co. [1911]

2 p. l., 475 p 19½ᶜᵐ. $1.25

© Mar. 23, 1911; 2c. Mar. 27, 1911*; A 283707; Thos. Y. Crowell & co. (11–5643) 1404

U. S. *Constitutional convention,* 1787.

The records of the Federal convention of 1787, ed. by Max Farrand ... New Haven, Yale university press; [etc., etc.] 1911.

3 v. 26ᶜᵐ. $15.00

© Mar. 20, 1911; 2c. Mar. 21, 1911; A 283596; Yale university press. (11–5506) 1405

Vlerebome, Abraham, 1843–

The life of James Riley, commonly called Farmer Riley, one of the world's greatest psychics; a complete and accurate account of the wonderful manifestations produced through his mediumship, at his home, and in different parts of the United States. And the author's twenty-two years' experience in the investigation of psychic phenomena. A. Vlerebome, author. [Akron, O., The Werner company, ᶜ1911]

5 p. l., 9–296 p. pl., 2 port. (incl. front.) 20ᶜᵐ. $1.00

© Feb. 28. 1911; 2c. Mar. 16, 1911*; A 283437; A. Vlerebome and H. G. Thompson, Cleveland, O. (11–5722) 1406

Voltaire, François Marie Arouet de, 1694–1778.

... Lettres philosophiques, publiées, avec une introduction et des commentaires, par Henri Labroue ... Paris, C. Delagrave [ᶜ1910]

2 p. l., 316 p. 18½ᶜᵐ. fr. 3.50

© Feb. 10. 1911; 2c. Mar. 4, 1911*; A—Foreign 2545; Ch. Delagrave. (11–5540) 1407

Waterman, Lucius.

God's balance of faith and freedom; being the Mary Fitch Page lectures at the Berkeley divinity school, 1910, by the Rev. Lucius Waterman ... with introduction by the bishop of Connecticut. Milwaukee, The Young churchman company; [etc., etc., ᶜ1911]

xiii, 144 p. fold. tab. 19ᶜᵐ. $1.00

© Mar. 10, 1911; 2c. Mar. 13, 1911; A 283518; Young churchman co. (11–5513) 1408

Watson, Charles R.

God's plan for world redemption; an outline study of the Bible and missions, by Charles R. Watson ... Philadelphia, Pa., The Board of foreign missions of the United Presbyterian church of N. A. [°1911]

xiii, [2], 17-225 p. front., illus., plates (partly col.) 19ᶜᵐ. $0.50

© Mar. 15, 1911; 2c. Mar. 17, 1911*; A 283465; Board of foreign missions of the United Presbyterian church of N. A. (11-6179) 1409

Watson, Thomas Edward, 1856–

Waterloo, by Thomas E. Watson ... 2d ed. New York and Washington, The Neale publishing company, 1910.

xvii, 157 p. 19ᶜᵐ. $1.00

© Dec. 1, 1910; 2c. Mar. 25, 1911*; A 283692; Neale pub. co. (11-5932) 1410

Whalen, William Wilfrid.

The lily of the coal fields. By Will W. Whalen. [2d ed.] Boston, Mayhew publishing company [°1910]

3 p. l., 208 p. pl. 19½ᶜᵐ. $1.00

Revised version of "Bridget; or What's in a name?"

© Dec. 1, 1910; 2c. Dec. 29, 1910; A 280094; W. W. Whalen, Emmitsburg, Md. (11-1006) 1411

Wharton, Sydney.

The wife decides; a novel, by Sydney Wharton; illustrations by Joseph Cummings Chase, frontispiece by J. Knowles Hare, jr. New York, G. W. Dillingham company [°1911]

312 p. incl. col. front. plates. 19ᶜᵐ. $1.50

© Mar. 18, 1911; 2c. Mar. 29, 1911*; A 283789; G. W. Dillingham co. (11-5999) 1412

Willits, Alphonso Albert, 1821–

Sunbeams, by "The apostle of sunshine" A. A. Willits, D. D. Pub. by the author. Philadelphia, Press of Patterson and White company [°1911]

2 p. l., 154 p. front. (port.) 19½ᶜᵐ. $2.00

© Mar. 8, 1911; 2c. Mar. 11, 1911*; A 283335; A. A. Willits, Spring Lake, N. J. (11-5531) 1413

Zander, Richard, 1855–

... Die leibesübungen und ihre bedeutung für die gesundheit, von prof. dr. R. Zander. 3. aufl., mit 19 abbildungen im text und auf tafeln. Leipzig, B. G. Teubner, 1911.

viii, 151, [1] p. illus., plates. 18½ᶜᵐ. (Aus natur und geisteswelt; sammlung wissenschaftlich - gemeinverständlicher darstellungen. 13 bdchen.) M. 1.25

© Jan. 4, 1911; 2c. Mar. 22, 1911*; A—Foreign 2653; B. G. Teubner. (11-5654) 1414

Armstrong, Joseph.

The mother church. A history of the building of the
original edifice of the First church of Christ, scientist, in
Boston, Massachusetts. By Joseph Armstrong. 11th ed.
Boston, The Christian science publishing society, 1911.
ix, 107 p., 1 l. front., plates, facsims. (1 fold.) 19½ᶜᵐ.
© Mar. 24, 1911; 2c. Mar. 27, 1911*; A 283705; Mary E. Armstrong, Dor-
chester, Mass. (11–6020) 1415

Billeter, Gustav.

Die anschauungen vom wesen des griechentums, von
Gustav Billeter. Leipzig und Berlin, B. G. Teubner, 1911.
xviii, 477, [1] p. 23ᶜᵐ. M. 13
© Jan. 26, 1911; 2c. Mar. 27, 1911*; A—Foreign 2697; B. G. Teubner.
(11–6378) 1416

Brown, Arthur Judson, 1856–

... The why and how of foreign missions, by Arthur
Judson Brown. [Churchman's ed.] New York, Domestic
and foreign missionary society of the Protestant Episco-
pal church in the United States of America [°1911]
xii, 275 p. 19ᶜᵐ. $0.50
© Mar. 15, 1911; 2c. Mar. 24, 1911*; A 283636; Young people's mission-
ary movement of the U. S. and Canada, N. Y. (11–6180) 1417

Bruinier, Johannes Weijardus, 1867–

... Das deutsche volkslied; über wesen und werden des
deutschen volksgesanges, von J. W. Bruinier. 4., um-
gearb. und verb. aufl. Leipzig. B. G. Teubner, 1911.
3 p. 1., 158 p. 18½ᶜᵐ. (Aus natur und geisteswelt ... 7. bdchen.)
M. 1.25
© Dec. 28, 1910; 2c. Mar. 22, 1911*; A—Foreign 2660; B. G. Teubner.
(11–6370) 1418

Brush, Frederick Crosby.

The business problems of a profession, by Frederick
Crosby Brush ... New York, N. Y., The press of the Den-
tal digest, 1911.
viii, 88 p. 18½ᶜᵐ. $1.00
© Feb. 1, 1911; 2c. Mar. 23, 1911*; A 283632; F. C. Brush, N. Y.
(11–6449) 1419

Byron, George Gordon Noël Byron, *6th baron*, 1788–1824.

... Byron's fourth canto of Childe Harold, The prisoner
of Chillon, and other poems, ed. with notes and introduc-
tion by H. E. Coblentz ... New York [etc.] Longmans,
Green, and co., 1911.
xviii p., 1 l., 138 p. 18½ᶜᵐ. (*Half-title:* Longmans' English classics, ed
by A. H. Thorndike ...) $0.25
"Bibliographical note": p. xv.
© Feb. 27, 1911; 2c. Mar. 9, 1911*; A 283267; Longmans, Green & co.
(11–6436) 1420

249

Cables, Henry Albert, 1869–

... Golden rules of diagnosis and treatment of diseases; aphorisms, observations, and precepts on the method of examination and diagnosis of diseases, with practical rules for proper remedial procedure. By Henry A. Cables ... St. Louis, C. V. Mosby company, 1911.

298 p. 21½ᶜᵐ. (Medical guide and monograph series) $2.50
© Feb. 2, 1911; 2c. Feb. 27, 1911; A 283597; C. V. Mosby co.
(11–6028) 1421

Champlin, John Denison, 1834–

The young folks' cyclopædia of persons and places, by John Denison Champlin ... with numerous illustrations. 6th ed., rev. New York, H. Holt and company, 1911.

vi, 1105 p. illus., pl. 21ᶜᵐ. $3.0.
© Mar. 25, 1911; 2c. Mar. 29, 1911*; A 283782; Henry Holt & co.
(11–6361) • 1422

Cutten, George Barton, 1874–

Three thousand years of mental healing, by George Barton Cutten ... New York, C. Scribner's sons, 1911.

viii p., 3 l., 3–318 p. front., plates, ports. 21ᶜᵐ. $1.50
© Feb. 25, 1911; 2c. Mar. 2, 1911; A 283659; Charles Scribner's sons.
(11–6029) 1423

Doyen, Eugène.

... Atlas d'anatomie topographique ... fasc. no. 7.: Membres. Paris, A. Maloine, 1911.

1 p. l., 36 pl. 32½ᶜᵐ. fr. 7.50
At head of title: Dr. E. Doyen, J.-P. Bouchon, R. Doyen.
© Mar. 17, 1911; 2c. Apr. 6, 1911*; A—Foreign 2731; E. Doyen, Paris.
 1424

French, George, 1853– ed.

New England, what it is and what it is to be, ed. by George French. Boston, Boston chamber of commerce, 1911.

xii p., 1 l., 431 p. illus., maps. 20½ᶜᵐ. $2.00
© Mar. 20, 1911; 2c. Mar. 24, 1911*; A 283657; Boston chamber of commerce. (11–6010) 1425

Frischeisen-Köhler, Max, 1878– ed.

Weltanschauung philosophie und religion in darstellungen von Wilhelm Dilthey, Bernhard Groethuysen, Georg Misch, Karl Joël, Eduard Spranger, Julius von Wiesner, Hans Driesch, Erich Adickes, Hermann Schwarz, Hermann graf Keyserling, Paul Natorp, Georg Simmel, Georg Wobbermin, Paul Deussen, Carl Güttler, Arthur Bonus, Bruno Wille, Ernst Troeltsch, Julius Kaftan, Max Frischeisen-Köhler. Berlin, Reichl & co., 1911.

3 p. l., [ix]–xxii p., 1 l., 484 p., 1 l. 25½ᶜᵐ.
On verso of half-title: Schriftleitung: Max Frischeisen-Köhler.
"Bibliographischer anhang": p. [473]–477.
© Jan. 17, 1911; 2c. Mar. 22, 1911*; A—Foreign 2639; Reichl & co.
(11–6178) 1426

Gerrard, Thomas J.

Marriage and parenthood, the Catholic ideal, by the
Rev. Thomas J. Gerrard ... New York, J. F. Wagner
[1911]

 3 p. l., 179 p. front. 19½ᶜᵐ. $1.00
© Feb. 9, 1911; 2c. Mar. 11, 1911*; A 283331; Jos. F. Wagner.
 (11-6383) 1427

Goepp, Rudolph Max, 1866–

State board questions and answers, by R. Max Goepp
... 2d ed., thoroughly rev. Philadelphia and London,
W. B. Saunders company, 1911.

 715 p. 25ᶜᵐ. $4.00
© Mar. 23, 1911; 2c. Mar. 24, 1911*; A 283647; W. B. Saunders co.
 (11-6032) 1428

Hamilton, Cicely Mary, 1875–

A pageant of great women, by Cicely Hamilton ...
[London] The Suffrage shop, 1910.

 2 p. l., [9]–69 p., 1 l. front., ports. 20ᶜᵐ.
© Apr. 19, 1910; 1c. Feb. 18, 1911; 1c. Mar. 11, 1911; D 23797; C. Hamil-
ton, London. (11-6435) 1428*.

Hochwalt, Albert Frederick.

The pointer and the setter in America. By A. F. Hoch-
walt ... Cincinnati, Sportsmen's review publishing co.,
1911.

 548 p. illus. 20½ᶜᵐ. $3.00
© Mar. 15, 1911; 2c. Mar. 25, 1911*; A 283697; Sportsmen's review pub. co.
 (11-6186) 1429

Japan. *Admiral staff.*

Der japanisch-russische seekrieg, 1904/1905 ... Über-
setzt von ... v. Knorr. 2. bd. Das zusammenwirken der
flotte mit dem landheere ... Berlin, E. S. Mittler und
sohn, 1911.

 v p., 1 l., 263 p. fold. maps in pocket. 24½ᶜᵐ. M. 6
© Mar. 27, 1911; 2c. Apr. 10, 1911*; A—Foreign 2747; Ernst Siegfried
Mittler & sohn. 1430

Johnson, A P *ed.*

Library of advertising ... comp. and ed. by A. P. John-
son ... Chicago, Cree publishing company [°1911]

 2 v. illus., col. pl. 26½ᶜᵐ. $5.00 per vol.
 CONTENTS.—Department store and retail advertising.—Fundamental
principles, advertising mediums.
© Mar. 7, 1911; 2c. Mar. 9, 1911*; A 283270-283271; Cree pub. co., Chi-
cago, Ill. (11-6012) 1431, 1432

Kirchner, Oskar *i. e.* Emil Otto Oskar von, 1851–

Blumen und insekten; ihre anpassungen aneinander
und ihre gegenseitige abhängigkeit, von prof. dr. O. von
Kirchner; mit 159 abbildungen im text und 2 tafeln.
Leipzig und Berlin, B. G. Teubner, 1911.

 iv p, 1 l., 436 p. illus., II pl. 23ᶜᵐ. M. 7.50
© Feb. 8, 1911; 2c. Mar. 27, 1911*; A—Foreign 2696; B. G. Teubner.
 (11-6036) 1433

Kiser, Samuel Ellsworth, 1862– *comp.*

Poems that have helped me, collected by S. E. Kiser.
Chicago, P. F. Volland & company [°1911]
 64 p. 16ᶜᵐ. $0.50
© Mar. 14, 1911; 2c. Mar. 17, 1911*; A 283460; P. F. Volland & co.
 (11–6360) **1434**

Klein, Felix *i. e.* **Christian Felix,** 1849–

... Über die theorie des kreisels ... mit 143 figuren im
text. Leipzig, B. G. Teubner, 1897–1910.
 viii, 966 p. illus., diagrs. 25½ᶜᵐ. M. 32.60
 At head of title: F. Klein und A. Sommerfeld.
 CONTENTS.—hft. I. Einführung in die kinematik und kinetik des krei-
 sels.—hft. II. Durchführung der theorie im falle des schweren symmetri-
 schen kreisels.—hft. III. Die störenden einflüsse astronomische und geo-
 physikalische anwendungen.—hft. IV. Die technischen anwendungen der
 kreiseltheorie.
© Dec. 28, 1910; 2c. Mar. 22, 1911*; A—Foreign 2619; B. G. Teubner.
 (11–6033) **1435**

Krische, Paul.

... Agrikulturchemie, von dr. Paul Krische ... mit 22
abbildungen im text. Leipzig, B. G. Teubner, 1911.
 vi, 124, [2] p. illus. 18½ᶜᵐ. (Aus natur und geisteswelt. 314. bdchen.)
 M. 1.25
© Jan. 14, 1911; 2c. Mar. 22, 1911*; A—Foreign 2657; B. G. Teubner.
 (11–6183) **1436**

Lawrence, Edwin Gordon.

The Lawrence reader and speaker; a compilation of
masterpieces in poetry and prose, including many of the
greatest orations of all ages, with biographical notes of
the authors, poets, and orators ... by Edwin Gordon Law-
rence ... Chicago, A. C. McClurg & co., 1911.
 xiv, 351 p. 20ᶜᵐ. $1.50
© Mar. 25, 1911; 2c. Mar. 29, 1911*; A 283765; A. C. McClurg & co.
 (11–6432) **1437**

Lawyers co-operative publishing co., *Rochester, N. Y.*

The rule in Shelley's case as expounded in book 29
New series, Lawyers reports annotated. Rochester, N. Y.,
The Lawyers co-operative publishing co. [°1911]
 2 p. l., p. 935–1170. 26ᶜᵐ. $1.00
© Mar. 22, 1911; 2c. Mar. 24, 1911*; A 283662; Lawyers co-operative pub.
 co. (11–5963) **1438**

Lefèvre, Jules.

Chaleur animale et bioénergétique, par Jules Lefèvre
... préface de M. A. Dastre ... avec 211 figures dans le
texte. Paris, Masson et cⁱᵉ, 1911.
 xv, [1], 1107 p. illus. (partly col.) diagrs. 25ᶜᵐ. fr. 25
© Mar. 3, 1911; 2c. Mar. 25, 1911*; A—Foreign 2667; Masson & co.
 (11–6453) **1439**

Ley, Heinrich, 1872–

Die beziehungen zwischen farbe und konstitution bei organischen verbindungen, unter berücksichtigung der untersuchungsmethoden dargestellt von dr. H. Ley ... mit 51 figuren im text und 2 tafeln. Leipzig, S. Hirzel, 1911.

viii, 246 p. illus., 2 pl., diagrs. 23ᶜᵐ. M. 8
© Feb. 28, 1911; 2c. Mar. 18, 1911; A—Foreign 2615; S. Hirzel.
(11-6455) 1440

Lindau, Paul.

... Illustrierte romane und novellen. 5. bd. Hängendes moos. (1. t.) ... Berlin, S. Schottlaenders schlesische verlags-anstalt [1911]
231 p. illus. 20½ᶜᵐ. M. 3
© Apr. 6, 1911; 2c. Apr. 6, 1911*; A—Foreign 2719; S. Schottlaenders schlesische verlag. 1441

Mackenzie, Alastair St. Clair, 1875–

The evolution of literature, by A. S. Mackenzie ... New York, T. Y. Crowell & company [1911]
xvii, 440 p. front., 9 pl. 21½ᶜᵐ. $2.50
© Mar. 27. 1911; 2c. Mar. 29, 1911*; A 283785; Thos. Y. Crowell & co.
(11-6363) 1442

Maine. *Laws, statutes, etc.*

The Maine townsman, containing the statutory laws of Maine respecting the duties of town officers, powers and obligations of towns, cities and plantations, and laws affecting general business. Revised to January 1, 1911, by John T. Fagan ... Portland, Loring, Short & Harmon, 1910.

xiii, 930 p. 23½ᶜᵐ. $5.00
© Feb. 1, 1911; 2c. Mar. 21, 1911; A 283688; Loring, Short & Harmon.
(11-6011) 1443

Naske, Carl.

Zerkleinerungsvorrichtungen und mahlanlagen. von Carl Naske ... mit 257 figuren im text. Leipzig, O. Spamer, 1911.

x, 235 p. illus., diagrs. 24ᶜᵐ. (*Half-title:* Chemische technologie in einzeldarstellungen, herausgeber: F. Fischer) M. 13.50
© Feb. 13, 1911; 2c. Mar. 27, 1911*; A—Foreign 2699; Otto Spamer.
(11-6044) 1444

Ohio. *Laws, statutes, etc.*

Annotations to the general code of the state of Ohio, comp. and rev. by W. J. Tossell ... assisted by the editorial staff of the American publishers company. Norwalk, O., The American publishers company, 1911.

2 p. l., 1229 p. 26ᶜᵐ. $7.00
© Feb. 17, 1911; 2c. Feb. 18, 1911; A 283685; Amer. publishers co.
(11-5960) 1445

Pick, Alois, 1859–

Clinical symptomatology, with special reference to life-threatening symptoms and their treatment, by Alois Pick ... and Adolph Hecht ... an authorized translation under the editorial supervision of Karl Konrad Koessler ... New York and London, D. Appleton and company, 1911.

xiii, 833 p. 24½ᶜᵐ. $6.00
© Mar. 24, 1911; 2c. Mar. 28, 1911*; A 283754; D. Appleton & co.
(11–6452) 1446

Pischel, Richard, 1849–1909.

... Leben und lehre des Buddha, von Richard Pischel. 2. aufl., mit einer tafel. Leipzig, B. G. Teubner, 1910.

vi p., 1 l., 126 p. pl. 18½ᶜᵐ. (Aus natur und geisteswelt. 109. bdchen.)
M. 1.25
© Dec. 28, 1910; 2c. Mar. 22, 1911*; A—Foreign 2655; B. G. Teubner.
(11–6182) 1447

Porterfield, Allen Wilson. ·

Karl Lebrecht Immermann; a study in German romanticism, by Allen Wilson Porterfield ... New York, The Columbia university press, 1911.

xi, 153 p. 23ᶜᵐ. (Half-title: Columbia university Germanic studies) $1.00
Bibliography: p. 142–151.
© Mar. 23, 1911; 2c. Mar. 25, 1911*; A 283668; Columbia university press.
(11–6169) 1448

Pratique médico-chirurgicale.

... Nouvelle Pratique médico-chirurgicale illustrée ... Directeurs: E. Brissaud, A. Pinard, P. Reclus ... Secrétaire général: Henry Meige ... t. 1–4. Paris, Masson et cⁱᵉ, 1911.

4 v. illus. (partly col.) plates. 25ᶜᵐ. fr. 25 per vol.
At head of title: P. m. c. i. e. Pratique médico-chirurgicale.
t 1 & 2 © Feb. 24, 1911; 2c. each Mar. 25, 1911*; A—Foreign 2668; t. 3 & 4 © Mar. 17, 1911; 2c. each Apr. 6, 1911*; A—Foreign 2727; Masson & co. (11–6450) 1449, 1450

Roozeboom, H. W. Bakhuis.

Die heterogenen gleichgewichte vom standpunkte der phasenlehre, von dr. H. W. Bakhuis Roozeboom ... 3. hft. Die ternären gleichgewichte. 1. t. Systeme mit nur einer flüssigkeit ohne mischkristalle und ohne dampf von dr. F. A. H. Schreinemakers ... Braunschweig, F. Vieweg & sohn, 1911.

xii, 312, (2) p. diagrs. 23½ᶜᵐ. M. 10
© Mar. 20, 1911; 2c. Apr. 10, 1911*; A—Foreign 2745; Friedr. Vieweg & sohn, Brunswick, Germany. 1451

Ruhräh, John, 1872–

A manual of the diseases of infants and children, by John Ruhräh ... illustrated. 3d ed., thoroughly rev. Philadelphia and London, W. B. Saunders company, 1911.

2 p. l., 9–534 p. illus., plates (partly col.) 19½ᶜᵐ. $2.50
© Mar. 22, 1911; 2c. Mar. 24, 1911*; A 283643; W. B. Saunders co.
(11–6030) 1452

Ruoff, Henry Woldmar, 1867– *ed.*

The standard dictionary of facts; history, language, literature, biography, geography, travel, art, government, politics, industry, invention, commerce, science, education, natural history, statistics and miscellany, ed. by Henry W. Ruoff ... Buffalo, N. Y., The Frontier press company, 1911.

908 p. incl. plates, ports. front., plates, ports. 25ᶜᵐ. $6.75
© Mar. 18, 1911; 2c. Mar. 28, 1911*; A 283752; Frontier press co.
(11–6437) 1453

Russia. *Glavnyĭ shtab.*

Der russisch-japanische krieg, amtliche darstellung des russischen Generalstabes; deutsche vom russischen Kriegsministerium mit allerhöchster genehmigung autorisierte ausgabe von freiherr von Tettau ... bd. 3: Schaho-Sandepu. 1. t. Die schlacht am Schaho. Berlin, E. S. Mittler und sohn, 1911.

xiii, 358 p. fold. maps in pocket. 24½ᶜᵐ. M. 8.50
© Mar. 16, 1911; 2c. Apr. 10, 1911*; A—Foreign 2746; Ernst Siegfried Mittler & sohn. 1454

Scott, Robert, *comp.*

Cyclopedia of illustrations for public speakers, containing facts, incidents, stories, experiences, anecdotes, selections, etc., for illustrative purposes, with cross-references; comp. and ed. by Robert Scott and William C. Stiles ... New York and London, Funk and Wagnalls company, 1911.

vii, 836 p. 25½ᶜᵐ. $5.00
© Mar. 22, 1911; 2c. Mar. 23, 1911*; A 283628; Funk & Wagnalls co.
(11–6362) 1455

Singer, Berthold, 1860–

Patent and trade mark laws of the world, by B. Singer ... Chicago [Hammond press, W. B. Conkey company] 1911.

2 p. l., 7–539 p. 24ᶜᵐ. $1.75
© Mar. 23, 1911; 2c. Mar. 27, 1911*; A 283732; B. Singer, Chicago.
(11–6040) 1456

Thesing, Curt Egon, 1879–

... Experimentelle biologie ... bd. 2. Von dr. Curt Thesing ... Leipzig B. G. Teubner, 1911.

2 p. l., 132 p. illus.,.pl. 18½ᶜᵐ. (Aus natur und geisteswelt; sammlung wissenschaftlich-gemeinverständlicher darstellungen. 337. bdchen.) M. 1.25
© Jan. 20, 1911; 2c. Mar. 22. 1911*; A—Foreign 2654; B. G. Teubner.
(11–6034) 1457

[Thomasson, Wm.]

Songs of discontent, by an optimist. Foreword of a movement to create a new civilization that will solve the labor problem and bring to earth the long-dreamed-of

[Thomasson, Wm.]—Continued

millennium. Ft. Madison, Ia., Aragain publishing co., 1911.

75 p. 17ᶜᵐ. $0.50
© Feb. 24, 1911; 2c. Mar. 6, 1911*; A 283200; Aragain pub. co.
(11-6384) 1458

Tscholl, John.

War on the white plague, by Rev. John Tscholl ... [Saint Paul, Willwerscheid & Raith, ᶜ1910]

135, [1] p. incl. front. (port.) illus. 22½ᶜᵐ. $1.00
© Oct. 1, 1910; 2c. Mar. 23, 1911*; A 283625; J. Tscholl, Chisholm, Minn.
(11-6451) 1459

Underwood, Edna Worthley.

A book of dear dead women, by Edna Worthley Underwood ... Boston, Little, Brown, and company, 1911.

4 p. l., 327 p. 19½ᶜᵐ. $1.25
"The painter of dead women" reprinted from the Smart set for January, 1910.
CONTENTS.—One of Napoleon's loves.—The painter of dead women.—The mirror of La Granja. — Liszt's Concerto pathétique. — Sister Seraphine.—The sacred relics of Saint Euthymius.—The Opal isles.—The house of gauze.—The king.
© Mar. 25, 1911; 2c. Mar. 28, 1911*; A 283751; Little, Brown, and company. (11-5998) 1460

Vance, Louis Joseph, 1879-

Cynthia-of-the-minute; a romance, by Louis Joseph Vance ... illustrations by Arthur I. Keller. New York, Dodd, Mead and company, 1911.

5 p. l., 349 p. front., plates. 19½ᶜᵐ. $1.25
© Mar. 31, 1911; 2c. Apr. 3, 1911*; A 283907; L. J. Vance, N. Y.
(11-6444) 1461

Vogel, J H.

Das acetylen, seine eigenschaften, seine herstellung und verwendung, unter mitwirkung von dr. Anton Levy-Ludwig in Berlin, dr.-ing. Armin Schulze in Berlin, ing. Alfred Schneider, Chemnitz, dr. Paul Wolff in Berlin, von professor dr. J. H. Vogel-Berlin; mit 137 figuren im text. Leipzig, O. Spamer, 1911.

viii, 294 p. illus. 24ᶜᵐ. (Half-title: Chemische technologie in einzeldarstellungen, herausgeber: F. Fischer) M. 16.50
"Literaturverzeichnis": p. [279]-281.
© Jan. 21, 1911; 2c. Mar. 22, 1911*; A—Foreign 2620; Otto Spamer.
(11-6459) 1462

Westinghouse air brake company, Pittsburg.

General conference of officers and representatives of the Westinghouse air brake co. & Westinghouse traction brake co. held in Wilmerding, Pennsylvania, October 17, 18, 19, 20, 1910. [Akron, O. and Pittsburg, Made by the Werner company, ᶜ1911]

3 p. l., [9]-241 p. incl. illus., plates, ports. 29ᶜᵐ.
© Mar. 6, 1911; 2c. Mar. 6, 1911*; A 283207; Westinghouse air brake co., Wilmerding, Pa. (11-6043) 1463

MAY 1 1911
From the
U. S. Government
Nc. 18, April, 1911.

PART I, BOOKS, GROUP I

1469

/ &o 3 5.

Alexander, Louis Charles, 1839–

The autobiography of Shakespeare; a fragment ... ed. by Louis C. Alexander. New York, The Baker & Taylor company; [etc., etc., ˆ1911]

3 p. l., 9–176 p. 22½ᶜᵐ. $1.50

© Mar. 10, 1911; 2c. Mar. 11, 1911; A 283367; Baker & Taylor co. (11–6959) **1464**

Allen, James, 1864–

Man: king of mind, body and circumstance, by James Allen ... London, W. Rider & son, limited, 1911.

70 p. 19ᶜᵐ. (*Half-title:* Rider's mind and body handbooks) $0.50

© 1c. Mar. 28, 1911*; A ad int. 546; pubd. Mar. 14, 1911; J. Allen, Ilfracombe, England. (11–6950) **1465**

[**Appel, Joseph Herbert**] 1873– *comp.*

Golden book of the Wanamaker stores ... Jubilee year, 1861–1911. [Philadelphia? ˁ1911]

x, 318 p. illus., plates, 3 port. (incl. front.) 22½ᶜᵐ. $0.50

Compiled by Joseph Herbert Appel and Leigh Mitchell Hodges.

© Mar. 1, 1911; 2c. Mar. 6, 1911*; A 283209; John Wanamaker, Phila. (11–6964) **1466**

Bevier, Isabel.

The house; its plan, decoration and care, by Isabel Bevier ... Chicago, American school of home economics, 1911.

4 p. l., 224 (*i. e.* 234) p. incl. illus., plates, plans. plates, plans. 20ᶜᵐ. $1.25

Bibliography: p. 47.

© Jan. 16, 1911; 2c. Mar. 24, 1911*; A 283650; Home economics assn. (11–6939) **1467**

Bible. *O. T. Selections. English.*

Selections from the Old Testament, ed. with introduction and notes by Henry Nelson Snyder ... Boston, New York [etc.] Ginn and company [ˁ1911]

xix, 210 p. 17½ᶜᵐ. (*On cover:* Standard English classics)

© Mar. 17, 1911; 2c. Mar. 20, 1911*; A 283534; Ginn & co. (11–6952) **1468**

Borup, George.

A tenderfoot with Peary, by George Borup; with a preface by G. W. Melville ... with forty-six illustrations from photographs and a map. New York, Frederick A. Stokes company [1911]

xvi, 317 p. front. (port. group) plates, ports., fold. map. 21ᶜᵐ. $2.10

© Mar. 24, 1911; 2c. Mar. 27, 1911*; A 283703; Frederick A. Stokes co. (11–6719) **1469**

257

Cicero, Marcus Tullius.

M. Tulli Ciceronis Cato maior de senectute, ed. with introduction and notes, by Frank Ernest Rockwood ... New York, Cincinnati [etc.] American book company [°1911]

200 p. 19ᶜᵐ.

© Mar. 11, 1911; 2c. Mar. 14, 1911*; A 283378; Amer. book co. [Copyright is claimed on Vocabulary, etc.] (11-6962) 1470

Clarke, Augustus Peck, 1833-

A volume of original poems, by Augustus P. Clarke ... 2d ed.—enl. Cambridge, Mass. [Press of Caustic-Claflin company] 1911.

117 p. front. (port.) pl. 19ᶜᵐ. $1.50

© Mar. 21, 1911; 2c. Mar. 25, 1911*; A 283690; A. P. Clarke. (11-6177) 1471

[Clymer, Reuben Swinburne] 1878-

Soul science and immortality. The art of building a soul. The secret of the coming Christ. Authorized text book of the Church of illumination. Allentown, Pa., The Philosophical publishing co. [°1911]

1 p. l., 7-200 p. 23½ᶜᵐ. $1.50

© Mar. 20, 1911; 2c. Mar. 17, 1911; A 283686; R. S. Clymer, Allentown, Pa. (11-6486) 1472

Cornelius, Hans, 1863-

Elementargesetze der bildenden kunst, grundlagen einer praktischen ästhetik, von Hans Cornelius. 2., verm. aufl., mit 245 abbildungen im text und 13 tafeln. Leipzig und Berlin, B. G. Teubner, 1911.

x, 201, [1] p. illus., XIII pl. (partly col., incl. col. front.) 25ᶜᵐ. M.8

© Jan. 20, 1911; 2c. Mar. 22, 1911*; A—Foreign 2635; B. G. Teubner. (11-6940) 1473

Crane, Arthur Morton.

The ceremonies of a choral eucharist, by Arthur Morton Crane. New York, The American church publishing company, 1911.

ix p., 1 l., 79 p. front. 17½ᶜᵐ. $1.00

© Mar. 24, 1911; 2c. Mar. 25, 1911; A 283727; Amer. church pub. co. (11-6953) 1474

Darwin, Charles Robert, 1809-1882.

Die fundamente zur entstehung der arten; zwei in den jahren 1842 und 1844 verfasste essays, von Charles Darwin. Hrsg. von seinem sohn Francis Darwin. Autorisierte deutsche übersetzung von Maria Semon, mit einem porträt Charles Darwins und einer faksimiletafel. Leipzig und Berlin, B. G. Teubner, 1911.

viii, 325, [1] p. front. (port.) facsim. 23½ᶜᵐ. M.5

© Feb. 4, 1911; 2c. Mar. 27, 1911*; A—Foreign 2698; B. G. Teubner. (11-6945) 1475

Des Ombiaux, Maurice, 1868–

... Le maugré. Paris, Calmann-Levy [ᶜ1911]

3 p. L, 349 p., 1 l. 19ᶜᵐ. fr. 3.50

© Feb. 22, 1911; 2c. Mar. 27, 1911; A—Foreign 2713; Calmann-Lévy.
(11–6732) 1476

Dickinson, Edward, 1853–

The education of a music lover; a book for those who
study or teach the art of listening, by Edward Dickinson
... New York, C. Scribner's sons, 1911.

xi p., 1 l., 293 p. 19¼ᶜᵐ. $1.50
Bibliography: p. 291–293.

© Mar. 18, 1911; 2c. Mar. 23, 1911*; A 283626; Chas. Scribner's sons.
(11–6477) 1477

Foerster, Friedrich Wilhelm, 1869–

Jugendlehre; ein buch für eltern, lehrer und geistliche,
von dr. Fr. W. Foerster ... 51. bis 55. tausend. Berlin,
G. Reimer, 1911.

xviii, 718 p. 23¼ᶜᵐ. M. 5
"Hilfsliteratur für die ethische jugendlehre": p. [713]

© Jan. 20, 1911; 2c. Mar. 22, 1911*; A—Foreign 2633; Georg Reimer.
(11–6473) 1478

Lebensführung; ein buch für junge menschen, von Fr.
W. Foerster. 16. bis 20. tausend. Berlin, G. Reimer,
1910.

vii, 298 p. 20ᶜᵐ. M. 3

© Jan. 20, 1911; 2c. Mar. 22, 1911*; A—Foreign 2638; Georg Reimer.
(11–6949) 1479

Fuller, Caroline Macomber.

The bramble bush, by Caroline Fuller ... New York
and London, D. Appleton and company, 1911.

ix, [1], 307, [1] p. front. 19¼ᶜᵐ. $1.25

© Mar. 24, 1911; 2c. Mar. 29, 1911*; A 283779; D. Appleton & co.
(11–6023) 1480

Funk, Isaac Kaufman, 1839–

The widow's mite, and other psychic phenomena, by
Isaac K. Funk ... 3d ed. New York and London, Funk
& Wagnalls company, 1911.

xvi, 560 p. illus. 23ᶜᵐ. $2.00
"Bibliography—(partial)": p. 545–556.

© Mar. 16, 1911; 2c. Mar. 28, 1911*; A 283736; Funk & Wagnalls co.
(11–6019) 1481

Garnier, Paul Louis, 1879–

... P'tit fi, l'enfant sans mère. Paris, P. Ollendorff,
ᶜ1911·

2 p. l., 281 p., 1 l. 19ᶜᵐ. fr. 3.50

© Mar. 3, 1911; 2c. Mar. 25, 1911*; A—Foreign 2669; P. L. Garnier, Paris.
(11–6728) 1482

Handbuch für eisenbetonbau, hrsg. von ... F. Emperger.
Ergänzungsband i (zur 1. wie zur 2. aufl.) Berlin, W.
Ernst & sohn, 1911.
6 p. l., 210 p. illus. 27ᶜᵐ.
© Mar. 10, 1911; 2c. Mar. 25, 1911*; A—Foreign 2683; Wilhelm Ernst &
sohn. 1483

Huebner, Solomon S.

Property insurance, comprising fire and marine insur-
ance, corporate surety bonding, title insurance, and credit
insurance, by Solomon S. Huebner ... New York and
London, D. Appleton and company, 1911.
xxii, 421 p. forms (partly fold.) 20ᶜᵐ. $2.00
"Bibliography on property insurance": p. 389–403.
© Mar. 24, 1911; 2c. Mar. 28, 1911*; A 283744; D. Appleton & co.
(11–6009) 1484

Kaye, James R.

The chart Bible, by Rev. James R. Kaye ... New York,
Chicago [etc.] Fleming H. Revell company [ᶜ1911]
288 p. incl. charts. 21ᶜᵐ. $1.50
© Feb. 26 1911; 2c. Mar. 16, 1911*; A 283433; Fleming H. Revell co.
(11–6723) 1485

Kenilworth, Walter Winston.

Thoughts on things psychic, by Walter Winston Kenil-
worth ... New York, R. F. Fenno & company [ᶜ1911]
3 p. l., 230 p. 20ᶜᵐ. $1.00
© Mar. 20, 1911; 2c. Mar. 29, 1911*; A 283788; R. F. Fenno & co.
(11–6021) 1486

Kiser, Samuel Ellsworth, 1862–

The whole glad year, by Samuel Ellsworth Kiser. Chi-
cago, Printed in the shop of P. F. Volland & co. [ᶜ1911]
16 l. 21ᶜᵐ. $1.00
© Mar. 15, 1911; 2c. Mar. 17, 1911; A 283851; P. F. Volland & co.
(11–6961) 1487

Knight, William Allen, 1863–

Outside a city wall, by William Allen Knight ... Bos-
ton, New York [etc.] The Pilgrim press [1911]
63 p. front. 18¼ᶜᵐ. $0.50
CONTENTS.—Gethsemane.—Calvary.—The garden tomb.
© Mar. 25, 1911; 2c. Mar. 28, 1911*; A 283739; W. A. Knight, Brighton,
Mass. (11–6725) 1488

Lawrence, John Strachan, 1849–

The descendants of Moses and Sarah Killham Porter of
Pawlet, Vermont, with some notice of their ancestors and
those of Timothy Hatch, Amy and Lucy Seymour Hatch,
Mary Lawrence Porter and Lucretia Bushnell Porter.
Comp. by John S. Lawrence. Grand Rapids, Mich., F. A.
Onderdonk, printer, 1910.
xiii, 190 p. front. (facsim.) 24ᶜᵐ. $2.50
© Feb. 28, 1911; 2c. Mar. 4, 1911; A 283821; J. S. Lawrence, Grand Rapids.
(11–6467) 1489

Lazzeri, Giulio, 1861–

Elemente der geometrie (unter verschmelzung von ebe-
ner und räumlicher geometrie) von G. Lazzeri und A. Bas-
sani ... mit genehmigung der verfasser aus dem italieni-
schen übersetzt von P. Treutlein ... mit 336 figuren im
text. Leipzig und Berlin, B. G. Teubner, 1911.
 xvi, 491, ₁1₁ p. diagrs. 23½ᶜᵐ. M. 14
© Jan. 9, 1911; 2c. Mar. 22, 1911*; A—Foreign 2618; B. G. Teubner.
 (11-6946) 1490

₁Lewis, Angelo John₁ 1839–

Later magic, with new miscellaneous tricks and recol-
lections of Hartz the wizard, by Professor Hoffmann
₁pseud.₁ ... New and enl. ed., with 266 illustrations. New
York, E. P. Dutton & company; ₁etc., etc.₁ 1911.
 xviii p., 1 l., 738 p. front. (port.) illus. 21½ᶜᵐ. $2.00
© Mar. 23, 1911; 2c. Mar. 27, 1911*; A 283698; E. P. Dutton & co.
 (11-6720) 1491

Lewis-Johnson, Annie i. e. Sara Annie.

New dawn; a philosophical story of the unfolding of
man through the power of evolution. By Annie Lewis-
Johnson. New York, Roger brothers; ₁etc., etc.₁ 1911.
 3 p. l., ₁3₁–332 p., 1 l. 21ᶜᵐ. $1.00
© Mar. 24, 1911; 2c. Mar. 25, 1911*; A 283670; A. Lewis-Johnson.
 (11-6714) 1492

The **man** in the blue coat, from the German by George
Johannes. Erie, Pa., The Erie printing co. ₁ᶜ1911₁
 226 p. 19½ᶜᵐ. $1.00
© Mar. 15, 1911; 2c. Mar. 16, 1911*; A 283449; Erie printing co.
 (11-6957) 1493

Medbury, Charles S 1865–

From the throne of Saul to Bethlehem, by Chas. S.
Medbury ... for advanced training-classes, adult Bible
classes ... etc. ... Cincinnati, O., The Standard publish-
ing company, ᶜ1911.
 185 p. illus. 17ᶜᵐ. $0.50
© Mar. 4, 1911; 2c. Mar. 9, 1911*; A 283279; Standard pub. co.
 (11-6727) 1494

Michie, Thomas Johnson, ed.

The encyclopedic digest of Texas reports (civil cases)
... Under the editorial supervision of Thomas Johnson
Michie. v. 3. Charlottesville, Va., The Michie company,
1911.
 2 p. l., 1111 p. 26ᶜᵐ. $7.50
© Apr. 13, 1911; 2c. Apr. 14, 1911*; A 286190; Michie co. 1495

Morice, Charles, 1861–

... Il est ressuscité! ... 2. éd. Paris, A. Messein, 1911.
 242 p., 3 l. 19ᶜᵐ. fr. 3.50
© Feb. 24, 1911; 2c. Mar. 25, 1911*; A—Foreign 2671; Albert Messein.
 (11-6729) 1496

Neff, Silas S.

Power through perfected ideas, by Silas S. Neff ...
Philadelphia, Pa., Neff college publishing co., 1911.

120 p. 21^{cm}. $2.00

© Feb. 25, 1911; 2c. Mar. 20, 1911*; A 283529; S. S. Neff, Philadelphia.
(11-6488) 1497

Nolton, Jessie Louise, ed.

Chinese cookery in the home kitchen; being recipes for
the preparation of the most popular Chinese dishes at
home. Ed. by Jessie Louise Nolton ... Detroit, Mich.,
Chino-American publishing company [c1911]

[135] p. 24 x 13^{cm}.

© Mar. 8, 1911; 2c. Mar. 13, 1911*; A 283356; Chino-Amer. pub. co.
(11-6969) 1498

O'Hara, John Myers.

Pagan sonnets, by John Myers O'Hara. Portland, Me.,
Smith and Sale, 1910.

ix p., 3 l., 42 p., 1 l. 21 x 21^{cm}. $2.00

© Mar. 25, 1911; 2c. Mar. 29, 1911*; A 283761; J. M. O'Hara, N. Y.
(11-6168) 1499

Parr, Samuel Wilson, 1857–

The chemical examination of water, fuel, flue gases and
lubricants; a course for engineering students, chemistry
16, as given in the Division of applied chemistry at the
University of Illinois, by S. W. Parr ... Urbana, Ill.,
1911.

100 p. illus. 24^{cm}. $1.00

© Feb. 21, 1911; 2c. Mar. 16, 1911*; A 283441; S. W. Parr, Urbana, Ill.
(11-6973) 1500

Pohle, Joseph, 1852–

God: His knowability, essence, and attributes; a dog-
matic treatise prefaced by a brief general introduction to
the study of dogmatic theology, by the Reverend Joseph
Pohle ... Authorized English version, with some abridge-
ment and added references, by Arthur Preuss. St. Louis,
Mo. [etc.] B. Herder, 1911.

2 p. l., iii–vi, 479 p. 20½^{cm}. $2.00

"Readings" at end of chapters.

© Mar. 23, 1911; 2c. Mar. 27, 1911*; A 283713; Jos. Gummersbach, St.
Louis. (11-6487) 1501

Potts, D Walter, 1870–

A fortnight in London schools, by D. Walter Potts ...
Litchfield, Ill., Press of Printing & stationery company
[c1909]

148 p. plates, ports. 19½^{cm}. $1.00

© Mar. 15, 1911; 2c. Mar. 1, 1911; A 283603; D. W. Potts, St. Louis, Ill.
(11-6472) 1502

The Radford architectural company.

Radford's home builder; a book of original and artistic
house plans designed by architects who have made a study
of low and medium priced houses; contains 108 house
plans requiring over 300 half tone cuts and zinc etchings
to illustrate. Chicago, New York, The Radford architec-
tural company [°1911]

110 p. illus. 27½ᶜᵐ. $0.25

© Mar. 14, 1911; 2c. Mar. 18, 1911*; A 283503; Radford architectural co.
(11–6941) 1503

Risser, René.

Mécanisme historique, actuariel et financier de la loi
des retraites ouvrières et paysannes, par M. René Risser
... Paris, Éditions des Juris-classeurs, 1911.

279 p. 25½ᶜᵐ. fr. 1.50

"Index bibliographique": p [13]

© Feb. 1, 1911; 2c. Mar. 25, 1911*; A—Foreign 2673; Éditions des Juris-
classeurs. (11–6500) 1504

Servy, Jacques.

... Hercule et le lion. Paris, Calmann-Lévy [°1911]

3 p. l., 270 p., 1 l. 19ᶜᵐ. fr. 3.50

© Feb. 1, 1911; 2c. Mar. 27, 1911; A—Foreign 2714; Calmann-Lévy.
(11–6963) 1505

Setzler, Edwin Boinest, 1871–

An introduction to advanced English syntax, by Edwin
B. Setzler ... Columbia, S. C., The State co., printers,
1911.

151 p. 19ᶜᵐ.

© Mar. 17, 1911; 2c. Mar. 20, 1911; A 285364; E. B. Setzler, Newberry,
S. C. (11–6431) 1506

Snyder, Isaac Newton.

Looking skyward and the earth, illustrated. By Isaac
Newton Snyder ... [Liberty, Ind., Press of Express
printing co.] 1911.

5 p. l., 15–146 p., 1 l. front., illus. 20½ᶜᵐ. $1.30

"Authorities consulted": p. [12]

© Feb. 28, 1911; 2c. Mar. 14, 1911*; A 283397; I. N. Snyder, Liberty,
Ind. (11–6944) 1507

Underhill, Evelyn.

Mysticism; a study in the nature and development of
man's spiritual consciousness, by Evelyn Underhill ...
London, Methuen & co., ltd. [1911]

xv, 600 p. 23ᶜᵐ. 15/

Bibliography: p. 563–585.

© 1c. April 1, 1911*; A ad int. 557; pubd. Mar. 2, 1911; E. Underhill, Lond.
(11–6489) 1508

Vaucaire, Maurice, 1863–

... Une vraie jeune fille. Paris, P. Lafitte & c'° [°1910]
335 p., 2 l. 19ᶜᵐ. fr. 3.50
At head of title: Maurice Vaucaire et Marcel Luguet.
© Mar. 3, 1911; 2c. Mar. 25, 1911*; A—Foreign 1670; Pierre Lafitte & co.
(11–6731) 1509

Vickers, George Morley, 1841–

Book of selections for home and school entertainments,
containing choice recitations and readings from the best
authors ... written and ed. by George M. Vickers; with
annotations; hints upon gesture and dramatic poses, by
Frances F. Pierce ... Philadelphia, Pa., National pub-
lishing co. [°1911]
254 p. illus., plates. 21ᶜᵐ. $1.00
© Mar. 22, 1911; 1c. Mar. 29, 1911; 1c. Apr. 4, 1911*; A 283760; Geo. W.
Bertron, Philadelphia. (11–6434) 1510

Wagner, William Henry, 1858–

Wagner phonography; an original and natural method
of expressing sounds of speech; a connected-vowel, light-
line, one-position system, very simple, legible and rapid
... by W. H. Wagner ... Book 1, book 2. Los Angeles,
Cal., The author, 1911.
79, 63 p. 19½ᶜᵐ. $1.00
© Mar. 8, 1911; 2c. Mar. 15, 1911; A 283405; W. H. Wagner, Los Angeles.
(11–6482) 1511

[Winter, William Jefferson] 1878– *ed.*

In memory of Frank Worthing, actor, born at Edin-
burgh, Scotland, October 12, 1866, died at Detroit, Michi-
gan, December 27, 1910 ... New York, Printed for distri-
bution, 1911.
79 p. incl. front. ports. 24½ᶜᵐ.
© Mar. 4, 1911; 2c. Mar. 9, 1911*; A 283275; J .Winter, New Brighton.
N. Y. (11–6170) 1512

Witthaus, Rudolph August.

Medical jurisprudence, forensic medicine and toxicol-
ogy, by R. A. Witthaus ... and Tracy C. Becker ... with
the collaboration of August Becker, esq.; A. L. Becker,
esq.; Chas. A. Boston, esq. [etc.] ... 2d ed. v. 4. New
York, W. Wood and company, 1911.
ix p., 1 l., [5]–1261 p. illus. 25ᶜᵐ. $6.00
© Apr. 15, 1911; 2c. Apr. 17, 1911*; A 286227; William Wood & co.
1513

Woods, Charles Coke.

The reign of reason in religion, by Rev. Charles Coke
Woods, PH. D. [Los Angeles, Cal., Press of the Grafton
publishing company, °1911]
73, [1] p. 17½ᶜᵐ. $0.20
© Mar. 19, 1911; 2c. Mar. 27, 1911*; A 283714; C. C. Woods, Whittier, Cal.
(11–6018) 1514

Achorn, John Warren.

Nature's help to health, by John Warren Achorn ...
New York, Moffat, Yard and company, 1911.

2 p. l., 79 p. 18ᶜᵐ. $0.50
© Mar. 25, 1911; 2c. Mar. 29, 1911*; A 283771; Moffat, Yard & co.
(11-7260) 1515

Bailey, Liberty Hyde, 1858-

The country-life movement in the United States, by
L. H. Bailey. New York, The Macmillan company, 1911.

xi. 220 p. 19½ᶜᵐ.
© Apr. 5, 1911; 2c. Apr. 6, 1911*; A 283975; Macmillan co.
(11-7239) 1516

Burke, Edmund, 1729?-1797.

Burke's speech on conciliation with America, ed. by
Daniel V. Thompson ... New York, H. Holt and com-
pany, 1911.

xxxix p., 1 l., 117 p. front. (port.) 17ᶜᵐ. (Half-title: English read-
ings for schools. General editor: W. L. Cross) $0.30
"Descriptive bibliography": p. xxxv-xxxix.
© Mar. 25, 1911; 2c. Mar. 30, 1911*; A 283796; Henry Holt & co.
(11-6710) 1517

Catherwood, Mrs. Mary (Hartwell) 1847-1902.

Rocky Fork, by Mary Hartwell Catherwood; illustrat-
ed by Frank T. Merrill. New ed. Boston, Lothrop, Lee
& Shepard co. [ᶜ1911]

vi p., 1 l., 9-322 p. incl. front. plates. 19½ᶜᵐ. $1.25
© Mar. 27, 1911; 2c. Mar. 29, 1911*; A 283793; Lothrop, Lee & Shepard co.
(11-6024) 1518

Colvin, Fred Herbert, 1867-

Machine shop mechanics; the why of things in the shop,
by Fred H. Colvin ... New York [etc.] McGraw-Hill book
company, 1911.

5 p. l. 177 p. illus. 18ᶜᵐ. $1.00
© Mar. 25, 1911; 2c. Mar. 28, 1911; A 283919; McGraw-Hill book co.
(11-6971) 1519

Cooke, Frances.

Her journey's end, by Frances Cooke ... New York,
Cincinnati [etc.] Benziger brothers, 1911.

307 p. 19ᶜᵐ. $1.25
© Mar. 29, 1911; 2c. Mar. 31, 1911*; A 283852; Benziger bros.
(11-6713) 1520

Defoe, Daniel, 1661-1731.

Defoe's Robinson Crusoe, ed. by Wilbur L. Cross ...
New York, H. Holt and company, 1911.

xxxiii, [1] p., 2 l., 370 p. front. (port.) illus., map. 17½ᶜᵐ. (Half-title:
English readings for schools. General editor: W. L. Cross) $0.50
"Descriptive bibliography": p. xxxi-xxxiii.
© Mar. 27, 1911; 2c. Mar. 30, 1911*; A 283797; Henry Holt & co.
(11-6956) 1521

265

₁Dodgson, Charles Lutwidge₁ 1832-1898.

... Alice's adventures in Wonderland, by Lewis Carroll ₁*pseud.*₁ New York, Charles E. Merrill company ₁°1911₁

187 p. illus. 17ᶜᵐ. (Merrill's story books) $0.30

© Mar. 29, 1911; 2c. Mar. 31, 1911*; A 283843; Chas. E. Merrill co.
(11-6958) 1522

Eberhart, Noble Murray, 1870-

A working manual of high frequency currents, by Noble M. Eberhart ... Chicago, New medicine publishing co. ₁°1911₁

1 p. l., 7-303 p. incl. illus., plates. front. (port.) 20½ᶜᵐ. $2.00

© Mar. 30, 1911; 2c. Apr. 1, 1911*; A 283883; N. M. Eberhart, Chicago.
(11-7257) 1523

Eliot, George, *pseud., i. e.* Marian Evans, *afterwards* Cross, 1819-1880.

... George Eliot's Silas Marner, ed. by May McKitrick ... New York, Cincinnati ₁etc.₁ American book company ₁°1911₁

220 p. incl. front. (port.) 17ᶜᵐ. (Eclectic English classics) $0.20

© Mar. 28, 1911; 2c. Mar. 30, 1911*; A 283816; Amer. book co.
(11-6715) 1524

Fess, Simeon Davidson, 1861-

Civics of Ohio, by S. D. Fess ... Boston, New York ₁etc.₁ Ginn and company ₁°1911₁

v, 133 p. illus. (maps, form) 19ᶜᵐ.

© Mar. 9, 1911; 2c. Mar. 29, 1911*; A 283790; Ginn & co.
(11-6385) 1525

Fuller, Anna, 1853-

Later Pratt portraits, sketched in a New England suburb, by Anna Fuller ... illustrated by Maud Tousey Fangel. New York and London, G. P. Putnam's sons, 1911.

vii, 415 p. front., plates. 19½ᶜᵐ.

CONTENTS.—Old lady Pratt's spectacles.—The tomboy.—The downfall of Georgiana. — William's Willie. — A brilliant match. — Jane. — Peggy's father.—The dean of the boarding house.—The dander of Susan.—Ships in the air.—The passing of Ben.

© Mar. 25, 1911; 2c. Apr. 7, 1911*; A 286000; A. Fuller, Boston.
(11-7262) 1526

Georgia. *Laws, statutes, etc.*

The code of the state of Georgia, adopted August 15, 1910; prepared by John L. Hopkins. Atlanta, Ga., Foote & Davies company, printers, 1911.

2 v. 25½ᶜᵐ. $3.00

© Jan. 15, 1911; 2c. Apr. 1, 1911*; A 283881; State of Georgia.
(11-6374) 1527

Gordon, Henry Evarts, 1855–

Vocal expression in speech; a treatise on the fundamentals of public speaking adapted to the use of colleges and universities, by Henry Evarts Gordon, A. M., with the editorial coöperation of Rollo L. Lyman ... Boston, New York [etc.] Ginn and company [c1911]

vii, 315 p. 19ᶜᵐ. $1.00

© Mar. 28, 1911; 2c. Mar. 30, 1911*; A 283818; Ginn & co.

(11–6433) 1528

Grenfell, Wilfred Thomason, 1865–

What will you do with Jesus Christ, by Wilfred T. Grenfell ... Boston, New York [etc.] The Pilgrim press [c1910]

30 p., 1 l. front. (port.) 18½ᶜᵐ. $0.50

© Mar. 25, 1911; 2c. Mar. 28, 1911*; A 283740; W. T. Grenfell, Boston.

(11–6726) 1529

Hapgood, Norman, 1868–

Industry and progress, by Norman Hapgood; addresses delivered in the Page lecture series, 1910, before the Senior class of the Sheffield scientific school, Yale university. New Haven, Yale university press; [etc., etc.] 1911.

3 p. l., 123 p. 21ᶜᵐ. $1.25

© Mar. 29, 1911; 2c. Mar. 30, 1911; A 283871; Yale university press.

(11–6498) 1530

Hart, Albert Bushnell, 1854–

The obvious Orient, by Albert Bushnell Hart ... New York and London, D. Appleton and company, 1911.

x, 369 p. 20ᶜᵐ. $1.50

© Mar. 24, 1911; 2c. Mar. 28, 1911*; A 283845; D. Appleton & co.

(11–7266) 1531

Hiscox, Gardner Dexter, d. 1908.

Gas, gasoline, and oil-engines, including producer-gas plants ... describing and illustrating the theory, design, construction, and management of the explosive motor for stationary, marine, and vehicle motor power, by Gardner D. Hiscox ... A list of United States patents issued on the gas-engine industry to the present time is included. Illustrated by four hundred and twelve engravings. 20th ed., rev. and enl. New York, The Norman W. Henley publishing company, 1911.

1 p. l., 7–476 p. illus. 23½ᶜᵐ. $2.50

© Mar. 28, 1911; 2c. Mar. 30, 1911*; A 283822; Norman W. Henley pub. co. (11–6458) 1532

Jones, Lewis Henry, 1844–

Education as growth; or, The culture of character; a book for teachers' reading circles, normal classes, and individual teachers, by L. H. Jones ... Boston, New York [etc.] Ginn and company [c1911]

v, 275 p. 20ᶜᵐ. $1.25

© Mar. 27, 1911; 2c. Mar. 30, 1911*; A 283823; L. H. Jones, Ypsilanti, Mich. (11–6474) 1533

Kipling, Rudyard, 1865–

Three poems, by Rudyard Kipling. Oxford, The Clarendon press; [etc., etc.] 1911.

cover-title, 6 p. 20ᶜᵐ.
CONTENTS.—The river's tale.—The Roman centurion speaks.—The pirates of England.
© 1c. Apr. 1, 1911*; A ad int. 556; pubd. Mar. 3, 1911; R. Kipling, Batemans Burwash, England. (11-7217) 1534

Kraus, Edward Henry, 1875–

Tables for the determination of minerals by means of their physical properties, occurrences, and associates, by Edward Henry Kraus ... and Walter Fred Hunt ... New York [etc.] McGraw-Hill book company, 1911.

vii, 254 p. 24ᶜᵐ. $2.00
© Mar. 31, 1911; 2c. Apr. 1, 1911*; A 283865; McGraw-Hill book co.
(11-6947) 1535

Lang, Gustav.

Der schornsteinbau, von Gustav Lang ... 4. hft. Sockel, grundbau, fuchs und einsteigöffnungen, bekämpfung der rauch- und russplage ... Hannover, Helwingsche verlagsbuchhandlung, 1911.

vi, 337–550 p. incl. illus., diagrs. 27½ᶜᵐ. M. 7
© Feb. 27, 1911; 2c. Apr. 17, 1911*; A—Foreign 2764; Helwingsche verlagsbuchhandlung. 1536

Lea, Fannie Heaslip.

Quicksands, by Fannie Heaslip Lea; with illustrations by Clinton Balmer. New York, Sturgis & Walton company, 1911.

5 p. l., 3–331 p. front., plates. 19½ᶜᵐ. $1.20
© Mar. 31, 1911; 2c. Apr. 4, 1911*; A 283928; Sturgis & Walton co.
(11-6717) 1537

Lewandowsky, M., ed.

Handbuch der neurologie, bearb. von G. Abelsdorff ... R. Bárány ... M. Bielschowsky [etc.] hrsg. von M. Lewandowsky. 2. bd. Spezielle neurologie, 1 ... Berlin, J. Springer, 1911.

4 p. l., 1161 p. illus., plates (partly col.) 26ᶜᵐ.
© Feb. 27, 1911; 2c. Apr. 17, 1911*; A—Foreign 2769; Julius Springer.
1538

Lummis, Charles Fletcher, 1859–

The gold fish of Gran Chimú, by Charles F. Lummis ... Chicago, A. C. McClurg & co., 1911.

3 p. l., 126 p. front., illus., plates. 18ᶜᵐ. $0.75
© Mar. 29, 1911; 2c. Apr. 3, 1911*; A 283891; A. C. McClurg & co.
(11-6443) 1539

My friend Will, including "The little boy that was," by Charles F. Lummis ... Chicago, A. C. McClurg & co., 1911.

59 p. front., plates. 18ᶜᵐ. $0.75
© Mar. 29, 1911; 2c. Apr. 3, 1911*; A 283892; A. C. McClurg & co.
(11-6716) 1540

Lyle, Samuel Harley, *jr.*

Ways of men, by Samuel Harley Lyle, jr. ... Franklin,
N. C., S. H. Lyle, jr., 1911.

74 p. 18½ᶜᵐ. $1.00

© Mar. 20, 1911; 1c. Mar. 27, 1911; 1c. Apr. 3, 1911*; A 283918; S. H.
Lyle, jr. (11–6960) 1541

Lynch, Frederick Henry, 1867–

The peace problem; the task of the twentieth century,
by Frederick Lynch ... with an introduction by Andrew
Carnegie. .New York, Chicago ₁etc.₎ Fleming H. Revell
company ₁ᶜ1911₎

127 p. 20ᶜᵐ. $0.75

© Mar. 9, 1911; 2c. Mar. 30, 1911*; A 283817; Fleming H. Revell co.
(11–6496) 1542

Lynde, Carleton John, 1872–

Home waterworks; a manual of water supply in coun-
try homes, by Carleton J. Lynde ... New York, Sturgis
& Walton company, 1911.

xii p., 2 l., 3–270 p. illus. 19ᶜᵐ. (*Half-title:* The young farmer's prac-
tical library, ed. by E. Ingersoll) $0.75

© Mar. 28, 1911; 2c. Mar. 30, 1911; A 283801; Sturgis & Walton co.
(11–6972) 1543

McKinney, Alexander Harris, 1858–

Practical pedagogy in the Sunday school, by A. H.
McKinney ... New York, Chicago ₁etc.₎ Fleming H. Revell
company ₁ᶜ1911₎

128 p. 19½ᶜᵐ. $0.50

© Mar. 21, 1911; 2c. Mar. 30, 1911*; A 283806; Fleming H. Revell co.
(11–6724) 1544

₁**Martel de Janville, Sibylle Gabrielle Marie Antoinette de
Riquetti de Mirabeau,** *comtesse* **de₎** 1850–

... L'affaire Débrouillar-Delatamize. Paris, Calmann-
Lévy ₁ᶜ1911₎

2 p. l., 235 p., 1 l. 19ᶜᵐ. fr. 3.50

Author's pseudonym, "Gyp," at head of title.
On cover: Roman dialogué.

© Mar. 22, 1911; 2c. Apr. 3, 1911*; A—Foreign 2712; Calmann-Lévy.
(11–6730) 1545

. **Meakin, John Phillips,** 1851– *comp.*

From the four winds; quaint and helpful poems as com-
piled and recited by John Phillips Meakin. Fraternal
poems for fraternal people. ₁Rahway, N. J., The Quinn
& Boden co. press, 1911₎

xvi p., 1 l., 189 p. front. (port.) 19½ᶜᵐ. $1.50

© Mar. 23, 1911; 2c. Mar. 23, 1911; A 283618; J. P. Meakin, New York.
(11–7219) **1546**

Merrow, Florenz S.

The reconstruction of Elinore Wood, by Florenz S. Merrow, M. D. N[ew] Y[ork] Washington [etc.] Broadway publishing co. [c1911]

321 p. front., illus., plates. 20½ᶜᵐ. $1.50

© Feb. 11, 1911; 2c. Mar. 18, 1911*; A 283484; F. S. Merrow, Peoria, Ill.
(11-7264) 1547

Moulton, Richard Green, 1849–

World literature and its place in general culture, by Richard G. Moulton ... New York, The Macmillan company, 1911.

ix, 502 p. 20ᶜᵐ. $1.75
"List of books": p. 483-493.

© Mar. 29, 1911; 2c. Mar. 30, 1911*; A 283804; Macmillan co.
(11-6359) 1548

Mowry, William Augustus, 1829–

Essentials of United States history, by William A. Mowry and Blanche S. Mowry; with many maps and illustrations. New York, Boston [etc.] Silver, Burdett and company [c1911]

x, 382, 56 p. incl. front., illus. maps. 19½ᶜᵐ. $0.90
Bound with this: A short sketch of the history of Indiana, by Cyrus W. Hodgin ... New York, Boston [etc., c1906]
"Appendix A. Bibliography": p. 3-11.

© Mar. 27, 1911; 2c. Mar. 29, 1911*; A 283759; Silver, Burdett & co.
(11-6708) 1549

Ostwald, Wilhelm, 1853–

Introduction to chemistry, by Wilhelm Ostwald; authorized translation by William T. Hall and Robert S. Williams ... with 74 figures in the text. 1st ed. 1st thousand. New York, J. Wiley & sons; [etc., etc.] 1911.

ix, 368 p. illus. 21ᶜᵐ. $1.50

© Mar. 28, 1911; 2c. Mar. 30, 1911*; A 283800; W. T. Hall and R. S. Williams, Boston. (11-6454) 1550

Pattullo, George.

The untamed; range life in the Southwest, by George Pattullo. New York, D. Fitzgerald, inc. [c1911]

288 p. col. front., plates. 19½ᶜᵐ. $1.20
CONTENTS.—Ol' Sam, a mule.—The marauder, a coyote.—Corazón, a roping horse.—The outlaw, a steer.—Shiela, a wolfhound.—Molly, a range cow.—The baby and the puma, mountain lion.—The mankiller, a jack.—Neutria, a mountain cowhorse.

© Apr. 1, 1911; 2c. Apr. 3, 1911*; A 283898; Desmond Fitzgerald, inc.
(11-6948) 1551

Phillpotts, Eden, 1862–

Demeter's daughter, by Eden Phillpotts ... New York, John Lane company, 1911.

348 p. 19½ᶜᵐ. $1.35

© Mar. 27, 1911; 2c. Mar. 30, 1911*; A 283833; E. Phillpotts, Torquay, England. (11-6441) 1552

Pickering, Henry Goddard, 1848–
Sed quaere ... a volume of charades. Boston, Priv. print., 1911.

[108] p. 18ᶜᵐ. $1.00

© Feb. 17, 1911; 2c. Mar. 11, 1911*; A 283340; H. G. Pickering, Boston. (11–7216) 1553

Reid, Mary Eliza.
Bacteriology in a nutshell; a primer for nurses. Comp. and arranged by Mary E. Reid ... 4th ed., rev. and enl. ... Cincinnati, O., July 1904; Charleston-on-Kanawha, W. Va., 1907–1910.

v, 206 p. 19½ᶜᵐ. $1.15

© Dec. 1, 1910; 1c. Nov. 25, 1910; 1c. Mar. 29, 1911*; A 283769; M. E. Reid, Charleston, W. Va. (11–7251) 1554

Reinsch, Paul Samuel, 1869– ed.
Readings on American state government, ed. by Paul S. Reinsch ... Boston, New York [etc.] Ginn and company [°1911]

vi, 473 p. 21½ᶜᵐ. $2.25

"Bibliographical note, by William L. Bailey": p. 465–470.

© Mar. 25, 1911; 2c. Mar. 30, 1911*; A 283824; P. S. Reinsch, Madison, Wist. (11–6497) 1555

Roberts, Morley, 1857–
Thorpe's way, by Morley Roberts. New York, The Century co., 1911.

5 p. l., 3–374 p. 19½ᶜᵐ.

© Apr. 5, 1911; 2c. Apr. 6, 1911*; A 283967; Century co. (11–6955) 1556

Rohr, Moritz i. e. Louis Otto Moritz von, 1868–
... Die optischen instrumente, von dr. Moritz von Rohr ... 2., verm. und verb. aufl., mit 88 abbildungen im text. Leipzig, B. G. Teubner, 1911.

vi, 140 p. illus., diagrs. 18½ᶜᵐ. (Aus natur und geisteswelt ... 88. bdchen.) M. 1.25

© Feb. 9, 1911; 2c. Mar. 27, 1911*; A–Foreign 2691; B. G. Teubner. (11–7252) 1557

Schauffler, Robert Haven, 1879– ed.
... Memorial day (Decoration day) its celebration, spirit, and significance as related in prose and verse, with a non-sectional anthology of the civil war, ed. by Robert Haven Schauffler ... New York, Moffat, Yard and company, 1911.

xxvii, 327 p. 19ᶜᵐ. (Half-title: Our American holidays) $1.00

© Mar. 25, 1911; 2c. Mar. 29, 1911*; A 283774; Moffat, Yard & co. (11–6709) 1558

Schreiner, Olive, "*Mrs.* S. C. Cronwright Schreiner."

Woman and labor, by Olive Schreiner ... New York, Frederick A. Stokes company [1911]

5 p. l., 3–299 p. 19½ᶜᵐ.

© Mar. 31, 1911; 2c. Apr. 5, 1911*; A 283958; F. A. Stokes co.
(11–7240) 1559

[Simpson, Bertram Lenox]

The unknown God, by B. L. Putnam Weale [*pseud.*] ... New York, Dodd, Mead and company, 1911.

3 p. l., 391 p. 19½ᶜᵐ.

© Apr. 4, 1911; 2c. Apr. 5, 1911*; A 283957; Dodd, Mead & co.
(11–6954) 1560

Smith, Francis Scott Key, 1872--

Francis Scott Key, author of the Star spangled banner; what else he was and who, by F. S. Key-Smith ... Washington, D. C., Key-Smith and company [ᶜ1911]

104 p. 4 pl., 3 port. (incl. front.) facsim. 19½ᶜᵐ. $0.75

© Mar. 28, 1911; 2c. Mar. 29, 1911; A 283831; F. S. Key-Smith.
(11–7226) 1561

Stokes, Charles Francis.

Naval surgery, by Surgeon-General Charles Francis Stokes, United States Navy ... New York, W. Wood and company, 1911. .

1 p. l., p. [969]–1029. illus. 28ᶜᵐ. $2.00
"Reprinted from American practice of surgery; editors: Joseph Decatur Bryant, M. D., Albert Henry Buck, M. D."

© Mar. 31, 1911; 2c. Apr. 1, 1911*; A 283864; Wm. Wood & co.
(11–7259) 1562

Stratemeyer, Edward, 1862--

... Dave Porter and his rivals; or, The chums and foes of Oak hall, by Edward Stratemeyer ... illustrated by John Goss. Boston, Lothrop, Lee & Shepard co. [1911]

vi p., 1 l., 308 p. front., plates. 19ᶜᵐ. (*His* Dave Porter series [v. 7]) $1.25

© Mar. 27, 1911; 2c. Mar. 29, 1911*; A 283794; Lothrop, Lee & Shepard co.
(11–6442) 1563

Teall, Gardner Callahan, 1878

The contessa's sister; a novel, by Gardner Teall. Boston and New York, Houghton Mifflin company, 1911.

4 p. l., 243, [1] p., 1 l. 19½ᶜᵐ.

© Mar. 25, 1911; 2c. Apr. 7, 1911*; A 286010; G. Teall, New York.
(11–7261) 1564

Wilson, Guy H.

His beautiful life, by Guy H. Wilson. Dallas, Tex., Johnston printing co., 1910.

242 p. incl. front. (port.) 16½ x 9½ᶜᵐ. $0.75

© Sept. 1, 1910; 2c. Mar. 8, 1911*; A 283242; G. H. Wilson, Athens, Tex.
(11–7263) 1565

The **American** state reports, containing the cases of general value and authority ... decided in the courts of last resort of the several states. Selected, reported, and annotated by A. C. Freeman. v. 136. San Francisco, Bancroft-Whitney company, 1911.

15 p., 1 l., 17-1200 p. 23ᶜᵐ. $4.00
© Apr. 14, 1911; 2c. Apr. 20, 1911*; A 286315; Bancroft-Whitney co.
1566

Arrhenius, Svante August, 1859-

Die vorstellung vom weltgebäude im wandel der zeiten. Das werden der welten. Neue folge, von Svante Arrhenius. Aus dem schwedischen übersetzt von L. Bamberger; mit 28 abbildungen. 4. bis 6. verm. und verb. aufl. Leipzig, Akademische verlagsgesellschaft m. b. h., 1911.

xii. 206 p., 1 l. illus. 24½ᶜᵐ. M 5
© Feb. 15, 1911; 2c. Mar. 22, 1911*; A—Foreign 2648; Akademische verlagsgesellschaft m. b. h. (11-7558) 1567

Bell, John Joy, 1871-

A kingdom of dreams, by J. J. Bell; with a frontispiece by E. S. Hodgson. London, New York [etc.] Cassell and company, ltd., 1911.

vi p., 1 l., 344 p. col. front. 19½ᶜᵐ. 6/
© 1c. Apr. 11, 1911*; A ad int. 580; publd. Mar. 16, 1911; Cassell & co., ltd., New York. (11-7747) **1568**

Bible. *O. T. Deuteronomy. English.*

... Commentary on the book of Deuteronomy, by W. G. Jordan ... New York, The Macmillan company, 1911.

xi, 263 p. 17ᶜᵐ. (*Half-title:* The Bible for home and school, S. Mathews, general editor) $0.75
© Mar. 15, 1911; 2c. Mar. 16, 1911*; A 283431; Macmillan co.
(11-7760) 1569

Brady, Cyrus Townsend, 1861-

Hearts and the highway; a romance of the road, first set forth by Lady Katharine Clanranald and Sir Hugh Richmond, and now transcribed by Cyrus Townsend Brady ... illustrated by F. C. Yohn. New York, Dodd, Mead and company, 1911.

xi p., 2 l., 3-321 p. col front., col. plates. 19½ᶜᵐ. $1.25
© Apr. 8, 1911; 2c. Apr. 10, 1911*; A 286056; Dodd, Mead & co.
(11-7743) 1570

Brower, Harriette.

The art of the pianist; technic and poetry in piano playing, for teacher and student, by Harriette Brower. New York, C. Fischer, 1911.

1 p. l., vii-ix, [3], 3-209 p. plates. 20½ᶜᵐ. $1.25
"A few of the following chapters, in somewhat altered form, have appeared in the 'Musician,' and 'Etude.'"—Introd.
© Feb. 23, 1911; 2c. Apr. 3, 1911*; A 283910; Carl Fischer.
(11-7309) 1571

273

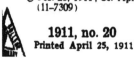

Burke, Steve *i. e.* **Joseph Stephen,** 1860–
Revival addresses, by Steve Burke. New York and
Chicago, The Revell company press, 1911.
253 p. front. (port.) 19½ᶜᵐ. $1.00
© Mar. 2, 1911; 2c. Mar. 18, 1911*; A 283511; S. Burke, U. S.
(11–7564) 1572

Caffin, Charles Henry, 1854–
A guide to pictures for beginners and students, by
Charles H. Caffin ... New York, The Baker & Taylor
company, 1910.
253 p. front., plates. 19ᶜᵐ. (*On cover:* The guide series)
© July 27, 1908; 2c. Mar. 20, 1911; A 283934; Baker & Taylor co.
(11–7568) 1573

Carpenter, Frank George, 1855–
... How the world is housed, by Frank G. Carpenter ...
New York, Cincinnati [etc.] American book company
[ᶜ1911]
352 p. illus. 19ᶜᵐ. (*His* Readers on commerce and industry) $0.60
© Mar. 28, 1911; 2c. Mar. 30, 1911*; A 283815; F. G. Carpenter, Washing-
ton, D. C. (11–7553) 1574

Colles, William Morris, 1855–
Success in literature, by William Morris Colles and
Henry Cresswell. New York, Duffield and company, 1911.
vi p., 2 l., 11–360 p. 19½ᶜᵐ. $1.25
© Mar. 30, 1911; 2c. Apr. 1, 1911*; A 283874; Duffield & co.
(11–7544) 1575

Craig, Sarah E Woodworth.
Scientific cooking with scientific methods, by Sarah E.
Woodworth Craig ... Cincinnati, O., Standard publish-
ing co., 1911.
ix p., 1 l., 404 p. 20ᶜᵐ. $1.00
© Mar. 13, 1911; 2c. Mar. 18, 1911*; A 283496; S. E. W. Craig, Cincinnati,
O. (11–7767) 1576

Daab, Friedrich *i. e.* **C. H. L. Friedrich,** *ed.*
Das suchen der zeit; blätter deutscher zukunft, hrsg.
von Friedrich Daab und Hans Wegener. 6. bd. Giessen,
A. Töpelmann (vormals J. Ricker) 1911.
149 p. 19½ᶜᵐ. M. 2.50
© Feb. 6, 1911; 2c. Apr. 17, 1911*; A—Foreign 2771; Alfred Töpelmann.
 1577

Dortch, David Elijah, 1851–
Bible lights on baptism, by Rev. D. E. Dortch ... Tul-
lahoma, Tenn., The Gospel Winchester company, ᶜ1911.
211 p., 1 l. illus. (incl. port.) 23½ᶜᵐ. $1.00
© Mar. 20, 1911; 2c. Apr. 1, 1911*; A 283863; D. E. Dortch, Tullahoma,
Tenn. (11–7761) 1578

Fowler, George Little, 1855–

Locomotive breakdowns, emergencies, and their reme-
dies; an up-to-date catechism ... by Geo. L. Fowler, M. E.
Enlarged and revised to date by Wm. W. Wood ... Con-
tains over 500 practical questions with their answers.
7th rev. ed. ... New York, The Norman W. Henley pub-
lishing co., 1911.

293 p. front., illus., fold. pl. 17ᶜᵐ.

© Mar. 21, 1911; 2c. Mar. 24, 1911*; A 283640; Norman W. Henley pub.
co. (11-7765) **1579**

Friedrich, Ernst, 1867–

... Geographie des welthandels und weltverkehrs, von
dr. Ernst Friedrich ... Jena, G. Fischer, 1911.

viii, 429. (1) p., 1 l. 6 fold. maps. 26ᶜᵐ. M. 11

© Mar. 9, 1911; 2c. Apr. 1, 1911*; A—Foreign 2709; Gustav Fischer, Jena,
Germany. (11-7315) **1580**

Gregory, Mary Huston.

Checking the waste; a study in conservation, by Mary
Huston Gregory ... Indianapolis, The Bobbs-Merrill
company [c1911]

5 p. l., 318 p. 19ᶜᵐ.

© Apr. 1, 1911; 2c. Apr. 5, 1911; A 283995; Bobbs-Merrill co.
(11-7313) **1581**

Guiart, Jules, 1870–

... Les parasites, inoculateurs de maladies; avec 107
figures dans le texte. Paris, E. Flammarion,.1911.

vi, 362 p., 1 l. illus. 19ᶜᵐ. (Bibliothèque de philosophie scientifique)
fr. 3.50

© Mar. 15, 1911; 2c. Mar. 23, 1911*; A—Foreign 2664; Ernest Flammarion.
(11-7258) **1582**

Haswell, Alanson Mason, 1847–

Wayside verses, by A. M. Haswell. [Springfield? Mo.]
1910.

3 p. l., [9]–160 p. 19¼ᶜᵐ. $1.00

© Mar. 8, 1911; 2c. Mar. 31, 1911*; A 283855; A. M. Haswell, Springfield,
Mo. (11-7281) **1583**

Henderson, William James, 1855–

Some forerunners of Italian opera, by W. J. Henderson
... New York, H. Holt and company, 1911.

vii p., 1 l., 243 p. 19ᶜᵐ. $1.25
With music.

© Mar. 24, 1911; 2c. Mar. 29, 1911*; A 283781; Henry Holt & co.
(11-7308) **1584**

Hicks, Isaac Perry, 1856–

The estimators' price book and pocket companion; a
guide to prices of all kinds of building materials; with
handy rules, tables and information for the estimator.

Hicks, Isaac Perry—Continued

3d ed. Rev. and enl. By I. P. Hicks ... New York, David Williams company, 1911.

184 p. 15½ᶜᵐ. $1.00

"Second" edition, on title-page changed to "3d," in manuscript.

© Feb. 28, 1911; 2c. Mar. 15, 1911; A 283735; David Williams co.
(11-7335) 1585

Hoffmann, *Frau* Adolf.

Nicht umsonst gelebt. Drei lebensbilder von frau Adolf Hoffmann, Genf. 3· bis 5. tausend. Stuttgart, Ev. gesellschaft, 1910.

168 p. front. (port.) 20ᶜᵐ. (*Half-title:* Aus klaren quellen)

CONTENTS.—Helene von Orleans. — Dr. Marie Wood-Allen. — Eva von Prosch.

© Dec. 28, 1910; 2c. Mar. 22, 1911; A—Foreign 2650; Verlag der ev. gesellschaft. (11-7267) 1586

Johnson, Gertrude Tacy, 1856–

Domestic science, a text in cooking and syllabus in sewing, prepared for use in the Kansas City elementary schools, yet eminently fitted for home work ... 2d ed., rev. and enl. By Gertrude T. Johnson. Kansas City, Mo., The Burton publishing co., 1911.

153 p. incl. front.. illus. pl. 19ᶜᵐ. $0.60

© Apr. 1, 1911; 2c. Apr. 3, 1911*; A 283908; G. T. Johnson, Kansas City, Mo. ¡Copyright is claimed on Appendix and 29 new illustrations¡
(11-7764) 1587

[Johnson, Levi C.]

The Colorado situation; or, Maria and her husband in politics and society, by "Jacob Short" [*pseud.*] Denver, Col., Printed by Western newspaper union, 1911.

189 p. illus. 20½ᶜᵐ. $1.25

© Jan. 23, 1911; 2c. Feb. 2, 1911*; A 280527; L. C. Johnson, Denver, Col.
(11-7753) 1588

Juvenile protective association of Chicago.

Manual of juvenile laws, Juvenile protective association of Chicago; comp. and rev. by Harry E. Smoot ... [Chicago, Blakely printing company] 1911.

108 p. 18½ᶜᵐ. $0.25

© Feb. 17, 1911; 2c. Mar. 31, 1911*; A 283854; Juvenile protective assn. of Chicago. (11-7573) 1589

König, Eberhard, 1871–

... Der dombaumeister von Prag ... Mainz, J. Scholz [°1911]

199, [1] p. illus. 20ᶜᵐ. (*Half-title:* Mainzer volks- und jugendbücher) M. 3

© Mar. 7, 1911; 2c. Mar. 25, 1911*; A—Foreign 2685; Jos. Scholz.
(11-7284) 1590

Lawson, James Gilchrist.

Deeper experiences of famous Christians, gleaned from their biographies, autobiographies and writings, by J. Gilchrist Lawson ... Chicago, Ill., Glad tidings publishing company [c1911]

xiii, [1], 15–381, [1] p. incl. front., ports. 20ᶜᵐ. $1.00
© Mar. 29, 1911; 2c. Mar. 31, 1911*; A 283839; J. G. Lawson, Chicago.
(11-7297) 1591

Lhotzky, Heinrich *i. e.* **Johannes Heinrich,** 1859–

... Das buch der ehe. Düsseldorf und Leipzig, K. R. Langewiesche [c1911]

20? p., 2 l. 19ᶜᵐ. M.3
© Feb. 10, 1911; 2c. Apr. 1, 1911*; A - Foreign 2703; Karl Robert Langewiesche. (11-7756) 1592

McCarthy, Justin Huntly, 1860–

The king over the water; or, The marriage of Mr. Melancholy, by Justin Huntly McCarthy ... New York and London, Harper & brothers, 1911.

3 p. l., 377, [1] p. 19½ᶜᵐ. $1.50
© Apr. 6, 1911; 2c. Apr. 8, 1911*; A 286030; Harper & bros.
(11-7302) 1593

McCutcheon, George Barr, 1866–

What's-his-name, by George Barr McCutcheon; with illustrations by Harrison Fisher. New York, Dodd, Mead and company, 1911.

5 p. l., 243 p. col. front., col. plates. 19½ᶜᵐ. $1.25
© Apr. 7, 1911; 2c. Apr. 10, 1911*; A 286055; G. B. McCutcheon, New York. (11-7738) 1594

Mack, William, *ed.*

Cyclopedia of law and procedure, William Mack ... editor-in-chief. v. 37. New York, The American law book company, 1911.

3 p. l., 1799 p. 26ᶜᵐ. $7.50
© Apr. 19 1911; 2c. Apr. 20, 1911*; A 286316; Amer. law book co.
 1595

Matthews, R S.

"The retail butcher," by R. S. Matthews. [Memphis, Press the H. W. Dixon co., c1911]

101 p. incl. illus., port. 23½ᶜᵐ. $3.00
© Apr. 1, 1911; 2c. Apr. 3, 1911*; A 283912; R. S. Matthews, Memphis, Tenn. (11-7766) 1596

Maupassant, Guy de, 1850–1893.

L'auberge, et autres contes, par Guy de Maupassant; avec introduction, notes et vocabulaire par Dr. A. Schinz. New York, W. R. Jenkins co. [c1911]

xiv, 177 p. 16ᶜᵐ. (*On cover:* Contes choisis, no. 25) $0.25
CONTENTS.—L'auberge.—Le garde.—La mère sauvage.—Le bonheur.—L'infirme.—La main.—Deux amis.—L'aventure de Walter Schnaffs.
© Mar. 22, 1911; 2c. Mar. 24, 1911*; A 283667; Wm. R. Jenkins co.
(11-7283) 1597

Moore, Addison.

Hindrances to happiness, by Addison Moore ... New York, Hodder and Stoughton, George H. Doran company [°1911]

97 p. 20ᶜᵐ. $0.50

© Mar. 31, 1911; 2c. Apr. 1, 1911*; A 283873; Geo. H. Doran co. (11-7567) 1598

Morris, Gouverneur, 1876–'

Yellow men and gold, by Gouverneur Morris ... with illustrations by Charles B. Falls. New York, Dodd, Mead and company, 1911.

244 p. col. front., illus., col. plates. 19½ᶜᵐ. $1.20

© Apr. 8, 1911; 2c. Apr. 10. 1911*; A 286057; Dodd, Mead & co. (11-7742) 1599

North Carolina. *Constitution.*

The constitution of the state of North Carolina, annotated, by Henry G. Connor ... and Joseph B. Cheshire, jr. ... Raleigh, Edwards & Broughton printing company, 1911.

lxxx, 510 p. 23½ᶜᵐ. $3.75

© Mar. 11, 1911; 2c. Mar. 22, 1911*; A 283589; H. G. Connor, Wilson, N. C., and J. B. Cheshire, jr., Raleigh, N. C. (11-7755) 1600

Pegram, Sherley.

Sherley; book of poems, choice and rare, by Sherley Pegram ... Richmond, Va., The Hermitage press, 1911.

xii, 191 p. front. (port.) 19½ᶜᵐ. $1.50

© Apr. 3. 1911; 2c. Apr. 3, 1911; A 286046; S. Pegram, Elkin, N. C. (11-7287) 1601

Pfefferkorn, Otto Wilhelm Gottholdt, 1863–

Pianistic hints, by Otto W. G. Pfefferkorn. Gainesville, Ga., The Brenan publishing company [°1911]

3 p. l., 34 p. 20ᶜᵐ.

© Mar. 3, 1911; 2c. Mar. 21. 1911*; A 283575; O. W. G. Pfefferkorn, Gainesville, Ga. (11-7306) 1602

Pratt food company.

Pratts poultry pointers. Philadelphia, Chicago [etc.] Pratt food company, °1911·

1 p. l., [5]–161 p. illus. 18½ᶜᵐ.

© Mar. 27. 1911; 2c. Mar. 21, 1911*; A 283570; Pratt food co. (11-7292) 1603

Roberts, David.

Dr. David Roberts practical home veterinarian ... 9th ed., rev. to 1911. Waukesha, Wis., Dr. David Roberts veterinary co., °1911.

182 p., 1 l. illus. 23ᶜᵐ. $1.00

© Mar. 6, 1911; 2c. Mar. 18, 1911*; A 283504; D. Roberts, Waukesha, Wis. (11-7293) 1604

Robinson, George Livingstone, 1864–
The abiding value of the Old Testament, by George L.
Robinson ... New York, Young men's Christian associa-
tion press, 1911.
50 p. 18ᶜᵐ. $0.35
© Mar. 29, 1911; 2c. Mar. 30, 1911*; A 283819; International committee of
Y. M. C. A., New York. (11–7762) 1605

A satchel guide for the vacation tourist in Europe; a com-
pact itinerary of the British Isles, Belgium and Hol-
land, Germany and the Rhine, Switzerland, France,
Austria, and Italy. By W. J. Rolfe, LITT. D. With
maps. Rev. annually. 1st ed. for 1911. Boston and
New York, Houghton Mifflin company; [etc., etc.] 1911.
x p., 1 l., 328 p. 3 fold. maps (2 in pockets) 3 fold. plans. 16ᶜᵐ.
40th annual edition.
© Mar. 25, 1911; 2c. Apr. 7, 1911*; A 286005; Houghton Mifflin co.
(11–7752) 1606

Schnitzler, Arthur, 1862–
Anatol: a sequence of dialogues by Arthur Schnitzler;
paraphrased for the English stage by Granville Barker.
London, Sidgwick & Jackson, limited, 1911.
5 p. l., 3–125 p. 19ᶜᵐ.
© 1c. Apr. 5, 1911*; A ad int. 569; pubd. Mar. 6, 1911; Mitchell Kennerley,
New York. (11–7545) 1607

Segall, Sol.

-אַרפֿע:קלאַנג (געריבטע) ... פֿון סאָל. סנ"ל. אר
.1911 ,וויסגנעבען פֿון ר· מ· סענאַלל, ניו יאָרק

96 p. front. (port.) 18½ᶜᵐ. $0.25
© Mar. 1, 1911; 2c. Mar. 16, 1911*; A 283445; Sol Segall, New York.
(11–7547) 1608

Stewart, A D.
Heather and peat, by A. D. Stewart. London, A. Mel-
rose, 1911.
v, 288 p. 18½ᶜᵐ. $1.20
© 1c. Mar. 3, 1911*; A ad int. 502; pubd. Feb. 3, 1911; Fleming H. Revell
co., New York. (11–7304) 1609

Same. New York, Chicago [etc.] Fleming H. Revell
company [c1911]
319 p. 19½ᶜᵐ. $1.20
© Mar. 25, 1911; 2c. Mar. 30, 1911*; A 283802; Fleming H. Revell co.
(11–7305) 1610

Taine, Hippolyte Adolphe, 1828–1893.
Les origines de la France contemporaine, par H. A.
Taine. Extracts with annotations and biographical
sketch, by J. F. Louis Raschen ... New York, Cincinnati
[etc.] American book company [c1911]
272 p. 16½ᶜᵐ $0.60
"Works of reference on Taine": p. 10.
© Mar. 30, 1911; 2c. Apr. 1, 1911*; A 283859; J. F. L. Raschen, Easton,
Pa. (11–7296) 1611

Tucker, William Jewett, 1839-

The function of the church in modern society, by William Jewett Tucker ... Boston and New York, Houghton Mifflin company, 1911.

v. (1), 109, (1) p., 1 l. 17½ᶜᵐ. (*Half-title:* Modern religious problems, ed. by A. W. Vernon)

© Mar. 25, 1911; 2c. Apr. 7. 1911*; A 286004; W. J. Tucker, Hanover, N. H. (11-7565) **1612**

Wallnöfer, Adolf, 1854-

Resonanztonlehre, von Wallnöfer. Berlin, Verlag Dreililien, 1911.

63, (1) p. illus. 29 x 12½ᶜᵐ.

In pocket: Resonanzton- und vocal-übungsbeispiele, von Ad. Wallnöfer. Ausg. fur alt oder bass. Berlin, Verlag Dreililien (ᶜ1910) 19 p.

© Feb 27. 1911; 2c. Mar. 22, 1911*; A -Foreign 2661; Dreililien verlag. (11-7310) **1613**

West Virginia. *Supreme court of appeals.*

Reports of cases determined ... from February 1, 1910, to October 18, 1910, by William G. Conley, attorney general and ex-officio reporter. v. 67. Charleston, The Tribune printing co., 1910.

xxxix, 751. p. 23ᶜᵐ. $2.50

© Apr. 11, 1911; 2c. Apr. 13, 1911; A 286356; State of West Virginia, Charleston, W. Va. **1614**

Wichert, Ernst, 1831-1902.

Die verlorene tochter; humoreske von Ernst Wichert; ed., with notes and vocabulary by E. H. Babbitt. New York, H. Holt and company, 1911.

iv, 117 p. 17ᶜᵐ. $0.35

© Mar. 11, 1911; 2c Mar. 20, 1911*; A 283543; Henry Holt & co. (11-7285) **1615**

Wildenbruch, Ernst *i. e.* Adam Ernst von, 1845-1909.

Kindertränen; zwei erzählungen von Ernst von Wildenbruch; ed., with introduction, notes, vocabulary, and exercises by A. E. Vestling ... New York, H. Holt and company, 1911.

v, 179 p. 17ᶜᵐ. $0.35

CONTENTS.—Der letzte.--Die landpartie.

© Mar. 27, 1911; 2c. Mar. 29, 1911*; A 283780; Henry Holt & co. (11-7282) **1616**

Ziegler, G A.

Prohibition and anti-prohibition, by Rev. G. A. Ziegler, D. M., W. E. Rommell, v. D. M., and Geo. Herz. New York, Chicago (etc.) Broadway publishing co. (ᶜ1911)

146 p. front., plates, ports., map. 20ᶜᵐ. $1.00

© Mar. 1, 1911; 2c. Mar. 18, 1911*; A 283489; Broadway pub. co. (11-7576) **1617**

Abbott, Benjamin Vaughan, 1830–1890.

The clerks' and conveyancers' assistant. A collection
of forms of conveyancing, contracts, and legal proceed-
ings, for the use of the legal profession, business men, and
public officers in the United States. With copious instruc-
tions, explanations, and authorities. By Benj. **V**. Abbott
and Austin Abbott. 3d ed., rev. and enl., by Clarence F.
Birdseye ... New York, Baker, Voorhis and company,
1911.

xi, 1686 p. 24½ᶜᵐ.

© Mar. 24, 1911; 2c. Apr. 6, 1911*; A 283968; Clarence F. Birdseye, New
York. (11-7864) **1618**

American historical association.

The study of history in secondary schools, report to the
American historical association, by a Committee of five:
Andrew C. McLaughlin, chairman, Charles H. Haskins,
James H. Robinson, Charles W. Mann, James Sullivan.
New York, The Macmillan company, 1911.

3 p. l., 72 p. 19ᶜᵐ. $0.25

© Mar. 15, 1911; 2c. Mar. 16, 1911*; A 283430; Macmillan co.
(11-7878) **1619**

Andreae, Karl, 1841–

Die entwicklung der theoretischen pädagogik, von Carl
Andreae. Leipzig, B. G. Teubner, 1911.

vii, (1), 188 p. 21ᶜᵐ. M. 2.60

© Dec. 28, 1910; 2c. Mar. 22, 1911*; A—Foreign 2636; B. G. Teubner.
(11-8102) **1620**

Balliett, Sarah Joanna (Dennis) *"Mrs.* **L. D. Balliett,"**
1847–

Nature's symphony; or, Lessons in number vibration,
by Mrs. L. Dow Balliett ... Atlantic City, N. J.; London,
L. N. Fowler & co., 1911.

x, 11–127 p. 22½ᶜᵐ. $1.25

© Mar. 11, 1911; 2c. Apr. 1, 1911*; A 283885; Mrs. L. D. Balliet, Atlantic
City, N. J. (11-8095) **1621**

Barringer, Daniel Moreau.

The law of mines and mining in the United States, by
Daniel Moreau Barringer ... and John Stokes Adams ...
v. 2. St. Paul, Minn., The Keefe-Davidson co., 1911.

xliv, 798, (1) p. diagrs. $7.50

© Mar. 10, 1911; 2c. Mar. 13, 1911*; A 283350; D. M. Barringer, Philadel-
phia. **1622**

Boissonnas, Frédéric.

Le Parthénon. Introduction par Maxime Collegnon ...
photographies de Frédéric Boissonnas ... et W.-A. Man-
sell & co. Paris, Librairie centrale d'art et d'architec-
ture (etc., 1910)

Various paging. plates. fol. fr. 100

© Dec. 30, 1910; 2c. Jan. 21, 1911*; A—Foreign 2404; Ch. Eggimann,
Paris. **1623**

Boynton, George B 1842–1911.

The war maker; being the true story of Captain George B. Boynton, by Horace Smith; with portrait. Chicago, A. C. McClurg & co., 1911.

415 p. front. (port.) 21ᶜᵐ. $1.50

© Mar. 25, 1911; 2c. Mar. 29, 1911*; A 283764; A. C. McClurg & co.
(11–7556) 1624

Brooks, Elizabeth Harper.

Java and its challenge, by Elizabeth Harper Brooks. A mission study course for the Pittsburg conference young people. ₍Cincinnati, O., Jennings & Graham, ᶜ1911₎

196 p. front. (map) plates, ports. 19ᶜᵐ. $0.50

"List of reference books": p. 196.

© Mar. 24, 1911; 2c. Mar. 28, 1911; A 286052; E. H. Brooks, Beaver, Pa.
(11–7566) 1625

Chappelle, L L.

The diverging paths; a story of the pioneer days of Missouri, by L. L. Chappelle. New York, Chicago ₍etc.₎ Broadway publishing co. ₍ᶜ1911₎

214 p. front., plates. 20ᶜᵐ. $1.50

© Feb. 1, 1911; 2c. Mar. 18, 1911*; A 283490; Broadway pub. co.
(11–7872) 1626

Child conference for research and welfare.

Proceedings of the Child conference for research and welfare. 2. 1910 ... New York city, G. S. Stechert & co. ₍1911₎

1 p. l., iv, 286 p., 1 l. 23½ᶜᵐ.

© Jan. 10, 1911; 2c. Jan. 11, 1911; A 280206; G. Stanley Hall, Worcester, Mass. 1627

Coburn, Foster Dwight, 1846– *ed.*

Uncle Sam's farm book; a manual of useful and practical information upon subjects of everyday interest to the farmers of the central West, gathered from the writings of the experts of the U. S. Agricultural department; selected and collated by F. D. Coburn ... St. Joseph, Mo., The News corporation, 1911.

371 p. incl. illus., port. 23½ᶜᵐ.

© Mar. 30, 1911; 2c. Apr. 5, 1911*; A 283944; Louis T. Golding, St. Joseph, Mo. (11–7769) 1628

Curran, Charles H.

Through lands of yesterday; a story of romance and travel, by Charles H. Curran, M. D. Boston, Chapple publishing company, limited, 1911.

3 p. l., 421 p. front., plates. 19ᶜᵐ. $1.50

© Mar. 15, 1911; 2c. Mar. 18, 1911; A 283605; C. H. Curran, Holyoke, Mass. (11–8101) 1629

Duggar, John Frederick, 1868–

Southern field crops (exclusive of forage plants) by John Frederick Duggar ... New York, The Macmillan company, 1911.

xxvii, 579 p. illus. 19½ᶜᵐ. (Half-title: The rural ... text-book series, ed. by L. H. Bailey)
"Literature" at end of chapters.

© Apr. 5, 1911; 2c. Apr. 6, 1911*; A 283974; Macmillan co.
(11–7770) 1630

Ely, Helena Rutherfurd.

The practical flower garden, by Helena Rutherfurd Ely ... with illustrations made from photographs taken in the author's garden, and in the "Connecticut garden." New York, London, The Macmillan company, 1911.

xiii, 304 p. col. front., illus., plates (partly col.) 20ᶜᵐ.

© Apr. 5, 1911; 2c. Apr. 6, 1911*; A 283973; Macmillan co.
(11–7295) 1631

Faris, John Thomson, 1871–

The romance of the English Bible, by John T. Faris. Philadelphia, The Westminster press, 1911.

63 p. 2 port. (incl. front.) facsim. 18½ᶜᵐ. $0.25
Contents.—In the days of the manuscripts.—When Bibles were scarce.—Tyndale, the martyr translator.—Five sixteenth century versions.—The story of the King James version.—The debt of the English language to the King James version.—The revised version of 1881–1885.—The American standard version.

© Mar. 21, 1911; 2c. Mar. 23, 1911*; A 283635; Trustees of the Presbyterian board of publ. & Sabbath school work, Philadelphia.
(11–8093) 1632

Farseth, Olaus C 1852–

Raad og vink i menighedsarbeidet, af O. C. Farseth ... Minneapolis, Minn., Augsburg publishing house, 1911.

234 p., 1 l. 20ᶜᵐ. $0.65

© Mar. 15, 1911; 2c. Mar. 20, 1911*; A 283523; Augsburg pub. house.
(11–8091) 1633

Favor, Ernest Howard, 1878–

The fruit-growers guide-book, by E. H. Favor ... St. Joseph, Mo., The fruit-grower, 1911.

285, [3] p. illus. 18ᶜᵐ. $1.00
"Books on agriculture": 3 p. at end.

© Mar. 13, 1911; 1c. Mar. 18, 1911; 1c. Mar. 27, 1911; A 286045; Fruit-grower. (11–7772) 1634

FitzGerald, Thomas W. H., ed.

Ireland and her people; a library of Irish biography together with a popular history of ancient and modern Erin ... Prepared and ed. by Thos. W. H. FitzGerald. v. 5. [History] Chicago, FitzGerald book company [1911]

3 p. l., [431]–871 p. front., ports., pl., map. 24½ᶜᵐ. $3.00

© Apr. 15, 1911; 2c. Apr. 24, 1911*; A 286390; FitzGerald book co.
 1635

Greendlinger, Leo.

Accountancy problems with solutions. v. 1. By Leo Greendlinger ... with introduction by John R. Loomis ... [2d ed.] New York city, Business book bureau, 1911.

6 p. l., 393 p. 23½ᶜᵐ. $5.00
© Mar. 29, 1911; 2c. Apr. 3, 1911*; A 283913; Business book bureau. (11-7757) 1636

Gusman, Pierre, 1862–

L'art décoratif de Rome de la fin de la repvbliqve av IVᵉ siècle. [1] Paris, Librairie centrale d'art et d'architectvre [ᶜ1911]

1 v. plates. 38½ᶜᵐ. fr. 25
© Mar. 20, 1911; 2c. Apr. 6, 1911*; A—Foreign 2735; Ch. Eggimann, Paris. 1637

Illinois. *Appellate courts.*

Reports of cases determined ... v. 155, 156, A. D. 1911 ... Ed. by W. Clyde Jones and Keene H. Addington ... Chicago, Callaghan & company, 1911.

2 v. 23ᶜᵐ. $3.50 per vol.
© v. 155, Apr. 13, 1911; v. 156, Apr. 15, 1911; 2c. each Apr. 22, 1911*; A 286364, 286377; Callaghan & co. 1638, 1639

Iowa. *Supreme court.*

Reports of cases at law and in equity ... September term, 1909, and January term, 1910, by W. W. Cornwall, reporter. v. 28, being volume 145 of the series. Chicago, Ill., T. H. Flood & co., 1910.

viii, 860 p. 23½ᶜᵐ. $3.00
© Apr. 11, 1911; 2c. Apr. 14, 1911; A 286403; W. C. Hayward, sec. of state. Des Moines, Ia. 1640

[Kupffer, Elisar von] 1872–

... Ein neuer flug und eine heilige burg. Deutsche ausg. München, Verlag Akropolis [1911]

1 p. l., 190 p. 24½ᶜᵐ. M. 3.50
Author's pseudonym "Elisarion," at head of title.
© Jan. 15, 1911; 2c. Mar. 25, 1911*; A—Foreign 2686; E. von Kupffer, Munich, Germany. (11-8089) 1641

Lowndes, *Mrs.* Marie Adelaide (Belloc) 1868–

Jane Oglander, by Mrs. Belloc Lowndes ... London, W. Heinemann, 1911.

2 p. l., 268 p. 20ᶜᵐ. 6/
© 1c. Apr. 8, 1911*; A ad int. 574; pubd. Mar. 14, 1911; Charles Scribner's sons, New York. (11-8097) 1642

Maryland. *Court of appeals.*

Reports of cases argued and adjudged ... William T. Brantly, state reporter. v. 113. Containing cases in January, April and October terms, 1910 ... Baltimore, King brothers, 1911.

xxvi, 778 p. 23½ᶜᵐ. $0.90
© Mar. 28, 1911; 2c. Apr. 24, 1911*; A 286422; W. T. Brantly, for the state of Maryland, Baltimore. 1643

Maxwell, William Babington.

Mrs. Thompson, by W. B. Maxwell. London, Hutchinson & co., 1911.

2 p. l., 383, ₁₁ p. 19½ᶜᵐ. 6/
© 1c. Apr. 13, 1911*; A ad int. 583; pubd. Apr. 11, 1911; D. Appleton & co., New York. (11–8099) · **1644**

Monaghan, James, *ed.*

Monaghan's cumulative annual digest of Pennsylvania decisions; being a digest of all the reported decisions of the Supreme, superior and county courts for the year 1910 ... James Monaghan, ed., assisted by Geo. H. Smith ... Newark, N. J., Soney & Sage, 1911.

2 p. l., 1004 numb. col. 26½ᶜᵐ. $6.00
© Apr. 15, 1911; 2c. Apr. 18, 1911*; A 286264; J. Monaghan, Philadelphia.
1645

... The **Pacific** reporter, with key-number annotations. v. 112. Permanent ed. ... January 9–February 27, 1911. St. Paul, West publishing co., 1911.

xv, 1291 p. 26½ᶜᵐ. (National reporter system--State series) $4.00
© Apr. 15, 1911; 2c. Apr. 24, 1911*; A 286419; West pub. co. **1646**

Page, Charles Nash, 1860–

Page's home floriculture; a complete guide for the growing of flowers in the house and garden. Cut flower work—landscape gardening, etc. By Chas. N. Page ... Des Moines, Ia., The author [ᶜ1911]

173, ₁₁ p. illus. 17½ᶜᵐ.
© Mar. 31, 1911; 2c. Apr. 6, 1911*; A 283985; C. N. Page, Des Moines, Iowa. (11–7771) **1647**

Pennsylvania. *County courts.*

Pennsylvania county court reports containing cases decided in the courts of the several counties of the commonwealth of Pennsylvania. v. 37. Philadelphia, T. & J. W. Johnson co., 1910.

xxii, 761 p. 23½ᶜᵐ. $5.00
© Apr. 4, 1911; 2c. Apr. 19, 1911*; A 286287; T. & J. W. Johnson co., Philadelphia. **1648**

Peters, Madison Clinton, 1859–

Hebrew hopes of heaven; what the Old Testament has to say about the great hereafter, by Madison C. Peters ... San Francisco, The Jewish times press [ᶜ1911]

24 p. 19ᶜᵐ. $0.50
© Feb. 25, 1911; 2c. Mar. 23, 1911*; A 283631; M. C. Peters, Brooklyn, N. Y. (11–8087) **1649˙**

Picard, Ernest.

... 1870. La guerre en Lorraine ... Paris, Plon-Nourrit et cⁱᵉ, 1911.

2 v. fold. maps. 19ᶜᵐ.
© Mar. 17, 1911; 2c. each Apr. 6, 1911*; A—Foreign 2725; Plon-Nourrit & co. (11–7881) **1650**

Reception to Mr. John H. Flagler. McKeesport, forty years after. New York, Priv. print. [The Cheltenham press] 1910.
6 p. l., [11]-88 p. front. (port.) pl., port. group. 21½ᶜᵐ.
© Mar. 4, 1911; 2c. Mar. 18, 1911*; A 283514; J. H. Flagler, New York, N. Y. (11-7857) 1651

Rogers, Louis William, 1859–
Hints to young students of occultism, by L. W. Rogers. 3d ed. Ridgewood, N. J., The Theosophical book co., 1911.
162 p. 17½ᶜᵐ.
© Mar. 6, 1911; 2c. Apr. 5, 1911*; A 283942; L. W. Rogers, Ridgewood, N. J. (11-8088) 1652

[**Shaw, A B A**]
The mind supreme; a study of the powers of self and personal success power. A book for everybody. 1st ed. [Pocatello, Id.] The International publishing co. [ᶜ1911]
97 p. 19ᶜᵐ. $1.00
© Feb. 28, 1911; 2c. Mar. 6, 1911; A 283479; Internatl. pub. co. (11-8092) 1653

Shaw, Thomas, 1843–
Weeds and how to eradicate them, by Thomas Shaw ... 3d ed., rev. St. Paul, Minn., Webb publishing co. [ᶜ1911]
236 p. front., illus. 16½ᶜᵐ $0.50
© Mar. 20, 1911; 2c. Apr. 6, 1911*; A 283982; Webb pub. co. (11-7768) 1654

Shepherd, May F.
Sadie; or, Happy at last [by] May F. Shepherd. New York, Chicago [etc.] Broadway publishing co. [ᶜ1911]
245 p. 20ᶜᵐ. $1.50
© Feb. 13, 1911; 2c. Mar. 18, 1911*; A 283481; M. F. Shepherd, Atlanta, Ga. (11-7870) 1655

Silberrad, Una Lucy, 1872–
Sampson Rideout, Quaker, by Una L. Silberrad. London, New York [etc.] T. Nelson and sons [1911]
vi, [7]-411, [1] p. col. front. 19ᶜᵐ.
© 1c. Apr. 12, 1911*; A ad int. 582; pubd. Mar. 15, 1911; U. L. Silberrad, London. (11-8100) 1656

... The **Southwestern** reporter, with key-number annotations. v. 133. Permanent ed. ... February 1–March 1, 1911. St. Paul, West publishing co., 1911.
xvi, 1358 p. 26½ᶜᵐ. (National reporter system—State series) $4.00
© Apr. 12, 1911; 2c. Apr. 24, 1911*; A 286417; West pub. co. 1657

——— Missouri decisions reported in the Southwestern reporter vols. 18, 19, and 20, February, 1892, to February, 1893 ... St. Paul, West publishing co., 1911.
Various paging. 26½ᶜᵐ. $5.50
© Apr. 10, 1911; 2c. Apr. 24, 1911*; A 286418; West pub. co. 1658

Steele, Chester K.

The mansion of mystery; being a certain case of importance, taken from the note-book of Adam Adams, investigator and detective, by Chester K. Steele ... New York, Cupples & Leon company [c1911]

2 p. l., 310 p. front., plates. 19½ᶜᵐ. $0.90

© Mar. 15, 1911; 2c. Mar. 21, 1911*; A 283553; Cupples & Leon co.
(11–7871) 1659

Stuart, Henry Longan.

Fenella; a novel, by Henry Longan Stuart ... London, Chatto & Windus, 1911.

vi, 389 p. 19½ᶜᵐ.

© 1c. Apr. 7, 1911*; A ad int. 570; pubd. Mar. 9, 1911; Chatto & Windus, London. (11–8098) 1660

Sutherland, Howard Vigne.

The woman who could; a play with a purpose, by Howard V. Sutherland. New York, D. Fitzgerald, inc., 1911.

4 p. l., 191 p. 19½ᶜᵐ.

© Apr. 1, 1911; 2c. Apr. 3, 1911; D 23880; Desmond Fitzgerald, inc.
(11–7286) 1660*

Texas. *Courts of civil appeals.*

The Texas civil appeals reports. Cases argued and adjudged ... during October, November and December, 1908. A. E. Wilkinson, reporter Texas Supreme court, J. A. Martin, assistant reporter. v. 52. Chicago, T. H. Flood & co., 1911.

xxviii, 725 p. 24ᶜᵐ. $3.00

© Apr. 5, 1911; 2c. Apr. 7, 1911; A 286402; Alfred E. Wilkinson, Austin, Tex. 1661

Turpin, Edna Henry Lee.

A short history of the American people, by Edna Henry Lee Turpin; with an introduction by S. C. Mitchell ... New York, The Macmillan company, 1911.

xviii p., 1 l., 478 p. illus., maps. 19½ᶜᵐ.
"List of books for reference use": p. 433–434.

© Apr. 5, 1911; 2c. Apr. 6, 1911*; A 283972; Macmillan co.
(11–7853) 1662

[Vickers, George Morley] 1841– *ed.*

The education of sex; a compilation from the writings and teachings of many eminent physicians and authorities—whose names appear throughout the book—forming a text-book on the physiology of marriage, the phenomena of life, existing social evils and their needed reforms. Philadelphia and London, The Gravic publishing company [c1911]

2 p. l., 3–275 p. illus. 21ᶜᵐ. $2.00

© Mar. 31, 1911; 2c. Apr. 4, 1911*; A 283923; Gravic pub. co.
(11–7574) 1663

Wagner, Richard, 1813–1883.

Richard Wagners briefwechsel mit seinen verlegern, hrsg. von Wilhelm Altmann ... bd. 1. Leipzig, Breitkopf & Härtel; [etc., etc., 1911]

xi, 239 p. 26^{cm}. M. 6

© Mar. 25, 1911; 2c. Mar. 25, 1911*; A—Foreign 2684; Breitkopf & Härtel. (11-7873) **1664**

Wallace, *Sir* Donald Mackenzie, 1841–

... Russia ... by Sir Donald Mackenzie Wallace ... Boston and Tokyo, J. B. Millet company [°1910]

3 v. col. fronts., plates. 25^{cm}. (Oriental series, vol. XXII–XXIV)
$2.50 per vol.

Vol. III, by Luigi Villari, published in 1905, by T. F. Unwin, London, under title: Russia under the great shadow.

Vol. I–II first published in 1877.

CONTENTS.—v. 1-2. Its history and condition to 1877.—v. 2. Russia of to-day.

© Mar. 10, 1911; 2c. v. 1, 2 Apr. 11, 1911*; 1c. v. 3 Apr. 11, 1911*; 1c. v. 3 Apr. 22, 1911; A 286004-286096; J. B. Millet co.
(11-7750) **1665-1667**

Williams, William Henry, 1874–

Railroad correspondence file, by W. H. Williams ... rev. and supplemented by John L. Hanna ... [New York, Wynkoop Hallenbeck Crawford co.] °1911·

231 (*i. e.* 235) p. pl. 25^{cm}.

© Mar. 22, 1911; 2c. Apr. 6, 1911*; A 283986; W. H. Williams, Plainfield. N. J. (11-7763) **1668**

Wirz, Georg.

Neue wege und ziele für die weiterentwicklung der sing- und sprechstimme, auf grund wissenschaftlicher versuche mit lauten, von dr. med. Georg Wirz ... Leipzig, Breitkopf & Härtel, 1911.

79, [3] p. 22½^{cm}. M. 2.50

© Mar. 10, 1911; 2c. Mar. 25, 1911*; A—Foreign 2681; Breitkopf & Härtel.
(11-7874) **1669**

Woermann, Karl.

Geschichte der kunst aller zeiten und völker, von Karl Woermann. 3. bd. Die kunst der christlichen völker vom 16. bis zum ende des 19. jahrhunderts ... Leipzig und Wien, Bibliographisches institut, 1911.

xx, 776 p. illus., plates (partly fold., partly col.) 26^{cm}. M. 17

© Mar. 4, 1911; 2c. Apr. 17, 1911*; A—Foreign 2765; Bibliographisches institut. **1670**

Zwiedineck-Südenhorst, Otto von, 1871–

... Sozialpolitik, von dr. Otto von Zwiedineck-Südenhorst ... Leipzig und Berlin, B. G. Teubner, 1911.

vii, [1] p., 1 l., 450 p. 23^{cm}. (B. G. Teubners handbücher für handel und gewerbe ...) M. 10

© Jan. 15, 1911; 2c. Mar. 22, 1911*; A—Foreign 2625; B. G. Teubner.
(11-7885) **1671**

Adams, John Duncan, 1879–

Metal work and etching, by John D. Adams; with additional designs by other writers ... Chicago, Popular mechanics co. [ᶜ1911]

88 p. illus. 17½ᶜᵐ. (Popular mechanics twenty-five-cent handbook series) $0.25

© Mar. 28, 1911; 2c. Apr. 1, 1911*; A 283861; H. H. Windsor, Chicago. (11-8161) **1672**

Aikens, Charlotte Albina, 1868–

Hospital management, a handbook for hospital trustees, superintendents, training-school principals, physicians, and all who are actively engaged in promoting hospital work; ed. by Charlotte A. Aikens ... Philadelphia and London, W. B. Saunders company, 1911.

2 p. l., 9–488 p. illus., plates, plans, facsims. 21ᶜᵐ.

© Apr. 6, 1911; 2c. Apr. 7, 1911*; A 286014; W. B. Saunders co. (11-8140) **1673**

American school of home economics, *Chicago.*

The profession of home making; a condensed home-study course on domestic science; the practical application of the most recent advances in the arts and sciences to the home industries, prepared by teachers of recognized authority ... Chicago, American school of home economics, 1911.

736 p. illus. 20½ᶜᵐ. $3.00

Contains Bibliographies.

© Mar. 1, 1911; 2c. Mar. 24, 1911*; A 283651; Home economics assn., Chicago. (11-8146) **1674**

Anders, James Meschter, 1854–

A text-book of medical diagnosis, by James M. Anders ... and L. Napoleon Boston ... with 418 illustrations in the text and 25 plates, 17 of them in colors. Philadelphia and London, W. B. Saunders company, 1911.

1195 p. illus., xxv pl. (partly col.) 25ᶜᵐ.

© Apr. 7, 1911; 2c. Apr. 8, 1911*; A 286042; W. B. Saunders co. (11-8139) **1675**

Ayer, Frederick Fanning.

Bell and wing, by Frederick Fanning Ayer. New York and London, G. P. Putnam's sons, 1911.

viii p., 1 l., 1266 p. 23ᶜᵐ.

Poems.

© Mar. 25, 1911; 2c. Apr. 7, 1911*; A 286002; F. F. Ayer, New York. (11-8186) **1676**

Bexell, John Andrew.

Farm accounting and business methods; a text-book for students in agriculture and a manual for home-study, by J. A. Bexell ... Springfield, Mass., The Home correspondence school, 1911.

161 p. illus. (incl. forms) 23ᶜᵐ.

© Apr. 5, 1911; 2c. Apr. 7, 1911*; A 286020; Home correspondence school. (11-8108) **1677**

289

Borcherdt, Hans Heinrich.

Carl Hauptmann, er und über ihn, mit beiträgen von Paul Dubray, Ferdinand Gregori, Jean Paul von Kaczkowski-Ardeschah, Rudolf von Koschützki, Georg Muschner, Gertrud Prellwitz, Carl Theodor Strasser hrsg. von Hans Heinrich Borcherdt. München-Leipzig, Hans Sachs-verlag. Gotthilf Haist, 1911.

viii, 199 p. front. (port.) pl. 20ᶜᵐ. M. 3.50
"Verzeichnis der schriften Carl Hauptmanns": p. 197–199.
© Jan. 2, 1911; 2c. Mar. 22, 1911*; A—Foreign 2637; Hans-Sachs-verlag, Gotthilf Haist. (11–8137) **1678**

Byron, George Gordon Noël Byron, *6th baron,* 1788–1824.

Selections from Byron: Childe Harold, canto IV, The prisoner of Chillon, Mazeppa, and other poems, ed. with introduction and notes by Samuel Marion Tucker ... Boston, New York [etc.] Ginn and company [°1911]

xliii, 185 p. incl. front. (port.) 17½ᶜᵐ. (*On cover:* Standard English classics) $0.30
© Feb. 10, 1911; 2c. Mar. 11, 1911*; A 283339; S. M. Tucker, Brooklyn, N. Y. (11–8127) **1679**

Capus, Alfred.

... Théâtre complet. [t.] 6, 7 ... Paris, A. Fayard [1911]

2 v. 19ᶜᵐ. fr. 3.50 per vol.
CONTENTS.—6. L'attentat. L'oiseau blessé. Qui perd gagne.—7. Les deux hommes. Un ange. L'aventurier.
© Feb. 17, 1911; 2c. each Apr. 6, 1911*; A—Foreign 2730; Arthème Fayard.
1680

Daniel, Thomas Cushing.

... Real money versus banks of issue promises to pay, the most important factor in civilization and least understood, by T. Cushing Daniel ... [Washington? D. C.] Printed for the author, 1911.

vii, 9–275 p. fold. tab. 20ᶜᵐ.
© Feb. 23, 1911; 2c. Apr. 4, 1911*; A 283932; T. C. Daniel, Washington, D. C. (11–7312) **1681**

Dodge, Henry Nehemiah, 1843–

John Murray's landfall; a romance and a foregleam. by Henry Nehemiah Dodge ... New York and London, G. P. Putnam's sons, 1911.

xv, 233 p. front., plates, port. 15½ᶜᵐ.
Poem.
© Mar. 25, 1911; 2c. Apr. 7, 1911*; A 283998; H. N. Dodge, Morristown, N. J. (11–7546) **1682**

Döring, Fritz.

Der weiberschreck; Die beiden Wolges, von Fritz Döring; illustriert von Jos. Loukota. Stuttgart [etc.] Union deutsche verlagsgesellschaft [°1911]

2 p. l., [9]–187 p. illus., plates. 20½ᶜᵐ. M. 2.50
© Mar. 23, 1911; 2c. Apr. 10, 1911*; A—Foreign 2742; Union deutsche verlagsgesellschaft. (11–8194) **1683**

Dominik, Hans.

... Glück auf! Roman ... Berlin, C. Duncker [°1911]
cover-title, 308 p. 18½ᶜᵐ.
"Feuilleton-manuskript."

© Jan. 15, 1911; 2c. Mar. 22, 1911*; A—Foreign 2623; Carl Duncker.
(11–8135) 1684

Doyen, Eugène, 1859–

... Nouveau traitement des maladies infectieuses; l'im-
munité (en six leçons) Paris, A. Maloine [etc.] 1911.
2 p. l., 424 p. 19ᶜᵐ.

© Mar. 17, 1911; 2c. Apr. 6, 1911*; A—Foreign 2726; E. Doyen, Paris.
(11–8182) 1685

Emerson, Ralph Waldo, 1803–1882.

... The American scholar, Self-reliance, Compensation,
by Ralph Waldo Emerson; ed., with notes and sugges-
tions for study by Orren Henry Smith ... New York,
Cincinnati [etc.] American book company [°1911]
132 p. incl. front. (port.) 17ᶜᵐ. (Eclectic English classics) $0.20

© Mar. 18, 1911; 2c. Mar. 21, 1911*; A 283566; Amer. book co. [Copy-
right is claimed on Notes and suggestions for study]
(11–8125) 1686

Geissler, Max, 1868–

Das heidejahr, tagebuch des einsiedlers, von Max Geiss-
ler. 1. bis 5. tausend. Leipzig, L. Staackmann, 1911.
340 p. 17½ᶜᵐ. M. 5

© Feb. 14, 1911; 2c. Apr. 1, 1911*; A—Foreign 2705; L. Staackmann.
(11–8131) 1687

General history of Shelby County, Missouri. Chicago,
H. Taylor & company, 1911.
xvi, 671 p. plates, ports. 27½ᶜᵐ. $15.00
Compiled by William H. Bingham.

© Mar. 20, 1911; 2c. Mar. 27, 1911*; A 283708; Henry Taylor & co.
(11–8155) 1688

Griffis, William Elliot, 1843–

China's story in myth, legend, art, and annals, by Wil-
liam Elliot Griffis ... Boston and New York, Houghton
Mifflin company, 1911.
xii p., 1 l., 302 p., 1 l. front., plates, ports. 19ᶜᵐ.

© Mar. 25, 1911; 2c. Apr. 7, 1911*; A 286008; W. E. Griffis, Ithaca, N. Y.
(11–7880) 1689

Günther, Siegmund *i. e.* **Adam Wilhelm Siegmund, 1848–**

Vergleichende mond- und erdkunde, von dr. Siegmund
Günther ... mit 23 abbildungen im text und 4 tafeln.
Braunschweig, F. Vieweg & sohn, 1911.
xi, 193 p. illus., fold. plates. 22½ᶜᵐ. (*Added t.-p.:* Die wissenschaft;
sammlung naturwissenschaftlicher und mathematischer monographien. 37.
hft.) M. 5

© Feb. 21, 1911; 2c. Mar. 22, 1911*; A—Foreign 2641; Friedr. Vieweg &
sohn. (11–8183) 1690

Hall, Archibald McClelland, *ed.*

Select orations, ed., with introduction, by Archibald McClelland Hall ... New York, The Macmillan company, 1911.

xxxv, 307 p. 14½ᶜᵐ. ₁Macmillan's pocket American and English classics₁ $0.25

Bibliography: p. xiii.

© Mar. 29, 1911; 2c. Mar. 30, 1911*; A 283803; Macmillan co.
(11–8123) 1691

Huch, Friedrich.

Enzio, ein musikalischer roman, von Friedrich Huch. 4. bis 6. tausend. München, M. Mörikes verlag, 1911.

513 p. 19ᶜᵐ. M. 6

© Jan. 28, 1911; 2c. Mar. 22, 1911*; A—Foreign 2626; Martin Mörikes verlag. (11–8192) 1692

Kennerly, Clarence Hickman, 1881–

Facts and figures; or, The A B C of Florida trucking, by C. H. Kennerly. St. Augustine, Fla., The Record company, 1911.

137 p. illus. 19ᶜᵐ.

© Apr. 1, 1911; 2c. Apr. 6, 1911*; A 283977; C. H. Kennerly, Palatka, Fla.
(11–8166) 1693

Klinghardt, Hermann, 1847–

Französische intonationsübungen für lehrer und studierende; texte und intonationsbilder, mit einleitung und anmerkungen von H. Klinghardt und M. de Fourmestraux. Cöthen, O. Schulze. 1911.

vii, 114, 35, ₁1₁ p. 22ᶜᵐ. M. 3.80

© Feb. 27, 1911; 2c. Apr. 1, 1911*; A—Foreign 2706; Otto Schulze verlag.
(11–8128) 1694

Küntzel, Georg, 1870– *ed.*

... Die politischen testamente der Hohenzollern nebst ergänzenden aktenstücken. bd. 1, 2 ... hrsg. von Georg Küntzel und Martin Hass. Leipzig und Berlin, B. G. Teubner, 1911.

2 v. 21ᶜᵐ. (Quellensammlung zur deutschen geschichte, hrsg. von F. Brandenburg und G. Seeliger)

© bd. 1 Jan. 20, 1911; 2c. Mar. 27, 1911*; A—Foreign 2690; © bd. 2 Feb. 2, 1911; 2c. Apr. 1, 1911*; A—Foreign 2707; B. G. Teubner.
(11–7879) 1695, 1696

Lewald, *Frau* Emmi (Jansen) 1866–

Der magnetberg, roman von Emmi Lewald (Emil Roland) Berlin, G. Stilke, 1911.

2 p. l., 443, ₁1₁ p. 19¼ᶜᵐ.

© Mar. 2, 1911; 2c. Apr. 10, 1911*; A—Foreign 2743; Georg Stilke.
(11–8191) 1697

Marcolongo, Roberto, 1862– •

... Theoretische mechanik; autorisierte deutsche bearbeitung von H. E. Timerding ... 1. bd. Leipzig und Berlin, B. G. Teubner, 1911.

viii, 346 p. diagrs. 23ᶜᵐ. M. 11

© Jan. 23, 1911; 2c. Mar. 22, 1911*; A—Foreign 2629; B. G. Teubner.
(11–8184) 1698

Mathewson, Frank Elliott, 1869–
Applied mechanical drawing for first and second year
classes in high schools ... by Frank Elliott Mathewson ...
assisted by Judson L. Stewart ... Springfield, Mass., The
Taylor-Holden company, 1911.
158 p. illus., diagrs. 20½*m*. (The Haytol series of textbooks for in-
dustrial education) $1.00
© Mar. 3, 1911; 2c. Mar. 13, 1911*; A 283373; F. E. Mathewson, Cleveland.
(11–8143) 1699

Michaelis, Paul, 1863–
Von Bismarck bis Bethmann, die politik und kultur
Grosspreussens, von dr. Paul Michaelis. 1. bis 4. aufl.
Berlin und Leipzig, Schuster & Loeffler, ᶜ1911.
366 p. 19*cm*. M. 5
© Mar. 1, 1911; 2c. Apr. 10, 1911*; A—Foreign 2744; Schuster & Löffler.
(11–8116) 1700

Milton, John, 1608–1674.
... Milton's L'allegro, Il penseroso, Comus, and Lyci-
das, ed. by Philo Melvyn Buck, jr. ... New York, Cincin-
nati ₁etc.₁ American book company ₍ᶜ1911₎
84 p. 17*cm*. (Eclectic English classics) $0.20
© Apr. 7, 1911; 2c. Apr. 10, 1911*; A 286061; Amer. book co. ₁Copyright
is claimed on "John Milton," p. 75–84₁ (11–8126) 1701

Mitteilungen aus den sächsischen kunstsammlungen,
hrsg. mit unterstützung der generaldirektion des Kö-
nigl. sammlungen zu Dresden. Jahrgang I ... Leipzig,
Breitkopf & Härtel, 1910.
3 p. l., 108 p. illus., plates (partly col.) 28½*cm*. M. 8
© Mar. 16, 1911; 2c. Apr. 1, 1911*; A—Foreign 2708; Breitkopf & Härtel.
(11–8162) 1702

Moler, Arthur B 1866–
The manual on hairdressing, manicuring, facial mas-
sage, electrolysis and chiropody, by A. B. Moler. ₁New
York? ᶜ1911₁
179 p. illus. 19½*m*. $1.00
Cover-title: The manual of beauty culture.
© Mar. 2, 1911; 2c. Mar. 28, 1911*; A 283756; A. B. Moler, New York.
(11–6970) 1703

Neissl, Wilhelm M.
Vademecum for the practicing physician, containing
synonyms, definitions, symptomatology, therapy and se-
lected prescriptions ... also a list of new drugs with dos-
age ... by Wilhelm M. Neissl ... St. Louis, Mo., W. M.
Neissl, 1911.
360 p., 2 l. 16*cm*.
© Mar. 10, 1911; 2c. Mar. 15, 1911*; A 283406; W. M. Neissl.
(11–8141) 1704

Nettelton, William John, b. 1842.
Poems, by W. J. Nettelton. Louisville, Ky., Mrs. W. J.
Nettelton ₍ᶜ1911₎
3 p. l., ₁3₁–141 p. front. (port.) 20*cm*.
© Apr. 4, 1911; 2c. Apr. 7, 1911*; A 286012; Mrs. W. J. Nettelton.
(11–8187) 1705

Ozar Yisrael; an encyclopedia of all matters concerning Jews and Judaism, in Hebrew ... J. D. Eisenstein, editor ... v. 3, 4. New York, J. D. Eisenstein, 1909–1910.

2 v. illus. 28ᶜᵐ. $3.00 per vol.
© July 5, 1909; July 20, 1910; 2c. each Dec. 30, 1910; A 280119; J. D. Eisenstein, New York. 1706

Palmer, Albert Wentworth, 1879–
The mountain trail and its message, by Albert W. Palmer. Boston, New York [etc.] The Pilgrim press [c1911]

31 p. front., plates. 18½ᶜᵐ. $0.50
© Mar. 25, 1911; 2c. Mar. 28, 1911*; A 283743; Luther H. Cary, Boston.
(11–8149) 1707

Potter, Thomas Chalmers, 1854–
Queenie; the autobiography of an Italian queen bee, by T. Chalmers Potter ... New York, Moffat, Yard and company, 1911.

6 p., 2 l., 9–82 p. front., plates. 19ᶜᵐ. $0.75
© Mar. 25, 1911; 2c. Mar. 29, 1911*; A 283772; Moffat, Yard & co.
(11–8148) 1708

Prescott, Augusta.
The stairway on the wall, by Augusta Prescott. New York, The Alice Harriman company, 1911.

5 p. l., 17–315, [1] p. 19½ᶜᵐ. $1.35
© Apr. 6, 1911; 2c. Apr. 8, 1911*; A 286036; Alice Harriman co.
(11–7303) 1709

Radford, William A.
Radford's handy book of practical barn plans and all kinds of out-buildings; being a complete collection of practical, economical and common-sense plans of barns, out-buildings and stock-sheds, by William A. Radford ... Chicago, Ill., New York, N. Y., The Radford architectural company, c1911.

160 p. illus. (incl. plans) 22ᶜᵐ.
© Mar. 14, 1911; 2c. Mar. 18, 1911*; A 283502; Radford architectural co.
(11–8163) 1710

Rosegger, Peter, 1843–
... Der Lex von Gutenhag, von P. K. Rosegger, ed. with notes, vocabulary, and exercises, by Bayard Quincy Morgan ... Boston, D. C. Heath & co., 1911.

vii, 142 p. 17ᶜᵐ. (Heath's modern language series)
© Mar. 18, 1911; 2c. Mar. 22, 1911*; A 283587; D. C. Heath & co.
(11–8130) 1711

Ruoff, Henry Woldmar, 1867– ed.
Masters of achievement; the world's greatest leaders in literature, art, religion, philosophy, science, politics and industry, ed. by Henry W. Ruoff ... Buffalo, N. Y., The Frontier press company [c1911]

1038 p. incl. plates, ports. 26ᶜᵐ.
First pub. in 1910.
© Mar. 30, 1911; 2c. Apr. 7, 1911*; A 286021; Frontier press co.
(11–8129) 1712

Schönherr, Karl.

Aus meinem merkbuch, von Karl Schönherr. 1. bis 5.
tausend. Leipzig, L. Staackmann, 1911.

188 p. 19ᶜᵐ. M. 4
CONTENTS.—Die "lehrerin."—Mein altes bergpfarrerl.—Die reinigung.—
Der hirt.—Die hoffnung der mutter.—Der schnauzl.—Die erste beicht'.—
Abgestürzt.—Tiroler bauern von 1809.—Als der vater starb.—Der ehren-
posten.—Die mütter.—Meine erste begegnung mit dem dichter Adolf Pich-
ler.—Raufer.
© Mar. 14, 1911; 2c. Apr. 1, 1911*; A—Foreign 2704; L. Staackmann.
(11-8193) 1713

Seltzer, Charles Alden.

The range riders, by Charles Alden Seltzer; illustrated
by Clarence Rowe. New York, Outing publishing com-
pany, 1911.

310 p. front., illus. 20ᶜᵐ. $1.25
CONTENTS.—The double cross.—The trail of the serpent.—The kid and
the cowboys.—The messenger from Conejos.—A tragedy on Little Elk.—
The man who rode "Purgatory."—The execution of Lanky.—The six-
teenth man.—The nester on Carrizo.—The prince of the Z O.
© Apr. 6, 1911; 2c. Apr. 8, 1911*; A 286034; Outing pub. co.
(11-7301) 1714

Shakespeare, William, 1564–1616.

... Shakespeare's Hamlet. ed. by Albert E. Shower ...
New York, Cincinnati [etc.] American book company
[°1911]

176 p. 16½ᶜᵐ. (Eclectic English classics) $0.20
© Apr. 6, 1911; 2c. Apr. 8, 1911*; A 286032; Amer. book co. [Copyright is
claimed on The Elizabethan theatre and Notes and questions]
(11-8189) 1715

... Shakespeare's Merchant of Venice, ed. with an intro-
duction and suggestions for study by Gilbert Sykes Blake-
ly ... New York, Cincinnati [etc.] American book com-
pany [°1911]

112 p. 16½ᶜᵐ. (Eclectic English classics) $0.20
© Apr. 6, 1911; 2c. Apr. 8, 1911*; A—286031; Amer. book co. [Copyright
is claimed on Introduction, etc.] (11-8189) 1716

Streightoff, Frank Hatch.

The standard of living among the industrial people of
America, by Frank Hatch Streightoff. Boston and New
York, Houghton Mifflin company, 1911.

xix, 196 p., 1 l. illus. (tables, charts) 21ᶜᵐ. (Half-title: Hart, Schaff-
ner & Marx prize essays, VIII)
Bibliography: p. [XVI]–xix.
© Mar. 25, 1911; 2c. Apr. 7, 1911*; A 286009; Hart, Schaffner & Marx,
Chicago. (11-8117) 1717

Tscholl, John.

Panzer gegen lungenschwindsucht und gegen ein gan-
zes heer von krankheiten, von Rev. John Tscholl ... [Saint
Paul, Willwerscheid & Raith, printers, °1910]

138, [2] p. incl. front. (port.) illus. 22½ᶜᵐ. $1.00
© Oct. 1, 1910; 2c. Mar. 23, 1911*; A 283623; J. Tscholl, Chisholm, Minn.
(11-8138) 1718

Weber, Alexander Otto, 1868–

... Der gefesselte spötter. Illustriert von Harry Jaeger-Mewe. 1. bis 5. tausend. Berlin, Weber-haus-verlag, g. m. b. h., 1911.

[96] p. illus. 24½ᶜᵐ. M. 2.50
© Jan. 20, 1911; 2c. Mar. 22. 1911*; A—Foreign 2630; Weber-haus-verlagsgesellschaft m. b. h. (11–8136) 1719

Weeks, Andrew Gray, jr.

Illustrations of diurnal *Lepidoptera*, with descriptions, by Andrew Gray Weeks, jr. 2d v. Boston, Printed by the University press, Cambridge, 1911.

9 p. l., [ix]–xv, [1], 37 p. front. (port.) col. plates. 23½ᶜᵐ.
© Apr. 10, 1911; 2c. Apr. 12, 1911*; A 286138; A. G. Weeks, jr., Boston.
 1720

Weeks, Ida Ahlborn.

The poems of Ida Ahlborn Weeks. Souvenir ed. Sabula, Ia., Pub. by her friends, 1910.

xi, [1], 136 p. 21½ᶜᵐ.
© Nov. 1, 1910; 2c. Apr. 7, 1911*; A 286027; L. T. Weeks, Newton, Ia.
(11–8124) 1721

Who's who in New York city and state; a biographical dictionary of contemporaries. 5th biennal ed., 1911. New York, W. F. Brainard [1911]

1 p. l., 1024 p. 20½ᶜᵐ. $5.00
© Mar. 11, 1911; 2c. Apr. 8, 1911*; A 286033; W. F. Brainard.
(11–7854) 1722

Winans, Walter.

The art of revolver shooting, together with all information concerning the automatic and single-shot pistol, and how to handle them to the best advantage, by Walter Winans ... New ed., rev. and enl. Head and tail pieces drawn by the author; original photographs by Rouch, Fry, Purdey, Penfold, and others. New York and London, G. P. Putnam's sons, 1911.

2 p. l., iii–xvii p., 1 l., 349 p. front., illus. 28½ᶜᵐ.
© Apr. 1, 1911; 2c. Apr. 7, 1911*; A 286003; W. Winans, England.
(11–7555) 1723

Wolf, Franz.

... Unruhige nächte; mondäne skizzen von clubsesseln. two steps u. pleureusen. Berlin, Hesperus verlag, g. m. b. h. [1911]

3 p. l., [9]–216 p. 20ᶜᵐ. M. 2
© Mar. 22, 1911; 2c. Apr. 10, 1911*; A—Foreign 2741; Hesperus verlag, g. m. b. h. (11–8132) 1724

Wright, William Burnet, 1838–

The heart of the Master, by William Burnet Wright ... Boston and New York, Houghton Mifflin company, 1911.

4 p. l., 247, [1] p. 20ᶜᵐ. $1.25
© Mar. 25, 1911; 2c. Apr. 7, 1911*; A 286011; W. B. Wright, Buffalo.
(11–7758) 1725

Annunzio, Gabriele d', 1863–

... Les lions rouges; illustrations de Lobel-Riche. Paris, P. Lafitte & cⁱᵉ [°1911]

124 p. incl. front., illus. 24ᶜᵐ. (*On cover:* Idéal bibliothèque, no. 23) fr. 0.95

© Mar. 24, 1911; 2c. Apr. 6, 1911*; A—Foreign 2728; Pierre Lafitte & co. (11–8591) 1726

Bain, Francis William, 1863–

The ashes of a god ... translated from the original manuscript by F. W. Bain ... New York and London, G. P. Putnam's sons, 1911.

xxiii, 152 p. front. 21ᶜᵐ.

© Feb. 23. 1911: 2c. Apr. 7. 1911*; A 283999; F. W. Bain, Poonah, India. (11–8276) 1727

Baker, William Athanase.

... Prose et pensées ... 2. éd., rev., cor. et considérablement augm. Montréal, Daoust & Tremblay, 1911.

2 p. l., [7]–113 p., 1 l. 17½ᶜᵐ.

CONTENTS.—Les pensées de Pascal.—Pascal et la pensée moderne.--Goethe.—L'education et ses théories.—Place à l'amour, comédie.

© Mar. 20, 1911; 2c. Apr. 3, 1911; A—Foreign 2718; W. A. Baker, Montreal, Canada. (11–8590) 1728

Balzac, Honoré de, 1799–1850.

... L'amour masqué; ou, Imprudence et bonheur; roman inédit. Paris, J. Gillequin et cⁱᵉ [°1911]

62 p. 24ᶜᵐ. (*On verso of half-title:* "In extenso" [2. série. no. 16])

© Mar. 17, 1911; 2c. Apr. 6, 1911*; A—Foreign 2729; Jean Gillequin & co. (11–8596) 1729

[Bargone, Charles i. e. **Frédéric Charles Pierre Édouard]** 1876–

La maison des hommes vivants, par Claude Farrère [pseud.] Paris, Annales politiques et littéraires [°1911]

3 p. l., 299 p. 19ᶜᵐ.

On cover: 21. ed.

© Mar. 19, 1911; 2c. Apr. 6, 1911*; A—Foreign 2722; Librairie des annales. (11–8596) 1730

Benson, Harrison T 1837--

Benson's compendium on mines, mining, minerals, ores, rocks, weights of metals and rocks ... By H. T. Benson ... Denver, Colo., Hall & Williams [°1909]

2 p. l., 105 p. illus. 18½ᶜᵐ. $2.00

© Nov. 16, 1909; 2c. Apr. 1, 1911*; A 283856; H. T. Benson, and Hall & Williams, Denver. (11–8601) 1731

Bent, Allen Herbert, 1867–

A bibliography of the White Mountains, by Allen H. Bent. Boston, Pub. for the Appalachian mountain club, by Houghton Mifflin company, 1911.

3 p. l., [v]–vii, 114 p. front., ports. 22½ᶜᵐ. $1.00

© Feb. 9, 1911; 2c. Apr. 11, 1911*; A 286098; Appalachian Mountain club, Boston. (11–7858) 1732

297

Beresford, J D.

The early history of Jacob Stahl, by J. D. Beresford ...
London, Sidgwick & Jackson, ltd., 1911.
viii, 404 p. 19ᶜᵐ.
© 1c. Mar. 31, 1911*; A ad int. 555; pubd. Mar. 2, 1911; Little, Brown,
and company, Boston. (11-8611) **1733**

Bible. *N. T. Gospels. Selections. English.*

"My words" as reported by Matthew, Mark, Luke,
John, Paul, chronologically arranged by months; comp.
and arranged by William Forney Hovis. Cincinnati, Jen-
nings and Graham; New York, Eaton and Mains [°1911]
[47] p. 20ᶜᵐ. $0.50
© Apr. 4, 1911; 2c. Apr. 7, 1911*; A 283994; Jennings and Graham.
(11-8605) **1734**

Bible. *O. T. Psalms. Selections. English.*

A little book of Psalms, ed. by Edwin Osgood Grover.
Boston, Chicago, W. A. Wilde company [°1911]
342 p. 15½ᶜᵐ.
© Mar. 30, 1911; 2c. Apr. 3, 1911*; A 283902; W. A. Wilde co.
(11-8606) **1735**

Bradley-Birt, Francis Bradley, 1874–

... Persia; through Persia from the Gulf to the Caspian,
by F. B. Bradley-Birt ... Boston and Tokyo, J. B. Millet
company [°1910]
xi, 323 p. incl. col. front. plates. 25ᶜᵐ. (Oriental series, vol. xx)
$2.50
Published in 1909, by Smith, Elder & co., London, under title: Through
Persia, from the Gulf to the Caspian.
© Mar. 10, 1911; 2c. Apr. 11, 1911*; A 286092; J. B. Millet co.
(11-7751) **1736**

Campbell, Thomas Joseph, 1848–

Isaac Jogues, s. J., discoverer of Lake George, by T. J.
Campbell, s. J. New York, The American press, 1911.
4 p. l., 7–55 p. front., plates, ports. 24ᶜᵐ.
One of the monographs of the "Pioneer priests of North America," re-
printed with some emendations and additions.
© Apr. 3, 1911; 2c. Apr. 8, 1911*; A 286050; American press.
(11-8579) **1737**

Davis, John Patrick, 1878–

The master of brevity ... by John P. Davis. Newark,
N. J., Campbell & Norris, printers, °1911·
4 p. l., 40 numb. l., 1 l. front. (port.) 18ᶜᵐ.
© Mar. 17, 1911; 2c. Mar. 20, 1911*; A 283549; J. P. Davis, Newark, N. J·
(11-8583) **1738**

Doyle, *Sir* Arthur Conan, 1859–

Songs of the road, by A. Conan Doyle ... London,
Smith, Elder & co., 1911.
viii, 137 p. 18ᶜᵐ.
© 1c. Apr. 14, 1911*; A ad int. 585; pubd. Mar. 17, 1911; A. C. Doyle, Lon-
don. (11-8594) **1739**

Eschstruth, Nataly von, 1860–

Die Roggenmuhme, humoristischer roman, von Nataly
von Eschstruth. Leipzig, P. List [°1910]

3 p. l., [5]–381 p. 18½ᶜᵐ. M. 3
© Dec. 28, 1910; 2c. Mar. 22, 1911*; A—Foreign 2624; Paul List.
(11–8593) 1740

Farnsworth, Edward Clarence.

The passing of Mary Baker Eddy, by Edward C. Farns-
worth. Portland, Me., Smith & Sale, printers, 1911.

3 p. l., 3–67, [1] p. $0.35
CONTENTS.—The passing of Mary Baker Eddy.—The law of love and
sacrifice.—The purpose of the higher drama.
© Apr. 8, 1911; 2c. Apr. 12, 1911*; A 286127; E. C. Farnsworth, Portland,
Me. (11–7855) 1741

Fenwick, Malcolm C.

The church of Christ in Corea, by Malcolm C. Fenwick.
New York, Hodder & Stoughton, George H. Doran com-
pany [°1911]

vi p., 3 l., 134 p. front. (port. group) plates. 19½ᶜᵐ. $1.00
© Mar. 24, 1911; 2c. Mar. 25, 1911*; A 283683; G. H. Doran co.
(11–8299) 1742

Foerster, Friedrich Wilhelm, 1869–

Lebenskunde, ein buch für knaben und mädchen, von
dr. Fr. W. Foerster. 20. bis 25. tausend. Berlin, G. Rei-
mer, 1909.

xi, 364 p. 20ᶜᵐ. M. 6
© Jan. 20, 1911; 2c. Mar. 22, 1911*; A—Foreign 2628; Georg Reimer.
(11–8300) 1743

Haynes, Nathaniel Smith, 1844–

Jesus as a controversialist [by] Nathaniel S. Haynes,
A. M. Cincinnati, O., The Standard publishing co., 1911.

xiii, 142 p. 16ᶜᵐ. $0.75
© Mar. 29, 1911; 2c. Apr. 10, 1911*; A 286068; Standard pub. co.
(11–8094) 1744

Hilscher, Solomon S.

The eternal evangel, by Solomon. S. Hilscher. New
York, Chicago [etc.] Broadway publishing co. [°1911]

262 p., 1 l. 20ᶜᵐ. $1.50
"Authorities cited": p. 261–262.
© Feb. 11, 1911; 2c. Mar. 18, 1911*; A 283482; S. S. Hilscher, Iola, Kan.
(11–8464) 1745

Hoover, Francis T.

Not in His steps; a story of the ministerial dead-line of
fifty years. By Rev. Francis T. Hoover ... Introduction
by Rev. William E. Park ... Cleona, Pa., Holzapfel pub-
lishing company [1911]

6 p. l., [xi]–xvi, 19–360 p. incl. plates. front., pl., ports. 21ᶜᵐ. $1.00
© Apr. 3, 1911; 2c. Apr. 3, 1911; A 286192; G. Holzapfel, Cleona, Pa.
(11–8477) 1746

Iffert, August, 1859–

Sprechschule für schauspieler und redner, von August Iffert. Leipzig, Breitkopf & Härtel, 1911.

2 p. l., 98 p. 20^{cm}. (*On cover:* Breitkopf & Härtel's musikbücher) M. 6

Separate issue, rewritten and extended, of the language part of the author's Allgemeine gesangschule.

© Mar. 4, 1911; 2c. Mar. 25, 1911*; A—Foreign 2682; Breitkopf & Härtel. (11-8485) **1747**

Kipling, Rudyard, 1865–

Three poems by Rudyard Kipling. Garden City, New York, Doubleday, Page & company, 1911.

2 p. l., 3-9 p. 18½^{cm}. $0.25

CONTENTS. — The river's tale. — The Roman centurion speaks. — The pirates in England.

© Apr. 4, 1911; 2c. Apr. 8, 1911*; A 286053; R. Kipling, Batemans Burwash, England. (11-8595) **1748**

Knight, Edward Frederick, 1852–

... Turkey; the awakening of Turkey; the Turkish revolution of 1908, by E. F. Knight ... Boston and Tokyo, J. B. Millet company [1910]

x, 324 p. incl. col. front. plates. 25^{cm}. (Oriental series, vol. xxi) $2.50

Published in 1909, by J. Milne, London, under title: The awakening of Turkey.

© Mar. 10, 1911; 2c. Apr. 11, 1911*; A 286093; J. B. Millet co. (11-7749) **1749**

Liguori, Alfonso Maria de, *Saint*, 1696–1787.

Little St. Alphonsus' manual. A selection of prayers and devotions taken mostly from the works of St. Alphonsus de Liguori ... founder of the Congregation of the Most Holy Redeemer. Comp. by a member of the same congregation. Ilchester, Md., The Redemptorist fathers [1911]

3 p. l., 303 p. front. (port.) 13^{cm}. $0.60

© Mar. 27, 1911; 2c. Mar. 30, 1911*; A 283812; Ferd. A. Litz, Baltimore. Md. (11-8603) **1750**

Lillibridge, William Otis, 1878–1909.

A breath of prairie, and other stories, by Will Lillibridge ... with five illustrations in color by J. N. Marchand. Chicago, A. C. McClurg & co., 1911.

xi, 13-417 p. col. front., col. plates. 21½^{cm}. $1.20

CONTENTS.—A breath of prairie.—The dominant impulse.—The stuff of heroes.—Arcadia in Avernus.—Journey's end.—A prairie idyl.—The madness of whistling wings.—A frontier romance: a tale of Jumel mansion.—The cup that o'erflowed: an outline.—Unjudged.—The touch human.—A dark horse.—The worth of the price.

© Apr. 8, 1911; 2c. Apr. 12, 1911*; A 286113; A. C. McClurg & co. (11-7745) **1751**

Mill, John Stuart, 1806–1873. .
The subjection of women, by John Stuart Mill; with a
foreword by Carrie Chapman Catt. New York, Freder-
ick A. Stokes company [c1911]
> xv, 223 p. 18¼ᶜᵐ. $0.60
> © Apr. 7, 1911; 2c. Apr. 10, 1911*; A 286076; Frederick A. Stokes co.
> (11–7884) 1752

Möller, Karl, 1868–
Zehnminuten-turnen. (Atmung und haltung) Eine
handreichung für das tägliche turnen in knaben- und
mädchenschulen, wie im hause. Von Karl Möller ... Mit
80 textbildern und zwei übungstabellen mit 53 figuren ...
Leipzig und Berlin, B. G. Teubner, 1911.
> viii, [2], 98 p. illus., 2 fold. pl. 18¼ᶜᵐ.
> "Literatur": 1 page preceding p. 1.
> © Feb. 3, 1911; 2c. Mar. 27, 1911*; A—Foreign 2692; B. G. Teubner.
> (11–8460) 1753

Molitor, David Albert, 1866–
Kinetic theory of engineering structures dealing with
stresses, deformations and work for the use of students
and practitioners in civil engineering, by David A. Moli-
tor ... New York [etc.] McGraw-Hill book company, 1911.
> xv p., 1 l., 366 p. diagrs. 24ᶜᵐ.
> Bibliography: p. 359–361.
> © Mar. 25, 1911; 2c. Apr. 4, 1911*; A 283936; D. A. Molitor, Kansas City,
> Mo. (11–8599) 1754

Moody, Walter Dwight, *ed.*
Business administration; theory, practice and applica-
tion; editor-in-chief, Walter D. Moody ... managing edi-
tor, Samuel MacClintock ... [Business law and legal
forms] Chicago, La Salle extension university [1911]
> 10 p. l., vi, 514 p. 24½ᶜᵐ. $3.00
> © Apr. 13, 1911; 2c. Apr. 22, 1911*; A 286375; La Salle extension univ.
> 1755

Orr, Edwin Gilpin, *comp.*
The real estate broker's cyclopedia. A compilation of
selling plans, advertising phrases, practical methods,
general information ... Comp. and ed. by Edwin Gilpin
Orr. Cincinnati [Printed by the Knowles & Holtman co.]
1911.
> 635, [1] p. 27ᶜᵐ.
> © Mar. 31, 1911; 2c. Apr. 7, 1911*; A 283997; E. G. Orr, Cincinnati.
> (11–8457) 1756

Parkinson, Edward Kneeland.
The practical country gentleman; a handbook for the
owner of a country estate, large or small, by Edward K.
Parkinson ... with 40 illustrations. Chicago, A. C. Mc-
Clurg & co., 1911.
> ix, 9–189 p. front., plates. plan. 19½ᶜᵐ. $1.25
> "The greater part of this book appeared originally in 'The Boston tran-
> script' and the balance in 'The Country gentleman.'"
> © Apr. 8, 1911; 2c. Apr. 12, 1911*; A 286115; A. C. McClurg & co.
> (11–8109) 1757

Patten, Gilbert.

Clif Stirling, behind the line, by Gilbert Patten ... Philadelphia, D. McKay [1911]

v, 7-336 p. col. front., plates. 19½ᶜᵐ. (*On cover:* Clif Stirling series) $1.25

© Apr. 15, 1911; 2c. Apr. 18, 1911; A 286263; David McKay. **1758**

Payson, Howard.

The boy scouts of the Eagle patrol, by Lieut. Howard Payson. New York, Hurst & company [ᶜ1911]

302 p. incl. front. plates. 19½ᶜᵐ. $0.50

© Feb. 23, 1911; 2c. Feb. 25, 1911*; A 283012; Hurst & co.
(11-8476) **1759**

Pearl, Raymond, 1879– *comp.*

... Poultry diseases and their treatment, comp. by Raymond Pearl, Frank M. Surface, and Maynie R. Curtis. Orono, Me., 1911.

ix, 216 p. illus. 23ᶜᵐ. $0.25

At head of title: ... Maine. Agricultural experiment station, Orono, Maine.

© Apr. 7, 1911; 2c. Apr. 10, 1911*; A 286065; Maine agricultural experiment station, Orono, Me. (11-8110) **1760**

Pennsylvania. *Supreme court.*

Pennsylvania state reports, v. 229, containing cases decided ... at May and October terms, 1910, and January term, 1911. Reported by William I. Schaffer, state reporter. New York, The Banks law publishing co., 1911.

xxx, 738 p. 24ᶜᵐ. $0.89

© Apr. 27, 1911; 2c. Apr. 28, 1911*; A 286515; Robert McAfee, sec. of the commonwealth for the state of Pennsylvania, Harrisburg, Pa. **1761**

Perry, Lawrence.

Prince or chauffeur? a story of Newport, by Lawrence Perry ... with four illustrations by J. V. McFall. Chicago, A. C. McClurg & co., 1911.

5 p. l., 9-382 p., 1 l. col. front., col. plates. 21ᶜᵐ. $1.35

© Apr. 8, 1911; 2c. Apr. 12, 1911*; A 286114; A. C. McClurg & co.
(11-7744) **1762**

Peyre de Bétouzet, Henri, 1880–

... Dans les décombres, roman ... Paris, Fontemoing & cⁱᵉ, 1911.

2 p. l., 350 p., 1 l. 19ᶜᵐ. fr. 3.50

© Mar. 17, 1911; 2c. Apr. 6, 1911*; A—Foreign 2721; Fontemoing & co.
(11-8294) **1763**

Phillips, David Graham, 1867–1911.

... The grain of dust; a novel. Illustrated by A. B. Wenzell. New York and London, D. Appleton and company, 1911.

3 p. l., 427, [1] p. 12 p. front., plates. 19½ᶜᵐ. $1.30

© Apr. 7, 1911; 2c. Apr. 13, 1911*; A 286149; D. Appleton & co.
(11-7868) **1764**

Rees, *Sir* **John David, 1854–**

... India; the real India, by J. D. Rees ... Boston and
Tokyo, J. B. Millet company [c1910]

xi, 326 p. incl. col. front. plates. 25ᶜᵐ. ·(Oriental series, vol. xix)
$2.50

F rst published in 1908, by Methuen & co., London, under title: The real
India.

© Mar. 10, 1911; 2c. Apr. 11, 1911*; A 286091; J. B. Millet co.

(11–7748) 1765

Reimann, Ludwig.

Der verführer meiner tochter. Nach dem leben nieder-
geschrieben von Ludwig Reimann ... Berlin, B. Blau-
rock [c1911]

88 p. 20¼ᶜᵐ. M. 1

© Feb. 10, 1911; 2c. Mar. 27, 1911; A—Foreign 2693; Bruno Blaurock.

(11–8303) 1766

Saint-Simon, Louis de Rouvroy, *duc* **de, 1675–1755.**

... Mémoires sur le siècle de Louis xiv et la régence; ex-
traits suivis illustrés notices et annotations, par Aug. Du-
pouy ... Paris, Bibliothèque Larousse [c1911]

4 v. front., plates, ports. 20¼ᶜᵐ.

© Mar. 17, 1911; 2c. each Apr. 6, 1911*; A—Foreign 2723; Librairie La-
rousse & co., Paris. (11–8291) 1767

Salge, Bruno.

... Therapeutisches taschenbuch für die kinderpraxis.
Von dr. B. Salge ... 5. verb. aufl. Berlin, Fischer's medi-
cin. buchhandlung. H. Kornfeld, 1911.

2 p. l., 178 p. 18ᶜᵐ. (Fischer's therapeutische taschenbücher, 1)
M.3.50

© Jan. 23, 1911; 2c. Mar. 22, 1911*; A—Foreign 2627; Fischer's medicin.
buchhandlung, H. Kornfeld. (11–8447) 1768

Seaman, Augusta Huiell.

When a cobbler ruled the king, by Augusta Huiell Sea-
man; with decoration and drawings by George Wharton
Edwards. New York, Sturgis & Walton company, 1911.

· x p., 3 l., 3–352 p. plates. 19¼ᶜᵐ. $1.25

© Apr. 8, 1911; 2c. Apr. 10, 1911*; A 286063; Sturgis & Walton co.

(11–7739) 1769

Sheridan, Ramie A.

... Jess of Harbor hill, by Ramie A. Sheridan ... New
York, Cupples & Leon company [c1911]

2 p. l., 314 p. front., plates. 19¼ᶜᵐ. (*His* Harbor hill romances)

© Mar. 27, 1911; 2c. Apr. 3, 1911*; A 283899; Cupples & Leon co.

(11–8610) 1770

Slaught, Herbert Ellsworth, 1861–

Solid geometry, with problems and applications, by
H. E. Slaught ... and N. J. Lennes ... Boston, Allyn and
Bacon, 1911.

vi, 190 p. illus., diagrs. 19ᶜᵐ. $0.75

© Apr. 3, 1911; 2c. Apr. 8, 1911*; A 286044; H.E. Slaught, Chicago, &
N. J. Lennes, New York. (11–8479) 1771

Smiley, Clara L.

"The clothespin brigade," by Clara L. Smiley. New York, Chicago [etc.] Broadway publishing co. [c1911]

3 p. l., 5–70 p. front., plates. 20ᶜᵐ. $0.75

© Feb. 13, 1911; 2c. Mar. 24, 1911*; A 283666; C. L. Smiley, Le Mars, Mass. (11–8612) 1772

Stauber, B T.

Romance of the universe, by B. T. Stauber ... New York, Chicago [etc.] Broadway publishing co. [c1911]

2 p. l., ii, 3–131 p. 20ᶜᵐ. $1.00

© Feb. 4, 1911; 2c. Mar. 18, 1911*; A 283486; B. T. Stauber, Lincoln, Kan. (11–8607) 1773

Stephens, Robert Neilson, 1867–1906.

A soldier of Valley Forge; a romance of the American revolution, by Robert Neilson Stephens ... and G. E. Theodore Roberts ... with a frontispiece in full colour from a painting by Frank T. Merrill. Boston, L. C. Page & company, 1911.

3 p. l., 328 p. col. front. 20ᶜᵐ. $1.50

© Apr. 10, 1911; 2c. Apr. 12, 1911*; A 286131; L. C. Page & co., inc. (11–7746) 1774

Ware, Martin Wiener, 1869–

Plaster of Paris and how to use it, by Martin W. Ware ... 2d ed., rev. and enl. Illustrated with 90 original drawings. New York, Surgery publishing company, 1911.

viii, 99, [2] p. illus. 20½ᶜᵐ.

© Apr. 6, 1911; 2c. Apr. 7, 1911*; A 286017, Surgery pub. co. (11–8448) 1775

Webster, Noah, 1758–1843.

Webster's new standard dictionary ... based upon the unabridged dictionary of the English language of Noah Webster, LL. D.; rev. and brought up to date in accordance with the most recent eminent English and American authorities, containing the 1910 census with maps. New York, Syndicate publishing company, 1911.

[1050] p. incl. maps. plates (partly col., partly double) tables. 20ᶜᵐ. $2.50

"New century reference library; treasury of facts": 162 p. at end.

© Mar. 29, 1911; 2c. Mar. 31, 1911*; A 283845; Frank E. Wright, New York. (11–8483) 1776

Wentworth, Patricia.

More than kin, by Patricia Wentworth ... New York and London, G. P. Putnam's sons, 1911.

iv p., 1 l., 363 p. 19ᶜᵐ. $1 35

Published in Great Britain, under title: A little more than kin.

© Apr. 11, 1911; 2c. Apr. 13, 1911*; A 286147; G. P. Putnam's sons. (11–7869) 1777

Harvard College Library

PART I, BOOKS, GROUP MAY 17 1911

no. 24, May, 1911

1783

From the
U. S. Government.

Bagley, William Chandler.

Craftsmanship in teaching, by William Chandler Bagley ... New York, The Macmillan company, 1911.

ix, 247 p. 19½ᶜᵐ. $1.10

Contents.—Craftsmanship in teaching.—Optimism in teaching.—How may we promote the efficiency of the teaching force?—The test of efficiency in supervision.—The supervisor and the teacher.—Education and utility.—The scientific spirit in education.—The possibility of training children to study.—A plea for the definite in education.—Science as related to the teaching of literature.—The new attitude toward drill.—The ideal teacher.

© Apr. 12, 1911; 2c. Apr. 13, 1911*; A 286159; Macmillan co.
(11–8865) 1778

Beecham, Robert K 1838–

Gettysburg, the pivotal battle of the civil war, by Captain R. K. Beecham ... with illustrations and map. Chicago, A. C. McClurg & co., 1911.

5 p. l., 9–298 p. front., plates, ports., fold. map. 21½ᶜᵐ. $1.75
© Apr. 8, 1911; 2c. Apr. 12, 1911*; A 286112; A. C. McClurg & co.
(11–8816) 1779

Betts, George Herbert.

... The recitation, by George Herbert Betts ... Boston, New York [etc.] Houghton, Mifflin company [c1911]

viii p., 2 l., 120, [2] p. 18ᶜᵐ. (Riverside educational monographs, ed. by H. Suzzallo)
First published 1910.

© Mar. 25, 1911; 2c. Apr. 7, 1911*; A 286006; Houghton, Mifflin co.
(11–8863) 1780

Boccaccio, Giovanni.

... The Decameron "La comedia umana," now for the first time completely translated by John Payne; with introduction by Hugo Albert Rennert ... illustrations by Jacques Wagrez. 9th and 10th day. Philadelphia, Printed for subscribers only by G. Barrie & sons [1911]

2 v. fronts., illus., plates. 21ᶜᵐ. $30.00 per vol.
© Apr. 22, 1911; 2c. each Apr. 26, 1911*; A 286466; George Barrie & sons.
 1781

Brolaski, Harry.

Easy money; being the experiences of a reformed gambler; all gambling tricks exposed, by Harry Brolaski. Cleveland, O., Searchlight press, 1911.

1 p. l., 7–328 p. front. (port.) illus. (incl. ports.) 20ᶜᵐ. $1.00
© Apr. 11, 1911; 2c. Apr. 13, 1911*; A 286172; H. Brolaski, Redondo Beach, Cal. (11–8584) 1782

Burke, Edmund, 1729?–1797.

... Burke's speech on conciliation with the American colonies, ed. by Ernest R. Clark ... New York, Cincinnati [etc.] American book company [c1911]

112 p. incl. front. (port.) 17ᶜᵐ. (Eclectic English classics) $0.20
© Apr. 7, 1911; 2c. Apr. 10, 1911*; A 286062; Amer. book co. [Copyright is claimed on Suggestions for study and Notes] (11–8818) 1783

305

Carhart, *Mrs.* **Lucy Ann (Morris)** 1824–

Genealogy of the Morris family; descendants of Thomas Morris of Connecticut, comp. by Mrs. Lucy Ann (Morris) Carhart; ed. by Charles Alexander Nelson, A. M. New York, The A. S. Barnes company, 1911.

ix, 478 p. front. (port.) 23ᶜᵐ. $4.50

© Mar. 9, 1911; 2c. Apr. 12, 1911; A 286253; A. S. Barnes co. (11–8581) 1784

Cassot, Cécile Christine, 1853–

... Héroïque, roman. Paris, H. Daragon, 1911.

260 p. 19½ᶜᵐ. fr. 3.50

© May 1, 1911; 2c. Apr. 6, 1911*; A—Foreign 2720; C. Cassot, Paris. (11–8853) 1785

Clement, Ernest Wilson, 1860–

The Japanese floral calendar, by Ernest W. Clement, M. A., profusely illustrated. 2d and rev. ed. Chicago, The Open court publishing company; [etc., etc.] 1911.

2 p. l., 66 p. front., illus. 24½ᶜᵐ.

© Apr. 3, 1911; 2c. Apr. 6, 1911*; A 283983; Open court pub. co. (11–8841) 1786

Crawford, Matthew.

The gladiolus; a practical treatise on the culture of the gladiolus, with notes on its history, storage, diseases, etc., by Matthew Crawford, with an appendix by Dr. W. Van Fleet. [1st ed.] Chicago and New York, Vaughan's seed store, 1911.

4 p. l., 98 p. front., illus., plates. 20ᶜᵐ. $1.25

© Apr. 8, 1911; 2c. Apr. 10, 1911*; A 286066; Vaughan's seed store. (11–8866) 1787

Dudley, Carl Hermon.

St. Paul's friendships and his friends, by Carl Hermon Dudley ... Boston, R. G. Badger, 1911.

287 p. 19½ᶜᵐ. $1.50

© Apr. 4, 1911; 2c. Apr. 13, 1911*; A 286167; C. H. Dudley, Silver Creek, N. Y. (11–8290) 1788

Dudley, *Mrs.* **Lucy Bronson.**

"A writer's inkhorn," by Mrs. Lucy Bronson Dudley ... illustrated by original photographs. New York [The James Kempster printing company] 1910.

145 p. incl. front., illus. 17½ᶜᵐ.

© Apr. 12, 1911; 2c. Apr. 15, 1911*; A 286210; L. B. Dudley, New York. (11–8488) 1789

The **Euclid** avenue Presbyterian church, Alexander Mc-Gaffin, minister; dedication services, April 2–7, 1911. Cleveland, O. [Printed by the Britton printing company] 1911.

[38] p. incl. front., illus., plates. 30½ᶜᵐ.

© Apr. 3, 1911; 2c. Apr. 6, 1911*; A 283981; Trustees of the Euclid avenue Presbyterian church, Cleveland, O. (11–8839) 1790

Farbovich, Pinchus.

הגדה של פסח מיט נײעם פירוש: פרשת פינחס פון
רב פינחס פארבאװיץ ...

Chicago, Sun sign co. [1911]

לך (i. e. 67), [1] p. 22^{cm}.

Title also in English and German on front cover.
© Mar. 17, 1911; 2c. Mar. 22, 1911; A 283893; P. Farbovich, Chicago.
(11–8840) 1791

... The **Federal** reporter, with key-number annotations.
v. 183. Permanent ed. ... February–March, 1911. St.
Paul, West publishing co., 1911.

xii, 1118 p. 22¼^{cm}. (National reporter system—United States series)
$3.50
© Apr. 25, 1911; 2c. May 1, 1911*; A 286588; West pub. co. 1792

Follansbee, Frank D.

Deductive thought; the achievement of health, happi-
ness and plenty through reason, by Frank D. Follansbee.
Chicago, Ill. [R. R. Donnelley & sons co., °1911]

3 p. l., 9–139 p. 15½^{cm}.
© Apr. 5, 1911; 2c. Apr. 10, 1911*; A 286067; F. D. Follansbee, Chicago.
(11–8465) 1793

**Green, Alice Sophia Amelia (Stopford) "Mrs. J. R.
Green," 1848–**

Irish nationality, by Alice Stopford Green ... London,
Williams and Norgate [°1911]

v, [1], 7–256 p. 17½^{cm}. (Added t.-p.: Home university library of modern
knowledge. New York, H. Holt and company) 1/
"Some Irish writers on Irish history": p. 255–256.
© 1c. Apr. 10, 1911; A ad int. 576; pubd. Apr. 5, 1911; Williams & Nor-
gate. (11–8824) 1794

Hayes, Alice Jeannette, 1855–

A convert's reason why, by A. J. Hayes ... Cambridge,
Printed at the Riverside press [°1911]

vii, [1] p., 1 l., 212 p. 19½^{cm}. $1.00
© Apr. 10, 1911; 2c. Apr. 15, 1911*; A 286201; A. J. Hayes, South Fram-
ingham, Mass. (11–8838) 1795

Hewlett, Maurice Henry, 1861–

Brazenhead the Great, by Maurice Hewlett. New York,
C. Scribner's sons, 1911.

xiii, 316 p. 20^{cm}. $1.50
© Apr. 5, 1911; 2c. Apr. 17, 1911*; A 286246; Charles Scribner's sons.
(11–8275) 1796

Howard, William Lee, 1860–

Confidential chats with girls, by William Lee Howard ...
New York, E. J. Clode [°1911]

viii, 3–128 p. 19½^{cm}. $1.00
© Apr. 14, 1911; 2c. Apr. 15, 1911*; A 286203; Edward J. Clode.
(11–8585) 1797

Hudson, Clarence W.

Notes on plate-girder design, by Clarence W. Hudson ... 1st ed. 1st thousand. New York, John Wiley & sons; ₍etc., etc.₎ 1911.

vii, 75 p. illus., plates. 23½ᶜᵐ. $1.50
© Apr. 8, 1911; 2c. Apr. 12, 1911*; A 286130; C. W. Hudson, Upper Montclair, N. J. (11–8602) **1798**

Ilbert, *Sir* Courtenay Peregrine, 1841–

Parliament; its history, constitution and practice, by Sir Courtenay Ilbert ... London, Williams and Norgate ₍ᶜ1911₎

v, 7–254 p. 17½ᶜᵐ. (*Added t.-p.:* Home university library of modern knowledge. New York, H. Holt and company) 1/
Bibliography: p. 247–252.
© 1c. Apr. 10, 1911; A ad int. 575; pubd. Apr. 5, 1911; Williams & Norgate. (11–8857) **1799**

... The **Indiana** digest; a digest of the decisions of the courts of Indiana ... Comp. under the American digest classification. v. 5. Exemptions – Intercourse. St. Paul, West publishing co., 1911.

iii, 1058 p. 26½ᶜᵐ. (American digest system—State series) $6.00
© Apr. 22, 1911; 2c. May 1, 1911*; A 286589; West pub. co. **1800**

Job, Herbert Keightly, 1864–

The blue goose chase; a camera-hunting adventure in Louisiana, by Herbert K. Job ... illustrations by the author and William F. Taylor. New York, The Baker & Taylor company, 1911.

7 p. l., 331 p. front., plates. 19½ᶜᵐ. $1.25
© Apr. 15, 1911; 2c. Apr. 17, 1911; A 286273; Baker & Taylor co. (11–8475) **1801**

Kerschensteiner, Georg, 1854–

Education for citizenship; prize essay by Dr. Georg Kerschensteiner ... tr. by A. J. Pressland from the 4th improved and enl. ed. for and pub. under the auspices of the Commercial club of Chicago. Chicago, New York ₍etc.₎ Rand, McNally & company ₍ᶜ1911₎

xx, 133 p. 21ᶜᵐ.
© Apr. 3, 1911; 2c. Apr. 6, 1911*; A 283966; Rand, McNally & co. (11–8862) **1802**

Lambert, Rose.

Hadjin and the Armenian massacres, by Rose Lambert ... New York, Chicago ₍etc.₎ Fleming H. Revell company ₍ᶜ1911₎

5 p. l., 9–10 p., 2 l., 13–106 p. front. plates, ports., map. 19½ᶜᵐ. $0.75
© Apr. 2, 1911; 2c. Apr. 10, 1911*; A 286059; Fleming H. Revell co. (11–8289) **1803**

Laufer, Calvin Weiss.

Key-notes of optimism, by Calvin Weiss Laufer, A. M. Boston, Sherman, French & company, 1911.

5 p. l., 152 p. 21ᶜᵐ. $1.00
© Apr. 11, 1911; 2c. Apr. 17, 1911*; A 286236; Sherman, French & co. (11–8604) **1804**

Lee, Richard Henry, 1732–1794.

The letters of Richard Henry Lee, collected and ed. by
James Curtis Ballagh ... v. 1. New York, The Macmillan company, 1911.

xxvii, 467 p. front. (port.) 23½cm. $2.50
"Published under the auspices of the National society of the colonial
dames of America."
© Apr. 12, 1911; 2c. Apr. 15, 1911*; A 286204; Macmillan co.
(11–8814) 1805

Meade, Norman Gardner, 1876–

The electric vehicle; its construction, operation and
maintenance, by Norman G. Meade ... New York, Hill's
print shop, 1911.

128 p. illus. 17cm.
On cover: Compliments of the New York Edison company.
© Apr. 5, 1911; 2c. Apr. 11, 1911*; A 286099; N. G. Meade, Auburn, N. Y.
(11–8439) 1806

Méheut, M.

Études d'animaux, par M. Méheut, sous la direction de
E. Grasset. t. 1–4. Paris, É. Lévy [c1911]

4 v. plates. 44½ x 34cm.
© Oct. 10, 1909; 2c. Apr. 14, 1911*; A– Foreign 2760; Émile Lévy.
(11–8869) 1807

Meschler, Moritz.

Three fundamental principles of the spiritual life, by
Moritz Meschler, s. J. St. Louis, Mo. [etc.] B. Herder,
1911.

vi, [2], 240 p. 19½cm. $1.00
© Apr. 7, 1911; 2c. Apr. 10, 1911*; A 286075; Joseph Gummersbach, St.
Louis. (11–8840) 1808

Meyer, Adolf, 1866–

Dementia praecox; a monograph by Adolf Meyer, M. D.,
Smith Ely Jelliffe, M. D., August Hoch, M. D. Boston,
R. G. Badger, 1911.

71 p. 24cm. $2.00
© Apr. 4, 1911; 2c. Apr. 13, 1911*; A 286169; Richard G. Badger.
(11–8845) 1809

Miethe, Adolf i. e. Christian Heinrich Emil Adolf, 1862– ed.

Mit Zeppelin nach Spitzbergen; bilder von der studien-
reise der deutschen arktischen Zeppelin-expedition; mit
einem vorwort S. K. H. des prinzen Heinrich von Preus-
sen, hrsg. von A. Miethe und H. Hergesell ... mit 269
schwarzen und farbigen reproduktionen nach naturauf-
nahmen. Berlin [etc.] Deutsches verlagshaus Bong & co.
[c1911]

4 p. l., 291 p. illus, plates (partly col.) 2 col. port. (incl. front.) 27cm.
© Mar. 25, 1911; 2c. Apr. 17, 1911*; A—Foreign 2775; Deutsches verlags-
haus Bong & co. (11–8461) 1810

Murray, John Ogden, 1840–

Jefferson Davis and the southern people were not traitors, nor rebels. They were patriots, who loved the Constitution and obeyed the laws made for the protection of all American citizens ... a short story of the Confederate soldier, the ideal soldier of the world, by J. Ogden Murray ... ₁Manassas, Manassas Democrat press₁ 1911.

48 p. illus. (port.) 24ᶜᵐ. $0.25

© Mar. 7, 1911; 2c. Mar. 21, 1911; A 283658; J. O. Murray, Charlestown, W. Va. (11–8817) 1811

Norris, George William, 1875–

Studies in cardiac pathology, by George William Norris ... with 85 original illustrations. Philadelphia and London, W. B. Saunders company, 1911.

vii, 233 p. incl. illus., plates. 26½ᶜᵐ. $5.00

© Apr. 10, 1911; 2c. Apr. 11, 1911*; A 286100; W. B. Saunders co. (11–8843) 1812

... The **Northwestern** reporter, with key-number annotations. v. 129. Permanent ed. Containing all the decisions of the supreme courts of Minnesota, Michigan, Nebraska, Wisconsin, Iowa, North Dakota, South Dakota ... January 20–March 10, 1911. St. Paul, West publishing co., 1911.

xii, 1247 p. 26½ᶜᵐ. (National reporter system—State series) $4.00

© Apr. 20, 1911; 2c. May 1, 1911*; A 286587; West pub. co. 1813

Pilcher, *Mrs.* Margaret Hamilton (Campbell)

Historical sketches of the Campbell, Pilcher and kindred families, including the Bowen, Russell, Owen, Grant, Goodwin, Amis, Carothers, Hope, Taliaferro, and Powell families, by Margaret Campbell Pilcher. Nashville, Tenn. ₁Press of Marshall & Bruce co., °1911₁

444 p. front., illus. (coats of arms) plates, ports. 24ᶜᵐ.

Articles also contributed by Calvin McClung, Charles Campbell, and William B. Campbell.

© Apr. 10, 1911; 2c. Apr. 14, 1911*; A 286198; M. C. Pilcher, Nashville, Tenn. (11–8284) 1814

Plaut, Felix.

... The Wassermann sero-diagnosis of syphilis in its application to psychiatry, by Dr. Felix Plaut ... Authorized translation by Smith Ely Jelliffe ... and Louis Casamajor ... New York, The Journal of nervous and mental disease publishing company, 1911.

vii, 188 p. 25ᶜᵐ. (Nervous and mental disease monograph series, no. 5)

"Literature": p. 184–186.

© Apr. 4, 1911; 2c. Apr. 7, 1911*; A 286016; Journal of nervous & mental disease pub. co. (11–8844) 1815

Pollard, Percival, 1869–

Masks and minstrels of new Germany, by Percival Pollard. Boston, J. W. Luce and company, 1911.

1 p. l., v–viii p., 1 l., 299 p., 1 l. 19½ᶜᵐ.

CONTENTS.—An evening in a German cabaret.—The überbrettl movement.—On collecting and on minstrelsy.—The pioneers of Germany's new nationalism.—Detlev von Liliencron.—Otto Erich Hartleben.—Otto Julius Bierbaum.—A few formalists.—Richard Dehmel.—Mere entertainment.—Ernst von Wolzogen.—Drama and Frank Wedekind.—Ludwig Thoma's "Moral."—Vienna's essence, Schnitzler.—Hugo von Hoffmansthal.—Bahr and finis.

© Apr. 3, 1911; 2c. Apr. 5, 1911*; A 283940; L. E. Bassett, Boston.
(11–8851) 1816

Putnam, John Pickering, 1847–

Plumbing and household sanitation, by J. Pickering Putnam ... a course of lectures delivered before the plumbing school of the North end union, Boston. Garden City, New York, Doubleday, Page & company, 1911.

718 p. incl. illus., plates, charts. front. 21ᶜᵐ. $3.75

© Apr. 8, 1911; 2c. Apr. 12, 1911*; A 286132; J. P. Putnam, Boston.
(11–8830) 1817

Quiller-Couch, *Sir* Arthur Thomas, 1863–

Brother Copas, by Arthur Quiller-Couch ("Q") ... New York, C. Scribner's sons, 1911.

viii p., 1 l., 301 p. 19½ᶜᵐ. $1.20

© Apr. 5, 1911; 2c. Apr. 17, 1911*; A 286247; Charles Scribner's sons.
(11–8277) 1818

Singleton, Esther.

A guide to great cities for young travelers and others; western Europe, by Esther Singleton ... New York, The Baker & Taylor company, 1911.

295 p. front., plates. 19ᶜᵐ. (*On cover:* The guide series) $1.25

CONTENTS.—Rouen.—Amiens.—Rheims.—Paris.—Blois. — Tours. — Bordeaux. — Lyons. — Marseilles. — Madrid. —Toledo.—Seville.—Cordova.—Granada.—Barcelona.—Lisbon.

© Apr. 15, 1911; 2c. Apr. 17, 1911; A 286274; Baker & Taylor co.
(11–8823) 1819

Stacpoole, Henry De Vere.

The ship of coral, by H. De Vere Stacpoole. New York, Duffield & company, 1911.

vi p., 1 l., 311 p. 19½ᶜᵐ. $1.20

© Apr. 17, 1911; 2c. Apr. 19, 1911*; A 286286; Duffield & co.
(11–8609) 1820

Sterling, George.

The house of orchids, and other poems, by George Sterling ... San Francisco, A. M. Robertson, 1911.

140 p. 20ᶜᵐ. $1.25

© Apr. 11, 1911; 2c. Apr. 17, 1911; A 286272; G. Sterling, Carmel, Cal.
(11–8588) 1821

Strong, James Clark, 1826–

Biographical sketch of James Clark Strong ... Los Gatos, Cal., 1910.

3 p. l., 106 p. incl. ports. front. (port.) 19½ᶜᵐ. $1.00
© Apr. 1, 1911; 2c. Apr. 10, 1911*; A 286082; J. C. Strong, Los Gatos, Cal. (11–8815) **1822**

Troly-Curtin, Marthe.

Phrynette, by Marthe Troly-Curtin; with a frontispiece by Frank H. Desch. Philadelphia & London, J. B. Lippincott company, 1911.

333, [1] p. col. front. 19½ᶜᵐ. $1.25
Published in Great Britain under title: Phrynette and London.
© Apr. 14, 1911; 2c. Apr. 15, 1911; A 286256; Grant Richards, ltd., London. (11–8474) **1823**

Vaschide, Nicolas, d. 1907.

... Le sommeil et les rêves. Paris, E. Flammarion. 1911.

2 p. l., 305 p., 1 l. 19ᶜᵐ. (Bibliothèque de philosophie scientifique)
"Bibliographie": p. [299]–302.
© Apr. 5, 1911; 2c. Apr. 12, 1911*; A—Foreign 2754; Ernest Flammarion. (11–8466) **1824**

Wight, Charles Albert, 1856–

Some old time meeting houses of the Connecticut Valley, by Charles Albert Wight ... [Chicopee Falls, Mass., The Rich print, °1911]

5 p. l., 144 p. front., plates, ports., plan, facsims. 23ᶜᵐ. $2.00
© Apr. 3, 1911; 2c. Apr. 10, 1911*; A 286088; C. A. Wight, Chicopee Falls, Mass. (11–8578) **1825**

Willard, John Ware.

A history of Simon Willard, inventor and clockmaker, together with some account of his sons—his apprentices—and the workmen associated with him, with brief notices of other clockmakers of the family name, by his great grandson, John Ware Willard. [Boston, Printed by E. O. Cockayne, °1911]

4 p. l., 133 p. front., illus., plates (partly col.) ports., plan, facsims. 32½ᶜᵐ. $5.00
© Apr. 7, 1911; 2c. Apr. 12, 1911*; A 286140; J. W. Willard, Boston. (11–8831) **1826**

Winter, Nevin Otto, 1869–

Argentina and her people of to-day; an account of the customs, characteristics, amusements, history and advancement of the Argentinians, and the development and resources of their country, by Nevin O. Winter ... illustrated from original and selected photographs by the author. Boston, L. C. Page and company, 1911.

xiv, 421 p. front., plates, fold. map. 20½ᶜᵐ.
Bibliography: p. 413–414.
© Apr. 3, 1911; 2c. Apr. 6, 1911*; A 283989; L. C. Page & co., inc. (11–8580) **1827**

Abhedânanda, swâmi.

Human affection and divine love, by Swâmi Abhedâ-
nanda. New York, The Vedânta society [°1911]
2 p. l., 46 p. 6¼ᶜᵐ. $0.50

© Apr. 14, 1911; 2c. Apr. 17, 1911*; A 286225; Swâmi Abhedânanda. New
York, N. Y. (11–8947) **1828**

Apel, Paul, 1872–

Hans Sonnenstössers höllenfahrt, von Paul Apel; ein
traumspiel. Berlin, Oesterheld & co., 1911.
122 p. 19ᶜᵐ.

© Feb. 16, 1911; 2c. Apr. 1, 1911; D 23820; Oesterheld & co.
(11–8296) **1828***

Baker, Richard Philip, 1866–

... The problem of the angle-bisectors ... Chicago, Ill.,
The University of Chicago press [1911]
vi, 99 p. diagrs. 28¼ᶜᵐ. $1.00

© Mar. 27, 1911; 2c. Mar. 31, 1911*; A 283841; University of Chicago.
(11–8943) **1829**

Boardman, Normand Smith, 1858–

The children of the saints; an early Christian romance,
by Rev. N. S. Boardman, M. A. New York, Cochrane pub-
lishing company, 1911.
70 p. 19ᶜᵐ. $0.50

© Mar. 15, 1911; 2c. Apr. 17, 1911*; 286254; Cochrane pub. co.
(11–8951) **1830**

Bragg, Edward Milton, 1874–

Marine engine design, including the design of turning
and reversing engines, by Edward M. Bragg ... New
York, D. Van Nostrand company, 1911.
v, [7]–172 p. illus., diagrs. 20¼ᶜᵐ. $2.00

© Apr. 11, 1911; 2c. Apr. 18, 1911*; A 286278; D. Van Nostrand co.
(11–8969) **1831**

Brittain, Horace L.

Selections from American orations; an historical read-
er for schools, comp. and ed. by Horace L. Brittain and
James G. Harris. New York, Cincinnati [etc.] American
book company [1911]
266 p. illus. 19ᶜᵐ.

© Apr. 28, 1911; 2c. May 1, 1911; A 286568; H. L. Brittain and J. G. Har-
ris, Boston, Mass. **1832**

Burrell, David James, 1849–

At the gate beautiful; the story of a day, by David
James Burrell. New York, American tract society [°1911]
2 p. l., 3–71 p. front. 19¼ᶜᵐ. $0.50

© Apr. 21, 1911; 2c. Apr. 22, 1911*; A 286374; Amer. tract soc.
(11–8978) **1833**

313

Chadsey, Effie M *comp.*

Beautiful thoughts about happiness, by many authors, comp. by Effie M. Chadsey; decorations by Frederic M. Grant. Boston and Chicago, W. A. Wilde company [c1911]

[111] p. 20ᶜᵐ. $0.75

© Mar. 30, 1911; 2c. Apr. 3, 1911*; A 283903; W. A. Wilde co., Chicago. (11–8979) **1834**

Coughlin, Joseph James, 1880–

Osirus and other poems [by] Joseph J. Coughlin. Boston, R. G. Badger, 1911.

2 p. l., 7–162 p. 19½ᶜᵐ. $1.50

© Apr. 8, 1911; 2c. Apr. 13, 1911*; A 286170; J. J. Coughlin, U. S. (11–8936) **1835**

Dillon, *Mrs.* **Mary C** **(Johnson)**

Miss Livingston's companion; a love story of old New York, by Mary Dillon ... with illustrations by E. A. Furman. New York, The Century co., 1911.

viii p., 2 l., 3–434 p. front., plates. 19½ᶜᵐ. $1.30

© Apr. 15, 1911; 2c. Apr. 24, 1911*; A 286408; Century co. (11–8981) **1836**

Espé de Metz, G.

.... . 70, cinq tableaux de la guerre ... Paris, L. Fournier, 1911.

270 p., 3 l. 18¼ᶜᵐ. fr. 3.50

© Mar. 22, 1911; 2c. Apr. 6, 1911; D 23942; L. Fournier. (11–8493) **1836ᵃ**

Fay, Irving Wetherbee, 1861–

The chemistry of the coal-tar dyes, by Irving W. Fay ... New York, D. Van Nostrand company, 1911.

vi, 467 p. illus. 22½ᶜᵐ. $4.00

© Apr. 11, 1911; 2c. Apr. 18, 1911*; A 286279; D. Van Nostrand co. (11–8972) **1837**

Fitch, Michael Hendrick, 1837–

... The Chattanooga campaign, with especial reference to Wisconsin's participation therein, by Michael Hendrick Fitch ... [Madison] Wisconsin history commission, 1911.

xiii, 255 p. 6 maps (incl. front.) 23½ᶜᵐ. (Wisconsin history commission: Original papers, no. 4)

© Apr. 3, 1911; 2c. Apr. 6, 1911*; A 283993; Wisconsin history commission (in behalf of the state of Wisconsin) (11–8819) **1838**

Fitch, Warren R.

Flowers from the wayside; a book of verse, by Warren R. Fitch. Boston, Sherman, French & company, 1911.

3 p. l., 62 p. 19½ᶜᵐ. $1.00

© Apr. 10, 1911; 2c. Apr. 17, 1911*; A 286235; Sherman, French & co. (11–8935) **1839**

Green, Alice Sophia Amelia (Stopford) *"Mrs.* J. R. Green,*"* 1848–

Irish nationality, by Alice Stopford Green ... London, Williams and Norgate ₁1911₎

v, ₁1₎, 7–256 p. 17½ᶜᵐ. (*Added t.-p.:* Home university library of modern knowledge. New York, H. Holt and company) 1/
© 1c. May 3, 1911*; A ad int. 612; pubd. Apr. 5, 1911; Henry Holt & co., New York. **1840**

Hauptmann, Carl Ferdinand Maximilian, 1858–

... Napoleon Bonaparte ... München, G. D. W. Callwey ₁ᶜ1911₎

2 v. 20ᶜᵐ.
CONTENTS.—1. t. Bürger Bonaparte.—2. t. Kaiser Napoleon.
© Jan. 20, 1911; 2c. Mar. 22, 1911; D 23711; Georg D. W. Callwey.
(11–8133) **1840***

Hauptmann, Gerhart Johann Robert, 1862–

Die ratten, Berliner tragikomödie von Gerhart Hauptmann. Berlin, S. Fischer, 1911.

3 p. l., ₁9₎–212 p., 1 l. 20ᶜᵐ.
© Jan. 17, 1911; 2c. Mar. 22, 1911; D 23712; S. Fischer verlag.
(11–8134) **1840****

Ilbert, *Sir* Courtenay Peregrine, 1841–

Parliament; its history, constitution and practice, by Sir Courtenay Ilbert ... London, Williams and Norgate ₁1911₎

v, 7–254 p. 17½ᶜᵐ. (*Added t.-p.:* Home university library of modern knowledge. New York, H. Holt and company) 1/
© 1c. May 3, 1911*; A ad int. 613; pubd. Apr. 5, 1911; Henry Holt & co., New York. **1841**

Irving, Washington, 1783–1859.

... Irving's Tales of a traveler, ed. by James R. Rutland ... New York, Cincinnati ₁etc.₎ American book company ₁ᶜ1911₎

432 p. incl. front. (port.) 17ᶜᵐ. (Eclectic English classics) $0.40
© Apr. 15, 1911; 2c. Apr. 18, 1911*; A 286258; Amer. book co.
(11–8955) **1842**

Le Queux, William, 1864–

The money-spider, by William Le Queux ... Boston, R. G. Badger ₁ᶜ1911₎

4 p. l., 360 p. 19½ᶜᵐ.
© Apr. 8, 1911; 2c. Apr. 24, 1911*; A 286392; W. Le Queux, London.
(11–8983) **1843**

Macdonald, James Ramsay, 1866–

The socialist movement, by J. Ramsay Macdonald ... London, Williams and Norgate ₁ᶜ1911₎

xiii, 15–256 p. 17ᶜᵐ. (*Added t.-p.:* Home university library of modern knowledge. New York, H. Holt and company) 1/
Bibliography: p. 249–252.
© 1c. May 3, 1911*; A ad int. 610; pubd. Apr. 5, 1911; Henry Holt & co., New York. **1844**

[McElfresh, William Edward] 1867–
Directions for laboratory work in physics 2. [Williamstown, Mass.] Williams college, 1911.
186 p. illus. (incl. tables) diagrs. 20½ᶜᵐ.
© Mar. 20, 1911; 2c. Mar. 25, 1911*; A 283672; W. E. McElfresh, Williamstown, Mass. (11–8944) 1845

Michie, Thomas Johnson, ed.
Railroad reports (vol. 60 American and English railroad cases, new series); a collection of all cases affecting railroads of every kind, decided by the courts of last resort in the United States. Ed. by Thomas J. Michie. v. 37. Charlottesville, Va., The Michie company, 1911.
vii, 844 p. 23½ᶜᵐ. $4.50
© Apr. 29, 1911; 2c. May 2, 1911*; A 286611; Michie co. 1846

[Monbart, Helene von] 1870–
Der kaiser, eine tragödie in fünf akten, von Hans von Kahlenberg [pseud.] für die bühne bearb. von Hans Olden. Berlin - Charlottenburg, Vita, deutsches verlagshaus [ᶜ1911]
3 p. l., [5]–176 p., 1 l. 19ᶜᵐ.
© Jan. 15, 1911; 2c. Feb. 4, 1911; D 23926; Felix Heinemann, Vita, deutsches verlagshaus g. m. b. h. (11–8295) 1846*

Mordecai, Samuel Fox, 1852–
Law notes ... By Samuel F. Mordecai ... v. 1. Durham, N. C., 1911.
2 p. l., 252 p. 24ᶜᵐ.
© Apr. 8, 1911; 2c. Apr. 11, 1911*; A 286103; S. F. Mordecai, Durham, N. C. (11–8873) 1847

Muir, William Carpenter Pendleton.
A treatise on navigation and nautical astronomy, including the theory of compass deviations, prepared for use as a text-book at the U. S. Naval academy, by Commander W. C. P. Muir ... 3d ed., rev. and enl. Annapolis, Md., The United States Naval institute, 1911.
xvi p., 1 l., 764 p. illus., diagrs. 20ᶜᵐ.
© Apr. 6, 1911; 2c. Apr. 10, 1911*; A 286064; Philip R. Alger, sec. & treasurer U. S. Naval institute, Annapolis, Md. (11–8968) 1848

Natorp, Paul Gerhard, 1854–
... Philosophie, ihr problem und ihre probleme; einführung in den kritischen idealismus, von dr. Paul Natorp ... Göttingen, Vandenhoeck & Ruprecht, 1911.
2 p. l., 172 p. 19½ᶜᵐ. (Wege zur philosophie. Ergänzungsreihe: Einführungen in die philosophie der gegenwart, nr. 1) M. 2.50
© Feb. 22, 1911; 2c. Apr. 17, 1911*; A—Foreign 2781; Vandenhoeck & Ruprecht. (11–8976) 1849

Nixon, Warren Case, 1886–

The care, operation and management of the Parsons marine steam turbine, by W. C. Nixon ... Annapolis, Md., School of marine engineering, U. S. Naval academy, 1911.
4 p. l., 216 p. illus. 24ᶜᵐ.

© Apr. 12, 1911; 2c. Apr. 13, 1911*; A 286146; W. C. Nixon, Annapolis, Md. (11-8971) **1850**

Noodt, Gustav, ed.

Leitfaden der naturlehre für lyzeen (höhere lehrerin-nenseminare) ... hrsg. von prof. dr. Gustav Noodt. 2. bd. ... Leipzig und Berlin, B. G. Teubner, 1911[
v, (1), 231–478 p. illus., plates (partly fold., col.) diagrs. 25ᶜᵐ. M. 3.80
© Mar. 1, 1911; 2c. Apr. 29, 1911*; A—Foreign 2857; B. G. Teubner.
 1851

Norrevang, Arne.

The woman and the fiddler; a play in three acts by Arne Norrevang; tr. from the Norwegian by Mrs. Herman Sandby. Philadelphia, Brown brothers, 1911.
105 p. 21ᶜᵐ.

© Apr. 4, 1911; 2c. Apr. 14, 1911; D 23956; Mrs. H. Sandby, Philadelphia. (11-8592) **1851***

Order of the eastern star. *Grand chapter of New York.*

The authorized standard ritual of the Order of eastern star in the state of New York; a system of forms and ceremonies, with necessary instructions for chapters, as revised by a committee appointed at the annual session of the Grand chapter, held in June, 1897. New York, The Grand chapter, 1911.
4 p. l., (5)–235 p. illus. 15ᶜᵐ. $0.75
© Mar. 23, 1911; 2c. Mar. 15, 1911; A 283924; Grand chapter, Order of the eastern star, state of New York, New York. (11-8991) **1852**

Philipson, David, 1862–

The Jew in English fiction, by Rabbi David Philipson ... New ed., rev. and enl. Cincinnati, The Robert Clarke company, 1911.
4 p. l., 5–207 p. 20½ᶜᵐ. $1.25
CONTENTS.—Introductory.—Marlowe's "Jew of Malta."—Shakespeare's "Merchant of Venice."—Cumberland's "The Jew."—Scott's "Ivanhoe."—Dickens's "Oliver Twist" and "Our mutual friend."—Disraeli's "Coningsby and Tancred."—George Eliot's "Daniel Deronda."—Zangwill's "Children of the ghetto" and others.
© Apr. 13, 1911; 2c. Apr. 17, 1911*; A 286238; Robert Clarke co. (11-8852) **1853**

Rooker, William Velpeau.

The weatherbeaten man; a tale of American patriotism, by William Velpeau Rooker. New York, Cochrane publishing company, 1911.
229 p. 19ᶜᵐ. $1.50
© Apr. 5, 1911; 2c. Apr. 22, 1911*; A 286369; W. V. Rooker, Noblesville, Ind. (11-8953) **1854**

Russell, Thomas Herbert, 1862–

Questions and answers for automobile students and mechanics; a book of self-instruction for automobile students and mechanics, as well as for all those interested in motoring. By Thomas H. Russell ... Chicago, Ill., The Charles C. Thompson co., 1911.

140 p. 20ᶜᵐ. $1.00

© Mar. 25, 1911; 2c. Mar. 30, 1911; A 286224; Charles C. Thompson co. (11–8974) 1855

Sajous, Charles Euchariste de Medici.

The internal secretions and the principles of medicine, by Charles E. de M. Sajous ... v. 2d. With twenty-four illustrations. 4th ed. Philadelphia, F. A. Davis company, 1911.

ix, 801–1873 p. illus., plates. 24½ᶜᵐ. $6.00

© May 2, 1911; 2c. May 3, 1911; A 286675; F. A. Davis co. 1856

Schwarz, Otto.

Diskontpolitik; gedanken über englische, französische und deutsche bank-, kredit- und goldpolitik; eine vergleichende studie von Otto Schwarz ... Leipzig, Duncker & Humblot, 1911.

xi, 240 p. 24ᶜᵐ. M.6

"Benutzte literatur": p. (x)–xi.

© Feb. 2, 1911; 2c. Apr. 17, 1911*; A—Foreign 2761; Duncker & Humblot. (11–8992) 1857

Scott, Dukinfield Henry, 1854–

The evolution of plants, by Dukinfield Henry Scott ... London, Williams and Norgate [ᶜ1911]

v, 7–256 p. illus. 17½ᶜᵐ. (*Added t.-p.:* Home university library of modern knowledge. New York, H. Holt and company)

Bibliography: p. 245–247.

© 1c. May 3, 1911*; A ad int. 611; pubd. Apr. 5, 1911; Henry Holt & co. New York. 1858

Service, Robert William.

The trail of the '98; a Northland romance, by Robert W. Service ... with illustrations by Maynard Dixon. Toronto, W. Briggs, 1911.

vii p., 1 l., (4), 3–514? p. front., plates. 19½ᶜᵐ.

© 1c. Jan. 5, 1911; A ad int. 438; pubd. Dec. 10, 1910; Dodd & Mead & co., New York. 1859

Shakespeare, William, 1564–1616.

... Shakespeare's Twelfth night; or, What you will; ed. by Charles B. Weld ... New York, Cincinnati [etc.] American book company [ᶜ1911]

112 p. 16½ᶜᵐ. (Eclectic English classics) $0.20

© Apr. 14, 1911; 2c. Apr. 18, 1911*; A 286262; Amer. book co (11–8933) 1860

Simms, William Gilmore, 1806–1870.

... William Gilmore Simms's The Yemassee; a romance of Carolina; ed., with introduction and notes, by M. Lyle Spencer ... Richmond, Atlanta [etc.] B. F. Johnson publishing co. [ᶜ1911]

xv, [1], 441 p. front. (port.) illus. (map) 19½ᶜᵐ. (Johnson's English classics) $0.80

© Apr. 19, 1911; 2c. Apr. 20, 1911; A 286337; M. Lyle Spencer, Montgomery, Ala. (11–8982) 1861

Smalley, George Washburn, 1833–

Anglo-American memories, by George W. Smalley ... New York and London, G. P. Putnam's sons, 1911.

ix p., 1 l., 441 p. front. (port.) 24ᶜᵐ.

"These memories were written in the first instance for Americans and have appeared week by week each Sunday in the New York tribune."

© Mar. 25, 1911; 2c. Apr. 7, 1911*; A 286001; G. W. Smalley, London. (11–35360) 1862

Smith, Marshall, comp.

Compendium of Scriptural truths; a collection of articles and sayings, comp. and ed. by Marshall Smith. New York, Chicago [etc.] Broadway publishing co. [ᶜ1911]

4 p. l., 7–117 p. 20ᶜᵐ. $1.25

© Apr. 1, 1911; 2c. Apr. 17, 1911*; A 286234; M. Smith, Milner, Ga. (11–8977) 1863

Thackeray, William Makepeace.

The works of William Makepeace Thackeray; with biographical introductions by his daughter Lady Ritchie ... v. 12, 13. The Newcomes. [The centenary biographical ed.] New York and London, Harper & brothers [1911]

2 v. fronts., illus., plates. 21½ᶜᵐ.

© Apr. 18, 1911; 2c. each Apr. 29, 1911*; A 286550; Harper & bros. [Copyright is claimed on Introduction to The Newcomes] 1864

Trevena, John.

The reign of the saints, by John Trevena ... London, A. Rivers, ltd., 1911.

vi p., 1 l., 376 p. 19ᶜᵐ. 6/

© 1c. Apr. 20, 1911*; A ad int. 590; pubd. Mar. 22, 1911; Alston Rivers, ltd. (11–8952) 1865

Walker, Sydney Ferris.

Cold storage, heating and ventilating on board ship, by Sydney F. Walker ... New York, D. Van Nostrand company, 1911.

vi, 269 p. illus. 20½ᶜᵐ. $2.00

© Mar. 13, 1911; 2c. Apr. 13, 1911*; A 286173; D. Van Nostrand co. (11–8967) 1866

Warman, Cy, 1855–
Songs of Cy Warman. Boston, Rand Avery co.; [etc., etc., °1911]

5 p. l., 9–177 p. 19½ᶜᵐ. $1.00

© Apr. 15, 1911; 2c. Apr. 19, 1911*; A 286285; Rand Avery co.
(11–8934) 1867

Wells, Lucy Colton.
The children of the old stone house, by Lucy Colton Wells; frontispiece by Harriet Roosevelt Richards, cover design by Sarah K. Smith. Wilmington, Del., The New Amstel magazine company [°1911]

241 p. front., fold. plan. 22½ᶜᵐ. $1.25

© Apr. 1, 1911; 2c. Apr. 19, 1911*; 286290; New Amstel magazine co.
(11–8608) 1868

Witthaus, Rudolph August, 1846–
Manual of toxicology, by R. A. Witthaus ... reprinted from Witthaus' and Becker's Medical jurisprudence, forensic medicine and toxicology, 2d ed. New York, W. Wood and company, 1911.

ix p., 1 l., [5]–1261 p. illus. 25ᶜᵐ.

© Apr. 15, 1911; 2c. Apr. 17, 1911*; A 286226; Wm. Wood & co.
(11–8985) 1869

Wolbarst, Abraham Leo.
Gonorrhea in the male; a practical guide to its treatment, by Abr. L. Wolbarst ... New York, The International journal of surgery co., 1911.

2 p. l., 175, vi p. 21ᶜᵐ. $1.00

© Mar. 30, 1911; 1c Mar. 28, 1911; 1c. Apr. 18, 1911*; A 286257; Internatl. journal of surgery co. (11–8986) 1870

Young, Gilbert Amos, 1875–
Notes on steam engines, by Gilbert A. Young ... Lafayette, Ind., Burt-Haywood company, 1911.

x, 148 p. diagrs. 23½ᶜᵐ.

"References": p. iii.

© Mar. 20, 1911; 2c. Mar. 23, 1911*; A 283611; G. A. Young, West Lafayette, Ind. (11–8828) 1871

Zwemer, Samuel Marinus, 1867–
The unoccupied mission fields of Africa and Asia, by Samuel M. Zwemer ... New York, Student volunteer movement for foreign missions, 1911.

xx, 260 p. front., plates, ports., maps. 21ᶜᵐ. $1.00

"Select bibliography": p. 235–244.

© Apr. 7, 1911; 2c. Apr. 14, 1911*; A 286193; Student volunteer movement for foreign missions. (11–8425) 1872

Adventures of school-boys, by John R. Coryell, M. E. Ditto, M. S. McCobb, David Ker and others ... New York and London, Harper & brothers, 1911.

4 p. l., 191, [1] p. front., plates. 18½ᶜᵐ. $0.60

CONTENTS. — "Lazarus," by Margaret E. Ditto. — The smiting of the Amalekite, by M. S. McCobb. — Glory and peace, by M. S. McCobb. — The Lakeland skating race, by J. R. Coryell. — The switchman's box, by M. White, jr. — A great mystery, by F. B. Stanford. — Tried by fire, by W. Thomson. — Duke Donohue, by E. S. Brooks. — A fight in the snow, by D. Ker. — In Trinity backs, by W. E. Barlow. — Captain Jack, by J. M. Hallowell. — Washington's school-days, by W. F. Carne.

© Apr. 18, 1911; 2c. Apr. 20, 1911; A 286340; Harper & bros. (11–8954)

1873

Barnes, Harold Edgar.

Corporate organization and administration, by H. Edgar Barnes ... New York, Universal business institute, inc., ᶜ1910.

515 p. forms. 22ᶜᵐ. $20.00

Publisher's lettering: vol. ɪ.

© Sept. 20, 1910; 1c. Apr. 1, 1911; 1c. Apr. 12, 1911*; A 286116; Universal business institute, inc. (11–9181)

1874

—— Questions and problems, by B. Franklin De Frece ... New York, Universal business institute, inc., ᶜ1910.

1 p. l., [5]–119 p. 22ᶜᵐ. $10 00

Publisher's lettering: vol. ɪɪ.

© Sept. 20, 1910; 1c. Apr. 1, 1911; 1c. Apr. 12, 1911*; A 286117; Universal business institute, inc. (11–9182)

1875

Bigelow, Melville Madison, 1846–

The law of fraudulent conveyances, by Melville Madison Bigelow ... with editorial notes, by Kent Knowlton ... Boston, Little, Brown and company, 1911.

lxix, 762 p. 24½ᶜᵐ. $6.50

© Apr. 15, 1911; 2c. Apr. 22, 1911*; A 286378; M. M. Bigelow, Cambridge, Mass. (11–9247)

1876

Bryant, Joseph D., *ed.*

American practice of surgery; a complete system of the science and art of surgery, by representative surgeons of the United States and Canada. Editors: Joseph D. Bryant ... Albert H. Buck ... v. 8. New York, W. Wood and company, 1911.

xii, 1146 p. illus., plates (partly col.) 27½ᶜᵐ. $7.00

© Apr. 29, 1911; 2c. May 8, 1911*; A 286748; William Wood & co.

1877

Carlyle, Thomas, 1795–1881.

... Carlyle's Essay on Burns; ed. with an introduction and suggestions for study by Edwin L. Miller ... New York, Cincinnati [etc.] American book company [ᶜ1911]

128 p. incl. front. (map) 16½ᶜᵐ. (Eclectic English classics) $0.20

© Apr. 18, 1911; 2c. Apr. 21, 1911*; A 286338; Amer. book co. [Copyright is claimed on Introduction and Suggestions for study, etc.] (11–9263)

1878

Conyers, Dorothea.
Some happenings of Glendalyne, by Dorothea Conyers. London, Hutchinson & co., 1911.
3 p. l., 327, [1] p. 19½ᶜᵐ. 6/
© 1c. Apr. 25, 1911*; A ad int. 596; pubd. Mar. 28, 1911; D. Conyers, England. (11-9234) **1879**

Crockett, Samuel Rutherford, 1860–
Love in Pernicketty town, by S. R. Crockett ... London, New York [etc.] Hodder and Stoughton [ᶜ1911]
viii, 320 p. 19½ᶜᵐ. 6/
© 1c. Apr. 26, 1911*; A ad int. 599; pubd. Mar. 28, 1911; S. R. Crockett, England. (11-9235) **1880**

Daughtry, Osmond.
Ear-tests and how to prepare for them (including exercises in staff and tonic sol-fa notations) by Osmond Daughtry ... New York, C. Fischer [ᶜ1911]
48 p. 18½ᶜᵐ. $0.60
© Mar. 8, 1911; 2c. Apr. 3, 1911*; A 283909; Carl Fischer. (11-8964) **1881**

[Fischer, Hans] 1869–
An den ufern des Araxes, ein deutscher roman aus Persien, von Kurt Aram [pseud.] 1. bis 3. tausend. Berlin-Charlottenburg, Vita, deutsches verlagshaus [ᶜ1911]
403 p. front. (port.) 18½ᶜᵐ. M. 4
© Apr. 1, 1911; 2c. Apr. 19, 1911*; A—Foreign 2807; Felix Heinemann, Berlin-Charlottenburg. (11-9264) **1882**

Forman, Henry James, 1879–
The ideal Italian tour, by Henry James Forman ... Boston and New York, Houghton Mifflin company, 1911.
x, 413, [1] p. front., plates. 17ᶜᵐ. $1.50
© Apr. 15, 1911; 2c. Apr. 25, 1911*; A 286438; H. J. Forman, New York. (11-9237) **1883**

Gilgamesh.
Das Gilgamesch-epos, neu übersetzt von Arthur Ungnad und gemeinverständlich erklärt von Hugo Gressmann. Göttingen, Vandenhoeck & Ruprecht, 1911.
iv, 232 p. 23½ᶜᵐ. (On verso of t.-p.: Forschungen zur religion und literatur des Alten und Neuen Testaments ... 14. hft.] M. 5
© Feb. 23, 1911; 2c. Apr. 17, 1911*; A—Foreign 2766; Vandenhoeck & Ruprecht. (11-9258) **1884**

Holst, Bernhart Paul, ed.
Practical American encyclopedia; a universal reference library in the arts, sciences and literature, with nearly one thousand illustrations ... editor in chief, Bernhart Paul Holst ... associate editor, Ruric Neval Roark ... and many assistant editors and contributors. Chicago, New York [etc.] The W. B. Conkey company, 1911.
2 v. illus., plates, ports., maps. 22ᶜᵐ. $10.00
© Apr. 10, 1911; 2c. Apr. 12, 1911*; A 286133; Holst pub. co., Boone, Ia. (11-9256) **1885**

The Horseless age.

The operation, care and repair of automobiles; ed. from the files of the Horseless age by Albert L. Clough. Rev. ed. ... New York city, The Horseless age company, ᶜ1911·
299, vi p. illus. 23ᶜᵐ. $1.00
ⓒ Apr. 8, 1911; 2c. Apr. 11, 1911; A 286222; Horseless age co.
(11-8973) 1886

Jacoby, James Calvin, 1850–

Around the home table, by Rev. J. C. Jacoby ... Phila-delphia, Pa., The Lutheran publication society ₍ᶜ1911₎
367 p. front. (port.) 19ᶜᵐ. $1.00
ⓒ Apr. 8, 1911; 2c. Apr. 11, 1911*; A 286102; J. C. Jacoby, Boulder, Col.
₍Copyright is claimed on new matter and on two chapters: "The inspira-tion of the Scriptures" and "The immortality of the soul"₎
(11-9166) 1887

Jervis, William Percival, 1850–

A pottery primer, by W. P. Jervis ... New York, The O'Gorman publishing co., ᶜ1911.
2 p. l., ₍11₎-188 p. front., illus., ports. 23½ᶜᵐ.
ⓒ Apr. 10, 1911; 2c. Apr. 14, 1911*; A 286182; W. P. Jervis, Oyster Bay, N. Y. (11-9043) 1888

₍Jordan, Mrs. Charlotte Brewster₎ comp.

Mothers' day book; for and about mothers from mother-lovers throughout the world. ₍Philadelphia, Pa., The Studio press, ᶜ1911₎
35 p. front. 20½ᶜᵐ. $0.50
ⓒ Feb. 1, 1911; 2c. Feb. 24, 1911; A 286293; Studio press.
(11-9261) 1889

Kent, Charles Foster, 1867–

Biblical geography and history, by Charles Foster Kent ... New York, Charles Scribner's sons, 1911.
xviii, 296 p. maps (partly fold., incl. front.) plan. 19½ᶜᵐ.
"Selected bibliography": p. 279–282.
ⓒ Apr. 8, 1911; 1c. Apr. 17, 1911; 1c. Apr. 25, 1911*; A 286434; Charles Scribner's sons. (11-9238) 1890

Kirschbaum, Simon.

Business organization and administration, credits and private finance, by Simon Kirschbaum ... New York, Universal business institute, inc., ᶜ1910·
2 p. l., 7-356 p. 22ᶜᵐ. $20.00
Publisher's lettering: vol. I.
ⓒ Nov. 29, 1910; 1c. Apr. 18, 1911; A 286120; Universal business institute, inc. (11-9185) 1891

—— Questions and problems, by Edward M. Hyans ... New York, Universal business institute, inc., ᶜ1910·
1 p. l., 5-64 p. 22ᶜᵐ. $10.00
Publisher's lettering: vol. II.
ⓒ Nov. 29, 1910; 1c. Apr. 1, 1911; 1c. Apr. 12, 1911*; A 286121; Universal business institute, inc. (11-9186) 1892

Lalis, Anthony, 1875–

Lietuviškos ir angliškos kalbu žodynas. Sutaisē Antanas Lalis ... 3., išnaujo taisytas ir gausiai papildytas, spaudimas. Chicago, Ill., Turtu ir spauda "Lïetuvos," 1911.

2 pt. in 1 v. 23ᶜᵐ.
CONTENTS.—1. dalis. Lietuviškai-Angliška.—2. dalis. Angliškai-Lietuviška.

© Apr. 12, 1911; 2c. Apr. 17, 1911; A 286275; A. Olszewski, Chicago.
(11-9033) 1893

The **lawyers** reports annotated. New series. Book 30. Burdett A. Rich, Henry P. Farnham, editors. 1911. Rochester, N. Y., The lawyers co-operative publishing company, 1911.

ix, 1301 p. 25ᶜᵐ. $4.00
© May 2, 1911; 2c. May 5, 1911*; A 286714; Lawyers co-operative pub. co.
 1894

Lipper, Milton William, 1884–

Investments, by Milton W. Lipper ... New York, Universal business institute, inc., ᶜ1910.

452 p. plates, forms. 22ᶜᵐ. $20.00
Publisher's lettering: vol. I.

© Oct. 24, 1910; 1c. Apr. 1, 1911; 1c. Apr. 12, 1911*; A 286122; Universal business institute, inc. (11-9183) 1895

—— Questions and problems, by Arthur Loewenheim ... New York, Universal business institute, inc., ᶜ1910.

1 p. l., 5-50 p. 22ᶜᵐ. $10.00
Publisher's lettering: vol. II.

© Oct. 24, 1910; 1c. Apr. 1, 1911; 1c. Apr. 12, 1911*; A 286123; Universal business institute, inc. (11-9184) 1896

Louisiana. *Supreme court.*

Reports ... Annotated ed. ... Book 17, containing a verbatim reprint of vols. 5 & 6 of Robinson's reports. St. Paul, West publishing co., 1911.

ix, 323, viii, 358 p. 22½ᶜᵐ. $7.50
© Apr. 26, 1911; 2c. May 5, 1911*; A 286707; West pub. co. 1897

Lowndes, *Mrs.* Marie Adelaide (Belloc) 1868–

Jane Oglander, by Mrs. Belloc Lowndes ... New York, C. Scribner's sons, 1911.

2 p. l., 314 p. 19½ᶜᵐ. $1.25
© Apr. 22, 1911; 2c. Apr. 25, 1911*; 286437; Charles Scribner's sons.
(11-9156) 1898

Mathiez, Albert.

... Rome et le clergé français sous la Constituante; la constitution civile du clergé, l'affaire d'Avignon. Paris, A. Colin, 1911.

3 p. l., 533 p., 1 l. 19ᶜᵐ. fr. 5
© Mar. 31, 1911; 2c. Apr. 22, 1911*; A—Foreign 2833; Max Leclerc and H. Bourrelier, Paris. (11-9170) 1899

Maurel, André, 1863–

Little cities of Italy, by André Maurel; tr. by Helen
Gerard ... with a preface by Guglielmo Ferrero. Flo-
rence—San Gimignano—Monte Oliveto—Pisa—Lucca—
Prato—Pistoia—Arezzo—Lecco — Bergamo — Brescia—
Verona—Vicenza — Padua — Mantua — Arqua. With 30
illustrations. New York and London, G. P. Putnam's
sons, 1911.

xvii p., 1 L, 295 p. front., plates, ports. 21ᶜᵐ. $2.50
© Apr. 19, 1911; 2c. Apr. 24, 1911*; A 286396; G. P. Putnam's sons.
 (11–9162) 1900

Miller, Daniel, ed.

Pennsylvania German. A collection of Pennsylvania
German productions in poetry and prose. Ed. by Daniel
Miller ... v. 2. Reading, Pa., D. Miller, I. M. Beaver,
1911.

vii, ₁9₁–265 p. front., illus., plates, ports. 19½ᶜᵐ. $1.00
© May 1, 1911; 2c. May 4, 1911*; A 286680; D. Miller. 1901

Monnette, Orra Eugene, 1873–

Monnet family genealogy, an emphasis of a noble Hu-
guenot heritage, somewhat of the first immigrants Isaac[1]
and Pierre[1] Monnet; being a presentation of those in
America bearing the name as variously spelled, Monet,
Monete, Monett, Monette, Monnet, Monnett, Monnete,
Monnette, Monay, Maunay, Money, Monie, Monnie, Mo-
nat, Monatt, Manett, Mannett, Munnitt, Munnett, Manee,
Maney, Amonnet, Amonet, etc., with complete genealogies
of the main lines; including the history of la noble maison
de Monet de la Marck, seigneurs et barons, from the year
1632; the genealogy of seigneurs de Monnet, la maison de
Salins, from the year 1184; and containing short accounts
of certain of the Pillot, Nuthall, Sprigg, Hillary, Mariarte,
Crabb, Williams, Osborn, Burrell, Hellen, Lake and Bird,
Caldwell, Slagle, Reichelsdörfer, Hagenbuch, Schissler,
Braucher, Wayland, Wilhoit, Kinnear, Hull, Ludwig, Lutz,
et al., families connecting with the ancestral lines. With
coats of arms, fac-similes of original documents and rec-
ords, maps and charts, color plates and cuts of distin-
guished members of the family, in illustration. Written
and comp. by Orra Eugene Monnette ... [Los Angeles,
Cal., C. E. Bireley company, 1911]

9 p. l., 5–1151, 16, lxxviii p. incl. illus., plates, ports., maps, facsims., coats
of arms. col. front., col. pl. 26ᶜᵐ.
© Apr. 12, 1911; 2c. Apr. 21, 1911*; A 286360; O. E. Monnette, Los An-
 geles. (11–8960) 1902

New Hampshire. *Supreme court.*

The New Hampshire reports. June, 1908–December,
1910. John H. Riedell, reporter. v. 75. Concord, Printed
by the Rumford printing company, 1910 ₁1911₁

xxix, 673 p. 24ᶜᵐ. $3.00

© May 3, 1911; 2c. May 6, 1911*; A 286719; John H. Riedell, Manchester,
N. H. 1903

North, James.

The cameo shell, and other poems, by Dr. James North
... selected by Cora Marguerite North. ₁Philadelphia,
Pa., Printed by the John C. Winston co.₁ 1911.

55 p. 19½ᶜᵐ. $1.00

© Apr. 9, 1911; 2c. Apr. 20, 1911*; A 286302; J. North, Atlantic City, N. J.
(11–9262) 1904

... The **Northeastern** reporter, with key-number annota-
tions. v. 93. Permanent ed. ... December 20, 1910–
March 21, 1911. St. Paul, West publishing co., 1911.

xxiv, 1298 p. 26½ᶜᵐ. (National reporter system—State series) $4.00

© Apr. 29, 1911; 2c. May 5, 1911*; A 286709; West pub. co. 1905

Notes on the Minnesota reports, including the citations of
each case as a precedent (1) by any court of last resort
in any jurisdiction of this country; (2) by the exten-
sive and thorough annotations of the leading annotated
reports; (3) by all important modern text-books.
v. 1. Rochester, N. Y., The Lawyers co-operative pub-
lishing company, 1911.

2 p. l., 1241 p. 24ᶜᵐ. $7.50

© Apr. 3, 1911; 2c. Apr. 20, 1911*; A 286317; Lawyers co-operative pub.
co. (11–9159) 1906

Palau, Gabriel.

The practical Catholic; maxims suited to Catholics of
the day, by Rev. Gabriel Palau, s. J.; authorized American
translation by Francis A. Ryan ... New York, Cincin-
nati ₁etc.₁ Benziger brothers, 1911.

350 p. 13½ᶜᵐ.

© Apr. 5, 1911; 2c. Apr. 7, 1911*; A 286018; Benziger bros.
(11–9243) 1907

Richardson, James D.

A compilation of the messages and papers of the presi-
dents, by James D. Richardson ... (with additions) v. 11.
Index. ₁New York₁ Bureau of national literature, 1911.

2 p. l., ₁3₁, 840 p., 1 l. front., maps. 25ᶜᵐ.

© Apr. 1, 1911; 2c. Apr. 19, 1911; A 286685; Bureau of national literature.
1908

Ritchie, Arthur.

Spiritual studies in St. John's Gospel, by the Rev. Arthur Ritchie ... vol. 1. Milwaukee, The Young churchman co., 1911.

viii, 210 p. 16ᶜᵐ. $0.75

© Apr. 19, 1911; 2c. Apr. 24, 1911*; A 286415; Young churchman co. (11–9171) 1909

Robbins, Alice Emily.

A tour and a romance, by Alice E. Robbins ... London, A. Melrose, 1911.

viii, 280 p. front., plates. 19½ᶜᵐ.

© 1c. Apr. 7. 1911*; A ad int. 567; pubd. Mar. 11, 1911; A. Melrose, London. (11–9231) 1910

Robertson, James Alexander, *ed. and tr.*

Louisiana under the rule of Spain, France, and the United States, 1785–1807 ... v. 2. Cleveland, O., The Arthur H. Clark company, 1911.

5 p. l., [13]–391 p. maps (partly fold.) 24½ᶜᵐ. $5.00

© May 1, 1911; 2c. May 4, 1911; A 286691; J. A. Robertson, Manila, P. I.
 1911

Seawell, Molly Elliot, 1860–

The ladies' battle, by Molly Elliot Seawell. New York, The Macmillan company, 1911.

v. 7–119 p. 18ᶜᵐ. $1.00

© Apr. 20, 1911; 2c. Apr. 21, 1911*; A 286333; Macmillan co. (11–9065) 1912

Siedel, Ernst.

Der weg zur ewigen schönheit, lebensweisheit für jungfrauen; auf verlangen in druck gegeben von kirchenrat dr. Ernst Siedel ... mit buchschmuck von William Krause. 18.–21. tausend. Dresden, E. L. Ungelenk, 1911.

2 p. l., 499, [1] p. 19½ᶜᵐ. M. 4

© Mar. 6, 1911; 2c. Apr. 17, 1911*; A—Foreign 2768; C. Ludwig Ungelenk. (11–9168) 1913

Slater, Thomas, 1855–

Cases of conscience for English-speaking countries, solved by Rev. Thomas Slater ... v. 1. New York, Cincinnati [etc.] Benziger brothers, 1911.

2 p. l., 7–351 p. 23ᶜᵐ.

© Apr. 10, 1911; 2c. Apr. 13, 1911*; A 286145; Benziger bros., New York. N. Y. (11–9244) 1914

Sombart, Werner, 1863–

... Die Juden und das wirtschaftsleben. Leipzig, Duncker & Humblot, 1911.

xxvi, 476 p. 24ᶜᵐ. M. 9

"Quellen und literaturnachweis": p. [435]–476.

© Feb. 21, 1911; 2c. Apr. 17, 1911*; A—Foreign 2762; Duncker & Humblot. (11–9055) 1915

Stevenson, Robert Louis, 1850–1894.

... An inland voyage and Travels with a donkey, by Robert Louis Stevenson; ed. by Gilbert Sykes Blakely ... New York, Cincinnati [etc.] American book company [°1911]

xxi, 128, viii, vii p. front. (port.) map. 16½ᶜᵐ. (Gateway series) $0.40

© Apr. 18, 1911; 2c. Apr. 21, 1911*; A 286339; Amer. book co. [Copyright is claimed on Introduction and Notes] (11-9164) 1916

U. S. *Circuit courts of appeals.*

... Reports, with annotations ... v. 104. St. Paul, West publishing co., 1911.

xlvii, 734 p. 23½ᶜᵐ. $2.85

© Apr. 29, 1911; 2c. May 5, 1911*; A 286708; West pub. co. 1917

Weld, Louis Dwight Harvell, 1882–

Practical salesmanship, by Louis D. H. Weld ... New York, Universal business institute, inc., °1910.

2 p. l., 7–411 p. 22ᶜᵐ. $20.00
Publisher's lettering: vol. I.

© Oct. 21, 1910; 1c. Apr. 1, 1911; 1c. Apr. 12, 1911*; A 286124; Universal business institute, inc. (11-9179) 1918

—— Questions and problems, by John M. Brock ... New York, Universal business institute, inc., °1910·

1 p. l., 5–79 p. 22ᶜᵐ. $10.00
Publisher's lettering: vol. II.

© Oct. 21, 1910; 1c. Apr. 1, 1911; 1c. Apr. 12, 1911; A 286125; Universal business institute, inc. (11-9180) 1919

Wemyss, Mary C E.

People of Popham, by Mary C. E. Wemyss. Boston and New York, Houghton Mifflin company [1911]

3 p. l., 3–337, [1] p., 1 l. 19ᶜᵐ. $1.20

© Apr. 15, 1911; 2c. Apr. 25, 1911*; A 286441; M. C. E. Wemyss, London. (11-35362) 1920

Wundt, Wilhelm Max, 1832–

Probleme der völkerpsychologie, von Wilhelm Wundt. Leipzig, E. Wiegandt, 1911.

4 p. l., 120 p. 22ᶜᵐ. M. 3.80

© Feb. 25, 1911; 2c. Apr. 17, 1911*; A—Foreign 2782; Ernest Wiegandt. (11-9169) 1921

Yager, Willard E.

The Onéota; medicine in the forest [by] Willard E. Yager ... Oneonta, N. Y. [Oneonta Herald pub. co.] 1911.

84 p. illus. 23ᶜᵐ.

© Apr. 6, 1911; 2c. Apr. 10, 1911*; A 286072; W. E. Yager, Oneonta, N. Y. (11-9250) 1922

Arkansas. *Supreme court.*

Arkansas reports, v. 94. Cases determined from February, 1910, to May, 1910. T. D. Crawford, reporter. ₁Little Rock₁ Published by the state of Arkansas, 1911.

xxi, 640 p. 23½ᶜᵐ. $1.50

© Apr. 24, 1911; 2c. May 8, 1911*; A 286760; Earle W. Hodges, sec. of state of Arkansas, Little Rock, Ark. **1923**

Austin, Leonard Strong, 1846–

The metallurgy of the common metals, gold, silver, iron, copper, lead, and zinc, by Leonard S. Austin ... 3d ed., rev. and enl. San Francisco, Mining and scientific press; ₁etc., etc.₁ 1911.

528 p. illus. 23½ᶜᵐ. $4.00

© Apr. 17, 1911; 2c. Apr. 24, 1911*; A 286397; Dewey pub. co., San Francisco. (11–9299) **1924**

Austin, *Mrs.* Mary (Hunter) 1868–

The arrow maker; a drama in three acts, by Mary Austin ... New York, Duffield and company, 1911.

xiii, 128 p. front. (port.) 19½ᶜᵐ.

© Apr. 8, 1911; 2c. Apr. 12, 1911; D 24073; Duffield & co. (11–9259) **1924***

Bush, *Mrs.* Rebecca Gibbons Tatnall, 1853–

What and how; a practical cook book for every day living, by Mrs. Bush. Pub. by Miss Edna N. Taylor. Wilmington, Del., New Amstel magazine company, 1910.

2 p. l., 7–336 p. 22ᶜᵐ. $1.25

© Dec. 22, 1910; 2c. Apr. 21, 1911*; A 286358; Edna N. Taylor, Wilmington, Del. (11–9290) **1925**

Buswell, Henry Foster, 1842–

Practice and pleading in personal actions in the courts of Massachusetts. By Henry F. Buswell and Charles H. Walcott ... 5th ed., rev. and enl. Boston, Little, Brown, and company, 1911.

xlii p., 1 l., 716 p. 25ᶜᵐ. $6.50

© Apr. 15, 1911; 2c. Apr. 25, 1911*; A 286456; H. F. Buswell, Canton, Mass., and John Walcott, Concord, Mass. (11–9248) **1926**

Byron, George Gordon Noël Byron, *6th baron*, 1788–1824·

... Childe Harold's pilgrimage, canto fourth, and The prisoner of Chillon, by Lord Byron; ed. with an introduction and notes by Charles Elbert Rhodes ... New York, Charles E. Merrill company ₁ʼ1911₁

141 p. front. (port.) 17ᶜᵐ. (Merrill's English texts) $0.25

© Mar. 14, 1911; 2c. Mar. 24, 1911*; A 283638; C. E. Merrill co. (11–9260) **1927**

329

Carus, Paul, 1852–
Philosophie als wissenschaft, von Paul Carus, uebers. von des verfassers pamphlet The philosophy of form. Chicago, The Open court publishing company, 1911.

4 p. l., 53 p. 19½ᶜᵐ.
© Mar. 28, 1911; 2c. Apr. 6. 1911*; A 283984; Open court pub. co.
(11–9241) 1928

Celestine,
Eternity; a lenten course of seven sermons, including a sermon for Good Friday, by the Rev. Celestine, o. m. cap. New York, J. F. Wagner [ᶜ1911]

68 p. 20½ᶜᵐ. $0.40
© Jan. 31 1911; 2c. Mar. 7, 1911*; A 283220; Joseph F. Wagner.
(11–9245) 1929

Clements, Wib F.
What the Sam Hill, by Wib. F. Clements. New York, Chicago [etc.] Broadway publishing co. [ᶜ1911]

60 p. front., plates. 20½ᶜᵐ. $0.75
© Feb. 9, 1911; 2c. Mar. 18, 1911*; A 283487; W. F. Clements, Agency, Ia.
(11–8937) 1930

Crüwell, Gottlieb August, 1866–
Schönwiesen, ein schauspiel, von G. A. Crüwell ... Berlin, S. Fischer, 1911.

177 p., 1 l. 19ᶜᵐ.
© Mar. 1, 1911; 2c. Apr. 17, 1911*; D 23972; S. Fischer, verlag.
(11–9269) 1930*

Dalton, Sir Cornelius Neale, 1842–
The real Captain Kidd; a vindication, by Sir Cornelius Neale Dalton ... New York, Duffield and company, 1911.

vi, 335 p. 19¼ᶜᵐ. $1.25
© Apr. 25, 1911; 2c. Apr. 27, 1911*; A 286496; Duffield & co.
(11–9302) 1931

Frossard, Édouard.
Varieties of United States cents of the year 1794, described and illustrated, by Ed. Frossard and W. W. Hays, illustrated from the magnificent cent collection of E. Gilbert ... and reprinted, with additional numbers, by Thos. L. Elder ... New York city, The Elder numismatic press, ᶜ1910.

1 p. l., 5–26 p., 1 l. iv pl. 29ᶜᵐ.
© Mar. 1, 1911; 2c. Apr. 1, 1911*; A 283887; Thos. L. Elder, New York.
(11–9161) 1932

Gavf, Emma.
A comedy of circumstance, by Emma Gavf; illustrated by Wallace Morgan. Garden City, New York, Doubleday, Page & company, 1911.

6 p. l., 3–253 p. col. front., plates. 19½ᶜᵐ. $1.00
© Apr. 20, 1911; 2c. Apr. 28, 1911*; A 286529; Doubleday, Page & co.
(11–9232) 1933

Gill, Augustus Herman, 1864–
A short hand-book of oil analysis, by Augustus H. Gill
... 6th ed., rev. and enl. Philadelphia and London, J. B.
Lippincott company, 1911.
6 p. l., 11–188 p. incl. illus., tables. 21ᶜᵐ. $2.00
"References" at end of some of the chapters.
© Mar. 24, 1911; 2c. Apr. 21, 1911*; A 286349; J. B. Lippincott co.
(11–9297) 1934

Girola, A M.
Translation method for the study of modern languages,
by A. M. Girola & Charles Raupers. English-German
part. 1st book. New York, A. M. Girola & C. Raupers,
1911.
224 p. 20¼ᶜᵐ. $1.50
© Dec. 23, 1910; 2c. Apr. 3, 1911; A 283921; A. M. Girola & C. Raupers.
(11–9255) 1935

Gowing, Frederick Henry, 1860–
Building plans for modern homes [by] Frederick H.
Gowing ... Boston, Mass. [F. H. Gowing, ᶜ1911]
[52] p. illus. (incl. plans) 19 x 27ᶜᵐ.
© Apr. 3, 1911; 2c. Apr. 4, 1911*; A 283931; F. H. Gowing.
(11–9280) 1936

Grabein, Paul, 1869–
Das neue geschlecht, roman, von Paul Grabein. Leip-
zig [etc.] Grethlein & co. [ᶜ1910]
274 p. 20ᶜᵐ. M. 3.50
© Mar. 31, 1911; 2c. Apr. 17, 1911*; A—Foreign 2773; Grethlein & co.
(11–9267) 1937

Hamel, George Thomas, 1869–
Modern practice of canning meats, by G. T. Hamel.
St. Louis, The Brecht company, ᶜ1911·
100 p. illus. 23¼ᶜᵐ. $5.00
© Feb. 25, 1911; 2c. Mar. 22, 1911*; A 283590; Gus. V. Brecht butchers'
supply co. (11–9172) 1938

Haworth, Paul Leland.
The path of glory, by Paul Leland Haworth; with illus-
trations by Harry C. Edwards. Boston, Little, Brown,
and company, 1911.
viii p., 1 l., 348 p. front., plates. 19¼ᶜᵐ. $1.25
© Apr. 15, 1911; 2c. Apr. 27, 1911*; A 286505; Little, Brown, and com-
pany. (11–9153) 1939

Hibben, John Grier, 1861–
A defence of prejudice, and other essays, by John Grier
Hibben ... New York, C. Scribner's sons, 1911.
4 p. l., 183 p. 19¼ᶜᵐ. $1.00
CONTENTS.—A defence of prejudice.—The philosophy of opposition.—
The paradox of research.—On responsibility.—The whole and the part.—
The gospel of might.—The dialectic imagination.—The art of thinking.—
The vocation of the scholar.—The superfluous in education.—Secondary
strains.
© Apr. 22, 1911; 1c. Apr. 17, 1911; 1c. Apr. 25, 1911*; A 286433; Charles
Scribner's sons. (11–9569) 1940

Horstmann, Henry Charles, 1858–
Practical armature and magnet winding; a comprehensive treatise for the workers; fully illustrating the theoretical principles and shop practice of armature and magnet work; by Henry C. Horstmann and Victor H. Tousley ... 2d ed., enl. Chicago, F. J. Drake & co. [ʿ1911]
v, 259 p. incl. illus., tables. 17ᶜᵐ. $1.50
© Apr. 14, 1911; 2c. Apr. 17, 1911; A 286304; H. C. Horstmann and V. H. Tousley, Chicago. (11-9292) 1941

Huntington, Ellsworth, 1876–
Palestine and its transformation, by Ellsworth Huntington ... Boston and New York, Houghton Mifflin company, 1911.
xvii, 443, [1] p. front., illus., plates, maps, plans. 21ᶜᵐ.
© Apr. 15, 1911; 2c. Apr. 25, 1911*; A 286442; E. Huntington, New Haven, Conn. (11-9236) 1942

Kaiser, Georg.
Die jüdische witwe, biblische komödie, von Georg Kaiser. Berlin, S. Fischer, 1911.
163, [1] p. 19ᶜᵐ.
© Mar. 1, 1911; 2c. Apr. 17, 1911*; D 23973; S. Fischer, verlag. (11-9257) . 1942*

Kilner, Martin.
Die andre hälfte, roman von Martin Kilner ... Berlin-Charlottenburg, Vita, deutsches verlagshaus [ʿ1911]
4 p. l., [5]–324 p. 19ᶜᵐ. M. 3.50
© Apr. 1, 1911; 2c. Apr. 19, 1911*; A—Foreign 2806; Felix Heinemann. Berlin-Charlottenburg. (11-9268) 1943

Lake, Edmund Francis, 1863–
Composition and heat treatment of steel, by E. F. Lake. 2d ed. rev. and cor. New York [etc.] McGraw-Hill book company, 1911.
x, 252 p. illus., diagrs. 24ᶜᵐ. $2.50
© Apr. 20, 1911; 2c. Apr. 21, 1911*; A 286345; McGraw-Hill book co. (11-9295) 1944

Law, James.
Text book of veterinary medicine, by James Law ... v. 2. 3d ed., rev. and enl. ... Ithaca, N. Y., The author, 1911.
1 p. l., 597 p. 24ᶜᵐ. $4.00
© May 2, 1911; 2c. May 9, 1911*; A 286767; J. Law. 1945

Lieber, Francis, 1800–1872.
Manual of political ethics, designed chiefly for the use of colleges and students at law ... By Francis Lieber ... 2d ed., rev. and ed. by Theodore D. Woolsey, with an introduction by Nicholas Murray Butler. Philadelphia and London, J. B. Lippincott company, 1911.
2 v. 23½ᶜᵐ. $5.50
© Apr. 6, 1911; 2c. Apr. 21, 1911*; A 286353; J. B. Lippincott co. (11-9302) 1946

MacGregor, Wallace F 1874–

Science of successful threshing. Dingee-MacGregor.
6th ed., rev. and enl. Racine, Wis., J. I. Case threshing
machine co., incorporated, 1911.

256 p. illus. 19ᶜᵐ.
"By Wallace F. MacGregor, assisted by W. W. Dingee (retired)"
© Mar. 14, 1911; 2c. Apr. 1, 1911; A 283961; R. T. Robinson, Racine, Wis.
(11–9271) 1947

Mack, William, ed.

Cyc. annotations to Cyclopedia of law and procedure,
1–36 cyc. ... Ed. by De Witt C. Blashfield under the
supervision of William Mack ... Canadian cases ed. by
John King ... New York, The American law book com-
pany; [etc., etc.] 1911.

xvi, 3758 p. 26ᶜᵐ. $7.20
© Mar. 7, 1911; 2c. Mar. 8, 1911*; A 283233; American law book co., New
York, N. Y. 1948

Mighels, Philip Verrill, 1867 -

Thurley Ruxton, by Philip Verrill Mighels ... illustra-
tions by James Montgomery Flagg. New York, D. Fitz
Gerald, inc., 1911.

3 p. l., 378 p. col. front., plates. 19½ᶜᵐ. $1.20
© Apr. 18, 1911; 2c. Apr. 27, 1911*; A 286494; Desmond FitzGerald, inc.
(11–9151) 1949

Möhring, Frau Elisabeth, 1869–

Hinter dem nebel; zwei novellen von Elisabeth Heyde-
mann-Möhring. Berlin-Charlottenburg, Vita, deutsches
verlagshaus [°1911]

197, [1] p., 1 l. 19ᶜᵐ. M. 3
CONTENTS.—Und es erhob sich ein sturm.—Ecce homo.
© Apr. 1, 1911; 2c. Apr. 19, 1911*; A—Foreign 2808; Felix Heinemann,
Berlin-Charlottenburg. (11–9265) 1950

Molière, Jean Baptiste Poquelin, 1622–1673.

Les femmes savantes, par Molière; ed., with introduc-
tion. notes, and vocabulary, by Charles A. Eggert ... New
York, Cincinnati [etc.] American book company [°1911]

187 p. 16½ᶜᵐ. $0.40
© Apr. 21, 1911; 2c. Apr. 25, 1911*; A 286429; Charles A. Eggert, Chi-
cago. (11–9570) 1951

Noguchi, Hideyo.

Serum diagnosis of syphilis and the butyric acid test
for syphilis, by Hideyo Noguchi ... 14 illustrations. 2d
ed. Philadelphia & London, J. B. Lippincott company
[°1911]

ix, 238 p. incl. illus. (partly col.) tables. col. plates. 22½ᶜᵐ. $2.50
Bibliography: p. 187–229.
© Apr. 17, 1911; 2c. Apr. 21, 1911*; A 286351; J. B. Lippincott co.
(11–9287) 1952

Partridge, George Everett, 1870–
The nervous life, by G. E. Partridge ... New York,
Sturgis & Walton company, 1911.
1 p. l., v–viii p., 2 l., 3–216 p. 19½ᶜᵐ. $1.00
© Apr. 19, 1911; 2c. Apr. 21, 1911*; A 286346; Sturgis & Walton co.
(11–9286) **1953**

Peters, Edward Dyer, 1849–
The practice of copper smelting, by Edward Dyer Pe-
ters ... New York [etc.] McGraw-Hill book company,
1911.
xi, 693 p. illus. 24ᶜᵐ. $5.00
© Apr. 21, 1911; 2c. Apr. 24, 1911*; A 286399; McGraw-Hill book co.
(11–9288) **1954**

Roberts, Isabel J.
The little girl from back East, by Isabel J. Roberts.
New York, Cincinnati [etc.] Benziger brothers, 1911.
132 p. front. 17½ᶜᵐ.
© Mar. 29, 1911; 2c. Mar. 31, 1911*; A 283853; Benziger bros.
(11–9150) **1955**

Roe, Joseph Wickham.
Steam turbines; a short treatise on theory, design, and
field of operation, by Joseph Wickham Roe ... New York
[etc.] McGraw-Hill book company, 1911.
vii p., 1 l., 143 p. illus., tables, diagrs. (partly fold.) 23½ᶜᵐ. $2.00
"References" at end of chapters.
Bibliography: p. 135–136.
© Apr. 21, 1911; 2c. Apr. 24, 1911*; A 286391; McGraw-Hill book co.
(11–9293) **1956**

Royce, George Monroe, 1850–
The passing of the American, by Monroe Royce ...
New York, Thomas Whittaker (inc.) 1911.
189 p. 19ᶜᵐ. $1.20
© Apr. 19, 1911; 2c. Apr. 21, 1911*; A 286331; G. M. Royce, New York.
(11–9301) **1957**

Scheffel, Joseph Victor von, 1826–1886.
Ekkehard; Audifax und Hadumoth, by Joseph Victor
von Scheffel, ed. with notes, exercises, and vocabulary, by
Charles Hart Handschin ... and William F. Luebke ...
New York, Cincinnati [etc.] American book company
[°1911]
251 p. illus. (map) 16½ᶜᵐ. $0.60
© Mar. 30, 1911; 2c. Apr. 1, 1911*; A 283860; C. H. Handschin and W. F
Luebke, Oxford, O. (11–9034) **1958**

Schlesinger, Georg.
Selbstkostenberechnung im maschinenbau, zusammen-
stellung und kritische beleuchtung bewährter methoden
mit praktischen beispielen, von dr.-ing. Georg Schlesinger
... Berlin, J. Springer, 1911.
2 p. l., 170 p. illus., forms. 27½ᶜᵐ.
© Feb. 27, 1911; 2c. Apr. 17, 1911*; A—Foreign 2763; Julius Springer.
(11–9304) **1959**

Schneider, Norman Hugh.

Wiring houses for the electric light, with special reference to low voltage battery systems, by Norman H. Schneider ... 1st ed. New York, Spon & Chamberlain; [etc., etc.] 1911.

viii, 86 p. illus. 18^{cm}. (*On cover:* The model library, no. 33) $0.25
© Apr. 18, 1911; 2c. Apr. 19, 1911; A 286330; Spon & Chamberlain, New York. (11-9294) **1960**

Sharts, Joseph William, 1875–

The vintage, by Joseph Sharts ... New York, Duffield & company, 1911.

4 p. l., 299 p. col. front. 19½^{cm}. $1.20
© Apr. 25, 1911; 2c. Apr. 27, 1911*; A 286495; Duffield & co.
(11-9152) **1961**

Snedeker, Caroline Dale.

The coward of Thermopylæ, by Caroline Dale Snedeker. Garden City, New York, Doubleday, Page & company, 1911.

6 p. l., 3–466 p. col. front., illus., col. plates. 19½^{cm}. $1.20
© Apr. 20, 1911; 2c. Apr. 28, 1911*; A 286530; Doubleday, Page & co.
(11-9233) **1962**

Spencer, Henry Percival, 1883–

A rape of Hallowe'en [by] Henry Percival Spencer ... Boston, R. G. Badger, 1911.

107 p. 19½^{cm}. $1.00
CONTENTS.—A rape of Hallowe'en.— The straggler.— Rosaline.— Ellen Dee.—Yorktown.
© Apr. 15, 1911; 2c. Apr. 24, 1911*; A 286400; H. P. Spencer, Watertown, N. Y. (11-9568) **1963**

Stimson, Frederic Jesup, 1855–

A concise law dictionary of words, phrases, and maxims, with an explanatory list of abbreviations used in law books, by Frederic Jesup Stimson ... Rev. ed., by Harvey Cortlandt Voorhees ... Boston, Little, Brown, and company, 1911.

3 p. l., 346 p. 23^{cm}. $3.00
© Apr. 15, 1911; 2c. Apr. 25, 1911*; A 286455; Little, Brown, and company. (11-9249) **1964**

Strümpell, Adolf i. e. Gustav Adolf von, 1853–

A text-book of medicine for students and practitioners, by Dr. Adolf v. Strümpell ... 4th American ed., tr. by permission from the 17th rev. German ed., with editorial notes, additional chapters, and a section on mental diseases, by Herman F. Vickery ... and Philip Coombs Knapp ... with six plates, three of which are in color, and two hundred and twenty-four illustrations in the text ... New York and London, D. Appleton and company, 1911.

2 v. illus. (partly col.) 6 pl. (3 col.) 24½^{cm}. $12.00
© Apr. 18, 1911; 2c. Apr. 20, 1911*; A 286329; D. Appleton & co.
(11-9288) **1965**

Sue, Eugène i. e. **Marie Joseph Eugène,** 1804–1857.
The galley slave's ring; or, The family of Lebrenn; a
tale of the French revolution of 1848, by Eugene Sue.
Tr. from the original French by Daniel De Leon. ₁New
York₁ New York labor news company, 1911.

4 p. l., 223 p. 19½ᶜᵐ.

© Apr. 22, 1911; 2c. Apr. 26, 1911*; A 286470; New York labor news co.,
New York. (11–9154) **1966**

The **traveling** engineers' association, to improve the
locomotive engine service of American railroads; exami-
nation questions and answers, for firemen for promotion
and new men for employment. ₁Buffalo?₁ ᶜ1911.

225 p., 1 l. illus., diagrs. 16½ᶜᵐ. $1.00

© Mar. 21, 1911; 2c. Apr. 4, 1911*; A 283925; W. O. Thompson, Buffalo.
(11–9173) **1967**

Wagner, Richard.
Richard Wagners briefwechsel mit seinen verlegern,
hrsg. von Wilhelm Altmann ... 2. Briefwechsel mit
B. Schott's söhne ... Leipzig, Breitkopf & Härtel; ₁etc.,
etc., 1911₁

viii, 252 p. 26ᶜᵐ. M. 6

© Apr. 20, 1911; 2c. May 8, 1911*; A—Foreign 2887; B. Schott's söhne,
Mainz, Germany. **1968**

Wegele, Carl.
Die therapie der magen- und darmerkrankungen, von
sanitätsrat dr. Carl Wegele ... 4. umgearb. aufl., mit 11
abbildungen im text. Jena, G. Fischer, 1911.

viii p., 1 l., 458, ₁2₁ p. illus. 24½ᶜᵐ. M. 7.50

© Mar. 24, 1911; 2c. Apr. 17, 1911*; A—Foreign 2770; Gustav Fischer.
(11–9289) **1969**

Wells, Paul.
The man with an honest face; being the personal ex-
periences of a gentleman who signs the name of Howard
Dana, at a critical time in his career, by Paul Wells ...
New York and London, D. Appleton and company, 1911.

x, 322 p., 1 l. front., plates. 19½ᶜᵐ.

© Apr. 21, 1911; 2c. Apr. 26, 1911*; A 286476; D. Appleton & co.
(11–9157) **1970**

Wilson, John Fleming.
The land claimers, by John Fleming Wilson; with illus-
trations of Arthur E. Becher. Boston, Little, Brown,
and company, 1911.

5 p. l., 291 p. front., plates. 19½ᶜᵐ. $1.50

© Apr. 15, 1911; 2c. Apr. 26, 1911*; A 286463; Little, Brown, and com-
pany. (11–9155) **1971**

PART I, BOOKS, GROUP JUN 1 1911
no. 28, May, 1911
From the 1977
U. S. Government.

[Bacon, *Mrs.* Mary Schell (Hoke)] 1870–
Operas that every child should know; descriptions of
the text and music of some of the most famous master-
pieces, by Dolores Bacon [*pseud.*] decorated by Blanche
Ostertag. Garden City, New York, Doubleday, Page &
company, 1911.
vii p., 2 l., 3–460 p. front. 19ᶜᵐ. $0.90
CONTENTS.—Balfe: The Bohemian girl.—Beethoven: Fidelio.—Berlioz:
The damnation of Faust.—Bizet: Carmen.—De Koven: Robin Hood —
Flotow: Martha.—Humperdinck: Hänsel and Gretel.—Mascagni: Caval-
leria rusticana—Meyerbeer: ,The prophet.—Mozart: The magic flute.—
Sullivan: Pinafore.—Verdi: Rigoletto, Il trovatore, Aïda.—Wagner: The
Nibelung ring, The mastersingers of Nuremberg, Lohengrin.
© Apr. 20, 1911; 2c. Apr. 28, 1911*; A 286528; Doubleday, Page & co.
(11-9908) 1972

Barrett, John, 1866–
The Pan American union: peace, friendship, commerce,
by John Barrett ... [Baltimore, Munder-Thomsen press]
1911.
253, [1] p. incl. col. front., illus., plates. 22ᶜᵐ.
© Apr. 10, 1911; 2c. Apr. 12, 1911*; A 286139; J. Barrett, Washington,
D. C. (11-9549) 1973

Beresford, John Davys, 1873–
The early history of Jacob Stahl, by J. D. Beresford ...
Boston, Little, Brown, and company [ᶜ1911]
viii, 513 p. 19¼ᶜᵐ. $1.35
© Apr. 29, 1911; 2c. May 2, 1911*; A 286599; Little, Brown, and company.
(11-9900) 1974

Blades, Franklin, 1830–
Is the life of man eternal? ... By Franklin Blades ...
New York, Cochrane publishing company, 1911.
126 p. 19ᶜᵐ. $1.00
© Apr. 7, 1911; 1c. Apr. 17, 1911; 1c. Apr. 22, 1911*; A 286368; Cochrane
pub. co. (11-9929) 1975

Bosworth, Eva Bird.
Trees and peaks; a nature study [by] Eva Bird Bos-
worth ... [Denver, Col., Printed by W. H. Kistler station-
ary [!] company] ᶜ1911·
93 p. incl. illus., plates, port., plan. 19½ᶜᵐ. $0.50
© Apr. 17, 1911; 2c. Apr. 20, 1911*; A 286319; E. B. Bosworth, Denver.
(11-9560) 1976

[Brandt, Herman D] 1870–
Bridal chef; suggestions and practical recipes for the
new housekeeper. Saint Louis, Brandt & Cordes, 1911.
310 p. incl. col. front. 25½ᶜᵐ. $2.50
© Apr. 15, 1911; 2c. Apr. 21, 1911*; A 286357; Brandt & Cordes.
(11-9916) 1977

1911, no. 28
Printed May 16, 1911

Brauns, Dirk Hendrik, 1874–
Theory of the rotation of the plane of polarisation ... by D. H. Brauns, PH. D. Detroit, Mich. [°1911]
21 p. diagrs. 23ᶜᵐ. $0.30
© Apr. 11, 1911; 2c. Apr. 13, 1911*; A 286163; .D. H. Brauns, Detroit.
(11–9562) 1978

Calderon, George.
The fountain; a comedy in three acts, by George Calderon ... London [etc.] Gowans & Gray, ltd., 1911.
161 p. 15ᶜᵐ. (*Half-title:* Repertory plays, no. 2)
© Apr. 3, 1911; 2c. Apr. 20, 1911; D 24019; G. Calderon, London.
(11–9571) 1978*

Chapin, Edward Whitman.
Evenings with Shakespeare, and other essays, by Edward W. Chapin. Cambridge, Printed at the Riverside press, 1911.
4 p. l., 250 p. 20ᶜᵐ.
CONTENTS.— Coriolanus.— Hamlet.— Macbeth.— Othello.—King Lear.— Henry v and Falstaff.—The tempest.—Oliver Wendell Holmes.—Ralph Waldo Emerson.—Alexander Hamilton.—Robert Louis Stevenson.—Oliver Goldsmith.—Addison's Sir Roger de Coverley papers.
© Apr. 20, 1911; 2c. Apr. 25, 1911*; A 286430; E. W. Chapin, Holyoke, Mass. (11–9566) 1979

Claretie, Jules i. e. Arnaud Arsène *known as* Jules, 1840–
Which is my husband? by Jules Claretie ... tr. by Mary J. Safford ... New York, D. Appleton and company, 1911.
viii p., 2 l., 3–349, [1] p. front., plates. 19½ᶜᵐ. $1.25
© Apr. 28, 1911; 2c. May 2, 1911*; A 286616; D. Appleton & co.
(11–9901) 1980

Columbia university.
... Lectures on literature. New York, The Columbia university press, 1911.
viii, 404 p. 23½ᶜᵐ. $2.00
CONTENTS.—Approaches to literature. by B. Matthews.—Oriental literatures: Semitic literatures. by R. J. H. Gottheil; The literature of India and Persia, by A. V. W. Jackson; Chinese literature. by F. Hirth.—Classical literatures: Greek literature, by E. D. Perry; Latin literature, by N. G. McCrea.—Literary epochs: The middle ages, by W. W. Lawrence; The renaissance, by J. B. Fletcher: The classical rule, by J. Erskine; The romantic emancipation, by C. H. Page.—Modern literatures: Italian literature in the eighteenth century, by C. L. Speranza: Spanish literature, by H. A. Todd; English literature, by A. H Thorndike; French literature, by A. Cohn; German literature, by C. Thomas; Russian literature, by J. A. Joffi, The cosmopolitan outlook, by W. P. Trent.—Literary criticism, by J. E. Spingarn.
© Apr. 18, 1911; 2c. Apr. 19, 1911; A 286381: Columbia univ. press.
(11–9925) 1981

Ellis, Edward Sylvester, 1840–
Adrift on the Pacific; a boys story of the sea and its perils, by Edward S. Ellis ... with four illustrations by J. Watson Davis. New York, A. L. Burt company [°1911]
2 p. l., 3–273 p. front., plates. 19½ᶜᵐ. (Burt's library of the world's best books) $1.00
© Apr. 28, 1911; 2c. May 2, 1911*; A 286598; A. L. Burt co.
(11–9903) 1982

Encyclopædia britannica.

The encyclopædia britannica; a dictionary of arts, sciences, literature and general information. 11th ed. v. 1-14, 21-28. Cambridge, At the University press, 1910-1911.

22 v. illus., plates, maps. 30ᶜᵐ. 27/ per vol.
v. 1-14 © 1c. each Jan. 16, 1911; A ad int. 444-457; pubd. Dec. 19, 1910; v. 21-28 © 1c. each Apr. 3, 1911; A ad int. 559-566; pubd. Mar. 6, 1911; Encyclopædia britannica co., New York. 1983-2004

Ford, Sewell, 1868–

Torchy, by Sewell Ford ... illustrations by George Brehm and James Montgomery Flagg. New York, E. J. Clode [ᶜ1911]

4 p. l., 311 p. front., plates. 19½ᶜᵐ. $1.25
© Apr. 29, 1911; 2c. May 1, 1911; A 286600; Edward J. Clode.
(11-9899) 2005

Frohman, Daniel, 1853–

Memories of a manager; reminiscences of the old Lyceum and of some players of the last quarter century, by Daniel Frohman ... Garden City, New York, Doubleday, Page & company, 1911.

xvii, 235 p. front., plates, ports. 19½ᶜᵐ. $1.00
"Originally published in the columns of The Saturday evening post."
© Apr. 20, 1911; 2c. Apr. 28, 1911*; A 286527; Doubleday, Page & co.
(11-9924) 2006

Grinnell, George Bird, 1849–

Trails of the pathfinders, by George Bird Grinnell ... New York, C. Scribner's sons, 1911.

x, 460 p. front., illus. (map) plates, ports. 20½ᶜᵐ. $1.50
"The chapters in this book appeared first as part of a series of articles under the same title contributed to Forest and stream several years ago."
CONTENTS.—Alexander Henry.—Jonathan Carver.—Alexander Mackenzie.—Lewis and Clark.—Zebulon M. Pike.—Alexander Henry (the younger)—Ross Cox.—The commerce of the prairies.—Samuel Parker.—Thomas J. Farnham.—Fremont.
© Apr. 22, 1911; 2c. Apr. 25, 1911*; A 286435; Charles Scribner's sons.
(11-9543) 2007

Grolier club, New York.

A catalogue of the first editions of the works of Alexander Pope (1688-1744) together with a collection of the engraved portraits of the poet and of his friends. New York, The Grolier club, 1911.

2 p. l., iii-vii, 85, [1] p. front., ports., facsim. 24ᶜᵐ. $3.00
© Apr. 24, 1911; 2c. May 1, 1911*; A 286573; Grolier club.
(11-9909) 2008

Horton, Guy Bertram, 1875–

An annotated continuation of the Vermont digest, 1905-1910; a digest of the reported decisions of the Supreme court of Vermont contained in volumes 78 to 83 inclusive of the Vermont reports, with annotations correlating

Horton, Guy Bertram—Continued
these decisions with the Vermont digest, by Guy B. Horton ... Burlington, Vt. [Free press printing co.] 1911.
1 p. l., 348 col. 27½ᶜᵐ.
© Mar. 25, 1911; 2c. Apr. 6, 1911; A 286219; Robert Roberts, Burlington, Vt. (11-9158) 2009

[Hoskin, Edmund Foster] 1863–
Ball to ball billiards. [Chicago, W. A. Spinks & co., '1911]
1 p. l., 5-52 p. incl. illus., plates, diagrs. 16½ᶜᵐ. $0.50
© Mar. 21, 1911; 2c. Mar. 23, 1911*; A 283622; William A. Spinks & co. (11-9920) 2010

Houston, Edwin James, 1844–
The jaws of death; or, In and around the cañons of the Colorado, by Prof. Edwin J. Houston ... Illustrated by H. Weston Taylor. Philadelphia, Boston [etc.] The Griffith & Rowland press [1911]
395 p. front., illus., plates, map. 20½ᶜᵐ. (Half-title: The young mineralogist series III) $1.25
© Apr. 26, 1911; 2c. Apr. 29, 1911*; A 286545; A J. Rowland, sec., Philadelphia. (11-9897) 2011

Hueffer, Ford Madox, 1873–
Memories and impressions; a study in atmospheres, by Ford Madox Hueffer ... New York and London, Harper & brothers, 1911.
xviii p., 2 l., 335, [1] p. 16 port. (incl. front.) 21½ᶜᵐ. $1.60
© Apr. 6, 1911; 2c. Apr. 8, 1911*; A 286029; Harper & bros. (11-9563) 2012

Husband, Joseph.
A year in a coal-mine, by Joseph Husband. Boston and New York, Houghton Mifflin company, 1911.
3 p. l., 171, [1] p. front. (port.) 19ᶜᵐ. $1.10
© Apr. 15, 1911; 2c. Apr. 25, 1911*; A 286439; J. Husband, Minneapolis. (11-9915) 2013

Jacques, Norbert, 1880–
... Heisse städte, eine reise nach Brasilien. Berlin, S. Fischer, 1911.
4 p. l., 11-228, [2] p. 20ᶜᵐ. M. 3
© Feb. 15, 1911; 2c. Apr. 17, 1911*; A—Foreign 2767; S. Fischer verlag. (11-9551) 2014

Jaloux, Edmond, 1878–
... L'éventail de crêpe. Paris, P. Lafitte et cⁱᵉ, ᶜ1911.
3 p. l., 343 p. 19ᶜᵐ. fr. 3.50
© Apr. 7, 1911; 2c. Apr. 22, 1911*; A—Foreign 2831; Pierre Lafitte & co. (11-9574) 2015

Jews. Liturgy and ritual.
Ritual for Jewish worship, ed. by Max Landsberg, ph. d. Rochester, N. Y. [Press of D. R. Mann] 1911.
2 p. l., 229 p. 18ᶜᵐ. $1.00
© Mar. 31, 1911; 2c. Apr. 8, 1911*; A 286049; Max Landsberg, Rochester, N. Y. (11-9930) 2016

Jordan, John Woolf, 1840– *ed.*
Colonial families of Philadelphia. Editor: John W.
Jordan ... New York, Chicago, The Lewis publishing
company, 1911.
2 v. front., plates, ports., facsims., coats of arms. 27½ᶜᵐ. $50.00
© Apr. 22, 1911; 2c. Apr. 26, 1911*; A 286467; Lewis pub. co.
(11-9544) 2017

King, *Mrs.* **Maria M.**
The new astronomy and laws of nature, the physical
and spiritual universe; their forms, laws and phenomena.
Mysteries in science explained; being in part, an epitome
of the three volumes entitled "Principles of nature," in-
spirationally given by Mrs. Maria M. King, with illustra-
tions and additions, and a brief statement of the theories
of astrology, ancient and modern astronomy and the neb-
ular hypotheses, by Andrew Jackson King ... Hammon-
ton, N. J., A. J. King, 1911.
199 p. front. (port.) illus., diagrs. 23ᶜᵐ.
© Apr. 4, 1911; 2c. Apr. 6, 1911*; A 283990; A. J. King.
(11-9927) 2018

Kirkman, Marshall Monroe, 1842–
Second supplement to the volume Air brake of the Sci-
ence of railways, by Marshall M. Kirkman, embodying
description and instruction for the manipulation of the
New York engine and tender automatic control brake
equipment. Chicago, Cropley Phillips company, 1911.
1 p. l., 5–59 p. illus., diagrs. (1 fold.) 20ᶜᵐ.
© Apr. 22, 1911; 2c. Apr. 24, 1911*; A 286416; Cropley Phillips co.
(11-9291) 2019

Kremnitz, *Frau* **Marie (von Bardeleben)** 1852– •
Laut testament, roman, von Mite Kremnitz. Berlin-
Charlottenburg, Vita, deutsches verlagshaus [ᶜ1911]
276 p. 19ᶜᵐ. M. 3.50
© Apr. 1, 1911; 2c. Apr. 19, 1911*; A—Foreign 2809; Felix Heinemann,
Berlin-Charlottenburg. (11-9564) 2020

L'Arronge, Hans, 1874–
Die macht der blonden, roman von Hans L'Arronge.
Berlin, Verlag continent, g. m. b. h. [ᶜ1911]
352 p. 20ᶜᵐ. M. 4.
© Apr. 6, 1911; 2c. Apr. 19, 1911; A—Foreign 2812; Verlag continent,
g. m. b. h. (11-9565) 2021

Lemercier de Neuville, Louis, 1830–
... Ombres chinoises; dessins de Jean Kerhor. Paris,
Le Bailly, O. Bornemann, succʳ, 1911.
172 p., 1 l. illus. 19ᶜᵐ. fr. 3
CONTENTS.—Notice historique.—Construction du théâtre et des ombres.—
La fête de Catherine.—L'infortuné voyageur.—La soirée Courtepince.—Les
trois souhaits.—La cassette du docteur.—Le crime de Saint-Just.—Les pa-
pillons de Fanchette.—L'île déserte.—Le bon roi Dagobert.
© Apr. 5, 1911; 2c. Apr. 22, 1911*; D 24029; Oscar Bornemann.
(11-9573) 2021*

Magnus, Louis.

... Les sports d'hiver, par Louis Magnus et Renaud de La Fregeolière; préface de Abel Ballif ... Ouvrage orné de 48 pages d'illustrations photographiques et cinématographiques hors texte. Paris, P. Lafitte & c⁰ᵉ [°1911]

347 p. illus., plates. 20½ᶜᵐ. (Sports-bibliothèque) fr. 5 "Bibliographie": p. [343]-347.

© Apr. 7, 1911; 2c. Apr. 22, 1911*; A—Foreign 2835; Pierre Lafitte & co. (11-9921) 2022

Marshall, Archibald, 1866–

The eldest son, by Archibald Marshall ... London, Methuen & co. ltd. [1911]

viii, 344 p., 1 l. 19½ᶜᵐ. 6/

© 1c. Apr. 26, 1911*; A ad int. 598; publ. Mar. 30, 1911; Dodd, Mead & co., New York. (11-9904) 2023

Matthay, Tobias Augustus, 1858 -

Some commentaries on the teaching of pianoforte technique; a supplement to "The act of touch" and "First principles" by Tobias Matthay ... London, New York [etc.] Longmans, Green, and co., 1911.

ix, 55 p. 20½ᶜᵐ. $0.50

© Mar. 15, 1911; 2c. Apr. 10, 1911*; A 286060; Longmans, Green & co., New York. (11-9907) 2024

Moedebeck, Hermann W L 1857–1910.

Moedebecks Taschenbuch zum praktischen gebrauch für flugtechniker und luftschiffer ... bearb. und hrsg. von professor dr. R. Süring; mit 238 textabildungen. 3. gänzlich umgearb. und verb. aufl. Berlin, M. Krayn, 1911.

xiv p., 1 l., 920 p. front. (port.) illus. 18ᶜᵐ.

© Feb. 1, 1911; 2c. Mar. 4, 1911; A—Foreign 2810; M. Krayn. (11-9914) 2025

Moore, John Trotwood.

Jack Ballington, forester, by John Trotwood Moore ... illustrations by George Gibbs. Philadelphia, The John C. Winston co. [°1911]

xii p., 1 l., 341 p. incl. front. plates. 19ᶜᵐ. $1.20

© Apr. 20, 1911; 2c. May 1, 1911*; A 286578; John C. Winston co. (11-9896) 2026

Morton, Marguerite W.

Prize drills and dances; fifteen exercises for primary, intermediate, and advanced classes, with music and illustrations, by Marguerite W. Morton. Chicago, A. Flanagan company [°1911]

143 p. front., diagrs. 18ᶜᵐ. $0.30

© Apr. 15, 1911; 2c. Apr. 20, 1911*; A 286312; A. Flanagan co. (11-9919) 2027

Ohio. *Circuit courts.*

Ohio circuit court reports. New series. v. 13. Cases adjudged ... Vinton R. Shepard, editor. Cincinnati, The Ohio law reporter company, 1911.

3 p. l., v–viii, 637 p. 23½ᶜᵐ. $2.50

© May 9, 1911; 2c. May 11, 1911; A 286849; Ohio law reporter co.

2028

Ottenheimer, I. & M., *pub.*

Ottenheimers' manual of general information ... containing latest census statistics, voting statistics, postal regulations, salaries of government officers, valuable tables ... Baltimore, Md., I. & M. Ottenheimer, ᶜ1911·

128 p. 15ᶜᵐ.

© Apr. 4, 1911; 2c. Apr. 6, 1911*; A 283976; I. & M. Ottenheimer.
(11–9567)

2029

[**Reid, Jessie**] *comp.*

The book of love; with an introduction by Madison Cawein; drawings by Wladyslaw T. Benda. New York, The Macmillan company, 1911.

xxii, 346 p. front., illus: 17ᶜᵐ. (*On back of cover:* The friendly library)

© Apr. 5, 1911; 2c. Apr 6, 1911*; 283971; Macmillan co.
(11–9922)

2030

Rowley, Daisy Woodruff.

Nine hundred model lessons for piano teachers [by] D. W. Rowley ... Birmingham, Ala., Dispatch printing company, 1911.

316 p. 23ᶜᵐ. $10.00

© Apr. 10, 1911; 2c. Apr. 19, 1911*; A 286296; D. W. Rowley, Birmingham, Ala. (11–9906)

2031

Salley, Alexander Samuel, 1871– *ed.*

... Narratives of early Carolina, 1650–1708, ed. by Alexander S. Salley, jr. ... with two maps and a facsimile. New York, C. Scribner's sons, 1911.

xi p., 2 l., 3–388 p. 2 maps (incl. front., 1 fold.) facsim. 22½ᶜᵐ. (*Half-title:* Original narratives of early American history) $3.00

CONTENTS.—The discovery of New Brittaine, 1650.—Francis Yeardley's narrative of excursions into Carolina, 1654.—A relation of a discovery, by William Hilton, 1664.—A brief description of the province of Carolina, by Robert Horne (?) 1666.—A relation of a voyage on the coast of the province of Carolina, 1666, by Robert Sandford.—Letters of early colonists, 1670.—A faithfull relation of my Westoe voyage, by Henry Woodward.—Carolina, or a description of the present state of that country, by Thomas Ashe, 1682.—An account of the province of Carolina, by Samuel Wilson, 1682.—Letters of Thomas Newe, 1682.—Journal of Elder William Pratt, 1695–1701.—Letter of Edward Randolph to the Board of trade, 1699.—Reverend John Blair's mission to North Carolina, 1704.—Party-tyranny, by Daniel Defoe, 1705.—The present state of affairs in Carolina, by John Ash, 1706.—A new description of that fertile and pleasant province of Carolina, by John Archdale, 1707.—From the history of the British empire in America, by John Oldmixon, 1708.

© Apr. 22, 1911; 2c. Apr. 25, 1911*; A 286436; Charles Scribner's sons.
(11–9548)

2032

343

Schon, Hans August Evald Conrad von, 1851–

Hydro-electric practice; a practical manual of the development of water power, its conversion to electric energy, and its distant transmission, by H. A. E. C. von Schon ... 2d ed. Philadelphia & London, J. B. Lippincott company, 1911.

xvii, 383 p. illus., plates, charts, diagrs. 25½cm. $6.00
© Mar. 27, 1911; 2c. Apr. 21, 1911*; A 286352; J. B. Lippincott co.
(11–9913) 2033

Steubenville, O. Chamber of commerce.

Steubenville, Ohio, "the heart of the workshop of the world," famous for iron, steel, tin, glass, pottery, paper, coal, oil, gas and fire clay. [Steubenville] The Steubenville Germania press under the auspices of the Chamber of commerce [1911]

1 p. l., 20 p. front., illus., plates (1 col.) port. 31 x 19½cm. $0.50
© Mar. 11, 1911; 2c. Mar. 13, 1911; A 283572; Joseph Neiderhuber, Steubenville, O. (11–9547) 2034

Stuart, Henry Longan.

Fenella; a novel, by Henry Longan Stuart ... Garden City, New York, Doubleday, Page & company, 1911.

2 p. l., ii–iii, 400 p. 19½cm. $1.20
© Apr. 27, 1911; 2c. May 1, 1911*; A 286563; Doubleday, Page & co.
(11–9898) 2035

Townshend, George.

... The conversion of Mormonism, by George Townshend. [Hartford, Conn., Church missions publishing company, 1911]

59 p. plates, ports., facsim. 18½cm. (Soldier and servant series)
$0.25
© Mar. 25, 1911; 2c. Mar. 28, 1911; A 286292; Church missions pub. co.
(11–9928) 2036

U. S. Laws, statutes, etc.

Herrick's annual public land laws, 1911. (Sixty-first Congress, third session) Comp. ... by Samuel Herrick ... [Washington, L. G. Kelly printing co., [1911]

16 p. 23cm.
© Apr. 1, 1911; 2c. Apr. 22, 1911*; A 286365; S. Herrick, Washington, D. C. (11–9246) 2037

Wentworth-James, Gertie De S.

The price ... by Gertie De S. Wentworth-James ... London, Everett & co., ltd., 1911.

319, [1] p. 19½cm. 6/
© 1c. Apr. 26, 1911*; A ad int. 597; pubd. Mar. 27, 1911; Mitchell Kennerley, New York. (11–9905) 2038

Wherry, Edith.

The red lantern; being the story of the goddess of the red lantern light, by Edith Wherry ... New York, John Lane company, 1911.

5 p. l., 13–306 p. 19cm. $1.30
© Apr. 7, 1911; 2c. May 2, 1911*; A 286605; John Lane co.
(11–9902) 2039

13235.∠

Harvard College Library

PART I, BOOKS, GROUP 1 JUN 1 1911

no. 29, May, 1911

From the

2044

Allen, Fred Raphael, 1880– U. S. Government.

In sonnet wise [by] Fred Raphael Allen. Boston, R. G. Badger, 1911.

109 p. 19½ᶜᵐ. $1.00

© Apr. 4, 1911; 2c. Apr. 13, 1911*; A 286166; F. R. Allen, Boston. (11–9933) 2040

Beach, Chandler B., *ed.*

The new student's reference work for teachers, students and families; ed. by Chandler B. Beach, A. M. v. 5. Containing How and why stories by Elinor Atkinson, and lesson outlines. Chicago, F. E. Compton & company, 1911.

1 p. l., p. 2245–2838. illus., plates (partly col.) 25ᶜᵐ.

© May 10, 1911; 2c. May 15, 1911*; A 286916; C. B. Beach, Riverside, Ill. 2041

Bishop, Leon Wilbur, 1888–

The wireless operators' pocketbook of information and diagrams, by Leon W. Bishop. Lynn, Mass., Bubier publishing company; [etc., etc.] 1911.

vii, 174, [3], 23 p. incl. front., illus., tables, diagrs. 17½ᶜᵐ.

"Supplement ... latest call list of wireless stations": 23 p. at end.

© Mar. 25, 1911; 2c. Apr. 15, 1911*; A 286197; Bubier pub. co. (11–9960) 2042

The citator. Missouri ed. Revision of 1911; a compilation of citations of Missouri Supreme court and courts of appeal decisions, constitution, revised statutes, session laws, court rules, charters, etc., comp. ... by the Citator publishing company. New York, The Citator publishing company [ᶜ1911]

3 p. l., 1087 p. 22ᶜᵐ.

© Apr. 25, 1911; 2c. May 2, 1911*; A 286621; Citator pub. co. (11–10015) 2043

The claims and opportunities of the Christian ministry; John R. Mott, editor; introduction from a letter written to the editor by Theodore Roosevelt ... New York, Young men's Christian association press, 1911.

156 p. 18½ᶜᵐ. $0.50

Originally published as a series of separate pamphlets.

CONTENTS. — Foreword: the editor. — Introduction: from a letter by T. Roosevelt.—I. The claims of the ministry on strong men, by G. A. Gordon.—II. The right sort of men for the ministry, by W. F. McDowell.—III. The modern interpretation of the call to the ministry, by E. I. Bosworth.—IV. The preparation of the modern minister, by W. W. Moore.—V. The minister and his people, by P. Brooks.—VI. The minister and the community, by W. Wilson.—VII. The call of the country church, by A. S. Hoyt.—VIII. The weak church and the strong man, by E. I. Bosworth.—IX. The minister as preacher, by C. E. Jefferson.—X. The independence of the ministry, by Dean G. Hodges.

© Apr. 19, 1911; 2c. Apr. 21, 1911*; A 286332; Internatl. com. of Y. M. C. A., New York. (11–10026) 2044

345

Compton, C G.

The house of bondage, by C. G. Compton ... London, W. Heinemann, 1911.

2 p. l., 448 p. 19½ᶜᵐ. 6/

© 1c. Apr. 20, 1911; A ad int. 606; pubd. Mar. 20, 1911; C. G. Compton. London. (11–9973) 2045

Davies, Thomas Witton, 1851–

"Magic," black and white; charms and counter charms. Divination and demonology among the Hindus, Hebrews, Arabs and Egyptians ... An epitome of "supernaturalism" magic, black, white and natural; conjuring and its relation to prophecy, including Biblical and Old Testament terms and words for magic ... Present ed. prepared for publication under the editorship of Dr. L. W. de Laurence, by T. Witton Davies ... Chicago, Ill., De Laurence, Scott & co., 1910.

xvi, 130 p. incl. front. 19½ᶜᵐ. $1.50

"This treatise was presented to the University of Leipzig [for the degree of doctor of philosophy] July, 1897."—Pref.

"Books and editions consulted or referred to ...": p. [xi]–xvi.

© Dec. 5, 1910; 2c. Dec. 28, 1910*; A 278621; De Laurence, Scott & co. (11–657) 2046

Delano, George Studson, 1851–

Sasanoa and the wool witch; a romance of legendary history, by Rev. George S. Delano. Portland, Me., Smith & Sale, 1911.

6 p. l., 3–95, [1] p. front. (port.) 21ᶜᵐ. $1.00

© Apr. 20, 1911; 2c. Apr. 26, 1911*; A 286459; Smith & Sale. (11–10021) 2047

Elkin, Heiman Jacob, 1864–

The triangle [by] Heiman J. Elkin. New Orleans, Steeg printing and publishing company [c1911]

141 p. 19ᶜᵐ.

© Apr. 11, 1911; 2c. Apr. 14, 1911*; A 286178; Heiman J. Elkin, New Orleans. (11–9970) 2048

Glaspell, Susan.

The visioning; a novel by Susan Glaspell ... New York, Frederick A. Stokes company [1911]

4 p. l., 464 p. 19½ᶜᵐ. $1.25

© Apr. 29, 1911; 2c. May 2, 1911*; A 286618; Frederick A. Stokes co. (11–9941) 2049

Die **handelsgesetze** des erdballs, deutsche ausgabe signatur D. bd. 13, abt. 2. Mittel-Europa II, enthaltend das handels-, wechsel-, konkurs- und seerecht des Deutschen Reiches ... Berlin, R. v. Decker's verlag, 19[11]

4 p. l., 7–1366 p. 27½ᶜᵐ. M. 47

© Mar. 22, 1911; 2c. May 10, 1911*; A—Foreign 2901; R. v. Decker's verlag. 2050

Harris, Gideon.

... Audels answers on refrigeration and ice making; a practical treatise, with illustrations, by Gideon Harris and associates. London, New York, T. Audel & co., 1911.

2 v. fronts. (v. 1: port.) illus., diagrs. (partly fold.) 21½**. $4.00
© Apr. 28, 1911; 2c. Apr. 29, 1911*; A 286548; Theodore Audel & co.
(11-9961) 2051

Hart, Edward, 1854–

Chemistry for beginners. 1. Inorganic, by Edward Hart ... 5th ed., rev. and enl., with 78 illustrations and 2 plates. Easton, Pa., The Chemical publishing co.; [etc., etc.] 1910.

viii, 214 p. illus., 11 pl. 17½**.
© Apr. 10, 1911; 2c. Apr. 14, 1911*; A 286176; E. Hart, Easton, Pa.
(11-9958) 2052

Hartman, Franz.

Magic, white and black; or, The science of finite and infinite life, containing practical knowledge, instruction and hints for all sincere students of magic and occultism, by Franz Hartman ... Faithfully reproduced from the London ed. of 1893, and prepared for publication from new printing plates, under the editorship of Dr. L. W. de Laurence ... Chicago, Ill., De Laurence, Scott & co., 1910.

284 p. front. (port.) illus. pl. 19½ᶜᵐ. $2.15
© Dec. 12, 1910; 2c. Dec. 28, 1910*; A 278619; De Laurence, Scott & co.
(11-656) 2053

Hess, Herbert William, 1880–

Advertising, by Herbert W. Hess ... New York, Universal business institute, inc., ᶜ1910·

2 p. l., 7–507 p. illus., plates (partly col., partly fold.) 22**. $20.00
Publisher's lettering: vol. i.
© Oct. 25, 1910; 1c. Apr. 1, 1911; 1c. Apr. 12, 1911*; A 286118; Universal business institute. (11-9950) 2054

—— Questions and problems, by W. S. Fowler ... New York, Universal business institute, inc., ᶜ1910.

1 p. l., 5–62 p. 22ᶜᵐ. $10.00
Publisher's lettering: vol. ii.
© Oct. 25, 1910; 1c. Apr. 1, 1911; 1c. Apr. 12, 1911*; A 286119; Universal business institute. (11-9951) 2055

Hitt, Rodney, 1882– comp.

Electric railway dictionary; definitions and illustrations of the parts and equipment of electric railway cars and trucks, comp. under the direction of a committee appointed by the American electric railway association, by Rodney Hitt ... Supervising committee: H. H. Adams ... Paul Winsor ... Richard McCulloch ... 1st ed. New York, McGraw publishing company, 1911.

2 p. l., 63, 292 p. illus. 31½ᶜᵐ. $5.00
© Apr. 20, 1911; 2c. Apr. 26, 1911*; A 286472; McGraw pub. co.
(11-9964) 2056

Horatius Flaccus, Quintus.

Horace. The Epistles. With introduction and notes by Edward P. Morris ... New York, Cincinnati [etc.] American book company [c1911]

1 p. l., 5–239 p. 19ᶜᵐ. [With his Horace. The Satires ... New York, Cincinnati, etc., c1909] $1.25
Morris and Morgan's Latin series.
© Mar. 29, 1911; 2c. Apr. 18, 1911*; A 286259; Edward P. Morris & Morris H. Morgan, New Haven. (11–9935) **2057**

Houllevigue, Louis, 1863–

... Le ciel et l'atmosphère ... Paris, A. Colin, 1911.

xii, 304 p., 2 l. 19ᶜᵐ. fr. 3.50
CONTENTS.—La terre dans l'univers.—Les principes de la météorologie.—La prévision du temps.—Le vol des oiseaux.—L'ultra-violet.—La synthèse de la lumière.—La télégraphie sans fil.—Les aurores polaires.—Les comètes.—Les étoiles filantes.—La fin d'un monde.
© Mar. 31, 1911; 2c. Apr. 22, 1911*; A—Foreign 2832; Max Leclerc & H. Bourrelier, Paris. (11–9956) **2058**

Hugo, Victor Marie, comte, 1802–1885.

... Les travailleurs de la mer, par Victor Hugo. Abridged and ed., with introduction and notes, by E. F. Langley ... Boston, D. C. Heath & co., 1911.

xix, [1], 306 p. front. (port.) illus. (map) 18½ᶜᵐ. (Heath's modern language series) $0.80
© Apr. 8, 1911; 2c. Apr. 14, 1911; A 286269; D. C. Heath & co. (11–10022) **2059**

Johnson, Owen McMahon, 1878–

The prodigious Hickey; a Lawrenceville story, by Owen Johnson ... New York, The Baker and Taylor company, 1910.

5 p. l., [3]–335 p. incl. illus., plates. front. 20ᶜᵐ. $1.50
"First published as 'The eternal boy.'"
© July 2, 1910; 2c. May 3, 1911*; A 286633; Baker & Taylor co. (11–9943) **2060**

Kneser, Adolf, 1862–

Die integralgleichungen und ihre anwendungen in der mathematischen physik, vorlesungen an der universität zu Breslau gehalten von Adolf Kneser. Braunschweig, F. Vieweg und sohn, 1911.

viii, 243 p. 23½ᶜᵐ. M. 6
"Literarische notizen": p. [240]–243.
© Jan. 5, 1911; 2c. Apr. 21, 1911*; A—Foreign 2819; Friedrich Vieweg & sohn. (11–9955) **2061**

Kretzer, Franz.

Pflanzenkunde für gehobene bürgerschulen und andere mittlere lehranstalten, nach biologischen grundsätzen in fünf stufen bearb. von Franz Kretzer ... Braunschweig, F. Vieweg & sohn, 1911.

5 pt. illus. 23½ᶜᵐ. M. 3.35
© Apr. 5, 1911; 2c. Apr. 21, 1911*; A—Foreign 2815; Friedrich Vieweg & sohn. (11–9959) **2062**

Kullnick, Max *i. e.* **Adolf Max,** 1876–

From Rough rider to President, by Dr. Max Kullnick; tr. from the original German by Frederick von Reithdorf ... with frontispiece. Chicago, A. C. McClurg & co., 1911.

viii, ｢2｣, 11–289 p. front. (port.) 21½ᶜᵐ. $1.50
© Apr. 29, 1911; 2c. May 3, 1911*; A 286632; A. C. McClurg & co.
(11–10008) 2063

Kunow, O.

Die neuere und neueste weltgeschichte in tabellen, nach der gleichzeitigkeit der ereignisse geordnet von dr. O. Kunow. Halle a. d. S., Buchhandlung des Waisenhauses, 1911.

2 p. l., 18 fold. tab. 33½ x 21ᶜᵐ.
© Jan. 10. 1911; 2c. Apr. 21, 1911*; A—Foreign 2814; Buchhandlung des waisenhauses. (11–9945) 2064

Lamon, Ward Hill, 1828–1893.

Recollections of Abraham Lincoln 1847–1865, by Ward Hill Lamon; ed. by Dorothy Lamon Teillard. Washington, D. C., The editor, 1911.

xxxv, ｢9｣–337 p. illus., plates, 2 port. (incl. front.) facsims. (1 fold.) 19½ᶜᵐ. i $1.50
© May 1, 1911; 2c. May 2. 1911*; A 286619; Dorothy Lamon Teillard, Washington, D. C. (11–9937) 2065

Lawton, Eba Anderson.

Major Robert Anderson and Fort Sumter, 1861, by Eba Anderson Lawton. New York, The Knickerbocker press, 1911.

1 p. l., 19 p. front. (port.) facsims. 23½ᶜᵐ
© Apr. 14, 1911; 2c. Apr. 24, 1911*; A 286398; E. A. Lawton, New York.
(11–10009) 2066

Lebeau, Henri.

... Otahiti, au pays de l'éternel été. Paris, A. Colin, 1911.

xviii, 259 p., 2 l. 19ᶜᵐ. fr. 3.50
© Mar. 31, 1911; 2c. Apr. 22, 1911*; A—Foreign 2827; Max Leclerc & H. Bourrelier, Paris. (11–9946) 2067

Lees, *Mrs.* **Marie Grace (D'Unger)** 1863–

Lassita; in the land of mañana, by Marie Grace Lees. Chicago, Priv. print, 1911.

2 p. l., ｢7｣–9 p. 21½ᶜᵐ. $0.50
© Apr. 15, 1911; 2c. Apr. 17, 1911; A 286420; M. G. Lees, Chicago.
(11–9969) 2068

Lin Shao-Yang.

A Chinese appeal to Christendom concerning Christian missions, by Lin Shao-Yang ... London, Watts & co., 1911.

vi, 319 p. 21ᶜᵐ.
© 1c. Apr. 22, 1911*; A ad int. 592; pubd. Mar. 24, 1911; G. P. Putnam's sons, New York. (11–10024) 2069

349

Lombroso-Ferrero, Gina.

Criminal man, according to the classification of Cesare Lombroso, briefly summarised by his daughter Gina Lombroso-Ferrero, with an introduction by Cesare Lombroso, illustrated. New York and London, G. P. Putnam's sons, 1911.

2 p. l., iii–xx, 322 p. illus., plates, ports. 21½ᶜᵐ. (*Half-title:* The science series) $2.00

"Works of Cesare Lombroso (briefly summarised)": p. 283–309.

"Bibliography of the chief works of Cesare Lombroso": p. 310–313.

© Apr. 8, 1911; 2c. Apr. 24, 1911*; A 286395; G. P. Putnam's sons. (11–9953) 2070

Maxwell, William Babington.

Mrs. Thompson; a novel, by W. B. Maxwell ... New York, D. Appleton and company, 1911.

3 p. l., 366 p., 1 l. 19½ᶜᵐ. $1.30

© Apr. 28, 1911; 2c. May 2, 1911*; A 286617; D. Appleton & co. (11–9944) 2071

Michie, Thomas Johnson, *ed.*

The encyclopedic digest of Texas reports (civil cases) ... Under the editorial supervision of Thomas Johnson Michie. v. 4. Charlottesville, Va., The Michie company, 1911.

v, [vii], 1076 p. 26ᶜᵐ. $7.50

© May 12, 1911; 2c. May 13, 1911*; A 286884; Michie co., Charlottesville, Va. 2072

Milne, William James, 1843–

First year algebra, by William J. Milne ... New York, Cincinnati [etc.] American book company [ᶜ1911]

320 p. diagrs. 18ᶜᵐ. $0.85

© Apr. 21, 1911; 2c. Apr. 25, 1911*; A 286428; W. J. Milne, Albany, N. Y. (11–9957) 2073

O'Meara, Kathleen, 1839–1888.

Frederic Ozanam, professor at the Sorbonne; his life and works, by Kathleen Omeara (Grace Ramsay) ... with a preface by His Eminence Cardinal Manning; preface to the present edition by Thomas M. Mulry ... New York, Christian press association publishing company [ᶜ1911]

xx, iii–vii, 345 p. 19½ᶜᵐ. $0.75

© Apr. 10, 1911; 2c. Apr. 18, 1911*; A 286277; Christian press assn. pub. co. (11–9947) 2074

Perkins, James Breck, 1847–1910.

France in the American revolution, by James Breck Perkins. Boston and New York, Houghton Mifflin company, 1911.

xix, 544 p., 1 l. 20½ᶜᵐ. $2.00

© Apr. 10, 1911; 2c. Apr. 25, 1911*; A 286440; Mary E. Perkins, Rochester, N. Y. (11–10010) 2075

Ramsay, Rina.

The way of a woman; a novel, by Rina Ramsay; with illustrations by J. Vaughn McFall. New York, Dodd, Mead and company, 1911.

5 p. l., 304 p. col. front., col. plates. 19½ᶜᵐ.
© May 4, 1911; 2c. May 5, 1911*; A 286695; Dodd, Mead & co.
(11-9972) 2076

Ray, H Cordelia.

Poems, by H. Cordelia Ray. New York, The Grafton press, 1910.

ix, ₁5₁-169 p. 19½ᶜᵐ. $1.00
© July 15, 1910; 2c. Apr. 3, 1911; A 286137; H. C. Ray, Woodside, N. Y.
(11-9931) 2077

Richardson, Norval, 1877–

George Thorne, by Norval Richardson ... with a frontispiece in colour by John Goss. Boston, L. C. Page & company, 1911.

viii, 333 p. incl. col. front. 20ᶜᵐ. $1.25
© May 1, 1911; 2c. May 4, 1911*; A 286661; L. C. Page & co., inc.
(11-9940) 2078

Rostand, Edmond, 1868–

... Les musardises. Édition nouvelle, 1887–1893. Paris, E. Fasquelle, 1911.

2 p. l., ₁vii₁-viii. 298 p., 1 l. 20½ᶜᵐ. fr. 3
© Apr. 9, 1911; 2c. Apr. 27, 1911*; A—Foreign 2847; Eugène Fasquelle,
Paris. (11-9934) 2079

Sherrill, Clarence Osborne.

Military topography for the mobile forces, including map reading, surveying and sketching, with more than 175 illustrations and one map of vicinity of Fort Leavenworth, by Captain C. O. Sherrill ... 2d ed. Adopted by direction of the commandant for use as text book in the Army service schools, Fort Leavenworth, Kansas. Adopted by the War department as a text book in garrison schools for officers, and as the basis for all promotion examinations in topography, also for the use of the organized militia. Adopted by the Coast artillery school, Fort Monroe, Va. ₁Menasha, Wis., Press of George Banta publishing co., ᶜ1911₁

xviii, 353 p. incl. illus., tables. diagrs. fold. maps (1 in pocket) 22ᶜᵐ.
$2.50
"List of books consulted": p. xiv.
© Apr. 4, 1911; 2c. Apr. 14, 1911; A 286217; C. O. Sherrill, Fort Crocket,
Tex. (11-9979) 2080

Steinhauff, A.

Lehrbuch der erdkunde für höhere schulen, hrsg. von A. Steinhauff ... und prof. dr. M. G. Schmidt ... Ausg. M (für höhere mädchenschulen) 5, 6. teil ... Leipzig und Berlin, B. G. Teubner, 1911.

2 v. illus., plates. 24ᶜᵐ.
t. 5 © Mar. 21, 1911; t. 6 © Mar. 18, 1911; 2c. each May 10, 1911*; A—
Foreign 2917, 2921; B. G. Teubner. 2081, 2082

351

Stockton, Thomas Coates, 1837-1910.

The Stockton family of New Jersey, and other Stocktons, by Thomas Coates Stockton ... Washington, D. C., The Carnahan press, 1911.

xxviii p., 1 l., 350 p. front. (coat of arms) plates, ports., map. 23½ᶜᵐ. $5.00

© Apr. 27, 1911; 2c. Apr. 28, 1911*; A 286535; Mrs. Thomas Coates Stockton, San Diego, Cal. (11-9936) 2083

Utah. *Supreme court.*

Reports ... Alonzo Blair Irvine, reporter. v. 36. June, 1909-December, 1909. Chicago, Callaghan & co., 1911.

xix, 666 p. 23½ᶜᵐ. $6.00

© Apr. 25, 1911; 2c. May 15, 1911*; A 286910; Callaghan & co. 2084

Wallington, Mrs. Nellie Urner, *ed.*

American history by American poets, ed. by Nellie Urner Wallington ... New York, Duffield & company, 1911.

2 v. 19½ᶜᵐ. $1.50 per vol.

© Apr. 25, 1911; 2c. Apr. 27, 1911; A 286612; Duffield & co. (11-9932) 2085

Watts, Mary Stanbery, 1868-

The legacy; a story of a woman, by Mary S. Watts ... New York, The Macmillan company, 1911.

3 p. l., 394 p. 20ᶜᵐ. $1.50

© May 3, 1911; 2c. May 4, 1911*; A 286657; Macmillan co. (11-9942) 2086

White, Stewart Edward, 1873-

The cabin, by Stewart Edward White; illustrated with photographs by the author. Garden City, New York, Doubleday, Page & company, 1911.

6 p. l., 3-282 p., 1 l. col. front., plates. 22ᶜᵐ. $1.50

© Apr. 20, 1911; 2c. Apr. 28, 1911*; A 286531; Doubleday, Page & co. (11-9923) 2087

Whittier, John Greenleaf, 1807-1892.

Whittier correspondence from the Oak Knoll collections, 1830-1892; ed. by John Albree. Salem, Mass., Essex book and print club, 1911.

x p., 1 l., 295, ¹l₁ p. pl., 10 port. (incl. front.) 23ᶜᵐ. $7.00

© Mar. 17, 1911; 2c. Apr. 28, 1911*; A 286538; Essex book & print club. (11-9938) 2088

Winter, William, 1836-

Over the border, by William Winter ... New York, Moffat, Yard and company, 1911.

302 p. incl. front. plates, ports. 23ᶜᵐ. $3.00

© Apr. 25, 1911; 2c. May 4, 1911*; A 286665; W. Winter, New Brighton, N. Y. (11-9985) 2089

Wyman, Bruce.

The special law governing public service corporations, and all others engaged in public employment, by Bruce Wyman ... New York, Baker, Voorhis & co., 1911.

2 v. 24ᶜᵐ. $12.50

© Apr. 21, 1911; 2c. Apr. 27, 1911*; A 286501; B. Wyman, Cambridge, Mass. (11-9552) 2090

[Altmeyer, Henry B]

Sermons delivered before mixed congregations, embracing apologetics, Catholic faith and Christian morals, intended for infidels, Protestants and Catholics. Huntington, W. Va., Standard printing & publishing company, '1911·

3 p. l., [5]-331, [1] p. illus. 23^{cm}. $1.00
© Apr. 25, 1911; 2c. Apr. 27, 1911*; A 286513; H. B. Altmeyer, Huntington, W. Va. (11-10042) 2091

Aulard, François Victor Alphonse, 1849-

... Napoléon 1^{er} et le monopole universitaire; origines et fonctionnement de l'Université impériale. Paris, A. Colin, 1911.

ix, 385 p., 1 l. 19^{cm}. fr. 4
© Mar. 31, 1911; 2c. Apr. 22, 1911*; A—Foreign 2830; Max Leclerc & H. Bourrelier, Paris. (11-9991) 2032

Bauer, Heinrich.

Practical history of the violin ... containing 778 genuine violin labels in true photographical reproduction, 1,200 violinmakers' names and biographies, etc., etc., by Heinrich Bauer. New York, The H. Bauer music co., '1911·

37 p. incl. front. (port.) 39 pl. 28^{cm} $1 50
© May 1, 1911; 2c. May 2, 1911; A 286627; H. Bauer, New York. (11-10057) 2093

Bernstein, Henry, 1876-

... Après moi; pièce en trois actes, représentée pour la première fois le 20 février 1911 sur la scène de la Comédie-Française. Paris, A. Fayard [¹1911]

5 p. l., [13]-251, [2] p. 19^{cm}. fr. 3.50
On cover: 7. éd.
© Apr. 5, 1911; 2c. Apr. 22, 1911*; D 24028; H. Bernstein, Paris (11-10063) 2093*

Boggs, *Mrs.* **Louise E** (Shackelford) *comp.*

Haphazard quotations, collected during an idle summer month, with a winter addition, by L. E. B. (Mrs. John Boggs) ... New York, The Alice Harriman company, 1911.

79 p. 19¼^{cm}. $0.75
© Mar. 18, 1911; 2c. Apr. 8, 1911*; A 286037; Alice Harriman co. (11-10068) 2094

Bosher, *Mrs.* **Kate Lee (Langley)** 1865-

Miss Gibbie Gault; a story, by Kate Langley Bosher ... frontispiece by Harriet Roosevelt Richards. New York and London, Harper & brothers, 1911.

4 p. l., 325, [1] p. front. 19¼^{cm}. $1.20
© May 4, 1911; 2c. May 6, 1911*; A 286721; Harper & bros. (11-10051) 2095

353

₁Brockett, Linus Pierpont₁ 1820–1893.

Scouts, spies and heroes of the great civil war; how they lived, fought and died for the Union; including thrilling adventures, daring deeds, heroic exploits, exciting experiences, wonderful escapes of spies, scouts and detectives; with anecdotes, watchwords, battle cries, and humorous and pathetic incidents of the war, embracing true stories of daring, courage and self-sacrifice, by Captain Powers Hazelton ₁pseud.₁ Superbly embellished with many thrilling and very attractive illustrations. Philadelphia, Pa., National publishing co. ₁°1911₁

256 p. incl. front. plates, groups of ports. 25ᶜᵐ. $1.00

A new issue of the first part of "The camp, the battle field and the hospital ... By Dr. L. P. Brockett." 1866.

© Apr. 10, 1911; 2c. Apr. 26, 1911*; A 286465; George W. Bertron, Philadelphia. (11–10006) **2096**

Brown, Isaac Hinton, 1842–1889.

Brown's standard elocution and speaker; a thoroughly practical treatise on the science and art of human expression ... by Professor I. H. Brown ... Rev. and enl. by Charles Walter Brown ... Chicago, Laird and Lee ₁°1911₁

4, v–ix, ₁1₁, 11–275 p. front., illus. 20ᶜᵐ. $1.00

© Apr. 24, 1911; 2c. Apr. 28, 1911*; A 286524; Wm. H. Lee. Chicago. (11–10065) **2097**

Byron, George Gordon Noël Byron, 6th baron, 1788–1824.

... Byron's Childe Harold (canto ɪᴠ) Prisoner of Chillon and other selections; ed. by W. H. Venable ... New York, Cincinnati ₁etc.₁ American book company ₁°1911₁

170 p. incl. front. (port.) 16½ᶜᵐ. (Eclectic English classics) $0.20

© Apr. 28, 1911; 2c. May 1, 1911*; A 286567; Amer. book co. (11–10067) **2098**

Crooker, Joseph Henry, 1850–

The church of tomorrow, by Joseph Henry Crooker. Boston, New York ₁etc.₁ The Pilgrim press ₁°1911₁

vii, 272 p. 19½ᶜᵐ. $1.00

© Apr. 25, 1911; 2c. Apr. 28, 1911*; A 286534; J. H. Crooker, Roslindale, Mass. (11–10043) **2099**

D'Alès, Adhemer.

Dictionnaire apologétique de la foi catholique ... 4. éd. entièrement refondue sous la direction de A. D'Alès ... fasc. 6. Évangiles–Fin du monde. Paris, G. Beauchesne & cⁱᵉ, 1911.

cover-title, 1601–1920 numb. col. 29½ᶜᵐ. fr. 5

© Apr. 28, 1911; 2c. May 12, 1911*; A—Foreign 2934; Gabriel Beauchesne & cie. **2100**

Daudet, Alphonse, 1840–1897.
Le siège de Berlin, et autres contes, par Alphonse Dau-
det; with notes and vocabulary by E. Rigal ... and G.
Castegnier ... New York, William R. Jenkins co. [°1911]
 115 p. 16ᶜᵐ. (*On cover:* Contes choisis, no. 2) $0.25
 CONTENTS.—Le siège de Berlin. — La dernière classe. — La mule du
pape.—L'enfant espion.—Salvette et Bernadou.—Un teneur de livres.
© May 2, 1911; 2c. May 5, 1911*; A 286704; William R. Jenkins co.
 (11–10202) 2101

Davis, John D 1854–
A dictionary of the Bible, by John D. Davis ... with
many new and original maps and plans and amply illus-
trated. 3d ed., rev. throughout and enl. Philadelphia,
The Westminster press, 1911.
 vii, 840 p., 1 l. front., illus., plates, maps. 23ᶜᵐ.
© Apr. 29, 1911; 2c. May 3, 1911*; A 286626; Trustees of the Pres. board
of publ. & Sabbath school work, Philadelphia. (11–10041) 2102

Deeping, Warwick *i. e.* **George Warwick,** 1877–
Joan of the tower, by Warwick Deeping; with a frontis-
piece by A. C. Michael. London, New York [etc.] Cassell
and company, ltd., 1911.
 iv, 399 p. col. front. 19ᶜᵐ. 2/6
© 1c. May 5, 1911*; A ad int. 621; publd. Apr. 6, 1911; Cassell & co., ltd.,
New York. (11–10054) 2103

Dennen, Grace Atherton, 1874–
The dawn meadow [by] G. A. Dennen. Boston, R. G.
Badger, 1911.
 181 p. 19½ᶜᵐ. $1.25
© Apr. 7, 1911; 2c. Apr. 17, 1911*; A 286233; Richard G. Badger.
 (11–10053) 2104

Dryden, John, 1631–1700.
All for love and The Spanish fryar, by John Dryden;
ed. by William Strunk, jr. ... Boston and London, D. C.
Heath and company [°1911]
 xlv, [1], 340 p. front. (port.) 15½ᶜᵐ. (*Half-title:* The belles-lettres
series. Section III. The English drama ... General editor, G. P. Baker)
$0 60
 Bibliography: p. [331]–338.
© Apr. 26, 1911; 2c. Apr. 29, 1911*; A 286544; D. C. Heath & co.
 (11–10200) 2105

Dunning, John Wirt.
The eternal riddle, by John Wirt Dunning. Boston,
Sherman, French & company, 1911.
 3 p. l., 241 p. 21ᶜᵐ. $1.20
 CONTENTS.—What is man?—Immortality.—Is there a God I can trust?—
Why do we suffer?—What shall I think about the Bible?—Is prayer a
rational occupation?—Can I get back to childhood?—Can I forget the
past?—What is it to be saved?—What about our sins?—How near may I
come to heaven and miss it?—What is the supreme mission of the Chris-
tian?—What are the signs of a Christian?—What shall I think about Je-
sus?—What is Christian faith?—Does the world need a new religion?
© May 2, 1911; 2c. May 5, 1911*; A 286713; Sherman, French & co.
 (11–10194) 2106

Frank, Maude Morrison, 1870–

High school exercises in grammar, by Maude M. Frank ... New York, Longmans, Green, and co., 1911.

viii, 198 p. 19¼ᶜᵐ. $0.75
© Apr. 19, 1911; 2c. Apr. 25, 1911*; A 286447; Longmans, Green & co. (11–10066) 2107

Garst, Mrs. Laura (DeLany)

In the shadow of the drum tower, by Laura DeLany Garst. Cincinnati, Foreign Christian missionary society ['1911]

136 p. front., plates, ports. 18½ᶜᵐ. $0.50
CONTENTS.—My little sister in far-away China.—Dr. Macklin of Nanking.—My little sister at home.
© Apr. 29 1911; 2c. May 5, 1911*; A 286684; Foreign Christian missionary soc. (11–10192) 2108

Gilman, Mrs. Charlotte (Perkins) Stetson, 1860–

The man-made world; or, Our androcentric culture, by Charlotte Perkins Gilman. New York, Charlton company, 1911.

260 p. 19½ᶜᵐ. $1.00
© Feb. 7, 1911; 2c. May 3, 1911*; A 286641; C. P. Gilman, New York. (11–35307) 2109

Glæsser, Johannes.

Auf der flucht vor der schande; deutsch-amerikanischer roman, von Johannes Glæsser. 2. aufl. 11.–20. tausend. Milwaukee, Wis., German American directory publ. co. ['1911]

347 p., 1 l. 19½ᶜᵐ. $1.00
© Apr. 15, 1911; 2c. Apr. 20, 1911*; A 286301; J. Glæsser, Milwaukee, Wis. (11–10062) 2110

Gontrum, John F 1857–

Poems, by John F. Gontrum. Baltimore, Md. [The Lord Baltimore press] 1911.

150 p. front. (port.) 20ᶜᵐ.
© Apr. 28, 1911; 2c. May 1, 1911*; A 286564; John B. Gontrum, Raspeburg, Md. (11–10061) 2111

Haddock, Frank Channing.

The will in salesmanship; or, How brain-power wins business success; a lecture written for the National school of salesmanship, Minneapolis, Minnesota, by Frank Channing Haddock ... [Minneapolis, Minn., The National school of salesmanship, ᶜ1911]

v, 7–44 p. diagrs. 17½ᶜᵐ.
© Mar. 24, 1911; 2c. Apr. 20, 1911*; A 286320; Natl. school of salesmanship, Minneapolis. (11–10108) 2112

Handbuch für eisenbetonbau. 2. neubearb. aufl. ... hrsg. dr. ingenieur F. von Emperger ... 2. bd. Der baustoff und seine bearbeitung. Berlin, W. Ernst & sohn, 1911.

xv, 353 p. illus., diagrs. 27ᶜᵐ. M. 14
© May 2, 1911; 2c. May 15, 1911*; A—Foreign 2939; Wilhelm Ernst & sohn. 2113

Keller, Arthur.
Kinderpflege-lehrbuch. Bearb. von dr. med. Arthur Keller ... und dr. med. Walther Birk ... Mit einem beitrage von dr. med. Axel Tagesson Möller. Mit 40 abbildungen im text. Berlin, J. Springer, 1911.
vi p., 1 l., 140 p. illus. 23½ᶜᵐ.
© Feb. 27, 1911; 2c. Apr. 17, 1911*; A—Foreign 2772; Julius Springer.
(11–9974) 2114

Lord & Thomas.
Concerning a literature which compels action; pub. by Lord & Thomas ... in the interest of advertising as a profession. Chicago and New York, Lord & Thomas [ᶜ1911]
4 p. l., [11]–47 p. 18½ᶜᵐ.
Half-title: Altruism in advertising.
© Apr. 11, 1911; 2c. Apr. 15, 1911*; A 286200; Lord & Thomas, Chicago.
(11–10073) 2115

MacArthur, Robert Stuart, 1841–
The Baptists, their principle, their progress, their prospect, by Robert Stuart MacArthur ... Philadelphia, Boston [etc.] American Baptist publication society [1911]
48 p. 21½ᶜᵐ. $0.15
© Apr. 12, 1911; 2c. Apr. 29, 1911*; A 286547; A. J. Rowland, sec., Philadelphia. (11–10045). 2116

Maeterlinck, Maurice, 1862–
L'oiseau bleu; féerie en six actes et douze tableaux, par Maurice Maeterlinck ... [Paris, 1911]
36 p. illus. 29½ᶜᵐ.
"L'Illustration théatrale ... 7ᵉ année—175 1ᵉʳ avril, 1911."
© Apr. 1, 1911; 2c. Apr. 22, 1911*; D 24030; Eugène Fasquelle, Paris.
(11–10019) 2116*

Manzoni, Alessandro, 1785–1873.
... I promessi sposi, storia milanese del secolo xvii scoperta e rifatta da Alessandro Manzoni. Chapters i–viii, ed. with introduction, notes and vocabulary, by J. Geddes, jr. ... and E. H. Wilkins ... Boston, D. C. Heath & co., 1911.
vii, 183 p. front. (port.) illus. (map) pl. 17ᶜᵐ. (Heath's modern language series) $0.60
© Apr. 8, 1911; 2c. Apr. 14, 1911; A 286270; D. C. Heath & co.
(11–10201) 2117

Mercedes, *Sister, originally* **Mary Antonio Gallagher,** 1846–
The mercy manual, containing the little office of the Blessed Virgin Mary and the office for the dead, tr. by Rev. Jas. L. Meagher, D. D., and prayers used by the Sisters of mercy, comp. by "Mercedes," from approved sources. New York, Christian press association publishing company [ᶜ1911]
1 p. l., 464 p. front., plates. 13½ᶜᵐ. $1.00
© Apr. 13, 1911; 2c. Apr. 15, 1911*; A 286209; Christian press assn pub. co., New York. (11–10048) 2118

Miller, Charles Armand, 1864–

The sacramental feast; a communion book to aid the devout communicant worthily to eat and to drink at the Lord's table, by Charles Armand Miller ... ₍Columbia, S. C., Press of Lutheran board of publication, *1911₎
108 p. 19½ᶜᵐ. $0.50
© Apr. 25, 1911; 2c. Apr. 28, 1911*; A286525; Lutheran board of publ., Columbia, S. C. (11–10046) 2119

Newte, Horace W C.

The socialist countess; a story of to-day, by Horace W. C. Newte ... London, Mills & Boon, limited ₍1911₎
2 p. l., vii–viii. 382 p. 19½ᶜᵐ. 6/
© 1c. May 6, 1911*; A ad int. 623; pubd. Apr. 7, 1911; H. W. C. Newte. England. (11–10055) 2120

Pratt food company.

Pratts pointers on cows, sheep and hogs, including their care, feeding, housing and diseases, containing valuable information from experienced authorities. Philadelphia, Pa. ₍etc.₎ Pratt food company ₍ᶜ1911₎
1 p. l., 5–172, iii p. illus. 18½ᶜᵐ. $0.50
© Apr. 10, 1911; 2c. Apr. 19, 1911*; A 286289; Pratt food co. (11–10080) 2121

Reilly, Thomas à Kempis.

Messages of truth in rhyme and story. By Rev. Thomas à Kempis Reilly ... Philadelphia, J. J. McVey, 1911.
7 p., p. ix, 127 p. front. 17½ᶜᵐ. $0.50
Partly reprinted from "The Rosary magazine" and "The Young eagle."
CONTENTS.—Preface.—Charity (poem)—Because I love him.—Persuaded?—Signs of the times.—History of Catholic belief in the Immaculate conception.—Ambition (poem)
© May 1, 1911; 2c. May 4, 1911*; A 286668; John Joseph McVey. (11–10193) 2122

Roberts, George Lucas.

Natural one-book geography, arranged and adapted by George L. Roberts and Frederick J. Breeze ... assisted by Adelaide Steele Baylor ... from the Natural introductory and Natural school geographies, by Jacques W. Redway and Russell Hinman. New York, Cincinnati ₍etc.₎ American book company ₍ᶜ1911₎
109, xi, ₍1₎, 110–202 p. illus. (incl. maps) 32ᶜᵐ.
© Apr. 13, 1911; 2c. Apr. 27, 1911*; A 286506; Amer. book co. (11–10094) 2123

Roller, Henry B.

The twentieth century revival; a call to prayer. Get ready for the great awakening, by Rev. Henry B. Roller ... Cincinnati, Jennings and Graham; New York, Eaton and Mains ₍ᶜ1911₎
115 p. 17½ᶜᵐ. $0.50
© Apr. 17, 1911; 2c. Apr. 20, 1911*; A 286297; Jennings & Graham. (11–10044) 2124

Rose, Laura.

Farm dairying, by Laura Rose ... Chicago, A. C. Mc-
Clurg & co., 1911.

xiv, 15–298 p. front. (port.) illus. (incl. plans) plates. 19½ᶜᵐ. $1.25
© Apr. 29, 1911; 2c. May 3, 1911*; A 286631; A. C. McClurg & co.
(11–10079) 2125

Sampson, Jane Felton.

Abroad with the Fletchers, by Jane Felton Sampson;
illustrated from photographs taken by the author. Bos-
ton, L. C. Page & company, 1911.

viii, 368 p. front., plates. 19½ᶜᵐ. (On verso of half-title: The little
pilgrimages series) $1.75
© Apr. 29, 1911; 2c. May 4, 1911*; A 286660; L. C. Page & co., inc.
(11–10103) 2126

Schroeder, Theodore.

"Obscene" literature and constitutional law; a foren-
sic defense of freedom of the press, by Theodore Schroe-
der ... New York, Priv. print. for forensic uses, 1911.

439 p. 24ᶜᵐ. $5.00
© Apr. 11, 1911; 2c. Apr. 15, 1911; A 286692; T. Schroeder, New York.
(11–10111) 2127

Scott, Morgan.

Boys of Oakdale academy, by Morgan Scott ... with
four original illustrations by Martin Lewis. New York,
Hurst & company [ᶜ1911]

4 p., 1 l., 5–312 p. front., plates. 20½ᶜᵐ. $0.60
© Apr. 22, 1911; 2c. May 5, 1911*; A 286689; Hurst & co.
(11–10052) 2128

Shakespeare, William, 1564–1616.

... Shakespeare's The merchant of Venice; ed., with
notes, outline study and examination questions by Maud
Elma Kingsley ... and Frank Herbert Palmer ... Boston,
The Palmer company, 1911.

3 p. l., ix–xiii, 137, 21 p. 17ᶜᵐ. (The Kingsley English texts) $0.40
© Apr. 3, 1911; 2c. Apr. 29, 1911*; A 286541; Palmer co.
(11–10064) 2129

Shartle, Thomas Boyd, 1870–

Rhymes of the city of roses [by] T. B. Shartle. v. 1.
Boston, R. G. Badger, 1911.

58 p. 19½ᶜᵐ.
© Apr. 4, 1911; 2c. Apr. 13, 1911*; A 286168; T. B. Shartle, U. S.
(11–10020) 2130

Singer, Emil, 1870–

Das frühzeitige altern, eine folge falscher körperpflege,
ärztliche ratschläge von dr. med. Emil Singer ... Leip-
zig, F. A. Wolfson [ᶜ1911]

172 p. 23½ᶜᵐ. M. 2.80
© Mar. 20, 1911; 2c. Apr. 17, 1911*; A—Foreign 2780; Helios-verlag.
(11–9975) 2131

Soares, Theodore Gerald, 1869–
A Baptist manual; the polity of the Baptist churches and of the denominational organisations, by Theodore Gerald Soares ... Philadelphia, Boston [etc.] American Baptist publication society [1911]
xii, 156 p. 19ᶜᵐ. $0.75
© Apr. 17, 1911; 2c. Apr. 29, 1911*; A 286546; A. J. Rowland, sec., Philadelphia. (11-10047) 2132

South Carolina. *Supreme court.*
Reports ... v. 86. Containing cases of November term, 1909, and April term, 1910. By C. M. Efird, state reporter. Columbia, S. C., The R. L. Bryan company, 1911.
x, 659 p. 23½ᶜᵐ. $2.00
© Apr. 22, 1911; 2c. May 16, 1911*; A 286940; R. L. Bryan co. 2133

Streatfeild, Richard Alexander, 1866–
... Musique & musiciens modernes; traduction française de Louis Pennequin ... Paris, H. Falque, 1910.
2 p. l., 101 p., 1 l. 23ᶜᵐ. fr. 3.50
"Ces articles ont paru au cours de l'année 1910 dans la Revue du temps présent."
CONTENTS.—Hector Berlioz.—Franz Liszt.—Richard Wagner.—Giuseppe Verdi.—Peter Tschaïkowsky.—Johannes Brahms.—Richard Strauss.
© Apr. 6, 1911; 2c. Apr. 22, 1911*; A—Foreign 2837; Louis Pennequin, Paris. (11-10058) 2134

Stringfield, Thomas, 1866–
Captured by the Apaches; forty years with this savage band of Indians; a true story by "Two Braids" (Tommy Stringfield) who was taken captive in 1870, and liberated in 1909 ... Hamilton, Tex., Herald print [°1911]
[65] p. illus. (incl. ports.) 22½ᶜᵐ. $0.50
© Nov. 1, 1910; 2c. Apr. 21, 1911*; A 286334; Tommie Stringfield, San Gabriel, Tex. (11-10011) 2135

[Terrail, Gabriel] 1859–
... L'Angleterre, aspects inconnus. Paris, P. Ollendorff, °1911·
2 p. l., 302 p., 1 l. 19ᶜᵐ. fr. 3.50
Author's pseudonym, "Mermeix," at head of title.
© Apr. 6, 1911; 2c. Apr. 22, 1911*; A—Foreign 2834; Mermeix, Paris. (11-10109) 2136

Tipton, David Matthews, 1853–
An honest effort, by David Matthews Tipton. Wichita, Kan., The Missionary press co. [°1911]
107 p. 17ᶜᵐ. $0.60
CONTENTS.—Introductory.—Religion.—Life lessons.—Temperance.—The cure of wrong doing.—A talk to young people.—Miscellany.—Conclusions.
© Apr. 12, 1911; 2c. Mar. 29, 1911; A 286252; D. M. Tipton, Wichita, Kan. (11-10191) 2137

[Violet, Jeanne] 1875–
April's lady, by Guy Chantepleure [pseud.] tr. by Mary J. Safford. New York, Dodd, Mead and company, 1911.
3 p. l., 330 p. 19½ᶜᵐ. $1.25
© May 4, 1911; 2c. May 5, 1911*; A 286694; Dodd, Mead & co. (11-9971) 2138

Artaud de Montor, Alexis François.

The lives and times of the popes ... Being a series of volumes giving the history of the world during the Christian era, retranslated, revised, and written up to date from Les vies des papes, by the Chevalier Artaud de Montor ... [v. 10. Lateran ed.] New York, The Catholic publication society of America [1911]

4 p. l., 3–275 p. ports. 26ᶜᵐ. $10.00
© May 16. 1911; 2c. May 19, 1911*; A 289023; Catholic publication soc. of America. 2139

Belloc, Hilaire i. e. Joseph Hilaire Pierre, 1870-

The French revolution, by Hilaire Belloc ... London, Williams and Norgate [ᶜ1911]

xi, 13–256 p. 17½ᶜᵐ. (Added t.-p.: Home university library of modern knowledge. New York, H. Holt and company) 1/
© lc. May 3, 1911*; A ad int. 615; pubd. Apr. 5, 1911; Henry Holt & co., New York. (11–10306) 2140

Bruce, William Speirs, 1867-

Polar exploration, by William S. Bruce ... London, Williams and Norgate [ᶜ1911]

vii, [3], 11–256 p. illus. (charts) 17½ᶜᵐ. (Added t.-p.: Home university library of modern knowledge. New York, H. Holt and company) 1/
© lc. May 3, 1911*; A ad int. 619; pubd. Apr. 5, 1911; Henry Holt & co., New York. (11–10328) 2141

Brunner, Arnold William, 1857-

A city plan for Rochester; a report prepared for the Rochester civic improvement committee, Rochester, N. Y., by Arnold W. Brunner ... Frederick Law Olmsted ... Bion J. Arnold ... [New York, Printed at the Cheltenham press] 1911.

39 p. incl. front., illus., pl 2 maps (1 fold.) 31½ᶜᵐ.
© Feb. 10, 1911; 2c. Apr. 24, 1911; A 286473; Rochester civic improvement committee. (11–10320) 2142

Buffalo fine arts academy.

Oils, water colors, pastels & drawings. By James McNeill Whistler. Lent by Mr. Richard Canfield. [Buffalo? 1911]

44, [5] p. incl. front., illus., plates. 23ᶜᵐ.
On back cover: Buffalo fine arts academy. Albright art gallery. March 7 to April 27, 90–1911-10.
© Apr. 26, 1911; 2c. Apr. 28, 1911*; A 286540; Richard Canfield, New York. (11–10322) 2143

Burt, Benjamin Chapman, 1852-

Railway station service, by B. C. Burt ... 1st ed., 1st thousand. New York, J. Wiley & sons; [etc., etc.] 1911.

viii, 292 p. 19¼ᶜᵐ. $2.00
© Apr. 25, 1911; 2c. Apr. 28, 1911*; A 286521; B. C. Burt, Chicago. (11–10334) 2144

361

Cassagnac, Guy de.
... L'agitateur ... Paris, Plon-Nourrit et c¹ᵉ [°1911]
4 p. l., iii, 305 p., 1 l. 19ᶜᵐ. fr. 3.50
© Apr. 10, 1911; 2c. Apr. 27, 1911*; A—Foreign 2843; Plon-Nourrit & cie.
(11–10349) **2145**

Cattelle, Wallis Richard, 1848–
The diamond, by W. R. Cattelle ... New York, John
Lane company, 1911.
5 p. l., 9–433 p. front., plates, ports. 21½ᶜᵐ. $2.00
© Apr. 21, 1911; 2c. May 4, 1911*; A 286656; John Lane co.
(11–10089) **2146**

Chamberlayne, Charles Frederic, 1855–
A treatise on the modern law of evidence, by Charles
Frederic Chamberlayne ... v. 1. Administration. Al-
bany, N. Y., M. Bender and company; [etc., etc.] 1911.
cxxii, 1089 p. 26½ᶜᵐ. $7.00
© May 4, 1911; 2c. May 5, 1911*; A 286715; C. F. Chamberlayne, Schen-
ectady, N. Y. (11–10355) **2147**

Cheney, Anne Cleveland. '
By the sea, and other poems; by Anne Cleveland Che-
ney. Boston, Sherman, French & company, 1911.
5 p. l., 69 p. 19½ᶜᵐ. $1.00
Partly reprinted from various periodicals.
© Apr. 27' 1911; 2c. May 5, 1911*; A 286712; Sherman, French & co.
(11–10348) **2148**

Cooper, Frederic Taber, 1864–
The craftsmanship of writing, by Frederick Taber
Cooper. New York, Dodd, Mead and company, 1911.
6 p. l., 3–275 p. 19½ᶜᵐ.
© May 4, 1911; 2c. May 5, 1911*; A 286697; Dodd, Mead & co.
(11–10351) **2149**

Elizabeth, *queen of Rumania,* 1843–
From memory's shrine; the reminiscences of Carmen
Sylva (H. M. Queen Elisabeth of Roumania) tr. from the
German, by Her Majesty's desire, by her former secre-
tary, Edith Hopkirk ... Philadelphia & London, J. B.
Lippincott company, 1911.
270 p., 1 l. 2 pl., 7 port. (incl. front.) 21½ᶜᵐ. $2.50
CONTENTS.—Clara Schumann.—Grandmamma.—Ernest Moritz Arndt.—
Bernays. — Two old retainers. — Fanny Lavater. — Bunsen.—Perthes. — A
faith-healer.—Mary Barnes.—The family valette.—Karl Sohn, the portrait-
painter.—Weizchen.—A group of humble friends.—My tutors.—Marie.—My
brother Otto.
© Mar. 9, 1911; 2c. Mar. 21. 1911*; A 286542; J. B. Lippincott co.
(11–35358) **2150**

Estes, Rufus, 1857–
Good things to eat, as suggested by Rufus; a collection
of practical recipes for preparing meats, game, fowl, fish,
puddings, pastries, etc., by Rufus Estes ... Chicago, The
author [°1911]
142 p., 1 l. incl. front. (port.) 23½ᶜᵐ. $2.00
© May 2, 1911; 2c. May 8, 1911*; A 286742; R. Estes, Chicago.
(11–10336) **2151**

Flynn, William Earl, 1861–

The Flynn system of health culture.· v. 1. By W. Earl
Flynn and Lucile Eaves ... Lincoln, Nebr., Woodruff
bank note co., 1911.

440 p. front. (port.) illus. 19½ᶜᵐ.

© Apr. 22, 1911; 2c. Apr. 27, 1911; A 286559; Lucile Eaves, Lincoln, Neb.
(11-10331) 2152

Freeman, Elizabeth Anderson.

A pilgrimage to Rubidoux ₁a poem₁ Elizabeth Ander-
son Freeman, author and publisher. ₁Riverside, Cal.,
Printed by W. D. Clark₁ ᶜ1911·

14 l. incl. mounted plates. 18 x 23ᶜᵐ. $4.00

© Apr. 12, 1911; 2c. Apr. 20, 1911*; A 286306; E. A. Freeman, Riverside,
Cal. (11-10359) 2153

Fuss, Albertus G 1872–

Freemasonry made plain; an analysis of the policy,
rules, practices and tendency of the order, by a mason
released from his obligations of secrecy ... Williams-
port, Md., A. G. Fuss ₁ᶜ1911₁

80 p. 18ᶜᵐ. $0.40

© Apr 24, 1911; 2c. Apr. 27, 1911*; A 286503; A. G. Fuss.
(11-10372) 2154

Garner, Samuel.

Essentials of Spanish grammar, by Samuel Garner ...
New York, Cincinnati ₁etc.₁ American book company
₁ᶜ1911₁

232 p. 19ᶜᵐ. $1.00

© May 4, 1911; 2c. May 6, 1911*; A 286722; S. Garner, Annapolis, Md.
(11-10344) 2155

Goldsmith, Elizabeth Edwards, 1860–

Sacred symbols in art, by Elizabeth E. Goldsmith, with
fifty-three illustrations. New York and London, G. P.
Putnam's sons, 1911.

xvi p., 1 l., 283 p. front., illus. 17ᶜᵐ.

© Apr. 8, 1911; 2c. Apr. 24, 1911*; A 286394; E. E. Goldsmith, New York.
(11-10321) 2156

Granger, Amédée, 1879–

A radiographic atlas of the pathologic changes of bones
and joints, by Amédée Granger ... New York, Tʰᵉ A. L.
Chatterton co. ₁ᶜ1911₁

2 p. l., ₁7₁–206 p., 1 l. incl. LXXVIII pl. 29ᶜᵐ. $6 00

© Apr. 7, 1911; 2c. Apr. 19, 1911*; A 286291; A. Granger, New Orleans.
(11-10330) 2157

Green, Sanford Moon, 1807-1901.

Green's Michigan practice; a treatise on the practice of the courts of common law of the state of Michigan, with forms, by Sanford M. Green ... 3d .ed. ... by Clark A. Nichols ... v. 1. Chicago, Callaghan & company, 1911.
1 p. l., v-viii, 909 p. 24½ᶜᵐ. $6.50
© Apr. 27, 1911; 2c. May 6, 1911*; A 286717; Callaghan & co.
(11-10354) **2158**

Grimsehl, Ernst *i. e.* **Carl Ernst Heinrich,** 1861-

Lehrbuch der physik für realschulen, von E. Grimsehl ... mit 389 textfiguren und einer farbigen tafel. Leipzig und Berlin, B. G. Teubner, 1911.
vii, 269, ⟨1⟩ p. illus., col. pl. 23ᶜᵐ. M. 2.60
© Mar. 6, 1911; 2c. Apr. 29, 1911*; A—Foreign 2852; B. G. Teubner.
(11-10317) **2159**

[**Hicks, Elizabeth Rubicam**]

Rubicam manual of shorthand as developed and taught in the Rubicam shorthand college, St. Louis, Mo. St. Louis, Mo., W. L. Musick publishing company [ᶜ1911]
1 p. l., 66 p. 19½ᶜᵐ. $2.00
By Elizabeth R. Hicks and Margaret E. Ross.
© Apr. 25, 1911; 2c. Apr. 28, 1911*; A 286523; Rubicam shorthand college.
(11-10213) **2160**

Hirst, Francis Wrigley, 1873-

The stock exchange; a short study of investment and speculation, by Francis W. Hirst ... London, Williams and Norgate [ᶜ1911]
v, 7-256 p. 17½ᶜᵐ. (*Added t.-p.:* Home university library of modern knowledge. New York, H. Holt and company) 1/
Bibliography: p. 255-256.
© 1c. May 3, 1911*; A ad int. 618; pubd. Apr. 5, 1911; Henry Holt & co., New York. (11-10371) **2161**

Houghton, Albert Allison, 1879-

Molding concrete bath tubs, aquariums, and natatoriums; a practical treatise ... by A. A. Houghton ... fully illustrated by original drawings. New York, The N. W. Henley publishing co., 1911.
5 p. l., 13-64 p. illus. 19ᶜᵐ. (*On cover:* Concrete worker's reference books, no. 7) $0.50
© Apr. 22, 1911; 2c. Apr. 25, 1911*; A 286431; Norman W. Henley pub. co.
(11-10091) **2162**

Howard, Philip Eugene, 1870-

A prayer before the lesson, for superintendents and teachers in the Sunday-school and in the quiet hour at home, by Philip E. Howard. Philadelphia, The Sunday school times company [ᶜ1911]
iv, 153 p. 16ᶜᵐ. $0.50
© Feb. 15, 1911; 2c. May 3, 1911*; A 286646; Sunday school times co.
(11-10356) **2163**

Jaurès, Jean Léon, 1859–

... L'organisation socialiste; l'armée nouvelle. Paris,
J. Rouff et c¹ᵉ ['1911]
685, ¹l¹ p. 19ᶜᵐ. fr. 3.50
ⓒ Apr. 13, 1911; 2c. Apr. 27, 1911*; A—Foreign 2845; J. Rouff & cie.
(11–10368) 2164

Kaempffert, Waldemar Bernhard, 1877–

The new art of flying, by Waldemar Kaempffert; with
numerous illustrations. New York, Dodd, Mead and com-
pany, 1911.
xvii, 291 p. front., plates, diagrs. 19½ᶜᵐ. $1.50
Contains material which appeared in an article written by the author
and published in "Harper's monthly magazine."
ⓒ May 4, 1911; 2c. May 5, 1911*; A 286693; W. Kaempffert, New York.
(11–10090) 2165

Kobbé, Gustav, 1857–

A tribute to the dog, by Gustav Kobbé; including the
famous tribute by Senator Vest. New York, Frederick A.
Stokes company [1911]
28 p. 18½ᶜᵐ. $0.35
ⓒ Apr. 15, 1911; 2c. Apr. 21, 1911; A 286609; Frederick A. Stokes co.
(11–10314) 2166

Lambert, William Harrison, 1842–

The faith of Abraham Lincoln; an address before the
Presbyterian social union of Philadelphia, February 22,
1909, by William H. Lambert ... Philadelphia, The Sun-
day school times company ['1911]
1 p. l., 32 p. 19ᶜᵐ. $0.35
ⓒ Feb. 15, 1911; 2c. May 3, 1911*; A 286644; Sunday school times co.
(11–10205) 2167

Landes, Sarah Windle.

Elementary domestic science; a text book for schools.
v. 1. By Sarah Windle Landes ... 2d ed., rev. and enl.
Stillwater, Okla., Students supply house ['1911]
2 p. l., 3–180 p. 21ᶜᵐ.
ⓒ Apr. 14, 1911; 2c. Apr. 26, 1911*; A 286464; S. W. Landes, Stillwater,
Okl. (11–10092) 2168

Lawyers co-operative publishing co., *Rochester, N. Y.*
Editorial dept.

Notes on the American decisions ... v. 10, including
70–78 Am. dec. San Francisco, Bancroft-Whitney co.;
Rochester, N. Y., The Lawyers co-op. pub. co., 1911.
1 p. l., 1424 p. 24ᶜᵐ. $6.50
ⓒ May 18, 1911; 2c. May 19, 1911*; A 289035; Bancroft-Whitney co. and
Lawyers co-op. pub. co. 2169

Lucke, Charles Edward.

... Power, by Charles E. Lucke ... New York, The Columbia university press, 1911.

vii, 316 p. 20½ᶜᵐ. $2.00
At head of title: Columbia university lectures.
© May 1, 1911; 2c. May 1, 1911; A 286049; Columbia univ. press.
(11–10340) 2170

Mahood, John Wilmot, 1864–

The lost art of meditation, by J. W. Mahood ... New York, Chicago [etc.] Fleming H. Revell company [ᶜ1911]

190 p. 19½ᶜᵐ. $1.00
© Apr. 22, 1911; 2c. Apr. 26, 1911*; A 286471; Fleming H. Revell co.
(11–10197) 2171

Meyer, Conrad Ferdinand, 1825–1898.

... Jürg Jenatsch, von Konrad Ferdinand Meyer, ed. with introduction and notes, by A. Kenngott ... Boston, D. C. Heath & co., 1911.

xvi, 220 p. illus. (map) 2 port. (incl. front.) 17ᶜᵐ. (Heath's modern language series) $0.60
Bibliography: p. xvi.
© Apr. 28, 1911; 2c. May 3, 1911*; A 286639; D. C. Heath & co.
(11–10347) 2172

Morrison, *Mrs.* Adèle (Sarpy) 1842–

Memoirs of Adele Sarpy Morrison. Saint Louis [Woodward & Tiernan printing company] 1911.

5 p. l., 206 p., 1 l. front. (port.) plates. 23½ᶜᵐ.
© Apr. 26, 1911; 2c. May 1, 1911*; A 286580; A. S. Morrison, St. Louis.
(11–10361) 2173

Oppenheim, Edward Phillips, 1866–

The tempting of Tavernake, by E. Phillips Oppenheim ... Boston, Little, Brown, and company, 1911.

vi, 359 p. 20ᶜᵐ.
© May 6, 1911; 2c. May 9, 1911*; A 286771; Little, Brown, and company.
(11–10363) 2174

Pierce, Willard Ide.

Plain talks on materia medica, with comparisons, by Willard Ide Pierce, m. d. Philadelphia, Boericke & Tafel, 1911.

viii p., 1 l., 5–792 p. 23½ᶜᵐ. $5.00
© Apr. 22, 1911; 2c. May 3, 1911*; A 286636; Boericke & Tafel.
(11–10333) 2175

Practical electricity ... with questions and answers. 6th ed. [Cleveland, O., Cleveland armature works, 1911]

3 p. l., 471 p. incl. illus., tables. 15ᶜᵐ. $2.00
Compiled by the Cleveland armature works, with the assistance of John C. Lincoln.
© Apr. 4, 1911; 2c. Apr. 1, 1911; A 286221; Cleveland armature works, Cleveland, O. (11–10088) 2176

Read, Benjamin Maurice, 1853–

Historia ilustrada de Nuevo Mexico, por el lic. Benjamin M. Read ... Cuatro libros en un tomo. Santa Fe, N. M., Compania impresora del Nuevo Mexicano, 1911.

616 p. incl. illus., ports 28ᶜᵐ $10.00

© Apr. 17, 1911; 2c. May 6, 1911*; A 286718; B. M. Read, Santa Fe. N. M
(11–10360) 2177

Scheel, Karl Friedrich Franz Christian, 1866–

Grundlagen der praktischen metronomie, von prof. dr. Karl Scheel ... mit 39 abbildungen im text. Braunschweig, F. Vieweg und sohn, 1911.

xii. 168 p. illus. 22½ᶜᵐ. (Added t.-p.: Die wissenschaft; sammlung naturwissenschaftlicher und mathematischer monographien. 36. hft.) M. 5.20

© Jan. 6, 1911; 2c. Apr. 21, 1911*; A—Foreign 2817; Friedrich Vieweg & sohn. (11–10083) 2178

Shelby, Annie Blanche.

Auction bridge; a clear, concise, and up-to-date statement of the tenets, rules, and principles governing the game of auction bridge, by Annie Blanche Shelby ... also, the laws of auction bridge, as in use by the leading clubs. New York, Duffield & company, 1911.

xi. 120 p. 15½ᶜᵐ. $1.00

© Apr. 25, 1911; 2c. Apr. 27, 1911*; A 286499; Duffield & co.
(11–10324) 2179

₍Shore, Mrs. Teignmouth₎

The school of love, by Priscilla Craven ₍pseud.₎ ... London, T. W. Laurie ₍'1911₎

vi. 369, ₍1₎ p. 19½ᶜᵐ. 6/

© 1c. May 2. 1911*; A ad int. 609; publd. Apr. 21, 1911; D. Appleton & co., New York. (11–10367) 2180

Singer sewing machine company.

Singer instructions for art embroidery. ₍New York₎ Singer sewing machine company, ᶜ1911·

92 p., 1 l. illus., col. plates. 27½ᶜᵐ. $0.35

© Apr. 10, 1911; 2c. Apr. 13, 1911*; A 286155; Singer sewing machine co. (11–10338) 2181

Smith, George Carroll, 1853–

What to eat and why, by G. Carroll Smith ... Philadelphia and London, W. B. Saunders company, 1911.

1 p. l., 5–310 p. 23ᶜᵐ.
Bibliography: p. 297–299.

© May 2, 1911; 2c. May 3, 1911*; A 286634; W. B. Saunders co. (11–10332) 2182

Swett, John, 1830–

Public education in California; its origin and development, with personal reminiscences of half a century, by John Swett. New York, Cincinnati [etc.] American book company [c1911]

320 p. illus. (port.) 19ᶜᵐ. $1.00
List of author's educational works, addresses and papers: p. 6–7.
© Apr. 28, 1911; 2c. May 3, 1911*; A 286624; J. Swett, Martinez, Cal.
(11–10310) **2183**

Topin, A.

Heine, 1797–1856. La vie de Heine.—L'homme. L'œuvre.—Heine et son temps. Par A. Topin ... 4 planches hors texte. Paris, Bibliothèque Larousse [c1911]

110, [2] p. 2 pl., 2 port. (incl. front.) 20½ᶜᵐ. fr. 1
"Bibliographie": 1 p. following p. 110.
© Apr. 14, 1911; 2c. Apr. 27, 1911*; A—Foreign 2842; Librairie Larousse.
(11–10307) **2184**

United States playing card co.

The official rules of card games. Hoyle up-to-date. Publishers' 15th ed. of rules of popular games ... Cincinnati, The United States playing card company [c1911]

254 p. illus. 18½ᶜᵐ. $0.25
© Mar. 9, 1911; 2c. Apr. 25, 1911*; A 286444; United States playing card co. (11–10326) **2185**

Vachell, Horace Annesley, 1861–

John Verney, by Horace Annesley Vachell ... London, J. Murray, 1911.

vii, 338 p. 20ᶜᵐ. $1.50
© 1c. May 6, 1911*; A ad int. 624; pubd. Apr. 7, 1911; George H. Doran co., New York. (11–10364) **2186**

Wilbor, William Chambers, 1852–

Ode to Niagara, and other poems, by William Chambers Wilbor, ph. d. New York, Eaton & Mains; Cincinnati, Jennings & Graham [c1911]

iv, 50 p. 18½ᶜᵐ. $0.50
© Apr. 29, 1911; 2c. May 4, 1911*; A 286658; Eaton & Mains.
(11–10069) **2187**

Winans, James Albert.

Notes on public speaking, for the classes in public speaking, Cornell university [by] James Albert Winans. [Ithaca, N. Y., Journal print] 1911.

2 p. l., 3–126 p. 23ᶜᵐ. $0.50
© Apr. 11, 1911; 2c. Apr. 14, 1911*; A 286179; J. A. Winans, Ithaca, N. Y.
(11–10070) **2188**

Wylie, Ida Alena Ross, 1885–

Dividing waters, by I. A. R. Wylie ... London, Mills & Boon, limited [1911]

2 p. l., vii–viii, 411, [1] p. 20ᶜᵐ. 6/
© 1c. May 6, 1911*; A ad int. 625; pubd. Apr. 7, 1911; I. A. R. Wylie, London. (11–10366) **2189**

Allen, James, 1864–
Man; king of mind, body, and circumstance, by James
Allen ... New York, T. Y. Crowell & co. ₁1911₁
5 p. l., 54 p., 1 l. 19ᶜᵐ. $0.50
© Apr. 26, 1911; 2c. Apr. 28, 1911*; A 286526; Thomas Y. Crowell & co.
(11–10627) 2190

Ascoli, Nicola d'.
... Il canzoniere. ₁New York, York printing co., *1910₁
135 p. port. 24½ᶜᵐ. $1.00
© Dec. 31, 1910; 2c. Apr. 21, 1911*; A 286342; N. D'Ascoli, New York.
(11–10412) 2191

... The Atlantic reporter, with key-number annotations.
v. 78. Permanent ed. ... December 15, 1910–March
30, 1911. St. Paul, West publishing co., 1911.
xiv, 1288 p. 26½ᶜᵐ. (National reporter system—State series) $4.00
© May 15, 1911; 2c. May 20, 1911*; A 289084; West pub. co. 2192

Bonar, James, 1852–
Disturbing elements in the study and teaching of po-
litical economy, by James Bonar ... Baltimore ₁Williams
& Wilkins company₁ 1911.
5 p. l., 145 p. 20½ᶜᵐ. $1.00
© May 3, 1911; 2c. May 4, 1911*; A 286673; Johns Hopkins press.
(11–10650) 2193

₁**Burritt, Alice**₁ 1841–
The family of Blackleach Burritt, jr., pioneer and one
of the first settlers of Uniondale, Susquehanna County,
Pennsylvania. Washington, D. C., Press of Gibson bros.
₁ᶜ1911₁
68 p. col. front. (coat of arms) 24ᶜᵐ.
"Books consulted by the compiler": p. ₁5₁
© May 4, 1911; 2c. May 4, 1911*; A 286677; Alice Burritt, Washington,
D. C. (11–10206) 2194

Candolle, Alphonse Louis Pierre Pyramus de, 1806–1893.
Zur geschichte der wissenschaften und der gelehrten
seit zwei jahrhunderten, nebst anderen studien über wis-
senschaftliche gegenstände insbesondere über vererbung
und selektion beim menschen, von Alphonse de Candolle
..., deutsch hrsg. von Wilhelm Ostwald. Leipzig, Akade-
mische verlagsgesellschaft m. b. h., 1911.
xx, 466 p. front. (port.) 24½ᶜᵐ. (*Added t.-p.:* Grosse männer, studien
zur biologie des genies, hrsg. von W. Ostwald, 2. bd.) M. 12
© Mar. 5, 1911; 2c. Apr. 29, 1911*; A—Foreign 2851; Akademische ver-
lagsgesellschaft m. b. h. (11–10628) 2195

Carus, Paul, 1852–
Personality, with special reference to superpersonali-
ties and the interpersonal character of ideas, by Paul
Carus ... Chicago, The Open court publishing co.; ₁etc.,
etc.₁ 1911.
vi, 68 p. 20½ᶜᵐ. $1.00
© Apr. 26, 1911; 2c. May 1, 1911*; A 286560; Open court pub. co.
(11–10626) 2196

369

Chapin, Howard Millar.

How to enamel; being a treatise on the practical enameling of jewelry with hard enamels, by Howard M. Chapin ... 1st ed., 1st thousand. New York, J. Wiley & sons; [etc., etc.] 1911.

xii, 70 p. incl. illus., plates. 19½ᶜᵐ. $1.00

© May 1, 1911; 2c. May 3, 1911*; A 286638; H. M. Chapin, Providence, R. I. (11-10393) **2197**

Coppens, Charles.

... Who are the Jesuits? By Rev. Charles Coppens ... St. Louis, Mo. [etc.] B. Herder, 1911.

vii, 106 p. 19½ᶜᵐ. $0.50

"References for information on the Jesuits": p. 102-103.

© Apr. 29, 1911; 2c. May 2, 1911*; A 286596; Joseph Gummersbach, St. Louis. (11-10624) **2198**

Dawson, Thomas Fulton, 1853–

Life and character of Edward Oliver Wolcott, late a senator of the United States from the state of Colorado, by Thomas Fulton Dawson ... [New York, The Knickerbocker press] °1911·

2 v. fronts., plates, ports. 24½ᶜᵐ.

© Apr. 21, 1911; 2c. Apr. 28, 1911*; A 286518; Knickerbocker press. (11-10383) **2199**

Dawson, William James, 1854– *ed.*

... The great English novelists; with introductory essays and notes, by William J. Dawson and Coningsby W. Dawson ... New York and London, Harper & brothers, 1911.

2 v. 18½ᶜᵐ. (*Their* The reader's library [vol. VI–VII]) $2.00

CONTENTS.—v. 1. The growth and technique of the English novel. Love scenes. Historic personages. Epics of conflict.—v. 2. The masters of the modern novel. Humour. High-water mark. Children in fiction.

© May 4, 1911; 2c. May 6, 1911*; A 286720; Harper & bros. (11-10653) **2200**

Earp, Edwin Lee, 1867–

The social engineer, by Edwin L. Earp ... New York, Eaton & Mains; Cincinnati, Jennings & Graham [°1911]

xxiii, 326 p. 20½ᶜᵐ. $1.50

© May 5, 1911; 2c. May 10, 1911*; A 286795; Eaton & Mains. (11-10649) **2201**

Egloffstein, Hermann, *freiherr* von und zu, 1861–

Im dienste des grossherzogs Carl Alexander, ein erinnerungsblatt von Hermann freiherrn von Egloffstein. Berlin, Gebrüder Paetel, 1911.

80 p. front. (port.) 20ᶜᵐ. M. 2

© Mar. 17, 1911; 2c. Apr. 29, 1911*; A—Foreign 2868; Gebrüder Paetel. (11-10644) **2202**

Futrelle, Jacques, 1875–

The high hand, by Jacques Futrelle ... with illustrations by Will Grefé. Indianapolis, The Bobbs-Merrill company [ᶜ1911]

4 p. l., 295, [1] p. front., plates. 19ᶜᵐ. $1.25
© May 6, 1911; 2c. May 10, 1911*; A 286792; Bobbs-Merrill co.
(11–10640) 2203

Groos, Karl, 1861–

Das seelenleben des kindes. Ausgewählte vorlesungen von dr. Karl Groos ... 3. umgearb. u. verm. aufl. Berlin, Reuther & Reichard, 1911.

2 p. l., 334 p. 23ᶜᵐ. M. 4.80
© Apr. 1, 1911; 2c. May 6, 1911*; A—Foreign 2885; Reuther & Reichard.
(11–10629) 2204

Haeckel, Ernst Heinrich Philipp August, 1834–

The answer of Ernst Haeckel to the falsehoods of the Jesuits, Catholic and Protestant, from the German pamphlet "Sandalion," and "My church departure"; being Haeckel's reasons, as stated by himself, for his late withdrawal from the Free Evangelical church, with comments by Joseph McCabe and Thaddeus Burr Wakeman. New York, The Truth seeker company, 1911.

46 p. front., plates, ports. 20ᶜᵐ. $0.25
© Apr. 25, 1911; 2c. Apr. 26, 1911; A 286643; Truth seeker co.
(11–10625) 2205

Halleck, Reuben Post, 1859–

History of American literature, by Reuben Post Halleck ... New York, Cincinnati [etc.] American book company [ᶜ1911]

431 p. incl. front. (port.) illus. 19ᶜᵐ $1 25
References and Suggested readings at end of chapters.
© Apr. 28, 1911; 2c. May 1, 1911*; A 286570; Amer. book co.
(11–10661) 2206

Harris, Ada Van Stone, ed.

Favorites from Fairyland; an approved selection arranged for home and supplementary reading in the third grade, with an introduction, by Ada Van Stone Harris ... illustrated by Peter Newell. New York and London, Harper & brothers, 1911.

xiii, [1], 129, [1] p. front., 5 pl. 19ᶜᵐ. $0.35
CONTENTS.—Little Snowdrop.—Cinderella; or, The little glass slipper — The ugly duckling.—Jack and the bean-stalk.—Beauty and the beast.—The sleeping beauty in the wood.
© Mar. 27, 1911; 2c. May 4, 1911*; A 286655; Harper & bros.
(11–10654) 2207

Hart, Estelle Pugsley.

Thoughts in poetry, by Estelle Pugsley Hart. [New York city, Tobias press, ᶜ1911]

5 p. l., 9–143 p. 17½ᶜᵐ. $1 00
© Mar. 8, 1911; 2c. May 8, 1911*; A 286739; E. P. Hart, New York.
(11–10655) . 2208

Heyse, Paul Johann Ludwig, 1830–
Vetter Gabriel; novelle von Paul Heyse; ed., with introduction, notes and vocabulary by Robert N. Corwin ...
New York, H. Holt and company, 1911.
xi, 216 p. 17ᶜᵐ. $0.35
"The present text is from volume III of the 1904 edition of the Moralische novellen, published by J. G. Cotta'sche buchhandlung nachfolger, Stuttgart und Berlin,—with some slight revision in spelling in accordance with the eighth edition of Duden's Orthographisches wörterbuch."
Bibliography: p. x–xi.
© Apr. 27, 1911; 2c. May 2, 1911; A 286733; Henry Holt & co.
(11–10656) 2209

Hoppe, Hermann.
Weltende. Roman von Hermann Hoppe. Schweidnitz,
L. Heege [ᶜ1911]
404 p., 1 l. 20ᶜᵐ. M. 5
© Mar. 1, 1911; 2c. Apr 17, 1911*; A—Foreign 2783; L. Heege.
(11–10415) 2210

Hughes, Jasper Seaton, 1843–
The Revelation, by Jasper Seaton Hughes. [Holland!
Mich.] The author [ᶜ1910]
4 p. l., 7–177 p. 20ᶜᵐ. $2.00
© Apr. 16, 1911; 2c. Apr. 21, 1911*; A 286336; J. S. Hughes, Holland,
Mich. (11–10622) 2211

Jacquin, Pierre.
L'action française au Maroc; étude sociale, administrative, économique et politique, par Pierre Jacquin. Paris,
C. Delagrave [ᶜ1911]
2 p. l., 184 p. 19ᶜᵐ. fr. 3
© Apr. 11, 1911; 2c. Apr. 27, 1911*; A—Foreign 2846; Ch. Delagrave.
(11–10642) 2212

Lawrance, Marion.
... Housing the Sunday school; or, A practical study of
Sunday school buildings, by Marion Lawrance ... Philadelphia, The Westminster press, 1911.
4 p. l., 5–146 p. front., illus. (incl. plans) plates. 22½ᶜᵐ. (Modern
Sunday school manuals, ed. by C. F. Kent) $2.00
© Apr. 29, 1911; 2c. May 3, 1911*; A 286625; M. Lawrance, Chicago.
(11–10632) 2213

Lectures on illuminating engineering delivered at the
Johns Hopkins university, October and November,
1910, under the joint auspices of the University and
the Illuminating engineering society ... Baltimore,
Md., The Johns Hopkins press, 1911.
2 v. illus., port., diagrs. 23½ᶜᵐ.
© Apr. 24, 1911; 2c. Apr. 25, 1911; A 286461; Johns Hopkins press.
(11–10341) 2214

Levi, Harry.
... Jewish characters in fiction: English literature, by
Rabbi Harry Levi. 2d ed.—rev. and enl. Philadelphia,
Pa., The Jewish Chautauqua society, 1911.
173 p. 19½ᶜᵐ. (The Chautauqua system of Jewish education) $1.00

Levi, Harry—Continued

Bibliographies at end of chapters.
"Supplementary bibliography of English fiction in which Jewish characters appear": p. 170–173.

© Apr. 15, 1911; 2c. Apr. 20, 1911*; A 286305; Jewish Chautauqua soc.
(11–10652) 2215

Marie *de France, 12th cent.*

Three lays of Marie de France, retold in English verse by Frederick Bliss Luquiens. New York, H. Holt and company, 1911.

vii p., 1 l., ix–xxxiii, 63 p. 20ᶜᵐ. $1.10
CONTENTS.—Introduction.—Sir Launfal.—The maiden of the ash.—The lovers twain.—Bibliography (p. 57–63)

© Apr. 22, 1911; 1c. May 2, 1911; 1c. May 6, 1911*; A 286732; Henry Holt & co. (11–10346) 2216

Menken, Henry, *ed.*

... California bungalow homes. 3d ed. of Bungalow-craft—15th thousand ... arranged and ed. by Henry Menken. Los Angeles, Cal., The Bungalowcraft co., ᶜ1911·

128 p. incl. illus., plans. 20 x 28ᶜᵐ. $1.00
© Apr. 20, 1911; 2c. Apr 29, 1911*; A 286549; Bungalowcraft co., Los Angeles. (11–10633) 2217

Myers, Frank A 1850–

The future citizen, by F. A. Myers ... Boston, Sherman, French & company, 1911.

6 p. l., 189 p. 21ᶜᵐ. $1.20
CONTENTS.—Mental inheritance.—Marriage.—Race suicide.—Cost of the child. — Boy. — Education. — Parental mistakes. — Home. — Why boys go wrong.—Biology of crime.—Juvenile crimes.—External remedial efforts.—Child labor. — The American spirit. — Socialism. — Labor. — Cities a problem.—The church.

© Apr. 26, 1911; 2c. Apr. 29, 1911*; A 286555; Sherman, French & co.
(11–10647) 2218

New York (*State*) *Supreme court.*

... Reports of cases heard and determined in the appellate division of the Supreme court of the state of New York. Jerome B. Fisher, reporter. v. 140. 1911. [Official ed.] Albany, N. Y., J. B. Lyon company [1911]

cxi, 1024 p. 24ᶜᵐ. $1.00
© Apr. 10, 1911; 2c. May 20, 1911*; A 289068; Edward Lazansky, sec. of the state of New York, in trust for benefit of people of said state, Albany, N. Y. 2219

Oberammergau passion-play.

The passion play at Ober Ammergau, by Esse Esto Maplestone; with complete text from the German. New York, Broadway publishing co. [ᶜ1911]

226 p. 20ᶜᵐ. $1.00
"The text of the passion play from the German": p. 19–226.

© Apr. 13, 1911; 2c. Apr. 22, 1911*; A 286387; E. E. Maplestone, Chicago
(11–10660) 2220

Oppenheim, Edward Phillips, 1866–

The moving finger, by E. Phillips Oppenheim ... with illustrations by J. V. McFall. Boston, Little, Brown, and company, 1911.

viii p., 1 l., 301 p. front., 3 pl 20ᶜᵐ $1.25
© May 6, 1911; 2c. May 10, 1911*; A 286783; Little, Brown, and company. (11–10641) 2221

Painter, Mrs. Lydia Ethel F.

Under Egypt's skies, by Lydia Ethel F. Painter. ₁Wausau, Wis., Helen B. Van Vechten, 1910₁

7 p. l., 139 (i. e. 148) p. front. (port.) plates (1 col.) 27ᶜᵐ.
© Mar. 1, 1911; 2c. May 2, 1911*; A 286607; Kenyon V. Painter. Cleveland, O. (11–10643) 2222

Pfohl, Ernst.

Neues wörterbuch der französischen und deutschen sprache für den schul- und handgebrauch. Von prof. Ernst Pfohl ... Leipzig, F. A. Brockhaus, 1911.

2 v. in 1. 19ᶜᵐ. M. 7
© Mar. 18, 1911; 2c. Apr. 29, 1911*; A—Foreign 2861; F. A. Brockhaus. (11–10350) 2223

Philips, Dirk, 1504–1570.

Enchiridion; or, Hand book of the Christian doctrine and religion, compiled (by the grace of God) from the Holy Scriptures for the benefit of all lovers of the truth. By Dietrich Philip ... Tr. from the German and carefully compared with the Dutch (in which language the book was originally written). By A. B. Kolb. Elkhart, Ind., Mennonite publishing co., 1910.

539 p. 20½ᶜᵐ. $1.50
© Apr. 11, 1911; 2c. Apr. 15, 1911; A 286586; Abram B. Kolb, Elkhart, Ind. (11–10623) 2224

Poincaré, Henri i. e. Jules Henri, 1854–

... Der wert der wissenschaft, mit genehmigung des verfassers ins deutsche übertragen von E. Weber, mit anmerkungen und zusätzen von H. Weber ... und einem bildnis des verfassers. 2. aufl., mit einem vorwort des verfassers. Leipzig und Berlin, B. G. Teubner, 1910.

vii, ₁1₁ 251, ₁1₁ p. front. (port.) 19½ᶜᵐ. (Wissenschaft und hypothese, II) M. 3.60
© Mar. 13, 1911; 2c. Apr. 29, 1911*; A—Foreign, 2869; B. G. Teubner. (11–10084) 2225

Richardson, Rufus Byam, 1845–

A history of Greek sculpture, by Rufus B. Richardson ... New York, Cincinnati ₁etc.₁ American book company ₁ᶜ1911₁

291 p. front., illus. 19ᶜᵐ. (Half-title: Greek series for colleges and schools) $1.50
Bibliography: p 281
© Apr. 28, 1911; 2c. May 1, 1911*; A 286566; Amer. book co. (11–10319) 2226

Riley, Elihu Samuel, 1845–

Yorktown; an American historic drama, in five acts, by
Elihu S. Riley. Annapolis, Md., The Arundel press, 1911.
1 p. l., 52 p. 24ᶜᵐ.

© Apr. 18, 1911; 2c. Apr. 25, 1911*; D 24046; E. S. Riley, Annapolis, Md.
(11–10658) **2226***

Rocholl, Rudolf, 1822–1905.

Predigten des sel. kirchenrat d. R. Rocholl, auf wunsch
veröffentlicht durch B. Schubert ... Elberfeld, Lutheri-
scher bücherverein, 1911.
130 p. 23ᶜᵐ. M. 2.50

© Apr. 4, 1911; 2c. May 6, 1911*; A—Foreign 2886; Luth. bücherverein.
(11–10630) · **2227**

Rummel, Walter, *freiherr* von, 1873–

Die Provence, von Walter freiherr von Rummel; mit
bildbeigaben nach photographien des verfassers, buch-
schmuck von Josef Windisch. Berlin, Vereinigung heimat
und welt [ᶜ1911]
140, [2] p. illus., plates. 19ᶜᵐ. M. 2.50
"Literatur": 1 p. at end.

© Mar. 31, 1911; 2c. May 6, 1911*; A—Foreign 2881; Heimat & welt ver-
lag. (11–10645) **2228**

Sands, Hayden.

Lights and shadows, by Hayden Sands. New York, The
De Mille company [ᶜ1911]
142 p. 20ᶜᵐ. $1.25

© Apr. 15, 1911; 2c. May 2, 1911; A 286735; H. Sands, New York. ·
(11–10345) **2229**

Schimpf, Henry William, 1868–

Essentials of volumetric analysis; an introduction to
the subject, adapted to the needs of students of pharma-
ceutical chemistry, embracing the subjects of alkalimetry,
acidimetry, precipitation analysis, oxidimetry, indirect
oxidation, iodometry, assay processes for drugs, estima-
tion of alkaloids, carbolic acid, sugars, theory, applica-
tion and description of indicators, by Henry W. Schimpf
... 2d ed.—rewritten and enl., 1st thousand. New York,
J. Wiley & sons; [etc., etc.] 1911.
xiv, 358 p. illus. 21ᶜᵐ. $1.50

© May 1, 1911; 2c. May 3, 1911*; A 286635; H. W. Schimpf, New York.
(11–10398) **2230**

Southwestern reporter.

Texas decisions reported in the Southwestern reporter,
annotated, vols. 132 and 133, December, 1910, to March,
1911 ... St. Paul, West publishing co., 1911.
Various paging. 26½ᶜᵐ. $5.50

© May 13, 1911; 2c. May 20, 1911*; A 289083; West pub. co. **2231**

Spielmeyer, Walther.

Technik der mikroskopischen untersuchung des nerven-systems, von dr. W. Spielmeyer ... Berlin, J. Springer, 1911.

iv p., 1 l., 131, [1] p. 21ᶜᵐ.
© Mar. 18, 1911; 2c. Apr. 29, 1911*; A—Foreign 2853; Julius Springer.
(11–10315) 2232

Spingarn, Joel Elias, 1875–

The new Hesperides, and other poems, by Joel Elias Spingarn. New York, Sturgis & Walton company, 1911.

5 p. l., 60 p., 1 l. 20ᶜᵐ. $1.00
Partly repr nted from various periodicals.
© May 5, 1911; 2c. May 8, 1911*; A 286741; J. E. Spingarn, New York.
(11–10659) 2233

Thomas, Frank Willard, 1869–

A concise manual of platen presswork, by F. W. Thomas ... 3d ed. Chicago and New York, The Inland printer company [ᶜ1911]

31 p. illus. 19ᶜᵐ. $0.25
"Originally appeared in the Practical printer of St. Louis ... the author ... has revised and enlarged the matter for republication here."
© Apr. 14, 1911; 2c. Apr. 26, 1911; A 286629; Inland printer co.
(11–10634) 2234

Trabert, Wilhelm, 1863–

Lehrbuch der kosmischen physik, von Wilhelm Trabert ... mit 149 figuren im text und einer tafel. Leipzig und Berlin, B. G. Teubner, 1911.

x, 662 p. fold. map, diagrs 24ᶜᵐ. M. 22
© Feb. 25, 1911; 2c. Apr. 29, 1911*; A—Foreign 2860; B. G. Teubner.
(11–10316) 2235

Vice commission of Chicago.

The social evil in Chicago; a study of existing conditions with recommendations by the Vice commission of Chicago: a municipal body appointed by the mayor and the City council of the city of Chicago, and submitted as its report to the mayor and City council of Chicago. Chicago, Gunthorp-Warren printing company, 1911.

3 p. l., 399 p. incl. plates, tables. 24ᶜᵐ.
© Apr. 5, 1911; 2c. May 9, 1911*; A 286768; Vice commission of the city of Chicago, Chicago. (11–10651) 2236

Webster, Henry Kitchell, 1875–

The girl in the other seat, by Henry Kitchell Webster... New York and London, D. Appleton and company, 1911.

4 p. l., 341, [1] p. front., 3 pl. 19½ᶜᵐ. $1.25
© May 5, 1911; 2c. May 9, 1911; A 286788; D. Appleton & co.
(11–10637) 2237

Wister, Owen, 1860–

Members of the family, by Owen Wister, with illustrations by H. T. Dunn. New York, The Macmillan company, 1911.

317 p. front., 11 pl. 20ᶜᵐ. $1.25
© May 10, 1911; 2c. May 11, 1911*; A 286819; Macmillan co.
(11–10638) 2238

Abbott, Lyman, 1835–

America in the making, by Lyman Abbott. New Haven, Yale university press; [etc., etc.] 1911.

vii, 233 p. 20ᶜᵐ. (*Half-title:* Yale lectures on the responsibilities of citizenship) $1.15

© May 5, 1911; 2c. May 6, 1911*; A 286744; Yale univ. press.
(11-10765) 2239

Auskunftsbuch für die chemische industrie, hrsg. von H. Blücher. 7. aufl. 1910–11. Berlin, F. Siemenroth, 1911.

xiii, [i] p., 1 l., 1362, 37 p. illus. 23½ᶜᵐ. M. 25

© Jan. 15, 1911; 2c. Apr. 17, 1911*; A—Foreign 2774; Franz Siemenroth.
(11-9962) 2240

Bennett, Enoch Arnold.

Mental efficiency, and other hints to men and women, by Arnold Bennett ... New York, George H. Doran company [*1911]

119 p. 20ᶜᵐ. $0.75

CONTENTS.—Mental efficiency.—Expressing one's individuality.—Breaking with the past.—Settling down in life.—Marriage.—Books.—Success.—The petty artificialities.—The secret of content.

© Apr. 25, 1911; 1c. Apr. 26, 1911; 1c. May 1, 1911*; A 286562; George H. Doran co. (11-10755) 2241

Bezard, J.

... De la méthode littéraire; journal d'un professeur dans une classe de première. Paris, Vuibert, 1911.

2 p. l., 738 p. 19ᶜᵐ. fr. 3.50

© Apr. 10, 1911; 2c. Apr. 27, 1911*; A—Foreign 2848; Vuibert.
(11-10773) 2242

Borchers, Wilhelm i. e. **Johannes Albert Wilhelm,** 1856–

Metallurgy; a brief outline of the modern processes for extracting the more important metals, by W. Borchers ... authorized translation from the German by William T. Hall ... and Carle R. Hayward ... 1st ed. 1st thousand. New York, J. Wiley & sons; [etc., etc.] 1911.

v, 271 p. illus., diagrs. 23½ᶜᵐ. $3.00

© May 3, 1911; 2c. May 5, 1911*; A 286702; William T. Hall and Carle R. Hayward, Boston. (11-10749) 2243

Brewer, Luther Albertus, 1858–

History of Linn County, Iowa, from its earliest settlement to the present time, by Luther A. Brewer and Barthinius L. Wick ... Cedar Rapids, The Torch press, 1911.

xv, 496 p. front., illus. (maps) plates, ports., plan, facsim. 28ᶜᵐ. $5.00

© Feb. 6, 1911; 2c. Feb. 13, 1911*; A 280780; L. A. Brewer, Cedar Rapids, Ia. (11-10358) 2244

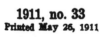

Crowell & Murray.

The iron ores of Lake Superior, containing some facts of interest relating to mining and shipping of the ore and location of principal mines, with original maps of the ranges, by Crowell & Murray ... Cleveland, The Penton publishing company, 1911.

3 p. l., 9–186, vii p. illus., fold. maps, fold. tables, fold charts. 23½^{cm}. $3.50

© May 3, 1911; 2c. May 8, 1911*; A 286759; Benedict Crowell and C. B. Murray, Cleveland, O. (11-10752) 2245

Fowler, Nathaniel Clark, 1858–

Practical salesmanship; a treatise on the art of selling goods, by Nathaniel C. Fowler, jr. ... Assisted by twenty-nine expert salesmen, sales-managers and prominent business men. Boston, Little, Brown, and company, 1911.

xx, 317 p. 19^{cm}.

© Apr. 15, 1911; 2c. Apr. 26, 1911*; A 286462; Little, Brown, and company. (11-10767) 2246

Frost, Harwood.

Good engineering literature; what to read and how to write, with suggestive information on allied topics, by Harwood Frost ... Chicago, Ill., The author, agents, Chicago book company [1911]

1 p. l., v–xii, 422 p. 20^{cm}. $1.00
"List of technical indexes": p. 405–407.

© Apr. 28, 1911; 2c. May 5, 1911*; A 286698; H. Frost, Chicago. (11-10751) 2247

Goldsmith, Oliver, 1728–1774.

Goldsmith's Deserted village, ed. by A. M. Van Dyke ... New York, Cincinnati [etc.] American book company [1911]

32 p. 17^{cm}. (Eclectic English classics) $0.20
[Bound with Gray, Thomas. Elegy in a country churchyard. New York. 1911]

© Apr. 29, 1911; 2c. May 2, 1911*; A 286601; Amer. book co. [Copyright claimed on Introduction, Notes, etc.] 2248

... Goldsmith's The vicar of Wakefield, ed. by Alexander F. Hansen ... New York, Cincinnati [etc.] American book company [c1911]

224 p. incl. front. (port.) 16½^{cm}. (Eclectic English classics) $0.20
Bibliography: p. 213–214.

© Apr. 27, 1911; 2c. May 1, 1911*; A 286569; Amer. book co. (11-10762) 2249

Grosse, Heinz.

Lene, Berliner roman aus der gegenwart, von Heinz Grosse. Charlottenburg, E. Beyer [c1911]

248 p. 21^{cm}. M. 3

© Feb. 15, 1911; 2c. May 6, 1911*; A—Foreign 2882; Eduard Beyer verlag. (11-10774) 2250

The **handy** cyclopedia of things worth knowing; a manual of ready reference ... Chicago, A. J. Dubois, 1911.

382 p. 17½ᶜᵐ. $1.00

© Apr. 29, 1911; 2c. May 3, 1911*; A 286640; Joseph Trienens, Chicago. (11-10780) 2251

Hassell, Susan Whitcomb.

The old home [by] Susan Whitcomb Hassell. San Diego, Cal., Frye & Smith, printers [ᶜ1911]

3 p. l., 9–93 p. illus. 14½ x 22ᶜᵐ. $0.75

© Apr. 23, 1911; 2c. May 1, 1911*; A 286579; S. W. Hassell, Everett, Wash. (11-10766) 2252

Hodges, George, 1856–

The training of children in religion, by George Hodges ... New York and London, D. Appleton and company, 1911.

3 p. l., 328 p., 1 l. 20ᶜᵐ. $1.50

© Apr. 21, 1911; 2c. Apr. 26, 1911*; A 286469; D. Appleton & co. (11-10757) 2253

Hoechstetter, Sophie, 1873–

Passion, roman von Sophie Hoechstetter. Berlin, S. Fischer [ᶜ1911]

175, [1] p. 18ᶜᵐ. [Fischers bibliothek zeitgenössischer romane. 3. serie, 5. bd.] M. 1

© Feb. 15, 1911; 2c. Apr. 17, 1911; A—Foreign 2779; S. Fischer, verlag. (11-10414) 2254

Holm, John James.

Holm's race assimilation; or, The fading leopard's spots; a complete scientific exposition of the most tremendous question that has ever confronted two races in the world's history, by Prof. John James Holm ... Naperville, Ill., Atlanta, Ga., J. L. Nichols & company [ᶜ1910]

526 p. incl. front. (port.) illus. plates, ports. 20½ᶜᵐ. $1.50

© July 16, 1910; 2c. Apr. 13, 1911*; A 286148; J. J. Holm, Tampa, Fla. (11-10763) 2255

Huch, Friedrich.

Peter Michel, ein komischer roman von Friedrich Huch. München, M. Mörike, 1911.

349, [1] p. 19ᶜᵐ. M. 3

© Mar. 18, 1911; 2c. Apr. 29, 1911*; A—Foreign 2856; Martin Mörikes verlag. (11-10778) 2256

Iowa. *Supreme court.*

Reports of cases at law and in equity ... January term, 1910. By W. W. Cornwall, reporter. v. 29, being volume 146 of the series. Chicago, Ill., T. H. Flood & co., 1910.

viii, 852 p. 23½ᶜᵐ. $3.00

© May 16, 1911; 2c. May 22, 1911*; A 289124; W. C. Hayward, sec. of state of Iowa, Des Moines, Ia. 2257

Johnson, A. P., ed.

Library of advertising. Show window display and specialty advertising. Comp. and ed. by A. P. Johnson ... Chicago, Cree publishing company [1911]

293 p. incl. front., illus., plates. 26½ᶜᵐ. $5.00

© Apr. 20, 1911; 2c. Apr. 22, 1911*; A 286379; Cree pub. co. 2258

Kagey, Charles Claudius, 1870–

Land survey and land titles; a text book for schools and students in the laws of real property. By Charles Claudius Kagey ... Tuscola, Ill., The Land title book co., 1911.

1 p. l., 2–187 p. illus. (incl. maps) 22ᶜᵐ. $1.12
"Notices": p. 183–187.

© Apr. 1, 1911; 2c. Mar. 27, 1911; A 286762; C. C. Kagey, Tuscola. Ill.
(11–10769) 2259

Kelly, Howard Atwood.

Stereo-clinic ... [section 20. Troy, N. Y., The Southworth co., 1911]

4 pt. in 2 v. illus. 23 x 18½ᶜᵐ. $10.75

CONTENTS.—Complete tear of the perineum.—Hematoma of the vulva.—Carcinoma of the clitoris.—Removal of cyst of Bartholin's gland.

© May 15, 1911; 2c. each May 16, 1911; A 286951–286954; Southworth co.
 2260-2263

Kirkman, Marshall Monroe, 1842–

Operating trains ... forming one of the series of the volumes comprised in the Revised and enlarged edition of The science of railways, by Marshall M. Kirkman. Ed. 1911. Chicago, Cropley Phillips company, 1911.

vi p. 1 l., 7–651 p. incl. illus. (partly col.) pl., tables, forms. 20ᶜᵐ.

© Apr. 21, 1911; 2c. May 6, 1911*; A 286726; Cropley Phillips co.
(11–10748) 2264

Knoop, Gerhard J Ouckama, 1861–

Verfalltag, roman von Gerhard Ouckama Knoop. Berlin, E. Fleischel & co., 1911.

3 p. l., 279 p. 20½ᶜᵐ. M. 3.50

© Apr. 6, 1911; 2c. May 6, 1911*; A—Foreign 2884; Egon Fleischel & co.
(11–10777) 2265

Ladenburg, Albert, 1842–

Naturwissenschaftliche vorträge in gemeinverständlicher darstellung, von Albert Ladenburg. 2., bedeutend verm. aufl. (Volksausg.) Mit 1 tabelle und 30 abbildungen im text. Leipzig, Akademische verlagsgesellschaft m. b. h., 1911.

vi p., 1 l., 326 p. illus., diagrs. (1 fold.) 24ᶜᵐ. M. 5

CONTENTS.—Die fundamentalbegriffe der chemie.—Die chemische konstitution der materie.—Beziehungen zwischen den atomgewichten und den eigenschaften der elemente. — Stereochemie. — Die aggregatzustände und ihr zusammenhang.—Die vier elemente des Aristoteles.—Die spektralanalyse und ihre kosmischen konsequenzen. — Über das ozon. — Das zeitalter

Ladenburg, Albert—Continued

der organischen chemie.—Das radium und die radioaktivität.—Über den einfluss der naturwissenschaften auf die weltanschauung.—Epilog zur Kasseler rede.—Kekulé und seine bedeutung für die chemie.—Synthese.—Über einige neuere chemisch-technische entdeckungen.—Theorie der lösungen.

© Mar. 15, 1911; 2c. Apr. 29, 1911*; A—Foreign 2854; Akademische verlagsgesellschaft, m. b. h. (11–10400) **2266**

Lemonnier, Camille i. e. Antoine Louis Camille, 1835–

... Comme va le ruisseau; illustrations de Geo. Dupuis. Paris, P. Lafitte & c^{ie} [^c1911]

122 p. incl. front., illus. 24½^{cm}. (Idéal-bibliothèque ino. 24₁) fr. 0.95

© Apr. 7, 1911; 2c. Apr 22, 1911*; A—Foreign 2828; Pierre Lafitte & co.
(11–10417) **2267**

Macdonald, Duncan Black, 1863–

Aspects of Islam, by Duncan Black Macdonald ... New York, The Macmillan company, 1911.

xiii p., 1 l., 375 p. 19½^{cm}. $1.50
"The present volume contains the Hartford-Lamson lectures for 1909."

© Apr. 26, 1911; 2c. Apr. 27, 1911*; A 286493; Macmillan co.
(11–10756) **2268**

Masefield, John.

William Shakespeare, by John Masefield ... London, Williams and Norgate [^c1911]

viii, 9–256 p. 17½^{cm}. (Added t.-p.: Home university library of modern knowledge. New York, H. Holt and company) 1/

© 1c. May 3, 1911*; A ad int. 617; pubd. Apr. 5, 1911; Henry Holt & co., New York. (11–10416) **2269**

... **Meissonier**; huit reproductions facsimile en couleurs. Paris, P. Lafitte et c^{ie}, ^c1911·

80 p. col. front., illus., col. plates. 20½^{cm}. (Half-title: Les peintures illustres)
Series title also at head of t.-p.

© Mar. 24, 1911; 2c. Apr. 6, 1911*; A—Foreign 2724; Pierre Lafitte & cie.
 2270

Minnesota. *Supreme court.*

Minnesota reports, v. 112; cases argued and determined ... July 22–December 9, 1910. Henry Burleigh Wenzell, reporter. St. Paul, Lawyers' co-operative publishing co., 1911.

xx, 610 p. 22½^{cm}. $2.00

© May 20, 1911; 2c. May 23, 1911*; A 289151; Julius A. Schmahl, sec. of the state of Minnesota, in trust for the benefit of the people of said state, St. Paul, Minn. **2271**

Musselman, De Lafayette.

Musselman's bookkeeping. College ed. For business colleges, high schools and academies. Quincy, Ill., D. L. Musselman [^c1911]

111 p. incl. forms. 27^{cm}. $1.00

© Apr. 17, 1911; 1c. Apr. 29, 1911; 1c. May 5, 1911*; A 286705; D. L. Musselman, Quincy, Ill. (11–10770) **2272**

Newbigin, Marion I.

Modern geography, by Marion I. Newbigin ... London, Williams and Norgate [ᶜ1911]

256 p. illus. 17½ᶜᵐ. (*Added t.-p.:* Home university library of modern knowledge. New York, H. Holt and company) 1/
"Notes on books": p. 249–250.

© 1c. May 3, 1911*; A ad int. 614; pubd. Apr. 5, 1911; Henry Holt & co., New York. (11–10390) **2273**

Odd-fellows, Independent order of. *Sovereign grand lodge.*

Rebekah degree code and digest of law affecting the Rebekah branch of the Independent order of Odd fellows, revised and adopted by the Sovereign grand lodge, September, 1900, with all legislation on the Rebekah branch up to and including the session of 1910. Baltimore, Md., The Sovereign grand lodge, I. O. O. F., 1911.

54 p. 21ᶜᵐ. $0.25

© Apr. 7, 1911; 2c. Apr. 13, 1911*; A 286161; Sovereign grand lodge of the Independent order of Odd-fellows. (11–10110) **2274**

Peter, Richard.

Die jungen herren; ein Wiener roman, von Richard Peter. Berlin, F. Fontane & co., 1911.

4 p. l., 556 p. illus. 21ᶜᵐ. M. 6

© Mar 28, 1911; 2c. Apr. 21, 1911*; A—Foreign 2821; F. Fontane & co. (11–10418) **2275**

Pilcher, Lewis Stephen.

Odium medicum, and other addresses and studies in medical life and affairs, by Lewis Stephen Pilcher ... Philadelphia, Pa., J. B. Lippincott company [ᶜ1911]

v, 234 p. pl., facsim. 25ᶜᵐ.

CONTENTS.—Odium medicum. — Evolution of the American surgeon. — The place of the medical spirit in the ideal hospital.—Specialization in surgery and hospital surgeons.—On the organization of the surgical staff in general hospitals.—The cure of cancer.—Ethical codes for medical men.—Thoughts apropos of trained nurses. — Jacobus Berengarius Carpensis. — The Mondino myth.—A surgeon to the pope.

© Apr. 4, 1911; 2c. Apr. 21, 1911*; A 286350; L. S. Pilcher, Brooklyn. (11–10746) **2276**

Platt, Charles, 1869–

Practical medical chemistry, for physicians and students. By Charles Platt ... and William A. Pearson ... 6th ed., rewritten and enl. Philadelphia, J. J. McVey, 1911.

viii, 9–260 p. 24ᶜᵐ. $2.50

© May 1, 1911; 2c. May 4, 1911*; A 286667; John Joseph McVey. (11–10744) **2277**

Proctor, Mary.

Half-hours with the summer stars, by Mary Proctor ...
Chicago, A. C. McClurg & co., 1911.
xxiii p., 1 l., 232 p. front., 9 pl. 17½ᶜᵐ. $0.75
© Apr. 29. 1911; 2c. May 3, 1911*; A 286630; A. C. McClurg & co.
(11-10399) 2278

Ray, Anna Chapin, 1865–

... Buddie, the story of a boy, by Anna Chapin Ray ...
with illustrations from drawings by Harriet Roosevelt
Richards. Boston, Little, Brown, and company, 1911.
4 p. l., 286 p., 1 l. front., 3 pl. 20ᶜᵐ. (*Her* The Buddie books) $1.50
© May 6, 1911; 2c. May 10, 1911*; A 286782; Little, Brown, and company.
(11-10758) 2279

Reuling, Carlot Gottfrid, 1861–

Die strasse der erkenntnis, roman von Carlot Gottfrid
Reuling. Berlin, E. Fleischel & co., 1911.
2 p. l., 330 p. 20½ᶜᵐ. M. 4
© Apr. 6, 1911; 2c. May 6, 1911*; A—Foreign 2883; Egon Fleischel & co.
(11-10775) 2280

Roe, Clifford Griffith, 1875–

... Horrors of the white slave trade; the mighty crusade
to protect the purity of our homes ... by Hon. Clifford G.
Roe ... [and others] Illustrated with thirty-two half tone
engravings ... [New York? ᶜ1911]
448 p. front., plates, ports. 22ᶜᵐ.
© Apr. 7, 1911; 2c. May 4, 1911*; A 286666; Clifford G. Roe and B. S.
Steadwell, Chicago. (11-10768) 2281

Schroeder, Fritz, 1853–

Übungsbuch für das mädchenturnen in mädchenschulen
ohne turnhalle, von Fritz Schroeder ... und Hella Ver-
hülsdonk ... mit 48 abbildungen im text. Leipzig und
Berlin, B. G. Teubner, 1911.
xvi, 240 p. illus. 18½ᶜᵐ. M. 2.60
© Feb. 24, 1911; 2c. Apr. 29, 1911*; A—Foreign 2867; B. G. Teubner.
(11-10389) 2282

Smith, Frederick George, 1880–

Evolution of Christianity; or, Origin, nature, and devel-
opment of the religion of the Bible, by F. G. Smith ...
Anderson, Ind., Gospel trumpet company [ᶜ1911]
356 p. 18½ᶜᵐ. $1.00
© May 3, 1911; 2c. May 6, 1911*; A 286723; Gospel trumpet co.
(11-10753) 2283

Speer, Robert Elliott, 1867–

A Christian's habits, by Robert E. Speer. Philadel-
phia, The Westminster press, 1911.
114 p. 20ᶜᵐ. $0.50
© May 6, 1911; 2c. May 9, 1911*; A 286769; Trustees of the Presbyterian
board of publ. and Sabbath school work, Philadelphia.
(11-10754) 2284

Stockley, Cynthia.

The claw, by Cynthia Stockley ... New York and London, G. P. Putnam's sons, 1911.

vii, 449 p. front. 19½ᶜᵐ. $1.35
© May 6, 1911; 2c. May 10, 1911*; A 286780; C. Stockley, Great Britain.
(11-10639) 2285

Taylor, Frederick Winslow, 1856-

The principles of scientific management, by Frederick Winslow Taylor ... New York and London, Harper & brothers, 1911.

2 p. l., ₁7₁-77 p. 23ᶜᵐ. $1.50
© Mar. 20, 1911; 2c. Apr. 14, 1911*; A 286181; F. W. Taylor, Philadelphia.
(11-10339) 2286

Watkins, Mrs. Anne S.

A basketful of all sorts of eggs ₁by₁ Anne S. Watkins ... ₁New York, Press of Vechten Waring company, ᶜ1911₁

28 p. 18½ᶜᵐ.
Poems.
© Apr. 14, 1911; 2c. Apr. 17, 1911*; A 286243; A. S. Watkins, U. S.
(11-10779) 2287

Wedekind, Frank, 1864-

... The grisley suitor; a story by Frank Wedekind ... tr. from the German by Francis J. Ziegler. Philadelphia, Brown brothers, 1911.

33 p. 20½ᶜᵐ. (Modern authors' series) $0.25
© May 6, 1911; 2c. May 10, 1911*; A 286807; Brown bros.
(11-10760) 2288

... Rabbi Ezra, The victim; two stories, by Frank Wedekind ... tr. from the German by Francis J. Ziegler. Philadelphia, Brown brothers, 1911.

37 p. 20½ᶜᵐ. (Modern authors' series) $0.25
© May 6, 1911; 2c. May 10, 1911*; A 286805; Brown bros.
(11-10761) 2289

Wolcott, Theresa Hunt.

The minister's social helper, by Theresa Hunt Wolcott. Philadelphia, The Sunday school times company ₁ᶜ1911₁

iii, 5-364 p. illus. 19ᶜᵐ. $1.00
© Mar. 27, 1911; 2c. May 3, 1911*; A 286645; Sunday school times co.
(11-10388) 2290

Wolzogen und Neuhaus, Ernst Ludwig, freiherr von, 1855-

... Der erzketzer, ein roman vom leiden des wahrhaftigen ... Berlin, F. Fontane & co. ₁ᶜ1910₁

2 v. 21ᶜᵐ. M. 8
© Mar. 28. 1911; 2c. each Apr. 21, 1911*; A—Foreign 2820; F. Fontane & co. (11-10413) 2291

The **American** Catholic who's who ... St. Louis, Mo.
[etc.] B. Herder, 1911.
3 p. l., [4] p.. 2 l., 710 p. 23^{cm}.
Compiler: 1911, Georgina Pell Curtis.
© Apr. 29, 1911; 2c. May 3, 1911*; A 286647; G. P. Curtis, Chicago.
(11-10944) 2292

Baldwin, Charles Sears, 1867–
Writing and speaking, a text-book of rhetoric, by
Charles Sears Baldwin ... New York [etc.] Longmans,
Green, and co., 1911.
2 v. 19½^{cm}. $0.70
© Apr. 19, 1911; 2c. each Apr. 25, 1911*; A 286449, 286450; Longmans,
Green & co. (11-10960) 2293, 2294

Barnekow, Hans, *freiherr* **von.**
Was ich in Amerika fand, nach zwanzigjährigem auf-
enthalt, von freiherr Hans von Barnekow. Berlin, K.
Siegismund, 1911.
2 p. l., 161 p. 23½^{cm}.
© Mar. 15, 1911; 2c. Apr. 29, 1911*; A—Foreign 2859; Karl Siegismund.
(11-10945) 2295

Bernard, Henry Meyners.
Some neglected factors in evolution; an essay in con-
structive biology, by Henry M. Bernard ... ed. by Ma-
tilda Bernard; with 47 illustrations. New York and Lon-
don, G. P. Putnam's sons, 1911.
xxi, 489 p. illus. 22^{cm}. $3.00
© May 6, 1911; 2c. May 10, 1911*; A 286778; Matilda Bernard. Great Brit-
ain. (11-10979) 2296

Bisbee, Frederick Adelbert, 1855–
A summer flight, by Frederick A. Bisbee ... Boston,
The Murray press, 1911.
xiii, 370 p. incl. front., illus. 20^{cm}. $1.25
© Apr. 24, 911; 2c. Apr. 26, 1911*; A 286457; Melvin S. Nash, Boston.
(11-11069) 2297

Brown, Helen Dawes, 1857–
Orphans, by Helen Dawes Brown. Boston and New
York, Houghton Mifflin company, 1911.
3 p. l., 286 p., 1 l. 19^{cm}. $1.20
© May 6, 1911; 2c. May 12, 1911*; A 286860; H. D. Brown, Montclair,
N. J. (11-10950) 2298

Brown, William Leon.
Christian science falsely so called, by William Leon
Brown. New York, Chicago [etc.] Fleming H. Revell com-
pany [c1911]
1 p. l., 5-113 p. 19¼^{cm}. $1.00
© Apr. 21, 1911; 2c. Apr. 24, 1911*; A 286389; W. L. Brown, Lawrence,
Ind. (11-10948) 2299

Buehman, Estelle M.
Old Tucson; a hop, skip and jump history from 1539 Indian settlement to new and greater Tucson, by Estelle M. Buehman. Tucson, Ariz., State consolidated publishing co., 1911.
66 p. illus. 20ᶜᵐ. $0.50
© Apr. 1, 1911; 2c. Apr. 19, 1911*; A 286295; E. M. Buehman, Tucson, Ariz. (11-10941) **2300**

Conference of mayors and other officials (*New York*)
Proceedings of the 1st annual conference ... New York, Charities publication committee, 1911.
ix, 193 p. front., illus., ports. 23½ᶜᵐ. $0.50
On back of cover, vol. 1: Conference of mayors of the state of New York.
© Apr. 19, 1911; 2c. Apr. 24, 1911*; A 286406; State charities aid assn., New York. (11-10772) **2301**

Crantz, Paul.
... Planimetrie zum selbstunterricht, von Paul Crantz ... mit 99 figuren im text. Leipzig, B. G. Teubner, 1911.
iv, 134 p. diagrs. 18½ᶜᵐ. (Aus natur und geisteswelt ... 340. bdchen.) M. 1.25
© Feb. 24, 1911; 2c. Apr. 29, 1911*; A—Foreign 2863; B. G. Teubner. (11-10973) **2302**

Davis, Richard Harding, 1864–
The consul, by Richard Harding Davis. New York, C. Scribner's sons, 1911.
3 p. l., 62 p. front. 19ᶜᵐ. $0.50
© May 6, 1911; 2c. May 12, 1911*; A 286857; Charles Scribner's sons. (11-10953) **2303**

A **documentary** history of American industrial society; ed. by John R. Commons, Ulrich B. Phillips, Eugene A. Gilmore, Helene L. Sumner, and John B. Andrews ... With a preface by Richard T. Ely and introduction by John B. Clark. v. 10. Labor movement. Cleveland, O., The Arthur H. Clark company, 1911.
370 p. front. (facsims.) 24½ᶜᵐ. $5.00
© May 18, 1911; 2c. May 20, 1911*; A 289063; Arthur H. Clark co. **2304**

Drake, Allison Emery.
Selected and supplementary discoveries showing Aryo-Semitic cognation, by Allison Emery Drake ... Denver, The Herrick book and stationery company; [etc., etc.] 1911.
[16] p. 24ᶜᵐ.
© May 1, 1911; 2c. May 5, 1911*; A 286711; A. E. Drake, Denver. **2305**

Ewald, Walther.
Soziale medizin. Ein lehrbuch für ärzte, studierende, medizinal- und verwaltungsbeamte, sozialpolitiker, behörden und kommunen. Von dr. med. Walther Ewald ... 1. bd. Berlin, J. Springer, 1911.
xi, 592 p. illus., maps, diagrs. 26ᶜᵐ.
Contains "Literatur."
© Mar. 20, 1911; 2c. Apr. 29, 1911*; A—Foreign 2855; Julius Springer. (11-10743) **2306**

Freemasons. *U. S. A. A. Scottish rite. Supreme council. Northern jurisdiction.*

... Proceedings of the Supreme council ... in annual meeting held at the city of Detroit ... September 20th, A. D. 1910 ... Boston, Mass. [1911]

491 p. front., illus., plates, ports. 22½ᶜᵐ. $1.00
© Feb. 3, 1911; 2c. Mar. 4, 1911; A 283391; Newton D. Arnold, in trust for Supreme council of sovereign grand inspectors-general of the 33d and last degree, A. A. Scottish rite for the northern masonic jurisdiction of the United States of America. 2307

Green, Sanford M.

Green's Michigan practice; a treatise on the practice of the courts of common law of the state of Michigan, with forms, by Sanford M. Green ... 3d ed. ... v. 2. Chicago, Callaghan & company, 1911.

v, 909–1747 p. 24½ᶜᵐ. $6.50
© May 23, 1911; 2c. May 26, 1911*; A 289243; Callaghan & co. 2308

Grieb, Christoph Friedrich.

Chr. Fr. Grieb' englisch-deutsches und deutsch-englisches wörterbuch, mit besonderer rücksicht auf aussprache und etymologie neubearb. und verm. von dr. Arnold Schröer. 11. aufl. Berlin-Schöneberg, Mentorverlag, g. m. b. h. [ᶜ1911]

2 v. 27ᶜᵐ. M. 17
CONTENTS.—1. bd. Englisch-deutsch.—2. bd. Deutsch-englisch.
© Jan. 5, 1911; 1c. Mar. 25, 1911*; 1c. May 23, 1911; A—Foreign 2689; Mentor-verlag, g. m. b. h. (11–5981) 2309

Harrison, Henry Sydnor.

Queed, a novel, by Henry Sydnor Harrison; with a frontispiece by R. M. Crosby. Boston and New York, Houghton Mifflin company, 1911.

x, 430 p., 1 l. front. 19½ᶜᵐ. $1.35
© May 6, 1911; 2c. May 12, 1911*; A 286862; H. S. Harrison, Charleston-Kanawha, W. Va. (11–10951) 2310

Higgins, Charles, *ed.*

Modern universal encyclopedia; a reference book of universal knowledge, with illustrations and pronunciations. Ed. by Charles Higgins ... Charles Annandale ... R. Archer Johnson, LL. D., H. D. Lovett, M. A., assisted by a large corps of specialists and experts. New York and Chicago, Fidelity publishing house [ᶜ1910]

2 p. l., [7]–624 p. illus. (incl. ports.) plates, facsims., diagrs. 21ᶜᵐ. $3.50
© Feb. 15, 1911; 2c. May 8, 1911*; A 286738; Fidelity pub. house. (11–10962) 2311

Horner, Jacob W]

Military socialism, by Dr. Walter H. Sensney [pseud.] Indianapolis, The author, 1911.

109 p. 19ᶜᵐ. $0.25
© Apr. 25, 1911; 2c. Apr. 28, 1911*; A 286522; Eliza J. Butler, Columbus, Ind. (11–10956) 2312

Hoskins, Leander Miller, 1860–

Theoretical mechanics; an elementary text-book, by L. M. Hoskins ... 4th ed. Stanford university, Cal., The author, 1911.

xi, 456 p. diagrs. 23cm. $3.00

© May 1, 1911; 2c. May 8, 1911*; A 286765; L. M. Hoskins, Palo Alto, Cal. (11-10978) 2313

Kallmeyer, Charles.

How to become a citizen of the United States of America. New York, C. Kallmeyer [ʻ1911]

88, 32 p. 20$\frac{1}{4}$cm. $1.00

Wie werde ich bürger der Vereinigten Staaten von Amerika?: 32 p. at end.

© Mar. 25, 1911; 2c. Mar. 29, 1911*; A 283758; Charles Kallmeyer. (11-10071) 2314

Kellicott, William Erskine, 1878–

The social direction of human evolution; an outline of the science of eugenics, by William E. Kellicott ... New York and London, D. Appleton and company, 1911.

xi, [1], 249 p. pl., diagrs. (1 fold.) 19$\frac{1}{2}$cm. $1.50

"This small volume is based upon three lectures on eugenics delivered at Oberlin college in April, 1910."—Pref.

© Apr. 21, 1911; 2c. Apr. 26, 1911*; A 286468; D. Appleton & co. (11-10955) 2315

Kibbee, James L.

The maverick, in a prologue and four acts; a drama of the West, by James L. Kibbee ... South Whitley, Ind., 1911.

2 p. l., 85 p. 21$\frac{1}{4}$cm.

© Apr. 8, 1911; 2c. Apr. 12, 1911; D 23912; J. L. Kibbee, South Whitley, Ind. (11-10963) 2315ᵃ

Knowles, Ellin J (Toy) "Mrs. J. H. Knowles," 1835–

Heart talks on Bible themes, by Mrs. J. H. Knowles ... New York, Chicago [etc.] Fleming H. Revell company [ʻ1911]

3 p. l., 5-237 p. front. 19$\frac{1}{2}$cm.

"These Heart talks are selections from those originally written by me for the Sunday school journal and Bible magazine."—Foreword.

© Apr. 22, 1911; 2c. Apr. 26, 1911*; A 286460; Fleming H. Revell co. (11-10946) 2316

Koehne, John B.

A challenge to modern skepticism, by John B. Koehne, D. D. Philadelphia, Ferris & Leach, 1911.

309 p. front. (port.) 19$\frac{1}{2}$cm.

© Apr. 25, 1911; 2c. Apr. 27, 1911*; A 286512; J. B. Koehne, Philadelphia (11-11060) 2317

Koontz, Frederick Luther.

The dial of destiny, by Frederick Luther Koontz ...
Boston, Mass., The Roxburgh publishing company, incorporated [c1911]

2 p. l., 323 p. front., plates. 20½ᶜᵐ. $1.50
© Apr. 24, 1911; 2c. Apr. 25, 1911*; A 286454; F. L. Koontz, Louisville,
Ky. (11-10954) 2318

Laukis, Joseph, 1866–

How to write letters in English and Lithuanian languages; a comprehensive and practical guide to correspondence. Showing the structure, composition, formalities and uses of the various kinds of letters, notes and cards. Kaip rašyti laiškus lietuviškoje ir angliškoje kalbose ... Suredagavo J. Laukis. Chicago, Ill., Spauda "Lietuvos," 1911.

293 p. 20ᶜᵐ. $0.75
© Apr. 10, 1911; 2c. Apr. 17, 1911; A 286276; A. Olszewski, Chicago.
(11-10964) 2319

Lehmann, Otto, 1855–

Die neue welt der flüssigen kristalle und deren bedeutung für physik, chemie, technik und biologie, von dr. O. Lehmann ... mit 246 abbildungen im text. Leipzig, Akademische verlagsgesellschaft m. b. h., 1911.

vi p., 1 l., 388 p. illus. 23½ᶜᵐ. M. 12
Bibliographical foot-notes.
© Mar. 15, 1911; 2c. Apr. 29, 1911*; A—Foreign 2862; Akademische ver-
lagsgesellschaft m. b. h. (11-10971) 2320

Lombroso, Cesare, 1835–1909.

... Crime, its causes and remedies, by Cesare Lombroso ... tr. by Henry P. Horton, M. A., with an introduction by Maurice Parmelee ... Boston, Little, Brown, and company, 1911.

xlvi, 471 p. 23½ᶜᵐ. (The modern criminal science series, pub. under the auspices of the American institute of criminal law and criminology)
$4.50
"Translator's note": p. [xxxvii]
"Bibliography of the writings of Cesare Lombroso on criminal anthropology": p. [453]–464.
© May 6, 1911; 2c. May 11, 1911*; A 286834; Little, Brown, and company.
(11-10957) 2321

Lutheran church.

The book of concord; or, The symbolical books of the Evangelical Lutheran church. Tr. from the original languages, with analyses and an exhaustive index. Ed. by Henry Eyster Jacobs ... People's ed., by authority of the General council of the Evangelical Lutheran church in North America. Philadelphia, General council publication board, 1911.

1 p. l., 758 p. 21½ᶜᵐ. $1.50

Lutheran church—Continued

·CONTENTS.—Preface to the Christian book of concord.—The general creeds.—The Augsburg confession.—The apology of the Augsburg con fession.—The Smalcald articles.—The small catechism.—The large catechism.—The formula of concord.—Analyses and indexes to the book of concord.

© Apr. 25, 1911; 2c. May 10, 1911*; A 286809; Board of publ. of the General council of the Evangelical Lutheran church in North America.
(11-10947) 2322

Mills, David Collier, 1877–

The twentieth century hat factory, by David C. Mills ... Danbury, Conn., The Lee-McLachlan company, 1910–1911.

4 p. l., 19–122 p. incl. plates. fold. pl. 26½ᶜᵐ. $2.50
© Apr. 19, 1911; 2c. May 1, 1911*; A 286592; Lee-McLachlan co.
(11-10966) 2323

Mississippi Valley historical association.

Proceedings of the Mississippi Valley historical association for the year 1909–1910. v. 3. Ed. by Benjamin F. Shambaugh ... Cedar Rapids, Ia., The Torch press, 1911.

452 p. 25ᶜᵐ. $1.50
© May 10, 1911; 2c. May 17, 1911*; A 286977; Mississippi Valley historical assn., Lincoln, Neb. 2324

Missouri. *St. Louis, Kansas City and Springfield courts of appeals.*

Cases determined ... reported for the St. Louis court of appeals, May 31, 1910, to June 14, 1910, by Thomas E. Francis ... for the Kansas City court of appeals, June 28, 1910, to October 3, 1910, by John M. Cleary ... and for the Springfield court of appeals, July 7, 1910, by Lewis Luster ... official reporters. v. 149. Columbia, Mo., E. W. Stephens, 1911.

xvii, 805, xviii p. 23½ᶜᵐ.
© Apr. 4, 1911; 2c. Apr. 5, 1911; A 289047; E. W. Stephens, Columbia, Mo.
 2325

Missouri. *Supreme court.*

Reports of cases determined ... between June 30 and November 29, 1910. Perry S. Rader, reporter. v. 230. Columbia, Mo., E. W. Stephens [1911]

xviii, 811, vi p. 23½ᶜᵐ.
© Apr. 26, 1911; 2c. Apr. 27, 1911; A 289046; E. W. Stephens. 2326

Osborn, *Mrs.* Lucy Reed (Drake) 1844–

Light on soul winning, by Mrs. Lucy D. Osborn ... New York, Chicago [etc.] Fleming H. Revell company [ᶜ1911]

160 p. front. (port.) 19½ᶜᵐ. $0.75
© Apr. 20, 1911; 2c. Apr. 24, 1911*; A 286393; Fleming H. Revell co.
(11-10949) 2327

Paulsen, John Olaf, 1851–

... Billeder fra Bergen, barndoms- og ungdomsminder. Kristiania og Kjøbenhavn, Gyldendalske boghandel, Nordisk forlag, 1911.

226 p. front. (port.) 20ᶜᵐ.
© Feb. 15, 1911; 2c. Mar. 9, 1911; A—Foreign 2897; Gyldendalske boghandel, Nordisk forlag. (11–11070) **2328**

Perris, George Herbert, 1866–

A short history of war and peace, by G. H. Perris ... London, Williams and Norgate [ᶜ1911]

vi, 7–256 p. 17½ᶜᵐ. (*Added t.-p.:* Home university library of modern knowledge. New York, H. Holt and company) 1/
"Note on books": p. 253–254.
© 1c. May 3, 1911*; A ad int. 616; pubd. Apr. 5, 1911; Henry Holt & co., New York. (11–10958) **2329**

Pfungst, Oskar.

Clever Hans (the horse of Mr. von Osten) a contribution to experimental animal and human psychology, by Oskar Pfungst; with an introduction by Prof. C. Stumpf, and one illustration and fifteen figures. Tr. from the German by Carl L. Rahn ... with a prefatory note by James R. Angell ... New York, H. Holt and company, 1911.

vi p., 1 l., 274 p. incl. front. illus. (charts) 19½ᶜᵐ. $1.50
"Table of references": p. 267–274.
Supplements i–iv: p. 245–265.
© Mar. 31, 1911; 2c. Apr. 22, 1911*; A 286386; Henry Holt & co. (11–10970) **2330**

Robb, Charles, 1826–1872.

Poems of Charles Robb, ed. by Mrs. M. L. Robb Hutchinson ... Chicago, W. B. Conkey company [ᶜ1910]

202 p. incl. front. (port.) 20ᶜᵐ.
© Mar. 8, 1911; 2c. Apr. 8, 1911*; A 286043; Mrs. M. L. R. Hutchinson, Williamsburg, O. (11–8589) **2331**

Robinson, Harry Perry, 1860–

Essence of honeymoon, by H. Perry Robinson ... New York and London, Harper & brothers, 1911.

4 p. l., 311, [1] p. front., 7 pl. 19½ᶜᵐ.
© May 11, 1911; 2c. May 15, 1911*; A 286901; Harper & bros. (11–10952) **2332**

Soulé, Julien Elizabeth, 1879–

... Telegraphy: railroading, express and freight. Jacksonville, Fla., 1911.

v, 95 p. incl. diagrs., forms. 21ᶜᵐ.
At head of title: Soulé's practical method of training.
© Apr. 24, 1911; 2c. Apr. 28, 1911*; A 286533; J. E. Soulé, Jacksonville. Fla. (11–10965) **2333**

Spofford, Charles Milton, 1871–

The theory of structures, by Charles M. Spofford ... Printed for the use of students at the Massachusetts institute of technology. New York [etc.] McGraw-Hill book company, 1911.

2 p. l., iii–x, 363 p. illus., diagrs. 24ᶜᵐ.
© May 5, 1911; 2c. May 11, 1911*; A 286838; C. M. Spofford, Boston. (11–10968) **2334**

Stekel, Wilhelm, 1868–

Die sprache des traumes. Eine darstellung der symbolik und deutung des traumes in ihren beziehungen zur kranken und gesunden seele, für ärzte und psychologen, von dr. Wilhelm Stekel ... Wiesbaden, J. F. Bergmann, 1911.

viii, 539 p. 26ᶜᵐ. M. 12.60
© Feb. 27, 1911; 2c. Mar. 11, 1911*; A—Foreign 2604; J. F. Bergmann.
(11–5515) 2335

Thackeray, William Makepeace.

The works of William Makepeace Thackeray; with biographical introductions by his daughter Lady Ritchie ... [The centenary biographical ed.] v. 14, 15. New York and London, Harper & brothers [1911]

2 v. front., illus, illus., plates. 21½ᶜᵐ.
CONTENTS.—14. The Christmas books of Mr. M. A. Titmarsh.—15. Ballads, and The rose and the ring.
© May 15, 1911; 2c. each May 20, 1911; A 289061, 289062; Harper & bros.
[Copyright claimed on introductions only] 2336, 2337

Thorpe, Francis Newton, 1857–

A school history of the United States. By Francis Newton Thorpe ... Rev. ed. New York, Philadelphia, Hinds, Noble & Eldredge [ᶜ1911]

334 p. front., illus., plates (1 col.) maps. 19½ᶜᵐ. $0.80
Pub. in 1900 under title: A history of the United States for junior classes.
"Books to read" at end of each chapter.
© Apr. 28, 1911; 2c. May 4, 1911*; A 286662; Hinds, Noble & Eldredge.
(11–10942) 2338

The **Virginia** law register. v. 16. May 1910 to April 1911 ... Charlottesville, Va., The Michie company, 1911.

1 p. l., 1008 p. 23½ᶜᵐ. $6.00
© Apr. 20, 1911; 2c. May 13, 1911*; A 286898; Michie co.
 2339

Wagner, Adolf, 1869–

... Die fleischfressenden pflanzen, von dr. Adolf Wagner ... mit 82 abbildungen im text. Leipzig, B. G. Teubner, 1911.

1 p. l., 128 p. illus. 18½ᶜᵐ. (Aus natur und geisteswelt ... 344. bdchen.) M. 1.25
© Mar. 1, 1911; 2c. Apr. 29, 1911; A—Foreign 2864; B. G. Teubner.
(11–10974) 2340

Walsh, John Henry, 1853–

Practical methods in arithmetic, by John H. Walsh ... Boston, New York [etc.] D. C. Heath & co. [ᶜ1911]

iv, 395 p. diagrs. 19ᶜᵐ. $1.25
© Apr. 17, 1911; 2c. Apr. 24, 1911*; A 286412; D. C. Heath & co.
(11–10976) 2341

/ ⌐ ⊃ ∂ ⌐ ⊃.

Harvard College Library

PART I, BOOKS, GROUP 1 JUN 9 1911

no. 35, June, 1911

From the 2347

U. S. Government.

Bell, John Joy, 1871–

A kingdom of dreams, by J. J. Bell ... with a frontispiece by E. S. Hodgson. New York, Cassell and company, limited, 1911.

vi p., 1 l., 332 p. col. front. 19½ᶜᵐ. $1.20
© May 16, 1911; 2c. May 18, 1911*; A 286991; Cassell & co., ltd.
(11–11285) 2342

Carus, Paul, 1852–

The philosophy of form, by Paul Carus; an expanded reprint of the author's introduction to his "Philosophy as a science." Chicago, The Open court publishing company; [etc., etc.] 1911.

2 p. l., 50 p. 19½ᶜᵐ. $0.25
© Apr. 26 1911; 2c. May 1, 1911*; A 286561; Open court pub. co.
(11–11059) 2343

Charmatz, Richard, 1879–

... Österreichs innere geschichte von 1848 bis 1907 ... 1. Von Richard Charmatz. 2. aufl. Leipzig, B. G. Teubner, 1911.

x, 146 p. 18½ᶜᵐ. (Aus natur und geisteswelt ... 242. bdchen.)
© Mar. 14, 1911; 2c. May 10, 1911*; A—Foreign 2910; B. G. Teubner.
(11–11072) 2344

Coates, Joseph Hornor.

The spirit of the Island, by Joseph Hornor Coates ... illustrated by Sidney M. Chase. Boston, Little, Brown, and company, 1911.

5 p. l., 273 p. front., plates. 19½ᶜᵐ. $1.25
© May 13, 1911; 2c. May 16. 1911*; A 286946; Little, Brown, & company.
(11–11279) 2345

Collier, Price, 1860–

The West in the East from an American point of view, by Price Collier. New York, C. Scribner's sons, 1911.

ix p., 1 l., 534 p. 21ᶜᵐ. $1.50
© May 6, 1911; 2c. May 12, 1911*; A 286858; Charles Scribner's sons.
(11–11073) 2346

Cortissoz, Royal.

John La Farge, a memoir and a study, by Royal Cortissoz. Boston and New York, Houghton Mifflin company, 1911.

xii p., 1 l. 268 p., 1 l. 12 pl., 3 port. (incl. front.) 24½ᶜᵐ. $4.00
© Apr. 29, 1911; 2c. May 12, 1911*; A 286865; R. Cortissoz, New York.
(11–11181) 2347

Curtis, Edward S.

The North American Indian; being a series of volumes picturing and describing the Indians of the United States and Alaska, written, illustrated, and published by Edward S. Curtis; ed. by Frederick Webb Hodge, foreword

· 393

Curtis, Edward S.—Continued

by Theodore Roosevelt; field research conducted under the patronage of J. Pierpont Morgan ... v. 6, 7. 1911.
2 v. fronts., plates. 32½ᶜᵐ. $160.00 each
© May 22, 1911; 2c. each May 24, 1911*; A 289188; E. S. Curtis, New York. 2348

Davis, Wallace Clyde, 1866– •

Essentials of operative dentistry ... by W. Clyde Davis ... [Lincoln, Neb.] The author, 1911.
266 p. illus. 23½ᶜᵐ. $3.00
© May 6, 1911; 2c. May 9, 1911*; A 286774; W. C. Davis, Lincoln, Neb. (11-11203) 2349

Egelhaaf, Gottlob, 1848–

Bismarck, sein leben und sein werk, von Gottlob Egelhaaf. Stuttgart, C. Krabbe verlag, E. Gussmann, 1911.
x, 456 p. front. (port.) 22½ᶜᵐ. M. 9
© Apr. 8, 1911; 2c. May 10, 1911*; A—Foreign 2920; Carl Krabbe verlag, Erich Gussmann. (11-11295) 2350

Eichinger, Alfons.

... Die pilze, von dr. Alfons Eichinger ... mit 54 abbildungen im text. Leipzig, B. G. Teubner, 1911.
2 p. l., 124 p. illus. 18½ᶜᵐ. (Aus natur und geisteswelt ... 334. bdchen.) M. 1.25
© Mar. 16, 1911; 2c. May 10, 1911*; A—Foreign 2908; B. G. Teubner. (11-11191) 2351

L'escrime: fleuret, par Kirchhoffer; épée, par J. Joseph-Renaud; sabre, par Léon Lecuyer; 48 gravures. Paris, Bibliothèque Larousse [1911]
63 p. illus. plates. 19½ᶜᵐ. fr. 1.30
© Apr. 14, 1911; 2c. Apr. 27, 1911*; A—Foreign 2844; Librairie Larousse. (11-11194) 2352

Farrington, Edward Holyoke, 1860–

Testing milk and its products; a manual for dairy students, creamery and cheese factory operators, food chemists, and dairy farmers, by E. H. Farrington ... and F. W. Woll ... 20th rev. and enl. ed. Madison, Wis., Mendota book company, 1911.
vi, 297 p. incl. illus., tables. front. (port.) 20ᶜᵐ. $1.25
© Jan. 16, 1911; 2c. Apr. 27, 1911; A 286763; E. H. Farrington and F. W. Woll, Madison, Wis. (11-11176) 2353

Ferber, Edna.

Dawn O'Hara, the girl who laughed, by Edna Ferber; frontispiece in colors by R. Ford Harper. New York, Frederick A. Stokes company [1911]
5 p. l., 302 p. col. front. 19½ᶜᵐ. $1.25
© May 13, 1911; 2c. May 16, 1911; A 286959; Frederick A. Stokes co. (11-11286) 2354

Green, Alice Sophia Amelia (Stopford) *"Mrs. J. R. Green,"* 1848–

Irish nationality, by Alice Stopford Green ... New York, H. Holt and company; [etc., etc., ᶜ1911]
256 p. 18ᶜᵐ. (*Half-title:* Home university library of modern knowledge, no. 6) $0.75
"Some Irish writers on Irish history": p. 255–256.
© May, 8, 1911; 2c. May 11, 1911*; A 286816; Henry Holt & co. (11–11071) **2355**

Griffith, Ira Samuel.

Wood-working for amateur craftsmen, by Ira S. Griffith ... Chicago, Popular mechanics co. [ᶜ1911]
121 p. illus. 18ᶜᵐ. (Popular mechanics handbooks) $0.25
© May 1, 1911; 2c. May 10, 1911*; A 286785; Henry H. Windsor, Chicago. (11–11196) **2356**

Groton, William Mansfield, 1850– *ed.*

The Sunday-school teacher's manual, designed as an aid to teachers in preparing Sunday-school lessons, ed. by the Rev. William M. Groton ... [2d ed.] Philadelphia, G. W. Jacobs & company [ᶜ1911]
4 v. front. (port.) 18ᶜᵐ. $1.60
First edition, 1909, issued in one volume.
Bibliographies at end of chapters.
CONTENTS.—pt. 1. The Sunday-school.—pt. 2. The Bible.—pt. 3. The church.—pt. 4. The prayer book.
© May 6, 1911; 2c. May 12, 1911*; A 286844–286847; George W. Jacobs & co. (11–11062) **2357–2360**

Halligan, James Edward, *ed.*

Fundamentals of agriculture, ed. by James Edward Halligan ... Boston, New York [etc.] D. C. Heath and company, 1911.
xiv, 492 p. illus. 21ᶜᵐ. $1.20
"References for collateral reading" at end of each chapter.
© Apr. 15, 1911; 2c. Apr. 24, 1911*; A 286411; D. C. Heath & co. (11–11178) **2361**

Harrower, Henry Robert, 1883–

Essays on laboratory diagnosis for the general practitioner, by Henry R. Harrower ... Chicago, New medicine publishing co., 1911.
291 p. 17½ᶜᵐ. $2.00
© Apr. 19, 1911; 2c. Apr. 24, 1911*; A 286414; Henry R. Harrower, Chicago. (11–11202) **2362**

Hewlett, Maurice Henry, 1861–

The agonists, a trilogy of God and man, by Maurice Hewlett ... New York, C. Scribner's sons, 1911.
xi p., 2 l., [2], 5–235 p. 20ᶜᵐ. $1.50
CONTENTS.—Minos, king of Crete.—Ariadne in Naxos.—The death of Hippolytus.
© May 6, 1911; 2c. May 12, 1911*; A 286854; Charles Scribner's sons. (11–11077) **2363**

Hubbard, Sara Anderson, 1832–

The soul in a flower, by Sara A. Hubbard. Chicago, A. C. McClurg & co., 1911.

vi, 7–64 p. 19ᶜᵐ. $0.50

© Apr. 29, 1911; 2c. May 4, 1911*; A 286797; A. C. McClurg & co. (11–11190) **2364**

Ibsen, Sigurd, 1859–

... Menneskelig kvintessens. Kristiania og Kjøbenhavn, Gyldendalske boghandel, Nordisk forlag, 1911.

4 p. l., [11]–215 p., 1 l. 23ᶜᵐ. kr. 3.80

CONTENTS. — Natur og menneske.—Hvorfor politiken bliver tilbage.— Om menneskeanlæg og om menneskekunst.—Om store mænd. Et vurderingsforsøg.

© Mar. 30, 1911; 2c. Apr. 13, 1911; A—Foreign 2759; Gyldendalske boghandel, Nordisk forlag. (11–11291) **2365**

Ingram, Eleanor Marie, 1886–

Stanton wins, by Eleanor M. Ingram ... with illustrations by Edmund Frederick. Indianapolis, The Bobbs-Merrill company [°1911]

5 p. l., 256 p., 1 l. col. front., col. plates. 18ᶜᵐ. $1.00

© May 13, 1911; 2c. May 18, 1911*; A 286980; Bobbs-Merrill co. (11–11281) **2366**

Loening, Grover Cleveland.

Monoplanes and biplanes, their design, construction and operation; the application of aerodynamic theory with a complete description and comparison of the notable types, by Grover Cleveland Loening ... 278 illustrations. New York, Munn & company, inc., 1911.

1 p. l., [vii]–xiv p., 1 l., 331 p. front., illus., diagrs. 21½ᶜᵐ. $2.50

Contains References.

© May 12, 1911; 2c. May 13, 1911*; A 286886; Munn & co., inc. (11–11198) **2367**

Luther, Mark Lee.

The sovereign power, by Mark Lee Luther ... with illustrations by Chase Emerson. New York, The Macmillan company, 1911.

vii, 324 p. col. front., plates. 20ᶜᵐ. $1.30

© May 17, 1911; 2c. May 18, 1911*; A 286990; Macmillan co. (11–11282) **2368**

Meriwether, Lee, 1862–

Seeing Europe by automobile; a five-thousand-mile motor trip through France, Switzerland, Germany, and Italy; with an excursion into Andorra, Corfu, Dalmatia. and Montenegro, by Lee Meriwether ... New York, The Baker & Taylor company, 1911.

6 p. l., 415 p. front., plates. 21½ᶜᵐ. $2.00

© May 12, 1911; 2c. May 13, 1911*; A 286897; Baker & Taylor co. (11–11294) **2369**

Murphy, John Benjamin, 1857– *ed.*
... General surgery, ed. by John B. Murphy ... Chicago, The Year book publishers [c1911]
611 p. illus., xxxiii pl. (incl. col. front.) 19^{cm}. (The practical medicine series ... vol. ii ... Series 1911) $2.00
© May 2, 1911; 2c. May 11, 1911*; A 286835; Yearbook publishers.
(11–11204) 2370

The **new** third year mechanical examination for engineers and firemen ... Chicago, F. J. Prior [c1911]
167 p. 16^{cm}. (Prior system of self-educational text and reference books)
© May 6, 1911; 2c. May 12, 1911*; A 286868; Frederick J. Prior.
(11–11199) 2371

[**Obenchain,** *Mrs.* **Eliza Caroline (Calvert)**] 1856–
To love and to cherish, by Eliza Calvert Hall [*pseud.*]
... illustrated by J. V. McFall. Boston, Little, Brown, and company, 1911.
6 p. l., 3–205 p. front., plates. 17½^{cm}. $1.00
© May 13, 1911; 2c. May 16, 1911*; A 286949; Little, Brown, & company.
(11–11278) 2372

The **Ohio** law reporter. v. 8. A weekly journal published in the interest of the legal profession in the state of Ohio; Vinton R. Shepard, ed. Cincinnati, The Ohio law reporter company, 1911.
xviii, 676 p. 23½^{cm}. $2.50
© May 24, 1911; 2c. May 27, 1911*; A 289300; Ohio law reporter co.
 2373
Owen, T Grafton.
Drippings from the eaves, by T. Grafton Owen. Seattle, Wash., Press of Lowman & Hanford company [c1911]
172 p. incl. front. plates. 25½^{cm}. $2.00
© Apr. 20, 1911; 2c. Apr. 28, 1911*; A 286532; Mrs. L. M. Parsons, Vancouver, B. C. (11–11078) 2374

Pammel, Louis Hermann, 1862–
Weeds of the farm and garden, by L. H. Pammel ...
New York, Orange Judd company; [etc., etc.] 1911.
xi, 281 p. front., illus. 20^{cm}. $1.50
"Partial bibliography ... arranged by Harriette S. Kellogg": p. 255–258.
© May 1, 1911; 2c. May 10, 1911*; A 286808; Orange Judd co.
(11–11177) 2375

Pemberton, Max, 1863–
White motley; a novel, by Max Pemberton ... New York, Sturgis & Walton company, 1911.
vi p., 1 l., 314 p. front. 19½^{cm}. $1.30
© May 17, 1911; 2c. May 18, 1911*; A 286996; Sturgis & Walton co.
(11–11283) 2376

Penkert, Anton.
... Das gassenlied, eine kritik von Anton Penkert.
Leipzig, Breitkopf & Härtel, 1911.
83 p. 20^{cm}. (Kampf gegen musikalische schundliteratur, 1) pf. 60
© Apr. 10, 1911; 2c. Apr. 21, 1911*; A- –Foreign 2816; Breitkopf & Härtel.
(11–11083) 2377

Pickert, H J

The diagram short-line to typewriting; touch typewriting made easy ... Chicago, Ill., Mayer & Miller company [°1911]
144 p. 19¾ᶜᵐ. $0.50
On cover: By H. J. Pickert.
© Apr. 1, 1911; 2c. Apr. 13, 1911*; A 286156; H. J. Pickert, Chicago.
(11-11303) 2378

Pierce, Robert Morris.

Dictionary of aviation, by Robert Morris Pierce ... New York, The Baker & Taylor company, 1911.
1 p. l., 267 p. 17ᶜᵐ. $1.40
© May 12, 1911; 2c. May 13, 1911*; A 286883; Robert M. Pierce, New York. (11-11197) 2379

Pilcher, Paul M.

Practical cystoscopy and the diagnosis of surgical diseases of the kidneys and urinary bladder, by Paul M. Pilcher ... with 233 illustrations, 29 of them being in colors. Philadelphia and London, W. B. Saunders company, 1911.
2 p. l., 3-398 p. illus. (partly col.) xi col. plates (incl. front.) 24¾ᶜᵐ.
$5.50
© Apr. 21, 1911; 2c. Apr. 22, 1911*; A 286376; W. B. Saunders co.
(11-11201) 2380

Porter, *Mrs.* Eleanor (Hodgman) 1868–

Miss Billy, by Eleanor H. Porter; with a frontispiece in colour from a painting by Griswold Tyng. Boston, L. C. Page & company, 1911.
viii, 356 p. col. front. 19½ᶜᵐ. $1.25
© May 10, 1911; 2c. May 16, 1911*; A 286944; L. C. Page & company (inc.) (11-11284) 2381

Presbrey, Frank Spencer, 1855–

Presbrey's information guide for transatlantic travelers. 7th ed. New York, Frank Presbrey co., °1911.
8 numb. l., 9-136 p. incl illus., maps. col. plates. 22 x 11ᶜᵐ. $1.00
© Apr. 28, 1911; 2c. May 4, 1911*; A 286681; Frank Presbrey co.
(11-11185) 2382

Reed, Hugh T 1850–

Cadet life at West Point, by Col. Hugh T. Reed ... 3d ed. Richmond, Ind., I. Reed & son [°1911]
315 p. incl. illus., plates, plan, facsims. front. (port.) 20ᶜᵐ. $1.50
© Apr. 22, 1911; 2c. Apr. 28, 1911*; A 286539; Hugh T. Reed, Winter Park, Fla. (11-11195) 2383

Robertson, James Wilson, 1857–

Conservation of life in rural districts [by] James W. Robertson ... New York, Association press, 1911.
46 p. 16ᶜᵐ. $0.25
© May 9, 1911; 2c. May 10, 1911*; A 286790; Internatl. committee of Y. M. C. A., New York. (11-11288) 2384

Sanford, Carlton Elisha, 1847–

Thomas Sanford, the emigrant to New England; ancestry, life and descendants, 1632–4. Sketches of four other pioneer Sanfords and some of their descendants, in appendix, with many illustrations, by Carlton E. Sanford ... Rutland, Vt., The Tuttle company, printers [1911]

2 v. fronts., plates, ports., map, facsims., coats of arms. 26ᶜᵐ.
"The medieval origins of the Sanfords and the origin of Thomas Sanford who came to America in 1632–4, by Charles A. Hoppin," vol. 1, p. 13–52.
© May 1, 1911; 2c. May 11, 1911*; A 286839; C. E. Sanford, Potsdam, N. Y. (11–11088) **2385**

Schneidemühl, Georg, 1853–

Handschrift und charakter, ein lehrbuch der handschriftenbeurteilung. Auf grund wissenschaftlicher und praktischer studien bearb. von dr. Georg Schneidemühl ... mit 164 handschriftproben im text. Leipzig, T. Grieben's verlag (L. Fernau) 1911.

3 p. l., ɪvɪ–xiv, 319 p. illus. (facsims.) 25½ᶜᵐ.
© Apr. 12, 1911; 2c. May 10, 1911*; A—Foreign 2904; G. Schneidemühl, Berlin. (11–11292) **2386**

Scott, Dukinfield Henry, 1854–

The evolution of plants, by Dukinfield Henry Scott ... New York, H. Holt and company; [etc., etc., ʿ1911]

256 p. illus. 18ᶜᵐ. (Half-title: Home university library of modern knowledge, no. 9) $0.75
Bibliography: p. 245–247.
© May 8, 1911; 2c. May 11, 1911*; A 286813; Henry Holt & co. (11–11188) **2387**

Scott, Morgan.

Rival pitchers of Oakdale, by Morgan Scott ... with four original illustrations by Elizabeth Colborne. New York, Hurst & company [ʿ1911]

4 p., 1 l., 5–311 p. front., plates. 20½ᶜᵐ. $0.60
© May 12, 1911; 2c. May 16, 1911*; A 286928; Hurst & co. (11–11280) **2388**

Shearer, John G 1859–

Canada's war on the white slave trade; by Rev. J. G. Sheerer [!], Lucy W. Brookings [!] and Rev. Father L. Minehan. [Toronto? ʿ1911]

1 p. l., p. 483–513, 364–387. 21ᶜᵐ.
CONTENTS.—Canada's war on the white slave trade, by Rev. J. G. Shearer.—Conditions in Toronto, by Miss L. W. Brooking.—A priest's protest ɪbyɪ Rev. Father L. Minehan.
© Apr. 13, 1911; 2c. Apr. 14, 1911; A 286311; L. H. Walter, Chicago. (11–11065) **2389**

Sherrill, Clarence Osborne.

Military map reading, by Captain C. O. Sherrill ... 2d ed. 11th thousand. Adopted by the War department for use by the organized militia. Adopted for use at the

Sherrill, Clarence Osborne—Continued

Army service schools, Fort Leavenworth, Kansas. ₁Menasha, Wis., Press of George Banta publishing co., ⸢1911₁

2 p. l., 63 p. illus. 22ᶜᵐ. $0.90
© Apr. 4, 1911; 2c. Apr. 11, 1911; A 286597; C. O. Sherrill, Fort Crocket,
Tex. (11-11193) **2390**

Stainer, *Sir* John, 1840-1901.

... La musique dans ses rapports avec l'intelligence et les émotions, essai d'esthétique musicale; traduction française par Louis Pennequin. Paris, H. Falque, 1911.

56 p. 22ᶜᵐ. fr. 1
© Apr. 6, 1911; 2c. Apr. 22, 1911*; A—Foreign 2836; Louis Pennequin.
Paris. (11-11084) **2391**

Stevenson, Robert Louis, 1850-1894.

... Lay morals, and other papers, by Robert Louis Stevenson; with a preface by Mrs. Stevenson. New York, C. Scribner's sons, 1911.

xiv, 316 p. 17½ᶜᵐ. (*Half-title:* The biographical edition of the works
of Robert Louis Stevenson) $1.00
CONTENTS. — Preface by Mrs. Stevenson. — Lay morals. — Father Damien.—The Pentland rising.—College papers.—Criticisms.—Sketches.—The
Great North road.—The Young Chevalier.—Heathercat.
© May 6, 1911; 2c. May 12, 1911*; A 286855; Charles Scribner's sons.
(11-11076) **2392**

Selections from Robert Louis Stevenson; ed. by Henry Seidel Canby and Frederick Erastus Pierce ... New York, C. Scribner's sons, 1911.

xxi, 457 p. 19ᶜᵐ. $1.00
Bibliography: p. xv–xvi
© May 6, 1911; 2c. May 12, 1911*; A 286856; Charles Scribner's sons.
(11-11075) **2393**

Watson, Bruce Mervellon, 1860-

Complete arithmetic, by Bruce M. Watson ... and Charles E. White ... Boston, New York ₁etc.₁ D. C. Heath & company ⸢ᶜ1911₁

viii, 404 p. incl. illus., tables, diagrs. 19½ᶜᵐ. $0.60
© Apr. 22, 1911; 2c. Apr. 25, 1911*; A 286451; D. C. Heath & co.
(11-10975) **2394**

Wright, George Frederick, 1838-

The ice age in North America and its bearings upon the antiquity of man, by G. Frederick Wright ... 5th ed. with many new maps and illustrations, enl. and rewritten to incorporate the facts that bring it up to date, with chapters on Lake Agassiz and The probable cause of glaciation, by Warren Upham ... Oberlin, O., Bibliotheca sacra company, 1911.

xxi, 763 p. front., illus., plates (partly fold.) maps (partly fold.) diagrs
23ᶜᵐ. $5.00
Bibliography: p. ₁711₁-741.
© May 1, 1911; 2c. May 12, 1911*; A 286879; Bibliotheca sacra co.
(11-10977) **2395**

2402

Abbott, George Knapp, 1880–
Hydrotherapy for students and practitioners of medicine, embodying a consideration of the scientific basis, principles and practice of hydrotherapy and some allied branches of physiologic therapy, by George Knapp Abbott ... Loma Linda, Cal., The College press, 1911.

xiv, 308 p. illus., col. plates. 23½ᶜᵐ. $3.00

© May 1, 1911; 2c. May 12, 1911*; A 286851; College press. (11–11345)

2396

Abbott, Keene, 1876–
A melody in silver, by Keene Abbott. Boston and New York, Houghton Mifflin company, 1911.

3 p. l., 148, ₍2₎ p. 19¼ᶜᵐ. $0.75

© Apr. 29, 1911; 2c. May 12, 1911*; A 286864; K. Abbott, Omaha, Neb. (11–11217)

2397

Alexander, Kirkland Barker, 1874–
The log of the North shore club; paddle and portage on the hundred trout rivers of Lake Superior, by Kirkland B. Alexander; with 40 illustrations. New York and London, G. P. Putnam's sons, 1911.

xvii, 228 p. front., plates. 18¼ᶜᵐ. $1.25

© May 6, 1911; 2c. May 10, 1911*; A 286781; K. B. Alexander, Detroit, Mich. (11–11222)

2398

A **babe** unborn. London, G. Richards ltd., 1911.

358 p., 1 l. 19¼ᶜᵐ. 6/

© 1c. Apr. 13, 1911*; A ad int. 584; pubd. Mar. 15, 1911; Century co., New York. (11–11211)

2399

Same. New York, The Century co., 1911.

4 p. l., 11–359 p. 19¼ᶜᵐ. $1.20

© May 11, 1911; 2c. May 12, 1911*; A 286871; Century co. (11–11287)

2400

Bangs, John Kendrick, 1862–
Jack and the check book, by John Kendrick Bangs; illustrated by Albert Levering. New York and London, Harper & brothers, 1911.

4 p. l., 235, ₍1₎ p. incl. illus., plates. front. 18¼ᶜᵐ. $1.00

CONTENTS.—Jack and the check-book.—The great wish syndicate.—Puss, the promoter.—The golden fleece.—The invisible cloak.—The return of Aladdin.

© May 18, 1911; 2c. May 20, 1911*; A 289060; Harper & bros. (11–11317)

2401

Bingham, Hiram, 1875–
Across South America; an account of a journey from Buenos Aires to Lima by way of Potosí, with notes on Brazil, Argentina, Bolivia, Chile, and Peru, by Hiram Bingham ... with eighty illustrations and maps. Boston and New York, Houghton Mifflin company, 1911.

xvi, 405, ₍1₎ p. double front., plates (partly double) maps, plans. 22ᶜᵐ. $3.50

Partly reprinted from various periodicals.

© Apr. 29, 1911; 2c. May 12, 1911*; A 286866; H. Bingham, New Haven, Conn. (11–11225)

2402

401

Bunnell, Sterling Haight, 1871–
Cost-keeping for manufacturing plants, by Sterling H.
Bunnell ... New York, D. Appleton and company, 1911.
ix, [1], 232 p., 1 l. illus., fold. plan. fold. tab. 24½ᶜᵐ. $3.00
© May 5, 1911; 2c. May 9, 1911; A 286787; D. Appleton & co.
(11-11266) 2403

Castle, Mrs. Agnes (Sweetman)
The ninth wave, by Agnes and Egerton Castle. New
York, R. H. Paget, 1911.
103 p. 21½ᶜᵐ. $0.25
© May 10, 1911; 2c. May 12, 1911.; A 286875; Agnes and Egerton Castle,
England. (11-11214) 2404

The coming of Jesus; letters to first communicants by
a missionary priest, tr. by A. M. Otterbein. Techny, Ill.,
Society of the Divine word, 1911.
230 p., 1 l. incl. front. 14½ᶜᵐ. $0.35
© Apr. 24, 1911; 2c. Apr. 29, 1911*; A 286558; Society of the Divine word.
(11-11332) 2405

Dumstrey, Fritz, 1862–
Die körperpflege der frau in gesunden und kranken
tagen, von dr. med. F. Dumstrey ... Leipzig, F. A. Wolf-
son [°1911]
165 p. 23½ᶜᵐ. M. 2 80
© Mar. 30, 1911; 2c. May 10, 1911*; A—Foreign 2915; Helios-verlag.
Franz A. Wolfson. (11-11208) 2406

Fairchild, Henry Pratt.
Greek immigration to the United States, by Henry
Pratt Fairchild. New Haven, Yale university press; [etc.,
etc.] 1911.
xvii p., 2 l., 3–278 p. incl. front.. tables. 15 pl. 21ᶜᵐ. $2.00
Bibliography: p. 267-270.
© May 9, 1911; 2c.. May 9, 1911; A 286793; Yale univ. press.
(11-11324) 2407

Foster, William Trufant, 1879–
Administration of the college curriculum, by William
T. Foster ... Boston, New York [etc.] Houghton Mifflin
company [°1911]
xiv, 390 p., 1 l. diagrs. 20½ᶜᵐ.
Bibliography: p. [341]-350.
© Apr. 4, 1911; 2c. Apr. 7, 1911*; A 286007; W. T. Foster, Portland, Or.
(11-3541²) 2408

Garshin, Vsevolod Mikhaïlovich, 1855–1888.
... A red flower; a story, tr. from the Russian of Vse-
volod Garshin. Philadelphia, Brown brothers, 1911.
37 p. 20½ᶜᵐ. (Modern authors' series) $0.25
© May 6, 1911; 2c. May 10, 1911*; A 286806; Brown bros.
(11-11212) 2409

Graham, Winifred.
Mary, by Winifred Graham. New York, M. Kennerley,
1910.
2 p. l., 398 p. 19ᶜᵐ. $1.35
© Mar. 29, 1911; 2c. May 20, 1911*; A 289077; Mitchell Kennerley.
(11-11316) 2410

Grimshaw, Beatrice Ethel.

When the red gods call, by Beatrice Grimshaw ... New York, Moffat, Yard & company, 1911.

3 p. l., 364 p. 19½ᶜᵐ. $1.35

© May 17, 1911; 2c. May 19, 1911*; A 289021; Moffat, Yard & co.
(11–11319) 2411

Gruber, Georg B.

... Der alkoholismus, ein grundriss von dr. Georg B. Gruber ... mit 7 abbildungen im text und 1 tafel. Leipzig, B. G. Teubner, 1911.

2 p. l., 128 p., 1 l. diagrs. (1 fold.) 18½ᶜᵐ. (Aus natur und geisteswelt
... 103. bdchen.) M. 1.25

© Mar. 14, 1911; 2c. May 10, 1911*; A—Foreign 2909; B. G. Teubner.
(11–11064) 2412

Harris, Virgil McClure, 1862–

Ancient, curious and famous wills, by Virgil M. Harris ... Boston, Little, Brown, and company, 1911.

xiii, 472 p. 23½ᶜᵐ. $4.00

© May 6, 1911; 2c. May 12, 1911*; A 286870; Little, Brown, and company.
(11–11263) 2413

₁Hawkins, Anthony Hope₁ 1863–

Mrs. Maxon protests, by Anthony Hope ₁pseud.₁ ... illustrated by R. F. Schabelitz. New York and London, Harper & brothers, 1911.

3 p. l., 361, ₁1₁ p. front., plates. 19½ᶜᵐ. $1.35

© May 18, 1911; 2c. May 20, 1911*; A 289065; A. H. Hawkins, London.
(11–11314) 2414

Hobbs, William Herbert, 1864–

Characteristics of existing glaciers, by William Herbert Hobbs ... New York, The Macmillan company, 1911.

xxiv p., 1 l., 301 p. illus., 34 pl. (incl. front., maps) 23ᶜᵐ. $3.25
"References" at end of each chapter.

© May 10, 1911; 2c. May 11, 1911*; A 286821; Macmillan co.
(11–11341) 2415

₁The Horton mfg. co., Bristol, Conn.₁

Tricks and knacks of fishing; a collection of pointers ... gathered from famous fishing guides and expert anglers ... ₁Bristol? Conn., ᶜ1911₁

2 p. l., 7–115 p. illus., plates. 18½ᶜᵐ.

© Apr. 6, 1911; 2c. Apr. 18, 1911; A 286405; Horton mfg. co., Bristol,
Conn. (11–11335) 2416

Huntley, Mrs. Florence (Chance)

The dream child, by Florence Huntley ... 9th ed. Chicago, Indo-American book company, 1911.

4 p. l., 238 p. pl., 2 port. (incl. front.) 20ᶜᵐ. $1.00

© May 13, 1911; 2c. May 15, 1911*; A 286915; Indo-Amer. book co.
(11–11215) 2417

Hurd, Rukard.

Hurd's iron ore manual ... of the Lake Superior district, with values based on 1911 prices and guarantees at Lake Erie, method of determination of prices, premiums and penalties, tables of values and statistical data, by Rukard Hurd ... St. Paul, Minn., F. M. Catlin, sales agent [°1911]

4 p. l., 162 p. front. (map) illus. 23ᶜᵐ. $7.50
© May 11, 1911; 2c. May 13, 1911*; A 286887; R. Hurd, St. Paul, Minn.
(11-11340) 2418

Ilbert, *Sir* Courtenay Peregrine, 1841–

Parliament; its history, constitution and practice, by Sir Courtenay Ilbert ... New York, H. Holt and company; [etc., etc., °1911]

256 p. 18ᶜᵐ. (*Half-title:* Home university library of modern knowledge, no. 1) $0.75
Bibliography: p. [247]–254.
© May 8, 1911; 2c. May 11, 1911*; A 286814; Henry Holt & co.
(11-11269) 2419

Kerbey, Joseph Orton.

An American consul in Amazonia, by Major J. Orton Kerbey ... New York, W. E. Rudge, 1911.

7 p. l., [3]–370 p front., illus., plates, ports., maps, facsim. 24½ᶜᵐ.
© May 10, 1911; 2c. May 10, 1911*; A 286804; J. O. Kerbey, Washington, D. C. (11-11224) 2420

Kingsbury, Susan Myra, 1870– *ed.*

Labor laws and their enforcement, with special reference to Massachusetts, by Charles E. Persons, Mabel Parton, Mabelle Moses and three "fellows"; ed. by Susan M. Kingsbury, PH. D. On the fellowship foundation of the Massachusetts state federation of women's clubs, 1905–1909. New York [etc.] Longmans, Green, and co., 1911.

3 p. l., [ix]–xxii, 419 p. pl., fold. tables, fold. diagr. 23½ᶜᵐ. (*Half-title:* Women's educational and industrial union, Boston. Dept. of research. Studies in economic relations of women. vol. ii) $2.00
CONTENTS. — Preface, by E. F. Gay. — Introduction, by S. M. Kingsbury.—The early history of factory legislation in Massachusetts, by C. E. Persons.—Unregulated conditions in women's work, by Mabel Parton and Caroline Manning.—Weakness of the Massachusetts child labor laws, by Grace F. Ward.—Administration of labor legislation in the United States, with special reference to Massachusetts, by Edith Reeves and Caroline Manning.—Labor laws of Massachusetts, 1902–1910, by Edith Reeves.— The regulation of private employment agencies in the United States, by Mabelle Moses.
© May 6, 1911; 2c. May 12, 1911*; A 286842; Women's educational and industrial union, Boston. (11-11267) 2421

Know thyself; or, Nature's secrets revealed; a word at
the right time to the boy, girl, young man, young wo-
man, husband, wife, father and mother, also timely
counsel, help and instruction for every member of
every home; including important hints on social pur-
ity, heredity, physical manhood and womanhood, by
noted specialists; introduced by Bishop Samuel Fal-
lows ... one of the collaborators ... medical department
by W. J. Truitt ... Marietta, O., The S. A. Mullikin
company, 1911.
602 p. col. front., illus., col. plates. 20½ᶜᵐ. $2.25
© Apr. 24, 1911; 2c. May 8, 1911*; A 286745; S. A. Mullikin co.
(11-11207) 2422

Laselle, Mary Augusta, 1860–
Dramatizations of school classics; a dramatic reader for
grammar and secondary schools, by Mary A. Laselle ...
Boston, New York [etc.] Educational publishing company
[ᶜ1911]
160 p. illus., plates. 19½ᶜᵐ. $0.50
© Apr. 29, 1911; 2c. May 4, 1911*; A 286659; Educational pub. co.
(11-11232) 2423

Lehmann-Haupt, Ferdinand Friedrich Carl, 1861–
Die geschicke Judas und Israels im rahmen der weltge-
schichte. Von prof. dr. C. F. Lehmann-Haupt ... 1.–10.
tausend ... Tübingen, J. C. B. Mohr (P. Siebeck) 1911.
93 p. 20ᶜᵐ. (Religionsgeschichtliche volksbücher für die deutsche christ-
liche gegenwart. II. reihe, hft. 1 u. 6. Hrsg. von F. M. Schiele) M. 1
© Mar. 31, 1911; 2c. May 10, 1911*; A—Foreign 2926; J. C. B. Mohr (Paul
Siebeck) (11-11256) 2424

Lockwine, Alexandra Agusta Guttman, 1863–
Camping, by Biddy, known in real life as Alexandra G.
Lockwine, R. N. New York, The Advertisers printing co.
[ᶜ1911]
182 p. incl. illus., plates. 19½ᶜᵐ. $1.00
© May 12, 1911; 2c. May 20, 1911; A 289074; Mrs. A. G. Lockwine, New
York. (11-11333) 2425

MacDonald, Alexander, bp., 1858–
Religious questions of the day; or, Some modernistic
theories and tendencies exposed, by the Rt. Rev. Alexan-
der MacDonald ... v. 3. New York, Christian press
association publishing company [ᶜ1911]
3 p. l., 329 p. 19½ᶜᵐ. $1.00
© May 8, 1911; 2c. May 12, 1911*; A 286878; Christian press assn. pub. co.
(11-11061) 2426

Marshall, William Isaac, 1840–1906.
Acquisition of Oregon and the long suppressed evidence
about Marcus Whitman, by Principal William I. Marshall
... Seattle, Lowman & Hanford co., 1911.
2 v. front. (port.) 24ᶜᵐ. $10.00
© Apr. 11, 1911; 2c. May 15, 1911*; A 286913; Clarence B. Bagley, Seattle,
Wash. (11-11223) 2427

Norman, Edwin Gates.

Massachusetts trial evidence, including citations from Massachusetts reports, volumes 1-205, by Edwin Gates Norman and Arthur Stillman Houghton ... New York, Baker, Voorhis & co., 1911.

ix, 1123 p. 24ᶜᵐ. $7.50

© Apr. 28, 1911; 2c. May 11, 1911*; A 286818; E. G. Norman and A. S. Houghton, Worcester, Mass. (11-11262) 2428

Ohl, Jeremiah Franklin, 1850–

The inner mission; a handbook for Christian workers, by the Rev. J. F. Ohl ... Philadelphia, General council publication house, 1911.

2 p. l., 3-253 p. incl. tables. front., plates, ports. 20½ᶜᵐ. $1.00

© May 5, 1911; 2c. May 10, 1911*; A 286810; Board of publ. of the general council of the Evangelical Lutheran church in North America. (11-11252) 2429

Parker, John Scott, 1873– ed.

The law of New Jersey corporations, their organization and management, with the text of the statutes relating to all stock companies, except banks, building and loan associations, canal, insurance, plank road, provident loan, safe deposit, surety, trust and turnpike companies. With forms and precedents ... by John S. Parker ... v. 1, 2. Chicago, Callaghan & co., 1911.

2 v. 24½ᶜᵐ.

v. 1 © May 10, 1911; 2c. May 15, 1911*; A 286911; v. 2 © May 22, 1911; 2c. May 26, 1911; A 289244; Callaghan & co. (11-11261) 2430, 2431

Paterson, William Romaine, 1871–

The old dance master, by William Romaine Paterson (Benjamin Swift) ... Boston, Little, Brown, and company, 1911.

vi, 373 p. 19½ᶜᵐ. $1.25

© May 13, 1911; 2c. May 16, 1911*; A 286943; Little, Brown, and company. (11-11322) 2432

Potts, *Mrs.* Anna M (Longshore)

The logic of a lifetime, by Anna M. Longshore-Potts ... Alameda, Cal., The author, 1911.

5 p. l., [7]-303 p. front. (port.) 19ᶜᵐ.

© Mar. 21, 1911; 2c. Apr. 20, 1911*; A 286309; A. M. L. Potts, Alameda, Cal. (11-11331) 2433

Rose, William Ganson.

The ginger cure, by William Ganson Rose. Cleveland, Rose publishing company, 1911.

85, [1] p. 18ᶜᵐ. $0.50

© May 6, 1911; 2c. May 11, 1911*; A 286831; W. G. Rose, Cleveland, O (11-11235) 2434

Schwedtman, Ferdinand Charles, 1867–

Accident prevention and relief; an investigation of the subject in Europe, with special attention to England and Germany, together with recommendations for action in the United States of America, by Ferd. C. Schwedtman and James A. Emery, for the National association of manufacturers. New York, For the National association of manufacturers of the United States of America [°1911]

xxxvi, 481 p. incl. illus., pl. front., diagrs. 24ᶜᵐ. $15.00
© May 11, 1911; 2c. May 12, 1911; A 286896; Natl. assn. of mfrs. of the U. S. of Amer. (11–11268) **2435**

[See, Evelyn Arthur]

Absolute life on trial; a plain statement of the progress of absolute life against the opposition of the mortality and perversion of the world; the state's prosecution as seen in the light of the truths of the new life. London, C. F. Cazenove; Chicago, The Absolute press, 1911.

364 p. front., 4 pl. 20½ᶜᵐ. $1.50
© May 8, 1911; 2c. May 12, 1911*; A 286843; Mona Rees, Chicago.
(11–11255) **2436**

Sinclair, Upton Beall, jr., 1878–

Love's pilgrimage; a novel [by] Upton Sinclair. New York and London, M. Kennerley [°1911]

5 p. l., 3–663 p. 19ᶜᵐ. $1.35
© May 18, 1911; 2c. May 17, 1911; A 289071; Mitchell Kennerley.
(11–11315) **2437**

Sinks, Perry Wayland.

In the refiner's fire; the problem of human suffering ... By Perry Wayland Sinks ... Chicago, The Bible institute colportage association [°1911]

88 p. 20½ᶜᵐ. $0.50
© May 8, 1911; 2c. May 12, 1911*; A 286841; Bible institute colportage assn. of Chicago. (11–11254) **2438**

Spear, Raymond Herbert, ed.

The Commercial world encyclopedia of accounting ... Ed. by R. H. Spear, assisted by the editors of the Commercial world correspondence courses in higher accounting. v. 2. Detroit, Mich., The Commercial world publishing company, 1908 [1911]

2 p. l., 549–1111 p. front. (port.) illus. 28ᶜᵐ.
© May 26, 1911; 2c. May 29, 1911*; A 289304; Commercial world pub. co.
 2439

[Stratemeyer, Edward] 1862–

The Rover boys down East; or, The struggle for the Stanhope fortune, by Arthur M. Winfield [pseud.] ... New York, Grosset & Dunlap [°1911]

vi, 288 p. front., plates. 19½ᶜᵐ. (On cover: The Rover boys' series for young Americans [v. 15]) $0.60
© May 1, 1911; 2c. May 3, 1911*; A 286648; Edward Stratemeyer, Newark. (11–11213) **2440**

Tuberculosis league of Pittsburgh. *Dispensary aid society.*

Tuberculosis or consumption and how to avoid it; lessons for school children, provided by Dispensary aid society of Tuberculosis league of Pittsburgh ... ₁Pittsburg, Tuberculosis league, ᶜ1911₁

cover-title, 47 p. illus. 18ᶜᵐ. $0.10

© July 22, 1910; 2c. May 6, 1911*; A 286731; Tuberculosis league of Pittsburgh. (11–11206) 2441

Tuttle, Alonzo Hubert.

Supplement. The state of Ohio. Rev. by Alonzo Hubert Tuttle. ₁New York, Cincinnati ₁etc.₁ American book company, 1911₁

p. 225–268. 18ᶜᵐ. ₁*With* Peterman, A. L. Elements of civil government. New York, 1911₁

© May 16, 1911; 2c. May 19, 1911*; A 289019; American book co. 2442

Vorse, Mary Heaton.

The very little person, by Mary Heaton Vorse, with illustrations by Rose O'Neill. Boston and New York, Houghton Mifflin company, 1911.

4 p. l., 163, ₁1₁ p., 1 l. front., illus., plates. 18¼ᶜᵐ. $1.00

© Apr. 29, 1911; 2c. May 12, 1911*; A 286863; M. H. Vorse, Provincetown, Mass. (11–11216) 2443

Wells, Morris Benjamin, 1867–

Five gallons of gasoline, by Morris B. Wells; illustrations by Harrison Fisher. New York, Dodd, Mead & company, 1911.

5 p. l., 351 p. col. front. 19¼ᶜᵐ. $1.25

© May 4, 1911; 2c. May 5, 1911*; A 286696; Dodd, Mead & co. (11–11313) 2444

Wing, I E.

The world's progress, with illustrative texts from masterpieces of Egyptian, Hebrew, Greek, Latin, modern European and American literature; fully illustrated. I. E. Wing, M. A., writer and associate compiler. Associates: Very Rev. J. K. Brennan ... Gisle Bothne ... ₁and others₁ ... ₁Chicago₁ The Delphian society ₁ᶜ1911₁

10 v. col. fronts., illus., plates, ports., maps. 25ᶜᵐ. $50.00

© Apr. 12, 1911; 2c. May 5, 1911*; A 286706; Delphian society, Chicago. (11–11293) 2445

Wisconsin. *Supreme court.*

Wisconsin reports, 144. Cases determined ... October 15, 1910–January 31, 1911. Frederic K. Conover, official reporter. Chicago, Callaghan and company, 1911.

xxvii, 733 p. 23¼ᶜᵐ. $1.45

© May 15, 1911; 2c. May 20, 1911*; A 289048; James A. Frear, sec. of state of the state of Wisconsin, for the benefit of the people of said state, Madison, Wis. 2446

Agasse-Lafont, Édouard.

Les applications pratiques du laboratoire à la clinique; principes, techniques, interprétations des résultats, par le Dr. E. Agasse-Lafont ... préface par M. le professeur G. Hayem. 254 figures, dont 109 en couleurs, 4 planches hors texte en couleurs. Paris, Vigot frères, 1911.

xiv, 501 p., illus. (partly col.) 4 col. pl., fold. tab. 19½ᶜᵐ. fr. 10
© Apr. 21, 1911; 2c. May 12, 1911*; A—Foreign 2937; Vigot frères.
(11-11749) **2447**

Bagley, William Chandler.

Educational values, by William Chandler Bagley ... New York, The Macmillan company, 1911.

xx p., 1 l., 267 p. 19½ᶜᵐ. $1 10
© Apr. 26, 1911; 2c. Apr. 27, 1911*; A 286492; Macmillan co.
(11-11432) **2448**

Baker, Etta Anthony.

... The captain of the "S. I. G.'s," by Etta Anthony Baker ... with illustrations by H. Burgess. Boston, Little, Brown, and company, 1911.

x p., 2 l., 323 p. incl. front. plates. 20ᶜᵐ. (The Staten Island giants series) $1.50
© May 13, 1911; 2c. May 16, 1911*; A 286945; Little, Brown, and company.
(11-11321) **2449**

Bibliophile society.

... Tenth year book, 1911. [10th anniversary number] ... Printed for members only [1911]

195 p. front., plates (partly fold.) 24½ᶜᵐ. $16.50
© May 26, 1911; 2c. June 2, 1911*; A 289417; Bibliophile soc., Boston.
 2450

Calthrop, Dion Clayton, 1875–

Perpetua; or, The way to treat a woman, by Dion Clayton Calthrop. London, A. Rivers, ltd., 1911.

vii, 320 p 19ᶜᵐ. $1.30
© 1c. Apr. 11. 1911*; A ad int. 581; pubd. Mar. 15, 1911; John Lane co.,
N. Y. (11-11745) **2451**

Chamberlin, Georgia Louise.

The Hebrew prophets; or, Patriots and leaders of Israel. pt. 3 ... By Georgia Louise Chamberlin ... Chicago, Ill., The University of Chicago press [1911]

v, 169–237 p. fronts. (1 fold.) plates, fold. map. 22ᶜᵐ. (Constructive Bible studies. Secondary series)
© May 26, 1911; 2c. June 5, 1911*; A 289475; University of Chicago.
 2452

Couvreur, André, 1865–

... Une invasion de macrobes. Paris, P. Lafitte & cⁱᵉ [°1910]

2 p. l., 291 p. 19ᶜᵐ. fr. 3.50
© June 18, 1910; 2c. May 12, 1911*; A—Foreign 2947; A. Couvreur, Paris
(11-11555) **2453**

1911, no. 37
Printed June 8, 1911

Curtis, Edward S.

The North American Indian; being a series of volumes picturing and describing the Indians of the United States and Alaska, written, illustrated, and published by Edward S. Curtis; ed. by Frederick Webb Hodge, foreword by Theodore Roosevelt; field research conducted under the patronage of J. Pierpont Morgan ... v. 8. 1911.

xii, 227 p. front., plates. 32½ᶜᵐ. $160.00
© May 22, 1911; 2c. May 25, 1911; A 289378; E. S. Curtis, New York.
 2454

Dahms, P.

... An der see; geologisch-geographische betrachtungen für mittlere und reife schüler, von prof. dr. P. Dahms ... mit 61 abbildungen im text. Leipzig und Berlin, B. G. Teubner, 1911.

iv p., 1 l., 210 p. illus. 20½ᶜᵐ. (Dr. Bastian Schmids naturwissenschaftliche schülerbibliothek, 3) M. 3
© Mar. 6, 1911; 2c. May 10, 1911*; A—Foreign 2923; B. G. Teubner.
(11-11675) 2455

Dickson, Harris, 1868–

Old Reliable, by Harris Dickson ... with illustrations by Emlen McConnell and H. T. Dunn. Indianapolis, The Bobbs-Merrill company [ᶜ1911]

4 p. l., 341 p. front. plates. 19ᶜᵐ. $1.25
© May 13, 1911; 2c. May 18, 1911*; A 286979; Bobbs-Merrill co.
(11-11320) 2456

Doyle, *Sir* Arthur Conan, 1859–

The last galley; impressions and tales, by Arthur Conan Doyle ... London, Smith, Elder & co., 1911.

vi, [2], 298 p. col. front., pl. 19½ᶜᵐ.
CONTENTS.—The last galley.—The contest.—Through the veil.—An iconoclast.—Giant Maximin.—The coming of the Huns.—The last of the legions.—The first cargo.—The home-coming.—The red star.—The silver mirror.—The blighting of Sharkey.—The marriage of the brigadier.—The Lord of Falconbridge.—Out of the running.—"De profundis."—The great Brown-Pericord motor.—The terror of Blue John Gap.
© 1c. May 23, 1911*; A ad int. 643; pubd. Apr. 25, 1911; A. C. Doyle, London. (11-11744) 2457

... The **Federal** reporter, with key-number annotations. v. 184. Permanent ed. ... March–April, 1911. St. Paul, West publishing co., 1911.

xiii, 1088 p. 23ᶜᵐ. (National reporter system—United States series) $3.50
© May 26, 1911; 2c. June 2, 1911*; A 289410; West pub. co. 2458

Gebhardt, Johannes, *ed.*

Auf dichters spuren; eine sammlung von gedichten aus vergangenheit und gegenwart, für schüler mit kurzen erläuterungen versehen, von Johannes Gebhardt. Leipzig, B. Liebisch, 1911.

2 p. l., 171 p. front. 20½ᶜᵐ. M. 1.60
© Mar. 28, 1911; 2c. May 22, 1911*; A—Foreign 2983; Bernh. Liebisch.
(11-11754) 2459

Ginzberg, Louis.

The legends of the Jews, by Louis Ginzberg; tr. from
the German manuscript by Paul Radin. [v.] 3. Bible
times and characters from the exodus to the death of
Moses. Philadelphia, The Jewish publication society of
America, 1911.

x, 481 p. 22ᶜᵐ. $2.00

© May 26, 1911; 2c. June 2, 1911*; A 289392; Jewish publ. soc. of America.
 2460

Hessen, Robert.

Die sieben todfeinde der menschheit, von Robert Hes-
sen. München, A. Langen [ᶜ1911]

2 p. l., 173, [1] p. 19½ᶜᵐ. M. 2.50
CONTENTS.—Syphilis.—Tuberkulose.—Alkoholismus.—Der schulteufel.—
Prüderie.—Nervenschwäche.—Widernatürlichkeit.—Fazit.

© Apr. 10, 1911; 2c. May 10, 1911*; A—Foreign 2912; Albert Langen.
(11–11325) 2461

Hoffman, Frederick Louis, 1865–

Insurance science and economics; a practical discus-
sion of present-day problems of administration, methods
and results ... by Frederick L. Hoffman ... Chicago, New
York, The Spectator company, 1911.

3 p. l., xiii, 5–366 p. 25ᶜᵐ. $3.00
References at end of each chapter.

© May 10, 1911; 2c. May 18, 1911*; A 286993; Spectator co.
(11–11326) 2462

Illinois. *Supreme court.*

Reports of cases at law and in chancery ... v. 248 ...
Samuel Pashley Irwin, reporter of decisions. Blooming-
ton, Ill., 1911.

viii, [9]–704 p. 22½ᶜᵐ. $1.50

© May 27, 1911; 2c. June 3, 1911*; A 289421; Samuel Pashley Irwin.
 2463

... The **Indiana** digest; a digest of the decisions of the
courts of Indiana ... Comp. under the American di-
gest classification. v. 6. Interest–Maxims. St. Paul,
West publishing co., 1911.

iii, 1061 p. 26½ᶜᵐ. (American digest system—State series) $6.00
© May 22, 1911; 2c. June 2, 1911*; A 289409; West pub. co. 2464

James, William, 1842–1910.

Some problems of philosophy; a beginning of an intro-
duction to philosophy, by William James. New York
[etc.] Longmans, Green, and co., 1911.

xi, [1], 236, [2] p. 22ᶜᵐ.
Incomplete at the author's death. Dr. H. M. Kallen has largely pre-
pared the book for the press. cf. Prefatory note, signed Henry James, jr.

© May 29, 1911; 2c. May 13, 1911*; A 268890; Henry James, jr., Cam-
bridge, Mass. (11–11289) 2465

[Kaler, James Otis] 1848–
The camp on Indian Island, by James Otis [pseud.] ...
Philadelphia, The Penn publishing company, 1911.
320 p. front., plates. 19ᶜᵐ. $0.60
© May 19, 1911; 2c. May 20, 1911*; A 289056; Penn pub. co.
(11–11448) 2466

Keferstein, Hans Horst, 1857– '
... Grosse physiker; bilder aus der geschichte der astro-
nomie und physik, von dir. prof. dr. Hans Keferstein ...
für reife schüler, mit 12 bildnissen auf tafeln. Leipzig
und Berlin, B. G. Teubner, 1911.
iv p., 1 l., 233, [1] p. 12 port. (incl. front.) 20½ᶜᵐ. (Dr. Bastian
Schmids naturwissenschaftliche schülerbibliothek, 4) M. 3
"Literaturverzeichnis": 1 p. at end.
CONTENTS.—Coppernicus. — Keppler. — Galilei. — Newton.—Faraday —
Robert Mayer.—Helmholtz.
© Mar. 21, 1911; 2c. May 10, 1911*; A—Foreign 2924; B. G. Teubner.
(11–11662) 2467

Kirkman, Marshall Monroe, 1842–
Locomotive appliances ... forming one of the series of
volumes comprised in the rev. and enl. ed. of The science
of railways, by Marshall M. Kirkman. Ed. 1911. Chi-
cago, Cropley Phillips company, 1911.
1 p. l., 570 p. illus., fold. plates. 20ᶜᵐ.
© Apr. 29, 1911; 2c. May 18, 1911*; A 286992; Cropley Phillips co.
(11–11339) 2468

Lapauze, Henry, 1867–
... Le roman d'amour de M. Ingres; illustré de huit
phototypies hors-texte, d'après Ingres. Paris, P. Lafitte
& cⁱᵉ [°1910]
336 p., 2 l. incl. front. (port.) plates, ports., facsims. 19ᶜᵐ. fr. 3.50
© Nov. 3, 1910; 2c. May 12, 1911*; A—Foreign 2942; Pierre Lafitte & cie.
(11–11557) 2469

Leblanc, Maurice, 1864–
... La frontière, roman. Paris, P. Lafitte & cⁱᵉ [°1911]
3 p. l., [9]–347 p., 1 l. 19ᶜᵐ. fr. 3.50
© Apr. 21, 1911; 2c. May 12, 1911*; A—Foreign 2932; M. Leblanc, Paris.
(11–11558) 2470

Lemoine, Georges, 1859–
Les interventions médicales d'urgence, par G. Lemoine
... Paris, Vigot frères, 1911.
vii, 369 p., 1 l. 19½ᶜᵐ. fr. 6
· © Apr. 21, 1911; 2c. May 12, 1911*; A—Foreign 2936; Vigot frères.
(11–11748) 2471

412

Lemonnier, Camille *i. e.* **Antoine Louis Camille, 1835–**
... La chanson du carillon. Paris, P. Lafitte & cⁱᵉ [ᶜ1911]
2 p. l., [7]–347 p., 1 l. 19ᶜᵐ. fr. 3.50
© Apr. 21, 1911; 2c. May 12, 1911*; A—Foreign 2933; Pierre Lafitte & co.
(11–11553) 2472

Leroux, Gaston.
... Le fantôme de l'opéra. Paris, P. Lafitte & cⁱᵉ [ᶜ1910]
3 p. l., 520 p. 19ᶜᵐ. fr. 3.50
On cover: 23ᵐᵉ éd.
© Mar. 28, 1910; 2c. May 12, 1911*; A—Foreign 2946; Pierre Lafitte & cie.
(11–11667) 2473

Le Roux, Robert Charles Henri, *called* **Hugues, 1860–**
... O mon passé; illustrations de J. Jamet. Paris, P.
Lafitte & cⁱᵉ [ᶜ1910]
113 p. incl. front., illus. 24½ᶜᵐ. (Idéal-bibliothèque [20]) fr. 0.95
© Dec. 3, 1910; 2c. May 12, 1911*; A—Foreign 2941; Pierre Lafitte & cie.
(11–11551) 2474

Logos; internationale zeitschrift für philosophie der kul-
tur ... bd. 1. 1910, hft. 1–3. Tübingen, J. C. B. Mohr
(P. Siebeck) 1910/11.
3 v. 25ᶜᵐ. M. 9
Editor: 1910, G. Mehlis.
© Mar. 7, 1911; 2c. each May 10, 1911*; A—Foreign 2927; J. C. B. Mohr
(Paul Siebeck) (11–11329) 2475

Louisiana. *Supreme court.*
Reports of cases argued and determined in the Su-
preme court of Louisiana and the Superior court of the
Territory of Louisiana. Annotated ed. ... Book 16, con-
taining a verbatim reprint of vols. 3 & 4 of Robinson's
reports. St. Paul, West publishing co., 1911.
x, 336, viii, 340 p. 23ᶜᵐ. $7.50
© May 25, 1911; 2c. June 2, 1911*; A 289412; West pub. co. 2476

Maugham, William Somerset, 1874–
... L'explorateur; tr. de l'anglais par Mᵐᵉ Thérèse Ber-
ton. Paris, P. Lafitte & cⁱᵉ [ᶜ1910]
331, [1] p. 19ᶜᵐ. fr. 3.50
At head of title: M. Somerset-Maugham [!]
© Dec. 3, 1910; 2c. May 12, 1911*; A—Foreign 2945; Pierre Lafitte & cie.
(11–11666) 2477

Monts, Carl *i. e.* **Friedrich Wilhelm Ludwig Carl,** *graf*
von, 1801–1886. ·
... La captivité de Napoléon III en Allemagne; souvenirs
tr. de l'allemand par Paul Bruck-Gilbert et Paul Lévy;
ouvrage illustré de huit planches hors texte. Paris, P. La-
fitte et cⁱᵉ [ᶜ1910]
2½ p. l., vii, [1], 331, [1] p. front., plates, ports. 20½ᶜᵐ. fr. 5
At head of title: Général comte C. de Monts, gouverneur de Cassel.
© Nov. 16, 1910; 2c. May 12, 1911; A—Foreign 2943; Pierre Lafitte & cie.
(11–11682) 2478

Moorehead, Robert J.

Fighting the devil's triple demons; startling revelations—revolting social conditions—gross evil forces hitherto unheard of now at work—vice organized with devilish ingenuity—the young menaced as never before—drinking and pandering nurtured by corrupting social customs—humanity outraged and aroused. Three books in one volume: the traffic in innocent girls ... rum's ruinous rule ... the sins of society ... by Rob't J. Moorehead and other well known students of social conditions. Profusely illustrated with striking pictures. Philadelphia, Pa., National publishing co. [^c1911]

xii, 168, 144, 159 p. incl. col. front., illus., plates. 23½^{cm}. $1.50

© Apr. 23, 1911; 2c. Apr. 27, 1911*; A 286497; William R. Vansant, Chicago. (11–11461) 2479

Moras, Edmond Raymond, 1864–

Autology (study thyself) and autopathy (cure thyself) ... by E. R. Moras ... [Highland Park? Ill.] ^c1911·

96 p. 15 x 11½^{cm}. $0.10

On cover: Guide to autology.

© May 1, 1911; 2c. May 13, 1911*; A 286892; E. R. Moras, Highland Park, Ill. (11–11453) 2480

Autology (study thyself) and autopathy (cure thyself) [by] E. R. Moras ... [7th ed.] [Highland Park? Ill., ^c1911]

4 p. l., 7–308 p. front. (port.) pl. 22½^{cm}. $5.00

© May 1, 1911; 2c. May 13, 1911*; A 286891; E. R. Moras, Highland Park, Ill. (11–11452) 2481

Neuendorff, R.

... Praktische mathematik. 1. t. Von dr. R. Neuendorff ... Leipzig, B. G. Teubner, 1911.

vi, 104, [1] p. illus., diagrs. (partly fold.) 18½^{cm}. (Aus natur und geisteswelt ... 341. bdchen.) M. 1.25

© Feb. 24, 1911; 2c. Apr. 29, 1911*; A—Foreign 2865; B. G. Teubner. (11–11665) 2482

Orczy, Emmuska i. e. Emma Magdalena Rosalia Maria Josefa Barbara, baroness, 1865–

... Un amateur de mystères. Paris, P. Lafitte & c^{ie} [^c1910]

3 p. l., 333 p., 1 l. 19^{cm}. fr. 3.50

At head of title: J. Joseph-Renaud, d'après l'anglais de E. Orczy.

© Nov. 2, 1910; 2c. May 12, 1911*; A—Foreign 2944; Pierre Lafitte & cie. (11–11554) 2483

A true woman, by Baroness Orczy ... London, Hutchinson & co., 1911.

viii, 351, [1] p. 19½^{cm}. $1.50

© 1c. May 19, 1911*; A ad int. 638; pubd. Apr. 20, 1911; George H. Doran co., New York. (11–11565) 2484

... The **Pacific** reporter, with key-number annotations. v. 113. Permanent ed. ... March 6–April 3, 1911. St. Paul, West publishing co., 1911.

xiii, 1270 p. 26½ᶜᵐ. (National reporter system—State series) $4.00

© May 23, 1911; 2c. June 2, 1911*; A 289411; West pub. co. **2485**

Page, Gertrude.

Winding paths, by Gertrude Page ... London, Hurst & Blackett ltd., 1911.

3 p. l., 408 p. 20ᶜᵐ. 6/

© 1c. May 23, 1911*; A ad int. 644; pubd. May 2, 1911; D. Appleton & co., New York. (11–11746) **2486**

Rebenstorff, Hermann Heinrich Albert.

... Physikalisches experimentierbuch ... 1. t. Von prof. H. Rebenstorff ... Leipzig und Berlin, B. G. Teubner, 1911.

vi, 230 p. illus. 20½ᶜᵐ. (Dr. Bastian Schmids naturwissenschaftliche schülerbibliothek, 1) M. 3

© Feb. 28, 1911; 2c. May 10, 1911*; A—Foreign 2922; B. G. Teubner. (11–11663) **2487**

Scull, Guy Hamilton.

Lassoing wild animals in Africa, by Guy H. Scull ... with an introduction by Theodore Roosevelt, and a foreword by Charles S. Bird, with thirty-two illustrations from photographs. New York, Frederick A. Stokes company, 1911.

xix, 135 p. front. (port.) plates. 19½ᶜᵐ. $1.25

© May 12, 1911; 2c. May 16, 1911; A 286958; Frederick A. Stokes co. (11–11334) **2488**

Sienkiewicz, Henryk, 1846–

... Quo vadis; traduction de B. Kozakiewicz et J.-L. Janasz; illustrations de Orazi. Paris, P. Lafitte & cⁱᵉ [ᶜ1910]

120 p. incl. front., illus. 24ᶜᵐ. (Idéal-bibliothèque (19ı)) fr. 0.95

© Nov. 1, 1910; 2c. May 12, 1911*; A—Foreign 2940; Pierre Lafitte & cie. (11–11552) **2489**

Stammer, Georg.

Strafvollzug und jugendschutz in Amerika; eindrücke und ausblicke einer gefängnisstudienreise, von Georg Stammer. Berlin, R. v. Decker, 1911.

viii, 73 p. front. (port.) 22½ᶜᵐ. M. 1.50

© Mar. 22, 1911; 2c. May 10, 1911*; A—Foreign 2919; R. v. Decker's verlag. (11–11460) **2490**

Stedman, Thomas Lathrop, 1853–

A practical medical dictionary ... by Thomas Lathrop Stedman ... New York, W. Wood and company, 1911.

ix p., 1 l., 1000 p. illus. 24½ᶜᵐ.

© May 13, 1911; 2c. May 17, 1911*; A 286961; William Wood & co. (11–11344) **2491**

Vahlen, Karl Theodor, 1869–

... Konstruktionen und approximationen in systematischer darstellung, eine ergänzung der niederen, eine vorstufe zur höheren geometrie, von Theodor Vahlen; mit 127 figuren im text. Leipzig und Berlin, B. G. Teubner, 1911.

xii, 349, [1] p. diagrs. 23ᶜᵐ. (B. G. Teubners sammlung von lehrbüchern auf dem gebiete der mathematischen wissenschaften. bd. xxxiii) M. 11

© Mar. 20, 1911; 2c. May 10, 1911*; A—Foreign 2903; B. G. Teubner.
(11–11664) 2492

Weatherford, Willis Duke, 1875–

Introducing men to Christ; fundamental studies, by W. D. Weatherford ... Nashville, Tenn., Dallas, Tex., Publishing house of the M. E. church, South, Smith & Lamar, agents, 1911.

176 p. 20½ᶜᵐ. $0.50
Bibliography: p. 174–176.

© May 15, 1911; 2c. May 17, 1911*; A 286960; Smith & Lamar.
(11–11330) 2493

Williston, Samuel, 1861–

Lectures on business law and the negotiable instruments law, by Samuel Williston ... American institute of banking, Boston chapter. [Chelsea, Mass., Bay state press] 1910–1911.

4 p. l., [288] p. 24½ᶜᵐ. $5.00

© May 6, 1911; 2c. May 11, 1911; A 286972; S. Williston, Belmont, Mass.
(11–11327) 2494

Wolf, Luther Benaiah, 1857– *ed.*

Missionary heroes of the Lutheran church, ed. by L. B. Wolf ... Philadelphia, Pa., The Lutheran publication society [°1911]

viii, 246 p. front., plates, ports., 2 tab. (1 fold.) 19ᶜᵐ. $0.75

© May 8, 1911; 2c. May 10, 1911*; A 286784; Lutheran publ. soc.
(11–11253) 2495

Young, Platt.

Glossary of terms typographical with the appendix removed, by Platt Young. New York, 1911.

2 p. l., 39, [1] p. 17 x 13ᶜᵐ. $0.50

© May 3, 1911; 2c. May 4, 1911*; A 286674; P. Young, New York.
(11–11074) 2496

Balch, Allie Sharpe.

Sunshine, rain, and roses, by Allie Sharpe Balch. New
York and London, G. P. Putnam's sons, 1911.

vi, 132 p. 19cm. $1.25

"The verses in this volume originally appeared in the Washington her-
ald."

© May 6, 1911; 2c. May 10, 1911*; A 286779; A. S. Balch, Washington,
D. C. (11-11550) **2497**

Barclay, *Mrs.* Florence Louisa (Charlesworth) 1862–

Through the postern gate; a romance of seven days, by
Florence L. Barclay ... New York and London, G. P.
Putnam's sons, 1911.

2 p. l., [3]–269 p. 19cm. $1.25

© May 17, 1911; 2c. May 23, 1911*; A 289153; F. L. Barclay, Hertford,
England. (11-11737) **2498**

Baumgarten, Otto, 1858–

Die abendmahlsnot, ein kapitel aus der deutschen kir-
chengeschichte der gegenwart, von professor d. Otto
Baumgarten ... 1.–5. tausend ... Tübingen, J. C. B.
Mohr (P. Siebeck) 1911.

39 p. 20cm. (Religionsgeschichtliche volksbücher für die deutsche
christliche gegenwart. IV. reihe. 15. hft.) M. 0.50

© Mar. 31, 1911; 2c. May 10, 1911*; A—Foreign 2907; J. C. B. Mohr (Paul
Siebeck) (11-11328) **2499**

Brehm, Alfred Edmund, 1829–1884.

Brehms Tierleben. Allgemeine kunde des tierreichs.
Mit etwa 2000 abbildungen im text, über 500 tafeln in far-
bendruck, kupferätzung und holzschnitt und 13 karten.
4., vollständig neubearb. aufl., hrsg. von prof. dr. Otto
zur Strassen ... Vogel. 1. bd. Leipzig und Wien, Bi-
bliographisches institut, 1911.

xvi, 498 p. illus., plates (partly col.) 26cm M. 12

© Mar. 17, 1911; 2c. May 10, 1911*; A—Foreign 2902; Bibliographisches
institut Meyer, Leipzig. (11-11342) **2500**

Call, Annie Payson, 1853–

Brain power for business men, by Annie Payson Call
... Boston, Little, Brown and company, 1911.

4 p. l., 124 p. 17cm. $0.75

© May 13, 1911; 2c. May 16, 1911*; A 286948; Little, Brown, and company.
(11-11678) **2501**

Clark, Ellery Harding, 1874–

Reminiscences of an athlete; twenty years on track and
field, by Ellery H. Clark ... Boston and New York,
Houghton Mifflin company, 1911.

5 p. l., 196 p., 1 l. front., plates, ports. 19½cm $1.25

© Apr. 29, 1911; 2c. May 12, 1911*; A 286861; E. H. Clark, Boston.
(11-11674) **2502**

Colton, Matthew M.

Frank Armstrong's vacation, by Matthew M. Colton; with four original illustrations by Arthur O. Scott. New York, Hurst & company [°1911]

4 p., 1 l., 5–310 p. front., plates. 20½ᶜᵐ. $0.60
© Apr. 29, 1911; 2c. May 5, 1911*; A 286690; Hurst & co.
(11–11562) **2503**

Colville, Frank M.

Oklahoma poems, and other verse, by Frank M. Colville ... [Oklahoma City, Press of the Warden printing company] 1911.

64 p. port. 24 x 13½ᶜᵐ. $1.00
© Apr. 8, 1911; 2c. Apr. 13, 1911; A 286585; F. M. Colville, Edmond, Okl.
(11–11547) **2504**

Deering, Fremont B.

The border boys on the trail, by Fremont B. Deering. New York, Hurst & company [°1911]

307 p. front., plates. 19½ᶜᵐ. $0.50
© Apr. 27, 1911; 2c. May 5, 1911*; A 286688; Hurst & co.
(11–11561) **2505**

Dombres, Georges.

... L'énigme de la rue Cassini. Paris, P. Lafitte & cⁱᵉ [°1911]

336 p. 19ᶜᵐ. fr. 3.50
© Apr. 21, 1911; 2c. May 12, 1911*; A—Foreign 2931; Pierre Lafitte & co.
(11–11556) **2506**

Elliott, Byron K 1835–

A treatise on the law of roads and streets, by Byron K. Elliott and William F. Elliott ... 3d ed., rev. and enl. ... Indianapolis, The Bobbs-Merrill company, 1911.

2 v. 24ᶜᵐ. $13 00
© Apr. 4, 1911; 2c. May 18, 1911*; A 289000; Bobbs-Merrill co.
(11–11580) **2507**

Euripides.

... Andromache, mit erklärenden anmerkungen von N. Wecklein. Leipzig und Berlin, B. G. Teubner, 1911.

91, [1] p. 21½ᶜᵐ. (On cover: Griechische und lateinische klassiker) M. 2
© Feb. 15, 1911; 2c. May 10, 1911*; A—Foreign 2911; B. G. Teubner.
(11–11439) **2508**

Fischer-Dückelmann, Anna.

Die frau als hausärztin; ein ärztliches nachschlagebuch der gesundheitspflege und heilkunde in der familie, mit besonderer berücksichtigung der frauen- und kinderkrankheiten, geburtshilfe und kinderpflege, von dr. med. Anna Fischer-Dückelmann ... Mit 485 original-illustrationen, 38 tafeln und kunstbeilagen in feinstem farbendruck, dem porträt der verfasserin und einem modellalbum: mann und weib. Gänzlich neubearb. und verm.

Fischer-Dückelmann, Anna—Continued
750,000 jubiläums-ausg. Stuttgart, Süddeutsches ver-
lags-institut [°1911]
2 v. front. (port.) illus., plates (partly col.) 25ᶜᵐ. M. 20
Album containing 5 colored plates (3 superimposed) at end of v. 2.
© Mar. 20, 1911; 2c. May 10, 1911*; A—Foreign 2905; Süddeutsches ver-
lags-institut, Julius Müller. (11–11346) 2509

Foley, James William, 1874–
The verses of James W. Foley ... Author's complete
ed. Bismarck, N. D., R. D. Hoskins [°1911]
3 v. front. (port.) 20ᶜᵐ. $3.75
CONTENTS.—v. 1. Book of boys and girls.—v. 2. Book of plains and
prairie.—v. 3. Book of life and laughter.
© May 1, 1911; 2c. May 15, 1911*; A 286921; J. W. Foley, Bismarck, N. D.
(11–11752) 2510

Ford, Jeremiah Denis Matthias, 1873– ed.
Old Spanish readings, selected on the basis of critically
edited texts. Ed. with introduction, notes and vocabu-
lary, by J. D. M. Ford ... Boston, New York [etc.] Ginn
and company [°1911]
xliii, 312 p. 19ᶜᵐ. (International modern language series) $1.50
© May 5, 1911; 2c. May 22, 1911*; A 289111; J. D. M. Ford, Cambridge,
Mass. (11–11753) 2511

Frank, Henry, 1854–
Psychic phenomena, science and immortality; being a
further excursion into unseen realms beyond the point
previously explored in "Modern light on immortality,"
and a sequel to that previous record, by Henry Frank ...
Boston, Sherman, French & company, 1911.
8 p. l., [13]–556 p. 21ᶜᵐ. $2.25
© May 5, 1911; 2c. May 19, 1911*; A 289037; Sherman, French & co.
(11–11680) 2512

Hall, Granville Stanley, 1846–
Educational problems, by G. Stanley Hall ... New
York and London, D. Appleton and company, 1911.
2 v. diagrs. 24½ᶜᵐ. $7.50
CONTENTS.—v. 1. The pedagogy of the kindergarten. The educational
value of dancing and pantomime. The pedagogy of music. The religious
training of children and the Sunday-school. Moral education. Children's
lies: their psychology and pedagogy. The pedagogy of sex. Industrial
education.—v. 2. The budding girl. Missionary pedagogy. Special child-
welfare agencies outside the school. Preventive and constructive move-
ments. Sunday observance. The German teacher teaches. Pedagogy of
modern languages. Pedagogy of history. Pedagogy and the press. The
pedagogy of elementary mathematics. Pedagogy of reading: how and
what? Pedagogy of drawing. School geography. Some defects of our
public schools. The American high school. Civic education.
© May 5, 1911; 1c. May 9, 1911; 1c. May 10, 1911*; A 286789; D. Apple-
ton & co. (11–11434) 2513

Hansbrough, Henry Clay, 1848–
The second amendment, by Henry Clay Hansbrough.
Minneapolis, The Hudson publishing company, 1911.
5 p. l., 359 p. front. 19½ᶜᵐ. $1.40
© May 10, 1911; 2c. May 19, 1911; A 289088; Hudson pub. co.
(11–11446) 2514

Idaho (*Ter.*) *Supreme court.*

Reports of cases argued and determined in the Supreme court of Idaho territory. From January term, 1866, to September term, 1880 inclusive. By H. E. Prickett ... v. 1. New series. With notes on Idaho reports. San Francisco, Cal., Bancroft-Whitney company, 1911.

vii, 880 p. 23½ᶜᵐ. $5.00

© Apr. 17, 1911; 2c. May 19, 1911*; A 289034; Bancroft-Whitney co.
(11-11579) 2515

Johnson, Owen McMahon, 1878–

The Tennessee Shad, chronicling the rise and fall of the firm of Doc Macnooder and the Tennessee Shad, by Owen Johnson ... New York, The Baker & Taylor company, 1911.

6 p. l., 11-307 p. front., plates. 19ᶜᵐ. (*His* Lawrenceville stories)
$1.20

© May 19, 1911; 2c. May 20, 1911; A 289105; Baker & Taylor co.
(11-11563) 2516

Jones, Edward Smyth.

The sylvan cabin; a centenary ode on the birth of Lincoln, and other verse, by Edward Smyth Jones; with introduction by William Stanley Braithwaite. Boston, Sherman, French & company, 1911.

96 p. 19½ᶜᵐ. $1.00

© Apr. 24, 1911; 2c. Apr. 29, 1911*; A 286556; Sherman, French & co.
(11-11548) 2517

Jones, Wallace Franklin, 1870–

Principles of education applied to practice, by W. Franklin Jones ... New York, The Macmillan company, 1911.

xi, 293 p. 19½ᶜᵐ. $1.00

© May 10, 1911; 2c. May 11, 1911*; A 286820; Macmillan co.
(11-11433) 2518

Lin Shao-Yang.

A Chinese appeal to Christendom concerning Christian missions, by Lin Shao-Yang. New York and London, G. P. Putnam's sons, 1911.

iv p., 1 l., 321 p. 22ᶜᵐ. $1.50.

© May 19, 1911; 2c. May 22, 1911*; A 289104; G. P. Putnam's sons.
(11-11676) 2519

Lutz, *Mrs.* **Grace (Livingston) Hill-,** 1865–

Dawn of the morning, by Grace Livingston Hill Lutz ... with illustrations in color by Anna Whelan Betts. Philadelphia & London, J. B. Lippincott company, 1911.

320 p. col. front., col. plates. 19½ᶜᵐ. $1.25

© May 2, 1911; 2c. May 24, 1911*; A 289162; J. B. Lippincott co.
(11-11742) 2520

Macdonald, Alice Belle, 1860–

Foundation English; the expression of ideas, by Alice
B. Macdonald ... Boston, New York [etc.] B. H. Sanborn
& co., 1911.

xxv p., 1 l., 287 p. 12 pl. 20ᶜᵐ.

© May 12, 1911; 2c. May 15, 1911*; A 286923; A. B. Macdonald, Lawrence,
Mass.· (11–11437) 2521

Marshall, Archibald, 1866–

The eldest son, by Archibald Marshall ... New York,
Dodd, Mead and company, 1911.

viii, 375 p. 19½ᶜᵐ. $1.25

© May 23, 1911; 2c. May 24, 1911*; A 289181; Dodd, Mead & co.
(11–11741) 2522

Miller, Francis Trevelyan, ed.

... The photographic history of the civil war ... [v. 1, 2]
Francis Trevelyan Miller, editor-in-chief; Robert S. La-
nier, managing editor. Thousands of scenes photo-
graphed 1861–65, with text by many special authorities.
New York, The Review of reviews co., 1911.

2 v. front., illus., maps. 28½ᶜᵐ. $3.10 each
At head of title: Semi-centennial memorial.
CONTENTS.—v. 1. The opening battles.—v. 2. Two years of grim war.
v. 1 © May 15, 1911; 2c. May 16, 1911*; A 286931; v. 2 © June 5, 1911;
2c. June 7, 1911*; A 289524; Patriot pub. co., Springfield, Mass.
(11–11566) 2523, 2524

Montana (*Ter.*) *Supreme court.*

Reports of cases argued and determined in the Supreme
court of Montana territory from December term, 1868,
to August term, 1880. v. 1–3. By Henry N. Blake ...
with notes on Montana reports. San Francisco, Cal.,
Bancroft-Whitney company, 1911.

3 v. 23ᶜᵐ.

© Apr. 17, 1911; 2c. each May 19, 1911*; A 289033; Bancroft-Whitney co.
(11–11577) 2525

Montgomery, Lucy Maud, 1874–

The story girl, by L. M. Montgomery ... with frontis-
piece and cover in colour by George Gibbs ... Boston,
L. C. Page & company, 1911.

3 p. l., v–vi, 365 p. col. front. 20ᶜᵐ. $1.50

© May 18, 1911; 2c. May 22, 1911*; A 289112; L. C. Page & co., inc.
(11–11564) 2526

Morgan, George Campbell.

[The analysed Bible, v. 9] The book of Genesis, by the
Rev. G. Campbell Morgan, D. D. London, New York [etc.]
Hodder and Stoughton [1911]

xii, 292 p. front. (fold. tab.) 20½ᶜᵐ. 3/6

© 1c. June 7, 1911*; A ad int. 665; pubd. June 6, 1911; Fleming H. Revell
co., New York. 2527

Müller, Carl Hugo.

Die physische welt und ihr mechanismus, von Carl
Hugo Müller-Rastenburg. 2. bd. ... Rastenburg (Ost-
preussen) Mundus-verlag. 1910.

iii, 95 p. fold. pl. (partly col.) 24ᶜᵐ. M. 2.50

© May 18, 1911; 2c. June 2, 1911*; A—Foreign 3018; Mundus verlag.

2528

The **new** international year book; a compendium of the
world's progress for the year 1910. Editor, Frank
Moore Colby ... associate editor, Allen Leon Churchill.
New York, Dodd, Mead and company, 1911.

4 p. l., 837 p. illus., plates, ports., col. maps. 26ᶜᵐ. $5.00

© May 20, 1911; 2c. May 22, 1911*; A 289107; Dodd, Mead & co.

2529

Newman, John Henry, *cardinal*, 1801–1890.

The second spring; a sermon by John Henry Newman,
D. D.; ed., with introduction, notes and exercises, by Fran-
cis P. Donnelly ... New York [etc.] Longmans, Green,
and co., 1911.

vii, 97 p. 19½ᶜᵐ. $0.50

© May 4, 1911; 2c. May 16, 1911*; A 289934; Longmans, Green, & co.
(11–11677) 2530

Nolen, John.

Madison: a model city, by John Nolen ... Boston,
Mass., 1911.

2 p. l., 9–168 p. front., illus., plans (partly fold.) 27½ᶜᵐ. $0.75

© Mar. 31, 1911; 2c. May 11, 1911*; A 286812; J. Nolen, Cambridge, Mass.
(11–11568) 2531

Pennsylvania. *Andersonville memorial commission.*

Pennsylvania at Andersonville, Georgia; ceremonies at
the dedication of the memorial erected by the common-
wealth of Pennsylvania in the National cemetery at An-
dersonville, Georgia, in memory of the 1849 soldiers of
Pennsylvania who perished in the Confederate prison at
Andersonville, Georgia, 1864 and 1865. 1905. [n. p.,
C. E. Aughinbaugh, printer to the state of Pennsylvania,
1909]

94 p. front., plates, ports., facsims. 22½ᶜᵐ.

© Jan. 1, 1911; 2c. Feb. 21, 1911*; A 280937; James D. Walker, Pittsburg,
Pa. (11–1931) 2532

Pope, John William, 1826–

Tom Perkins, the story of a base ball player, by J. Wil-
liam Pope; with illustrations by Rowland R. Murdoch.
Pittsburgh, Pa., Brockett printing company [°1911]

2 p. l., [3]–54 p. plates. 18ᶜᵐ. $0.50

© May 10, 1911; 2c. May 11, 1911*; A 286832; H. B. Brockett, jr., Pitts-
burg, Pa. (11–11757) 2533

Reynolds, Cuyler, 1866– *ed.*

Hudson-Mohawk genealogical and family memoirs; a record of achievements of the people of the Hudson and Mohawk valleys in New York state, included within the present counties of Albany, Rensselaer, Washington, Saratoga, Montgomery, Fulton, Schenectady, Columbia and Greene. Prepared under the editorial supervision of Cuyler Reynolds ... New York, Lewis historical publishing company, 1911.

4 v. fronts., ports. 27½ᶜᵐ.
© May 9, 1911; 2c. Mav 12, 1911*; A 286850; Lewis historical pub. co.
(11–11569) **2534**

Rosenthal, Henry S.

Building, loan and savings associations, how to organize and successfully conduct them ... by Henry S. Rosenthal. 3d ed. Rev. and enl. Cincinnati, Chicago, American building association news co., 1911.

xv, 425 p. incl. tables. front. 23ᶜᵐ. $3.50
© May 1, 1911; 2c. May 15, 1911*; A 286918; Henry S. Rosenthal, Cincinnati. (11–11689) **2535**

Sale, Edith Tunis.

Red Rose inn, by Edith Tunis Sale ... with a frontispiece by Ethel Franklin Betts. Philadelphia & London, J. B. Lippincott company, 1911.

175, [1] p. col. front. 18½ᶜᵐ. $1.00
© Apr. 27, 1911; 2c. May 24, 1911*; A 289161; J. B. Lippincott co.
(11–11739) **2536**

Sanders, Everett M.

Liberty sub-district schools manual of exercises in physical training for grades I to VIII inclusive, prepared by E. M. Sanders ... Pittsburgh, Nicholson printing company, 1911.

155 p. 15½ᶜᵐ.
© Apr. 29, 1911; 2c. May 15, 1911*; A 286927; E. M. Sanders, Pittsburg.
(11–11672) **2537**

Schaff-Herzog encyclopedia.

The new Schaff-Herzog encyclopedia of religious knowledge, ed. by Samuel Macauley Jackson ... v. 10. Reusch–Son of God. New York and London, Funk and Wagnalls company [1911]

xvii, [1], 499 p. 27½ᶜᵐ.
© May 22, 1911; 2c. May 24, 1911*; A 289160; Funk & Wagnalls co.
 2538

Shipp, E Richard, 1864–

Questions and answers on equity, prepared with reference to Adams, Bispham, Eaton, Fetter, Pomeroy, Smith, Story, and selected cases. By E. Richard Shipp, LL. M. Washington, D. C., J. Byrne & co., 1911.

1 p. l., 92 p. 17ᶜᵐ. (*On cover:* John Byrne & co's quiz books) $0.50
© May 13, 1911; 2c. May 13, 1911*; A 286895; John Byrne & co.
(11–11576) **2539**

[Shore, *Mrs.* Teignmouth]
The rose with a thorn, by Priscilla Craven [*pseud.*] ...
New York, D. Appleton and company, 1911.
vi, 415, [1] p. front. 19½ᶜᵐ. $1.25
Published in Great Britain under title: The school of love.
© May 19, 1911; 2c. May 23. 1911*; A 289155; D. Appleton & co.
(11–11740) 2540

Sprague, Roger, 1869–
From western China to the Golden Gate; the experiences of an American university graduate in the Orient, with thirty illustrations, by Roger Sprague. Berkeley, Lederer, Street & Zeus co., 1911.
128 p. incl. front., illus. 18ᶜᵐ. $0.85
© Apr. 26. 1911; 2c. May 2. 1911*; A 286610; R. Sprague, Berkeley. Cal.
(11–11571) 2541

Starbuck, Mary.
Nantucket, and other verses, by Mary Starbuck. [New York, J. J. Little & Ives company, ᶜ1911]
18 l. 17ᶜᵐ.
Partly reprinted from various periodicals.
© May 15. 1911; 2c. May 17, 1911*; A 286964; M. Starbuck, Nantucket, Mass. (11–11669) 2542

Synge, John Millington, 1871–1909.
The Aran Islands, by J. M. Synge; with drawings by Jack B. Yeats. Boston, J. W. Luce & company, 1911.
xvi, 19–234 p., 1 l. incl. front., plates. map. 19½ᶜᵐ. $1.25
© Apr. 17. 1911; 2c. May 22, 1911*; A 289094; L. E. Bassett, Boston.
(11–11681) 2543

Tolstoĭ, Lev Nikolaevich, *graf*, 1828–1910, *comp.*
The cycle of reading; thoughts of the world's greatest authors on truth, on life, and the ways thereof, selected. compiled and arranged for daily reading by Leo Tolstoi, with special introduction for the American edition by the author's son, tr. by Leonard Lewery. pt. 1. New York city, The International library publishing company [ᶜ1911]
112 p. 20ᶜᵐ. $0.25
© May 5. 1911; 2c. May 9. 1911*; A 286772; International library pub. co.
(11–11679) 2544

Turnbull, Francese Hubbard (Litchfield) "*Mrs.* Lawrence Turnbull."
The royal pawn of Venice; a romance of Cyprus, by Mrs. Lawrence Turnbull ... Philadelphia & London, J. B. Lippincott company, 1911.
3 p. l., 360 p., 1 l. front. (port.) 20ᶜᵐ. $1.50
© Apr. 27. 1911; 2c. May 24. 1911*; A 289163; F. L. Turnbull, Baltimore. Md. (11–11738) 2545

Vernede, R E.
The quietness of Dick, by R. E. Vernede; illustrations by Victor Perard. New York, H. Holt and company, 1911.
4 p. l., 290 p. front., plates. 19½ᶜᵐ. $1.25
© Apr. 22. 1911; 2c. May 2, 1911; A 286734; Henry Holt & co.
(11–11743) 2546

The **American** state reports, containing the cases of general value and authority ... decided in the courts of last resort of the several states. Selected, reported, and annotated by A. C. Freeman. v. 137. San Francisco, Bancroft-Whitney company, 1911.
15 p., 1 l., 17-1217 p. 23ᶜᵐ $4.00
© May 27, 1911; 2c. June 7, 1911*; A 289522; Bancroft-Whitney co.

2547

Bellinger, Martha.

The stolen singer, by Martha Bellinger; with illustrations by Arthur William Brown. Indianapolis, The Bobbs-Merrill company [ᶜ1911]
5 p. l., 382 p. front., plates. 19ᶜᵐ. $1.25
© May 20, 1911; 2c. May 24, 1911*; A 289191; Bobbs-Merrill co.
(11-11896)

2548

Bleibtreu, Karl, 1859–

Kein glück. Romantische liebe; zwei erzählungen aus napoleonischer zeit, von Carl Bleibtreu; illustriert von Chr. Speyer. Stuttgart, C. Krabbe verlag, E. Gussmann [ᶜ1911]
96 p. illus. 20½ᶜᵐ. M. 2
© Apr. 1, 1911; 2c. May 10. 1911*; A--Foreign 2918; Carl Krabbe verlag (Erich Gussmann) (11-11991)

2549

Boy-Ed, *Frau* **Ida,** 1852–

Nur wer die sehnsucht kennt, roman von Ida Boy-Ed. 2.-5. aufl. Stuttgart und Berlin, J. G. Cotta, 1911.
356 p. 20ᶜᵐ. M. 3.50
© Apr. 1, 1911; 2c. May 10. 1911*; A--Foreign 2913; J. G. Cotta'sche buchhandlung nachfolger. (11-11993)

2550

Brieger, Alfred.

... Ginevra, roman. Berlin, F. Ledermann, 1911.
2 p. l., 421 p. 21½ᶜᵐ. M. 6
© Feb. 26, 1911; 2c. May 19. 1911*; A--Foreign 2958; Franz Ledermann.
(11-11931)

2551

Calthrop, Dion Clayton, 1875–

Perpetua; or, The way to treat a woman, by Dion Clayton Calthrop. New York, John Lane company, 1911.
5 p. l., 315 p. 19½ᶜᵐ. $1.30
© May 15, 1911; 2c. May 24, 1911*; A 289170; John Lane co.
(11-11895)

2552

Clark, Carl Herbert, 1872–

Marine gas engines, their construction and management, by Carl H. Clark, s. b. 102 illustrations. New York, D. Van Nostrand company, 1911.
2 p. l., iii-v, 117 p. illus. 20ᶜᵐ. $1.50
© May 3, 1911; 2c. May 20, 1911*; A 289079; D. Van Nostrand co.
(11-11982)

2553

425

Clark, Joseph, 1854–

Fishin' fer men; or, The redemshun of Jeriko kort house, by Timothy Stand-by (Joseph Clark). Drawings by Marie Grace Clark. Cincinnati, Jennings and Graham; New York, Eaton and Mains [°1911]

244 p. front., plates. 19½ᶜᵐ.
"The twenty-four Timothy Stand-by letters combined in this volume were originally published as a serial in the Adult Bible class monthly ... under the title 'The redemshun of Jeriko kort house.'"
© May 6, 1911; 2c. May 10, 1911; A 289129; J. Clark, Columbus, O.
(11–11978) 2554

Dante Alighieri.

... La Divina commedia; ed. and annotated by C. H. Grandgent ... v. 2· Purgatorio. Boston, D. C. Heath & co., 1911.

v. [1], 297 p. 18ᶜᵐ. (Heath's modern language series) $1.25
© May 29, 1911; 2c. June 1, 1911*; A 289381; D. C. Heath & co. 2555

Dauthendey, Max, 1867–

... Die acht gesichter am Biwasee; japanische liebesgeschichten. München, A. Langen [°1911]

277 p., 1 l. 19ᶜᵐ. M. 3.50
CONTENTS.—Die segelboote von Yabase im abend heimkehren sehen.— Den nachtregen regnen hören in Karasaki.—Die abendglocke vom Mijderatempel hören.—Sonniger himmel und brise von Amazu.—Der wildgänse flug in Katata nachschauen. — Von Ishiyama der herbstmond aufgehen sehen.—Das abendrot zu Seta.—Den abendschnee am Hirayama sehen.
© Apr. 10, 1911; 2c. May 10, 1911*; A—Foreign 2900; Albert Langen.
(11–11928) 2556

De Renne, Wymberley Jones.

Books relating to the history of Georgia in the library of Wymberley Jones De Renne, of Wormsloe, Isle of Hope, Chatham County, Georgia. Comp. and annotated by Oscar Wegelin. [Savannah, Ga., The Morning news] 1911.

3 p. l., [3]–268. xviii p. front., pl., 34 facsim. (1 fold.) 34ᶜᵐ. $7.50
© May 1, 1911; 2c. May 22, 1911*; A 289123; Wymberley Jones De Renne, Savannah, Ga. (11–11916) 2557

Douglas, Amanda Minnie, 1837–

... Helen Grant's harvest year, by Amanda M. Douglas; illustrated by Bertha Davidson Hoxie. Boston, Lothrop, Lee & Shepard co. [1911]

4 p. l., 412 p. front., plates. 19ᶜᵐ. (Her The Helen Grant books) $1.25
© May 23. 1911; 2c. May 25, 1911*; A 289216; Lothrop, Lee & Shepard co.
(11–11894) 2558

Eames, Roscoe L.

Eames' geometric shorthand without shading, by Roscoe L. Eames ... rev. and improved. San Francisco, The author, 1911.

2 p. l., 92 p. 15ᶜᵐ. $0.75
© May 12, 1911; 2c. May 22, 1911*; A 289100; R. L. Eames, Berkeley, Cal.
(11–11917) 2559

Earl, John Prescott.
The school team on the diamond, by John Prescott Earl
... illustrated by Ralph L. Boyer. Philadelphia, The
Penn publishing company, 1911.
339 p. front., plates. 19½ᶜᵐ. $1.25
© May 18, 1911; 2c. May 20, 1911*; A 289057; Penn. pub. co.
(11-11447) 2560

Einhorn, David, 1809-1879.
David Einhorn, memorial volume: selected sermons
and addresses, ed. by Kaufmann Kohler; a biographical
essay, by Kaufmann Kohler; a memorial oration, by
Emil G. Hirsch. Limited ed. New York, Bloch publish-
ing company, 1911.
vi, iii-iv p., 1 l., v-viii, 482 p. 4 port. (incl. front.) 23ᶜᵐ.
© May 2, 1911; 2c. May 15, 1911*; A 286906; Bloch pub. co.
(11-11977) 2561

Everybody's cyclopedia; a concise and accurate compila-
tion of the world's knowledge, prepared from the latest
and best authorities in every department of learning;
including a chronological history of the world ... a
treasury of facts ... a statistical record of the world ...
Prepared under the direction of Charles Leonard-Stu-
art ... George J. Hagar ... editors-in-chief, assisted by
a corps of eminent editors, educators, scientists, in-
ventors, explorers, etc. New York, Syndicate publish-
ing company [1911]
5 v. illus., plates (partly col., partly fold.) diagrs. 20ᶜᵐ. $4.00 per
vol.
© May 13, 1911; 2c. May 17, 1911*; A 286967; F. E. Wright, New York.
(11-11923) 2562

Fisher, Herbert Albert Laurens, 1865-
The republican tradition in Europe, by H. A. L. Fisher
... London, Methuen & co., ltd. [1911]
xii, 305, [1] p. 20ᶜᵐ.
© 1c. May 19, 1911*; A ad int. 635; pubd. Apr. 27, 1911; H. A. L. Fisher,
Great Britain. (11-11905) 2563

Frank, Bruno, 1887-
... Flüchtlinge; novellen. München, A. Langen [*1911]
3 p. l., 217, [1] p. 19ᶜᵐ. M. 3
CONTENTS.—Pantomime.—Der glücksfall.—Das böse.—Die melodie.—
Die mutter einer ganzen stadt.—Der papagei.—Ein abenteuer in Venedig.
© Apr. 10, 1911; 2c. May 10, 1911*; A—Foreign 2899; Albert Langen.
(11-11992) 2564

Franke, Otto, 1863-
Ostasiatische neubildungen; beiträge zum verständnis
der politischen und kulturellen entwicklungs-vorgänge im
Fernen Osten; mit einem anhange: Die sinologischen
studien in Deutschland. Von dr. O. Franke ... Ham-
burg, C. Boysen, 1911.
x p., 1 l., 395, [1] p. 25½ᶜᵐ. M. 7.50
© Apr. 1, 1911; 2c. May 22, 1911*; A—Foreign 2970; C. Boysen.
(11-11973) 2565

Gabrini, Francis.

Meditations on the Blessed Virgin, from the German of the Rev. Francis Gabrini, s. j. New ed., carefully rev. by Rt. Rev. Alex. MacDonald ... New York, Christian press association publishing company [°1911]

384 p. 19ᶜᵐ. $1.00

© Apr. 21, 1911; 2c. Apr. 27, 1911*; A 286507; Christian press assn. pub. co. (11-11980) **2566**

Glaister, Robert.

The mystery of Christ. To all who have an ear to hear what the Spirit saith. By Robert Glaister ... Exeter and London, Printed by J. Townsend & sons [°1911]

65 p. diagr. 18½ᶜᵐ. 1/9

© 1c. May 5, 1911*; A ad int. 620; pubd. Apr. 7. 1911; R. Glaister, London. (11-11981) **2567**

Goetz, Adolf.

25 jahre hamburgische seeschiffahrtspolitik, von Adolf Goetz. Hamburg, Verlagsanstalt und druckerei gesellschaft m. b. h. [°1911]

3 p. l., 3-331 p. 19 x 17ᶜᵐ. M. 8.50

© Apr. 13, 1911; 2c. May 19, 1911*; A—Foreign 2956; Verlagsanstalt und druckerei-gesellschaft m. b. h. (11-11999) **2568**

Grillon, Octave, 1865–

Practical pan man's guide; containing the best recipes for the manufacture of dragee and useful advices in general pan work. By Octave Grillon ... N[ew] Y[ork] For sale by O. Grillon [°1911]

191 p. illus., pl. 16ᶜᵐ. $10.00

© May 2, 1911; 2c. May 5, 1911*; A 286682; Octave Grillon, New York. (11-11912) **2569**

Heckscher, Robert Valantine.

Through dust to light; poems from an apprenticeship, by Robert Valantine Heckscher. Boston, Sherman, French & company, 1911.

9 p. l., [3]-169 p. 19½ᶜᵐ. $1.00

Partly reprinted from the Atlantic monthly.

© May 19, 1911; 2c. May 23, 1911*; A 289152; Sherman, French & co. (11-11924) **2570**

Hendricks, Eldo Lewis, 1866–

A preliminary report of a study in reading, by Eldo L. Hendricks ... New York, Boston [etc.] Silver, Burdett & company [°1911]

32 p. incl. tab., x charts. 23ᶜᵐ.

"Selected bibliography": p. 31-32.

© May 12, 1911; 2c. May 15, 1911*; A 286920; Silver, Burdett & co. (11-11435) **2571**

Jury, John George, 1866–

Adjudicated forms of pleading and practice, with annotations and correlative statutes, adapted to use generally in all code states and territories, and in particular to the following: Alaska, Arizona, Arkansas, California,

Jury, John George—Continued

Colorado, Hawaii, Idaho, Iowa, Kansas, Minnesota, Missouri, Montana, Nebraska, Nevada, New Mexico, North Dakota, Oklahoma, Oregon, South Dakota, Texas, Utah, Washington, Wisconsin and Wyoming. By John G. Jury ... San Francisco, Bender-Moss company, 1911.

2 v. 24ᶜᵐ. $13.50

© May 15, 1911; 2c. each May 22, 1911*; A 289108; Bender-Moss co. (11–11918) 2572

Kilpatrick, Thomas B.

New Testament evangelism, by T. B. Kilpatrick ... appendices prepared by J. G. Shearer ... New York, Hodder & Stoughton, George H. Doran company [°1911]

xii, 313 p. 20ᶜᵐ. $1.25

© Apr. 29, 1911; 2c. May 1, 1911*; A 286581; George H. Doran co. (11–11979) 2573

Kirkman, Marshall Monroe, 1842–

The air brake; its construction and working ... forming one of the series of volumes comprised in the Revised and enlarged edition of The science of railways, by Marshall M. Kirkman. Edition 1911. Chicago, Cropley Phillips company, 1911.

1 p. l., iv, 707 (i. e. 733) p. illus., plates (partly col., partly fold.) 20ᶜᵐ.

© May 15, 1911; 2c. May 20, 1911*; A 289049; Cropley Phillips co. (11–11910) 2574

Michigan. *Supreme court.*

Michigan reports. Cases decided ... from September 28 to December 22, 1910. James M. Reasoner, state reporter. v. 163, 1st ed. Chicago, Callaghan & co., 1911.

xxx, 763 p. 23ᶜᵐ. $1.30

© May 25, 1911; 2c. May 29, 1911; A 289541; Frederick C. Martindale, sec. of state for the state of Michigan, Lansing, Mich. 2575

Miller, Florence M.

Historical pageants, State normal school, Fitchburg, Massachusetts [by] Florence M. Miller. Fitchburg, Mass., 1911.

71 p. incl. front., illus. 21½ᶜᵐ. $0.25

On cover: State normal school, Fitchburg, Massachusetts. History department.

© Apr. 28, 1911; 2c. May 5, 1911*; A 286701; J. D. Miller co., Leominster, Mass. (11–11900) 2576

Mitchell, Frances Marian.

Joan of Rainbow Springs, by Frances Marian Mitchell; illustrated by F. Vaux Wilson. Boston, Lothrop, Lee & Shepard co. [1911]

480 p. incl. front. plates. 20ᶜᵐ. $1.35

© May 23, 1911; 2c. May 25, 1911*; A 289217; Lothrop, Lee & Shepard co. (11–11897) 2577

Monnier, Philippe, 1864–

... Blaise, der gymnasiast, einzige berechtigte über-
setzung aus dem französischen von dr. Rudolph Engel
und Marie Doederlein. München, A. Langen [°1911]
229, [1] p. 19ᶜᵐ. M. 3
© Apr. 10, 1911; 2c. May 10, 1911*; A—Foreign 2925; Albert Langen.
(11–11929) 2578

Moras, Edmond Raymond, 1864–

Eye truths, the purposes of light and the uses of sight
(guide to autology—part III—11th ed.) ... by E. R. Moras
... [Highland Park? Ills.] °1911·
95 p. 15 x 11¼ᶜᵐ.
© May 1, 1911; 2c. May 13, 1911*; A 286893; E. R. Moras, Highland Park,
Ill. (11–11454) 2579

Natural self-treatment (guide to autology, part II)
11th ed., 1911. To understand your ailments is to know
how to cure them [by] E. R. Moras ... [Highland Park?
Ill.] °1911·
94 p. 15 x 11¼ᶜᵐ.
© May 1, 1911; 2c. May 13, 1911*; A 286894; E. R. Moras, Highland Park,
Ill. (11–11451) 2580

Münzer, Kurt, 1879–

Der gefühlvolle Baedeker, auch ein handbuch für
reisende durch Deutschland, Italien, die Schweiz u. Tirol,
von Kurt Münzer; mit einer orig.-radierung, zwölf fak-
simile-wiedergaben nach radierungen und zeichnungen
von Hermann Struck, nebst zwei bildtafeln ... Berlin-
Ch., Vita, deutsches verlagshaus [°1911]
334 p., 1 l. incl. front. plates. 19½ᶜᵐ. M. 5
© Apr. 10, 1911; 2c. May 19, 1911*; A—Foreign 2957; Vita, deutsches ver-
lagshaus. (11–11974) 2581

New York (State) Court of appeals.

Reports of cases decided ... from and including de-
cisions of November 15, 1910, to decisions of February 7,
1911, with notes, references and index. J. Newton Fiero,
state reporter. v. 200. Albany, J. B. Lyon company,
1911.
xxxii, 656 p. 23¼ᶜᵐ. $0.65
© Apr. 12, 1911; 2c. May 20, 1911*; A 289066; Edward Lazansky, Albany.
 2582

New York (State) Courts of record.

Miscellaneous reports. Cases decided in the courts of
record of the state of New York other than the Court of
appeals and appellate division of the Supreme court.
Charles C. Lester, reporter. Official ed. v. 68, 1911.
Albany, N. Y., J. B. Lyon company [1911]
xxxi, [1], 699 p. 23¼ᶜᵐ. $0.75
© Apr. 10, 1911; 2c. May 20, 1911*; A 289067; Edward Lazansky, Albany.
 2583

Oertel, Otto.

Im bann der heimat, eine geschichte erzählt von Otto Oertel. Leipzig, G. Merseburger, 1911.
133 p. 19¼ᶜᵐ. M. 3

© Apr. 21, 1911; 2c. May 22, 1911*; A—Foreign 2971; Georg Merseburger. (11–11994) **2584**

Ohio. *Circuit courts.*

Reports of cases argued and determined ... v. 31, Circuit court reports; v. 21, Circuit decisions. Norwalk, O., The American publishers company, 1911.
xxxi, 726 p. 25ᶜᵐ. $2.50

© June 3, 1911; 2c. June 6, 1911; A 289521; American publishers co.
2585

Oklahoma. *Supreme court.*

Oklahoma reports, v. 27. Cases determined ... July 12, 1910–January 10, 1911. Howard Parker, state reporter. Guthrie, Okl., Oklahoma bank and office supply co., 1911.
xvi, 913 p. 22¼ᶜᵐ. $1.50

© June 5, 1911; 2c. June 8, 1911*; A 289561; Howard Parker, state reporter, for the benefit of the state of Oklahoma, Guthrie, Okl.
2586

Pendlebury, J.

Plain everyday navigation for the oceangoing yachtsman and others, by Capt. J. Pendlebury. Yonkers, N. Y., Truan press [°1911]
2 p. l., [3]–44 p. port., maps, tables. 25ᶜᵐ. $2.50

© May 2, 1911; 2c. May 4, 1911*; A 286663; J. Pendlebury, Arlington, N. J. (11–11983) **2587**

Presber, Rudolf, 1868–

Die bunte kuh, humoristischer roman, von Rudolf Presber. Berlin, Concordia deutsche verlags-anstalt g. m. b. h., 1911.
663 p. 20ᶜᵐ. M. 5

© Mar. 27, 1911; 2c. May 22, 1911*; A—Foreign 2982; Concordia deutsche verlags-anstalt, g. m. b. h. (11–11930) **2588**

Quick, Herbert *i. e.* **John Herbert,** 1861–

Yellowstone nights, by Herbert Quick ... Indianapolis, The Bobbs-Merrill company [°1911]
3 p. l., 345 p. 19ᶜᵐ. $1 25

© May 20, 1911; 2c. May 24, 1911*; A 289190; Bobbs-Merrill co. (11–11898) **2589**

Runyon, Damon *i. e.* **Alfred Damon,** 1880–

The tents of trouble, by Damon Runyon. (Ballads of the wanderbund, and other verse) New York, Desmond Fitzgerald, inc. [°1911]
131 p. 20ᶜᵐ. $1.00
Partly reprinted from various periodicals.

© May ,, 1911; 2c. May 16, 1911*; A 286930; Desmond Fitzgerald, inc. (11–11926) **2590**

Sittenfeld, Konrad, 1862–

'Ablösung vor!' Roman von Conrad Alberti (Sittenfeld) Berlin-Charlottenburg, Vita deutsches verlagshaus [¹1911]

388 p. 18½ᶜᵐ. M. 4

© Apr. 3, 1911; 2c. May 19, 1911*; A—Foreign 2960; Vita, deutsches verlagshaus. (11–11927) **2591**

Synge, John Millington, 1871–1909.

Riders to the sea, by J. M. Synge. Boston, J. W. Luce & company, 1911.

1 p. l., vii–x p., 3 l., 17–45 p., 1 l. 19½ᶜᵐ. $0.50

A play in one act.

© Apr. 21, 1911; 2c. May 22, 1911*; A 289095; L. E. Bassett, Boston. (11–11995) **2592**

Tully, Richard Walton.

The merry college farce: A strenuous life, by Richard Walton Tully ... New York, N. Y., The Preparatory school play bureau, ᶜ1911.

62 p. 22ᶜᵐ.

© Mar. 10, 1911; 1c. Apr. 10, 1911; 1c. May 8, 1911*; D 24155; R. W. Tully, Alma, Cal. (11–11925) **2592***

Turner, Frank G.

The New Jersey law of attachment, with forms. By Frank G. Turner ... Newark, N. J., Soney & Sage, 1911.

vii p., 1 l., 158 p. 23½ᶜᵐ. $3.00

© May 4, 1911; 2c. May 6, 1911*; A 286725; F. G. Turner, Jersey City, N. J. (11–11996) **2593**

Washington, George, *pres. U. S.,* 1732–1799.

... The farewell address of George Washington; ed. by Frank W. Pine ... New York, Cincinnati [etc.] American book company [ᶜ1911]

49, vii p. incl. front. (port) 16½ᶜᵐ. (Gateway series) $0.30
"Notes" bound at end of volume.
Bibliography: p. vii.
Bound with this: The first Bunker hill oration of Daniel Webster; ed. by Frank W. Pine .:. New York, 1911.

© May 9, 1911; 2c. May 11, 1911*; A 286824; American book co. (11–11902) **2594**

Washington *(Ter.) Supreme court.*

Washington territory reports ... v. 1. ⟨New series⟩ Cases determined in the Supreme court of territory of Washington. John B. Allen, reporter. Reprint ed. With notes on Washington reports. Seattle and San Francisco, Bancroft-Whitney co., 1911.

viii, 616, xlii, 19 p. 23ᶜᵐ. $3.00

© Apr. 17, 1911; 2c. May 19, 1911*; A 289036; Bancroft-Whitney co. (11–11578) **2595**

432

ЈƂ20ЈЈ.4
Harvard College Library

PART I, BOOKS, GROUP I JUN 26 1911
no. 40, June, 1911 From the 2602
U. S. Government.

The **American** decisions; cases of general value and authority decided in the courts of the several states from the earliest issue of the state reports to the year 1869. Comp. and annotated by the Editorial department of the Lawyers co-operative publishing company. v. 61–80. San Francisco, Cal., Bancroft-Whitney co.; Rochester, N. Y., The Lawyers co-op. pub. co., 1911.

20 v. 24ᶜᵐ. $55.00
© June 8, 1911; 2c. each June 9, 1911*; A 289618; Bancroft-Whitney co. and Lawyers co-op. pub. co. **2596**

Baker, Estelle.

The rose door, by Estelle Baker. Chicago, C. H. Kerr & company, 1911.

202 p. incl. front. plates. 20ᶜᵐ. $1.00
© May 24, 1911; 2c. May 29, 1911*; A 289315; Charles H. Kerr & co. (11-12127) **2597**

Baker, Josephine Turck.

The correct preposition; how to use it; a complete alphabetic list, by Josephine Turck Baker ... Chicago, Ill., Correct English publishing company [c1911]

1 p. l., 5–169 p. 19ᶜᵐ. $1.00
© May 18, 1911; 2c. May 22, 1911*; A 289096; J. T. Baker, Chicago. (11-12047) **2598**

Beecher, Franklin A.

The law of wills in Michigan, with forms, by Franklin A. Beecher ... with introduction by Hon. Henry S. Hulbert ... Detroit, F. S. Drake, 1911.

xxiii, 444 p. 24ᶜᵐ. $5.00
© May 15, 1911; 2c. May 27, 1911*; A 289290; Fred S. Drake. (11-12458) **2599**

Belloc, Hilaire i. e. Joseph Hilaire Pierre, 1870–

The French revolution, by Hilaire Belloc ... New York, H. Holt and company; [etc., etc., c1911]

x p., 1 l., 13–256 p. illus. 18ᶜᵐ. (Half-title: Home university library of modern knowledge, no. 3) $0.75
© May 25, 1911; 2c. May 27, 1911*; A 289279; Henry Holt & co. (11-12435) **2600**

The Girondin ... by Hilaire Belloc. London and New York [etc.] T. Nelson and sons [1911]

vi, [7]–372 p. col. front. 19ᶜᵐ. 2/
© 1c. May 31, 1911*; A ad int. 656; publd. May 3, 1911; H. Belloc, London. (11-12264) **2601**

Benischke, Gustav, 1867–

Die schutzvorrichtungen der starkstromtechnik gegen atmosphärische entladungen und überspannungen, von dr. Gustav Benischke. 2. erweiterte aufl., mit 114 eingedruckten abbildungen. Braunschweig, F. Vieweg & sohn, 1911.

viii, 123 p. illus. 22½ᶜᵐ. (Added t.-p.: Elektrotechnik in einzeldarstellungen ... 1. hft.) M. 3.50
© May 5, 1911; 2c. May 22, 1911*; A—Foreign 2977; Friedr. Vieweg & sohn. (11-12101) **2602**

433

Benson, Arthur Christopher, 1862–

Ruskin; a study in personality, by Arthur Christopher Benson ... London, Smith, Elder & co., 1911.

x, 264 p. 21ᶜᵐ.
© 1c. May 22, 1911*; A ad int. 639; pubd. Apr. 22, 1911; A. C. Benson, Cambridge, England. (11–12052) 2603

Bible. *Selections. English.*

The comprehensive analysis of the Bible; being an arrangement of the topics, persons, places, and things mentioned and discussed in the Old and New Testaments, with descriptions, comments, and the principal Scriptural references thereto ... By Montgomery F. Essig ... Illustrated with half-tone reproductions of famous paintings by great artists. Nashville, Tenn., Macon, Ga. [etc.] The Southwestern company [ᶜ1910]

584 p. incl. front., illus., pl. 28ᶜᵐ.
© June 16, 1910; 2c. May. 20, 1911*; A 289055; Southwestern co (11–12253) 2604

Botsky, Katarina.

... Der trinker, roman. München, A. Langen [ᶜ1911]

2 p. l., 150 p. 19ᶜᵐ. M. 2
© Apr. 10, 1911; 2c. May 10, 1911*; A—Foreign 2898; Albert Langen. (11–12051) 2605

Brickner, Walter Max.

1000 surgical suggestions, practical brevities in diagnosis and treatment, by Walter M. Brickner ... with the collaboration of Eli Moschcowitz, M. D., James P. Warbasse, M. D., Harold Hays, M. D., and Harold Neuhof, M. D. ... 4th American ed. New York, Surgery publishing company, 1911.

227 p. 18ᶜᵐ.
"First edition, 'Surgical suggestions,' 1906. Second edition, '500 surgical suggestions,' 1907. Third edition. '700 surgical suggestions,' 1909."
© May 17, 1911; 2c. May 24, 1911*; A 289159; Surgery pub. co. (11–12132) 2606

Brown, Edna Adelaide, 1875–

Four Gordons, by Edna A. Brown; illustrated by Norman Irving Black. Boston, Lothrop, Lee & Shepard co. [1911]

4 p. l., 376 p. front., plates. 20½ᶜᵐ. $1.50
© May 23, 1911; 2c. May 25, 1911*; A 289215; Lothrop, Lee & Shepard co. (11–12124) 2607

Buonarroti, Michel Angelo, 1475–1564.

·L'œuvre littéraire de Michel-Ange, d'après les archives Buonarroti, etc., traduites par Boyer d'Agen; ouvrage illustré de 26 dessins de Michel-Ange d'après la collection Alinari. Paris, C. Delagrave [ᶜ1911]

2 p. l., 196 p. 25 pl. 25½ᶜᵐ. fr. 7.50
© Apr. 28, 1911; 2c. May 12, 1911*; A—Foreign 2938; Ch. Delagrave. (11–12050) 2608

Cave, Robert Catlett.

The men in gray, by Robert Catlett Cave ... Nashville, Tenn., Confederate veteran, 1911.

143 p. front. (port.) 2 pl. (1 col.) 19½ᶜᵐ. $1.00
CONTENTS.—The men in gray.—A defense of the South.—Cavalier loyalty and Puritan disloyalty in America.
© May 11, 1911; 2c. May 17, 1911*; A 286965; R. C. Cave, St. Louis, Mo.
(11-12072) 2609

Collins, John S.

[Across the plains in '64] Part II. [Omaha, Neb., National printing company, 1911]

152 p. plates. 20ᶜᵐ. [With his Across the plains in '64· Omaha, 1904]
© May 1, 1911; 2c. May 19, 1911*; A 289015; Robert F. Gilder, Omaha.
 2610

Conyngton, Thomas.

A manual of corporate management, containing forms, directions, and information for the use of lawyers and corporate officials, by Thomas Conyngton ... 3d ed. New York, The Ronald press co., 1911.

xviii, 19-422 p. 23½ᶜᵐ. $3.00
© Apr. 15, 1911; 2c. May 26, 1911*; A 289242; Ronald press co.
(11-12075) 2611

Cullum, Ridgwell, 1867–

The trail of the axe; a story of the Red Sand Valley, by Ridgwell Cullum ... Philadelphia, G. W. Jacobs & company [°1911]

422 p.. col. front. 20½ᶜᵐ. $1.25
© May 27, 1911; 2c. May 31, 1911*; A 289344; George W. Jacobs & co.
(11-12262) 2612

Davis, Edward Parker, 1856–

Mother and child, by Edward P. Davis ... 3d ed. Philadelphia, J. B. Lippincott company, 1911.

274 p. illus., plates. 19½ᶜᵐ.
1st edition by Davis and J. M. Keating.
© Apr. 24, 1911; 2c. May 24, 1911*; A 289164; J. B. Lippincott co.
(11-12131) 2613

Davis, Gwilym George.

The principles and practice of bandaging, by Gwilym G. Davis ... 3d ed., rev. Illustrated from original drawings by the author. Philadelphia, P. Blakiston's son & co., 1911.

xiii, 128 p. illus. 21ᶜᵐ. $1.00
© May 15, 1911; 2c. May 16, 1911*; A 286939; G. G. Davis, Philadelphia.
(11-12105) 2614

Ely, Wilmer Mateo.

... The young treasure seekers; the adventures of Charley West and Walter Hazard on a perilous cruise hunting for treasure, by Wilmer M. Ely ... with four page illustrations by J. Watson Davis. New York, A. L. Burt company [°1911]

2 p. l., 3-298 p. front., plates. 19½ᶜᵐ. (The boy chums series) $1.00
© May 17 1911; 2c. May 25, 1911*; A 289227; A. L. Burt co.
(11-12058) 2615

Flandrau, Charles Macomb, 1871–

Prejudices, by Charles Macomb Flandrau ... New York and London, D. Appleton and company, 1911.

6 p. l., 3–264 p., 1 l. 18cm. $1.25
"These extracts from my notebook originally appeared in the Bellman."
CONTENTS. — Some dogs. — Little pictures of people. — Wanderlust. — Travel.—Fellow passengers.—Parents and children.—What is education?— Just a letter. — In the undertaker's shop. — Writers. — "Ann Veronica." — Holidays.—Servants.—Mrs. White's.
© May 19, 1911; 2c. May 23, 1911*; A 289154; D. Appleton & co.
(11–12048) 2616

[**George, Frederic**]

The construction of a motion picture play, by Robert Blake [pseud.] [Syracuse? N. Y.] ©1911.

1 p. l., 48, [1] p. 23cm. $1.00
© May 1, 1911; 2c. May 6, 1911*; A 286729; Frederic George. Syracuse, N. Y. (11–12135) 2617

Groszmann, Maximilian Paul Eugen, 1855–

The career of the child [by] Maximilian P. E. Groszmann ... Boston, R. G. Badger [©1911]

335 p. 19½cm. $2.50
© Apr. 15, 1911; 2c. Apr. 24, 1911*; A 286401; Richard G. Badger.
(11–12066) 2618

[**Grousset, Paschal**] 1844–1909.

... Mémoires d'un collégien, par André Laurie [pseud.] ed. with exercises, notes, and vocabulary, by O. B. Super ... Boston, D. C. Heath & co., 1911.

iii, 219 p. 17cm. (Heath's modern language series) $0.50
© May 10, 1911; 2c. May 17, 1911*; A 286957; D. C. Heath & co.
(11–12434) 2619

Haecker, Valentin, 1864–

Allgemeine vererbungslehre, von Valentin Haecker ... mit 135 figuren im text und 4 lithographierten tafeln. Braunschweig, F. Vieweg & sohn, 1911.

x, 392 p. illus., 4 col. pl. 24¼cm. M. 14
"Literaturverzeichnis" at end of chapters.
© May 4, 1911; 2c. May 22, 1911*; A—Foreign 2978; Friedrich Vieweg & sohn. (11–12091) 2620

Higgins, Aileen Cleveland.

A little princess of the patio, by Aileen Cleveland Higgins ... illustrated by Ada C. Williamson. Philadelphia, The Penn publishing company, 1911.

310 p. front., plates. 19½cm. $1.25
© May 27, 1911; 2c. May 29, 1911*; A 289314; Penn pub. co.
(11–12126) 2621

Huxley, Thomas Henry, 1825–1895.

Selections from Huxley, embracing the Autobiography; On the advisableness of improving natural knowledge; A liberal education and where to find it; On a piece of chalk.

436

Huxley, Thomas Henry—Continued
Ed., with introduction and notes, by John P. Cushing ...
Boston, New York [etc.] Ginn and company [c1911]
xiii, 82 p. 17ᶜᵐ. (Standard English classics) $0.25
"Books for reference": p. xiii.
© Apr. 27, 1911; 2c. May 20, 1911*; A 289089; Ginn & co.
(11–12092) 2622

Janson, Kristofer Nagel, 1841–
... Digte, utgivne paa hans syttiaarige fødselsdag femte
mai 1911. Kristiania og København, Gyldendalske bog-
handel, Nordisk forlag [c1911]
162, [3] p. illus. (port.) 21½ᶜᵐ. kr. 3.50
© May 5, 1911; 2c. May 18, 1911; A—Foreign 2985; Gyldendalske boghan-
del, Nordisk forlag. (11–12049) 2623

[Kaler, James Otis] 1848–
With Sherman to the sea; a boy's story of General
Sherman's famous march and capture of Savannah, by
James Otis [pseud.] ... with four illustrations by J. Wat-
son Davis. New York, A. L. Burt company [c1911]
2 p. l., 3–317 p. front., plates. 19½ᶜᵐ. $1.00
© May 17, 1911; 2c. May 25, 1911*; A 289226; A. L. Burt co.
(11–12057) 2624

Kingsley, *Mrs*. **Florence (Morse)** 1859–
The return of Caroline, by Florence Morse Kingsley ...
frontispiece by Herman Methfessel. New York and Lon-
don, Funk & Wagnalls company, 1911.
65 p. front. 16½ᶜᵐ.
© Apr. 20, 1911; 2c. May 27, 1911*; A 289274; Funk & Wagnalls co.
(11–12060) 2625

Kraus, Ernst.
Populäre allgemeine musiklehre für musiklernende und
freunde der tonkunst verfasst von Ernst Kraus; mit zahl-
reichen in den text gedruckten notenbeispielen und abbil-
dungen. Prag und Leipzig, M. Urbánek, c1911.
viii, 183, [1] p. illus. 23ᶜᵐ.
© Apr. 10, 1911; 2c. May 10, 1911*; A—Foreign 2914; Mojmir Urbánek.
(11–12303) 2626

Kyle, John Johnson.
Manual of diseases of the ear, nose, and throat, by John
Johnson Kyle ... 3d ed., rev. and enl., with 176 illustra-
tions. Philadelphia, P. Blakiston's son & co., 1911.
xxxii, 670 p. illus. (partly col.) 19½ᶜᵐ. $3.00
© May 15, 1911; 2c. May 16, 1911*; A 286938; P. Blakiston's son & co.
(11–12104) 2627

Leslie, Joseph Benjamin, 1851–
Submerged Atlantis restored; or, Rĭn-gä'-sĕ nŭd sĭ-ĭ-
kĕl'zē (links and cycles) ... by J. Ben Leslie. Rochester,
N. Y., Austin publishing company, 1911.
807 p. illus., plates, 2 port. (incl. front.) diagrs. 24ᶜᵐ. $4.00
© May 1, 1911; 2c. May 5, 1911*; A 286683; J. Ben Leslie, Buffalo.
(11–12137) 2628

Macdonald, James Ramsay, 1866–

The socialist movement, by J. Ramsay Macdonald ... New York, H. Holt and company; [etc., etc., °1911]

xiii, 15–256 p. 18ᶜᵐ. (*Half-title:* Home university library of modern knowledge, no. 10) $0.75

Bibliography: p. 249–252.

© May 8, 1911; 2c. May 11, 1911*; A 286815; Henry Holt & co. (11–12110) 2629

McLaughlin, Andrew Cunningham, 1861–

A history of the United States for schools, by Andrew C. McLaughlin ... and Claude Halstead Van Tyne ... New York, Chicago, D. Appleton and company [°1911]

xiii, 430, lxviii p. illus., maps. 19½ᶜᵐ. $1.00

"Suggested readings" at end of chapters.

© May 12, 1911; 2c. May 17, 1911*; A 286976; D. Appleton & co. (11–12074) 2630

Marchmont, Arthur Williams, 1852–

Elfa: a romance. By Arthur W. Marchmont ... London, New York [etc.] Hodder and Stoughton [°1911]

4 p. l., 295, [1] p. 19½ᶜᵐ. 6/

© 1c. May 29, 1911*; A ad int. 654; pubd. May 1, 1911; A. W. Marchmont, England. (11–12128) 2631

Mitchell, Silas Weir, 1830–

John Sherwood, ironmaster, by S. Weir Mitchell ... New York, The Century co., 1911.

5 p. l., 3–316 p. 20ᶜᵐ. $1.20

© May 20, 1911; 2c. May 26, 1911*; A 289254; Century co. (11–12056) 2632

Morgan, William Henry, 1836–

Personal reminiscences of the war of 1861–5; in camp—en bivouac—on the march—on picket—on the skirmish line— on the battlefield—and in prison, by W. H. Morgan. Lynchburg, Va., J. P. Bell company, inc., 1911.

4 p. l., 7–286 p. front. (port.) 20½ᶜᵐ. $1.00

© Apr. 29, 1911; 2c. May 15, 1911*; A 286908; W. H. Morgan, Floyd, Va. (11–12070) 2633

Morgan-De-Groot, J.

The hand of Venus; a novel, by Dr. J. Morgan-De-Groot ... London, Hutchinson & co., 1911.

2 p. l., 371, [1] p. 19½ᶜᵐ. 6/

© 1c. May 29, 1911*; A ad int. 653; pubd. May 2, 1911; J. Morgan-de-Groot, England. (11–12449) 2634

Müller, Oskar.

Wege zu gesundem leben, eine darstellung der heilmethoden für laien, von dr. med. Oskar Müller ... Leipzig, Abel & Müller, g. m. b. h., 1911.

3 p. l., ix–xv, 319 p. 19½ᶜᵐ. M. 4

© Apr. 5, 1911; 2c. May 22, 1911*; A — Foreign 2975; Abel & Müller, g. m. b. h. (11–12133) 2635

O'Brien, Rossell Galbraith, 1846–

Building the American nation; an allegory. [By] R. G. O'Brien. [Oakland, Cal., ᶜ1911]

56 p. 18½ᶜᵐ.
© Apr. 28, 1911; 2c. May 3, 1911; D 24124; R. G. O'Brien, Oakland, Cal.
(11-12046) 2635*

Odd-fellows, Independent order of. *Sovereign grand lodge.*

Journal of proceedings of the Right worthy grand lodge of the United States and the Sovereign grand lodge of the Independent order of odd fellows, from its formation in February, 1821 ... v. 24. Baltimore, Md., The Sovereign grand lodge of the Independent order of odd fellows, 1911.

2 p. l., [3]–902, x, 126 p. 22ᶜᵐ. front., ports. $1.50
© May 13, 1911; 2c. June 9, 1911*; A 289599; Sovereign grand lodge of
the Independent order of odd-fellows. 2636

Pagés, Calixte C 1857–

Manuel de culture physique, par C. C. Pagés ... 86 figures dans le texte. Paris, Vigot frères, 1911.

x, 240 p. illus. 18½ᶜᵐ. fr. 3.50
© Apr. 21, 1911; 2c. May 12, 1911*; A—Foreign 2935; Vigot frères.
(11-12134) 2637

Phin, John, 1832–

The seven follies of science, to which is added a small budget of interesting paradoxes, illusions, marvels, and popular fallacies. A popular account of the most famous scientific impossibilities and the attempts which have been made to solve them. With numerous illustrations. By John Phin ... 2d ed., greatly enl. New York, D. Van Nostrand company, 1911.

ix, 231 p. illus. 20ᶜᵐ. $1.25
© May 4, 1911; 2c. May 20, 1911*; A 289081; D. Van Nostrand co.
(11-12090) 2638

Pratt, Clyde Horace, 1880–

Pratt's special automobile treatise ... information in regard to every part of the gasoline automobile, including its mechanisms, operation, driving, repair and care ... fully illustrated, by Clyde H. Pratt ... [Cleveland? O., ᶜ1911]

1 p. l., 1, 220 p. illus. 21½ᶜᵐ. $1.50
© Apr. 1, 1911; 2c. May 15, 1911*; A 286902; C. H. Pratt co., Cleveland.
(11-12267) 2639

Rawie, Henry Christian, 1860–

... The sphinx catechism, by Henry Rawie ... Baltimore, Md., Geo. W. King printing company [ᶜ1911]

234 p. 18½ᶜᵐ. (Science of value. no. 10) $1.00
© May 13, 1911; 2c. May 16, 1911; A 289032; Henry Rawie, Baltimore.
(11-12275) 2640

Richards, Linda Ann Judson, 1841–

Reminiscences of Linda Richards, America's first trained nurse. Boston, Whitcomb & Barrows, 1911.

xvi, 121 p. pl., 2 port. (incl. front.) 19ᶜᵐ. $1.00

© May 13, 1911; 2c. May 18, 1911*; A 289005; L. Richards, Lowell, Mass. (11–12129) 2641

₁Roujon, Henry₁ 1853–

... Véronèse; huit reproductions facsimile en couleurs. Paris, P. Lafitte et cⁱᵉ, 1911.

80 p. illus., viii col. pl. (incl. front.) 20½ᶜᵐ. (*Half-title:* Les peintres illustres ₁no. 26₁) fr. 1.95
"Œuvres de Paul Véronèse": p. ₁77₁–80.

© Apr. 7, 1911; 2c. Apr. 22, 1911*; A—Foreign 2829; Pierre Lafitte & cie. (11–12428) 2642

Schöpf, Johann David, 1752–1800.

Travels in the Confederation ⟨1783–1784⟩ from the German of Johann David Schoepf, tr. and ed. by Alfred J. Morrison ... Philadelphia, W. J. Campbell, 1911.

2 v. front. (port.) 20ᶜᵐ.

CONTENTS.—v. 1. New Jersey, Pennsylvania, Maryland, Virginia.—v. 2. Pennsylvania, Maryland, Virginia, the Carolinas, East Florida, the Bahamas.

© May 24, 1911; 2c. May 25, 1911*; A 289194; Alfred J. Morrison, Hampden Sidney, Va. (11–12073) 2643

Truesdale, John, *comp.*

Camp, battlefield and hospital, containing the thrilling stories told by the heroes of our nation ... together with songs, ballads, anecdotes and humorous incidents of the war, comp. by Captain John Truesdale ... Philadelphia, Pa., National publishing co. ₁ᶜ1911₁

viii, 17–256 p. plates, ports. 21ᶜᵐ. $1.00
A reissue of the text as far as p. 255 of "The blue coats and how they lived" ₁ᶜ1867₁ The plates are not reproduced here.

© May 13, 1911; 2c. May 20, 1911*; A 289059; George W. Bertron, Philadelphia. (11–12069) 2644

U. S. *Laws, statutes, etc.*

The judicial code; being the judiciary act of the Congress of the United States, approved March 3, a. d. 1911. With an introduction and annotations by James Love Hopkins ... Chicago, Callaghan and company, 1911.

1 p. l., 254 p. incl. maps. 24½ᶜᵐ. $2.50

© May 4, 1911; 2c. May 15, 1911*; A 286912; Callaghan & co. (11–12233) 2645

Ward, Josephine Mary (Hope-Scott) *"Mrs. W. P. Ward."*

The job secretary; an impression, by Mrs. Wilfrid Ward ... New York ₁etc.₁ Longmans, Green, and co., 1911.

2 p. l., 275 p. 19½ᶜᵐ. $1.20

© May 15, 1911; 2c. May 29, 1911*; A 289317; Longmans, Green, & co. (11–12125) 2646

The **American** and English annotated cases; containing
the important cases selected from the current Ameri-
can, Canadian, and· English reports, thoroughly anno-
tated. Editors: William M. McKinney and H. Noyes
Greene. v. 19. Northport, N. Y., E. Thompson com-
pany, 1911.

1 p. l., viii, 1368 p. 26ᶜᵐ. $5.00
© June 13, 1911; 2c. June 14, 1911*; A 289750; Edward Thompson co.

2647

Arnold, Matthew, 1822–1888.

Arnold's Sohrab and Rustum, and other poems, selected
and ed. by Walter S. Hinchman ... New York, H. Holt
and company, 1911.

xxvii, 98 p. front. (port.) 17ᶜᵐ. (*Half-title:* English readings for
schools. General editor: W. L. Cross) $0.25
"Descriptive bibliography": p. xxv–xxvii.
© May 20, 1911; 2c. May 25, 1911*; A 289197; Henry Holt & co.
(11–12240) 2648

Bell, Hill McClelland, 1860–

An orthoepy and orthography, by Hill M. Bell ... with
exercises and additions by Margaret Oliver ... and a
supplement on revised orthography by Homer H. Seer-
ley ... Des Moines, Ia., Huntwell publishing company,
1911.

160 p., 1 l. 19½ᶜᵐ. $0.48
© Apr. 22, 1911; 2c. May 1, 1911; A 286591; Morton E. Weldy, Des
Moines, Ia. (11–12696) 2649

Bloundelle-Burton, John Edward, 1850–

Under the salamander; a romance, by John Bloundelle-
Burton ... London, Everett & co., ltd., 1911.

320 p. 19½ᶜᵐ.
© 1c. June 5, 1911*; A ad int. 660; publ. May 8, 1911; J. Bloundelle-Bur-
ton, London. (11–12828) 2650

Boucher, L T comp.

South Dakota laws made plain; laws and legal forms
prepared for the use of business men, farmers and me-
chanics. Comp. by Hon. L. T. Boucher ... [Sedalia, Mo.]
Bankers law publishing co., ᶜ1911.

cover-title. 100 p. 22ᶜᵐ.
© May 20, 1911; 2c. May 24, 1911*; A 289168; Bankers law pub. co., Corn-
ing, Ia. (11–12459) 2651

Bruce, William Speirs, 1867–

Polar exploration, by William S. Bruce ... New York,
H. Holt and company; [etc., etc., ᶜ1911]

vi, [4], 11–256 p. illus. (charts) 18ᶜᵐ. (*Half-title:* Home university
library of modern knowledge, no. 8) $0.75
© May 25, 1911; 2c. May 27, 1911*; A 289277; Henry Holt & co.
(11–12726) 2652

441

Buck, Jirah Dewey, 1838–

The new avatar and the destiny of the soul; the findings of natural science reduced to practical studies in psychology, by Jirah D. Buck ... Cincinnati, The Robert Clarke company, 1911.

xxiv, 226 p. 21½ᶜᵐ. $2.00

© May 20, 1911; 2c. May 24, 1911*; A 289169; Stewart & Kidd co., Cincinnati. (11–12252) **2653**

Bunyan, John, 1628–1688.

Bunyan's Pilgrim's progress, ed. by J. H. Gardiner ... New York, H. Holt and company, 1911.

xli, [1], 237 p. front. (port.) illus. (incl. facsim.) 17ᶜᵐ. (*Half-title:* English readings for schools. General editor: W. L. Cross) $0.40
"Descriptive bibliography": p. xxxix–xli.

© May 12, 1911; 2c. May 25, 1911*; A 289198; Henry Holt & co. (11–12250) **2654**

Burrows, Lansing.

How Baptists work together; for use as textbook in study courses either with the individual, with the church B. Y. P. U., or as supplemental studies in the church Sunday school [by] Lansing Burrows ... Nashville, Tenn., Sunday school board, Southern Baptist convention [°1911]

138 p. 17½ᶜᵐ. $0.50

© Mar. 18, 1911; 2c. May 18, 1911*; A 289012; Sunday school board, Southern Baptist convention. (11–12254) **2655**

Clark, Ida Hood.

Domestic science, by Ida Hood Clark ... Boston, Little, Brown and company, 1911.

xi p., 1 l., 290 p. front., illus., plates. 19½ᶜᵐ. $1.50
"Books of reference": p. 290.

© May 27, 1911; 2c. May 31, 1911*; A 289347; Little, Brown, and company. (11–12718) **2656**

Deeping, Warwick *i. e.* **George Warwick,** 1877–

Joan of the tower, by Warwick Deeping ... with a frontispiece by A. C. Michael. London, New York [etc.] Cassell & company, limited, 1911.

iv, 399 p. col. front. 20ᶜᵐ. $1.20

© Apr. 6, 1911; 2c. June 5, 1911*; A 289484; Cassell & co., ltd. (11–12829) **2657**

Dickens, Charles, 1812–1870.

... Dickens's A tale of two cities; ed. by J. W. Pearce ... New York, Cincinnati [etc.] American book company [°1911]

331 p. 16½ᶜᵐ. (Eclectic English classics) $0.40

© May 9, 1911; 2c. May 11, 1911*; A 286823; American book co. [Copyright is claimed on Notes and suggestions for study] (11–12826) **2658**

Estienne, Henri, 1528-1598.

The Frankfort book fair; the Francofordiense emporium of Henri Estienne, ed. with historical introduction, original Latin text with English translation on opposite pages and notes, by James Westfall Thompson. Chicago, The Caxton club, 1911.

xviii, 204 p. front. (port.) illus., 4 pl., 3 facsim. 29½ᶜᵐ. $12.50
Bibliography: p. 191-194.

© Feb. 20, 1911; 2c. May 19, 1911; A 289267; J. W. Thompson, Chicago.
(11-12292) 2659

Fisher, Herbert Albert Laurens, 1865-

The republican tradition in Europe, by H. A. L. Fisher ... The Lowell lectures for 1910. New York and London, G. P. Putnam's sons, 1911.

xii p., 1 l., 363 p. 23ᶜᵐ. $2.50

© May 19, 1911; 1c. May 23, 1911; 1c. May 31, 1911*; A 289334; H. A. L. Fisher, Oxford, England. (11-12701) 2660

Gilmore, Florence.

Dr. Dumont, by Florence Gilmore ... St. Louis, Mo. [etc.] B. Herder, 1911.

2 p. l., 123 p. 18½ᶜᵐ $0.50

© May 23, 1911; 2c. May 26, 1911*; A 289271; Joseph Gummersbach, St. Louis. (11-12266) 2661

Grinnell, George Bird, 1849- ed.

Harper's camping and scouting; an outdoor guide for American boys; consulting editors: George Bird Grinnell ... Dr. Eugene L. Swan ... New York and London, Harper & brothers, 1911.

xvi p., 2 l., 3-397, [1] p. incl. front., illus. 20½ᶜᵐ. *(On verso of t.-p.:* Harper's practical books for boys) $1.75

© May 18, 1911; 2c. May 20, 1911*; A 289064; Harper & bros. (11-12259) . 2662

Hampton, Celwyn Emerson.

A falling spark, by Celwyn E. Hampton ... Columbus, O., The Edward T. Miller company, 1911.

139 p. front. (port.) 17½ᶜᵐ. $2.00
Poems.

© May 25, 911; 2c. May 29, 1911*; A 289310; C. E. Hampton, San Antonio, Tex. (11-12239) 2663

Hemenway, Herbert Daniel, 1873-

How to make home and city beautiful, prepared to help those interested in making attractive homes and beautiful cities, by H. D. Hemenway. Northampton, Mass. [°1911]

104 p. incl. illus., tab. front., fold. plan. 23½ᶜᵐ. $1.00

© Apr. 8, 1911; 2c. Apr. 15, 1911; A 289134; H. D. Hemenway, Northampton, Mass. (11-12258) 2664

Heyman, Emanuel Sylvain, 1855–

The Heyman system, by Emanuel Sylvain Heyman; a scientific treatment of endowment insurance and pensions for the protection of the employe and his dependents, in case of total disability through sickness or accident, premature death and superannuation, and for the establishment of persistency and closer relationship between employer and employe. ¡Chicago¶¡ 1911.

4 p. l., 5–30 p., 1 l. port. 22½ᶜᵐ.
© May 22, 1911; 2c. May 26, 1911*; A 289255; E. S. Heyman, Chicago. (11–12273) **2665**

Hindhede, Mikkel, 1862–

Mein ernährungs-system. Eine umwälzung und verbilligung unsrer ernährung. Mit einem muster-kochbuch. Von dr. med. Hindhede. Autorisierte uebersetzung von Marie Dietz. Mit einem vorwort zur deutschen ausg. von professor dr. Kafemann ... Berlin und Leipzig, W. Vobach & co. ¡ᶜ1911¡

196 p. 21½ᶜᵐ. M. 2.60
© Apr. 27, 1911; 2c. May 22, 1911*; A—Foreign 2974; W. Vobach & co. (11–12453) **2666**

Horstmann, Henry Charles, 1858–

Modern electrical construction; a reliable, practical guide for the beginner in electrical construction, showing the latest approved methods of installing work of all kinds according to the safety rules of the National board of fire underwriters, by Henry C. Horstmann and Victor H. Tousley ... 3d ed., rev. and enl. Chicago, F. J. Drake & co. ¡ᶜ1911¡

358 p. illus. 17ᶜᵐ. $1.50
© May 15, 1911; 2c. May 20, 1911*; A 289076; Horstmann and Tousley, Chicago. (11–12268) **2667**

Jones, J Sparhawk, 1841–

Saved by hope, by J. Sparhawk Jones ... Philadelphia, The Westminster press, 1911.

206 p. 19½ᶜᵐ. $1.00
CONTENTS.—A letter of counsel.—God's hope.—Our brother.—Micah and his Levite.—The power of conscience.—Peter's question.—The thunders of Horeb.—The way.—The pool of Bethesda.—The inspiration of the Almighty.—Religion—a prophet.—The sight of the soul.—From man to God.—A New Year sermon.—Life immortal.
© May 22, 1911; 2c. May 29, 1911*; A 289309; Calvary Presbyterian church, inc., Philadelphia. (11–12247) **2668**

King, Mary Rayner Hyman, 1875–

The judgment, by Mary R. H. King, illustrated by Julian Onderdonk. New York, Cochrane publishing co., 1911.

205 p. front., plates. 19ᶜᵐ. $1.50
© Apr. 27, 1911; 2c. May 10, 1911*; A 286803; Cochrane pub. co. (11–12710) **2669**

Lansing, Marion Florence, 1883–

... Barbarian and noble, by Marion Florence Lansing, M. A., illustrated by reproductions of drawings from old engravings. Boston, New York [etc.] Ginn and company [°1911]

viii, 183 p. incl. front., illus. 17½ᶜᵐ. (Mediaeval builders of the modern world) $0.40
© May 3, 1911; 2c. May 22, 1911*; A 289117; M. F. Lansing, Cambridge, Mass. (11–12440) 2670

Leaming, Thomas, 1858–

A Philadelphia lawyer in the London courts, by Thomas Leaming, illustrated by the author. New York, H. Holt and company, 1911.

xiii p., 1 l., 199 p. incl. front. 5 pl. 23ᶜᵐ. $2.00
© May 13, 1911; 2c. May 25, 1911*; A 289202; Henry Holt & co. (11–12232) 2671

McCook, Henry Christopher, 1837–

Quaker Ben; a tale of colonial Pennsylvania in the days of Thomas Penn, by Henry C. McCook ... Philadelphia, G. W. Jacobs & co. [1911]

5 p. l., [3]–336 p. col. front., plates. 20½ᶜᵐ. $1.35
© May 27, 1911; 2c. May 31, 1911*; A 289346; George W. Jacobs & co. (11–12263) 2672

Macdonald, Loren B.

Life in the making; an approach to religion through the method of modern pragmatism, by Loren B. Macdonald ... Boston, Sherman, French & company, 1911.

2 p. l., 223 p. 21ᶜᵐ. $1.20
© May 19, 1911; 2c. May 25, 1911*; A 289211; Sherman, French & co. (11–12249) 2673

Marden, Orison Swett, 1848–

Pushing to the front, by Orison Swett Marden ... Toledo, Petersburg, N. Y. [etc.] The Success company's branch offices [°1911]

viii, 824 p. front., plates, ports. 21½ᶜᵐ. $3.95
© May 23, 1911; 2c. May 26, 1911*; A 289261; O. S. Marden, New York. (11–12700) 2674

Miller, Daniel, 1843–

Rambles in Europe. By Daniel Miller ... Reading, Pa., D. Miller, I. M. Beaver, 1911.

viii, [9]–399 p. front. (port.) illus., plates. 19½ᶜᵐ. $1.25
© May 20, 1911; 2c. May 23, 1911*; A 289136; D. Miller. (11–12439) 2675

Moldenke, Richard George Gottlob, 1864–

The production of malleable castings; a practical treatise on the processes involved in the manufacture of malleable cast iron. By Richard Moldenke. Cleveland, O., The Penton publishing company [°1910]

3 p. l., 125, vii p. front. (port.) illus., plates. 23½ᶜᵐ. $3.00
© Apr. 15, 1911; 1c. Apr. 3, 1911; 1c. Apr. 17, 1911*; A 286250; Penton pub. co. (11–12269) 2676

445

Morice, Charles, 1861–
He is risen again; a vision, by Charles Morice. London, E. Nash, 1911.
2 p. l., 230 p., 1 l. 19½ᶜᵐ. $1.25
© 1c. May 11, 1911*; A ad int. 629; pubd. Apr. 12, 1911; George H. Doran co., New York. (11–12708) 2677

Murphy, Andrew Judson, 1876–
Baptismal regeneration, by Andrew J. Murphy. Knoxville, Tenn., S. B. Newman & co., printers [°1911]
82 p. incl. port. 18½ᶜᵐ. $0.50
© May 17, 1911; 2c. May 19, 1911*; A 289020; A. J. Murphy, Fountain City, Tenn. (11–12251) 2678

Newbigin, Marion I.
Modern geography, by Marion I. Newbigin ... New York, H. Holt and company; [etc., etc., °1911]
256 p. illus. 18ᶜᵐ. (*Half-title:* Home university library of modern knowledge, no. 7) $0.75
"Notes on books": p. 249–250.
© May 25, 1911; 2c. May 27, 1911*; A 289278; Henry Holt & co. (11–12725) 2679

Paret, William, *bp.,* 1826–1911.
Reminiscences, by the Rt. Rev. William Paret ... Philadelphia, G. W. Jacobs & co. [1911]
xv p., 1 l., 209 p. front. (port.) 20ᶜᵐ. $1.50
© May 20, 1911; 2c. May 23, 1911*; A 289140; George W. Jacobs co. (11–12706) 2680

The **practical** operation of arc lamps. Cleveland, O., National carbon company, 1911.
75 p. illus., diagrs. 15½ᶜᵐ.
© May 4, 1911; 2c. May 8, 1911*; A 286754; National carbon co. (11–12719) 2681

Pratique médico-chirurgicale.
... Nouvelle Pratique médico-chirurgicale illustrée ... Directeurs: E. Brissaud, A. Pinard, P.-Reclus ... Secrétaire général: Henry Meige. t. 5, 6. Paris, Masson et cie., 1911.
2 v. illus., plates (partly col.) diagrs. 25ᶜᵐ. fr. 0.25 each
CONTENTS.—t. 5. Labyrinthe–Omonplate.—t. 6. Omphalite–Poudres.
© May 19, 1911; 2c. each June 10, 1911*; A—Foreign 3047; Masson & cie.
2682

Prestridge, John Newton, 1853–
The church a composite life, by J. N. Prestridge, D. D. Louisville, Ky., The World press, 1911.
199 p. 20ᶜᵐ. $1.00
© May 17, 1911; 2c. May 20, 1911; A 289158; J. N. Prestridge, Louisville, Ky. (11–12705) 2683

Robbins, Alice E.
A tour and a romance, by Alice E. Robbins ... New York, The Baker and Taylor company, 1911.
viii, 280 p. front., plates. 19½ᶜᵐ. $1.50
© May 10, 1911; 2c. May 11, 1911*; A 286836; Baker & Taylor co. (11–12711) 2684

Roosevelt, Theodore, *pres. U. S.*, 1858–

Applied ethics; being one of the William Belden Noble lectures for 1910, by Theodore Roosevelt ... Cambridge, Harvard university, 1911.

4 p. l., [3]–50 p., 1 l. 19½ᶜᵐ. $0.75
© May 17, 1911; 2c. May 22, 1911*; A 289130; T. Roosevelt, Oyster Bay, N. Y. (11–12272) 2685

Scott, *Sir* **Walter,** *bart.*, 1771–1832.

Scott's Lady of the lake, ed. by Alfred M. Hitchcock ... New York, H. Holt and company, 1911.

xxix, 193 p. front. (port.) illus. 17ᶜᵐ. (*Half-title:* English readings for schools. General editor: W. L. Cross) $0.35
"Descriptive bibliography": p. xxv–xxix.
© May 9, 1911; 2c. May 25, 1911*; A 289200; Henry Holt & co.
(11–12238) 2686

Scott, Walter Dill, 1869–

Influencing men in business; the psychology of argument and suggestion, by Walter Dill Scott ... New York, The Ronald press company, 1911.

168 p. illus. 20ᶜᵐ.
© Apr. 22, 1911; 2c. May 26, 1911*; A 289240; Ronald press co.
(11–12274) 2687

Semple, Ellen Churchill, 1863–

Influences of geographic environment, on the basis of Ratzel's system of anthropo-geography, by Ellen Churchill Semple ... New York, H. Holt and company; [etc., etc.] 1911.

xvi p., 1 l., 683 p. maps. 23ᶜᵐ. $4.00
© May 25, 1911; 2c. May 27, 1911*; A 289283; Henry Holt & co.
(11–12727) 2688

... The **Southwestern** reporter, with key-number annotations. v. 134, 135. Permanent ed. ... March 8–March 29, 1911, April 5–April 26, 1911. St. Paul, West publishing co., 1911.

2 v. 26½ᶜᵐ. (National reporter system—State series) $4.00 each
v. 134 © May 18, 1911; v. 135 © June 6, 1911; 2c. each June 14, 1911*;
A 289729, 289730; West pub. co. 2689, 2690

Stowe, Charles Edward, 1850–

Harriet Beecher Stowe: the story of her life, by her son, Charles Edward Stowe, and her grandson, Lyman Beecher Stowe ... Boston and New York, Houghton Mifflin company, 1911.

vi p., 2 l., 313, [1] p. front., plates, ports., double facsim. 21ᶜᵐ. $1.50
© May 6, 1911; 2c. May 12, 1911*; A 286867; C. E. Stowe, New York.
(11–12848) 2691

Underwood and Underwood.

The United States of America through the stereoscope; one hundred outlooks from successive positions in different parts of the world's greatest republic .·. New York, Ottawa, Kan. [etc.] Underwood & Underwood [°1911]

177 p. 4 fold. maps. 19½ᶜᵐ.
© Dec. 28, 1910; 2c. May 15, 1911*; A 286909; Underwood & Underwood.
(11–12849) 2692

Urban, Henry F.

Die entdeckung Berlins, von Henry F. Urban; mit
zeichnungen von Paul Haase. Sonderabdruck aus dem
"Berliner lokal-anzeiger." Berlin, A. Scherl g. m. b. h.,
1911.

viii, 192 p. illus. 18½ᶜᵐ. M. 1

© Apr. 7, 1911; 2c. May 22, 1911*; A—Foreign 2972; August Scherl g. m.
b. h. (11–12438) 2693

Wagner, Richard, 1813–1883.

Mein leben, von Richard Wagner. München, F. Bruck-
mann a.-g., 1911.

2 v. 26½ᶜᵐ. M. 25

© Apr. 28, 1911; 2c. each May 29, 1911*; A—Foreign 2997; F. Bruckmann,
ltd. (11–12302) 2694

Wemyss, George.

The secret book, by George Wemyss; with a frontis-
piece by Clinton Balmer. New York, Sturgis & Walton
company, 1911.

3 p. l., 3–356 p. col. front. 19ᶜᵐ. $1.20

© May 23, 1911; 2c. May 27, 1911*; A 289287; Sturgis & Walton co.
(11–12059) 2695

Wentworth-James, Gertie De S.

The price, by Gertie De S. Wentworth-James ... Lon-
don and New York, M. Kennerley, 1911.

342 p. 19½ᶜᵐ. $1.35

© May 26, 1911; 2c. May 29, 1911*; A 289308; Mitchell Kennerley.
(11–12265) 2696

Williamson, James Joseph, 1834–

Prison life in the Old capitol and reminiscences of the
civil war, by James J. Williamson ... illustrations by B. F.
Williamson. West Orange, N. J., 1911.

x, 11–162 p. front., illus. 19½ᶜᵐ. $1.50

Major Henry Wirz, c. s. a.: p. 132–153.

© May 9, 1911; 2c. May 23, 1911*; A 289150; J. J. Williamson, West
Orange, N. J. (11–12071) 2697

Worden, Edward Chauncey.

Nitrocellulose industry; a compendium of the history,
chemistry, manufacture, commercial application and
analysis of nitrates, acetates and xanthates of cellulose
as applied to the peaceful arts, with a chapter on gun
cotton, smokeless powder and explosive cellulose nitrates,
by Edward Chauncey Worden ... 324 illustrations. New
York, D. Van Nostrand company, 1911.

2 v. 3 port. (incl. fronts.) illus. 24½ᶜᵐ. $10.00

Bibliographical foot-notes.

© May 4, 1911; 2c. each May 20, 1911*; A 289093, 289082; D. Van Nos-
trand co. (11–11911) 2698, 2699

Albert-Petit, A.

... Histoire de Normandie; ouvrage illustré de gravures hors texte. Paris, Boivin & c^{le} [°1911]

vii, 256 p. plates. 20½^{cm}. fr. 3

© May 12, 1911; 2c. May 26, 1911; A—Foreign 2993; Boivin & cie.
(11–12437) 2700

Barbour, Ralph Henry, 1870–

The house in the hedge, by Ralph Henry Barbour; illustrated by Gertrude A. Kay. New York, Moffat, Yard and company, 1911.

5 p. l., 251 p. col. front., plates. 19½^{cm}. $1.10

© May 27, 1911; 2c. June 3, 1911*; A 289434; Moffat, Yard & co.
(11–12712) 2701

Bentley, Harry Clark, 1877–

The science of accounts; a presentation of the underlying principles of modern accounting. Designed as a work of reference for accountants, and as a text book for advanced students of accountancy, by Harry C. Bentley ... New York, The Ronald press company, 1911.

393 p. 23½^{cm}. $3.00

© May 24, 1911; 2c. May 26, 1911*; A 289241; H. C. Bentley, Brookline, Mass. (11–12533) 2702

Bosanquet, William Cecil, 1866–

Spirochætes, a review of recent work with some original observations, by W. Cecil Bosanquet ... Philadelphia and London, W. B. Saunders company, 1911.

152 p. incl. col. front., illus. 23½^{cm}. $2.50

Bibliography: p. 117–136.

© May 20, 1911; 2c May 23, 1911*; A 289139; W. B. Saunders co.
(11–12479) 2703

Chamberlayne, Charles Frederic.

A treatise on the modern law of evidence, by Charles Frederic Chamberlayne ... v. 2. Procedure. Albany, N. Y., M. Bender and company; [etc., etc.] 1911.

xxviii, 1901–2192, 2193a–2328a p. 26½^{cm}. $7.00

© June 15, 1911; 2c. June 16, 1911; A 289853; C. F. Chamberlayne, Schenectady, N. Y. 2704

Chandler, Robert Adams.

Questions and answers on the automobile; a quiz manual for students, by Robert Adams Chandler ... Boston, Mass., The author, 1911.

80 p. 15½^{cm}. 0.25

© May 17, 1911; 2c. May 19, 1911*; A 289045; R. A. Chandler, Boston.
(11–12528) 2705

449

Codman, Anna K (Crafts) *"Mrs. Russell Codman,"* 1869–

An ardent American, by Mrs. Russell Codman; frontispiece by James Montgomery Flagg. New York, The Century co., 1911.

vi. 411 p. col. front. 20ᶜᵐ. $1.20
© May 20, 1911; 2c. May 26, 1911*; A 289253; Century co.
(11–12504) 2706

Coffin, Henry Sloane.

Social aspects of the cross, by Henry Sloane Coffin ... New York, Hodder & Stoughton, George H. Doran company [ᶜ1911]

5 p. l., 3–83 p. 20ᶜᵐ. $0.60
⊛ May 22, 1911; 2c. May 23, 1911*; A 289135; George H. Doran co.
(11–12516) 2707

Duggar, Benjamin Minge, 1872–

Plant physiology, with special reference to plant production, by Benjamin M. Duggar ... New York, The Macmillan company, 1911.

xv, 516 p. front., illus. 19¼ᶜᵐ. (*Half-title:* The rural text-book series, ed. by L. H. Bailey) $1.60
"References" at end of each chapter.
© May 31, 1911; 2c. June 1, 1911*; A 289365; Macmillan co.
(11–12733) 2708

Elliott, Francis Perry.

The haunted pajamas, by Francis Perry Elliott; with illustrations by Edmund Frederick. Indianapolis, The Bobbs-Merrill company [ᶜ1911]

5 p. l., 355 p. col. front., col. plates. 19¼ᶜᵐ. $1.25
© May 27, 1911; 2c. June 1, 1911*; A 289385; Bobbs-Merrill co.
(11–12502) 2709

Ely, Leonard Wheeler, 1868–

Joint tuberculosis, by Leonard W. Ely ... New York, W. Wood and company, 1911.

xi, 243 p. fold. col. front., illus. 24ᶜᵐ. $2.50
© May 20, 1911; 2c. May 23, 1911*; A 289137; William Wood & co.
(11–12720) 2710

Esparbès, Georges Thomas, *called* **Georges d',** 1865–

... Le briseur de fers; illustrations de M. Toussaint. Paris, P. Lafitte & cⁱᵉ [ᶜ1911]

120 p. incl. front., illus. 24½ᶜᵐ. (Idéal-bibliothèque ɪno. 25₁) fr. 0.95
© May 12, 1911; 2c. May 26, 1911; A—Foreign 2991; Pierre Lafitte & cie.
(11–12824) 2711

Favre de Coulevain, *Mlle.*

The unknown isle, by Pierre de Coulevain [pseud.] ... tr. from the French by Alys Hallard. London, New York [etc.] Cassell and company, ltd., 1911.

434 p. 22ᶜᵐ. $1.35
© June 1, 1911; 2c. June 2, 1911*; A 289399; Cassell & co., ltd., New York.
(11–12506) 2712

Fiske, Annette.

Structure and functions of the body; a hand-book of anatomy and physiology for nurses and others desiring a practical knowledge of the subject, by Annette Fiske ... Philadelphia and London, W. B. Saunders company, 1911.

221 p. illus. 21cm. $1.25

© May 25, 1911; 2c. May 26, 1911*; A 289251; W. B. Saunders co.
(11-12730) 2713

Glasgow, Ellen Anderson Gholson, 1874–

The miller of Old Church, by Ellen Glasgow. Garden City, New York, Doubleday, Page & company, 1911.

3 p. l., v–vi, 432 p. 19½cm. $1.35

© May 27, 1911; 2c. June 1, 1911*; A 289382; Doubleday, Page & co.
(11-12503) . 2714

Goodman, Frederic Simeon, 1858–

Elementary studies in the life and letters of Paul [by] Fred S. Goodman. 6th ed. rev. New York, Association press, 1911.

viii, 108 p., 1 l. front. (map) 18½cm. $0.40
References: p. vii–viii.

© May 22, 1911; 2c. May 23, 1911*; A 289138; Internatl. committee of
Y. M. C. A., New York, N. Y. (11-12515) 2715

Grafton, Charles Chapman, bp., 1830–

The lineage from apostolic times of the American Catholic church, commonly called the Episcopal church, by the Right Rev. C. C. Grafton ... Milwaukee, The Young churchman company [1911] .

xxi, 296 p. front., illus. (map) plates. 19½cm. $0.75
"Books referred to" at end of each chapter.

© May 17, 1911; 2c. May 22, 1911*; A 289115; Young churchman co.
(11-12514) 2716

Hanotaux, Gabriel i. e. Albert Auguste Gabriel, 1853–

Jeanne d'Arc, par Gabriel Hanotaux ... [Paris] Hachette et cie, 1911.

2 p. l., xiii, 421, ix, [2] p. illus. 24cm. fr. 10

© May 5, 1911; 2c. May 26, 1911; A—Foreign 2989; G. Hanotaux, Paris.
(11-12436) 2717

Harrison, James M.

Applied heating and ventilation, with charts and formulas, embodying modern practice in steam, hot blast and forced hot water heating, with eleven designs of heating systems, sixteen charts for quick calculations, and forty-nine formulas. By James M. Harrison. New York, New York heating and ventilation school, [c]1911·

4 p. l., 7–133 p. incl. plates, charts. 28 x 36cm. $10.00

© May 6, 1911; 2c. May 20, 1911*; A 289087; New York heating & ventilation school. (11-12832) 2718

Hearne, Isabel.

Queen Herzeleid; or, Sorrow-of-Heart, and episode in the boyhood of the hero, Parzival; a poetic play in three acts, by Isabel Hearne. London, D. Nutt, 1911.

xxi, 78 p. 20ᶜᵐ.

© Mar. 30, 1911; 1c. Apr. 8, 1911; 1c. May 19, 1911; D 24264; I. Hearne, Sudbury, England. (11-12237) 2718*

Hebron, Conn.

Hebron, Connecticut. Bicentennial August 23d to 25th, 1908. An account of the celebration of the two hundredth anniversary of the incorporation of the town. 1708. 1908. Hebron, Conn., Bicentennial committee, 1910.

77 p. incl. front. (fold. map) plates, groups of ports. 24½ᶜᵐ. $1.50

Comp. by F. C. Bissell.

© May 24, 1911; 2c. May 26, 1911*; A 289257; Hebron bi-centennial committee. (11-12845) 2719

Hirst, Francis Wrigley, 1873–

The stock exchange; a short study of investment and speculation, by Francis W. Hirst ... New York, H. Holt and company; [etc., etc., ᶜ1911]

256 p. 18ᶜᵐ. (Half-title: Home university library of modern knowledge, no. 5) $0.75

Bibliography: p. 255-256.

© May 25, 1911; 2c. May 27, 1911*; A 289280; Henry Holt & co. (11-12487) 2720

Howard, Leland Ossian, 1857–

The house fly, disease carrier; an account of its dangerous activities and of the means of destroying it, by L. O. Howard, PH. D. New York, Frederick A. Stokes company [ᶜ1911]

xix, 312 p. col. front., illus., plates. 21ᶜᵐ. $1.00

"Bibliographical list": p. 261-272.

© May 25, 1911; 2c. May 31, 1911*; A 289351; Frederick A. Stokes co. (11-12722) 2721

Introductory science; an elementary course in some of the principles of physics, chemistry and physiography, by the teachers of science in the Bridgeport high school ... Bridgeport, Conn., 1911.

73 p. incl. front. (port.) illus. 22½ᶜᵐ. $0.50

© May 12, 1911; 2c. May 12, 1911; A 289133; Henry D. Simonds, Bridgeport, Conn. (11-12482) 2722

James, George Wharton, 1858–

A little journey to some strange places and peoples in our southwestern land (New Mexico and Arizona.) For home and school, intermediate and upper grades. By George Wharton James. Chicago, A. Flanagan company [ᶜ1911]

270 p. col. front., illus. 19½ᶜᵐ. (On cover: Library of travel) $0.50

© May 17, 1911; 2c. May 19, 1911*; A 289040; A. Flanagan co. (11-12843) 2723

Lavedan, Henri Léon Émile, 1859–

... Mon filleul. Paris, P. Lafitte & c¹ᵉ ₍ᶜ1911₎

3 p. l., 3–307, ₍1₎ p., 1 l. front. (port.) 19ᶜᵐ. fr. 3.50
© May 5, 1911; 2c. May 26, 1911; A—Foreign 2992; Pierre Lafitte & cie.
(11–12241) 2724

Lockwood, Laura Emma, 1863– ed.

Letters that live, selected and ed. by Laura E. Lock-
wood and Amy R. Kelly. New York, H. Holt and com-
pany, 1911.

xiii, 253 p. 16ᶜᵐ. $1.50
© May 13, 1911; 2c. May 25, 1911; A 289196; Henry Holt & co.
(11–12697) 2725

Lynch, Mrs. Sophronia Brinkley.

Allegheny and Aurora, and other poems, by Mrs.
Sophronia Brinkley Lynch. ₍Washington?₎ D. C.₎ ᶜ1911·

75 p. 21ᶜᵐ.
© May 25, 1911; 2c. May 25, 1911*; A 289222; S. B. Lynch, Washington.
(11–12815) 2726

Lynde, Francis, 1856–

The price, by Francis Lynde. New York, C. Scrib-
ner's sons, 1911.

viii p., 1 l., 458 p. 19½ᶜᵐ. $1.30
© May 27, 1911; 2c. June 3, 1911*; A 289438; Charles Scribner's sons.
(11–12713) 2727

Masefield, John.

William Shakespeare, by John Masefield ... New
York, H. Holt and company; ₍etc., etc., ᶜ1911₎

viii, 9–256 p. 18ᶜᵐ. (*Half-title:* Home university library of modern
knowledge, no. 2) $0.75
© May 25, 1911; 2c. May 27, 1911*; A 289281; Henry Holt & co.
(11–12695) 2728

Meserve, Frederick Hill.

The photographs of Abraham Lincoln, by Frederick
Hill Meserve. New York, Priv. print., 1911.

110 p. incl. front., mounted photos., facsim. pl. 28½ᶜᵐ. $35.00
© May 20, 1911; 2c. May 24, 1911*; A 289165; F. H. Meserve, New York.
(11–12517) 2729

Michie, Thomas Johnson, ed.

The encyclopedic digest of Texas reports (civil cases)
... Under the editorial supervision of Thomas Johnson
Michie. v. 5. ₍Counties–Declaration₎ Charlottesville,
Va., The Michie company, 1911.

iv p., 1 l., 1228 p. 26ᶜᵐ. $7.50
© June 14, 1911; 2c. June 15, 1911*; A 289771; Michie co. 2730

Monlaur, M Reynès.

... Le sceau ... ₍4. éd.₎ Paris, Plon-Nourrit et c¹ᵉ ₍ᶜ1911₎

3 p. l., 294 p., 1 l. 19ᶜᵐ. fr. 3.50
© Apr. 28, 1911; 2c. May 12, 1911*; A—Foreign 2930; Plon-Nourrit & cie.
(11–12823) 2731

Moorhead, Joseph, 1829–

Original poems, written by Joseph Moorhead ...
[Blairsville, Pa.] The author, 1911.

2 p. l., [3]–75, [1] p. front. (port.) 23ᶜᵐ. $1.00
© May 10, 1911; 2c. May 23, 1911*; A 289146; J. Moorhead, Blairsville,
Pa. (11–12510) 2732

Muir, John, 1838–

The mountains of California, by John Muir, illustrated
from preliminary sketches and photographs furnished by
the author. New and enl. ed. New York, The Century
co., 1911.

xiv, 389 p. incl. front., illus. plates. 21ᶜᵐ. $1.50
1st edition 1894.
© May 23, 1911; 2c. May 26, 1911*; A 289252; Century co.
(11–12846) 2733

[Murdock, Harold] 1862–

Notes from a country library. Boston, The Club of
odd volumes, 1911.

3 p. l., 98, [2] p. illus. 21ᶜᵐ. $6.00
© May 17, 1911; 2c. May 22, 1911*; A 289113; Club of odd volumes, Bos-
ton. (11–12839) 2734

Opie, Martha J.

... Poems, by Martha J. Opie. Tavvistock, Eng., Wil-
liamstown, Pa., Times publ. house [c1911]

5 p. l., 2–103 p. front. (port.) 20ᶜᵐ.
© Dec. 8, 1910; 2c. May 27, 1911*; A 289297; M. J. Opie, Williamstown,
Pa. (11–12507) 2735

Paddock, Miner Hamlin, 1846–

Mineral science; a study of inorganic nature introduc-
tory to physics, chemistry, physiography, by Miner H.
Paddock ... Boston, New York [etc.] B. H. Sanborn &
company [c1911]

xiv, 148 p. incl. front., illus., plates, diagrs. 18½ᶜᵐ.
© May 29, 1911; 2c. May 31, 1911; A 289402; M. H. Paddock, Providence,
R. I. (11–12732) 2736

Perris, George Herbert, 1866–

A short history of war and peace, by G. H. Perris ...
New York, H. Holt and company [c1911]

vi, 7–256 p. 18ᶜᵐ. (Half-title: Home university library of modern
knowledge, no. 4) $0.75
"Note on books": p. 253–254.
© May 25, 1911; 2c. May 27, 1911*; A 289282; Henry Holt & co.
(11–12532) 2737

Punnett, Reginald Crundall.

Mendelism, by R. C. Punnett ... 3d ed., entirely re-
written and much enl. New York, The Macmillan com-
pany, 1911.

xiv, 192 p. front. (port.) illus., vi pl. (5 col.) 20ᶜᵐ. $1.25
© May 26, 1911; 2c. May 27, 1911*; A 289288; Macmillan co.
(11–12478) 2738

Ruoff, Henry Woldmar, 1867– ed.

The volume library; a concise, graded repository of practical and cultural knowledge designed for both instruction and reference; editor-in-chief: Henry W. Ruoff ... Chicago, The W. E. Richardson company, 1911.

3 p. l., 11–678, xviii p. incl. illus., maps. plates (partly col.) 30ᶜᵐ. $7.50

© May 25, 1911; 2c. May 29, 1911*; A 289323; W. E. Richardson co. (11–12508) 2739

Schneider, Norman Hugh.

Low voltage electric lighting with the storage battery, specially applicable to country houses, farms, small settlements, launches, yachts, etc., by Norman H. Schneider ... 1st ed. New York, Spon & Chamberlain; [etc., etc.] 1911.

ix, 85 p. illus. 18½ᶜᵐ. (On cover: The model library, no. 30) $0.25

© May 18, 1911; 2c. May 19, 1911*; A 289038; Spon & Chamberlain. (11–12526) 2740

Shakespeare, William, 1564–1616.

Shakespeare's As you like it, ed. by John W. Cunliffe and George Roy Elliott ... New York, H. Holt and company, 1911.

xxix, [3], 3–162 p. front. (port.) illus. 17ᶜᵐ. (Half-title: English readings for schools. General editor: W. L. Cross) $0.35

"Descriptive bibliography": p. xxv–xxix.

© May 12, 1911; 2c. May 25, 1911*; A 289201; Henry Holt & co., New York. (11–12820) 2741

Shakespeare's Julius Cæsar, ed. by Ashley H. Thorndike ... New York, H. Holt and company, 1911.

liii, [3], 134 p. front., illus. 17ᶜᵐ. (Half-title: English readings for schools. General editor: W. L. Cross) $0.35

"Descriptive bibliography": p. xlix–liii.

© May 6, 1911; 2c. May 25, 1911*; A 289199; Henry Holt & co. (11–12819) 2742

Stevenson, Robert Louis, 1850–1894.

The letters of Robert Louis Stevenson, ed. by Sidney Colvin. A new ed., rearranged in four volumes with 150 new letters ... New York, C. Scribner's sons, 1911.

4 v. fronts. (ports.) 21ᶜᵐ. $6.00

CONTENTS.—v. 1. 1868–1880. Scotland—France—California.—v. 2. 1880–1887. Alps and Highlands—Hyères—Bournemouth.—v. 3. 1887–1891. The Adirondacks—Pacific voyages—First year at Vailima.—v. 4. 1891–1894. Second, third, and fourth years at Vailima—The end.

© May 27, 1911; 2c. each June 1, 1911*; A 289384; Charles Scribners sons. (11–12822) 2743

Swift, Lindsay, 1856–

... William Lloyd Garrison, by Lindsay Swift ... Philadelphia, G. W. Jacobs & company [°1911]

412 p. front. (port.) 19½ᶜᵐ. (Half-title: American crisis biographies, ed. by E. P. Oberholtzer) $1.25

Bibliography: p. [387]–390.

© May 27, 1911; 2c. May 31, 1911*; A 289345; George W. Jacobs & co. (11–12519) 2744

Tyrrell, Henry Grattan.

History of bridge engineering, by Henry Grattan Tyrrell ... Chicago, The author, 1911.

479 p. front., illus. 24^{cm}. $4.00

© May 27, 1911; 2c. May 31, 1911*; A 289352; H. G. Tyrrell, Evanston, Ill
(11-12522) 2745

Vachell, Horace Annesley, 1861–

John Verney, by Horace Annesley Vachell ... New York, Hodder & Stoughton, George H. Doran company [°1911]

5 p. l., 3–334 p. 19½^{cm}. $1.20

© June 2, 1911; 2c. June 3, 1911*; A 289447; George H. Doran co.
(11-12714) 2746

Waller, Edith.

English for Italians (Lezioni d'inglese per gl'Italiani) by Edith Waller. New York, W. R. Jenkins co. [1911]

xxiii, 297 p. front. (fold. map) illus. 21^{cm}. $1.00

© May 20, 1911; 2c. May 24, 1911*; A 289173; William R. Jenkins co.
(11-12699) 2747

Whiting, Lilian.

Boston days, the city of beautiful ideals; Concord, and its famous authors; the golden age of genius; dawn of the twentieth century; first decade of twentieth century, by Lilian Whiting ... Boston, Little, Brown and company, 1911.

xii, 543 p. front., plates, ports., facsims. (partly fold.) 21½^{cm}. $1.50
1st edition 1902.

© May 27, 1911; 2c. May 31, 1911*; A 289335; Little, Brown, and company.
(11-12844) 2748

Wilkinson, William Cleaver, 1833–

Daniel Webster; a vindication, with other historical essays, by William Cleaver Wilkinson ... New York and London, Funk & Wagnalls company, 1911.

5 p. l., 3–419 p. 20^{cm}. $1.25
Partly reprinted from Scribner's monthly.
CONTENTS.—Webster's public character.—Webster's private character.—
A forgotten chapter in the history of the civil war.—Erasmus: the man
and the man of letters.—The secret of ancient Rome.—The change from
the old world to the new.—Some common sense about Saul of Tarsus.

© Apr. 17, 1911; 2c. May 27, 1911*; A 289275; Funk & Wagnalls co.
(11-12518) 2749

Wood, Robert Williams, 1868–

Physical optics, by Robert W. Wood ... New and rev. ed. New York, The Macmillan company, 1911.

xvi p., 1 l., 705 p. front., illus., plates (partly col.) diagrs., fold. chart.
23^{cm}. $5.25

© May 24, 1911; 2c. May 25, 1911; A 289264; Macmillan co.
(11-12731) 2750

Archer, William, 1856–

The life, trial, and death of Francisco Ferrer, by William Archer ... London, Chapman & Hall, ltd., 1911.

ix p., 2 l., 332 p. front., plates, ports., facsims. 23^{cm}. 10/6

© 1c. May 25, 1911; A ad int. 648; pubd. Apr. 25, 1911; W. Archer, London. (11–13017) 2751

Bennett, Charles Edwin, 1858–

... The teaching of Latin and Greek in the secondary school, by Charles E. Bennett, A. B. and George P. Bristol, A. M. ... New ed. New York [etc.] Longmans, Green, and co., 1911.

2 p. l., [vii]–xvi p., 1 l., 336 p. map. 20¼^{cm}. (*Half-title:* American teachers series, ed. by J. E. Russell) $1.50

Contains bibliographies.

© May 1, 1911; 2c. May 16, 1911*; A 2863935; Longmans, Green, & co. (11–12511) 2752

Bonin, Elsa von.

Das leben der Renée von Catte, roman von Elsa von Bonin. Berlin, E. Fleischel & co. [*1911]

3 p. l., 281 p., 1 l. 20¼^{cm}. M. 3.50

© Apr. 19, 1911; 2c. June 2, 1911*; A—Foreign 3014; Egon Fleischel & co. (11–13337) 2753

Brix, Ad.

... Praktischer schiffbau, bootsbau. 4. völlig umgearb. aufl. des gleichnamigen buches vom geh. admiralitätsrat A. Brix; hrsg. vom Akademischen verein Hütte e. v. Berlin; mit 328 textabbildungen. Berlin, W. Ernst & sohn, 1911.

vi, 327, [1] p. illus. 24½^{cm}. M. 10

At head of title: "Hütte."

© Mar. 27, 1911; 2c. Apr. 5, 1911; A—Foreign 2998; Akademischer verein Hütte, e. v., Berlin. (11–13029) 2754

Burnet, Étienne.

... Microbes et toxines; avec une introduction de Élie Metchnikoff; 71 figures dans le texte et un portrait inédit de Pasteur. Paris, E. Flammarion, 1911.

xi, 349 p., 1 l. incl. front. (port.) illus. 19^{cm}. (Bibliothèque de philosophie scientifique) fr. 3.50

© May 10, 1911; 2c. May 31, 1911*; A—Foreign 3001; Ernest Flammarion. (11–13121) 2755

California. *Supreme court.*

Reports of cases determined ... C. P. Pomeroy, reporter. v. 158. San Francisco, Bancroft-Whitney company, 1911.

xxxvii, 897 p. 23^{cm}. $3.25

© June 9, 1911; 2c. June 15, 1911*; A 289798; Bancroft-Whitney co. 2756

1911, no. 43

Printed June 23, 1911

Campbell, Thomas Joseph.
Pioneer priests of North America, 1642–1710, by the
Rev. T. J. Campbell, s. J. v. 3. Among the Algonquins.
New York, The America press, 1911.
xii, 312 p. front., plates, ports., maps. 23½⁰ᵐ. $2.00
© June 12, 1911; 2c. June 16, 1911*; A 289819; America press. 2757

Cotonio, Theodore.
Annotations to Louisiana reports (I. M.—125 La.)
comp. under the direction of Theodore Cotonio ...　New
Orleans, Louisiana publishing co. [c1911]
2 v. 24ᶜᵐ $45.00
© May 24, 1911; 2c. each June 2, 1911*; A 289415; T. Cotonio, New Or-
leans. (11–13199) 2758

Crawford, Alexander.
Kapak, by Alexander Crawford. Edinburgh and Lon-
don, W. Blackwood and sons, 1911.
viii, 385, [1] p. 19½ᶜᵐ. 6/
© 1c. June 8, 1911*; A ad int. 667; pubd. May 11, 1911; A. Crawford, Lon-
don. (11–13358) 2759

Danaher, Franklin Martin.
Bar examinations (New York) and courses of law study,
containing the statutes and rules of court regulating ad-
mission to the bar in New York state and forms and
instructions for the bar examinations and some of the
questions, with the answers thereto, heretofore used by
the New York state board of law examiners, with addi-
tional questions on the New York code of civil procedure;
also courses of law study suitable for the use of clerks in
law offices. [By] Franklin M. Danaher ...　5th ed. Al-
bany, J. B. Lyon company, printers, 1911.
vii, 513 p. 24ᶜᵐ. $4.00
© May 31, 1911; 2c. June 2, 1911*; A 289391; F. M. Danaher, Albany,
N. Y. (11–13198) 2760

Davis, Floyd, 1859–
An elementary course of instruction on coal mining.
For fire bosses, mine examiners, mine foremen, mine
managers, and mine superintendents. By Floyd Davis ...
Saint Louis, The Western correspondence school of min-
ing engineering [c1911]
3 p. 1., 142 p. 19½ᶜᵐ.
© May 26, 1911; 2c. June 1, 1911*; A 289362; F. Davis, St. Louis.
(11–13208) 2761

Derr, Ezra Z　　　1851–
The uncaused being and the criterion of truth; to which
is appended an examination of the views of Sir Oliver
Lodge concerning the ether of space; by E. Z. Derr ...
Boston, Sherman, French & company, 1911.
vii, 110 p. 19½ᶜᵐ. $1.00
© May 22, 1911; 2c. May 25, 1911*; A 289210; Sherman, French & co.
(11–13344) 2762

Du Bose, Horace Mellard, 1858–

... Life of Joshua Soule, by Horace M. Du Bose ...
Nashville, Tenn., Dallas, Tex., Publishing house of the
M. E. church, South, Smith & Lamar, agents, 1911.

285 p. front. (port.) 19½ᶜᵐ. (Methodist founders' series, ed. by
Bishop W. A. Candler) $1.00

© Apr. 22, 1911; 2c. Apr. 28, 1911*; A 286537; Smith & Lamar, Nashville,
Tenn. (11–12709) 2763

Ellis, Edward Sylvester, 1840–

... The flying boys in the sky, by Edward S. Ellis ...
illustrated by Edwin J. Prittie. Philadelphia, The John
C. Winston company [°1911]

304 p. front., plates. 19½ᶜᵐ. (Half-title: The flying boys series [v. 1])
$0.60

© May 23, 1911; 2c. June 7, 1911*; A 289528; John C. Winston co.
(11–13139) 2764

... The flying boys to the rescue, by Edward S. Ellis ...
illustrated by Edwin J. Prittie. Philadelphia, The John
C. Winston company [°1911]

304 p. front., plates. 19½ᶜᵐ. (Half-title: The flying boys series [v. 2])
$0.60

© May 23, 1911; 2c. June 7, 1911*; A 289527; John C. Winston co.
(11–13140) 2765

Oonomoo, the Huron, by Edward S. Ellis ... New York,
Hurst & company [°1911]

256 p. incl. front., plates. 19½ᶜᵐ. $0.50

© June 5, 1911; 2c. June 8, 1911*; A 289552; Hurst & co.
(11–13359) 2766

Farrington, Frank, 1872–

Store management—complete, by Frank Farrington ...
Chicago, Byxbee publishing company [°1911]

252 p. front., plates. 18ᶜᵐ. $1.00

© May 18, 1911; 2c. May 24, 1911; A 289405; Byxbee pub. co.
(11–13218) 2767

Fechner, Hanns, 1860–

... Die angelbrüder, ein malersommer in Mittenwald;
mit 16 bildern, skizzen und studien, vom verfasser. Ber-
lin, F. Fontane & co. [°1911]

4 p. l., 240 p. front., illus., plates. 21ᶜᵐ. M. 4

© Mar. 28, 1911; 2c. Apr. 21, 1911*; A—Foreign 2818; F. Fontane & co.
(11–13142) 2768

Gibson, Henry William, 1867–

Camping for boys [by] H. W. Gibson. New York, As-
sociation press, 1911.

249 p. front., illus. 18ᶜᵐ. $1.00
Bibliography at end of most of the chapters.

© May 26, 1911; 2c. May 27, 1911*; A 289286; Internatl. committee of
Y. M. C. A., New York. (11–13024) 2769

459

Good, James Isaac, 1850–

History of the Reformed church in the U. S., in the nineteenth century, by Rev. Prof. James I. Good ... New York, The Board of publication of the Reformed church in America, 1911.

xv, 662 p. front., illus., ports. 24ᶜᵐ.

© May 26, 1911; 2c. May 29, 1911; A 289460; J. I. Good, Philadelphia, Pa. (11–13130) 2770

Greenwood, Augustus George, 1883–

The dumb ambassador, by A. G. Greenwood ... London, Everett & co., ltd., 1911.

319 p. 20ᶜᵐ. 6/

© 1c. May 22, 1911*; A ad int. 640; pubd. Apr. 24, 1911; A. G. Greenwood, England. (11–13137) 2771

Gundolf, Friedrich.

Shakespeare und der deutsche geist, von Friedrich Gundolf. Berlin, G. Bondi, 1911.

viii, 360 p. 24ᶜᵐ. M. 7.50

CONTENTS.—1. buch. Shakespeare als stoff: I. Das theater. II. Der rationalismus.—2. buch. Shakespeare als form: I. Lessing. II. Wieland.—3. buch. Shakespeare als gehalt: I. Herder. II. Goethe. III. Stürmer und dränger. IV. Publikum und theater. V. Schiller. VI. Klassik und romantik.

© Apr. 25, 1911; 2c. June 2, 1911*; A—Foreign 3008; Georg Bondi. (11–13339) 2772

Hampton, Celwyn Emerson.

History of the Twenty-first U. S. infantry, from 1812 to 1863, by Captain Celwyn E. Hampton. Columbus, O., The Edward T. Miller co., 1911.

221 p. col. front., 5 pl., 5 port., 2 maps. 24½ᶜᵐ. $2.50

"Books and papers of reference for the war of 1812 period": p. 104; "Books and papers of reference for the war of the rebellion period": p. 212.

© May 15, 1911; 2c. May 19, 1911; A 289122; C. E. Hampton, San Antonio, Tex. (11–13027) · 2773

Harmon, Albert V.

Large fees and how to get them; a book for the private use of physicians, by Albert V. Harmon, M. D., with introductory chapter by G. Frank Lydston, M. D. Chicago, W. J. Jackman [ᶜ1911]

2 p. l., 3–213 p. 20ᶜᵐ.

© May 2, 1911; 2c. May 6, 1911; A 286925; W. J. Jackman. (11–13206) 2774

Henne am Rhyn, Otto, 1828–

... Illustrierte religions- und sittengeschichte aller zeiten und völker; mit 10 tafeln und 154 textbildern. 1.–5. tausend. Stuttgart, Strecker & Schröder [ᶜ1911]

viii, 263 p. front. (port.) illus., plates. 22½ᶜᵐ. M. 3

"Literatur": p. 255–259.

© Apr. 1, 1911; 2c. May 19, 1911*; A—Foreign 2959; Strecker & Schröder. (11–13131) 2775

Hiorth-Schøyen, Rolf.

... For din skyld, digte. Kristiania og Kjøbenhavn, Gyldendalske boghandel, Nordisk forlag, 1911.
114 p. 20ᶜᵐ. kr. 2
© May 17, 1911; 2c. May 31, 1911*; A—Foreign 2999; Gyldendalske boghandel, Nordisk forlag. (11–13336) **2776**

₁Hurter, Heinrich von₁ 1825–1895.

The beauty and truth of the Catholic church; sermons from the German, adapted and ed. by Rev. Edward Jones; with an introduction by the Most Rev. John Ireland, D. D. Vol. 1. St. Louis, Mo. ₁etc.₁ B. Herder, 1911.
1 p. L, iv, ₍2₎–326 p. 20ᶜᵐ. $1.25
© May 22, 1911; 2c. May 26, 1911*; A 289272; Joseph Gummersbach, St. Louis. (11–13129) **2777**

Johnson, Alexander.

... The almshouse, construction and management, by Alexander Johnson ... New York, Charities publication committee, 1911.
x, 263 p. incl. front., illus., plans. plates (1 fold.) 20½ᶜᵐ. (Russell Sage foundation ₁publications₁) $1.25
© June 1, 1911; 2c. June 5, 1911*; A 289464; Russell Sage foundation, New York. (11–13148) **2778**

Kimball, Arthur Lalanne, 1856–

A college text-book of physics, by Arthur L. Kimball ... New York, H. Holt and company, 1911.
ix, 692 p. illus., diagrs. 22½ᶜᵐ. $2.75
© May 13, 1911; 2c. May 25, 1911*; A 289203; Henry Holt & co. (11–13119) **2779**

Klein, Charles, 1867–

The gamblers; a story of to-day, by Charles Klein and Arthur Hornblow ... illustrations by C. E. Chambers. New York, G. W. Dillingham company ₍ᶜ1911₁
351 p. incl. front. plates. 20ᶜᵐ. $1.50
© June 2, 1911; 2c. June 7, 1911*; A 289530; G. W. Dillingham co. (11–13138) **2780**

Kümmel, Otto.

... Das kunstgewerbe in Japan, van Otto Kümmel; mit 168 textabbildungen und 4 markentafeln. Berlin, R. C. Schmidt & co.; ₁etc., etc.₁ 1911.
vi, ₍2₎, 199, ₍1₎ p. illus. 22½ᶜᵐ. (Bibliothek für kunst- und antiquitätensammler, bd. 2) M. 6
© Apr. 25, 1911; 2c. June 2, 1911*; A — Foreign 3019; Richard Carl Schmidt & co. (11–13354) **2781**

Ladd, George Trumbull, 1842–

Elements of physiological psychology; a treatise of the activities and nature of the mind, from the physical and experimental points of view (thoroughly rev. and

Ladd, George Trumbull—Continued

re-written) by George Trumbull Ladd ... and Robert Sessions Woodworth ... [New ed.] New York, C. Scribner's sons, 1911.

xix, 704 p. illus. 23ᶜᵐ. $4.00
© May 27, 1911; 2c. June 3, 1911*; A 289436; Charles Scribner's sons. (11-13120) **2782**

McCall, Samuel Walker, 1851–

... The business of Congress, by Samuel W. McCall ... New York, The Columbia university press, 1911.

vii, 215 p. 20½ᶜᵐ. (*Half-title:* Columbia university lectures ... George Blumenthal foundation, 1909) $1.50
© June 5, 1911; 2c. June 6, 1911; A 289553; Columbia university press. (11-13147) **2783**

Mattson, Peter August.

Minnen och bilder från Bibelns länder, af Peter August Mattson. Rock Island, Ill., Augustana book concerns tryckeri, 1911.

606 p. illus., map. 20½ᶜᵐ. $2.00
© May 17, 1911; 2c. May 22, 1911*; A 289125; P. A. Mattson, ᶜ/ₒ G. A. College, St. Peter, Minn. (11-13018) **2784**

Moret, Alexandre, 1868–

In the time of the Pharaohs, by Alexandre Moret ... tr. by Mme. Moret; with 16 plates and a map. New York and London, G. P. Putnam's sons, 1911.

xi, 310 p. xvi pl. (incl. front.) fold. map. 21½ᶜᵐ. $2.00
"The following articles ... first appeared in ... Revue de Paris."—Pref.
CONTENTS.—The restoration of the Egyptian temples.—Pharaonic diplomacy.—Egypt before the pyramids.—Around the pyramids.—"The Book of the dead."—Magic in ancient Egypt.
© May 19, 1911; 1c. May 23, 1911; 1c. May 31, 1911*; A 289333; G. P. Putnam's sons. (11-13132) **2785**

Paul, Harry Gilbert.

John Dennis; his life and criticism, by H. G. Paul, PH. D. New York, The Columbia university press, 1911.

viii, 229 p. front. (port.) 24ᶜᵐ. (*Half-title:* Columbia university studies in English) $1.25
"List of Dennis's writings": p. 213–218.
© May 26, 1911; 2c. May 27, 1911*; A 289299; Columbia univ. press. (11-13334) **2786**

The **ready** parliamentarian; a simplified manual of parliamentary law for all those who have use for such knowledge but not the time to study all its complexities and details. It is especially commended to those societies who have adopted Roberts' Rules of order as their final authority, as it conforms to that authority. 1st ed. By Sr. E. C. S. R. [Tampa, Fla., Rinaldi printing company] ᵉ1911·

2 p. l., 38, [3] p. 14½ᶜᵐ. $0.25
© Apr. 25, 1911; 2c. Apr. 26, 1911; A 286686; Sister Esther Charlotte, St. Augustine, Fla. (11-12489) **2787**

Reetz, Henry Christian, 1888–
Electroplating; a treatise for the beginner and for the most experienced electroplater, by Henry C. Reetz ... Chicago, Popular mechanics company [c1911]
3 p. l., 9–99 p. illus., diagrs. 17½ᶜᵐ. (Popular mechanics twenty-five-cent handbook series) $0.25
© Apr. 25, 1911; 2c. Apr. 29, 1911*; A 286543; H. H. Windsor, Chicago. (11–13350) 2788

Rockwell, Frederick Frye, 1884–
Home vegetable gardening; a complete and practical guide to the planting and care of all vegetables, fruits and berries worth growing for home use, by F. F. Rockwell. New York, McBride, Winston & company, 1911.
4 p. l., 262 p. front., illus., plates. 19½ᶜᵐ. $1.00
© May 15, 1911; 1c. May 19, 1911; 1c. May 25, 1911*; A 289234; McBride, Winston & co. (11–13022) 2789

Rugg, *Mrs.* **Ellen Rebecca (Foster)** 1842–
The descendants of John Rugg, by Ellen R. Rugg ... New York, F. H. Hitchcock [c1911]
4 p. l., 580 p. 24ᶜᵐ. $6.00
© May 29, 1911; 2c. June 2, 1911*; A 289389; Frederick H. Hitchcock. (11–13211) 2790

Saylor, Henry Hodgman, 1880–
Bungalows; their design, construction and furnishing, with suggestions also for camps, summer homes and cottages of similar character ... by Henry H. Saylor. New York, McBride, Winston & company, 1911.
6 p. l., 188, [3] p. front., illus. (incl. plans) 26ᶜᵐ. $1.50
© May 27, 1911; 2c. June 1, 1911*; A 289363; McBride, Winston & co. (11–13352) 2791

[**Slocomb, George Whitney**]
Something for nothing; what it is and how it may be cured; or, Single tax socialism ... [Los Angeles, Cal., G. W. Slocomb] c1911·
48 p. 19½ᶜᵐ. $0.2
© May 11, 1911: 2c. May 17, 1911*; A 286963; G. W. Slocomb, Los Angeles. (11–12488) 2792

Solenberger, *Mrs.* **Alice (Willard)** *d.* 1910.
... One thousand homeless men; a study of original records, by Alice Willard Solenberger. New York, Charities publication committee, 1911.
2 p. l., vii–xxiv, 374 p. incl. tables. plates. 20½ᶜᵐ. (Russell Sage foundation [publications]) $1.25
© May 29, 1911; 2c. June 5, 1911*; A 289463; Russell Sage foundation, New York. (11–13151) 2793

Stegemann, Hermann, 1870–
Theresle, roman von Hermann Stegemann. Berlin, E. Fleischel & co., 1911.
3 p. l., 327 p. 20½ᶜᵐ. M. 4
© Apr. 19, 1911; 2c. June 2, 1911*; A—Foreign 3015; Egon Fleischel & co. (11–13338) 2794

Strassmann, Fritz, 1858– *ed.*

Medizin und strafrecht, ein handbuch für juristen, laienrichter und ärzte, unter mitwirkung von med.-rat. dr. H. Hoffmann ... und dr. H. Marx ... hrsg. von geh. med.-rat dr. F. Strassmann ... Mit einem anhang: Die kriminellen vergiftungen von dr. P. Fraenckel ... Berlin-Lichterfelde, P. Langenscheidt, 1911.

viii, 564 p. illus. 27½ᶜᵐ. ₍Encyklopädie der modernen kriminalistik. bd. 9₎ M. 20

© Apr. 10, 1911; 2c. June 2, 1911*: A—Foreign 3010; P. Langenscheidt.
(11–13026) 2795

Sturgis, Roger Faxton, 1862–

Taxation; a problem, by Roger F. Sturgis. Boston, Boston news bureau company, 1911.

32 p. 23ᶜᵐ. $0.25

© May 24, 1911; 2c. May 27, 1911*; A 289266; Boston news bureau co.
(11–13362) 2796

Synodalalbum. Bilder von allgemeinem interesse aus der Deutschen Ev.-Luth. synode von Missouri, Ohio u. a. st. St. Louis, Mo., Concordia publishing house, 1911.

85, ₍1₎ p. illus. 16 x 24ᶜᵐ.

© May 8, 1911; 2c. May 18, 1911*; A 286989; Concordia pub. house.
(11–12513) 2797

Tabor, Grace.

The landscape gardening book, wherein are set down the simple laws of beauty and utility which should guide the development of all grounds, by Grace Tabor. New York, McBride, Winston & company, 1911.

5 p. l., 180 p. front., illus. (incl. plans) plates. 26½ᶜᵐ. $2.00

© May 15, 1911; 1c. May 19, 1911; 1c. May 25, 1911*; A 289235; McBride, Winston & co. (11–13023) 2798

Thompson, Maurice de Kay, 1877–

Applied electrochemistry, by M. de Kay Thompson ... New York, The Macmillan company, 1911.

xii p., 1 l., 329 p. illus. 22½ᶜᵐ. $2.10
Bibliographical foot-notes.

© May 31, 1911; 2c. June 1, 1911*: A 289364; Macmillan co.
(11–13349) 2799 ·

Vale, Ruby Ross.

A digest of the decisions of the courts of the commonwealth of Pennsylvania from 1754 to 1907 ... by Ruby R. Vale ... and Thomas E. Vale ... v. 7. ₍Negotiable instruments–Quo warranto₎ Philadelphia, The George T. Bisel company, 1911.

2 p. l., p. 9476–11157. 27ᶜᵐ. $8.00

© June 8, 1911; 2c. June 10, 1911*; A 289638; George T. Bisel co.
 2800

American school of correspondence, *Chicago.*

Cyclopedia of motion-picture work; a general reference work on the optical lantern, motion head, specific project- *4-* ing machines, talking pictures, color motography, fixed camera photography, motography, photo-plays, motion-picture theater, management and operation, audience, program, etc. Prepared by David S. Hulfish ... illustrated with over three hundred engravings. Chicago, American school of correspondence, 1911.

2 v. fronts., illus., plates. 25ᶜᵐ. $7.50

© June 2, 1911; 2c. June 5. 1911*; A 289474; Amer. school of correspond-
ence. (11-13595) 2801

Arnold, James Newell.

Vital record of Rhode Island, 1636-1850. First series; births, marriages and deaths; a family register for the people, by James N. Arnold ... v. 20. Rhode Island American: marriages H to Z, deaths A and B ... Providence, R. I., Narragansett historical publishing company, 1911.

xcvii p., 2 l., ₁21₁-640 p. 29ᶜᵐ. $7.50

© May 15. 1911; 2c. June 19, 1911*; A 289883; J. N. Arnold, Providence,
R. I. 2802

Arthur, William, 1860-

Our home city, by William Arthur ... ₁Omaha? Neb.₁ ꞏ1911·

133, ₁3₁ p. 16ᶜᵐ. $0.25
Maps on 1st and 4th p. of cover.

© May 25. 1911; 2c. May 29. 1911*; A 289324; W. Arthur, Omaha, Neb.
(11-13219) 2803

Austlid, Andreas.

... Ein folkelærar ... Kristiania og Kjøbenhavn, Gyldendalske boghandel, Nordisk forlag, 1911.

177 p. 21½ᶜᵐ. kr. 3
"Her endar fyrste boki um Kristen Kold ... I andre boki skal me fylgja han ... heilt til enden."—p. 177.

© May 15, 1911; 2c. May 31. 1911*; A—Foreign 3000; Gyldendalske bog-
handel, Nordisk forlag. (11-13621) 2804

Avery, Charles Luther, 1886- *ed.*

The Pacific cases, annotated ... Book 1, containing all decisions reported in California reports, volumes 1-7. Edited and annotated by Charles L. Avery and Harry Zimmerhackel ... under the general supervision of William H. Courtright, ll. b. Denver, The W. H. Courtright publishing company, 1911.

1627 p. 26½ᶜᵐ. $7.50

© May 15, 1911; 2c. May 26, 1911*; A 289245; William H. Courtright,
Denver. (11-13197) 2805

1911, no. 44
Printed June 24, 1911

Bargone, Charles₁ i. e. Frédéric Charles Pierre Édouard, 1876–

... La bataille. Éd. définitive. Paris, P. Ollendorff, °1911.

3 p. l., vi p., 1 l., 319, ₁1₁ p. 19ᶜᵐ. fr. 3.50
Author's pseudonym, Claude Farrère, at head of title.
© May 5, 1911; 2c. May 26, 1911; A—Foreign 2994; C. Farrère, Paris.
(11–12468) 2806

Briggs, Thomas Henry, 1877–

Reading in public schools, by Thomas H. Briggs ... and Lotus D. Coffman ... Rev. and enl. Chicago, Row, Peterson & co. ₍°1911₎

332 p. illus. 20ᶜᵐ. $1.25
Contains bibliographies.
© May 29, 1911; 2c. June 5, 1911*; A 289490; T. H. Briggs and Lotus D. Coffman, Charleston, Ill. (11–13620) 2807

Britan, Halbert Hains.

The philosophy of music; a comparative investigation into the principles of musical æsthetics, by Halbert Hains Britan ... New York ₍etc.₎ Longmans, Green, and co., 1911.

xiv, 252 p. 20½ᶜᵐ. $1.35
"References": p. ix.
© May 16, 1911; 2c. May 29, 1911*; A 289318; Longmans, Green, & co.
(11–13603) 2808

Carus, Paul, 1852–

The Buddha; a drama in three acts and four interludes, by Paul Carus ... Chicago, The Open court publishing co., 1911.

iv, 68 p. 19½ᶜᵐ.
© Apr. 21, 1911; 2c. May 15, 1911*; D 24212; Open court pub. co.
(11–12509) 2808*

Comfort, Will Levington.

She buildeth her house, by Will Levington Comfort ... with a frontispiece by Martin Justice. Philadelphia & London, J. B. Lippincott company, 1911.

3 p. l., 5–352 p. col. front. 19½ᶜᵐ. $1.25
© May 15, 1911; 2c. June 9, 1911*; A 289591; J. B. Lippincott co.
(11–13520) 2809

Currier, Charles Warren, 1857–

Lands of the Southern cross; a visit to South America, by Rev. Charles Warren Currier ... Washington, D. C., Spanish-American publication society, 1911.

401 p. incl. front. (map) plates. 20ᶜᵐ. $1.50
Bibliography: p. 396–401.
© June 2, 1911; 2c. June 3, 1911*; A 289456; C. W. Currier, Washington.
(11–13546) 2810

Daniels, Ernest Darwin, 1865–

... A sight book in Latin; parallel passages for sight translation, by Ernest Darwin Daniels ... Boston, New York [etc.] B. H. Sanborn & co., 1911.
xiii, 118 p. 18ᶜᵐ. (The Students' series of Latin classics)
© May 29, 1911; 2c. June 2, 1911*; A 289403; E. D. Daniels, Brooklyn, N. Y. (11–13525) 2811

Davis, Malcolm B.

Health, happiness and long life; or, Looking on the bright side ... self-improvement and how to promote happiness ... together with advice to young men and young women ... by Malcolm B. Davis, M. D., and Mrs. Kate Chalmers Jenness. Philadelphia, Pa., National publishing co. [ᶜ1911]
iv, [7]–256 p. plates. 21ᶜᵐ. $1.00
© May 13, 1911; 2c. May 20, 1911*; A 289058; George W. Bertron, Philadelphia. (11–13207) 2812

Defoe, Daniel, 1661–1731.

... The life and adventures of Robinson Crusoe, written by Daniel Defoe; ed. by Kate Stephens ... New York, Cincinnati [etc.] American book company [ᶜ1911]
256 p. illus. 16½ᶜᵐ. (Eclectic English classics)
© May 27, 1911; 2c. May 31, 1911*; A 289336; Amer. book co. (11–12827) 2813

Eisenhüttenwesen, unter redaktioneller mitwirkung von

direktor Wilhelm Venator ... und dr. Colin Ross ... mit über 1600 abbildungen und zahlreichen formeln. München und Berlin, R. Oldenbourg; [etc., etc.] 1911.
xii, 785 p. illus. 18ᶜᵐ. (Illustrierte technische wörterbücher in sechs sprachen ... bd. XI) M. 10
© Apr. 27, 1911; 2c. May 22, 1911*; A—Foreign 2980; R. Oldenbourg. (11–12530) 2814

Ellis, Edward Sylvester, 1840–

The hunter's cabin; an episode of the early settlements of southern Ohio, by Edward S. Ellis ... New York, Hurst & company [ᶜ1911]
256 p. incl. front., plates. 19½ᶜᵐ. $0.50
© June 5, 1911; 2c. June 10, 1911*; A 289629; Hurst & co. (11–13613) 2815

Irona; or, Life on the southwest border, by Edward S. Ellis ... New York, Hurst & company [ᶜ1911]
245 p. incl. front., plates. 19½ᶜᵐ. $0.50
© June 7, 1911; 2c. June 10, 1911*; A 289631; Hurst & co. (11–13614) 2816

The lost trail, by Edward S. Ellis ... New York, Hurst & company [ᶜ1911]
203 p. incl. front., plates. 19½ᶜᵐ. $0.50
© June 5, 1911; 2c. June 10, 1911*; A 289630; Hurst & co. (11–13615) 2817

Ellis, Edward Sylvester, 1840–
The ranger; or, The fugitives of the border, by Edward S. Ellis ... New York, Hurst & company [c1911]
224 p. incl. front., plates. 19½ᶜᵐ. $0.50
© June 6, 1911; 2c. June 10, 1911*; A 289632; Hurst & co.
(11–13616) 2818

Grahame-White, Claude.
The story of the aëroplane, by Claude Grahame-White. Boston, Small, Maynard and company [c1911]
1 p. l., 380 p. tables. 20½ᶜᵐ. $2.50
© May 24, 1911; 2c. May 26, 1911; A 289608; Small, Maynard & co., inc.
(11–13601) 2819

Haney, Lewis Henry.
History of economic thought; a critical account of the origin and development of the economic theories of the leading thinkers in the leading nations, by Lewis H. Haney ... New York, The Macmillan company, 1911.
xvii, 567 p. 20½ᶜᵐ. $2.00
"Bibliographical note": p. 551–556.
© June 7, 1911; 2c. June 8, 1911*; A 289555; Macmillan co.
(11–13625) 2820

Hazlewood, Francis Tomlinson, 1839–1908.
The discontented clam, and other stories, by Francis T. Hazlewood; illustrated by his daughter Charlotte Hazlewood. Boston, Sherman, French & company, 1911.
2 p. l., 87 p. illus. 21½ x 18ᶜᵐ. $1.00
CONTENTS.—The discontented clam.—How one squirrel got his stripes.—The jewel in the toad's mouth.—The old frog and his grandsons.—The turtle's reward.—The priceless pearl.—Bos'n's Thanksgiving.—Aunt Julia's Christmas present.—Mag Wilson.
© May 29, 1911; 2c. June 3, 1911*; A 289452; Sherman, French & co.
(11–13612) 2821

Holland, Rupert Sargent, 1878–
The boy scouts of Birch-bark Island, by Rupert Sargent Holland ... with illustrations by Herbert Pullinger. Philadelphia & London, J. B. Lippincott company, 1911.
292 p. col. front., plates. map. 19½ᶜᵐ. $1.25
© May 29, 1911; 2c. June 9, 1911*; A 289595; J. B. Lippincott co.
(11–13522) 2822

Horstmann, Henry Charles, 1858– *ed.*
Electrical workers standard library; complete, practical, authoritative, comprehensive, up-to-date working manuals for electrical workers ... Henry C. Horstmann, Victor H. Tousley ... assisted by the instructors, Electrical department, National institute of practical mechanics. Brotherhood ed. Chicago, National institute of practical mechanics [c1911]
7 v. illus., diagrs. 18ᶜᵐ. $24.00
"Authorities consulted" at beginning of each volume.
CONTENTS.—v. 1. Elementary electricity, by S. Aylmer-Small.—v. 2. Electrical construction, by Horstmann and Tousley.—v. 3. Dynamo electric

Horstmann, Henry Charles—Continued

machinery, by C. F. Swingle.—v. 4. Electric wiring and tables, by Horstmann and Tousley.—v. 5. Armature winding, by Horstmann and Tousley.—v. 6. Operating and testing, by Horstmann and Tousley.—v. 7. Electrical dictionary, by P. E. Lowe.
© June 5, 1911; 2c. June 7, 1911*; A 289520; National institute of practical mechanics. (11–13599) 2823

Housman, Laurence, 1867–

Pains and penalties; an historical tragedy, in four acts, by Laurence Housman. London, Sidgwick & Jackson, ltd. [c1911]

3 p. l., [5]–89, [1] p. 19⁰ᵐ.
© May 10, 1911; 2c. May 11, 1911*; D 24187; Sidgwick & Jackson, ltd. (11–11549) 2823*

International correspondence schools, *Scranton, Pa.*

Tratado de alumbrado y tranvías eléctricos, preparado especialmente para los estudiantes de las Escuelas internacionales de enseñanza por correspondencia. t. 4 ... Scranton, Pa., International textbook company [1911]

Various paging. illus., plates, diagrs. 23ᶜᵐ.
© Feb. 14, 1911; 2c. June 20, 1911*; A 289912; International textbook co.
2824

Kephart, Horace, 1862–

The book of camping and woodcraft; a guidebook for those who travel in the wilderness, by Horace Kephart. [4th ed.] New York, Outing publishing company, 1910.

xiv p., 1 l., 331 p. front., illus., plates. 18ᶜᵐ. $2.00
© Jan. 14, 1911; 2c. June 7, 1911*; A 289529; Outing pub. co. (11–13531) 2825

Knott, John Olin, 1859–

Seekers after soul, by John O. Knott, PH. D. Boston, Sherman, French & company, 1911.

5 p. l., 208 p. 21ᶜᵐ. $1.20
"The chapter on 'The persistence of ideas' is the essence of a thesis presented a few years ago to the faculty of Washington and Lee university for the degree of doctor of philosophy." The chapters on Job and Browning were published in a somewhat different form in the "Methodist review," Nashville, Tenn.
CONTENTS.—Job: the soul's pathfinder.—Plato: intimations of immortality.—Kant: a protest against materialism.—Hegel: theistic evolution.—Persistence of ideas: the spirit in the trend of thought.—Robert Browning: the subtle assertor of the soul.
© May 27, 1911; 2c. June 1, 1911*; A 289383; Sherman, French & co. (11–13128) 2826

Lenéru, Marie.

... Les affranchis, pièce en trois actes ... préface de M. Fernand Gregh. 4. éd. Paris, Hachette et cⁱᵉ, 1911.

xx, 227, [1] p. 19ᶜᵐ. fr. 3.50
© Apr. 21, 1911; 2c. May 12, 1911*; D 24192; Hachette & cie. (11–12816) 2826*

Linke, Franz *i. e.* **Karl Wilhelm Franz,** 1878–

Aeronautische meteorologie, von dr. Franz Linke ...
1. t. Frankfurt a. M., F. B. Auffarth, 1911.

viii, 133 p. illus., tables, diagrs. 22½ᶜᵐ. (*Added t.-p.*: Luftfahrzeugbau und -fürung, hand- und lehrbücher des gesamtgebietes ... hrsg. von P. Neumann. 1. bd.)
© Jan. 25, 1911; 2c. June 2, 1911*; A—Foreign 3007; Franz Benjamin Auffarth. (11–13122) 2827

Lyon & Healy, *Chicago.*

Rare old violins. Chicago, Lyon & Healy [ᶜ1911]

cover-title, 1 p. l., [5]–102 p. mounted illus. 26½ x 13½ᶜᵐ.
© May 12, 1911; 2c. May 19, 1911*; A 289014; Lyon & Healy. (11–13604) 2828

Lytton, *Hon. Mrs.* **Judith Anne Dorothea (Blunt)**

Toy dogs and their ancestors, including the history and management of toy spaniels, Pekingese, Japanese and Pomeranians, by the Hon. Mrs. Neville Lytton, with numerous illustrations. London, Duckworth & co., 1911.

xix, 358 p., 1 l. col. front., plates (partly col.) ports., plans. 24½ᶜᵐ. 25/
© 1c. June 3, 1911* A ad int. 658; publ. May 19, 1911; J. Lytton, London. (11–13530) 2829

Mackenzie, George Norbury, *ed.*

Colonial families of the United States of America, in which is given the history, genealogy and armorial bearings of colonial families who settled in the American colonies from the time of the settlement of Jamestown, 13th May, 1607, to the battle of Lexington, 19th April, 1775; ed. by George Norbury Mackenzie ... v. 2. Baltimore, Md., The Seaforth press, 1911.

4 p. l., [3]–941 p., 1 l. illus. 25½ᶜᵐ.
© May 25, 1911; 2c. June 19, 1911*; A 289862; G. N. Mackenzie, Baltimore. 2830

Metal worker, plumber and steam fitter.

Practical sheet metal work and demonstrated patterns ... v. 2, 4, 5 ... Ed. by J. Henry Teschmacher, jr. New York, D. Williams company, 1911.

3 v. illus., diagrs. 28ᶜᵐ. $1.50 a vol.
CONTENTS.—v. 2. Gutters and roof outlets. — v. 4. Ridging and corrugated iron work.—v. 5. Cornice patterns.
v. 2 © Mar. 3, 1911; v. 4, 5 © Apr. 24, 1911; 2c. each Apr. 27, 1911; A 289908–289910; David Williams co. 2831–2833

Methodist brotherhood.

The constitution, by-laws and ritual of the Methodist brotherhood, prepared and ed. by Dr. Frank E. Day ... and Anson E. Hagle ... [Albion, Mich., The Recorder press] 1911.

90 p. incl. illus., plates. 15½ᶜᵐ. $0.35
© May 10, 1911; 2c. May 18, 1911; A 289298; A. E. Hagle, St. Joseph, Mo. (11–13346) 2834

Nellis, Andrew J.

The law of street railroads; a complete treatise on the law relating to the organization of street railroads, the acquisition of their franchises and property, their regulation by statute and ordinance, their operation and liability for injuries to the person and property of passengers, employees and travelers, and others on the public streets and highways, including also pleading and practice, by Andrew J. Nellis. 2d ed. Albany, N. Y., M. Bender & co., 1911.

2 v. 24⬚. $13.00

© June 5, 1911; 2c. June 7, 1911*; A 289536; Matthew Bender & co.
(11-13609) 2835

Oppenheim, James, 1882–

Pay envelopes; tales of the mill, the mine and the city street, by James Oppenheim; illustrated by Harry Townsend. New York, B. W. Huebsch, 1911.

259 p. front., plates. 19⬚. $1.25
"The stories collected in this volume first appeared in the following magazines: The American, Everybody's, Forum, Metropolitan, Pearson's, Success."
CONTENTS.—The great fear—Meg.—Saturday night.—The cog.—Slag.—A woman.—Joan of the mills.—The empty life.—The young man.—The broken woman.—Stiny Bolinsky.

© May 1, 1911; 2c. June 9, 1911*; A 289603; B. W. Huebsch.
(11-13523) 2836

Patten, *Mrs. Francis Jarvis, comp.*

Our New England family recipes, comp. by Mrs. Francis Jarvis Patten. [New York, National society New England women, ᶜ1910]

134 p. illus. 18½⬚. $1.00
"National society New England women": p. 131–134.

© Nov. 10, 1910; 2c. Feb. 23, 1911; A 283687; National society of New England women. (11-12715) 2837

Payson, Howard.

The boy scouts on the range, by Lieut. Howard Payson. New York, Hurst & company [ᶜ1911]

306 p. front., plates. 19½ ᶜᵐ. $0.50

© May 16, 1911; 2c. May 19, 1911*; A 289017; Hurst & co.
(11-11449) 2838

Preyer, David C.

The art of the Vienna galleries, giving a brief history of the public and private galleries of Vienna, with a critical description of the paintings therein contained. By David C. Preyer ... Boston, L. C. Page & company, 1911.

vi p., 1 l., xiii–xiv, 331 p. front., plates, ports. 20⬚. $2.00
Bibliography: p. 319–320.

© June 2, 1911; 2c. June 5, 1911*; A 289486; L. C. Page & co., inc.
(11-13353) 2839

Robison, William Michael, 1846–

The scar, by Mike Robison. Nashville, Tenn., The Cumberland press, 1911.

96 p. 20ᶜᵐ. $0.50
© May 29, 1911; 2c. June 2. 1911*; A 289413; R. L. Baskette, Nashville, Tenn. (11–13357) 2840

Russia. *Laws, statutes, etc.*

Handbuch des gesamten russischen zivilrechts [bearb. von Klibanski] ... 1. bd. (1. & 2. buch.) Berlin, Vereinigte verlagsanstalten G. Braunbeck & Gutenberg-druckerei a. g., 1911.

xxv, (2), 487 p. 26ᶜᵐ. M. 14
© May 1, 1911; 2c. June 2. 1911*; A—Foreign 3009; Braunbeck-Gutenberg a.-g., Berlin. (11–13608) 2841

Schleiermacher, Friedrich Ernst Daniel, 1768–1834.

The theology of Schleiermacher; a condensed presentation of his chief work, "The Christian faith," by George Cross ... Chicago, Ill., The University of Chicago press [1911]

xi, 344 p. 20ᶜᵐ. $1.50
"Works of reference": p. 335–337.
© May 31, 1911; 2c. June 5. 1911*; A 289473; University of Chicago. (11–13345) 2842

Scott, John Reed, 1869–

In her own right, by John Reed Scott ... with illustrations in color by Clarence F. Underwood. Philadelphia and London, J. B. Lippincott company, 1911.

336 p. col. front., col. plates. 20ᶜᵐ. $1.25
© May 15. 1911; 2c. June 9. 1911*; A 289594; J. R. Scott, Washington. (11–13521) 2843

Tassin, Algernon.

Rust; a play in four acts, by Algernon Tassin. New York, Broadway publishing co. [1911]

172 (i. e. 166) p. 20ᶜᵐ.
© May 4. 1911; 2c. May 4. 1911; D 24188; A. Tassin, New York. (11–11668) 2843*

Taylor's digest of merchandising and advertising information. 1911 ed. [Chicago? 1911]

359 p. 13ᶜᵐ.
© May 2, 1911; 2c. May 8. 1911*; A 286766; Taylor-Critchfield co., Chicago. (11–11067) 2844

Thoinot, Léon Henri, 1858–

Medicolegal aspects of moral offenses, by L. Thoinot ... tr. from the original French and enl. by Arthur W. Weysse ... Illustrated with seventeen engravings, including four charts and diagrams. (Only authorized translation into English) Philadelphia, F. A. Davis company, 1911.

xv, 487 p. illus. 22½ᶜᵐ. $3.00
© May 31, 1911; 2c. June 5, 1911*; A 289493; F. A. Davis co. (11–13538) 2845

Ammerman, Mary David.
The white rose of the Miami, by Mary David Ammerman. New York, Chicago [etc.] Broadway publishing co. [¹1911]
154 p. 20ᶜᵐ. $1.50
© Apr. 13, 1911; 2c. May 27, 1911; A 289734; M. D. Ammerman, Millersbury, Ky. (11-14098) **2846**

Beals, Charles Elmer.
Religious studies for laymen; studies in theology, by Charles Elmer Beals ... Lectures I–XIII. New York, Cochrane publishing co., 1911.
109 p. 19ᶜᵐ. $0.60
Bibliography: p. 109.
© May 31, 1911; 2c. June 5, 1911*; A 289461; C. E. Beals, Eastport, Me. (11-13751) **2847**

Boissière, Albert.
The man without a face, L'homme sans figure, by Albert Boissière. English version by Florence Crewe-Jones; illustrations by J. H. Redman. New York, G. W. Dillingham company [¹1911]
6 p., 1 l., 7–339 p. incl. front. plates. 19ᶜᵐ. $1.25
© June 9, 1911; 2c. June 13, 1911*; A 289688; G. W. Dillingham co. (11-13980) **2848**

Buck, Charles Neville.
The lighted match, by Charles Neville Buck ... illustrations by R. F. Schabelitz. New York, W. J. Watt & company [¹1911]
307, [8] p. front., plates (1 double) ports. 19ᶜᵐ. $1.25
"Two popular authors & something about them": 8 p. at end.
© June 10, 1911; 2c. June 12, 1911*; A 289669; W. J. Watt & co. (11-13729) **2849**

Carter, Ada.
Priest and layman, by Ada Carter ... New York, Wessels & Bissell co., 1911.
317 p. 19½ᶜᵐ. $1.20
© Apr. 19, 1911; 2c. May 8, 1911; A 289622; Wessels & Bissell co. (11-13728) **2850**

Charlton, Randal.
The bewildered bride; a matter of fact, transcribed by Randal Charlton ... London, E. Nash, 1911.
vi p., 1 l., 312 p. 19½ᶜᵐ. 6/
© 1c. June 4, 1911; A ad int. 670; pubd. May 4, 1911; R. Charlton, London. (11-14099) **2851**

Cherubini, E.
Pinocchio in Africa, tr. from the Italian of Cherubini by Angelo Patri ... Original drawings by Charles Copeland. Boston, New York [etc.] Ginn and company [¹1911]
viii, 152 p. incl. front. illus. 17½ᶜᵐ. $0.40
© Apr. 24, 1911; 2c. May 20, 1911*; A 289090; Angelo Patri, New York. (11-14097) **2852**

473

Clarke, Helen Archibald.

A guide to mythology for young readers, by Helen A. Clarke ... New York, The Baker & Taylor company, 1910.

399 p. front., plates. 19ᶜᵐ. (*On cover:* The guide series)
© Dec. 15, 1908; 2c. Mar. 20, 1911; A 283933; Baker & Taylor co.
(11-6951) 2853

Curtis, Alice Turner.

Grandpa's little girls and Miss Abitha, by Alice Turner Curtis ... illustrated by Wuanita Smith. Philadelphia, The Penn publishing company, 1911.

206 p. front., plates. 19½ᶜᵐ. $1.00
© June 10, 1911; 2c. June 12, 1911*; A 289676; Penn pub. co.
(11-13982) 2854

Davis, Lee Barham.

The power of conscience, by Lee Barham Davis. New York, The Stuyvesant press, 1911.

vii, 225 p. 19½ᶜᵐ. $1.00
© June 10, 1911; 2c. June 12, 1911*; A 289663; Stuyvesant press.
(11-13731) 2855

Farmer, Fannie Merritt, 1857–

Catering for special occasions, with menus & recipes, by Fannie Merritt Farmer ... illustrated with half tone engravings of set tables; decorations by Albert D. Blashfield. Philadelphia, D. McKay [°1911]

x, 240 p. front., illus., plates. 20¼ᶜᵐ. $1.00
© June 7. 1911; 2c. June 9, 1911*; A 289600; David McKay.
(11-14120) 2856

Foster, Charles.

... The story of the Bible from Genesis to Revelation. Told in simple language adapted to all ages, but especially to the young. By Charles Foster, with three hundred illustrations ... Philadelphia, Pa., Charles Foster publishing co. [°1911]

704 p. col. front., illus., col. plates. 23ᶜᵐ. $1.50
© June 7, 1911; 2c. June 8, 1911; A 289617; W. A. Foster, Philadelphia.
(11-14112) 2857

Givins, Robert C.

Jones abroad, by Robert C. Givins ... Chicago, Ill., The Jones abroad publishing company [°1911]

520 p illus. 20ᶜᵐ. $1.25
© June 2, 1911; 2c. June 13, 1911*; A 289694; Jones abroad pub. co.
(11-14096) 2858

Grover, Delo Corydon.

The volitional element in knowledge and belief; and other essays in philosophy and religion, by Delo Corydon Grover ... introduction by Francis J. McConnell ... Boston, Sherman, French & company, 1911.

3 p. l., ix, 168 p. 20¼ᶜᵐ. $1 20
© May 31. 1911; 2c. June 3, 1911*; A 289453; Sherman, French & co.
(11-13723) 2859

Halm, Eugene Wallace John, 1883– ed.

The life work of "Farmer" Burns, formerly the
world's champion wrestler, exponent of clean living, and
temperate habits ... E. W. Halm, editor. Omaha, Neb..
A. J. Kuhlman [°1911]

117, [63] p. incl. front., illus., ports. 22½ᶜᵐ. $1.50
© May 27, 1911; 2c. May 31, 1911*; A 289359; Martin Burns, Omaha, Neb.
(11–13769) 2860

Hapgood, George.

Home games, by George Hapgood ... Philadelphia,
The Penn publishing company, 1911.

199 p. 15ᶜᵐ. $0.50
© June 3, 1911; 2c. June 5, 1911*; A 289470; Penn pub. co.
(11–13771) 2861

Hellyer, Henry Leon, 1880–

From the rabbis to Christ; a personal narrative sug-
gesting the kind of gospel that will appeal to the Jew, by
H. L. Hellyer. Philadelphia, The Westminster press,
1911.

87 p. 18½ᶜᵐ. $0.25
© May 31, 1911; 2c. June 5, 1911; A 289506; Trustees of the Presbyterian
board of publication and Sabbath school work, Philadelphia.
(11–13750) 2862

Hobart, Alvah Sabin, 1847–

A key to the New Testament; or, Letters to teachers
concerning the interpretation of the New Testament, by
Alvah S. Hobart ... Philadelphia, Boston [etc.] The Grif-
fith & Rowland press [°1911]

176 p. 17½ᶜᵐ. $0.40
© Feb. 17, 1911; 2c. Mar. 23, 1911*; A 283616; A J. Rowland, sec., Phila-
delphia. (11–7759) 2863

Hodson, Jane, ed.

How to become a trained nurse: a manual of informa-
tion in detail. With a complete list of the various train-
ing schools for nurses in the United States and Canada.
3d ed. Edited by Jane Hodson ... New York, W. Abbatt,
1911.

6 p. l., [11]–307 p. col. front., illus., plates, group of ports., fold. forms.
22ᶜᵐ. $2.25
"General list of books for nurses": p. 305–307.
© May 10, 1911; 2c. May 29, 1911; A 289707; William Abbatt.
(11–14125) 2864

Jodidi, Samuel Leo, 1867–

The sugar beet and beet sugar [by] Dr. Samuell [!] Jo-
didi, PH. D. [Chicago, Beet sugar gazette company, °1911]
1 p. l., 94 p. 20ᶜᵐ.
© Mar. 3, 1911; 2c. Mar. 27, 1911*; A 283700; Beet sugar gazette co.
(11–8107) 2865

Kelly, Thomas L.

Some plain sermons, by Rev. Thomas L. Kelly ... St. Louis, Mo. [etc.] B. Herder, 1911.

4 p. l., 319 p. 20ᶜᵐ. $1.25
© June 6, 1911; 2c. June 8, 1911*; A 289583; Joseph Gummersbach, St. Louis. (11-14111) **2866**

Lincoln, Joseph Crosby, 1870-

The woman-haters; a yarn of Eastboro twin-lights, by Joseph C. Lincoln ... New York and London, D. Appleton and company, 1911.

ix p., 1 l., 338 p., 1 l. front., plates. 19½ᶜᵐ. $1.25
© June 9, 1911; 2c. June 13, 1911*; A 289700; D. Appleton & co. (11-14100) **2867**

McMurtrie, Douglas Crawford.

The conservation of vision; an essay on the care of the eyes: eye-strain, eye diseases, illumination, improvement, by Douglas C. McMurtrie. New York city, 1911.

43, [1] p. 18¼ᶜᵐ. $0.50
© Apr. 26, 1911; 2c. June 3, 1911*; A 289448; D. C. McMurtie, New York. (11-14124) **2868**

Magie, William Francis, 1858-

Principles of physics, designed for use as a textbook of general physics, by William Francis Magie ... New York, The Century co., 1911.

ix, 570 p. illus., diagrs. 22½ᶜᵐ. $2.50
© June 2, 1911; 2c. June 3, 1911*; A 289422; Century co. (11-13757) **2869**

Morgan, S Rowland, 1877-

A consideration of the great law as revealed in history and in the uncreeded gospel of Christ, by S. R. Morgan. Philadelphia, 1911.

2 p. l., 21 p 21¼ᶜᵐ. $0.50
© May 17, 1911; 2c. May 19, 1911*; A 289041; S. R. Morgan, Philadelphia. (11-14110) **2870**

New Mexico. *Supreme court.*

Reports of cases determined in the Supreme court of the territory of New Mexico, from January 1, 1909, to December 31, 1910. Paul A. F. Walter, reporter. v. 15. Santa Fe, N. M., New Mexican printing company, 1911.

752 p. 23½ᶜᵐ. $2.70
© June 19, 1911; 2c. June 23, 1911*; A 289999; New Mexican printing co. **2871**

Norton, Charles.

Modern yeasting & distillation; a work on the manufacture of whiskey and alcohol ... by Charles Norton. Chicago, Ill. [Mitchell, Larimer & Titus, printers] 1911.

68 p. illus. 22ᶜᵐ. $12.00
© June 3, 1911; 2c. June 7, 1911*; A 289518; C. Norton, Chicago. (11-14122) **2872**

Oxtoby, James Veech, 1872–

Legal phases of central station rate making for electric supply, including the status of the wholesale customer, the status of the special customer and reasonable profit, its definition, collection and distribution, by James V. Oxtoby ... being a revision of papers read by the author at the annual meetings of the Association of Edison illuminating companies held in 1907, 1908 and 1910. New York, Printed but not published by order of the Association of Edison illuminating companies, 1911.
3 p. l., 5–225 p. 23½ᶜᵐ.
© May 22, 1911; 2c. June 5, 1911*; A 289468; Assn. of Edison illuminating cos. (11–14105) **2873**

Page, Gertrude.

Winding paths, by Gertrude Page ... New York, D. Appleton and company, 1911.
3 p. l., 405 p. 19½ᶜᵐ. $1.25
© June 9, 1911; 2c. June 13, 1911*; A 289701; D. Appleton & co. (11–14102) **2874**

Philip, Brother.

Meditations on our last end and on sin and the sacrament of penance, by Brother Philip ... New and rev. ed. Authorized English version. New York, La Salle bureau of supplies, 1911.
x. 468 p. 19½ᶜᵐ. $1 00
© Apr. 1, 1911; 2c. June 5, 1911*; A 289466; Peter Muth, New York. (11–13749) **2875**

Poor's manual of industrials ... 2d annual number, 1911. New York, Poor's railroad manual co. [1911]

cvii, 2260 p. 23ᶜᵐ. $7.50
© June 8, 1911; 2c. June 14, 1911*; A 289718; Poor's railroad manual co. **2876**

Prenowitz, Joseph Salamon, 1871–

נעריכטע פֿן י. ש. פּרענאָוויץ.

Poems by J. S. Prenowitz. v. 1.

פילאַרעלפיא, אָזער בראַאָרערס, 1910.

4 p. l., 7–192 p., 1 l. 18ᶜᵐ. $0.50
© Apr. 27, 1911; 2c. May 8, 1911; A 286853; J. S. Prenowitz, Philadelphia. (11–13724) **2877**

Rauschen, Gerhard, 1854–

Hilfsbuch für den katholischen religionsunterricht in der ersten klasse der höheren mädchenschule, von Gerhard Rauschen ... Bonn, P. Hanstein, 1911.
vi, 92 p. 22½ᶜᵐ. M. 1.50
© May 1, 1911; 2c. June 9, 1911*; A—Foreign 3029; Peter Hanstein. (11–13752) **2878**

Sherwood, Margaret Pollock, 1864–

Nancy's pilgrimage, by Margaret Sherwood. Philadelphia, The Westminster press, 1911.

165 p. front., plates. 19ᶜᵐ.

First published in Forward.

© May 30, 1911; 2c. June 5, 1911; A 289505; Trustees of the Presbyterian board of publication and Sabbath school work, Philadelphia.
(11–13732) 2879

Smith, Clarke.

About us and the deacon, by Clarke Smith. Philadelphia, The Literary bureau, inc. [c1911]

319 p. front., plates. 20ᶜᵐ. $1.50

© June 10, 1911; 2c. June 14, 1911*; A 289746; Literary bureau, inc.
(11–14101) 2880

Stirling, Yates, jr.

A United States midshipman in Japan, by Lt. Com. Yates Stirling, jr. ... illustrated by Ralph L. Boyer. Philadelphia, The Penn publishing company, 1911.

396 p. front., plates. 19½ᶜᵐ. $1.25

© June 12, 1911; 2c. June 13, 1911*; A 289698; Penn pub. co.
(11–13979) 2881

Tripp, Bartlett, 1842–

My trip to Samoa, by Hon. Bartlett Tripp ... Cedar Rapids, Ia., The Torch press, 1911.

182 p. front., plates. 21ᶜᵐ. $3.00

© June 2, 1911; 2c. June 5, 1911*; A 289488; Torch press.
(11–13709) 2882

U. S. *Circuit court of appeals.*

... Reports, with annotations ... v. 105. St. Paul, West publishing co., 1911.

xlvii, 723 p. 23½ᶜᵐ. $2.85

© June 7, 1911; 2c. June 22, 1911*; A 289983; West pub. co.
 2883

·Verus, *pseud.*

Die gefährliche frau; briefe an frau Elsie Lindtner, von Verus. 1.–3. aufl. Berlin-Schöneberg, R. Jacobsthal & co. [c1911]

176 p. 19½ᶜᵐ. M. 2

© May 13, 1911; 2c. May 22, 1911*; A—Foreign 2973; R. Jacobsthal & co.
(11–13624) 2884

Wagner, Hans.

Praktische ratschläge für wäschereien, von Hans Wagner. Berlin, Romen's wäscherei-verlag, °1911·

2 p. l., [17]–295 p. 22ᶜᵐ. M. 4.50

© Jan. 15, 1911; 2c. June 2, 1911*; A—Foreign 3005; H. Wagner, Berlin.
(11–13596) 2885

Wallin, John Edward Wallace.

... Spelling efficiency in relation to age, grade and sex, and the question of transfer; an experimental and critical study of the function of method in the teaching of spelling, by J. E. Wallace Wallin ... Baltimore,. Warwick & York, inc., 1911.

viii, 91 p. 20ᶜᵐ. (Educational psychology monographs) $1.25
Bibliography: p. 85–86.
© May 1, 1911; 2c. May 2, 1911; A 289220; Warwick & York, inc.
(11–13617) **2886**

Walter-Hähnel, *Frau* Elise.

Gesunde sprechstimme, das natursystem der tiefatmung und sprechtechnik, singen und sprechen im ausatmen, gesundschulung kranker stimmen, leichtfasslich erklärt von Elise Walter-Hähnel. bd. 1. Berlin, H. Rosenberg (H. Mewis) 1910.

3 p. l., 132 p. illus. (partly col.) 26½ᶜᵐ. M. 3
© Dec. 29, 1910; 2c. Mar. 22, 1911*; A—Foreign 2649; H Rosenberg
(Hugo Mewis) Berlin. (11–12469) **2887**

Whittier, Clarke Butler, 1872–

Cases on common law pleading, selected from decisions of English and American courts, by Clarke B. Whittier ... pt. 1. St. Paul, West publishing company, 1911.

xi, 246 p. 25ᶜᵐ. (American casebook series. J. B. Scott. general editor)
© Apr. 15, 1911; 2c. June 2, 1911*; A 289408; West pub. co.
(11–13200) **2888**

Willets, Gilson, 1869–

The first law; a romance, by Gilson Willets ... illustrations by Robert A. Graef. New York, G. W. Dillingham company [*1911]

352 p. col. front., plates. 19ᶜᵐ. $1.50
© June 9, 1911; 2c. June 13, 1911*; A 289689; G. W. Dillingham co.
(11–13981) **2889**

Winterburn, *Mrs.* Florence (Hull) 1858–

Vacation hints, by Florence Hull Winterburn. New York, Fifth avenue book company, 1911.

94 p. 15ᶜᵐ. $0.25
© May 26, 1911; 2c. May 29, 1911*; A 289302; Fifth ave. book co.
(11–12721) **2890**

Woods, Robert Archey, 1865– *ed.*

... Handbook of settlements, ed. by Robert A. Woods and Albert J. Kennedy. New York, Charities publication committee, 1911.

1 p. l., v–xiii, [1], 326 p. 24ᶜᵐ. (Russell Sage foundation [publications])
$1.50
"General bibliography": p. xi–xiii.
Includes "Literature."
© June 1, 1911; 2c. June 5, 1911*; A 289465; Russell Sage foundation,
New York. (11–13150) **2891**

Wordsworth, William.

The complete poetical works of William Wordsworth.
[v.] 6–10. [Large paper ed.] Boston and New York,
Houghton Mifflin company, 1911.
5 v. front., plates, ports. 23½ᶜᵐ. $5.00 a vol.
CONTENTS.—VI. The excursion.—VII. 1816–1822.—VIII. 1823–1833.—IX.
Last poems.—X. Prefatory essays, postscripts and notes.
© June 12, 1911; 2c. each June 16, 1911*; A 289829; Houghton Mifflin co
2892

Yerkes, Robert Mearns, 1876–

Introduction to psychology, by Robert M. Yerkes ...
New York, H. Holt and company, 1911.
3 p. l., ix–xii, 427 p. diagrs. 21ᶜᵐ. $1.50
"Supplementary reading" at end of each chapter.
© June 2, 1911; 2c. June 6, 1911*; A 289498; Henry Holt & co.
(11–13747) 2893

Young, John Wesley.

Lectures on fundamental concepts of algebra and geom-
etry, by John Wesley Young ... prepared for publication
with the coöperation of William Wells Denton ... with a
note on The growth of algebraic symbolism by Ulysses
Grant Mitchell ... New York, The Macmillan company,
1911.
vii, 247 p. diagrs. 20½ᶜᵐ. $1.60
© June 7, 1911; 2c. June 8, 1911*; A 289559; Macmillan co.
(11–14129) 2894

Young men's Christian associations. *International com-mittee. County work department.*

The rural church and community betterment, ed. by
County work department. New York, Association press.
1911.
136 p. 19½ᶜᵐ. $1.00
© May 27, 1911; 2c. May 29, 1911*; A 289316; International committee of
Y. M. C. A., New York. (11–13748) 2895

Ziegler, Theobald, 1846–

Die geistigen und sozialen strömungen des neunzehnten
jahrhunderts, von Theobald Ziegler. 10. bis 14. tausend.
Ungekürzte volksausg. Berlin, G. Bondi, 1911.
vii, [1] 704 p. 12 port. 23½ᶜᵐ. M. 4.50
© Apr. 23, 1911; 2c. June 2, 1911*; A—Foreign 3020; Georg Bondi.
(11–13708) 2896

Zimmermann, Wilhelm.

The art of mordanting and staining and the complete
treatment of wood surfaces; a handbook and aid for
architects, cabinet makers, decorators, painters, piano
factories and trade schools, by William Zimmermann ...
Boston, Mass., The Arti-stain co., 1911.
139, [1] p. 22ᶜᵐ. $3.00
© Apr. 4, 1911; 2c. June 3, 1911*; A 289433; William F. Purscher. Boston.
(11–14123) 2897

Arizona. *Supreme court.*

Reports of cases argued and determined in the Supreme court of the territory of Arizona, from March, 1908, to March, 1909. James R. Dunseath, reporter. v. 12. San Francisco, Bancroft-Whitney company, 1911.
xx, 473 p. 23ᶜᵐ. $4.25
© June 19, 1911; 2c. June 26, 1911*; A 292077; Bancroft-Whitney co.
2898

Azan, Paul Jean Louis, 1874–

... Souvenirs de Casablanca, avec une préface du Gᵃˡ d'Amade; ouvrage illustré de 173 photographies de l'auteur et de 4 cartes. Paris, Hachette et cⁱᵉ, 1911.
2 p. l., xii p., 1 l., 419, ₁1₁ p., 1 l. front. (port.) plates, fold. map. 25ᶜᵐ.
fr. 10
© May 18, 1911; 2c. June 10, 1911*; A—Foreign 3046; Hachette & cie.
(11–14002)
2899

Ballard, Emerson Etheridge, *ed.*

The law of real property; being a complete analytical epitome of all current decisions of the courts of last resort of the several states ... Ed. by Emerson E. Ballard ... v. 13. Chicago, Ill., T. H. Flood & co., 1911.
4 p. l., 1134 p. 23½ᶜᵐ. $6.00
© June 6, 1911; 2c. June 24, 1911*; A292035; T. H. Flood & co. 2900

Beal, J. H.

Elementary principles of the theory and practice of pharmacy, by J. H. Beal ... pt. 3. Scio, O., J. H. Beal, 1911.
213 p. illus. 23ᶜᵐ. $1.50
CONTENTS.—pt. 3. Animal and vegetable drugs.
© June 21, 1911; 2c. June 24, 1911*; A 292030; J. H. Beal, Scio, O.
2901

Bell, John Joy, 1871–

Jim Crow, by J. J. Bell ... London, New York ₁etc.₁ Hodder and Stoughton ₍ᶜ1911₎
4 p. l., 130 p. 18ᶜᵐ. 1/
© 1c. June 13, 1911*; A ad int. 669; pubd. May 15, 1911; George H. Doran co., New York. (11–14408)
2902

Benedict, Robert D.

Stories from the old French chronicles, retold in modern English, by Robert D. Benedict. Boston, R. G. Badger, 1911.
143 p. 19½ᶜᵐ. $1.50
© May 25, 1911; 2c. June 2, 1911*; A 289398; Richard G. Badger.
(11–14006)
2903

Billings, Cornelius K G 1862–

Fort Tryon hall, the residence of C. K. G. Billings, esq.; a descriptive and illustrated catalogue issued privately by the owner. Washington Heights, N. Y., 1910.
₁154₁ p. 68 pl. 30ᶜᵐ.

481

Billings, Cornelius K. G.—Continued
"Fort Tryon hall, described by Mr. Barr Ferree": p. [7]–[24]
"The paintings and other objects of art collected by Mr. C. K. G
Billings": p. [25]–[142]
"Famous horses owned by Mr. C. K. G. Billings": p. [143]–[149]
© Dec. 10, 1911; 2c. May 18, 1911; A 289483; C. K. G. Billings, New York.
(11–13993) 2904

Browning, Robert, 1812–1889.
Poems of Robert Browning, selected and ed. by Charles
W. Hodell ... New York, H. Holt and company, 1911.
2 p. l., iii–xxxii, 182 p. front. (port.) 17ᶜᵐ. (Half-title: English read-
ings for schools. General editor, W. L. Cross)
© June 2, 1911; 2c. June 5, 1911; A 289499; Henry Holt & co.
(11–14416) 2905

Byron, George Gordon Noël Byron, 6th baron, 1788–1824.
Lettres de Lord Byron, tr. par Jean Delachaume, avec
une préface de G. Clemenceau. Paris, Calmann-Lévy
[°1911]
2 p. l., xii, 446 p. front. (port.) 23ᶜᵐ. fr. 7.50
© May 31, 1911; 2c. June 12, 1911*; A—Foreign 3050; Calmann-Lévy.
(11–14114) 2906

Catholic encyclopedia ... ed. by Charles G. Herbermann
... v. 11. New York. R. Appleton company [1911]
xv, 799 p. illus:, plates (partly col.) ports. 27½ᶜᵐ. $6.00
© June 20, 1911; 2c. June 24, 1911*; A 292025; Robert Appleton co.
2907

Cecilia, Madame.
The training of children and of girls in their teens, by
Madame Cecilia ... New York, Cincinnati [etc.] Benziger
brothers, 1911.
3 p. l., 5–118 p. 18ᶜᵐ. $0.75
© June 7, 1911; 2c. June 9, 1911*; A 289615; Benziger bros.
(11–14190) 2908

Clifford, Chandler Robbins, 1858–
Rugs of the Orient, by C. R. Clifford. New York, Clif-
ford & Lawton [°1911]
108 p. incl. illus., plates. plates. map. 32½ᶜᵐ. $3.00
© May 31, 1911; 2c. June 8, 1911*; A 289582; Clifford & Lawton.
(11–13994) 2909

Cullum, Ridgwell, 1867–
The one way trail, by Ridgwell Cullum ... 2d ed. Lon-
don, Chapman & Hall, ltd., 1911.
vi, 325 p. 19½ᶜᵐ.
© 1c. May 24, 1911; A ad int. 645; pubd. Apr. 25, 1911; George W. Jacobs
& co., Philadelphia. (11–14410) 2910

Cummings, Scott.
The Rexworth mystery, by Scott Cummings; illustrated
by Anna W. Speakman. Philadelphia, Pa., Philadelphia
suburban publishing company [°1911]
272 p. front., plates. 19½ᶜᵐ. $1.50
© June 12, 1911; 2c. June 15, 1911*; A 289790; Philadelphia suburban pub.
co. (11–14407) 2911

Dewey, Melvil, 1851–
... Decimal classification and relativ index for libraries, clippings, notes, etc. Ed. 7. By Melvil Dewey ... Lake Placid Club, N. Y., Forest press, 1911.
777, [13] p. 26ᶜᵐ. $6.00
© June 8, 1911; 2c. June 14, 1911*; A 289722; M. Dewey, Lake Placid, N. Y. (11–14174) 2917

Dewing, Elizabeth Bartol, 1885–
A big horse to ride, by E. B. Dewing ... New York, The Macmillan company, 1911.
vii, 505 p. 20ᶜᵐ. $1.50
© June 14, 1911; 2c. June 15, 1911*; A 289764; Macmillan co. (11–14409) 2913

Dexter, Franklin Bowditch.
Biographical sketches of the graduates of Yale college with annals of the college history. v. 5. June, 1792–September, 1805, by Franklin Bowditch Dexter ... New York, H. Holt and company, 1911.
4 p. l., 815 p. 8vo. $5.00
© June 15, 1911; 2c. June 23, 1911*; A 292007; Henry Holt & co. 2914

Dolph, John Mather.
My dreams, dedicated to the friends of John Mather Dolph, in loving memory by his children. [East Aurora, N. Y., The Roycrofters] 1911.
13, [1] p. incl. front. (port.) 22ᶜᵐ.
© May 22, 1911; 2c. May 23, 1911*; A 289156; Bertha D. Gumaer, Port Jervis, N. J. (11–14161) 2915

Dornblüth, Otto Wilhelm Albert Julius, 1860–
Wollen und können, der weg zum erfolg, populäre gesundheitspflege des geistes und der nerven. 4., verm. aufl. der "Hygiene der geistigen arbeit," von dr. med. O. Dornblüth ... Berlin, Deutscher verlag für volkswohlfahrt g. m. b. h., 1911.
4 p. l., 5–272 p. 20ᶜᵐ. M. 5
© May 6, 1911; 2c. June 9, 1911*; A—Foreign 3024; Deutscher verlag für volkswohlfahrt, g. m. b. h. (11–14126) 2916

Feer, Emil, 1864– *ed.*
Lehrbuch der kinderheilkunde, bearb. von prof. dr. Feer ... prof. dr. Finkelstein ... [u. a.] hrsg. von prof. dr. E. Feer ... mit 2 tafeln und 160 teils farbigen abbildungen im text. Jena, G. Fischer, 1911.
vii, 734 p. illus. (partly col.) 2 col. pl. 26ᶜᵐ. M. 11.50
"Literatur" at end of each chapter.
© Apr. 29, 1911; 2c. June 9, 1911*; A—Foreign 3034; Gustav Fischer. (11–14000) 2917

Fowler, Ella Field.
Echoes of the night ... by Ella Field Fowler. Peekskill, N. Y. [New York, Printing by Francis Emory Fitch, inc.] 1911.
52 p. 18½ᶜᵐ.
© May 17, 1911; 2c. May 24, 1911; A 289369; E. F. Fowler, Peekskill, N. Y. (11–14158) 2918

Gallier, Humbert de.
... Les mœurs et la vie privée d'autrefois. Paris, Calmann-Lévy [°1911]
2 p. l., v, 384 p. 19ᶜᵐ. fr. 3.50
© May 24, 1911; 2c. June 12, 1911*; A—Foreign 3049; Calmann-Lévy.
(11-14133) 2919

Goineau, Alexandre.
Manuel-formulaire pratique et usuel des retraites ouvrières et paysannes, par MM. Alexandre Goineau ... et René Risser ... Paris, Éditions des "Juris-classeurs," 1911.
12, 32, 461, [183] p. 19ᶜᵐ. fr. 7.50
On cover: 2. éd.
© May 18, 1911; 2c. June 10, 1911*; A—Foreign 3044; A. Goineau and René Risser, Paris. (11-14434) 2920

Gordin, Jacob, 1853–1909.

יעקב גאָרדינ׳ס דראַמען ... וניו יאָרקן "סוירקעל פון
יעקב גאָרדינ׳ס פריינט" [1911]

2 v. fronts. (ports.) 22ᶜᵐ. $3.00

CONTENTS.

ג באַגר. גאָט.מענש און טייַפעל. אליישע בן אבויה. דער מטירף. סאסאַ.
אויף די בערג.—ב באַגר׳ מעידעלע אפרה. קריצער סאָנאַטאַ. די א אמת׳ע
קראַט. דער אונבעקאַנטער. אין א היים.

© May 26, 1911; 2c. June 9, 1911*; A 289619; Estate of Jacob M. Gordin, Brooklyn. (11-14164) 2921

Greene, Arthur Maurice, 1879–
Pumping machinery; a treatise on the history, design, construction and operation of various forms of pumps, by Arthur M. Greene, jr. ... 1st ed. 1st thousand. New York, J. Wiley & sons; [etc., etc.] 1911.
vi, 703 p. illus., plates, diagrs. 23½ᶜᵐ. $4.00
Bibliography: p. 679-691.
© June 12, 1911; 2c. June 14, 1911*; A 289724; A. M. Greene, jr., Troy, N. Y. (11-14426) 2922

Guesde, Jules, 1845–
... En garde! contre les contrefaçons, les mirages et la fausse monnaie des réformes bourgeoises; polémiques. Paris, J. Rouff et cⁱᵉ, °1911.
477 p. 19ᶜᵐ. fr. 3.50
© May 26 1911; 2c. June 10, 1911*; A—Foreign 3040; Publications Jules Rouff & cie. (11-14456) 2923

Hallerbach, Wilhelm.
Die citronensäure und ihre derivate, von Wilhelm Hallerbach ... Berlin, J. Springer, 1911.
2 p. l., 104 p. 22ᶜᵐ. M. 3.60
Bibliographical foot-notes.
© May 8, 1911; 2c. June 9, 1911*; A—Foreign 3028; Julius Springer.
(11-14427) 2924

Heinrichsdorff, Wilhelm.

Erziehung zum bewussten sehen, empfinden und darstellen. Lehrbuch für den neuzeitlichen zeichenunterricht. [Von] Wilhelm Heinrichsdorff ... Bielefeld, W. Bertelsmann, 1911.

3 pt. in 1 v. illus., plates. 35 x 25ᶜᵐ. M. 19

© May 1, 1911; 2c. June 9, 1911*; A—Foreign 3035; W. Bertelsmann verlag, g. m. b. h. (11–13995) 2925

Lockwood, Laura Emma, 1863– ed.

Specimens of letter-writing, selected and ed. by Laura E. Lockwood ... and Amy R. Kelly ... New York, H. Holt and company, 1911.

xli, 274 p. 17ᶜᵐ. (On cover: English readings) $0.75

© June 2, 1911; 2c. June 5, 1911; A 289500; Henry Holt & co. (11–14415) 2926

Manning, Edwin Cassander, 1838–

Biographical, historical and miscellaneous selections by Edwin Cassander Manning, president Kansas state historical society, Winfield, Kansas, March 7, 1838–January 1, 1911. Cedar Rapids, Ia., Priv. print., 1911.

194 p., 1 l. front., plates, ports. 24½ᶜᵐ.

© June 1, 1911; 2c. June 7, 1911*; A 289533; E. C. Manning, Winfield, Kan. (11–14419) 2927

Montana. Supreme court.

Reports of cases argued and determined ... from October 6, 1910, to February 23, 1911. Official report. v. 42. San Francisco, Bancroft-Whitney company, 1911.

xxiii, 667 p. 23ᶜᵐ. $4.00

© June 17, 1911; 2c. June 26, 1911*; A 292068; Bancroft-Whitney co. 2928

Morton, William Albert, 1866–

Mother stories from the Book of Mormon, by William A. Morton ... Salt Lake City, Utah, W. A. Morton [1911]

2 p. l., 139 p. 19¼ x 16ᶜᵐ. $0.50

© Apr. 6, 1911; 2c. May 16, 1911*; A 286942; William A. Morton, Salt Lake City, Utah. (11–14109) 2929

Mozans, H. J., pseud.

Following the conquistadores. Along the Andes and down the Amazon, by H. J. Mozans ... with an introduction by Colonel Theodore Roosevelt ... New York and London, D. Appleton and company, 1911.

xx, 542 p. front., plates, map. 23½ᶜᵐ. $3.50
Bibliography: p. 529–534.

© June 9, 1911; 2c. June 13, 1911*; A 289704; D. Appleton & co. (11–14181) 2930

Muir, John, 1838–

My first summer in the Sierra, by John Muir; with illustrations from drawings made by the author in 1869 and from photographs by Herbert W. Gleason. Boston and New York, Houghton Mifflin company, 1911.

vii, [1], 353, [1] p., 1 l. front., illus., plates. 21ᶜᵐ. $2.50
© June 3, 1911; 2c. June 15, 1911*; A 289773; J. Muir, Martinez, Cal.
(11–14183) 2931

Oberst, Adolf.

Kurzgefasste chirurgische operationslehre (operationskurs) für studierende und ärzte, von dr. Ad. Oberst ... mit 232 zum teil farbigen abbildungen. Berlin, S. Karger, 1911.

xii, 198 p. illus. (partly col.) 26ᶜᵐ. M. 6.20
© May 8, 1911; 2c. June 9, 1911*; A—Foreign 3031; S. Karger.
(11–14128) 2932

O'Reilly, Joseph John Edward, 1872–

How to become a patrolman ⟨5th ed.⟩ By J. J. O'Reilly ... New York city, The Chief publishing company [1911]
238 p. 17ᶜᵐ. $0.75
© June 5, 1911; 2c. June 7, 1911*; A 289525; Chief pub. co.
(11–14008) 2933

Pankhurst, E Sylvia.

The suffragette; the history of the women's militant suffrage movement, 1905–1910, by E. Sylvia Pankhurst ... New York, Sturgis & Walton company, 1911.

7 p. l., 3–517 p. front., plates. 19½ᶜᵐ. $1.50
© May 29, 1911; 2c. June 7, 1911*; A 289532; Sturgis & Walton co.
(11–14011) 2934

Parsons, Frank, 1854–1908.

Legal doctrine and social progress, by Frank Parsons ... New York, B. W. Huebsch, 1911.

9, xi–xvi, 17–219 p. 19½ᶜᵐ. $1.50
© Apr. 13, 1911; 2c. June 9, 1911*; A 289604; B. W. Huebsch.
(11–14013) 2935

Pillsbury, Walter Bowers, 1872–

The essentials of psychology, by W. B. Pillsbury ... New York, The Macmillan company, 1911.

xi, 362 p. illus. 19½ᶜᵐ. $1.25
© June 7, 1911; 2c. June 8, 1911*; A 289558; Macmillan co.
(11–14143) 2936

Sawyer, Edith Augusta, 1869–

Jose: our little Portuguese cousin, by Edith A. Sawyer ... illustrated by Diantha Horne Marlowe. Boston, L. C. Page & company, 1911.

vi p., 2 l., 92 p. front., plates. 19½ᶜᵐ. (On verso of half-title: The little cousin series) $0.60
© June 2, 1911; 2c. June 5, 1911; A 289692; L. C. Page & co. (inc.)
(11–13983) 2937

Scudder, Charles Locke, 1860–

The treatment of fractures, with notes upon a few common dislocations, by Charles Locke Scudder ... 7th ed., thoroughly rev. and enl., with 990 illustrations. Philadelphia and London, W. B. Saunders company, 1911.

. 708 p. incl. illus., 2 pl. col. front. 25ᶜᵐ.
Bibliography: p. 686–690.
© May 26, 1911; 2c. May 27, 1911*; A 289289; W. B. Saunders co.
(11–13998) 2938

Sharp & Alleman co.

Sharp & Alleman co.'s lawyers and bankers directory for 1911. July ed. ... [29th year] Philadelphia, Pa., New York, Sharp & Alleman co., 1911.

Various paging. 23½ᶜᵐ. $5.00
© June 21, 1911; 2c. June 24, 1911*; A 292044; Sharp & Alleman co.
 2939

Sheran, William Henry.

A textbook of English literature for Catholic schools, by Rev. William Henry Sheran ... New York, Cincinnati [etc.] American book company [ᶜ1911]

xii, 498 p. incl. front., illus., ports. maps. 19½ᶜᵐ. $1.25
Contains "References."
© June 1, 1911; 2c. June 3, 1911*; A 289449; American book co.
(11–14418) 2940

Spargo, John, 1876–

Sidelights on contemporary socialism, by John Spargo. New York, B. W. Huebsch, 1911.

154 p. 19ᶜᵐ. $1.00
The third lecture has already appeared in print in the American journal of sociology. cf. Foreword.
CONTENTS.—Marx, leader and guide.—Anti-intellectualism in the socialist movement: a historical survey.—The influence of Marx on contemporary socialism.
© Apr. 20, 1911; 2c. June 9, 1911* A 289605; B. W. Huebsch.
(11–14012) 2941

Swift, Morrison Isaac.

The horroboos, by Morrison I. Swift. Boston, The Liberty press, 1911.

2 p. l., [3]–241 p. 22ᶜᵐ. $1.00
© June 9, 1911; 2c. June 12, 1911*; A 289659; M. I. Swift, Revere, Mass.
(11–14433) 2942

Taylor, Hannis, 1851–

The origin and growth of the American Constitution; an historical treatise in which the documentary evidence as to the making of the entirely new plan of federal government embodied in the existing Constitution of the United States is, for the first time, set forth as a complete and consistent whole, by Hannis Taylor ... Boston and New York, Houghton Mifflin company, 1911.

xlii p., 1 l., 676 p., 1 l. 22½ᶜᵐ. $4.00
© June 3, 1911; 2c. June 15, 1911* A 289775; H. Taylor, Washington.
(11–14435) 2943

Texas. *Court of criminal appeals.*
The Texas criminal reports. Cases argued and adjudged ... during April, May and June, 1910. Reported by Rudolph Kleberg. v. 59. Chicago, Ill., T. H. Flood & company, 1911.
xx, 721 p. 24ᶜᵐ. $3.00
© June 14, 1911; 2c. June 24, 1911*; A 292034; Rudolph Kleberg, Austin, Tex. 2944

Thackeray, William Makepeace.
Works of William Makepeace Thackeray; with biographical introductions by his daughter Lady Ritchie ... v. 16, 17. [The centenary biographical ed.] New York and London, Harper & brothers [1911]
2 v. illus., plates. 21½ᶜᵐ.
CONTENTS.—v. 16, 17. The Virginians.
© June 15, 1911; 2c. June 19, 1911*; A 289856; Harper & bros. 2945

Tiedemann, Ludwig von.
Ludw. v. Tiedemann's landwirtschaftliches bauwesen. Handbuch für landwirte und baumeister. Mit einem vorwort von dr. Jul. Kühn ... 4. verb. und stark verm. aufl. Hrsg. von P. Fischer ... 1. halbbd. Halle a. S., L. Hofstetter, 1911.
2 p. l., 400 p. illus. 24ᶜᵐ. M. 15
© Apr. 20, 1911; 2c. June 9, 1911*; A—Foreign 3032; Ludwig Hofstetter. (11–13996) 2946

Veit, Johann, 1852–
Die behandlung der frauenkrankheiten, für die praxis dargestellt, von dr. J. Veit ... mit 39 zum teil farbigen abbildungen. Berlin, S. Karger, 1911.
iv, 244 p. illus. (partly col.) 27ᶜᵐ. M. 7.50
© May 8, 1911; 2c. June 9, 1911*; A—Foreign 3033; S. Karger. (11–14001) 2947

Williams, John Harvey, 1864–
The mountain that was "God"; being a little book about the great peak which the Indians named "Tacoma," but which is officially called "Rainier," by John H. Williams ... 2d ed. rev. and greatly enl., with 190 illustrations, including eight colored halftones. Tacoma, John H. Williams; New York [etc.] G. P. Putnam's sons. 1911.
1 p. l., [7]–142, [2] p. incl. illus., col. plates. col. front., maps. 26ᶜᵐ. $1.50
© May 24, 1911; 2c. May 29, 1911*; A 289303; J. H. Williams, Tacoma, Wash. (11–14182) 2948

Wood, Casey Albert, 1856– ed.
... The eye, ear, nose and throat, ed. by Casey A. Wood ... Albert H. Andrews ... Gustavus P. Head ... Chicago, The Year book publishers, 1911.
365 p. col. front., illus., plates. 19½ᶜᵐ. (The practical medicine series ... vol. III ... Series 1911) $1.50
© May 29, 1911; 2c. June 10, 1911*; A 289633; Year book publishers. (11–14429) 2949

Alabama. *Supreme court.*

Report of cases argued and determined ... during the November term, 1909–1910. By Lawrence H. Lee, Supreme court reporter. v. 167. Montgomery, Ala., The Brown printing company, 1911.

xix, 747 p. 23½ᶜᵐ. $2.00

© June 5, 1911; 2c. June 19, 1911*; A 289855; Emmet O'Neal, governor of Alabama, for use of said state, Montgomery, Ala. **2950**

Atchison, Topeka and Santa Fé railway company.

... Instructions for maintaining and operating air brake apparatus. Topeka, The Hall lithographing company, ᶜ1911.

219 p. fold. plates. 18½ᶜᵐ.

© May 19, 1911; 2c. June 3, 1911*; A 289440; M. E. Hamilton, Topeka, Kan. (11–14425) **2951**

Atkinson, Frederick William.

The disintegrating church, by Frederick William Atkinson. New York, Chicago [etc.] Broadway publishing co. [ᶜ1911]

78 p. 20¼ᶜᵐ. $1.00

© Apr. 12, 1911; 2c. May 27, 1911; A 289738; F. W. Atkinson, Santa Cruz, Cal. (11–14558) **2952**

Baker, Josephine Turck.

The correct word; how to use it; a complete alphabetic list, by Josephine Turck Baker ... Chicago, Ill., Correct English publishing company [ᶜ1910]

1 p. l., 5–235 p. 19½ᶜᵐ. $1.00

© Mar. 10, 1911; 2c. Feb. 25, 1911; A 289329; J. T. Baker, Chicago. (11–14521) **2953**

Blan, Louis Benjamin.

A special study of the incidence of retardation, by Louis B. Blan ... New York city, Teachers college, Columbia university, 1911.

3 p. l., 111 p. illus. (charts) 23½ᶜᵐ. (Teachers college, Columbia university. Contributions to education, no. 40) $1.00

Bibliography: p. 109–111.

© June 2, 1911; 2c. June 10, 1911; A 289667; L. B. Blan, Port Richmond, N. Y. (11–14545) **2954**

Bøckman, Marcus Olaus, 1849–

Lykke i livet, af M. O. Bøckman og E. Kr. Johnsen. Minneapolis, Minn., Augsburg publishing house, 1911.

239 p. front., illus. 20ᶜᵐ. $1.00

© May 25, 1911; 2c. May 31, 1911*; A 289361; Augsburg pub. house. (11–14555) **2955**

489

Bouché-Leclercq, Auguste i. e. Louis Thomas Auguste, 1842–

... L'intolérance religieuse et la politique. Paris, E. Flammarion, 1911.

xii, 370 p., 1 l. 19cm. (Bibliothèque de philosophie scientifique) fr. 3.50

© May 31, 1911; 2c. June 12, 1911*; A—Foreign 3051; Ernest Flammarion.
(11–14556) 2956

Burke, Mary Cecilia.

School room echoes, book 2. ¡By¡ Mary C. Burke ... Boston, R. G. Badger, 1911.

224 p. front. (port.) 18½cm. $1.00

© June 21, 1911; 2c. June 28, 1911*; A 292108; M. C. Burke, New York.
2957

Burroughs, John, 1837–

Bird stories from Burroughs; sketches of bird life taken from the works of John Burroughs ... Boston, New York ¡etc.¡ Houghton Mifflin company ¡°1911¡

vi p., 1 l., 174 p., 1 l. col. front., plates (partly col.) 19½cm. $0.60

© May 20, 1911; 2c. June 15, 1911*; A289780; Houghton Mifflin co. ¡Copyright is claimed on editorial work and illustrations¡
(11–14537) 2958

Cajori, Florian, 1859–

Notes on the history of geometry and algebra, by Florian Cajori ... Boston, New York ¡etc.¡ D. C. Heath & company ¡°1911¡

25 p. illus. (ports.) pl. 20½cm.
"Wells's mathematics": 44 p at end.

© June 5, 1911; 2c. J¡ne 12, 1911*; A 289658; D. C. Heath & co.
(11–14534) 2959

Chamberlain, James Franklin.

... North America; a supplementary geography, by James Franklin Chamberlain ... and Arthur Henry Chamberlain ... New York, The Macmillan company, 1911.

xi, 299 p. front., illus., maps. 19cm. (The continents and their people) $0.55

© June 7, 1911; 2c. June 8, 1911*; A 289556; Macmillan co.
(11–14530) 2960

Clark, George Ramsey.

A short history of the United States Navy, by Captain George R. Clark, u· s. n., Professor William O. Stevens, PH. D., Instructor Carroll S. Alden, PH. D., Instructor Herman F. Krafft, LL. B. ... Philadelphia & London, J. B. Lippincott company, 1911.

2 p. l., 3–505 p. front., illus., plates, ports. 21cm. $3.00
"Authorities": p. 481–486.

© May 31, 1911; 2c. June 9, 1911*; A 289610; J. B. Lippincott co.
(11–14532) 2961

Crampton, Henry Edward, 1875–

... The doctrine of evolution; its basis and its scope, by Henry Edward Crampton ... New York, The Columbia university press, 1911.

ix, 311 p. 20½ᶜᵐ. $1.50
At head of title: Columbia university lectures.
© June 12, 1911; 2c. June 12, 1911; A 289752; Columbia univ. press.
(11–14538) 2962

Danske gymnastik-forbund, *Copenhagen.*

"Vidar," den danske gymnastik, frie bevægelser og stillinger; smidighedsøvelser (forberedende øvelser) udgivet af Dansk gymnastik-forbund; A. Clod-Hansen, formand for øvelsesudvalget ... Kjøbenhavn, Gyldendalske · boghandel, Nordisk forlag, 1911.

1 p. l., 60 p. 22½ᶜᵐ. *and* portfolio of 24 pl. 55 x 41ᶜᵐ. kr. 10
© Feb. 14, 1911; 2c. June 13, 1911*; A—Foreign 3053; A. Clod-Hansen, Copenhagen, Denmark. (11–14542) 2963

De la méthode dans les sciences. 2. série. Par MM. B. Baillaud ... Léon Bertrand ... L. Blaringhem ... Émile Borel ... Gustave Lanson ... Lucien March ... A. Meillet ... Jean Perrin ... Salomon Reinach ... R. Zeiller ... Paris, F. Alcan, 1911.

2 p. l., ii p., 1 l., 365 p. 18½ᶜᵐ. (*On cover:* Nouvelle collection scientifique) fr. 3.50
CONTENTS.—Avant-propos, par E. Borel.—Astronomie, jusqu'au milieu du XVIIIᵉ siècle, par B. Baillaud.—Chimie physique, par J. Perrin.—Géologie, par L. Bertrand.—Paléobotanique, par R. Zeiller.—Botanique, par L. Blaringhem.—Archéologie, par S. Reinach.—Histoire littéraire, par G. Lanson.—Linguistique, par A. Meillet.—Statistique, par L. March.
© May 18, 1911; 2c. June 10, 1911*; A—Foreign 3043; Félix Alcan and R. Lisbonne. (11–14535) 2964

Donahoe, Daniel, 1855–

... Brief of Edward S. Gard, whose liberty is in jeopardy. Presented and filed by privilege of court heretofore granted herein. Daniel Donahoe, esquire, James Hartnett, esquire, attorneys for Edward S. Gard. Chicago, Geo. Hornstein co., printer [ᶜ1911]

cover-title, 66 p. 25ᶜᵐ. $2.50
At head of title: Jeopardy in government of men. No. 7702 in the Supreme court of Illinois, April term, A. D. 1911. People of the state of Illinois ... vs. Michael Zimmer ... Petition for mandamus.
© June 1, 1911; 2c. June 2, 1911; A 289626; James Hartnett, Chicago.
(11–14722) 2965

Faris, John Thomson, 1871–

"Making good"; pointers for the man of to-morrow, by John T. Faris ... New York, Chicago [etc.] Fleming H. Revell company [ᶜ1911]

288 p. 20½ᶜᵐ. $1.20
© Apr. 29, 1911; 2c. June 15, 1911*; A 289762; Fleming H. Revell co.
(11–14550) 2966

Farthing, Paul, ed.

Philo history; chronicles and biographies of the Philosophian literary society of McKendree college; ed. by Paul and Chester Farthing. Lebanon, Ill., Pub. for the Society, 1911.

214 p. illus. (incl. ports.) 23½ᶜᵐ.

© June 9, 1911; 2c. June 12, 1911*; A 289678; Paul and Chester Farthing, Odin, Ill. (11-14546) **2967**

Fisher, Jonathan B.

A trip to Europe and facts gleaned on the way; observations, narratives and general notes of travel as viewed and given by a primitive Pennsylvania farmer. Also a collection of numerous interesting facts relative to the places and countries visited. With twenty-six illustrations and a complete map of Germany. By Jonathan B. Fisher ... Sugarcreek, O., J. C. Miller, printer, 1911.

x, 346 p. front., illus., fold. map. 18½ᶜᵐ. $0.50

© June 13, 1911; 2c. June 16, 1911*; A 289813; J. B. Fisher, New Holland, Pa. (11-14526) **2968**

Gordon, James L.

The young man and his problems, by James L. Gordon. New York and London, Funk & Wagnalls company, 1911.

vi, 329 p. 19½ᶜᵐ. $1.00

© May 13, 1911; 2c. May 25, 1911*; A 289225; Funk & Wagnalls co. (11-14553) **2969**

Greene, Francis Vinton, 1850–

The revolutionary war and the military policy of the United States, by Francis Vinton Greene ... New York, C. Scribner's sons, 1911.

xxi, 350 p. maps. 23ᶜᵐ. $2.50

© May 27, 1911; 2c. June 3, 1911*; A 289437; Charles Scribner's sons. (11-14531) **2970**

Homerus.

The Iliad of Homer, tr. into English blank verse, by Arthur Gardner Lewis ... New York, The Baker & Taylor company, 1911.

2 pt. in 1 v. 20ᶜᵐ.

© June 8, 1911; 2c. June 9, 1911*; A 289612; Baker & Taylor co. (11-14519) **2971**

Jackson, Giles B.

The industrial history of the negro race of the United States [by] Giles B. Jackson and D. Webster Davis. Richmond, Va., Negro educational association, 1911.

369 p. incl. front. (ports.) illus., pl. 19½ᶜᵐ.

© June 7, 1911; 2c. June 9, 1911*; A 289585; G. B. Jackson, Richmond. [Copyright is claimed on revised ed.] (11-14730) **2972**

Jones, Walter Clyde, ed.

Notes on the Illinois reports; a cyclopedia of Illinois law ... by W. Clyde Jones and Keene H. Addington ... editors in chief, and Donald J. Kiser ... v. 8. Chicago, Callaghan & company, 1911.

1 p. l., 1181 p. 26½ᶜᵐ. $7.50

© June 27, 1911; 2c. June 30, 1911*; A 292156; Callanghan & co.

2973

Keyes, Angela Mary.

Stories and story-telling, by Angela M. Keyes ... New York, D. Appleton and company, 1911.

viii, 286 p. 19½ᶜᵐ. $1.25

© June 9, 1911; 2c. June 13, 1911*; A 289702; D. Appleton & co.
(11–14714) 2974

Kirkman, Marshall Monroe, 1842–

Supplement to the volume Operating trains, of The science of railways, by Marshall M. Kirkman ... Chicago, Cropley Phillips company, 1911.

3 p. l., 5–66 p. illus. 20ᶜᵐ.

© June 3, 1911; 2c. June 7, 1911*; A 289545; C. Phillips co.
(11–13600) 2975

Knights of alpha and ladies of omega of the world.

Ritual, subordinate assembly of the order of Knights of alpha and ladies of omega of the world, a fraternal benevolent association, detail of officers and order of business, adopted by the Supreme assembly, August 30, 1910. [St. Paul, Minn., The Volkszeitung company] ᶜ1911.

3 p. l., [9]–92 p. illus. (port.) 19½ᶜᵐ. $1.00

© May 10, 1911; 2c. June 9, 1911*; A 289601; J. R. White, St. Paul.
(11–14191) 2976

Labaw, George Warne, 1848–

A genealogy of the Warne family in America; principally the descendants of Thomas Warne, born 1652, died 1722, one of the twenty-four proprietors of East New Jersey, by Rev. George Warne Labaw ... New York, Frank Allaben genealogical company [ᶜ1911]

701 p. front., illus., plates, ports., facsims., charts, col. coats of arms. 25ᶜᵐ. $6.50

© Mar. 22, 1911; 2c. June 17, 1911*; A 289835; Frank Allaben genealogical co. (11–14529) 2977

Lewin, Walter Henry.

Did Peary reach the Pole? By "an Englishman in the street" (W. Henry Lewin) London, Simpkin, Marshall, Hamilton, Kent & co., ltd., 1911.

vii, 9–84 p., 1 l. fold. map. 19ᶜᵐ. $1.00

© 1c. June 9, 1911; A ad int. 666; pubd. May 20, 1911; W. H. Lewin, London. (11–14540) 2978

London, Jack, 1876–

The cruise of the Snark, by Jack London ... New York, The Macmillan company, 1911.

xiv, 340 p. col. front., illus., pl. 20½ᶜᵐ. $2.00

© June 14, 1911; 2c. June 15, 1911*; A 289765; Macmillan co. (11–14527) 2979

Loomis, Henry Thomas, 1856–

New Practical letter writing; a text book for use in schools, a reference book ... by Henry T. Loomis ... Cleveland, O., The Practical text book company [ᶜ1911]

220 p. illus. 19½ᶜᵐ. $0.75

© June 12, 1911; 2c. June 14, 1911*; A 289740; Practical text book co. (11–14520) 2980

McLeod, Malcolm James.

The unsearchable riches, by Malcolm James McLeod ... New York, Chicago [etc.] Fleming H. Revell company [ᶜ1911]

235 p. 20½ᶜᵐ. $1.25

© May 20, 1911; 2c. June 15, 1911*; A 289758; Fleming H. Revell co. (11–14552) 2981

Macnaughtan, S.

Peter and Jane, by S. Macnaughtan ... New York, Dodd, Mead & company, 1911.

2 p. l., 370 p. 19½ᶜᵐ. $1.25

© June 17, 1911; 2c. June 19, 1911*; A 289866; Dodd, Mead & co. (11–14720) 2982

Matthews, James Brander, 1852–

A study of versification, by Brander Matthews ... Boston, New York [etc.] Houghton Mifflin company [ᶜ1911]

vii p., 1 l., 275, [1] p. 20ᶜᵐ. $1.25
"Bibliographical suggestions": p. 266–267.

© May 18, 1911; 2c. June 15, 1911*; A 289781; B. Matthews, New York. (11–14523) 2983

Méheut, M.

Études d'animaux, par M. Meheut, sous la direction de F. Grasset. t. 2ᵐᵉ [livr. 5] Paris, E. Lévy [1911]

2 p. l., [20] pl., 1 l. 44½ x 34ᶜᵐ. fr. 24

© May 15, 1911; 2c. June 27, 1911*; A—Foreign 3135; Émile Lévy. 2984

[Meyer, Wilhelm]

Wandern, spiel und sport, ein praktisches handbuch für jedermann. M. Gladbach, Volks vereins verlag g. m. b. h. [ᶜ1911]

3 p. l., 11–290 p. illus. 17ᶜᵐ.

© Apr. 10, 1911; 2c. Apr. 19, 1911; A—Foreign 3038; Volksvereins-verlag, g. m. b. h. (11–14543) 2985

Morice, Charles, 1861–

The re-appearing (Il est ressuscité!) ; a vision of Christ in Paris, by Charles Morice; tr. by John N. Raphael; with an introduction by Coningsby Dawson. New York, Hodder & Stoughton. George H. Doran company [ᶜ1911]
211 p. 19½ᶜᵐ. $1.20
© June 9, 1911; 2c. June 10, 1911; A 289796; George H. Doran co. (11–14549) 2986

Morris, Charles, 1833–

School history of the United States of America, by Charles Morris ... Philadelphia, J. B. Lippincott company [ᶜ1911]
xiii p., 1 l., 451, xxxviii p. front., illus., maps. 19½ᶜᵐ.
© May 13, 1911; 2c. June 9, 1911*; A 289593; J. B. Lippincott co. (11–14533) 2987

Murray, T C.

Birthright; a play in two acts, by T. C. Murray. Dublin, Maunsel and co., ltd., 1911.
43, [1] p. 20ᶜᵐ. (*On cover:* Abbey theatre series, vol. xiv)
© Apr. 15, 1911; 2c. June 2, 1911*; D 24382; T. C. Murray, Rathduff Blarney, Ireland. (11–14162) 2987*

Older, Cora Miranda (Baggerly) *"Mrs.* **Fremont Older."**

Esther Damon, by Mrs. Fremont Older. New York, C. Scribner's sons, 1911.
4 p. l., 3–355 p. 19½ᶜᵐ. $1.25
© May 27, 1911; 2c. June 3. 1911*; A 289439; Charles Scribner's sons. (11–14712) 2988

Painter, Franklin Verzelius Newton, 1852–

Introduction to Bible study: the Old Testament, by F. V. N. Painter ... Boston, Chicago, Sibley & company [ᶜ1911]
vi, 265 p. front., plates, maps. 19½ᶜᵐ. $1.00
© June 12, 1911; 2c. June 13, 1911*; A 289716; Sibley & co. (11–14557) 2989

Pfeil-Burghausz, Richard Friedrich Adelbert, *graf* **von,** 1846–

Vor vierzig jahren. Persönliche erlebnisse und bilder aus grosser zeit. Von Richard graf von Pfeil ... mit 14 bildern und 4 karten. Schweidnitz, L. Heege [ᶜ1911]
xvi, 294 p., 1 l. front., plates, ports., fold. maps, facsim. 19½ᶜᵐ. M. 5
© Apr. 10, 1911; 2c. May 22, 1911*; A—Foreign 2981; L. Heege. (11–14524) 2990

Pharasius, *pseud.*

... Un coin du voile; étude philosophique sur la recherche de la vérité. Paris, Leymarie, 1911.
306, [2] p. 23ᶜᵐ. fr. 4.50
© May 18, 1911; 2c. June 10, 1911*; A—Foreign 3039; Pharasius, Paris. (11–14145) 2991

Poe, Edgar Allan, 1809–1849.

The complete poems of Edgar Allan Poe, collected, ed., and arranged with memoir, textual notes and bibliography, by J. H. Whitty ... Boston and New York, Houghton Mifflin company, 1911.

lxxxvi, 304 p., 1 l. front. (port.) illus. (facsim.) plates. 21ᶜᵐ. $2.00
Bibliography: p. [289]–297.

© May 6, 1911; 2c. June 15, 1911*; A 289783; J. H. Whitty, Richmond, Va
(11–14522) 2992

Rabenort, William Louis, 1870–

Spinoza as educator, by William Louis Rabenort ... New York city, Teachers college, Columbia university, 1911.

vi, [2], 87 p. 23½ᶜᵐ. (Teachers college, Columbia university. Contributions to education, no. 38) $1.00
Bibliography: p. 86–87.

© May 29, 1911; 2c. June 10, 1911; A 289666; W. L. Rabenort, New York.
(11–14544) 2993

Ryan, John Augustine, 1869–

Francisco Ferrer, criminal conspirator; a reply to the articles by William Archer in McClure's magazine, November and December, 1910, by John A. Ryan ... St. Louis, Mo. [etc.] B. Herder, 1911.

2 p. l., 87 p. 15ᶜᵐ. $0.15

© May 24, 1911; 2c. May 26, 1911*; A 289247; Joseph Gummersbach, St. Louis. (11–14525) 2994

Stall, Sylvanus, 1847–

With the children on Sundays; through eye-gate and ear-gate into the city of child-soul, by Sylvanus Stall ... Philadelphia, Pa., The Uplift publishing company [c1911]

330 p. incl. front. (port.) illus., plates (partly col.) 24ᶜᵐ. $1.75

© May 29, 1911; 2c. June 3, 1911; A 289579; S. Stall, Bala, Pa.
(11–14565) 2995

Standard statistics bureau, New York.

"Standard" bond descriptions. no. 1, v. 1. [New York?] [1911·

749 l. 28ᶜᵐ. $70.00
Cover-title.

© May 27, 1911; 2c. May 31, 1911*; A 289360; Standard statistics bureau.
(11–14009) 2996

Textile world record.

... Kinks on worsted combing, drawing and spinning, from the questions and answers department of the Textile world record, comp. and ed. by Clarence Hutton. Boston, Mass., Lord & Nagle company [c1911]

1 p. l., [7]–94 p. illus. 15½ᶜᵐ. (The Textile world record kink books, no. 4) $0.75

© June 10, 1911; 2c. June 12, 1911*; A 289657; Lord & Nagle co.
(11–14121) 2997

The **Arizona** cook book. Albuquerque, N. M., Press of
the Morning journal. 1911.
5 p. l., [13]–418 p. 24ᶜᵐ. $2.00
© May 22, 1911; 2c. June 13, 1911; A 289693; Williams public library
assn. (11–14747) 2998

Bartels, C O.
Auf frischer tat; beobachtungen aus der niederen tier-
welt in bilderserien nach natur-aufnahmen, von C. O. Bar-
tels. 2. sammlung. 10 serien mit 74 abbildungen. Stutt-
gart, E. Schweizerbart'sche verlagsbuchhandlung, Nä-
gele & dr. Sproesser, 1911.
35 p. 10 fold. pl. 24ᶜᵐ. M. 3
© May 6, 1911; 2c. June 15. 1911*; A—Foreign 3067; E. Schweizerbart'-
sche verlagsbuchhandlung. Nägele & dr. Sproesser.
(11–14762) 2999

Baur, Erwin.
Einführung in die experimentelle vererbungslehre, von
prof. dr. phil. et med. Erwin Baur; mit 80 textfiguren und
9 farbigen tafeln. Berlin, Gebrüder Borntraeger, 1911.
4 p. l., 293 p. illus., ix col. pl., fold. tab. 27ᶜᵐ. M. 8.50
"Literatur": p. [269]–286.
© May 11, 1911; 2c. June 15, 1911*; A—Foreign 3071; Gebr. Borntraeger.
(11–14579) 3000

Béchamp, Pierre Jacques Antoine, 1816–1908.
The blood and its third anatomical element; application
of the microzymian theory of the living organization to
the study of the anatomical and chemical constitution of
the blood and to that of the anatomical and physiological
causes of the phenomena of its coagulation and of its
other spontaneous changes, by A. Béchamp ... tr. from
the French by Montague R. Leverson ... Philadelphia,
Boericke & Tafel, 1911.
xvi, 440 p. front. (port.) 20ᶜᵐ. $1.50
© June 9, 1911; 2c. June 15. 1911*; A 289789; M. R. Leverson, New York.
(11–14742) 3001

Behrens, Otto.
Die bedeutung der betriebs-krankenkassen in der deut-
schen krankenversicherung. Auf grund graphischer ta-
feln dargestellt und erläutert, von Otto Behrens ... Ber-
lin, Deutscher verlag für volkswohlfahrt. g. m. b. h., 1911.
27, [1] p. 25 fold. diagr. (in pocket) 28½ᶜᵐ. M. 3
© May 3, 1911; 2c. June 15. 1911*; A—Foreign 3074; Deutscher verlag für
volkswohlfahrt, g. m. b. h. (11–14784) 3002

Bell, John Joy, 1871–
Jim, by J. J. Bell ... New York, Hodder & Stoughton.
George H. Doran company [c1911]
4 p. l., 150 p. 18ᶜᵐ. $0.60
Published in Great Britain under title: Jim Crow.
© June 20. 1911; 2c. June 21. 1911*; A 289947; George H. Doran co.
(11–14750) 3003

Bible. *N. T. Gospels. English.*

The Holy Gospel; a comparison of the Gospel text as it is given in the Protestant and Roman Catholic Bible versions in the English language in use in America, with a brief account of the origin of the several versions, by Frank J. Firth ... New York, Chicago ⌈etc.⌉ Fleming H. Revell company ⌈c1911⌉

5 p. l., 13–501 p. 22½ᶜᵐ. $1.00
© May 20, 1911; 2c. June 15, 1911*; A 289768; F. J. Firth, Philadelphia. (11-14770) **3004**

Bindloss, Harold, 1866–

Vane of the timberlands, by Harold Bindloss ... New York, Frederick A. Stokes company ⌈c1911⌉

4 p. l., 375 p. 19½ᶜᵐ. $1.25
"Published in England under the title, 'The protector.'"
© June 17, 1911; 2c. June 21, 1911*; A 289943; Frederick A. Stokes co. (11-14752) **3005**

Booth, Walter Sherman, 1827– ᵇ

The constable's manual for the state of Minnesota; a complete guide for constables and other officers of justices' courts in their various duties under the revised laws, 1905, and general laws, 1905, 1907, 1909, 1911, by Walter S. Booth ... 8th ed. Minneapolis, Minn., W. S. Booth & son, 1911.

149 p. 19½ᶜᵐ. $0.75
© June 14, 1911; 2c. June 19, 1911*; A 289887; W. S. Booth, Minneapolis. (11-14786) **3006**

Boughton, Martha Arnold.

The quest of a soul, and other verse, by Martha Arnold Boughton. New York, Chicago ⌈etc.⌉ Fleming H. Revell company ⌈c1911⌉

127 p. 19½ᶜᵐ. $1.00
© June 5, 1911; 2c. June 15, 1911*; A 289760; Fleming H. Revell co. (11-14563) **3007**

Brown, Charles Reynolds, 1862–

The modern man's religion, by Charles Reynolds Brown ... New York city, Teachers college, Columbia university, 1911.

vii, 166 p., 1 l. 20ᶜᵐ. (*Half-title:* Teachers college lectures on the religious life. Series 1) $1.00
© June 10, 1911; 2c. June 13, 1911*; A 289710; Teachers college, Columbia university. (11-14771) **3008**

Collingwood, George Elmer, 1865–

Train rule examinations made easy; a complete treatise for train rule instructors, superintendents, trainmasters, conductors, enginemen, brakemen, switchmen, train despatchers, operators and others ... By G. E. Collingwood ... Contains complete set of examination questions, with

Collingwood, George Elmer—Continued

their answers. New York, The Norman W. Henley publishing company, 1911.

234 p. incl. front. (fold. map) illus. 16ᶜᵐ. $1.25

© June 14, 1911; 2c. June 15, 1911*; A 289787; Norman W. Henley pub. co. (11–14748) 3009

₁Dawson, Marjorie₁

Thoughts for flirts, by Mary Dale ₁pseud.₁ illustrated by Isabella Morton. New York, H. Lechner ₁ᶜ1911₁

104 p., 1 l. front., plates. 19ᶜᵐ. $0.75

© May 11, 1911; 2c. June 15, 1911*; A 289792; Marjorie Dawson, New York. (11–14726) 3010

Dingler, Hugo.

Die grundlagen der angewandten geometrie; eine untersuchung über den zusammenhang zwischen theorie und erfahrung in den exakten wissenschaften, von dr. Hugo Dingler. Leipzig, Akademische verlagsgesellschaft m. b. h., 1911.

viii, 159, ₁1₁ p. 23ᶜᵐ. M. 5

© Mar. 5, 1911; 2c. Apr. 29, 1911*; A—Foreign 2858; Akademische verlagsgesellschaft, m. b. h. (11–14740) 3011

Dreyer, Max, 1862–

Auf eigener erde, von Max Dreyer. Berlin-Wien, Ullstein & co. ₁ᶜ1911₁

460, ₁1₁ p. 19ᶜᵐ. M. 3

© May 8, 1911; 2c. June 9, 1911*; A—Foreign 3025; Ullstein & co. (11–14737) 3012

Duke, William Cleveland, 1850–

The policeman; his trials and his dangers, by W. C. Duke. ₁Rev. ed.₁ ₁Atlanta, Ga., Converse publishing company, ᶜ1911₁

106 p., 1 l. incl. front., ports. 17ᶜᵐ. $0.50

© June 7, 1911; 2c. June 10, 1911*; A 289645; W. C. Duke, Atlanta, Ga. (11–14569) 3013

Fillmore, Parker Hoysted, 1878–

The young idea; a neighborhood chronicle, by Parker H. Fillmore ... illustrations by Rose Cecil O'Neill. New York, John Lane company, 1911.

341 p. incl. front., illus. 19ᶜᵐ. $1.25

Partly reprinted from various periodicals.

© June 16, 1911; 2c. June 20, 1911*; A 289921; John Lane co. (11–14753) 3014

Frederick, Lemira, pseud.

His own estate, by Lemira Frederick. New York, Cochrane publishing company, 1911.

144 p. 19ᶜᵐ. $1.00

© June 8, 1911; 2c. June 16, 1911*; A 289810; Cochrane pub. co. (11–14718) 3015

Green, Sanford Moon.

Green's Michigan practice; a treatise on the practice of the courts of common law of the state of Michigan, with forms, by Sanford M. Green ... 3d ed. ... by Clark A. Nichols. v. 3. Chicago, Callaghan & company, 1911.

iii, [1], 1748-2537 p. 24½ᶜᵐ. $6.50

© June 26, 1911; 2c. June 30, 1911*; A 292155; Callaghan & co. 3016

Grist, William Alexander.

The historic Christ in the faith of to-day, by William Alexander Grist. New York, (hicago [etc.] Fleming H. Revell company [ᶜ1911]

517 p. 23½ᶜᵐ. $2.50

© Apr. 20, 1911; 2c. June 15, 1911*; A 289761; Fleming H. Revell co. (11-14772) 3017

Hillis, Newell Dwight, 1858-

The contagion of character; studies in culture and success, by Newell Dwight Hillis ... New York, Chicago [etc.] Fleming H. Revell company [ᶜ1911]

332 p. 19ᶜᵐ. $1.20

© Apr. 29, 1911; 2c. June 15, 1911*; A 289759; Fleming H. Revell co. (11-14551) 3018

Hough, Alfred J.

Egyptian melodies, and other poems, by Alfred J. Hough ... Boston, R. G. Badger, 1911.

90 p. 19½ᶜᵐ. $1.50

© June 6, 1911; 2c. June 8, 1911*; A 289581; A. J. Hough, Proctorsville. Vt. (11-14561) 3019

Howells, William Dean, 1837-

Parting friends; a farce, by W. D. Howells ... New York and London, Harper & brothers, 1911.

57 p. incl. front., plates. 13½ᶜᵐ. $0.50

© June 15, 1911; 2c. June 17, 1911*; A 289836; Harper & bros. (11-14566) 3020

Hunnicutt, George Fredrick, 1863- *comp.*

Southern crops as grown and described by successful farmers, and published from time to time in the Southern cultivator, including Farish Furman's favorite formula. Comp. by G. F. Hunnicutt ... [Enl. and rev. ed.] [Atlanta, Ga., The Cultivator publishing company, ᶜ1911]

382 p. incl. front., illus. 19½ᶜᵐ. $1.00

© June 10, 1911; 2c. June 15, 1911*; A 289755; Cultivator pub. co. (11-14768) 3021

Ingersoll, Ernest, 1852-

Animal competitors; profit and loss from the wild four-footed tenants of the farm, by Ernest Ingersoll ... New York, Sturgis & Walton company, 1911.

xv, 319 p. front., illus., pl. 19½ᶜᵐ. (*Half-title:* The young farmer's practical library. ed. by E. Ingersoll) $0.75

© June 8, 1911; 2c. June 13, 1911*; A 289699; Sturgis & Walton co. (11-14765) 3022

Jenkens, Charles Augustus.
The bride's return; or, How Grand Avenue church
came to Christ; a story with a supreme purpose ... By
Rev. C. A. Jenkens ... with illustrations by Hazel Robin-
son. Charlotte, N. C., C. H. Robinson & company [°1911]
342 p. incl. front. (port.) plates. plates. 19½ᶜᵐ. $1.25
© June 5, 1911; 2c. June 19, 1911*; A 289858; C. H. Robinson & co.
(11-14719) 3023

Jones, Lauder William.
A laboratory outline of organic chemistry, by Lauder
William Jones ... New York, The Century co., 1911.
viii, 191 p. illus., tables, diagrs. 18½ᶜᵐ. $1.20
© June 16, 1911; 2c. June 20, 1911*; A 289899; Century co.
(11-14761) 3024

Jones, Mabel Cronise.
Achsah, the sister of Jairus, by Mabel Cronise Jones.
New York, Chicago [etc.] Broadway publishing co. [1911]
76 p. col. front. 20ᶜᵐ. $1.00
© Mar. 20, 1911; 2c. May 27, 1911; A 289733; M. C. Jones, Harrisburg. Pa.
(11-14751) 3025

Kilner, Walter John.
The human atmosphere; or, The aura made visible by
the aid of chemical screens, by Walter J. Kilner ... New
York, Rebman company [°1911]
xiii, 329 p. incl. plates. 21ᶜᵐ. $4.00
© June 8, 1911; 2c. June 9, 1911*; A 289602; Rebman co.
(11-14760) 3026

Löhnis, Felix, 1874–
Landwirtschaftlich-bakteriologisches praktikum; anlei-
tung zur ausführung von landwirtschaftlich-bakteriologi-
schen untersuchungen und demonstrations-experimenten,
von dr. F. Löhnis ... Mit 3 tafeln und 40 abbildungen im
text. Berlin, Gebrüder Borntraeger, 1911.
vii, 156 p. illus., iii pl. (incl. front.) 19ᶜᵐ. M. 3.40
© May 11, 1911; 2c. June 15, 1911*; A—Foreign 3070; Gebr. Borntraeger.
(11-14741) 3027

Lowery, Irving E 1850–
Life on the old plantation in ante-bellum days; or, A
story based on facts, by Rev. I. E. Lowery, with brief
sketches of the author by the late Rev. J. Wofford White
... Columbia, S. C., The State co., printers, 1911.
186 p. front. (port.) 20ᶜᵐ. $1.25
"Appendix. Signs of a better day for the negro in the South. Being
the reprint of a series of articles written for the Daily record of Colum-
bia, S. C., by Rev. I. E. Lowery," p. 133–186.
© June 10, 1911; 2c. June 14, 1911*; A 289717; State co.
(11-14732) 3028

Mershon, Ralph Smith.
Poems, by Ralph Smith Mershon. Printed manuscript.
Zanesville, O. [The Champlin press, Columbus, O.] 1911.
3 p. l., 3–404 p. 20½ᶜᵐ. $3.00
© June 16, 1911; 2c. June 19, 1911*; A 289881; R. S. Mershon, Zanesville,
O. (11-14564) 3029

Messer, Clarence Johnson.

Next-night stories, by Clarence Johnson Messer; illustrated by Adam C. Maurer. New York, Broadway publishing co., 1911.

5 p. l., 7-142 p. front., plates. 20½ᶜᵐ. $1.25
CONTENTS.—The first night. The proud and foolish peacock.—The second night. The donkey and the wolf.—The third night. The fox, the raccoon and the bear.—The fourth night. The frog girl.—The fifth night. Granny Chipmunk's lesson.—The sixth night. Dandy Beaver and Sappy Woodchuck.—The seventh night. The bird of prey.—The eighth night. The hen that ran away.
© Apr. 12, 1911; 2c. May 27, 1911; A 289739; C. J. Messer, Malden, Mass.
(11-14717) 3030

Moreux, Th 1867–

... Quelques heures dans le ciel; illustrations d'après les dessins et photographies de l'auteur. Paris, A. Fayard [°1911]

126, [2] p. incl. illus., plates. 24ᶜᵐ. fr. 1
© May 19, 1911; 2c. June 10, 1911*; A—Foreign 3045; Arthème Fayard.
(11-14580) 3031

Murray, David Ambrose.

Christian faith and the new psychology; evolution and recent science as aids to faith, by David A. Murray ... New York, Chicago [etc.] Fleming H. Revell company [°1911]

384 p. 20½ᶜᵐ. $1.50
© June 3, 1911; 2c. June 15, 1911*; A 289769; Fleming H. Revell co.
(11-14773) 3032

Paul, George P 1879–

Nursing in the acute infectious fevers, by George P. Paul ... 2d ed., thoroughly rev. Philadelphia and London, W. B. Saunders company, 1911.

246 p. illus., plates (1 col.) diagrs. 21ᶜᵐ. $1.00
© June 14, 1911; 2c. June 16, 1911*; A 289820; W. B. Saunders co.
(11-14756) 3033

Quervain, Fritz de.

Spezielle chirurgische diagnostik für studierende und ärzte, bearb. von dr. F. de Quervain ... mit 462 abbildungen im text und 4 tafeln. 3., vervollständigte aufl. Leipzig, F. C. W. Vogel, 1911.

xix, 730 p. illus. (partly col.) 4 col. pl. 26ᶜᵐ. M. 18
© May 15, 1911; 2c. June 15, 1911*; A—Foreign 3084; F. C. W. Vogel.
(11-14755) 3034

Ransom, Luther A d. 1910.

The great cottonseed industry of the South, by Luther A. Ransom ... New York, Oil, paint and drug reporter, 1911.

125 p. illus. 24ᶜᵐ. $1.25
© June 1, 1911; 2c. June 15, 1911*; A 289793; Oil, paint & drug reporter.
(11-14785) 3035

Robison, Clarence Hall.

Agricultural instruction in the public high schools of the United States, by Clarence Hall Robison ... New York city, Teachers college, Columbia university, 1911.

viii, 205 p. front. (map) 23½ᶜᵐ. (Teachers college, Columbia university. Contributions to education. no. 39) $1.50
"List of references on agricultural education": p. 191–200.

© June 2, 1911; 2c. June 10, 1911; A 289668; C. H. Robison, Upper Montclair, N. J. (11–14766) 3036

Sawyer, Edith Augusta, 1869–

Elsa's gift home; or, More about the Christmas makers' club, by Edith A. Sawyer ... illustrated by Florence E. Nosworthy ... Boston, L. C. Page & company, 1911.

5 p. l., 229 p. front., plates. 20½ᶜᵐ.

© June 15, 1911; 2c. June 17, 1911*; A 289854; L. C. Page & co., inc. (11–14715) 3037

Sharpless, Frances M.

Poems, by Frances M. Sharpless. Philadelphia, Printed for private circulation by J. B. Lippincott company, 1911.

2 p. l., 3–159 p. 22ᶜᵐ.

© May 24, 1911; 2c. June 9, 1911*; A 289592; Frances M. White, Cardington, Pa. (11–14562) 3038

Stevenson, Robert Louis, 1850–1894.

Stevenson's Treasure Island, ed. by Stuart P. Sherman ... New York, H. Holt and company, 1911.

xlv, (1), 258 p. front. (port.) illus. (facsim.) plates. 17ᶜᵐ. (Half-title: English readings for schools) $0.40
"Descriptive bibliography": p. xliii–xlv.

© June 10, 1911; 2c. June 20, 1911*; A 289925; Henry Holt & co. (11–14754) 3039 .

Taylor, Frederick Winslow, 1856–

Shop management, by Frederick Winslow Taylor ... with an introduction by Henry R. Towne ... New York and London, Harper & brothers, 1911.

207 p. illus., fold. tab. 23ᶜᵐ. $1.50

© June 15, 1911; 2c. June 17, 1911*; A 289837; F. W. Taylor, Germantown, Pa. (11–14746) 3040

Thorndike, Edward Lee, 1874–

Animal intelligence; experimental studies, by Edward L. Thorndike ... New York, The Macmillan company, 1911.

viii p., 1 l., 297 p. illus. 20ᶜᵐ. (On cover: The animal behavior series) $1.60
CONTENTS.—The study of consciousness and the study of behavior.—Animal intelligence.—The instinctive reactions of young chicks.—A note on the psychology of fishes.—The mental life of the monkeys.—Law and hypotheses of behavior.—The evolution of the human intellect.

© June 14, 1911; 2c. June 15, 1911*; A 289766; Macmillan co. (11–14536) 3041

Torrey, Reuben Archer, 1856-- *ed.*
The higher criticism and the new theology; unscientific, unscriptural, and unwholesome, ed. by Dr. R. A. Torrey. Montrose, Penna., Montrose Christian literature society [°1911]
284 p. 19ᶜᵐ. $0.15
© May 8, 1911; 2c. May 9. 1911; A 289625; R. A. Torrey, Montrose, Pa.
(11-14554) . 3042

Virtue, George Ole, 1862--
The government of Minnesota, by G. O. Virtue ... New York, C. Scribner's sons, 1910.
xi, 200 p. 19ᶜᵐ. $0.60
© Feb. 26, 1911; 2c. June 13, 1911*; A 289686; Charles Scribner's sons.
(11-14570) 3043

Walter, Robert.
Götterdämmerung, eine geschichte vom untergang Wuotans, von Robert Walter ... Mainz, J. Scholz [°1911]
191, [1] p. illus. 20ᶜᵐ. (*Half-title:* Mainzer volks- und jugendbücher. [buch 14]) M. 3
© May 2, 1911; 2c. June 9, 1911*; A—Foreign 3027; Jos. Scholz.
(11-14735) 3044

White, William Alanson, 1870--
... Mental mechanisms, by William A. White ... New York, The Journal of nervous and mental disease publishing company, 1911.
vii, 151 p. 25ᶜᵐ. (Nervous and mental disease monograph series, no. 8)
$2.00
© June 7. 1911; 2c. June 10, 1911*; A 289653; W. A. White, Washington, D. C. (11-14757) 3045

Winter, Lovick Pierce.
A life of Martin Luther, the great reformer of the sixteenth century, by Lovick Pierce Winter. Nashville, Tenn., Dallas, Tex., Publishing house of the M. E. church, South, Smith & Lamar, agents, 1911.
321 p. front. (port.) 20ᶜᵐ. $1.00
© June 6, 1911; 2c. June 12. 1911*; A 289674; Smith & Lamar, Nashville, Tenn. (11-14588) 3046

Wislicenus, Georg, 1858--
Die deutschen hafenstädte, in bildern von professor Willy Stöwer, text von admiralitätsrat Georg Wislicenus. Berlin, Deutscher verlag g. m. b. h. [°1911]
4 p. l., 88 p. illus., 16 col. pl. 40 x 59ᶜᵐ. M. 25
Issued in 4 parts.
© Apr. 8, 1911; 2c. June 15. 1911*; A—Foreign 3076; Deutscher verlag, g. m. b. h. (11-14589) 3047

[Zimmerman, Jacob]
Black and white ... with illustrations by Joseph Rodgers. Philadelphia, The Literary bureau, inc. [°1911]
3 p. l., 5-167 p. front., plates. 19ᶜᵐ. $1.00
© May 18, 1911; 2c. May 19, 1911*; A 289018; Literary bureau, inc.
(11-14716) 3048

Adams, Cyrus Cornelius, 1849–

... A text-book of commercial geography, by Cyrus C. Adams ... New York, D. Appleton and company, 1911.

xvi, 508 p. front., illus., plates, maps. 20ᶜᵐ. (*Half-title:* Twentieth century text-books) $1.30

© June 17, 1911; 2c. June 20, 1911*; A 289917; D. Appleton & co.
(11–15035) 3049

Annunzio, Gabriele d', 1863–

Le martyre de Saint Sébastien; mystère en cinq actes, par Gabriele d'Annunzio ... ₁Paris, Impr. de l'Illustration₁ °1911·

52 p. illus. 30ᶜᵐ.
On cover: L'Illustration théatrale. 7ᵉ année–181. 27 mai 1911.
© May 27, 1911; 2c. June 10, 1911*; D 24449; Calmann-Lévy, Paris.
(11–14736) 3049*

Arrighi, Antonio Andrea.

The story of Antonio, the galley-slave; a romance of real life, in three parts, by Antonio Andrea Arrighi. New York, Chicago ₁etc.₁ Fleming H. Revell company ₁°1911₁

3 p. l., 5–266 p. front. (port.) 20½ᶜᵐ. $1.25
CONTENTS. — A drummer boy with Garibaldi, at the siege of Rome, 1849.—The galley-slave of Civitá Vecchia.—A herald of the cross in America and Italy.
© May 20, 1911; 2c. June 15, 1911*; A 289757; Fleming H. Revell co.
(11–15195) 3050

Blackall, Robert Henry, 1868–

Up-to-date air brake catechism; the only practical and complete work published, treating on the equipment manufactured by the Westinghouse air brake company ... 2,000 questions with their answers ... By Robert H. Blackall ... 25th ed., entirely rev., enl. and reset. New York, The Norman W. Henley publishing company, 1911.

7 p. l., ₁17₁–352 p. illus., col. plates. 17½ᶜᵐ. $2.00
© June 14, 1911; 2c. June 15, 1911*; A 289788; Norman W. Henley pub. co. (11–15026) 3051

Brieux, Eugene, 1858–

Three plays by Brieux ... with preface by Bernard Shaw; English versions by Mⁿ. Bernard Shaw, Sᵗ. John Hankin and John Pollock. New York, Brentano's, 1911.

liv, 333 p. 19½ᶜᵐ. $1.50
CONTENTS. — Preface. — Maternity, tr. by Mrs. B. Shaw. — The three daughters of M. Dupont, tr. by St. J. Hankin.—Damaged goods, tr. by J. Pollock.—Maternity (new version) tr. by J Pollock.
© May 10, 1911; 2c. May 11, 1911; A 289745; Charlotte Frances Shaw, London. (11–15330) 3052

Curtis, William Eleroy, 1850–

Turkestan: "the heart of Asia," by William Eleroy Curtis ... pictures by John T. McCutcheon. New York,

Curtis, William Eleroy—Continued

Hodder & Stoughton, George H. Doran company [c1911]

5 p. l., 3–344 p. front., plates, ports., fold. map. 21½ᶜᵐ. $2.00
Map attached to back of cover.
© June 21, 1911; 2c. June 22, 1911*; A 289978; George H. Doran co.
(11–15040) • 3053

Dillon, John Forrest, 1831–

Commentaries on the law of municipal corporations.
By John F. Dillon ... 5th ed., thoroughly rev. and enl. ...
v. 1–4. Boston, Little, Brown, and company, 1911.

4 v. 24½ᶜᵐ. $6.50
Published also under title: The law of municipal corporations.
© June 15, 1911; 2c. June 17, 1911*; A 289844; J. F. Dillon, New York.
(11–15197) 3054

Doyle, Sir Arthur Conan, 1859–

The last galley; impressions and tales, by Arthur Conan Doyle ... Garden City, New York, Doubleday, Page & company, 1911.

6 p. l., 3–321 p. col. front., pl. 19½ᶜᵐ. $1.20
CONTENTS.—The last galley.—The contest.—Through the veil.—An iconoclast. — Giant Maximin. — The coming of the Huns. — The last of the legions.—The first cargo.—The home-coming.—The red star.—The silver mirror.—The blighting of Sharkey.—The marriage of the brigadier.—The lord of Falconbridge.—Out of the running.—"De profundis."—The great Brown-Pericord motor.—The terror of Blue John Gap.
© June 20, 1911; 2c. June 22, 1911*; A 289971; A. C. Doyle, London.
(11–15192) 3055

Eliot, George, pseud., i. e. Marian Evans, afterwards Cross, 1819–1880.

... Silas Marner, the weaver of Raveloe; ed., with introduction and notes by Franklin T. Baker ... New York, C. Scribner's sons, 1911.

xix, 191 p. front. (port.) 16½ᶜᵐ. (Half-title: The Scribner English classics, ed. by F. H. Sykes) $0.25
"Selected bibliography": p. [vi]
© June 17, 1911; 2c. June 23, 1911*; A 289989; Charles Scribner's sons.
(11–15194) 3056

Gabelentz, Georg von der, 1868–

Tage des teufels, phantasien; novellen von Georg von der Gabelentz. 2. tausend. Leipzig, L. Staackmann, 1911.

312 p., 1 l. 20½ᶜᵐ. M. 4
CONTENTS.—Der gelbe schädel.—Der steinbruch.—Ein ring.—Die vogelprinzessin. — Die fackeln des Galiläers. — Der Weihnachtsmann. —Jener andere.—Gespenster.—Die neue Circe.—Der spiegel.
© Mar. 24, 1911; 2c. June 15, 1911*; A—Foreign 3069; L. Staackmann.
(11–15044) 3057

Gaebelein, Arno Clemens, 1861–

The prophet Daniel; a key to the visions and prophecies of the book of Daniel, by A. C. Gaebelein ... New York, N. Y., Publication office "Our hope" [c1911]

1 p. l., ii, 228 p. 20ᶜᵐ.
© May 27, 1911; 2c. June 15, 1911*; A 289805; A. C. Gaebelein, New York.
(11–15340) 3058

Going, Charles Buxton, 1863–

Principles of industrial engineering, by Charles Buxton Going ... New York [etc.] McGraw-Hill book company, 1911.

x p., 1 l., 174 p. 24ᶜᵐ. $2.00
© June 16, 1911; 2c. June 19, 1911*; A 289873; McGraw-Hill book co.
(11-15025) 3059

Graham, Julia Frances.

Emily Roe of Baltimore, by Julia Frances Graham. Chicago, M. A. Donohue & co. [1911]

402 p. 19ᶜᵐ.
© Feb. 15, 1911; 2c. June 19, 1911; A 289889; J. F. Graham, St. Louis, Mo.
3060

Emily Roe of Baltimore, by Julia Frances Graham ... 2d ed. ... St. Louis, F. T. Borden, 1911.

403 p. incl. front. (port.) 19½ᶜᵐ. $1.35
© June 15, 1911; 2c. June 19, 1911*; A 289890; J. F. Graham, St. Louis, Mo. (11-14721) 3061

Haliburton, Margaret Winifred.

... Teaching poetry in the grades, by Margaret W. Haliburton ... and Agnes G. Smith ... Boston, New York [etc.] Houghton Mifflin company [ᶜ1911]

vi p., 1 l., 167, [1] p., 1 l. 18½ᶜᵐ. (Riverside educational monographs, ed. by H. Suzzallo) $0.60
© May 10, 1911; 2c. June 15, 1911*; A 289782; Houghton Mifflin co.
(11-15052) 3062

Heard, Wilby, pseud.

Confessions of an industrial insurance agent; a narrative of fact, by Wilby Heard ... New York, Indianapolis [etc.] Broadway publishing co. [ᶜ1911]

1 p. l., 5–35 p. 20½ᶜᵐ. $0.50
© May 8, 1911; 2c. May 27' 1911; A 289731; Broadway pub. co.
(11-15031) 3063

Hill, David Jayne, 1850–

... World organization as affected by the nature of the modern state, by David Jayne Hill. New York, The Columbia university press, 1911.

ix, 214 p. 20½ᶜᵐ. (Half-title: Columbia university lectures ... The Carpentier lectures, 1910–1911) $1.50
© June 12, 1911; 2c. June 12, 1911; A 289751; Columbia univ. press.
(11-15179) 3064

Hirschfeld, Georg, 1873–

... Angst und Emma, und andre geschichten, von Georg Hirschfeld. Stuttgart, J. Engelhorns nachf., 1911.

160 p. 18½ᶜᵐ. (Engelhorns allgemeine roman-bibliothek. 27. jahrg., bd. 19) 75 pf.
CONTENTS.—Angst und Emma.—Frau Brösels klugheit.—Arme leute.—Der gefährliche Schulz. — Der falsche schein. — Ein stückchen wurst.—Mesalliance. — Liebe armendirektion. — Frau Kistenmacher und Napoleon.
© Apr. 29, 1911; 2c. June 15, 1911*; A—Foreign 3080; J. Engelhorns nachfolger. (11-15045) 3065

Hotz, Wilhelm, 1870–

Kochbuch für gesunde und kranke, nebst kurzgefasster ernährungslehre, kochvorschriften, speisezettel und illustrationen, von dr. of med. W. Hotz ... Mellenbach i Thür, Verlag "Gesundes leben," 1911.

viii, 257 p., 1 l. illus., col. double plates. 24½ᶜᵐ. M. 3.50

© Mar. 1, 1911; 2c. May 19, 1911*; A—Foreign 3086; Verlag Gesundes leben. (11–15024) 3066

Hunkey, John.

How I became a non-Catholic ... by John Hunkey. Cincinnati, O., The Standard publishing company, 1911.

viii, 334 p. 20ᶜᵐ. $1.00

© June 16, 1911; 2c. June 22, 1911*; A 289979; Standard pub. co. (11–15339) 3067

Hurn, Ethel Alice.

... Wisconsin women in the war between the states, by Ethel Alice Hurn, B. A. ₍Madison₎ Wisconsin history commission, 1911.

xix, 190 p. front. (port.) 6 pl. (1 fold.) 23½ᶜᵐ. (Wisconsin history commission: Original papers, no. 6) $1.00

© June 8, 1911; 2c. June 12, 1911; A 289888; Wisconsin history comn., in behalf of the state of Wisconsin, Madison, Wis. (11–15204) 3068

Kelsey, Francis Willey, 1858– ed.

Latin and Greek in American education, with symposia on the value of humanistic studies, ed. by Francis W. Kelsey. New York, London, The Macmillan company, 1911.

x, 396 p. 22½ᶜᵐ. $1.50

Formerly "published in the School review or the Educational review."— Pref.

© May 29, 1911; 2c. June 19, 1911*; A 289865; Macmillan co. (11–15327) 3069

Kirk, Edward.

A practical treatise on foundry irons: comprising pig iron, and fracture grading of pig and scrap irons; scrap irons; mixing irons; elements and metalloids; grading iron by analysis; chemical standards for iron castings; testing cast iron; semi-steel; malleable iron; etc., etc. By Edward Kirk ... Philadelphia, H. C. Baird & co., 1911.

xviii, 276 p. 23½ᶜᵐ. $3.00

© June 14, 1911; 2c. June 16, 1911*; A 289812; E. Kirk, Philadelphia. (11–15023) 3070

₍Klarmann, Andrew F ₎ 1866–

Chapters in Christian doctrine ... New York, Cincinnati ₍etc.₎ F. Pustet & co., 1911.

246 p. 18½ᶜᵐ. $0.75

© June 10, 1911; 2c. June 12, 1911*; A 289675; Fr. Pustet & co. (11–14769) 3071

[Leclercq, *Mme.* Marie]

... En secret! Paris, Calmann-Lévy [°1911]

2 p. l., 373, [1] p. 19^{cm}. fr. 3.50
Author's pseudonym, Mary Floran, at head of title.
© May 24, 1911; 2c. June 12, 1911*; A—Foreign 3048; Calmann-Lévy.
(11–14560) 3072

Le Fevre, Ralph.

... History of New Paltz, New York, and its old families
(from 1678 to 1820) including the Huguenot pioneers and
others who settled in New Paltz previous to the revolu-
tion; with an appendix bringing down the history of cer-
tain families and some other matter to 1850, by Ralph
Le Fevre ... [2d ed.] Albany, N. Y., Brandow printing
company, 1909.

xiv, 593, [8], [v]–vi, 208 p. front., illus. (incl. maps, facsims.) ports.
24^{cm}. $5.00
© Mar. 4, 1910; 1c. May 17, 1911; 1c. June 8, 1911; A 289931; R. Le Fevre,
New Paltz, N. Y. (11–15199) . 3073

Lindelöf, Uno Lorentz.

Elements of the history of the English language, by
Uno Lindelöf ... tr. by Robert Max Garrett ... [Seattle]
University of Washington, 1911.

4 p. l., [15]–128 p. 20^{cm}. (*Half-title:* University of Washington publica-
tions in English. vol. 1) $0.75
© June 13, 1911; 2c. June 19, 1911*; A 289868; Robert Max Garrett, Se-
attle, Wash. (11–15053) 3074

Lockhart, Charles Fulton, 1872–

Practical instructor and reference book for locomotive
firemen and engineers: a practical treatise ... By Charles
F. Lockhart ... Over eight hundred examination ques-
tions with their answers are included. These cover the
examinations required by the different railroads. New
York, The Norman W. Henley publishing co., 1911.

362 p. incl. front., illus. 17½^{cm}. $1.50
© June 14, 1911; 2c. June 15, 1911*; A 289794; Norman W. Henley pub.
co. (11–15022) 3075

Lytton, *Hon. Mrs.* **Judith Anne Dorothea (Blunt)**

Toy dogs and their ancestors, including the history and
management of toy spaniels, Pekingese, Japanese and
Pomeranians, by the Hon. Mrs. Neville Lytton, with nu-
merous illustrations. New York, D. Appleton and com-
pany, 1911.

xviii p., 1 l., 358 p., 1 l. col. front., plates (partly col.) ports., plans.
24^{cm}. $7.50
© June 9, 1911; 2c. June 13, 1911*; A 289705; J. Lytton, London.
(11–14764) 3076

MacGregor, Theodore Douglas, 1879–

Pushing your business, a text-book of advertising, giv-
ing practical advice on advertising, for banks, trust com-
panies, safe deposit companies, investment brokers, real

MacGregor, Theodore Douglas—Continued
estate dealers, insurance agents, and all interested in
promoting their business by judicious advertising. By
T. D. MacGregor ... 4th ed., rev. and enl. New York,
The Bankers publishing co., 1911.
4 p. l., 197 p. illus. 19½ᶜᵐ. $1.25
© June 16, 1911; 2c. June 21, 1911*; A 289942; Bankers pub. co.
(11-15034) 3077

Mack, William, ed.
Cyclopedia of law and procedure. Popular ed. William Mack, LL. D., editor-in-chief. Book 2. Receivers–
Telegraphs and telephones. New York, The American
law book company, 1911.
vi, [1886] p. 25ᶜᵐ. $7.50
© June 23, 1911; 2c. June 24, 1911*; A 292027; American law book co.
3078

Manni, Giuseppe.
Italian spoken in twenty-two days ... Containing about
four hundred practical remarks on orthoepy, phonology,
etymology and syntax; all spoken sentences in common
use; a conversational guide for the English-speaking
tourist in Italy having what is needful for every-day life.
By Joseph Manni ... Rome, "Mundus" printing-office
[°1911]
135 p. 18ᶜᵐ. $0.29
© May 15 1911; 2c. June 6, 1911; A—Foreign 3087: Joseph Manni, Rome.
(11-15054) 3079

Moriarty, William Daniel.
The function of suspense in the catharsis [by] W. D.
Moriarty ... Ann Arbor, Mich., G. Wahr, 1911.
61 p. 19ᶜᵐ. $0.60
© June 6, 1911; 2c. June 16, 1911*; A 289823; W. D. Moriarty, Ann Arbor,
Mich. (11-15046) 3080

National society of the colonial dames of America. *Delaware.*
A calendar of Delaware wills, New Castle County,
1682–1800, abstracted and compiled by the Historical re-
search committee of the Colonial dames of Delaware.
New York, F. H. Hitchcock [°1911]
218 p. 24½ᶜᵐ. $3.50
© May 24, 1911; 2c. June 2, 1911*; A 289388; Frederick H. Hitchcock,
New York, N. Y. (11-14184) 3081

Orczy, Emmuska i. e. **Emma Magdalena Rosalia Maria
Josefa Barbara,** *baroness,* 1865–
The heart of a woman, by Baroness Orczy ... New
York, Hodder & Stoughton, George H. Doran company
[°1911]
2 p. l., 3–321 p. 19½ᶜᵐ. $1.20
Published in Great Britain under title: A true woman.
© June 17, 1911; 2c. June 19, 1911*; A 289880; George H. Doran co.
(11-15193) 3082

Osborne, Thomas De Courcey, 1844–

The Koran Christ, also, Mohammedan memorabilia and personal memoranda of travel. By Thos. D. Osborne ... Louisville, Ky., Baptist book concern, 1910.

4 p. l., [5]–128 p. front., plates, ports. 19½ᶜᵐ.
© June 1, 1911; 2c. June 2, 1911; A 289539; T. D. Osborne, Louisville, Ky.
(11–15337) 3083

Oswald publishing company, *New York.*

The American manual of presswork. New York, Oswald publishing company, 1911.

xi, [1] p., 1 l., 155, [1] p. col. front., illus., plates (partly col.) 31½ᶜᵐ.
$4.00
"While the contents of the book first appeared in ... the American printer, the matter was edited expressly for the purposes of this manual."—Publisher's pref.
© June 1, 1911; 2c. June 14, 1911*; A 289744; Oswald pub. co.
(11–15189) 3084

Palmer, Henry Robinson, 1867–

The country by the sea; a book of verse, by Henry Robinson Palmer. Providence, R. I., Brown alumni magazine company, 1911.

96 p. 20½ᶜᵐ. $1.00
Partly reprinted from various periodicals.
© June 19, 1911; 2c. June 21, 1911*; A 289951; Brown alumni magazine co. (11–15049) 3085

Presbyterian brotherhood of America.

Presbyterian men; addresses and proceedings of the fourth national convention, Presbyterian brotherhood of America, held at St. Louis, Mo., February 21, 22, 23, 1911. Chicago, Ill., The Presbyterian brotherhood of America, 1911.

425 p. front. (port.) 19½ᶜᵐ. $0.50
© June 6, 1911; 2c. June 17, 1911*; A 289851; Presbyterian brotherhood of America. (11–15338) 3086

Putnam, Ruth.

William the Silent, prince of Orange ⟨1533–1584⟩ and the revolt of the Netherlands, by Ruth Putnam ... New York and London, G. P. Putnam's sons, 1911.

2 p. l., iii–xxiv p., 1 l., 518 p. front., illus., plates, ports., maps (1 fold.) facsims., geneal. tables. 20ᶜᵐ. (*Half-title:* Heroes of the nations, ed. by H. W. C. Davis) $1.50
"The author has made use of the material collected for her Memoir of William of Orange, published in two volumes in 1895, but the present narrative is entirely rewritten."—Publishers' note.
Bibliography: p. 497–506.
© June 9, 1911; 2c. June 17, 1911*; A 289831; R. Putnam, Washington. (11–15039) 3087

Read, Eugene Bruce, 1837–

Devotional poems for the quiet hour, by Eugene B. Read. Boston, Sherman, French & company, 1911.

5 p. l., 125 p. 19½ᶜᵐ. $1.00
© May 26, 1911; 2c. June 3, 1911*; A 289451; Sherman, French & co. (11–15328) 3088

Remsen, Daniel Smith, 1853–

Post-mortem use of wealth, including a consideration of ante-mortem gifts; legal point of view, by Daniel S. Remsen ... ethical point of view, by Felix Adler, Charles F. Aked, James J. Fox, David H. Greer, Newell Dwight Hillis, F. de Sola Mendes, Henry W. Warren, David G. Wylie. New York and London, G. P. Putnam's son, 1911.
xi, 131 p. 21ᶜᵐ. $1.25
© May 26, 1911; 2c. June 17, 1911*; A 289832; D. S. Remsen, Brooklyn.
(11–15032) 3089

Richman, Irving Berdine, 1861–

California under Spain and Mexico, 1535–1847; a contribution toward the history of the Pacific coast of the United States, based on original sources (chiefly manuscript) in the Spanish and Mexican archives and other repositories, by Irving Berdine Richman, with maps, charts, and plans. Boston and New York, Houghton Mifflin company, 1911.
xvi, 541. ₁1₁ p. front., illus., maps, plans, charts, tables. 23ᶜᵐ.
1 folded table, 1 folded map in pockets.
© June 3, 1911; 2c. June 15, 1911*; A 289774; I. B. Richman, Muscatine, Ia. (11–15200) 3090

Routier, Gaston, 1868–

... Le Napoléon de mes rêves ... Paris, Éditions de "L'Époque moderne," 1911.
222 p. 23ᶜᵐ. fr. 3
At head of title: Gaston-Routier.
© Jan. 15, 1911; 2c. June 21, 1911*; A—Foreign 3088; Gaston-Routier, Paris. (11–15041) 3091

Schäffer, *Mrs.* Mary T S.

Old Indian trails; incidents of camp and trail life, covering two years exploration through the Rocky Mountains of Canada, by Mary T. S. Schäffer ... with 100 illustrations from photographs by the author and by Mary W. Adams, and a map. New York ₁etc.₁ G. P. Putnam's sons, 1911.
xiv p., 1 l., 364 p. front., illus., fold. map. 21ᶜᵐ. $2.00
© June 9, 1911; 2c. June 17, 1911*; A 289833; M. T. S. Schäffer, Philadelphia. (11–15201) 3092

Swartz, Mifflin Wyatt.

On the characteristics and use of the old in the dramas of Euripides ... Nashville, Tenn., For the author, Publishing house of the M. E. church, South, 1911.
xiv p., 1 l., 115 p. 23ᶜᵐ. $1.50
Thesis (PH. D.)—University of Virginia.
"A partial bibliography": p. xi.
© May 29, 1911; 2c. June 22, 1911*; A 289973; M. W. Swartz, Jackson, Miss. (11–15051) 3093

American school of correspondence, *Chicago.*

Motion-picture theater; instruction paper prepared by David S. Hulfish ... Chicago, Ill., American school of correspondence [c1911]

1 p. l., 46, [4] p. illus. (incl. plan, form) 24½ᶜᵐ. $0.50
Contains examination paper.

© June 13, 1911; 2c. June 17, 1911*; A 289838; American school of correspondence. (11–15542) 3094

Beach, Joseph Warren.

The comic spirit in George Meredith; an interpretation, by Joseph Warren Beach. New York [etc.] Longmans, Green, and co., 1911.

4 p. l., 230 p. 19½ᶜᵐ. $1.25

© June 12, 1911; 2c. June 23, 1911*; A 292004; Longmans, Green, & co. (11–15549) 3095

Benson, Arthur Christopher, 1862–

Ruskin; a study in personality, by Arthur Christopher Benson ... New York and London, G. P. Putnam's sons, 1911.

2 p. l., v–ix p., 323 p. 19½ᶜᵐ. $1.50

© June 19, 1911; 2c. June 21, 1911*; A 289948; A. C. Benson, Cambridge, England. (11–15332) 3096

Blanchard, Charles Elton.

The nut cracker, and other human ape fables, by Charles Elton Blanchard, M. D. New York, Chicago [etc.] Broadway publishing co. [c1911]

109 p. 20ᶜᵐ.

© Apr. 24, 1911; 2c. May 27, 1911; A 289735; C. E. Blanchard, Youngstown, O. (11–15354) 3097

Boutet de Monvel, Roger, 1879–

... Les Anglais à Paris, 1800–1850; avec 16 gravures. 2. éd. Paris, Plon-Nourrit et cⁱᵉ, 1911.

4 p. l., vii, 376 p. plates, ports. 20½ᶜᵐ. fr. 4

© June 9, 1911; 2c. June 23, 1911*; A—Foreign 3098; Plon-Nourrit & cie. (11–15606) 3098

Boutroux, Étienne Émile Marie, 1845–

... William James. Paris, A. Colin, 1911.

2 p. l., 142 p., 1 l. front. (port.) 19ᶜᵐ. fr. 3

© June 2, 1911; 2c. June 23, 1911*; A—Foreign 3093; Max Leclerc and H. Bourrelier, Paris. (11–15604) 3099

Brown, Isaac Washington, 1848–

Birds that work for us, by Col. Isaac W. Brown ... Marion, Ind., Teacher's journal company [c1911]

117, [1] p. incl. pl. 16ᶜᵐ. $0.50

© May 20, 1911; 2c. June 14, 1911*; A 289741; Teacher's journal co. (11–15581) 3100

Campbell, James Mann, 1840–
Grow old along with me, by James M. Campbell ...
New York, Chicago [etc.] Fleming H. Revell company
[°1911]
244 p. 19½ᶜᵐ. $1.25
© June 3, 1911; 2c. June 15, 1911*; A 289767; Fleming H. Revell co.
(11–15341) 3101

Davis, Duke, 1878–
Flashlights from mountain and plain, by Duke Davis.
Bound Brook, N. J., The Pentecostal union, 1911.
3 p. l., [13]–266 p. incl. plates. pl., port. 20ᶜᵐ. $0.80
© June 6, 1911; 2c. June 13, 1911*; A 289697; Pentecostal union.
(11–15359) 3102

Delany, John Bernard, bp., 1864–1906.
The life and writings of the Right Reverend John Ber-
nard Delany ... by G. C. D. Lowell, Mass., The Lawler
printing company, 1911.
7 p. l., 452 p. front. (port.) col. pl. 22ᶜᵐ. $2.50
© June 14, 1911; 2c. June 16, 1911; A 289930; Lawler printing co.
(11–15601) 3103

Dominik, Hans.
... Der eiserne weg. Roman ... Berlin, C. Duncker
[°1911]
cover-title, 312 p. 18¼ᶜᵐ.
"Feuilleton-manuskript."
© May 22, 1911; 2c. June 26, 1911*; A—Foreign 3116; Carl Duncker.
(11–15569) 3104

Dumont-Wilden, Louis, 1875–
La Belgique illustrée, par Dumont-Wilden; préface
d'Émile Verhaeren, conclusion par Louis Frank; 570 re-
productions photographiques, 22 cartes et plans en noir,
10 planches hors texte en noir, 6 cartes en couleurs, 3
planches hors texte en couleurs. Paris, Librairie La-
rousse [°1911]
2 p. l., iii, [1], 302, [2] p. illus., plates (part col.) maps. 33ᶜᵐ. fr. 15
"Bibliographie de la Belgique": p. [295]–299.
© May 26, 1911; 2c. June 23, 1911*; A—Foreign 3100; Librairie Larousse
& cie. (11–15610) 3105

Folkestad, Sigurd, 1877–
Paa kongevei [af] Sigurd Folkestad. Strum, Wis.,
1911.
141 p. 19½ᶜᵐ. $0.50
© June 1, 1911; 2c. June 23, 1911*; A 292014; S. Folkestad, Strum, Wis.
(11–15552) 3106

Gray, Thomas, 1716–1771.
Essays and criticisms, by Thomas Gray, ed. with in-
troduction and notes, by Clark Sutherland Northup ...
Boston and London, D. C. Heath & co. [°1911]
liii, 378 p. illus. (plan) 15½ᶜᵐ. (Half-title: The belles-lettres series.
Section ıv. Literary criticism and critical theory. General editor, C. H.
Herford ...) $0.60
© May 25, 1911; 2c. June 15, 1911*; A 289785; D. C. Heath & co.
(11–15551) 3107

How, Louis.

Lyrics and sonnets, by Louis How. Boston, Sherman, French & company, 1911.
[56] p. front. 19½ᶜᵐ. $1.00
© June 19, 1911; 2c. June 21, 1911*; A 289950; Sherman, French & co.
(11–15048) 3108

Illinois. *Appellate courts.*

Reports of cases determined ... v. 157, A. D. 1911 ... Ed. by W. Clyde Jones and Keene H. Addington ... Chicago, Callaghan & company, 1911.
xviii, 645 p. 23ᶜᵐ. $3.50
© June 30, 1911; 2c. July 7, 1911*; A 292325; Callaghan & co.
 3109

Job, Herbert Keightley, 1864–

The sport of bird-study; a book for young or active people, by Herbert Keightley Job ... 2d ed., rev. Profusely illustrated with photographs from life by the author. New York, Outing publishing company, 1911.
5 p. l., ix–xiii p., 1 l., 284, iv p. front., plates. 21ᶜᵐ. $1.50
© May 31, 1911; 2c. June 26, 1911*; A 292073; Outing pub. co.
(11–15582) 3110

Jones, Walter Clyde, *ed.*

Notes on the Illinois reports; a cyclopedia of Illinois law ... by W. Clyde Jones and Keene H. Addington ... and Donald J. Kiser ... v. 4, 7. Chicago, Callaghan & company, 1911.
2 v. 26½ᶜᵐ. $7.50 a vol.
v. 4 © Nov. 10, 1910; v. 7 © Apr. 27, 1911; 2c. each July 7, 1911*; A 292323;
292324; Callaghan & co. 3111, 3112

Katz, Richard.

Werke klassischer kunst, zum studium der bildenden künste der Griechen und Römer, hrsg. von Rich. Katz ... 200 tafeln mit ca. 1000 abbildungen in farben- stein- und lichtdruck samt text. Stuttgart, C. Ebner, ᶜ1910.
3 v. illus., 208 pl. (partly col., partly fold.) 34 x 26ᶜᵐ.
© Dec. 15, 1910; 2c June 23, 1911*; A—Foreign 3107; Carl Ebner.
(11–15523) 3113

Kimball, Charles Porter.

Motoring through northern Italy; Napoleon's first campaign, by Charles Porter Kimball. Chicago, Priv. print. [by R. R. Donnelley and sons company] 1911.
27 p., 1 l. incl. illus., map. 24½ᶜᵐ.
© June 10, 1911; 2c. June 26, 1911*; A 292064; C. P. Kimball, Chicago.
(11–15607) 3114

King, Charles Albert, 1865–

... Elements of woodwork, by Charles A. King ... New York, Cincinnati [etc.] American book company [ᶜ1911]
x, 146 p. illus. 19ᶜᵐ. (King's series in woodwork and carpentry)
$0.60
© June 14, 1911; 2c. June 16, 1911*; A 289811; C. A. King. Bay City, Mich.
(11–15347) 3115

Kirchner, Friedrich, 1848–1900.

... Kirchner's Wörterbuch der philosophischen grund-begriffe. 6. aufl. 3. neubearbeitung, von dr. Carl Michaëlis. Leipzig, F. Meiner, 1911.

vi p., 1 l., 1124 p. 20½ᶜᵐ. (Philosophische bibliothek, bd. 67) M.12.50
© Apr. 15, 1911; 2c. June 26, 1911*; A—Foreign 3128; Felix Meiner.
(11–15603) 3116

Kossowicz, Alexander.

Einführung in die mykologie der nahrungsmittelge-werbe; kurzer grundriss zum selbststudium und zum ge-brauche für ärzte, gärungschemiker, käser, konserven-fabrikanten, landwirte, militärintendanten, militärver-pflegsbeamte, molkereibakteriologen, molkereischüler, nahrungsmittelchemiker, pharmazeuten, technische che-miker und tierärzte, von dr. Alexander Kossowicz ... mit fünf tafeln und 21 textabbildungen. Berlin, Gebrüder Borntraeger, 1911.

viii, 138 p. illus., plates. 25½ᶜᵐ. M.4
Plates 1 and 2 are illustrations in text.
"Literatur": p. [119]–128.
© May 11, 1911; 2c. June 15, 1911*; A—Foreign 3073; Gebr. Borntraeger.
(11–15343) 3117

Külpe, Oswald, 1862–

... Die philosophie der gegenwart in Deutschland; eine charakteristik ihrer hauptrichtungen nach vorträgen ge-halten im ferienkurs für lehrer 1901 zu Würzburg, von Oswald Külpe. 5., verb. aufl. Leipzig, B. G. Teubner, 1911.

4 p. l., 136 p. 18½ᶜᵐ. (Aus natur und geisteswelt ... 41. bdchen.)
M.1.25
© Apr. 19, 1911; 2c. June 23, 1911*; A—Foreign 3101; B. G. Teubner.
(11–15602) 3118

Laue, Max, 1879–

Das relativitätsprinzip, von dr. M. Laue ... mit 14 in den text eingedruckten abbildungen. Braunschweig, F. Vieweg & sohn, 1911.

x, 208 p. diagrs. 22½ᶜᵐ. (Added t.-p.: Die wissenschaft ... 38. hft.)
M.6.50
"Literatur": p. [201]–205.
© June 1, 1911; 2c. June 15, 1911*; A—Foreign 3083; Friedrich Vieweg &
sohn. (11–15344) 3119

Lié Sou, G.

... T'seu-hsi, impératrice des Boxers, par G. Lié Sou. Paris, Éditions d'Art et de littérature [1911]

2 p. l., 204 p. front. 19ᶜᵐ. (Les femmes illustres) fr. 2.50
© June 2, 1911; 2c. June 23, 1911*; A—Foreign 3099; J. Ed. Richardin,
Paris. (11–15609) 3120

Lloyd, John William.

Aw-aw-tam Indian nights; being myths and legends of the Pimas of Arizona, as received by J. William Lloyd from Comalk-Hawk-Kih (Thin Buckskin) thru the interpretation of Edward Hubert Wood. Westfield, N. J., The Lloyd group [°1911]

2 p. l., 241 p. port. 19½ᶜᵐ. $1.50
© June 17, 1911; 2c. June 21, 1911*; A 289952; J. W. Lloyd, Westfield, N. J. (11-15554) 3121

McLaughlin, Mary Louise.

China painting. A practical manual for the use of amateurs in the decoration of hard porcelain, by M. Louise McLaughlin. New ed., 21st thousand. Cincinnati, The Robert Clarke company, 1911.

viii, 9-140 p illus. 20ᶜᵐ. $1.00
© June 22, 1911; 2c. June 26, 1911*; A 292061; Stewart & Kidd co., Cincinnati. (11-15522) 3122

Manes, Alfred, 1877–

... Grundzüge des versicherungswesens, von prof. dr. Alfred Manes ... 2., veränderte aufl. Leipzig, B. G. Teubner, 1911.

iv p., 1 l., 146 p. 18½ᶜᵐ. (Aus natur und geisteswelt ... 105. bdchen.) M. 1.25
© Apr. 25, 1911; 2c. June 23, 1911*; A—Foreign 3102; B. G. Teubner. (11-15619) 3123

Maupassant, Guy de, 1850–1893.

... Œuvres choisies de Guy de Maupassant; poésies, contes, romans et nouvelles, théâtre; préface et analyses par F. Bernot ... Paris, C. Delagrave [°1911]

2 p. l., 404 p. 16½ᶜᵐ. (Collection Pallas) fr. 3.50
© June 2, 1911; 2c. June 23, 1911*; A—Foreign 3090; Ch. Delagrave. (11-15561) 3124

Michie, Thomas Johnson, ed.

Railroad reports (vol. 61 American and English railroad cases, new series) ... Ed. by Thomas J. Michie. v. 38. Charlottesville, Va., The Michie company, 1911.

vii, 843 p. 23½ᶜᵐ. $4.50
© June 30, 1911; 2c. July 3, 1911*; A 292246; Michie co. 3125

Moret, Alexandre, 1868–

... Rois et dieux d'Égypte; avec 20 gravures dans le texte, 16 planches et 1 carte hors texte. Paris, A. Colin, 1911.

3 p. l., ii, 318 p. illus., xvi pl (incl. front.) fold. map. 19ᶜᵐ. fr. 4
"Le présent volume se compose d'articles de revues et de conférences faites au Musée Guimet."
CONTENTS.—La reine Hatshopsitou et son temple de Deir-el-Bahari.—La révolution religieuse d'Aménophis IV.—La passion d'Osiris.—Immortalité de l'âme et sanction morale en Égypte et hors d'Égypte.—Les mystères d'Isis.—Quelques voyages légendaires des Égyptiens en Asie.—Homère et l'Égypte.—Le déchiffrement des hiéroglyphes.
© June 2, 1911; 2c. June 23, 1911*; A—Foreign 3094; Max Leclerc and H. Bourrelier, Paris. (11-15611) 3126

Mukerji, A P swami.
Yoga lessons for developing spiritual consciousness, by
Swamie A. P. Mukerji ... Chicago, Ill., Yogi publication
society; [etc., etc., ⁰1911]
191 p. 20ᶜᵐ.
© June 13, 1911; 2c. June 16, 1911*; A 289809; Yogi publication soc.
(11–15605) 3127

Myers, Cortland, 1864–
Real prayer, by Cortland Myers ... New York, Chi-
cago [etc., Fleming H. Revell company [⁰1911]
1 p. l., 7–100 p. 19½ᶜᵐ. $0.50
© June 20, 1911; 2c. June 23, 1911*; A 289993; Fleming H. Revell co.
(11–15597) 3128

OSheel, Shaemas, 1886–
The blossomy bough; poems, by Shaemas OSheel.
New York city, Shaemas OSheel, thru the Franklin
press, ⁰1911.
109 p. incl. front. (port.) 21ᶜᵐ. $1.00
Partly reprinted from various periodicals.
© June 17, 1911; 2c. June 21, 1911*; A 289934; S. OSheel, New York.
(11–15547) 3129

Pastonchi, Francesco, 1875–
Fiamma, tragedia in quattro atti, di Francesco Pas-
tonchi e Giannino Antona-Traversi. Torino, S. Lattes &
c.; [etc., etc.] 1911.
6 p. l., [11]–219 p. illus. 21½ᶜᵐ.
© May 26, 1911; 2c. June 10, 1911*; D 24447; S. Lattes & co.
(11–15555) 3129*

Scott, Fred Newton, 1860–
The new composition-rhetoric. Ed. of 1911. By Fred
Newton Scott ... and Joseph Villiers Denney ... Boston,
Allyn and Bacon, 1911.
xii, 468 p. illus. 19ᶜᵐ. $1.20
© June 15, 1911; 2c. June 21, 1911*; A 289944; F. N. Scott, Ann Arbor,
Mich., and Joseph Villiers Denney, Columbus, O. (11–15334) 3130

Sembower, Charles Jacob.
The life and the poetry of Charles Cotton, by Charles
Jacob Sembower ... [Philadelphia] University of Penn-
sylvania; New York, D. Appleton and company, agents,
1911.
2 p. l., 127 p. 20ᶜᵐ. $1.50
© June 19, 1911; 2c. June 21, 1911; A 289985; Univ. of Pennsylvania,
Philadelphia. (11–15550) 3131

Shakespeare, William, 1564–1616.
... Henry the Fourth, by William Shakespeare; ed..
with notes, introduction, glossary, list of variorum read-
ings, and selected criticism, by Charlotte Porter. [1st
folio ed.] New York, Thomas Y. Crowell company [⁰1911]
2 v. fronts. 16ᶜᵐ. $1.50
© June 19, 1911; 2c. each June 21, 1911*; A 289939–289940; Thomas Y.
Crowell co. (11–15553) 3132, 3133

Smith, Preserved, 1880–

The life and letters of Martin Luther, by Preserved
Smith ... Boston and New York, Houghton Mifflin com-
pany, 1911.

xvi p., 1 l., 490 p. front., plates, ports., facsim. 23ᶜᵐ. $3.50
Bibliography: p. [433]–470.
© May 31, 1911; 2c. June 15, 1911*; A 289776; P. Smith, Amherst, Mass.
(11–15608) 3134

Steuer, Adolf, 1871–

Leitfaden der planktonkunde, von dr. Adolf Steuer ...
mit 279 abbildungen im text und 1 tafel. Leipzig und
Berlin, B. G. Teubner, 1911.

2 p. l., 382 p. illus., col. pl. 24ᶜᵐ. M. 7
© Apr. 21, 1911; 2c. June 23, 1911*; A—Foreign 3106; B. G. Teubner.
(11–15345) 3135

Sweet, James S.

Business practice correspondence for use in business
colleges ... and ... other educational institutions, by
J. S. Sweet ... Chicago, Santa Rosa, Cal. [etc.] J. S.
Sweet publishing company [°1911]

56 p. 20ᶜᵐ. $0.50
© June 8, 1911; 2c. June 13, 1911*; A 289709; J. S. Sweet, Santa Rosa,
Cal. (11–15033) 3136

Symmes, Harold, 1878–1910.

Children of the shadow, and other poems, by Harold
Symmes. New York, Duffield and company, 1911.

vii, [1], 97 p. 19½ᶜᵐ. $1.00
Partly reprinted from various periodicals.
© June 13, 1911; 2c. June 15, 1911*; A 289756; Mabel Symmes, San Fran-
cisco. (11–15546) 3137

Symons, William Leonard, 1870–

Copyright of prints and labels, by William M. [!] Sy-
mons ... Fort Wayne, Ind., Trade mark title co., 1911.

24 p. 16ᶜᵐ.
© June 12, 1911; 2c. June 14, 1911*; A 289719; Trade mark title co.
(11–15348) 3138

Terrell, Mary Church.

Harriet Beecher Stowe; an appreciation, by Mary
Church Terrell. Washington, D. C., Murray bros. press,
1911.

23 p. 20ᶜᵐ. $0.50
© June 7, 1911; 2c. June 10, 1911; A 292020; M. C. Terrell, Washington.
(11–15615) 3139

Thomas, Augustus, 1859–

As a man thinks; a play in four acts, by Augustus
Thomas. New York, Duffield & company, 1911.

213 p. front. (port.) 21½ᶜᵐ.
© June 13, 1911; 2c. June 15, 1911; D 24521; Duffield & co.
(11–15333) 3139*

Van Dyke, Henry, 1852–

Who follow the flag, Phi beta kappa poem, Harvard
university, June, 1910, by Henry Van Dyke. New York,
C. Scribner's sons, 1911.

3 p. l., 14 p. 18ᶜᵐ. $0.25
© May 27, 1911; 2c. June 3, 1911*; A 289435; Charles Scribner's sons.
(11–15050) 3140

Webster, Noah, 1758–1843.

Laird & Lee's Webster's new standard dictionary of
the English language, for all grammar and common school
grades; contains hundreds of new words, definitions, pro-
nunciation, synonyms, etymology ... based on the original
Webster and other eminent authorities. Comp. and ed.
by E. T. Roe, LL. B., with the assistance of prominent
specialists ... Rev. ed. 840 illustrations—19 full-page
plates ... Chicago, Laird & Lee [ᶜ1911]

xii, [9]–750 p. incl. illus., plates. front., plates, map. 18ᶜᵐ. $0.80
© May 18, 1911; 2c. May 22, 1911; A 289485; Wm. H. Lee, Chicago.
(11–15047) 3141

Williamson, Mrs. Mary Lynn (Harrison) 1850–

Life of Washington, by M. L. Williamson ... Rich-
mond, Atlanta [etc.] B. F. Johnson publishing company
[ᶜ1911]

211 p. incl. front., illus. 19ᶜᵐ. $0.40
© June 16, 1911; 2c. June 20, 1911; A 289953; B. F. Johnson pub. co.
(11–15205) 3142

Wood, Irving Francis, 1861–

... Adult class study, by Irving F. Wood. Boston, New
York [etc.] The Pilgrim press [ᶜ1911]

vii, 143 p. 19½ᶜᵐ. (Modern Sunday-school manuals, ed. by C. F. Kent)
$0.75
Contains bibliographies.
© June 16, 1911; 2c. June 20, 1911*; A 289898; I. F. Wood, Northampton,
Mass. (11–15598) 3143

Yuille, George Allen.

The confession of a trust magnate, by George Allen
Yuille. Chicago, Ill. [The Henneberry company] 1911.

4 p. l., 7–217 p. 20ᶜᵐ. $1.00
© June 15, 1911; 2c. June 22, 1911*; A 289975; G. A. Yuille, Chicago.
(11–15177) 3144

American academy of political and social science, *Philadelphia*.

Political and social progress in Latin-America ... Philadelphia, American academy of political and social science, 1911.

iv p., 1 l., 211 p. 25ᶜᵐ. (The annals, vol. xxxvii, no. 3)
"Book department": p. [173]-211.

CONTENTS.—Individual effort in trade expansion, by E. Root.—The fourth international conference of the American states, by H. White.—The fourth Pan-American conference, by P. S. Reinsch.—The Monroe doctrine at the fourth Pan-American conference, by A. Alvarez.—Banking in Mexico, by E. Martinez-Sobral.—The way to attain and maintain monetary reform in Latin-America, by C. A. Conant.—Current misconceptions of trade with Latin-America, by C. A. Kahler.—Investment of American capital in Latin-American countries, by W. H. Schoff.—Commerce with South America.—Public instruction in Peru, by A. A. Giesecke.—The monetary system of Chile, by G. Subercaseaux.—The social evolution of the Argentine Republic, by E. Quesada.—Commercial relations of Chile, by H. L. Jones.—Closer commercial relations with Latin-America, by B. N. Baker.—Immigration—a Central American problem, by E. B. Filsinger.

© May 31, 1911; 2c. June 2, 1911*; B 244705; American academy of political and social science. (11-13738) 3144*

American bankruptcy reports annotated ... Ed. by Melvin Bender and Harold J. Hinman ... v. 25. Albany, N. Y., M. Bender & co., 1911.

xxviii, 1044 p. 24ᶜᵐ. $5.00

© June 29, 1911; 2c. June 29, 1911; A 292192; Matthew Bender & co.
 3145

... The **American** digest annotated, key-number series, v. 10 ... September 1, 1910, to January 31, 1911 ... Prepared and ed. by the editorial staff of the American digest system. St. Paul, West publishing co., 1911.

vii, 2643 p. 26¼ᶜᵐ. (American digest system. Key-number series)
$6.00

© June 14, 1911; 2c. July 3, 1911*; A 292230; West pub co. 3146

Antona-Traversi, Giannino, 1860–

... La madre, dramma in quattro atti. Milano [etc.] R. Sandron, 1911.

2 p. l., 226 p. 19½ᶜᵐ.

© June 9, 1911; 2c. June 23, 1911*; D 24545; G. Antona-Traversi, Milan. (11-15667) 3146*

Arnold, Felix, 1879–

Outline history of education, by Felix Arnold, PH. D. New York, The Bay press, 1911.

109 p. 20¼ᶜᵐ. $0.75

© June 15, 1911; 2c. June 8, 1911; A 292097; F. Arnold, New York. (11-15714) 3147

Batz, *baron* **de.**

Études sur la contre-révolution. Les conspirations et la fin de Jean, baron de Batz, 1793–1822, par le baron de Batz ... Paris, Calmann-Lévy [ᶜ1911]
2 p. l., 583 p. 23ᶜᵐ. fr. 7.50
© Apr. 5, 1911; 2c. Apr. 17, 1911*; A—Foreign 2804; Calmann-Lévy.
(11-15866) 3148

Bodemer, Horst.

... Wilderer, roman. Berlin, C. Duncker [ᶜ1911]
2 p. l., 245, [1] p. 19½ᶜᵐ. M. 3
© May 22, 1911; 2c. June 26, 1911*; A—Foreign 3115; Carl Duncker.
(11-15670) 3149

Cullum, Ridgwell, 1867–

The one-way trail; a story of the cattle country, by Ridgwell Cullum ... Philadelphia, G. W. Jacobs & company [ᶜ1911]
415 p. 20½ᶜᵐ. $1.25
© June 20, 1911; 2c. June 26, 1911*; A 292071; George W. Jacobs & co.
(11-15861) 3150

De La Pasture, Elizabeth (Bonham) "Mrs. Henry De La Pasture," 1866–

Master Christopher, by Mrs. Henry de la Pasture (Lady Clifford) ... New York, E. P. Dutton & company [ᶜ1911]
4 p. l., 407 p. 19½ᶜᵐ. $1.35
© June 24, 1911; 2c. June 28, 1911*; A 292105; E. P. Dutton & co.
(11-15863) 3151

Döring, Konrad.

... Die dollarprinzessin, roman. Berlin, C. Duncker [ᶜ1911]
2 p. l., 256 p. 19½ᶜᵐ. M. 3
© May 22, 1911; 2c. June 26, 1911*; A—Foreign 3119; Carl Duncker.
(11-15669) . 3152

Elster, Otto, 1852–

Piccolomini-studien, von O. Elster; mit einem titelbilde: Octavio Piccolomini. Leipzig, G. Müller-Mann, 1911.
142 p. 23ᶜᵐ. M. 2.50
© May 1, 1911; 2c. June 9, 1911*; A—Foreign 3030; G. Müller Mann'sche verlagsbuchhandlung. (11-15864) 3153

Enriques, Federigo, 1871–

Fragen der elementargeometrie, aufsätze von U. Amaldi, E. Baroni [u. a.] ... gesammelt und zusammengestellt von Federigo Enriques ... 1. t. Leipzig und Berlin, B. G. Teubner, 1911.
x, 366 p. diagrs. 23ᶜᵐ. M. 10
© Mar. 25, 1911; 2c. June 23, 1911*; A—Foreign 3105; B. G. Teubner.
(11-15721) 3154

Georgia. *Court of appeals.*

Reports of cases decided ... at the March and October terms, 1910. v. 8. Stevens and Graham, reporters. Atlanta, The State library, 1911.

xxxiii, 974 p. 23½ᶜᵐ. $1.75

© June 29, 1911; 2c. July 3, 1911*; A 292256; State of Georgia, Atlanta, Ga. **3155**

Georgia. *Supreme court.*

Reports of cases decided ... at the March and October terms, 1910. v. 135. Stevens and Graham, reporters. Atlanta, The State library, 1911.

xxviii, 983 p. 23½ᶜᵐ. $1.75

© June 29, 1911; 2c. July 3, 1911*; A 292257; State of Georgia, Atlanta, Ga. **3156**

Guy-Grand, Georges.

... Le procès de la démocratie. Paris, A. Colin, 1911.

3 p. l., 326 p., 1 l. 19ᶜᵐ. (*Half-title:* Le mouvement social contemporain) fr. 3.50

© June 2, 1911; 2c. June 23, 1911*; A—Foreign 3095; Max Leclerc and H. Bourrelier, Paris. (11–15689) **3157**

Hansey, *Mrs.* **Jennie Adrienné,** 1843–

New standard domestic science cook-book, comp., rev. and arranged by Jennie A. Hansey ... and Ella M. Blackstone [*pseud.*] ... A new and original system of classification, fourteen hundred recipes for all occasions ... 135 special drawings, 17 full-page plates. Chicago, Laird & Lee [*1911*]

vi, 491 p. incl. front., illus. 21ᶜᵐ. $1.50

Ella M. Blackstone pseud. of Jennie A. Hansey.

© May 23, 1911; 2c. June 26, 1911*; A 292074; Wm. H. Lee, Chicago. (11–15683) **3158**

... The **Indiana** digest; a digest of the decisions of the courts of Indiana ... Comp. under the American digest classification. v. 7. Mayhem–Plea. St. Paul, West publishing co., 1911.

iii, 1020 p. 26½ᶜᵐ. (American digest system—State series) $6.00

© June 24, 1911; 2c. July 3, 1911*; A 292225; West pub. co. **3159**

Kidder, Martha Ann, 1871–

Æonian echoes, and other poems, by Martha A. Kidder. Boston, Sherman, French & company, 1911.

8 p. l., 219 p. front. (port.) 19½ᶜᵐ. $1.25

Partly reprinted from various periodicals.

© June 16, 1911; 2c. June 21, 1911*; A 289949; Sherman, French & co. (11–15662) **3160**

King, Charles Albert, 1865–
... Elements of construction, by Charles A. King ...
New York, Cincinnati [etc.] American book company
[c1911]
xiii, 181 p. illus., diagrs. 19ᶜᵐ. (King's series in woodwork and carpentry) $0.70
© June 21, 1911; 2c. June 24, 1911*; A 292024; C. A. King, Bay City, Mich.
(11-15682)　　　　　　　　　　　　　　　　　　3161

Krobath, Karl, 1875–
... Sterben, ein roman aus Kärnten ... 2. aufl. Leipzig, L. Staackmann, 1911.
473 p. 20ᶜᵐ. M. 5
© Apr. 25, 1911; 2c. June 26, 1911*; A—Foreign 3117; L. Staackmann.
(11-15668)　　　　　　　　　　　　　　　　　　3162

Lawrence, Edwin Gordon.
Speech-making; explicit instructions for the building
and delivery of speeches, by Edwin Gordon Lawrence ...
New York, The A. S. Barnes company, 1911.
5 p. l., vii–ix, 256 p. 19½ᶜᵐ. $1.00
© June 12, 1911; 2c. June 19, 1911*; A 289864; A. S. Barnes co.
(11-15666)　　　　　　　　　　　　　　　　　　3163

Louisiana. *Supreme court.*
Reports of cases argued and determined in the Supreme court of Louisiana and in the Superior court of
the territory of Louisiana. Annotated ed. ... Book 15,
containing a verbatim reprint of vols. 1 & 2 of Robinson's reports. St. Paul, West publishing co., 1911.
xvi, 383, x, 360 p. 23ᶜᵐ. $7.50
© June 26, 1911; 2c. July 3, 1911*; A 292227; West pub. co.　　3164

Macilwaine, Sydney Wilson.
Medical revolution; a plea for national preservation of
health based upon the natural interpretation of disease,
by Sydney W. Macilwaine ... London, P. S. King and
son, 1911.
© 1c. June 24, 1911*; A ad int. 683; pubd. May 26, 1911; S. W. Macilwaine, England. (11-15679)　　　　　　　　　　3165

Murphy, James Arthur, 1865–
Handbook for the railway mail and custom service,
written and comp. by James A. Murphy ... and Horatio
M. Pollock ... Albany, N. Y., New York education company, 1911.
1 p. l., 266 (i. e. 267) p. 20ᶜᵐ. $1.25
© May 31, 1911; 2c. June 1, 1911; A 289627; New York education co.
　　　　　　　　　　　　　　　　　　　　　3166

... The **New York** supplement, with key-number annotations. v. 127. Permanent ed. (New York state reporter, vol. 161) ... February 27–April 3, 1911. St.
Paul, West publishing co., 1911.
xxxiii, 1274 p. 23½ᶜᵐ. (National reporter system. N. Y. supp. and
state reporter) $3.00
© June 26, 1911; 2c. July 3, 1911*; A 292229; West pub. co.　　3167

Osborne, Ralph Hills, 1835–
Bible subjects and texts, by Rev. R. H. Osborne ... for
the use of members of adult Bible class of the Sunday
schools. Cincinnati, O., Press of Jennings & Graham
[ᶜ1911]
215 p. front. (port.) 19ᶜᵐ. $0.60
© May 28, 1911; June 9, 1911; A 289884; R. H. Osborne, Neoga, Ill.
(11–15700) 3168

... The Pacific reporter, with key-number annotations.
v. 114. Permanent ed. ... April 10–May 8, 1911. St.
Paul, West publishing co., 1911.
xv, 1258 p. 26½ᶜᵐ. (National reporter system—State series) $4.00
© June 21, 1911; 2c. July 3, 1911*; A 292228; West pub. co. 3169

Pain, Barry Eric Odell.
An exchange of souls, by Barry Pain. London, E.
Nash, 1911.
256 p. 19½ᶜᵐ. 2/
© 1c. June 29, 1911*; A ad int. 690; pubd. May 31, 1911; B. Pain, London.
(11–15862) 3170

Pastor, Willy, 1867–
... Im Norden. Leipzig, F. Eckardt, 1911.
3 p. l., 65 p. 20½ᶜᵐ. M. 1.20
CONTENTS.—Das land der sonne.—Lund.—Die schwedischen wälder.—
Stockholm.—Die wasser Norwegens.—Im drachenzeichen.—Am Sjöstrand.
© Apr. 5, 1911; 2c. June 26, 1911*; A—Foreign 3125; Fritz Eckhardt ver-
lag, g. m. b. h. (11–15865) 3171

Pemberton, Max, 1863–
Captain Black; a romance of the nameless ship, by
Max Pemberton ... New York, Hodder & Stoughton,
George H. Doran company [ᶜ1911]
3 p. l., iii–iv p., 2 l., 3–327 p. front. (map) 19½ᶜᵐ. $1.20
© June 23, 1911; 2c. June 24, 1911*; A 292032; George H. Doran co.
(11–15859) 3172

Penniman, Henry Griffith, 1864–
Manual of fidelity insurance and corporate suretyship.
Descriptive of surety and fidelity bonds with their practi-
cal uses, and the conditions under which they should be
written, with hints to agents. By Henry G. Penniman ...
New York, Chicago, The Spectator company, 1911.
viii, 268 p. 19ᶜᵐ. $2.00
© May 26, 1911; 2c. June 15, 1911*; A 289795; Spectator co.
(11–15685) 3173

Pope, Amy Elizabeth.
Home care of the sick, by Amy Elizabeth Pope ...
[Text book ed.] Chicago, American school of home eco-
nomics, 1911.
3 p. l., 190 (i. e. 196) p. illus. 20ᶜᵐ. $1.25
Contains test questions.
Bibliography: p. [122]
© June 14, 1911; 2c. June 24, 1911*; A 292054; Home economics assn.
(11–15680) 3174

Priest, Mary Elizabeth, 1868–

Recitations & dialogues for special days in the Sunday school, arranged by Mary E. Priest. Philadelphia, The Westminster press, 1911.

232 p. 19½ᶜᵐ. $0.35
© May 29, 1911; 2c. June 2, 1911*; A 289407; Trustees of the Presbyterian board of publication and Sabbath-school work, Philadelphia.
(11–15663) 3175

The Ramblers club, *Minneapolis, Minn.*

The club woman's cook book ... comp. ... by the Ramblers club. Minneapolis, Minn., The Ramblers club, 1911.

1 p. l., 7–165, [1] p. 19½ᶜᵐ. $0.50
© June 12, 1911; 2c. June 24, 1911*; A 292033; Mrs. T. F. Quinby, Minneapolis. (11–15684) 3176

Rosenberg, Louis James, 1876–

The medical expert, and other papers, by Louis J. Rosenberg. New York, Broadway publishing co. [*1911*]

2 p. l., 7–35 p. 20ᶜᵐ. $0.50
CONTENTS.—The medical expert.—Professional secrecy.—The metabolism of morality.
© Apr. 15, 1911; 2c. May 27, 1911; A 289732; L. J. Rosenberg, Detroit.
(11–15678) 3177

Saleeby, Caleb Williams, 1878–

Woman and womanhood; a search for principles, by C. W. Saleeby ... New York and London, M. Kennerley, 1911.

3 p. l., 398 p. 22ᶜᵐ. $2.50
© June 1, 1911; 2c. June 27, 1911*; A 292092; Mitchell Kennerley.
(11–15875) 3178

Saunier, Charles, 1865–

Anthologie d'art français. La peinture—xixᵉ siècle, par Charles Saunier ... Paris, Bibliothèque Larousse [*1911*]

2 v. plates. 20½ᶜᵐ.
© June 2, 1911; 2c. each June 23, 1911*; A—Foreign 3097; Librairie Larousse. (11–15672) 3179

Sidis, Boris.

Philistine and genius, by Boris Sidis ... New York, Moffatt, Yard and company, 1911.

3 p. l., 105 p. 18ᶜᵐ. $0.75
© June 15, 1911; 2c. June 23, 1911*; A 292005; Moffat, Yard & co.
(11–15713) 3180

Söhle, Karl, 1861–

... Der heilige Gral, eine musikantengeschichte, mit bildnis des verfassers und einer selbstbiographie. 1.–5. tausend. Leipzig, L. Staackmann, 1911.

80 p. front. (port.) 17ᶜᵐ. M. 1
© Apr. 13, 1911; 2c. June 15, 1911*; A—Foreign 3066; L. Staackmann.
(11–15671) 3181

... The **Southeastern** reporter, with key-number annotations. v. 70. Permanent ed. ... February 25–May 13, 1911. St. Paul, West publishing co., 1911.
xv, 1279 p. 26¼ᶜᵐ. (National reporter system—State series) $4.00
© June 28, 1911; 2c. July 3, 1911*; A 292231; West pub. co. **3182**

Stone, William, 1864–

Definite work in child training, to be used in Junior Epworth league, Junior Christian endeavor, also as supplemental lessons in the Sunday school and for use in the home, by Rev. William Stone. Philadelphia, J. J. Hood co. [°1911]
180 p. front., illus. (partly col.) 20¼ᶜᵐ. $1.25
Bibliography: p. 160.
"Junior songs": p. [163]–[178]
© Mar. 20, 1911; 2c. June 20, 1911*; A 289906; W. Stone, Trenton, N. J.
(11–15701) **3183**

Terramare, Georg.

Die ehmals waren, von Georg Terramare. Einband und buchschmuck von Bianca Glossy. Leipzig, L. Staackmann, 1911.
189, [1] p. illus. 19ᶜᵐ. M. 3
CONTENTS.—Ritter Gersachs kreuzfahrt.—Die Pinsdorfer Hobl.—Ein abschied.—Der alte organist.
© Mar. 30, 1911; 2c. June 15, 1911*; A—Foreign 3068; L. Staackmann.
(11–15873) **3184**

Treutlein, Peter i. e. **Josef Peter**, 1845–

Der geometrische anschauungsunterricht als unterstufe eines zweistufigen geometrischen unterrichtes an unseren höheren schulen, von P. Treutlein ... mit einem einführungswort von F. Klein und mit 38 tafeln und 87 abbildungen im text. Leipzig und Berlin, B. G. Teubner, 1911.
x, 216 p. illus., diagrs. 23ᶜᵐ. M. 5
"Figurenteil" (40 p.) in pocket on back cover.
"Verzeichnis von schriften über den geometrischen anschauungsunterricht": p. [209]–216.
© Mar. 28, 1911; 2c. June 23, 1911*; A—Foreign 3104; B. G. Teubner.
(11–15884) **3185**

Wagner, Richard, 1813–1883.

My life, by Richard Wagner ... London, Constable and company ltd., 1911.
2 v. fronts. (ports.) 23ᶜᵐ.
"Authorised translation from the German."
© 1c. June 15, 1911; A ad int. 682; pubd. May 24, 1911; Dodd, Mead & co., New York. (11–15716) **3186**

Wallace, Edgar, 1875–

The other man, by Edgar Wallace; illustrations by T. J. Fogarty. New York, Dodd, Mead and company, 1911.
vi p., 1 l., 304 p. col. front., col. plates, diagr. 19¼ᶜᵐ. $1.25
© June 23, 1911; 2c. June 24, 1911*; A 292023; Dodd, Mead & co.
(11–15860) **3187**

Warthin, Aldred Scott, 1866–

Practical pathology; a manual of autopsy and laboratory technique for students and physicians, by Aldred Scott Warthin ... 2d ed., rewritten and enl. ... 55 figures. Ann Arbor, G. Wahr, 1911.

2 p. l., ₁viiι–xvi, 321 p. illus. 26ᶜᵐ. $3.00
© June 10, 1911; 2c. June 16, 1911*; A 289806; George Wahr.
(11–15681) 3188

Washburne, Mrs. Marion (Foster) 1863–

Study of child life, by Marion Foster Washburne ... ₁Textbook ed.₁ Chicago, American school of home economics, 1911.

iii, ₁3₁, ₁3₁–183 (i. e. 194) p. illus., plates. 20ᶜᵐ. $1.25
Contains text questions.
Bibliography: p. 170–174.
© June 14, 1911; 2c. June 24, 1911*; A 292053; Home economics assn.
(11–15712) 3189

Winn, Edith Lynwood, 1868–

Representative violin solos and how to play them ... by Edith Lynwood Winn. Book 1. New York, C. Fischer, 1911.

v, 89 p. 18½ᶜᵐ. $1.00
© May 18, 1911; 2c. June 20, 1911*; A 289901; Carl Fischer.
(11–15717) 3190

Women's educational and industrial union, Boston. Dept. of research.

... The living wage of women workers; a study of incomes and expenditures of four hundred and fifty women workers in the city of Boston, by Louise Marion Bosworth ... prepared under the direction of the Department of research, Women's educational and industrial union, Boston, ed., with an introduction by F. Spencer Baldwin ... Philadelphia, The American academy of political and social science, 1911.

vi, 90 p. incl. tables. 25ᶜᵐ. (Supplement to the Annals of the American academy of political and social science. May, 1911)
© May 31, 1911; 2c. June 2, 1911*; B 244706; American academy of political and social science. (11–13739) 3190*

Woodruff, Wilburn Edgar, 1879–

Hints to healthseekers, and containing a climatic guide to Arizona towns ₁by₁ W. Edgar Woodruff. ₁Los Angeles, Cal., Los Angeles printing co., °1911₁

3 p. l., ₁9₁–126 p. illus. 21ᶜᵐ. $0.75
© May 19, 1911; 2c. May 27, 1911*; A 289294; W. E. Woodruff, Huntington Park, Cal. (11–15677) 3191

Allen, Philip Schuyler, 1871– ed.

Daheim, a German first reader; selections for reading, reciting, and singing during the first year of German in secondary schools, ed. by Philip Schuyler Allen ... New York, H. Holt and company, 1911.

xiv. 230 p. 19½ᶜᵐ. $0.70
© June 16, 1911; 2c. June 20, 1911*; A 289924; Henry Holt & co. (11–16275) 3192

Bill, Edward Lyman.

Hitting the thought trail; brieflets for busy men, by Edward Lyman Bill ... New York, Cherouny publishing company [°1911]

206 p. front. (port.) 23½ᶜᵐ. $1.75
© Apr. 29, 1911; 2c. May 27, 1911; A 289825; E. L. Bill, New York. (11–16272) 3193

Birdsall, Ralph, 1871–

Fenimore Cooper's grave and Christ churchyard, by Ralph Birdsall ... illustrated from photographs by A. J. Telfer, J. B. Slote, and W. H. Yates ... New York, F. H. Hitchcock, 1911.

74 p. incl. front., illus. pl. 21ᶜᵐ. $1.00
© May 2, 1911; 2c. June 13, 1911; A 289797; R. Birdsall, Cooperstown, N. Y. (11–16284) 3194

Blades, Paul Harcourt.

Don Sagasto's daughter; a romance of southern California [by] Paul Harcourt Blades. Boston, R. G. Badger [°1911]

433 p. 19½ᶜᵐ. $1.50
© June 30, 1911; 2c. July 3, 1911*; A 292239; Richard G. Badger. (11–16263) 3195

Boddy, John T.

The spirit of the age, and other poems, by John T. Boddy. [Pittsburg, Printed by the Harris printing co., °1911]

288 p. 20ᶜᵐ. $1.00
© June 3, 1911; 2c. June 7, 1911*; A 289537; J. T. Boddy, Lincoln Place, Pa. (11–16334) 3196

Bölsche, Franz, 1869–

Übungen und aufgaben zum studium der harmonielehre, von Franz Bölsche ... Leipzig, Breitkopf & Härtel, 1911.

vi, 123 p. 23½ᶜᵐ. M. 2.50
© May 20, 1911; 2c. June 15, 1911*; A—Foreign 3082; Breitkopf & Härtel. (11–16282) 3197

Carter, Charles Franklin.

Some by-ways of California, by Charles Franklin Carter. 2d ed. San Francisco, Whitaker & Ray-Wiggin co., 1911.

3 p. l., iii–vi, 199 p. front. 20ᶜᵐ.

529

Carter, Charles Franklin—Continued

CONTENTS.—Pala.—The Mojave desert.—Leaves from an artist's diary.—The home of Ramona.—Lompoc and Purisima.—Jolon.—San Juan Bautista.—Pescadero.—The charm of Southern California.—The nightingale's peer.
© June 3, 1911; 2c. June 24, 1911*; A 292051; C. F. Carter, Waterbury, Conn. (11–16287) **3198**

Connolly, James, 1842–

The magic of the sea; or, Commodore John Barry in the making, by Captain James Connolly. St. Louis, Mo. [etc.] B. Herder, 1911.
2 p. l., 554 p. 20cm. $1.50
© June 21, 1911; 2c. June 23, 1911*; A 292009; Joseph Gummersbach, St. Louis. (11–16257) **3199**

Cotton, Alfred Cleveland, 1847–

Care of children, by Alfred Cleveland Cotton ... [Text book ed.] Chicago, American school of home economics, 1911.
iv, [2], 208 (i. e. 212) p. illus, plates, diagrs. 20cm. $1.25
Contains test questions.
Bibliography: p. [174]
© June 14, 1911; 2c. June 24, 1911*; A 292052; Home economics assn. (11–16349) **3200**

Cox, Alethea Crawford.

Imaginary biographical letters from great masters of music to young people, by Alethea Crawford Cox and Alice Chapin; a series of fanciful messages from the best-known composers of the past to the young people of the present. Philadelphia, Theodore Presser co.; [etc., etc., ⁰1911]
223 p. illus. 18cm. $1.25
CONTENTS.—A dream of the masters.—Johann Sebastian Bach.—George Frederick Handel.—Franz Josef Haydn.—Wolfgang Amadeus Mozart.—Ludwig van Beethoven.—Gioachino Antonio Rossini.—Ignaz Moscheles.—Franz Peter Schubert.—Hector Louis Berlioz.—Felix Mendelssohn.—François Frédéric Chopin.—Robert Schumann.—Franz Liszt.—Richard Wagner.
© June 26, 1911; 2c. June 27, 1911*; A 292102; T. Presser co. (11–16281) **3201**

D'Arnoux, Calixte Erneste de Beaupré, *vicomte*, 1858–

Poems [by] C. E. d'Arnoux. Boston, The Poet lore company, 1911.
62 p. 19cm. $1.00
© June 10. 1911; 2c. June 13, 1911*; A 289714; C. E. d'Arnoux, St. Louis. (11–16276) **3202**

Degan, Joseph P.

The natural touch and speed typewriter instructor, arranged for the class room and self instruction ... Adapted for the L. C. Smith, Remington, Monarch, Underwood, Fox, Densmore, Victor, Royal, Sterns, Fay-Sho, and similar machines. Quincy, Ill., J. P. Degan [⁰1911]
51, [1] p. illus. 18 x 26cm. $1.25
© June 7, 1911; 2c. June 23, 1911*; A 292008; Joseph P. Degan, Quincy, Ill. (11–16360) **3203**

Dorsey, George Amos, 1868–

Pravda o Slovákoch a Slavianoch. Napísal Prof. Dr. George A. Dorsey ... sostavil Samo Strobl. Chicago, Ill., Tlačou Mally a spol. [°1911]

152 p. 18½ᶜᵐ. $0.35
© June 1, 1911; 2c. June 3, 1911; A 289696; Samuel Strobl, Chicago.
(11–16337) **3204**

Duryea, Mrs. Nina Larrey (Smith) 1874–

The house of the seven gabblers, by Nina Larrey Duryea; illustrated by Hermann Heyer. New York and London, D. Appleton and company, 1911.

ix, [1], 271, [1] p., 1 l. front., illus. 19½ᶜᵐ. $1.25
© June 9, 1911; 2c. June 13, 1911*; A 289703; D. Appleton & co.
(11–16259) **3205**

Fenner, Henry Milne, 1879–

History of Fall River, Massachusetts, comp. for the Cotton centennial by Henry M. Fenner, under the direction of the historical committee of the Merchants association ... [Fall River, Mass.] Fall River merchants association, 1911.

2 p. l., 106 p. front., illus. (map) 23½ᶜᵐ. $0.50
© June 14, 1911; 2c. June 19, 1911; A 292080; Merchants assn., Fall River, Mass. (11–16292) **3206**

Fleharty, Clara Viola.

A wild rose, by Clara Viola Fleharty ... Boston, R. G. Badger [°1911]

282 p. front. 19½ᶜᵐ. $1 25
© June 30, 1911; 2c. July 3, 1911*; A 292238; C. V. Fleharty, Chicago.
(11–16260) **3207**

Hansen, Angell Watland.

Min Gud og jeg; en samling digte for kristendom og afhold. af Angell Watland Hansen, med et forord af prof. Sven Oftedal. Minneapolis, Minn., Forfatterens forlag, 1911.

72 p. front. (port.) 20½ᶜᵐ. $0.50
© May 15, 1911; 2c. June 8, 1911*; A 239550; A. W. Hansen, Minneapolis. (11–16335) **3208**

Hegeler, Wilhelm, 1870–

Der mut zum glück, roman von Wilhelm Hegeler. Berlin [etc.] Ullstein & co. [°1911]

2 p. l., 308 p., 1 l. 16ᶜᵐ. (Added t.-p : Ullstein-bücher) M. 1
© Apr. 18, 1911; 2c. June 2, 1911*; A—Foreign 3012; Ullstein & co.
(11–16342) **3209**

Jacobs, Francis Warren.

A tragedy of the Christ ... poems ... [by] Francis Warren Jacobs. [Guthrie, Okl., Oklahoma bank and office supply co., °1911]

242 p., 1 l. 19½ᶜᵐ. $2.50
© June 20, 1911; 2c. June 29, 1911*; A 292136; F. W. Jacobs, Sapulpa, Okl. (11–16345) **3210**

Kansas. *Laws, statutes, etc.*
A manual of the law of roads and highways in the state of Kansas; with forms and record entries. 12th ed. By Wm. R. Arthur ... Topeka, Kan., Crane & company, 1911.
121 p. 23½ᶜᵐ. $0.50
© June 21, 1911; 2c. June 23, 1911*; A 292019; Crane & co. (11-16354) 3211

Kimball, Everett.
The public life of Joseph Dudley; a study of the colonial policy of the Stuarts in New England, 1660–1715, by Everett Kimball ... New York [etc.] Longmans, Green, and co., 1911.
viii, 239 p. 23ᶜᵐ. (*Half-title:* Harvard historical studies ... vol. xv) $2.00
© June 16, 1911; 2c. June 23, 1911*; A 292003; President and fellows of Harvard college. (11-16293) 3212

Klinck, Albert J.
The lady in mauve, by Albert J. Klinck. Boston, Sherman, French & company, 1911.
2 p. l., 134 p. 19½ᶜᵐ. $1.00
© June 19, 1911; 2c. July 3, 1911*; A 292243; Sherman, French & co. (11-16265) 3213

Le Bon, Gustave, 1841–
... Les opinions et les croyances; genèse—évolution ... Paris, E. Flammarion, 1911.
3 p. l., 340 p. 19ᶜᵐ. (Bibliothèque de philosophie scientifique) fr. 3.50
© June 14, 1911; 2c. June 26, 1911*; A—Foreign 3134; Ernest Flammarion. (11-16273) 3214

Lücke, M.
Biblische symbole; oder, Bibelblätter in bildern, nebst einem lebensbilde unseres Heilandes, in den hauptzügen der jugend gezeichnet. 2. veränderte und verm. aufl. Revidiert und zusammengestellt von prof. M. Lücke. Chicago, Boston, The John A. Hertel co. [ᶜ1911]
182, 72 p. front., illus., col. plates. 24½ᶜᵐ. $3.00
© June 7, 1911; 2c. June 10, 1911*; A 289634; John A. Hertel co. (11-16271) 3215

McCormack, P J.
Dennis Horgan, gentleman, and other sketches, by Rev. P. J. McCormack. Boston, De Wolfe and Fiske company, 1911.
5 p. l., 3–117 p. front. (port.) 19½ᶜᵐ.
CONTENTS.—Dennis Horgan—gentleman.—The ancient owner of the modern store.—The colonel's man.—"'Twas on a market day."—A puzzling case.—The story the captain told—The brute.
© June 1, 1911; 2c. June 3, 1911*; A 289450; P. J. McCormack, Boston. (11-16256) 3216

McLaughlin, Andrew Cunningham, 1861–
... A history of the American nation, by Andrew C. McLaughlin ... [23d ed.] New York, D. Appleton and company, 1911.
2 p. l., iii–xvi, 608 p. front., illus., port., maps, facsims. 20ᶜᵐ. (*Half-title:* Twentieth century text-books, ed. by A. F. Nightingale ...) $1.40

532

McLaughlin, Andrew Cunningham—Continued
First ed., 1899.
Contains references.
© June 10, 1911; 2c. June 20, 1911*; A 289918; D. Appleton & co.
(11-16289) 3217

Marie, Pierre, 1853–
La pratique neurologique, publiée sous la direction de
Pierre Marie ... par MM. O. Crouzon, G. Delamare ...
Secrétaire de la redaction: O. Crouzon; avec 302 figures
dans le texte. Paris, Masson et cⁱᵉ, 1911.
xviii, 1402 p. illus. 25½ᶜᵐ. fr. 30
© June 2, 1911; 2c. June 23, 1911*; A—Foreign 3091; Masson & cie.
(11-16350) 3218

Meany, John L.
Analysis of life; or, Editorials, by John L. Meany.
[Houston, Tex., Printed by Southwest publishing co.]
°1911·
115 p. 19ᶜᵐ.
© May 26, 1911; 2c. June 1, 1911; A 289607; J. L. Meany, Houston, Tex.
(11-16274) 3219

Michel, Robert, 1876–
Geschichten von insekten, von Robert Michel. Berlin,
S. Fischer, 1911.
3 p. l., [9]-224 p. 18½ᶜᵐ. M. 3
© May 27, 1911; 2c. July 1, 1911*; A—Foreign 3149; S. Fischer verlag
(11-16343) 3220

Miomandre, Francis de.
... Au bon soleil. Paris, Calmann-Lévy [°1911] ·
3 p. l., 310 p., 1 l. 19ᶜᵐ. fr. 3.50
© June 14, 1911; 2c. June 26, 1911*; A—Foreign 3132; Calmann-Lévy.
(11-16341) 3221

Missouri. *St. Louis, Kansas City and Springfield courts of appeals.*
Cases determined ... reported for the St. Louis court
of appeals, June 14, 1910, to October 24, 1910, by Thomas
E. Francis ... for the Kansas City court of appeals, Oc-
tober 1, 1910, by John M. Cleary ... and for the Spring-
field court of appeals, November 10, 1910, by Lewis Lus-
ter ... official reporters. v. 150. Columbia, Mo., E. W.
Stephens, 1911.
xix, 808, xviii p. 23½ᶜᵐ. $3.00
© May 23, 1911; 2c. May 24, 1911; A 292398; E. W. Stephens. 3222

Cases determined ... reported for the St. Louis court
of appeals, by Thomas E. Francis ... for the Kansas City
court of appeals, October 3, 1910, to November 7, 1910,
by John M. Cleary ... and for the Springfield court of
appeals, November 10, 1910, to December 5, 1910, by
Lewis Luster ... official reporters. v. 151. Columbia,
Mo., E. W. Stephens, 1911.
xviii, 785, xviii p. 23½ᶜᵐ. $3.00
© June 14, 1911; 2c. June 10, 1911; A 292399; E. W. Stephens. 3223

Missouri. *Supreme court.*
Reports of cases determined ... between November 29,
and December 27, 1910. Perry S. Rader, reporter.
v. 231. Columbia, Mo., E. W. Stephens [1911]
xviii, 841, vi p. 23½ᶜᵐ. $3.00
© July 3, 1911; 2c. July 5, 1911; A 292400; E. W. Stephens. 3224

Moseley, Ella Lowery.
The wonder lady, by Ella Lowery Moseley; illustrated
by John Goss. Boston, Lothrop, Lee & Shepard co. [1911]
3 p. l., v–ix, 256 p. front., plates. 18½ᶜᵐ. $1.00
© June 28, 1911; 2c. June 30, 1911*; A 292173; Lothrop, Lee & Shepard co.
(11–16258) 3225

Moses, Bernard, 1846–
... The government of the United States, by Bernard
Moses ... New York, D. Appleton and company, 1911.
2 p. l., iii–iv p., 1 l., 424, 36 p. 19½ᶜᵐ. (*Half-title:* Twentieth century
text-books, ed. by A. F. Nightingale ...) $1.05
Contains references.
On cover: Minnesota edition.
"The government of Minnesota, by William W. Folwell": 36 p. at end.
© June 9, 1911; 2c. June 20, 1911*; A 289920; D. Appleton & co.
(11–16267) 3226

[Noder, A] 1864–
Meine käfersammlung humoristisch-satirische "Ju-
gend" bilderbogen aus Preussen, von A. de Nora [pseud.]
illustriert von A. Schmidhammer und M. Hagen. 1.–3.
tausend. Leipzig, L. Staackmann, 1911.
2 v. illus. 18½ᶜᵐ. M 2
CONTENTS.—Species Bavaricae —Species Borussicae.
© Apr. 13. 1911; 2c. June 26, 1911*; A—Foreign 3120; L. Staackmann.
(11–16279) 3227

Odell, Frank Iglehart, 1886–
... Larry Burke, sophomore, by Frank I. Odell ... illus-
trated by H. C. Edwards. Boston, Lothrop, Lee & Shep-
ard co. [1911]
379 p. incl. front. plates. 19½ᶜᵐ. (*His* The Larry Burke books)
$1 25
© June 28. 1911; 2c. June 30, 1911*; A 292171; Lothrop, Lee & Shepard co.
(11–16264) 3228

Ottman, Ford C 1859–
God's oath: a study of an unfulfilled promise of God.
by Ford C. Ottman ... New York, Hodder & Stoughton,
George H. Doran company [°1911]
6 p. l., 3–278 p. 19½ᶜᵐ. $1.25
© June 30. 1911; 2c. July 1, 1911*; A 292193; George H. Doran co.
(11–16346) 3229

Ovington, Mary White.
Half a man: the status of the negro in New York, by
Mary White Ovington; with a foreword by Dr. Franz
Boas ... New York [etc.] Longmans, Green, and co., 1911.
xi. 236 p. 19½ᶜᵐ. $1.00
© June 16. 1911; 2c. June 23, 1911*; A 292000; Longmans, Green & co.
(11–16291) 3230

Porter, Henry Dwight, 1845–

William Scott Ament, missionary of the American
board to China, by Henry D. Porter ... New York, Chi-
cago [etc.] Fleming H. Revell company [ᶜ1911]
377 p. front., plates, ports., map, geneal chart. 21½ᶜᵐ. $1.50
© June 16, 1911; 2c. June 23, 1911*; A 289996; Fleming H. Revell co.
(11–16347) 3231

The **practical** home and school educator, containing
courses of reading and study, with outlines and ques-
tions arranged to accompany the New practical refer-
ence library ... v. 6. Chicago, New York, Dixon-Han-
son-Bellows company, 1911.
3 p. l., 5–496 p. illus., plates (partly col.) diagrs. 24½ᶜᵐ. $3.25
© June 30, 1911; 2c. July 5, 1911*; A 292286; Dixon-Hanson-Bellows co.
 3232

Prod'homme, J G 1871–

... Nicolo Paganini; a biography, by J. G. Prod'homme;
tr. from the original French edition by Alice Mattullath.
New York, Boston, C. Fischer; [etc., etc., ᶜ1911]
67 p. plates, ports., facsim. 23½ᶜᵐ. (Celebrated musicians) $1.00
"Compositions of Paganini": p. 64–65; Bibliography: p. 66–67.
© June 2, 1911; 2c. June 20, 1911*; A 289902; Carl Fischer, New York.
(11–16283) 3233

Redway, Jacques Wardlaw, 1849–

The Redway school history, outlining the making of the
American nation, by Jacques Wardlaw Redway, F. R. G. S.
With many maps and illustrations. New York, Boston
[etc.] Silver Burdett and company [ᶜ1911]
xii, 424, 59 p. incl. front. (ports.) illus. maps. 20ᶜᵐ. $1.00
"Appendix": 59 p. at end.
Contains bibliographies.
© June 1, 1911; 2c. June 2, 1911; A 289848; J. W. Redway, Mt. Vernon,
N. Y. (11–16290) 3234

Reik, Henry Ottridge, 1868–

Diseases of the ear, nose, and throat, for the family
physician and the undergraduate medical student, by
Henry Ottridge Reik ... assisted by A. J. Neilson Reik
... with eighty-one illustrations in the text and two col-
ored inserts. New York and London, D. Appleton and
company, 1911.
xv, 374 p. illus., 2 col. pl. 22½ᶜᵐ. $3.00
© June 9, 1911; 2c. June 20, 1911*; A 289919; D. Appleton & co.
(11–16351) 3235

Reiss, Rodolphe Archibald.

... Manuel de police scientifique (technique) 1. Vols
et homicides. Lausanne, Payot & cⁱᵉ; [etc., etc.] 1911.
515 p. illus. 25½ᶜᵐ. fr. 15
© June 9, 1911; 2c. June 23, 1911*; A—Foreign 3092; Payot & cie.
(11–16269) 3236

Rockwood, Roy, *pseud.*

Lost on the moon; or, In quest of the field of diamonds, by Roy Rockwood ... New York, Cupples & Leon company [c1911]

2 p. l., 248 p. front., plates. 19½ᶜᵐ. $0.60
© June 29, 1911; 2c. July 1, 1911*; A 292188; Cupples & Leon co.
(11-16261) 3237

Schweriner, Oskar T.

... Hohkönigsburg, ein roman aus alten und neuen tagen. Berlin, C. Duncker [c1911]

2 p. l., 216 p. 20ᶜᵐ. M. 3
©·May 22, 1911; 2c. June 26, 1911*; A—Foreign 3118; Carl Duncker.
(11-16338) 3238

Sittler, Paul.

Grundlinien einer gesunden lebensweise. (Briefe an einen gebildeten laien.) Von dr. med. Paul Sittler ... Würzburg, C. Kabitzsch, 1911.

2 p. l., 74 p. 20ᶜᵐ. M. 1.30
© May 20, 1911; 2c. June 26, 1911*; A—Foreign 3126; Curt Kabitzsch, A. Stuber's verlag. (11-16352) 3239

Steiner, Bernard Christian, 1867–

... Maryland under the commonwealth; a chronicle of the years 1649–1658, by Bernard C. Steiner ... Baltimore, The Johns Hopkins press, 1911.

vii, 9–178 p. 25ᶜᵐ. (Johns Hopkins university studies in historical and political science ... Series XXIX, no. 1) $1.00
Appendix. A summary of the proceedings of the Provincial courts, 1649 to 1658, chronologically arranged: p. 117–178.
© June 13, 1911; 2c. June 26, 1911*; A 292062; Johns Hopkins press.
(11-16268) 3240

Wagner, Richard, 1813–1883.

My life, by Richard Wagner ... Authorized translation from the German. New York, Dodd, Mead and company, 1911.

2 v. fronts. (ports.) 23½ᶜᵐ. $8.50
© June 28, 1911; 2c. June 29, 1911*; A 292141; Dodd, Mead & co.
(11-16280) 3241

Wight, Joseph K.

The beginning of things in nature and in grace; or, A brief commentary on Genesis, by Joseph K. Wight. Boston, Sherman, French & company, 1911.

3 p. l., 188 p. 21ᶜᵐ. $1.20
© May 29, 1911; 2c. June 3, 1911*; A 289454; Sherman, French & co.
(11-16270) 3242

Woolley, Edwin Campbell, 1878–

Exercises in English, by Edwin C. Woolley ... Boston, New York [etc.] D. C. Heath & co. [c1911]

xxviii, 147 p. 17ᶜᵐ. $0.60
© June 23, 1911; 2c. June 26, 1911*; A 292070; D. C. Heath & co.
(11-16278) 3243

Anderson, James H.
Riddles of prehistoric times, by James H. Anderson.
New York, Baltimore [etc.] Broadway publishing company, 1911.
263 p. front. (port.) plates, maps. 20ᶜᵐ. $1.50
© Mar. 21, 1911; 2c. May 27, 1911*; A 289736; J. H. Anderson, Dallas, Tex. (11-16487) 3244

Archer, Vachel B.
Archer's law and practice in oil and gas cases, embracing an analysis of all important cases in each state producing petroleum oil and natural gas, including the decisions of the federal courts, the analysis of each case showing the law of the case and the facts and pleadings from which the courts deduced its conclusions. Including remedies of conflicting claimants, and the practice in oil and gas cases, together with table of cases analyzed and table of cases cited, with comprehensive index, by V. B. Archer ... Charleston, W. Va., The Tribune printing co. [°1911]
lx, 1060 p. 25ᶜᵐ. $7.50
© June 2, 1911; 2c. June 6, 1911; A 289586; V. B. Archer, Parkersburg, W. Va. (11-16392) 3245

Ayer, Margaret Hubbard.
Five hundred ways to be beautiful, by Margaret Hubbard Ayer. New York, Ament & Weeks [°1911]
128 p. incl. front. (port.) plates. 18½ᶜᵐ. $0.25
© June 9, 1911; 2c. June 16, 1911*; A 289808; Ament & Weeks. (11-16491) 3246

Bergmann, Walther.
Das römische recht aus dem munde seiner verfasser. Eine systematische neuordnung der wichtigeren uns erhaltenen römischen rechtssprüche von dr. iur. Walther Bergmann ... 1. bd. Paderborn, Junfermannsche buchdruckerei, 1910.
ii, 639 p. 25½ᶜᵐ. M. 7.50
© May 16, 1911; 2c. July 1, 1911*; A—Foreign 3140; Junfermannsche buchhandlung, Paderborn, Germany. (11-16468) 3247

Bloem, Walter, 1868–
... "Das jüngste gericht" (Der paragraphenlehrling) roman von Walter Bloem. Umschlagzeichnung von Ernst Heilemann. 7.–16. tausend. Berlin-Ch., Vita, deutsches verlagshaus [°1911]
270 p. 19ᶜᵐ. ("Aus zeit und leben"; sammlung guter romane der gegenwart. bd. 2) M. 1.50
© May 16, 1911; 2c. June 26, 1911*; A—Foreign 3123; Vita, deutsches verlagshaus. (11-16381) 3248

Bolduan, Charles Frederick, 1873–

Immune sera; a concise exposition of the main facts and theories of infection and immunity, by Dr. Charles Frederick Bolduan ... 4th ed., rewritten and enl. 1st thousand. New York, J. Wiley & sons; [etc., etc.] 1911.

xi, 226 p. illus. 19½ᶜᵐ. $1.50
"Literature": p. 183.
© June 23, 1911; 2c. June 26, 1911*; A 292065; C. F. Bolduan, New York.
(11–16460) **3249**

The book of Chicagoans; a biographical dictionary of leading living men of the city of Chicago. [v. 2] 1911. Ed. by Albert Nelson Marquis ... Chicago, A. N. Marquis & company, 1911.

1 p. l., vii–xvi, 746 p. 24½ᶜᵐ. $12.50
© Apr. 24, 1911; 2c. Apr. 26, 1911*; A 286480; Albert Nelson Marquis. Chicago. **3250**

Boy scouts of America.

... The official handbook for boys. Proof copy. New York, Pub. for the Boy scouts of America; Garden City, N. Y., Doubleday, Page & company, 1911.

xiv, 320 p. front., illus. 18½ᶜᵐ. $0.25
© June 2, 1911; 2c. June 6, 1911; A 289841; Boy scouts of America, New York. (11–15620) **3251**

Brown, John Richard.

Jesus the joyous comrade [by] John Richard Brown. New York, Association press, 1911.

57 p. 18ᶜᵐ. $0.40
© June 12, 1911; 2c. June 14, 1911; A 283829; Internatl. committee of Y. M. C. A., New York. (11–16481) **3252**

Bumm, Ernst, 1858–

Grundriss zum studium der geburtshilfe. In achtundzwanzig vorlesungen und fünfhundertzweiundneunzig bildlichen darstellungen, von dr. Ernst Bumm ... 7. verb. aufl. Wiesbaden, J. F. Bergmann, 1911.

xi, 815, [1] p. illus. (partly col.) plates (1 fold.) 28½ᶜᵐ. M. 15
"Literatur" at end of chapters.
© May 18, 1911; 2c. July 1, 1911*; A—Foreign 3141; J. F. Bergmann.
(11–16492) **3253**

Burns, Louisa.

Studies in the osteopathic sciences. The nerve centers. v. 2. [By] Louisa Burns ... Cincinnati, Monfort & co.. 1911.

328 p. illus., plates. 24ᶜᵐ. $4.00
© July 10, 1911; 2c. July 14, 1911*; A 292441; L. Burns, Los. Angeles. **3254**

Church, William S.

Legal and business forms for use in Alaska, Arizona. California, Colorado. Hawaii, Idaho, Kansas, Montana. Nebraska, Nevada, New Mexico, North Dakota, Oklahoma, Oregon, South Dakota, Utah, Washington, and

Church, William S.—Continued
Wyoming, by W. S. Church ... San Francisco, Bender-
Moss company, 1911.
v , 1382 p. 23½ᶜᵐ. $7.50
ⓒ June 7, 1911; 2c. June 14, 1911*; A 289728; Bender-Moss co.
(11-16391) 3255

Comert, Marguerite.
... L'appuyée. Paris, Calmann-Lévy [°1911]
2 p. l., 306 p. 19ᶜᵐ. fr. 3.50
ⓒ June 14, 1911; 2c. June 26, 1911*; A—Foreign 3133; Calmann-Lévy.
(11-16380) 3256

Davies, C T.
The horse, and how to care for him, by C. T. Davies ...
Philadelphia, The Penn publishing company, 1911.
183 p. front., illus. 15ᶜᵐ. $0.50
ⓒ June 3, 1911; 2c. June 5, 1911*; A 289471; Penn pub. co.
(11-16499) 3257

Davis, Henry William Carless, 1874–
Medieval Europe, by H. W. C. Davis ... London, Wil-
liams and Norgate [°1911]
256 p. illus. (maps) 17ᶜᵐ. (Added t.-p.: Home university library of
modern knowledge. New York, H. Holt and company) 1/
"Note on books": p. 255–256.
ⓒ 1c. June 30, 1911*; A ad int. 693; pubd. June 2, 1911; Henry Holt & co.,
New York. (11-16486) 3258

Dieck, Wilhelm, 1867–
Anatomie und pathologie der zähne und kiefer im Rönt-
genbilde, mit besonderer berücksichtigung der aufnah-
metechnik, von prof. dr. med. W. Dieck ... Mit 52 text-
abbildungen und 251 photographischen Röntgenbildern
auf 17 tafeln. Hamburg, L. Gräfe & Sillem (E. Sillem)
1911.
92 p. illus., xvii pl., diagrs. 30ᶜᵐ. (Added t.-p.: ... Archiv und atlas
der normalen und pathologischen anatomie in typischen Röntgenbildern ...)
M. 30
At head of added t.-p.: Fortschritte auf dem gebiete der Röntgenstrahl-
en. Herausgeber: prof. dr. Albers-Schönberg. ergänzungsbd. 25)
ⓒ May 20, 1911; 2c. July 1, 1911*; A--Foreign 3144; Lucas Gräfe & Sil-
lem. (11-16490) 3259

Dincklage-Campe, Friedrich, freiherr von, 1839–
In schwerer bö. Novelle von F. frhr. von Dincklage.
3. aufl. Leipzig, G. Müller-Mann [°1911]
176 p. front. (port.) 19½ᶜᵐ. M. 2
ⓒ May 18, 1911; 2c. July 1, 1911*; A—Foreign 3146; G. Müller-Mann'sche
verlagsbuchhandlung. (11-16372) 3260

Doyle, Sir Arthur Conan, 1859–
Songs of the road, by Arthur Conan Doyle. Garden
City, N. Y., Doubleday, Page & company, 1911.
6 p. l., 3–137 p. 18½ᶜᵐ. $1.00
ⓒ May 12, 1911; 2c. May 29, 1911; A 292161; A. C. Doyle, London.
(11-16447) 3261

Dumcke, Julius, 1867–

Deutscher briefsteller; muster zu briefen jeder art, mit anhang; die fremdwörter, die zahlen, die wichtigsten abkürzungen sowie postalische bemerkungen. Zum schluss konjugation und wörterbuch des deutschen zeitworts, von dr. Julius Dumcke. Berlin-Schöneberg, Langenscheidt [°1911]

xvi, 392, [38] p. 16½ᶜᵐ. M. 3
Half-title: Langenscheidts briefsteller.
© May 26, 1911; 2c. July 1, 1911*; A—Foreign 3147; Langenscheidtsche verlagsbuchhandlung (Prof. G. Langenscheidt) (11-16452) **3262**

Fritsch, Karl Wilhelm, 1874–

Um Michelburg, ein roman von K. W. Fritsch. Berlin-Schöneberg, Buchverlag der "Hilfe" g. m. b. h., 1911.

216 p. 19¼ᶜᵐ. M. 3
© May 1, 1911; 2c. June 26, 1911*; A—Foreign 3124; Buchverlag der "Hilfe," g. m. b. h. (11-16375) **3263**

Galsworthy, John, 1867–

The little dream; an allegory in six scenes, by John Galsworthy. New York, C. Scribner's sons, 1911.

3 p. l., 3–35 p. 19ᶜᵐ.
© June 17, 1911; 2c. June 23, 1911; D 24584; Charles Scribner's sons. (11-15869) **3263⁺**

Gamble, Frederick William, 1869–

The animal world, by F. W. Gamble ... with introduction by Sir Oliver Lodge ... London, Williams and Norgate [°1911]

xii, 13–255, [1] p. illus. 17ᶜᵐ. (Added t.-p.: Home university library of modern knowledge. New York, H. Holt and company) 1/
Bibliography: 1 p. at end.
© 1c. June 30, 1911*; A ad int. 697; pubd. June 2, 1911; Henry Holt & co., New York. (11-16457) **3264**

Geddes, Patrick, 1854–

Evolution, by Patrick Geddes ... and J. Arthur Thomson ... London, Williams and Norgate [°1911]

xv, 16–256 p. 17ᶜᵐ. (Added t.-p.: Home university library of modern knowledge. New York, H. Holt and company) 1/
Bibliography: p. 249–256.
© 1c. June 30, 1911*; A ad int. 694; pubd. June 7, 1911; Henry Holt & co., New York (11-16459) **3265**

Gilmore, Eugene Allen, 1871–

Handbook on the law of partnership, including limited partnerships, by Eugene Allen Gilmore ... St. Paul, Minn., West publishing co., 1911.

xiii, 721 p. 23½ᶜᵐ. [The hornbook series. 34] $3.75
© June 20, 1911; 2c. July 3, 1911*; A 292226; West pub. co. (11-16467) **3266**

[Gould, Arthur]

The science of regeneration; or, Sex enlightenment; a
study of the sacred laws that govern the sex forces, by
A. G. Chicago, Ill., Advanced thought publishing co.;
[etc., etc.] 1911.

3 p. l., 5-161 p. front. (port.) 20ᶜᵐ. $1.00
© June 13, 1911; 2c. June 16, 1911*; A 289814; Advanced thought pub. co.
(11-16504) 3267

Groth, B H A.

... The sweet potato, by B. H. A. Groth ... [Philadel-
phia] University of Pennsylvania; New York, D. Apple-
ton and company, agents, 1911.

4 p. l., 104 p. LIV pl. 26ᶜᵐ. (Contributions from the Botanical labora-
tory of the University of Pennsylvania, vol. IV, no. 1) $2.00
© June 1, 1911; 1c. June 8, 1911; 1c. June 30, 1911*; A 292169; Univ. of
Pennsylvania. (11-16497) 3268

Hegel, Georg Wilhelm Friedrich, 1770-1831.

... Grundlinien der philosophie des rechts. Von d.
Georg Wilhelm Friedrich Hegel ... Berlin, 1821 ... Mit
den von Gans redigierten zusätzen aus Hegels Vorlesun-
gen neu hrsg. von Georg Lasson ... Leipzig, F. Meiner,
1911.

xcv, 380 p. 20½ᶜᵐ. (Philosophische bibliothek, bd. 124) M. 5.40
Added t.-p.: Naturrecht und staatswissenschaft im grundrisse ...
© May 10, 1911; 2c. June 26, 1911*; A—Foreign 3127; Felix Meiner.
(11-16505) 3269

Krause, Rudolf.

Kursus der normalen histologie. Ein leitfaden für den
praktischen unterricht in der histologie und mikroskopi-
schen anatomie. Von Rudolf Krause ... Mit 30 figuren
im text und 208 mehrfarbigen abbildungen auf 98 tafeln
nach originalzeichnungen des verfassers. Berlin [etc.]
Urban & Schwarzenberg, 1911.

xii, 441 p. illus. (partly col.) 98 pl. (partly col.) 25ᶜᵐ. M. 20
© June 1, 1911; 2c. July 1, 1911*; A—Foreign 3143; Urban & Schwarzen-
berg. (11-16463) 3270

La Tour et Taxis, Alex de, princesse.

Le violon de Jacob Stainer. Paris, Calmann-Lévy
[°1911]

2 p. l., 239, [1] p. 19ᶜᵐ. fr. 3.50
© Jan. 25, 1911; 2c. Mar. 27, 1911; A—Foreign 2803; Calmann-Lévy.
(11-16382) 3271

Lefferts, Sara Tawney, comp.

Land of play; verses — rhymes — stories, selected by
Sara Tawney Lefferts; illustrated by M. L. Kirk & Flor-
ence England Nosworthy. New York, Cupples & Leon
company [°1911]

128 p. col. front., illus., col. plates. 25ᶜᵐ. $2.50
© June 15, 1911; 2c. June 30, 1911*; A 292152; Cupples & Leon co.
(11-16450) 3272

MacFarren, H W.

Mining law for the prospector, miner, and engineer, by
H. W. MacFarren. San Francisco, Mining and scientific
press; [etc., etc.] 1911.
355 p. illus., diagrs. 20⁰⁰. $2.00
© June 22, 1911; 2c. June 27, 1911*; A 292095; Dewey pub. co., San Francisco. (11-16496) 3273

Maggiolo, Vesconte de, d. 1551, supposed author.

Atlas of portolan charts. Facsimile of manuscript in
British museum edited by Edward Luther Stevenson ...
New York, The Hispanic society of America, 1911.
4 p. l., facsim.: 2 pl., 20 maps. 29ᶜᵐ.
© June 1, 1911; 2c. June 5, 1911; A 289496; Hispanic society of America.
(Maps 11-3) 3274

Marinoni, Antonio, 1879–

An elementary grammar of the Italian language, by
A. Marinoni ... New York, William R. Jenkins co. [°1911]
x, 176 p. 19⁰⁰. $0.90
© June 29, 1911; 2c. July 1, 1911*; A 292186; William R. Jenkins co.
(11-16446) 3275

[Mogyoróssy, Árkád]

Palaestra ... 3d, newly written ed., by Arcadius Avel-
lanus [pseud.] ... pt. 1, nos. 11-12 ... [Philadelphia,
Printed by Latin press, 1911]
cover-title, p. 161-192. 8vo. $0.50
© June 24, 1911; 2c. June 26, 1911; A 292147; Arcadius Avellanus, Williamstown, Mass. 3276

Mosum, H O pseud.

Der mann von fünfundvierzig; bekenntnisse an einen
jugendfreund, von H. O. Mosum ... 1.-6. tausend. Leip-
zig, G. Wigand [°1911]
2 p. l., 183 p. 20⁰⁰. M. 2
© Apr. 12, 1911; 2c. June 2, 1911*; A—Foreign 3006; Georg Wigand.
(11-16378) 3277

Neppelberg, Anders.

Drivende skyer, en samling digte, av Anders Neppel-
berg. Minneapolis, Minn., Forfatterens forlag, 1911.
152 p. 21ᶜᵐ. $0.65
© May 20, 1911; 2c. June 10, 1911*; A 289647; A. Neppelberg, Minneapolis. (11-16376) 3278

Olmsted, Everett Ward.

Gramática castellana; a Spanish grammar for schools
and colleges, by Everett Ward Olmsted ... and Arthur
Gordon ... New York, H. Holt and company, 1911.
xii, 519 p. front. (map) 19ᶜᵐ. $1.40
© June 7, 1911; 2c. June 20, 1911*; A 289922; Henry Holt & co.
(11-16448) 3279

Page, Newell Caldwell, 1880–

Notes on physical laboratory experiments in electrical measurements, by N. C. Page ... Boston, A. D. Maclachlan [°1911]

56 p. diagrs. 23ᶜᵐ. $0.50
© Mar. 4, 1911; 2c. Mar. 9, 1911*; A 283282; N. C. Page, Winchester, Mass. (11–8147) 3280

Palmer, Robert Manning, 1867–

All about Airedales; a book of general information valuable to dog lovers and owners, breeders and fanciers, illustrated from selected photographs of noted dogs and rare scenes. The Airedale terrier reviewed. By R. M. Palmer ... Seattle, Wash., The A– A– A– publishing co., 1911.

120 p. 23½ᶜᵐ. $1.00
© June 14, 1911; 2c. June 20, 1911*; A 289914; A. A. A. pub. co. (11–16498) 3281

Phillips, James David.

Notes on mechanical drawing [by] J. D. Phillips [and] H. D. Orth. Madison, University of Wisconsin, 1911.

72 p. illus., diagrs. 19 x 26½ᶜᵐ. $1.50
© June 24, 1911; 2c. June 28, 1911*; A 292129; J. D. Phillips, H. D. Orth, Madison, Wis. (11–16493) 3282

Prokosch, Eduard.

An introduction to German, by Eduard Prokosch ... New York, H. Holt and company, 1911.

x, 316 p. map. 19½ᶜᵐ. $1.15
© June 16, 1911; 2c. June 20, 1911*; A 289923; Henry Holt & co. (11–16451) 3283

Raabe, Wilhelm Karl, 1831–1910.

Altershausen, von Wilhelm Raabe. Im auftrage der familie hrsg. und mit einem nachwort versehen von Paul Wasserfall. 1. bis 10. tausend. Berlin, O. Janke, 1911.

255, [1] p. 20ᶜᵐ. M. 3
© May 16, 1911; 2c. June 15, 1911*; A—Foreign 3081; Otto Janke. (11–16379) 3284

Read, Melbourne Stuart.

An introductory psychology, with some educational applications, by Melbourne Stuart Read ... Boston, New York [etc.] Ginn and company [°1911]

viii, 309 p. illus. 19½ᶜᵐ. $1.00
"References" at end of each chapter.
© Mar. 29, 1911; 2c. June 30, 1911*; A 292167; M. S. Read, Hamilton, N. Y. (11–16482) 3285

Sargent, Charles Sprague, ed.

Trees and shrubs; illustrations of new or little known ligneous plants, prepared chiefly from material at the Arnold arboretum of Harvard university, and ed. by Charles Sprague Sargent ... v. 2, pt. 3 ... Boston and New York, Houghton Mifflin company, 1911.

cover-title, 117–189, [1] p. plates. 33½ᶜᵐ. $5.00
© June 26, 1911; 2c. July 14, 1911*; A 292450; C. S. Sargent, Brookline, Mass. 3286

Schrickel, Leonhard, 1876–
... Die weltbrandschmiede, roman. Berlin, E. Fleischel & co., 1911.
2 p. l., 283 p. 20½ᶜᵐ. M. 3.50
© Apr. 19, 1911; 2c. June 2, 1911*; A—Foreign 3016; Egon Fleischel & co. (11–16371) **3287**

Schweriner, Oskar T.
... Polize X 24; original roman. Berlin, C. Duncker [ᶜ1911]
2 p. l., 275, [1] p. 20ᶜᵐ. M. 3.50
© May 22, 1911; 2c. June 26, 1911*; A—Foreign 3122; Carl Duncker. (11–16449) **3288**

Simon, Hermann Theodor, 1870–
Der elektrische lichtbogen; experimentalvortrag auf wunsch des wissenschaftlichen vereins zu Berlin gehalten am 11. januar 1911, von dr. Hermann Th. Simon ... mit 31 figuren und 1 farbentafel, sowie 22 versuchsbeschreibungen. Leipzig, S. Hirzel, 1911.
2 p. l., 52 p. illus., col. pl., diagrs. 24ᶜᵐ. M. 2
© May 23, 1911; 2c. July 1, 1911*; A—Foreign 3139; S. Hirzel. (11–16462) **3289**

Spivak, C D.
Yiddish dictionary, containing all the Hebrew and Chaldaic elements of the Yiddish language, illustrated with proverbs and idiomatic expressions, comp. by Dr. C. D. Spivak and Sol. Bloomgarden (Yehoash) [New York?] ᶜ1911·
3 p. l., [vi–xxxi p., 1 l., 340 p. 21ᶜᵐ. $2.50
© May 19, 1911; 2c. May 27, 1911*; A 289291; C. D. Spivak, Denver, and S. Bloomgarden, New York. (11–16453) **3290**

Van Dyke, Joseph Smith.
"Be of good cheer," by Joseph S. Van Dyke ... Boston, Sherman, French & company, 1911.
4 p. l., 119 p. 19½ᶜᵐ. $1 00
© June 12, 1911; 2c. July 3, 1911*; A 292242; Sherman, French & co. (11–16484) **3291**

Whitehead, Alfred North, 1861–
An introduction to mathematics, by A. N. Whitehead ... London, Williams and Norgate [ᶜ1911]
vi, 7–256 p. diagrs. 17ᶜᵐ. (Added t.-p.: Home university library of modern knowledge. New York, H. Holt and company)
"Bibliography: note on the study of mathematics": p. 251–252.
© 1c. June 30, 1911*; A ad int. 696; pubd. June 2, 1911; Henry Holt & co., New York. (11–16458) **3292**

Zobeltitz, Fedor Karl Maria Hermann August von, 1857–
Ein schlagwort der zeit. roman von Fedor von Zobeltitz; illustriert von M. Barascudts. Stuttgart, Carl Krabbe verlag, E. Gussmann [ᶜ1911]
276 p. plates. 20½ᶜᵐ. M. 4
© June 3, 1911; 2c. June 23, 1911*; A—Foreign 3103; Carl Krabbe verlag, Erich Gussmann. (11–16339) **3293**

Academy of political science, *New York*.

... The reform of the currency, ed. by Henry Raymond Mussey. New York, The Academy of political science, 1911.

1 p. l., p. 197–493. 24ᶜᵐ. (Proceedings ... vol. I, no. 2)
CONTENTS.—I. Historical: Successes and failures of the First and Second banks of the United States, by R. C. H. Catterall; Lessons of state banking before the civil war, by J. T. Holdsworth.—II. The present currency and banking problem: The business man's view of currency reform, by I. T. Bush; American banks in times of crisis under the national banking system, by E. W. Kemmerer; Bank notes and lending power, by J. L. Laughlin; Recent tendencies in state banking legislation, by G. E. Barnett; The relation of state to national banks, by J. F. Ebersole; The need of an expansion joint in our monetary system, by R. D. Kent.—III. The central bank: A united reserve bank of the United States, by P. M. Warburg; The banking and currency problem and its solution, by V. Morawetz; The necessity for a central bank, by G. E. Roberts; How to prevent cash suspension by banks, by A. J. Frame; Principles that must underlie monetary reform in the United States, by P. M. Warburg; The transition from existing conditions to central banking, by C. A. Conant.—IV. Foreign banking systems: Lessons from the Bank of England, by J. F. Johnson; Lessons from the Bank of France, by J. P. Norton; The banking system of Mexico, by R. M. Breckenridge; The Italian banking system, by J. D. Magee; The banking systems of the Netherlands, Russia, and Japan, by E. B. Patton; German banks and stock exchange speculation, by C. Parker.—V. Discussions at the Monetary conference: History of the conference; First–third session; Addresses at the anniversary dinner.
ⓒ Feb. 8, 1911; 2c. June 23, 1911; B 245119; Academy of political science. (11-16266) 3293*

[Adams, William Frederick] 1848–

Staples, Wealtha Staples; with records relating to some of the Berkley-Taunton, Massachusetts families ... Springfield, Mass., Priv. print., 1911.

70 p. incl. front., pl., map. plates, ports., double map. 24ᶜᵐ. $2.00
ⓒ May 20, 1911; 2c. June 26, 1911; A 292078; W. F. Adams, Springfield, Mass. (11-16549) 3294

Ade, John, 1828–

Newton County, by John Ade; a collection of historical facts and personal recollections concerning Newton County, Indiana, from 1853 to 1911. Indianapolis, The Bobbs-Merrill company [ᶜ1911]

6 p. l., 314 p. front. (port.) fold. map. 20ᶜᵐ. $1.25
ⓒ June 27, 1911; 2c. July 1, 1911*; A 292178; J. Ade, Kentland, Ind. (11-16546) 3295

Askew, *Mrs.* Alice J de C (Leake)

Two Apaches of Paris, by Alice & Claude Askew ... New York, W. Rickey & company, 1911.

vi, 334 p. 19ᶜᵐ. $1.25
ⓒ July 1, 1911; 2c. July 3, 1911*; A 292251; William Rickey & co. (11-16563) 3296

Autry, Allen Hill.

Warning signals; or, Romanism an American peril, by Allen Hill Autry ... Little Rock, Ark., The Doctrinal interpreter, 1911.

147 p. 19ᶜᵐ. $0.75
ⓒ June 16, 1911; 2c. June 28, 1911*; A 292110; A. H. Autry, Nashville, Ark. (11-16782) 3297

545

Bible. *Selections. English.*
Worker's companion; or, 150 Bible readings, by W. C.
Frazier ... Cincinnati, O., Printed at God's revivalist
office [°1911]
290 p. incl. front. (port.) 19½ᶜᵐ. $1.00
© June 5, 1911; 2c. July 7, 1911*; 292321; W. C. Frazier, Greensboro.
. N. C. (11-16784) 3298

Blanchard, Amy Ella, 1856–
Talbot's Angles, by Amy E. Blanchard ... Boston,
D. Estes & company [°1911]
291 p. col. front., plates. 21½ᶜᵐ. $1.50
© July 1, 1911; 2c. July 3, 1911; A 292253; Dana Estes & co.
(11-16562) 3299

Booth, Walter Sherman, 1827–
The township manual for the state of Minnesota; a
complete guide for township officers in their various du-
ties under the revised laws, 1905, and general laws, 1905,
1907, 1909 and 1911, by Walter S. Booth. 21st ed. Min-
neapolis, Minn., W. S. Booth & son, 1911.
284 p. 19½ᶜᵐ. $1.00
© June 30, 1911; 2c. July 3, 1911*; A 292245; W. S. Booth, Minneapolis.
(11-16557) 3300

Corning, Hanson Kelly.
Lehrbuch der topographischen anatomie, für studie-
rende und ärzte. Von dr. H. K. Corning ... 3., vollstän-
dig umgearb. aufl., mit 667 abbildungen, davon 420 in far-
ben. Wiesbaden, J. F. Bergmann, 1911.
xvi, 808 p. illus. (partly col.) 28ᶜᵐ. M. 16.60
Contains "Literatur."
© May 26, 1911; 2c. July 1, 1911*; A—Foriegn 3142; J. F. Bergmann.
(11-16768) 3301

Crane, Herbert Stanley.
Missouri cases. A complete citator-digest of all the
decisions of the Supreme court and Court of appeals re-
ports in the state of Missouri ... comp. by Herbert Stan-
ley Crane. Kansas City, Mo., The Frank T. Riley pub.
co., 1911.
1055 p. 26½ᶜᵐ. $15.00
© Mar. 6, 1911; 2c. Mar. 11, 1911*; A 283328; F. T. Riley pub. co.
 3302

Donahoe, Daniel, 1855–
Nunc pro tunc conviction ... John A. Brown, plaintiff
in error, vs. United States of America, defendant in error.
Error to the District court of the United States for the
Northern district of Illinois, eastern division. Reply
brief. Daniel Donahoe, esquire, James Hartnett, esquire,
counsel for John A. Brown. Chicago, Geo. Hornstein co.,
printer [°1911]
1 p. l., 34 p. 25ᶜᵐ. $2.50
U. S. Circuit court of appeals, 7th circuit, October term, 1910, no. 1763.
© June 27, 1911; 2c. June 29, 1911*; A 292140; James Hartnett, Chicago,
Ill. (11-16556) 3303

English, Lilla Gertrude.

Love lights for maid, wife and mother, by Lilla Gertrude English. ₁Chicago, W. B. Conkey company, printers, ⁹1911₁

171 p. front. (port.) 19ᶜᵐ. $1.00
© June 30, 1911; 2c. July 7. 1911; A 292329; L. G. English, Lincoln, Neb.
(11–16791) 3304

'Η ἐπανάστασις τοῦ εἰκοσίενα εἰς ηονογραφίας, ὅλα τὰ μεγάλα γεγονότα καὶ ὅλαι αἱ μεγάλαι φυσιογνωμίαι τοῦ ἱεροῦ ἀγῶνος μὲ περιγαφὰς καὶ εἰκόνας. Τομος Β. Νέα Τόρκη, Τυπογραφικὰ καταστήματα "'Ατλαντίδος." 1910.

1 p. l., ₁5₁–218 p. plates, ports. 24ᶜᵐ. (Πατριωτικὴ βιβλιοθήκη) $1.00

© Mar. 1, 1911; 2c. Mar. 18, 1911; A 283573; Atlantis, inc., New York.
 3305

Foerster, Friedrich Wilhelm, 1869–

Schuld und sühne; einige psychologische und pädagogische grundfragen des verbrecherproblems und der jugendfürsorge, von F. W. Foerster. München, C. H. Beck'sche verlagsbuchhandlung, O. Beck, 1911.

v p., 1 l., 216 p. 24ᶜᵐ. M. 3.50
© May 12, 1911; 2c. July 1, 1911*; A—Foreign 3150: C. H. Beck'sche verlagsbuchhandlung. (11–16567) 3306

₁**Greef,** *Frau* **Helene**₁ 1862–

Hier bin ich! roman von Erika Riedberg ₁pseud.₁ mit dem bildnis der verfasserin. Leipzig, G. Müller-Mann ₍ᶜ1911₁

208 p. front. (port.) 19½ᶜᵐ. M. 2
℗ May 18, 1911; 2c. July 1, 1911*; A—Foreign 3148; G. Müller-Mann'sche verlagsbuchhandlung. (11–16373) 3307

Grimshaw, Robert, 1850–

... Locomotive catechism; a practical and complete work on the locomotive—treating on the design, construction, repair and running of all kinds of locomotives ... Contains over 3,000 examination questions with their answers ... By Robert Grimshaw, M. E. Fully illustrated by 437 engravings and three folding plates. 28th rev. ed. New York, The Norman W. Henley publishing company, 1911.

4 p. l., ₁11₁–817 p. illus., 3 fold. pl. 19ᶜᵐ. $2.50
© June 30, 1911; 2c. July 1, 1911*; A 292185; Norman W. Henley pub. co.
(11–16566) • 3308

Haines, Lynn, 1876–

The Minnesota legislature of 1911 ... ₁by₁ Lynn Haines ... ₁Minneapolis₁ ᶜ1911·

128 p. 20ᶜᵐ. $0.60
© June 22, 1911; 2c. June 24, 1911*; A 292056; L. Haines, Minneapolis.
(11–16796) 3309

Hasbrouck, Stephen.

Altar fires relighted; a study of modern religious tendencies from the standpoint of a lay observer, by Stephen Hasbrouck ... New York, The Burnett publishing co., 1911.

xxiv, 352 p. 21½ᶜᵐ. $2.00

© Mar. 25, 1911; 2c. July 3, 1911; A 292319; Burnett pub. co.
(11-16785) 3310

Hobson, John Atkinson, 1858–

The science of wealth, by J. A. Hobson ... London, Williams and Norgate ₍ᶜ1911₎

vii, ₍1₎, 9–256 p. diagrs. 17½ᶜᵐ. (*Added t.-p.:* Home university library of modern knowledge. New York, H. Holt and company) 1/
"Note on books": 1 page following p. vii.

© 1c. June 30, 1911*; A ad int. 695; pubd. June 2, 1911; Henry Holt & co., New York. (11-16797) 3311

International clinics; a quarterly of clinical lectures ... Ed. by Henry W. Cattell ... v. 1, 21st series. 1911. Philadelphia and London, J. B. Lippincott company, 1911.

x, 300 p. 24ᶜᵐ. $2.00

© Mar. 15, 1911; 2c. Mar. 21, 1911*; A 283564; J. B. Lippincott co.
 3312

Johnson, Amandus.

The Swedish settlements on the Delaware; their history and relation to the Indians, Dutch and English, 1638–1664, with an account of the South, the New Sweden, and the American companies, and the efforts of Sweden to regain the colony ... by Amandus Johnson ... ₍Philadelphia₎ University of Pennsylvania; New York, D. Appleton & company, agents, 1911.

2 v. col. front., plates, ports., maps (3 fold.) facsims. 26½ᶜᵐ. $6.00
Bibliography: v. 2, p. 767–812.

© June 14, 1911; 2c. June 19, 1911*; A 289894; A Johnson, Philadelphia.
(11-16548) 3313

Johnson, Willis Ernest, 1869–

South Dakota, a republic of friends, by Willis E. Johnson ... Pierre, S. D., The Capital supply company ₍ᶜ1911₎

334 p. incl. front., illus., plates. fold. map. 20ᶜᵐ. $1.00

© June 16, 1911; 2c. July 3, 1911*; A 292236; W. E. Johnson, Aberdeen, S. D. (11-16554) 3314

Knox, James Samuel.

The science of applied salesmanship ... v. 1. By James Samuel Knox ... Des Moines, Ia., Knox school of applied salesmanship, 1911.

264 p. front. (port.) 23½ᶜᵐ. $2.00

© June 22, 1911; 2c. June 26, 1911; A 292107; J. S. Knox, Des Moines, Ia.
(11-16795) 3315

B 2035.4

Copp, Elbridge J 1844– U. S. Government

Reminiscences of the war of the rebellion, 1861–1865, by Col. Elbridge J. Copp, the youngest commissioned officer in the Union army who rose from the ranks. Published by the author. Nashua, N. H., Printed by the Telegraph publishing company, 1911.

536, iv p. incl. illus., plates, ports. front. 24ᶜᵐ.
© May 1, 1911; 2c. July 1, 1911*; A 292180; E. J. Copp.
(11–16900) 3316

Davis, Harold Palmer.

The Davis handbook of the Porcupine gold district, with a directory of incorporated companies and a review of mining in northern Ontario with an analysis of the production and dividends of the Cobalt silver district, by H. P. Davis ... New York, H. P. Davis [1911]

131, [2] p. incl. illus., pl. fold. map. 24½ᶜᵐ. $1.00
© June 6, 1911; 2c. June 23, 1911*; A 292016; H. P. Davis.
(11–16494) 3317

Dillon, John Forrest.

Commentaries on the law of municipal corporations. By John F. Dillon ... 5th ed., thoroughly rev. and enl. ... v. 5. Boston, Little, Brown, and company, 1911.

3 p. l., 738 p. 24½ᶜᵐ. $32.50 a set.
© July 19, 1911; 2c. July 21, 1911*; A 292625; J. F. Dillon, New York.
3318

Friedlaender, Hugo.

Interessante kriminal-prozesse von kulturhistorischer bedeutung ... nach eigenen erlebnissen von Hugo Friedlaender ... eingeleitet von justizrat dr. Sello ... [bd. 3] Berlin, H. Barsdorf, 1911.

vi p., 1 l., 356 p. illus. 21½ᶜᵐ. M. 3
© May 29, 1911; 2c. July 18, 1911*; A—Foreign 3218; Herman Barsdorf.
3319

Gannon, Frederic Augustus, 1881–

Shoe making, old and new, by Fred A. Gannon ... [Salem, Mass., Printed by Newcomb & Gauss, ᶜ1911]

2 p. l., [3]–76 p. front., plates, 2 port. on 1 l. 21½ᶜᵐ. $1.00
© May 11, 1911; 2c. June 28, 1911; A 292131; F. A. Gannon, Salem, Mass.
(11–16897) 3320

Hall, Albert Neely, 1883–

Handicraft for handy boys; practical plans for work and play, with many ideas for earning money, by A. Neely Hall ... with nearly six hundred illustrations and working-drawings by the author and Norman P. Hall. Boston, Lothrop, Lee & Shepard co. [1911]

xxii p., 1 l., 437 p. front., illus., plates. 20½ᶜᵐ. $2.00
© June 28, 1911; 2c. June 30, 1911*; A 292170; Lothrop, Lee & Shepard co.
(11–16895) 3321

549

Handbuch der hygiene, unter mitwirkung von ... dr. R. Abel [et al.] hrsg. von prof. dr. M. Rubner ... prof. dr. M. v. Gruber ... und prof. dr. M. Ficker ... 2. bd., 2. abt. Wasser und abwasser ... Leipzig, S. Hirzel, 1911. x p., 1 l., 410 p. illus., col. plates. 26ᶜᵐ. M. 15

© May 30, 1911; 2c. July 18, 1911*; A—Foreign 3210; S. Hirzel.

 3322

Johnston, John Kilgore, 1860–

Report on the bituminous coal beds of Pennsylvania in territory adjacent to the Pennsylvania railroad, east of Pittsburgh and Erie, by John K. Johnston. Tyrone [Philadelphia, Printed by Stephen Greene co.] 1911. 155 p. plates, fold. tab. 24ᶜᵐ.

© June 30, 1911; 2c. July 3, 1911*; A 292259; J. K. Johnston, Tyrone, Pa. (11–16894) **3323**

King, Charles Albert, 1865–

... Handbook in woodwork and carpentry, for teachers and normal schools, by Charles A. King ... New York, Cincinnati [etc.] American book company [ᶜ1911] x, 132 p. incl. front., illus., diagrs. 19ᶜᵐ. (King's series in woodwork and carpentry) $1.00

© July 5, 1911; 2c. July 7, 1911*; A 292303; C. A. King, Bay City, Mich. (11–16968) **3324**

Lambeth, William Alexander, 1867–

Trees, and how to know them; a manual with analytical and dichotomous keys of the principal forest trees of the South, by W. A. Lambeth ... Richmond, Atlanta [etc.] B. F. Johnson publishing company [ᶜ1911] 2 p. l., [3]–52 p. illus. 19½ᶜᵐ. $0.60 Blank pages at end of volume for Notes.

© June 24, 1911; 2c. July 1, 1911*; A 292177; W. A. Lambeth, University of Va., Charlottesville. Va. (11–16976) • **3325**

Lane, John Veasey, 1861–

Rodney, the ranger, with Daniel Morgan on trail and battlefield, by John V. Lane ... illustrated by John Goss. Boston, L. C. Page & company, 1911. viii p., 1 l., 297 p. front., plates. 21ᶜᵐ. $1.50

© July 5, 1911; 2c. July 7, 1911*; A 292317; L. C. Page & co., inc. (11–16565) **3326**

Lanier, Henry Wysham, 1873–

Photographing the civil war, by Henry Wysham Lanier. vol. I, II. New York, The Review of reviews co., 1911. 2 v. front., plates. 28ᶜᵐ.
Substantially the same as The photographic history of the civil war ... Francis Trevelyan Miller, editor-in-chief; with narrative text omitted and illustrative material rearranged.

v. 1 © May 24, 1911; 1c. May 25, 1911; 1c. June 16, 1911; A 289246; v. 2 © June 29, 1911; 2c. July 7, 1911; A 292318; Review of reviews co. (11–16902) **3327, 3328**

Louisiana. *Supreme court.*

Louisiana reports, v. 127; cases argued and determined in the Supreme court of Louisiana sitting at New Orleans at term beginning first Monday of October, 1909, and at term beginning first Monday of October, 1910 ... Ed. under the direction of the court by Charles G. Gill. St. Paul, West publishing co., 1911.

xxix, 1216 numb. col. 23ᶜᵐ. $4.00
© June 27, 1911; 2c. July 17, 1911*; A 292495; West pub. co. **3329**

McGee, Gentry Richard.

A history of Tennessee from 1663 to 1911, for use in schools, by G. R. McGee ... New York, Cincinnati [etc.] American book company [ᶜ1911]

302, xl p. front., illus. 19ᶜᵐ. $0.75
On cover: Tennessee edition.
© July 1, 1911; 2c. July 7, 1911*; A 292304; G. R. McGee, Jackson, Tenn.
(11-16551) **3330**

Mann, Albert R.

Beginnings in agriculture, by Albert R. Mann ... New York, The Macmillan company, 1911.

x, 317 p. incl. illus., plates. front. 19½ᶜᵐ. (*Half-title:* The rural textbook series, ed. by L. H. Bailey) $0 75
© June 10, 1911; 2c. June 12, 1911*; A 289664; Macmillan co.
(11-16500) **3331**

Marsh, Charles A *comp.*

College entrance examination papers in plane geometry, comp. by Charles A. Marsh, A. M. [and] Harrie J. Phipps ... New York, Charles E. Merrill company, 1911.

178 p. diagrs. 19½ᶜᵐ. $0.60
© June 22, 1911; 2c. June 27, 1911*; A 292091; Charles E. Merrill co.
(11-16978). **3332**

Merrill, James Andrew, 1861–

Industrial geography of Wisconsin, by James A. Merrill ... Chicago, Des Moines, The Laurel book co., 1911.

182 p. incl. front., illus. maps. 20ᶜᵐ. $1.00
© June 7, 1911; 2c. June 22, 1911*; A 289976; Laurel book co., Des Moines, Ia. (11-16799) **3333**

Missouri. *St. Louis, Kansas City and Springfield courts of appeals.*

Cases determined ... reported for the St. Louis court of appeals, October 24, 1910, by Thomas E. Francis ... for the Kansas City court of appeals, November 7, 1910, to January 16, 1911, by John M. Cleary ... and for the Springfield court of appeals, December 5, 1910, to January 3, 1911, by Lewis Luster ... official reporters. v. 152. Columbia, Mo., E. W. Stephens, 1911.

xvii, 796, xviii p. 23½ᶜᵐ. $3.00
© July 10, 1911; 2c. July 20, 1911*; A 292608; E. W. Stephens. **3334**

Morey, Charles W.

... Advanced arithmetic, by Charles W. Morey ... New York, C. Scribner's sons, 1911.

x, 428 p. diagrs. 19½ᶜᵐ. (Morey's arithmetics) $0.65
© June 17, 1911; 2c. June 23, 1911*; A 289991; Charles Scribner's sons.
(11–16977) 3335

The **New York** criminal reports; reports of cases decided in all courts of the state of New York ... by Charles H. Mills ... v. 25. Albany, N. Y., W. C. Little & co., 1911.

iv, vii–xv, 598 p. 24ᶜᵐ. $5.50
© July 15, 1911; 2c. July 20, 1911*; A 292605; W. C. Little & co.
 3336

... The **Northwestern** reporter, with key-number annotations. v. 130. Permanent ed. ... March 17–May 26, 1911. St. Paul, West publishing co., 1911.

xiii, 1269 p. 26½ᶜᵐ. (National reporter system—State series) $4.00
© July 5, 1911; 2c. July 17, 1911*; A 292494; West pub. co. 3337

Ohio. *Supreme court.*

Reports of cases argued and determined ... Reported by Emilius O. Randall, Supreme court reporter. New series, v. 83. Cincinnati. The W. H. Anderson company, 1911.

xlv, 614 p. 23ᶜᵐ. $2.50
© July 8, 1911; 2c. July 11, 1911; A 292479; Emilius O. Randall, for the
state of Ohio, Columbus, O. 3338

Pennsylvania. *Supreme court.*

Pennsylvania state reports, v. 230, containing cases decided ... January term, 1911. Reported by William I. Schaffer, state reporter. New York, The Banks law publishing co., 1911.

xxxii, 734 p. 24ᶜᵐ. $0.91
© July 17, 1911; 2c. July 18, 1911*; A 292521; Robert McAfee, sec. of the
commonwealth for the state of Pennsylvania, Harrisburg, Pa. 3339

Piercy, Willis Duff.

... Great inventions and discoveries, by Willis Duff Piercy. New York, Charles E. Merrill company [ᶜ1911]

206 p. incl. front., illus. 19ᶜᵐ. (Graded supplementary reading series)
$0.40
© June 30, 1911; 2c. July 11, 1911*; A 292366; Charles E. Merrill co.
(11–16967) 3340

Poor's manual of the railroads of the United States ... 44th annual number, 1911. New York, Poor's railroad manual co.; American bank note company [1911]

cviii, 2706 p. maps (partly fold.) 23ᶜᵐ. $10.00
© July 12, 1911; 2c. July 17, 1911*; A 292498; Poor's railroad manual co.
 3341

Prior, Frederick J.

The Canadian new first, second and third year examinations for engineers and firemen; complete explanatory

Prior, Frederick J.—Continued

and instructive answers to the three series of examination questions ... Chicago, F. J. Prior; [etc., etc., ⁰1911]
213 p. 16ᶜᵐ. (Prior system of self-educational text and reference books) $2.50
© June 24, 1911; 2c. June 28, 1911*; A 292125; F. J. Prior, Chicago.
(11–16966) 3342

Randall, John Herman, 1871–

A new philosophy of life, by J. Herman Randall. New York, Boston, H. M. Caldwell co. [⁰1911]
3 p. l., 5–78 p. 19ᶜᵐ. $1.50
CONTENTS.—Foreword.—The universal mind.—The divinity of man.—The powers and possibilities of the subconscious mind.—Faith as a vital force.—The law of suggestion.—Auto-suggestion.—Mind and medicine.—Physical wholeness.—Awakening latent mental powers.—The achievement of character. — The conquest of fear and worry. — The psychology of prayer.—Spiritual consciousness.—The rediscovery of Jesus.
© June 30, 1911; 2c. July 3, 1911; A 292362; H. M. Caldwell co., Boston.
(11–16783) 3343

Rauschen, Gerhard, ed.

Florilegium patristicum, digessit vertit adnotavit Gerardus Rauschen ... fasc. 2. Ed. 2., aucta et emendata. Bonnae, P. Hanstein, 1911.
2 p. l., 135 p. 21½ᶜᵐ.
© May 1, 1911; 2c. June 9, 1911*; A—Foreign 3026; Peter Hanstein.
(11–16377) 3344

Roe, Edward Thomas, 1847–

The new standard American business guide; a complete compendium of how to do business by the latest and safest methods ... By E. T. Roe ... [10th ed.] New York, Leslie-Judge co. [⁰1911]
480 p. illus., tables. 21ᶜᵐ. $1.90
Earlier editions published under titles: "The standard American business guide," "Safe methods; or, How to do business," etc., etc.
© June 26, 1911; 2c. June 28, 1911*; A 292116; A. W. Dewar, Chicago.
(11–16794) 3345

Rolfe, John Carew, 1859–

A junior Latin book, with notes, exercises, and vocabulary, by John C. Rolfe ... and Walter Dennison ... Rev. ed. Boston and Chicago, Allyn and Bacon [⁰1911]
vi, 397, 149 p. 12 maps (partly fold., incl. front.) 19ᶜᵐ. $1.25
© June 30, 1911; 2c. July 6, 1911*; A 292291; J· C. Rolfe, Philadelphia, W. Dennison, Swarthmore, Pa. (11–16981) 3346

Ross, Mrs. Meriel Aimie.

The pawns of fate, by M. A. Ross ... London and New York, Harper & brothers, 1911.
3 p. l., 294 p. 19½ᶜᵐ. 6/
© 1c. June 15, 1911*; A ad int. 672; pubd. May 18, 1911; M. A. Ross, London. (11–16887) 3347

Rowe, Harry M.

Bookkeeping and accountancy; presenting the art of bookkeeping in accordance with the principles of modern accountancy, by Harry M. Rowe ... script by C. P. Zaner. Baltimore, The H. M. Rowe company [c1910]

vi, 263 p. illus. (forms.) 23½ᶜᵐ. $1.50

© July 5, 1911; 2c. July 5, 1911*; A 292283; H. M. Rowe, Baltimore. (11-16792) **3348**

Russell, Lev.

Index to the statutes of Kentucky, by Lev Russell. Lexington, Ky., J. E. Hughes, 1911.

2 p. l., [3]-160 p. 25½ᶜᵐ.

© Jan. 15, 1911; 2c. Feb. 27, 1911; A 283571; James E. Hughes, Lexington, Ky., and L. Russell, Lebanon, Ky. **3349**

Russia. *Glavnyi shtab.*

Der russisch-japanische krieg, amtliche darstellung des russischen Generalstabes; deutsche vom russischen kriegsministerium mit allerhöchster genehmigung autorisierte ausgabe von freiherr von Tettau ... bd. 3: Schaho-Sandepu. 2. t. Von der schlacht am Schaho bis einschliesziich der schlacht bei Sandepu. Vorstoss des kavallerie-korps Mischetschenko auf Yinkou. Berlin, E. S. Mittler und sohn, 1911.

ix, 345 p. fold. maps in pocket. 24½ᶜᵐ. M. 7.70

© May 19, 1911; 2c. June 9, 1911; A—Foreign 3198; E. S. Mittler & sohn. **3350**

Shaw, George Bernard, 1856–

... Dramatische werke ... Berlin, S. Fischer, 1911.

3 v. front. (port.) 20ᶜᵐ. M. 10

"Autorisierte übertragung von Siegfried Trebitsch."

CONTENTS. — 1. bd. Unerquickliche stücke: Einleitung: Was ich der deutschen kultur verdanke. Vorrede: Hauptsächlich über mich selbst. Die häuser des Herrn Sartorius. Der liebhaber. Frau Warrens gewerbe.—2. bd. Erquickliche stücke: Vorrede zum zweiten band. Helden. Candida. Der mann des schicksals. Man kann nie wissen.—3. bd. Stücke für Puritaner: Warum für Puritaner? Über die ethik des teufels. Besser als Shakespear. Der teufelsschüler. Anmerkungen zum Teufelsschüler. Cäsar und Cleopatra. Anmerkungen zu Cäsar und Cleopatra. Kapitän Brassbounds bekehrung. Anmerkung zu Kapitäns Brassbounds bekehrung.

© May 27, 1911; 2c. each July 1, 1911*; A—Foreign 3145; S. Fischer verlag. (11-16982) **3351**

Sommerfeld, Adolf.

Das geheimnis der Kamorra, des geheimbundes ursprung u. wesen, von Adolf Sommerfeld ... Berlin, Verlag Continent, g. m. b. h. [c1911]

187 p. 20ᶜᵐ.

© June 21, 1911; 2c. July 5, 1911; A—Foreign 3171; Verlag Continent, g. m. b. h. (11-16960) **3352**

Southwestern reporter.

Missouri decisions reported in the Southwestern reporter annotated vols. 133, 134, and 135, February to April, 1911 ... St. Paul, West publishing co., 1911.
Various paging. 26½ᶜᵐ. $5.50
© June 30, 1911; 2c. July 17. 1911*; A 292493; West pub. co. 3353

Soyer, Nicolas.

Soyer's paper-bag cookery, by Nicolas Soyer ... London, A. Melrose, 1911.
3 p. l., ₍5₎-112 p. front. (port.) 16½ᶜᵐ.
© 1c. July 6, 1911*; A ad int. 701; pubd. June 6, 1911; Sturgis & Walton co., New York. (11-16896) 3354

Spottiswoode, *Mrs.* Sybil Gwendolen, 1879–

Her husband's country, by Sybil Spottiswoode ... New York, Duffield and company, 1911.
4 p. l., 3-420 p. 19½ᶜᵐ. $1.20
© June 13, 1911; 2c. June 15, 1911*; A 289770; Duffield & co.
(11-16889) 3355

Stevens, Charles McClellan, 1861– *ed.*

Standard home and school dictionary; containing literary, scientific, encyclopedic and pronouncing features, based on the latest and best authorities ... Ed., rev. and enl. by Prof. C. M. Stevans, PH. D., including the official census of 1910. Over twelve hundred illustrations and numerous full-page plates. Philadelphia, Pa., National publishing co. ₍ᶜ1911₎
640 p. front. (ports.) illus., plates (1 col.) fold. maps, tables. 21½ᶜᵐ.
$1.75
On verso of t.-p.: New edition, revised and enlarged.
© June 17, 1911; 2c. June 29, 1911*; A 292135; William R. Vansant, Chicago. ₍Copyright is claimed on additional matter₎
(11-16984) 3356

Stevens, Thomas Wood, 1880–

Book of words; a pageant of the old Northwest, by Thomas Wood Stevens, presented by the State normal school, Milwaukee, June 15 and 16, 1911. ₍Milwaukee, Press of I. S. Bletcher & co., ᶜ1911₎
1 p. l., 5-76 p., 1 l. 23½ᶜᵐ.
© June 15, 1911; 2c. June 26, 1911*; D 24571; T. W. Stevens, Chicago.
(11-16285) 3356*

Stevenson, Robert Louis, 1850–1894.

An inland voyage and Travels with a donkey, by Robert Louis Stevenson; ed., with introduction and notes by Louis Franklin Snow ... Boston, New York ₍etc.₎ Ginn and company ₍ᶜ1911₎
xvi, 268 p. incl. front. (port.) maps. 17ᶜᵐ. (Standard English classics)
$0.35
"Authorities and references": p. xiv-xv.
© Apr. 10, 1911; 2c. June 30, 1911*; A 292168; Louis Franklin Snow, Lexington, Ky. (11-16770) 3357

Stevenson, Robert Louis, 1850-1894.

Stevenson's Treasure Island, ed., with introduction and notes, by Frank Wilson Cheney Hersey ... Boston, New York [etc.] Ginn and company [c1911]

lxxv, 249 p. incl. front. (facsim.) illus. 17ᶜᵐ. (Standard English classics) $0.45

Bibliography: p. lxxiii-lxxiv.

© May 13, 1911; 2c. June 30, 1911*; A 292165; Ginn & co.
(11-16561) 3358

Teskey, Adeline Margaret.

The yellow pearl; a story of the East and the West, by Adeline M. Teskey ... New York, Hodder and Stoughton, George H. Doran company [c1911]

3 p. l., 3-208 p. col. front. 19ᶜᵐ. $1.00

© July 6, 1911; 2c. July 8, 1911*; A 292337; George H. Doran co.
(11-16564) 3359

Throckmorton, Josephine Holt.

Sergeant Jimmy, by Holt Throckmorton. Washington, D. C., Press of Judd & Detweiler, inc. [c1911]

170 p. col. pl. 24ᶜᵐ.

© June 12, 1911; 2c. June 12, 1911*; A 289684; J. H. Throckmorton, Washington. 3360

Washington, George, pres. U. S., 1732-1799.

Washington's farewell address, and Webster's first Bunker Hill oration, ed. by William Edward Simonds ... New York, H. Holt and company, 1911.

xlv, 65 p. front. (port.) 17ᶜᵐ. (Half-title: English readings for schools. General editor: W. L. Cross) $0.25

"Descriptive bibliography": p. xli-xlv.

© June 10, 1911; 2c. June 20, 1911*; A 289926; Henry Holt & co.
(11-16899) 3361

Webster, Noah, 1758-1843.

... Webster's reliable dictionary for home, school and office, based on Webster's imperial and Webster's universal dictionaries, and ed. by Thomas H. Russell ... Akron, O., The Saalfield publishing company [c1911]

2 p. l., 7-567, 151 p. col. front., illus., col. plates. 19½ᶜᵐ.

© June 6, 1911; 2c. June 28, 1911*; A 292109; Walter R. Deuel, New York. (11-16985) 3362

Will, Arthur Percival, ed.

Standard encyclopædia of procedure; editor: Arthur P. Will ... supervising editors: James De Witt Andrews ... Edgar W. Camp ... v. 2. [Answers-Arrest of judgment] Los Angeles, Chicago, L. D. Powell company [1911]

3 p. l., 1037 p. 24ᶜᵐ. $6.00

© June 29, 1911; 2c. July 17, 1911*; A 292517; L. D. Powell co. 3363

... **Annals** of educational progress in 1910. [v. 1] a report upon current educational activities throughout the world ... Philadelphia and London, J. B. Lippincott company, 1911.

396 p. 19½ᶜᵐ. (*Half-title:* Lippincott's education series, ed. by M. G. Brumbaugh. vol. VIII)
1910, by John Palmer Garber.
© Mar. 6, 1911; 2c. Mar. 21, 1911*; A 283562; J. B. Lippincott co.
(11-8104) 3364

Armfield, Anne Constance (Smedley) *"Mrs. Maxwell Armfield."*
The larger growth (mothers and fathers) by Constance Smedley Armfield. New York, E. P. Dutton & company [1911]

ix, [2], 382 p. 19½ᶜᵐ. $1.35
© July 10, 1911; 2c. July 12, 1911*; A 292401; E. P. Dutton & co.
(11-17100) 3365

Braun, Lily (von Kretschman) von Gizycki.
Memoiren einer sozialistin, kampfjahre; roman von Lily Braun ... München, A. Langen [1911]

2 p. l., 657 p. 19ᶜᵐ. M. 6
© June 8, 1911; 2c. July 19, 1911*; A—Foreign 3237; Albert Langen.
3366

Browning, Robert, 1812-1889.
From day to day with the Brownings. comp. by Wallace and Frances Rice. New York, Barse & Hopkins [1911]

1 p. l., 7-127 p. front. (port.) 20ᶜᵐ. $0.75
© June 26, 1911; 2c. July 13, 1911*; A 292405; Barse & Hopkins.
(11-17084) 3367

Burrowes, Katharine.
Tales of the great composers: Bach, Handel, Haydn, by Katharine Burrowes ... Detroit, Mich., Katharine Burrowes; [etc., etc., °1911]

2 p. l., 46 p. 23ᶜᵐ. $0.50
© June 22, 1911; 2c. June 26, 1911*; A 292067; K. Burrowes.
(11-17086) 3368

[**Chartier, Edward Morris**] 1860–
New modern shorthand for class and self instruction by the Modern publishing company ... Rev. ed. Hammond, Ind., Modern publishing company, 1911.

101 p. 18½ᶜᵐ. $2.00
© June 5, 1911; 2c. May 31, 1911*; A 289343; Modern pub. co.
(11-16891) 3369

Cooper, Clayton Sedgwick.
College men and the Bible [by] Clayton Sedgwick Cooper ... New York, Association press, 1911.

xiv, 195 p. front., illus. (map) plates, ports. 21½ᶜᵐ. $1.00
Bibliography: p. [161]-179.
© July 10, 1911; 2c. July 12, 1911*; A 292384; Internatl. committee Y. M. C. A. (11-17107) 3370

557

Detached dwellings (pt. 2) Country and suburban. New York, The American architect, 1911.

1 p. l., 26 p. illus., plates. 31½ᶜᵐ. $5.00
© Apr. 19, 1911; 2c. June 7, 1911*; A 289523; American architect.
3371

Dilley, Edgar Meek, 1874–

The Red Fox's son; a romance of Bharbazonia, by Edgar M. Dilley; with a frontispiece in colour by John Goss. Boston, L. C. Page & company, 1911.

5 p. l., 363 p. col. front. 20ᶜᵐ. $1.50
© July 3, 1911; 2c. July 7, 1911*; 292316; L. C. Page & co., inc. (11-17099)
3372

Freytag, Gustav, 1816–1895.

... Die journalisten; lustspiel in vier akten, von Gustav Freytag; ed., with introduction, bibliography, notes, questions on the text, theme subjects for free reproduction, and vocabulary, by H. A. Potter ... New York, Charles E. Merrill company [c1911]

264 p. front. (port.) 18ᶜᵐ. (Merrill's German texts) $0.60
Bibliography: p. 21.
© June 30, 1911; 2c. July 11, 1911*; A 292367; Charles E. Merrill co. (11-17077)
3373

Holmes, Oliver Wendell, 1809–1894.

From day to day with Holmes, comp. by Wallace and Frances Rice. New York, Barse & Hopkins [c1911]

1 p. l., 7–126 p. front (port.) 20ᶜᵐ. $0.75
© June 26, 1911; 2c. July 13, 1911*; A 292408; Barse & Hopkins. (11-17082)
3374

Horatius Flaccus, Quintus.

... Horace; Odes and epodes, ed., with introduction and notes, by Paul Shorey ... rev. by Paul Shorey and Gordon J. Laing ... Boston, B. H. Sanborn & co., 1910.

xxxvii, 514 p. 18ᶜᵐ. (The students' series of Latin classics) $1.40
© Aug. 29, 1910; 2c. June 21, 1911; A 292099; P. Shorey and G. J. Laing, Chicago. (11-17081)
3375

Horton. Robert Forman, 1855–

The Hero of heroes; a life of Christ for young people, by Robert F. Horton ... illustrated by James Clark, R. I. London, Jarrold & sons [c1911]

ix, 11–326 p. col. front., col. plates. 20ᶜᵐ. 3/6
© 1c. July 12, 1911*; A ad int. 704; pubd. June 13, 1911; Fleming H. Revell co., New York. (11-17106)
3376

The International correspondence schools, *Scranton, Pa.*

Modelos Mitchell y lecciones fáciles sobre el manejo de las locomotoras, preparados para los estudiantes de las Escuelas internacionales ... 1. ed. ... Scranton, Pa., International text-book company, 1911.

[142] p. incl. illus. (partly col.) plates (partly col., partly fold.) 26½ x 33½ᶜᵐ.
Loose-leaf edition in portfolio; part of plates superimposed; pasteboard model of revolving valve in pocket.
© pt. 3, 5, Dec. 20, 1910; pt. 1, 6, Jan. 12, 1911; pt. 2, 4, Jan. 17, 1911; 2c. June 20, 1911*; A 289913; International textbook co. (11-17096)
3377

Johnston, Mary, 1870–

The long roll, by Mary Johnston, with illustrations by N. C. Wyeth. Boston and New York, Houghton Mifflin company, 1911.

x p., 1 l., 683, [1] p. col. front., 3 col. pl. 19½ᶜᵐ.
© May 27, 1911; 2c. June 15, 1911*; A 289784; M. Johnston, Richmond, Va. (11-13141) 3378

McConkey, James Henry, 1858–

Life talks; a series of Bible talks on the Christian life, by James H. McConkey. 1st ed. Harrisburg, Pa., F. Kelker, 1911.

1 p. l., 5–121 p. 16ᶜᵐ.
© June 29, 1911; 2c. July 6, 1911*; A 292290; J. H. McConkey, Wrightsville, Pa. (11-16480) 3379

Marcuse, Julian, 1862–

Die fleischlose küche; eine theoretische einleitung und ein praktisches kochbuch, von dr. med. Julian Marcuse und Bernardine Woerner. München, E. Reinhardt [°1911]

2 p. l., 552 p. 20½ᶜᵐ. M.3
© Apr. 22, 1911; 2c. July 6, 1911; A—Foreign 3164; Ernst Reinhardt. (11-17095) 3380

Ranlett, Susan Alice, 1853–

Some memory days of the church in America, by S. Alice Ranlett. Milwaukee, The Young churchman co.; [etc., etc., °1911]

4 p. l., 116 p. front., plates, ports. 17½ᶜᵐ. $0.75
"Reprinted, in considerable part, from the Young Christian soldier."
© July 8, 1911; 2c. July 12, 1911*; A 292387; Young churchman co. (11-17110) 3381

Robinson, Charles, 1852–

Comparative and rational Christian science, by Charles Robinson ... Chicago, Rational health methods society, 1911.

271 p. front. (port.) pl. 20ᶜᵐ. $1.50
The treatise by William Adams has reproduction of original t.-p.
CONTENTS.—Author's introduction: new light from an old flame.—The elements of Christian science: a treatise upon moral philosophy and practice, by William Adams. 1850.—Extracts from Science and health, by Mary B. G. Eddy.—Good sense methods for physical and mental improvement.
© July 1, 1911; 2c. July 10, 1911*; A 292350; C. Robinson, Chicago. (11-17108) 3382

The scenic New England tour book, covering only the recommended routes and tours in the New England states, the Adirondacks and Harlem Valley ... Boston, Mass., Walker lithograph and publishing company [°1911]

15 p. l., 212 p. incl. maps. 22 x 12ᶜᵐ.
Compiler: 1911, R. Beck.
© May 17, 1911; 2c. May 19, 1911*; A 289043; Walker lithograph & pub. co. (11-12136) 3383

Schnitzler, Arthur, 1862–

Anatol: a sequence of dialogues, by Arthur Schnitzler; paraphrased for the English stage by Granville Barker. New York, M. Kennerley, 1911.

4 p. l., 3–125 p. 20ᶜᵐ.　$1.00

© May 4, 1911; 2c. June 27, 1911; A 292163; Mitchell Kennerley.
(11–17080)　　　　　　　　　　　　　　　　3384

Semeria, Giovanni, b. ca. 1867.

The eucharistic liturgy in the Roman rite; its history and symbolism adapted from the Italian of Rev. Giovanni Semeria ... by Rev. E. S. Berry ... New York, Cincinnati [etc.] F. Pustet & co., 1911.

287 p. front., illus., fold. tab. 19½ᶜᵐ.　$1.50

© May 9, 1911; 2c. May 11, 1911*; A 286833; Frederick Pustet & co.
(11–17109)　　　　　　　　　　　　　　　　3385

Serret, J. A.

... Lehrbuch der differential- und integralrechnung ... 4. und 5. aufl. Bearb. von Georg Scheffers. 2. bd. Integralrechnung ... Leipzig und Berlin, B. G. Teubner, 1911.

xiv, 638, [1] p. diagrs. 22½ᶜᵐ.　M. 2.50

© May 19, 1911; 2c. July 19, 1911*; A—Foreign 3233; B. G. Teubner.
　　　　　　　　　　　　　　　　　　　　3386

Shepherd, Henry Elliott, 1844–

The representative authors of Maryland, from the earliest time to the present day, with biographical notes and comments upon their work. By Henry E. Shepherd ... New York, Whitehall publishing company, 1911.

234 p. 4 port. (incl. front.) 19½ᶜᵐ.　$1.50

© June 23, 1911; 2c. July 7, 1911*; A 292307; Whitehall pub. co.
(11–17076)　　　　　　　　　　　　　　　　3387

Tappan, Frank Lee, 1857–

Aquaria fish, management and care of the aquarium and its inhabitants, by Frank L. Tappan. [Minneapolis? Minn., 1911]

94 p., 2 l. incl. front.. illus. 23ᶜᵐ.　$1.00

CONTENTS.—pt. 1. The propagation and care of the Paradise fish.—pt. 2. Arrangement and care of the aquarium.

© May 25, 1911; 2c. June 2, 1911*; A 289404; F. L. Tappan, Minneapolis.
(11–15342)　　　　　　　　　　　　　　　　3388

Toch, Maxmilian.

Materials for permanent painting; a manual for manufacturers, art dealers, artists and collectors, by Maxmilian Toch ... New York, D. Van Nostrand company, 1911.

208 p. col. front., plates. 19½ᶜᵐ.　$2.00

© June 10, 1911; 2c. July 10, 1911*; A 292360; D. Van Nostrand co.
(11–17097)　　　　　　　　　　　　　　　　3389

Arnold, Matthew, 1822–1888.

… Sohrab and Rustum, and other poems, by Matthew Arnold, selected and edited by Charles Swain Thomas … Boston, New York [etc.] Houghton Mifflin company [°1911]

viii, 124 p. 17½ᵉᵐ.' $0.15

© Feb. 25, 1911; 2c. July 14, 1911*; A 292448; Houghton Mifflin co. [Copyright is claimed on notes only] (11–17502) 3390

The Baptist message: all the gospel for all the world; articles previously published, with the writers and place of publication indicated … Nashville, Tenn., The Sunday school board, Southern Baptist convention [°1911]

216 p. 18ᵉᵐ. $0.50

© Apr. 28, 1911; 2c. May 18, 1911*; A 289011; Sunday school board, Southern Baptist convention. (11-12512) 3391

Bellaigue, Camille, 1858–

Notes brèves, par Camille Bellaigue. Paris, C. Delagrave [°1911]

2 p. l., 356, [2] p. 19ᵉᵐ. fr. 3.50

© June 23, 1911; 2c. July 15, 1911*; A—Foreign 3181; Ch. Delagrave. (11–17493) 3392

Botsford, George Willis, 1862–

A history of the ancient world, by George Willis Botsford … with maps and numerous illustrations. New York, The Macmillan company, 1911.

xviii p., 1 l., 588 p. front., illus., plates, maps. 20½ᵉᵐ. $1.50

"Useful books": p. 566–568.

© July 12, 1911; 2c. July 13, 1911*: A 292419; Macmillan co. (11–17476) 3393

Brothers of the Christian schools.

… Catechism of Christian doctrine, no. 3. Philadelphia, Pa., J. J. McVey, 1911.

2 p. l., ix–xvii, 378 p. 17ᵉᵐ. $0.40

At head of title: Course of religious instruction, Institute of the Brothers of the Christian schools.

© May 25, 1911; 2c. May 27, 1911*; A 289292; John Joseph McVey. 3394

Buckley, James Monroe, 1836–

… Theory and practice of foreign missions, by James M. Buckley. New York, Eaton & Mains; Cincinnati, Jennings & Graham [°1911]

151 p. 20ᵉᵐ. (The Nathan Graves foundation lectures delivered before Syracuse university) $0.75

© June 30, 1911; 2c. July 14, 1911*; A 292437; Eaton & Mains. (11–17466) 3395

561

Cope, Henry Frederick, 1870–

... The evolution of the Sunday school, by Henry Frederick Cope ... Boston, New York [etc.] The Pilgrim press [°1911]

vii p., 2 l., 3–240 p. 19½ᶜᵐ. (Modern Sunday-school manuals, ed. by C. F. Kent) $0.75
"Some helpful books for further study": p. 231–236.
© July 1, 1911; 2c. July 13, 1911*; A 292411; H. F. Cope, Chicago.
(11-17464) 3396

Corpus nummorum italicorum.

Primo tentativo di un catalogo generale delle monete medievali e moderne coniate in Italia o da Italiani in altri paesi. vol. 1. Casa Savoia. Roma. Tip. della R. Accademia de' Lincei, 1910.

vi p., 1 l., 532 p. XLII pl. 33½ᶜᵐ.
© Feb. 25, 1911; 2c. Mar. 22, 1911; A—Foreign 2952; Alessandro Mattioli Pasqualini, per Sua Maestà il re Vittorio Emmanuele III, Rome.
3397

[Critchett, R D]

Mr. Preedy and the countess; an original farce in three acts, by R. C. Carton [pseud.] New York, S. French; [etc., etc.] °1911·

155 p. illus. (plans) 18½ᶜᵐ.
© July 15, 1911; 2c. July 13, 1911*; D 24675; Samuel French, ltd., London.
(11-17501) 3397*

Dilger & Kyser, Birmingham, Ala.

Dilger & Kyser's quick action cotton seed calculator ... [Birmingham. Printed by Lawrence printing co., °1911]

[141] p. 17½ x 9ᶜᵐ.
"Figured and compiled by Ben and Ethel Dilger."
© July 5, 1911; 2c. July 7, 1911*; A 292315; Ben I. Dilger, Birmingham, Ala. (11-16959) 3398

Dollero, Adolfo.

... México al día (impresiones y notas de viaje) ... Paris [etc.] Vᵈᵃ de C. Bouret, 1911.

972 p. illus. 23ᶜᵐ.
© May 15, 1911; 2c. July 10, 1911; A—Foreign 3168; A. Dollero, Mexico, Mex. (11-17481) 3399

[Driden, Paul K]

The price; a play in three acts. Philadelphia, Printed by G. W. Jacobs & company [°1911]

129 p. 19ᶜᵐ.
© June 26 1911; 2c. June 29, 1911; D 24660; George W. Jacobs & co.
(11-17083) 3399*

Eycleshymer, Albert Chauncey, 1867–

A cross-section anatomy, by Albert C. Eycleshymer ... and Daniel M. Schoemaker ... Average position of organs from eleven reconstructions, by Peter Potter ...

Eycleshymer, Albert Chauncey—Continued
sections of the female pelvis, by Carroll Smith ... drawings, by Tom Jones ... New York and London, D. Appleton and company, 1911.
xvi, 373 p. incl. plates (partly col.) tables. 38½ᶜᵐ. $20.00
Bibliography: p. 345–346.
© June 24, 1911; 2c. June 27, 1911*; A 292093; D. Appleton & co.
(11–17469) 3400

Feyerabend, Karl.
... A pocket-dictionary of the Greek and English languages, comp. by Prof Karl Feyerabend ... 1. pt. Greek-English. Berlin-Schöneberg, Langenscheidt [ᶜ1911]
xi, [1], 419 p. 16ᶜᵐ. (Toussaint-Langenscheidt method) M. 2
© Jan. 5, 1911; 2c. June 2, 1911; A—Foreign 3163; Langenscheidtsche verlagsbuchhandlung. (11–17503) 3401

Fulda, Ludwig, 1862–
Der talisman; dramatisches märchen in vier aufzügen, von Ludwig Fulda, ed. with introduction, notes, questions and vocabulary, by Otto Manthey-Zorn ... Boston, New York [etc.] Ginn and company [ᶜ1911]
xxiii, 239 p. incl. front. (port.) 17½ᶜᵐ. (International modern language series) $0.45
© May 22, 1911; 2c. July 12, 1911*; A 292388; Otto Manthey-Zorn, Amherst, Mass. (11–17500) 3402

Gooch, Frank Austin, 1852–
Outlines of qualitative chemical analysis, by Frank Austin Gooch ... and Philip Embury Browning ... 3d ed., rev. 1st thousand. New York, J. Wiley & sons; [etc., etc.] 1911.
vi, 145 p. front. (double chart) illus. 21ᶜᵐ. $1.25
© July 10, 1911; 2c. July 12, 1911*; A 292381; F. A. Gooch and P. E. Browning, New Haven, Conn. (11–17470) 3403

Goucher, John Franklin, 1845–
... Growth of the missionary concept, by John F. Goucher. New York, Eaton & Mains; Cincinnati, Jennings & Graham [ᶜ1911]
202 p. 20ᶜᵐ. (The Nathan Graves foundation lectures delivered before Syracuse university) $0.75
© June 28, 1911; 2c. July 14, 1911*; A 292438; Eaton & Mains.
(11–17465) 3404

Granville, William Anthony, 1863–
Elements of the differential and integral calculus (rev. ed.) by William Anthony Granville ... with the editorial coöperation of Percey F. Smith ... Boston, New York [etc.] Ginn and company [ᶜ1911]
xv, 463 p. 2 port. (incl. front.) diagrs. 24ᶜᵐ. [Mathematical texts, ed. by P. F. Smith] $2.50
© Apr. 30, 1911; 2c. July 13, 1911*; A 292423; W. A. Granville, Gettysburg, Pa., and P. F. Smith, New Haven, Conn. (11–17471) 3405

International clinics; a quarterly of clinical lectures ... Ed. by Henry W. Cattell ... v. 2, 21st series, 1911. Philadelphia and London, J. B. Lippincott company, 1911.
ix, 297 p. col. front., illus., plates. 24ᵉᵐ.
© June 14, 1911; 2c. July 19, 1911*; A 292582; J. B. Lippincott co.
3406

Iowa. *Supreme court.*
Reports of cases at law and in equity ... January and May terms, 1910. By W. W. Cornwall, reporter. v. 30, being volume 147 of the series. Chicago, Ill., T. H. Flood & co., 1910.
viii, 858 p. 23½ᵉᵐ. $3.00
© June 28, 1911; 2c. July 22, 1911; A 292663; W. C. Hayward, sec. of state of Iowa, Des Moines, Ia.　　**3407**

Jamblichus, *of Chalcis.*
Theurgia; or, The Egyptian mysteries, by Iamblichos: Reply of Abammon, the teacher, to the letter of Porphyry to Anebo, together with solutions of the questions therein contained, tr. from the Greek by Alexander Wilder ... New York, The Metaphysical publishing co. [1911]
283 p. 24½ᵉᵐ.
© June 22, 1911; 2c. June 24, 1911*; A 292028; Metaphysical pub. co.
(11-16483)　　**3408**

Kent, Charles Foster, 1867–
Descriptions of one hundred and forty places in Bible lands, to be seen through the stereoscope or by means of stereopticon slides, by Charles Foster Kent ... with five patent maps ... New York [etc.] Underwood & Underwood [1911]
96 p. fold. maps. 19½ᵉᵐ.
"The stereographs and slides have been specially arranged by Professor Kent for use with his 'Biblical geography and history,' published by Charles Scribner's sons."
© June 13, 1911; 2c. June 21, 1911*; A 289954; Underwood & Underwood.
(11-17474)　　**3409**

Lincoln, Abraham, *pres. U. S.,* 1809–1865.
Selections from the letters, speeches, and state papers of Abraham Lincoln, ed. with introduction and notes, by Ida M. Tarbell ... Boston, New York [etc.] Ginn and company [1911]
xxvii, 124 p. front. (port.) 17½ᵉᵐ. (Standard English classics) $0.30
© July 1, 1911; 2c. July 13. 1911*; A 292429; Ida M. Tarbell, New York.
(11-17482)　　**3410**

Michie, Thomas Johnson, *ed.*
The encyclopedic digest of Texas reports (civil cases) ... Under the editorial supervision of Thomas Johnson Michie. v. 6. [Declarations and admissions–Evidence] Charlottesville, Va., The Michie company, 1911.
v p., 1 l., 1242 p. 26ᵉᵐ. $7.50
© July 22, 1911; 2c. July 24, 1911*; A 292662; Michie co.　　**3411**

Miller, Francis Trevelyan, *ed.*

... The photographic history of the civil war ... [v. 3, 4] Francis Trevelyan Miller, editor-in-chief; Robert S. Laner, managing editor. Thousands of scenes photographed 1861–65, with text by many special authorities. New York, The Review of reviews co., 1911.

2 v. fronts., illus., ports., maps. 28½ᶜᵐ. $3.10 each
CONTENTS.—v. 3. The decisive battles.—v. 4. The cavalry.

© July 14, 1911; 2c. each July 19, 1911*; A 292565, 292566; Patriot pub. co., Springfield, Mass. 3412, 3413

Mills, Enos Abijah, 1870–

The story of Estes Park, by Enos A. Mills. Longs Peak, Estes Park, Col., The author, ᶜ1911.

52 p. incl. front., illus. 19½ᶜᵐ.

© June 28, 1911; 2c. July 13, 1911*; A 292432; F. A. Mills, Longs Peak, Col. (11–17479) 4314

National child labor committee, *New York.*

... Child employing industries. Proceedings of the sixth annual meeting of the National child labor committee. Philadelphia, The American academy of political and social science, 1910.

v, 274 p. 26ᶜᵐ. (Supplement to the Annals of the American academy of political and social science. March, 1910)

© Mar. 23, 1910; 2c. Mar. 28, 1910*; B 209630; American academy of political and social science. (10–8740) 3414*

National institute of practical mechanics.

Modern American engineering; a complete series of practical text books prepared especially for the use of steam engineers, electricians, erecting engineers and power users generally. Prepared by a corps of experts, electrical engineers and designers connected with the National institute of practical mechanics ... Chicago, National institute of practical mechanics [ᶜ1911]

5 v. illus., plates (partly fold.) tables, diagrs. 23ᶜᵐ. $30.00
Editor-in-chief, C. F. Swingle.
CONTENTS.—v. 1. Steam boilers, steam engines, their construction, care and operation.—v. 2. Marine engines, turbines, gas engines, air compressors, elevators, refrigeration.—v. 3. Electricity for engineers, generators, switchboards, armature winding.—v. 4. Millwrighting, shafting, mechanical drawing, machine designing.—v. 5. Ventilating, plumbing, steam and hot water heating, gas-fitting.

© June 28, 1911; 2c. each July 10, 1911*; A 292359; National institute of practical mechanics. (11–17098) 3415

Nutting, Herbert Chester.

A Latin primer, by H. C. Nutting ... New York, Cincinnati [etc.] American book company [ᶜ1911]

240 p. illus. 19ᶜᵐ. $0.50

© July 11, 1911; 2c. July 13, 1911*; A 292416; H. C. Nutting, Berkeley, Cal. (11–17497) 3416

Paderewski, Ignacy Jan, 1860–

Chopin; a discourse, by I. J. Paderewski; tr. from the Polish by Lawrence [!] Alma Tadema. New York, H. B. Schaad, 1911.

[31] p. 15½ᶜᵐ. $0.25
© June 19, 1911; 2c. June 21, 1911*; A 289962; H. B. Schaad.
(11–15715) 3417

Peabody museum of American archaeology and ethnology, *Harvard university.*

Memoirs. v. 5, nos. 1 & 2. Cambridge, The Museum, 1911.

2 v. in 1. illus., plates (1 fold.)
CONTENTS.—v. 5, no. 1. Explorations in the department of Piten, Guatemala, Tikal, by Teobert Maler.—v. 5, no. 2. Preliminary study of the prehistoric ruins of Tikal, Guatemala, by Alfred M. Tozzer.
© July 10, 1911; 2c. July 15, 1911*; A 292476; Peabody museum of American archaeology and ethnology, Harvard university, Cambridge, Mass.
 3418

Pfalz, Walter.

Naturgeschichte für die grossstadt ... von Walter Pfalz ... 2. t. ... Leipzig und Berlin, B. G. Teubner, 1911.

vii, 212 p. illus. 21ᶜᵐ. M. 3
© May 12, 1911; 2c. July 19, 1911*; A—Foreign 3254; B. G. Teubner.
 3419

Richards, Henry W 1865–

The organ accompaniment of the church services; a practical guide for the student, by H. W. Richards ... Boston, Mass., The Boston music co. G. Schirmer (inc.); New York, G. Schirmer; [etc., etc., ʻ1911]

viii, 187 p. 19½ᶜᵐ. $1.50
© June 22, 1911; 2c. June 26, 1911*; A 292069; G. Schirmer.
(11–17491) 3420

Rose, Walter Malins.

Notes on Texas reports. A chronological series of annotations ... By Walter Malins Rose ... rev. and brought down to date, by Charles L. Thompson ... book 6. San Francisco, Bancroft-Whitney company, 1911.

2 p. l., 1506 p. 23½ᶜᵐ. $7.50
© July 14, 1911; 2c. July 22, 1911*; A 292656; Bancroft-Whitney co.
 3421

Rotch, Abbott Lawrence, 1861–

Charts of the atmosphere for aeronauts and aviators, by A. Lawrence Rotch ... and Andrew H. Palmer ... 1st ed., 1st thousand. New York, J. Wiley and sons; [etc., etc.] 1911.

96 p., 1 l. incl. 24 charts. 24 x 30ᶜᵐ. $2.00
© July 10, 1911; 2c. July 12, 1911*; A 292386; A. L. Rotch, Milton, Mass.
(11–17472) 3422

Roujon, Henry.

... Quentin La Tour; huit reproductions facsimile en couleurs. Paris, P. Lafitte et cie, 1911.

80 p. illus., VIII col. pl. (incl. front.) 20½ᶜᵐ. (Les peintres illustres) fr. 1.95

© June 16, 1911; 2c. July 15, 1911*; A—Foreign 3178: Pierre Lafitte & cie.
 3423

Shepperson, Alfred B.

"Cotton futures"; the business of buying and selling cotton for future delivery as conducted on the New York, New Orleans and Liverpool cotton exchanges and its advantages to merchants, manufacturers, bankers, and farmers, by Alfred B. Shepperson ... New York, A. B. Shepperson, 1911.

3 p. l., xii, 66 p. 18ᶜᵐ. $0.50

© June 27, 1911; 2c. June 30, 1911*; A 291536; A. B. Shepperson.
(11–15688) 3424

Sylvester, Charles Herbert, ed.

The new practical reference library. Editor in chief: Charles H. Sylvester ... associate editor: William F. Rocheleau ... assistant editors: Kenneth L. M. Pray ... Anna McCaleb ... Helga Leburg Hanson ... Albertus V. Smith ... [New census ed.] Chicago, New York, Dixon-Hanson-Bellows company, 1911.

5 v. illus., plates (partly col.) ports., maps. 25½ᶜᵐ. $16.50

© July 13, 1911; 2c. July 15, 1911*; A 292465; Dixon-Hanson-Bellows co.
(11–17494) 3425

Texas. *Courts of civil appeals.*

The Texas civil appeals reports. Cases argued and adjudged ... during December, 1908, and January and February, 1909. A. E. Wilkinson, reporter Texas Supreme court, J. A. Martin, assistant reporter. v. 53. Chicago, T. H. Flood & co., 1911.

xxv, 739 p. 24ᶜᵐ. $3.00

© July 15, 1911; 2c. July 21, 1911; A 292664; Alfred E. Wilkinson, Austin, Tex. 3426

Thomson, Valentine.

... Chérubin et l'amour. Paris, Calmann-Lévy [°1911]

2 p. l., 236 p., 1 l. front., plates, port. 19ᶜᵐ. fr. 3.50

"Sources": p. [229]–236.

© June 28, 1911; 2c. July 10, 1911*; A—Foreign 3167; Calmann-Lévy.
(11–17475) 3427

Vail, Henry Hobart, 1839–

A history of the McGuffey readers, by Henry H. Vail. With three portraits ... New ed. Cleveland, The Burrows brothers co., 1911.

2 p. l., 72 p. 3 port. (incl. front.) 16ᶜᵐ. (The bookish books—IV) $0.55

© June 16, 1911; 2c. July 7, 1911*; A 292299; H. H. Vail, New York.
(11–17495) 3428

Venable, William Henry, 1836–

A Buckeye boyhood, by William Henry Venable. Cincinnati, The Robert Clarke company, 1911.

5 p. l., 3–190 p. 19½ᶜᵐ. $1.25
© July 3. 1911; 2c. July 8. 1911*; A 292330; Stewart & Kidd co., Cincinnati, O. (11–17483) **3429**

Wagner, Richard, 1813–1883.

Das liebesverbot; oder, Die novize von Palermo; grosse komische oper in 2 akten, von Richard Wagner ... Leipzig, Breitkopf & Härtel ₍etc.₎ 1911.

68 p. 23½ᶜᵐ.
Libretto.
© June 23, 1911; 2c. July 6. 1911*; D 24637; Breitkopf & Härtel, C. F. W. Siegel (R. Linnemann) Leipzig. (11–17087) **3429***

White, Charles Lincoln, 1863–

Lincoln Dodge, layman, by Charles L. White. New York, The Mission press ₍ᶜ1911₎

2 p. l., 177 p. 15ᶜᵐ. $0.15
© June 12, 1911; 1c. June 12, 1911; 1c. June 23, 1911*; A 292017; C. L. White, New York. (11–15599) **3430**

White, M.

White's modern dictionary of the English language, giving the orthography, pronunciation and meanings of more than 37,000 words ... ed. by M. White ... To which has been added a supplement of nearly 4,000 new words and scientific terms and a comprehensive list of words and terms used in aviation, with definitions, most of which are found in no other dictionary. New York, Hurst & company ₍ᶜ1911₎

448 p. 19½ᶜᵐ. $0.25
© June 14, 1911; 2c. June 20. 1911; A 292297; Hurst & co. ₍Copyright is claimed on aviation terms appearing on last 4 pages and on introduction₎ (11–17496) **3431**

White, William Alfred, 1875–

Harmonic part-writing. by William Alfred White ... Boston, New York ₍etc.₎ Silver, Burdett & company ₍ᶜ1911₎

xv, 174 p. 22ᶜᵐ. $1.50
© July 5, 1911; 2c. July 7, 1911*; A 292301; Silver, Burdett & co. (11–17489) **3432**

Whittier, John Greenleaf, 1807–1892.

... Snow-bound; and other poems, by John Greenleaf Whittier; with biographical sketch and explanatory notes by A. J. Demarest ... Philadelphia, Christopher Sower company ₍ᶜ1911₎

106 p. front. (port.) illus. (incl. map) 16ᶜᵐ. (Classics in the grades) $0.35
Bibliography: p. 105–106.
© June 29, 1911; 2c. July 1, 1911; A 292183; Crhistopher Sower co. (11–17499) **3433**

Barbery, Bernard.

... Les résignées ... Paris, Calmann-Lévy [°1911]

3 p. l., 327 p. 19ᶜᵐ. fr. 3.50

© July 5, 1911; 2c. July 17, 1911*; A—Foreign 3208; Calmann-Lévy.
(11–17839) 3434

Barclay, *Mrs.* Cornelia Cochrane (Barclay) 1851–

Our American Barclays, by Cornelia Barclay Barclay.
Rev. ed. New York, F. H. Hitchcock, 1911.

82 p. 20ᶜᵐ.

© May 8, 1911; 2c. July 18, 1911*; A 292519; C. B. Barclay, U. S.
(11–17836) 3435

Barhite, Jared.

Dalmaqua; a legend of Aowasting Lake, near Lake Min-
newaska, Shawangunk Mountains, New York, by Jared
Barhite ... Boston, New York [etc.] Educational publish-
ing company [°1911]

64 p. incl. front. (port.) plates. 19½ᶜᵐ. $0.30

© July 1, 1911; 2c. July 8, 1911*; A 292340; Educational pub. co.
(11–17629) 3436

Baulu, Marguerite.

... Modeste Autome; roman. Paris, A. Leclerc, 1911.

2 p. l., 317 p., 1 l. 19ᶜᵐ. fr. 3.50

© June 16, 1911; 2c. July 15. 1911*; A—Foreign 3191; Alfred Leclerc.
(11–17844) 3437

Beaunier, André, 1869–

... Le sourire d'Athèna. Paris, Plon-Nourrit et cⁱᵉ,
1911.

4 p. l., iv, 298 p., 1 l. 19ᶜᵐ. fr. 3.50

CONTENTS.—L'ile sainte [Délos]—Éleusis. — Épidaure. — Olympie.—Del-
phes.—Le sourire d'Athèna. Notes.

© June 23, 1911; 2c. July 15, 1911*; A—Foreign 3183; Plon-Nourrit & cie.
(11–17689) 3438

Bidwell, Daniel Doane, 1865–

A history of the Second division, Naval militia, Con-
necticut national guard, by Daniel D. Bidwell. Hartford,
Conn. [The Smith-Linsley company] 1911.

75, [1] p. illus. (incl. ports.) 23½ᶜᵐ. $0.75

© July 11, 1911; 2c. July 12, 1911*; A 292396; D. D. Bidwell, East Hart-
ford, Conn. (11–17834) 3439

Bordeaux, Henry, 1870–

... Le carnet d'un stagiaire; scènes de la vie judiciaire.
Paris, Plon-Nourrit et cⁱᵉ [°1911]

3 p. l., ix, 370 p., 1 l. 19ᶜᵐ. fr. 3.50

© June 16, 1911; 2c. July 15, 1911*; A—Foreign 3186; Plon-Nourrit & cie.
(11–17840) 3440

Brigham, Albert Perry, 1855–

Commercial geography, by Albert Perry Brigham. Boston, New York [etc.] Ginn and company [ᶜ1911]

xv, 469 p. front., illus., maps. 20ᶜᵐ. $1.30

© June 20, 1911; 2c. July 13, 1911*; A 292425; A. P. Brigham, Hamilton. N. Y. (11-17830) 3441

A **complete** course in canning; being a thorough exposition of the best, practical methods of hermetically sealing canned foods, and preserving fruits and vegetables. By an expert processor and chemist. Republished from the serial articles appearing in the Trade ... 2d ed., rev. 1911. [Baltimore, MacNeal printing company, 1911]

247 p. illus., fold. plan. 24ᶜᵐ. $5.00

© June 15, 1911; 2c. June 17, 1911; A 292320; The Trade, Baltimore. (11-17824) 3442

Donnay, Maurice Charles, 1859–

... Molière. Paris, A. Fayard [ᶜ1911]

384 p. 19ᶜᵐ. fr. 3.50
On cover: 4. éd.

© June 21, 1911; 2c. July 15, 1911*; A—Foreign 3184; Arthème Fayard. (11-17688) 3443

D'Ooge, Benjamin Leonard, 1860–

Latin for beginners, by Benjamin L. D'Ooge ... Boston, New York [etc.] Ginn and company [ᶜ1911]

xii, 348 p. col. front., illus., col. plates, map. 19½ᶜᵐ. $1.00

© Apr. 7, 1911; 2c. July 12, 1911*; A 292391; B. L. D'Ooge, Ypsilanti, Mich. (11-17838) 3444

Egidy, Emmy von, 1872–

Die prinzessin vom monde; zwei novellen von Emmy von Egidy. Berlin, S. Fischer, 1911.

4 p. l., [11]–213 p. 18½ᶜᵐ. M. 2.50
CONTENTS.—Walpurgas liebe.—Die prinzessin vom monde.

© May 5, 1911; 2c. June 15, 1911; A—Foreign 3203; S. Fischer, verlag. (11-17846) 3445

Eliot, George, *pseud., i. e.* **Marian Evans,** *afterwards* **Cross,** 1819–1880.

George Eliot's Silas Marner, ed. by Ellen E. Garrigues ... New York, H. Holt and company, 1911.

xxx, 253 p. front. (port.) illus. 17ᶜᵐ. (*Half-title:* English readings for schools. General editor: W. L. Cross) $0.40
"Descriptive bibliography": p. xxix–xxx.

© June 23, 1911; 2c. July 15, 1911*; A 292467; Henry Holt & co. (11-17626) 3446

Estray, Jean d'.

... Thi-Sen, la petite amie exotique. Paris, M. Bauche [1911]

4 p. l., [3]–356 p., 1 l. 19ᶜᵐ. fr. 3.50

© June 15, 1911; 2c. July 15, 1911*; A—Foreign 3174; J. d'Estray, Paris. (11-17843) 3447

Fenn, Robert Willson, 1867–

Horacio, a tale of Brazil. By R. W. Fenn. San Francisco [The author] 1911.

3 p. L, 299 p. 20^{cm}.

© May 13, 1911; 2c. July 3, 1911*; A 292244; R. W. Fenn, San Francisco.
(11–17623) 3448

Forbes-Mosse, *Frau* Irene (Flemming) 1864–

Berberitzchen, und andere, von Irene Forbes-Mosse. 2. aufl. Berlin, S. Fischer, 1910.

188 p., 2 l. 18½^{cm}. M. 2.50
CONTENTS.—Berberitzchen.—Glück in dornen.—Liselotte.

© Mar. 16, 1911; 2c. June 15, 1911; A—Foreign 3205; S. Fischer, verlag.
(11–17848) 3449

Freeman, Charles Edmund, 1855–

Adjustments through elimination, including a detailed explanation of why trial balance totals vary. By C. E. Freeman ... Indianapolis, Ind., C. E. Freeman [°1911]

[49] p. 21^{cm}. $2.00

© July 6, 1911; 2c. July 13, 1911*; A 292404; C. E. Freeman.
(11–17643) 3450

Gibbons, James, *cardinal*, 1834–

Beacon lights; maxims of Cardinal Gibbons, selected and arranged by Cora Payne Shriver. Baltimore, New York, John Murphy company [°1911]

192 p. front. (port.) 14 x 11^{cm}. $1.00

© July 13, 1911; 2c. July 14, 1911; A 292460; John Murphy co.
(11–17640) 3451

Giles, Leonidas B 1841–

Terry's Texas rangers, by L. B. Giles. [Austin, Tex., Von Boeckmann-Jones co., printers, °1911]

105 p. 18^{cm}. $1.00

© June 28, 1911; 2c. July 1, 1911; A 292265; L. B. Giles, Austin, Tex.
(11–17835) 3452

Goethe, Johann Wolfgang von, 1749–1832.

... Faust: a tragedy. By Johann Wolfgang von Goethe. The first part. Tr., in the original metres, by Bayard Taylor. · Boston, New York [etc.] Houghton Mifflin company [°1911]

xx, 368 p., 1 l. 18½^{cm}. (The Riverside literature series) $0.75

© June 27, 1911; 2c. July 14, 1911*; A 292449; Houghton Mifflin co.
(11–17628) 3453

Gordon, Ernest, 1867–

The breakdown of the Gothenburg system, by Ernest Gordon ... Westerville, O., The American issue publishing company [°1911]

2 p. l., [9]–155 p. 19½^{cm}. $0.50

© July 1, 1911; 2c. July 10, 1911*; A 292357; American issue pub. co.
(11–17644) 3454

Groff, John Eldred, 1854–

Materia medica for nurses; with an epitome of official drugs, preparations and chemicals, giving their medicinal uses and doses; and questions for self-examination, by John E. Groff ... 6th rev. ed., with an appendix on solutions, rearranged by Lucy C. Ayers ... Sections on therapeutics rewritten by Herman C. Pitts ... Philadelphia, P. Blakiston's son & co., 1911.

xi, 223 p. 19ᶜᵐ. $1.25

© June 30, 1911; 2c. July 3, 1911*; A 292224; P. Blakiston's son & co.
(11–17820) 3455

Hawkes, Herbert Edwin.

Second course in algebra, by Herbert E. Hawkes and William A. Luby ... and Frank C. Touton ... Boston, New York [etc.] Ginn and company [ᶜ1911]

vii, 264 p. ports., diagrs. 19ᶜᵐ. [Mathematical texts for schools, ed. by P. F. Smith] $0.75

© Apr. 10, 1911; 2c. July 12, 1911*; A 292390; H. E. Hawkes, New York, W. A. Luby and F. C. Touton, Kansas City, Mo. (11–17667) 3456

High noon; a new sequel to "Three weeks." Anonymous. New York, The Macaulay company, 1911.

343, [1] p. front. 19½ᶜᵐ. $1.50

© July 5, 1911; 2c. July 7, 1911*; A 292300; Macaulay co.
(11–17625) 3457

Illinois. *Supreme court.*

Reports of cases at law and in chancery ... v. 249 ... Samuel Pashley Irwin, reporter of decisions. Bloomington, Ill., 1911.

viii, [9]–703 p. 22½ᶜᵐ. $1.50

© July 24, 1911; 2c. July 27, 1911*; A 292728; Samuel Pashley Irwin.
 3458

Kadak, Paul K 1870–

Americký statistikár a samopočtár. Škola pre pospolitý ľud ... Sostavil a vydal Pavel K. Kadák ... Scranton, Pa. [ᶜ1911]

301 p. incl. illus., tables. 14½ᶜᵐ. $0.75

© June 22, 1911; 2c. June 26, 1911; A 292269; P. K. Kadak, Scranton, Pa.
(11–17648) 3459

Kroeger, Alice Bertha.

Guide to the study and use of reference books, by Alice Bertha Kroeger. Supplement 1909–1910, by Isadore Gilbert Mudge ... Chicago, Ill., American library association publishing board, 1911.

24 p. 24ᶜᵐ.

© May 15, 1911; 2c. June 30, 1911; A 292524; I. G. Mudge, New York.
 3460

Kroepelin, Herman, 1874–

Harte ehen, roman von Herman Kroepelin. 2. aufl. Berlin, S. Fischer, 1911.

2 p. l., ₍₇₎-370 p., 1 l. 20ᶜᵐ. M. 4
© May ₌, 1911; 2c. June 15, 1911; A—Foreign 3195; S. Fischer, verlag. (11–17849) 3461

Loewenstein, Louis Centennial, 1876–

Centrifugal pumps, their design and construction, by Louis C. Loewenstein ... and Clarence P. Crissey ... 320 illustrations, 8 folding plates. New York, D. Van Nostrand company, 1911.

vii, 435 p. illus., fold. pl., diagrs. (partly fold.) 24ᶜᵐ. $4.50
© June 20, 1911; 2c. July 10, 1911*; A 292361; D. Van Nostrand co. (11–17826) 3462

Louis, Henry, 1855–

Metallurgy of tin ₍by₎ Henry Louis ... New York ₍etc.₎ McGraw-Hill book company, 1911.

5 p. l., 138 p. front., illus. 24ᶜᵐ. $2.00
"This little work is in the main a reprint of a monograph on the metallurgy of tin, published originally in Mineral industry for 1896, vol. v."—Pref.
© July 11, 1911; 2c. July 12, 1911*; A 292385; McGraw-Hill book co. (11–17825) 3463

Maine. *Laws, statutes, etc.*

Maine corporation law. The statutes of Maine relating to business corporations, except banking, railroad and insurance companies, with notes of decisions and blank forms, comp. by Isaac W. Dyer ... 7th ed. Portland, Loring, Short & Harmon, 1911.

1 p. l., xxi, 281 p. 23½ᶜᵐ. $3.00
© July 6, 1911; 2c. July 10, 1911*; A 292349; Isaac W. Dyer, Portland, Me. (11–17681) 3464

Mandelstamm, Valentin, 1876–

... Un aviateur; illustrations de Lobel-Riche. Paris, P. Lafitte & cⁱᵉ ₍°1911₎

123 p. incl. front., illus., plates. 24½ᶜᵐ. (Idéal-bibliothèque ₍no. 26₎)
fr. 0.95
© June 16, 1911; 2c. July 15, 1911*; A—Foreign 3188; Pierre Lafitte & cie. (11–17845) 3465

Metzner, Henry Christian Anton, 1834–

A brief history of the North American gymnastic union, by Henry Metzner, tr. from the German by Theo. Stempfel, jr. In commemoration of the one hundredth anniversary of the opening of the first gymnastic field in Germany by Friedrich Ludwig Jahn. Indianapolis, Ind., The National executive committee of the North American gymnastic union, 1911.

62 p. 23½ᶜᵐ. $0.50
© July 6, 1911; 2c. July 10, 1911*; A 292363; National executive committee of the North American gymnastic union. (11–17674) 3466

Neefus, Peter I 1832–

Pen parables, by Peter I. Neefus. New York, American tract society [°1911]
262 p. front. (port.) 21ᶜᵐ. $1.50
© July 5, 1911; 2c. July 7, 1911*; A 292306; American tract soc. (11–17642) 3467

Netter, Arnold, 1875–

La méningite cérébro-spinale, par MM. Arnold Netter ... Robert Debré ... 54 figures et 3 planches hors texte. Paris, Masson et cⁱᵉ, 1911.
4 p. l., [xi]–xii, 284 p. illus., 2 col. pl., map, diagrs. 23ᶜᵐ. fr. 6
Contains bibliographies.
© June 9, 1911; 2c. July 15, 1911*; A—Foreign 3189; Masson & cie. (11–17822) 3468

Nyerges, Szilárd.

... Költeményei ... Cleveland, O., 1911.
280, [8] p. 17ᶜᵐ. $1.00
© June 12, 1911; 2c. July 10, 1911; A 292370; S. Nyerges, Cleveland, O. (11–17842) 3469

Ompteda, Georg, freiherr von, 1863–

Margret und Ossana, von Georg frhr. von Ompteda. Berlin [etc.] Ullstein & co., 1911.
461 p. 19ᶜᵐ. M. 3
© May 16, 1911; 2c. June 9, 1911; A—Foreign 3196; Ullstein & co. (11–17851) 3470

Ornament und figur.

Ein motivenschatz für das moderne kunstgewerbe insbesondere für graphische zwecke. Serie 1, 2. hälfte ... Wien und Leipzig, F. Wolfrum & co., 1911.
pl. 25–48 (partly col.) 45 x 34ᶜᵐ. M. 27
Cover-title.
In portfolio.
© May 5, 1911; 2c. July 19, 1911*; A—Foreign 3265; Friedr. Wolfrum & co. 3471

Plummer, Mary Wright, 1856–

Hints to small libraries, by Mary Wright Plummer ... 4th ed. Chicago, Ill., American library association publishing board, 1911.
67, [1] p. illus. 21ᶜᵐ.
© Apr. 24, 1911; 1c. June 7, 1911; 1c. June 24, 1911; A 292466; M. W. Plummer, New York. (11–35445) 3472

Rousseau, Jean Jacques, 1712–1778.

... Les confessions; extraits suivis illustrés, notices et annotations, par Henri Legrand ... six gravures dont trois hors texte. Paris, Bibliothèque Larousse [°1911]
219, [1] p. front., illus. (facsim.) plates, ports. 20½ᶜᵐ. fr. 1
"Bibliographie": p. 16–18.
© June 2, 1911; 2c. June 23, 1911*; A—Foreign 3096; Librairie Larousse, Paris. (11–17695) 3473

Scholl, Emil.

Das kuckuckskind, roman von Emil Scholl. 2. aufl. Berlin, S. Fischer, 1911.

3 p. l., ᵼ9ᵼ-308 p., 1 l. 18½ᶜᵐ. M. 3.50

© Mar. 3, 1911; 2c. June 15, 1911; A—Foreign 3204; S. Fischer, verlag. (11-17847) **3474**

Sharp, A E.

Elements of English grammar, by A. E. Sharp ... New York, William R. Jenkins co. ᵼ°1911ᵼ

3 p. l., 249 p. 19ᶜᵐ. $1.00

© June 23, 1911; 2c. June 27, 1911*; A 292086; William R. Jenkins co. (11-17631) **3475**

Sheldon, Samuel, 1862–

Electric traction and transmission engineering, by Samuel Sheldon ... and Erich Hausmann ... with 127 illustrations. New York, D. Van Nostrand company, 1911.

1 p. l., v–x, 307 p. illus., diagrs. 20½ᶜᵐ. $2.50

© June 15, 1911; 1c. July 10, 1911; 1c. July 11, 1911; A 292376; D. Van Nostrand co. (11-17823) **3476**

Skinner, Joseph Osmun.

A book of the laws of Washington relating to notaries public. A collection of the statutes and cases governing notaries public and commissioners of deeds as public officers, together with a manual applying Washington laws, written and unwritten, to the execution of oaths, affidavits, acknowledgments, depositions, protests and instruments in connection with insurance. With forms. By Joseph Osmun Skinner ... San Francisco, Bancroft-Whitney company, 1911.

xxiv, 365 p. 23½ᶜᵐ. $3.50

© June 27, 1911; 2c. July 6, 1911*; A 292288; J. O. Skinner, Seattle, Wash. (11-17680) **3477**

Slaught, Herbert Ellsworth, 1861–

Plane and solid geometry, with problems and applications, by H. E. Slaught ... and N. J. Lennes ... Boston, Allyn and Bacon, 1911.

xii, 470 p. illus., diagrs. 19½ᶜᵐ. $1.25

© July 10, 1911; 2c. July 17, 1911*; A 292477; H. E. Slaught, Chicago, and N. J. Lennes, New York. (11-17666) **3478**

Snow, William Benham, 1860–

Currents of high potential of high and other frequencies, by William Benham Snow ... 2d ed. New York, Scientific authors' publishing co., 1911.

1 p. l., v–xiv p., 1 l., 275 p. illus., v pl. (incl. front.) 24ᶜᵐ.

© June 28, 1911; 2c. July 7, 1911*; A 292298; W. B. Snow, New York. (11-17819) **3479**

Snowden, George Randolph.

The Christian's right to bear arms, by George Randolph Snowden ... Philadelphia [Printed by the J. B. Lippincott company] 1911.
41 p. 24ᶜᵐ.
"Authorities cited": p. 40–41.
© June 20, 1911; 2c. July 6, 1911*; A 292289; G. R. Snowden, Philadelphia. (11–17663) **3480**

Vivell, P Coelestin.

Vom musik-traktate Gregor⁸ des Grossen; eine untersuchung über Gregor⁸ autorschaft und über den inhalt der schrift, mit druckerlaubnis der kirchlichen obern, von P. Coelestin Vivell ... Leipzig, Breitkopf & Härtel, 1911.
x, 151 p. 20ᶜᵐ. (On cover: Breitkopf & Härtels musik-bücher) M. 4
© July 20, 1911; 2c. July 19, 1911*; A—Foreign 3263; Breitkopf & Härtel. (11–18067) **3481**

Williams, Isabel Cecilia.

"Deer Jane," by Isabel Cecilia Williams. New York, P. J. Kenedy & sons [°1911]
160 p. front. 19ᶜᵐ. $0.85
© May 27, 1911; 2c. July 10, 1911; A 292369; P. J. Kenedy & sons. (11–16888) **3482**

Wing, Joseph Elwyn, 1861–

Meadows and pastures, by Joseph E. Wing ... Chicago, The Breeder's gazette, 1911.
418 p. incl. front., illus. 20ᶜᵐ. $1.50
© June 29, 1911; 2c. June 19, 1911; A 292175; Sanders pub. co., Chicago. (11–16780) **3483**

Wisconsin. *Supreme court.*

Wisconsin reports. 145. Cases determined ... January 31–April 5, 1911. Frederic K. Conover, official reporter. Chicago, Callaghan and company, 1911.
xxx, 731 p. 23½ᶜᵐ. $1.30
© July 17, 1911; 2c. July 20, 1911*; A 292596; James A. Frear, sec. of state of the state of Wisconsin, for the benefit of the people of said state. Madison, Wis. **3484**

Wood, Charles Newton.

Wayside musings; a little volume of verse, by Charles Newton Wood. Kirksville, Mo., Journal printing company, 1911.
52 p., 1 l. front. (port.) 19ᶜᵐ. $0.50
© June 28, 1911; 2c. July 13, 1911*; A 292433; C. N. Wood. La Plata, Mo. (11–17696) **3485**

Woodworth, William A.

Woodworth shorthand and typewriting manual ... by Wm. A. Woodworth ... [Denver, Col.] °1911.
125, [6] p. 22ᶜᵐ. $2.00
© Mar. 11, 1911; 2c. May 18, 1911; A 289896; W. A. Woodworth, Denver, Col. (11–16892) **3486**

Blundell, Alice.

Idealism, possible and impossible, by Alice Blundell ...
London, J. Ouseley limited [°1911]

v p., 1 l., 9–106 p. 19½ᶜᵐ. 2/6

Contents.—Analogies of relativity.—Optimism.—Democracy.—Thucydides to Plato.

© 1c. June 17, 1911; A ad int. 709; publ. May 18, 1911; A. Blundell, London. (11–18101) **3487**

Butler, James Glentworth, 1821–

Present day conservatism and liberalism within Biblical lines; a concise and comprehensive exhibit, by James Glentworth Butler ... Boston, Sherman, French & company, 1911.

6 p. l., 122 p. 20ᶜᵐ. $1.00

© July 7, 1911; 2c. July 18, 1911*; A 292532; Sherman, French & co. (11–18100) **3488**

Curtis, William Eleroy, 1850–

Around the Black Sea; Asia Minor, Armenia, Caucasus, Circassia, Daghestan, the Crimea, Roumania, by William Eleroy Curtis ... New York, Hodder & Stoughton, George H. Doran company [°1911]

7 p. l., 3–456 p. plates, port. group, fold. map. 21½ᶜᵐ. $2.50

© July 11, 1911; 2c. July 13, 1911*; A 292421; George H. Doran co. (11–18104) **3489**

Demarest, Virginia.

Nobody's; a novel, by Virginia Demarest ... with frontispiece. New York and London, Harper & brothers, 1911.

2 p. l., 336 p., 1 l. front. 19½ᶜᵐ. $1.20

© July 20, 1911; 2c. July 22, 1911*; A 292648; Harper & bros. (11–18062) **3490**

Dever, Daniel Augustine, 1860–

The Holy Viaticum of life as of death, by Rev. Daniel A. Dever ... New York, Cincinnati [etc.] Benziger brothers, 1911.

2 p. l., 3–184 p. front. 18ᶜᵐ. $0.75

© July 14, 1911; 2c. July 15, 1911; A 292537; Benziger bros. (11–18099) **3491**

... The Federal reporter, with key-number annotations. v. 185. Permanent ed. ... May. 1911. St. Paul. West publishing co., 1911.

xii, 1101 p. 23ᶜᵐ. (National reporter system—United States series) $3.50

© July 12, 1911; 2c. July 28, 1911*; A 292775; West pub. co. **3492**

577

Hamilton, Green Polonius, 1867–

Beacon lights of the race, by G. P. Hamilton ... Memphis, E. H. Clarke & brother, 1911.

546, ₍2₎ p. illus. (incl. ports.) 23½ᶜᵐ. $2.50
© July 7, 1911; 2c. July 17, 1911*; A 292499; G. P. Hamilton, Memphis, Tenn. (11–18077) 3493

Hubbard, Elbert.

The complete writings of Elbert Hubbard. Author's ed. v. 10. East Aurora, N. Y., The Roycroft shop ₍1911₎

6 p. l., 9–296, ₍1₎ p. front.; ports. 30ᶜᵐ.
© July 25, 1911; 2c. July 27, 1911; A 292784; E. Hubbard, East Aurora, N. Y. 3494

Huizinga, Arnold van Couthen Piccardt, 1874–

The American philosophy pragmatism critically considered in relation to present-day theology, by A. v. C. P. Huizinga ... Boston, Sherman, French & company, 1911.

64 p. 20ᶜᵐ. $0.60
© July 10, 1911; 2c. July 12, 1911*; A 292383; Sherman, French & co. (11–18102) 3495

Ingalls, Carrie Crane.

Text-book on domestic art, with illustrations and drafts, by Carrie Crane Ingalls ... San Francisco, Foster & ten Bosch ₍ᶜ1911₎

8 p. l., 232 p. front. illus. 18ᶜᵐ. $1.50
© July 8, 1911; 2c. July 17, 1911*; A 292508; C. C. Ingalls, San Francisco (11–18056) 3496

Knorr, Iwan, 1853–

Lehrbuch der fugenkomposition, von Iwan Knorr. Leipzig, Breitkopf & Härtel, 1911.

vii, ₍1₎, 162 p., 1 l., 28 p. 23½ᶜᵐ. (Added t.-p.: Lehrgänge an dr. Hochs konservatorium in Frankfurt a. M.) M. 3
"Anhang. Fugenbeispiele": 28 p. at end.
© June 19, 1911; 2c. July 19, 1911*; A—Foreign 3262; Breitkopf & Härtel. (11–18068) 3497

₍Krout, Caroline Virginia₎

Dionis of the white veil, by Caroline Brown ₍pseud.₎ ... illustrated by Henry Roth. Boston, L. C. Page & company, 1911.

vi p., 1 l., 291 p. front., plates. 20ᶜᵐ. $1.50
© July 17, 1911; 2c. July 20, 1911*; A 292610; L. C. Page & co., inc. (11–18066) 3498

La Motte-Fouqué, Friedrich Heinrich Karl, freiherr de, 1777–1843.

Undine; a legend, by the Baron De La Motte Fouque: with illustrations by F. Bassett Comstock. New York, McLoughlin brothers ₍ᶜ1911₎

126 p., 1 l. incl. illus. plates. col. front. 24ᶜᵐ. $0.35
© Mar. 21. 1911; 2c. July 20, 1911*; A 292604; McLoughlin bros. (11–18064) 3499

Land, Hans, 1861-

Flammen, und andere geschichten, von Hans Land.
2. aufl. Berlin, S. Fischer, 1911.

5 p. l., ₍13₎-189 p., 1 l. 18½ᶜᵐ. M. 2.50

CONTENTS.— Flammen.— Der chauffeur.—Ein alltagslos.—Erling.—Tragischer fasching.— Jüngstes gericht.— Der glückspilz.— Spielzeug.—Der wille zum tode.—Ultima ratio reginae.

© May 12, 1911; 2c. June 15, 1911; A—Foreign 3200; S. Fischer, verlag. (11-18092) 3500

The **lawyers** reports annotated. New series. Book 31. Burdett A. Rich, Henry P. Farnham, editors. 1911. Rochester, N. Y., The Lawyers co-operative publishing company, 1911.

viii, 1295 p. 25ᶜᵐ. $4.00

© July 27, 1911; 2c. July 29, 1911*; A 292804; Lawyers co-operative pub. co. 3501

Leutelt, Gustav, 1860-

Das zweite gesicht, erzählung von Gustav Leutelt. Berlin, S. Fischer, 1911.

4 p. l., ₍11₎-204 p., 1 l. 18½ᶜᵐ. M. 2.50

© Apr. 6, 1911; 2c. June 15, 1911; A—Foreign 3194; S. Fischer, verlag. (11-18090) 3502

Ludwig, Emil, 1883-

Manfred und Helena, roman von Emil Ludwig. Berlin, S. Fischer, 1911.

4 p. l., 11-284 p., 2 l. 18½ᶜᵐ. M. 3.50

© May 4, 1911; 2c. June 15, 1911; A—Foreign 3202; S. Fischer, verlag. (11-18091) 3503

McClain, Laura Matilda Bowers, 1875-

The art and science of music, by Laura M. McClain. ₍Guthrie, Okl., Oklahoma bank and office supply co., ᶜ1911₎

80 p. 23ᶜᵐ. $1.00

© June 15, 1911; 2c. July 1, 1911; A 292284; L. M. McClain, Stillwater, Okl. (11-18069) 3504

Michigan. *Supreme court.*

Michigan reports. Cases decided ... from December 22, 1910, to March 13, 1911. James M. Reasoner, state reporter. v. 164. 1st ed. Chicago, Callaghan & co., 1911.

xxxi, 774 p. 23ᶜᵐ. $1.30

© July 26, 1911; 2c. July 29, 1911*; A 292791; Frederick C. Martindale, sec. of state for the state of Michigan, Lansing, Mich. 3505

Mordaunt, Elenor.

A ship of solace, by Elenor Mordaunt ... New York, Sturgis & Walton company, 1911.

3 p. l., 3-272 p. 19½ᶜᵐ. $1.00

© July 19, 1911; 2c. July 21, 1911*; A 292616; Sturgis & Walton co. (11-18065) 3506

... The **Northeastern** reporter, with key-number annotations. v. 94. Permanent ed. ... March 28–June 6, 1911. St. Paul, West publishing co., 1911.

xxi, 1217 p. 26½ᶜᵐ. (National reporter system—State series) $4.00

© July 24, 1911; 2c. July 28, 1911*; A 292776; West pub. co. 3507

Reisiger, Hans, 1884–

Maria Marleen, roman von Hans Reisiger. 2. aufl. Berlin, S. Fischer, 1911.

213 p., 1 l. 18½ᶜᵐ. M. 3

© May 5, 1911; 2c. June 15, 1911; A—Foreign 3201; S. Fischer, verlag. (11–18089) 3508

Riemann, Ludwig.

Das wesen des klavierklanges und seine beziehungen zum anschlag. Eine akustisch-ästhetische untersuchung für unterricht und haus dargeboten von Ludwig Riemann ... mit 120 abbildungen. Leipzig, Breitkopf & Härtel, 1911.

viii, 279 p. illus. 24ᶜᵐ. M. 6

© June 26, 1911; 2c. July 19, 1911*; A—Foreign 3261; Breitkopf & Härtel. (11–18070) 3509

... The **Southern** reporter, with key-number annotations. v. 54. Permanent ed. ... February 18–June 3, 1911. St. Paul, West publishing co., 1911.

xix, 1139 p. 26½ᶜᵐ. (National reporter system—State series) $4.00

© July 17, 1911; 2c. July 28, 1911*; A 292778; West pub. co. 3510

... The **Southwestern** reporter, with key-number annotations. v. 136. Permanent ed. ... May 3–May 31, 1911. St. Paul, West publishing co., 1911.

xvi, 1308 p. 26½ᶜᵐ. (National reporter system—State series) $4.00

© July 14, 1911; 2c. July 28, 1911*; A 292777; West pub. co. 3511

Taggart, Marion Ames, 1866–

... Nancy, the doctor's little partner, by Marion Ames Taggart ... illustrated by Etheldred Breeze. Boston, L. C. Page and company, 1911.

5 p. l., 283 p. front., illus., plates. 20½ᶜᵐ. (Her The doctor's little girl series) $1.50

© July 12, 1911; 2c. July 18, 1911*; A 292531; L. C. Page & co., inc. (11–18063) 3512

Thackeray, William Makepeace.

Works of William Makepeace Thackeray; with biographical introductions by his daughter Lady Ritchie ... [The centenary biographical ed.] v. 18, 19. New York and London, Harper & brothers [1911]

2 v. fronts. (v. 1: port.) illus., plates. 21½ᶜᵐ.

CONTENTS.—v. 18, 19. Adventures of Philip. 2 v.

© July 15, 1911; 2c. July 21. 1911*; A 292615; Harper & bros. [Copyright is claimed on Introduction only] 3513

Anderson, John Benjamin.

New thought, its lights and shadows; an appreciation and a criticism, by John Benjamin Anderson ... Boston, Sherman, French & company, 1911.

5 p. l., 149 p. 21ᶜᵐ. $1.00

© July 5, 1911; 2c. July 18, 1911; A 292533; Sherman, French & co.
(11–18188) 3514

Annunzio, Gabriele d', 1863–

Le martyre de Saint Sébastien, mystère composé en rythme français par Gabriele d'Annunzio et joué à Paris sur la scene du châtelet le xxii mai, MCMXI, avec la musique de Claude Debussy. ₍3. éd.₎ Paris, Calmann-Lévy ₍°1911₎

2 p. l., viii, 270 p. 20½ᶜᵐ.
Libretto only.

© June 7, 1911; 2c. July 17, 1911*; D 24704; Calmann-Lévy.
(11–17841) 3514*

Archer, Effie Archer.

... Needlecraft, by Effie Archer Archer. Garden City, N. Y., Doubleday, Page & company, 1911.

7 p. l., 3–381 p. col. front., illus., plates. 21ᶜᵐ. (*Half-title:* The children's library of work and play) $1.75
At head of title: The library of work and play.

© June 29, 1911; 2c. July 8, 1911; A 292568; Doubleday, Page & co.
(11–18185) 3515

Bierce, Ambrose.

Collected works of Ambrose Bierce. v. 5–9. New York & Washington, The Neale publishing company, 1911.

5 v. 22ᶜᵐ.

CONTENTS.—v. 5. Black beetles in amber.—v. 6. Monk and hangman's daughter. Fantastic fables.—v. 7. Devil's dictionary.—v. 8. Negligible tales. On with the dance. Epigrams.—v. 9. Tangential views.

v. 5 © Mar. 7, 1911; v. 6 © May 29, 1911; v. 7 © June 17, 1911; v. 8 © July 13, 1911; v. 9 © July 27, 1911; 2c. each July 31, 1911*; A 292837–292841; Neale pub. co. 3516–3520

Brennan, George Hugh, 1865–

Anna Malleen, by George H. Brennan. London and New York, M. Kennerley, 1911.

3 p. l., 377 p. 19ᶜᵐ. $1.35

© June 1, 1911; 2c. July 22, 1911*; A 292654; Mitchell Kennerley
(11–18195) 3521

Carman, Bliss *i. e.* William Bliss, 1861–

A painter's holiday, and other poems, by Bliss Carman. New York, Priv. print., 1911.

43, ₍1₎ p. 27ᶜᵐ. $5.00

Carman, Bliss *i. e.* William Bliss—Continued

"One hundred and fifty copies of this book on French hand-made paper privately printed by Frederic Fairchild Sherman."
CONTENTS.—A painter's holiday.—On the plaza.—Mirage.—A Christmas stranger.—The miracle.
© July 8, 1911; 2c. July 19, 1911*; A 292541; Frederic Fairchild Sherman. New York. (11-18169) 3522

Cassella, Nicholas.

"Pasi-codex." Raccolta cifrata di frasi telegrafiche comunemente adoperate nella corrispondenza familiare, d'affari e commerciale. Cusano Mutri, N. Cassella [c1911]
xxiv, 422 p. 8 x 12½ᶜᵐ.
© June 12, 1911; 2c. June 26, 1911; A—Foreign 3172; N. M. Cassella. (11-17646) 3523

Cézard, E.

... Métrique sacrée des Grecs et des Romains, par E. Cézard ... Paris, C. Klincksieck, 1911.
2 p. l., [viii]–viii, 538 p. 17½ᶜᵐ. (Nouvelle collection à l'usage des classes. Série supplémentaire I) fr. 3.50
© June 22, 1911; 2c. July 15, 1911*; A—Foreign 3187; E. Cézard, Beaune, France. (11-17852) 3524

[Chabrier, Jean] 1855–

... La maison du bonheur. Paris, J. Rouff & cⁱᵉ, 1911.
313 p. 19ᶜᵐ. fr. 3.50
Author's pseudonym, Jean Reibrach, at head of title.
© June 21, 1911; 2c. July 15, 1911*; A—Foreign 3182; Publications Jules Rouff & cie. (11-17693) 3525

Claretie, Jules *i. e.* Arnaud Arsène, *known as* Jules, 1840–

... L'obsession (—Moi et l'autre—) Paris, P. Lafitte & cⁱᵉ [c1911]
2 p. l., ii, 386 p., 1 l. plates. 19ᶜᵐ. fr. 3.50
© June 23, 1911; 2c. July 15, 1911*; A—Foreign 3176; Pierre Lafitte & cie (11-17690) 3526

Coffman, Lotus Delta, 1875–

The social composition of the teaching population, by Lotus Delta Coffman ... New York city, Teachers college, Columbia university, 1911.
vi, 87 p. tables, diagrs. 23½ᶜᵐ. (Teachers college, Columbia university. Contributions to education, no. 41) $1.00
© June 16, 1911; 2c. July 6, 1911*; A 292292; L. D. Coffman, Charleston, Ill. (11-18180) 3527

Crawford, J R.

Lovely Peggy; a play in three acts based on the love romance of Margaret Woffington and David Garrick, by J. R. Crawford. New Haven, Yale university press, 1911.
4 p. l., [3]–173 p. 20½ᶜᵐ.
"The play following was submitted in a competition held by the Yale university dramatic association, 1910–1911 ..."
"750 copies."
Bibliography: p. 171–173.
© June 17, 1911; 2c. June 17, 1911; D 24592; Yale univ. press. (11-17630) 3527*

Diver, Maud.

Awakening; a study in possibilities, by Maud Diver ...
New York, John Lane company, 1911.
432 p. 19ᶜᵐ. $1.30
Published in London under title: Lilamani.
© June 30, 1911; 2c. July 3, 1911*; A 292232; John Lane co.
(11-16262) 3528

Lilamani; a study in possibilities, by Maud Diver ...
London, Hutchinson & co., 1911.
5 p. 1., 3-424 p. 19½ᶜᵐ.
Published in New York under title: Awakening.
© 1c. June 9, 1911; A ad int. 684; pubd. May 9, 1911; John Lane co., New
York. (11-17624) 3529

Dorner, August Johannes, 1846-

... Pessimismus, Nietzsche und naturalismus, mit beson-
derer beziehung auf die religion. Leipzig, F. Eckardt,
1911.
viii, 327, [1] p. 23½ᶜᵐ. M. 6
© May 5, 1911; 2c. July 20, 1911*; A—Foreign 3273; Fritz Eckardt verlag,
g. m. b. h. (11-18186) 3530

Du Bois, William Edward Burghardt, 1868- ed.

... The college-bred negro American; report of a social
study made by Atlanta university under the patronage of
the trustees of the John F. Slater fund; with the proceed-
ings of the 15th annual Conference for the study of the
negro problems, held at Atlanta university, on Tuesday,
May 24th, 1910; ed. by W. E. Burghardt Du Bois ... and
Augustus Granville Dill ... Atlanta, Ga., The Atlanta
university press, 1910.
104 p. 22½ᶜᵐ. (The Atlanta university publications, no. 15) $0.75
"A select bibliography of higher education for negro Americans":
p. [8]-10.
© June 1, 1911; 2c. May 20, 1911; A 289548; Atlanta university, Atlanta,
Ga. (11-18178) 3531

Evans, Holden A.

Cost keeping and scientific management, by Holden A.
Evans ... New York [etc.] McGraw-Hill book company,
1911.
ix p., 1 l., 252 p. illus. (incl. forms) 24ᶜᵐ.
© July 14, 1911; 2c. July 17, 1911*; A 292491; McGraw-Hill book co.
(11-18196) 3532

Foster, Edwin W.

... Carpentry and woodwork, by Edwin W. Foster.
Garden City, N. Y., Doubleday, Page & company, 1911.
7 p. l., 3-566 p. col. front., illus., plates. 21ᶜᵐ. (Half-title: The chil-
dren's library of work and play) $1.75
At head of title: The library of work and play.
© June 29, 1911; 2c. July 8, 1911; A 292569; Doubleday, Page & co.
(11-18184) 3533

Frobenius, Leo, 1873–

Auf dem wege nach Atlantis; bericht über den verlauf der zweiten reise-periode der D. i. a. f. e. in den jahren 1908 bis 1910, von Leo Frobenius ... hrsg. von Herman Frobenius ... mit 48 tafeln, 27 illustrationen, einem bunten bild und 2 karten. Berlin-Charlottenburg, Vita, deutsches verlagshaus [°1911]

xv, 410 p., 1 l. col. front., illus. (partly mounted) 48 pl., 2 maps (1 fold.) 25½ᶜᵐ. M. 15.50

Half-title: Deutsche inner-afrikanische forschungs-expedition. Zweiter reisebericht.

© May 2, 1911; 2c. June 2, 1911*; A—Foreign 3011; Vita, deutsches verlagshaus. (11–13133) 3534

Gordon, Bertha Frances, 1879–

Songs of courage, and other poems, by Bertha F. Gordon. New York, The Baker & Taylor co., 1911.

70 p., 1 l. front. (port.) 18ᶜᵐ. $1.00

© July 14, 1911; 2c. July 15, 1911; A 292474; Baker & Taylor co. (11–18166) 3535

Harrington, George Wheaton, 1874–

A reversion of form, and other horse stories, by George W. Harrington. Boston, Sherman, French & company, 1911.

4 p. l., 226 p. 21ᶜᵐ. $1.20

© July 6, 1911; 2c. July 12, 1911*; A 292382; Sherman, French & co. (11–18194) 3536

Herold, A Ferdinand, 1865–

... Le jeune dieu, tragédie en quatre actes ... Paris, Mercvre de France, 1911.

93, [1] p. 19ᶜᵐ.

© June 21, 1911; 2c. July 15, 1911*; D 24695; A. F. Herold, Paris, France. (11–17694) 3536*

Holbrook, Lucius Roy.

The mess officer's assistant, prepared by Captain L. R. Holbrook ... 2d thousand. 2d ed. [Junction City, Kan., Press of the Junction City sentinel, °1911]

3 p. l., [iiii]–v p., 1 l., [9]–190 p. 17ᶜᵐ. $1.00

© May 15, 1911; 2c. June 19, 1911*; A 289893; L. R. Holbrook, Washington, D. C. (11–17662) 3537

Keyes, Charles Henry, 1858–

Progress through the grades of city schools; a study of acceleration and arrest, by Charles Henry Keyes ... New York city, Teachers college, Columbia university, 1911.

2 p. l., 79 p. diagrs. 23½ᶜᵐ. (Teachers college, Columbia university. Contributions to education, no. 42)

Bibliography: p. 75–79.

© June 9, 1911; 2c. June 14, 1911; A 292293; C. H. Keyes, New York. (11–18179) 3538

[Lapauze, *Mme.* Jean (Loiseau)] 1860–
... Une âme de vingt ans. Paris, P. Lafitte et cᶦᵉ [ᶜ1911]
350 p., 1 l. 19ᶜᵐ. fr. 3.50
Author's pseudonym, Daniel Lesueur, at head of title.
© June 23, 1911; 2c. July 15, 1911*; A—Foreign 3180; Pierre Lafitte & cie.
(11–17850) 3539

[Liénard, Albert] 1875–
... Siséra, tragédie en deux actes, en vers ... préface de
l'auteur. Paris, Mercvre de France, 1911.
62 p., 1 l. 19ᶜᵐ.
Author's pseudonym, Louis Payen, at head of title.
© June 21, 1911; 2c. July 15, 1911*; D 24694; Louis Payen, Paris, France.
(11–17691) 3539*

Lutz, *Mrs.* Grace (Livingston) Hill-, 1865–
Aunt Crete's emancipation, by Grace Livingston Hill-
Lutz ... illustrations by Clara E. Atwood. Boston, Mass.,
The Golden rule company [ᶜ1911]
143 p. incl. front., plates. 17½ᶜᵐ. $0.75
© July 13, 1911; 2c. July 14, 1911; A 292453; Golden rule co.
(11–17627) 3540

McEvoy, Thomas Jefferson, 1869–
Methods in education, by Thomas J. McEvoy ... Brook-
lyn, N. Y., The author, 1911.
xx, 433 p. 19½ᶜᵐ. $1.50
"First edition, September, 1908. Reprinted, May, 1911."
© June 20, 1911; 2c. July 3, 1911*; A 292240; T. J. McEvoy, Brooklyn
(11–18177) 3541

Macfarland, Henry Brown Floyd, 1861–
Washington, our national capital; an illustrated lecture
by Hon. Henry B. F. Macfarland. Newton Center, Mass.,
Horace K. Turner lecture co. [ᶜ1911]
1 p. l., 26 p. 23ᶜᵐ.
© 1c. June 16, 1911; C 221; Horace K. Turner lecture co.
(11–18079) 3541*

Mechling, George Washington.
History of the Evangelical Lutheran district synod of
Ohio, covering fifty-three years, 1857–1910, by Rev.
George Washington Mechling ... [Dayton, O., Press of
the Giele & Pflaum co.] 1911.
208 p. front. (port.) 23ᶜᵐ. $1.50
© June 10, 1911; 2c. June 14, 1911; A 292502; F. W. E. Peschau, V. B.
Christy, J. M. Wenrich, in trust for the Evangelical Lutheran district
synod of Ohio, etc., Miamisburg, O. (11–17813) 3542

Murray, William D 1858–

Our primary 'department, by William D. Murray, for teachers and parents ... Philadelphia, The Sunday-school times company [°1911]

3 p. l., v–ix, 140 p. front., illus. 18½ᶜᵐ. (*On cover:* The "Times" handbooks for Sunday-school workers. Number 10) $0.50

© June 24, 1911; 2c. July 17, 1911*; A 291881; Sunday school times co. (11–17641) **3543**

Murray, William Henry Harrison, 1840–1904.

How John Norton the trapper kept his Christmas, by W. H. H. Murray; illustrations by Frank T. Merrill. New York, The Platt & Peck co. [°1911]

109 p. front., plates. 21ᶜᵐ. $1.00

© July 1, 1911; 2c. July 22, 1911*; A 292651; Platt & Peck co. (11–18192) **3544**

Neff, Flora Trueblood Bennett.

Along life's pathway; a poem in four cantos with recreations, by Flora Trueblood Bennett Neff; illustrated by Samilla Love Jameson. Logansport, Ind., Priv. print. [The Publishers' press, Chicago] 1911.

3 p. l., 13–144 p., 1 l. incl. illus., plates (partly col.) ports. front., fold. col. pl. 24ᶜᵐ. $2.00

© July 15, 1911; 2c. July 21, 1911*; A 292612; F. T. B. Neff, Logansport, Ind. (11–18170) **3545**

New York (*State*) *Court of appeals.*

Reports of cases decided ... from and including decisions of February 7, to and including decisions of April 25, 1911, with notes, references and index. J. Newton Fiero, state reporter. v. 201. Albany, J. B. Lyon company, 1911.

xxxiv, 663 p. 23½ᶜᵐ. $0.65

© June 26, 1911; 2c. July 31, 1911*; A 292846; Edward Lazansky, sec. of the state of New York, in trust for the benefit of the people of the said state, Albany, N. Y. **3546**

——— *Courts of record.*

... The miscellaneous reports. Cases decided in the courts of record ... other than the Court of appeals and the appellate division of the Supreme court. Charles C. Lester, reporter. v. 69, 1911. [Official ed.] Albany, N. Y., J. B. Lyon company [1911]

xxxi, [1], 707 p. 24ᶜᵐ. $0.75

© June 26, 1911; 2c. July 31, 1911*; A 292845; Edward Lazansky, sec. of the state of New York, in trust for the benefit of the people of the said state, Albany, N. Y. **3547**

New York (*State*) *Supreme court.*

... Reports of cases heard and determined in the appellate division of the Supreme court of the state of New York. Jerome B. Fisher, reporter. v. 141. 1911. [Official ed.] Albany, N. Y., J. B. Lyon company [1911]
liv, 1011 p. 24ᶜᵐ. $1.00
© June 2, 1911; 2c. July 31, 1911*; A 292847; Edward Lazansky. sec. of the state of New York, in trust for the benefit of the people of the said state, Albany, N. Y. **3548**

Newark [N. J.] and its attractions ... New York, G. W. Richardson, 1911.
36 p. illus. 35ᶜᵐ.
© July 8, 1911; 2c. July 10, 1911*; A 292525; Geo. W. Richardson
(11–18078) **3549**

Pop, Ghiță.

... Taschenwörterbuch der rumänischen und deutschen sprache; mit angabe der aussprache nach dem phonetischen system der Methode Toussaint-Langenscheidt ... Von prof. dr. Ghiță Pop. Berlin-Schöneberg, Langenscheidt [ᶜ1911]
xvi, 508 p. 16ᶜᵐ. (Methode Toussaint-Langenscheidt) M. 2
© Apr. 8, 1911; 2c. June 2, 1911; A—Foreign 3162; Langenscheidtsche verlagsbuchhandlung. (11–17687) **3550**

Rude, Augustus Dealing, 1849–
... The A. D. Rude "great modern system" for designing and cutting men's garments, as taught at the New York cutting school ... [7th ed.] [New York, ᶜ1911]
2 p. l., 3–80 p. illus., diagrs. 35ᶜᵐ. $15.00
© July 18, 1911; 2c. July 19, 1911*; A 292551; A. D. Rude, New York.
(11–18181) **3551**

Ruoff, Henry Woldmar, 1867– *ed.*
The volume library; a concise, graded repository of practical and cultured knowledge designed for both instruction and reference; editor-in-chief: Henry W. Ruoff ... Chicago, The W. E. Richardson company, 1911.
3 p. l., 11–486, 535–830, xviii p. illus., plates (partly col.) maps. 30ᶜᵐ. $8.90
© July 17, 1911; 2c. July 20, 1911*; A 292602; W. E. Richardson co.
(11–18172) **3552**

Sanday, William.
Personality in Christ and in ourselves, by William Sanday ... New York, Oxford university press, American branch [ᶜ1911]
iii, 75 p. 21½ᶜᵐ. $0.50
© June 30, 1911; 2c. July 1, 1911; A 292497; Oxford university press, American branch. (11–18190) **3553**

587

Schürmann, Jos. J 1857–

... Secrets de coulisses. Paris, M. Bauche, ᶜ1911·

220 p. 19ᶜᵐ. fr. 3.50
At head of title: Impresario Schürmann.

© June 1, 1911; 2c. July 15, 1911*; A—Foreign 3192; J. Schürmann, Paris.
(11-18167) 3554

Sleffel, Charles Conrad.

... Working in metals, by Charles Conrad Sleffel. Garden City, N. Y., Doubleday, Page & company, 1911.

6 p. l., 3–419 p. col. front., illus., plates. 21ᶜᵐ. (*Half-title:* The children's library of work and play) $1.75
At head of title: The library of work and play.

© June 29, 1911; 2c. July 8, 1911; A 292575; Doubleday, Page & co.
(11-18183) 3555

Stringer, Arthur John Arbuthnott, 1874–

Irish poems, by Arthur Stringer. New York, M. Kennerley, 1911.

3 p. l., 5–110 p. 20ᶜᵐ. $1.00

© July 12, 1911; 2c. July 20, 1911*; A 292590; Mitchell Kennerley.
(11-18168) 3556

Wagner, Clara Eleanor.

Show me the man; vaudeville playlet, by Clara Eleanor Wagner ... ₍Columbus, O., The Nitschke press, 1911₎

18 p. 18ᶜᵐ.

© July 13, 1911; 2c. July 17, 1911*; D 24705; C. E. Wagner, Columbus, O.
(11-18171) 3556*

White & Kemble, *New York.*

White & Kemble's atlas & digest of railroad mortgages. Reading company ... ₍New York, ᶜ1911₎

17 p. fold. map. 45½ᶜᵐ. $10.00

© July 11, 1911; 2c. July 13, 1911*; A 291818; White & Kemble.
(11-17828) 3557

Whitechurch, Victor L.

The canon in residence, by Victor L. Whitechurch. New York, The Baker & Taylor co. ₍ᶜ1911₎

3 p. l., 246 p. 19ᶜᵐ. $1.20

© July 19, 1911; 2c. July 20, 1911*; A 292597; Baker & Taylor co.
(11-18191) 3558

Winch, William Henry.

... When should a child begin school? An inquiry into the relation between the age of entry and school progress. By W. H. Winch ... Baltimore, Warwick & York, inc., 1911.

4 p. l., ₍3₎–98 p. 20ᶜᵐ. (Educational psychology monographs) $1.25

© May 1, 1911; 2c. May 2, 1911; A 289665; Warwick & York, inc.
(11-18176) 3559

$B2035.$

Ajalbert, Jean, 1863–
... Le château de la Malmaison, par Jean Ajalbert ...
Paris, Éditions d'Art et de littérature [c1911]
132 p. incl. front., illus., plates, ports. 18½ᶜᵐ. (Les châteaux et les palais
nationaux) fr. 2
On cover: Son histoire, par Jean Ajalbert. Catalogue illustré des objets
exposés.
© June 21, 1911; 2c. July 15, 1911*; A—Foreign 3177; J. Ed. Richardin,
Paris. (11–18253) 3560

Baumgarten, Paul Clemens von, 1848–
Lehrbuch der pathogenen mikroorganismen, die patho-
genen bakterien, für studierende und ärzte, von dr. Paul
v. Baumgarten ... Mit 85 zum teil farbigen abbildungen
und 1 steindrucktafel. Leipzig, S. Hirzel, 1911.
x, 955, [1] p. illus. (partly col.) col. plates. 24½ᶜᵐ. M. 24
"Das vorliegende buch kann im ganzen als eine neue auflage meines vor
mehr als 20 jahren erschienenen 'Lehrbuches der pathologischen mykologie'
angesehen werden."—Vorwort.
Contains bibliographies.
© May 30, 1911; 2c. July 18, 1911*; A—Foreign 3213; S. Hirzel.
(11–18262) 3561

Bible. *N. T. Gospels. Harmonies. English.*
The Biblical life of Jesus Christ; a standard biography
of Our Lord in the words of the Gospels according to Mat-
thew, Mark, Luke and John, harmonized, arranged, dis-
played, analyzed, located, dated and described, with the
relevant historical events, in accordance with the well
known ancient authorities and such eminent modern Bib-
lical scholars as Andrews, Edersheim ... etc. By the Rev.
S. Townsend Weaver ... Philadelphia, The University
literature extension [c1911]
3 p. l., ix–xl, [2], 322 p. 20½ᶜᵐ.
© Apr. 29, 1911; 2c. Apr. 20, 1911; A 292530; S. T. Weaver, Pitman, N. J.
(11–18246) . 3562

Böhlau, Helene, *"Mme. al-Raschid, bey,"* 1859–
... Isebies; roman. München, A. Langen [c1911]
ix, 502 p., 1 l. pl. 19½ᶜᵐ. M. 5.50
© June 8, 1911; 2c. July 19, 1911*; A—Foreign 3241; Albert Langen.
(11–18277) 3563

Böttcher, Maximilian, 1872–
Willst du richter sein? Roman von Maximilian Bött-
cher. Leipzig [etc.] Grethlein & co. [c1911]
396 p. 20ᶜᵐ. M. 5
©May 24, 1911; 2c. July 18, 1911*; A—Foreign 3217; Grethlein & co.
(11–18276) 3564

Buchanan, George Howard, 1852–
B—if; a parody, by George H. Buchanan. Philadel-
phia, Arnold and company [c1911]
17 p. 18ᶜᵐ. $0.25
Printed on one side of leaf only.
© July 19, 1911; 2c. July 21, 1911*; A 292630; Arnold & co.
(11–18270) 3565

589

Cohnheim, Otto, 1873–

Chemie der eiweisskörper, von dr. Otto Cohnheim ... 3., vollständig neu bearb. aufl. Braunschweig, F. Vieweg & sohn, 1911.

xii, 388 p. 23ᶜᵐ.　M. 11
© June 15, 1911; 2c. July 19, 1911*; A—Foreign 3245; Friedr. Vieweg & sohn. (11–18263)　　　　　　　　　　3566

Cooke, Richard Joseph, 1853–

The wingless hour, by Richard J. Cooke. Cincinnati, Jennings and Graham; New York, Eaton and Mains [*1911]

203 p. 17½ᶜᵐ.　$0.50
CONTENTS.—The leakage of power.—The flight of the soul.—The lure of the quiet.—The love that abides.—The empty crib.—The longing for home.
© July 17, 1911; 2c. July 21, 1911*; A 292619; Jennings & Graham. (11–18274)　　　　　　　　　　3567

Elliff, Joseph Doliver.

A unit in agriculture; an outline course of study and student's laboratory manual, for teachers and students in secondary schools, by Joseph Doliver Elliff ... Chicago, Row, Peterson & company [*1911]

64 p. 20ᶜᵐ.　$0.50
© June 26, 1911; 2c. June 29, 1911; A 292372; J. D. Elliff, Columbia, Mo. (11–18255)　　　　　　　　　　3568

Fairbairn, James, comp.

Fairbairn's crests of the leading families in Great Britain and Ireland and their kindred in other lands, comp. from the best authorities by James Fairbairn, rev. by Laurence Butters ... ed. by Joseph MacLaren. Two volumes in one. New York, Heraldic publishing company, 1911.

3 p. l., 613 p. col. front., 137 pl. 29½ᶜᵐ.　$12.00
© June 28, 1911; 2c. July 19, 1911*; A 292557; P. J. Lang, New York.
[Copyright is claimed on new drawings made by an artist under the supervision of P. J. Lang] (11–18250)　　　3569

Federer, Heinrich.

Lachweiler geschichten. von Heinrich Federer. Berlin, G. Grote, 1911.

3 p. l., 381 p. 18½ᶜᵐ. (Half-title: Grote'sche sammlung von werken zeitgenössischer schriftsteller. 102. bd.)　M. 3.50
CONTENTS.—Unser nachtwächter Prometheus. — Der gestohlene könig von Belgien.—Der erzengel Michael.—Die manöver.—Vater und sohn im examen.
© May 9, 1911; 2c. July 19, 1911*; A—Foreign 3259; G. Grote'sche verlagsbuchhandlung. (11–18280)　　　　　• 3570

Fleurac, L　　　de.

... Les courses à pied et les concours athlétiques, par L. de Fleurac et P. Failliot; préface du Révérend de Courcy-Laffan; ouvrage orné de 48 pages d'illustrations

Fleurac, L de—Continued

photographiques et cinématographiques hors texte. Paris, P. Lafitte & c^le [^c1911]

2 p. l., xv, 326 p. illus., plates. 20½^cm. (Sports-bibliothèque) fr. 3.50
© June 16, 1911; 2c. July 15, 1911*; A—Foreign 3190; Pierre Lafitte & cie.
(11–18268) 3571

Geiger, Abraham, 1810–1874.

Judaism and its history, in two parts, by Dr. Abraham Geiger ... Tr. from the German by Charles Newburgh. New York, The Bloch publishing co. [^c1911]

406 p. 22½^cm. $2.00
© July 14, 1911; 2c. July 20, 1911*; A 292609; Charles Newburgh, Washington, D. C. (11–18248) 3572

Halbe, Max, 1865–

... Die tat des Dietrich Stobäus; roman. München, A. Langen [^c1911]

2 p. l., 584 p. 19^cm. M. 6
© June 8, 1911; 2c. July 19, 1911*; A—Foreign 3238; Albert Langen.
(11–18278) . 3573

Halfyard, Samuel Follett, 1871–

Fundamentals of the Christian religion, by Samuel F. Halfyard ... Cincinnati, Jennings & Graham; New York, Eaton & Mains [^c1911]

244 p. 19½^cm. $1.00
© July 19, 1911; 2c. July 22, 1911*; A 292638; Jennings & Graham.
(11–18247) 3574

Hanotaux, Gabriel i. e. Albert Auguste Gabriel, 1853–

... La fleur des histoires françaises ... Paris, Hachette et c^i, 1911.

2 p. l., ii, [2], 312, [4] p. 19^cm. fr. 3.50
© June 23, 1911; 2c. July 15, 1911*; A—Foreign 3185; Hachette & cie.
(11–18279) 3575

Horton, Robert Forman, 1855– .

The Hero of heroes; a life of Christ for young people, by Robert F. Horton ... illustrated by James Clark, R. I. New York, Chicago [etc.] Fleming H. Revell company [^c1911]

6, 9–326 p. 21½^cm. $1.25
© July 21, 1911; 2c. July 25, 1911*; A 292695; Fleming H. Revell co.
(11–18249) 3576

Iddings, Joseph Paxson, 1857–

Rock minerals, their chemical and physical characters and their determination in thin sections, by Joseph P. Iddings. 2d ed., rev. and enl. 1st thousand. New York, J. Wiley & sons; [etc., etc.] 1911.

xiii, 617 p. illus., tables (1 fold.) diagrs. (1 fold.) 23½^cm. $5.00
© July 15, 1911; 2c. July 19, 1911*; A 292564; J. P. Iddings, Brinklow, Md.
(11–18261) 3577

Johnson, Virginia Wales, 1849–
Summer days at Vallombrosa, by Virginia W. Johnson ... New York, The A. S. Barnes company, 1911.
220 p. front., plates. 19½ᶜᵐ. $1.25
© July 19, 1911; 2c. July 21, 1911*; A 292623; V. W. Johnson, Oakville, Cal. (11–18251) 3578

Kipling, Rudyard, 1865–
From day to day with Kipling, comp. by Wallace and Frances Rice. New York, Barse & Hopkins [°1911]
127 p. incl. front. (port.) 19½ᶜᵐ.
© June 29, 1911; 2c. July 22, 1911*; A 292661; Barse & Hopkins. (11–18271) 3579

Linn, James Weber, 1876– ed.
Poems by Wordsworth, Coleridge, Shelley, and Keats, selected and ed. by James Weber Linn ... New York, H. Holt and company, 1911.
lvii, 215 p. incl. front., ports. 17ᶜᵐ. (*Half-title:* English readings for schools. General editor: W. L. Cross) $0.40
"This volume includes all the poems by Wordsworth, Shelley, and Keats contained in the fourth book of Palgrave's Golden treasury, with the addition of The rime of the ancient mariner, The eve of St. Agnes, and favorite lyrics by lesser poets."
Descriptive bibliography: p. lv-lvii.
© June 28, 1911; 2c. July 15, 1911*; A 292469; Henry Holt & co. (11–18272) 3580

Love, Jeannette F.
The fall and rise of Cushan, and other poems, by Jeannette F. Love. Columbus, O., The Stoneman press co., 1911.
63, [1] p. front. (port.) 17ᶜᵐ. $1.00
© Mar. 16, 1911; 2c. July 3, 1911*; A 292249; J. F. Love, Columbus, O. (11–18283) 3581

Ludwig, Max.
... Der kaiser, roman. München, A. Langen [°1911]
2 p. l., 572 p. 19ᶜᵐ. M. 6
© June 8, 1911; 2c. July 19, 1911*; A—Foreign 3240; Albert Langen. (11–18281) 3582

McCollom, William C.
Vines and how to grow them; a manual of climbing plants for flower, foliage and fruit effects, both ornamental and useful, including those shrubs and similar forms that may be used as vines. By William C. McCollom ... Garden City, N. Y., Doubleday, Page & company, 1911.
5 p. l., 3–315 p. front., plates. 19½ᶜᵐ. $1.10
© June 28, 1911; 2c. July 19, 1911*; A 292554; Doubleday, Page & co. (11–18258) 3583

AUG 25 1911

From If

L. S. no. 62, August, 1911

PART I, BOOKS, GROUP I

3590

B2035. 4

Bell, Victor Charles, 1867–
Popular essays upon the care of the teeth and mouth, by Victor C. Bell ... 9th ed., carefully rev. ... New York [etc.] P. P. Simmons, 1911.
1 p. l., 131 p. front., illus. 20ᶜᵐ.
© July 13, 1911; 2c. July 17, 1911; A 292687; V. C. Bell, New York.
(11–18508) 3584

Blau, Karl.
... Das automobil, eine einführung in bau und betrieb des modernen kraftwagens, von ingenieur Karl Blau ... 2. aufl., mit 86 abbildungen und einem titelbild. Leipzig, B. G. Teubner, 1911.
vi p., 1 l., 126 p. incl. front., illus. 18½ᶜᵐ. (Aus natur und geisteswelt ... 166. bdchen.) M. 1.25
"Literatur": p. 117–123.
© May 17, 1911; 2c. July 19, 1911*; A—Foreign 3258: B. G. Teubner.
(11–18481) 3585

Bleekman, George, 1862–
The story of slate and the slate industry ... by George Bleekman ... [Harrisburg, Pa., The Telegraph printing company, ᶜ1911]
1 p. l., 5–92 p., 1 l. incl. illus., plans. 14½ x 22½ᶜᵐ. $1.00
© July 14, 1911; 2c. July 17, 1911*; A 292485; Capital city news syndicate, Harrisburg, Pa. (11–18479) 3586

Brockhaus' kleines konversations-lexikon.
Brockhaus' kleines konversations-lexikon. 5., vollständig neubearb. aufl. ... Leipzig. F. A. Brockhaus, 1911.
2 v. illus., plates (partly col.) maps, tables. 26ᶜᵐ. M. 24
© May 25, 1911; 2c. July 19, 1911*; A—Foreign 3264; F. A. Brockhaus.
(11–18444) 3587

The **Cambridge** history of English literature, ed. by A. W. Ward ... and A. R. Waller ... v. 7. Cavalier and puritan. Cambridge, At the University press, 1911.
x, 553 p. 24ᶜᵐ. $2.50 per vol.
© 1c. July 3' 1911; A ad int. 729: pubd. July 6, 1911; G. P. Putnam's sons.
 3588

Cawley, Thomas.
An Irish parish, its sunshine and shadows. By Rev. Thomas Cawley. Boston, Mass., Angel guardian press, 1911.
4 p. l., 189 p. front. (port.) plates. 20ᶜᵐ. $1.00
© June 29, 1911; 2c. July 3, 1911; A 292682; T. Cawley, Boston, Mass.
(11–18495) 3589

Complete air brake examination questions and answers: Westinghouse-New York; a standard up-to-date treatise for enginemen and students ... comp. and ed. by the world's leading air brake experts ... Chicago, F. J. Drake & co. [ᶜ1911]
iv, 376 p. front., fold. diagrs. 18ᶜᵐ. $2.00
© July 15, 1911; 2c. July 19, 1911; A 292595; Frederick J. Drake, Chicago.
(11–18482) 3590

593

Connecticut. *Supreme court of errors.*

Cases argued and determined ... January, 1910–January, 1911. v. 83. By James P. Andrews. New York, The Banks law publishing co., 1911.

xi, 823 p. 24ᶜᵐ. $2.25

© Aug. 1, 1911; 2c. Aug. 2. 1911*; A 292887; Matthew H. Rogers, sec. of the state, for the state of Connecticut, Hartford, Conn. 3591

Conway, Jessie B.

A guide to health, by Jessie B. Conway. Los Angeles, Cal. [°1911]

3 p. l., [11]–108 p. incl. plates (partly col.) front. (port.) 18½ᶜᵐ. $2.00

© May 27, 1911; 2c. June 12, 1911; A 292285; J. B. Conway, Los Angeles. (11–18501) 3592

Dudley, Emilius Clark, 1850– *ed.*

... Gynecology, ed. by Emilius C. Dudley ... and C. von Bachellé ... Chicago, The Year book publishers, 1911.

232 p. illus., plates. 19½ᶜᵐ. (The practical medicine series ... vol. IV ... Series 1911)

© July 15, 1911; 2c. July 22, 1911*; A 292647; Year book publishers. (11–18507) 3593

Ewen, William Richard Trotter, 1880–

Commercial law, comprising a series of lectures delivered before the Fire insurance club of Chicago, by William R. T. Ewen, jr. ... Chicago, Rollins publishing company [°1911]

100 p. 21½ᶜᵐ. $1.50

© June 20, 1911; 2c. June 23, 1911*; A 292018; Rollins pub. co. (11–18456) 3594

Fenton, Frances.

... The influence of newspaper presentations upon the growth of crime and other anti-social activity ... Chicago, Ill., The University of Chicago press [1911]

iii, 96 p. 24ᶜᵐ. $0.50

© June 30, 1911; 2c. July 7, 1911; A 292322; Univ. of Chicago. (11–18455) 3595

[**Fergerson, E A**]

Streams from Lebanon. Chicago and Boston, The Christian witness company, 1911.

272 p. front. (port.) 20ᶜᵐ. $1.00

© June 28, 1911; 2c. July 3, 1911*; A 292223; Christian witness co. (11–18486) 3596

Ferguson, Charles.

The university militant, by Charles Ferguson. New York and London, M. Kennerley, 1911.

184 p. 18ᶜᵐ. $1.00

© June 1, 1911; 2c. July 20, 1911*; A 292598; Mitchell Kennerley. (11–18458) 3597

594

Gilman, Elizabeth Hale.

... Housekeeping, by Elizabeth Hale Gilman. Garden
City, N. Y., Doubleday, Page & company, 1911.
viii p., 2 l., 3–389 p. col. front., illus., plates. 21ᶜᵐ. (*Half-title:* The
children's library of work and play) $1.75
© June 29, 1911; 2c. July 8, 1911; A 292570; Doubleday, Page & co.
(11–18475) 3598

Goldscheider, Alfred *i. e.* Johannes Karl August Eugen
Alfred, 1858–

Diagnostik der krankheiten des nervensystems. Eine
anleitung zur untersuchung nervenkranker, von geh. med.-
rat dr. A. Goldscheider ... 4. verb. und verm. aufl. hrsg.
unter mitwirkung von dr. Karl Kroner ... Mit 55 abbil-
dungen im text. Berlin, Fischer'ʰ medicin. buchhandlung
H. Kornfeld, 1911.
2 p. l., 288 p. illus. (partly col.) fold. tab. 24½ᶜᵐ. M. 8
© May 30, 1911; 2c. July 18, 1911*; A—Foreign 3211; Fischer's medicin.
buchhandlung H. Kornfeld. (11–18510) 3599

Griffith, Reginald Harvey.

Sir Perceval of Galles; a study of the sources of the
legend, by Reginald Harvey Griffith ... Chicago, Ill., The
University of Chicago press [1911]
viii, 131 p. 25ᶜᵐ.
© Mar. 31, 1911; 2c. Apr. 6, 1911*; A 283970;; Univ. of Chicago.
(11–18445) 3600

Griggs, Stephen Elind, 1880–

Souls of the infinite; an outline of the truth, by S. E.
Griggs ... illustrated by the author. New York, The Met-
ropolitan press, 1911.
vii, 171 p. front. (port.) illus., plates. 19ᶜᵐ. $1.00
© July 8, 1911; 2c. July 12, 1911*; A 292389; Metropolitan press.
(11–18454) 3601

Haller, John George, 1858–

The redemption of the prayer-meeting, by J. George
Haller, PH. D. Cincinnati, Jennings and Graham; New
York, Eaton and Mains; [etc., etc., ᶜ1911]
222 p. 19ᶜᵐ. $0.50
© July 20, 1911; 2c. July 22, 1911*; A 292639; Jennings & Graham.
(11–18485) 3602

[Harrah, Lewis Osborne] 1873–

The home cleaner ... Terre Haute, Ind., The Economy
supply co. [ᶜ1911]
128 p. 17½ᶜᵐ. $2.00
© July 18, 1911; 2c. July 21, 1911*; A 292618; Lewis O. Harrah, Terre
Haute. Ind. (11–18480) 3603

Harrington, Charles, 1856–1908.

A manual of practical hygiene for students, physicians,
and health officers. By Charles Harrington ... 4th ed..
rev. and enl. by Mark Wyman Richardson ... Illustrated

595

Harrington, Charles—Continued

with twelve plates in colors and monochrome, and one hundred and twenty-four engravings. Philadelphia and New York, Lea & Febiger, 1911.

2 p. l., 7–850 p. illus., xii pl. (partly col.) 24½ᶜᵐ.
© July 15, 1911; 2c. July 18, 1911*; A 292520; Lea & Febiger. (11–18503) 3604

Hiscox, Gardner Dexter, d. 1908.

Mechanical movements, powers and devices, contains: an illustrated description of mechanical movements and devices used in constructive and operative machinery and the mechanical arts ... by Gardner D. Hiscox ... illustrated by eighteen hundred engravings ... 12th ed. New York, The Norman W. Henley publishing co., 1911.

2 p. l., 403 p. illus. 23½ᶜᵐ. $2.50
© July 20, 1911; 2c. July 22, 1911*; A 292645; Norman Henley pub. co. (11–18483) 3605

Hodgson, Frederick Thomas, 1836–

... Mechanics, indoors and out, by Fred T. Hodgson. Garden City, N. Y., Doubleday, Page & company, 1911.

7 p. l., 3–426 p. col. front., illus., plates. 21ᶜᵐ. (Half-title: The children's library of work and play) $1.75
© June 29, 1911; 2c. July 8, 1911; A 292577; Doubleday, Page & co. (11–18476) 3606

[Kaler, James Otis] 1848–

The minute boys of Philadelphia, by James Otis [pseud.] ... illustrated by L. J. Bridgman. Boston, D. Estes and company [ᶜ1911]

315 p. incl. front. plates. 19½ᶜᵐ. $1.25
© July 24, 1911; 2c. July 25, 1911*; A 292703; Dana Estes & co. (11–18460) 3607

Kemmerich, Max, 1851–

Prophezeiungen, alter aberglaube oder neue wahrheit? Von dr. Max Kemmerich. München, A. Langen [ᶜ1911]

vi p., 1 l., 435 p., 1 l. 19ᶜᵐ. M. 5
© June 8, 1911; 2c. July 19, 1911*; A—Foreign 3239; Albert Langen. (11–18488) 3608

Lessing, Gotthold Ephraim, 1729–1781.

Lessings religion, zeugnisse gesammelt von M. Joachimi-Dege. München, E. Rentsch, 1911.

xiii, [1] p., 1 l., 134 p. 19ᶜᵐ. (Added t.-p.: Pandora, geleitet von O. Walzel. [bd. 3]) M. 2.50
© May 21, 1911; 2c. July 18, 1911*; A—Foreign 3216; Eugen Rentsch verlag, g. m. b. h. (11–18494) 3609

Lindau, Paul.

... Illustrierte romane und novellen. 3. bd. Die gehilfin (1. teil) ... Berlin, S. Schottlaender [1910]

348 p. illus. 20½ᶜᵐ.
© July 14, 1910; 2c. July 14, 1910*; A—Foreign 1473; S. Schottlaenders schlesische verlagsanstalt, Berlin. 3610

Macdonald, William.

Dry-farming: its principles and practice, by William
Macdonald ... New and rev. ed. New York, The Century
co., 1911.

xvi, 314 p. incl. 31 pl. front. 20ᶜᵐ. $1.20
© July 20, 1911; 2c. July 22, 1911*; A 292646; Century co.
(11–18259) 3611

Macilwaine, Sydney Wilson.

Medical revolution; a plea for national preservation of
health based upon the natural interpretation of disease,
by Sydney W. Macilwaine ... New York, H. Ober, 1911.

x p., 1 l., 134 p. 19½ᶜᵐ.
© July 21, 1911; 2c. July 24, 1911*; A 292670; S. W. Macilwaine, London.
(11–18504) 3612

Mannering, Ethel Turner, comp.

What comes from the heart; heart-throbs of sentiment,
selected by Ethel Turner Mannering. New York, The
Platt & Peck co. [ᶜ1911]

139 p. incl. col. front. 16½ᶜᵐ. $0.75
© July 18, 1911; 2c. July 22, 1911*; A 292649; Platt & Peck co.
(11–18273) 3613

[Metzler, Samuel N]

A medical memorandum; selected prescriptions and
formulas classified and arranged so as to facilitate the
work of the busy physician. [Indianapolis? Ind., ᶜ1911]

378 p. incl. front. (port.) 20ᶜᵐ. $5.00
© June 27, 1911; 2c. July 5, 1911*; A 292271; S. N. Metzler, Indianapolis,
Ind. (11–18502) 3614

Miller, Claude H.

... Outdoor sports and games, by Claude H. Miller,
PH. B. Garden City, N. Y., Doubleday, Page & company,
1911.

5 p. l., 3–395 p. col. front., illus., plates. 21ᶜᵐ. (Half-title: The chil-
dren's library of work and play) $1.75
© June 29, 1911; 2c. July 8, 1911; A 292573; Doubleday, Page & co.
(11–18265) 3615

Miller, Mrs. Mary Farrand (Rogers) 1868–

... Outdoor work, by Mary Rogers Miller. Garden
City, N. Y., Doubleday, Page & company, 1911.

xii, [2] p., 2 l., 3–519 p. col. front., illus., plates. 21ᶜᵐ. (Half-title: The
children's library of work and play) $1.75
At head of title: The library of work and play.
"The outdoor worker's library": p. 516–519.
© June 29, 1911; 2c. July 8, 1911; A 292567; Doubleday, Page & co.
(11–18256) 3616

Powell, Gideon Little, 1866–

Steps to success; or, "Making good," by Gideon L.
Powell ... Cincinnati, Jennings and Graham; New York,
Eaton and Mains [ᶜ1911]

318 p. 20½ᶜᵐ. $1.25
"Originally given in the form of Sunday evening addresses to the young
men of Caldwell [Idaho]"
© July 14, 1911; 2c. July 19, 1911*; A 292540; Jennings & Graham.
(11–18484) 3617

Rauschen, Gerhard, 1854–

Kleine kirchengeschichte; kirchengeschichtliche charakterbilder für höhere lehranstalten, von Gerhard Rauschen ... 3., verb. aufl. 6. bis 9. tausend. Mit 10 abbildungen. Bonn, P. Hanstein, 1911.

2 p. l., 76 p. illus. 20½ᶜᵐ.
© June 30, 1911; 2c. July 20, 1911*; A—Foreign 3280; Peter Hanstein.
(11–18489) 3618

Reed, John Oren, 1856–

College physics, by John Oren Reed ... and Karl Eugen Guthe ... New York, The Macmillan company, 1911.

xxviii p., 1 l., 622 p. illus., diagrs. 21½ᶜᵐ. $2.75
© July 19, 1911; 2c. July 21, 1911*; A 292614; Macmillan co.
(11–18517) 3619

Ribbert, Hugo i. e. Mor. Wilhelm Hugo, 1855–

Lehrbuch der allgemeinen pathologie und der pathologischen anatomie, von prof. dr. Hugo Ribbert ... mit 848 figuren. 4. aufl. Leipzig, F. C. W. Vogel, 1911.

viii, 797 p. illus. (partly col.) 25ᶜᵐ. M. 16
© June 12, 1911; 2c. July 19, 1911*; A—Foreign 3250; F. C. W. Vogel.
(11–18509) 3620

Roujon, Henry.

... H. & J. van Eyck; huit reproductions facsimile en couleurs. Paris, P. Lafitte et cⁱᵉ [1911]

79 p. illus., viii col. pl. (incl. front.) 20½ᶜᵐ. (Les peintres illustres
ıno. 29.) fr. 1.95
© July 7, 1911; 2c. July 29, 1911*; A—Foreign 3302; Pierre Lafitte & cie.
3621

Schmidtbonn, Wilhelm August, 1876–

Lobgesang des lebens; rhapsodien von Wilhelm Schmidtbonn. Berlin, E. Fleischel & co., 1911.

viii, 168 p. 20½ᶜᵐ. M. 3
© June 3, 1911; 2c. July 20, 1911*; A—Foreign 3278; Egon Fleischel & co.
(11–18292) 3622

Seton, Ernest Thompson, 1860–

Rolf in the woods; the adventure of a boy scout with Indian Quonab and little dog Skookum. Over two hundred drawings. Written & illustrated by Ernest Thompson Seton ... Garden City, N. Y., Doubleday, Page & company, 1911.

xv, 437 p. front., illus., plates. 21ᶜᵐ. $1.50
© June 28, 1911; 2c. July 19, 1911*; A 292548; E. T. Seton, Coscob, Conn.
(11–18473) 3623

Shakespeare, William, 1564–1616.

... The works of William Shakespeare. [Éd. de luxe] ... New York, The Hamilton book co. [1911]

10 v. fronts. (v. 1: port.) illus., plates. 20½ᶜᵐ.
© July 5, 1911; 2c. each July 14, 1911*; A 292434; Hamilton book co.
(11–18275) 3624

598

Shaw, Ellen Eddy.
... Gardening and farming, by Ellen Eddy Shaw. Garden City, N. Y., Doubleday, Page & company, 1911.
6 p. l., 3–376 p. col. front., illus., plates. 21ᶜᵐ. (*Half-title:* The children's library of work and play) $1.75
At head of title: The library of work and play.
© June 29, 1911; 2c. July 8, 1911; A 292574; Doubleday, Page & co.
(11–18257) 3625

Soulé, George, 1834–
Soulé's new science and practice of accounts, containing a full exposition, elucidation, and discussion of the science, practice and details of double entry and single entry book-keeping ... By Geo. Soulé ... 9th ed., rev., enl., 1911. New Orleans, The author [1911]
784 p. front. (port.) illus. (incl. forms) 24ᶜᵐ. $4.00
© July 17, 1911; 2c. July 21, 1911*; A 292634; G. Soulé.
(11–18457) 3626

Steiner, Rudolf, 1861–
The submerged continents of Atlantis and Lemuria, their history and civilization; being chapters from the Âkâshic records, by Rudolf Steiner ... authorized translation from the German. London, Theosophical publishing society, 1911.
3 p. l., 202 p. 19½ᶜᵐ. 3/6
© 1c July 8, 1911; A ad int. 688; pubd. June 9, 1911; Weller van Hook, Chicago. (11–18470) 3627

Taft, Marcus Lorenzo.
Strange Siberia along the Trans-Siberian railway; a journey from the Great wall of China to the skyscrapers of Manhattan, by Marcus Lorenzo Taft. New York, Eaton & Mains; Cincinnati, Jennings & Graham [°1911]
260 p. col. front., plates. 17½ᶜᵐ. $1.00
© May 16, 1911; 2c. July 14, 1911*; A 292436; Eaton & Mains.
(11–18252) 3628

Thackeray, William Makepeace, 1811–1863.
... Thackeray's English humorists of the eighteenth century, ed. and annotated by J. W. Cunliffe ... and H. A. Watt ... Chicago, New York, Scott, Foresman and company [°1911]
3 p. l., 9–271 p. 17ᶜᵐ. (*Half-title:* The Lake English classics, ed. by L. T. Damon) $0.30
© July 11, 1911; 2c. July 14, 1911*; A 292440; Scott, Foresman & co.
(11–18446) 3629

Thiersch, Hermann, 1874–
An den rändern des Römischen reichs; sechs vorträge über antike kultur, von Hermann Thiersch. München, Beck, 1911.
viii p., 1 l., 151 p. 19½ᶜᵐ. M. 3
CONTENTS.—1. Ägypten—Alexandria.—2. Arabien—Petra.—3. Syrien—Antiochia.—4. Kleinasien—die Griechenstädte.—5. Nordafrika—Karthago.—6. An Rhone und Rhein—Trier.
© Mar. 30, 1911; 2c. June 9, 1911; A—Foreign 3199; C. H. Beck'sche verlagsbuchhandlung. (11–18493) 3630

Umbstaetter, Herman Daniel, 1851–

The red-hot dollar, and other stories from the Black
cat, by H. D. Umbstaetter; with an introduction by Jack
London. Boston, L. C. Page & company, 1911.

3 p. l., v-ix p., 2 l., 3–239 p. 18½ᶜᵐ. $1.00
CONTENTS.—The red-hot dollar. — The unturned trump. — The real
thing.—When the cuckoo called.—One chance in a million.—Doodle's dis-
covery.—Kootchie.—Her eyes, your honor.—For the sake of Toodleums.—
In Hell's Cañon.—The mystery of the thirty millions.—Asleep at Lone
Mountain.
© July 25, 1911; 2c. July 28, 1911*; A 292773; L. C. Page & co., inc.
(11–18461) 3631

Wallenberg, Georg Jakob, 1864–

... Theorie der linearen differenzengleichungen, unter
mitwirkung von Alf Guldberg ... von Georg Wallenberg
... mit 5 figuren im text. Leipzig und Berlin, B. G. Teub-
ner, 1911.

xiv, 288 p. 23ᶜᵐ. (B. G. Teubners sammlung von lehrbüchern auf dem
gebiete der mathematischen wissenschaften ... bd. xxxv) M. 10
"Literaturverzeichnis": p. ₍274₎–283.
© May 24, 1911; 2c. July 19, 1911*; A—Foreign 3232; B. G. Teubner.
(11–18516) 3632

Waugh, William Francis, 1849–

A text-book of alkaloidal therapeutics; being a con-
densed resumé of all available literature on the subject of
the active principles added to the personal experience of
the authors, by W. F. Waugh, M. D., and W. C. Abbott,
M. D. 3d ed., rev. and enl. Chicago, The Abbott press.
1911.

4 p. l., ii, ₍3₎, 762 p. 24ᶜᵐ. $5.00
© July 18, 1911; 2c. July 21, 1911*; A 292636; Abbott press.
(11–18505) 3633

Weeks, Leroy Titus.

The poems of Leroy Titus Weeks. Sabula, Ia., L. T.
Weeks, 1911.

x, 168 p. front. (port.) 21½ᶜᵐ. $1.25
© June 11, 1911; 2c. July 12, 1911; A 292690; L. T. Weeks, Newton, Ia.
(11–18449) 3634

Wentworth, George.

... Arithmetic ... by George Wentworth and David
Eugene Smith. Boston, New York ₍etc.₎ Ginn and com-
pany ₍ᶜ1911₎

3 v. illus. 19ᶜᵐ. (Wentworth-Smith mathematical series)
bk. 1 © June 12, 1911; bk. 2 © June 20, 1911; bk. 3 © June 23, 1911; 2c.
each July 13, 1911*; A 292426–292428; G. Wentworth, Exeter, N. H..
and D. E. Smith, New York. (11–18260) 3635–3637

Wickenburg, Robert Ottokar, graf, 1874–

Die versuchung, roman von Robert graf Wickenburg.
Leipzig ₍etc.₎ Grethlein & co. ₍ᶜ1911₎

244 p. 20ᶜᵐ. M. 4
© May 30, 1911; 2c. July 18, 1911*; A—Foreign 3220; Grethlein & co.
(11–18451) 3638

$B2035.4$

Alderman, Edwin Anderson, 1861–

J. L. M. Curry; a biography, by Edwin Anderson Alderman and Armistead Churchill Gordon. New York, London, The Macmillan company, 1911.

xx p., 1 l., 468 p. front. (port.) 20½ᶜᵐ. $2.00

Bibliography: p. 453–454.

© July 12, 1911; 2c. July 13, 1911*; A 292420; Macmillan co.
(11–18603) 3639

[Behrens, Bertha]

Familie Lorenz, roman von W. Heimburg [pseud.] Stuttgart [etc.] Union deutsche verlagsgesellschaft [ᶜ1911]

393 p. 18½ᶜᵐ. M.4

© July 1, 1911; 2c. July 20, 1911*; A—Foreign 3281; Union deutsche verlagsgesellschaft. (11–18593) 3640

Bohm, Edward Frederick Charles.

The Carey act; how to acquire title to public lands under the act; a comprehensive survey of the regulations in force in the various states, by E. F. Bohm. [Rev. ed.] Chicago, National irrigation journal publishing co. [ᶜ1911]

69 p. 23ᶜᵐ.

© June 6, 1911; 2c. July 10, 1911; A 292686; E. F. Bohm, Cleveland, O.
(11–18621) 3641

Borchart, Elsbeth, 1878–

Zwei frauen, roman von Elsbeth Borchart ... Charlottenburg, E. Beyer [ᶜ1911]

322 p. 20½ᶜᵐ. M.3.50

© May 30, 1911; 2c. July 20, 1911*; A—Foreign 3282; Eduard Beyer verlag. (11–18589) 3642

Boynton, Frank David, 1863–

Actual government of New York; a manual of the local, municipal, state and federal government for use in public and private schools of New York state, by Frank David Boynton ... Boston, New York [etc.] Ginn and company [ᶜ1911]

xi, 421, lxxxv p. incl. front., illus., plates. map. 19ᶜᵐ. $1.00

Bibliography: p. x–xi.

© July 21, 1911; 2c. July 27, 1911*; A 292761; F. D. Boynton, Ithaca, N. Y.
(11–18625) 3643

Bulcke, Carl, 1876–

... Die süsse Lilli; Der trauerflor, zwei novellen. Leipzig, B. Elischer nachfolger [ᶜ1911]

2 p. l., 198 p. 20ᶜᵐ. M. 4

© May 15, 1911; 2c. July 19, 1911*; A—Foreign 3255; B. Elischer nachfolger. (11–18618) 3644

601

Business correspondence library ... Chicago, New York, The System company; [etc., etc., ◦1911]

3 v. 20½ᶜᵐ. $5.00

CONTENTS.—I. How to write the business letter.—II. How to get and hold business by letter.—III. How to handle the distant customer.

© July 1, 1911; 2c. July 17, 1911*; A 292488; System co.
(11–18623) 3645

Carriel, *Mrs.* **Mary (Turner)** 1845–

The life of Jonathan Baldwin Turner, by his daughter Mary Turner Carriel. [Jacksonville? Ill.] 1911.

xii, 298 p. front. (port.) plates. 23ᶜᵐ. $2.00

© July 17, 1911; 2c. July 19, 1911*; A 292547; M. T. Carriel, Jacksonville, Ill. (11–18606) 3646

Castell, Alexander.

... Die mysteriöse tänzerin; kleine geschichten. München, A. Langen [◦1911]

4 p. l., 11–170 p., 1 l. 15ᶜᵐ. (Kleine bibliothek Langen, bd. 106) M. 1

CONTENTS.—Die mysteriöse tänzerin.—Suzanne.—Die singenden krüppel.—Der einsame kavalier.—Das vermächtnis der baronin von B.—Der hohe tag.

© June 8' 1911; 2c. July 19, 1911*; A—Foreign 3244; Albert Langen.
(11–18713) 3647

Dannemann, Adolf, 1867– *ed.*

Enzyklopädisches handbuch der heilpädagogik, unter mitwirkung zahlreicher am erziehungswerke interessierter ärzte und pädagogen, hrsg. von professor dr. med. A. Dannemann ... hilfsschul-leiter H. Schober ... hilfsschul-lehrer E. Schulze ... Halle a. S., C. Marhold, 1911.

4 p., 1974 numb. col. 26½ᶜᵐ. M. 31

© Apr. 26, 1911; 2c. June 9, 1911; A—Foreign 3206; Carl Marhold verlagsbuchhandlung. (11–18605) 3648

Davis, Henry William Carless, 1874–

Medieval Europe, by H. W. C. Davis ... New York, H. Holt and company; [etc., etc., ◦1911]

256 p. illus. (maps) 18ᶜᵐ. (*Half-title:* Home university library of modern knowledge, no. 13) $0.75

"Note on books": p. 255–256.

© July 24, 1911; 2c. July 27, 1911*; A 292737; Henry Holt & co.
(11–18566) 3649

Dresden. Internationale hygiene-ausstellung, 1911.

Fortpflanzung vererbung rassenhygiene; katalog der gruppe rassenhygiene der Internationalen hygiene-ausstellung, 1911, in Dresden, hrsg. von prof. dr. Max von Gruber ... und priv.-doz. dr. Ernst Rüdin ... Erklärender text mit 230 abbildungen von M. v. Gruber, nebst einem bibliographischen anhang von dr. Rudolf Allers. München, J. F. Lehmann [◦1911]

2 p. l., 178 p. illus., diagrs. 24ᶜᵐ. M. 3

"Bibliographie": p. 166–178.

© May 30, 1911; 2c. July 19, 1911*; A—Foreign 3249; J. F. Lehmann.
(11–18622) 3650

Gerber, Paul Henry, 1863–

... Die menschliche stimme und ihre hygiene; sieben
volkstümliche vorlesungen von prof. dr. P. H. Gerber ...
2. aufl., mit 20 abbildungen im text. Leipzig, B. G. Teub-
ner, 1911.

iv, 116 p. illus. 18½ᶜᵐ. (Aus natur und geisteswelt ... 136. bdchen.)
M. 1.25
"Königsberger hochschulkurse, bd. v."
"Literatur": p. [112]–116.
© May 9, 1911; 2c. July 19, 1911*; A—Foreign 3243; B. G. Teubner.
(11–18514) 3651

Glasenapp, Carl Friedrich.

Das leben Richard Wagners in sechs büchern darge-
stellt von Carl Fr. Glasenapp. 6. bd. ... 1.–3. aufl. Leip-
zig, Breitkopf & Härtel, 1911.

xviii, 828, 39, [1] p. front. (port.) 25ᶜᵐ. M. 12
© July 25, 1911; 2c. Aug. 5, 1911*; A—Foreign 3340; Breitkopf & Härtel.
 3652

Grober, Julius, ed.

Das deutsche krankenhaus; handbuch für bau, einrich-
tung und betrieb der krankenanstalten bearb. von ... A. D.
Boethke ... [u. a.] unter mitwirkung von professor dr. E.
Dietrich ... hrsg. von prof. dr. Grober ... mit 392 teilweise
farbigen abbildungen im text und 5 beilagen. Jena, G.
Fischer, 1911.

vi, 1001, [1] p. illus., tables (partly fold.) 26ᶜᵐ. M. 30
Contains "Literatur."
© June 10, 1911; 2c. July 20, 1911*; A—Foreign 3275; Gustav Fischer.
(11–18581) 3653

Hahn, Hans, 1879–

Bericht über die theorie der linearen integralgleichun-
gen, von Hans Hahn ... 1. t. Leipzig und Berlin, B. G.
Teubner, 1911.

51 p. 25½ᶜᵐ. M. 1.20
© Apr. 6, 1911;·2c. July 19, 1911*; A—Foreign 3247; B. G. Teubner.
(11–18515) 3654

Hennig, Richard, 1874–

... Gut und schlecht wetter, von dr. Richard Hennig;
mit 46 abbildungen im text. Leipzig, B. G. Teubner, 1911.

3 p. l., 118 p. illus. 18½ᶜᵐ. (Aus natur und geisteswelt ... 349. bdchen.)
M. 1.25
"Literaturangaben": p. [117]
© May 10, 1911; 2c. July 19, 1911*; A—Foreign 3257; B. G. Teubner.
(11–18511) 3655

Hobson, John Atkinson, 1858–

The science of wealth, by J. A. Hobson ... New York,
H. Holt and company; [etc., etc., ᶜ1911]

viii, 9–256 p. illus. 18ᶜᵐ. (Half-title: Home university library of
modern knowledge, no. 11) $0.75
© July 24, 1911; 2c. July 27, 1911*; A 292738; Henry Holt & co.
(11–18626) 3656

Höcker, Paul Oskar, 1865–

... Lebende bilder, roman von Paul Oskar Höcker.
1., 2. bd. Stuttgart, J. Engelhorns nachf., 1911.
2 v. in 1. 18ᶜᵐ. (Engelhorns allgemeine roman-bibliothek ... 27.
jahrg., bd. 21)
© June 10, 1911; 2c. July 19, 1911*; A—Foreign 3229; J. Engelhorns nachf.
(11–18592) 3657

Hyan, Hans, 1868–

Die verführten, roman von Hans Hyan. [2. aufl.] Ber-
lin, Pan-verlag, 1911.
440 p., 1 l., 17½ᶜᵐ. M. 4.50
© May 15, 1911; 2c. July 19, 1911*; A—Foreign 3228; Pan-verlag.
(11–18588) 3658

Jacobs, Leon Ralph, 1885–

Celibacy; a novel, by Leon R. Jacobs. New York,
Washington [etc.] Broadway publishing co. [ᶜ1911]
6 p. l., 225 p. front., plates. 20½ᶜᵐ. $1.50
© July 24, 1911; 2c. July 26, 1911*; A 292707; L. R. Jacobs, New York.
(11–18559) 3659

Jahrbuch für orthopädische chirurgie ... 1., 2. bd. Ber-
lin, J. Springer, 1911.
2 v. in 1. 24ᶜᵐ.
Editor: 1909, P. Glaessner.
© June 7, 1911; 2c. July 20, 1911*; A—Foreign 3274; Julius Springer.
(11–18583) 3660

König, Johann Karl.

Joh. Karl König's Warenlexikon für den verkehr mit
drogen und chemikalien, mit lateinischen, deutschen, en-
glischen, französischen, holländischen und dänischen be-
zeichnungen. 12. aufl., vollständig neu bearb. von dr.
Georg Frerichs und dr. Heinrich Frerichs ... Braun-
schweig, F. Vieweg & sohn, 1911.
vi, 631 p. 25½ᶜᵐ.
© June 16, 1911; 2c. July 19, 1911*; A—Foreign 3234; Friedr. Vieweg &
sohn. (11–18580) 3661

Meynier, Octave Frédéric François.

... L'Afrique noire; ouvrage orné de 24 illustrations.
Paris, E. Flammarion, 1911.
3 p. l., 335 p. illus. 18½ᶜᵐ. (Bibliothèque de philosophie scientifique)
fr. 3.50
© July 12, 1911; 2c. July 24, 1911*; A—Foreign 3287; Ernest Flammarion.
(11–18565) 3662

Michaëlis, Karin i. e. Katharina Marie Bech (Brøndum) 1872–

... Elsie Lindtner, roman. [1.–10. tausend] Berlin,
Concordia deutsche verlags-anstalt g. m. b. h. [ᶜ1911]
171 p. 20ᶜᵐ. M. 2
© May 8, 1911; 2c. July 19, 1911*; A—Foreign 3227; Concordia deutsche
verlags-anstalt, g. m. b. h. (11–18584) 3663

[Mühlenfels, *Frau* Hedwig von] 1874–
Nach dem dritten kind; aus dem tagebuch einer offiziers-
frau, von Helene von Mühlau [*pseud.*] Berlin, E. Flei-
schel & co., 1911.

2 p. l., 232 p. 20ᶜᵐ. M. 3
© June 3, 1911; 2c. July 20, 1911*; A—Foreign 3277; Egon Fleischel & co.
(11–18590) **3664**

Norton, Roy.
... Les flottes évanouies, adapté de l'Anglais par Mˡˡᵉ
J. Crémieux. Paris, P. Lafitte & cⁱᵉ [ᶜ1911]

2 p. l., 328 p. 19ᶜᵐ. fr. 3.50
© June 23, 1911; 2c. July 15, 1911*; A—Foreign 3175; Pierre Lafitte & cie.
(11–18591) **3665**

Pennsylvania. *Superior court.*
Pennsylvania Superior court reports, v. 45, containing
cases decided ... April term, 1911. Reported by William
I. Schaffer, state reporter, and Albert B. Weimer, assist-
ant reporter. New York, The Banks law publishing co.,
1911.

xxxix, 724 p 24ᶜᵐ. $1.08
© Aug. 3, 1911; 2c. Aug. 4, 1911*; A 292942; Robert McAfee, sec. of the
commonwealth for the state of Pennsylvania, Harrisburg. **3666**

Poske, Friedrich Wilhelm Paul, 1852–
Oberstufe der naturlehre (physik nebst astronomie und
mathematischer geographie) Nach A. Höflers Natur-
lehre für die oberen klassen der österreichischen mittel-
schulen für höhere lehranstalten des Deutschen Reichès
bearb. von dr. Friedrich Poske ... 3., verb. und verm.
aufl., mit 494 zum teil farbigen abbildungen und vier ta-
feln. Braunschweig, F. Vieweg & sohn, 1911.

xvi, 359 p. illus. (partly col.) 2 col. pl., 2 charts (1 fold.) diagrs. 23ᶜᵐ.
M. 4
© June 17, 1911; 2c. July 19, 1911*; A—Foreign 3231; Friedr. Vieweg &
sohn. (11–18513) **3667**

Powers, Thomas J 1875–
The garden of the sun; a novel, by Captain T. J. Pow-
ers ... Boston, Small, Maynard & company [ᶜ1911]

3 p. l., 390 p. front., plates. 19½ᶜᵐ. $1.25
© June 24, 1911; 2c. July 29, 1911*; A 292795; Small, Maynard & co., inc.
(11–18561) **3668**

The Rand-McNally bankers' directory, *Chicago, comp.*
Key to numerical system of the American bankers' as-
sociation; a numerical and alphabetical list of banks of
the United States, comp. ... by the Rand-McNally bank-
ers' directory under the authority and according to the
system of the American bankers' association, May, 1911—
1st ed. Chicago, Rand, McNally & company [ᶜ1911]

viii, 493 (*i. e.* 497) p. 28ᶜᵐ. $1.50
© July 12, 1911; 2c. July 17, 1911*; A 292478; American bankers assn.
(11–18627) **3669**

Richardson, Ernest Cushing, 1860–

Periodical articles on religion, 1890–1899, comp. and ed., by Ernest Cushing Richardson, with the co-operation of Charles S. Thayer, William C. Hawks, Paul Martin, and various members of the faculty of the Hartford theological seminary, and some help from A. D. Savage, Solon Librescot and many others. Author index. New York, For the Hartford seminary press by C. Scribner's sons; [etc., etc., *1911]

4 p. l., 876 p. 24¼ᶜᵐ. $5.00

© July 14, 1911; 2c. July 18, 1911*; A 292538; E. C. Richardson, Princeton, N. Y. (11-18734) 3670

Rockwell, William Locke, 1870–

The New Jersey notaries and commissioners manual; the statutory and judicial law relating to these officers, their powers, duties, privileges and liabilities, the protest of commercial paper, the administration of oaths and affirmations, affidavits and acknowledgments to instruments, with forms. 2d ed., by W. Locke Rockwell ... Newark, N. J., Soney & Sage, 1911.

viii, 116 p. 24ᶜᵐ. $1.50

© July 12, 1911; 2c. July 15, 1911*; A 292461; W. L. Rockwell, Newark, N. J. (11-18607) 3671

Roda Roda, Alexander Friedrich Ladislaus, 1872–

... Junker Marius, ein buch für backfische. 1. bis 8. aufl. Berlin, Schuster & Loeffler, 1911.

259, [1] p. 17¼ᶜᵐ. M. 3

© May 30, 1911; 2c. July 18, 1911*; A—Foreign 3214; Schuster & Loeffler. (11-18716) 3672

Rohden, C.

Die offizinellen ätherischen öle und balsame. Zusammenstellung der anforderungen der 14 wichtigsten pharmakopoeen in wortgetreuer übersetzung. Im auftrage der firma E. Sachsse & co., fabrik ätherischer öle, Leipzig, bearb. von apotheker C. Rohden ... Berlin, J. Springer, 1911.

viii, 175, [1] p. 24ᶜᵐ. M. 7

© May 8, 1911; 2c. June 9, 1911; A—Foreign 3207; E. Sachsse & co., Leipzig. (11-18582) 3673

Rorer, Mrs. Sarah Tyson (Heston) 1849–

Home candy making, by Mrs. S. T. Rorer ... Philadelphia, Arnold and company [*1911]

89 p. 19ᶜᵐ.

© July 22, 1911; 2c. July 26, 1911*; A 292710; Mrs. S. T. Rorer, New York. (11-18571) 3674

Rosner, Karl Peter, 1873–

Es spricht die nacht, und andere novellen, von Karl
Rosner. Leipzig [etc.] Grethlein & co. [*1911]
206 p. 18½ᶜᵐ. M. 2
CONTENTS.—Es spricht die nacht.—Wer war es?—Spuk.—John Reab-
ney's bildnis.—Der gelbe tod.—Die hand von Bibân el-Melûk.
© May 23, 1911; 2c. July 18, 1911*; A—Foreign 3221; Grethlein & co.
(11-18586) 3675

Sales, Pierre, 1856–

... Elles vont à l'amour, roman. Paris, E. Flammarion
[*1911]
2 p. l., 410 p., 1 l. 19ᶜᵐ. fr. 3.50
© July 12, 1911; 2c. July 24, 1911*; A—Foreign 3286; Ernest Flammarion.
(11-18714) 3676

Schulze-Gaevernitz, Gerhart von, 1864–

England und Deutschland, von prof. dr. v. Schulze-
Gaevernitz. 3. und 4. aufl. Berlin-Schöneberg, Fort-
schritt (Buchverlag der "Hilfe") g. m. b. h., 1911.
48 p. 19ᶜᵐ. M. 0.50
© May 30, 1911; 2c. July 20, 1911*; A—Foreign 3279; Buchverlag der
"Hilfe," g. m. b. h. (11-18564) 3677

Sewell, Anna, 1820–1878.

Black Beauty; the autobiography of a horse, by Anna
Sewell; with illustrations in color by Robert L. Dickey.
New York, Barse & Hopkins [*1911]
5 p. l., 278 p. col. front., col. plates. 22½ᶜᵐ. $1.50
© June 15, 1911; 2c. July 13, 1911; A 292683; Barse & Hopkins.
(11-18560) 3678

Sheldon, Edward Austin, 1823–1897.

Autobiography of Edward Austin Sheldon, ed. by Mary
Sheldon Barnes; with an introduction by Andrew Sloane
Draper ... New York, The Ives-Butler company [*1911]
xii, 252 p. front. (port.) plates, port. group. 19½ᶜᵐ. $1.25
© June 29, 1911; 2c. June 30, 1911; A 292191; Ives-Butler co.
(11-18602) 3679

Sherman, George.

Practical printing; explaining the ways and means of
production in the modern printing plant, by George Sher-
man. New York, Oswald publishing company, 1911.
4 p. l., 141 p. illus. 19½ᶜᵐ. $1.50
© June 30, 1911; 2c. July 3, 1911*; A 292241; Oswald pub. co.
(11-18733) 3680

Teuchert, Emil.

Musik-instrumentenkunde in wort und bild, zusammen-
gestellt, bearb. und hrsg. von Emil Teuchert ... und E. W.
Haupt ... 2. t. Holzblasinstrumente ... Leipzig, Breit-
kopf & Härtel, 1911.
vi, [1], 99, [1] p. illus., fold. plates. 23½ᶜᵐ. M. 2
© July 5, 1911; 2c. Aug. 5, 1911*; A—Foreign 3342; Breitkopf & Härtel.
 3681

Tudor, Anthony.

The case of Paul Breen, by Anthony Tudor, LL. B.;
illustrated by Henry Roth. Boston, L. C. Page & company, 1911.

vii, 460 p. front., plates. 20ᶜᵐ. $1.50
© June 20, 1911; 2c. June 22, 1911*; A 289974; L. C. Page & co. (inc.)
(11-18563) 3682

Turner, William, 1871–

Lessons in logic, by William Turner ... Washington,
D. C., Catholic education press; [etc., etc.] 1911.

1 p. l., 302 p. 19ᶜᵐ. (Half-title: The Catholic university series of text-
books in philosophy, v. 1) $1.25
© July 20, 1911; 2c. July 22, 1911; A 292657; W. Turner, Washington,
D. C. (11-18598) 3683

Tyrrell, Henry Grattan.

A treatise on the design and construction of mill build-
ings and other industrial plants, by Henry Grattan Tyr-
rell ... Chicago and New York, The Myron C. Clark pub-
lishing co.; [etc., etc.] 1911.

xv, 490 p. illus., diagrs. 23½ᶜᵐ.
© July 19, 1911; 2c. July 26, 1911*; A 292713; H. G. Tyrrell, Evanston,
Ill. (11-18574) 3684

Villiers, Mme. A de.

Mal was andres; eine sammlung erprobter kochrezepte
für feinschmecker, von Mᵐᵉ A. de Villiers. 6. aufl. Leip-
zig, C. F. Amelang, 1911.

4 p. l., 176 p. 20ᶜᵐ. M. 5
© Apr. 10, 1911; 2c. June 15, 1911; A—Foreign 3197; C. F. Amelangs
verlag. (11-18575) 3685

Wolfgang, Bruno.

... Die schöne frau, und andere geschichten. Mün-
chen, A. Langen [ᶜ1911]

163, [1] p. 15ᶜᵐ. (Kleine bibliothek Langen, bd. 108) M. 1
CONTENTS.—Die schöne frau.—Der verleger.—Der grosse moment.—
Der dienstlich-seelische konflikt.—Das duell.—Das römische gastmahl.—
Fünf hemden.—Der pintsch.—Der fall Srb.—Die hexe.—Klim-bim.—Der
Apollo.—Die wurstreise.
© June 8, 1911; 2c. July 19, 1911*; A—Foreign 3252; Albert Langen.
(11-18717) 3686

Woodhull, John Francis, 1857–

... Electricity and its everyday uses, by John F. Wood-
hull, PH. D. Garden City, N. Y., Doubleday, Page & com-
pany, 1911.

vii p.; 3 l., 3–357 p. col. front., illus., plates. 21ᶜᵐ. (Half-title: The
children's library of work and play) $1.75
© June 29, 1911; 2c. July 8, 1911; A 292572; Doubleday, Page & co.
(11-18474) 3687

Woodward, Ray, comp.

For auld lang syne; a book of friendship, selected by
Ray Woodward. New York, The Platt & Peck co. [ᶜ1911]

2 p. l., 7–106 p. 19ᶜᵐ. $0.75
© July 20, 1911; 2c. July 22, 1911*; A 292650; Platt & Peck co.
(11-18245) 3688

608

Die **Alexanderskirche** mit der fürstengruft der Wittels-
bacher, in Zweibrücken. Festschrift zur weihefeier am
14. mai 1911 (mit 6 bildern) Zweibrücken, F. Lehmann
[ᶜ1911]
 81 p., 2 l. incl. illus., port., geneal. tab. 20½ᶜᵐ. M. 1
 © May 14, 1911; 2c. July 19, 1911*; A—Foreign 3235; Fr. Lehmanns buch-
 handlung, Jacob Peth. (11–18934) 3689

Cameron, Frank Kenneth, 1869–
 The soil solution, the nutrient medium for plant growth,
by Frank K. Cameron ... Easton, Pa., The Chemical pub-
lishing co.; [etc., etc.] 1911.
 2 p. l., [iii]–iv p., 1 l., 136 p. diagrs. 23ᶜᵐ. $1.25
 © July 20, 1911; 2c. July 22, 1911*; A 292640; Edward Hart, Easton, Pa.
 (11–18834) 3690

Campbell, James Wall Schureman.
 Digest and revision of Stryker's Officers and men of
New Jersey in the revolutionary war for the use of the
Society of the Cincinnati in the state of New Jersey, to-
gether with a copy of the order on John Pierce, esq., pay-
master-general to the Army of the United States, paya-
ble to Richard Cox, treasurer of the Society of the Cincin-
nati in the state of New Jersey, signed at Princeton, N. J.,
September 23rd, 1783, also, a copy of the account of Rich-
ard Cox, treasurer, with John Pierce, paymaster-general,
in connection therewith, and a list of members with an
exhibit of delinquent members of the Society of the Cin-
cinnati in the state of New Jersey, made by Richard Cox,
treasurer, July 5, 1788, rev. and comp. by James Wall
Schureman Campbell ... [New York, Williams printing
company, ᶜ1911]
 49, [1] p. front. (port.) 25ᶜᵐ.
 © June 29, 1911; 2c. July 28, 1911*; A 292786; Society of the Cincinnati
 in the state of New Jersey, Freehold, N. J. (11–18946) 3691

Carter, Thomas Lane.
 Out of Africa; a book of short stories, by Thomas Lane
Carter. New York and Washington, The Neale publish-
ing company, 1911.
 288 p. 19ᶜᵐ. $1.50
 CONTENTS.—The pity of it.—Up a tree.—"The Cauliflower."—The com-
 forting phonograph.—First lady of the land.—KCN.—A Kaffir Christ-
 mas.—Ah Sin's sin.—How like a soldier.—Me and Rhodes.—The miner.
 © Mar. 18, 1911; 2c. July 31, 1911*; A 292831; Neale pub. co.
 (11–18838) 3692

Chamot, Emile Monnin, 1867–
 ... The analysis of water for household and municipal
purposes, by E. M. Chamot ... and H. W. Redfield ...
Ithaca, N. Y., Taylor & Carpenter, 1911.
 2 p. l., [3]–130 p. 20½ᶜᵐ.
 At head of title: An introduction to the methods of analysis in use in
 the laboratory of sanitary chemistry of Cornell university. Part I.
 © Apr. 4, 1911; 2c. July 24, 1911*; A 292667; Taylor & Carpenter.
 (11–18831) 3693

Cooney, Dotia Trigg.

A study in ebony, by Dotia Trigg Cooney. New York and Washington, The Neale publishing company, 1911.
284 p. 19ᶜᵐ. $1.50
© Apr. 17, 1911; 2c. July 31. 1911*; A 292833; D. T. Cooney, Marshall. Mo. (11-18839) 3694

Frederick, Frank Forrest.

... Plaster casts and how they are made ... 3d ed. By Frank Forrest Frederick ... New York, The William T. Comstock co. [ᶜ1911]
132 p. illus. 19¼ᶜᵐ. $1.50
At head of title: A manual for art students and amateurs.
© June 28, 1911; 2c. July 7, 1911; A 292576; F. F. Frederick, Trenton, N. J. (11-18819) 3695

Gamble, Frederick William, 1869–

The animal world, by F. W. Gamble ... with introduction by Sir Oliver Lodge ... New York, H. Holt and company; [etc., etc., ᶜ1911]
xii, 13-256 p. illus. 18ᶜᵐ. (Half-title: Home university library of modern knowledge, no. 12) $0.75
Bibliography: p. 253-254.
© July 24, 1911; 2c. July 27, 1911*; A 292739; Henry Holt & co. (11-18830) 3696

Geddes, Patrick, 1854–

Evolution, by Patrick Geddes ... and J. Arthur Thomson ... New York, H. Holt and company; [etc., etc., ᶜ1911]
xiv, 15-256 p. 18ᶜᵐ. (Half-title: Home university library of modern knowledge, no. 14) $0.75
Bibliography: p. 2:9-256.
© July 24, 1911; 2c. July 27, 1911*; A 292736; Henry Holt & co. (11-18828) 3697

Gerard, Louise.

A tropical tangle, by Louise Gerard ... London, Mills & Boon, limited [1911]
4 p. l., 341. [1] p. 19¼ᶜᵐ 6ˊ
© 1c. July 25, 1911*; A ad int. 718; pubd. June 28, 1911; L. Gerard, London. (11-18939) 3698

Grover, Edwin Osgood, 1870– comp.

From me to you; a gift of friendly thoughts, collected by Edwin Osgood Grover. Chicago, P. F. Volland & co. [ᶜ1911]
64 p. 16ᶜᵐ. $0.50
© Mar. 17, 1911; 2c. Mar. 17, 1911; A 292783; E. O. Grover, New York. (11-18597) 3699

Harms, Heinrich, 1861–

Erdkundliches lernbuch für mittelschulen und verwandte anstalten; ein hilfsbuch für den einprägenden unterricht von II. Harms ... und A. Sievert ... 1. u. 2. teil. Leipzig, List & von Bressensdorf, 1911.
2 v. illus. (incl. maps) 23½ᶜᵐ.
© June 1, 1911; 2c. July 18, 1911*; A—Foreign 3219; List & von Bressensdorf. (11-18957) 3700

Helffenstein, Abraham Ernest, 1853–

Pierre Fauconnier and his descendants; with some account of the allied Valleaux, by Abraham Ernest Helffenstein ... Philadelphia [Press of S. H. Burbank & co.] 1911.

ix, 266 p. front., plates, ports., col. coats of arms. 26ᶜᵐ.
© July 11, 1911; 2c. July 24, 1911*; A 292685; A. E. Helffenstein. Philadelphia, Pa. (11–18945) **3701**

Levere, William C 1872–

Vivian of Mackinac, by William C. Levere. Chicago, Forbes & company, 1911.

299 p. front., plates. 20ᶜᵐ. $1.20
© July 27, 1911; 2c. July 31, 1911*; A 292813; Forbes & co.
(11–18840) **3702**

Neese, George Michael, 1839–

Three years in the Confederate horse artillery, by George M. Neese ... New York and Washington, The Neale publishing company, 1911.

4 p. l., 3–362 p. 21ᶜᵐ. $2.00
© May 19, 1911; 2c. July 31, 1911*; A 292832; Neale pub. co.
(11–18943) **3703**

Palmer, Bartlett J.

The philosophy and principles of chiropractic adjustments. A series of thirty-eight lectures, delivered by B. J. Palmer ... [v. 3] Davenport, Ia., The Palmer school of chiropractic 1911]

567 p. front., illus., plates, ports. 24ᶜᵐ. $4.00
© June 1, 1911; 2c. June 9, 1911; A 292852; B. J. Palmer, Davenport, Ia.
 3704

[Parrack, J B]

One heart that never ached, by Kress Kain [pseud.] Boston. The Roxburgh publishing company (incorporated) [c1911]

3 p. l., 234 p. $1 25
© July 3, 1911; 2c. July 8, 1911*; A 292343; J. B. Parrack, Garden City, Tex. (11–18940) **3705**

Ryce, Mark.

Mrs. Drummond's vocation, by Mark Ryce. New York, The Vail company, 1911.

2 p. l., 283 p. 19½ᶜᵐ. $1.50
© July 27, 1911; 2c. July 31, 1911*; A 292811; William Heinemann, London. (11–18938) **3706**

Sevey, Glenn Cyrus, 1879–

Peas and pea culture; a practical and scientific discussion of peas, relating to the history, varieties, cultural methods, insect and fungous pests, with special chapters on the canned pea industry, peas as forage and soiling

Sevey, Glenn Cyrus—Continued

crops, garden peas, sweet peas, seed breeding, etc. By
Glenn C. Sevey ... New York, Orange Judd company,
1911.

xi, 92 p. incl. front., illus. 19cm. $0.50
© June 15, 1911; 2c. July 26, 1911*; A 292716; Orange Judd co.
(11-18833) 3707

Smith, David Eugene, 1860–

The teaching of geometry, by David Eugene Smith.
Boston, New York [etc.] Ginn and company [°1911]

v, 339 p. illus., diagrs. 19cm. $1.25
© July 15, 1911; 2c. July 27, 1911*; A 292762; D. E. Smith. New York.
(11-18829) 3708

Tomlinson, Everett Titsworth, 1859–

Four boys in the Yosemite, by Everett T. Tomlinson ...
illustrated by George A. Newman. Boston, Lothrop, Lee
& Shepard co. [1911]

2 p. l., 3–405 p. front., plates 19½cm. $1.50
© July 27, 1911; 2c. July 29, 1911*; A 292803; Lothrop, Lee & Shepard co.
(11-18837) 3709

Troop, James, 1853–

Melon culture; a practical treatise on the principles in-
volved in the production of melons, both for home use and
for market: including a chapter on forcing and one on
insects and diseases and means of controlling the same,
by James Troop ... New York, Orange Judd company,
1911.

xii, 105 p. incl. front., illus. 19cm. $0.50
© July 11, 1911; 2c. July 26, 1911*; A 292715; Orange Judd co.
(11-18835) 3710

Woodward, Scott.

Life pictures in prose and verse, by Scott Woodward;
illustrated by Louise Howard. Traverse City, Mich.,
°1911·

166 p. front., illus., pl. 18cm. $1.25
© July 8, 1911; 2c. July 21, 1911; A 292694; S. Woodward, Traverse City.
Mich. (11-18448) 3711

Zapp, Arthur, 1852–

Berliner mädel, roman von Arthur Zapp. Charlotten-
burg, E. Beyer [°1911]

332 p. 1 l. 20½cm. M. 3.50
© May 30, 1911; 2c. July 20, 1911*; A—Foreign 3283; Eduard Beyer ver-
lag. (11-18587) 3712

Zweig, Arnold.

... Aufzeichnungen über eine familie klopfer; Das kind,
zwei erzählungen. München, A. Langen [°1911]

132 p. 15cm. (Kleine bibliothek Langen, bd. 110) M. 1
© June 8, 1911; 2c. July 19, 1911*; A—Foreign 3251; Albert Langen.
(11-18617) 3713

AUG 28 1911
From the
U. S. Cou ... r. t **PART I, BOOKS, GROUP I**
no. 65, August, 1911

B2035.4

3713*

Academy of political science, *New York.*

... Reform of the criminal law and procedure. New York, The Academy of political science, 1911.
1 p. l., p. 529–739. 24½ᶜᵐ. (Proceedings ... vol. ɪ, no. 4)
On cover: Edited by Henry Raymond Mussey.
CONTENTS.—ɪ. Crime and punishment: What is crime? By W. M. Ivins; The relation of the criminal to society, by F. H. Giddings; The consequences of unenforceable legislation, by H. S. Gans; Responsibility for crime by corporations, by A. W. Machen, jr.; The ethics of punishment, by F. Adler; Statistics of crime in the United States, by R. P. Falkner.—ɪɪ. Reform of criminal procedure: Needed changes in criminal procedure, by W. H. Taft; The difficulties of extradition, by J. B. Moore; The powers and importance of the magistrates' court, by A. R. Page; Expert evidence in criminal trials, by C. F. MacDonald; The effects of the twice-in-jeopardy principle in criminal trials, by C. C. Nott, jr.; Criminal-law reform in England and the United States, by E. R. Keedy.—ɪɪɪ. Treatment of juvenile delinquency: The state and the child, by J. W. Mack; The probation system in the juvenile court, by H. Folks and A. W. Towne; Treatment of minor cases of juvenile delinquency, by Madeleine Z. Doty.—ɪv. Discussions at the conference: History of the conference; Discussions; Addresses at the conference dinner.
© July 5, 1911; 2c. July 17, 1911; B 246426; Academy of political science. (11–19002) 3713*

American academy of political and social science, *Philadelphia.*

Risks in modern industry ... Philadelphia, American academy of political and social science, 1911.
iii, [3], 317 p. 25ᶜᵐ. (The annals. vol. xxxvɪɪɪ, no. 1)
"Book department": p. 283–317.
"Report of the Annual meeting committee": p. 279–281.
CONTENTS.—pt. ɪ. Industrial insurance and retiring allowances: Civil service pensions, by F. MacVeagh; Retirement systems for municipal employes, by F. S. Baldwin; Casualty insurance companies and employers' liability legislation, by E. W. De Leon; Some features of obligatory industrial insurance, by J. H. Boyd; Workingmen's compensation in the brewing industry, by L. B. Schram; Results of voluntary relief plan of United States steel corporation, by R. C. Bolling; Disability and death compensation for railroad employes, by D. L. Cease; Discussion.—pt. ɪɪ. Industrial accidents and their prevention: Prevention of industrial accidents, by C. Nagel; Inadequacy of present laws concerning accidents, by J. H. Hammond; Burden of industrial accidents, by J. Mitchell; Injustice of the present system, by J. B. Reynolds; Necessity for social insurance, by J. G. Brooks; Red cross measures for the prevention of disasters, by Mabel T. Boardman; Our lack of statistics, by Mrs. Florence Kelley; The three essentials for accident prevention, by C. Eastman; The necessity for safety devices, by J. C. Delaney; Government measures to increase mine safety, by J. A. Holmes.—pt. ɪɪɪ. Legal and constitutional questions involved in employers' liability and workmen's compensation: Law and social progress, by S. M. Lindsay; Constitutional problem of workmen's compensation, by W. D. Lewis; Present status of workmen's compensation laws, by W. G. Smith; Legal aspects of employers' liability laws, by J. M. Wainwright; A compensation law and private justice, by P. T. Sherman; An argument against liability, by W. S. Nichols.—pt. ɪv. Legislation concerning employers' liability and workmen's compensation: Conditions of progress in employers' liability legislation, by C. P. Neill; The system best adapted to the United States, by M. M. Dawson; Points to be considered in workmen's compensation legislation, by L. Packer; Principles of sound employers' liability legislation, by F. C. Schwedtman; Progress in legislation concerning industrial accidents, by G. W. Anderson; New Jersey employers' liability and workmen's compensation law, by W. B. Dickson; The New Jersey employers' liability act, by W. E. Edge; Recent

613

American academy of political and social science, *Philadelphia*—Continued

New York legislation upon workmen's compensation, by J. P. Cotton, jr.; Workmen's compensation and the industries of Massachusetts, by J. A. Lowell; Attitude of foreign countries toward liability and compensation, by L. K. Frankel; Recent progress in European countries in workmen's compensation, by H. J. Harris; Enterprise liability for industrial injuries, by C. H. Swan; Discussion.
© July 19, 1911; 2c. July 25, 1911; B 246309; American academy of political and social science. (11–19001) 3713**

The American architect, *New York.*

Garages, country and suburban; a series of authoritative articles on the structural features of the private garage and its equipment, the care of the car, the safe handling of gasolene and topics of interest to the owner and driver. To which is added more than eighty illustrations of garages of recent construction ... together with architect's working drawings for a typical garage. New York, The American architect [°1911]
1 p. l., 23 p., 1 l. illus., 64 pl. (incl. plans) 31½ᶜᵐ. $4.00
© Mar. 31, 1911; 2c. July 25, 1911*; A 292700; American architect. (11–18982) 3714

American electrochemical society.

Transactions of the American electrochemical society. v. 19. 19th general meeting, New York city, April 6, 7, 8, 1911. South Bethlehem, Pa., The American electrochemical society, 1911.
viii, 390 p. front. (port.) illus., diagrs. 23½ᶜᵐ. $3.00
© June 27, 1911; 2c. June 28, 1911; A 292946; Amer. electrochemical soc., South Bethlehem, Pa. 3715

Bible. *O. T. Selections.*

Srumsrum in Bible, ke buk meeta; Kusaien Old Testament stories, tr. from the Marshall Islands language into Kusaien, by Alek Kefas ... New York, American tract society [°1911]
391 p. front., illus. 19½ᶜᵐ.
© July 14, 1911; 2c. July 17, 1911*; A 292481; American tract soc. (11–18986) 3716

Bouknight, Talli J.

Ophiel, by Talli J. Bouknight. New York and Washington, The Neale publishing company, 1911.
63 p. 19ᶜᵐ. $1.25
Poem.
© July 1, 1911; 2c. July 31, 1911*; A 292824; T. J. Bouknight, Washington, D. C. (11–18992) 3717

Bozi, Alfred.

Die weltanschauung der jurisprudenz, von Alfred Bozi. 2. aufl. Hannover, Helwingsche verlagsbuchhandlung, 1911.
xii, 345 p. 24ᶜᵐ. M. 8
© May 5, 1911; 2c. June 26, 1911*; A—Foreign 3121; Helwing'sche verlagsbuchhandlung. (11–19005) 3718

Colorado. *Supreme court.*

Reports of cases determined in the Supreme court of the state of Colorado ... Extra annotated ed. v. 1–6. Chicago, Callaghan & co., 1911.

6 v. 23½^{cm}.

Title varies.

Vol. 1–3, Reports of cases determined in the Supreme court of the territory of Colorado. Reporters: v. 1–2, M. Hallett; v. 3, L. B. France.

© June 30, 1911; 2c. each July 27, 1911; A 292755–292760; Callaghan & co. (11–19003) 3719–3724

Daingerfield, Elliott, 1859–

George Inness; the man and his art, by Elliott Daingerfield. New York, Priv. print., 1911.

54 p., 1 l. col. front, 11 pl. (1 col.) 26½^{cm}. $7.50

© July 22, 1911; 2c. July 25, 1911; A 292717; Frederic Fairchild Sherman, New York. (11–18980) 3725

Fox, Fontaine Talbot, 1836–

A study in Alexander Hamilton, by Fontaine T. Fox ... New York and Washington, The Neale publishing company, 1911.

171 p. 19^{cm}. $1.00

© Mar. 1, 1911; 2c. July 31, 1911*; A 292823; Neale pub. co. (11–18996) 3726

Kramer, Harold Morton, 1873–

The rugged way, by Harold Morton Kramer; illustrated by F. Vaux Wilson. Boston, Lothrop, Lee & Shepard co. [1911]

5 p. l., 428 p. front., plates. 20^{cm}. $1.35

© July 31, 1911; 2c. Aug. 2, 1911*; A 292894; Lothrop, Lee & Shepard co. (11–18974) 3727

Lesh, Ulysses Samuel, 1868–

A knight of the golden circle [by] U. S. Lesh. Boston, R. G. Badger, 1911.

282 p. 19½^{cm}. $1.50

© July 20, 1911; 2c. July 26, 1911*; A 292722; Richard G. Badger. (11–18972) 3728

MacLane, Mary, 1881–

The story of Mary MacLane, by herself. New ed., with a chapter on the present (1911) New York, Duffield & company, 1911.

3 p l., 354 p. 2 port. (incl. front.) 18½^{cm}. $1.10

© July 25, 1911; 2c. Aug. 1, 1911; A 292870; Duffield & co. (11–18977) 3729

Mortenssen, Swan, 1864–

Är det verklig sanning? Svar på lifvets viktigaste frågor, af S. Mortensson ... Chicago, Svenska litteraturkommitteen, 1911.

382 p., 1 l. illus. 20^{cm}. $1 50

© June 15, 1911; 2c. July 31, 1911*; A 292806; S. Mortensson, Chicago. (11–18985) 3730

Müller, Aloys.

Das problem des absoluten raumes und seine beziehung zum allgemeinen raumproblem, von Aloys Müller. Braunschweig, F. Vieweg & sohn, 1911.

x, 154 p. 22ᶜᵐ. (*Added t.-p.:* Die wissenschaft ... 39. hft.) M. 4
"Verzeichnis der zitierten literatur": p. ₍152₎–154.

© June 19, 1911; 2c. July 19, 1911*; A—Foreign 3246; Friedr. Vieweg & sohn. (11–18987) 3731

National child labor committee, *New York.*

... Uniform child labor laws. Proceedings of the seventh annual conference of the National child labor committee. Philadelphia, The American academy of political and social science, 1911.

v, 224 p. 25ᶜᵐ. (Supplement to the Annals of the American academy of political and social science. July, 1911)

© July 19, 1911; 2c. July 25, 1911; B 246310; American academy of political and social science. (11–19000) 3731*

Perkins, Constantine Marrast.

The crucible of dreams, by Constantine Marrast Perkins. New York, Washington, Neale publishing co., 1911.

₍78₎ p., 1 l. front., illus., plates. 21½ᶜᵐ. $1.25
Illus. t.-p.
Text within ornamental border.

© Mar. 21, 1911; 2c. July 31, 1911*; A 292826; C. M. Perkins, Washington, D. C. (11–18990) 3732

Raine, William MacLeod.

A Texas ranger, by William MacLeod Raine ... illustrations by W. Herbert Dunton and Clarence Rowe. New York, G. W. Dillingham company ₍°1911₎

337 p. front., plates. 19ᶜᵐ. $1.25

© July 29, 1911; 2c. Aug. 3, 1911*; A 292911; G. W. Dillingham co. (11–18975) 3733

Rodin, Auguste, 1840–

... L'art; entretiens réunis par Paul Gsell. Paris, B. Grasset, 1911.

3 p. l., 3–318 p., 1 l. incl. illus., plates. 21½ᶜᵐ. fr. 6

© June 9, 1911; 2c. July 15, 1911*; A—Foreign 3179; Bernard Grasset. (11–18984) 3734

Warner, Charles Franklin, 1857–

... Home decoration, by Charles Franklin Warner, sc. d. Garden City, N. Y., Doubleday, Page & company, 1911.

xii, 374 p. col. front., illus., plates. 21ᶜᵐ. (*Half-title:* The children's library of work and play) $1.75
At head of title: The library of work and play.

© June 29, 1911; 2c. July 8, 1911; A 292571; Doubleday, Page & co. (11–18818) 3735

Harvard College Library

AUG 25 1911

From the

PART I, BOOKS, GROUP 1

Bo. So. August 19th

3740

B 2035.4

Ambler, Henry Lovejoy.
History of dentistry in Cleveland, Ohio, by Henry Lovejoy Ambler ... Cleveland, O., Publishing house of the Evangelical association, C, Hauser, agent, 1911.
181 p. incl. front. (port.) illus. 23½ᶜᵐ. $1.50
© July 24, 1911; 2c. July 25, 1911; A 292848; H. L. Ambler, Cleveland. (11-19218) **3736**

American school of correspondence, *Chicago.*
Cyclopedia of applied electricity; a general reference work on direct-current generators and motors, storage batteries, electric wiring, electrical measurements, electric lighting, electric railways, power stations, power transmission, alternating-current machinery, telephony, telegraphy, etc., prepared by a corps of electrical experts, engineers and designers of the highest professional standing. Illustrated with over two thousand engravings ... Chicago, American school of correspondence, 1911.
7 v. fronts. (ports.) illus., plates, diagrs. 25ᶜᵐ. $19.80
CONTENTS.—v. 1. Elements; Electrical measurements; Wiring; Welding.—v. 2. Dynamos; Principles; Calculations; Design; Types.—v. 3. Motors; Management; Storage batteries; Lighting.—v. 4. Alternating current machinery; Station appliances.—v. 5. Power transmission; Transformers; Electric railways.—v. 6. Power stations; Telegraphy; Wireless transmission.—v. 7. Telephone equipment; Systems; Operation; Index.
© July 28, 1911; 2c. each Aug. 2, 1911*; A 292885; Amer. school of correspondence. (11-19200) **3737**

Anderson, William B.
Far north in India; a survey of the mission field and work of the United Presbyterian church in the Punjab, by William B. Anderson and Charles R. Watson ... Rev. ed. Philadelphia, Pa., The Board of foreign missions of the United Presbyterian church of North America [c1911]
ix p., 2 l., [2], 17–312 p. front., plates, ports., fold. map, diagrs. 19ᶜᵐ. $0.50
Bibliography: p. 307–309.
© July 17, 1911; 2c. Aug. 3, 1911*; A 292916; Board of foreign missions of the United Presbyterian church of N. A. (11-19213) **3738**

Auburtin, Victor.
... Die kunst stirbt. München, A. Langen [c1911]
72 p. 19½ᶜᵐ. M. 1.20
© June 6, 1911; 2c. July 19, 1911*; A—Foreign 3236; Albert Langen. (11-19364) **3739**

[Barrow, Merris Clark]
"Bill Barlow's" book. The world of just you and I; being a selection of the best of "the sagebrush philosopher's" writings, from the originals, as published by "Bill" at the Budget printshop. Douglas, Wy., Mrs. Minnie F. Barrow, 1911.
188 p. 2 port. (incl. front.) 19½ᶜᵐ. $1.50
© July 20, 1911; 2c. July 24, 1911*; A 292680; Minnie F. Barrow. (11-19392) **3740**

617

Bierce, Ambrose.
The collected works of Ambrose Bierce. v. 10. The opinionator. New York & Washington, The Neale publishing company, 1911.
6 p. l., 17–394 p. 22½ᶜᵐ. $10.00
© Aug. 7, 1911; 2c. Aug. 11, 1911*; A 295078; Neale pub. co. 3741

Bruns, Trude.
... Die doktorskinder ... Mainz, J. Scholz [ᶜ1911]
189, [1] p. illus. 19½ᶜᵐ. (*Half-title:* Mainzer volks- und jugendbücher[
[buch. 15]) M. 3
© June 7, 1911; 2c. July 20, 1911*; A—Foreign 3271; Jos. Scholz.
(11–19399) 3742

California. *District courts of appeal.*
Reports of cases determined ... C. P. Pomeroy, reporter, H. L. Gear, assistant reporter. v. 14. San Francisco, Bancroft-Whitney company, 1911.
xxx, 950 p. 23ᶜᵐ. $3.25
© Aug. 7, 1911; 2c. Aug. 14, 1911*; A 295120; Bancroft-Whitney co.
 3743

Cartwright, George, 1739–1819.
Captain Cartwright and his Labrador journal, ed. by Charles Wendell Townsend ... with an introduction by Dr. Wilfred T. Grenfell, illustrations from old engravings, photographs, and a map. Boston, D. Estes & company, 1911.
xxxiii, 385 p. incl. front. plates, ports.. fold. chart. 21½ᶜᵐ. $2.00
© July 26, 1911; 2c. July 27, 1911*; A 292749; Dana Estes & co.
(11–19222) 3744

Cherry, P P.
The Portage path, by P. P. Cherry. Akron, O., The Western Reserve company, 1911.
4 p. l., 106 p. plates, ports.. maps (1 fold.) 18½ᶜᵐ.
© July 21, 1911; 2c. Aug. 1, 1911*; A 292874; P. P. Cherry, Akron, O.
(11–19418) 3745

Delbridge, Charles Lomax.
Delbridge rosin and corn calculator ... by Charles L. Delbridge ... St. Louis, Mo., The Delbridge company. ᶜ1911.
[96] p. 32½ᶜᵐ. $5.00
© July 21, 1911; 2c. July 27, 1911*; A 292742; C. L. Delbridge, St. Louis.
(11–19385) 3746

Drummond, *Mrs.* May Isobel (Harvey)
The story of Quamin; a tale of the tropics, by May Harvey Drummond. New York and London, G. P. Putnam's sons, 1911.
xxii p., 1 l., 313 p. 19ᶜᵐ. $1.25
CONTENTS.— The story of Quamin.— Mary and Martha.— Forbidden fruit.—Methuselah's courtship.—"Busha" chicken.—How Puss come to catch Rat.— Anancy and Tiger. — Anancy and Dog. — Anancy and his family.
© June 23, 1911; 2c. Aug. 2, 1911*; A 292897; M. H. Drummond, Lennoxville, Can. (11–18976) 3747

Dwelle, *Mrs.* Carrie Etta Werking, 1864–

Mrs. Dwelle's cook book; a manual of practical recipes.
St. Louis, Mo., E. E. Carreras, printer [°1911]

174 p. 19ᶜᵐ. $1.00
© July 1, 1911; 2c. July 24, 1911*; A 292679; C. E. Dwelle, Indianapolis, Ind. (11–19401) **3748**

Faris, John Thomson, 1871–

Winning the Oregon country, by John T. Faris ... New York, Missionary education movement of the United States and Canada, 1911.

x, 241 p. front., illus., plates, ports., maps (1 fold.) facsim. 19¼ᶜᵐ. $0.50
© July 8, 1911; 2c. July 21, 1911*; A 292621; Missionary education movement of the U. S. & Canada. (11–19223) **3749**

Gettell, Raymond Garfield, *comp.*

Readings in political science, selected and edited by Raymond Garfield Gettell ... Boston, New York [etc.] Ginn and company [°1911]

xli, 528 p. 21¼ᶜᵐ. $2.25
© July 29, 1911; 2c. Aug. 1, 1911*; A 292873; R. G. Gettell, Hartford, Conn. (11–19377) **3750**

Griffis, William Elliot, 1843–

The unmannerly tiger, and other Korean tales [by] William Elliot Griffis. New York, Thomas Y. Crowell company [°1911]

xi, 155 p. col. front., col. plates. 20 x 16ᶜᵐ. $1.00
CONTENTS.—The unmannerly tiger.—Tokgabi and his pranks.—East Light and the bridge of fishes.—Prince Sandalwood, the father of Korea.—The rabbit's eyes.—Topknots and crockery hats.—The sneezing colossus.—A bridegroom for Miss Mole.—Old White Whiskers and Mr. Bunny.—Peach-Blossom, Plum-Blossom, and Cinnamon Rose.—Tokgabi's menagerie, cats and dogs.—The great stone fire eater.—Pigling and her proud sister.—Sir One Long Body and Madame Thousand Feet.—The sky bridge of birds.—A frog for a husband.—The voice of the bell.—The king of the sparrows.—The woodman and the mountain fairies.
© July 31, 1911; 2c. Aug. 3, 1911*; A 292906; Thomas Y. Crowell co. (11–18973) **3751**

Hamby, William Henry, 1874–

Tom Henry of Wahoo County; a story of the Ozarks, by William H. Hamby; drawings by Sears Gallagher. Philadelphia, The Westminster press, 1911.

189 p. front., plates. 19ᶜᵐ. $0.60
© July 31, 1911; 2c. Aug. 4, 1911*; A 292940; Trustees of the Presbyterian board of publ. & Sabbath school work, Philadelphia. (11–19413) **3752**

Heine, Heinrich, 1799–1856.

Heine und die frau, ausgewåhlte bekenntnisse und betrachtungen des dichters zusammengefügt von Karl Blanck. München, E. Rentsch, 1911.

195 p. 19¼ᶜᵐ. (*Added t.-p.:* Pandora, geleitet von O. Walzel [bd. 1]) M. 2.50
© May 21, 1911; 2c. July 18, 1911*; A—Foreign 3215; Eugen Rentsch verlag, g. m. b. h. (11–19398) **3753**

Hervey, Eliphalet Williams.

Flora of New Bedford and the shores of Buzzards Bay, with a procession of the flowers. Rev. ed. By E. W. Hervey. New Bedford, E. Anthony & sons incorp., printers, 1911.

137 p. 23ᶜᵐ.

© July 29, 1911; 2c. July 31, 1911; A 292867; E. W. Hervey, New Bedford, Mass. (11-19208) 3754

Howard, Norman.

Songs along the way, by Norman Howard. New York and Washington, The Neale publishing company, 1911.

92 p. 19ᶜᵐ. $1.25

© July 1, 1911; 2c. July 31, 1911*; A 292825; N. Howard, New York. (11-19393) 3755

Idarius, Peter.

The standard American drawing and lettering book. Full instructions for mixing colors, care of brushes, etc.; a modern treatise on the art of sign writing, drawn and arranged by Peter Idarius ... Chicago, Laird & Lee [ᶜ1911]

103 p. 25 x 36½ᶜᵐ. $1.75

Printed on one side of leaf only.

© July 26, 1911; 2c. July 31, 1911; A 292844; Wm. H. Lee, Chicago. (11-19201) 3756

King, *Mrs.* Mary Rayner Hyman, 1875–

The judgment, by Mary R. H. King. New York, The Demille publishing co. [ᶜ1911]

4 p. l., [7]–266 p. 20ᶜᵐ. $1.20

© July 26, 1911; 2c. July 28, 1911*; A 292772; M. R. H. King, Kent, Tex. (11-19410) 3757

Kirk, William Frederick, 1877–

Right off the bat; baseball ballads, by William F. Kirk; illustrations by H. B. Martin. New York, G. W. Dillingham company [ᶜ1911]

73 p. illus. 19½ᶜᵐ. $0.50

© July 29, 1911; 2c. Aug. 3, 1911*; A 292910; G. W. Dillingham co. (11-19304) 3758

Laboulaye, Édouard de.

Les chemins de fer de Chine, par Édouard de Laboulaye; préface de M. Robert de Caix; une carte hors texte. Paris, E. Larose, 1911.

2 p. l., 340 p. 2 maps (1 fold.) 23ᶜᵐ. fr. 6

© July 7, 1911; 2c. July 29, 1911*; A—Foreign 3303; Émile Larose. (11-19383) 3759

Launey, *Mme.* **H.**

... Leçons de morale, par M^me H. Launey ... et J. Launey ... 8 gravures hors texte. Paris, Librairie Larousse, ʻ1911·

200 p. incl. 8 pl. 20½ᶜᵐ. fr. 1.80
At head of title: Enseignement primaire supérieur.
© July 7, 1911; 2c. July 29, 1911*; A—Foreign 3294; Librairie Larousse
& co. (11–19216) 3760

Levere, William C.

The history of the Sigma alpha epsilon fraternity, by William C. Levere ... ₍Chicago?₎ Pub. for the Fraternity in its fifty-fifth year, 1911.

3 v. col. fronts., plates, ports., facsims. 24½ᶜᵐ.
CONTENTS.—v. 1. From the founding of the fraternity to the agitation
for northern extension.—v. 2. From the beginning of national life to the
revival of Pennsylvania Delta.—v. 3. From the Boston convention of 1900
to the meeting of the Supreme council in 1910.
© May 3, 1911; 2c. each June 24, 1911; A 292785; Sigma alpha epsilon
fraternity, United States. (11–19406) 3761

London, Jack, 1876–

The strength of the strong, by Jack London ... illustrations by Dan Sayre Groesbeck ... Chicago, C. H. Kerr & company, co-operative ₍ᶜ1911₎

30 p. illus., pl. 17½ᶜᵐ.
© July 25, 1911; 2c. Aug. 1, 1911*; A 292862; J. London, Glen Ellen, Cal.
(11–19381) ⸗ 3762

Lorenz, Carl, 1858–

Tom L. Johnson, mayor of Cleveland, by Carl Lorenz. New York, The A. S. Barnes company, 1911.

vi p., 2 l., 203 p. front. (port.) 3 pl. 19½ᶜᵐ. $1.00
© July 5, 1911; 2c. July 21, 1911*; A 292622; A. S. Barnes co.
(11–19221) 3763

Marcy, *Mrs.* **Mary Edna (Tobias)** 1877–

Shop talks on economics, by Mary E. Marcy ... Chicago, C. H. Kerr & company, co-operative ₍ᶜ1911₎

59 p. 19½ᶜᵐ.
© July 25, 1911; 2c. Aug. 1, 1911*; A 292860; Charles H. Kerr & co.
(11–19380) 3764

Massachusetts. *Supreme judicial court.*

Massachusetts reports, 207. Cases argued and determined ... October 1910–February 1911. Henry Walton Swift, reporter. Boston, Little, Brown, and company, 1911.

xxi, 762 p. 24ᶜᵐ. $2.00
© Aug. 10, 1911; 2c. Aug. 14, 1911*; A 295119; Little, Brown, and com-
pany. 3765

Michel, Auguste Marie, 1862–

A mutilated life story; strange fragments of an autobiography; sketches of experiences as a nurse and doctor

Michel, Auguste Marie—Continued
in an African hospital, and in the American West. By
Auguste Marie Michel ... Chicago, The author [c1911]
2 p. l., iii–xiii, 171 p. 2 port. (incl. front.) 19½ᶜᵐ. $1.50
CONTENTS.—Autobiographical.—As introduction.—Amid pain and pesti-
lence in Africa.—A lost story and a fight.—Roses and thorns of human life.
© June 27, 1911; 2c. July 3, 1911*; A 292262; A. M. M. Bochatay, Chicago.
(11–19217) **3766**

Mumford, James Gregory, 1863–
One hundred surgical problems; the experiences of
daily practice dissected and explained, by James G. Mum-
ford ... Boston, W. M. Leonard, 1911.
354 p. plates. 24ᶜᵐ.
© July 27, 1911; 2c. July 28, 1911*; A 292774; W. M. Leonard, Boston.
(11–19219) **3767**

Myers, John Francis, 1834–
The poems of John Francis Myers; together with biog-
raphy. Bloomington, Ill., Press of Frank I. Miller com-
pany, 1911.
2 p. l., [11]–213, 8 p. plates, ports. 20½ᶜᵐ. $1.50
© July 25, 1911; 2c. July 29, 1911*; A 292788; J. F. Myers, Bloomington,
Ill. (11–19390) **3768**

Nebraska. *Supreme court.*
Reports of cases ... September term, 1910–January
term, 1911. v. 88. Harry C. Lindsay, official reporter.
Lincoln, Neb., State journal company, 1911.
xlvii, 897 p. 22ᶜᵐ. $2.00
© Aug. 7, 1911; 2c. Aug. 12, 1911*; A 295092; Harry C. Lindsay, reporter
of the Supreme court, for the benefit of the state of Nebraska, Lincoln,
Neb. **3769**

Persky, Serge.
Les maîtres du roman russe contemporain: Tolstoï,
Tchékhof, Korolenko, Véressaief, Gorki, Andréief, Mé-
rejkowsky, Kouprine, etc.; avec 8 portraits. Paris, C.
Delagrave, 1912.
2 p. l., 347 p., 1 l. 8 port. 19½ᶜᵐ. fr. 3.50
© July 13, 1911; 2c. July 29, 1911*; A—Foreign 3307; Ch. Delagrave.
(11–19358) **3770**

Rayner, Emma.
The dilemma of Engeltie; the romance of a Dutch colo-
nial maid, by Emma Rayner ... with a frontispiece in
full colour by George Gibbs. Boston, L. C. Page & com-
pany, 1911.
4 p. l., 402 p., 1 l. col. front. 20ᶜᵐ. $1.50
© Aug. 1, 1911; 2c. Aug. 4, 1911*; A 292960; L. C. Page & co., inc.
(11–19412) **3771**

Free to serve; a tale of colonial New York, by Emma
Rayner ... New ed., with a frontispiece in full colour by
George Gibbs. Boston, L. C. Page & company, 1911.
2 p. l., 434 p. col. front. 20ᶜᵐ. $1.50
© Aug. 1, 1911; 2c. Aug. 4, 1911*; A 292957; L. C. Page & co., inc.
(11–19411) **3772**

Reinsch, Paul Samuel, 1869–

Public international unions; their work and organization, a study in international administrative law, by Paul S. Reinsch ... Boston and London, Pub. for the World peace foundation, Ginn and company, 1911.

viii, 191 p. 24½ᶜᵐ. $1.65

© Apr. 15, 1911; 2c. July 12, 1911*; A 292393; P. S. Reinsch, Madison, Wis. (11–19378) 3773

Rusch, Franz.

... Himmelsbeobachtung mit blossem auge, für schüler, von Franz Rusch ... mit 30 figuren im text und einer sternkarte als doppeltafel. Leipzig und Berlin, B. G. Teubner, 1911.

2 p. l., 223, [1] p. illus., fold. pl. 20½ᶜᵐ. (Dr. Bastian Schmids naturwissenschaftliche schülerbibliothek, 5) M. 3

© May 26, 1911; 2c. July 19, 1911*; A—Foreign 3256; B. G. Teubner. (11–19209) 3774

Salisbury, Mary E comp.

From day to day with the poets, comp. by Mary E. Salisbury. New York, Barse & Hopkins [ᶜ1911]

1 p. l., 7–126 p. front. (port.) 20ᶜᵐ. $0.75

© June 26, 1911; 2c. July 13, 1911*; A 292409; Barse & Hopkins. (11–19355) 3775

Steiner, Rudolf, 1861–

The education of children from the standpoint of theosophy, by Rudolf Steiner ... authorized translation from the 2d German ed. London, Theosophical publishing society, 1911.

83, [1] p. 17½ᶜᵐ. 1/-
"Translated by W. B."

© 1c. July 6, 1911; A ad int. 700; pubd. June 7, 1911; Weller Van Hook, Chicago. (11–19407) 3776

Stockard, Henry Jerome, 1858–

A study in southern poetry, for use in schools, colleges and the library, by Henry Jerome Stockard ... New York and Washington, The Neale publishing company, 1911.

2 p. l., 3–346 p. 22½ᶜᵐ. $2.50

© Apr. 21, 1911; 2c. July 31, 1911*; A 292836; Neale pub. co. (11–19356) 3777

Théry, Edmond, 1855–

La fortune publique de la France, par Edmond Théry ... Paris, C. Delagrave [ᶜ1911]

2 p. l., 256 p. 18½ᶜᵐ. fr. 3.50

© July 13, 1911; 2c. July 29, 1911*; A—Foreign 3306; Ch. Delagrave. (11–19384) 3778

623

Ticknor, Francis Orray, 1822–1874.

The poems of Francis Orray Ticknor, ed. and collected by his granddaughter Michelle Cutliff Ticknor. New York and Washington, The Neale publishing company, 1911.

3 p. l., [3]–268 p. 21ᶜᵐ. $2.00
Bibliography: p. 267-268.
© July 24, 1911; 2c. July 31. 1911*: A 292830; Neale pub. co.
(11–19391) **3779**

Todd, Elizabeth, 1876–

Through sunshine and shadow with the twenty-third Psalm, by Elizabeth Todd. [Chicago, Printed by Regan printing house, ᶜ1911]

63 p. 19ᶜᵐ. $1.00
© June 15, 1911; 2c. July 14. 1911*: A 292444: E. Todd, Chicago.
(11–19212) **3780**

Van Loan, Charles Emmett, 1876–

The big league, by Charles E. Van Loan. Boston, Small, Maynard & company [ᶜ1911]

252 p. incl. front. 19½ᶜᵐ. $1.00
CONTENTS.—The Crab.—The low brow.—The fresh guy.—The quitter.—The bush league demon. — The cast-off. — The busher. — A job for the pitcher.—The golden ball of the Argonauts.
© June 24, 1911; 2c. July 29. 1911*; A 292794; Small, Maynard & co.. inc.
(11–18971) **3781**

Whitehead, Alfred North, 1861–

An introduction to mathematics, by A. N. Whitehead ... New York, H. Holt and company; [etc., etc., ᶜ1911]

256 p. diagrs. 18ᶜᵐ. (Half-title: Home university library of modern knowledge, no. 15) $0.75
"Bibliography; note on the study of mathematics": p. 251-252.
© July 24, 1911; 2c. July 27, 1911*; A 292740; Henry Holt & co.
(11–18827) **3782**

Whitmore, Orin Beriah, 1851–

Bible wines vs. the saloon keeper's Bible; a study of the two-wine theory of the Scriptures and an arraignment of the argument for Biblical sanction of the use of intoxicants. By Rev. Orin B. Whitmore ... With an introduction by the Rev. W. H. G. Temple ... Seattle, Press of the Alaska printing co., 1911.

3 p. l., 115 p., 1 l. 23ᶜᵐ.
© July 1, 1911; 2c. July 17, 1911*; A 292490; O. B. Whitmore, Seattle, Wash. (11–18999) **3783**

Wilbur, William Allen, 1864–

Modes of imagination in English rhetoric [by] William Allen Wilbur ... Washington, D. C., Press of. Judd & Detweiler, inc., 1911.

84 p. 24½ᶜᵐ. $1.00
© July 20, 1911; 2c. July 20, 1911*; A 292611; W. A. Wilbur, Washington.
(11–19357) **3784**

B2035.4

Benignus, Wilhelm *i. e.* Hermann Wilhelm Heinrich, 1861–
Freiheitshelden. Dichtungen von Wilhelm Benignus ...
Pittsburgh, Pa., German-American printing & publishing
co., ᶜ1911.

ₗ3ᵢ–32 p. incl. front. (port.) illus. 22ᶜᵐ. $0.50
© July 26, 1911; 2c. July 28, 1911; A 292849; W. Benignus, Atlantic City,
N. J. (11–19575) 3785

Bunge, Martin Ludwig Detloff, 1876–
Abraham Lincoln; a historical drama in four acts, by
Martin L. D. Bunge. Milwaukee, Wis., Co-operative
printery ₗᶜ1911ᵢ
38 p. 15ᶜᵐ.
© July 29, 1911; 2c. July 31, 1911; D 24814; M. L. D. Bunge, Milwaukee.
(11–19582) 3785*

Chadbourne, Carolyn Mirriamᵢ
Man's relation to invisible forces, by Mayma S ∴ L∴
ₗ*pseud.*ᵢ New York, Roger brothers; ₗetc., etc.ᵢ 1911.
155 p. front. 20ᶜᵐ. $1.50
© July 21, 1911; 2c. July 24, 1911*; A 292669; Roger bros.
(11–19549) 3786

Ernst, Paul, 1866–
Brunhild, trauerspiel in drei aufzügen, von Paul Ernst.
Berlin, Verband deutscher bühnenschriftsteller ₗᶜ1911ᵢ
3 p. l., 86 p., 1 l. 20½ᶜᵐ.
© June 9, 1911; 2c. July 19, 1911*; D 24723; Vertriebstelle des Verbandes
deutscher bühnenschriftsteller. (11–19396) 3786*

Ninon de Lenclos, trauerspiel in drei aufzügen, von
Paul Ernst. Berlin, Verband deutscher bühnenschrift-
steller ₗᶜ1911ᵢ
4 p. l., 66 p. 20½ᶜᵐ.
© June 9, 1911; 2c. July 19, 1911*; D 24722; Vertriebstelle des Verbandes
deutscher bühnenschriftsteller. (11–19397) 3786**

Faure, Gabriel, 1877–
... Un jour de fête, pièce en un acte ... Paris, Charpen-
tier et Fasquelle, 1911.
35 p. 19ᶜᵐ.
© July 13, 1911; 2c. July 29, 1911*; D 24805; Eugene Fasquelle, Paris.
(11–19573) 3786***

Gilbert, Edward.
Ninety years of masonry; the story of Terre Haute
lodge no. 19, Free and accepted masons of Terre Haute,
Indiana, A. D. 1819–A. D. 1909. By Edward Gilbert. v. 1.
Terre Haute, Ind., Press of the Moore-Langen printing
co., 1911.
ix, ₗ11ᵢ–213 p. front. (port.) fold. tab. 20½ᶜᵐ.
© May 18, 1911; 2c. May 26, 1911*; A 289270; E. Gilbert, Terre Haute,
Ind. (11–14571) 3787

625

Graves, Anson Rogers, *bp.*, 1842–

The farmer boy who became a bishop; the autobiography of the Right Reverend Anson Rogers Graves ... Akron, O., The New Werner company, 1911.

220 p. front., ports. 19ᶜᵐ. $0.50

© Aug. 1, 1911; 2c. Aug. 2, 1911*; A 292889; A. R. Graves, Excelsior, Minn. (11–19548) **3788**

Hoyt, Arthur Stephen, 1851–

Public worship for non-liturgical churches, by Arthur S. Hoyt ... New York, Hodder & Stoughton, George H. Doran company [1911]

6 p. l., 3–164 p. 19½ᶜᵐ. $0.75

"Books on worship": p. 164.

© Aug. 1, 1911; 2c. Aug. 2, 1911*; A 292895; George H. Doran co. (11–19553) **3789**

Longfellow, Henry Wadsworth, 1807–1882.

Évangéline de Longfellow; traduction en vers français par A. Bollaert. Publiée à l'occasion du millénaire de la Normandie. Précédée d'une préface de l'Honorable Pascal Poirier ... New York, °1911·

127 p. 21ᶜᵐ.

© July 11, 1911; 2c. July 14, 1911; A 292562; Aristide Bollaert, New York. (11–19572) **3790**

Nietzsche, Friedrich Wilhelm, 1844–1900.

Ecce homo, by Friedrich Nietzsche. Portland, Me.. Smith & Sale, printers, 1911.

60 p. 19ᶜᵐ. $0.50

© July 15, 1911; 2c. July 26, 1911*; A 292708; T. N. Foulis, Portland, Me. (11–19555) **3791**

Ompteda, Georg, *freiherr* **von,** 1863–

Prinzess Sabine; roman von Georg freiherrn von Ompteda. [3. aufl.] Berlin, E. Fleischel & co., 1911.

2 p. l., 288 p. 20ᶜᵐ. M. 3.50

© June 26, 1911; 2c. Aug. 4. 1911*; A—Foreign 3323; Egon Fleischel & co. (11–19578) **3792**

Regnier, Elizabeth Chase.

Fruits of the spirit, by Elizabeth Chase Regnier. Los Angeles, Cal., Glass book binding co., 1911.

72 p., 1 l. incl. port. 15½ᶜᵐ. $0.50

© July 29, 1911; 2c. Aug. 5, 1911*; A 292984; E. C. Regnier, Los Angeles, Cal. (11–19554) **3793**

Reinhard, Hans.

Das rätsel der liebe. Roman von Hans Reinhard ... Stuttgart [etc.] Union deutsche verlagsgesellschaft [1911]

259 p. 19½ᶜᵐ. M. 4

© July 1, 1911; 2c. Aug. 4. 1911*; A—Foreign 3331; Union deutsches verlagsgesellschaft. (11–19577) **3794**

Richelsen, John.

A certain Samaritan, by Rev. John Richelsen. New York, Chicago [etc.] Broadway publishing co. [c1911]
108 p. 20ᶜᵐ. $1.00
© June 18, 1911; 2c. July 29, 1911; A 295010; J. Richelsen, Allison Park, Pa. (11-19551) 3795

Schmidtbonn, Wilhelm August, 1876–

Der spielende Eros; vier schwänke von Wilhelm Schmidtbonn. Berlin, E. Fleischel & co., 1911.
3 p. l., 122 p. col. plates. 20½ᶜᵐ.
CONTENTS.—Die versuchung des Diogenes.—Helena im bade.—Der junge Achilles.—Pygmalion.
© June 3, 1911; 2c. July 20, 1911*; D 24735; Egon Fleischel & co. (11-18452) 3795*

Shakespeare, William, 1564–1616.

... The tragedy of Romeo and Juliet, ed. by W. A. Neilson ... and A. H. Thorndike ... New York, The Macmillan company, 1911.
xvi, 158 p. front. (port.) 15ᶜᵐ. (Half-title: The Tudor Shakespeare, ed. by W. A. Neilson and A. H. Thorndike) $0.35
© July 26, 1911; 2c. July 27, 1911*; A 292726; Macmillan co. (11-19574) 3796

Simpson, Albert B 1844–

We would see Jesus, by Rev. A. B. Simpson. New York, The Alliance press company [c1910]
[64] p. 18ᶜᵐ. $0.25
© Dec. 22, 1910; 2c. Aug. 4, 1911*; A 292944; A. B. Simpson, New York. (11-19552) 3797

When the Comforter came, by Rev. A. B. Simpson. New York, The Alliance press company [c1911]
[128] p. 19ᶜᵐ. $0.60
© Mar. 13, 1911; 2c. Aug. 4, 1911*; A 292945; A. B. Simpson, New York. (11-19547) 3798

The Spectator.

... Addison, Steele, Budgell. Selections from The Spectator; ed. with introduction and notes by Edwin Fairley ... New York, C. Scribner's sons, 1911.
xxxvii, 181 p. front. (port) 16½ᶜᵐ. (Half-title: The Scribner English classics, ed. by F. H. Sykes) $0.25
"Brief bibliography": p ix–x
© June 17, 1911; 2c. June 23, 1911*; A 289988; Charles Scribner's sons. (11-18450) 3799

Townsend, Luther Tracy, 1838–

Three lectures on doctrine of the trinity; trinitarian and Unitarian points of view, by Professor L. T. Townsend, D. D., delivered under the auspices of the Boston Bible club, January, 1911. Boston, The Excelsior print, 1911.
48 p. 22ᶜᵐ $0.15
© July 31, 1911; 2c. Aug. 5, 1911; A 292982; L. T. Townsend, Brookline, Mass. (11-19550) 3800

Truberg-Knaudt, Emma.

Die familie Renter. Erzählung von Emma Truberg-Knaudt ... Mit 6 abbildungen nach originalzeichnungen von H. Barmführ. Schwerin i. Meckl., F. Bahn, 1912.

243, ₁1₁ p. illus., plates. 19½ᶜᵐ. M. 3

© June 23, 1911; 2c. Aug. 1, 1911*; A—Foreign 3311; Fr. Bahn.
(11-19579) 3801

Voorhees, Gardner Tufts.

The absorption refrigerating machine; a complete. practical elementary treatise on the absorption system of refrigeration, and its broad general principles of operation, by Gardner T. Voorhees ... Chicago, New York, Nickerson & Collins co. ₁1911₁

160 p. incl. tables, diagrs. fold. diagrs. 20ᶜᵐ. $2.00
p. 145-160. advertising matter.

© July 31, 1911; 2c. Aug. 3, 1911*; A 292904; Nickerson & Collins co.
(11-19604) 3802

Vrooman, Frank Buffington.

The new politics, by Frank Buffington Vrooman ... New York, Oxford university press, American branch ₁ᶜ1911₁

300 p. 22½ᶜᵐ. $1.50
CONTENTS.—The philosophy of Ishmael —The philosophy of the common good.—The democracy of nationalism.

© July 29, 1911; 2c. Aug. 2, 1911*; A 292890; Oxford univ. press, Amer. branch. (11-19557) 3803

Wood, Harriet Emma.

Echoes from Eden; or, The glorious trio of Genesis, by Harriet Emma Wood ... Philadelphia, The J. C. Winston company ₁1911₁

3 p. 1, 9-406 p. 21ᶜᵐ. $1.50

© July 10, 1911; 2c. Aug. 4, 1911*; A 292948; H. E. Wood, Rochester, Pa.
(11-19214) 3804

Yale university. Class of 1882.

A history of the class of '82, Yale college, 1878-1910. Published for the class. ₁New York, The De Vinne press₁ 1911.

xiii, 513 p. incl. front., illus., plates, port. groups. 24ᶜᵐ.
Part of port. groups accompanied by guard sheet with descriptive letterpress.
Committee: Edwin L. Dillingham, J. Culbert Palmer, William H. Parsons (ex-officio)

© July 11, 1911; 2c. July 27, 1911*; A 292734; Edwin Lynde Dillingham, New York. (11-19405) 3805

Zobeltitz, Fedor Karl Maria Hermann August von, 1857-

Die spur des ersten, von Fedor von Zobeltitz. 11.-25. tausend. Berlin-Wien, Ullstein & co., 1911.

485 p., 1 l. 19ᶜᵐ. M. 3

© June 21, 1911; 2c. Aug. 1, 1911*; A—Foreign 3312; Ullstein & co.
(11-19576) 3806

Ashley, Roscoe Lewis, 1872–

The American federal state; its historical development, government and policies, by Roscoe Lewis Ashley ... Rev. ed. New York, The Macmillan company, 1911.

xlvi p., 1 l., 629 p. 20ᶜᵐ. $2.00

Half-title: A text book in civics for high schools and colleges. "General references" at beginning of each chapter.

© Aug. 2, 1911; 2c. Aug. 3, 1911*; A 292913; Macmillan co.
(11–19622) 3807

Babcock, Ernest Brown, 1877–

Elementary school agriculture; a teacher's manual to accompany Hilgard and Osterhout's "Agriculture for schools of the Pacific slope," by Ernest B. Babcock and Cyril A. Stebbins. New York, The Macmillan company, 1911.

3 p. l., 65 p. illus. 18½ᶜᵐ. $0.25

"Best reference books": p. 64; "Reference lists of bulletins and circulars": p. 65.

© July 19, 1911; 2c. July 21, 1911*; A 292613; Macmillan co.
(11–19592) 3808

Bennett, Enoch Arnold, 1867–

What the public wants; a play in four acts, by Arnold Bennett ... New York, George H. Doran company [°1911]

151 p. 20ᶜᵐ.

© July 6, 1911; 2c. July 8, 1911; D 24760; George H. Doran co.
(11–18447) 3808*

Bernay, Alexander.

Armin, drama in vier akten, von Alexander Bernay. Berlin, Boll u. Pickardt, 1911.

75, [1] p. 22½ᶜᵐ.

© June 20, 1911; 2c. July 20, 1911*; D 24736; Boll u. Pickardt verlagsbuchhandlung. (11–18585) 3808**

[Borchardt, Georg Hermann] 1871–

Der wüstling; oder, Die reise nach Breslau, lustspiel in zwei akten von Georg Hermann [pscud.] Berlin, E. Fleischel & co., 1911.

2 p. l., 90 p. 20½ᶜᵐ.

© June 3, 1911; 2c. July 20, 1911*; D 24737; Egon Fleischel & co.
(11–18453) 3808***

Busch, Frederick Carl, 1873–

Laboratory manual of physiology, by Frederick C. Busch ... 2d ed. ... New York, W. Wood and company, 1911.

xi, 212 p. illus., diagrs. 20½ᶜᵐ. $1.50

© Aug. 5, 1911; 2c. Aug. 7, 1911*; A 292989; Wm. Wood & co.
(11–19608) 3809

629

Cornelius, Hans, 1863–
Einleitung in die philosophie, von Hans Cornelius ...
2. aufl. Leipzig und Berlin, B. G. Teubner, 1911.
xv, 376 p. 23ᶜᵐ. M. 6.00
© May 23, 1911; 2c. Aug. 5, 1911*; A—Foreign 3346; B. G. Teubner.
(11–19591) 3810

Davenport, Mrs. Laura.
The small family cook book, comp. with particular reference to economy in the kitchen and reducing the cost of living. By Laura Davenport ... Chicago, The Reilly & Britton co. [ᶜ1911]
256 p. front., plates. 20½ᶜᵐ. $1.25
© Aug. 18, 1911; 2c. Aug. 5, 1911*; A 292979; Reilly & Britton co.
(11–19605) 3811

Doherty, Walter J.
Poems, by Walter J. Doherty. [Philadelphia, Printed by J. B. Lippincott co.] 1911.
4 p. l., 11–117 p. 2 port. (incl. front.) 20ᶜᵐ.
© June 20, 1911; 2c. July 19, 1911*; A 292581; W. J. Doherty, Fort Worth, Tex. (11–19644) 3812

Drach, George.
The words of the law; twelve lectures on the Ten commandments; based on Dr. Martin Luther's Small catechism, part I. By the Rev. George Drach ... Burlington, Ia., The German literary board, 1911.
155 p. 20ᶜᵐ. $0.85
© July 12, 1911; 2c. July 17, 1911*; A 292496; R. Neumann, Burlington, Ia. (11–19588) 3813

Eitz, Carl.
Bausteine zum schulgesangunterrichte im sinne der tonwortmethode, von Carl Eitz. Mit 4 tafeln. Leipzig, New York [etc.] Breitkopf & Härtel, 1911.
vii, 167 p. 4 tab. 24½ᶜᵐ. M. 3.00
"Schriftenverzeichnis": p. [156]–167.
© July 22, 1911; 2c. Aug. 5, 1911*; A—Foreign 3343; Breitkopf & Härtel.
(11–19598) 3814

Fifty prize hunting stories; a collection of true experiences with a shot-gun, submitted in response to the offer of prizes by Harrington & Richardson arms co. Worcester, Mass., Harrington & Richardson arms co. [1911]
109 p. illus. 19½ᶜᵐ.
© Aug. 2, 1911; 2c. Aug. 7, 1911*; A 295000; Harrington & Richardson arms co. (11–19595) 3815

Fisher, Theodor.
Die liebesjagd, operette in drei akten, von Theodor Fisher; musik von Hermann Ritzau ... Hannover, Bühnenverlag niedersachsen g. m. b. h., 1911.
64 p. 18½ᶜᵐ.
© May 16, 1911; 2c. July 19, 1911*; D 24724; Bühnenverlag niedersachsen, g. m. b. h. (11–18723) 3815*

Fletcher, Horace, 1849–

Die esssucht und ihre bekämpfung, von Horace Fletch-
er. Autorisierte deutsche bearbeitung nebst zusätzen von
dr. A. V. Borosini ... Dresden, Holze & Pahl ₍°1911₎
xv, 224 p. front. (port.) plates. 19ᶜᵐ.
© May 6, 1911; 2c. July 19, 1911*; A—Foreign 3253; Holze & Pahl.
(11–19613) 3816

Folger, Eva Celine Grear, 1871–

The glacier's gift, with fourteen illustrations, by Eva
C. G. Folger. New Haven, Conn., The Tuttle, Morehouse
& Taylor company, 1911.
5 p. l., 145 p. front., plates, port. 21½ᶜᵐ.
© Aug. 2, 1911; 2c. Aug. 4, 1911*; A 292951; E. C. G. Folger, East Ha-
ven, Conn. (11–19626) 3817

Fuller, Arthur Franklin, 1880–

... An odd soldiery; being the autobiography of Arthur
F. Fuller ... ₍Rev. ed.₎ Fort Worth, Tex., Sphynx pub-
lishing company ₍1911₎
131, ₍1₎ p. incl. illus., pl., ports. 21½ᶜᵐ. $0.50
© July 26, 1911; 2c. Aug. 3, 1911*; A 292929; A. F. Fuller, Fort Worth,
Tex. (11–19632) 3818

Gillespie, Henry La Fayette.

The Universalist church and freemasonry. 2d ed. By
H. L. F. Gillespie ... ₍Manchester? Ia., 1911₎
75 p. illus. 19½ᶜᵐ. $0.35
Bibliography: p. 70–73.
© June 1, 1911; 2c. Aug. 7, 1911*; A 295003; H. L. F. Gillespie, Chicago.
(11–19590) 3819

Glascock, James Luther, 1852–

Revivals of religion; before they occur, how to pro-
mote them, while they are in progress, and after they are
over, by the Rev. J. L. Glascock ... with an introduction
by Rev. H. C. Morrison ... Louisville, Ky., Pentacostal
pub. co. ₍°1911₎
109 p. front. (port.) 19¼ᶜᵐ. $0.50
© July 31, 1911; 2c. Aug. 4, 1911*; A 292958; J. L. Glascock, Cincinnati.
(11–19587) 3820

Goodhue, Isabel.

Good things; ethical recipes for feast days and other
days, with graces for all the days, by Isabel Goodhue;
decorations by Walter Francis. San Francisco, P. Elder
& company ₍°1911₎
v, 50 p. front., illus. 19½ᶜᵐ. $1.00
© July 28, 1911; 2c. Aug. 2, 1911*; A 292893; Paul Elder & co.
(11–19618) 3821

Herrick, Robert, 1868–

New composition and rhetoric for schools, by Robert
Herrick ... and Lindsay Todd Damon ... A revision, by

Herrick, Robert—Continued
Lindsay Todd Damon. Chicago, New York, Scott, Foresman and company [°1911]

1 p. l., 499 p. 19½ᶜᵐ. (*On cover:* The Lake English series) $1.00
© Aug. 4, 1911; 2c. Aug. 7, 1911*; A 292993; Scott, Foresman & co.
(11-19620) 3822

Hoesch, Felix.
Die schweinezucht. Naturgeschichte, rassengeschichte, züchtung und haltung der hausschweine, ihre stellung in der betriebslehre und der volkswirtschaft. Ein lehrbuch von Felix Hoesch ... 1. bd. Hannover, M. & H. Schaper, 1911.

xiii, [1], 476 p. illus. 26ᶜᵐ. M. 19
© June 12, 1911; 2c. Aug. 5, 1911*; A—Foreign 3354; M. & H. Schaper.
(11-19596) 3823

[Januszkiewicz, Hans von]
... Der Dorf-Daniel. Roman. 1.–5. tausend. Leipzig, F. E. Fischer, 1911.

326 p. 20ᶜᵐ. M. 4.00
Author's pseudonym, Hans von Reinfels, at head of title.
© June 6, 1911; 2c. Aug. 5, 1911*; A—Foreign 3352; Hans von Januszkiewicz, Zingst, Germany. (11-19639) 3824

Kaup, William J.
Machine shop practice; a study of conditions for uses in trade, industrial and technical schools and modern machine shops, and manufacturing plants, by William J. Kaup ... 1st ed., 1st thousand. New York, J. Wiley & sons; [etc., etc.] 1911.

ix, 227 p. incl. illus., diagrs., forms. 21ᶜᵐ. $1.25
© Aug. 2, 1911; 2c. Aug. 7, 1911*; A 292999; W. J. Kaup, Wilkinsburg, Pa. (11-19606) 3825

Kobrin, Leon, 1872–
The great Jew, by Leon Kobrin. New York, Hebrew publishing company, °1911·

111 p. 20ᶜᵐ.
Added title and text in Yiddish.
© July 14, 1911; 2c. July 15, 1911; D 24761; Hebrew pub. co.
(11-18718) 3825*

Leube, Wilhelm Olivier von, 1842–
Spezielle diagnose der inneren krankheiten; ein handbuch für ärzte und studierende, nach vorlesungen bearbeitet von dr. Wilhelm v. Leube ... 1. bd. 8. neu bearb. aufl. ... Leipzig, F. C. W. Vogel, 1911.

xii, 574 p. illus. 25½ᶜᵐ. M. 14
© July 5, 1911; 2c. Aug. 5, 1911*; A—Foreign 3353; F. C. W. Vogel.
(11-19616) 3826

Linebarger, Charles Estes.
A laboratory manual of physics for use in secondary schools, by C. E. Linebarger ... Boston, New York [etc.] D. C. Heath & co. [°1911]
175 p. illus., diagrs. 25 x 21½ᶜᵐ. $0.80
© July 9, 1911; 2c. Aug. 5, 1911*; A 292983; D. C. Heath & co.
(11-19607) 3827

Locke, William John, 1863–
The glory of Clementina, by William J. Locke; illustrations by Arthur I. Keller. New York, John Lane company, 1911.
4 p. l., 367 p. front., plates. 19½ᶜᵐ. $1.30
© Aug. 4, 1911; 2c. Aug. 8, 1911*; A 295008; John Lane co.
(11-19661) 3828

Marinoni, Antonio, 1879–
An Italian reader, with notes and vocabulary, by A. Marinoni ... 2d ed., rev. New York, William R. Jenkins co. [°1911]
iv p., 1 l., 181 p. 19ᶜᵐ. $0.90
© Aug. 3, 1911; 2c. Aug. 7, 1911*; A 292998; William R. Jenkins co.
(11-19636) 3829

National electrical contractors association.
The electrical equipment of the home ... issued co-operatively by the National electrical contractors association, National electric lamp association, and the Commercial section of the National electric light association. New York, 1911.
40 p. illus. (incl. plans) 23½ᶜᵐ. $0.50
© July 19, 1911; 2c. July 28, 1911*; A 292766; Philip S. Dodd, Cleveland.
(11-19602) 3830

The new American encyclopedic dictionary of the English language. Robert Hunter ... editor in chief, assisted by over 100 of the most eminent scholars of America and Europe. Complete and unabridged, defining thousands of encyclopedic words not found in any other dictionary of the English language. Chicago, The Riverside publishing company, 1911.
5 v. illus., plates (partly col., partly double) fold. maps. 28½ᶜᵐ. $25.00
Ed. by Edward T. Roe, Le Roy Hooker, and Thomas W. Handford: the Encyclopædic dictionary, ed. by Robert Hunter, was used as the basis of the work. cf. Pref.
Issued in 1902 as v. 6–12 of The Anglo-American encyclopedia and dictionary.
© Aug. 1, 1911; 2c. each Aug. 4, 1911*; A 292952; New Werner co., Akron, O. (11-19617) 3831

Ordonneau, Maurice, 1854–
... Helda, opérette en trois actes, musique de Auguste M. Fechner ... Paris, A. M. Fechner et cⁱᵉ, 1911.
118 p., 1 l. 19ᶜᵐ.
Libretto.
At head of title: Maurice Ordonneau et de Godement-Farlane.
© July 15, 1911; 2c. July 24, 1911*; D 24759; A. M. Fechner.
(11-18715) 3831*

Perfall, Karl Theodor Gabriel Christoph, *freiherr* **von,**
1851–
Denn das geld, roman von Karl von Perfall. Berlin,
E. Fleischel & co., 1911.
2 p. l., 316 p., 1 l. 20ᶜᵐ. M. 4
© June 30, 1911; 2c. Aug. 4, 1911*; A—Foreign 3329; Egon Fleischel &
co. ('1–19641) 3832

Pratt, *Mrs.* Ella (Farman) 1843–1907.
Happy children; a book of bed-time stories, by Ella
Farman Pratt. New York, Thomas Y. Crowell company
[ᶜ1911]
vii, 157 p. incl. col. front. col. plates. 20ᶜᵐ. $1.00
CONTENTS.—Little Miss Christmas.—The doll's sister.—The birds that
went to church.—Dorothy's picnic.—The little wild-flower club.—The little
girl that was lost.—"Little Esther Court, S. P. C. A."—Little Hope's coun-
try summer.
© Aug. 5, 1911; 2c. Aug. 10, 1911*; A 295046; Thomas Y. Crowell co.
(11–19663) 3833

Pratt, Henry Barrington, 1832–
The buried nations of the infant dead; a study in escha-
tology, by Rev. H. B. Pratt ... Hackensack, N. J., B. G.
Pratt company, 1911.
3 p. l., v, 158 p. front. (port.) 19ᶜᵐ. $0.75
© June 23, 1911; 2c. June 22, 1911; A 295016; H. B. Pratt, Hackensack,
N. J. (11–19589) 3834

Prod'homme, J G 1871–
Gounod (1818–1893) sa vie et ses œuvres, d'après des
documents inédits. Ouvrage précédé d'une étude sur la
famille du compositeur au xviiiᵉ siècle, et suivi d'une
bibliographie musicale et littéraire, d'une iconographie,
d'actes d'état-civil, de pièces d'archives, etc., par J.-G.
Prod'homme et A. Dandelot. Préface de M. Camille
Saint-Saëns. 40 planches hors texte ... Paris, C. Dela-
grave [ᶜ1911]
2 v. plates, ports., facsims. 19ᶜᵐ.
© July 13, 1911; 2c. each July 29, 1911*; A—Foreign 3305; Ch. Delagrave.
(11–19597) 3835

Rauscher, Ulrich.
... Richard Dankwards weltgericht, roman. Frankfurt
a/Main, Rütten & Loening, 1911.
2 p. l., 7–215, [1] p. 18½ᶜᵐ. M. 4
© June 24, 1911; 2c. Aug. 4, 1911*; A—Foreign 3332; Literarische an-
stalt Rütten & Loening. (11–19637) 3836

Raymond, Fr. V.
... Der freund der nervösen und skrupulanten, ein rat-
geber für leidende und gesunde; mit einem vorwort von
dr. med. Bonnaymé ... und einem empfehlungs-schreiben
von dr. med. Dubois ... [3. umgearb. und verm. aufl.
5. bis 10. tausend] Wiesbaden, H. Rauch, 1911.
xvi, 310 p., 1 l. 21ᶜᵐ. M. 3.50
© May 25, 1911; 2c. Aug. 5, 1911*; A—Foreign 3351; Hermann Rauch.
(11–19614) 3837

Reed, Alfred Zantzinger, 1875–

... The territorial basis of government under the state
constitutions, local divisions and rules for legislative ap-
portionment, by Alfred Zaṅtzinger Reed, PH. D. New
York, Columbia university, Longmans, Green & co.,
agents; ₍etc., etc.₎ 1911.

250 p. 25ᶜᵐ. (Studies in history, economics and public law. edited by
the Faculty of political science of Columbia university, vol. XL, no. 3,
whole no. 106) $1.75
"Bibliographical note": p. 242–250.
© July 3, 1911; 2c. Aug. 1, 1911*; A 292882; A. Z. Reed, New York.
(11–19621) 3838

Römer, Paul Heinrich, 1876–

Die epidemische kinderlähmung (Heine-Medinsche
krankheit). Von professor dr. Paul H. Römer ... Mit
57 in den text gedruckten abbildungen. Berlin, J. Sprin-
ger, 1911.

viii, 256 p. illus. 24½ᶜᵐ. M. 10
"Literatur": p. ₍237₎–256.
© June 24, 1911; 2c. Aug. 4, 1911*; A—Foreign 3328; Julius Springer.
(11–19615) 3839

St. John, Edward Porter.

Child nature & child nurture; a text-book for parents'
classes, mothers' clubs, training classes for teachers of
young children, and for home study, by Edward Porter
St. John ... Boston, New York ₍etc.₎ The Pilgrim press
₍1911₎

xi p., 1 l., 106 p. front., plates. 19½ᶜᵐ. $0.75
Partly reprinted from various periodicals.
© Aug. 1, 1911; 2c. Aug. 4, 1911*; A 292954; Luther H. Cary, Boston.
(11–19623) 3840

Schering, Arnold i. e. Carl Dietrich Arnold, 1877–

Geschichte des oratoriums, von Arnold Schering.
Leipzig, Breitkopf & Härtel, 1911.

4 p. l., ₍3₎–647, xxxix p. 23½ᶜᵐ. (Added t.-p.: Kleine handbücher der
musikgeschichte nach gattungen ... bd. III) M. 10
With music.
© July 7, 1911; 2c. Aug. 5, 1911*; A—Foreign 3341; Breitkopf & Härtel.
(11–19599) 3841

Schneider, Karl, 1879–

Die vulkanischen erscheinungen der erde, von dr. Karl
Schneider; mit 50 abbildungen, karten und profilen. Ber-
lin, Gebrüder Borntraeger, 1911.

viii, 272 p. illus. (incl. maps) 26ᶜᵐ. M. 12
© May 29, 1911; 2c. July 18, 1911*; A—Foreign 3212; Gebrüder Born-
traeger. (11–19609) 3842

Schüpbach, W.
... Porte-folio of designs for dress embroidery ₍by₎ W. Schupbach ₍and₎ J. Gysel ... v. 1. New York ₍L. Boeker, printer₎ 1911.
52 pl. 41½ᶜᵐ. $6.00
Cover-title.
© Apr. 1, 1911; 2c. Apr. 5, 1911*: A 283950; W. Schüpbach, J. Gysel, New York. (11-19656) **3843**

Sewell, Anna, 1820–1878.
Black Beauty; the autobiography of a horse, by Anna Sewell; with colored illustrations by John M. Burke. New York, The Platt & Peck co. ₍ᶜ1911₎
vii, 9–357 p. incl. plates. col. front., col. plates. 21½ᶜᵐ. $1.25
© July 26, 1911; 2c. Aug. 1, 1911; A 295015; Platt & Peck co. ₍Copyright is claimed on illustrations only₎ (11-19662) **3844**

Sinclair, Upton Beall, jr., 1878–
Samuel der suchende, roman von Upton Sinclair ... Hannover, A. Sponholtz, g. m. b. h. ₍ᶜ1911₎
2 p. l., 256 p. 19ᶜᵐ. M. 3
© May 31, 1911; 2c. Aug. 4, 1911*; A—Foreign 3322; Adolf Sponholtz verlag, g. m. b. h. (11-19643) **3845**

Soyer, Nicolas.
Soyer's paper-bag cookery, by Nicolas Soyer ... New York, Sturgis & Walton company, 1911.
3 p. l., 5–130 p. 17ᶜᵐ. $0.60
© Aug. 2, 1911; 2c. Aug. 5, 1911*: A 292976; Sturgis & Walton co. (11-19603) **3846**

Strahorn, Mrs. Carrie Adell.
Fifteen thousand miles by stage; a woman's unique experience during thirty years of path finding and pioneering from the Missouri to the Pacific and from Alaska to Mexico, by Carrie Adell Strahorn; with 350 illustrations from drawings by Charles M. Russell and others, and from photographs. New York ₍etc.₎ G. P. Putnam's sons, 1911.
xxv p., 1 l., 673 p. front. (port.) illus., col. plates. 23½ᶜᵐ. $4.00
© July 21, 1911; 2c. Aug. 2, 1911*: A 292896; C. A. Strahorn, Spokane, Wash. (11-19627) **3847**

Stright, Maurice T.
A pocket manual of the Stright system of shorthand, by Maurice T. Stright. Manila, P. I., 1910.
4 p. l., 89, ₍5₎ 17½ᶜᵐ.
© May 30, 1910; 2c. Nov. 5, 1910: A 295029; M. T. Stright, Manila, P. I. (11-19651) **3848**

Thackeray, William Makepeace, 1811–1863.
The English humorists of the eighteenth century, by William Makepeace Thackeray; ed. by Stark Young ... Boston, New York ₍etc.₎ Ginn and company ₍ᶜ1911₎
xxv, 285 p. 17½ᶜᵐ. (On cover: Standard English classics)
Contents.—Swift.—Congreve and Addison.—Steele.—Prior, Gay, and Pope.—Hogarth, Smollett, and Fielding.—Sterne and Goldsmith.
© Aug. 3, 1911; 2c. Aug. 7, 1911*; A 292994; Stark Young, Austin, Tex. (11-19619) **3849**

$B2035.4$

PART I, BOOKS, GROUP I

... The **Atlantic** reporter, with key-number annotations. v. 79. Permanent ed. ... April 6–July 6, 1911. St. Paul, West publishing co., 1911.

xv, 1214 p. 26¼ᶜᵐ. (National reporter system—State series) $4.00
© Aug. 16, 1911; 2c. Aug. 23, 1911*; A 293692; West pub. co. 3850

Benziger's advanced geography for the use of Catholic schools. New York, Cincinnati [etc.] Benziger brothers, 1911.

225 p. incl. illus., maps. 2 col. pl. 31½ x 25ᶜᵐ. $1.25
© July 24, 1911; 2c. Aug. 3, 1911*; A 292908; Benziger bros.
(11–20100) 3851

Blair, Barbara.

The journal of a neglected bull dog; being impressions of his master's love affairs, by Barbara Blair; drawings by Eugene A. Furman. Philadelphia, G. W. Jacobs & co. [1911]

6 p. l., 9–187 p. front., plates. 18ᶜᵐ. $0.75
© July 31, 1911; 2c. Aug. 10, 1911*; A 295042; George W. Jacobs co.
(11–19987) 3852

Brummer, Sidney David.

... Political history of New York state during the period of the civil war, by Sidney David Brummer, PH. D. New York, Columbia university, Longmans, Green & co., agents; [etc., etc.] 1911.

451 p. 25ᶜᵐ. (Studies in history, economics and public law, edited by the Faculty of political science of Columbia university, vol. xxxix, no. 2, whole no. 103) $3.00
"Bibliographical note": p. 448–451.
© July 3, 1911; 2c. Aug. 1, 1911*; A 292879; S. D. Brummer, New York.
(11–19977) 3853

Bubendey, Johann Friedrich.

Liebesboykott, operette in 3 akten, von Johann Friedrich Bubendey; musik von Alberto Curci ... Berlin, G. Lehmann, ᶜ1911·

75 p. 21½ᶜᵐ.
"Als manuskript gedruckt."
© 1c. July 28, 1911; D 24804; George Lehmann.
(11–20108) 3853*

Buschan, Georg Hermann Theodor, 1863 –

... Vom jüngling zum mann; ein ernstes wort zur sexuellen lebensführung. 1. bis 6. tausend. Stuttgart, Strecker & Schröder, 1911.

4 p. l., 88 p. 18ᶜᵐ. M. 2
© June 3, 1911; 2c. Aug. 4, 1911*; A—Foreign 3330; Strecker & Schröder.
(11–19982) 3854

637

Byers, Charles Alma, *comp.*

Quotations on art, music and literature, with nativity, for what noted, and dates of birth and death of the authors quoted. Comp. by Charles Alma Byers ... Los Angeles, Cal., The C. A. Byers publishing company, 1911.

6 p. l., ₍15₎–153 p. 18½ᶜᵐ. $1.25

© July 25, 1911; 2c. Aug. 3, 1911*; A 292935; C. A. Byers, Los Angeles. (11–20094) **3855**

• **California.** *Laws, statutes, etc.*

California street laws; a discussion of the general laws of California relating to the opening and improving of streets within incorporated cities and towns, of charter provisions, and of the principles relating to street work by private contract. with forms and an appendix containing the text of the statutes, by Ernest Stoddard Page. San Francisco, Bancroft-Whitney company, 1911.

xxiii, 1299 p. forms., diagrs. 23½ᶜᵐ. $7.50

© July 22, 1911; 2c. July 31, 1911*; A 292815; E. S. Page, Oakland, Cal. (11–20125) **3856**

Caro, Mathilde Tillie, 1870–

Restricted diet made palatable; recipes for cooking appetizing dishes in complete accordance with the dietary restrictions of physicians for diabetes or obesity, and such other conditions as forbid the use of sugars, starches and other carbo-hydrates. By M. T. Caro; with an introduction by Albert Abrams, M. D. Boston and San Francisco, Laurens Maynard company, 1911.

xiii, 112 p. 20ᶜᵐ. $1.00

© July 20, 1911; 2c. July 26, 1911*; A 292723; Laurens Maynard co. (11–20122) **3857**

Champ, Paul.

Lawn-tennis, golf, croquet, polo, par MM. Paul Champ, F. de Bellet, A. Després, F. Caze de Caumont. 50 gravures. Paris, Bibliothèque Larousse, ᶜ1911·

80 p. illus., plates. 19½ᶜᵐ. fr. 2

© July 7, 1911; 2c. July 29, 1911*; A—Foreign 3296; Librairie Larousse & co., Paris. (11–20098) **3858**

Chapin, Francis Stuart, 1888–

... Education and the mores, a sociological essay, by F. Stuart Chapin ... New York, Columbia university. Longmans, Green & co., agents; ₍etc., etc.₎ 1911.

106 p. 25ᶜᵐ. (Studies in history, economics and public law, edited by the Faculty of political science of Columbia university, vol. xliii, no. 2 whole no. 110) $0.75

Bibliography: p. 105–106.

© July 11, 1911; 2c. Aug. 1, 1911*; A 292883; F. S. Chapin, New York. (11–19976) **3859**

Crum, A R ed.
Romance of American petroleum and gas ... v. 1. A. R. Crum, editor in chief, A. S. Dungan, associate editor. New York, N. Y., Romance of American petroleum and gas co. [°1911]
363 p. front., illus., plates, ports. 28½ᶜᵐ. $10.00
© June 23, 1911; 2c. July 13, 1911; A 292528; Romance of Amer. petroleum & gas co. (11–20116) 3860

Davis, Charles Belmont, 1866–
Tales of the town, by Charles Belmont Davis ... New York, Duffield and company, 1911.
4 p. l., 339 p. front., plates. 19½ᶜᵐ. $1.30
CONTENTS.—The gray mouse.—The romance of a rich young girl.—Once to every man.—The conquerors.—The most famous woman in New York.—Where ignorance was bliss.—The extra girl.—The rescue.—Marooned.—The song and the Savage
© Aug. 8, 1911; 2c. Aug. 10, 1911*; A 295049; Duffield & co. (11–19989) 3861

Dean, John Marvin.
Rainier of the last frontier, by John Marvin Dean. New York, Thomas Y. Crowell company [1911]
vii, 373 p. col. front. 20½ᶜᵐ. $1.20
© Aug. 1, 1911; 2c. Aug. 10, 1911*; A 295045; Thomas Y. Crowell co. (11–19986) 3862

Demeny, Georges, 1850–
... Science et art du mouvement; éducation physique de la jeune fille; éducation et harmonie des mouvements. Paris, Librairie des Annales, 1911.
197 p., 1 l. illus., plates. 21½ᶜᵐ. fr. 2.50
© July 10, 1911; 2c. July 29, 1911*; A—Foreign 3304; Librairie des annales. (11–20097) 3863

Dolge, Alfred, 1848–
Pianos and their makers, by Alfred Dolge; a comprehensive history of the development of the piano from the monochord to the concert grand player piano. 300 illustrations. Covina, Cal., Covina publishing company, 1911.
478 p. front., illus., plates, ports. 25½ᶜᵐ.
© Aug. 5, 1911; 2c. Aug. 10, 1911*; A 295054; A. Dolge, Covina, Cal. (11–20107) 3864

Fletcher, Charles Robert Leslie, 1857–
A history of England, by C. R. L. Fletcher and Rudyard Kipling; pictures by Henry Ford. Oxford, At the Clarendon press; [etc., etc.] 1911.
250 p. illus. (incl. maps) col. plates. 25½ᶜᵐ. 7/6d.
© 1c. Aug. 12, 1911; A ad int. 737; pubd. July 15, 1911; C. R. L. Fletcher and Rudyard Kipling, London. (11–20110) 3865

Hall, James Parker, 1871–
Constitutional law [by] James Parker Hall ... Chicago, La Salle extension university [°1911]
1 p. l., xiv, 457 p. 24ᶜᵐ. $3.00
"This volume is one in a series entitled. American law and procedure"
© July 27, 1911; 2c. July 31, 1911*; A 292821; La Salle extension univ. (11–20126) 3866

Homerus.

The Odyssey of Homer, tr. into English verse by Alexander Pope; ed., with introduction and notes by Edgar S. Shumway, PH. D. ... and Waldo Shumway, B. A. New York, The Macmillan company, 1911.

xxxix, 478 p. front. (port.) 14½ᶜᵐ. ₍Macmillan's pocket American and English classics₎ $0.25

Bibliography: p. xxxiii–xxxix

© Aug. 2, 1911; 2c. Aug. 3, 1911*; A 292915; Macmillan co.

(11–19994) 3867

... The **Indiana** digest. A digest of the decisions of the courts of Indiana reported in vols. 1–8, Blackford's reports, Smith's reports, Wilson's Superior court reports, vols. 1–*172, Indiana reports, vols. 1–*43, Indiana Appellate court reports, vols. 1–91, Northeastern reporter; vol 92, pp. 1–480 ... comp. under the American digest classification. v. 8. Pleading–School lands. St. Paul, West publishing co., 1911.

iii, 1021 p. 26½ᶜᵐ. (American digest system. State series) $6.00

© July 26, 1911; 2c. Aug. 23, 1911*; A 293694; West pub. co. 3868

₍Kaler, James Otis₎ 1848–

Boy scouts in the Maine woods, by James Otis ... illustrated by Copeland. New York, Thomas Y. Crowell company ₍ᶜ1911₎

3 p. 1., 283 p. front., plates. 19½ᶜᵐ. $1.25

© Aug. 7, 1911; 2c. Aug. 10, 1911*; A 295047; Thomas Y. Crowell co.

(11–19985) 3869

Kemp, Oliver.

Wilderness homes; a book of the log cabin, by Oliver Kemp; illustrated by the author. (2d ed. rev.) New York, The Outing publishing company, 1908 ₍ᶜ1911₎

x p., 2 l., 3–163, ₍1₎ p. incl. front., illus. plates. 21½ᶜᵐ. $1.25

© July 20, 1911; 2c. July 24, 1911; A 292972; Outing pub. co.

(11–19990) 3870

Ker, Edmund Thomas.

River and lake names in the United States, by Edmund Thomas Ker. New York, Woodstock publishing company, 1911.

47 p. 20½ᶜᵐ. $0.50

© July 21, 1911; 2c. July 24, 1911*; A 292673; Woodstock pub. co.

(11–20101) 3871

Leiter, Rebecca, "*Mrs.* Henry Leiter," 1854– *comp.*

The Flower city cook book; comp. by Mrs. Henry Leiter and Miss Sara Van Bergh. Pub. under the auspices of the sisterhood affiliated with congregation Berith Kodesh. Rochester, N. Y. ₍The Dubois press, printers₎ 1911.

ix, 188 p. 23½ᶜᵐ. $1.25

© July 27, 1911; 2c. Aug. 5, 1911*; A 292971; Rebecca Leiter and Sara Van Bergh, Rochester, N. Y. (11–20117) 3872

Louisiana. *Supreme court.*

Reports ... Annotated ed. ... Book 14, containing a verbatim report of vols. 18 & 19 Louisiana reports. St. Paul, West publishing co., 1911.

2 v. in 1. 22½ᶜᵐ. $7.50

© July 31, 1911; 2c. Aug. 23, 1911*; A 293690; West pub. co. 3873

McCabe, Olivia.

The rose fairies, by Olivia McCabe; with pictures by Hope Dunlap. Chicago & New York, Rand, McNally & company [°1911]

159 p. col. front., illus., col. plates. 23½ᶜᵐ. $1.25

CONTENTS.—The rose fairies.—The white cock of the enchanted palace.—The shoes of silence.—Fairy Twilight and the princess.—Prince of the Sun Bright Isle.—The little girl and the crow in fairyland.

© Aug. 2, 1911; 2c. Aug. 4, 1911*; A 292955; Rand, McNally & co.
(11–19995) 3874

Mantovano, Battista, 1448–1516.

The eclogues of Baptista Mantuanus, ed., with introduction and notes, by Wilfred P. Mustard ... Baltimore, The Johns Hopkins press, 1911.

156 p. 19½ᶜᵐ. $1.50

© June 22, 1911; 2c. June 26, 1911*; A 292063; Johns Hopkins press.
(11–16340) 3875

... The **New York** supplement, with key-number annotations. v. 128. Permanent ed. (New York state reporter, vol. 162) ... April 10–May 22, 1911. St. Paul, West publishing co., 1911.

xxii, 1218 p. 23½ᶜᵐ. (National reporter system. N. Y. supp. and state reporter) $3.50

© July 27, 1911; 2c. Aug. 23, 1911*; A 293691; West pub. co. 3876

Notes on the Minnesota reports, including the citations of each case as a precedent (1) by any court of last resort in any jurisdiction in this country; (2) by the extension and thorough annotations of the leading annotated reports; (3) by all important modern text-books. v. 2, including 26–39 Minn. rep. Rochester, N. Y., The Lawyers co-operative publishing company, 1911.

1 p. l., 1326 p. 24ᶜᵐ. $7.50

© Aug. 15, 1911; 2c. Aug. 19, 1911*; A 295279; Lawyers co-operative pub. co. 3877

Paxson, Susan.

Two Latin plays for high-school students, by Susan Paxson ... Boston, New York [etc.] Ginn and company [°1911]

xii, 39 p. 19ᶜᵐ. $0.45

CONTENTS.—A Roman school.—A Roman wedding.

© June 12, 1911; 2c. July 13, 1911*; A 292431; S. Paxson, Omaha, Neb.
(11–20095) 3878

Pearson, Henry Carr.

Essentials of Latin for beginners, by Henry Carr Pearson ... Rev. New York, Cincinnati [etc.] American book company [c1911]

320 p. illus. (incl. map) 19ᶜᵐ. (*Half-title:* Morris and Morgan's Latin series ...) $0.90

© Aug. 7, 1911; 2c. Aug. 9, 1911*; A 295026; H. C. Pearson, New York.
(11-19996) 3879

Petersen, Cornelius.

Internationale reduktions-tabeller, udgivne af Cornelius Petersen. København, Brødrene Salmonsens forlag, 1911.

155 p. 26½ᶜᵐ. kr. 6.50

© June 15, 1911; 2c. July 1, 1911; A—Foreign 3339; C. Petersen, Copenhagen. (11-19983) 3880

Pettersen, Wilhelm Mauritz, 1860–

... Fra bjørkeskog og granholt ... Chicago, Ill., John Anderson pub. co., 1911.

256 p. incl. front. (map) illus., pl., ports. fold. map. 20½ᶜᵐ. $1.00

© June 28, 1911; 2c. July 12, 1911*; A 292397; W. Pettersen, Chicago.
(11-20111) 3881

Phillips, Wendell Christopher, 1857–

Diseases of the ear, nose and throat, medical and surgical, by Wendell Christopher Phillips ... illustrated with 545 half-tone and other text engravings, many of them original; including 31 full-page plates, some in colors. Philadelphia, F. A. Davis company, 1911.

xvi, 847 p. front., illus. (partly col.) plates (partly col.) 24½ᶜᵐ. $6.00

© July 27, 1911; 2c. July 29, 1911*; A 292790; F. A. Davis co.
(11-20124) 3882

Porter, George Henry, 1878–

... Ohio politics during the civil war period, by George H. Porter ... New York, Columbia university, Longmans, Green & co., agents; [etc., etc.] 1911.

255 p. maps. 25½ᶜᵐ. (Studies in history, economics and public law, edited by the Faculty of political science of Columbia university, vol. XL, no. 2, whole no. 105) $1.75

"Bibliographical note": p. 255.

© July 3, 1911; 2c. Aug. 1, 1911*; A 292881; G. H. Porter, New York.
(11-19978) 3883

Prévost, Marcel, 1862–

... Vom weiblichen überall (Feminités); einzig berechtigte übersetzung aus dem französischen von F. gräfin zu Reventlow. München, A. Langen [c1911]

2 p. l., 203 p., 1 l. 19ᶜᵐ.

© June 8, 1911; 2c. July 19, 1911*; A—Foreign 3230; Albert Langen.
(11-19997) 3884

Rogues de Fursac, Joseph *i. e.* **Marie Henri Joseph Pierre Étienne,** 1872–
Manual of psychiatry, by J. Rogues de Fursac ... tr. and ed. by A. J. Rosanoff ... 3d American from the 3d French ed. Rev. and enl. New York, J. Wiley & sons; ₍etc., etc.₎ 1911.
xvi, 484 p. illus. 21ᶜᵐ $2.50
© July 28, 1911; 2c. July 31, 1911*; A 292814; A. J. Rosanoff, Kings Park, N. Y. (11–20121) 3885

Sheehan, Patrick Augustine, 1852–
The queen's fillet, by Canon Sheehan ... New York ₍etc.₎ Longmans, Green, and co., 1911.
vi, 376 p. 19½ᶜᵐ. $1.35
© July 24, 1911; 2c. Aug. 10, 1911*; A 295039; Longmans, Green & co. (11–19988) 3886

Southwestern reporter.
Kentucky decisions reported in the Southwestern reporter, annotated, vols. 132, 133, 134, 135, and 136, December, 1910, to May, 1911 ... St. Paul, West publishing co., 1911.
Various paging. 26½ᶜᵐ. $6.00
© Aug. 16, 1911; 2c. Aug. 23, 1911*; A 293695; West pub. co. 3887

Texas decisions reported in the Southwestern reporter, annotated, vols. 134 and 135, March to April, 1911 ... St. Paul, West publishing co., 1911.
Various paging. 26½ᶜᵐ. $5.50
© July 26, 1911; 2c. Aug. 23, 1911*; A 293696; West pub. co. 3888

Stewart, Francis T 1874–
A manual of surgery for students and physicians, by Francis T. Stewart ... 2d ed., with 553 illustrations. Philadelphia, P. Blakiston's son & co., 1911.
xi, 682 p. illus. (partly col.) col. pl. 23ᶜᵐ. $4.00
© July 24, 1911; 1c. July 25, 1911; 1c. July 26, 1911*; A 292705; P. Blakiston's son & co. (11–20120) 3889

Swift, Fletcher Harper.
A history of public permanent common school funds in the United States, 1795–1905, by Fletcher Harper Swift ... New York, H. Holt and company, 1911.
ix, 493 p. incl. tables. 22½ᶜᵐ. $3.50
Bibliography: p. 457–468.
© July 13, 1911; 2c. July 15, 1911*; A 292470; H. Holt & co. (11–18604) 3890

Thackeray, William Makepeace.
The works of William Makepeace Thackeray, with biographical introductions by his daughter Lady Ritchie ... ₍The centenary biographical ed.₎ v. 20, 21. New York and London, Harper & brothers ₍1911₎
2 v. illus., plates, ports. 21ᶜᵐ.
CONTENTS.—v. 20. Roundabout papers, and The second funeral of Napoleon.—v. 21. Denis Duval. Lovel the widower. The wolves and the lamb.
© Aug. 15, 1911; 2c. each Aug. 18, 1911*; A 295242, 295243; Harper & bros. ₍Copyright claimed on introductions only₎ 3891, 3892

Tralow, Johannes.

Kain—der heiland, roman von Johannes Tralow. [2.
aufl.] Berlin, Concordia deutsche verlagsanstalt, g. m. b.
h. [ᶜ1911]
201 p. 20ᶜᵐ. M. 2.00
© May 25, 1911; 2c. Aug. 5, 1911*; A—Foreign 3348; Concordia deutsche
verlags-anstalt, g. m. b. h. (11–19642) 3893

U. S. *Circuit court of appeals.*

... Reports, with annotations. v. 106. St. Paul, West
publishing co., 1911.
xli, [3], 731 p. illus. 23½ᶜᵐ. $2.85
© July 28, 1911; 2c. Aug. 23, 1911*; A 293697; West pub. co. 3894

Upton, Uno.

The strugglers; a story, by Uno Upton. Chicago, Dear-
born publishing co. [ᶜ1911]
257 p. 19½ᶜᵐ. $1.00
© Aug. 3, 1911; 2c. Aug. 7, 1911*; A 292996; Dearborn pub. co.
(11–19660) 3895

Wagner, Richard, 1813–1883.

The dusk of the gods (Götterdämmerung); a dramatic
poem by Richard Wagner, freely translated in poetic
narrative form by Oliver Huckel. New York, Thomas Y.
Crowell company [1911]
xxii, [1], 100, [1] p. front., plates. 19½ᶜᵐ. $0.75
© Aug. 7, 1911; 2c. Aug. 14, 1911*; A 295136; Thomas Y. Crowell co.
(11–20106) 3896

Weber, Ernst, 1873–

Angewandtes zeichnen, neue ausgleiche und ausblicke
von dr. Ernst Weber ... Mit 186 abbildungen im text.
Leipzig und Berlin, B. G. Teubner, 1911.
iv p., 1 l., 124 p. illus. 21ᶜᵐ. M. 2.20
© June 30, 1911; 2c. Aug. 5, 1911*; A—Foreign 3345; B. G. Teubner.
(11–19992) 3897

Wegmann, Edward, 1850–

The design and construction of dams, including mason-
ry, earth, rock-fill, timber, and steel structures, also, the
principal types of movable dams, by Edward Wegmann
... 6th ed., rev. and enl., 1st thousand. New York, J. Wi-
ley & sons; [etc., etc.] 1911.
xvi, 529 p. incl. illus., plates, plans, tables, diagrs. front., plates (partly
fold.) diagrs. (partly fold.) 30½ᶜᵐ. $6.00
Bibliography: p. 507–519.
© July 24, 1911; 2c. July 26, 1911*; A 292714; E. Wegmann, New York.
(11–20115) 3898

[Weyl, Fernand]

... Les oiseaux, fantasie en 2 actes, d'après Aristo-
phane (traduction Lascaris) [Paris, L'Œuvre, ᶜ1911]
2 p. l., 64 p. 27½ᶜᵐ.
Author's pseudonym, Fernand Nozière, at head of title.
© July 7, 1911; 2c. July 29, 1911*; D 24806; Lugné-Poe.
(11–18993) 3898*

Harvard College Library

· PART I, BOOKS, GROUP ᵣSEP 14 1911
no. 70, August, 1911 From the 3904
 U. S. Govern.

Adams, I **William.**
Yodogima in feudalistic Japan, by I. William Adams ...
New York, The Mikilosch press, 1911.
1 p. l., 302 p. 20ᶜᵐ. $3.00
© July 31, 1911; 2c. Aug. 3, 1911*; A 292909; I. W. Adams, Cold Spring-
on-Hudson, N. Y. (11–20311) 3899

American railway engineering association.
Manual of the American railway engineering associa-
tion ... Edition of 1911. Chicago, Ill., American railway
engineering association ₁1911₁
477 p. illus., tables (partly fold.) diagrs. (partly fold.) 23ᶜᵐ. $2.50
© Aug. 4, 1911; 2c. Aug. 5, 1911; A 295111; Amer. railway engineering
assn. (11–20329) 3900

The **americana;** a universal reference library, comprising
the arts and sciences, literature, history, biography,
geography, commerce, etc., of the world. Editor-in-
chief: Frederick Converse Beach ... managing editor:
George Edwin Rines, assisted by more than one thou-
sand of the most eminent scholars and authorities in
America. Issued under the editorial supervision of the
Scientific American ... New York, Scientific American
compiling dep't ₍ᶜ1911₎
20 v. illus., plates (partly col., partly double) ports., maps (partly fold.)
plans, charts. diagrs. 26ᶜᵐ. $8.00 per vol.
© June 20, 1911; 2c. June 24, 1911; A 295147; F. C. Beach, New York.
(11–20302) 3901

———— Supplement; a comprehensive record of the latest
knowledge and progress of the world, compiled by the
Editorial staff of the Americana, assisted by expert
authorities. ₁New York₁ The Scientific American com-
piling dep't, 1911.
2 v. plates, ports. 26ᶜᵐ. $8.00 per vol.
Lettered vols. XXI–XXII.
© July 12, 1911; 2c. July 13, 1911; A 295148; F. C. Beach, New York.
(11–20303) 3902

Atkinson, William Walker, 1862–
The mind-building of a child, by William Walker Atkin-
son. Chicago, A. C. McClurg & co., 1911.
2 p. l., 7–81 p. 19½ᶜᵐ. $0.50
© Aug. 9, 1911; 2c. Aug. 12, 1911*; A 295094; Library shelf, Chicago.
(11–20292) 3903

Barnes, John Sanford, ed.
The logs of the Serapis—Alliance—Ariel, under the
command of John Paul Jones, 1779–1780, with extracts
from public documents, unpublished letters, and narra-
tives, and illustrated with reproductions of scarce prints:
ed. by John S. Barnes ... New York, Printed for the
Naval history society by the De Vinne press, 1911.
xliv, 138 p. incl. front. (port.) facsims. pl. 26ᶜᵐ. (Half-title: Pub-
lications of the Naval history society. vol. 1) $10.00
© Aug. 1, 1911; 2c. Aug. 4, 1911*; A 292937; Naval history soc.
(11–20497) 3904

Bible. *English.*

The 1911 Bible. The Holy Bible, containing the Old and New Testaments translated out of the original tongues, and with the former translations diligently compared and rev. by King James's special command, 1611; the text carefully corrected and amended by American scholars, 1911. With a new system of references. New York, Oxford university press, American branch; London [etc.] H. Frowde, 1911.

2 p. l., 1152, [8] p. maps, plan. 22½ᶜᵐ.

© Aug. 10, 1911; 2c. Aug. 14, 1911*; A 295138; Oxford univ. press., Amer. branch. (11–20319) 3905

Campbell, George, 1848–

George Campbell on progressive government, reduced to questions and answers ... Coffeyville, Kan., Fancher printing co. [ᶜ1911]

147 p. illus. 22½ᶜᵐ. $1.00

© Aug. 1, 1911; 2c. Aug. 9, 1911*; A 295034; G. Campbell, Coffeyville, Kan. (11–20294) 3906

Chilton, Claudius Lysias.

Song of the Southland, and other poems, by Claudius Lysias Chilton. Montgomery, Ala., The Paragon press, 1911.

6 p. l., 63 p. 23½ᶜᵐ. $1.00

© Aug. 9, 1911; 2c. Aug. 12, 1911*; A 295097; Arthur Bounds Chilton, Montgomery, Ala. (11–20349) 3907

Cossmann, H.

... Deutsche flora. 4., gänzlich neu bearb. aufl., mit 884 abbildungen. 1. t. Breslau, F. Hirt, 1911.

448 p. 19½ᶜᵐ. M. 4.25

© July 1, 1911; 2c. July 19, 1911*; A—Foreign 3242; Ferdinand Hirt. (11–20326) 3908

Coulter, John Lee.

Co-operation among farmers, the keystone of rural prosperity, by John Lee Coulter ... New York, Sturgis & Walton company, 1911.

3 p. l., v–vii p., 2 l., 3–281 p. 2 pl. (incl. front.) 19ᶜᵐ. (*Half-title:* The young farmers' practical library. ed. by Ernest Ingersoll) $0.75

© Aug. 11, 1911; 2c. Aug. 12, 1911*; A 295106; Sturgis & Walton co. (11–20291) 3909

De Lee, Joseph Bolivar, 1869– *ed.*

... Obstetrics, ed. by Joseph B. De Lee ... with the collaboration of Herbert M. Stowe ... Chicago, The Year book publishers [ᶜ1911] ·

233 p. illus., plates. 19ᶜᵐ. (The practical medicine series ... vol. v, series 1911) $1.25

© Aug. 1, 1911; 2c. Aug. 7, 1911*; A 292987; Year book publishers. (11–20323) 3910

Eckermann, Johann Peter, 1792-1854.
Johann Peter Eckermann, Gespräche mit Goethe in den letzten jahren seines lebens ⟨1823/1832⟩ nach der originalausgabe neu in auswahl hrsg. von Gerhard Merian. Berlin, F. Heyder ₍ᶜ1911₎
223 p. front. (port.) 17½ᶜᵐ. M. 3.00
© June 12, 1911; 2c. Aug. 5, 1911*; A—Foreign 3349; Fritz Heyder.
(11-20350) 3911

Eldridge, Edward Henry.
Shorthand dictation exercises, by Edward H. Eldridge ... with vocabulary in the Munson system of shorthand. Outlines prepared by B. H. Davis. New York, Cincinnati ₍etc.₎ American book company ₍ᶜ1911₎
240 p. 25½ x 22ᶜᵐ. $0.65
"Munson edition."
© July 27, 1911; 2c. July 29, 1911*; A 292801; E. H. Eldridge, Boston.
(11-20344) 3912

Fischer, Saxon.
Story of Ivan, by Saxon Fischer. Boston, Mass., Ivan publishing company ₍ᶜ1911₎
244 p. 20½ᶜᵐ.
© Aug. 8, 1911; 2c. Aug. 11, 1911*; A 295087; S. Fischer, Boston.
(11-20317) 3913

Geymüller, Heinrich Adolf, *freiherr* von, 1839-1909.
Heinrich von Geymüllers nachgelassene schriften ... Hrsg. von geheimrat prof. dr. Josef Durm ... und E. Laroche ... hft. 1. Architektur und religion. Basel, Kober, C. F. Spittlers nachf., 1911.
xvi, 120 p., 1 l. port. 22½ᶜᵐ.
© June 10, 1911; 2c. Aug. 5, 1911*; A—Foreign 3355; Kober, C. F. Spittlers nachfolger. (11-19991) 3914

Gould, Elizabeth Lincoln.
Felicia's folks, by Elizabeth Lincoln Gould ... illustrated by Mary L. Price. Philadelphia, The Penn publishing company, 1911.
195 p. front., plates. 19½ᶜᵐ. $1.00
© Aug. 12, 1911; 2c. Aug. 14, 1911*; A 295126; Penn pub. co.
(11-20310) 3915

Gran, Gerhard von der Lippe, 1856-
... Jean Jacques Rousseau. Kristiania, H. Aschehoug & co. (W. Nygaard) 1910.
xxii, 304 p. front. (port.) 22½ᶜᵐ. (*His* Det nittende aarhundredes tilblivelse, ı) kr. 5
© Nov. 11, 1910; 2c. July 19, 1911; A—Foreign 3284; H. Aschehoug & co.
(11-20096) 3916

Griffith, Walter Smith.
Swatches, by Walter Smith Griffith. Jersey City, N. J., Riant studio, 1911.
2 p. l., 190 p. incl. illus., plates. pl., port. 15½ᶜᵐ. $2.00
© Aug. 4, 1911; 2c. Aug. 7, 1911*; A 292988; W. S. Griffith, Jersey City, N. J. (11-20484) 3917

Hancock, Harrie Irving, 1868–

Dick Prescott's fourth year at West Point; or, Ready to drop the gray for shoulder straps, by H. Irving Hancock ... Philadelphia, Henry Altemus company [*1911]

252 p. incl. front., plates. 19½ᶜᵐ. $0.50

© Aug. 14, 1911; 2c. Aug. 15, 1911*; A 295163; Howard E. Altemus, Philadelphia. (11–20307) **3918**

Dick Prescott's second year at West Point; or, Finding the glory of the soldier's life, by H. Irving Hancock ... Philadelphia, Henry Altemus company [*1911]

253 p. incl. front., plates. 19½ᶜᵐ. (*On cover:* Altemus' West Point series) $0.50

© Aug. 10, 1911; 2c. Aug. 11, 1911*; A 295071; Howard E. Altemus, Philadelphia. (11–20305) **3919**

Dick Prescott's third year at West Point; or, Standing firm for flag and honor, by H. Irving Hancock ... Philadelphia, Henry Altemus company [*1911]

251 p. incl. front., plates. 19½ᶜᵐ. (*On cover:* Altemus' West Point series) $0.50

© Aug. 12, 1911; 2c. Aug. 14, 1911*; A 295125; Howard E. Altemus, Philadelphia. (11–20306) **3920**

Hawkes, Clarence, 1869–

Master Frisky's heroism, by Clarence Hawkes ... illustrated by Charles Copeland. Philadelphia, G. W. Jacobs & company [1911]

xvi, 193 p. front., plates. 19½ᶜᵐ. $1.00

© July 31, 1911; 2c. Aug. 10, 1911*; A 295041; George W. Jacobs & co. (11–20314) **3921**

An **historical** digest of the provincial press, being a collation of all items of personal and historic reference relating to American affairs printed in the newspapers of the provincial period ... Massachusetts series. v. 1. Comp. and ed. under the direction of Lyman Horace Weeks ... and Edwin M. Bacon ... Boston, The Society for americana, inc., 1911.

xiii, 564 p. incl. front. plates, ports., facsims. (partly fold.) 24½ᶜᵐ. $7.50

List of authorities: v. 1, p. 11–18.

© May 16, 1911; 1c. June 3, 1911; 1c. June 5, 1911*; A 289459; Society for americana. (11–13734) **3922**

Holmes, George S.

Analytical manual of the English Bible, by George S. Holmes ... Philadelphia, Pa., Press of J. B. Lippincott company [*1911]

viii, 260 p. geneal. tables. 26½ᶜᵐ.

© June 24, 1911; 2c. July 19, 1911*; A 292583; G. S. Holmes, Corvalis, Pa. (11–20335) **3923**

Jacobs, Thornwell.

The midnight mummer, and other poems, by Thornwell Jacobs ... Atlanta, The Redbrook company, 1911.
72 p. front., plates. 22ᶜᵐ. $1.00
© Aug. 10, 1911; 2c. Aug. 12, 1911*; A 295104; T. Jacobs, Atlanta.
(11–20348) 3924

Kemper, General William Harrison, 1839–

A medical history of the state of Indiana, by G. W. H. Kemper ... Chicago, Ill., American medical association press, 1911.
xxv p., 1 l., 393 p. incl. front., illus., ports. 20½ᶜᵐ. $2.50
© Aug. 7, 1911; 2c. Aug. 10, 1911*; A 295043; G. W. H. Kemper, Muncie, Ind. (11–20321) 3925

Klemm, Otto, 1884–

... Geschichte der psychologie, von Otto Klemm ... Leipzig und Berlin, B. G. Teubner, 1911.
x, 388 p. 19½ᶜᵐ. (Wissenschaft und hypothese, viii) M. 8.00
"Zur literatur": p. 9–11.
© May 31, 1911; 2c. Aug. 5, 1911*; A—Foreign 3347; B. G. Teubner.
(11–20333) 3926

Lewis, William Draper, 1867– comp.

Equity jurisdiction, bills of peace; a collection of cases with notes. By Wm. Draper Lewis ... and Miriam McConnell ... [Philadelphia? °1910]
cover-title, 72 p. 23ᶜᵐ. $0.70
"Compiled in the Biddle memorial library of the University of Pennsylvania."
© July 26, 1911; 2c. July 29, 1911*; A 292799; W. D. Lewis, Philadelphia.
(11–20504) 3927

Liseth, Rasmus A.

Den forlorne sön gaar hjem fra denne verden til den tilkommende. Av Rasmus A. Liseth. Andet oplag ... Minneapolis, Minn., K. T. Holter publishing companys trykkeri [1911]
260 p. front. (port.) 18ᶜᵐ. $1.00
© June 21, 1911; 2c. Aug. 12, 1911*; A 295114; R. A. Liseth, Carpio, N. D.
(11–20334) 3928

Meier, Adolphus Gustavas, 1879–

The practical orthodontist ... [by] A. G. Meier. St. Louis, Mo., Kutterer-Jansen printing co., °1911·
1 p. l., 56 p. illus. 23½ᶜᵐ.
© July 24, 1911; 2c. July 28, 1911*; A 292768; Kutterer-Jansen printing co. (11–20123) 3929

Mertins, Gustave Frederick.

A watcher of the skies, by Gustave Frederick Mertins ... New York, Thomas Y. Crowell company [1911]
3 p. l., 376 p. col. front. 20½ᶜᵐ. $1.25
© Aug. 10, 1911; 2c. Aug. 14, 1911*; A 295135; Thomas Y. Crowell co.
(11–20312) 3930

Miller, Francis Trevelyan, *ed.*

... The photographic history of the civil war ... [v. 8]
Francis Trevelyan Miller, editor-in-chief; Robert S. La-
nier, managing editor. Thousands of scenes photo-
graphed 1861–65, with text by many special authorities.
New York, The Review of reviews co., 1911.
382, [1] p. incl. front., illus., ports. 28½ᶜᵐ. $3.10
CONTENTS.—v. 8. Soldier life. Secret service.
ⓒ Aug. 15, 1911; 2c. Aug. 22, 1911*; A 295341; Patriot pub. co. 3931

Mitsotakis, Johannes K., 1840?–1905.

... Taschenwörterbuch der neugriechischen umgangs-
und schriftsprache; mit angabe der aussprache nach dem
phonetischen system der methode Toussaint-Langen-
scheidt ... Von prof. Joh. K. Mitsotakis ... 2. aufl. ...
Berlin-Schöneberg, Langenscheidtsche verlagsbuchhand-
lung [1911]
xvi, 996 p. 16ᶜᵐ. (Methode Toussaint-Langenscheidt) M. 3.50
Added t.-p. in modern Greek.
ⓒ June 15, 1911; 2c. Aug. 12, 1911*; A—Foreign 3362; Langenscheidtsche
verlagsbuchhandlung (Prof. G. Langenscheidt) (11–20354) 3932

Murray, Daniel Alexander, 1862–

Elements of plane trigonometry, by Daniel A. Murray
... New York [etc.] Longmans, Green, and co., 1911.
ix, 136 p. pl., diagrs. 21ᶜᵐ. $0.75
ⓒ July 26, 1911; 2c. Aug. 10, 1911*; A 295038; Longmans, Green, & co.
(11–20327) 3933

Musselman, De Lafayette.

Musselman's complete bookkeeping, a treatise on mod-
ern methods of accounting and office practice. Quincy,
Ill., D. L. Musselman [°1911]
143 p. illus. 27ᶜᵐ. $1.50
ⓒ Aug. 1, 1911; 2c. Aug. 10, 1911*; A 295036; D. L. Musselman.
(11–20295) 3934

Neal, E Virgil.

... Modern illustrative bookkeeping, advanced course,
by E. Virgil Neal and C. T. Cragin; rev. and enl. by J. E.
King. Script illustrations by E. C. Mills. New York,
Cincinnati [etc.] American book company [1911]
[149]–324 p. incl. illus., forms. 25ᶜᵐ. (Williams & Rogers series)
ⓒ Aug. 10, 1911; 2c. Aug. 12, 1911*; A 295107; Amer. book co.
(11–20293) 3935

Niblett, J T.

Storage batteries, stationary and portable; a clear ex-
position of the principles governing the action of storage
batteries. Detailed instructions regarding their construc-
tion, care and maintenance, by J. T. Niblett ... Chicago.
F. J. Drake & company [°1911]
1 p. l., 7–77, iv p. illus. 17ᶜᵐ. $0.50
ⓒ July 15, 1911; 2c. July 20, 1911*; A 292594; Frederick J. Drake. Chi-
cago. (11–20325) 3936

Noussanne, Henri de, 1865–

... Un jeune homme chaste. Paris, Calmann-Lévy
[ᶜ1911]
3 p. l., 300 p. 19ᶜᵐ. fr. 3.50
© June 21, 1911; 2c. July 10, 1911*; A—Foreign 3166; Calmann-Lévy.
(11–20486) 3937

Pichon, Jules E.

... Leçons pratiques de vocabulaire, de syntaxe et de
lecture littéraire, par J. E. Pichon ... Avec de nom-
breuses illustrations et un appendice: Les modes et les
temps des verbes français. Freiburg (Baden) J. Biele-
feld, 1911.
272, [1] p. illus. 20ᶜᵐ. $3.50
At head of title: Méthode directe pour l'enseignement des langues
vivantes.
"Appendice," A52 p., bound in paper cover, in pocket.
© June 3, 1911; 2c. Aug. 12, 1911*; A—Foreign 3367; J. Bielefelds verlag.
(11–20351) 3938

Pratique médico-chirurgicale.

... Nouvelle Pratique médico-chirurgicale illustrée ...
Directeurs: E. Brissaud, A. Pinard, P. Reclus ... Secré-
taire général: Henry Meige. t. 7, 8. Paris, Masson et
cⁱᵉ, 1911.
2 v. illus., plates, map, diagrs. 25ᶜᵐ. fr. 18 each
CONTENTS.—7. Pouls–Strophantus.—8. Strychnées–Zymothérapie.
© July 28, 1911; 2c. each Aug. 19, 1911*; A—Foreign 3396; Masson & cie.
3939

Roulet, Mary F Nixon-

Indian folk tales, by Mary F. Nixon-Roulet ... New
York, Cincinnati [etc.] American book company [ᶜ1911]
192 p. incl. front., illus. 19ᶜᵐ. (On cover: Eclectic readings) $.40
© Aug. 2, 1911; 2c. Aug. 4, 1911*; A 292939; M. F. Nixon-Roulet, Chi-
cago. (11–20301) 3940

Sakurai, Tadayóshi.

Niku-dan, menschenopfer; tagebuch eines japanischen
offiziers während der belagerung und erstürmung von
Port Arthur, von Tadayoshi Sakurai ... Übersetzt von
A. Schinzinger ... Mit 3 bildern, sowie einer kartenskizze
von Walther Schmidt ... Freiburg (Baden) J. Bielefeld,
1911.
206, [2] p. pl., 2 port. (incl. front.) fold. map. 20ᶜᵐ. M. 3.50
© June 16, 1911; 2c. Aug. 12, 1911*; A—Foreign 3368; J. Bielefelds ver-
lag. (11–20338) 3941

Schwengberg-Eggersdorf, Max, 1863–

Die blonde Sylterin. Die kurmacher von Borkum. Ge-
schichten vom Nordseestrand, von Max Eggersdorf. 4.
aufl. Leipzig, G. Müller-Mann [1911]
125 p. 19½ᶜᵐ. M. 1
© June 20, 1911; 2c. Aug. 4, 1911*; A—Foreign 3327; G. Müller-Mann'-
sche verlagsbuchhandlung. (11–20487) 3942

Southwestern reporter.

Missouri decisions reported in the Southwestern reporter, vols. 1, 2, 3, 4, and 5, August, 1886, to December, 1887; vols. 6, 7, 8, 9, and 10, January, 1888, to March, 1889; vols. 15, 16, and 17, February, 1891, to January, 1892 ... St. Paul, West publishing co., 1911.

3 v. 26½ᶜᵐ. $5.50 each.
© May 13, 1911, May 13, 1911, May 8, 1911; 2c. each May 22, 1911*; A 289098, 289099, 289097; West pub. co. 3943-3945

―― vols. 11, 12, 13, and 14, April, 1889, to February, 1891 ... St. Paul, West publishing co., 1911.

Various paging. 26½ᶜᵐ. $5.50
© May 11, 1911; 2c. May 20, 1911*; A 289085; West pub. co. 3946

Starr, George Henry, comp.

The Christmas spirit; a book of merriment, comfort and cheer, selected by George Henry Starr. New York, The Platt & Peck co. [°1911]

3 p. l., 9-138 p. 17½ᶜᵐ. $0.75
© July 26, 1911; 2c. Aug. 1, 1911*; A 292868; Platt & Peck co.
(11-20300) 3947

Stutenroth, Allen Wert, 1875–

The hope and resurrection of the dead, both of the just and the unjust. Practical Christianity, a reason of the hope that is in you. By Allen W. Stutenroth ... Chicago, Ill., The author [°1911]

236 p. 21½ᶜᵐ. $1.50
© Aug. 5, 1911; 2c. Aug. 8, 1911*; A 295013; A. W. Stutenroth, Chicago.
(11-20316) 3948

Thomas, J B.

Some parables of nature in the light of to-day, by J. B. Thomas ... Cincinnati, Jennings and Graham; New York, Eaton and Mains [°1911]

95 p. 18ᶜᵐ. $0.50
"This little gem of New Testament study is taken from the Methodist review."—Introd.
CONTENTS.—Introductory note.—Preliminary considerations.—Parables of the kingdom: I. The problem of environment; II. The problem of organic origins; III. The problem of a vital force; IV. The problem of destructive agencies; V. The problem of parabolic purpose; VI. The concluding disclosure.
© July 27, 1911; 2c. July 29, 1911*; A 292787; Jennings & Graham.
(11-20315) • 3949

Townsend, Richard Walter, 1859–

The passing of the Confederate, by R. Walter Townsend, suggested by the account given of the decrepit appearance of the Confederate veterans, during their march through the streets of Lumberton, N. C., at the unveiling of a monument to the memory of the Confederate dead from Robeson County, May 10, 1907. New York and Washington, The Neale publishing company, 1911.

20 p. 18½ᶜᵐ. $0.60
© Feb. 25, 1911; 2c. July 31, 1911*; A 292827; R. W. Townsend, Raeford, N. C. (11-20304) 3950

Lightning Source UK Ltd.
Milton Keynes UK
UKHW021028241218
334505UK00013B/1042/P

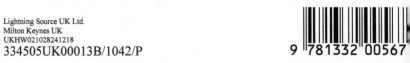

9 781332 005673